GOYA AND THE SPIRIT OF ENLIGHTENMENT

The exhibition is made possible by grants
from Manufacturers Hanover and The
New York Stock Exchange Foundation, Inc.

Transportation assistance has been pro-
vided by Iberia Airlines of Spain.

It is also supported by grants from the
National Endowment for the Humanities,
a federal agency, Banco Central, and
Comité Conjunto Hispano-Norteameri-
cano para la Cooperación Cultural y Edu-
cativa. An indemnity has been granted by
the Federal Council on the Arts and the
Humanities.

Additional support in New York has been
provided by the Robert Wood Johnson Jr.
Charitable Trust.

This exhibition was organized by the
Museum of Fine Arts, Boston, Museo del
Prado, Madrid, and The Metropolitan
Museum of Art, New York.

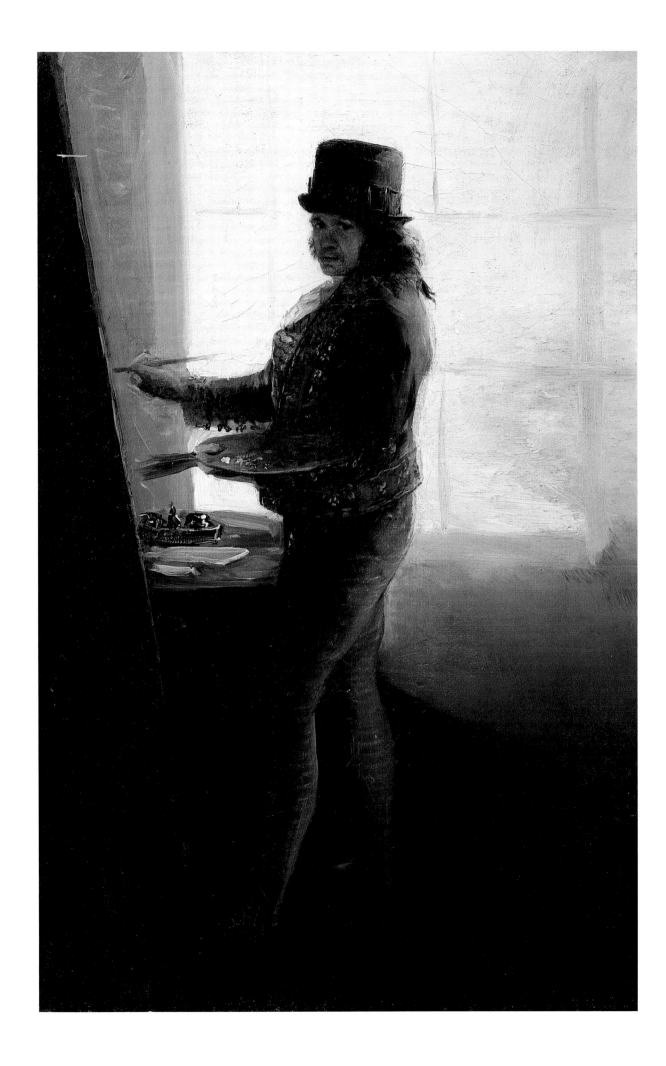

GOYA AND THE SPIRIT OF ENLIGHTENMENT

Alfonso E. Pérez Sánchez and Eleanor A. Sayre

Codirectors of the Exhibition

With contributions by Gonzalo Anes, Michael Armstrong Roche, Jeannine Baticle,
Nigel Glendinning, Fred Licht, Teresa Lorenzo de Márquez,
Manuela B. Mena Marqués, Margarita Moreno de las Heras, Alfonso E. Pérez Sánchez,
Eleanor A. Sayre, Stephanie Loeb Stepanek, Gary Tinterow, Jesusa Vega

Museo del Prado, Madrid Museum of Fine Arts, Boston The Metropolitan Museum of Art,
New York

published by

Museum of Fine Arts, Boston

Copyright © 1989 by Museum of Fine Arts
Boston, Massachusetts
ISBN 0-87846-300-3 (paper)
ISBN 0-87846-299-6 (cloth)
Library of Congress catalogue card no.
88-63605

Printed and typeset in U.S.A. by
Acme Printing Co., Wilmington, MA
Bound by Acme Bookbinding Co.
Charlestown, MA
Designed by Carl Zahn

Cover (and jacket):
Allegory on the Adoption of the Constitution of
1812 (cat. no. 74)
1812-1814
Oil on canvas
Nationalmuseum, Stockholm

Frontispiece:
Goya in His Studio (cat. no. 18)
About 1790-1795
Oil on canvas
Real Academia de Bellas Artes de San
Fernando, Madrid

Exhibition dates:
Museo del Prado
October 6 - December 18, 1988
Museum of Fine Arts, Boston
January 18 - March 26, 1989
The Metropolitan Museum of Art, New York
May 9 - July 16, 1989

Photographs have been generously supplied by
the lenders and by the following:
Jorg P. Anders
Jaime Blassi
Joan-Ramon Bonet Verdaguer Fotógraf, Palma
de Mallorca
Museum of Fine Arts, Boston
Sheldan Collins
Erik Dollitzer
Dollitzer, Strong, and Meyer
Lynton Gardiner
Studio Grünke
Lichtbildwerkstätte "Alpenland"
Archivo Mas, Barcelona
Instituto Amatller de Arte Hispánico
Nuove Edizioni Gabriele Mazzotta
Archivo Oronoz, Madrid
Terry Schaak, Chicago
Fotographía Palanzuelos

TABLE OF CONTENTS

LENDERS

Public Collections

THE ART INSTITUTE OF CHICAGO
Chicago, Illinois

THE ASHMOLEAN MUSEUM
Oxford, England

BANCO DE ESPAÑA
Madrid

BIBLIOTECA NACIONAL
Madrid

BIBLIOTHÈQUE NATIONALE
Paris

THE BOWES MUSEUM
Barnard Castle
Durham, England

THE BRITISH MUSEUM
London

THE CLEVELAND MUSEUM OF ART
Cleveland, Ohio

THE FITZWILLIAM MUSEUM
Cambridge

FLINT INSTITUTE OF ARTS
DeWaters Art Center
Flint, Michigan

FONDAZIONE MAGNANI-ROCCA
Corte di Mamiano
Parma

FUNDACIÓN BARTOLOMÉ MARCH
SERVERA
Mallorca

FUNDACIÓN LÁZARO GALDIANO
Madrid

THE J. PAUL GETTY MUSEUM
Malibu, California

GRAPHISCHE SAMMLUNG ALBERTINA
Vienna

HARVARD UNIVERSITY ART MUSEUMS
Cambridge, Massachusetts

KUNSTHALLE BREMEN
Bremen

MEADOWS MUSEUM
Southern Methodist University
Dallas, Texas

THE METROPOLITAN MUSEUM OF ART
New York

THE MINNEAPOLIS INSTITUTE OF ARTS
Minneapolis, Minnesota

MUSÉE DU LOUVRE
Paris

MUSEO MUNICIPAL DE BELLAS ARTES
DE SANTANDER
Santander

MUSEO DEL PRADO
Madrid

MUSEO DE LA REAL ACADEMIA DE
BELLAS ARTES DE SAN FERNANDO
Madrid

MUSEO ROMÁNTICO
Madrid

MUSEU DE ARTE DE SÃO PAULO
São Paulo

MUSEUM OF FINE ARTS
Boston, Massachusetts

THE NATIONAL GALLERY
London

NATIONAL GALLERY OF ART
Washington, D.C.

NATIONAL GALLERY OF CANADA
MUSÉE DES BEAUX-ARTS DU CANADA
Ottawa

NATIONALMUSEUM
Stockholm

THE NEW YORK PUBLIC LIBRARY
New York

PATRIMONIO NACIONAL
Palacio Real
Madrid

THE PHILLIPS COLLECTION
Washington, D.C.

REAL ACADEMIA DE LA HISTORIA
Madrid

STAATLICHE MUSEEN PREUSSISCHER
KULTURBESITZ, KUPFERSTICHKABINETT
Berlin

SZÉPMŰVÉSZETI MÚZEUM
Budapest

Private Collections

HEIRS OF THE MARQUES DE
CASA TORRES

BARTOLOMÉ MARCH SERVERA
Madrid

JAIME ORTIZ-PATIŇO

FAMILY OF THE DUQUES DE SUECA
Madrid

ANGELA MARÍA TELLEZ GIRÓN,
DUQUESA DE OSUNA
Seville

JOSÉ LUIS VÁREZ FISA
Madrid

IAN WOODNER FAMILY COLLECTION
New York

*and other European and American private
collectors who wish to remain anonymous*

FOREWORD

The Spanish artist Francisco Goya (1746-1828) was an outstanding individual who lived in a period of European history known for its advances in all fields. Through his works of art we can come to understand the depth and variety of the ideas of the Spanish Enlightenment and the Liberalism that grew out of it. The latest research on the history, literature, and intellectual currents of this period in Spain makes Goya's artistic genius more intelligible than ever before. Goya shared the Enlightenment's preoccupation with reason and superstition, authority and emancipation, society and the individual. The liberal ideals of popular sovereignty, government by law, and freedom of expression that spawned the Spanish Constitution of 1812 were held as well by Goya.

This is the first exhibition and catalogue whose aim is to demonstrate and interpret the relationship between Goya and the Enlightenment and to understand what Goya's work, which sprang from a tradition of enlightened Spanish thought, owed to his age and what his age owed to him. We hope this exhibition will lay to rest a common misperception that Goya was an isolated genius working in a cultural vacuum by presenting paintings, drawings, and prints that examine themes of the Enlightenment and Liberalism. The selection of works of art is designed to reveal both the close connection of Goya's art to the ideas and values of the literature and philosophy of his contemporaries in Spain as well as the artist's own penetrating observations. Two of the Enlightenment themes Goya considered are the importance of reason and the folly of vice. Throughout his works, viewers will see how the artist communicated psychological realities: for instance, the harm done by the hypocrisy of those who pretend to be what they are not, the abuses that arise from superstition, the dehumanizing effect of bigotry, and the undermining by war and famine of morality and the human instinct for compassion. Our goal is to demonstrate how Goya's images arose out of a need to create a visual language for the new questioning spirit and how his particular techniques and vivid style were suited to the exposition of these varied and subtle ideas. His immense imaginative powers become evident when we consider Goya's ability to draw from a vast array of sources in his culture and to forge innumerable new compositions and invent metaphors that have a universal and indelible value. Through Goya's work we can also appreciate why the Enlightenment – with its questions about the relationships of religion to politics, faith to reason, and war to morality, as well as the psychological roots of human behavior – is said to inaugurate the modern age, an age in which these preoccupations remain very much alive.

In 1984 the Museum of Fine Arts, Boston, the Museo del Prado, Madrid, and The Metropolitan Museum of Art, New York, under the directorships, respectively, of Jan Fontein, Alfonso E. Pérez Sánchez, and Philippe de Montebello, decided to collaborate on this exhibition. Alfonso E. Pérez Sánchez and Eleanor A. Sayre, curator emeritus of the Department of Prints, Drawings, and Photographs at the Boston Museum, both of whom long felt that a Goya exhibition dedicated to these ideas was needed, were to serve as codirectors. In this capacity they were responsible for the selection of the works to be exhibited and the compilation of the catalogue. Gary Tinterow, associate curator of the Department of European Paintings, guided the pro-

ject at the Metropolitan Museum. It was determined that the Museum of
Fine Arts would serve as the primary organizing institution, with responsibil-
ity for research and fund-raising during the planning stage, requesting loans,
and organizing the transportation of works of art. This catalogue, published
in Spanish and English editions, is a collaborative effort. The entries on
exhibited works were written by scholars in Spain and the United States in
association with both the Museo del Prado and the Boston Museum. In order
to provide a cultural and historical perspective, essays were sought from
European and American scholars, further reflecting the cooperative spirit of
the entire project.

Goya and the Spirit of Enlightenment opens at the Museo del Prado, travels
to the Museum of Fine Arts, and closes at The Metropolitan Museum of Art.
All but a few of the paintings seen in Madrid will travel to the United States,
where a similar number of paintings that could not be included in the Span-
ish exhibition will be shown. Since works of art on paper are fragile and
sensitive to light, different prints and drawings are exhibited on both sides of
the Atlantic. In their selection of drawings for the Spanish and American
exhibitions, the codirectors of the exhibition have attempted to present simi-
lar themes. Whenever possible, they have tried to show drawings from Spain
in the United States and send drawings from American collections to Spain.
For most of the prints, duplicate impressions were borrowed for the Spanish
and American exhibitions. However, since we can only know Goya's inten-
tions for the print series on the *Disasters of War* and the *Disparates* through
rare or unique working proofs, some of the prints from these series will be
seen in either Spain or the United States.

One of Goya's contemporaries, the satirist José Bartolomé Gallardo Blanco,
referred to Goya as a painter-philosopher. We hope that this exhibition and
catalogue will demonstrate this to be a truly fitting description of the artist.

ALFONSO E. PÉREZ SÁNCHEZ ALAN SHESTACK PHILIPPE DE MONTEBELLO
Director *Director* *Director*
Museo del Prado *Museum of Fine Arts* *The Metropolitan Museum*
Madrid *Boston* *of Art, New York*

DIRECTORS' ACKNOWLEDGMENTS

Goya and the Spirit of Enlightenment has been warmly supported by our friends and colleagues. We are especially beholden to the kind offices of the Spanish Ministry of Culture, in particular to Miguel Satrústegui Gil-Delgado, Subsecretario del Ministerio de Cultura, Carmen Giménez Martín, Directora del Centro Nacional de Exposiciones, and Javier Aiguabella, Centro Nacional de Exposiciones, each of whom contributed significantly, in expertise and guidance, to the successful realization of this project. For their support and invaluable assistance in negotiating important loans in Spain we should like to thank Plácido Arango, Leopóldo Rodes, and Alvaro Fernández-Villaverde, Marqués del Viso; we were also afforded the assistance of Zahíra Veliz. This exhibition has profited from the counsel of John Brealey, Conservator of Paintings at The Metropolitan Museum of Art, whose time for the past year has been divided between New York and Madrid. Roy Perkinson, Conservator of Prints, Drawings, and Photographs at the Museum of Fine Arts, Boston, examined most of the works of art on paper and provided the curators with valuable information on medium and condition.

We are grateful to the many European and American lenders who have made the exhibition possible. Several institutions made exceptions to their policies in order to lend works normally unavailable, and for this we are especially indebted to the directors of the Szépművészeti Múzeum, Budapest; the Patrimonio Nacional, Madrid; the Real Academia de Bellas Artes de San Fernando, Madrid; the National Gallery of Canada, Ottawa; the Fondazione Magnani-Rocca, Parma; the Museo Municipal, Santander; the Nationalmuseum, Stockholm; the Phillips Collection, Washington, D.C. Individual collectors have made even greater sacrifices. By entrusting their treasures to us, they have forgone their private pleasure in the interest of an appreciative public. While acknowledging our enormous debt to the collectors who wish to remain anonymous, we should like to single out for thanks: the heirs of the Marques de Casa Torres; Don Bartolomé March Servera; Jaime Ortiz-Patiño; Angela María Tellez Girón, Duquesa de Osuna; the family of the Duques de Sueca, José Luis Várez Fisa, and the Ian Woodner Family Collection.

The selection and organization of the exhibition and the writing of the catalogue were conducted by an international group working in collaboration under the supervision of the codirectors, Alfonso E. Pérez Sánchez in Madrid and Eleanor A. Sayre in Boston, both of whom also wrote essays and portions of the catalogue. Although the codirectors tended to set the tone and direction for research in their respective countries, often providing valuable research materials, authors were allowed to follow their own paths and reach independent conclusions. Authors read each other's entries and essays for comments, and the codirectors reviewed all catalogue work.

In Spain, Manuela Mena, as Subdirector of the Prado, handled various administrative matters, in addition to writing entries. Margarita Moreno de las Heras, Research Assistant, was responsible for the coordination of the exhibition in Spain. Sra. Moreno spent ten months conducting research in the Boston Museum office and returned to Spain to write most of the painting entries. Jesusa Vega, who assisted Eleanor Sayre with research in Spain, also wrote entries and an introduction on the *Disasters of War*, and the *Great Pyramid*.

In Boston, Stephanie Loeb Stepanek, Research Associate, served ably as manager of the office in the Boston Museum, coordinating the exhibition and catalogue from its earliest stage, as well as writing entries and an introduction to the Inquisition drawings. Michael Armstrong Roche, Research Assistant, contributed to the historical and literary research and participated in the selection process and the writing of grant applications during the planning phase. Mr. Armstrong Roche wrote a significant portion of the print and drawing entries and translated all entries and essays from Spanish and French into English, except catalogue numbers 7, 10, 11, 13, 16, 22, and 23. Teresa Lorenzo de Márquez, Research Assistant, assisted Eleanor Sayre in research on Goya's language and wrote an essay on carnival traditions in relation

to Goya's art and a number of entries on prints and drawings. Mrs. Lorenzo de Márquez also assisted in the editing of material translated into Spanish for the Spanish edition.

As coordinator of the exhibition at The Metropolitan Museum of Art, Gary Tinterow, Associate Curator in the Department of European Paintings, was chiefly responsible for its implementation in New York, but his sound advice has served equally his colleagues in Madrid and Boston. Mr. Tinterow also wrote the Chronology. Anne Norton, Research Assistant, whose knowledge of Spanish art, culture, and language has been a valuable asset, has worked closely with Mr. Tinterow in coordinating the project at the Metropolitan Museum and in the preparation of the Chronology.

Our deepest thanks are extended also to several international scholars for contributing their insightful essays which, in providing a historical, literary, and artistic background to Goya's art, are a valuable addition to the catalogue: Gonzalo Anes, Jeannine Baticle, Nigel Glendinning, and Fred Licht.

Needless to say, staff members and consultants at the three organizing institutions have worked tirelessly in various capacities to bring this exhibition to fruition. At the Museo del Prado we are grateful to: Agustín Martín González, Administrator, and Natividad Galindo, Registrar. Francisco Javier Rocha edited the Spanish edition of the catalogue.

At the Boston Museum, we would like to thank the following individuals for their support in this immense project: Ross Farrar, Deputy Director; Linda Thomas, Registrar; Désirée Caldwell, Exhibition Program Manager; George Peabody Gardner III, Director of Development; Janet Spitz, Assistant Director for Development for Corporate, Government, and Foundation Relations: Lisa Harris, Grants Officer; Peter Sutton, Mrs. Russell W. Baker Curator of European Paintings; Clifford S. Ackley, Curator, Department of Prints, Drawings and Photographs; Tom Wong, Museum Designer; Carl Zahn, Director of Publications, Designer; Margaret Jupe, Senior Editor; Faith Smith, Freelance Editor; Janice Sorkow, Director of Photographic Ser-

vices; Nancy Allen, Librarian; William Burback, Director of Education; Joan Hobson, Director of Public Programs; Linda Patch, Director of Publicity, and Joan Norris, Codirector of Publicity.

At The Metropolitan Museum of Art, Mahrukh Tarapor, Assistant Director, has overseen all details of the exhibition in New York, guiding the project through its various phases with great intelligence, diplomacy, and sensitivity. Emily Rafferty, Vice President for Development, secured substantial corporate support for the project, assisted by Nina McN. Diefenbach, Associate Manager. Other colleagues at the Metropolitan Museum have generously participated in the realization of this exhibition: Everett Fahy, John Pope-Hennessy Chairman, Katharine Baetjer, Curator and Administrator, and Susan A. Stein, Special Exhibitions Associate, Department of European Paintings; Jacob Bean, Chairman, Drawings Department; Colta F. Ives, Chairman, Department of Prints and Photographs; John Buchanan, Registrar and Herbert Moskowitz, Associate Registrar; and Linda M. Sylling, Assistant Manager for Operations.

We are especially cognizant of the indispensable role of our financial supporters, without whose generosity a project of this scale could not have been realized. Extraordinary corporate leadership gifts were provided by Manufacturers Hanover and The New York Stock Exchange Foundation, Inc. The early support of both the National Endowment for the Humanities, a federal agency, and the Comité Conjunto Hispano-Norteamericano para la Cooperación Cultural y Educativa made it possible for the initial planning of the exhibition to take place. Both of these funding agencies again awarded substantial grants for the organization and implementation of the project. Additional support was provided by an indemnity from the Federal Council on the Arts and the Humanities. The Banco Central has supported the project in Spain and the Robert Wood Johnson, Jr., Charitable Trust has helped to fund the installation at The Metropolitan Museum of Art. Transportation assistance has been provided by Iberia Airlines of Spain.

A.E.P.S. A.S. P.de M.

AUTHORS' ACKNOWLEDGMENTS

An exhibition and catalogue of this scale and complexity could not be organized without the support of many individuals – friends and colleagues – who have enthusiastically shared their knowledge and time.

Our gratitude must be extended first to the directors of the organizing museums, Alfonso E. Pérez Sánchez, Alan Shestack, Philippe de Montebello, and prior to Mr. Shestack at the Museum of Fine Arts, Boston, Jan Fontein, for their initial and ongoing support of this exhibition. We would also like to thank Ross Farrar, Deputy Director, and Désirée Caldwell, Exhibition Program Manager at the Boston Museum, and Mahrukh Tarapor, Assistant Director, at the Metropolitan Museum, and Agustín Martín González at the Museo del Prado for overseeing the administrative aspects of this exhibition. We wish to express our thanks as well to George Peabody Gardner, III, and his colleagues, Janet Spitz and Lisa Harris at the Boston Museum and Emily Rafferty and her colleague, Nina McN. Diefenbach, at the Metropolitan Museum for their fund-raising efforts and for administering the several grants supporting this exhibition and catalogue.

A vast amount of research was involved in preparing this exhibition and catalogue. We would like to extend a warm and special thanks to Francisco Márquez Villanueva for the generous spirit with which he gave of his knowledge of Spanish language and literature, as well as for his help with editing and proofreading Spanish translations of English material. Teresa Fernández de Bobadilla, with energy and skill, organized the library of the Goya office at Boston museum. At the Prado, as a conservation intern, Sra. Fernández de Bobadilla assisted in the preparation of works on paper for the exhibition. We are also grateful to several consultants who have assisted in Madrid and in the Boston Goya office in various roles during the past several years: Leticia Azcue, María Luisa Fernández, Amanda Powell, Evelyn Tate, and Judy Weinland. Others have generously volunteered their time to help in the organization of this exhibition – Rebecca Borden, Susan Kapilian, Wendy Kaplan, and Edith Schmidt – and

to them we offer our heartfelt appreciation for their efforts and loyalty.

María Jesús Gonzálo Ugarte, Consuelo Luca de Tena, and Deborah Anne Dietrick translated English and French entries and essays into Spanish for the Spanish edition of the catalogue. Rosalía Díez-Rosen, Margaret Randall, and Donald Share translated the following entries, respectively, from Spanish into English: cat. 13, 22-23; cat. 10-11; and cat. 7, 16.

A number of colleagues and friends in the international community have performed various services and contributed valuable advice, thus supporting the research of this catalogue and the organization of the exhibition: Mercedes Agulló y Cobo, José Luis Alonso Hernández, Samuel G. Armistead, Esther Bachiller, Juliet Wilson Bareau, Nancy Bialler, Rodolfo Cardona, Julio Caro Baroja, Antonio Correa, Dr. Robert Dluhy, Juan Manuel Fernández Albarracín, Jan Piet Filedt Kok, Carmen Herrero, José Guerrero Lovillo, Samuel Josefowitz, Juan Lugo and his family, Marlies Mueller, Herminia Allanegui and her late husband, María Pemán y Medina, Fernando Perpiña-Robert, Javier Portus, Nicola Spinosa, George Wachter, Richard Wallace, Eunice Williams, and David J. Zucker.

We would like to express our sincerest thanks to the many lenders listed in the front of this catalogue, to the private collectors who wish to remain anonymous, and to the individuals associated with these institutions and collectors who assisted in arranging for the loans: José María de Azcárate, Roseline Bacou, Kelly Bahmer, Istvan Bakoczi, P. M. Bardi, Laure Beaumont-Maillet, Stephanie Belt, Veronika Birke, Per Bjurström, Edgar Peters Bowron, J. Carter Brown, Marcus Burke, Marina Cano, Carmen Carrión Bolívar, Michael Conforti, Elizabeth Conran, Ann B. De Marco, Etienne Dennery, Peter Dreyer, Alexander Duckers, Karen Duncan, Juan Pablo Fusi Aizpurua, Alberto Galaverni, Eleanor Garvey, George Goldner, Manuel Gómez de Pablos, María Elena Gomez-Moreno, Sir Lawrence Gowing, Vartan Gregorian, Deborah Gribbon, Julio de la Guardia García, Delbert Gutridge, Ann Halpern,

Kathleen Harlemann, Vencel Hazi, Frances Hazlehurst, Concha Herrero, Joseph Holbach, Michael Jaffé, Mariano Rubio Jiménez, Jennifer Jones, Donald E. Knaub, Michel Laclotte, Leroy Ladurie, Ann Lurie, Suzanne Folds McCullagh, Neil MacGregor, Dorothy Mahon, Erwin Maurer, Ferenc Merényi, Hans Mielke, Erwin Mitsch, Jane Montgomery, Melissa Moore, Konrad Oberhuber, Enrique Pardo Canalis, Nicholas Penny, Laughlin Phillips, Simona Pizzetti, Andrée Pouderoux, Vera Powell, Chantal Régis, Eugenio Riccómini, Pierre Rosenberg, Anne Röver, John Rowlands, Mariano Rubio Jiménez, Antonio Rumeu de Armas, Elena Santiago Páez, Siegfried Salzmann, David E. Scrase, Douglas Shoenherr, Mary Solt, Federico Sopeña Ibañez, Margaret Stewart, Alice Ströbl, Agnes Szigeti, Shirley L. Thomson, Francisco Tur de Montis, Evan Turner, Dalmiro de la Valgoma y Díaz-Varela, José María Viñuela, Roberta Waddell, John Walsh, Christopher White, Sir David Wilson, James N. Wood, Christopher R. Young, Kristen Zaremba.

We have profited from the help of colleagues on the staff of the three organizing museums, as well as consultants and interns at these institutions, who assisted us with professionalism and expertise in their various capacities. Peter Sutton's advice and encouragement were greatly appreciated. Linda Thomas and her staff at the Boston Museum handled the responsibility for coordinating the shipping and insurance for this exceedingly complex exhibition with skill. Carl Zahn in Boston and Santiago Saavedra in Madrid designed and produced the handsome catalogues published for this exhibition. Margaret Jupe and Faith Smith in Boston and Francisco Javier Rocha in Madrid edited a vast amount of material from many authors with expertise, patience, and valor. Virginia Montgomery and Elizabeth Stouffer proofread galleys for the Boston catalogue. Janice Sorkow's efforts in the immense task of coordinating photographic materials for both Spanish and English editions of the catalogue are also appreciated. In addition, we would like to single out for mention: Lalia Abdel-Malek, Clifford S. Ackley, Nancy Allen, Pamela Baldwin, Jacob Bean, Carl Beck, Brent Benjamin, Suzanne Boorsch, John Brealey, Barbara Butts, Keith Christiansen, Philip Conisbee, Pamela Delaney, Mary Doherty, Judy Downs, Carl Easton, Gail English, Everett Fahy, Carmen Garrido, John Herrmann, Joan Hobson, Colta F. Ives, Reyes Junquera, Larry Kanter, Deborah E. Kraak, Melissa Kuronen, Patricia Loiko, Elizabeth Lunning, Carlos Manso, Barbara Martin, Felicitas Martínez, Marceline McKee, Dolores Muruzábal, Roy Perkinson, Bonnie Porter, Sue W. Reed, Gary Ruuska, Alicia Sanemeterio, Barbara S. Shapiro, Karen Sherry, Susan A. Stein, Jean-Michel Tuchscherer, and Tom Wong.

A project of such magnitude depends on the financial assistance of organizations and individuals. We offer our thanks to the several government and corporate sponsors who provided invaluable support for this exhibition, as well as to our friends Sam Abate, John Davidson, and Carl and Joan Silver, who enabled us to implement special projects in relation to the organization of the exhibition. We are also appreciative of the guidance and concern of Mariá Jesús Pablos, Thomas Middleton, and María Teresa Pons, at the Comité Conjunto Hispano-Norteamericano para la Cooperación Cultural y Educativa, and Marsha Semmel and Thomas Wilson at the National Endowment for the Humanities, and Alice Whelihan, Indemnity Administrator of the National Endowment for the Arts.

INTRODUCTION

Alfonso E. Pérez Sánchez

This exhibition, which commemorates the death of Carlos III, the enlightened monarch par excellence, sets out to examine Goya's context, his "trasmundo" (backdrop), as Edith Helman so happily expressed it years ago. A large selection of the master's work is studied with regard to the historical circumstances that accompanied and so often conditioned it, especially the desire for change the enlightened in Spain aspired to instill in their fellow Spaniards so that the country would be transformed and modernized, thereby recovering its traditional vigor. In the most advanced European countries, this movement was based since the end of the seventeenth century on the promotion of reason, scientific experimentation, knowledge of nature – which came to be regarded as an open book demanding careful reading – and a profound confidence in the noblest attributes of humanity, freed from superstition, willful ignorance, or deliberate deception. Unfortunately, following the Peninsular War, the tragic events of Fernando VII's reign truncated this movement.

The metaphor of light pushing back darkness and dispersing nocturnal terrors became a leitmotif in the work of the outstanding personages of the time. *Siglo de las luces* (century of lights), *Ilustración* (Enlightenment), *pensamiento ilustrado* (enlightened thought) are all expressions derived from that basic image of the search for truth. And together with the search for truth, of course, was the search for freedom. Truth and freedom were regarded as tightly linked and from a religious point of view that was never altogether renounced in late eighteenth century Europe, even among those who appeared to be in the vanguard of radical thought, the words of Saint John – the truth will make you free – and were interpreted in many ways, resonated deeply.

That love of freedom, which the unbiased use of reason introduced into human relations, dispersing shadows and making the exercise of humanity more fertile, gave rise in Spain to words that would soon pass into the European political vocabulary: *libertad* (freedom) and *liberalismo* (liberalism).

This new phenomenon of liberalism, which took root in progressive sectors of the bourgeoisie, would with unexpected virulence confront the conservative, reactionary, and repressive sectors that were so powerful in the Spain of that time and even later. The tension between the old social and institutional structures (the Church, with its enormous influence; the Inquisition; and the idle, ignorant sectors of the nobility) and the new attitudes manifested itself in many ways, from a wide-ranging battle of pamphlets – public, when freedom of the press existed, and clandestine, when censorship was imposed – to the most violent forms of physical confrontation and of cruel repression that the triumphant reaction would impose in Fernando VII's time.

The new attitude toward the ills of society such as mendicancy, prostitution, excessive and poorly paid work, and unjust distribution of property also set the conservative mentality, which assumed the hopelessness of these situations – with no relief but charity – against the progressive, which demanded social justice and economic restructuring in the name of a real transformation of society and the search for the happiness of its citizens.

In his maturity, Goya moved among people engaged directly with that

struggle for the renewal of Spanish life. His relations with Jovellanos (cat. 30) and the art historian Ceán Bermúdez, with Cabarrús (cat. 15) and the playwright Moratín, and the Aragonese group (the Azara, Pignatelli, and Goicoechea) – along with the most advanced, cultivated, and critical representatives of the aristocracy (the Osunas [cat. 6, 17], the Altamiras, and so on) placed him at the very center of a world of reflection on the ills of Spain and their possible remedies.

Goya's *Capricho* inscriptions – his first unequivocal appearance in the world of explicit criticism – share points of view with Cabarrús's or Jovellanos's reflections on the forces hostile to the free development of reason.

Goya "ha escogido, como asuntos proporcionados para su obra, entre la multitud de extravagancias y desaciertos que son comunes en toda sociedad civil, y, entre las preocupaciones y embustes vulgares, autorizados por la costumbre, la ignorancia o el interés, aquéllos que ha creído más aptos para suministrar materia para el ridículo y exercitar al mismo tiempo la fantasía del artífice" (has chosen as worthy subjects for his art from the multitude of follies and blunders common to every civil society, and from the vulgar concerns and lies, authorized by custom, ignorance, or self-interest, those he believed the most apposite to supply material for ridicule and at the same time to exercise the artist's fantasy).

That somber trilogy composed of custom, ignorance, and self-interest was explicitly censured in all of Goya's work subsequent to the *Caprichos*. As Jovellanos indicated in another context, new and more just laws could be passed against perverted custom, ignorance could be defeated by education, and private, self-seeking interest could be made to respect nature and its norms. Thus it was a whole political, educational, and moral program that Goya, like other enlightened thinkers, ardently supported.

Throughout the twentieth century, those who saw in the great Aragonese master an ignorant or, perhaps, even more, an impulsive, natural genius without training and study, endowed with unusual abilities but lacking education, in other words, all romantic instinct, have been pitted against those who, perhaps exaggerating the opposite position, have tried to make Goya an erudite reader of curiosities and rarities, connoisseur of old emblem books, and even a commentator of hermetic meanings.

Before so radical a polarity and without fabricating a tepid and convenient compromise, we must take a stand or, at least, clarify that which justifies one or the other position.

All students of Goya's work agree that he was, above all, a man of his time, interested in many fields, a keen interpreter of human behavior, categorical in his disdain and rejections, cordial and generous in his attachments.

Sustained until the last years of his life when he arrived in Bordeaux, as Moratín attested, "sordo, viejo, torpe y débil y sin saber una palabra de francés y tan contento y tan deseoso de ver mundo . . . en calidad de joven alumno" (deaf, old, lame, and weak and without a word of French and so happy and anxious to see the world . . . in the role of a young pupil), his devouring curiosity and his vital disposition are vigorously expressed in a well-known drawing (G-W 1758). In it an old, bearded, hesitant man, leaning on crutches – which paradoxically lend him a poised demeanor – gazes

inquisitively. Goya wrote confidently: "Aún aprendo" (And still I learn).[1] The man who says this is undoubtedly Goya himself, well aware that his true strength, which keeps him alive, is his extraordinary curiosity about everything around him. He drew from his surroundings his deepest lessons; he leaned – with whatever aids were called for – on the reality that enveloped him. Reality was, above all, his life in Spain, which he gradually revealed in the manner of a biography, rich in inner episodes but altogether devoid of noteworthy or novelesque external circumstances, unlike what his romantic biographers imagined. The key to his profound, stirring humanity was his continuous meditation on reality.

Goya developed slowly as an artist, achieving complete maturity relatively late. But can we say that the gradual enrichment of his art, scarcely interrupted by sudden explosions, resulted from a systematic investigation, a conscious program of reading and learning or, rather, from an exceptional receptive capacity, which enabled Goya to rapidly assimilate all that he saw, assuming attitudes, and visualizing concepts or principles not by intellectual means but by social and artistic ones? This dilemma is a rephrasing of the problem stated earlier of the enlightened Goya, a subject this exhibition is meant to help clarify.

It almost seems as if the artist and his contemporaries delighted in smudging the texts, muddling the evidence, and blurring the distinctions so that we can not arrive at a clear, definitive, and unequivocal conclusion. One significant example of the ambiguity of the evidence, which makes affirmations about Goya's culture problematic, is his possible knowledge of French. It has been said that he spoke French and even that he wrote it fluently, facts that could help to define the nature of his enlightenment. A letter to his friend Martín Zapater, dated November 14, 1787, is written in French and signed by Goya. Because of this letter, it has been supposed that Goya's knowledge of French enabled him to read many French works that, although prohibited by the Inquisition, circulated widely in Spain. However, Moratín tells us that in 1826 Goya arrived in Bordeaux "sin saber una palabra de francés" (without a word of French).

What is the truth? It is difficult to arrive at a definitive conclusion. In 1787 when Goya was enjoying the first flush of public success, influenced by his intellectual friends, he may have attempted to learn French and, with the help of one of his friends and of the dictionary, write: "Je me suis mis dans l'idee de l'apprendre, je ne scai si je reussirai" (I have decided to learn [French]; I do not know whether I will succeed).[2] Most likely he did not succeed, for there is no reason to doubt Moratín, a close observer of the last years of Goya's life. But if we cannot be certain of something so concrete about which we possess contemporary, if contradictory, evidence, we can be even less certain of other things that must be considered pure hypotheses.

The twentieth-century Spanish philosopher Ortega y Gasset noted that what letters we have of Goya's do not allow us to form an image of a lettered man, but rather convey "una mentalidad poco distante de la del obrero maual. Las cartas de Goya son cartas de un ebanista" (a mentality not too removed from that of a manual laborer. Goya's letters are the letters of a cabinetmaker). It is true that Martín Zapater, to whom Goya addressed the

bulk of his correspondence, was a solid bourgeois of the provinces, a businessman and banker, perhaps not especially inclined to theoretical questions or moral and literary reflections. But we must not forget that he was also an enlightened founding member of the Real Sociedad Económica Aragonesa de Amigos del País (Aragonese Royal Economic Society of Friends of the Nation) and first counselor and honorary academician at the Real Academia de Bellas Artes de San Luis (Royal Academy of Fine Arts of San Luis), and there is evidence of his generosity to scholarship students who went to Madrid to study architecture and printmaking.

Given Goya's tight, intimate, and familiar relationship with Zapater, we might expect Goya, in his letters, to have enlarged on his readings, concerns, and reflections, on everything, in other words, that he poured torrentially into his work and that continues to fascinate us to this day. Yet, the correspondence we have is of a distressing poverty in these matters. Money matters, family anecdotes, a shared interest in hunting, dogs, and firearms – little else is to be found.

He certainly conveyed many of his professional and material aspirations in a direct and familiar tone, sometimes with a blunt, unadorned sincerity: "¡ya soy pintor del rey con quince mil reales!" (I am now painter to the king, making 15,000 reales!). He wrote of his naive hopes – for example, his acquisition of a coach and his later disenchantment with it – and of his rise in royal esteem – "los Reyes están locos con tu amigo" (the king and queen are crazy about yours truly). He divulged his worry about changes in artistic fashion that, in some way, affected his own work – "lo que se estila aquí aora es estilo Arquitectónico" (the arquitectonic [neoclassical] style is now in vogue) – and expressed a conventional piety no different from any right-thinking man of his time: "¡qué Virgen del Carmen te he de pintar tan hermosa. Dios nos dé vida para su Santo servicio . . ." (What a beautiful Virgen del Carmen I will paint you! God grant us a long life so that we may serve him).

But, once again the ambiguity and the doubt: Francisco Zapater y Gómez, Martín's nephew and first editor of Goya's letters, stated that between 1789 and 1801 Goya "aspiró, halagado ya por la fortuna, una atmósfera nada pura que hubo de embriagarle, agitado por las nuevas ideas que recorren la Europa en pos de ejércitos vencedores en naciones extranjeras a España" (already graced with good fortune, breathed altogether impure airs that would intoxicate him, agitated by the new ideas that spread throughout Europe in the wake of armies victorious in nations foreign to Spain).[3] Evidence of this change of attitude should but does not appear in letters of those years. Therefore, we cannot make definitive claims about how that intoxication, which we have tried to highlight in this exhibition, happened, although it can certainly be detected in a large part of his works. As Xavier de Salas indicated when he published the correspondence, there is reason to suspect the letters were expurgated by Zapater's fearful nephew, champion in his time (1868) of an image of Goya cleansed of the accretions of the first writings of his romantic biographers Matheron and Iriarte, which presented an adventurous and "liberal" Goya.

But what is the true import of the literary sources known to and used by

Goya, and the final intent of the many enigmatic works he left us? The problem remains not so much in his commissioned paintings – compositions whose purpose was clear – or in portraits of friends or clients, as in the series of drawings organized in albums. These are like hushed confessions in which nightmares – and some are unequivocally inscribed as such in *Album C* – are blended with reflections on observed reality or meditations on certain aspects of life. We will never know with certainty whether he arrived at these images directly, through his readings of texts, or indirectly, thanks to the commentaries of others.

Following his illness, in a letter to Bernardo de Iriarte (1794) Goya stated that in the works created for himself during his convalescence "he logrado hacer observaciones a que regularmente no dan lugar las obras encargadas, en que el capricho y la invención no tienen ensanches" (I have succeeded in making observations that commissioned works customarily do not allow, in which *capricho* [originality] and *invención* [creativity] have no scope), a letter that indicates how Goya deliberately gave his *capricho* and *invención* free reign in those private, intimate works reserved for a few, trusted friends who shared his concerns and opinions.[4] Of course his *capricho* would be partly based on real events or people, although these sources of inspiration were handled freely and with *invención* so that personal or collective observations (made by his friends, perhaps) were sometimes sublimated into unconscious, disorderly images.

A large part of Goya's work, especially the prints and drawings after the *Caprichos*, which were withdrawn from circulation, reflects that private, intimate world, although at a time of relative optimism, he did consider publishing the *Disasters of War*, in which political criticism and enlightened humanitarian expression attain the highest form.

But can we be certain of what Goya meant to say in each case? Are the allusions we think we find in fact there in that very personal, enigmatic world of his prints and, above all, in the drawings he most jealously guarded and to which he referred as capricious inventions?

There is nothing more problematic than to try to discover the intentions and purposes of a person who does not want to make them explicit. And when a man like Goya – impulsive and blunt, with the uncouth spontaneity of the Aragonese – wanted to say something, he always found a way, sometimes a harshly frank way.

In the *Caprichos*, which were destined for a tolerant, cultivated audience, it was necessary perhaps to prudently veil certain direct references and even to clothe the whole series in the imprecise and somewhat ambiguous cover of the words of the prefatory text: "Seria suponer demasiada ignorancia en las bellas artes el advertir al público que en ninguna de las composiciones que forman esta coleccion se ha propuesto el autor, para ridiculizar los defectos particulares á uno ú otro individuo: que sería en verdad, estrechar demasiado los límites al talento y equivocar los medios de que se valen las artes de imitacion para producir obras perfectas" (One would assume too much ignorance of the fine arts if one warned the public that in none of the works that make up this series has the artist in exposing particular defects set out to ridicule any one or another individual: for surely this would limit talent

and not do justice to the means of which the arts of imitation avail themselves in order to create perfect works).

In the drawings he kept for himself until he died, such prudence was not called for; we can interpret these without bias and without imagining they hide something. Therefore, it is essential we take care in our analysis of them. The disquieting beauty of Goya's most enigmatic drawings presents itself to us as a continuous challenge. However, we can approach these drawings using the increasingly rich knowledge of the Spanish political, literary, and folkloric reality of Goya's time, which research and reflection have put at our disposal. But we must also be aware of the provisional and hypothetical nature of these interpretations and of how serious the risk is that all we believe we see is nothing but projection or the reflection of our private obsessions or of those who guide us in our speculations.

The artist very often expressed himself clearly and categorically, without skirting the most direct sexual themes (*Pr querer á una burra* [Because He Loved a Donkey] [G-W 1328], *Ciego enamorado de su potra* (Blind Man in Love with His Hernia) [G-W 1302], *El Maricón de la tia Gila"* (Auntie Gila's Faggot) [G-W 1276]). Therefore, it is difficult to comprehend why he should have felt the need to obscure allusions or criticisms with an intricate tangle of ambiguous expressions, literary games, or conceptual niceties that were difficult to render visually, criticisms that his harsh, Aragonese sincerity sometimes dispatched with the utmost directness, immediacy, and succinct clarity.

The critical attitude became more obvious in Goya's work after 1792, when his health failed and the European political world tumbled as a result of the fall of the French Bourbon dynasty. The dramatic consequences for his circle of enlightened friends – the hopes of some, the fears of others, the radicalization of certain attitudes, and the obvious tension of Spanish life, overwhelmed by the astonishing reality of France's revolution – led Goya to sharpen his focus and to assimilate more acutely and vehemently all that he observed and all that his friends around him opposed.

The slow process of development of his genius was finally complete. His deafness – and consequent isolation – enlarged his inner life. His receptivity was keener and his language became denser, richer, and more enigmatic. His black chalk images derived from the most diverse sources. A series of themes arising from enlightened discourse became keys to his art and are to be found time and again throughout his work until his death.

It is not necessary to call upon literary quotations, or to imagine Goya engaged in constant, erudite reading, even when, in a few cases, the literary source of some theme is evident. His powerful intuition quickly assimilated whatever was felt and said by his cultivated friends. He followed them as much in his external behavior as in his social, humanitarian, moral, and political concerns, which he hoped would transform the hard, unjust conditions of everyday life. His generous and impulsive natural disposition, his unique genius, was capable of realizing – in images of unforgettable power, nervous impulsiveness, or cruel irony – the whole bitter panoply of monstrosities that paraded before his eyes, illuminated by the light of reason given off by his friends.

Perhaps light is the fundamental symbol Goya borrowed from the enlightened repertory. Painter par excellence, endowed with a profound visual instinct, Goya reduced all he imagined to powerful images. Light, an essentially visual concept, must have been the most easily assimilated element of enlightened discourse, and thus we find it used again and again in Goya's most personal works. Boundless confidence in the power of truth and its enlightening force, and the struggle against darkness as a shelter for the shady, the obscure, and the perverse made the metaphor of light an essential element in literature as in art.

Capricho, plate 71 (G-W 594), becomes especially significant as an emblem and summary of the artist's beliefs: *Si amanece, nos vamos* (If they wake, we're leaving). Dawn – that is, the clarity of the sun, the triumph of reborn light – banishes the sprites, witches, and hobgoblins, whose domains are darkness and night. That dawn was the luminous splendor of science, of knowledge, of revealed and triumphant truth, following that kind of permanent night that seemed to be Spain's recent history.

In the latter part of the *Disasters of War* known as the *caprichos enfáticos* (emphatic caprices) (cat. 154-163), illustrating the dramatic battle between darkness and light, truth and hypocrisy, reason and superstitious obscurantism, Goya expressed himself using the visual representation of radiant light as a powerful testimony to all that was positive in liberal and enlightened ideas. Several prints of this series (cat. 161, 162) demonstrate the splendor of that threatened light, which was Truth. In the final image (cat. 163) Truth is also identified with Peace encouraging Labor to produce the joyous fruits of Abundance, representing the hopeful future that General Riego's pro-constitutional uprising in 1820 augured.

The redemptive value of labor is another of the noble concepts that enlightened thinkers and Goya used repeatedly and unwaveringly. In one instance, in the painted allegories for Godoy's palace, Goya had occasion to present Labor or Industry formally embodied in the person of a spinner. Various trades were often represented in his drawings, emphasizing the value of work in contrast to vice-ridden idleness. Often disguised as mendicancy in order to move others to pity and to sponge on the nuns' "sopa boba" (soup distributed to the poor in convents), idleness was vigorously denounced by, among others, Goya's friend Meléndez Valdés (cat. 24). The beggar in *Por no trabajar* (For Not Working) (cat. 76) is a good example, contrasting radically with *Ciego trabajador* (Blind Laborer) (cat. 76, fig. 1), an admirable instance of usefulness to society, even considering the man's dramatic misfortune.

However, as students of political economy have indicated, work was not always well paid nor did it always correspond to a just and fair distribution of responsibilities in a country in which manual labor was regarded as dishonorable. The effort of the laborer who obtains his meager sustenance with work and suffering stands in stark contrast to the existence and privileges of the idle classes, the nobility and the regular clergy toward whom Goya was unsparing, as were the most daring enlightened writers.

In some cases, the lament had the ring of a call to revolt (see cat. 130). In others, Goya emphasized very graphically how the poor laborer bore the

useless and the idle on his back (see cat. 49); in many, he remorselessly denounced certain social groups, especially the friars, portraying them severely as useless parasites (see cat. 112, fig. 1) whose traditional vices – gluttony, lust, sloth – were censured with implacable rigor. One noteworthy drawing in the Prado (cat. 112) shows a fat friar eating from his wide bowl while seated on the back of a poor laborer working a hard and probably barren piece of land with evident strain. Dated to the period when the ephemeral victory of the Liberals led many to hope for a profound economic and political change in the country, it is perhaps one of the most expressive examples of the desolate vision that the social reality of Spain, in need of radical reforms, presented to enlightened eyes after the war. Those reforms were thought to begin with education; Goya was often moved to take up his chalk and brushes to excoriate the absurdity of the kind of education given the nobility, which made ignorant and useless citizens of them, and to point out the need to dignify the people through a national program focused on those aspects of education that exalted and fostered progress.

Goya frankly portrayed the administration of justice as venal, inhuman, and pointlessly cruel, based on what he had seen of unfairly treated victims and what he had heard from enlightened jurists. The enlightened also clamored for the abolition of the Inquisition, an ancient disgrace, supported only by the most reactionary forces. Finally suppressed in the Constitution of 1812, though later restored by Fernando VII during the period of most violent repression, it is another of the recurring themes in Goya's works, supplying astonishing images (see cat. 98-106).

Alongside these major themes, common to all champions of enlightened and Liberal ideas, Goya with his peculiar sensibility reflected an ample range of moral themes, always observed from a critical vantage point, always showing the way to the transformation and reform of social life in the light of reason, the common good, and the correct use of freedom.

This exhibition gives significant examples of all of these themes, making available what has been written on these works and contributing a substantial cache of new observations and textual sources to help us understand Goya's complex creations a little better. Some of these observations will be accepted immediately and incorporated into the pool of common knowledge; others will be understood as mere hypotheses, as working suggestions; some certainly rather bold ones will have to be revised in the future.

The laudable literary spadework masterfully begun four decades ago by José López Rey, continued by Edith Helman, and more recently taken up by Roberto Alcalá Flecha – whose excellent book *Literatura e ideología en el arte de Goya* appeared too late to be used in this catalogue – cannot be regarded as finished. All further contributions will continue to be welcomed.

But we must not go beyond what is reasonable. The wealth of unequivocally enlightened sources is adequate to explain Goya's moral, political, and religious ideas. We must not, therefore, read into and interpret Goya's works to make him say what we wish him to. And I repeat, let us not forget the extent to which he could and knew how to be explicit when he wished. We must not forget as well that *invención* and *capricho*, to which Goya so often had recourse, demand a measure of freedom and even of irrationality

that could surprise the artist himself, who traveled byways toward a final destination sometimes even he did not know.

His drawings – especially those of his last years – are not equations to be solved. Let us be grateful for any help we may receive in interpreting them, but distrust those that come across as exclusive or definitive. Goya's genius – his fabulous capacity for invention – is richer, more fertile than his commentators' resources, and although we have taken large strides in our understanding of all that underlies his creations, we should not persuade ourselves that we have found the magic key to all of his secrets.

There will always be unanswered questions and – this is part of Goya's greatness – a redoubt of mystery and ambiguity we will come up against, trembling, astonished by the unfathomable depth of his potent genius.

1. Francisco de Goya, *Diplomatario*, ed. Angel Canellas López (Zaragoza, 1981), p. 497.
2. Francisco de Goya, *Cartas a Martín Zapater*, ed. Mercedes Agueda y Xavier de Salas (Madrid, 1982), p. 177.
3. Ibid., p. 17.
4. Goya, *Diplomatario*, p. 314. The letter is dated April 1, 1794.

FREEDOM IN GOYA'S AGE:
Ideas and Aspirations

Gonzalo Anes

When Carlos III died in 1788, Spain and the Indies were a great power, a decisive element in international relations. Administrative improvements and liberalizing measures had borne fruit in the closing years of the eighteenth century. Spain was then respected for its military might on both land and sea, for its cultural and scientific development, and for innovative proposals put forth by economists and ministers to reform ancient institutions. Within a few years – between 1808, when the Peninsular War broke out, and Fernando VII's death in 1833 – Spain lost its status as a powerful empire and became a secondary player on the world stage. The end of this period is marked by the failure of liberalizing efforts that would have further enabled Spain's economic development and procured a larger political role for it in the world.

Under Carlos III and Carlos IV, the enlightened monarchy both respected tradition and encouraged the cult of liberty, in accord with the demands of the age. One of the first liberalizing measures abolished duties on grain and allowed it to be traded freely within the kingdom, a decision reached after a careful consideration of consequences. The royal decree appeared – it was then said – "a la luz de una brillante antorcha que desterró las sombras y aclaró los errores con que se abrían las envejecidas preocupaciones de la tasa de los granos, de los registros y compulsiones que hacían vender el trigo como género de contrabando" (in the light of a brilliant beacon that banished the shadows and corrected errors characterizing the old-fashioned prejudices about the grain and registry assessments and restrictions, which made the trade in wheat resemble that of contraband).[1]

At the same time the Jesuits were expelled from Spain, Germans and Flemish were being recruited to people the abandoned lands of the Sierra Morena. The aim was to make the road from New Castile to Andalusia safer and to create a rural arcadia free of the agrarian problems burdening other parts of Spain. The so-called new settlements were to serve as an example of reforms designed to ensure the contentment of the *amados vasallos* (beloved subjects), to which the technical skills, the plow, and the hoe were to contribute equally. "La total felicidad del reino" (The complete happiness of the kingdom) seemed to depend, according to Olavide – planner and supervisor of the new settlements – on turning farms into villages. In order to achieve this, legal conditions would be needed that induced the landowners to undertake the breakup of the great estates, on the understanding that such a breakup would be more beneficial to them than an *atropellado* (crude) and *débil* (outmoded) form of cultivation.

The Societies of Friends of the Nation

The traditional Spanish *tertulias* (salons) in which friends gathered regularly and on a formal basis to discuss physics, mathematics, natural sciences, geography, history, and economics gave rise in some instances to Sociedades de los Amigos del País (Societies of Friends of the Nation). The first to constitute itself as such was the Basque Society. Others followed, among them the *Sociedad Tudelana de los deseos del bien público* (The Tudela Society of the Needs of the Commonweal) and the *Sociedad económica de los amigos del país de Baeza y Reino de Jaén* (The Economic Society of Friends

Fig. 1. Frontispiece, *Real Provisión de S.M. y señores del Consejo . . . en la ciudad de Vera y su jurisdicción para el fomento de la industria popular,* Madrid, 1776.
Etching
The Royal Patriotic Society of the City of Vera and its jurisdiction was one of the earliest founded in the kingdom. Its members were committed to fostering local industry.

Fig. 2. *Disipando Ylustra* (Enlightens by Dispersing)
Sociedad Económica de Valladolid
Emblem with motto and seal of the Economic Society of Valladolid
Etching

of the Nation of Baeza and the Kingdom of Jaén). Bernardo Ward, Fernando VII's minister, a firm believer in the usefulness of such societies existing in Dublin, Tuscany, Tours, Bern, and Metz had recommended the establishment of similar bodies in Spain (fig. 1).

In 1764 the Junta de Comercio (Commerce Council) also proposed the creation of corresponding academies and societies linked to general ones established in Madrid.[2] Pedro Rodríguez de Campomanes's *Discurso sobre el fomento de la industria popular* (Report on the Promotion of Popular Industry) of 1774 recommended establishing economic societies in the provinces. Thirty thousand copies of this report were distributed throughout the kingdom. The *Discurso* was accompanied by a letter listing norms for establishing a Society of Friends of the Nation. Favorable responses were not long in coming, and aristocrats and clerics enthusiastically backed the royal initiative in towns and cities throughout Spain: the citizens of Vera, in the kingdom of Granada, affirmed being "abrasados del ardiente fuego" (warmed by the intense fire) that descended from the throne. They immediately addressed themselves to the ardent patriots of nearby towns in order to induce "una noble emulación" (a noble emulation) in them. The vulgar, offensive, and erroneous notion that Spaniards were lazy would thus be proved wrong. Foreigners would be compelled to admit that when an enlightened government provided means and bestowed honors, it was easy "formar en ellos un pueblo sabio y una nación formidable" (to fashion a wise people and a formidable nation).[3]

The societies created sections for agriculture, industry, and commerce (fig. 2).[4] Reports – sometimes from abroad – were read in their meetings. All were inclined to examine issues in the light of the new beacon of the century: political economy. The most distinguished of the societies, to judge by their projects and published papers, were those in the Basque country, Madrid, Seville, Segovia, Valencia, Aragón, and Mallorca. The Madrid society had the distinction of reporting on the agrarian law, commissioning Don Gaspar Melchor de Jovellanos for this purpose. In 1795 Jovellanos finished his famous report based on suggestions sent by intendants, authorities, and institutions and written in the light of Adam Smith's doctrines. It proposed selling uncultivated lands and enclosing commons. About ecclesiastical property Jovellanos believed the king should request that prelates "que promoviesen por si mismos la enajenación de sus propiedades territoriales, para volverlas a las manos del pueblo" (themselves undertake the sale of lands in order to return them to the people). He believed individual interest and, therefore, private property and the freedom to dispose of it at will increased and assured "riqueza particular" (private wealth) and, as a result, general prosperity. He described entailment as a "monstruo" (monster) that, with respect to property, "continuamente la traga y engulle" (perpetually consumes and swallows it). The entailment of private estates took place that much more rapidly "cuanto era mayor el número de las familias que el de los cuerpos amortizantes" (the more families outnumbered entailing institutions) and the stronger the inclination to accumulate. Jovellanos proposed repealing all laws that allowed entailment of lands. He also favored abrogating all legal dispositions and regulations limiting individual activity and preventing

private initiatives, source of "riqueza particular" (private wealth). Private wealth would be generated and "la riqueza pública" (general prosperity) nourished by private interest "sin violencia" (without disruptions). The Societies of Friends of the Nation promoted the spread of new technologies that encouraged industrial and artisanal development. Private initiatives could count on the encouragement and legal support of the crown (fig. 3).

Industrial Development: The Legislation

In the second half of the eighteenth century, industrial development in Spain had characteristics analogous to that taking place in England. The crown stimulated it by issuing recommendations that would encourage popular industry. Private initiative developed the cotton textile industry. The American market and consumers' preferences favored the emergence and growth of this industry in Catalonia.

Certain trades were classified as low, though not everywhere in the kingdom. The Royal Decree of March 18, 1783, declared that not only the tanning trade, but also all remaining trades, such as those of the smith, tailor, shoemaker, carpenter, and others like them were "honestos y honrados" (honest and honorable) and did not lower the status of the person who practiced them or that of his family. Thenceforth, to practice these trades would not keep anybody from obtaining municipal posts or *hidalguía* (gentry) rank (fig. 4).

Tax exemptions were granted in order to foster the establishment of manufacturing enterprises and to modernize those in existence. There was an attempt to establish a just system in which aid needed would be distributed "para su fomento, las fábricas de una misma clase" (in order to foster the same kinds of factories equitably). Wherever enforced, the legal measures tended to liberalize. They were consonant with those adopted on domestic trade, trade with the Indies, guild corporations, and the dignity of trades. Along with greater freedom in the market, there was a more restrictive attitude toward the guilds. In 1779 it was established that "la enseñanza a mujeres y niñas de todas aquellas labores y artefactos" (the education of women and girls in all those forms of labor and production) regarded as appropriate to their gender should not be obstructed, nor what they made kept from being sold freely "con ningún pretexto" (under any pretext whatsoever) "que por los gremios u otras cualesquiera personas" (by the guilds or by any person). On September 2, 1784, it was decreed that "para mayor fomento de la industria y manufacturas" (to better promote industry and manufactures) all women in the kingdom be allowed to work in any trade they wished, so long as it was compatible "con el decoro y fuerzas de su sexo" (with the decorum and strength of their gender). All regulations or measures forbidding this were repealed. The liberalizing tendency continued in Carlos IV's reign. By the January 29, 1793, royal decree, the silk-spinner's guild was abolished. In this decree it was declared "ser libre tal arte y ejercicio, y común a todas las personas de ambos sexos" (that this craft and trade be free, and open to all persons of both sexes). In 1797, pursuing the Liberal tack, manufacturers were allowed to fix the prices of their products without the intervention of the authorities. Foreigners who could establish

Fig. 3. Frontispiece, *Discurso sobre el problema de si Corresponde a los Parrocos y Curas de las Aldeas el instruir* . . . Zaragoza, n.d.

The Friends of the Nation in Zaragoza sponsored the translation of this report from the Italian by F. Griselini because of the society's interest in parist priests' doing their part to spread enlightenment.

Fig. 4. Frontispiece, *Real Cédula*.
This royal decree of 1778 allowed textile manufacturers more freedom in setting the size and weight of stuffs.

Fig. 5. Frontispiece, *Libro Primero.*
Libro primero de acuerdos reservados de las juntas particulares de la dirección del Banco Nacional de San Carlos . . . Año 1782 (First Register of Decisions Taken by the Distinct Counsels of the Banco Nacional de San Carlos's Board of Directors . . . [in] 1782).
Banco de España, Madrid

Fig. 6. Frontispiece, *Real Cédula.*
Real Cédula de Fundación del Banco de San Carlos (Royal Decree Establishing the Banco de San Carlos), 1782.
Banco de España, Madrid

their training to the satisfaction of the inspectors of the Junta de Comercio (Trade Council) were also allowed to practice freely. The restrictions imposed by guild regulations were reduced in March 1798. It was then declared as a general rule that a person practicing one trade could not be kept from hiring another in a different trade. Thenceforth, prerequisites – for apprenticeship, *oficialía* (craftsman's status), *domicilio* (shop), or any other – prescribed by the regulations of the different trades would not be enforced. In 1807, when it was declared that the Junta de Comercio would determine guild regulations and arbitrate disputes among guild members, the privileges once enjoyed by guilds and similar corporations were considerably diminished. The liberalizing process that took place in the second half of the enlightened century thus came to its logical conclusion, to be interrupted by the Peninsular War, which began in 1808.

Domestic and Foreign Commerce and Trade with the Indies

The elimination of customs on trade within Spanish boundaries enabled a greater flow of goods and a more active commerce between Castile and Catalonia, Catalonia exporting more cloth from its factories to the rest of Spain much as Castilian and Aragonese exports to Catalonia increased as their grain and livestock became more competitive.

In 1728 the Real Compañía Guipuzcoana de Caracas (The Royal Guipuzcoan [Basque] Company of Caracas) was founded, modeled on those of Holland, England, and France. In 1751 a similar one was established in Catalonia. However, the widespread belief in the advantages of greater freedom in trade with the Indies was reflected by the October 12, 1778, decree authorizing thirteen Spanish ports to trade directly with twenty American ports. This measure made possible a more active, mutually beneficial trade between Spain and the Indies. In 1783 the Real Compañía de Filipinas (Royal Philippines Company) was established to expedite and promote trade with Asia. The establishment of this company is associated with don Francisco Cabarrús, proponent of the law on the *vales reales* (interest-bearing royal bonds that would circulate as legal tender) that financed the war with Great Britain.

The Bank of San Carlos

The National Bank of San Carlos was founded in 1782, and its main task was to redeem the *vales reales* (figs. 5, 6). Among other income-generating operations, the bank made loans, honored bank drafts, and was entrusted with exporting specie. The bank lost money from its monopoly of issuing contracts to supply the army and navy, speculation with its own shares, guaranteed loans of these shares, and purchasing French state debt on the eve of the revolution (1788). Because the bank served the needs of the treasury, its fate was bound up with the latter's. At the beginning of the nineteenth century, the bank entered a debt-settlement period.

Wars and Public Finances under Carlos III

Carlos III's reign was noted for its attempt to achieve armed neutrality by

upgrading the army and navy. There were also attempts to carry out reforms that would improve the lot of the needy and spread enlightenment in both Spain and America. It was essential to command the indicated resources, which required in turn that the royal treasury be managed more efficiently. The treaties with France, called Family Pacts, involved Spain in wars that brought about increased state spending.

The struggle between France and England in America for possession of the territories bordering the Ohio River made Spain's participation in the conflict inevitable. The result of the war was Spain's cession to England of Florida and other territories; these losses were compensated for when Spain received the Louisiana territories from France. Ownership of the Malvinas or Falkland islands gave rise to another war that again resulted in higher state spending. The construction of roads, of canals, and of new public buildings carried out under this reign demanded greater amounts of money, for which it was essential to reform the treasury. When the single-tax project failed, provincial taxes were reformed in 1786 so that duties could be collected more efficiently.

Spain's foreign relations under Carlos III led to participation in international wars. Spain took its rightful place as a great power; the Spanish crown could not avoid entanglement in so important an event as the rebellion of the English colonists in North America. The Declaration of Independence on July 4, 1776 could only succeed because the rebels could count on Spain's and France's support. Floridablanca and Aranda backed participating in the war because they expected to weaken a traditional adversary – Great Britain – and recover Gibraltar and Menorca. The antagonists' exhaustion and the mediation of Russia and Austria enabled the Peace of Versailles to be signed in September 1783. Months before, England had already recognized the independence of the United States.

It was to be expected that, following the example of the northern colonists, the "Spaniards in America" would follow suit, since they could count on British support and encouragement from the new power that it was believed would arise in North America. In 1783 Conde de Aranda seems to have predicted in a secret report to Carlos III that, although the new federal republic had come into this world a pigmy, in time it would become a giant, a great colossus. Freedom of conscience and the possibility of peopling the new lands would draw farmers and artisans of all nations. The new country would soon want to seize the Floridas in order to dominate the Gulf of Mexico and later the vast Mexican empire. It would be impossible to defend it against a formidable power, as the United States would come to be, situated on the same continent. In order to keep from losing the Spanish American territories, Conde de Aranda proposed creating three kingdoms: Mexico, Tierra Firme, and Peru. A Spanish prince could rule over each; Carlos III, as emperor, would remain the supreme sovereign. The three kingdoms would sign a trade agreement with Spain. France would take part in the agreement, since Spain's manufactures could not be expected to supply the entire American market. England would be excluded.[5]

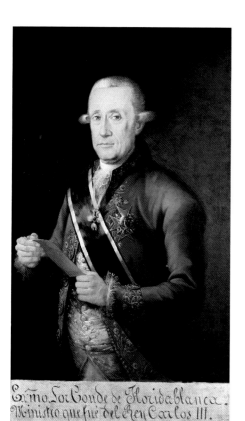

Fig. 7. Francisco Folch de Cardona,
Conde de Floridablanca.
Oil on canvas.
Banco de España, Madrid

Carlos IV and the Continuation of Enlightened Policy

Carlos IV's ascent to the throne did not change the orientation of policy
followed by his father. The first few months of his reign passed without
serious problems, save for those arising from the bad harvest of the summer
of 1788. In the spring of 1789 the scarcity of grain made itself felt. The
gathering and storing necessary to supply Madrid had provoked discontent in
towns in Old and New Castile, and it was feared disturbances would break
out when the scarcity became most acute during the months approaching
harvest time.

Spain and the French Revolution

News began to arrive from France about difficulties similar to those in Spain,
along with reports about the convocation and meeting of the Estates-General
soon to take place. This novelty – the Estates General had not been called
since 1614 – did not appear to perturb the men running the Spanish govern-
ment. The disturbances of July 1789 in Paris soon became known and roused
interest. It was believed that events in France would contribute "a restable-
cer el buen órden y el crédito" (to reestablish public order and [confidence in
the government's] credit). This optimism gave way to fear when the course
of the French Revolution became clear. Conde de Floridablanca (fig. 7 and
cat. 4), first secretary of state and the royal office, upon hearing the reports
arriving from Paris, feared that the revolutionary ideas emanating from the
French National Assembly would be echoed in Spain. There were reports
that the French were spreading "máximas de libertad" (slogans of liberty) in
the villages of the Pyrenees. It was believed by some in Spain that it would
be necessary to isolate the country "del contagio revolucionario" (from the
revolutionary contagion), and various measures were taken to prevent books
and pamphlets reporting the events in France from entering Spain. There
was an attempt to keep scholarship students who were continuing their
studies abroad from crossing the border, to prevent the French residing in
Spain from passing on news about the revolutionary events, and to isolate
French clerics taking refuge in Spain, for their mere presence was a living
example of the new French constitution.

In spite of the measures adopted to block the spread of revolutionary
notions in Spain and the Indies, there were evident signs of sympathy toward
them. Anonymous articles, broadsheets, and some disturbances and riots
expressed the support of people in sometimes surprising places. In popular
uprisings, some people even demanded "libertad, igualdad y asamblea
francesa" (liberty, equality, and a French assembly).[6] The enlightened, who
had shown interest in the work of the Encyclopedists and in the principles
that inspired the revolutionary movement in its beginnings, changed their
minds. Thenceforth they demonstrated their fear and repudiation of the
course of events in France. Thus, Conde de Floridablanca, who had collabo-
rated in the suppression of the Jesuit order and in the reforms of Carlos III's
reign, was not able to head off what he called the "contagio revolucionario"
(revolutionary contagion), nor did he know how to act in a situation in which
the events surpassed all forecasts. The "incendio" (fire) began reaching

the events surpassed all forecasts. The "incendio" (fire) began reaching incalculable proportions. Floridablanca limited himself to intransigence in his negotiations with Louis XVI's new ministers, since he was convinced the king did not act freely, but was coerced. When it became known in Madrid that the king of France had accepted the constitution approved by the National Assembly, Floridablanca let it be known that Carlos IV refused to recognize such an act could be freely willed. It was impossible in such circumstances to observe the agreements established in the so-called Family Pacts between the crowns of Spain and France. Because it was essential to negotiate with France, and given Floridablanca's unyielding position, Carlos IV decided to replace him with Conde de Aranda in February 1792. It was thought that Aranda, who sympathized with the Encylopedists and had been friendly with the *philosophes* while he served as Spanish ambassador in Paris, could communicate more easily with the men of the Revolution. Aranda's desire to reach an agreement with the French led him to advise the Spanish government to refrain from declaring war on France as Austria and Prussia had in April 1792, and his advice was taken.

The proclamation of the Republic and the imprisonment of Louis XVI and his family signaled the end of the propitiatory period. War began to seem inevitable. The Council of State favored breaking with France, while Conde de Aranda still hesitated. Given this stalemate, and following Carlos IV's personal confrontation with his minister Aranda, an alternative emerged aside from those advanced by the two court factions: the *golillas* (literally, ruffs), represented by Floridablanca, and the Aragonese, whose leading figure was Aranda. Manuel Godoy thus came to power when he was twenty-five (fig. 8 and cat. 64). He was named first secretary of state and the royal office on November 15, 1792. The monarchs, "afligidos e inciertos en sus resoluciones" (afflicted and uncertain about their decisions) sought the support of a man they judged to be incorruptible, who would owe them everything, and "fuese con ellos uno mismo y velase por ellos y su reino de una manera indefectible" (would be one with them and work for them and their kingdom in an unfailing manner). Godoy's being free of "influencias y relaciones anteriores" (previous influences or associations) persuaded the monarchs he would succeed "en los días temerosos que ofrecía la Europa" (in the fearful circumstances then prevailing in Europe).[7]

The Spanish government attempted to save Louis XVI's life by offering the French neutrality. Events gathered momentum when the king of France was executed in January 1793. Peace then was impossible. The Spanish government availed itself of the popular fervor awakened by the death of Louis XVI to obtain funds to finance the war. The men of the Convention also issued a call to arms: They sought to spread the Revolution to other lands. Barère, in a report submitted in the name of the Council of Defense, even exclaimed, referring to Spain: "Let liberty be carried to the most beautiful climate and the most magnanimous people in Europe!" At the beginning of March, the revolutionaries declared war on Spain.

In Spain patriotic fervor and clerical support at first gave the war the character of a crusade. When Godoy recounted these events in his memoirs,

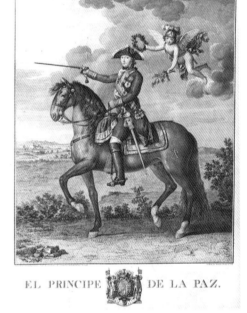

Fig. 8. Mariano Brandi,
El Príncipe de la Paz (Prince of Peace), Manuel Godoy, 1796.
Etching.
Museo Municipal, Madrid

he objected to those who affirmed that "'el gran movimiento' era obra de sermones y de influjos monacales" ("the great movement" was the work of monastic sermons and machinations). Without denying the influence of religion, "ofendida y amenazada" (insulted and threatened) in France, he insisted that in Spain "el espíritu nacional y el honor antiguo, inmemorial" (national spirit and ancient, immemorial honor) had induced the armed intervention in France. The uprising against the French had been driven, he wrote, by a people resistant to the death to any yoke, to any dictatorship "que intentara imponerle el extranjero" (that any foreigner attempted to impose). Men, horses, weapons, money were put at the disposition of the government for the war against the Convention's France. The unfavorable results of the campaign persuaded the Spanish government to sign the Peace of Basel in July 1795.

The antirevolutionary movement that took hold in France in Thermidor 1794 had made peace and understanding with Carlos IV's government possible. The English siege of France made it necessary for France to come to terms with Spain, as a result of which the first Treaty of San Ildefonso was signed in August 1796. Spain could no longer remain neutral in the Franco-English war, which brought interruptions in trade with the Indies after October 1796.

The offensive and defensive alliance with the Directory seems to have brought about a change in the reformist climate in Spain, contributing to the propagation of new religious and political principles.

The Growth of State Expenses Caused by Wars

The Treaty of San Ildefonso, affirming peace and friendship between Spain and the French Republic, led to war with Great Britain, which again raised state spending.

The ships built under Fernando VI, Carlos III, and Carlos IV had not succeeded in making Spain Britain's equal on the seas. The crews and the quality of the ships were still inferior. The English navy, commanded by Nelson and Admiral Jervis, defeated the Spanish navy near Cape San Vicente in February 1797. The British were able to disrupt regular communications between Spain and the Indies. The government in Madrid, burdened with the costs of war, began separate negotiations for peace without considering the French Directory's attitude. In Spain, opposition to Godoy caused his fall from power in May 1798.

Some thought Godoy's fall would enable men with political experience and Liberal ideas to take command of the government. It was indeed the moment for Jovellanos's fleeting tenure as minister of religion and justice.

The Need to Increase Treasury Revenues: Legal Measures and Consequent Reforms

The fall in regular treasury revenues following the interruption of trade with the Indies obliged the government to cover the deficit with debt issues. The measures adopted to increase state revenues were not as successful as hoped, and it became necessary to take measures of an extraordinary

character. Properties belonging to hospitals; hospices; charity, recluse, and orphan houses; guilds; memorial monuments; charitable institutions; and lay associations were to be sold by the decree of September 19, 1798. The proceeds from the sale were set aside for the Royal Bureau for the Retirement of Debt, whose promissory notes earned an interest of 3 percent, paid to those who thenceforth owned the auctioned properties. The opposition these sales provoked in ecclesiastical ranks compelled the king to try by diplomatic means to obtain a papal brief authorizing the sales. The Roman pontiff granted Carlos IV two such: one on July 14, 1805, and another more ample one on December 12, 1806. With these measures, apart from obtaining revenues for the treasury, property rights over the sold goods were definitively established.

The legal measures tending to limit or reduce the entailment of lands were not as effective as the most advanced idealogues of the enlightened century wished. On May 14, 1789 it was decreed that estates inherited by primogeniture could no longer be established, even if by way of bequest. The entailment of waif property in perpetuity was also prohibited, unless authorized by the king. Another royal decree of August 24, 1795, established that henceforth property destined for entailment would be subject to a 15 percent tax. The legal measure that could have had the most effect on entailed properties was issued on September 19, 1798. It set out to restore entailed lands "al cultivo de propietarios activos y laboriosos" (to active, diligent owners to cultivate), so long as present owners were inclined to sell them because administration or cultivation was of no benefit. This decree stipulated that all owners of estates inherited by primogeniture, owners of entailed lands, or lay associations owning lands were empowered to sell their properties, so long as they deposited the proceeds in the Royal Bureau for the Retirement of Debt, in exchange for which they would receive 3 percent on its value. The ideas Jovellanos developed in his famous *Informe de Ley Agraria* (Report on the Agrarian Law) were thus being applied with the caution and calm that respect for tradition and the interest and freedom of those affected by the measures demanded.

Spain Occupied by Napoleon's Troops

When Napoleon occupied a large part of Spain in 1808 in the name of the Franco-Spanish alliance, he did not expect to be met with resistance. The Aranjuez uprising had placed Carlos IV's heir, Fernando VII, on the throne amidst popular acclamation.[8] By acclaiming his name as if it were a battle cry, the people expressed their feelings of independence while moved by the promptings of an ancient loyalty that led them to take up arms in defense of the legitimate throne. They were also moved by a "vago y confuso" (vague and confused) desire for freedom. Their actions were reinforced by religious feeling, although this had by then softened under the influence of the critical spirit of the enlightened century. By an "efecto natural" (natural effect) that often makes itself felt on such occasions "agregóse más la nación a sus templos y altares, por lo mismo que los reputaba amenazados por el extrangero" (the nation rushed to the defense of its temples and altars, believing them to be threatened by the foreigner). Spaniards were fighting at

the same time for their independence, their religion, and their monarchy. The struggle would have to be bloody and obstinate, but its success was assured at the outset.[9]

Spain in 1808 found itself immersed in singular circumstances. The king, queen, and heirs were in captivity. There was no government. The people, abandoned by the royal family when they left the court to meet Napoleon in Bayonne, claimed sovereignty for themselves. That abandonment and the circumstances in which it came about, with French troops occupying the country, contributed "a dar mayor fuerza y ensanche al elemento popular, que impulsaba la guerra" (to giving more vigor and berth to the popular element, which became the driving force behind the war): "ni en la legislación de España, ni en ninguna del mundo, podía hallarse previsto un caso tan extraordinario" (neither in Spanish laws, nor in any in the world could such an extraordinary case have been foreseen). The only law governing the situation was that of self-preservation. The circumstances were the same throughout Spain. Hence the unanimous response – the uprising against the invader – in the different provinces of the kingdom. There was no constituted authority that could assume responsibility to "arrojar a la nación a una lucha tan desigual" (hurl a nation into such an unequal fight); there was no organized army, weapons, or money.[10] French troops were the masters of Madrid and the principal cities in Spain. They had control of all possible means of transport and communications. Any one province could not know what was happening in another. The fight and resistance were undertaken with heroism. But there was always the apprehension that what was taking place was only "una llamarada del furor popular" (a sudden outburst of popular fury). Hence the provincial authorities showed signs of indecisiveness that provoked distrust among the people, who were sometimes overcome by unruliness. This explains the violent deaths of such enlightened men as don Antonio Raimundo Ibáñez, "Marqués de Sargadelos," member of the patriotic Council of Ribadeo; don Juan Ignacio de Espinosa y Tello de Guzmán, Conde del Aguila, in Seville; Solano in Cádiz; Antonio de Lomas in Jaén; don Toribio Gragera de Vargas, Conde de la Torre del Fresno, and field marshal, military governor, and political figure from Badajoz; Barón de Albalat in Valencia; Marqués del Socorro in Cádiz; a councilman in Orense; General Filangieri in Villafranca del Bierzo; and Cevallos, director of the Artillery Academy in Valladolid. In Oviedo the mutineers tied the magistrates Conde del Pinar and Meléndez Valdés (cat. 24) to trees in order to compel them to execute prisoners. These mutinies were crimes committed by inflamed people "que veían en la prudencia traición" (who regarded prudence as treason).[11]

The passions of people without personal fortunes, those who made up most of the populace, explain the boldness with which they took up arms in defense of a throne they considered usurped, of a religion they believed in danger, and of a country invaded by troops they viewed as enemies. The first impulse was popular. Later the upper classes – generally more reflexive and guarded – joined the movement. Aristocrats, clerics, and common people were united in a common front against the invader, confirming "un concierto general, unánime, que aumentó hasta lo sumo las fuerzas de la nación y

opuso una barrera insuperable a todo el poder de Bonaparte" (a general, unanimous sense of purpose that magnified the nation's strength to its utmost and raised an insurmountable barrier to all of Bonaparte's power).[12]

The war against Napoleon's army forged national solidarity, from which only José Bonaparte's followers the *afrancesados* (French collaborationists) were exempted; the *afrancesados* were a minority of Spaniards who, out of conviction or convenience, swore allegiance to and served the new king, in some instances because they wished to collaborate in the regeneration of the old Spain. They hoped to bring about change in accord with the emperor's program, inherited from revolutionary France.

Because every Spanish class and region made common cause against the invader, privileges would be neither defended nor respected. Nobody claimed "exenciones y prerrogativas" (exemptions and prerogatives). All applied their energies and hopes to the same enterprise in order to save a country on which they based their hopes of "la salvación común" (universal salvation): "el noble y el plebeyo empuñaron al mismo tiempo las armas, pelearon juntos, sobrellevaron con buen ánimo las cargas y penalidades de la guerra, y lejos de encenderse entre ellos rivalidad y odios, reinó una noble emulación en provecho y gloria de la patria" (the aristocrat and the commoner both took up arms, fought together, happily endured the burdens and hardships of war, and far from rivalry or hatred flaring up between them, a noble emulation reigned to the benefit and glory of the nation).[13] Thus the feeling of equality began taking root, a feeling with more tradition in Spain perhaps than in any other country. There was no dearth of spoken and written manifestations of this attitude of rejection of privileges on the part of the members of the most exalted nobility: when seignories were suppressed by decree on August 6, 1811, the young Duque de Osuna distributed a statement among the inhabitants of his jurisdiction in which he hastened to declare that the general and extraordinary Cortes of the kingdom gathered in Cádiz "para plantar el terrible baluarte contra la tiranía" (to build an imposing bulwark against tyranny) had decided to "suspender y quitar los señoríos y jurisdicciones que antes tenían Grandes y otros" (suspend and abolish the seignories and jurisdictions grandees and others once possessed). He averred that before being a grandee he had come into this world a citizen and that, therefore, he was "el primero a sacrificar este vano oropel, cuando la nación lo quitó por convenir así al bien general" (the first to relinquish this vain tinsel when the nation revoked it in order to suit the good of all). He asked the inhabitants of his jurisdiction to remain free of French domination, to offer "obediencia y respeto al soberano congreso" (obedience and respect to the sovereign congress) and to hasten to congratulate it for finishing the constitution. He expected of them this "nueva prueba" (new proof) of the affection with which they had looked on "su casa y persona" (his family and person) until then.[14]

The ideas of liberty and equality must have achieved a much greater degree of acceptance than it is possible to document. When the guerrilla fighter dubbed *El Pastor* (The Shepherd) appeared on the estate Santa María del Bosque, belonging to the Condesa-Duquesa de Benavente (cat. 6, 17), he seized everything there was by armed robbery. He assured the steward, with

impulsive gestures, that there were no longer "duques ni ricos" (dukes nor rich men), that the land belonged "de todos" (to everyone), and that all money in his possession must be distributed among his followers.[15]

Once the war with the French broke out in 1808, the people in arms everywhere, "por una especie de generoso instinto" (by a kind of generous instinct), recognized that it was necessary to "someterse al freno de la autoridad" (submit to the restraints of authority) in order not to "ver malogrados sus esfuerzos" (see their efforts come to nothing).[16] By not recognizing the central government in the capital of the kingdom because it was subject to the enemy, each province prepared "su propio régimen y defensa" (its own government and defense). It happened easily, given the political fragmentation never altogether overcome in Spain, in spite of the two unifying bonds: the monarchy and religion. Thus emerged the separate provincial councils. Each one was "el retrato de la sociedad española" (the portrait of Spanish society) of that time: the councils were made up of the principal authorities, the military generals and chiefs, the magistrates, judges, mayors, scribes, members of the titled nobility, prelates, clerics – regular and secular – landowners, merchants, and a few representatives of the commoners. In the councils delegates represented the values of traditional as well as new social and political ideals. The authorities represented the monarchist principle; the nobles the aristocratic; the clerics the religious; and the representatives of the common estates the popular principle.

Members of all classes made up the councils, conscious as they were of the importance of remaining united. This convergence sparked the beginning of the liberal revolution.[17] Thus a kind of federated government came into being, which made the invaders' task more difficult. It would have been easier for the French to subdue the leaders of a central government. The existence of dispersed authorities such as the councils did not make for a well-defined target "contra el que pudieran asestarse los tiros de intriga" (against which the shots of intrigue could be aimed) nor was it even possible to reach accords "para daño y pérdida de la causa que defendían" (to the harm and loss of the cause they defended).[18] Karl Marx noted that the councils appeared to be constituted by universal suffrage. The people elected "a sus superiores naturales, elementos de la nobleza provincial, respaldadas por el clero, y poquísimas personalidades notables de las clases medias" (their natural superiors, elements of the provincial nobility, backed by the clergy, and few notable personages of the middle classes). Therefore, according to Marx, the possibilities of a true revolution were limited.[19] However, those that Marx considered "diques opuestos a la avalancha revolucionaria" (barriers against the revolutionary avalanche) were in fact the very same who adopted the measures that would put an end to the most characteristic institutions of the Old Regime.[20] Napoleon's recommendations to the Gran Duque de Berg when he wrote to the duque from Bordeaux on April 10, 1808, did not meet with a favorable response in Spain. The duque, was told to declare that the emperor's intention was to preserve not only the integrity of the provinces and the independence of the country, but also "les privilèges de toutes les classes" (the privileges of all classes).[21]

The Bayonne Constitution

Having obtained the royal family's confinement in France after the abdications of Bayonne, Napoleon must have considered it an easy matter to achieve the country's subjugation. Cortes were convened on May 24, 1808, in order to gather representatives of the three estates (clergy, nobility, and commons). The members of parliament were to report to Bayonne on June 15 with the task of "tratar de la felicidad de toda España" (discussing the happiness of all Spain). After "reconocer todos los males" (recognizing all of the ills) occasioned by the previous system, they were to propose "las reformas y remedios más convenientes para destruirlos en toda la nación y en cada provincia en particular" (the most suitable reforms and remedies to the ills of Spain and each particular province). It was desired that the clergy, nobility, and commoners be represented. The traditional right of cities with a voice in the Cortes to send representatives was recognized, and fifty clerics and fifty-eight nobles were added. Deputies from the army and navy, the high tribunals and consulting bodies, the three largest universities, commerce, and the American territories would also take part. Ninety-four of the 156 called appeared. By a manifesto distributed throughout the kingdom, all Spaniards were soon invoked to help the new government "en la regeneración" (in the regeneration) it was planning for "la felicidad de la patria" (the happiness of the nation). On June 6, by imperial decree, José I was proclaimed king of Spain and the Indies. Within nine days the sessions of the Cortes were initiated. Following various meetings, the representatives approved the constitution named after the city of Bayonne, in which the political system that would govern Spain was defined, according to which there would be a senate, Cortes, and a council of state. The rights of the people and of the press would be guarded by the senate. Laws were to be presented by the government to the council of state and later sent to the Cortes for approval. The members of the senate and of the council would be appointed by the crown. The deputies to the Cortes were to be elected by a restricted electoral body, whose establishment would be the responsibility of the city fathers, councilmen, and parish priests of the most important towns in the kingdom. The constitutional text was in this matter inspired by that governing France, and those in Naples, Westphalia, and Holland. There were articles in the Constitution of Bayonne that, had they been enforced, would have modified the structures of the Old Regime society by abolishing privileges, establishing the unification of the law, reducing the number of entailed estates, giving people the freedom to change residence, suppressing torture, and eliminating duties on domestic trade.

The Afrancesados *(French Collaborationists)*

This program and the conviction that the empire's power was impossible to resist explain why so many enlightened Spaniards swore loyalty to the new king. They thought perhaps that it would be possible to apply the principles that had inspired the best measures of the reigns of Carlos III and Carlos IV. The alternative for them was to support a diffuse revolutionary movement, certain aspects of which they rejected. The war against Napoleon's army,

moreover, could never, in their minds, end with the victory of the insurgents.

José I's first ministry was made up of men who had distinguished themselves during the reigns of Carlos III and Carlos IV: Mariano Luis de Urquijo, Pedro Ceballos, Miguel José de Azara, Gonzalo O'Farrill, José de Mazarredo, Conde de Cabarrús, and Sebastián Piñuela. Jovellanos refused to be made José I's minister of justice, preferring instead to join the Central Council in its efforts to organize the resistance to the invader, whose army numbered more than 110,000 troops.

Victories in the War

The insurrectionary council of Asturias was the first to declare war on Napoleon on May 24, 1808. The council sent two envoys to London, whose mission was to obtain English help, England being already immersed in war with France. The English could perhaps expect that support for the revolution in Spain would bring them advantages in Spanish America, and perhaps this vast territory's independence from Spain.

The Spanish army was then made up of 115,000 men. Of these, 15,000 were fighting in Denmark with the imperial troops as a result of the alliance Carlos IV and Napoleon had fashioned. Organization and tactical superiority, along with numbers, favored the imperial army. However, the uprisings of May and June 1808 produced the isolation of French troops in Portugal and Catalonia. Because the resistance was regionally organized, Napoleon thought it was possible to put down the points of resistance right away by occupying all of Spain. This resulted in the isolation of his columns, "al no poder dejar guarniciones que asegurasen la retaguardia" (since it became impossible to leave troops behind to protect the rear guard). Spanish successes, especially that at Bailén on July 19, 1808, obliged Napoleon to regard the Spanish campaign as a national war, and so he sent an army of 250,000 men, of which a large number were taken from the *Grande Armée.*

The Guerrilla War

The English army, which was arriving from Portugal, would not have sufficed to stop the French advance if it had not been for a special form of Spanish resistance to the French: the *guerrilla* (literally, little war), which was launched because there were insufficient numbers and means to engage in a regular war. The *guerrilla*, among whose participants were fugitives of the regular army, was the result of the defeat and dispersion of that army. It began to take shape in the first months of 1809. The support of the population guaranteed its success, since it created a hostile environment for the enemy soldiers and a generally, though not universally, favorable one for the guerrilla soldiers.

Scholars do not agree about the importance of the *guerrilla* in the war against Napoleon's army. At the time the courage of *guerrilla* fighters was exalted, while their military impact was generally underestimated.[22]

The Central Council, the Regency Council, and the General and Extraordinary Cortes

The need to unify the various efforts directed by the provincial councils led to the creation of a governing Supreme Central Council for the kingdom. It met in Aranjuez on September 25, 1808. Conde de Floridablanca presided, and Jovellanos was present.

Because of the advance of French troops, the Supreme Central Council moved to Seville and, later, to the Isla de León in Cádiz. Facing the danger of dispersal, the council decided that supreme power would be invested in a Regency Council on January 31, 1810. The provincial councils pushed for the convocation of a regular parliamentary assembly. This issue had already been discussed in the Supreme Central Council: the most radical members wanted a single assembly.

The Regency Council oversaw the direction and pursuit of the war. Simultaneously independence movements broke out in some territories of Spanish America (Buenos Aires and Venezuela). The regency's authority was limited and had no prospect of remaining in charge of state affairs. The only apparently effective solution, then, was to summon the Cortes, in spite of the enormous difficulties entailed by the war and the absence of agreement over who should participate.

At last the Cortes were gathered on Isla de León, "confundiéndose las alegres salvas" (mingling the joyful volleys) celebrating the event "con los tiros mortíferos que asestaban los enemigos" (with the deadly salvos fired by the enemy).

The Cortes had to "fundar un gobierno" (establish a government), raise and organize an army, and unite existing forces to confront the invader. Simultaneously, they had to carry out the political and institutional reform for which they had been called. Martínez de la Rosa indicated that the Cortes found themselves in a situation analogous to that of the constitutional assembly and the Convention in France. They had to "construir el Estado" (build the state) and oppose an invading [Napoleon's, in Spain's case] army. The deputies lacked experience, had no clear-cut orientation, and when they gathered "venidos de diversas tierras, congregados en un salón escueto" (from diverse lands, meeting in a small hall), they had no resources but "unos pliegos de papel y un tintero" (some sheets of paper and an inkwell).[23]

The Cortes reflected the general state of the nation. In previous centuries the Cortes had been made up of representatives sent by cities with a vote. This tradition was respected, in order to "hermanar de buen grado los tiempos antiguos y modernos" (harmonize the old and modern ways), although it was thought necessary to convene a larger number of deputies, representatives of the councils and town halls. The Central Council had prescribed that deputies elected in the provinces participate in the Cortes. They named *suplentes* (substitutes) to represent the provinces where elections had not been possible because of the war. The same was done with the representatives of the American provinces, when it was not possible to await the arrival of deputies elected there.

In the Cortes the struggle between defenders of traditional practices and

supporters of their reform or suppression began to emerge. Prelates, Spanish grandees and other nobles, and clerics participated in the assembly. Few deputies belonged to the general or common estate.

The Cortes' Decrees

On September 24, 1810, the Cortes and their sovereignty were decreed legally constituted. The Cortes reserved legislative power for themselves "en toda su extensión" (in all of its ramifications). The executive power was invested in the king. Judicial functions were to be carried out by "todos los tribunales y justicias establecidas en el Reino" (all the tribunals and courts established in the kingdom). On October 15, it was decreed that "los dominios españoles en ambos hemisférios" (the Spanish dominions in both hemispheres) formed "una sola y misma monarquía, una misma y sola nación, y una sola familia" (one and the same monarchy, one and the same nation, one and the same family) and that, as a result, "los naturales" (natives) born in the European possessions abroad were equal under the law. The Cortes were to take responsibility "con oportunidad y con un particular interés" (when the occasion called for it and with special care) to ensure that everything possible was done to contribute "a la felicidad de los de ultramar" (to the happiness of those living overseas) and to establish the "número y forma de la representación en ambos hemisferios" (number and nature of representation in both hemispheres).[24] On November 10 freedom of the press was decreed; the Cortes ensured "que la facultad individual de los ciudadanos de publicar sus pensamientos e ideas políticas" (that the individual ability of citizens to publish their political beliefs and ideas) was a check on the arbitrariness of rulers and a means of "ilustrar a la nación" (enlightening the nation). Thus, they decreed that all institutions and individuals, whatever their state or condition, were free to write, print, and publish their political ideas, without need of previous license, revision, or approval. On April 22, 1811, the Cortes, "con absoluta unanimidad" (with absolute unanimity), decreed "abolido para siempre el tormento en todos los dominios de la monarquia española" (torture forever abolished in all the territories of the Spanish monarchy).

In accord with the spirit that moved the deputies, and with practically universal backing throughout the kingdom, on August 6, 1811, the seignorial jurisdictions were incorporated to the nation. Vassalage was abolished so that henceforth nobody could call himself a lord of vassals. On May 26, 1813, the Cortes agreed to a desire expressed by several cities and declared "quitar y demoler todos los signos de vasallaje" (all signs of vassalage) in place on entrances, capitulary houses, or any other location (were removed and destroyed). Spanish cities did not recognize nor would they ever recognize – as the decree put it – "otro señorio que el de la Nación misma" (any other seignory than that of the nation itself), for "su noble orgullo no podría sufrir tener a la vista un recuerdo continuo de su humillación" (their noble pride could not endure having in view a continuous reminder of their humiliation). The truth is that by then these seignories were merely symbolic in importance, for the titular rights consisted only in making appointments to some, but not all, municipal posts and in the receipt of some ritual rents with no

economic significance. The exclusive monopolies on hunting, fishing, and milling were also abolished in August 1811.

On February 22, 1813, the Cortes decreed that the tribunal of the Inquisition was incompatible with the constitution. As a result, they reestablished, "en su primitivo vigor" (with its original effect), law 2, title 26 of the seventh *partida* (medieval legal code), which declared the bishops and their vicars free to arbitrate questions of faith. By decree of the same day, it was established that all images or inscriptions in which punishments and sentences imposed by the Inquisition were represented would be removed from all public buildings, so that no record of them would remain on view. Such reminders were thought to visit infamy on families whose predecessors had been tried, and made it possible for people sharing a surname to be "expuestas a mala nota" (exposed to ill repute).

At the same time that seignorial jurisdictions were abolished, the Cortes discussed reforming the law governing agricultural contracts. Property rights were described as sacred, inviolable, and absolute. Don Agustín Argüelles affirmed in April 1813 that "el libre uso de la propiedad habría de arreglarse siempre" (the free use of property ought always to be settled) by contracts or private agreements, "conforme al interés recíproco de unos y otros" (according to the mutual interest of both parties). The law should limit itself to expediting the drafting of contracts and their enforcement.[25]

On April 26, 1813, Conde de Toreno proposed to allow "establecer fábricas o artefactos, sin necesidad de permiso ni licencia alguna, sujetándose solamente a las reglas de policía adoptadas en los pueblos para su salubridad" (the establishment of factories and manufactures without need of authorization or license, subject only to the norms adopted by cities for their salubriousness). On June 8, 1813, it was decreed that all Spaniards and resident foreigners could freely establish "las fábricas o artefactos" (the factories or manufactures) they desired, without need of permission or license. Similarly, Spaniards could "ejercer libremente cualquiera industria u oficio útil, sin necesidad de exámen, título o incorporación a los gremios respectivos" (freely practice any useful industry or trade, without need of a test, title, or membership in the respective guilds). To this end, all regulations contradicting this decree were repealed. The Treasury Commission on May 6 affirmed that all protection the government gave industry should be confined "a no embarazar la acción de los particulares y a proteger su libertad" (to not hindering the initiatives of individuals and to protecting their liberty [of action]).

The aspiration to freedom was captured in the spirit and letter of the Cortes' decrees. The deputies wanted to contribute with adequate legislation to making all citizens content. It would suffice "dejar al hombre con las menos trabas posibles" (to leave every individual with as few obstacles as possible). The individual's interest and the desire for happiness to which his nature drove him would persuade and teach him which way he was to "dirigir sus miras" (direct his attention) and in what he was "de emplear mejor su industria para conseguir abundancia y riqueza" (to work to achieve abundance and wealth).[26]

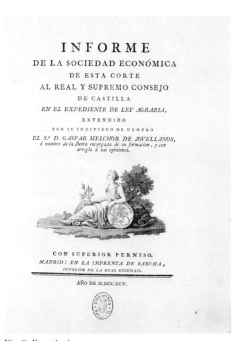

INFORME
DE LA SOCIEDAD ECONÓMICA
DE ESTA CORTE
AL REAL Y SUPREMO CONSEJO
DE CASTILLA
EN EL EXPEDIENTE DE LEY AGRARIA,
EXTENDIDO
POR SU INDIVIDUO DE NUMERO
EL S.ᵒʳ D. GASPAR MELCHOR DE JOVELLANOS,
á nombre de la Junta encargada de su formacion, y con
arreglo á sus opiniones.

CON SUPERIOR PERMISO.
MADRID: EN LA IMPRENTA DE SANCHA,
IMPRESOR DE LA REAL SOCIEDAD.

AÑO DE M.DCC.XCV.

Fig. 9. Frontispiece,
Gaspar Melchor de Jovellanos, *Informe de Ley
Agraria,*
Madrid, 1794.

On June 8, 1813, various measures were adopted to stimulate agriculture and the livestock industry. The general and extraordinary Cortes set out to protect property rights and to make amends for "los agravios" (damage) farmers had suffered. They hoped thereby to achieve "mayor fomento" (greater encouragement) of agriculture and livestock breeding, giving "mayor libertad" (greater freedom) to farmers' investments and repealing certain practices established to their detriment. To that end the Cortes decreed that all lands in private hands be enclosed and delimited in perpetuity, and that leases be freely contracted between the agents for the rent they agreed upon mutually and for whatever length of time convenient to both parties, without the least limitation. In the same decree it was established that in the first as well as in successive sales "ningún fruto ni producción de la tierra, ni los ganados ni sus esquilmos, ni los productos de la caza y la pesca, ni las obras del trabajo y la industria" (no fruit or product of the land, or livestock or their by-products, or the products of hunting and fishing, or construction or industry) be subject to price regulations. Moreover, the domestic trade in grain and other goods was to be entirely free of duties. Those who wished to dedicate themselves to buying and selling could do so, storing their wares wherever and however they wished, and selling them at the price that suited them.

The conceptual definition of the property right, consecrated by decree, meant that institutions limiting it — such as entails, estates inherited by primogeniture, and *manos muertas* (mortmain) — disappeared. On June 22, 1811, the deputy Laserna repeated Jovellanos's comments on entail in the *Informe de Ley Agraria* (Report on the Agrarian Law) (fig. 9) when he said: "Las leyes que favorecen la amortización sacan continuamente la propiedad territorial del comercio y circulación del Estado, la encadenan a la perpetua posesión de ciertos cuerpos y familias, excluyen para siempre a todos los demás individuos del derecho de aspirar a ella y uniendo el derecho indefinido de aumentarle a la prohibición absoluta de disminuirle facilitan una acumulación indefinida y abren un abismo espantoso que puede tragar con el tiempo toda la riqueza territorial del Estado" (Laws favoring entailment continually remove lands from trade and circulation, binding them to the perpetual possession of certain institutions and families, and forever exclude all other individuals from the right to aspire to ownership, and together with the unhampered right to increase property deny them the right to diminish it, enabling an indefinite accumulation and opening a frightful chasm that could in time swallow up all the territorial wealth of the nation).[27] Although on several occasions the Cortes discussed entailment and mortmain, the sovereign congress never legislated on them. Ecclesiastical entailment was repeatedly said to contradict general property rights, but it was believed an inappropriate time, in the circumstances then prevailing, to address disentailment. However, the council of state did recognize that it was in the public interest to restrict "los progresos de estas adquisiciones" (further acquisitions) and that ecclesiastical entailment should not be allowed to proceed beyond its present state.

On January 4, 1813, the Cortes decreed that "todos los terrenos baldios or

realengos" (all uncultivated and royal lands) and those commons belonging to villages on the peninsula, the islands, and the overseas provinces should be made private property. The owners of these lands were to enclose them and enjoy them freely and exclusively, giving them whatever use or cultivation they thought fit. "En ningún tiempo ni por título alguno" (For no amount of time or by any title) could they entail or transmit them "a manos muertas" (to mortmain).

The Cádiz Cortes' decrees thus defined a political regime that preserved only one institution – the monarchy, and even this limited in its powers – from those making up the previous form of government.[28]

Fernando VII's Return

Once Napoleon's army was expelled from Spain, Fernando VII was restored to the throne. In the manifesto of May 4, 1814, the king declared the Constitution of 1812 (fig. 10) had been approved "sin poder de provincia, pueblo ni junta, y sin noticia de las que se decían representadas por los *suplentes* de España e Indias" (without authorization from the provinces, people, or councils, and without a word from those who were said to be represented by *suplentes* (substitutes) for Spain and the Indies). According to the king, that act had been "el primer atentado contra las prerrogativas del trono, abusando del nombre de la nación" (the first encroachment on the crown's prerogatives, abusing the word nation). The legislation that followed – according to the king – "fueron adoptados y elevados a las leyes, que llamaron *fundamentales*, por medio de la gritería, amenazas y violencias de los que asistían a las *galerias* de las Cortes, con que se imponia y aterraba" (was adopted and elevated to laws, which they called *fundamentales* (fundamental), amidst tumult, threats, and violence by those observing in the galleries of the Cortes, through which [the rabble] imposed its will by frightening [the deputies]). The Constitution's approval, according to the manifesto, was achieved "a pesar de la repugnancia de muchos diputados, tal vez del mayor número" (in spite of the aversion of many deputies, perhaps the majority). That which had been "obra de una facción" (the work of a faction) would be dressed up "del especioso colorido de *voluntad general*" (in the specious garb of the *general will*) when, in fact, it was the work "de unos pocos sediciosos que en Cadiz y después en Madrid, ocasionaron a los buenos cuidados y pesadumbre" (of a few seditious people in Cádiz and later in Madrid, who afflicted the good with concern and sorrow). The manifesto alludes to "papeles públicos" (public papers) that, abusing freedom of the press, tried to "hacer odioso el poderio Real, dando a todos los derechos de la Majestad el nombre de *despotismo*, haciendo sinónimo los de Rey y *déspota*, y llamando *tiranos* a los reyes" (make royal authority hateful, giving all the king's rights the name of *despotism*, making king and *despot* synonymous words, and calling kings *tyrants*); "en todo se afectó el *democratismo*, quitando del ejército y armada y de todos los establecimientos que de largo tiempo habían llevado al título de *Reales*, este nombre, y sustituyendo el de *nacionales*, con que se lisonjeaba al pueblo" (throughout, *democratic ways* were affected, removing *royal* from the names of the army, navy, and other institutions that had long borne it and substituting *national*, thus flattering

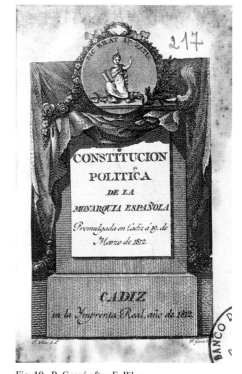

Fig. 10. P. Gassó after F. Pilar, Etching on title page of the Constitution of 1812. Private Collection, United States

the people). The king promised to work with constitutional representatives from Spain and the Indies, and with legitimately assembled Cortes, when the interests of his kingdom called for them, so that his subjects would be "prósperos y felices" (prosperous and happy), so that all would see him not as a despot and tyrant but as a king and a father to his subjects. To all the above were added the petitions and reports received "de varias partes del reino" (from various parts of the kingdom), expressing "la repugnancia y disgusto" (the loathing and disgust) with which the Constitution and "los demás establecimientos políticos de nuevo introducidos" (the other new political institutions) were looked upon in the provinces. The king, agreeing "con tan decididas y generales demostraciones" (with such decided and general manifestations) of the will of the people, "y por ser ellas justas y fundadas" (and because they were just and well founded), declared that it was his royal will "no jurar ni acceder a dicha *Constitución*" (not to swear or agree to said *Constitution*) or any decree issued by the general and extraordinary Cortes that deprived the monarchy of its rights and prerogatives according to Spanish tradition. Thus he declared the Constitution and such decrees "nulos y de ningún valor ni efecto, ahora ni en tiempo alguno, como si no hubiesen pasado jamás tales actos, y se quitasen de en medio del tiempo" (null and void, now and forever, as if such acts had never taken place, and they were removed from time).[29] However, many of the Cortes' decrees were not repealed. The legislative work in Cádiz thus had a greater impact in practice than is generally supposed.

The Repression

After the restoration of the absolutist regime, the retaliation began: the regents, some ministers, and the most important Liberals were ordered jailed. Some were sent to the African penitentiaries and to prisons and convents. Others left Spain, their exile initiating the series of emigrations that became so characteristic of Spain in later years. The émigrés left the country to escape political persecution. From England, where they generally went, they organized the resistance to the absolutist regime and were influenced by political, cultural, and artistic movements there. The number of émigrés increased when the followers of José I were sentenced to perpetual banishment by the decree of May 30, 1814.

Napoleon's defeat at Waterloo, his fall, and the political currents of those years encouraged the reactionaries in various European countries to restore the traditional order and to persecute those opposed to it. Thus emerged the alliance of throne and altar. The differences that had existed between clerics and nobles during the enlightened period disappeared after 1814 in the face of the danger of a revolution that would abolish all privileges. The Holy Alliance allowed sovereigns threatened by a revolution to count on foreign support to prevent the victory of the Liberals and their ideology.

In Spain the restoration of the absolutist regime meant the reestablishment of the old form of government. Proof of nobility for admission to army and navy schools was again exacted, repealing decrees issued by the Cortes on August 17, 1811, and March 9, 1813; the guilds were reestablished; the church was restored its rights, properties, and monasteries; and there was an

attempt to lessen the impact of the decree abolishing seignorial jurisdictions.[30]

The Revolution of 1820

The Liberals organized themselves into secret societies whose mission was to destroy the absolutist regime. They succeeded in doing this through *pronunciamientos* (military insurrections). The first of these took place in Pamplona in September 1814. A year later General Porlier rose in La Coruña. In April 1817 Generals Lacy and Milans del Bosch rebelled in Catalonia. In January 1819 another uprising took place in Valencia. All of these insurrections demonstrated the opposition to Fernando VII that existed even within the army.

Many of the troops assembled to crush the independence movements in America were discontent and did not want to go. On January 1, 1820, exploiting this favorable circumstance, the commander of the Asturian battalion, don Rafael del Riego, mutinied in Cabezas de San Juan and proclaimed the Constitution of 1812. Other uprisings in those months persuaded the king, in accord with "la voluntad general del pueblo" (the general will of the people), to swear allegiance to the Constitution. Fernando VII declared as much by decree on March 7, 1820. On March 20, a decree was issued suppressing the Inquisition at the same time that the king announced his pledge to uphold the Constitution. He declared "haber tomado las medidas oportunas para la pronta convocación de las Cortes" (having taken the opportune measures for the early convocation of Cortes). Meeting in the assembly with representatives of the nation, he affirmed that he was to devote himself to "concurrir a la grande obra de la prosperidad nacional" (take part in the great task of national prosperity).[31]

In the Cortes there was soon a move to suppress all forms of entailment. On September 27, 1820, entailed properties were declared free through a procedure that would be concluded when the present owners died. These owners could dispose of half of the entailed land as if it were free property. The other half was to be transmitted to whomever would inherit by primogeniture. The heirs could dispose of their part freely as owners. Thenceforth all forms of entailment were forbidden, and lands held in mortmain could not be enlarged by any means. Trustees of such lands could neither impose nor accept rents from the land. When the decree on seignorial jurisdictions was enforced, disputes arose between lords and vassals in the course of which lords were obliged to produce titles, since the seignorial or contractual origin of the taxes and dues exacted by lords was to be derived from these documents. In the face of the king's refusal to approve the decree presented to him on this occasion, the Cortes made it law in accord with Article 149 of the Constitution, which had been passed on the eve of the restoration of the absolutist regime.

Once again the Cortes took up the issue of freedom to contract agreements between interested parties, a point that had been promoted since the agrarian law was first put into effect. Don Agustín Argüelles, as minister of the interior, affirmed before the Cortes that "las personas ilustradas" (enlightened persons) knew that the government had to protect agriculture and

industry in a manner "más bien negativa que positiva" (more negative than positive); that its intervention "debería limitarse a remover estorbos, a hacer respetar la propiedad y dejar obrar libremente al interés individual" (should confine itself to removing obstacles, to ensure property was respected and to allow individual interests to act freely). This, it was thought, would be much more effective than all the support a government could offer.

On June 29, 1822, the Cortes again broached the matter of uncultivated and royal lands, much as they had on January 4, 1813. As they did then, the Cortes established that these lands should be divided in two equal parts: one part to be sold in joint ownership to the inhabitants of the villages in whose jurisdictions they lay and the other half to be divided among soldiers, peasants, and day laborers.

On August 9, 1820, the Cortes auctioned all the properties that had been set aside to pay interest on and to retire the state debt in 1813, 1815, and 1818. On October 1, 1820, the monastic orders were suppressed and the regulars reformed. All personal property and land belonging to monasteries, convents, and colleges was eliminated and henceforth applied to palliate the state's debt. The result of these measures was the suppression of half the religious institutes and houses in Spain and the sale of their goods at public auction in spite of the active resistance of the Church and the break with the Vatican in January 1823. More than 25,000 estates were sold to 7700 buyers. The prices posted give a value of 450 million reales for them; in the sale, this figure rose to over a billion. However, the funds raised for the treasury did not in fact definitively solve the debt problem.

The Independence of Spanish Continental America

The emancipation of the overseas provinces meant that commercial relations between the territories and Spain were disrupted. As a result a profitable commerce in which national and foreign goods were shipped from Spanish ports to the American provinces came to an end. Colonial products and specie arriving from America had paid for imports from Spain. Moreover, the treasury had received important sums in the form of treasury surpluses from the viceroyalties. The Spanish American ports were now open to trade with the United States and Great Britain.

The loss of the American continental provinces had debatable repercussions on the Spanish economy, and students of this event have not been able to come to a consensus. The most recent research demonstrates that the effects of independence were less important for Spain than has been generally supposed to date. The volume and value of foreign trade, as well as the treasury's revenue, did indeed fall off. Investment fell off as well, in spite of the fact that independence resulted in the arrival in Spain of capital sent by residents who preferred to liquidate their businesses and interests in America, once independence threatened. The sale of Spain's manufactured goods dropped as exports to that protected market ended. Banking, commercial, and transport services were also adversely affected in the ports that maintained economic ties with continental America. Thus, the negative effect of the loss of the American provinces varied according to the sector of the economy and the region, although it seems to have been less than had been

supposed judging by the volume of trade between 1792 and 1827.[32] Now it is estimated that the negative effect in the short run probably amounted to less than 6 percent of Spain's gross national product, such that the loss of the American continental empire could only explain "una pequeña parte del retraso" (a small part of the [long-term] lag) the Spanish economy showed between 1820 and 1914, in comparison to the most advanced European countries. In the most flexible, competitive sectors, there was adaptation to the new circumstances. This must have been the case for some agricultural products with respect to the markets of other nations. The question still remains to what extent the independence of continental America accelerated the end of the Old Regime and the Liberal revolution as Spain passed from empire to nation.[33]

The Restoration of Absolutism during the "Ominous Decade"

The attitude of the great powers toward the Liberal revolution that held sway in Spain, Portugal, the Kingdom of the Two Sicilies, and Piedmont brought the Congress of Verona into being, so that absolutism could be reimposed. France was to be responsible for intervening in Spain. To that end, an army was raised: "Los cien mil hijos de San Luis" (The Hundred Thousand Sons of Saint Louis, that is, King Louis XVIII of France). This army, along with the royalist bands constituting the "ejército de la Fe" (Army of Faith), made their way into an indifferent Spain, without meeting effective resistance from the national army. The triumph of the absolutists brought persecution and a new wave of emigration. The royalist regency ordered purges of all who had held public posts during the Liberal triennium. These were suspended by decree on October 26, 1823, and resumed on April 1, 1824. During the following ten years of absolutist reign (1823-1833), which the Liberals christened the ominous decade, "the reactionary posture and practice, with its funereal and obligatory cortege of revenge and fury, military orders, accusations, and purges, punishments and thrashings, was much more prominent than the religious reaction, however much the two appeared to give each other a hand at the beginning."[34] Although on its way from Cádiz to Madrid, the royal retinue was acclaimed by throngs – in various towns and cities along the route, the coach was led by people who stood in place of the horses – in effect, the king soon "divorciado cada vez más del sentimiento público" (became increasingly removed from public sentiment). Fernando VII did not succeed in restoring the traditional Spanish monarchy but "enthroned a fierce, degrading, personal, and somber monarchy."[35] This was the fruit of foreign intervention in Spain and the epilogue closing the first ephemeral Liberal experience in Spain.

1. Pedro Lynce de Verástegui, town hall delegate of Seville. His report is summarized in the *Memorial ajustado, hecho de orden del Consejo, del expediente sobre los daños y decadencia que padece la agricultura y sobre establecimiento de una ley agraria* (Madrid, 1784), p. 84.

2. An extract from the Junta's decision is included in *Memorial ajustado.*

3. *Real Provisión de S.M. y señores del Consejo, por la cual se aprueban los estratos y demás actas y acuerdos formados para el gobierno de una sociedad patriótica establecida en la Ciudad de Vera y su jurisdicción para el fomento de la industria popular* (Madrid, 1776), pp. 12, 26-27.

4. The economic society of Valladolid's description of its emblem with motto and seal is a characteristic statement of the aspirations of the Societies of Friends of the Nation: through Enlightenment to banish the ignorance, contradictions, and contempt suffered by agriculture, industry, and the arts. "Será un sol rompiendo una nube de tres partes, a quienes penetren y hieran otros tantos rayos del mismo sol, cuyos reflejos al propio tiempo que alegren y vivifiquen un país que se figurara por lo bajo, formen en las nubes un arco iris con tres fajas o colores encarnado, azul y verde, semejante al que en lo natural se descrubre después de alguna tempestad: por orla de este escudo se pondrá una cinta en la que se enlacen varios instrumentos pertenecientes a la agricultura, industriay y artes; en el centro de le colocará este lema: *disipando ilustra,* y alrededor *Sociedad Económica de Valladolid,* significando con esta alegoría que la sociedad se propone dar las luces convenientes en las tres comisiones para disipar las sombras con que han estado oscurececidos estos tres ramos por más de dos siglos en Valladolid y su provincia, restituyéndolos no sólo a su antiguo esplendor, sino ilustrándolos con nuevas luces y adelantamientos; prometiéndose que no vuelvan a padecer nuevo dilubio de ignorancias, contradicciones y desprecios, mediante la constancia y desvelos de la sociedad, como lo anuncia el arco iris en cuyos colores encarnado, azul y verde se simboliza su amor ardiente al bien público y su celo, y ansioso deseo de conseguirlo, con la segura esperanza de lograrlo." (There will be a sun breaking through a cloud in three parts, penetrated and pierced by as many rays from the same sun, whose reflections bring joy to and enliven the country illustrated below as well as form a rainbow in the clouds made up of three colors – red, blue, and green – resembling those found in nature after a storm. On the border of this emblem, a ribbon will be shown linking various implements belonging to agriculture, industry, and the arts; in the center an inscription will be placed that reads: *it enlightens by dissipating* [darkness], and around it *Economic Society of Valladolid,* meaning by this allegory that the society proposes to create the conditions through its three commissions that will scatter the shadows that have overcast these three fields of learning for more than two centuries in Valladolid and its province, not only restoring [this city and its hinterland] to their former splendor, but enlightening them with new knowledge and advances; and vowing to never again permit a fresh deluge of ignorance, contradictions, and disregard through the society's constancy and vigilance, much as the rainbow suggests, whose colors red, blue, and green symbolize the society's burning love and zeal for the common good and its anxious desire to attain it, along with its firm hope of succeeding.) Emblem with motto and seal of the Economic Society of Valladolid, Title XVI, section I of the Statutes. Archivo Histórico Nacional, Consejos, docket 947, file 7, pp. 67, 67 verso.

5. See Manuel Danvila y Collado, *Reinado de Carlos III*, pp. 468-471.

6. Gonzalo Anes, "La Revolución francesa y España: Algunos datos y documentos," in *Economía e 'ilustración' en la España del siglo XVIII* (Barcelona, 1969), pp. 139-198.

7. Manuel Godoy, *Memorias críticas y apologéticas para la Historia del reinado del Señor D. Carlos IV de Borbón*, Biblioteca de Autores Españoles, vol. 88 (Madrid, 1965), p. 15.

8. Francisco Martínez de la Rosa, *Espíritu del siglo* (Madrid, 1846), vol. 6, pp. 301-302.

9. Ibid., pp. 302-303.

10. Ibid., pp. 303-304.

11. Miguel Artola, *La España de Fernando VII, Historia de España*, directed by Ramón Menéndez Pidal, vol. 26 (Madrid, 1968), p. 309.

12. Martínez de la Rosa, *Espíritu del siglo*, VI, p. 306.

13. Ibid.

14. The statement was signed in Cádiz on September 6, 1812. Archivo Histórico Nacional, Osuna, docket 512. The letter and reference appear in Carmen Muñoz Roca Tallada, Condesa de Yebes, *La Condesa-duquesa de Benavente: una vida en unas cartas* (Madrid, 1955), p. 248.

15. Quoted in a letter written by the steward to the Condesa-Duquesa, Archivo Histórico Nacional, Osuna, docket 194. See Roca Tallada, *Benavente*, p. 234.

16. Martínez de la Rosa, *Espíritu del siglo*, vol. 6, pp. 308-309.

17. Ibid., pp. 311-312.

18. Conde de Toreno, *Historia del levantamiento, guerra y revolución de España*, vol. 1, p. 283.

19. Karl Marx, "The Spanish Revolution," *New Daily Tribune* , Sept. 9 - Dec. 2, 1854.

20. Miguel Artola, *Memorias del tiempo de Fernando VII*, Biblioteca de Autores Españoles, introduction.

21. *Correspondence de Napoléon I publiée par ordre de l'Empereur Napoléon III* (Paris, 1864), vol. 16, pp. 487-488.

22. Miguel Artola, *La España de Fernando VII*, pp. 264-265.

23. Martínez de la Rosa, *Espíritu del siglo*, vol. 7, p. 118.

24. On February 9, 1811, it was decreed that natives and inhabitants of America could seed and cultivate whatever nature and skill allowed them in those climes and promote all forms of manufacturing and the arts. It was also recognized that Americans, whether Spanish or Indian, had as much right as Peninsular Spaniards to obtain every kind of post, in any part of the empire, whether in ecclesiastical or in political and military careers.

25. Quoted in *Diario de sesiones*, April, 19, 1813.

26. According to Conde de Toreno's speech of December 22, 1811.

27. June 22, 1811 session. See Gaspar Melchor de Jovellanos, *Informe de Ley Agraria* (Madrid, 1794), p. 151.

28. Miguel Artola, *Antiguo Régimen y revolución liberal* (Madrid, 1978), p. 185.

29. *Manifiesto del Rey, declarando por nula y de ningún valor ni efecto la Constitución de las llamadas Cortes generales y extraordinarias de la nación, disponiendo al mismo tiempo lo que ha de observarse, a fin de que no se interrumpa la administración de justicia y el orden político y gubernativo de los pueblos* (May 4, 1814).

30. By royal resolution published on June 20 – after consultation with the cabinet on June 9, 1817 – and by another of November 19, 1819, the crown was given the right to name municipal officers in towns under seignorial jurisdiction. This decree reversed what had been established on August 6, 1811.

31. *Gaceta de Madrid*, Mar. 12, 1820.

32. See Fontana Lázaro, *Quiebra*, pp. 53-57.

33. Leandro Prados de la Escosura, *De imperio a nación: Crecimiento y atraso económico en España (1780-1930)* (Madrid, 1988), pp. 30-31, 67-94.

34. Marcelino Menéndez Pelayo, *Historia de los heterodoxos españoles* (Madrid, 1981), vol. 3, p. 523.

35. Ibid.

GOYA AND THE LINK WITH FRANCE
AT THE END OF THE OLD REGIME

Jeannine Baticle

How important was France to Goya's life and work? At first glance the answer seems straightforward; Goya moved in the world of *ilustrado* (enlightened) Spaniards, a circle that always followed French philosophical developments with interest. Even the *Encyclopédie* and the works of Voltaire and Rousseau were to be found in most of the libraries of the cultivated Spanish nobility, in spite of the Inquisition's restrictions.[1]

It was Ignacio de Luzán, the famous Aragonese poet, who said that Paris, where he lived from 1747 to 1749, was "the center of the sciences, the arts, scholarship, refinement, and good taste," and many of his compatriots shared his opinion.[2] In the same vein no literary or philosophical study of enlightened Spain fails to allude to the many great Spanish aristocrats who maintained a presence in France: the Duque de Villahermosa, the Duquesa de Veragua, the Marqués de Santa Cruz (fig. 1), the Duques del Infantado, and the Conde de Fuentes's son, the Marqués de Mora, lover of the celebrated Mademoiselle de Lespinasse, the Encyclopedists' oracle.[3] Finally, there was the Conde de Aranda, frequently, though wrongly, regarded as a notorious partisan of Voltaire's ideas, although he was above all an Aragonese nobleman of liberal views. Among others cited in this connection are the scientists, architects, and artists who went to Paris to study.[4]

These ties, as numerous and fruitful as they were, do not sufficiently explain Goya's knowledge of France, which he manifested so often throughout his youth and into adulthood. Goya's association with France must be considered in terms of historical and political relations between Spain and France. His dealings with France must also have been direct.

The essay is organized in two parts. The first examines Aragón's ties to France, especially its often overlooked physical proximity (the Somport Pass is about seventy-five miles as the crow flies from Zaragoza). The second part describes the economic and social consequences of the Bourbons' dynastic cosmopolitanism. Through the Third Family Pact the Bourbons opened Spain to modern international trade, retaining Franco-Spanish duties, however.

Aragón and France

The icy peaks of the summits ringing the abrupt, deep, circular valley of Astun dominate it; from this source, between the Somport and Portalet passes on the Franco-Spanish border, springs the Aragón River. The river is made up of a thousand rivulets flowing from Pyrenean lakes, which are squeezed into ravines that transform them into tumultuous torrents called *gaves* (mountain streams in the Pyrenees). On arriving at Jaca, the first Aragonese capital, the river suddenly becomes calm. It forks in the west, where it ends its course, merging with the Ebro, the great river of the Tertiary era. Its vast basin, framed by colossal cliffs, was the cradle of the ancient kingdom of Aragón, to which the small Pyrenean river gave its name.[5]

Invincible bastion of the Christian West in the ninth century, the Aragonese Pyrenees are crossed by the Roman Way through the Somport Pass, which, over the centuries, remained the principal route of access between southern France and Aragón. For 300 years the Muslim world retreated step-by-step along the Ebro to Zaragoza, which was recaptured by the Christians in 1118. The county of Aragón, whose capital was then still

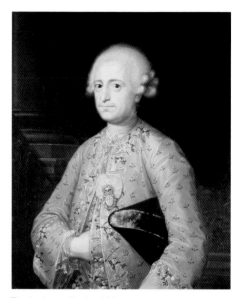

Fig. 1. Anton Raphael Mengs,
Marqués de Santa Cruz.
Oil on canvas.
Alba Collection, Madrid

Fig. 2. Goya's Birthplace in Fuendetodos, near Zaragoza.
(Photograph from the Más Archives, 1918)

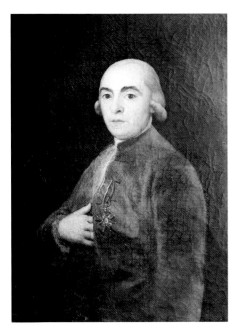

Fig. 3. *Juan Martín de Goicoechea*, 1789.
Oil on canvas.
Condesa de Orgaz, Madrid

Fig. 4. *Juan Agustín Ceán Bermudez*, about
1790-1797.
Oil on canvas.
Marqués de Perinat Collection, Madrid

Jaca, became a kingdom at the end of the eleventh century, and its first king, Sancho Ramírez, granted his subjects a special statute with tax exemptions, liberties,[6] and privileges, to which the Aragonese people remained profoundly attached until the advent of the Bourbons in 1700.[7] In the thirteenth century Jaca's legislative model served as the basis of the *fueros* (laws) of Aragón, which were promulgated in 1247. Maintained over the centuries in the Aragonese marches – the border region between Christian and Muslim Spain – these liberal concepts were revived with a marked vigor in Goya's day and furnished material to justify some of the claims of the Aragonese Sociedad Económica de los Amigos del País (Economic Society of Friends of the Nation). These liberal concepts also provoked the celebrated rebuff by the great Aragonese family of Palafox (see cat. 75). In 1794 the Conde de Teba, son of the Condesa de Montijo, with incredible insolence invoked the authority that the *hombres ricos* (the nobility) of Aragón had once exercised over the king of Spain, which led to their consequent independence from the central powers.[8]

The relative proximity of Zaragoza and of the routes of access to France enabled an important immigration from France, especially that originating in Béarn and Gascony. At the beginning of the seventeenth century this immigration became more important because the expulsion of the *moriscos* (Muslims) in 1610 deprived Aragón of the greater part of its rural and artisan labor force. Even before the departure of the *moriscos*, the French presence in Zaragoza was considerable. Bartolomé Joly estimated the number of immigrants at 10,000 or 12,000 in 1603, most of them *peladores* (wool carders).[9] Borruel also thought there were 10,000 in 1628.[10] According to modern demographic calculations, the population of the city was about 25,000 in that period. In 1648 a *fuero* decreed, probably because of the relentless war between France and Spain, that the children and grandchildren of the French, even those born in Aragón and married to locals, could not obtain benefices, dignities, or employment in the courts or government, and as a result in 1677 no more than 500 French people remained in Zaragoza.[11]

Basque immigration was equally high, and this contributed to maintaining contact between southwestern France and Aragón, for the Basques were particularly active in economic matters. Goya's paternal family was of Basque origin, and his great-great-grandfather Domingo Goya was almost certainly born in Cerain, near Cestona (Guipúzcoa), that is, less than forty miles from the French border. His grandfather Pedro Felipe was born in 1669 in Zaragoza, where he practiced as a notary.[12] (Goya was born near Zaragoza, in Fuendetodos [fig. 2].) The bonds with the paternal fatherland did not weaken, because Juán Martín Goicoechea (fig. 3), one of Goya's principal patrons in Zaragoza, was born on the Basque-Navarrese border, in the Valley of Burunda (Araquil). His mother was a Galarza. Since Goya's son married Gumersinda Goicoechea – progeny of Miguel Martín de Goicoechea and María Juana de Galarza, both born in the Valley of Burunda – in 1805, the bonds between Goya and the Basque-Navarrese remained strong.[13] This family history helps to explain how a French Basque, François Cabarrús (see cat. 15), played a leading role in the artist's career. Although Gaspar Melchor Jovellanos (see cat. 30) and Ceán Bermúdez (fig. 4) are often

credited with having introduced Goya to the court circle of *ilustrados* in Madrid, it appears rather that Juán Martín Goicoechea was the liaison.

When Goya wrote to his friend Martín Zapater (see fig. 5 and essay by Glendinning, fig. 4), who helped to found the Academia de Bellas Artes in Zaragoza, he almost never failed to ask to be remembered to Don Martín, who often requested some small service. And each time an important event took place in the professional life of the artist, Goya had Zapater inform Martín Goicoechea exclusively, "whom I esteem and to whom I owe so much," he emphasized.[14] Martín Goicoechea was born on November 1, 1732, in Bacaicoa (Navarra) and, when young, went to live in Zaragoza with his businessman uncle Lucas de Goicoechea.[15] His uncle sent him to Lyon to study silk manufacturing. "Silk manufacturing is truly a chapter in the history of decorative art in Spain," Yves Bottineau notes, "and the efforts to restore it were closely linked to the arrival of masters and journeymen from Lyon, to the protection of kings, and to measures taken by ministers and the enlightened ruling elite."[16] Martin Goicoechea, on his return to Zaragoza, dedicated himself to the improvement of silk manufacturing, Aragón's raw material being excellent. Aiming to revive the silk industry, he had a magnificent loom built on the principles of Jacques de Vaucanson, the well-known French inventor and inspector of silk factories. The city government of Zaragoza honored him on September 11, 1777, for he obtained higher standards in his manufactures by exacting them of his loom workers, whose training he guaranteed. By 1775 Goicoechea had become a great businessman and had created a corporation called the Compañía de los amigos de Zaragoza (Company of the Friends of Zaragoza), established to improve trade with other regions and to develop commerce in the city.[17]

Another of Goicoechea's interests was the Aragón Canal, of which he became treasurer. Promoted by Canon Ramón Pignatelli (fig. 6), work on the canal was resumed in 1770; Pignatelli was named its patron on May 9, 1771. The projects were at first confided to the French engineer Badin. An enormous enterprise, the construction of the Aragón Canal was conceived in the spirit of the Enlightenment and was to improve communications between Zaragoza and the north of Spain.[18] Antonio Payas, whose name appears often in Goya's correspondence, was its general administrator.

The Banco Nacional de San Carlos, founded in 1782 by François Cabarrús, chose Goicoechea as correspondent in Zaragoza and entrusted him with the business of supplying the army with uniforms, which were to be manufactured in the region. As a result, Goicoechea must have been in constant communication with Cabarrús.

Supported by the Sociedad Económica de los Amigos del País, which he joined in 1776, Martín Goicoechea decided to open a drawing academy (installed in the old seminary on the Plaza del Reyno) at his own expense, which, with Floridablanca's blessing, metamorphosed into the Academia de San Luís. He sometimes solicited Goya's advice on its organization. On February 22, 1790, Goicoechea was knighted (Caballero de la Orden de Carlos III) in recognition of his merits, and his insignia were conferred by Canon Ramón Pignatelli in the presence of don Hernández de Larrea, doyen of the chapter of the Basilica of Pilar, and of the Marqués de Villafranca de

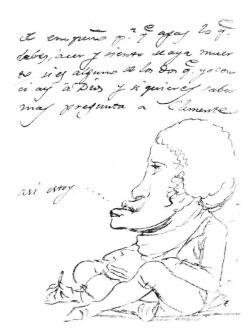

Fig. 5. A letter (detail) from Goya to Martín Zapater. Museo del Prado, Madrid

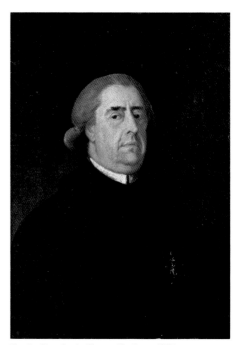

Fig. 6. *Ramón de Pignatelli,* about 1790. Oil on canvas. Private Collection, Madrid

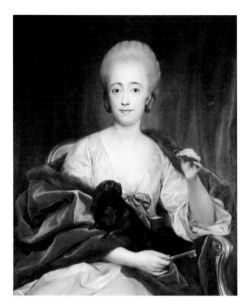

Fig. 7. Anton Raphael Mengs,
Duquesa de Huéscar.
Oil on canvas.
Alba Collection, Madrid

Fig. 8. Anonymous,
Conde de Aranda.
Alcora porcelain.
Banco de España, Madrid

Ebro. Goya painted his portrait on this occasion. A charitable man, Goicoechea used his own funds to encourage the fight against poverty. He was also benefactor of the Basilica of Pilar, whose retable of Christ – created by Juan Antonio de Atienza and the sculptor Joaquín Arali, Goya's friend – he offered to reconstruct.[19]

Juan Martín Goicoechea died on April 4, 1806, in his beautiful house, which stood on the Plaza del Pilar in Zaragoza until as recently as 1940.[20] Martín Zapater, his faithful friend and probable collaborator, had passed away in 1803. In the space of three years, Goya lost his two closest friends – the very models of enlightened Spaniards – who had always backed him during his youth.

It seems there was only one other intimate friend who played a beneficent and formative role in Goya's life: the poet Leandro Fernández Moratín (see essay by Glendinning, fig. 3), whom the artist met through Jovellanos and Cabarrús. Younger than the painter, Moratín backed Goya until his death in 1828; it was to a great extent through this intermediary that Goya penetrated the arcane mysteries of politics and court intrigue, which from the *Caprichos* to the *Disparates* made constant though veiled appearances in the prints of the master.[21]

Even if Goya was surrounded by great Aragonese nobles who filled high posts at court, it is unlikely that they or their entourage took pains to keep him abreast of political events. At any rate, it is enough to establish that two members of the most elevated Aragonese families, the Conde de Fuentes and the Conde de Aranda, occupied the Spanish embassy in Paris in succession and without interruption between 1764 and 1787, that is, for nearly twenty-three years.

Joaquín Pignatelli, Conde de Fuentes, on whose lands Goya was born, was the brother of Canon Ramón Pignatelli, who sponsored the Aragón Canal. Fuentes's second wife, the Duquesa de Huéscar (fig. 7), was the Duquesa de Alba's mother. His second marriage took place on the same day that his son, the Marqués de Villafranca, married the young Duquesa de Alba.[22] Another Aragonese much feared by the French for his difficult character, Don Pedro Abarca de Bolea, Conde de Aranda (fig. 8), succeeded Fuentes in Paris in 1774 and remained until 1787. Cultivated, original, and extremely ugly, the Conde de Aranda was remarried well into his maturity to a grand-niece; the unequal marriage provoked smiles in the courts of both Madrid and Versailles. His first secretary was Ignacio de Heredía; in 1787, Ignacio, returning home from Paris, visited his cousin Joaquín de Heredía in Zaragoza, canon of the Basilica of Pilar.[23] Several months later, Aranda, arriving from Paris, also stayed in Zaragoza, where he owned a palace; he admired Bayeu's frescos at Pilar, according to Casamayor's diary. It is important to note that he admired Bayeu's but not Goya's frescos, which may explain why Goya never painted the Conde de Aranda's portrait, even in 1792 when the Conde was, for a few ephemeral months, prime minister.

Another Aragonese family celebrated in the annals of the Enlightenment, the Azaras, were represented in Paris by the famous Nicolás de Azara, childhood friend of Ignacio de Heredía and admirer of Mengs, whom Bonaparte preferred to all others as Spanish ambassador to the consulate. Of

Nicolás's brother the reputed naturalist Félix de Azara (fig. 9), Goya made a superb portrait, which was deposited in the Museo de Bellas Artes in Zaragoza until 1976.

Two other, less-familiar Aragonese diplomats, both born in Zaragoza, had a decisive influence on French politics during the Revolution and the Empire. One was Clemente de Campos y Sahún Ardamy y Moranes, who spent ten years in Paris from 1773 to 1784.[24] He later replaced Las Casas in the Spanish embassy in Venice, where Moratín often visited him in October and November 1794.[25] Casamayor's diary reports Campos received the Cross of the Orden de Carlos III.[26] In 1828 Campos lived in Bordeaux, where Goya must have visited him. Campos, correspondent of the Conte d'Antraigues, who was then a Spanish agent, wrote the famous letter to Manuel Godoy (see cat. 64), dated July 3, 1793, on the new organization of the Committee on Public Health that was seized on an English ship in Toulon. Later, under the Convention, Saint-Just recalled that the Spanish ambassador's letters to Venice, which recorded the diplomatic deliberations of Hérault's time, were intercepted. This letter was the pretext used to condemn Hérault de Séchelles to death, although in fact the leaks for which he was blamed originated in d'Antraigues's network of informers, to which Hérault did not belong.[27]

Less sympathetic than Campos, the other Aragonese diplomat with French ties was Eugenio Izquierdo, a friend of Cabarrús's and a protégé of the Conde de Fuentes. Between 1775 and 1813 he was perhaps one of the best-informed Spaniards on French politics. When he died in Chantilly on May 29, 1813, his papers were immediately seized by order of the Ministry of Police, for they concerned official secrets.[28] At first the private tutor in France of the future Condes de Peñaflorida and the Marqués de Narros, he was affiliated with the Loge des Neuf Soeurs (Lodge of the Nine Sisters), in Paris, and was linked with Pablo Olavide, who was then taking refuge in France. Izquierdo is interesting in this context above all for his close rapport with members of the Lecouteulx bank. The Lecouteulxes were ardent partisans, associated with the Banco Nacional de San Carlos in France, and intimate friends of Cabarrús's. Izquierdo became a partner with the brothers Lefebvre in ownership of a copper foundry in Romilly-sur-Andelle, near Rouen, where he often stayed.[29] Director of the collection of natural history in Madrid, Izquierdo was made Godoy's official agent in Paris after 1798, and he thereafter performed great services for Napoleon, who held him in high esteem.

From these examples it may be seen to what extent the Aragonese were involved in the economic and political affairs of France between 1770 and 1814. The nature of these relations cannot be understood, however, unless they are seen in the light of the Third Family Pact, signed by the two crowns in 1761. Curiously, this very important treaty of alliance, which brought such serious consequences to both France and Spain, is generally overlooked in French histories, whereas Spanish histories above all stress its military consequences. Rare are the historians who recall the articles concerning double nationality, inheritances, and the economic agreements. Under the Third Family Pact, the subjects of both crowns would be "generally treated in everything and for everything as inhabitants of the country." Article XXIII abolished the windfall tax for Spaniards receiving inheritances in France, and

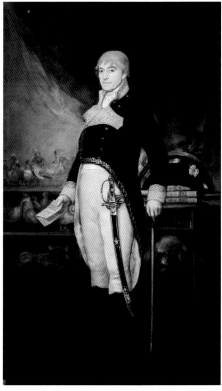

Fig. 9. *Félix de Azara*, 1805.
Oil on canvas.
Caja de Ahorros y Monte de Piedad de Zargoza,
Aragon, y la Rioja, Zaragoza

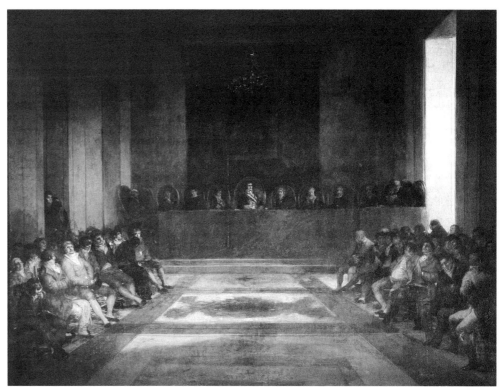

Fig. 10. *The Junta of the Philippines,* about 1815.
Oil on canvas. Musée Goya, Castres

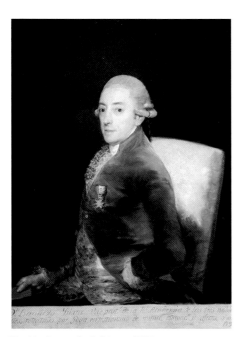

Fig. 11. *Bernardo de Iriarte,* 1797.
Oil on canvas.
Musée des Beaux Arts, Strasbourg

the French in Spain enjoyed the same privileges under Spanish law. According to Article XXIV, the subjects of both countries would be "treated in matters of commerce and imports in both kingdoms on equal terms."[30]

The incalculable consequences of these agreements, which at first involved close military cooperation, were felt in Spanish economic as well as political life. They explain at once why, even under the First Republic, the French ministers sought, at all costs, to maintain the fiction of the Franco-Spanish pact in order to avoid going to war with Spain. They also enable us to understand the exceptional conditions in which the Banco Nacional de San Carlos, one of the first European state banks (after England's), was created in 1782 by the just-naturalized French Basque François Cabarrús and the preeminent position it occupied in French financial affairs, to the great displeasure of the enemies of Catholic banking. French banking houses and bankers bought shares of the Banco Nacional de San Carlos, among them Lecouteulx, Magon de la Balue, Girardot and Haller, Lenormand, and Pierre Lalanne, Cabarrús's cousin in Paris. On the other hand, the Real Compañía de Filipinas, which Goya immortalized in 1815 with his famous *Junta de Filipinas* (fig. 10), was created by Cabarrús in 1785 with less cosmopolitan criteria. Its first director, Bernardo de Iriarte (fig. 11), later played a role in Goya's career as vice-protector of the Real Academia de San Fernando.[31] The military agreements of the Third Family Pact authorized the officers of each country to serve in one or the other army, on the same footing even with regard to promotion. Two personages, Baron de Batz and Comte de Saint-Simon,[32] the

latter having been associated for a time with Cabarrús, took advantage of this privilege, along with Colonel Allois d'Herculais, Danton's secret informer during the Terror, to mention only the most outstanding cases.[33]

The Cultural Consequences of the Third Family Pact in Goya's Circle

Choiseul in France and the Marqués de Grimaldi, who was then Spanish ambassador to the court at Versailles, were the principal architects of the Third Family Pact. When Grimaldi was recalled to Madrid in 1763 to be named Minister of State, he surrounded himself with foreigners and Spaniards who were, if not Francophiles, at least sympathetic to the viewpoints of enlightened Europe. The Esquilache uprising of 1766 and the expulsion of the Jesuits in 1767 put the Conde de Aranda – one of Grimaldi's principal adversaries – on the spot. Aranda had once been more interested in his own career than in leading the Aragonese party, and his capriciousness so irritated Carlos III that he was dismissed. For nearly ten years, Spain was governed by a foreign minister, despite the xenophobia of certain grandees. It has already been noted that Grimaldi's sympathies drew him closer to France, and his collaborators did not fail to remark on Cabarrús, who, installed in Madrid from 1772,[34] was well regarded by the French embassy. The French embassy's Spanish lawyer was José Gálvez, later (1775) all-powerful Minister of the Indies and avowed patron of Cabarrús.[35] French in origin and wife of José Gálvez's nephew, Felicia Maxans, Condesa de Gálvez, was regarded in 1790 as an intimate friend of Cabarrús's, and Cabarrús must have intended that his sons should marry the Condesa Gálvez's daughters.

A pamphlet dated 1775 and titled *El marques mas conturbado o Alexandro en Africa* (The Most Uneasy Marquis, or Alexander in Africa), a squib hostile to Grimaldi, named Bernardo del Campo among his friends. Bernardo del Campo was at first secretary of the recently created Orden de Carlos III. He then worked under Grimaldi at the Ministry of State, where Bernardo de Yriarte, whose name also figures in the pamphlet, was employed as first assistant. One of Bernardo de Yriarte's brothers, the diplomat Domingo de Yriarte, played a very important role in Franco-Spanish political relations until 1796. Finally, the Sicilian Marqués de Branciforte, future brother-in-law of Godoy, also belonged to the *camarilla* (royal inner circle); he helped Godoy attain the position of prime minister in 1792.[36]

The pamphlet denounced Grimaldi's ineptitude, blaming him for the disaster at Algiers (1775), an event that cost him his ministry at the end of 1776. According to Rafael Olaechea, it was Bernardo del Campo (then secretary to the Ministry of State) who must have suggested to Grimaldi that he propose the Spanish magistrate José Moñino, Conde de Floridablanca (see cat. 4) and Spanish ambassador to Rome, as his successor at the beginning of 1777.[37] Thoroughly Spanish, Floridablanca shared certain enlightened ideas with Grimaldi, but he knew how to apply reforms more pragmatically and vigorously. He retained most of Grimaldi's ministers, among them Miguel Múzquiz, minister of finance, who became Conde de Gausa in 1782 and whose portrait was painted by Goya about 1784-1785 (G-W 215). He was a protector of Cabarrús, who delivered his eulogy in 1785. José Gálvez also retained his post as Minister of the Indies.

DE LA BANQUE
D'ESPAGNE,
DITE
DE SAINT-CHARLES.

Par le Comte DE MIRABEAU.

Ploratur lacrimis amiffa pecunia veris.
Vous pleurez votre argent , vos larmes font finceres.
JUV.

1 7 8 5.

Fig. 12. Frontispiece of *La Banque d'Espagne,* by
Conte de Mirabeau, 1785.
Banco de España, Madrid

Cabarrús made himself conspicuous in 1778 through his report on freedom of commerce with the American territories, a problem that he knew well because he directed the Compañía Cabarrús y Aguirre, which specialized in the import of metallic currency from Spanish possessions in Central America. Thanks to his political connections, he easily obtained export visas for Bayonne. Once in Bayonne, the funds were transferred by a company, Lalanne, run by his parents; his own company, which did not engage exclusively in this commerce, was reputed for its trustworthiness in transfers of money.[38]

Jovellanos returned from Seville in 1778, accompanied by his friend Ceán Bermúdez. He met Cabarrús, with whom he formed a long and unfailing friendship, and thereafter saw him often at the home of the celebrated jurist and economist Campomanes, where Goya and the engraver González de Sepúlveda were sometimes received. These relations opened the way for Cabarrús to establish and direct the Banco Nacional de San Carlos in 1782; soon Jovellanos and Ceán Bermúdez were involved in running the new entity, Jovellanos as representative of the *parcialidades* of the Indians of New Spain and Ceán Bermúdez as first assistant to the secretariat of the bank.[39] In November 1784 Goya wrote Zapater that he "purchased 15 shares of the bank on the advice of some friends there"; each share was worth 2,000 reales.[40]

This bank was evidently founded in the spirit of the economic articles of the Third Family Pact. The great Catholic bank of Lecouteulx, already well-ensconced in Cádiz, became the privileged correspondent of the Banco de San Carlos in France, and two of its directors, Lecouteulx du Moley and Lecouteulx de la Noraye, maintained very friendly relations with Cabarrús.[41] Not surprisingly, in the spring of 1787, François Cabarrús – then thirty-five years old and successful in spite of the deaths of his patrons the Conde de Gausa and the Gálvezes between 1785 and 1787 – was called to the court of Versailles. He was summoned to give freely of his advice on financial matters; Mirabeau's violent diatribes against the Banco Nacional de San Carlos and the Lecouteulxes went unheeded (fig. 12). These attacks were fomented by Isaac Panchaud and Clavière, two Swiss bankers who favored an Anglo-Swiss cartel opposed to Necker, Louis XVI's finance minister.[42] Cabarrús left for France with a young secretary recommended by Jovellanos, Leandro Fernández de Moratín, already a well-known poet.

France's economic situation was troubled. The general comptroller of finances, Calonne, was dismissed in April 1787 and replaced by the counselor of state, Lambert, while Loménie de Brienne, the queen's candidate, contented himself provisionally with the title of chief royal counsel of finances. According to the *Mémoires secrets* (Secret Memoirs), Cabarrús was offered the recently established post of director of the Royal Treasury, which Necker and Laborde had refused. According to Brissot, Cabarrús would have served in this capacity for some time, but he was violently opposed by Panchaud and Clavière, who, through Mirabeau, prevailed.[43]

One easily imagines the interest roused by the banker's return to Madrid and the colorful stories with which Moratín must have regaled his friends – stories Goya must not have missed one scrap of. Throughout the whole of 1787 the artist worked for the Banco Nacional de San Carlos, executing

portraits of its directors as well as portraits of the family of one of the directors, the Conde de Altamira (fig. 13). To Goya we owe the marvelous portrait of the child Manuel Osorio de Zúñiga dressed in red.[44]

In November 1787 Goya assured Zapater he was learning French and even wrote him in this language. Was he planning a visit to France? In 1787 he sketched the funeral monument to Cabarrús's friend, the French engineer Charles Le Maur, which was engraved by Pierre Choffard (G-W 316), a Frenchman who never left Paris. Goya probably executed the astonishing portrait of Cabarrús when the general director of the Banco Nacional de San Carlos returned to Madrid; he appears in this portrait dumpy and preoccupied, just as he was described by his contemporaries. The work was paid for in April 1788.[45]

The year 1789 was of capital importance in the history of the world, but Spain did not immediately realize the extent of the danger that the troubles in France posed for the Bourbon dynasty; the Spaniards were joyfully celebrating the accession of Carlos IV (see cat. 32) and María Luisa de Parma (see cat. 33). Immediately after, in April 1789, Goya was finally appointed court painter, and Cabarrús's father was ennobled in France in virtue of services rendered by his son, who in November 1789 was made Conde de Cabarrús.[46]

The October days in Versailles and Paris sounded the knell of "the sweetness of life," and Louis XVI secretly sent an anguished appeal for help to Carlos IV, his first cousin.[47] After this, Floridablanca began to understand the problems that would arise between France and Spain; partisans of constitutional monarchy, with which Cabarrús sympathized, became suspect to him. Cabarrús was linked to one of the most impatient deputies of the Constituent Assembly, Charles de Lameth, brother of the equally restless Alexandre and Théodore de Lameth. Charles de Lameth had married a rich heiress of Bayonne, Marie-Anne Picot. Marie-Anne was a boarding-school friend, it is said, of Cabarrús's daughter, Teresa; in any case, she chaperoned the young Teresa in Paris. Teresa lived in France for several years with her mother and married Devin de Fontenay in 1788, a second cousin of the Lecouteulx du Moley family, whom she often visited.[48] Because of the elevated position of her father, one of the greatest European bankers, she was introduced into Parisian high society.

On May 16, 1790, Charles de Lameth violently attacked La Vauguyon, the French ambassador to Madrid, and demanded his recall, a request that exasperated the Spanish government. On June 14 an extraordinary session of the administrative counsel of the Banco Nacional de San Carlos examined its accounts, for Cabarrús was accused of authorizing a loan to France that had lost part of its value as a result of the turbulent political situation.[49] On June 18 Floridablanca was nearly assassinated by a Frenchman, Paul Péret, and on June 25 Cabarrús, who requested and received a passport to visit France (where he counted on arriving at the beginning of June, he reported later), was arrested and secretly imprisoned in Santa Isabel.[50] The real cause of his arrest is unknown, except that his most redoubtable adversary the Conde de Lerena, recently married to one of the queen's ladies-in-waiting, relentlessly plotted to have him imprisoned.[51]

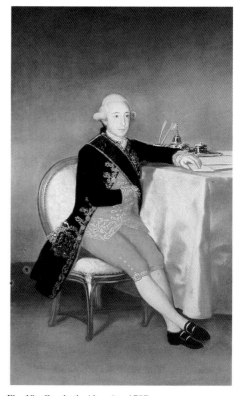

Fig. 13. *Conde de Altamira*, 1787.
Oil on canvas.
Banco de España, Madrid

Little esteemed by the new sovereigns, Jovellanos was banished from Madrid. He returned to the capital without authorization to save Cabarrús, even though Ceán Bermúdez tried to dissuade him on the grounds that it was an exceptionally serious situation. To Ceán's great indignation, Campomanes refused to interfere, and Jovellanos was obliged to return to Gijón, in Asturias (his birthplace), this time definitively banished.[52] In August 1790 the Conde de Valdecarzana, Jovellanos's cousin and first chamberlain, brusquely gave Goya permission to "take the maritime airs" of Valencia, as the artist himself put it ironically.[53] Valdecarzana, who the preceding year had signed Goya's nomination as court painter, was himself sent to Vienna the following winter. In Valencia, the Condesa de Cabarrús and her children were assigned a residence by royal decree, while the Condesa Gálvez was ordered to abandon Madrid and remove herself to Zaragoza. In December 1790 Ceán was sent to Seville but did not arrive until February 1791. Only Moratín escaped exile; the enlightened faction was displaced and did not regroup until the Peace of Basel in 1795.

For Goya it was the beginning of a descent into hell, but he became aware of it only by degrees. After he lost his powerful patrons, certain jealous colleagues, whom he called "vile men," exploited the situation and attacked him. He was denounced to the king for his refusal to continue the execution of tapestry cartoons.[54] He yielded, but his production between 1790 and 1792 slowed considerably.

In February 1792 Floridablanca was dismissed and replaced by the old Conde de Aranda, who served as stepping stone for the young and ambitious Manuel Godoy, Duque de Alcudia, the queen's favorite. Godoy, who was more energetic than his predecessor, was named prime minister at twenty-five, following the fall of the monarchy in France and the proclamation of the Republic.

Imprisoned on the outskirts of the capital, Cabarrús was taken to Madrid in May 1792.[55] The night following Cabarrús's return, Moratín took to the road, headed for France; he had secretly announced this journey to Jovellanos in the previous month.[56] He was received in Bayonne and Bordeaux by the Cabarrús family and arrived in Paris a few days before August 10; he carried a letter to Domingo de Yriarte, entrusted to him by Aranda in Aranjuez, which he delivered on August 6, 1792.[57] He met with the Lecouteulxes, visited the devastated Tuileries, trembled with fear during the insurrection, and then withdrew to England. He returned to Spain, through Cádiz, only at the end of 1796; his first call he paid to Goya.[58] The artist was probably involved in the attempt to save Louis XVI in November 1792, in which Cabarrús (semiliberated by Godoy) and the Marquesa de Santa Cruz (see cat. 66) had a hand; many circumstances suggest this, even though formal evidence is lacking.[59] In any case, at Godoy's prompting, Spain made an enormous sum — advanced by the Lecouteulxes — available to its consul general in Paris, Ocáriz. The money was wasted; it made its way to swindlers without serving its purpose.[60] Goya escaped to Andalusia in November 1792 and there fell gravely ill. He was received in Cádiz by Sebastián Martínez, a wealthy merchant and art collector (see cat. 19).

In Paris Jean-Lambert Tallien was appointed secretary of the insurrection-

ary Commune on August 10. At the time of her arrest, Madame de Tourzel, governess of the French princes, and her daughter Pauline were conducted to Tallien's office; Tallien seems to have been involved in their rescue during the massacres of September.[61] Madame de Tourzel was the Duc d'Havré's sister; the Duc was the French princes' agent in Madrid and stayed with the Conde de Aranda. It seems that, beginning in 1792, Tallien was a Spanish agent who acted through French emissaries and that his association with Teresa Cabarrús was not coincidental. Teresa may have met Tallien much earlier than is believed, for he acknowledged in 1792 having previously been secretary of the Lameth family, at whose house Teresa later affirmed they met for the first time.[62] She was now mistress of Félix Lepeltier, half-brother of Michel Lepeltier de Saint Fargeau and a deputy in the Convention. Tallien was later accused by certain Jacobins of having negotiated with Spain the transfer of the twenty-five votes that Saint Fargeau disposed of in order to try to save Louis XVI at the time of his trial. In any case, Tallien was entrusted with identifying Pâris, Lepeltier's assassin, who was said to have committed suicide in London in 1813. In fact, the agents of d'Antraigues's network, who were in the pay of Spain, helped him escape.[63]

On March 9, 1793, France declared war on Spain. Teresa Cabarrús tried at first to leave France but then remained with the Cabarrúses in Bordeaux; she settled there and was joined by Tallien, who was designated deputy on assignment for the region.[64] Thanks to him, she enabled several aristocrats to escape, among them Madame de Lâage de Volude, the Princesse de Lamballe's former lady-in-waiting; she was later given refuge in Madrid by the Condesa de Montijo, a great friend of Cabarrús.[65]

Goya returned to Madrid in the spring of 1793, and until January 1794, little is known of him. At that time he began to paint with energy again in spite of his faltering health and his deafness; he painted portraits of two Spanish superior officers who fought on the Franco-Spanish border. One of them, General Antonio Ricardos (fig. 14), was killed by the enemy in 1794. The other was Félix Colón de Larreátegui (G-W 339), whose brothers were friends of Cabarrús.[66] A third military man, General José de Urrutía, whose portrait Goya painted in 1798 (G-W 679), initiated the preliminaries of peace at the beginning of 1795, along with General Pérignon, later French ambassador to Spain.[67]

Another significant date in the Revolution was the attack of 9 Thermidor, year II (in the Republican calendar), July 27, 1794, apparently instigated by Tallien and Teresa, which brought about the downfall of Robespierre and the end of the Terror. In autumn 1794 Tallien seemed the master of events; secret agents warned their associates that Tallien was being "closely watched," on account of the Spanish origin of his mistress (who became his wife in December of that year) and of his influence in Madrid through Cabarrús, who served as secret intermediary between Godoy and the French governor.[68] Cabarrús had returned to full favor with Godoy despite the queen's animosity toward him.

Repeatedly after April 1794, Jovellanos alluded to Cabarrús in his journal as "el amigo" (the friend); Jovellanos had renewed a steady correspondence

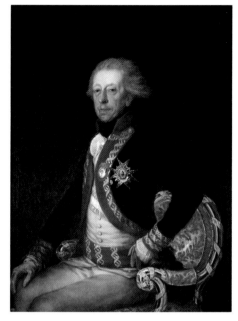

Fig. 14. *General Antonio Ricardos,* 1793-1794. Oil on canvas. Museo del Prado, Madrid

Fig. 15. *Mariano Luís de Urquijo,* about 1798-1800. Oil on canvas. Real Academia de la Historia, Madrid

with him. He sadly recorded the death of Cabarrús's second son, Francisco, engaged by the Republican army and killed near Ypres. Cabarrús kept Jovellanos abreast of French politics. The Asturian philosopher and statesman, for that matter, followed these events in the *Monitor*, which he could read at the English consul's. On October 5, 1795, when Cabarrús's name was nearly cleared, he sent Jovellanos a letter written by his daughter Teresa Tallien, which Jovellanos declared he would preserve as "a historic document"; on October 15 Jovellanos received another letter written to Cabarrús by Teresa.[69]

The peace treaty between Spain and France was signed by Domingo de Yriarte and Barthélemy in Basel in July 1795, a month after the death of Louis XVII, which had been the last obstacle to the suspension of hostilities. Cabarrús was cleared,[70] and soon thereafter the Duc d'Havré wrote to the Comte de Provence – the future Louis XVIII – saying the former director of the Banco Nacional de San Carlos was "more than a minister in Madrid." Cabarrús often went to Paris and reportedly fell half in love with his ravishing daughter Teresa, whom he had not seen for several years and who was ironically referred to in the newspapers as "reine du Directoire" (queen of the Directory), along with Joséphine de Beauharnais, her friend, and Juliette Récamier.[71]

In June 1796 a treaty of alliance between France and Spain was signed in Aranjuez, prepared by Charles Delacroix, Minister of Foreign Affairs for the Directory (future father of the artist Eugène Delacroix), and negotiated in Madrid by General Pérignon. In this treaty the political assurances of close military cooperation were reaffirmed. Although these had appeared already in the Third Family Pact of 1761, the family was now dynastically amputated on the French side.[72] The treaty of 1796 scandalized all the true royalists of Europe.

At the end of 1797 Godoy proposed Cabarrús for the Spanish ambassador's post in Paris, but his choice was rejected by Talleyrand, who had become minister of foreign affairs earlier that year. Talleyrand was evidently influenced by his good friend Isaac Panchaud, the Swiss banker, mortal enemy of the Lecouteulxes and thus hostile to Cabarrús.[73] Cabarrús returned to Madrid and advised Godoy, whose power was faltering, to choose enlightened Spaniards as his ministers, among them Jovellanos, Saavedra, and Bernardo de Yriarte. On his return to Madrid, Goya met Moratín several times a week; Moratín had remained friendly with Cabarrús, whom he regarded as a second father. Goya was perfectly situated to receive commissions for portraits by all these men, to whom he owed his success. Thanks to Jovellanos and Moratín, he was commissioned to decorate the cupola of the royal chapel of San Antonio de la Florida. In March 1798 Goya returned from Aranjuez, where he had been received by Jovellanos, minister of religion and justice, for six months; enjoining secrecy, Goya then informed Zapater of Godoy's imminent fall, which did indeed take place on March 28, 1798.[74] The Directory's machinations are said to have contributed to Godoy's reversal. In the following summer, the entire group of ninety-seven was once again dispersed, but it was Mariano Luís de Urquijo (fig. 15), a notorious Francophile (and, what is more, the lover of Godoy's sister, the Marquesa de Branciforte), who

replaced the Príncipe de la Paz (Prince of Peace); Godoy was not, for that matter, completely dismissed from the court.[75]

In July 1798 Ferdinand Guillemardet – a Burgundian doctor, former member of the Convention, and regicide – was named French ambassador to Spain. Guillemardet immediately established a rapport with Goya's patrons and had himself painted by the artist in a superb portrait (cat. 31). It is one of the master's greatest works, a veritable tricolor hymn. It seems that Guillemardet allowed the *Caprichos* (see cat. 38-62) to be printed in the attic of the French ambassador's residence, then the Palacio de Superunda, on San Bernardino Street.[76]

The *Caprichos* appeared in February 1799. After two days the sale was stopped, without explanation. "Too libertine" a work, declared the engraver Pedro González de Sepúlveda, who saw the first edition at the house of the Duquesa de Alba's architect, Pedro Arnal.[77] The word "libertine" in the eighteenth century was not, as it is too often supposed, equivalent to "licentious"; rather it meant free in spirit. "To think freely is not necessarily to think against."[78] Such liberty was necessary to undertake a lucid analysis of society's flaws, which no government and no religion ever fully resolve.

The *Caprichos* and their inscriptions are, in my view, a violent satire inspired by the disorders that had rocked Europe, particularly France, for ten years, in the guise of a moralistic criticism of contemporary Spanish society. The painter possessed a much greater knowledge of these events than is generally supposed, thanks to his Francophile friends. The *Caprichos* were begun in 1797, a period in which the last embers of enlightened Spain were being extinguished. Napoleon Bonaparte's rise to the Consulate in November 1799 and Godoy's return to power in 1800 (after which Godoy was entirely submissive to the First Consul's wishes) led to a complete eradication of the group of enlightened Spaniards who had sponsored Goya in his beginnings. Jovellanos and Urquijo were imprisoned, Meléndez Valdés (see cat. 24) and Ceán Bermúdez exiled, and Cabarrús banished to Barcelona; finally, Bernardo de Yriarte and the Condesa de Montijo were also banished. No one escaped.

How did Goya manage to retain his position? Perhaps he held trumps unknown to us, but he was also the most celebrated Spanish painter of his time, and it is difficult to discredit such a title. Through prodigious shrewdness, secrecy, and slyness, Goya knew how to veil the puzzles of the *Caprichos*, to render them so difficult to decipher that it is nearly impossible even today to retrieve their deep significance. The court must have preferred promoting him to having him hauled off by the *alguaciles* (constables), a Machiavellian method of reducing him to silence without fuss. He understood this well enough to stand prudently apart from the court between 1801 and 1808. Nevertheless, if the same Reason defended by his *ilustrado* friends slumbered, Goya's taste for rebellion was merely lulled. Shaken by the Peninsular War and the return of absolutism, Goya threw his most intense flames between 1808 and 1824 in order to express his vehement scorn for a humanity doomed without hope – "no hubo remedio" (it was hopeless) – to unhappiness and suffering. But, with Goya, this grandiose despair was once again a superb hope. Did he not choose to die in France?

1. The Inquisition reluctantly authorized laypeople to read prohibited French works; after 1768, when Charles III attempted to limit the powers of the Inquisition, many enlightened Spaniards succeeded in obtaining permission. See M. Défourneaux, *Inquisición y censura de los libros en la España del siglo XVIII* (Madrid, 1973).

2. See Sarrailh, *Espagne éclairée*, p. 353, n. 3.

3. The Duques del Infantado established themselves in Paris in 1777. They purchased the Hôtel Fitz James (built in 1767 by Chalgrin), on rue St. Florentin, in 1778, and also purchased the Château d'Issy, called Maison Beaujon, in 1784. The Duque del Infantado died in 1789, and the Duquesa returned to Spain in 1790; according to Madame Elliot, Marie Antoinette visited the Duquesa at Issy. The Duquesa relinquished the house on rue St. Florentin in 1800 to the banker Hérvas, brother-in-law of Maréchal Duroc; Hérvas resold it later to Talleyrand.

4. On this subject, see Yves Bottineau, *L'Art de Cour dans l'Espagne des Lumières* (Paris, 1986), who gives the most recent account of the issue in pt. 2, pp. 120ff.

5. The Ebro flows into an estuary of the Mediterranean at the Cape of Tortosa.

6. See J.M. Lacarra, *Aragón en el pasado* (Madrid, 1972), p. 44.

7. Even Felipe II would not dare to modify it at the time of the revolt of Zaragoza. Though confronted with a similar uprising, Felipe V demanded its abolition in 1707. Ibid., p. 202.

8. See P. de Demerson, "Un escrito del Conde de Teba: El discurso sobre la autoridad de los Ricos Hombres," *Hispania* 31 (1971), pp. 137-156.

9. Lacarra, *Aragón*, p. 191.

10. See J. de Asso, *Historia de la economía política de Aragón* (1798; reprint, Zaragoza, 1947), p. 202.

11. Ibid., p. 206.

12. See Marqués del Saltillo, *Miscelánea madrileña histórica y artística: Goya en Madrid, su familia y allegados, 1746-1856* (Madrid, 1932), p. 12; X. de Salas, "Aportaciones a la genealogía de D. Francisco de Goya," *Boletín de la Real Academia de la Historia (B.R.A.H.)* 175 (1977), pp. 405-413; E. Lafuente Ferrari, *Antecedentes, coincidencias e influencias del arte de Goya* (1947; reprint, Madrid, 1987), p. 285.

13. Saltillo, *Miscelánea*, pp. 37-38.

14. Goya to Zapater, June 13, 1787, Francisco de Goya, *Cartas a Martín Zapater*, ed. Mercedes Agüeda and Xavier de Salas (Madrid, 1982), p. 174.

15. A serious study of Juan Martín Goicoechea has yet to be undertaken; he is a very important figure and until now, only fragmentary information has been available to sketch his biography. See J.E. Jranzo, *El muy ilustre D. Juan Martín de Goicoechea: Estudio biográfico...* (Zaragoza, 1912).

16. Bottineau, *L'Art de Cour*, p. 221.

17. Jranzo, *Goicoechea*, p. 5.

18. See G. Pérez Sarrión, *El canal imperial de Aragón y la navegación hasta 1812* (Zaragoza, 1975), p. 55.

19. Jranzo, *Goicoechea*, p. 9.

20. Some years ago I had the opportunity to meet the descendants of the family of Juan Martín Goicoechea

in Zaragoza and was very kindly shown photographs of this residence.

21. Leandro Fernández de Moratín, *Diario, 1780-1808,* ed. René Andioc (Madrid, 1967); idem., *Epistolario,* ed. René Andioc (Madrid, 1973). These recent and comprehensive editions of Moratín's diary and letters have allowed us to better understand the writer, one of the most prominent in Spain in the years 1780-1820, who, in my view, was a much more likely collaborator on the inscriptions for the *Caprichos* than the prudent Ceán Bermúdez.

22. Goya thus became acquainted early in his youth with the Pignatellis and Albas, two important families who became his patrons.

23. See J.J. López González, *Zaragoza a finales del XVIII, 1782-1792* (Zaragoza, 1977), p. 274.

24. Archivo Histórico Nacional (A.H.N.), Estado, leg. 3416-1, expediente [file] Clemente de Campos.

25. Moratín, *Diario,* pp. 135-138.

26. López González, *Zaragoza,* p. 266.

27. Archives Nationales (A.N.), Paris. F⁷ 4436, plaquette 4, published in B. Courtois, *Papiers trouvés chez Robespierre* (Paris, 1794), p. 184.

28. Archives Départementales de l'Oise. Acte de décès [death certificate] de Izquierdo (Microfilm no. 2166).

29. A.H.N., Madrid, Estado leg. 2855-2.

30. See G.F. van Martens, *Recueil de principaux traités . . .* (Göttingen, 1791), articles XXIII and XXIV, pp. 9-10.

31. Bernardo de Iriarte, born in 1735 on the Canary Islands, is an important person who deserves a biography similar to that which Cotarelo dedicated to Bernardo's brother, the poet Tomás de Iriarte. Bernardo died in Bordeaux on July 11, 1814 (Bordeaux Municipal Archives).

32. Saint-Simon's sojourn in Spain is placed between 1787 and 1789. His association with Cabarrús would repay research; Cabarrús certainly influenced the future philosopher, creator of Saint-Simonianism.

33. J. Paz, *Documentos relativos a España que existen en los archivos nacionales de París* (Madrid, 1932); A.N., Paris, A.F. II 64, dossier 470.

34. See H.I. Priestley, *José Gálvez, Visitor General of New Spain, 1765-1767* (Berkeley, 1916), p. 96.

35. See A. Ortega Costa, *Noticia de Cabarrús y de su procesamiento* (Madrid, 1974), p. 102.

36. A.H.N., Madrid, Estado, leg. 6437.

37. Rafael Olaechea, *El Conde de Aranda y el partido aragonés* (Zaragoza, 1969), p. 110.

38. Ortega Costa, *Noticia,* p. 23.

39. See J.A. Calderón Quijano, *El banco de San Carlos* (Seville, 1962), pp. 34, 53, 55.

40. Goya, *Cartas,* no. 58, p. 122.

41. See M. Núñez de Arenas, *L'Espagne de Lumières au Romantisme* (Paris, 1963), pp. 42ff.

42. See H. Luthy, *La banque protestante en France* (Paris, 1961), vol. 2, chap. 4, para. 2.

43. *Mémoires secrets* 36 (Oct. 7, 1787), p. 89; Brissot, *Seconde lettre à un créancier de l'Etat* (Dec. 15, 1787).

44. Six official portraits of the directors of the bank are in the Banco de España, Madrid (G-W 223-228).

The exquisite *Condesa de Altamira* and *Manuel Osorio de Zuñiga* are in the Metropolitan Museum of Art, New York, 1975.1.148 and 49.7.41 (G-W 232, 233).

45. G-W 228; *El banco de España, 1782-1982,* exhib. cat. (Madrid, 1982), no. 13.

46. See M. Ferrus, *Madame Tallien* (Bordeaux, 1933), pp. 51ff; Archives Départementales, Gironde, 1B 57 fol. 175, under Domingo Cabarrús, the elder; A.H.N., Madrid, Consejos, libro 2735, a. 1789. no. 35, under Francisco Cabarrús.

47. A.H.N., Madrid, Estado, leg. 2882, expediente 68.

48. See A. Cary Morris, *The Diary and Letters of Gouverneur Morris,* (New York, 1888), vol. 1, p. 138.

49. Ortega Costa, *Noticia,* p. 97.

50. Ibid., p. 109.

51. Pedro López Lerena was born in Valdemoro (Getafe) in 1734. He was made Conde de Lerena in March, 1791, died Jan. 2, 1792. He married one of the queen's ladies-in-waiting in 1790, daughter of the Marqués de San Andrés, granddaughter of Madame Laura, foster sister of Queen María Luisa.

52. See J. Clisson Aldama, *J.A. Ceán Bermúdez, escritor y crítico de bellas Martes* (Oviedo, 1982), p. 64.

53. Goya, *Cartas,* no. 118, p. 204.

54. See Valentín de Sambricio, *Tapices de Goya* (Madrid, 1946), p. XCVII, no. 139.

55. Ortega Costa, *Noticia,* p. 173.

56. Moratín, *Epistolario,* p. 131.

57. J. Chaumié, "Lettres de Domingo de Yriarte . . . au Comte d'Aranda (Juin-Août, 1792)," *Bulletin de la Société de l'Histoire de France (B.S.H.F.)* 80 (1944-1945), p. 329. "D. Leandro Fernandez Moratin m'a remis la lettre de votre Excellence [Aranda] du 9 Avril [1792]."

58. Moratín, *Diario,* p. 174. See J. Baticle, "L'activité de Goya entre 1796 et 1806 à travers de *Diario* de Moratín," *Revue de l'art,* no. 3 (1971), pp. 111, 113.

59. J. Baticle, "Le portrait de la Marquise de Santa Cruz par Goya," *La Revue du Louvre,* no. 3 (1977), pp. 153-154; Edith Helman, in *El trasmundo de Goya,* 2nd ed. (Madrid, 1983), p. 39, was already struck by the coincidence between the trial of Louis XVI and Goya's brutal illness, noting that the revolutionary events profoundly disturbed the Spanish court.

60. See L. Hastier, "L'or espagnol au secours de Louis XVI," in *Vieilles histoires étranges énigmes* (Paris, 1960), pp. 28-36.

61. See Duchesse de Tourzel, *Mémoires* (Paris: Mercure de France, 1969), pp. 370, 384.

62. See M.H. Bourquin, *Monsieur et Madame Tallien* (Paris, 1987), p. 88. It is not clear why many historians deny this fact, since Tallien himself publicly admitted in 1792 to having been Lameth's secretary, a statement reported in *La Gazette de France,* Sept. 13, 1792.

63. See J. Chaumié, *Le réseau d'Antraigues et la Contrerevolution* (Paris, 1965), p. 311; A. Doyon, *Un agent royaliste pendant la Revolution: P.J. Le Maître* (Paris, 1969), p. 74. My own research has confirmed this fact.

64. Núñez de Arenas, *L'Espagne,* pp. 81-82.

65. See P. de Demerson, *María Francisca de Sales Portocarrero, Condesa de Montijo* (Madrid, 1975), p. 120.

66. Colón de Larreátegui belonged to an illustrious family (descended from Christopher Columbus); his eldest brother was the Duque de Veragua.

67. See P. Sainte Claire Deville, *A la recherche de Louis XVII* (Paris, 1946), pt. 3, chap. 2. This is one of the rare modern French works on the preliminaries of the Peace of Basel that uses the rich collections of the Archives des Affaires Etrangères and the Archives Nationales in Paris.

68. Musée Condé, Chantilly, Archives, Papiers Rey.

69. Gaspar Melchor de Jovellanos, *Diarios* (Oviedo, 1953), vol. 2, p. 171. These letters are thought to have been burned in 1936 during the fire at the Instituto de Jovellanos in Gijón. If so, their loss is irreparable.

70. Ibid., p. 189.

71. See J. García León y Pizarro, *Memorias de su vida,* 2 vols. in 1 (Madrid, 1894-1897), chap. 7, p. 117.

72. See Geoffroy de Grandmaison, *L'ambassade française en Espagne . . . 1789-1804* (Paris, 1892), p. 320.

73. It is evident that the rivalries of the Old Regime persisted under the Directory.

74. Goya, *Cartas,* Mar. 27, 1798, p. 231. A hasty reading of this letter gave rise in the past to the belief that the minister in question was Godoy, when in fact it was Jovellanos, whose portrait Goya executed in this period. In addition, March 27 fell on a Tuesday in 1798. "Hoy martes" (Today, Tuesday) is March 28, the day Godoy fell from power. In fact, Goya wrote: "mañana 28 de marzo pero por si acaso no tengo ganas *lo publica*" (tomorrow 28 March I'll make it known). He quite certainly learned of the Príncipe de la Paz's imminent sacking in Aranjuez.

75. It has never been observed how this situation left a way out for Godoy, which explains the abrupt rise to power of Urquijo.

76. As a result of an error committed by biographers of Lucien Bonaparte, most authors have believed the Palacio de Santa Cruz was to be found on Calle San Bernardino in the eighteenth century, when in fact it was situated on Calle de las Rejas. The present Palacio de Santa Cruz was then the Palacio de Superunda, built by J. de la Ballina, and was acquired only in 1846 by the Marqués de Santa Cruz. I hope soon to establish on the basis of documentary evidence that the *Caprichos* were secretly printed in the French embassy, which occupied the Palacio de Superunda in 1798.

77. See J. Baticle, "Un nuevo dato sobre los Caprichos de Goya," *Archivo Español de Arte* 49 (1976), pp. 330-331.

78. See F. Moureau, "Watteau libertin," in *Antoine Watteau (1684-1721): Le peintre, son temps et sa légende* (Paris and Geneva, 1987), p. 17.

ART AND ENLIGHTENMENT IN GOYA'S CIRCLE

Nigel Glendinning

Goya's world was a small one by modern standards. Zaragoza, where he was brought up, trained as an artist, and first practiced as a painter, had a mere 43,000 inhabitants at the end of his life, 42,600 in 1787, and less than that in the 1740s, when he was born. Madrid, which was central to the development of his personality and his art, had a population of only 147,543 in the 1780s. Cádiz, where Goya spent the winter of 1792-1793 recovering from a serious illness that left him deaf, had 65,987 inhabitants at the time; and Valencia, which he visited briefly in the 1780s, no more than 100,000.

Given these modest population figures, local feelings, regional ties, professional links, and family bonds were naturally strong in eighteenth-century Spain. People looked after their own and for the most part kept to their own class or calling. Francisco Bayeu, Goya's artist brother-in-law, married an artist's daughter; so did Mariano Maella, and Manuel Salvador Carmona on his second marriage. Aristocrats closed ranks too. They had to ask the king's permission to marry, and the relative standing of their titles was officially scrutinized when an alliance was proposed. Uncles sometimes married nieces to keep their estates and money within the family, which was bad for the bloodstock from a breeding point of view, as an English visitor, Lady Holland, pointed out in 1803.[1] Self-made men were rare, although Goya painted the portraits of at least two individuals who probably fell into that category: Sebastían Martínez Pérez, who left his home in Rioja when he was thirteen or fourteen years old to make a fortune in the South American or Indies trade, at its center in Cádiz; and Tomás Pérez Estala, who came from a rural Aragonese background to settle in Segovia, after travel to Paris and London, and marry the daughter of a prosperous cloth-factory owner. In reality, Goya was close to being a self-made man himself. His father practiced a manual craft and could not bear the courtesy title of "Don." Although Goya's mother's family came from rural *hidalgo* (petty noble) stock, the artist never managed to prove his *hidalguía*, even though he thought of doing so. Goya rose above his father by pursuing an honorable rather than a "mechanical" profession and by making money and investing it in bank shares, insurance policies, houses, and land.

The smallness of Spanish society as a whole encouraged and, indeed, required unity, even if it did not promote upward mobility. There was a feeling that the ruling elite had to foster interdependence among the different classes, because of a new awareness of the realities of the nation's economy and the laws that controlled its development. In Seville in 1779, Ignacio Luis de Aguirre stressed the need for upper-class Spaniards to show concern for those who were less fortunate than they and to sacrifice their personal interest to the general good.[2] In Valencia, when the Real Sociedad Económica (Economic Society) was founded, it was agreed that people of every social class and station in life should be eligible for membership. Don Manuel Velasco, in his "Discurso suasivo contra el egoismo" (Persuasive Discourse against Egoism [1799]), reminded his audience that the nobility, clergy, merchants, farmers, craftspeople, and employees were all entitled to be admitted as potential contributors to the region's progress.[3]

The desire to revive the fortunes of the country that led the Spanish government to encourage the creation of the economic or patriotic societies

also led to a new and practical interest in art and artists. Some academies of art were under the control of their local economic society. Such was the case at Zaragoza, where the Academia de Bellas Artes de San Luis (whose creation had initially been opposed by Carlos III)[4] published the crest of the Real Sociedad Aragonesa on the title page of its statutes. This heraldic device shows a bale of goods and a plowshare in front of a tree with a cross at the top, reminding the reader that art should serve commerce and agriculture as well as religion. In Valencia, the Academia de San Carlos emphasized techniques for drawing flowers, because of their relevance to designs for materials and other patterns.[5] Relating art to industry, improving the salability of products, and keeping down the importation of luxury goods that could be made in Spain provided good economic reasons for the state to encourage national arts and crafts. There were political reasons too for encouragement, since art could combine reality with symbol and myth to underline the values of the state or groups within it. Individual Spaniards had additional motives for supporting the arts. In the first place, the acquisition of works of art, like other luxuries, added to their prestige and enhanced their status. Secondly, the appreciation of the arts and their practice required civilized values and sensibility: two common objectives of the Enlightenment in the eighteenth century, often related to the rise of the bourgeoisie. In commissioned work art sometimes emphasized status and sometimes sensitivity. Frequently it seems that the former gave way to the latter in Goya's time. Certainly, two portraits of members of the same family in the Academia de San Fernando at Madrid bear this out: those of Juan Sixto García de la Prada and his son Manuel. Maella's portrait of Juan Sixto, who founded the family fortunes by assiduously building up his business in the Spanish capital in the second half of the eighteenth century, shows a determined-looking individual who is every inch a successful business man: opulently dressed, holding a sheaf of bank drafts or bills in his hand, with his letter-patent admitting him to the Order of San Carlos in 1794 in full view. The window in the background opens onto a symbolic scene representing International Trade, with ships at sea, not the view from the shop window in the Calle de Postas in Madrid. The son's portrait by José Madrazo – Goya also painted him – is a very different affair. Although Manuel García de la Prada expanded the family business with the help of his brothers-in-law Bernardo and Francisco del Mazo – the latter also painted by Goya – he seems to have asked for commerce to be kept out of this picture. Primarily, he has been portrayed as a man of ideas, sitting at a table in a thoughtful pose, with head on hand. An oval portrait of a woman, presumably his wife, smiles protectively from the wall behind him and underlines the importance of sentiment. Juan Sixto is all for status, it would seem; his son, for sensibility.

In Goya's society the arts were clearly in the ascendant. There was an increasing number of princes and nobles who drew and painted and made music. The future Carlos IV, when Príncipe de Asturias, was keen to climb the scaffolding at Aranjuez and give Francisco Bayeu a hand with his murals.[6] One of Carlos's sons, the Infante Don Sebastián, became an honorary academician of San Fernando in 1826, drew neatly, and published a short but useful treatise on varnishes in 1840. Another of the royal offspring, Francisco

de Paula Antonio (thought to have been Godoy's child in his time) made polished copies in oils of paintings in Rome when he was there. An increasing number of honorary academicians were admitted to San Fernando for their practical artistic ability rather than mere interest. The Marqués de Ureña entered the academy's painting competition in 1757, and Vicente María de Vera, whom Goya painted, was admitted for "merit" as a painter. Goya hinted at the latter's interest when he made his portrait as Duque de la Roca and Marqués de Sofraga in the 1790s and showed a painting under an open book on his table (fig. 1).[7] Works by aristocrats were on view at the academy's exhibitions. The Marquesa de Santa Cruz had miniatures on show in 1799, and the Conde de Fernán Núñez, later the subject of a portrait by Goya, also displayed his handiwork. Outside the academy, nobles drew and painted too, and so did the bourgeoisie. The *Memoirs* of the Marqués de las Amarillas speak of the lessons he had in his youth, first from a silversmith in drawing, then from accredited artists like José Maea and Pedro Pascual Moles.[8] Goya himself corrected and appraised the efforts of the future Comtesse Merlin and gave painting classes to Don Vicente Calderón de la Barca, one of the Guadalajara offshoots of a distinguished upper-class family.[9] A symbolic tailpiece for a section of the Conde de Sástago's book *Canal de Aragón* (Zaragoza, 1796) is the work of his son, the Marqués de Aguilar. And General Ricardos, another of Goya's sitters, employed his leisure in drawing, when he was not writing poetry or listening to music.

Fig. 1. *Duque de la Roca and Marqués de Sofraga*
Oil on canvas, 108.3 x 82.6 cm.
San Diego Museum of Art, 38.244

One of the warmest tributes to these well-born amateurs comes from Goya himself in his portrait of the Marquesa de Villafranca (fig. 2). She sits at her easel, brush in one hand and palette on a stand beside her. On the canvas she is painting there is a portrait of her husband, apparently looking at his wife, while she looks intently at a point in space to the left of the spectator, where we imagine that the marqués is posing for his picture. Velázquez was the source of inspiration for this interplay between the figures on the canvas and the space outside it. But Goya brings his own subtlety to this particular game.

The circles in which Goya moved, at different levels of society, often included gifted amateurs or those who may have lacked the technical equipment to draw or paint yet liked nothing better than to talk to artists about the subject. Goya's patron Sebastián Martínez, a Cádiz merchant, was one of these. According to the obituary in the Proceedings of the Academia de San Fernando Prize-Giving, published in 1802, Martínez spent his leisure hours, when treasurer general in Madrid, "en hablar de pinturas y adquirir nuevamente cuadros" (talking about pictures and buying new paintings).[10] In 1792, when Goya painted his portrait in Madrid and described him as a friend, Martínez was quick to make contact with artists in the capital. The sculptor Pedro González de Sepúlveda, recorded a courtesy visit from the merchant in his diary entry for July 27 that year: "Se vino a despedir . . . Dn Sebastián Martínez . . . ; él trajo los lucidados de las cabezas de Rafael hechos por el Sr. Mengs en Roma" (Don Sebastián Martínez came to say good-bye . . .; he brought with him explanatory drawings of the heads by Raphael that Mengs made in Rome).[11] Jovellanos was a similar art enthusiast who also painted a

Fig. 2. *Marquesa de Villafranca*, 1804
Oil on canvas, 195 x 126 cm.
Museo del Prado, Madrid, 2448

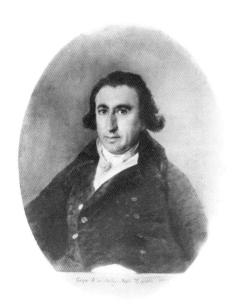

Fig. 3. *Martín Zapater* 1797.
Oil on canvas
Bilboa, Sota

little himself. González de Sepúlveda and Goya both enjoyed his friendship as well as his patronage.

But if many of Goya's friends and acquaintances were ready to listen to his views on art, he for his part found the opinions of others on a wide range of topics absorbing. The comments on social, economic, political, and religious issues that surface so often in Goya's drawings and etchings in the 1790s and later work owed as much to the discussion of ideas that Goya heard (or lip-read after he became deaf) as to the books he read.

Already, in Zaragoza, Goya knew men who believed in progress and worked for change. His close friend Martín Zapater (see fig. 3) was one of these. Of course, Zapater liked art too. His living room was hung with paintings by his artist acquaintances: two large canvases by Goya, apparently, in 1775, with smaller pictures of the four cardinal virtues to flank them, and a painting of Saint Barbara by another of Goya's brothers-in-law, Fray Manuel Bayeu.[12] Zapater's taste no doubt led him to play a central part in the foundation and development of the Academia de Bellas Artes in Zaragoza, but he also had an important role in local affairs, belonged to the Real Sociedad Aragonesa (the Economic Society in the area), and was its sole treasurer for a number of years in the 1790s. He was one of the wealthy Aragonese landowners (Juan Martín de Goicoechea, who also befriended Goya, was another) who carried out experiments on their own olive trees and vines to try to improve methods of cultivation and raise production for the benefit of everyone in the region.[13] The results of their work were passed on to farmers and farmworkers alike, and they also encouraged the study of socially useful topics like political economy in the younger generation. Zapater paid for some of the implements and instruments that were used in schools of agriculture, botany, and chemistry in Zaragoza, and he maintained the city's grain supply at his own expense when it was short. No doubt both Zapater and Goicoechea urged the Sociedad Aragonesa to make Goya a "socio de mérito" (honorary member) in 1790. Goya's letter of acceptance was read out on November 5 that year.[14]

Zapater's concern coupled with the artist's own rural family connections surely stimulated Goya's interest in the problems of commerce and agriculture. Ground that is cultivated, animals that are bred for food, products that are bought and sold are not mere decoration in his work. There is often sympathy for those whose livelihood is hard won. In tapestry cartoons like *Autumn* and *Winter*, for example, Goya showed his awareness of the harsh existence of day-laborers, on whose toil the sustenance and comfort of others depended. And it is probably not from mere chance that Goya painted his winter scenes for tapestries at a period when farmers and farmworkers everywhere in Spain were suffering from a series of crop failures and freezing winters. Enlightened landlords, like the Conde de Miranda, allowed their tenants to fall into arrears without prosecution in the late 1780s and also gave them grain to help them survive.[15] But if charity was one solution, another was to improve the distribution of land and methods of cultivation, topics much discussed in Jovellanos's circles at the time. The country people with asses on their back in *Capricho* 42 (cat. 49), *Tu que no puedes* (Thou who canst not) seem to reflect the artist's awareness of the need for change

on this issue. At the end of his life, farming still seemed to Goya a natural way to make a living. The estate he bought in 1819 across the River Manzanares to the left of the Extremadura highway was intended to be productive, and his son Javier and his grandson Mariano certainly set out to exploit its market-gardening potential in the 1830s.[16]

Agricultural problems and land tenure were not the only important issues in Spain. Other concerns about reform or change are reflected in paintings commissioned from Goya in the 1780s. A full-length portrait of Conde Floridablanca attributed to Goya (Madrid, Museo del Prado [G-W 204]) shows the count carrying a proposal for the creation of a national bank, which many considered fundamental to the economic well-being of the country. In another portrait (Madrid, Banco de España, cat. 4), whose attribution to Goya is not in doubt, Floridablanca is shown at work in his office, with books and papers strewn around to convey a sense of frenetic activity. The minister's encouragement of Spanish painting is very much in the picture. A copy of Palomino's *Práctica de la pintura* (1715-1724) lying on the floor is palpably being read, and Goya presents a new canvas to his patron. In the background, however, the main subject is the modernization of Spain. The clock is one of the latest and most accurate timepieces, and the plans for the Aragonese Canal, important both for transport and irrigation, are plain to be seen propped up against a table. Calculations of a financial kind fill a paper lying on the floor. In this case, of course, Floridablanca himself may have suggested some of the detail appropriate to the image of active leadership he wanted to project. In other works, however, Goya chose to show modern developments for himself. New constructions figure in a number of drawings (see cat. 149) and paintings. There is scaffolding in some, blocks of stone are transported in another, buildings are being erected. Since Goya's great-great-grandfather was a builder, there may have been a personal motive for interest in that area. But new types of transportation fascinated him too, whether on the grand scale of the Montgolfier balloons or on a lower and more comical level, like the one-dog-power vehicle he recorded in Paris.

On subjects such as these Madrid would have had something, but not much, to add to Goya's Zaragoza experience. Probably a new area for him in the capital was the law. He had many legal friends and contacts there, and they must have made him familiar with their anxieties about the Spanish legal system. His friend and patron Jovellanos rose to be minister of justice in 1797, and Meléndez Valdés became chief prosecuting counsel for the Crown at the same period. Ceán Bermúdez, intimate friend of Jovellanos from childhood and his close adviser on matters of art, had a post in the legal division of the Ministry of Colonial Affairs. Simón de Viegas, whose portrait by Goya, now lost, was exhibited at the Academia de San Fernando in 1797, was a reforming spirit in the legal profession, as was Manuel de Lardizábal y Uribe, whose brother, Miguel, was painted by Goya at a later date. Another lawyer who sat to Goya, Ramón de Posada y Soto, was related to Jovellanos by marriage;[17] while the family of another, Carlos López Altamirano, were long-standing acquaintances of Jovellanos, to judge from his diaries.[18] All were members of Jovellanos's circle, and several of them were exiled in the wake of his persecution at the end of the century.

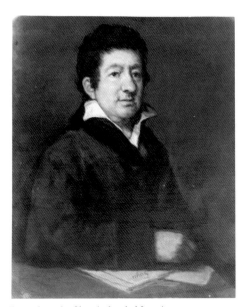

Fig. 4. *Leandro Vernández de Moratín*
Oil on canvas
Museo de Bellas Artes, Bilbao

Goya must surely have attended discussions about the need for constitutional reform, for equity before the law and greater justice in general in the legal system, for the elimination of torture and the improvement of prisons in order to preserve the rights and the human status of the accused and ensure the validity of evidence. On some of these issues Goya adopted the more obviously advanced position. Torture is a case in point. This was still being used to extract admissions of guilt from lower-class suspects in Madrid in the 1780s, and public whippings took place in Valladolid and were reported in the *Diario* as an edifying spectacle.[19] Yet the great English prison reformer John Howard, who visited Spain in 1783, had been pleased to find torture on the wane in some Spanish provinces, although prison conditions were still bad. Jovellanos was openly opposed to torture, under the influence of the Italian Beccaria and his major Spanish followers like Manuel de Lardizábal. On the question of equality before the law Spanish practice was not in harmony with enlightened opinion. Traditionally, upper-class offenders went to different jails from their social inferiors and were exempt from degrading kinds of punishment. Among Goya's friends, Meléndez Valdés was certainly strongly against this class distinction in matters of justice and argued for change.

As for Goya's point of view, the captions to his four etchings called *Prisoners* and the prints themselves (see cat. 95 and 96) indicate that he agreed with Beccaria's opposition to torture and with his friends who had adopted the same position. In a significant number of his drawings he put explosive related material, more particularly in those made between 1814 and 1823 showing past and present victims of the Inquisition (see cat. 99 and 104). These works, of course, link back to Goya's earlier Inquisition plates in the *Caprichos*, which, despite their irony and ambiguity, were seen by many of Goya's contemporaries as attacks on the innate injustice of the Holy Office. But his later drawings go further in their implications. They reflect the belief that the Inquisition inhibited scientific advance and ideological debate to the detriment of human progress. They also address religious tolerance (toward those of the Jewish faith, for example), which was less openly supported by writers of the Enlightenment period in Spain than by those in other countries. No doubt the biting irony of the captions and the manifest emotional involvement of the artist with his subject reflect the exasperation of a reforming spirit at the revival of the Inquisition in the wake of the Peninsular War. Very possibly the critical examination of the institution and its practices by men like the ecclesiastical historian Juan Antonio Llorente and the dramatist Leandro Fernández de Moratín (fig. 4), when Joseph Bonaparte had decreed its abolition earlier, led Goya to sharpen his own approach to the subject. The Cortes had made its own decree to abolish the Holy Office in February 1813.

Concern for victims of injustice was always strong in Goya. Like many of his contemporaries, he was also upset by undeserved privileges. He mocked useless aristocrats and complacent political leaders, and some of his plates in the *Caprichos* were believed to imply criticism of the monarchy itself. There is almost certainly comment in *Caprichos* plate 42, *Tu que no puedes* (You who cannot), on the unreasonable proportion of the tax burden borne by

working people. And he lambasted the potential corruption of the judicial system by showing, in *Caprichos* plates 21 (cat. 45) and 22, that prostitutes were sometimes victimized by the police while the magistrature covered up for them. These etchings, of course, were produced in a period rich in antihierarchical ideas, provoked by a dissatisfaction with the regime of Carlos IV and Godoy as much as by the French Revolution. However, legal circles are known to have discussed French doctrines widely in Madrid,[20] and there was open debate on the streets of the Spanish capital about the events in France. Inherited power, whether of nobles or kings, was increasingly questioned in published and unpublished literature. Elected rulers are preferred to hereditary monarchs in Cienfuegos's tragedy *Pítaco*; and aristocrats are criticized for destroying the livelihood of those below them in society in an anonymous Spanish Utopian fiction called *Tratado de la monarquía columbina* (The History of the Monarchy of Doves), published in 1790.

In the 1790s the more reactionary forces in Spain became nervous and resistant to change. One way in which they achieved their end was by wresting power from reforming ministers, like Jovellanos and those around him. When Jovellanos left office, his entire circle was affected, and many of them were victims of an apparently concerted attack. The brothers Lardizábal, the Minister of State Francisco Saavedra (see fig. 5), and later Urquijo and Bernardo de Iriarte (both of whom Goya painted) were banished from Madrid or imprisoned or both. Saavedra may also have been poisoned, as some contemporaries thought, if he was not simply made ill by the anxieties of his position and the strength of the opposition. When Saavedra, Jovellanos, and Urquijo were exiled (Ceán Bermúdez too), Goya must have missed their intellectual stimulus and friendship. But progressive attitudes did not disappear altogether in the early years of the nineteenth century, although they went underground to some degree. Fortunately, there were members of the establishment who wanted to keep some of the issues alive, more particularly those which did not present a challenge to their own power and could provide a useful escape valve for public opinion.

Goya's aristocratic connections became particularly important at this juncture. He had worked for the nobility from very early in his career. The Conde de Sobradiel in Zaragoza and the Infante Don Luis (whose wife was Aragonese) were important patrons in the 1770s and early 1780s. The infante was an ardent collector and keen on quality. Mengs bought good work for him in Italy.[21] Other patrons of Goya hardly needed to collect, for they had inherited notable galleries from their forebears. The Conde de Altamira, for instance (whose portrait and those of his wife and three children were painted by Goya), was descended from the Conde Duque de Olivares, Velázquez's patron. Their family had also acquired the title of Marqués de Villamanrique by marriage in the eighteenth century, and the series of great canvases on the life of Jacob by Murillo may have passed to them as a result, before it was sold to the Marqués de Santiago. As for the Osuna family, the ninth duke, Goya's patron, was descended from the Viceroy of Naples, who brought back Ribera's vast *Crucifixion* for the parish church of Osuna on his return from Italy in 1620; and his wife's seventeenth-century forebears had been gifted amateurs, one of whom had sat to Velázquez. Goya's Duque de

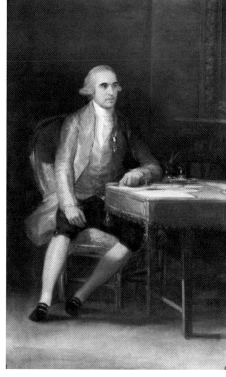

Fig. 5. *Don Francisco de Saavedra*, 1798
Oil on canvas, 196 x 118 cm.
Courtauld Institute, London

Osuna was obviously interested in prints as well as paintings. He had a brief role as treasurer of a company established in the 1790s to produce engravings of the best pictures in the royal collection; he bought four copies of Goya's *Caprichos* in 1799 and twenty-three volumes of Piranesi at the end of his life. The duchess had the more original taste, however, and together they bought from Goya in the late 1790s a remarkable group of witchcraft and theatrical subjects (also connected with superstition). These paintings are of special interest since they reflect an enlightened fascination with the irrational: the dark side of the human spirit, inevitably thrown into relief in the eighteenth century with its concentration on light and reason.

Circles like that of the Osunas sustained lively intellectual discussion and political debate in the early 1800s.[22] Other aristocrats with enlightened interests whom Goya painted were the Duquesa de Alba, the Marqués de San Adrián, and his wife, the Marquesa de Santiago. The Duquesa de Alba was fond of unconventional behavior and appears to have enjoyed breaking down the class barriers that normally separated her from those of lower social status. In her will she left her estates not to rich relatives with titles but to those who had worked for her, like Ramón Cabrera, her librarian, painted by Goya as a friend; Jaime Bonells, her doctor; and Tomás Berganza, one of her secretaries. It is difficult to say whether her conduct owed anything to an enlightened egalitarian standpoint in this instance, but she certainly supported the idea of individual freedom and released from slavery the negro girl she adopted, María de la Luz. Her strong humanitarian concern in that particular case and her affection for the child were singled out in a poem Manuel Quintana wrote on the subject and were untypical of her class in Quintana's view. The Marqués de San Adrián and the Marquesa de Santiago seem to have been libertarian in their approach to intellectual and moral rather than political issues. Plays performed at their house included Moratín's *La mojigata* (The Religious Hypocrite), which mocks religious hypocrisy and raises questions of freedom and control in the education of the young, pointing out the dangers of parental tyranny. The couple appear to have believed that virtue and vice were relative values, not absolutes. The marquesa's amorous affairs were notorious and met with some disapproval, while, for his part, her husband challenged convention in print. In the prologue to his translation of Jean Alexis Borrelly's *Elémens de l'art de penser; ou, La logique réduite a ce qu'elle a d'utile*, the marqués affirmed his respect for Enlightenment ideals. He published his translation because he felt it would serve to help young people to find out the truth for themselves, "que debe ser el objeto y fruto de todas nuestras tareas" (which should be the object of all our efforts). Reason was essential as an antidote to superstition and ignorance, and it opened up "[el] gran libro de la naturaleza abierto para todos" ([the] great book of nature, which all may read).[23]

There was no lack of art in the Santiago household either. The marqués belonged to the Academia de San Fernando, and the marquesa had inherited an important part of the remarkable picture collection formed by her great-great-grandfather, the first Marqués de Santiago, in the early years of the eighteenth century. Goya is said to have painted her when she was young, as well as in 1804 at the age of forty. Thus, her father may have been among the

artist's earliest patrons in Madrid. She was also related by marriage to another of Goya's early aristocratic subjects, Mariana de Pontejos, baptized María Ana de Jesús (with five other Christian names) on September 12, 1762.[24] The latter likewise inherited a portion of the original Santiago collection when she came into the Casa Pontejos title on the death of her father in October 1807. She was clearly in her twenties when Goya painted her.

Not all Goya's later aristocratic sitters had the artistic interests and the ideological openness of the earlier group. The Duque de San Carlos, portrayed by Goya in 1815, owned a copy of the *Caprichos*, it is true,[25] but his library had little to offer in relation to the Enlightenment, and he had virtually no paintings at all in 1804.[26] He had little sympathy with the political reforms and social changes envisaged by the liberals who supported the Cadiz Constitution of 1812 or the revolution in Spain that some intellectuals hoped for under the aegis of Joseph Bonaparte. His period in power was a time of repression, when every effort was made to retain the traditional privileges of both church and aristocracy.

Although Goya criticized members of the bourgeoisie who profited from the French connection during the Peninsular War yet failed to show any concern for the sufferings of their fellow countrymen, he probably respected the pro-Bonaparte stance adopted by some of his friends and valued some of their political and cultural objectives. The cleric Llorente, with his critical approach to the material wealth and land-ownership of the church, his perception of the dubious advantages of celibacy of the clergy (a source of unhealthy pride or hypocrisy in his view), and his love of the theater, would certainly have found a sympathetic ear, metaphorically, from Goya.[27] Llorente may well have stimulated Goya to explore further veins he had already opened up in the *Caprichos*. The young Manuel Silvela (see cat. B20), who, as a judge in Madrid at the age of twenty-seven in 1809,[28] wrestled daily with the orders for summary execution issued under the French occupation, may in his turn have helped Goya reach his sense of the arbitrariness of justice in wartime, so powerfully portrayed in the *Disasters of War*, plate 35 (cat. 87). Llorente's sharp eagerness and Manuel Silvela's thoughtful intensity as depicted by Goya certainly seem to reflect sympathy rather than indifference or mere objectivity.

After the restoration of Fernando VII in 1814, many liberals were persecuted or imprisoned, and some of Goya's *afrancesado* friends went into exile. This must have been another period of relative isolation for the artist, and the sense of bitterness and injustice wells up constantly in Goya's drawings and etchings. An acquaintance of Goya's who may have been in a position to share ideological preoccupations with him was Evaristo Pérez de Castro, whom Goya had painted a few years earlier, and who was in Madrid from the autumn of 1814 until late in 1816.

Pérez de Castro's portrait (fig. 6) was recognized by one of the sitter's children when it was exhibited in Madrid in 1900.[29] There is no reason to doubt its authenticity or the identity of its subject, even though some critics have wondered what made Goya depict a politician and diplomat like Pérez de Castro as an artist. There is no reason to wonder, in fact, since Pérez de Castro *was* a gifted amateur painter and a perceptive collector of works

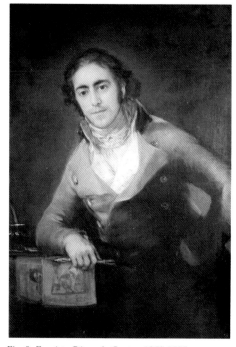

Fig. 6. *Evaristo Pérez de Castro*, 1803-1808
Oil on canvas, 99 x 69 cm.
Musée du Louvre, Paris, RF1476

of art as well as a politician of the liberal persuasion. León y Pizarro, who knew him when Pérez de Castro served as an attaché at the embassy in Vienna in 1798, described him as an industrious and well-educated young person; "adémas tenía mucho gusto por las bellas artes, y en especial la pintura, que ejercitaba por sí mismo bastante bien" (moreover he had a great liking for the fine arts, and especially painting, which he was quite good at himself).[30] Pérez de Castro evidently made etchings too. One of his works in that medium survives in the Biblioteca Nacional in Madrid.[31] As for his art collection, he inherited a few paintings and a number of prints from his father in 1801, but when his possessions were valued after his death, by Vicente López,[32] they included over a hundred paintings and a significant group of prints. Among the paintings were three by Goya, all connected with the Peninsular War: "Una escena de la Guerra de la Independencia," "Cuadro de Mamelucos" y "Cadáveres" ("A scene from the War of Independence," "Mamlukes," and "Dead Bodies"). Also in the collection were a copy of the *Tauromaquia* series of etchings; *The Garrotted Man*; a number of etchings after Velázquez, some of them certainly by Goya; and Ametller's engraving of Goya's portrait of General Urrutia.

Goya's portrait of Pérez de Castro is usually dated between 1803 and 1808, when he was between thirty-three and thirty-nine years old and officially posted at the embassy in Lisbon. But it seems that Goya must already have known him in the 1790s since his father, Pedro Antonio Pérez de Castro, had been one of Moratín's circle of friends in Madrid from the late 1780s. It was in the Pérez de Castro house that one of the first private performances of Moratín's challenging play *La mojigata* was given at that period. Moratín and Goya were often together at the time.

The association between Goya and Don Evaristo Pérez de Castro must have resumed after the Peninsular War, to judge from the works by Goya in Don Evaristo's collection. He had been an ardent supporter of freedom of the press at the Cortes of Cádiz in 1810, and his library reveals his deep interest in the French Revolution and the principal *philosophes*, such as Montesquieu, Voltaire, and Rousseau. He was in Madrid, without any diplomatic appointment, from the autumn of 1814 until late in 1816.[33] He published correspondence between Godoy and Maria Luisa in 1814 and appears to have shared Goya's interest in the political allegories of the Italian poet Casti at that period. He would certainly have appreciated the use that Goya made of Casti's *Gli animali parlanti* in the "Emphatic Caprices" from the *Disasters of War* (see cat. 154-163). In these he obliquely criticized Fernando VII's tyrannous regime from a liberal standpoint. Pérez de Castro may even have suggested to Goya that he use the poem, for he is a strong candidate for the authorship of a Spanish translation of the first canto of Casti's poem published in 1822.[34] Goya may also have taken an interest in the painting of Judith, attributed to Guido Reni, in Pérez de Castro's collection, when he was working on the "Black Paintings."

The paintings in the Quinta del Sordo were completed between 1820 and 1823, at a period when Fernando VII accepted the Constitution of Cádiz and was compelled to abandon his absolutist stance. The Spanish Cortes once again raised issues of reform in public education, crime and punishment, and

economic development. And important roles were played in its debates by admirers of Goya such as the poet Manuel Quintana, the scientist González de Azaola and the naval officer Vargas Ponce. Vargas, who had long been known as a man of advanced ideas, declared in a speech to the Real Academia de la Historia his confidence in the country's new-found freedom and the durability of the constitution.[35] The changing situation was watched eagerly from France by other friends of Goya: those who had been identified with Joseph Bonaparte's regime, like Juan Antonio Llorente, Manuel Silvela, and Leandro Fernández de Moratín. Spain was at the beginning of a revolution, according to Silvela. The country would need a great deal of tolerance and should beware of religious bigotry and general prejudice.[36] Goya's renewed attack on the Inquisition in the "Black Paintings" stemmed no doubt from a similar concern. But elsewhere in the same series the artist's view of Saturn differed from that of Silvela. The latter took Saturn as the symbol of the absolute monarch, who owned his people and, metaphorically, devoured his children.[37] Goya's figure seems broader and less specific in its implications, fundamentally ambiguous. Nevertheless, even in its late phase, Goya's art continued to reflect concrete ideas and adopt images that were usually nearer to reality than to myth.

Fig. 7. *Joaquín María de Ferrer*, 1824
Oil on canvas, 73 x 59 cm.
Marquesa de la Gándara, Rome

A crucial subject for those around Goya in the Bordeaux period was the fate of Spain. Vargas Ponce's optimism had proved hopelessly misplaced. But there was room for universal topics too, like education, which was a central concern of the Enlightenment everywhere. Since Moratín had stressed its importance in his plays, and Silvela ran a school in Bordeaux, the subject must have been frequently discussed by Goya's friends. A relatively new figure in Goya's life with clear views on the issue, more particularly as it affected women, was the wealthy Basque banker Joaquín Maria de Ferrer.[38] His portrait (fig. 7) and that of his wife were painted by Goya in 1824. Ferrer had a keen interest in art. Where education was concerned, he was passionately opposed to the inadequate training of women so common in Spain. Goya cannot have been ignorant of modern educational trends, since he had worked, years earlier, on a design to celebrate the Pestalozzi Institute in Madrid, which was on the principles of the great Swiss educationalist. In Pestalozzi's system mothers played a key role in stimulating the child's awareness of the world. The early sense of order and function had to be developed by the mother, who must be fully conscious of her role.

Goya's appreciation of these ideas and his knowledge of the part played by Spanish women in the Peninsular War may perhaps have encouraged him to modify the traditional stereotypes of women in his work. These do not entirely disappear during the Bordeaux period. The characteristically male images of women as prostitute or nun, flirt or virgin, witch or mother linger on. And yet the woman with the job – the milkmaid and the shepherdess – and, above all, the girl reading the book suggest a more positive perspective on women than heretofore. Goya's responsibility in relation to Rosario Weiss (who was perhaps his illegitimate daughter) may have helped to change his attitude. In any case, at the end of his life, he was still willing to learn: from books to some extent but rather more, one suspects, from friends and

acquaintances in the exchanges of the typical Spanish *tertulia* (salon). Goya did not isolate himself in his final years, although his drawings depict an increasing number of solitary figures. Restless socially and intellectually, he had the right spirit to capture the protests, progressive ideas, and arguments of his age. In the circles in which he moved, friends, patrons, and sitters no doubt spoke out as Spaniards will: in private when there was repression and in public when they felt free. Goya watched and let his art speak for him.

1. *The Spanish Journal of Elizabeth Lady Holland,* ed. The Earl of Ilchester (London, 1910), p. 23.

2. Aguirre, in *Memorias de la Real Sociedad Patriótica de Sevilla,* vol. 1 (Seville, 1779), pp. 56-65.

3. Velasco, in *Junta pública de la Real Sociedad Económica de Amigos del País de Valencia . . . 1799* (Valencia, 1800), p. 105.

4. The king had stated his preference for an academy in Zaragoza to encourage "la agricultura y las artes mecánicas" (agriculture and the crafts); Archivo General de Simancas, Secretaría de Hacienda, Leg. 8, June 1772.

5. See Real Academia de San Carlos, "Real Decreto . . . de 24 de octubre de 1778," in *Continuación de la noticia histórica de la Real Academia . . . de San Carlos* (Valencia, 1781), pp. 13-14.

6. Letter from Fray Manuel Bayeu to Martín Zapater, Sept. 2, 1786, Museo del Prado, MS. no. 50.

7. For details of the duke's artistic inclinations, see Nigel Glendinning, "El retrato en la obra de Goya: Aristócratas y burgueses de signo variado," in *Goya: Nuevas visiones: Homenaje a Enrique Lafuente Ferrari,* ed. I. Garcia de la Rasilla and F. Calvo Serraller (Madrid, 1987), pp. 190-191.

8. Pedro Agustín Girón, marqués de las Amarillas, *Recuerdos (1778-1837)* (Pamplona, 1978), vol. 1, pp. 68-69.

9. *Souvenirs et mémoires de Madame la Comtesse Merlin, publiés par elle-même* (Paris, 1836), vol. 1, pp. 182-183.

10. Real Academia de Bellas Artes de San Fernando, *Distribución de los premios . . .* (1802), p. 33.

11. Biblioteca Nacional, Madrid, MS. 12628, fol. 142v.

12. Letter from Fray Manuel Bayeu to Martín Zapater, Feb. 15, 1775, Museo del Prado, MS. no. 34.

13. Real Sociedad Aragonesa, *Compendio de las Actas de la Real Sociedad Aragonesa: Correspondientes al año de 1798* (Zaragoza, 1799), pp. 24, 63-64, and 71.

14. Archivo de la Real Sociedad Económica Aragonesa de Amigos del País, Zaragoza, *Actas: Año de 1790,* fols. 157 and 173. This information was kindly supplied by Dr. Philip Deacon.

15. Cabarrús reported finding individuals dying close to his house after the crop failures of 1786. A letter to the king from the Conde de Miranda, Feb. 23, 1790, refers to "la notoria escasez, miseria de los años y enfermedades que han reinado en todos los pueblos" (the notorious famine and extreme poverty and sickness of recent years which all towns and villages have experienced); Archivo Histórico Nacional (hereafter AHN), Consejos, Leg. 9958. The winters were also bitter, and heavy snowfalls led to floods in 1786 and 1787; *Diario Pinciano,* Apr. 26, 1788 (reprint, Valladolid, 1933, vol. 2), p. 122.

16. See Nigel Glendinning, "Goya's Country House in Madrid: The Quinta del Sordo," *Apollo* 123 (Feb. 1986), p. 108, n. 4.

17. For details of Posada y Soto's life, see Nigel Glendinning, "Goya's Patrons," *Apollo* 114 (Oct. 1981), pp. 242-243. A valuation of his property, Apr. 18, 1800, mentions eighteen paintings (not listed individually) at 5,000 reales and values the library at 17,000 reales; Archivo Histórico de Protocolos, Madrid (hereafter AHPM), Pedro de Valladares, MS. 21094, fol. 301ff.

18. The history of the López Altamirano family, more usually known by the second of the two surnames, has not been adequately researched as yet, so far as I am aware. Two brothers, born in Zamora, were important figures in the law and government in Goya's lifetime: Carlos Francisco López Altimirano Ramos y Balmaseda (b. 1727), who was admitted to the Order of San Juan in 1739, and Juan Antonio López Altamirano, admitted to the Order of Santiago in 1789. The latter was a law student in Salamanca, then, like Jovellanos, a *colegial* (scholar) of San Ildefonso in the University of Alcalá. He had legal posts in Granada in the 1760s and 1770s and the Canary Islands in the 1780s, rising to be a minister of the Consejo de Ordenes in 1789 and a member of the Consejo Real in 1799. Fermín López Altamirano, Carlos Francisco's nephew (and possibly Juan's son), had a title: Marqués de Valdegema. The Carlos Altamirano painted by Goya, and referred to as his friend, may have been a younger brother of Carlos Francisco and Juan or one of their sons or nephews. He was definitely appointed "Alcalde de la Cuadra de la Audiencia de Grados" in Seville, Aug. 3, 1791. It is not clear whether this automatically made him an "oidor" (auditor), but he certainly had this title when he died in 1800. His replacement was announced in the *Gaceta de Madrid* on Dec. 16 that year. It seems probable that he was the Carlos López Altamirano known to have obtained a law degree in Salamanca in Feb. 1779, to have been subsequently appointed rector of the university, and allowed to practice as a lawyer from Jan. 1783. References to the family can be found in AHN, Consejos, Libro 740, fols. 92, 191v., and 199v.; Consejos Leg. 13361, no. 29; Consejos Leg. 12142, no. 62; Ordenes militares: Santiago, Exp. 4539, and San Juan, 23460. He spent

some time traveling with Jovellanos immediately after his nomination for the post of Alcalde de la Cuadra; Jovellanos, *Diarios*, ed. Angel del Río (Oviedo, 1953), vol. 1, pp. 200ff.

19. *Diario Pinciano*, Apr. 18 and 25, 1787 (reprint, 1933, vol. 1), pp. 131 and 142.

20. See General Manuel Belgrano, "Autobiografía," in Museo Histórico Nacional, *Memorias y autobiografías* (Buenos Aires, 1910), vol. 1, p. 92.

21. See "Escritura de venta de setenta y un cuadros . . . por la Exma. Sra. Duquesa viuda de San Fernando en favor de Don José de Salamanca"; AHPM, 25239, fol. 169v. and fol. 170 (nos. 1 and 10).

22. Lady Holland heard criticism of the queen at their dinner table in June 1804; *Spanish Journal of Elizabeth Lady Holland*, p. 149.

23. Borrelly, *Elementos del arte de pensar; ó, La lógica reducida á lo que es meramente útil*, trans. Josef María Magallón y Armendáriz, Marqués de Santiago (Madrid, 1797), pp. ii and iii.

24. Archivo parroquial de la Iglesia de San Sebastián, Madrid, Bautismos, book no. 39, fol. 384v.

25. "Capital de bienes del Exmo. Sr. Duque de San Carlos," July 31, 1804, AHPM, 20223, fol. 801v. ("Caprichos de Goya, un tomo pasta en Estampa").

26. Ibid., fol. 797v.ff. There is, for example, reference to "Una Pintura grande que representa la Presentación con su marco dorado, en dos mil y quatro cientos reales vellon" on fol. 772. There is no list of pictures as a group.

27. For Juan Antonio Llorente's views, see particularly *Anales de la Inquisición de España* (Madrid, 1812); *Noticia biográfica . . . o Memorias para la historia de su vida escritas por él mismo* (Paris, 1818); and *Discursos sobre una constitución religiosa considerada como parte de la civil nacional. Su autor Americano* (Burdeos, 1821).

28. On Silvela's life see the biography written by his son in *Obras póstumas de D. Manuel Silvela* (Madrid, 1845), vol. 1, pp. vii-xxxxii.

29. On the early history of the portrait, see X. Desparmet Fitz-Gerald, *L'Oeuvre peint de Goya* (Paris, 1928-1950), text vol. 2, p. 158, no. 445; and N. Sentenach, "Notas sobre la Exposicion de Goya," in *España Moderna* 12 (June 1900), pp. 44, no. 99.

30. José García de León y Pizarro, *Memorias*, ed. Alvaro Alonso Castrillo (Madrid, 1953), vol. 1, p. 70. Pérez de Castro was proposed for the title of Honorary Academician (and duly admitted) at the Junta Particular of the Real Academia de San Fernando on July 6, 1800 "for his notorious love for the Fine Arts and his commitment to them."

31. Elena Páez Ríos, *Repertorio de grabados españoles en la Biblioteca Nacional* (Madrid, 1982), vol. 2, p. 397, no. 1663.

32. See "Partición . . . de los Bienes de Da María Agustina Colomera
. . . viuda del Señor Dn Pedro Antonio Pérez de Castro," Sept. 23, 1801, AHPM, 21095, fol. 625ff. and especially fol. 658 onwards. Evaristo Pérez de Castro inherited estate to the value of 253,551 reales. The

inventory made after his own death (Nov. 28, 1849) is in AHPM, 25720. Books and paintings are listed from fol. 61 onwards. The inventory was usefully exploited by José Valverde Madrid in an article on the portrait of Pérez de Castro in the Louvre in *Adarve* (Córdoba), May 1, 1978, p. 8. Goya prints in Pérez de Castro's collections are not, however, noted by Sr. Valverde.

33. Details from Pérez de Castro's personal files are in AHN, Estado, Leg. 3450^2. The most useful document is his "Hoja de servicios," listing his appointments from 1800 to his retirement in 1840.

34. Pérez de Castro had a three-volume edition of *Gli animali parlanti* in Italian in his library. This could have been either the Paris 1802 or Paris 1820 edition. It is possible that he had the earlier edition since the work seems to have been known in Spain at the time of the Peninsular War. For Goya's use of the work, see Nigel Glendinning, "A Solution to the Enigma of Goya's 'Emphatic Caprices,' " *Apollo* 107 (Mar. 1978), pp. 186-191.

35. "Alocución a la Academia de la Historia al volver a su seno . . .," June 16, 1820, Real Academia de la Historia, Madrid, MS. $9\text{-}29\text{-}8^O\text{-}6052$.

36. "Correspondencia de un refugiado," in *Obras póstumas de D. Manuel Silvela*, vol. 1, pp. 275-283.

37. Ibid., pp. 281-282.

38. For Ferrer's views on education, see *Historia de la monja alférez, Doña Catalina de Erauso, escrita por ella misma, e ilustrado con notas y documentos, por D. Joaquín Maria de Ferrer* (Paris, 1829), p. xii (general points about education), and p. xiii (women's education).

GOYA AND DAVID: Conflicting Paths to Enlightenment Morality

Fred Licht

Even before Goya embarked on his first explicitly moral work, that is, even before executing the *Caprichos* (1797-1799) (see cat. 38-62), he distinguished himself from his contemporaries as an artist to whom personal moral considerations were paramount. In view of David's *Oath of the Horatii* (1785) and *The Death of Socrates* (fig. 1), such a statement may seem outrageously perverse. Certainly, the astringent style and high, patriotic tone of David's masterpieces and their overall reference to republican Roman *virtus* imply a call to moral regeneration. Compared with the seductive color and graceful virtuosity of brushwork evident in the painting of most of David's immediate predecessors, his sharply defined juxtapositions of unbroken colors, stark economy of gesture, and eradication of ornamental details all vouch for a new probity of form and theme. David substituted a new authority, reason, for the old authority of revelation in order to arrive at a new moral standard that could then be imposed with the same militant rigor — and the same claim to being the only path to salvation — with which the Inquisition imposed its faith. Whether the political garb was Jacobin or imperial was unimportant. David always followed a preexistent code that had a concrete political, public character. Goya's moral quest was always private and never based on any form of public authority.

Only in their earliest works, when both artists still adhered to baroque and late baroque tenets, did their attitudes toward morality in art coincide. David in his mythological compositions and Goya in the religious frescoes of El Pilar cathedral in Zaragoza followed very similar conventions. Both assumed that the artist and the public shared common moral traditions reaching back to medieval amalgamations of classical and Judeo-Christian concepts. Good and

Fig. 1. Jacques Louis David,
Death of Socrates, 1787.
Oil on canvas.
The Metropolitan Museum of Art, New York,
Catharine Lorillard Wolfe Collection

evil were apprehended by the divine grace of revelation (beginning with the Decalogue, continuing through the Prophets, Christ's teachings, and the exemplary lives and deeds of the saints) and corroborated by the equally divine but very different gift of human intellect. It was enough for David to allude to the Contest between Mars and Minerva or for Goya to paint angels praising the Virgin to conduct the sensibilities of all who saw these paintings along paths of universally recognized righteousness.

The conventions shared by David and Goya in their early religious and mythological paintings no longer formed common ground between the two painters when it came to the painting of portraits. It was here that Goya struck out in new directions that increased in importance throughout his life. Whereas David's portraits tell us about the rank, esprit, and impeccable sociability of his sitters, who all seem to receive us with the utmost graciousness, Goya's portraits reveal a bias toward an impartial verdict about the ultimate moral worth of a given individual. David, to the end of his days, and with very few exceptions (*Pope Pius VII and Cardinal Consalves*, in the Philadelphia Museum of Art, McIlhenny Collection, comes to mind), retained a blessed and unshakable confidence in the essential goodness or at least perfectibility of human nature. In spite of his own physiognomic handicap and in spite of the frequently unappealing appearance of many of his sitters (fig. 2), he was able to convey what is worthy, admirable, and lovable in all members of the human race. That he was able to express this faith with irresistible sincerity and without ever having recourse to flattery is one of the many aspects of his talent that allow us to think of him as a portraitist who need not avoid comparison with Fouquet, with Rubens, or even with Rembrandt. For all their austerity of composition and palette, David's portraits have more in common with Rubens or Greuze than with those of his great Spanish colleague. If Goya's portraits, even at the beginning of his career, differ markedly from David's, it is not because Goya was any the less a product of the Enlightenment than the French artist. It is, rather, because he stemmed from a very different portrait tradition, whose most authoritative exponent was Velázquez.

Goya's intense admiration of Velázquez was not limited to matters of technical mastery. It derived from a similar conception of what constitutes the basic obligations of the portraitist. All of David's portraits could be called "transitive" since they all establish a social episode within which we meet the sitters and within which we can recognize, understand, and sympathize with the sitters' emotions, reactions, and sensibilities. Velázquez and Goya, on the other hand, tended to deprive their sitters of their sociohuman context, to strip the characters bare of all acquired polish, to concentrate on the isolated, sometimes paltry creature that lurks behind all the outward trappings, all the conventions by means of which we attempt to bridge the mysterious and sinister intervals that separate us one from another. While David and the enormously prestigious traditions that lay behind him were explicit about the moral nature of the sitter, Velázquez and Goya either withheld judgment, or else they revealed such infinitely complex ambiguities about our fellow men that judgment seems impossible. In either case, we are

Fig. 2. Jacques Louis David,
Madame David, 1813.
Oil on canvas.
National Gallery of Art, Washington, D.C.,
Samuel H. Kress Collection

forced to make a choice, presumably based on our personal moral standpoint. We must come to a decision, whereas David or Rubens or Rembrandt always made one for us before they set brush to canvas.

It is precisely this view of mortal humanity as a moral arena in which the outcome is suspended that also distinguishes Goya's genre scenes from similar works by eighteenth-century French or, for that matter, by other Spanish artists. Paret's delightful views into the daily routine of elegant *madrileños*, as they amuse themselves in aristocratic pastimes or go slumming among the merchants and proletarians of the capital, share a fundamental point of view with similar paintings executed in France, Germany, and Italy. Both Paret and his non-Spanish colleagues believed that it is good and fitting to observe men and women because they are children of God whose foibles, though sometimes frivolous, attain dignity and significance. The sheer enjoyment of the world, in their view, is essentially an action that carries a morally positive charge. Goya did not accept this view in which all values, social and moral, were as obvious and valid to the painter as they were to his sitters or to his audience. In many of Goya's superficially cheerful genre scenes, we cannot even be sure that anyone is really enjoying himself.

By themselves, the tapestry cartoons, despite their frequent overt or concealed social commentary, cannot lay claim to expressing a coherent morality. Only when considered as a prelude to the devastating and enduring statements of the *Caprichos* do the tapestry cartoons attain importance as a stage in the development of Goya's moral views. Their easily discernible deviation from accepted eighteenth-century norms can serve us well as an introduction to the later, infinitely more profound oeuvre. An unsettling discrepancy begins to appear between the apparently pleasant activity of the figures and the barren, unappealing landscape settings that no longer reflect or enhance the mood of wordly amusements. It is as if the accommodating backgrounds of the late rococo had vanished, leaving the actors bereft of suitable scenery. The old conventions that posited man's supremacy in the world have evaporated. The party is over, but some of the guests have not noticed yet that their mood of casual revelry is in contrast to the baleful new dawn. The laughter of the dancers in *La gallina ciega* (Blind Man's Bluff) (Museo del Prado; G-W 276) sounds forced. The dancers are trying too hard to enjoy themselves. The discomfort and pain of *Los pobres en la fuente* (Poor Folk at the Well) (Museo del Prado; G-W 267) or *El albañil herido* (*The Wounded Mason*) (cat. 13) are far more real and far more persuasive than the cheer that ostensibly forms the theme of the tapestries depicting sociable diversions. Goya has already broached themes that found full expansion in his mature work: man's exile from a structurally coherent world and man's attempt to assert himself in a universe that ignores his very existence.

The *Caprichos* have been justifiably interpreted as the crowning and most purgative visual statement of the Enlightenment. There can be little question about the influence of Enlightenment thought on Goya. The print that he had intended to be the title page, the famous *El sueño de la razon produce monstruos* (The sleep of reason produces monsters) (cat. 52) is evidence enough of the intellectual currents that nourish each image of the *Caprichos.* Yet the very fact that Goya did not pursue his original intentions and relegated

Fig. 3. Daniel Chodowiecki,
Afectation, (Affectedness), 1789.
Etching.
Kupferstichkabinett, Staatliche Museen Preussischer
Kulturbesitz, Berlin (West)

this key print to a less prominent position (as number 43 in the series) gives one pause. The longer one looks at this astonishing work, the more one realizes that although the Enlightenment was certainly the soil from which these perplexing Fleurs du Mal grew, the power that emanates from these pages is at great variance with the confident tones of reason in which the Enlightenment spoke. Not that the Enlightenment always sounded the same note. It is certainly possible to cite pages from Feijóo or Voltaire that are a far cry from what one generally thinks of as the general tenor of eighteenth-century serenity. But Goya's outbursts differed primarily in their disregard for the kind of decorum that was as automatic as it was sacrosanct for the intellectual community of the second half of the eighteenth century. The intensity of his imagery violates the code of self-restraint that marks the work of the contemporary intelligentsia.

Facing all proponents of the Enlightenment was a task to which they devoted their unstinting energies: to find a moral code that would reconcile man's higher, intangible faculties with the need for the regulation of social and political intercourse, without which no human community can hope to survive. The Enlightenment was primarily a didactic, educational movement based on an unshakable conviction that man's greatest chance of salvation lies in his ability to learn. Even when this axiomatic faith was subjected to the test of irony and laughter (as in Voltaire's *Candide*), intelligence, reason, and a fine mildness prevailed. In the face of the horrors wrought by man (the Bulgarian invasion) and those wrought by nature (the Lisbon earthquake) Candide learned, and we learn by following Voltaire's words, to live in accordance with and within the limits of our capacity to absorb the knowledge gained by intelligently observed experience. If we are seeking visual accompaniments to the philosophic tenets of the Enlightenment, we can go to any of the instructive manuals that were printed in great number throughout Europe. Of these, Daniel Chodowiecki's *Moralized Calendar* (figs. 3, 4) is perhaps the most celebrated and best example. The plan of this work is particularly germane to the Enlightenment spirit because it proceeds from one situation that is "bad" to a rectification that turns things around so that they become "good." The artist can castigate and satirize whatever it is he finds out of joint in his times, and having made us see the error of our ways, he appeals to our common sense to lead us onto a path of virtue.

Reexamining contemporary texts and captions written by Goya himself and by the friends whose help he enlisted for the public presentation of the *Caprichos*, we can have no doubt that the artist's work is thoroughly charged with moral purpose, which seeks to instruct (and by instructing to perfect) all who turn the pages. Goya's intensity of vision as well as his avowal to participate in all aspects of human existence (the rational as well as the emotional, the benevolent as well as the ignoble), though starting from didactic motivations, went beyond the goal of earlier and contemporary satirists. He recognized that indissoluble residuum of darkness which persists in even the most enlightened souls. Goya's sense of evil did not stop with the recognition of human weakness. In his view, it is not only the hypocrite who is at fault; it is not only the corrupt who must be unmasked and brought to justice.

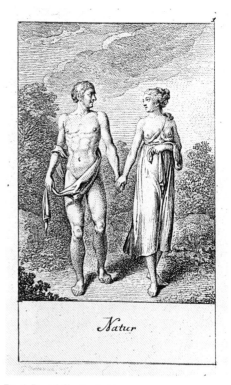

Fig. 4. Daniel Chodowiecki,
Natur, (Naturalness), 1789.
Etching.
Kupferstichkabinett, Staatliche Museen Preussischer
Kulturbesitz, Berlin (West)

Fig. 5. William Hogarth,
Gin Lane, 1750-1751.
Etching and engraving.
Museum of Fine Arts, Boston,
Harvey D. Parker Collection

The seeds of superstition, cruelty, and falseness germinate in all of us. Before we attain the right to accuse others, we must recognize our own potential for evildoing. An element essential to Enlightenment imagery is the suggestion, sometimes more and sometimes less overt, that the artist knows of an effective remedy for the situations he describes. This is not to say that all Enlightenment artists were as bland as Chodowiecki in counterposing the "wrong" against the "right." But even when Hogarth described the horrors of "Gin Lane" (fig. 5) or the dry rot of "Marriage à la Mode" (1743-1745), he did so from the privileged position of a man who knew better. We, in turn, following Hogarth's lead, are also put automatically on the side of righteousness. We feel fully entitled to pass verdict on the strength of Hogarth's evidence. Goya, by contrast, does not lead us to foregone conclusions. He challenges us to meditate on the intricate chain of cause and effect. Even his most patent exaggerations are never glib condemnations, as happens so often in Rowlandson, nor are they simple invitations to contempt. We must make our own way, testing the validity of our ideas and taking nothing for granted.

Glancing through Goya's *Caprichos*, we find it extremely difficult to know on whose side we are or whether, indeed, there are always sides in the human drama. Hogarth's point of view still maintains a great deal of the structure and equilibrium of Dante's *Divine Comedy*. Punishments correspond to transgressions, and there is a steadfast center that upholds an essentially rational universe, which specially privileged men (poets like Dante, artists like Hogarth) can approach and interpret for us. If the *Caprichos* resemble any *Comedy*, then it is Balzac's *Comédie Humaine*, which is fragmentary rather than unified, shifting in viewpoint rather than firm, obscure rather than "illuminated." In Dante we may feel terror and pity at the misdoings of Paolo and Francesca. But that pity does not prevent us from bowing to the divine justice that condemns them. In Balzac, on the contrary, we may recoil from Vautrin, but we are certainly not empowered to condemn him; nor does the author suggest that he (and by extension we), in similar situations, might not behave exactly like Vautrin. Like Balzac (and unlike Hogarth), Goya did not pretend to be immune to the follies he castigated. Whatever evils Goya portrayed, not only had he perceived them in others but he had also seen them in himself. Hogarth promises us that if we follow him, he will make us see right from wrong so that we can live worthy lives. Goya persuades us to think for ourselves. He does not necessarily predict what the results of our thinking will be. Hogarth speaks to those who already agree with him. Goya, unlike his great English predecessor, speaks to a less well-defined public. He speaks to us as if we were (and who is not?) participants rather than critical spectators in the baffling struggle between good and evil. We are made to feel the tremendous burden of being on guard against ourselves as well as against possible contamination by mankind's general folly.

Whatever Goya's averred intentions for the *Caprichos* may have been, the results went beyond his wishes. Perhaps his substitution of a self-portrait for the original title page can be interpreted in a very straightforward manner: the *Caprichos* are Goya's response to folly, cruelty, injustice, and superstition. They belong to no convention. Thanks to the astonishing findings of the

research team responsible for the present catalogue, we are now in a position to understand far better Goya's allusions and oblique references. The humanitarian purpose and intellectual content of the *Caprichos* are more comprehensible than ever before. What remains impervious to reason and contrary to intellect is the uncanny mood, the presence of unseen menaces that raise uncomfortable questions regarding the adequacy of our intellectual resources when combating evil.

In *Caprichos*, plate 25, *Si quebró el Cantaro* (Yes he broke the pitcher), we face a subject that is particularly dear to the Enlightenment: child-rearing. The Prado text "The son is naughty and the mother is wrathful. Which one is worse?" already poses something of a surprise by leaving moral judgment of the protagonists in suspense. If the text already introduces a mild deviance from the more confidently moral tone of the Enlightenment, the image makes a demonic impression quite disproportionate to the text or to the relatively common action presented. By eliminating one-point perspective, Goya sets his figures in an incoherent space that is in itself frightening because we cannot orient ourselves in it. Nothing in the background is fixed; lacking coordinates, space stretches to a bleak infinity. More extraordinary still is the composition of the figures. The laundress-mother has seized the child with frenzied violence, not only with her arms and hands but also, animal fashion, with her teeth. The gesture of the right hand conveys a passionate ferocity completely out of keeping with the minor nature of the child's offense. What Goya has expressed is not just a useful warning against excessive physical punishment. In addition, he has packed into his description of the mother a whole lifetime of grinding work and deprivation that must inevitably turn any mother into a beast and lead her to discharge her rage at the slightest provocation. The print, besides making an appeal "Mothers! Don't beat your children!" makes a flat statement: "Many mothers, brutalized by unbearable conditions, will vent their rage on their children."

In Chodowiecki's work, even if we have seen only one of a pair of images illustrating "wrong" and "right," it is easy enough to imagine what the counterpart will look like. If we attempt the same experiment with any of Goya's *Caprichos*, we draw a blank. *Si quebró el Cantaro* is certainly "wrong," and we can recognize the fact easily enough. But how do we remedy the situation? Chodowiecki's world, by comparison with Goya's, is sane. Only the affectations of ill-educated men and women are insane (fig. 3). Educate men and women to practice their natural virtue, and the harmony between a sane world and sane people is restored (fig. 4). If we were to do the unthinkable and replace Goya's brutal and brutalizing mother by an "enlightened" mother who calmly teaches her son to be more careful, the disconsolate scene with its hidden menace that surrounds the group would still be unsettling.

If a simple incident of a broken pitcher summons up the entire range of social and economic injustices of Goya's age and of all ages, including ours, what can we say of the vehemence of the far more shattering experiences of animal sloth, prejudice, and murderous wrath that are brought before us by the artist? Even in Goya's themes that follow venerable Aesopian traditions

and satirize the subject by means of emblematic animals, we find a similar pattern. Ostensibly, the theme of *Asta su abuelo* (and so was his grandfather), *Caprichos*, plate 39 (cat. 46) is derived from orthodox ideas of the Enlightenment, in this case that of the foolish and sterile mania of pride and genealogy. But the ultimate impression we carry away with us after seeing the print is one that sounds far greater depths than would seem indicated. The ominously dark atmosphere and grinning animals stir familiar terrors in us. We are not just looking at stupidity pilloried but experiencing an inner resonance that forces us to recognize very similar urges and prejudices in ourselves. What would seem to be a peculiarly Spanish eighteenth-century deformation of character turns out to be a universal human condition.

The sense of disorientation imparted to us by Goya's suppression of perspectival coordinates transforms even relatively harmless themes into a world of nightmare and suspense. This mood is intensified to the utmost in scenes that touch on the most vulnerable points of existence: sexual ensnarement (cat. 42, 44), the urge to impress others by pretending to unusual powers (cat. 48, 49), and vanity (cat. 55, 56). The human aberrations represented here are those which are in need of rectification but which we have not always been able to resolve. We look at our most hidden shame either as complacent witnesses to cruel stupidities or as outright participants. Goya's scenes of prostitutes represent the irrepressible and obscure urges inherent in all men and women, urges that cannot be exorcised by reasonable sermons on stoic virtue or equitable economics.

Much the same can be said of the scenes of sorcery. In the present catalogue it has been shown that most of Goya's basic imagery is derived from Quevedo and other seventeenth- and eighteenth-century thinkers and has specific meaning that can be expressed in so many words. What cannot be translated as satisfactorily is the obsessive nature of the images. As an enlightened thinker, Goya scorned witchcraft and superstition. As a man who looked deeply into the most obscure corners of his existence, he knew that superstition and the ritual of black masses were only overt manifestations of a fundamental fear that inhabits all of us and defies translation into rational discourse. Although there can be no doubt of Goya's deep respect and affection for the leading exponents of liberal thought in Spain, he was an uncomfortable companion, as prone to pointing out the limits of reason as to persecuting the monsters bred of reason's sleep.

Goya belonged to a generation that was fully trained in the relatively optimistic climate of the Enlightenment but grew to maturity under circumstances that modified (and, in some instances, destroyed) the confident courage of the Enlightenment's earlier phases. Another member of that generation was Sébastien Chamfort (1741-1794), whose life and thought oddly paralleled Goya's own. A close observer of the scurrilous nature of social conventions, he also knew himself to be caught in its snares. Like Goya, he knew of the inevitable contradictions of even the finest minds. Many of his aphorisms could serve as a guide to the *Caprichos:* "Each man has certain faults: first, those which are common to all men; second, those which are peculiarly his own; third, those of his class in the social order."[1] Or the following, which practically describes the *Caprichos:* "The honest man disa-

bused of his illusions is man at his best. He is a man who can see with enlightened vision in a dark room the ridiculous gestures of those who are walking about at random."[2] The differences between precision of purpose and ambiguity of expression that can be observed in the *Caprichos* are also foreshadowed by Chamfort: "Speron Speroni gives a very lucid explanation of how an author can state clearly, as he imagines, what a reader, in fact, finds extremely obscure. 'The author,' he says, 'proceeds from thought to expression whereas the reader goes from expression to thought.' "[3]

Chamfort's end was as grotesque as it was tragic. It was the very stuff of which *El sueño de la razon* was made. Arrested and subsequently released by the revolutionary tribunal, he still could not curb his tongue but spoke out boldly against injustice. When he was about to be arrested once again, he was prepared to die rather than submit to the humiliations of imprisonment. Under a pretext he asked his captors for permission to go into an adjoining room, where he shot himself. Unfortunately, the wounds inflicted were not lethal and he was well on his way to recovery when friends insisted on consulting a reputable physician, who practiced his arts on him. It was as a result of those medical attentions that Chamfort finally died in 1794. What better proof that the *Caprichos* (see, for example, plate 40 [cat. 48]) are not artificial constructs but very sober reflections on existing realities?

The events of the Reign of Terror and the consequent political and social upheavals in France may have bewildered Goya's progressive friends, but they did not necessarily shatter the hopes they nourished for a liberal constitution and for social reform. After Napoleon invaded Spain in 1808, the habit of looking to France for leadership and inspiration had to be abandoned. Politically as well as morally, the most advanced segment of Spain's leaders realized that they had to look to Spain, not to France or England, for the fulfillment of their dreams. Their highest realization was the Constitution of Cádiz, which returned to the ancient Spanish principles of civil liberties and sober, pragmatic logic.[4] This constitution is certainly related to the precepts of the Enlightenment, but at the same time it signals its insufficiency under radically changed circumstances. The so-called *Disasters of War* as well as the other works created under the direct impact of the Peninsular Wars, though they document with never surpassed authority the outrages perpetuated by man on man, go far beyond the scope of a short essay dealing with Goya's attitudes toward Enlightenment morals. In many ways, the *Disasters of War* are an exposition of human depravity on such a scale and of such intensity that all moral speculation becomes irrelevant. In a world in which such scenes as *Por qué?* (Why?) and *Esto es peor* (This is worse), plates 32 and 37 (figs. 6, 7) can occur, all reason, all logic, all hope of human dignity seem either ludicrous or blasphemous.

Fig. 6. *Por qué*,
Disasters of War, pl. 32.
Working proof, etching, burin, and lavis.
Museum of Fine Arts, Boston, 1931 Purchase Fund

Fig. 7. *Esto es peor*,
Disasters of War, pl. 37.
Working proof, etching, lavis (?), and charcoal.
Museum of Fine Arts, Boston, 1951 Purchase Fund

1. Sébastien Roch Nicolas Chamfort, *Products of a Perfected Civilization: Selected Writings of Chamfort*, trans. W. S. Merwin (New York, 1969), p. 162.

2. Ibid., p. 167.

3. Ibid., p. 186.

4. Francis D. Klingender, *Goya in the Democratic Tradition* (London, 1948), pp. 7-65.

CARNIVAL TRADITIONS IN GOYA'S ICONIC LANGUAGE

Teresa Lorenzo de Márquez

Fig. 1. Ass Reading a Parchment, fifteenth century.
Choir stall misericord.
Relief in wood.
Cathedral of Seville

Fig. 2. *Ruega por ella* (Pray for her), 1797-1798,
Caprichos, plate 31.
Etching and aquatint.
Museum of Fine Arts, Boston, Bequest of William P.
Babcock

The beginning of the Renaissance, a time characterized by great political, social, and religious upheavals that gave rise to the Reformation, is often compared to the final years of the eighteenth century, which were also marked by a crisis of moral values. Parallels between the artistic expressions of both periods are less often found. And yet the survival of certain elements of the art of the late Middle Ages and the beginning of the Renaissance, which are of enormous importance in Spanish Golden Age literature, survive in the eighteenth century, with traces easy to detect in Goya's work. The purpose of this essay is to analyze the artistic, literary, and popular antecedents and traditions that made possible the continuity of certain aspects of this late medieval art through the Enlightenment and Goya's prints and drawings.

Scholars who have studied Spanish Gothic choir stalls (executed from the fourteenth through the sixteenth centuries) have noted the thematic similarities between many of the scenes represented in the misericords and *brazales* (arm rests) on the one hand (fig. 1) and the *Caprichos* on the other.[1] Reflecting on this microcosm of incongruous scenes and strange figures, José María Pemán commented that "in order to find something comparable one must look ahead to Goya's *Caprichos*," rightly describing them as "an exaggerated and distorted vision of our own world, a jovial and burlesque interpretation. It is the *wondrous* in Goya: drunk with reality, rather than dreamer of unreality."[2]

Profane subjects do indeed abound in Spanish choir stalls, reflecting a severe criticism of medieval social and religious life, in the same fashion that similar subjects in Goya's prints and Album drawings implacably chastise the society of his time. In Gothic choir stalls throngs of lascivious friars, or friends of Bacchus; ecclesiastics with half-animal features; avaricious clerics; prostitutes; or symbolic, monstrous, fantastic, or demonical animals *cabalgan* (ride) or file past.[3] Among the vices exposed are Lust, Avarice, and Envy. The symbolism contained in these scenes is extremely rich and is paralleled in Goya's works on paper. Both present similar problems of interpretation and one must turn to certain sources (classical and medieval iconography, biblical and literary texts, sixteenth and seventeenth century emblemata, proverbs, and colloquial language) for keys to decipher them. Mateo Gómez's well-documented and detailed study of these profane subjects helps explain many details, incomprehensible or enigmatic to us, of some *Caprichos* and drawings. An exhaustive investigation is beyond the scope of this essay; therefore, a few representative examples have been selected from the corpus of Lust and of animal symbolism upon which to discuss these traditions in Goya's works.

Capricho 32, *Ruega por ella* (Pray for her) (fig. 2) shows an accumulation of symbols related to female seduction. If the bawd, the small vase, washbasin, and even the unshod foot are more or less easy allusions to trace in literature, the posture of the open legs, the personal pulchritude of the prostitute, the hair let down, and the comb are less known symbols of Lust.[4] However, all of them appear in the choir stall reliefs with the same sexual significance. On a *brazal* in the Cathedral of Barcelona, the figure of a woman seated on a great chair with her left hand on her genitalia and legs wide apart has been interpreted as a personification of Evil and Lust.[5] Figures of women washing

their legs in the cathedral choir stalls in Plasencia and Zamora are inter-
preted as allegories of voluptuousness, based on the idea, which has biblical
roots, that excessive personal cleanliness can be a lascivious provocation.
The let-down hair being washed or combed is imbued with the same mean-
ing; consequently, the comb is associated with harpies, sirens, and Venus-
Luxuria, as an attribute of female seduction (fig. 3).[6]

A subgroup within this topic of Lust is based on the double meaning of
hilar (to spin) as *futuere* (to copulate), frequent in Golden Age erotic poetry
and familiar to Carnival language.[7] Goya made use of it in *Caprichos* 44 and
73, *Hilan delgado* (They spin finely) (G-W 539), and *Mejor es holgar* (Idleness
is preferable) (fig. 4), and in the *Album B* drawing *Sn Fernando ¡como hilan!*
(San Fernando How they spin!) (cat. 35). These scenes of women spinning,
laden with erotic symbols and gestures, correspond to similar ones in choir
stalls, which have the particular feature that not only humans, but animals –
mainly monkeys and swine, traditional symbols of Lust – also hold the spin-
dle and distaff.[8] A misericord in the Cathedral of Toledo shows a group
made up of a woman with a spindle and a monkey grasping a hand-held
winding frame; as proof of the kind of spinning to which it refers, the woman
grips the monkey's leg and looks at its behind.[9] In a sense this scene recalls
Capricho 73 (fig. 4), in which spindle, thread, and ball of yarn contribute to
bring out the kind of relationship that binds the three figures together, and
the young woman's expression unambiguously conveys the sensual emotion
that overcomes her.[10]

Scatological subjects, also found in Goya's work, are frequent in the art of
the late Middle Ages.[11] These subjects, so offensive to modern sensibility,
have their source in medieval folk culture, where the human body played a
dominant role. The cornerstone of this medieval sensibility was the degrada-
tion or, rather, the transfer to the material sphere of all that is spiritual,
ideal, and abstract. At the same time this carried with it an acceptance of
the life of the belly, which also included the reproductive function. Acts of
defecation, copulation, and birth belonged to the same zone of the body and
were therefore closely linked.[12] The idea is not alien to Christian asceticism
as shown by the expression attributed to Augustine or Odo of Cluny: "Inter
faeces et urinam nascimur" (Between feces and urine we are born).[13] The
choir stall reliefs of men defecating must be understood in this context; they
were symbols as much of the fallen nature of man as of his lasciviousness.
Peter Bruegel included a similar scene when he represented Lust in his
drawings for a series of prints on the Seven Deadly Sins (fig. 5). Perhaps the
Album F drawing with the same scatological subject, published by Lafuente
Ferrari, could be interpreted as alluding to the sinful nature of man.[14] A
similar drawing *Comer mucho* (To Eat a Lot) (fig. 6) suggests this symbolism
more clearly. The inclusion in the inscription of the verb *comer* (to eat) –
with its double meaning – seems to support this view.[15] The obvious idea of
Gluttony insinuates the metaphorical one of Lust, and both show the materi-
alistic nature of the friar.

The fauna represented in the choir stalls is also derived from a rich icono-
graphic tradition. In the late Middle Ages animals or animal features were

Fig. 3. *Venus-Luxuria*, about 1450.
Miniature of the manuscript *Acerba*
by Cecco d'Ascoli.
Ink.
Bodleian Library, Oxford

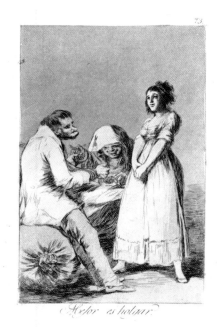

Fig. 4. *Mejor es holgar* (Idleness is preferable),
1797-1798,
Caprichos, plate 73.
Etching and aquatint.
Museum of Fine Arts, Boston, Gift of Lydia Evans
Tunnard in honor of Henry P. Rossiter

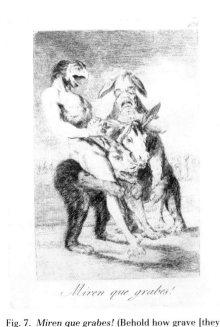

Fig. 6. *Comer mucho* (To Eat a Lot), 1824-1828,
Album G, page 55.
Black chalk.
Museo del Prado, Madrid

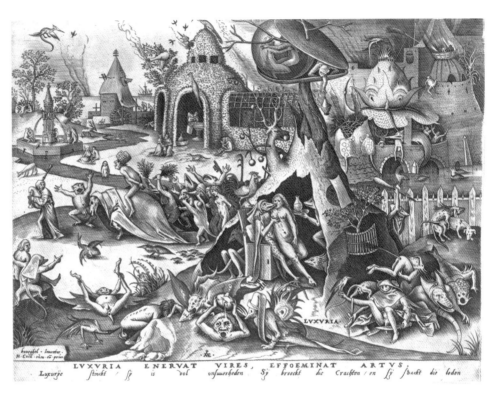

Fig. 5. Peter van der Heyen, after Peter Bruegel,
Lust (detail), from the series *Vices and Virtues,* about
1558.
Engraving.
Museum of Fine Arts, Boston,
Katherine Eliot Bullard Fund

Fig. 7. *Miren que grabes!* (Behold how grave [they
seem]!), 1797-1798,
Caprichos, plate 63.
Etching and aquatint.
The Metropolitan Museum of Art, New York, Gift of
M. Knoedler

used in literature and art as symbols of vices shared by lay people and
clerics. Roman capitals and Gothic gargoyles have animals or monstrous
heads, which have been interpreted as a criticism of religious life.[16] This
tradition continued unabated in the waning years of the Middle Ages, and its
echo was preserved for centuries in Carnival celebrations. This iconography
sheds light as well on the notable presence of animals in Goya's work. The
animal head of the main figure of *Capricho* 46, *Correccion* (Correction) (G-W
453), is close to artistic representations derived from the *Roman de Renart,*
which were very popular during the Middle Ages and common in Spanish
and other European choir stalls, reliefs, and capitals.[17] The half-fantastic
animals and humans in *Capricho* 63, *Miren que grabes!* (Behold how grave
[they seem]!) (fig. 7), are conceived in the same coded language. The riders'
faces recall Gothic gargoyles representative of human vices, and the mounts
give additional indications of their moral character. While the ass's head of
one and the wolf and swine features of the other are well-known symbols,
their bodies can be interpreted as allusive to Lust, which medieval iconogra-
phy conferred on bears because of their fondness for honey and the arbutus
fruit.[18] In the same way other examples of a social, religious, and even
political nature could be cited.

Spanish choir stalls, executed or inspired by artists from Germany and the Low Countries,[19] demonstrate some of the peculiar characteristics of Northern European art of the late Middle Ages and the early sixteenth century. In some respects this art was fundamentally religious and edifying and reflected the moral problems of the time, using as its language the forms, gestures, and symbols of the culture of folk humor, that inspired Carnival and other medieval rejoicings. Northern European painting displays a characteristic appreciation of the grotesque (for example, the satirical scenes of Hieronymus Bosch) alongside the new religious sensibility of Christian humanism. After the publication of the *Stultitiae Laus* (Praise of Folly) (1511), Erasmus's thematic influence on Netherlandish painting became evident.[20] With moral satire as their primary aim, painters and printmakers depicted scenes of daily life in which human defects were often ridiculed.

The points of contact between this form of art usually ascribed to the Low Countries and Goya are numerous and worthy of a much more detailed study. The allegorical world that Bosch represented in *The Earthly Paradise* (about 1503-1504) uses erotic symbols that are recast in Goya's work.[21] The theme of the tied and bound couple, common in choir stalls as a symbol of Lust, also appears in this painting. A young couple joined by the cherry tree branch (fig. 8) brings to mind *Capricho* 75, *¿No hay quien nos desate?* (Is there no one to untie us?) (fig. 9), down to the detail of the owl perched atop them. The satirical subjects of dirty old men and women, religious hypocrisy, and usurers in Netherlandish painting reveal a clear parallel with some of the subjects appearing in the *Caprichos* and in the *Album* drawings. One of the many versions of the unequal couple, attributed to the Amsterdam painter and printmaker Jacob Cornelis von Oostsanem, *The Peddlar of Spectacles* (1520-1525) (fig. 10), allows us to understand the meaning of those enigmatic *quevedos* (spectacles) that preside from the end of a stick over the strange scene played out in *Capricho* 57, *La filiacion* (Genealogy) (fig. 11). The painting – which combines the subjects of the old man and the old woman who respectively buy a young woman's and young man's love – shows a girl in the foreground selling spectacles to a man, which alludes to the old Dutch expression *brillen verkopen* (literally, to sell spectacles, meaning to deceive).[22] Once the semiotics of the spectacles of this *Capricho* are revealed, the other expressive elements used by Goya can be seen to reinforce the same idea. For instance, the young woman with a fox's mask also deceives the old man who appears so satisfied, his head leaning on her skirt; her hands placed above the man's temples, in fact, conceal horns, clearly visible in the preparatory drawing (fig. 12). The symbol must have been so well known in the sixteenth century that the image of spectacles is the only one appearing in an emblem by Juan de Borja, entitled *Sic animi affectus* (This is what the passions of the soul do), referring to the deceitful hopes that human passions give rise to, and in another – with lenses that multiply objects – by Sebastián de Covarrubias, *Sombras son de la verdad* (They are shadows of the truth), on lying.[23]

The numerous themes of social criticism common to both German and Netherlandish art and Goya's work raise the question of the way they and,

Fig. 8. Hieronymus Bosch,
Detail from *The Earthly Paradise*, about 1503-1504.
Oil.
Museo del Prado, Madrid

Fig. 9. *¿No hay quien nos desate?* (Is there no one to untie us?), 1797-1798,
Caprichos, plate 75.
Etching and aquatint.
Museum of Fine Arts, Boston, Gift of Lydia Evans Tunnard in honor of Henry P. Rossiter

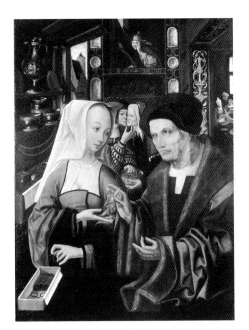

Fig. 10. Jacob Cornelis von Oostsanem,
The Peddlar of Spectacles, 1520-1525.
Oil.
Groningen Museum

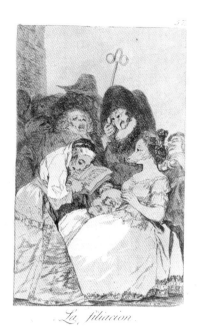

La filiación

Fig. 11. *La filiación* (Genealogy), 1797-1798,
Caprichos, plate 57.
Etching and aquatint.
Museum of Fine Arts, Boston, Gift of Lydia Evans
Tunnard in honor of Henry P. Rossiter

above all, the iconic language they shared remained alive in the Spanish eighteenth century. Although we cannot be sure whether Goya knew the reliefs of the Gothic choir stalls (limited access and the scant natural light in the choirs have always been obstacles to their viewing and study), other reliefs, capitals, and gargoyles with similar subjects were easy to see in many churches. Northern Renaissance paintings of moral criticism were another easily available source, as they were well-represented in the royal collections. The Spanish nobility and, above all, Felipe II were ardent admirers of them from the sixteenth century onward.[24] Finally, it is not farfetched to think that Goya must have carefully studied satirical prints of the sixteenth, seventeenth, and eighteenth centuries that came into his hands, probably more numerous than their limited representation in Spanish museums and libraries would make us suppose.[25] But neither the Gothic sculpture nor the presence of Netherlandish painting in Spain can by itself explain Goya's deep and varied knowledge of this iconography. Much more important and decisive is the direct influence of northern humanism – with its revaluation of Carnival language and humor – on the Spanish intellectual world and on Golden Age literature.

Medieval Carnival festivities – similar throughout Western Europe – were frameworks of popular life centered on the Church and its liturgy. Without ever becoming disconnected from the Church, these celebrations consecrated an alternative and often opposed vision to that dictated by official life. The rigid order of medieval society, with its hierarchies, norms, and prohibitions, was suspended during Carnival, and in its place a new world was created, free and without barriers, centered on people and human relations. Over the centuries, Carnival created new forms of speech or transformed the original semantic value of words, even as it developed the dialectic of The World Turned Upside Down, with its continuous shifting from top to bottom, front to rear, inside to out.[26] In sum, when the conditions of life in the late Middle Ages so dictated, this unofficial language was dedicated entirely to the parodic criticism of the established *ordo*. The culture of folk humor began to appear in recreational literature (*joca monacorum*, jestbooks, *sotties, sermons joyeux, farsas,* or *fastnachspiele*) and in pure poetry (*Libro de Buen Amor*), but did not exert its full influence in literature and thought until the Renaissance. The Strasbourg humanist Sebastian Brandt's *Narrenschiff* (Ship of Fools), first published in Basel in 1494, and above all Erasmus's *Stultitiae Laus*, are the fullest expressions of medieval humor and Carnival spirit. Their influence extended to all of Western Europe, and they left their mark as much on Rabelais's fiction as on Shakespeare's theater. In Spain this new language was used in different degrees and forms in the literature of the fool, and in Antonio de Guevara, Golden Age erotic poetry, the picaresque novel, Cervantes, Lope de Vega, and Quevedo.[27] Its echo was heard in the eighteenth century, when this scatological and obscene idiom, of verbal symbols and associations, continued to be used in the erotic poetry cultivated by Meléndez Valdés, Iriarte, Samaniego, and Moratín, among others.

Alongside this literary tradition the purely folkloric one of Carnival celebrations persisted, still very much alive in the eighteenth century and especially in Aragón, Navarra, and the Basque Country, where Goya could well

have become familiar with the symbols, forms, and gestures of the culture of folk humor.[28] Carnival rites and games, which he probably enjoyed from his childhood, must have taken on a transcendent meaning in the light of the culture he acquired as an adult. This Carnival language survived in the advanced circles of his time, and above all in contemporary erotic poetry, based on similar literary devices, subjects, and metaphors.

Goya's Carnival imagery appears in paintings, prints, and drawings in a manifest way, such as in the various scenes of masquerades, in rites such as those depicted in the *Burial of the Sardine* (cat. 136, fig. 1), and the tossing of *peleles* (effigies made of straw and rags) (G-W 296 and 1571).[29] At other times, however, the association is not so evident to the modern viewer, as in *Album B*, page 60, *Parten la vieja* (They halve the old woman) (G-W 420); *Album G*, page 14, *Mitad de Cuaresma* (Midway through Lent) (G-W 1722); and *Album G*, page 43, *Loco picaro* (Crazy Rogue) (G-W 1748); or as in *Capricho* 4, *El de la rollona* (The Childish Man) (cat. 41), where the man-child that Goya satirized was also one of the masqueraders common in these festivities.[30] In nineteenth-century Carnival prints with *aleluyas* (versified commentary) from Barcelona can be seen the image of a nurse and her charge, who is dressed much as the man-child in the *Capricho*, and held as well by a kind of leash (see fig. 13). The following *aleluya* comments on the print: "Alegre doña Neomisa / a un niño de cuarenta años / va sirviendo de nodriza" (Merry Mrs. Neomisa / Who is nurse / To a forty-year-old baby).[31] The *Capricho* and the print are expressions of the same traditional theme, used frequently in short farces and masquerades, and a common disguise during Shrovetide.[32]

However, the allusions are not exhausted by the visual association, but penetrate much more deeply in Goya's work. Prints and drawings are often enigmas that can be deciphered through the symbols and peculiar logic of Carnival language.[33] Thus, the presence of the swing stresses the sinful nature of the old man in *Old Man on a Swing among Demons* (cat. 179), the flogging of a man reveals the lust of the old women in *Sueño de azotes* (Dream of Floggings) (cat. 135), and the punctured tambourine appears as an emblem of Lust in *Suben alegres* (They rise merrily) (cat. 133), to cite only a few examples. These allegories and many others belong to a large corpus of erotic metaphors, shared by popular festivities and literature through the centuries, that keep appearing in Goya's prints and drawings. Other affinities are the scatological themes; the presence of urinals, chamber pots, and syringes; the allusions to horns; and every manner of creative recourse to colloquial language.[34] The translation of proverbs to visual forms was as important for Goya as it was for Northern Renaissance painters, and, within Spanish literature, for Juan de Valdés, the anonymous author of *Lazarillo de Tormes*, and Cervantes.

The imagery of The World Turned Upside Down was often used by Goya in the same Carnival context of social, political, and moral criticism: the asses riding on the mens' backs in *Capricho* 42, *Tú que no puedes* (You who cannot) (cat. 49); the wolf in *Disaster* 74, *Esto es lo peor!* (This is worst of all!) (cat. 160, fig. 2), the drawing in *Album H*, page 5 (G-W 1768) of the wolf wearing a cloak and a man dressed in an animal skin; or the hunted hunter in

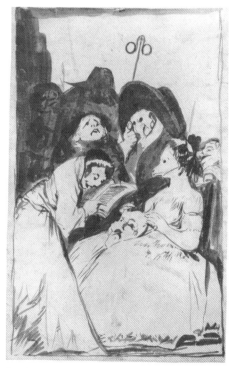

Fig. 12. Preparatory drawing for *La filiación*. Red chalk. Museo del Prado, Madrid

7. Alegre doña Neomisa, á un niño de cuarenta años vá sirviendo de nodriza.

Fig. 13. Anonymous, nineteenth century, *Carnaval de Barcelona* with *aleluyas* (detail). Woodcut, broadside.

Fig. 14. I. Honervogt,
Detail from *El mondo [sic]al revés*, reverse copy of
the Italian print *Il mondo alla reversa*, about 1572.
Woodcut

Si yerras los tiros! (If You Miss the Mark!) (cat. 128). All are inversions of a
social and political nature with a long literary and artistic tradition (see fig.
14).[35] Breeches placed over the heads and torsos of men or petticoats on
women's heads, which Goya depicted in *Caprichos* 26, *Ya tienen asiento* (Now
they have a seat) (G-W 509), and 54, *El vergonzoso* (The Shy One) (G-W 559);
and the drawings *La Moda al revés* (Dressing Upside Down) (G-W 629) and
Locos (Madmen) (*Album G*, page 39; cat. 177, fig. 1) appeared at Carnivals, as
well as in literature, and in such colloquial expressions as *al revés de la gente*
(the opposite of [normal] people), and *tener los pies en la cabeza y la cabeza
en los pies* (to have your feet where your head is and your head where your
feet are).[36] These were used to indicate sexual disturbance and perversion. It
is worth noting that Goya also used religious iconography *al revés* (reversed)
or *vuelta a lo humano* (turned human) in *Devota profesion* (Devout Profes-
sion), *Madre con niño deforme* (Mother with Deformed Child), and perhaps
Profeta maléfico (Malefic Prophet) (cat. 61, 127, and 176), in which the com-
parison with divine subjects helps to underscore man's sinful nature. Taken
sometimes to the limits of coarseness and blasphemy, commonplace in medie-
val literature and in Carnival celebrations, the religious parody was almost
accepted over the centuries or at least not resisted with too much rigor by

the Church.[37] In general, the world Goya captured in his prints and drawings was an enormous World Turned Upside Down of folly and misconduct, a *mundus perversus* rooted in the long medieval Christian tradition.

The fool as the hero and embodiment of the Carnival world and spirit drew Goya's attention very early. A significant proportion of Goya's prints after Velázquez of 1778 represent the court fools and dwarfs of Felipe IV (G-W 99-110, 112, 113). These works are a definite meeting of his art with a complex subject that would interest him throughout his life. Henceforth, Goya portrayed a whole gallery of pathological or feigned madmen, including Carnival fools, simpletons, rogues, quacks, and buffoons; that is, the whole range of real insanity and conceptual folly.

Echoes of the medieval iconography of the fool figure in the *Album B*, page 55, drawing entitled *Mascaras crueles* (Cruel Masks) (G-W 415). In this Carnival scene the clothing of one of the male masqueraders incorporates two traditional symbols: a hood with ass ears and what are perhaps bells on the large coat. Other attributes of conceptual folly – *quevedos* (spectacles), mirrors, and owls – are also represented in Goya's works.[38] The long tradition of the mirror as external conscience of the human being appears in the series Gassier calls the "magic screen" (G-W 648-654; see G., II, p. 489), in which the characters portrayed are not necessarily interested in knowing themselves and often turn their eyes away in order not to see the reality reflected in the mirror (fig. 15). In contrast, Holbein's Christian fool, in his illustration for Erasmus's *Stultitiae Laus*, gazes thoughtfully at the mocking image, covered by the classic hood, that the glass returns him (fig. 16). Classical symbol of wisdom, the owl was popularly identified with folly or ignorance, especially when associated with the fool. The mythic fool Till Eulenspiegel (his name a pun on mirror of the owl, mirror of wisdom, and mirror of the fool) is very often accompanied by this bird.[39] In a sense Goya's owls are also remote descendants of the same concept because they are allegories of certain follies that afflict mortals. Finally, the smiling or mocking individuals in several *Caprichos*,[40] who observe the main action from the background, are incriminating witnesses of immorality in the same manner as fools in choir stall reliefs and Netherlandish genre paintings.[41]

After the fifteenth century, the factitious fool, who feigned insanity professionally in order to entertain, came into his own in the Spanish and other European courts. This court fool, like the madman, was absolved of responsibility a priori and could break all social, political, and even religious rules with impunity, thus soon becoming the absolute and most incorruptible embodiment of reason and truth. His was the only voice that, sheltered by its presumed insanity, could be raised to make a radical criticism from the very heart of the societies of the old order. If they were to survive at such a dangerous game, ambiguity in discourse and the ability to make others laugh were indispensable because they made it possible for the provocations to be forgiven. Their humor made ample use of Carnival language, with its conceptual inversions and forbidden subjects, already discussed. Moreover, Spain was the only European country where the flesh-and-blood court fool created his own literature during the fifteenth and sixteenth centuries, with such figures as Antón de Montoro, Francesillo de Zúñiga, and the doctor Francisco

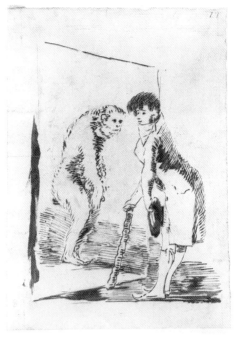

Fig. 15. *Petimetre / Mono* (Fop / Monkey), 1797-1798.
Brown wash.
Museo del Prado, Madrid

Fig. 16. Hans Holbein,
Fool Gazing into a Mirror, Basel, 1515.
Illustration for Erasmus, *Stultitiae Laus*.
Facsimile ed., Basel, 1931.
Museum of Fine Arts, Boston, William A. Sargent Collection

López de Villalobos, who were buffoons, poets, and writers at once. One of the genres of the literature of the fool, the *disparate* (folly), perfected by Juan del Encina as the quintessence of buffoonish folly, flowered again brilliantly in Goya's *Disparates* (Follies).[42] The word *capricho*, which in the eighteenth century was used in the theatrical lexicon of *tonadillas* (ditties) and plays, sometimes meant some form of entertainment from which a moral lesson could be extracted,[43] and also served in the sixteenth century, at least in Italy, to refer to the buffoons' witty sallies and to the very representations of Carnival.[44]

The language of folly, buffoonery, and Carnival remained in the eighteenth century the only possible voice to express a moral judgment freely and without concessions.[45] Enlightened Spaniards found in this language a weapon honed by several centuries of use. Goya only culminated a great tradition (both popular and literary, Spanish and European) that, paradoxically, offered him the means to recreate in his art a revealing vision of the society of his time. Like Erasmus's *Moria* (Folly), Goya invited us to contemplate "the countless hordes of mortals," which like "a swarm of flies or gnats" can be seen "quarreling amongst themselves, fighting, plotting, stealing, playing, making love, being born, growing old and dying."[46]

1. Isabel Mateo Gómez noted the similarity between the misericord in the Cathedral of Seville and the *Capricho Asta su abuelo* (Back to His Forebear) (cat. 46), in *Sillerías*, p. 44. However, *Sueño 27* (cat. 47) is a better example of an ass reading, since, in the *Capricho*, he is looking at pictures.

2. Pelayo Quintero Atauri, *Sillerías de coro en las iglesias españolas*, prologue by José María Pemán (Cádiz, 1928), pp. 12-13.

3. On the sexual meaning of the word *cabalgar*, shared by the choir stalls and Goya, and also frequently used in Spanish literature in all periods, see *Autoridades*, 1726-1739, and cat. 177. See also Mateo Gómez, *Sillerías*, pp. 368-369, figs. 212, 243, 342, 348.

4. Showing the foot was considered an obscene gesture. A deeply rooted folk belief was the relationship between the size of the foot and that of the sexual parts. It is that "regla muy general / del patituerto calzado" (very general rule / of the shod crooked-leg). A commentary on this popular verse includes a reference taken from the *Viajes del padre Labat en España, 1705-1706*, in which clerics, along with women, are warned they should not allow their feet to show when they walk, because Spaniards draw certain conclusions from their size. See Alzieu, *Poesía erótica*, pp. 186 n. 5; p. 189, poem 97.

5. Mateo Gómez, *Sillerías*, p. 364.

6. Mateo Gómez, *Sillerías*, pp. 381-385. Skirts raised to show legs and the naked foot, along with the comb are also frequently found in miniatures of the period as symbols of Venus-Luxuria. See John B. Friedman, "L'iconographie de Vénus et de son miroir à la fin du Moyen âge," in *L'érotisme au Moyen Age*, ed. Bruno Roy (Montreal, 1977), pls. 8, 12-14, pp. 67-68, 80-82.

7. Alzieu, *Poesía erótica*, poems 45, 77, pp. 67, 133-136. In Asturian Carnival processions the *filaora* (spinner) appeared, who, after spinning, pretended to give birth. See Caro Baroja, *Carnaval*, p. 207.

8. Mateo Gómez, *Sillerías*, pp. 63, 92, 369.

9. Mateo Gómez, *Sillerías*, p. 91.

10. *Hilo* (thread) and *huso* (spindle) are metaphors for the phallus, although the *huso* can sometimes mean the female sex. See Alzieu, *Poesía erótica*, poems 45, 76, 77, pp. 67, 131, 134. *Ovillo* (ball of yarn, literally little egg) can mean testicles. See Cela, *Diccionario secreto* I, pp. 180-181. The old bawd holds the *huso* (spindle) in her hands, and the thread links the man to the young woman who is grasping the *ovillo* at the level of her genitalia. Because the verb *holgar* (to be idle) was one of the most employed to denote the sexual act and sexual pleasure, the meaning of this *Capricho* could not be clearer.

11. Three misericords, one in the cathedral of León and two in the cathedral of Ciudad Rodrigo, show a man defecating. A variation on the theme, which can be seen in the Cathedral of Seville, shows two men whose behinds face one another's. In the choir stalls of the cathedral of Zamora the men have simian features (symbolizing Lust) and in a relief in the cathedral of Cologne, a fool (a character who always has sexual connotations in choir stall carvings) and a man are in the same position. The latter have been interpreted as alluding to homosexuality. See Mateo Gómez, *Sillerías*, pp. 136-138, 172, fig. 181.

12. Mikhail Bakhtin, *Rabelais and His World* (Cambridge, Mass. and London, 1968), pp. 18-21, 148-149, 151-152.

13. Bruno Roy, "L'humour érotique au XV siècle," in *L'érotisme au Moyen Age*, p. 160.

14. Enrique Lafuente Ferrari, "Un dibujo inédito de Goya de la serie sepia (Cuaderno F)," in *Goya*, nos. 140-150 (1979), pp. 206-209.

15. To eat as a synonym for *futuere* (to copulate) is well known since antiquity. See J.N. Adams, *The Latin Sexual Vocabulary* (Baltimore, 1982), pp. 138-141. See also Alzieu, *Poesía erótica*, poems 130, verse 14, and 136, pp. 255, 276.

16. Nilda Guglielmi, "El status del loco y de la locura en el siglo XII. A propósito de dos escenas románicas (Parma-Aulnay)," *Anales de historia antigua y medieval* 17 (1972), pp. 210-248, and figs.

17. Mateo Gómez, *Sillerías*, pp. 203-206, fig. 204.

18. The arbutus berry, like all berries, is fruit symbolic of the pleasures of life, and appears with this meaning in Hieronymus Bosch's *The Earthly Paradise*, in the Museo del Prado, Madrid (see fig. 8). See Charles de Tolnay, *Hieronimus Bosch* (New York, 1966), pl. 218, p. 31. In a choir stall of the cathedral of Seville, a bear and a fool dance, embracing each other, a relief that both Mateo Gómez and Diego Angulo interpret as an allegory of Lust and probably even of homosexuality. In twentieth-century usage *el abrazo del oso* (the bear hug) is used as a euphemism for male sodomy. See Mateo Gómez, *Sillerías*, pp. 95-98, 375. In Basque Carnival traditions the bear hunt was represented as an analogy to the death and ritual burning of the figure of Carnival. See Caro Baroja, *Carnaval*, pp. 177, 254-255, n. 1.

19. Mateo Gómez, *Sillerías*, pp. 26-30.

20. See George Marlier, *Erasme et la peinture flamande de son temps* (Damme, 1954).

21. See *Suben alegres* (They rise merrily) (cat. 133).

22. J. Held, "Dr. Friedlander's Scholarly Study of Early Flemish and Dutch Painting," in *Art in America* (1939), p. 82. The same subject appears in a painting of the school of Fontainebleau, *Women Between Two Ages* (1570-1580), in which a young woman hands spectacles to an old man, who makes a gesture of paying for them, while she abandons herself to the young man's caresses. Jean Adhémar, "French Sixteenth Century Genre Paintings," *The Journal of the Warburg and Courtauld Institutes* 8 (1945), pl. 44a, pp. 235-236.

23. Henkel, *Emblemata*, cols. 1424-1425.

24. See J. Allende-Salazar, "D. Felipe de Guevara: Coleccionista y escritor de arte del siglo XVI," *Archivo Español de arte y arqueología* 1 (1925), p. 192.

25. German and Netherlandish prints were very popular in the sixteenth and seventeenth centuries throughout Western Europe. The English Hispanist Helen Grant suspects that Spanish copies of Italian prints of Netherlandish or German origin were done in Antwerp, although she has never found them in Spain. There are, however, prints of follies or proverbs with Spanish texts preserved in the British Museum and the Bibliothèque Nationale in Paris. Although there were no known formal prohibitions of these prints in Spain, Grant gives evidence that the Inquisition destroyed them, which would explain their absence in official libraries and museums. After 1789 themes taken from The World Turned Upside Down were used in French prints in the service of the Revolution. See H. Grant, "Images et gravures du monde à l'envers dans leurs relations avec la pensée et la littérature espagnoles," in *L'image du monde renversé et ses représentations littéraires et para-littéraires de la fin du XVI siècle au milieu du XVII*, ed. P. Lafond and Agustín Redondo (Paris, 1979), pp. 17-18, 21, 25-26, 31-32.

26. See Bakhtin, *Rabelais and His World*.

27. See Francisco Márquez Villanueva, "Literatura bufonesca o del 'loco,'" *Nueva revista de filología hispánica* 34, no. 2 (1985-1986), pp. 501-528. See also Agustín Redondo, "Tradición carnavalesca y

creación literaria: Del personaje de Sancho Panza al episodio de la ínsula Barataria en el 'Quijote,'" *Bulletin hispanique* 80, nos. 1-2 (1978), pp. 39-70.

28. See Caro Baroja, *Carnaval*.

29. Among others, see *Capricho* 6, *Nadie se conoce* (They are all strangers to each other) (G-W 461).

30. See José López Rey, "Goya's Vision of Mid-lent Merriment," *Art Quarterly* (1946), pp. 141-143. The pregnant man was also a typical Carnival character. See François Delpech, "La patraña del hombre preñado: algunas versiones hispánicas," *Nueva revista de filología hispánica* 34, no. 2 (1985-1986), pp. 548-598.

31. Carnival prints are published in Caro Baroja, *Carnaval*.

32. See Redondo, "Tradición carnavalesca y creación literaria," p. 57 n. 80. See also Roberto Alcalá Flecha, "El tema del niño malcriado en el *Capricho* 4 'El de la Rollona,' de Goya," *Goya* 198 (May-June, 1987), pp. 340-345 n. 32.

33. The enigma, especially the erotic one, was very common in the Golden Age. See Donald MacGrady, "Notas sobre el enigma erótico, con especial referencia a los 'Cuarenta enigmas en Lengua española,'" *Criticón* 27 (1984), pp. 71-108. The use of a language in serial code is also shared by the literature of the fool. See Francisco Márquez Villanueva, "La buenaventura de Preciosa," *Nueva revista de filología hispánica* 34, no. 2 (1985-1986), pp. 741-768.

34. The use of syringes was typical of Carnival. Young people of both sexes amused themselves throwing water at each other. See Caro Baroja, *Carnaval*, pp. 57-59.

35. A reverse copy of a popular Italian print of 1572 with a Spanish title and text, printed at the beginning of the seventeenth century (Bibliothèque de l'Arsenal, Paris), also offers an image of The World Turned Upside Down in which asses ride on the backs of men (fig. 14). See Grant, "Images et gravures du monde à l'envers," p. 21. In proverbs and fables the wolf's stratagems to carry off sheep were frequent images of deception and were used in medieval art to criticize religion. See Mateo Gomez, *Sillerías*, p. 145. The same subject appeared in political satire. See anonymous "Coplas hechas al rey don Enrique reprehendiéndole sus vicios y el mal gobierno destos reynos de Castilla," in *Coplas satíricas y dramáticas de la Edad Media*, ed. Eduardo Rincón, (Madrid, 1968), pp. 66-70.

36. Bakhtin, *Rabelais and His World*, pp. 81-82. In England Henry VIII, when he announced the break with the Church, put Luther's letter on his head and the pope's at his feet. Pedro de Rivadeneyra in *Historia eclesiástica del cisma del reyno de Inglaterra* recounts how the English gave rise to disorder, perverting all divine and human affairs and turning "la cabeza en pie y los pies en cabeza" (the head into a foot, the feet into a head). Popular prints and broadsides, especially German ones, show men who put their hats on their feet and their shoes on their heads. See Grant, "Images et gravures du monde à l'envers," p. 27.

37. Many popular celebrations of the Middle Ages, centered on the Church and the liturgy, were parodies of religious worship that, at first, were enjoyed in the sacred precincts themselves. Although toward the end of the Middle Ages there was an attempt to

prohibit them – at least those taking place within the Church – their echo was heard in Carnival celebrations for centuries. Recreational literature, composed for entertainment on feast days, also parodied all the subjects of the Church's teaching and liturgy. See Bakhtin, *Rabelais and His World*, pp. 83-86, 95, 229-230. In the sixteenth century the religious parody appeared in spontaneous peasant expressions that the Church punished only symbolically. See Agustín Redondo, "Le discours d'opposition des groupes ruraux face au pouvoir ecclésiastique, dans la Castille du XVI siècle: Analyse des quelques exemples," in *Les discours des groupes domines, Actes du colloque organisé à la Sorbonne par le GRIMESREP* (1986), pp. 37-47. This association between religious celebration and popular criticism can be observed in the disturbances brought about during the Esquilache uprising (1766), which have been compared to the Carnival in Rome in 1580 or with that of Bordeaux in 1651. For several days the people of Madrid expressed and sang their revolt with gestures and attitudes, turning as well to certain symbols of the religious feast day. See Jacques Soubeyroux, "Pauperismo y relaciones sociales en el Madrid del siglo XVIII," *Estudios de historia social*, nos. 12-13 (1980), p. 136.

38. See Robert Klein, "Un aspect de l'hermeneutique à l'âge classique: Le thème du fou et l'ironie humaniste," *Archivio di Filosofia* 3 (1963), p. 17.

39. William Willeford, *The Fool and His Scepter* (Evanston, 1969), pls. 14-15, p. 34.

40. *Caprichos* 2, 13, 26, 30, 38, 76, 79 (G-W 454, 476, 502, 510, 524, 605, 611).

41. In the painting *The Peddlar of Spectacles* (fig. 10), toward the background a fool smiles, half hiding his face with his hand. The old bawd also smiles in *Capricho* 73, *Mejor es holgar* (Idleness is preferable) (fig. 4). In the painting *Lascivious Old Man*, by Quentin Massys (National Gallery of Art, Washington, D.C.), the fool appears already as a witness, a tradition perpetuated by the subsequent Netherlandish masters. See Marlier, *Erasme et la peinture flamande*, pls. 33, 35-36, p. 234.

42. Márquez Villanueva, "Literatura bufonesca," p. 509.

43. Nigel Glendinning, "Goya y las tonadillas de su época," *Segismundo*, no. 2 (Madrid, 1966), pp. 106-108.

44. References to the word *capricho* with this meaning appeared in the correspondence of Fra Mariano Felti, buffoon of the court of Leo X, with the Duque de Mantua, and in Aretino's remarks on this buffoon. See Enid Welsford, *The Fool: His Social and Literary History* (London, 1935), p. 17.

45. At the end of the eighteenth century, the concept of the fool as speaker of the truth was so entrenched in popular culture that it even appeared in *tonadillas* (ditties). In a ditty by Esteve (1784) called *La razón de estado* (Reason of State), a fool, half-hidden behind his cape, in the Puerta del Sol [central Madrid square] accurately indicates what lurks behind the surface of the "very distinguished" passersby that throng that public place. See José Subirá, *Tonadillas satíricas y picarescas* (Madrid, 1927), pp. 43-44.

46. Erasmus of Rotterdam, *Praise of Folly*, trans. Betty Radice (1971; reprint, Harmondsworth, 1976), p. 143.

INTRODUCTION TO THE PRINTS AND DRAWINGS SERIES

Eleanor A. Sayre

The First Two Journal-Albums, A and B, 1796-1797
(cat. 35-37, 59)

The earliest description of Goya's first two albums of drawings was written in 1860 by Valentín Carderera, who knew Goya and had acquired a great part of his graphic work. The earlier of the two albums, according to Carderera, was an artist's: "carnet de poche, en papier hollandais bleuâtre, relié dans le sens de la hauteur" (pocket sketchbook, of bluish Netherlandish paper, bound perpendicularly), a type of little book in which European artists liked to make notes on the spot but was then unknown in Spain. He believed it "fut commencé dans un voyage avec la célèbre duchesse d'Albe, doña Maria Teresa de Silva, lorsque cette noble dame s'établit pour quelque temps dans sa ville seigneuriale de San Lucar de Barramenda [*sic*]" (was begun on a trip with the celebrated Duquesa de Alba, doña María Teresa de Silva, when this noble lady settled for a time in her domains, the village of San Lúcar de Barrameda).[1]

Goya almost certainly acquired these imported sketchbooks in 1796 in the south of Spain, possibly in Seville but more likely in the port city of Cádiz which is not far from Sanlúcar.[2] In a dispute over payment it was alleged that Goya had failed to fulfill his obligations as a Pintor de Cámara (court painter) because "en todo el año de 96 ha estado en Sevilla" (for the whole of the year 1796 he was in Seville).[3] Goya had written to a fellow Aragonese, the sculptor Joaquín Aralí, on May 25, 1796, that he was going to Sanlúcar de Barrameda;[4] on July 22 the same friend, writing to the art historian Juan Agustín Ceán Bermúdez in Seville, asked to be remembered to Goya "si acaso se halla en és a de vuelta de San Lúcar" (if he has gone back there from San Lúcar).[5]

This early book was indeed made from good Netherlandish paper with a watermark showing a fragment of a letter.[6] The drawings, whose maximum known size is 172 by 101 millimeters,[7] give the impression of small grisaille paintings, for they are executed in brush and gray wash, touched at times with black wash or with graphite. The compositions, on both sides of each page, have a delicate, rococo elegance. There are physical variations in the individuals Goya depicted, but if we may categorize the whole group of people as a race, it is a predominantly small-boned and rather tall race, with narrow shoulders that slope improbably and arms that appear fragile and at times too short. No sheet from this book, generally called the Sanlúcar Album, has been included in the exhibition since the character of the subject matter, Goya's delight in womankind – often in the person of the Duquesa – does not fall within the scope of the exhibition.

Like all the drawing books, this one was broken up by Goya's son, Javier, who mounted its sheets in pink paper albums.[8] Even when the books belonged to the artist and were still intact, they did not resemble the usual artists' notebooks, which are apt to consist of casual assemblies of portrait heads, drapery studies, and sketches for compositions. Neither were they sketchbooks with an intermittent record of places Goya saw or picturesque figures drawn from life, which could be used later in other contexts. From the very beginning Goya transmuted these books into visual equivalents of literary journals. They consisted of pictorial entries of varying lengths that

pertained predominantly to what Goya thought, rather than to what he had seen. Each book had its own visual consistency, a fact that suggests Goya intended their content to be seen and absorbed by friends.

After the painter's grave illness of 1792-1793, he was intermittently incapacitated for considerable stretches of time. He was ill that fall. Aralí, writing to Ceán in Seville, reported: "Según las noticias que tenemos de Goya parece no le ba nada vien de su salud, lo que generalmente sentimos todos sus amigos y cuantos le conocen" (According to the news we have of Goya, it seems that he is not at all well, which generally all his friends and anyone who knows him feel badly about).[9] By then Goya was probably in Cádiz in lodgings. Leandro Fernández de Moratín, who visited the city briefly, noted on Christmas day in the multilingual code he used in his diary: "chez Goya, quia aeger" (at Goya, who ill). Moratín went to see him a number of times, sometimes in the company of Sebastián Martínez (see cat. 19).[10]

Goya's second journal-album was made from equally good Netherlandish paper, 237 by 148 millimeters, this time with a watermark showing a SHIELD AND BEND surmounted by a FLEUR-DE-LYS, or fragments of LETTERS.[11] This album too was bound at the left, and the drawings executed in brush and gray wash, again on both sides of the sheet. However, these were touched, or heightened, with black or with a brown that may have been black iron gall ink that turned brown with time. The drawings have lost the character of grisailles, since the heightening contributes a sparkling, overall pattern that is particularly striking in the earlier pages. The compositions in this book share with those of *Album A* an angular and often trapezoidal geometry. The race of men and women depicted retain their sloping shoulders and short arms but have acquired a skeletal formation that is slightly sturdier.

Unlike the Sanlúcar Album, this one can be reconstructed, since Goya himself numbered the pages, the highest one known being 94. By page 28 Goya had begun to experiment with setting figures against a rectangular, dark background and ten pages later had settled into this mode for the remainder of the book. As Carderera observed, this device increases the chiaroscuro effect of the drawings.[12] Goya also made brilliant use of small areas of white to call attention to details that had an ideological importance. For example, in page 38, a scene on the *paseo* (promenade), the use of white forces us to see the old procuress seated watchfully at the right and the pair of seductively turned-out toes that mark a young woman as a prostitute.[13] It is the brilliant white of the young ladies' sashes against the dark of their skirts that makes us see that these appear to be gently lifted by the swaying of bottoms; and a rectangle of light in the sky leads to the face of the young woman at the right so that we note her bright eye and calculating face (fig. 1).[14] This expressionistic, unrealistic use of light was already visible in Goya's paintings, such as his wall paintings for the Cartuja de Aula Dei of 1774.[15] It was further refined and exploited in the *Caprichos*.

By page 55 Goya began to supply legends for the drawings, in brush, in pen, or even both, on the same page. These legends help us to grasp the meaning of a single drawing. But they do more. They help us to comprehend

Fig. 1. Two *majas* parading on the *paseo*, *Album B*, p. 38.
Brush with gray wash, touched with brown.
Kunsthalle, Hamburg

it in a way that is possible only when we perceive it as a page within an entry in a journal, an integrant of the sequence in which it lies. In looking at page 84, S^n *Fernando ¡como hilan!* (San Fernando How they spin!) (cat. 35), we need to have seen the ten drawings surrounding it.[16] On page 77 a woman's brothers kill her lover; next, 78, a "confessor" comes through the window to visit young ladies; then, 79, a prostitute is seen to feign embarrassment; in 80, a penitent is flailing his back during a Good Friday procession to impress his mistress;[17] in 81 wind lifts the skirts of two prostitutes; in 82 a second pair are marched off to San Fernando in custody; in 83 two prostitutes with a customer are seen trying to escape the notice of a *gato muy negro* (very black cat), slang for an *alguacil* (constable);[18] in 84 (cat. 35) we see three prostitutes in San Fernando, where it is to be hoped they will be reformed; in 85 a man and two young women feel one another for fleas; in 86 a priest has had an amorous escapade; and, finally, in 87 there is again a question of fleas that plays on a double meaning of *pulga* as sexual appetite.[19] The answer as to whether the three prostitutes in page 84 will be improved by time spent in San Fernando lies in part in Goya's examination in this sequence of the character of prostitutes and his observations on the prevalence of human lust.

If the books resemble written journals in the sense that they record what Goya thought, they are also literary in Goya's use of language. His feeling for it is evident in the titles he wrote for his drawings. They are pungent, never hackneyed, and they often play with a word's multiple meanings in the best tradition of Spanish literature. Although the journal-albums were pictorial, Goya was beginning to infuse the pictures with visual puns. Pages 92 and 93, facing each other, are a splendid example of a brief drawing entry in which various meanings of several words are fully realized, both visually and verbally (cat. 36 and 37).

1. Valentín Carderera, "François Goya: Sa vie, ses dessins et ses eaux-fortes," *Gazette des Beaux-Arts* 7 (1860), p. 223. Signs of cutting can be observed on the left sides of rectos of the sheets; see Eleanor A. Sayre, "Eight Books of Drawings by Goya, I," *Burlington Magazine* 106 (Jan. 1964), p. 20.

2. See Jeannine Baticle, "L'Activité de Goya entre 1796 et 1806 vue a travers le 'Diario' de Moratin," *Revue de l'art*, no. 13 (1971), p. 111.

3. See Valentín de Sambricio, *Tapices de Goya*, Docs. 157-163.

4. See Xavier de Salas, "Sobre un autorretrato de Goya y dos cartas inéditas sobre el pintor," *Archivo español de arte* 37 (1964), p. 319.

5. "Sirvase V.M. de dar memorias a Goya, si acaso se halla en ésa de vuelta de San Lúcar"; Ibid., p. 320.

6. See Sayre, "Eight Books of Drawings," p. 20.

7. The fragments of letters in the watermark visible in one or two sheets are illegible.

8. On Javier's breaking up the albums, and the reason he may have had for doing so, see Eleanor A. Sayre, "An Old Man Writing: A Study of Goya's Albums," Museum of Fine Arts, Boston, *Bulletin* 56 (Autumn 1958), p. 125.

9. Aralí to Ceán, Sept. 1796, in de Salas, "Sobre un autorretrato de Goya," p. 320.

10. Leandro Fernández de Moratín, *Diario (Mayo 1780 - Marzo 1808)*, ed. René and Mireille Andioc (Madrid, 1968), pp. 174 - 176. Moratín arrived in Cádiz December 22, 1796, and left January 11. Jeannine Baticle called attention to the usefulness of this record in "L'Activité de Goya," pp. 111 - 113.

11. This watermark is reproduced in Sayre, "Eight Books of Drawings," p. 22.

12. "Dans les derniers feuillets de cette suite, on voit peu à peu que Goya prend plaisir à donner plus d'effet de clair-obscur à ses compositions," Carderera, "François Goya," p. 224.

13. For an eighteenth-century Spanish dictum on how to recognize prostitutes, see *Capricho* 7 (cat. 42).

14. Inscribed upper left, in brush and gray: *38*; Kunsthalle, Hamburg, 38545; G-W 406; G., I, 51.

15. G-W 42-48; Gud. 40-46.

16. Pages 77-87; G-W 435-445; G. I, 80-90.

17. On this practice, periodically forbidden, see Leocadio Doblado [José Blanco White], *Letters from Spain*, 2nd ed. (London, 1825), pp. 257-258.

18. See *Capricho* 21 (cat. 45).

19. See Alzieu, *Poesía Erótica*, no. 65, *Letra*.

Introduction to the *Caprichos*, published 1799

The *Sueños* (Dreams), about 1797

(cat. 38-58, 60-62)

Goya first conceived of this set of prints as *Sueños* (Dreams) rather than as *Caprichos*, and completed drawings of at least twenty-eight dreams including a title page that he inscribed *Sueños 1º (First Dream)* at the top; *Ydioma universal. Dibujado y Grabado p^r F^{co} de Goya año 1797* (Universal language. Drawn and graved by Francisco de Goya in the year 1797) on a pedestal; and *El Autor soñando. Su yntento solo es desterrar bulgaridades perjudiciales, y perpetuar con esta obra de caprichos, el testimonio solido de la verdad.* (The author dreaming. His only purpose is to banish harmful ideas commonly believed, and to perpetuate with this work of *Caprichos* the solid testimony of truth.) at the bottom (cat. 51).[1]

Goya's word *capricho* is not adequately translated as caprice or fantasy, since neither of these words conveys an additional Spanish meaning that is applicable to both Goya's *Sueño* drawings and the print series that developed from them. The first meaning given in an eighteenth-century dictionary is "estravagancia, conducta de un hombre, que en vez de seguir la razon, se deja llevar de la fantasía, ú obstinacion" (extravagance, conduct of a man who, instead of adhering to reason, lets himself be led by fantasy or stubbornness).[2]

The *Sueños* were to have been a visual refashioning of the literary *Sueños* of the seventeenth-century satirist Francisco de Quevedo y Villegas (see cat. 48 and particularly cat. 50). Between 1607 and 1635 Quevedo wrote a group of *Sueños*, in which he dreamed that he found himself conversing with the inhabitants of the netherworld, native or otherwise. Where Dante had consigned sinners to nine rationally descending circles, populated by men and women whose sins, graded according to ethical principles, determined the level of Hell in which they might be found, the Spanish writer cared not at all for any hierarchy of sin. His is the witty, ironic, quite personal point of view of a gentleman intermittently attached to court, and he cheerfully consigned to perdition not only those who led disgraceful lives but also whole categories of persons who plagued him. His great contribution to the literature on Hell was his insistence that the line between human beings and devils is very thin, so that a devil can as well be possessed by a human as the other way around.[3] In Hell sodomites pose an ever present danger to devils,[4] and busybodies and nonstop talkers continue to torture people as they once did on earth;[5] tailors have no need to be transported there for they arrive by themselves and are superabundant.[6] On earth, humans – for example, venal judges – make splendid agents for demons (see cat. 45).[7] Quevedo's opinion was that the most striking difference between devils and human beings is that the former, who lack our hypocrisy, readily acknowledge as sins actions that we in the world choose to condone. Unquestionably, Goya was attracted not only by Quevedo's dream format but also by his views on the interpenetration of the human and the diabolic. To a *Sueño* in which physicians have made themselves allies of the devil being the stupid asses they resemble, Goya gave the title *Brujas disfrazadas en físicos comunes* (Witches disguised as ordinary physicians) (cat. 47).

Quevedo's *Sueños* were not the only precedent available to an eighteenth-century artist of the power of sin to transform men and women. There was an earlier, impressive, visual example in the paintings of Hieronymus Bosch in the great royal collections at the Escorial near Madrid. In 1605 Fray José de Sigüenza noted that those who did not look attentively at Bosch's paintings considered them *disparates* (things outside the limits of reason); "sus pinturas no son disparates, sino vnos libros de gran prudencia y artificio, y si disparates son, son los nuestros, no los suyos" (his paintings are not follies, but books of great prudence and artfulness, and if they are follies, they are our own, they are not his).[8] He perceived that the strange creatures Bosch painted were men and women whose vices were grafted onto their human selves, so that they had become wholly or in part the animals that symbolize the deadly sins they committed.[9]

In Goya's *Sueños* (as well as his *Caprichos*), those with failings may retain their human shape (cat. 54); or Bosch-like, they may acquire physical attributes of animals symbolizing the vices in which they indulge; or at the last they may turn themselves into unholy witches, like those in *Sueño 3, De Brujas* (Dream. Concerning Witches) (cat. 60).

Compositional and ideological sources for eleven of the *Sueños* are to be found in pages from *Album B.* Goya intended to use all but three *Sueños* as *Caprichos*, for these drawings show signs of having been dampened, laid on top of a prepared copper plate, and paper and plate run together through a printing press to transfer the design onto the plate, a somewhat unorthodox but quick way that Goya favored. He then etched, aquatinted, and burnished the plates, modifying designs, making changes, adding highlights as he worked so that in the end a print would express cogently, with passion, the essence of the subject matter he had in mind. Drawings treated in this fashion do not, however, remain undamaged. Ink lines bleed; paper wrinkles and shows the marks of the copper plate. Five *Sueños* drawings appear in the present exhibition; all of them are shown with the *Caprichos* for which they were used (cat. 47, 50, 51, 54, 60).

The *Caprichos*, 1797–1798

In addition to the *Sueños*, Goya utilized additional pages from both *Albums A* and *B* for compositions and ideas. He also made many new sanguine drawings expressly for the etchings. The work was completed by January 17, 1799, when he was paid for four sets the Duquesa de Osuna had purchased (see cat. 17).[10] Much, if not all, of the paper for the edition had probably been slipped into Goya's bills for the frescoes of San Antonio de la Florida.[11]

An announcement appeared on February 6 in the *Diario de Madrid* for a "Coleccion de estampas de asuntos caprichosos, inventadas y grabadas al agua fuerte, por Don Francisco Goya" (Collection of prints of extravagant subjects, invented and etched by Francisco Goya).[12] Because the well-known text of this announcement has a strong literary flavor, it has long been believed to have been composed for Goya by a friend;[13] nevertheless it reiterates the essence of what Goya himself had written on the title page of his *Sueños*, for the announcement continues: "Persuadido el autor de que la

censura de los errores y vicios humanos (aun que parece peculiar de la eloqüencia y la poesia) puede tambien ser objeto de la pintura: ha escogido como asuntos proporcionados para su obra, entre la multitud de extravagancias y desaciertos que son comunes en toda sociedad civil, y entre las preocupaciones y embustes vulgares, autorizados por la costumbre, la ignorancia ó el interes, aquellos que ha creido mas aptos á subministrar materia para el ridiculo, y exercitar al mismo tiempo la fantasia del artifice.'' (The author is convinced that censuring human errors and vices – although it seems the preserve of oratory and poetry – may also be a worthy object of painting. As subjects appropriate to his work, he has selected from the multitude of stupidities and errors common to every civil society, and from the ordinary obfuscations and lies condoned by custom, ignorance, or self-interest, those he has deemed most fit to furnish material for ridicule, and at the same time to exercise the author's imagination.)[14] The prints could be bought, we read, in a perfume shop, Calle del Desengaño, 1, the building in which Goya had lived for some years.[15]

The choice of this shop is odd. Possibly it was a precaution, since the numerous purveyors of books and prints in Madrid were subject to visits from Inquisition inspectors.[16] Examples of material seized under the Borbón kings include a print of Cupid kissing Venus on the lips, the Diderot *Encyclopédie*, and an 1805 edition of Leandro Fernández de Moratín's, *El sí de las niñas* (The Young Ladies' Agreement to Marriage).[17] On the other hand, the *Caprichos* were advertised in the press.

In Goya's day the Holy Office, in addition to morality, took responsibility for the preservation not only of the status quo of faith but also of the state and of the society from which it derived its power. The publication of a set of prints that attacked the vices of the clergy and of the highest nobility constituted a risk for Goya, one that could be justified only if the cultivated, enlightened audience for whom the prints were intended were able to understand what he said covertly in them.

The Valencian professor Gregorio González Azaola, writing in 1811, characterized the *Caprichos* as "un libro instructivo de 80 poesías morales gravadas, ó un tratado satírico de 80 vicios y preocupaciones de las qe mas afligen la sociedad" (a didactic book of 80 graved moral poems, or a satiric treatise on 80 of the vices and misapprehensions that most afflict society), and said the set could be used as "una piedra de toque para probar la fuerza de penetracion y viveza de comprension de todo género de personas" (a touchstone for assaying the power to penetrate [the *Caprichos*] and the sharpness of wit of every kind of person.)[18] The *Caprichos* are related to the emblems of the sixteenth and seventeenth centuries, whose witty texts explained the morality of their visual images. They, too, must be read. Over and above Goya's brief, provocative captions, the "texts" are implicit in his visual images. A worldly knowledge of life in Spain was essential, as well as familiarity with iconography, theater gestures, thieves' cant, and slang, both ordinary and erotic, and an acquaintance with traditional subjects of Spanish literature.

Anyone reading through the various explanations to a single *Capricho*, written by Goya's contemporaries, often finds that a word with more than

one meaning recurs. Goya's prints were read in part by noting visual puns. He had used this device in *Album B* (see cat. 35-37, 59), but he employed it in the prints with brilliant subtlety, for he allowed viewers to choose for themselves between the different meanings implicit in a visual form. Thus the *buho* (owl) in *Capricho* 68, *Linda maestra!* (A fine teacher!) (cat. 57), is simultaneously the owl hunting at night and the streetwalker implied linguistically, since *buho* was slang for such women. If Goya's contemporaries preferred to see the creature as an owl, then they might read the print as a scene of witches abroad on a moonlit night; but if they chose to understand the bird as a streetwalker, then they became aware of other visual puns in the print and realized, as a number of people did, that the emblem he had etched is concerned with the perversion of education. A procuress is setting a girl on the road to prostitution. Goya described the nature of her teaching by using visual puns that depend on the language of eroticism. Yet, as the contemporary explanations to the *Caprichos* demonstrate, the prints are not titillating, but serious works whose wellspring is to be found in Goya's passionate interest in reform.[19]

In 1803 Goya offered the plates to the king for the Real Calcografía (Royal Chalcography), together with all the unsold sets, 240 of them, acquiring in return a pension for his son.[20] In 1825 he wrote that he had been denounced to the Inquisition even though he had donated the plates to the king.[21] Despite the agreement he had made with the crown, Goya retained a number of sets and disposed of them himself during the Peninsular War. On the last page of the Prado manuscript of explanations, there is a scribbled-over note in Goya's hand: "37. / exemplares / se llebo Ranz / dia 29 de Agosto / A 1810" (Ranz [a bookseller] took 37 copies August 29 Year 1810). Either Goya or the Real Calcografía made copies available in Cádiz in 1811.[22]

Contemporary Explanations to the *Caprichos*

Ayala (about 1799-1803): This manuscript, perhaps the earliest, is forthright, earthy, and indiscreet, for it does not hesitate to identify categories of persons, or even individuals such as the Queen or Godoy. It belonged to the dramatist Adelardo López de Ayala; present whereabouts unknown; published in full by the Conde de la Viñaza in 1887.[23]

Prado (about 1799-1803): Someone wrote at the top of the first sheet of this famous manuscript, "Explicacn de los *Caprichos* de Goya escrita de propria mano" (Explanation of Goya's *Caprichos*, written in his own hand). But "written in his own hand" does not necessarily mean "is the author of." Almost forty years ago it was noted that the literary style of this document does not have the lively, pungent character to which Goya's letters and inscriptions have accustomed us.[24] Valentín Carderera, who had failed in his wish to study with Goya, but instead became the first great acquisitor of the artist's graphic work, believed that it had been intended that the Real Calcografía should print and sell these explanations with the prints, but that "al publicarlo [los *Caprichos*] la Calcoga no hizo uso de . . . la explin acaso por que designaba mas explicitame los vicios de la Corte, y asi solo corre manuscrita entre algunos aficionados" (when the Royal Chalcography pub-

lished it [the set of *Caprichos*], no use was made of . . . the explanation, possibly because it identified the vices of Madrid more explicitly [than the *Diario* text], and therefore it circulated only in manuscript in the hands of some enthusiasts).[25]

The generally moralistic tone of the Prado manuscript may make Carderera's suggestion that it was viewed as dangerous seem surprising. It is only when Goya's drawings and other surviving manuscripts have helped us to grasp the meaning of the *Caprichos*, that we see that Carderera was correct. It is not an innocent document. It is capable of biting irony (see, for example, cat. 53) and, like the prints, it too contains puns that transform the interpretation (see, for example, cat. 41). Museo del Prado, Madrid; published in full by the Conde de la Viñaza.[26]

The Ayala and the Prado manuscripts are linked to one another in that thirty-two of the individual explanations share sentences or phrases, either word for word or with slight variations.[27] In one instance, no. 35, the wording of the entire text is identical, and in three others very nearly so.[28] Almost certainly the writer of one of the two relied on the other. It seems easier to move from the candid Ayala to the more literary and veiled Prado than the other way around.

Although with time each of the two sets of explanations was altered by copyists, by people adding material or making changes, the character of growth each of the two generated was by no means the same. If we liken the manuscripts to trees, the text of the Ayala put forth vigorous, fruitful offshoots, whereas the text of the Prado did not, since it remained virtually unchanged in the many copies that have survived.[29] In a few instances these copies received small graftings in the form of brief parenthetical additions. However, much, though not all, of the subject matter added to them is traceable to the Ayala manuscript.[30]

The manuscripts that follow belong to the Ayala tree. The order in which they appear does not imply a known chronology.

Sánchez Gerona (1811 or later):[31] The prints, cut within the border lines, were pasted onto sheets of paper with the same CAPELLADES Maltese cross watermark found in preliminary drawings by Goya for the so-called *Disasters of War*, executed about 1810. The set opens with a slightly cut version of the Cádiz 1811 González Azaola article, "Satiras de Goya";[32] the descriptions he gives of two *Caprichos* seem to have been drawn from a manuscript much like the present one. The set seems to have been prepared so that the owner could use the prints as a *piedra de toque* (touchstone) for judging the ability of the owner's friends to read them, since the title appears on a separate page just before each print, and the explanation is on the verso; private collection, United States. A second version of the explanations is in the Kupferstichkabinett, Staatliche Museen Preussischer Kulturbesitz, Berlin.

Douce (by 1818): Francis Douce's copy of a translation into English by Samuel Dobree of a manuscript that is sometimes dependent on the Ayala, more often close to the Sánchez Gerona, and at times independent. There are instances where the explanations appear mistaken or seem to have been

sanitized. It is in a set of *Caprichos* offered for sale in London, in 1818, by Sotheby; published in full by Nigel Glendinning;[33] Bodleian Library, Oxford.

Puigblanch (fragments, 1811): A passage on Goya in Antonio Puigblanch, *La inquisición sin máscara* (Cádiz, 1811), quotes from explanations of *Caprichos* 23 and 24; published by Nigel Glendinning.[34] The same phrase used for no. 23 exists in the Sánchez Gerona manuscript; one similar to no. 24 is in the Stirling Maxwell explanations.

Stirling Maxwell: copy of an earlier, unidentified manuscript, bound into a set of *Caprichos* with posthumous hand coloring, which belonged to Sir William Stirling Maxwell; individual texts longer and more detailed than those of the Sánchez Gerona. Also bound into the set is a copy of the Prado manuscript headed: "Ynterpretacion de los Caprichos de Goya, copiada de la que tenia el cavallero Yngles Mr. Cambell" [*sic*]; private collection, Canada.

Simon: bound into a set of *Caprichos* with contemporary hand coloring. The fact that some explanations contain mistakes, such as *gefes* (chiefs) instead of *jueces* (judges) in *Capricho* 21, suggests that it was dictated rather than copied; Norton Simon, Pasadena.

Nelson-Atkins: related to the Simon manuscript, but even more closely to the Lefort and Biblioteca Nacional manuscripts; on paper with the watermark MIQUEL ELIAS; The Nelson-Atkins Museum of Art, Kansas City, Missouri. Another set was copied onto the margins of a set of *Caprichos*, and French translations supplied, given in "sténographie," when the content seemed likely to shock; private collection, United States.

Paul Lefort (partial): Paul Lefort quoted from, or summarized, thirteen explanations from a manuscript he believed was written by Goya, translating the material into French.[35] Explanations include phrases found in the Nelson-Atkins manuscript, such as the statement in no. 2 that the bride has two faces like Janus (a detail shared only by these two manuscripts); however, the Lefort also had access to some of the parenthetical material that characterizes the Biblioteca Nacional group; present whereabouts unknown.

Biblioteca Nacional: on paper with a RAMON ROMANI crown and shield watermark, the text is distinguished by the addition of material in parenthesis that seems to have been taken from the additions made to the Prado manuscript; published in full by Edith Helmann;[36] Biblioteca Nacional, Madrid, MS 20258 - no. 23. The photocopy of a second, very close manuscript in a private collection, Spain, was kindly given me by the architect José María Muguruza. A third, on the same ROMANI paper, gives the additions as footnotes rather than parentheses; private collection, Switzerland.

Excluded from this discussion are other contemporary manuscripts, such as one by Juan Antonio Llorente (cat. 73), written by persons who did not have access to these other manuscripts and who put down, sometimes successfully, what they believed the *Caprichos* were about.

1. Some *Sueño* drawings have been lost. All those known belong to the Prado; see G-W 460, 464, 473, 477, 480, 484, 488, 505, 528, 531, 537-538, 560, 572, 576, 578, 582, 584, 588, 590, 592-593, 620, 622-625, 627; G., II, 39-65 and 101.

2. Terreros, *Diccionario*, 1786-1793, under *capricho*.

3. Francisco de Quevedo y Villegas, *Obras escogidas*, 2nd ed. (Madrid, 1794), vol. 1, pp. 24-28, "El Alguacil Alguacilado."

4. Ibid., p. 77, "Las Zahurdas de Pluton."

5. Ibid., pp. 384-386, "Visita de los Chistes."

6. Ibid., pp. 55-57, "Las Zahurdas de Pluton."

7. Ibid., p. 36, "El Alguacil Alguacilado."

8. Fray José de Sigüenza, *Historia de la Orden de San Gerónimo*, bk. 4, discourse 17 (Madrid, 1605), reprinted in F.J. Sánchez Cantón, *Fuentes literarias para la historia del arte español* (Madrid, 1923), vol. 1, p. 426. Sigüenza was cited by Antonio Ponz in 1773, and the essence of this statement on Bosch repeated in his *Viaje de España; seguido de los dos tomos del viaje fuera de España*, ed. Casto María del Rivero (Madrid, 1947), vol. 2, letter 5, para. 39, p. 215, and n. 1.

9. Sigüenza, *Historia de la Orden de San Gerónimo*, p. 431.

10. Receipt, Archivo de Osuna, 515-517, published by the Condesa de Yebes, in *La Condesa-Duquesa de Benavente: Una vida en unas cartas* (Madrid, 1955), p. 47.

11. See Sayre, *Changing Image*, p. 61.

12. *Diario de Madrid*, Feb. 6, 1799, pp. 149-150; the first page is reproduced in Tomás Harris, *Goya: Engravings and Lithographs* (Oxford, 1964), vol. 1, p. 103.

13. See, for example, F.J. Sánchez Cantón, *Los Caprichos de Goya y sus dibujos preparatorios* (Barcelona, 1949), p. 16.

14. The announcement is reproduced in Harris, *Goya*, vol. 1, p. 103.

15. It is the address given in the parish church records for all but the first of his five children; see Enrique Lafuente Ferrari, *Antecedentes, coincidencias e influencias del arte de Goya* (Madrid, 1947), pp. 288-289. In February 1800 he was looking for new lodgings; in May Godoy bought the dwelling as a gift for his mistress, Pepita Tudó; and in June Goya bought Calle de Valverde, 15; see Jeannine Baticle, "L'Activité de Goya entre 1796 et 1806 vue a travers le 'Diario' de Moratin," *Revue de l'Art*, no. 13 (1971), p. 112.

16. On censorship, see Lea, *Inquisition*, vol. 3, pp. 480-549; vol. 4, pp. 528-534. The first *pragmática* was issued September 7, 1558.

17. Dirección General de Bellas Artes, Archivos y Bibliotecas, La Inqvisicion, Palacio de Velázquez (Madrid, 1892), pp. 153-158.

18. *Semanario Patriótico*, no. 11, Mar. 27, 1811, pp. 24-25. Enriqueta Harris gave the full text in "A contemporary review of Goya's 'Caprichos,' " *Burlington Magazine* 106 (Jan. 1964), p. 42.

19. See also Camilo José Cela, *Diccionario del Erotismo* (Barcelona, 1988), vol. 2, under *Goya*: "Goya entra en el arte erótico mundial a través de *Los Caprichos* por el sesgo de su más negra amargura:

su voluntad de ilustrar todas las perversiones, magnificar el amor carnal y satirizar el envilecido mundo de intereses y supersticiones que se tejen a su alrededor en la España negra. . . . Pocos llegaron, como Goya, a la crítica acerba, a la amargura y al humor dramático, y sólo él, perseguido por la Inquisición, nos ha dejado algo tan válido e inimitable como sus *Caprichos.*" (Goya's *Caprichos* enter the corpus of erotic art used to express his blackest bitterness: his desire to illustrate perversions, to magnify carnal love and to satirize the debased world of self-interest and superstitions being woven around him in black Spain. . . . Few would achieve the scathing criticism, bitterness and dramatic humor that Goya did, and he alone, persecuted by the Inquisition, has left us so valid and inimitable a work as his *Caprichos.*)

20. Two letters on this affair exist, July 7 and October 9, the earlier in the archives of the Palacio Real, the other in the Prado. They have been quoted in full a number of times; see, for example, Angel Canellas López, ed., *Francisco de Goya: Diplomatario* (Zaragoza, 1981), nos. 223-224.

21. See letter from Goya to Joaquín Ferrer, Dec. 20, 1825, quoted in *Colección de cuatrocientas cuarenta y nueve reproducciones . . . de Don Francisco Goya* (Madrid: Saturnino Calleja, 1924), p. 55.

22. They were advertised in a footnote to the article by González Azaola; see Harris, "A contemporary review of Goya's 'Caprichos,' " p. 42. In 1816 they were advertised by the Real Calcografía; H., Appendix VI, p. 449. María Luisa and Godoy, attacked in the plates, were no longer in Spain.

23. C. Muñoz y Manzano, Conde de la Viñaza, *Goya: Su tiempo, su vida, sus obras* (Madrid, 1887), pp. 327-359.

24. Sánchez Cantón, *Los Caprichos de Goya*, pp. 18-19. See also René Andioc, "Al margen de los *Caprichos*: Las 'explicaciones' manuscritas," *Nueva revista de filología hispánica* 33, no. 1 (1984), pp. 276-282; he suggests Leandro Fernández de Moratín as the author; pp. 281-282. The allegation that the Prado manuscript is autograph has been doubted with reason; see Harris, *Goya*, vol. 1, p. 98.

25. Carderera copied into a prepublication set of the *Caprichos* a draft of Goya's advertisement for the set, the Prado explanations, and a statement from which this excerpt is taken. The copy, orginally owned by Ceán Bermúdez, is in the British Museum, 1975-10-25-420(1-85), see Juliet Wilson Bareau, *Goya's Prints. The Tomás Harris Collection in the Bristish Museum* (London, 1981), pp. 43, 102.

26. Conde de la Viñaza, *Goya*, pp. 327-359. He used a copy of it owned by Carderera; p. 327, n. 1.

27. Nos. 3, 6, 7, 8, 9, 10, 12, 14, 15, 16, 17, 18, 26, 29, 31, 35, 38, 39, 40, 41, 43, 44, 45, 48, 54, 55, 57, 60, 65, 66, 75, 77.

28. Nos. 14, 60, and 65.

29. For an analysis of the textual variations in two examples, in Zaragoza and Pontevedra, see Pedro Javier González Rodríguez, "El ejemplar de los *Caprichos* de Goya, con comentarios manuscritos, del museo de Pontevedra," *El Museo de Pontevedra* 40 (1986), pp. 407-490.

30. Five such manuscripts are known to me. Two are closely related to each other: one, written per-

haps in 1814, on paper with the watermarks SHIELD WITH HORN, IPING, and 1806, is inscribed "Car: [Caroline] Duff Gordon." It is the manuscript referred to in a note in a first edition of the *Caprichos* in the British Museum, written by a curator at the British Museum: "An impression . . . with the name of Caroline Duff Gordon, Cádiz, 1814 in old paper cover. . . . It contained an old MS explanation on paper with watermark 1806." The Duff Gordon *Caprichos* are now in the Huntington Library, San Marino, California. A similar manuscript, copied from one belonging to "el cavallero Yngles Mr. Cambell [*sic*]" (the English gentleman Mr. Cam[p]bell), is in a hand-colored set of the *Caprichos* once owned by Sir William Stirling Maxwell and now in a private collection in Canada. The remaining three have also a close relationship to one another. One, formerly in the Tomás Harris collection, was acquired by the Fitzwilliam Museum, Cambridge, a second belongs to me, and a third was once owned by Norton Simon. To this last manuscript a few excerpts from two manuscripts published by the cataloguer Paul Lefort were added in Spanish translation and in another and later hand. We might also cite, although it is not a part of this group, an independent French translation of the Prado manuscript to which were added, in a different hand, glosses explaining some of the terms; Staatliche Graphische Sammlung, Munich.

31. Aureliano Beruete y Moret, *Goya grabador* (Madrid, 1918), p. 34, described this set, giving its owner as Sánchez Gerona. He may have been José Sánchez Gerona, an engraver and the director of the Real Calcografía.

32. See Harris, "A contemporary review of Goya's 'Caprichos,' " p. 42.

33. Nigel Glendinning, "Goya and England in the Nineteenth Century," *Burlington Magazine* 106 (1964), pp. 7-9.

34. Nataniel Jomtob [Antonio Puigblanch], *La inquisición sin máscara* (Cádiz, 1811), pp. 441-442; see Glendinning, "Goya and England in the Nineteenth Century", p. 7 and n. 17; see also Andioc, "Al margen de los *Caprichos*: Las 'explicaciones' manuscritas", pp. 275-276.

35. Paul Lefort, "Essai d'un catalogue raisonné de l'oeuvre gravé et lithographié de Francisco Goya," *Gazette des Beaux-Arts* 22 (1867) p. 200, n. 1.

36. Helman, *Trasmundo*, pp. 213-229.

Introduction to *Journal-Album C,* about 1808-1814

(cat. 76-81, 98-115)

For the two eighteenth-century books of drawings by Goya, *Albums A* and *B,* it was possible to determine both the order of their precedence and almost to the month the period during which Goya filled their pages. For not one of the remaining six albums can such precise limits be set. Stylistic differences between drawings in the earlier and later parts of *Journal-Album C* suggest that it was executed over a longer stretch of time than *Albums A* and *B* together. The striking subject matter of the later part of *Album C* is what gives the book its character. Pages 85-114 show historical scenes of an Inquisition plainly coming to an end (see cat. 98-106); page 115 is an allegorical drawing on freedom of the press (cat. 107); page 116, a scene of drunkenness (cat. 108); page 117, a second allegory in which a white-clad figure holds a small book whose light will bring people out of the darkness (cat. 109); page 118, a third allegory where scales of Justice appear in the sky (cat. 110); after these, there is another long passage, pages 119-131, that attacks failings of clerics and depicts the secularization of both monks and nuns (cat. 111-115).

Some sixty years ago, Félix Boix and F.J. Sánchez Cantón proposed that two of the allegorical drawings represented freedom of the press and the promulgation of a constitution in Spain.[1] Of the three occasions during Goya's lifetime when constitutional government was adopted – 1808, 1812, and 1820 – they favored the third. Later scholars have concurred, and have believed that this entire section of *Journal-Album C* was drawn during the constitutional period of 1820-1823. Both the suppression of the Inquisition and secularization of some members of the monastic orders were attendant on constitutional government.

When we examine the drawings from the point of view of style and consider how each of the three constitutions was likely to have affected Goya, we begin to doubt that this date can be correct. If the drawings were executed during the constitutional triennial, we would expect them to have been drawn in a manner that still had something in common with the *Album F* drawings of 1817-1820 (see cat. 144-153), that their style would be the same as that of the later part of the *Fatales consequencias de la sangrienta guerra en España con Buonaparte. Y otros caprichos enfaticos* (The terrible results of the bloody war in Spain with Napoleon. And other emphatic *Caprichos*), the *Disasters of War,* etched between 1820 and 1823 (see cat. 154-163), and that we would be able to see in the *Album C* drawings signs of movement towards the style of the Bordeaux drawings of 1824-1828 (see cat. 164-179). That is not the case. Instead, the *Album C* drawings are related stylistically to Goya's paintings and etchings executed during the Peninsular War (see cat. 67, 68, 82-96). All these seem to have been characteristic of the years around 1800, done during a period when Goya was tempering with small curves the sharp corners of the compositions and was translating their geometric angularity into more concentrated masses. An additional development is visible. The *Album B* drawings of 1796-1797 had something of the character of eighteenth-century English watercolor drawings in which forms tended to be defined by outlines and then filled in with color. In *Album C*

the drawings are clearly conceived in terms of brush and form often suggested by means of an interplay of light and shadow. Even in the earliest pages of the book, Goya brilliantly suggests the three-dimensional solidity of men and women with delicate lines of shading (see cat. 76 and 77).

In *Album C* the men and women, whose physical type characteristics Goya restlessly altered over the decades, appears much the same as the race depicted in etchings and paintings executed during the Peninsular War. It is a sturdy, strong-boned people, plainly capable of bringing armed resistance against Napoleon to a successful conclusion.

We should also ask which of the three constitutions was likely to have evoked in Goya the passionate, joyful response of the allegorical drawings (cat. 107, 109-110).[2] It cannot have been the Constitution of 1808. In January and February French troops began to occupy citadels in northern Spain, in March Carlos IV abdicated in favor of his son Fernando, and shortly afterwards French cavalry and infantry were welcomed into Madrid. In April Napoleon lured both king and ex-king across the border to Bayonne where they bartered away the Spanish crown. On June 15 Napoleon convoked a Spanish Junta composed primarily of those most likely to profit from the constitution he intended to propose. The Junta signed this constitution after deliberating less than a month, largely on the emperor's terms.

Although reforms long sought by liberal-minded Spaniards were included, it was a cynical document.[3] Three of its initial provisions specified which Spanish crown properties were to be bestowed on the new king, Napoleon's brother José I, how much allowance he and members of his family should have, and the high-ranking household officials to which the royal household was entitled.[4] There was to be freedom of the press, but not until two years after the adoption of the constitution, and, even then, it pertained only where France's interests could not be considered endangered.[5] The suppression of the Inquisition and the reduction in number of monastic foundations were not included in this constitution. They were among Napoleon's improvised decrees given from the Campo Imperial de Madrid on December 4 as he waited for the capitulation of the city.[6]

The constitution had been signed at Bayonne on July 7. By that date, the citizens of Spain – with no king, no central government of their own, and no army at their command – had already embarked with spontaneous, collective determination on a six-year struggle for independence. It was not until December 23, a Saturday, that heads of households in Madrid were required to swear allegiance to the new French king and constitution after a high mass in the parish churches at ten in the evening.[7] It is far from certain that Goya had by then returned from his journey to Zaragoza to paint "las glorias de aquellos naturalaes" (the glorious deeds of her citizens).[8] Few citizens can have understood clearly to what they were pledging themselves, since the French delayed publishing the text of the *Constitución* of Bayonne for another three months.[9] The vast majority of Spaniards greeted not only the document but also everything French with intense hatred.

Although political freedom of the press as guaranteed by the Bayonne Constitution was illusory, religious freedom was not. While the capital was

occupied in 1812, Juan Antonio Llorente, who had been secretary of the
Inquisition of Madrid from 1789 to 1791, published two stinging works on the
history and practices of the Inquisition (cat. 73).[10] Perhaps it was this unprec-
edented event that set Goya to drawing his own thirty-page pictorial account
of prisoners of an institution whose demise throughout Spain was foreseen in
his captions.[11]

The course of the war was uneven and French law prevailed only where
French troops were in command. The central Spanish Junta, on its side,
withdrew to the Isla de León in the south of Spain, and on September 24,
1810, opened their own Cortes (parliament). On October 15 they began
debates on the burning issue of freedom of the press.[12] As one delegate put
it, "la censura previa que encadena a la imprenta es contraria a la propaga-
ción de las luces y obra de los tiranos, que aman necesariamente las
tinieblas" (prior censorship that binds the press is contrary to the spread of
enlightenment and is the tool of tyrants who must by necessity love the
darkness).[13] The delegates passed a measure prohibiting libel, calumny,
subversion, and pornography;[14] and some proved unwilling to see religious
heresies published.[15] The full decree of freedom of the press was promul-
gated on November 10, censorship to be retained only in matters of religion.[16]
The Cortes adhered resolutely to the principles of the decree, permitting
such violent journals as *El procurador* and *El atalaya de la Mancha* to print
whatever attacks they chose and, in practice, allowed considerable religious
freedom (see cat. 107).[17]

Toward the end of January 1812, the Cortes, by then meeting in the city of
Cádiz and under bombardment by the French, approved an admirable consti-
tution. It was promulgated in this city on March 19.[18] The Cádiz *Constitución*
of 1812 was as idealistic as Napoleon's had been cynical. It broke with the
old, entrenched absolutism, declaring that sovereignty rested solely in the
nation. A hereditary monarchy was retained, but the power to make laws
was now held jointly by the Cortes and the king, and responsibility for their
execution was given to the crown.[19] Political freedom of the press was not an
illusion but a fact protected by the Cortes, whose sessions were public.[20]

The Cádiz Constitution was read publicly in Madrid at Mass in the parish
churches three days after Wellington entered the city on August 12, 1812
(see cat. 97). After Mass, citizens, probably Goya among them, swore alle-
giance to this Constitution and the Te Deum was then sung.[21] Early in
November the French reoccupied the city, and in April 1813 evacuated it
permanently.

Churches, monasteries, and convents possessed a great wealth of land,
acquired in part at the time of the reconquest, in part through royal gifts, and
in part from rich members of the faithful. The fact that much of this land
was entailed and could not be sold to those who might have cultivated it
profitably was seen by enlightened intellectuals as an impediment to a
healthy agrarian economy. The Cortes passed laws prohibiting the establish-
ment of fresh entails, authorizing the sale of lands and houses, and denying
permission for the churches and convents to continue the accumulation of
real estate, and placed some limitations on the reestablishment of convents

and monasteries damaged during the fighting. These reforms were a factor in the enmity many churchmen felt toward the constitution (see cat. 49, 62, 110-115).

On March 22, 1814, after the French had been driven from Spain, Fernando VII returned to Spain. Treacherous, vindictive, and reactionary, he signed, nine days before he reentered the capital on May 13 (after an absence of six years), a secret document overthrowing the Constitution. Prominent Liberals were arrested, as were delegates to the Cortes, and the king entered the city as absolute monarch.

There followed a reign that must be described as appalling. "The committee reigns supreme," the Prussian ambassador von Werther wrote that year. "It issues decrees and orders the arrest of all whose opinions it suspects. The countless victims, who are jailed indiscriminately with robbers and murderers, include many men distinguished both for their talents and for their services to the nation. This despotism is so much the more revolting because it is exercised by fanatical, avaricious and revengeful priests, equally lacking in ability and in moral sentiment. The finances are in a state of hopeless confusion. Yet the King gives everything that comes into the exchequer to the friars."[22]

Almost every year a major uprising occurred, and on March 9, 1820, Fernando VII found it prudent to swear to the Constitution at six in the afternoon in the presence of the provisional *Ayuntamiento constitucional* (constitutional government).[23] With the return of freedom of the press, much that had been considered censorable burst into print. Yet in the three years before the king again overthrew the Constitution, Goya never dared publish either his *Disasters of War* or his *Disparates*. In 1824 he went into voluntary exile. On psychological grounds alone, it is hard to conceive that the confident drawings of *Album C* could have been produced during that constitutional triennial.

Unlike the first two journal-albums that Goya acquired, he put this one together himself, making it not from the good Netherlandish paper artists liked but out of sheets of common Spanish writing paper with a CROWN and SHIELD watermark on which the letters F / GA DO / and an indecipherable last name appear. An advantage in this album was that he could insert pages into a passage, changing earlier numbering where necessary. The use of common paper is consistent with the album's having been begun during the Peninsular War, when good paper could not be bought. Almost the entire work is preserved in the Prado, not as a book but as miscellaneous pages that, like most album drawings, were once mounted on a characteristic pink nineteenth-century paper.

1. Félix Boix and F.J. Sánchez Cantón, *Museo del Prado: Goya: Cien dibujos inéditos* (Madrid, 1928), nos. 81, 82.

2. Some of the material that follows was first published in Swedish, Sayre, "Goyas 'Spanien, Tiden och Historien.' "

3. For a historical account of this constitution, its text, and a commentary on it, see Pierre Conrad, "La constitution de Bayonne (1808)," *Bibliothèque d'histoire moderne* (Paris, 1910), vol. 2, fasc. 4.

4. Articles 21-26.

5. On freedom of the press see Articles 39, 45-49; on when it was to begin, see Article 145.

6. Conrad, "La constitution de Bayonne," vol. 2, p. 63, n. 2. See also Gabriel H. Lovett, *Napoleon and the Birth of Modern Spain* (New York, 1965), vol. 1, p. 311. These decrees were not published in the *Diario de Madrid* until December 24, pp. 691-693. On José I's decrees of 1809, see Lovett, *Napoleon*, vol. 2, pp. 518-519.

7. The notice appeared the day of the swearing in the *Diario de Madrid*, Dec. 23, p. 690.

8. On Goya's movements see Sayre, *Changing Image*, pp. 126-127.

9. Conrad, "La constitution de Bayonne," vol. 2, p. 66; it was printed in the *Gaceta de Madrid*, Mar. 29-Apr. 2, 1809.

10. Juan Antonio Llorente, *Memoria histórica, sobre qual ha sido la opinion nacional de España acerca del tribunal de la Inquisicion* (Madrid, 1812); idem, *Anales de la Inquisicion* (Madrid, 1812). Llorente had signed the Bayonne Constitution.

11. See pages 113, *Ya vas á salir de penas* (You will not suffer much longer), and 114, *Pronto seras libre* (Soon you will be free); G-W 1348, 1349; G., I, 257, 258.

12. See Lovett, *Napoleon*, vol. 1, p. 376 and vol. 2, pp. 437-440; *Actas de las Cortes de Cádiz: Antología*, ed. Enrique Tierno Galván (Madrid, 1964), vol. 1, pp. 19-31.

13. Session of October 16; *Actas de las Cortes*, vol. 1, p. 20.

14. Session of October 17; Ibid., p. 23.

15. Session of October 21; Ibid., p. 25.

16. See Lovett, *Napoleon*, vol. 2, pp. 439-440.

17. José Maria Queipo de Llano, Conde de Toreno, *L'aperçu des révolutions survenues dans le gouvernement d'Espagne de 1808 á 1814*, quoted in Joseph Pecchio, *Six mois en Espagne* (Paris, 1822), p. 29.

18. On this period see Lovett, *Napoleon*, vol. 2, chaps. 10-11.

19. *Constitución politica de la monarquía española*, Articles 3, 14-16 (Madrid, 1812), pp. 4-5, 8.

20. Ibid., Article 131, sec. 24, and Article 126, pp. 42 and 38.

21. *Diario de Madrid*, Aug. 15, 1812, pp. 181-182.

22. Dispatch, Aug. 25, 1814, quoted by F.D. Klingender, *Goya in the Democratic Tradition* (London, 1948), p. 155.

23. *Diario de Madrid*, Mar. 10, 1820, p. 329.

*Fatales consequencias de la sangrienta guerra en España con Buona-
parte. Y otros caprichos enfaticos* (The terrible results of the bloody
war in Spain against Bonaparte. And other emphatic *caprichos*), the
so-called *Disasters of War*
Part 1, 1810-1814
(cat. 82-94)

Some of the ill-clad heroic troops who had successfully defended Zaragoza
when it was besieged by the French came down to Madrid in the fall of 1810,
their triumphal visit coinciding with the arrival of other equally ragged vic-
tors of battles in Valencia and Castilla la Vieja.[1] On October 4 Goya's name
appeared in one of the lists of "donativos hechos para el exército de Aragon"
(donations made to the army of Aragon) published in the *Diario de Madrid* in
1808: "D. Francisco Goya 21 varas de lienzo" (Don Francisco Goya 21 yards
of linen).[2] The artist, by then sixty-two, had already departed for Zaragoza,
summoned by Palafox (see cat. 75) "a ver y examinar las ruinas de aquella
ciudad, con el fin de pintar las glorias de aquellos naturales" (to see and
examine the ruins of that city, to paint the glorious deeds of her inhabitants).[3]
Two fellow members of the Academia de San Fernando, Juan Gálvez and
Fernando Brambila, set out about the same time, intending to execute a
series of aquatints on the siege. They later reported that they had made "un
viage sumamente arriesgado para aquella Ciudad, en donde sufrieron infini-
tos travajos y prisiones en su viage" (an extremely hazardous journey to that
city in the course of which they suffered infinite hardships and arrests).[4]

 Two years after Goya's death a Spanish historian reported that the artist
"llegó a Zaragoza á ultimos de Octubre de 1808, y formó, aunque precipi-
tadamente, dos bocetos de las principales ruinas, figurando en uno de ellos el
hecho de arrastrar los muchachos, en el choque del 4 agosto, por la calle del
Coso los cadáveres franceses; y como á ultimos de noviembre se aproxi-
maron las tropas de Napoleon, no pudo continuar el proyecto, y partió al
lugar de Fuen de Todos, corregimiento de Zaragoza, pueblo de su naturaleza,
en el que para evitar un compromiso, los cubrió con un baño que despues no
pudo quitar, y quedo inutilizado aquel trabajo" (arrived in Zaragoza at the
end of October of 1808 and executed, though hastily, two oil sketches of the
main ruins, one of them depicting the deed of the boys who dragged French
corpses through del Coso street during the clash on August 4. Because
Napoleon's troops were again approaching at the end of November, he was
unable to continue the project and left for Fuendetodos, in the province of
Zaragoza, where he was born, and while there, to avoid being compromised,
he covered the sketches with a coating which he was unable afterwards to
remove, leaving his work useless.)[5] That spring the Englishwoman Lady
Holland recorded in her diary the destruction of other works Goya had done
in Zaragoza: "In his [Palafox's] room there were several drawings done by
the celebrated Goya, who had gone from Madrid on purpose to see the ruins
of Zaragossa; these drawings and one of the famous heroine above men-
tioned [Agustina de Aragón (see cat. 84)], also by Goya, the French officers
cut and destroyed with their sabers, at the moment too when Palafox was

dying in his bed."[6] Perhaps what hung on the wall were indeed drawings, but her informant seems to have been General Doyle, and it is equally probable that the word Lady Holland heard was "sketches," a term also used for preliminary studies in oil. Soldiers use sabers to slash paintings on canvas, but they tear up unmounted drawings and smash those that have been framed under glass.

Goya, perhaps still in the north, was absent from the capital on February 27 and did not attend a special junta at which members of the Academia de San Fernando were obliged to swear fidelity and obedience to José Bonaparte and the Constitution of Bayonne.[7] Gálvez and Brambila, returning directly to Madrid, tried to proceed with their aquatints commemorating the first siege of Zaragoza, but after completing three plates, they were discovered by the French to be working on them and forced to flee to the south of Spain. In 1814 they finished thirty-six aquatints in Cádiz, *Ruinas de Zaragoza* (Ruins of Zaragoza), in which they depicted well-known heroes and heroines, panoramic views of encounters with the French, and the ruined buildings of that city.[8]

Goya does not seem to have begun working on his aquatints of the resistance until 1810.[9] Possibly it was the defiant opening of the Spanish Cortes on September 29 on the Isla de León near Cádiz, at a moment when almost the entire nation was dominated by the French, that gave him hope that the time might yet come when his prints on the "sangrienta guerra en España con Buonaparte" (bloody war in Spain against Bonaparte) could be published. His prints are fundamentally different from those of Gálvez and Brambila or even those of their seventeenth-century predecessors Jacques Callot – who etched the famous *Les Miseres et les mal-hevrs de la gverre*, in which soldiers are seen indulging in plunder, arson, sacrilege, and rape and are afterward justly executed by a variety of methods – and Romeyn de Hooghe – who illustrated a less well-known account of the brutal, unrestrained terrorism inflicted in Brabant during the invasion of the Dutch Republic by Louis XIV in 1672.[10] Goya probed the effects of war on nameless individuals (Agustina de Aragón is the only person who can be identified).[11] His interest lay in what it means for a peasant with knife, ax, or homemade lance to attack trained, fully armed troops and what it is like for those who confront such passion; in feelings of women violated by soldiers, of men who rape, and of husbands forced to witness such acts; in the ability of the dead when they become countless to so benumb survivors that they no longer remember that each corpse was once a neighbor known to them; in the degradation of the human spirit that permits men to commit atrocities; in inexorable famine and death touching the lives of the men, women, and children living in Madrid and its environs.

In each of his series of works of art on paper, Goya seems to have reconsidered the medium and perceived further possibilities. In this series he experimented with brushing lavis directly on the plate to achieve a more flexible tonal shading than aquatint; in plates executed around 1810, when good copper plates could still be found, he replaced etched lines of shading with flecks and dots to suggest the softness of a woman's face and neck

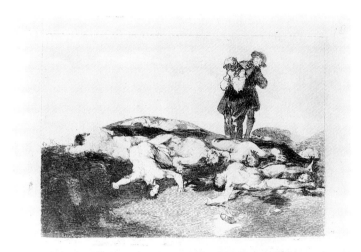

Fig. 2. *Enterrar y callar, Disasters of War,* plate 18,
Working proof,
Etching, burnished lavis, drypoint and burin,
Museum of Fine Arts, Boston, 1981 Purchase Fund

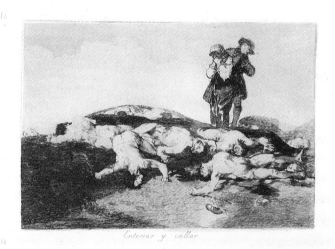

Fig. 3. *Enterrar y callar, Disasters of War,* plate 18
First edition, 1863,
Etching, burnished lavis, drypoint and burin,
Museum of Fine Arts, Harvey D. Parker Collection

and the vulnerability of the naked body of a man. As in the *Caprichos*, light performs its function of calling attention to what Goya wants us to notice. In plate 18, *Enterrar y callar* (Bury them and hush) (fig. 2),[12] he illuminates the dead heaped together on earth whose barrenness is emphasized with a dry patch of white containing an empty shoe in the foreground, as he does the living man and woman who cover their noses as they search for someone who is missing. Light, modified by counterpoints of graved lines, stippling, and delicate lavis, is also used to suggest both the sculptural beauty of the rigid bodies and the heat that has made their stench unbearable.

Fernando VII set foot on free Spanish soil on March 24, 1814. On the ninth, Goya, having made known to the regency his "ardientes deseos de perpetuar por medio del pincel las mas notables y heroicas acciones ó escenas de nuestra gloriosa insurreccion contra el tirano de Europa" (burning desire to perpetuate with his brushes the most notable and heroic actions or scenes of our glorious insurrection against the tyrant of Europe) was granted a stipend in addition to his expenses while he worked on them.[13] He had completed two scenes – the uprising of the people of Madrid in 1808 against the French Mamelukes, *The Second of May*, and subsequent execution of Spanish leaders, *The Third of May*[14] – when Fernando VII, entering Madrid, published his fateful decree of May 4.

It was to be as though nothing that had happened during Fernando's absence had taken place, and it was as impossible for Goya to publish the plates of the *Disasters of War* that he had completed by then – those whose subject matter was "the bloody war in Spain against Bonaparte" – as it was to continue his painted record of the "glorious insurrection." Goya stored the copper plates away. In 1820, when constitutional government returned, Goya enlarged the set with the *caprichos enfáticos* (cat. 154-163) and put together a mock-up set with the title used throughout this exhibition.[15] Goya

did not publish this version during the brief revival of the Constitution from 1820 to 1823, and it was not until thirty-five years after his death that the Academia de San Fernando brought out the first edition.[16] The Academia printed the copper plates with an overlying tone of ink that covered whatever damage might have occurred to the plates. Unfortunately at the same time this tone of ink gave the prints an overall muddy aspect that veiled Goya's expressionistic compositions of light and dark (fig. 3).[17] It also almost totally obscured the psychological impact and moving visual beauty of the clearly printed working proofs pulled for the artist himself. For this reason, only the latter are used in the exhibition.

1. Felipe Pérez y González, *Un cuadro . . . de historia: Alegoría de la villa de Madrid, por Goya: ¿Goya fué afrancesado?* (Madrid, 1910), p. 28.

2. *Diario de Madrid*, Oct. 4, 1808, p. 312. Pérez y González called attention to this gift; see *Obras completas: Un cuadro . . . de historia*, p. 30. Money and supplies had begun to be collected by September 19; see *Gaceta de Madrid*, Oct. 11, 1808, p. 1284; Goya's gift is listed on p. 1286.

3. Letter from Goya to Josef Munarriz, Oct. 2, 1808, Real Academia de San Fernando, archives; the full text may be found in Angel Canellas López, *Francisco de Goya: Diplomatario* (Zaragoza, 1981), no. 227.

4. Juan Gálvez and (or) Fernando Brambila, *Pequeña memoria de las circunstancias que ocurrieron para egecutar la obra de las estampas del primer sitio de Zaragoza*, Real Academia de San Fernando, archives, *Premios generales*, 1832, I-42.

5. Agustín Alcaide Ibieca, *Historia de los dos Sitios que pusieron á Zaragoza en los años de 1808 y 1809 las tropas de Napoleón* (Madrid, 1830-1831), vol. 3, p. 51.

6. *The Spanish Journal of Elizabeth Lady Holland* (London, 1910), pp. 324-325. Palafox survived.

7. F.J. Sánchez Cantón, "Goya en la Academia," in Real Academia de Bellas Artes de San Fernando, *Primer centenario de Goya, Discursos* (Madrid, 1928), p. 19.

8. Gálvez and (or) Brambila, *Pequeña memoria.*

9. A few plates are dated, all of them *1810.*

10. The French etcher Jacques Callot (1592-1635) published his much-copied set, *Les Miseres et les mal-hevrs de la gverrre* in 1633. The etchings of Romeyn de Hooghe (1645-1708) are illustrations to [A. de Wicquefort] *Advis Fidelle aux Veritables Hollandois. Touchant ce qui s'est passé dans les Villages de Bodegrave & Swammerdam, & les cruautes inoüies, que les François ont exercées. avec Un Memoire de la derniere marche de l'Armée de roí en Brabant & en Flandre* [The Hague], 1673. Small copies of these plates also appeared in other books; see John Landwehr, *Romeyn de Hooghe (1645-1708) as Book Illustrator* (Amsterdam, 1780).

11. Goya's two preliminary drawings, G-W 1002; G., II, 168; and G-W 1001; G., II, 169 are related to the drawing of the event by Gálvez and Brambila and their aquatint *Bateria del Portillo*, in which the inscription describes Agustina de Aragón clambering on top of the corpses to fire the cannon. They depicted the cannon as near a triangular tent protecting part of the earthworks. Without specifying precisely what it was, Goya added a similar triangular shape in his second drawing and retained it in the print; see Sayre, *Changing Image*, pp. 134-135.

12. Etching, burnished lavis, drypoint and burin, Museum of Fine Arts, Boston, 1981 Purchase Fund, 51.1641; G-W 1030; H. 138, III, 1.

13. Order signed by Juan Alvarez Guerra, Mar. 9, 1814; see Valentín de Sambricio, *Tapices de Goya* (Madrid, 1946), Doc. 225. Goya requested assistance, saying that he was then penniless, presumably due to the settlement made with his son in 1812 after the death of his wife.

14. G-W 982; Gud. 623; and G-W 984; Gud. 624, respectively.

15. On this mock-up set, now in the British Museum, see below, part 2 of the introduction to the *Disasters of War.*

16. The copper plates were inherited by Goya's son, Javier, who stored them away until his death in 1854. In November 1862 the Real Academia de San Fernando voted to acquire eighty plates of the *Desastres*, together with eighteen *Disparates* from Don Jaime Machén for 28,000 reales; see Catharina Boelcke-Astor, "Die Drucke der Desastres de la Guerra von Francisco Goya," *Münchner Jahrbuch der Bildenden Kunst* 3-4 (1952-1953), p. 260.

17. Etching, burnished lavis, drypoint and burin; first edition, 1863; Museum of Fine Arts, Boston, Harvey D. Parker Collection (1911 Purchase), M 21914 18-80; G-W 1020; H. 138, III, 1.

Fig. 4. *Mucho sabes, y aun aprendes* (You know a lot and are still learning), *Album E,* verso of page 15(?). Brush with gray and black wash. Museum of Fine Arts, Boston, William Francis Warden Fund, 58.359.

Introduction to *Journal-Album E,* about 1814-1817

(cat. 125-132)

Goya himself made *Journal-Album E* into a book measuring 268 by 189 millimeters, out of good Netherlandish paper from the firm J. Honig and Zoonen.[1] The drawings, all in brush with gray and black wash, were given further visual unification by the addition of black borders. For this reason *Journal-Album E* is often called the "Black Border" album.

Following the lead of August L. Mayer, scholars have generally placed the series early in the nineteenth century. Mayer dated it about 1805,[2] whereas Gassier and Wilson placed the drawings from about 1806 to 1812.[3] However, on stylistic grounds it seems to me difficult, if not impossible, to believe that these drawings were executed during the same years as the earlier plates of the *Fatales consequencias de la sangrienta guerra en España con Buonaparte,* let alone in a period of time close to the *Caprichos.*[4] In the first place, the compositions are infused with a greater classicism than is found either in that part of the *Fatales consequencias* or in *Album C.* In each of the latter, principal figural masses tended to have broken, jagged outlines; lines defining individual forms shared in this characteristic. In *Album E* such compositional restlessness no longer predominates. Furthermore, Goya often expresses form with broad but delicate, tonal brushstrokes that have the capability of making a drawing seem bathed in light, a fine example being the hunter in *¡Si yerras los tiros!* (If You Miss the Mark!) (cat. 128). There is also a perceptible difference in the race of people depicted in *Album E.* In general, they have lost the stockiness of their counterparts in *Album C.* Men and women tend to be even better proportioned, indeed as nobly formed as the citizens of Madrid in Goya's great 1814 paintings of the events of the second and third of May.[5]

In most of the albums, only a few drawings depict clothing that identifies a man or a woman as belonging to the middle or upper class. Yet there are two instances in *Album E* where sartorial clues to the dating of the series are found. In page 48, *Piensalo bien* (Think it over well), a young woman wears not a bonnet but a *toque* or hat of a kind that was very much in fashion in 1815.[6] Wearing trousers rather than breeches and boots was not uncommon in Spain even during the Peninsular War, as we see, for example, in plate 26 of the *Disasters of War, No se puede mirar* (One cannot look). A different aspect of trousers in this drawing is that they have excessively wide legs such as those worn by the contemptuous gentleman on page 16, *Despreciar los ynsultos* (To Disdain the Insults).[7] In Goya's painting of 1815 *Fernando VII Presiding over the Junta Real de la Real Compañía Filipinas,* similar trousers are worn by one of the members.[8] The style can also be seen in plates [16], [17] and [A] of the *Disparates.* Then, having gone out of fashion, these wide-legged trousers disappear from Goya's work.[9]

Even more significant in determining a date than fashion is the subject matter of some of the drawings. The crippled beggar in a drawing with the title *Trabajos de la guerra* (Works Wrought by the War) speaks of a war that has taken place.[10] Both page 27, *¡Si yerras los tiros!* (If You Miss the Mark!), and page 41, *Dios nos libre de tan amargo lance* (God save us from such a

bitter fate), reflect a period that is troubled and lawless (cat. 128 and 131). Common people, heeding the reactionaries who came into power with the return of Fernando VII in 1814, happily smashed symbols of the constitution, as a laborer does with his pickax in page 19, *No sabe lo qe hace* (He doesn't know what he's doing) (cat. 125).[11] Page 22 is a drawing of a bearded woman with her son (cat. 126) based, as the inscription states, on Ribera's portrait *Magdalena Ventura with Her Husband and Son.* The nineteenth-century history of this painting is relevant to the dating of the album. It belonged at the time to the Duque de Medinaceli, and in 1814, during the war, was taken by the French and was listed with the paintings exhibited in Paris on July 25, 1814, in the newly opened Musée Royal.[12] However, Louis XVIII had by then signed a decree ordering restitution to German nobles and Spanish grandees of art works taken from them during the wars of the Republic and the Empire.[13] It is, of course, possible that Goya viewed this painting before the war,[14] but the time when it was most available to him was after August 1815, when it was returned to Spain.[15] Rather than going to the Medinaceli, it remained for some years in the Academia de San Fernando, where Goya could see it, could consider the relationship between a freak and her child, and draw his own profound portrait of the pair.[16]

A fascination of this album with pages whose two sides were initially interchangeable is that occasionally we find on the present versos the beginnings of a composition that was abandoned, perhaps to be begun afresh later. Through these we see that Goya set to work on a drawing in precisely the same manner that he did on a painting or an etching. There was first what might be called an emplacement, brief notes on where the principal compositional mass was to lie. In this example (fig. 4), a seated woman is barely indicated, save for the notation that her hair was to be dressed in a classical fashion. She was abandoned, perhaps because she was too low on the sheet; Goya turned the sheet around and indicated a second emplacement of a boy seeking to escape from a naked, predatory woman. Better pleased, Goya indicated a few bodily outlines, sketched heads and expressions lightly, and began giving form to the woman's breast with shading. We sense the urgency with which he set down on the sheet of paper many aspects, almost simultaneously, of his concept of a subject.

1. The fact that imported paper had again become available in itself suggests a date for the album after the close of the Peninsular War. The pages were loose when Goya began to draw on them, for there are instances where it can be seen that he made an earlier suggestion of the compositional placement on one side of the sheet and then, dissatisfied, turned it over and began again.

2. August L. Mayer, "Echte und falsche Goya-Zeichnungen", *Belvedere* 9 (Jan.-June 1930), pp. 215-217. Harry B. Wehle relied on Mayer's work when he attempted to give Goya's album drawings both order and chronology; see *Fifty Drawings by Francisco Goya*, The Metropolitan Museum of Art Papers, no. 7 (New York, 1938), p. 11.

3. See G-W, p. 289; G., I, p. 168.

4. G-W 1385-1429; G., I, nos. 113-150.

5. G-W 982 and 984; Gud. 623 and 624, respectively.

6. Private collection, France; G-W 1412; G., I, 138. A veritable burst of *toques* appears among the bonnets in the pages of *Journal des dames et des modes: Costumes Parisiens* (Paris, 1815), see nos. 1451, 1454, 1459-1461, 1463, 1466, 1499, 1530.

7. The J. Paul Getty Museum, Malibu, Calif., 82.GG.96; G-W 1391; G, I, 119. Such trousers may have been a Spanish fashion, for nothing quite like them appears in the *Journal des dames et des modes.* In 1816 the *Journal* began to show "pantalons à la Russe" which, though equally wide, were gathered in at the cuff; *Journal des dames* (1816), no. 1584.

8. G-W 1535; Gud. 666. Count Gustaf de la Gardie recorded in his diary, July 2, 1815, a visit to Goya's studio during the artist's absence: "He is busy with a big painting ordered by the Philippine Company, and representing the King, after His arrival here, honouring the Company's meeting with His presence." Quoted by Per Bjurström, "Jacob Gustaf de la Gardie ach Goya," *Tillväxt och Förvaltning* (1961), from the English summary, p. 81. Juliet Bareau kindly drew my attention to this account.

9. G-W 1596, 1598 and 1601; H. 263, 264 and 266. It became fashionable to gather the wide legs in at the cuff, a style that is lampooned in a political lithograph published by Martinet: *1807. autre tems, autre....Calicot. 1817.* A gentleman at the left in *Disparate General*, plate [9] (G-W 1583), wears trousers of this style.

10. Private collection, France; G-W 1420; G., I, 143.

11. F.D. Klingender dated this drawing after 1814 on these grounds; see *Goya in the Democratic Tradition* (London, 1948), p. 195.

12. *Notice des tableaux des écoles primitives de l'Italie, de l'Allemagne et de plusieurs autres tableaux de différentes écoles, exposés dans le grand Salon du Musée Royal, ouvert le 25 juillet, 1814* (Paris, 1814), no. 49.

13. See Ilse Hemple Lipschutz, *Spanish Painting and the French Romantics* (Cambridge, Mass., 1972), p. 51.

14. A copy of the painting in the Ruiz de Alda collection, Madrid, is at present known. For the description of a reduced version, now lost, that hung in La Granja Palace, San Ildefonso, see Juan Agustín Ceán Bermúdez, *Diccionario histórico de los más ilustres profesores de las bellas artes en España* (Madrid, 1800), vol. 4, p. 193. See Craig Felton and William B. Jordan, *Jusepe de Ribera*, Kimbell Art Museum, Fort Worth (1982), no. 11.

15. In an annotated copy of the second edition of the *Notice des tableaux des écoles primitives* (Paris, 1815), belonging to the Museum of Fine Arts, Boston, the owner indicates this Ribera, no. 49, as being among those he had examined and made notes on, but "qu'on a rendus en aoust 1815 aux diverses puissances sur lesquelles en les avait pris sous Napoleon." See also the crate list of fifty-seven paintings, reprinted by Lipschutz, *Spanish Painting*, p. 319. It is in the third crate: "Rivera [sic] La barbuda (De los Grandes de España)" (Ribera. The bearded [woman] [Belonging to the Spanish Grandees]).

16. It is listed in *Catalogo de los cuadros, estatuas y bustos que existen en la Real Academia de S. Fernando en este año de 1818* (Madrid, 1819), no. 199, pp. 19-20. It hung at that time in the Sala del Pasillo. There is a proof of an anonymous, unfinished engraving after the painting in the Biblioteca Nacional, Madrid.

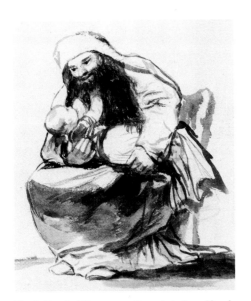

Fig. 5. Detail of *Esta muger Fue retratada en Napoles por Jose Ribera ò el Españoleto, por los años* 1640,
Album E, page 22,
Brush and gray and black wash,
Museum of Fine Arts, Boston,
Gift of Frances and Philip Hofer in honor of
Eleanor A. Sayre

Fig. 6. Detail of *La madre Celestina,*
Album D, page 22,
Brush and gray and black wash,
Museum of Fine Arts, Boston,
William Francis Warden Fund

Introduction to Journal-Album D, about 1816-1818

(cat. 133-135)

In *Album D* Goya continued to use brush and gray wash and was again able to acquire good Netherlandish paper, measuring 237 by 147 millimeters, this time with a FLEUR-DE-LYS watermark and illegible fragments of letters. It is the shortest of the books of drawings; the highest known numbered page, 23, came to light recently.[1] Subject matter in *Album C* and clothing in *Album E* gave evidence that was helpful in dating the series. Here, we are not as fortunate. We see in everyday guise, the quintessential procuress and her magic potions (cat. 134), a monk snoring, or members of an order chanting drunkenly as they leave chapel, their habits pulled clumsily on over lay breeches.[2] We also see procuresses and clerics as the witches and warlocks into which they have turned themselves through vices (see cat. 133). Two ancient witches are richly clothed, but in each case it is hard to be certain whether Goya was intending to depict costumes of earlier centuries or unbecoming, exaggerated versions of fashionable dresses in the later part of the second decade of the nineteenth century.[3] One of these witches, in *Cantar y bailar* (Singing and Dancing), is lifted into the air by a song she is playing on her guitar;[4] the other, whose title *Visiones Sab. . .* (Visions. . .) is now partly lost, shows a terrifying hag raising aloft an unfortunate man, who is bound to her arms by entwining serpents.

In the second part of the *Caprichos*, Goya had depicted the transformation into witches and warlocks of bawds and clerics who indulged in vice (cat. 57-61). In these prints Goya attacked their vices with stinging passion, yet we also sense his underlying, optimistic belief that, could he but illumine the evils they practice, they would recognize them, understand, and turn away. There is no comparable wellspring apparent in any of the pages of *Album D*, whose general mood seems one of pessimism and whose bleakness was perhaps justified under Fernando VII.

Officially, Goya seems at the time to have been in reasonably good odor when he was working on this album. In 1816 the Real Calcografía (Royal Chalcography) included the *Caprichos* in an advertisement of the prints they had for sale.[5] That same year, or possibly the following, he was one of five artists selected to decorate with grisailles one of the rooms in the Royal Palace for María Isabel de Branganza, Fernando VII's second wife.[6]

When describing the physical aspects of the journal-albums some thirty years ago, I gave each of them a letter of the alphabet in order to assign to these books a rough chronology.[7] I thought then that *Album D* was earlier because a few of the drawings have a silvery tonality something like that of the *Album A* and *Album B* drawings. I now believe that I was mistaken in placing this book before *Album E* rather than after it.[8] The race of people is slightly taller in *Album D* than in *Album E* and, even more important, in some of the drawings we catch the beginning of a stylistic change that is pronounced in *Album F*. The change is easily seen when one compares an *Album E* drawing with one from *Album D*. In the drawing of Magdalena Ventura from the former, the contours of the child she holds, and of her face, and even of her body, hidden though it is under thick clothing, are all easily

discernible (fig. 5). There is not the same clarity in a drawing from *Album D* of the vital, old bawd Celestina (fig. 6). The volumetric aspects of forms in the latter are far more ambiguous. The fingers of the left hand greedily clasping a bottle of wine are easily read, but those of the right are barely suggested. We cannot see precisely where her ear is situated on her head; we do not know at what point the edge of her shawl overlaps her sleeves, nor can we say which is the lower edge of her skirt. In addition, Goya added black lines on the right side of her shawl and skirt and over her lap that have nothing to say about the curving shape of her body and constitute instead an abstract, linear pattern superimposed on three-dimensional forms.

Goya made such lines serve the same purpose as the burnished highlights in the *Caprichos*, that is to force the viewer to notice whatever he wished them to see. Here, the dark, angular lines lead inexorably toward Celestina's scheming face. In another instance, *Suben alegres* (They rise merrily) (cat. 133), he succeeded in making the black pattern convey expressionistically the noisy movement of two witches flying through the air.

It is possible that Goya acquired this drawing book in the south of Spain, as he probably had *Albums A* and *B*. On September 13, 1817, he went before a notary in Madrid to give one Manuel Sillero power to draw the salary to which Goya was entitled as court painter.[9] This suggests that it was his intention to be absent from Madrid for some time. Later that month he was in Seville and had begun work on a painting for the Cathedral of Seville of two martyrs, Saints Justa and Rufina, staying, it has been reported, in the house of a Sevillian painter, José María Arango, whose hospitality Goya repaid by painting him at the age of twenty-seven.[10] Juan Agustín Ceán Bermúdez had secured the commission for the religious painting for Goya from the cathedral chapter and had then watched over the project like an anxious mother hen. On September 27 Ceán Bermúdez wrote to a friend: "ya está bosquejando el cuadro" (now at last he is roughing out the [full size] painting),[11] and on January 14, to the same friend: "Salió perfectísimamente, y es la mejor obra que pintó y pintara Goya en su vida, y el Cabildo y toda la Ciudad están locos de contento" (It came out to absolute perfection and is the best work Goya has painted in all his life and will paint, and the Chapter and the whole city are wild with joy).[12] Goya was paid 28,000 *reales de vellón.*

The artist was back in Madrid by March 28, 1817, when he acknowledged the receipt of 10,000 *reales de vellón* for his portrait of the tenth Duque de Osuna, painted the preceding year.[13] For 1818 no evidence has come to light on where Goya might have been, or what work he may have done.

1. *No puede ya con los 98 años* (Ninety-eight years is too much of a burden), in which an old person totters about on a pair of canes. The drawing, unknown to G-W and G., was sold at auction by the Galerie Kornfeld, Bern, June 20-22, 1984, *Moderne Kunst des neunzehnten und zwanzigsten Jahrhunderts*, no. 378.

2. Page [c]; G-W 1380; G., I, 109; and page 7, *De esto nada se sabe* (About this, nothing is known); G-W 1371; G., I, 99. For a more seemly view of undergarments, see the monk at the right in *Disas-*ters of War, plate 43. The brother to the left of him is caught in flight still wearing lay breeches; in the preliminary drawing both monks had them on; G-W 1062; H. 163 and G-W 1063; G., II, 194, respectively.

3. Pages 3 and [g]; G-W 1369 and 1384; G. I, 97 and 112, respectively. In the second half of this decade, dresses had lost their classical, columnar shape and become wider at the bottom. The bottom quarter of the skirts was almost always decorated by horizontal lines; sleeves were also larger and more important than they had been earlier; see *Journal des dames et des modes: Costumes Parisiens* (Paris), for the relevant years.

4. Page 3; G-W 1369; G., I, 97.

5. *Gaceta de Madrid*, Sept. 26, 1816; see H., Appendix VI. The *Caprichos* had already been disseminated during the Peninsular War, see the Introduction to the *Caprichos*.

6. *Saint Elizabeth Tending a Sick Woman*; G-W 1568; Gud. 652. Fernando VII married his nineteen-year-old niece on September 29, 1816.

7. Eleanor A. Sayre, "An Old Man Writing: A Study of Goya's Albums," Museum of Fine Arts, Boston, *Bulletin* 56 (autumn 1958), Appendix I, pp. 130-134.

8. Harry B. Wehle, *Fifty Drawings by Francisco Goya*, The Metropolitan Museum of Art Papers, no. 7 (New York, 1938), p. 11, was correct in the order of the two albums, although not, I think, in dating *Album E* as early as about 1805; he dated *Album D* about 1815. G-W 1368-1384 and G., I, p. 140, date the latter about 1801-1803.

9. Valentín de Sambricio, *Tapices de Goya* (Madrid, 1946), Doc. 249.

10. C. Muñoz y Manzano, Conde de la Viñaza, *Goya: Su tiempo, su vida, sus obras* (Madrid, 1887), p. 258, no. 104. The painting is not at present known.

11. Letter from Ceán Bermúdez to Tomás de Verí, written from Seville, quoted in Nigel Glendinning, *Goya and His Critics* (New Haven, 1977), p. 56. On Ceán and this painting, see idem, *Goya*, pp. 55-58 and Appendix I, pp. 287-290. For the Spanish text, see Xavier de Salas, "Dos notas, a dos pinturas de Goya de tema religioso," *Archivo español de arte*, no. 185 (1974), p. 390.

12. Quoted in de Salas, "Dos notas, a dos pinturas de Goya," p. 391; see also Glendinning, *Goya*, p. 56.

13. Archivo Nacional 515-8 bis; see Condesa de Yebes, *La condesa-duquesa de Benavente* (Madrid, 1955), p. 49.

Introduction to the *Disparates*, about 1816-1817
(cat. 136-143)

Goya probably worked on the *Disparates* (Follies) in Madrid at the same press he had used for his *Tauromaquia* of 1816.[1] He seems to have undertaken each new series with a burst of creative energy that affected not only his style but also his technique. The race of men and women in this set is losing the air of nobility it had in *Album E* and is growing elongated. Patches of delicate shading are combined with a pattern of strong dark accents. Aquatint is used with an unorthodox freedom that permitted Goya to brush acid directly onto a copper plate when he chose, or blot at the edge of a tone to soften a transition.[2]

Although Goya was unable to publish the *Disasters of War* during his lifetime, we know from a mock-up copy composed of working proofs with titles written in his hand what every caption was to be, the order in which the prints were to appear, and the tonal beauty and elegant clarity that he intended that the printers should give each image.

Unfortunately, in addition to lacking a mock-up set of the *Disparates*, we have almost no solid information concerning the prints. We cannot even be certain that Goya intended all twenty-two of the plates customarily called *Disparates* to form part of his set, since one of the prints made its first appearance in 1816 as plate 34 in a mock-up set of the *Tauromaquia*. This set was given to the art historian Juan Agustín Ceán Bermúdez so that he might work on Goya's titles. Edited by Ceán, the title reads: *Treinta y tres Estampas, que representan diferentes suertes y actitudes del arte de lidiar los Toros; y una el modo de poder volar los hombres con alas* (Thirty-three prints that represent different *suertes* (passes) and positions in the art of bullfighting, and one of the manner in which men can fly with wings). In the table of contents the print is succinctly described as *Modo de volar* (A Way of Flying).[3]

Possibly, at one time Goya put together a similar mock-up set of the *Disparates*, since working proofs of fourteen plates have come down to us that have brief titles in his hand, written in the lower margins.[4] In every case these captions specify a particular *Disparate*. The first barrier to our understanding the series is that we do not know what the titles of the remaining prints would have been.

A second difficulty is that we lack completed working proofs with the aquatint, as well as the etching, for some of the *Disparates*. It is a lack that affects connoisseur and scholar alike. At present, working proofs are known for only sixteen of the twenty-one (or twenty-two) prints that constitute the series. The posthumous impressions of the *Disparates* to which we are accustomed fall far short of conveying the power and beauty of the prints, and furthermore they are incapable of transmitting the intricate, delicate, revealing patterns of balanced light and dark tonalities of Goya's working proofs printed on early nineteenth-century Spanish laid paper. As always, it is these abstract patterns that direct us toward what is important in the image. When an image has been distorted by printers with aesthetic ideas of

their own, or through the wear of the plate, almost inevitably we fail to comprehend the full meaning of Goya's print. Working proofs are shown in the present exhibition, save in one instance where none is known.

The third difficulty is that we do not know in what order the artist wished the prints to be published. Goya arranged the *Disasters of War* in order, and numbered the *Caprichos* and all but the first of his journal-albums. It is important to be aware of the sequential context of a print or drawing, for what surrounds it often explains, comments on, or enhances its meaning. The customary order given the *Disparates* is that of an edition published by the Real Academia de San Fernando in 1864.[5] Four plates from the series had by then become separated from the others.[6] There is no proof whatever that the Academia derived the order from Goya, and indeed it is likely that they simply based what they did on the sequence given the prints in a paperbound copy of an earlier posthumous edition inscribed: *GOYA / Los Proverbios / Madrid hacia 1848* (Goya / The Proverbs / Madrid, about 1848).[7]

It is tantalizing to find numbers written in pen in the upper margins of a number of working proofs, at the upper right, the upper left, or, in a few instances, in both corners. Unfortunately, these seem to be in four handwritings, not one of them autograph. In 1951 Camón Aznar published the *Disparates* in a sequence that these numbers suggested to him. But it is impossible to rely on these numbers since they are contradictory; yet because the possibility remains that some small part of them may reflect an order originally set by Goya, the numbers are given here (see table).

Since so much solid information concerning the *Disparates* is lacking, we need to examine them with both care and judgment if we are to understand what Goya meant in these haunting prints. Whatever knowledge of Goya's iconographical usage has been gained from the other series of prints, drawings, and paintings should be brought to the task. One print, of an old man rising from his body to confront phantoms (cat. 137), appears to be related to the two famous *Sueños* (Dreams) frontispiece drawings and *Capricho* 43, *El sueño de la razon produce monstruos* (The sleep of Reason produces monsters) (cat. 50-52). Since this *Disparate* has no caption in Goya's hand identifying it as a specific folly, I have dared to suggest that he intended it as the frontispiece to a new series in which once again he would attack *bulgaridades perjudiciales* (harmful ideas commonly believed), which had gained fresh strength under Fernando VII.

1. An additional reason to suppose the press was the same is that the SERRA and MORATO papers used for the *Disparates'* trial proofs were also used in the first edition of the *Tauromaquia*. Goya is known to have been in the capital much of 1816 and 1817. We know nothing of his activity or whereabouts in 1818.

2. An example where both practices were used is *Disparate Cruel*; G-W 1579; H. 253.

3. Sayre, *Changing Image*, pp. 200, 207, 248-250. When I examined the set, it belonged to the Carderera family. It is now in the British Museum, London, 1975-10-25-422 (1-37). See Juliet Wilson Barreau, *Goya's Prints: The Tomás Harris Collection in the British Museum* (London, 1981), pp. 44, 104.

4. Some, if not all, of the titles were written in graphite by Goya. His original letters were carefully overwritten in pen by someone else, to make them more easily legible.

5. G-W 1571, 1573, 1575, 1576, 1578, 1579, 1581-1583, 1585, 1587, 1589, 1591, 1593, 1594, 1596, 1598, 1600; H. 248-265, III, 1.

6. These are the plates listed as A, B, C and D. They were published first in Paris by *L'Art* 2 (1877); G-W 1601-1604; H. 266-269.

7. Museum of Fine Arts, Boston, 1973.701, by exchange, Bequest of Horatio G. Curtis, and Harvey D. Parker Collection. The Academia likewise called their edition *Los Proverbios*.

A small number of sets were printed at this time on two types of paper. Handwritten tiltes in one of them, now in the British Museum, were the source for the proverbs Harris used as titles to the *Disparates* in his catalogue raisonné.

Old Numbers on Working Proofs of *Disparates* and *L'Art*

Right	Left	Academia and *L'Art*	Title	Medium
-	2	6	Disparate Cruel	etching[1]
3	-	6	*Disparate Cruel*, lower margin	aquatint
-	1a	7	Disparate Desordenado, touched	etching
4	-	7	*Disparate Desordenado*, lower margin	aquatint
5	-	11	*Disparate Pobre*, lower margin	aquatint[2]
-	14	11	Disparate Pobre, touched	aquatint
-	-	15	Disparate Claro, touched	etching
7	-	15	*Disparate Claro*, lower margin	aquatint
8	-	9	*Disparate General*, lower margin	aquatint[3]
-	12	B	*Disparate puntual*, lower margin	aquatint
-	13	2	Soldiers Frightened by a Phantom	aquatint
16	15	1	*Disparate Femenino*, lower margin	aquatint
17	15	5	*Disparate Volante*, lower margin	aquatint
18	9	3	*Disparate Ridiculo*, lower margin	aquatint
19	8	12	*Disparate Alegre*, lower margin	aquatint
20	-	A	*Disparate conocido*, lower margin	aquatint
21	6	14	*Disparate de Carnabal*, lower margin	aquatint[4]
22	-	C	*Disparate de Bestia*, lower margin	aquatint
-	3	10	Woman Carried Off by a Horse	etching[5]
25	-	10	Woman Carried Off by a Horse	etching
-	4	13	Modo de volar	etching
		13	*Modo de volar*[6]	etching
-	-	D	*Disparate de tontos*, lower margin	aquatint
-	-	18	Old Man Confronting Phantoms	aquatint
-	-	4	Giant	etching[7]
		8*	Aristocrats in Sacks	
		16*	Indecisiveness	
		17*	Man Being Mocked	

Note: The prints are arbitrarily arranged according to the right-hand number.

Titles in italics are in Goya's hand.

*No working proof is known for this print.

1. Another etched working proof survives; see H. 253, I, 1.

2. This working proof is now in a private collection, Germany.

3. The Beurdeley working proof is in the Mead Art Museum, Amherst College, Amherst, Mass.

4. There is a second working proof with aquatint; see H. 261, I, 2.

5. A third etched working proof is known; see H. 257, I, 1.

6. This impression was used by Goya as plate 34 in the mock-up set of the *Tauromaquia* given Ceán to edit; *34*, top center.

7. Two additional etched working proofs are known; see H. 251, I, 1.

Introduction to *Journal-Album F,* about 1817-1820
(cat. 144-153)

The drawings in *Album F* are in brush and brown wash on Spanish paper watermarked with a decorative SHIELD, containing the letter M, that is crowned with a cross and has a dependent heart. The maker's name appears as PAULAR, perhaps that of the manufactory owned by one of the richest Carthusian monasteries in Spain, El Paular.[1] The book of paper, sewn together on the left side, was not in pristine condition when Goya began to draw in it. Near the top of the first nineteen pages sealing wafers had been affixed, most of them still covered with paper that occasionally had fragments of writing. The upper part of three other sheets had been used. Goya ignored or obliterated all these defects or incorporated them into the drawings. For example, he covered an entry concerning a financial transaction in 1799 with wash that suggests the abutment of a bridge under which a group of men are seen fishing.[2]

Despite the appalling conditions in Spain during the years of Fernando VII's reign, Goya's interest in the world was as penetrating and as diverse as ever. In this journal-album there is a passage of five pages on dueling in the past (see cat. 144 and 145)[3] and one of ten on the pleasures of hunting in the present.[4] Three pages depict sins that beset us.[5] There are the credulous, the wretched, and travelers, some undergoing comic misadventures on the road.[6] And there are passages of poignant reflection on what Goya saw happening around him.

Recently, scholars have dated *Album F* between 1812 and 1820, or even 1823,[7] but there are a number of reasons why it seems to me that this span of time can be narrowed. The race appears thinner than in either the earlier or the later part of the *Disasters of War*; physiologically, it is closer to the *Disparates.*

Furthermore, a few pages are connected with other works of art that can be dated. One drawing figures in the early history of the first lithographic press to have been established in Spain. The person behind the venture was Felipe Bauzá, head of the Hidrografía (Bureau of Hydrography), who saw in this new medium a quick, inexpensive way to print naval charts. José María Cardano, an outstanding map engraver and a pilot, was selected to learn lithography in Paris and Bavaria and to oversee the construction of a press in Madrid.[8] He returned to Spain late in 1818 and within a few months had the press functioning, when Goya, almost seventy-three years old, tried it out. His is the earliest dated Spanish print in this medium that is known to have survived – a not altogether technically successful pen lithograph of an old woman spinning, inscribed *Madrid Febrero 1819.*[9] Another of Goya's experimental lithographs with which he experienced similar difficulties depicts a dueler wearing the clothing of a bygone century, who pierces his opponent through with a sword.[10] This lithograph, printed the following month, is based on page 12 of *Album F.*[11]

Artists elsewhere in Europe had only just begun to be interested in lithography, and it may have been for this reason that Cardano invited Goya to try the press, hoping that Spanish artists would also sense its possibilities.

Fig. 7. *Skaters,*
Album F, page 30.
Sepia.
Museum of Fine Arts, Boston, Otis Norcross Fund and Gift of Mrs. Thomas B. Card

1. See Antonio Ponz, *Viaje de España; seguido de los dos tomos del viaje fuera de España*, ed. Casto María del Rivero (Madrid, 1947), vol. 10, p. 881, letter 4, para. 45. The first edition of this volume appeared in Madrid, 1781. See also [Jean François, baron de Bourgoing], *Nouveau voyage en Espagne* (Paris, 1789), vol. 1, pp. 157-158.

2. Page F [a], The Frick Collection, New York; G-W 1455; G., I, 364. The other two where wash obscures writing are G-W 1483 and 1508; G., I, 328 and 353.

3. Pages 10-15; G-W 1438-1443; G., I, 284-289.

4. Pages 96-106. Page 96, *A Hunter with His Dog Beside Him, Pointing*, is perhaps that listed in G., I, p. 497, under lost drawings as F. j.; it was on the London market in 1986. The other nine are G-W 1510-1518; G, I, 355-363.

5. Pages 63-65; G-W 1484-1486; G., I, 329-331.

6. Pages 38-39; G-W 1463-1464; G., I, 308-309.

7. See G-W 1431-1518; G., I, 277-364 and p. 386.

8. Félix Boix, "La Litografía y sus orígines en España," *Arte Español* 7, no. 8, 1925, pp. 282-283.

9. G-W 1643; H. 270. See Boix, "La Litografía," p. 283.

10. G-W 1644; H. 271.

11. G-W 1440; G., I, 286. Paul Lefort, "Essai d'un catalogue raisonné de l'oeuvre gravé et lithographié de Francisco Goya," *Gazette des Beaux-Arts* 25 (1868), pp. 176-178, described an impression belonging to him as being signed and inscribed *Madrid, Marzo 1819*. This seems to be the impression Lefort reproduced, p. 177, in facsimile by Pilinski. The inscription Lefort cites (but not the signature) can be seen written at the left of the print in duplicate reproductions printed on thin paper included only in deluxe copies of the journal; one such is described in H., no. 271.

The Carderera impression also known to Lefort and now in the Biblioteca Nacional, Madrid, was printed on the verso of a lithograph after Murillo by Cardano. The verso of the Prado impression shows fragments of a ship and rigging.

12. Boix, "La Litografía," p. 283.

13. See Goya's letters to Joaquín Ferrer, Dec. 6 and 20, 1825, see *Colección de cuatrocientas curarenta y nueve reproducciones . . .* (Madrid: Saturnino Calleja, 1924), pp. 54-55. They are the first great lithographs.

14. Boix, "La Litografía," p. 285.

15. Page 35, a scene of unpalatable-looking monks, gloating as they turn the pages of a book, may have an ideological relationship with *Capricho*, plate 71, *Contra el bien general* (Against the Common Good) (cat. 158, fig. 2); G-W 1460; G., I, 305 and G-W 1116; H. 191, respectively.

16. Museum of Fine Arts, Boston, 61.166; G-W 1456; G., I, 301.

Indeed, on March 16, Fernando VII broadened the potential activity of the press by decreeing that it should be "un Establecimiento público de litografía o arte de grabar en piedra, bajo la Dirección de D. José Cardano" (a public institution for lithography, or the art of graving on stone, under the directorship of Don José Cardano), who was to be decorated "con los honores de su litógrafo de Cámara en premio de su incesante y provechosa aplicación, y para el estímulo de otros" (with the honor of court lithographer in recognition of his constant and profitable application and also to encourage others).[12]

Goya may have been the more willing to respond to the invitation to try the press because of the political inclinations of Bauzá and Cardano. Cardano, perhaps then and certainly later a friend of Goya's, turned the press over to his brother and left Spain voluntarily in 1822, settling in Paris. It was José Cardano whose opinion Goya sought on the great Bordeaux lithographs of bulls that were so far ahead of their time.[13] Bauzá was forced to emigrate to London when the Constitution was abrogated in 1823 because he had been a delegate to the Cortes.[14]

Goya used drawings in *Album F* as the ideological source for two plates of the *caprichos enfáticos*, that extraordinary portion of the *Disasters of War* etched after Fernando VII was forced to accept a return of constitutional government in 1820. The subject of these is the Constitution of 1812 (see cat. 147 and 151; 148 and 162).[15]

In this book Goya suggests the illusion of form principally through light and darkness that tend to leave the specific contours of shapes ambiguous. Even more marked than in *Album D* is Goya's use of lines which do not define shapes but are superimposed on them. These lines function as do musical variations on a theme, alter its pace, its character, or its mood. Thus, in a drawing of men and women skating, page 30, we see that, rather than detailing the quality of skirt, jacket, or cape, surface lines are used to suggest the movements made by the skaters (fig. 7).[16] Or in the fight between two peasants on page 73, we note that these lines form an abstract pattern that both states the bitterness of the struggle and comments on the tense, expressionistic distortion of male bodies (cat. 152).

Fatales consequencias de la sangrienta guerra en España con Buona-parte. Y otros caprichos enfaticos (The terrible results of the bloody war in Spain against Bonaparte. And other emphatic *caprichos*), the so-called *Disasters of War.*

Part 2, 1820-1823
(cat. 154-163)

After seven years of a troubled, repressive, vindictive rule, Fernando VII found it prudent to swear to the Constitution on March 9, 1820. With the return of freedom of the press during the three years constitutional monarchy managed to survive, much that had been considered censorable burst into print. Goya prepared to publish his extraordinary set of prints on war and famine, not as the set was constituted in 1814, but expanded. He etched a frontispiece, *Tristes presentimientos de lo que ha de acontecer* (Sad forebodings of what is to happen),[1] inserted several additional plates into the old part that concerned the active resistance of Spaniards to Napoleon, and added a group of allegorical prints (cat. 154-163). When the new plates were completed, he put together a set, adding a caption in pencil below each image, had the plates bound, and had someone carefully letter the title in pen and brown ink on the flyleaf of the binding: *Fatales consequencias / de la sangrienta guerra en España / con Buonaparte. / Y otros caprichos enfaticos, / en 85 estampas. / Inventados, dibuxados y grabados, por el pintor original / D. Francisco de Goya y Lucientes. / En Madrid* (The terrible results of the bloody war in Spain against Buonaparte. And other emphatic *caprichos* in 85 prints. Invented, drawn, and graved by the creative painter, don Francisco de Goya y Lucientes. In Madrid). He gave the set to Juan Agustín Ceán Bermúdez so that he might edit the title and the captions.[2] The work, as it is seen today, has eighty rather than eighty-five plates. Five plates became separated from their fellows after Goya's death, two of the *caprichos enfáticos*, plate 81, *Fiero monstruo* (Fierce Monster) (cat. 163, fig. 3)[3] and plate 82, *Esto es lo verdadero* (This is the true [way]) (cat. 163), and the three small plates of prisoners that were pasted in at the very end (see cat. 95-96).[4]

It is not difficult to know which plates Goya added at the end of the set or inserted among the earlier prints, since his style had changed considerably during the intervening years. There are marked physical differences in the race shown in the new ones. It is not the race of tough and sturdy men and women he depicted during the Peninsular War. Nor is it the taller, frailer race he drew between 1817 and 1820 in the pages of *Album F*. What we see etched in the *caprichos enfáticos* is the same race that he depicted in the "Black Paintings," where tall, large-boned men and women predominate.

Whenever Goya returned to the medium of etching, he explored its possibilities anew. The *caprichos enfáticos* and inserted prints are stylistically different, not only from the earlier *Disasters of War* but also from the *Disparates* of about 1816 to 1817. In the *Disparates*, aquatint played a major, sometimes dramatic, role; the patchy etching that lay underneath it served as often to increase the illusion of chiaroscuro in figures as to model the shifting planes of bodies in motion. In most of the plates executed between 1820 and 1823 Goya dispensed altogether with aquatint. He used

etching, drypoint, and burin in a tonal manner, with subtlety, and often with extraordinary delicacy. Lines were grouped in a way that often suggests the medium of painting, as, for example, in plate 8, *Siempre sucede* (It always happens) (fig. 8.); there, short, abstract lines of shading rarely adapt themselves to the contours of the bodies of the horses running headlong across the background, and even when they do, in the case of the horse thrown violently to the ground, they retain an abstract quality.[5] It is as though Goya perceived how to distill an essential characteristic of his oil paintings and to manifest his energetic brushstrokes in a different medium.

Goya's liking for the ambiguity of edges that delimit forms had become even more pronounced by 1820. It is characteristic of his prints etched during the triennial period that in *Siempre sucede* it has become impossible to separate the body of the fallen rider from that of his steed, and it is characteristic that lines of shading to the right sweep unimpeded across both the horses and the smoke of battle behind them. Goya suggested rather than depicted the violence of the physical movements, reserving detail for that which contributes to the iconographical meaning of the scene; a cavalry officer's helmet, his taut, concerned face, and another rider's hand suddenly stilled. To an even greater extent than he had been able to do in the past, Goya organized the composition into an expressionistic pattern that in itself constitutes a comment on the rout that is taking place.

Goya had called the set of prints he had published in 1799 *Caprichos*, a work that, as the collector Valentín Carderera rightly perceived, satirized vices current in Madrid (see the introduction to the *Caprichos*). The subject matter of these prints reflects what was being written at the time (part of it censorable) and what was discussed among friends. *Caprichos* is one of the two words Carderera also used to categorize the paintings Goya executed between 1820 and 1823 in his house, called the Quinta del Sordo, on the banks of the Manzanares, the "Black Paintings": "apenas hay pared, sin exceptuar las de la escalera, que no estén llenas de sus caprichos y caricaturas, a las que no pocos han prestado ocasión los mismos que concurrían a visitarle" (there is scarcely a wall, including the stair-well, which is not filled with his *caprichos* and caricatures, sometimes those who visited him providing the subject of them).[6] *Caprichos*, things which do not adhere to reason, in this case, *caprichos enfáticos* (emphatic *caprichos*) are what Goya's title page tells were added to the *Disasters of War*. Nigel Glendinning has suggested that the phrase as it is used here was intended to convey the technical meaning: "to make a point or give a warning by insinuation rather than by direct statement."[7] These enigmatic prints were etched during the same three years that he decorated the walls of his house. When Goya was living in Bordeaux, he began at the age of seventy-nine yet another set of *caprichos*, trying out his ideas in the old medium of etching (cat. 179) and also in the new one, lithography.[8]

The *caprichos enfáticos* echoed with biting clarity the passionate writings of the early nineteenth-century Liberals who believed in the rule of constitutional government with its inherent power to rectify injustice. As in the *Caprichos* of 1799, Goya did not hesitate to attack hypocrisy and overween-

Fig. 8. *Siempre sucede* (It always happens),
Disaster of War, plate 8.
Working proof,
Etching and drypoint,
Museum of Fine Arts, 1951 Purchase Fund

ing greed where he found it in the monastic orders (cat. 155), and there are new examples of the unreason that flourished during the reign of Fernando VII when both Church and State were at their most reactionary. When we look at these prints in the form of rare working proofs printed for Goya, the most moving and the most beautiful prove to be the pair that comment on fragile, constitutional Spain. In plate 79, clothed in her simple dress, this Spain emits a glory of light even though she lies helpless on the ground as Justice mourns her passing. Those whom we might expect to support the truth and goodness embodied in her governance, the clergy, are the very ones wish to bury her. Goya wrote *Murió la verdad* (Truth died) (cat. 161). In plate 80, *Si resucitará?* (Will she rise again?) (cat. 162), neither the priests who threaten her nor the monks who beat and stone her and have readied her grave have as yet been able to extinguish what Goya now depicts as an unearthly glow (cat. 162). On April 7, 1823, a French army, at the invitation of Fernando VII, invaded Spain and on May 23 occupied Madrid. On October 1 Cádiz surrendered, and absolutist government returned. Goya never offered the *Disasters of War* for sale.

1. G-W 993; H. 121.

2. Below this title is written in another hand: *Este exemplar es el unico que se arregló y encuaderno pa que Dn Agus-/ tin Cean Bermudez corrigiese los epigrafes y esta portada. asi debe tenerse en mucha / estima. Los epigrafs son de mano de Goya.* (This copy is the only one that was put in order and bound so that Agustín Ceán Bermúdez might correct the captions and the title page. Thus it should be held in high esteem. The captions are in Goya's hand.) The writing appears to be that of Valentín Carderera, who acquired the set. It now belongs to the British Museum 1975-10-25-421(1-87); see Juliet Wilson Bareau, *Goya's Prints: The Tomás Harris Collection in the British Museum* (London, 1981), p. 44, 103.

3. G-W 1136; H. 201.

4. The copper plates were inherited by Goya's son, Javier, who stored them away until his death in 1854. In November 1862 the Real Academia de San Fernando voted to acquire eighty plates of the *Desastres*, together with eighteen *Disparates* from Don Jaimé Machén for 28,000 reales; see Catharina Boelcke-Astor, "Die Drücke der Desastres de la Guerra von Francisco Goya", *Münchner Jahrbuch der bildenden Kunst* 3-4 (1952-1953), p. 260. On the prisoners, see Bareau, *Goya's Prints* (London, 1981), p. 44.

5. Etching and drypoint, working proof, Museum of Fine Arts, Boston, 1951 Purchase Fund, 51.1628; G-W 1003; H. 128, I, 1.

6. See Valentín Carderera, "Goya," *Semanario pintoresco*, 1838; the article is reprinted in Enrique Lafuente Ferrari, *Antecedentes, coincidencias e influencias del arte de Goya* (Madrid, 1947), Appendix II, 3; this passage, p. 307.

7. Nigel Glendinning, "A Solution to the Enigma of Goya's 'Emphatic Caprices,'" *Apollo* 107 (Mar. 1978), p. 186.

8. G-W 1700-1702; H. 279-281 and G-W 1823, 1825-1829; H. 30, 32-35 (G-W 1828 not in H.). G-W 1824 and 1828; H. 33-34 seem to me to be copies. On these prints, see Eleanor A. Sayre, *Late Caprichos of Goya: Fragments from a Series* (New York, 1971). Writing on December 20, 1825, to Joaquín Ferrer, who had asked him to reprint the *Caprichos* of 1799, Goya said he no longer owned the plates, "ni yo las copiaria pr qe tengo mejores ocurrencias en el dia para que se vendieran con mas utilidad" (nor would I copy them because right now I have better ideas [for *Caprichos*] that might be sold with more effect). Quoted in *Colección de cuatrocientas cuarenta y nueve reproducciones* (Madrid: Saturnino Calleja, 1924), p. 55.

Fig. 9. *Andar sentado á pie y a cavallo,*
Album G, page 10
Black chalk.
Museum of Fine Arts, Boston,
Gift of the Frederick J. Kennedy Foundation

Introduction to Journal-Albums G and H, 1824-1828

(cat. 164-173, 174-178)

Journal-Album G and *Journal-Album H,* known as the Bordeaux albums, were both made of the same greenish paper that, with the years, has all too often faded to cream, or even turned somewhat yellow, from overexposure to light. Their maximum known sizes are 193 by 156 millimeters and 193 by 158 millimeters. In some pages we may find either the upper or the lower part of a watermark – bleeding HEART surmounted by a TREFOIL, above a CROSS flanked by RAMPANT LIONS[1] – or occasionally the initials of the firm: R J. At one time the books must have been bound, since traces of the needle holes can occasionally be seen at the left edge of a drawing. Goya drew in these books with black chalk, sometimes wetting it to give darker lines.[2]

Goya had withdrawn to France in 1824. We know when he crossed the border almost to the day, for on June 24 the Sous-Préfet of Bayonne wrote to the Ministre de l'Intérieur that he had granted Goya a provisional pass to Paris "pour consulter les médecins et prendre les eaux qui lui seront ordon-nées" (to consult doctors and to take whatever waters are prescribed for him).[3] He arrived in Paris on June 30, according to the police who kept watch on potential subversives;[4] and on September 1, he applied for a pass-port to settle in Bordeaux.[5] He probably arrived there in time to welcome into his household Doña Leocadia Zorrilla de Weis[s],[6] her second son, Guil-lermo, and her daughter, Mariquita (or to give her her true name, María del Rosario), who was then not quite ten.[7] Goya was profoundly proud of Mari-quita. When she wanted to go to Paris to learn to be a miniaturist, he remarked: "yo tambien quiero, por ser el fenómeno tal vez mayor qe habra en el mundo de su edad hacer lo qe hace, la acompañan calidades muy apreciables" (I also wish [it], as she is perhaps the greatest phenomenon in the world to be doing what she does at her age; she is endowed with exceptional talents).[8]

The Bordeaux albums, like their predecessors, satirize the world Goya saw around him, many of the targets being ones at which he had previously aimed, and satire is the principal force behind the sequence of *locos* (crazy people) in *Album G,* pages 32-41 (see cat. 168-170). Both albums contain in addition drawings that are not harsh in spirit. In *Album H* we encounter the python, the crocodile, and the thin man seen at the Bordeaux fair of 1826; and in *Album G* there are drawings that are visual jokes such as *Andar sentado à pie y a cavallo* (To Travel Seated, on Foot and on Horseback) (fig. 9).

Once again, stylistic changes can be observed; edges of forms are more ambiguous than ever, and their ambiguity is increased when hatching used to shade areas leaps across boundaries from form to form as in *Andar sentado.* Yet Goya's visual imagination is so acute that when the drawing is viewed from the proper distance, the shading suggests the presence of volu-metric forms we do not see. Lines that, looked at cursorily, appear to outline form may in reality serve the more important function of creating an abstract pattern to suggest mood or movement. For example, in *Andar sentado* lines that seem to outline the rider's leg and the horse's belly in relief accent the

intensity with which the hobbyhorse is ridden. It is a characteristic of the drawings (as well as the paintings and prints executed in Bordeaux) that the principal compositional mass is off-center so that the rectangular surface on which it appears seems to contain it only with difficulty.

Throughout the years the bodily proportions of the men and women Goya depicted from imagination waxed and waned.[9] In the earlier part of the 1770s, he painted an elegant, elongated race of people as, for example, in *The Sacrifice to Priapus* (cat. 2); then as the decade passed, men and women gradually lost height, and their bodies took on the muscular sturdiness of country men and women. It is the race we see in the tapestry cartoons of 1775-1780. By the mid-1780s, Goya's people again grew taller and lost some of their robustness, as we see them in *Winter* (cat. 10), in the *Annunciation* sketch and its finished altarpiece (cat. 7 and 8), or in the 1786-1787 Osuna paintings (cat. 11-12A). During the 1790s, slightness of body became increasingly visible, and by the last years of the century, men and women had acquired the rococo fragility of the figures in *The Devil's Lamp* (cat. 25), the *Album B* drawings, and the *Caprichos.* With the beginning of the new century, however, Goya's men and women grew physically stronger until by 1810, when Goya began to etch the *Disasters of War,* the race had developed stocky, hardy bodies (cat. 82-94). Because the race has become such a sturdy breed, the Spanish resistance to the French that Goya depicts becomes very credible. Because he has given Spaniards bodies that are not easily broken, what jailors do to men in *Prison Interior* (cat. 71) and what the Inquisition does to men and women in *Album C* are the more dismaying (cat. 98-106). The figure of Spain in the *Allegory on the Adoption of the Constitution of 1812* (cat. 74), idealized though she may be, is clearly their close kin.

In 1814 the war, which began as a spontaneous uprising against French occupiers, came to a successful conclusion. Simultaneously, Goya's race gained stature, so that physically many of the combatants in *The Second of May* and *The Third of May* (cat. 80, fig. 1) have a heroic nobility. For the most part it is still this beautifully proportioned race that we see in the drawings of *Album E,* executed between about 1814 and 1816 (cat. 125-132).[10]

On entering the capital in May 1814, Fernando VII abrogated the Constitution, and embarked on his infamous absolutist reign. In August employees and pensioners of the palace were informed that they had to prove they had remained loyal during the occupation. Goya and his son were among a group notified on April 14, 1815 that they had been cleared.[11] The previous month the Inquisition had summoned Goya to reveal who had commissioned the *Naked Maja* and the *Clothed Maja.*[12] In the *Disparates,* etched about 1816 to 1817, which satirize life under the new king, the men and women Goya depicted have lost their physical nobility and begun to grow thinner and taller. This phase of the race may be seen at its finest in 1817 in Goya's painting of the two martyrs saints Justa and Rufina.[13] By comparison, the clergy and boys depicted two years later in the *Last Communion of San José de Calasanz*[14] seem to stem from a somewhat slighter race, and one that is not quite as tall. To it belong the people seen in the drawings of *Album F* (cat. 144-153).

In 1820 Fernando VII was forced to accede to constitutional government, which held until 1823. During the triennial period the bony structure of the race started to broaden and their muscles began filling out. These are the men and women one encounters in the etched *caprichos enfáticos* – the closing series of the *Disasters of War* – and in the "Black Paintings" from the walls of Goya's Quinta del Sordo.

In Bordeaux the pulsating force of changes in the physique of imaginary people did not abate. In *Albums G* and *H* both men and women look as though they had been crossbred with a race of giants that has endowed many of them with thick bones, large hands, and overpowering bodies. We cannot know why Goya saw mankind in this fashion during the last part of his life. Possibly it was a reflection of inner pride for, although he turned eighty during those years, he retained his titanic creative force.

1. The watermark is reproduced in Eleanor A. Sayre, "An Old Man Writing: A Study of Goya's Albums," Museum of Fine Arts, Boston, *Bulletin* 56 (autumn 1958), p. 133. Later research has revealed more of it.

2. I was mistaken earlier in believing that the darker, oilier-looking lines were made with a lithographic crayon; ibid., p. 133.

3. Manuel Núñez de Arenas, "La suerte de Goya en Francia," *Bulletin hispanique* 52, no. 3 (1950), p. 233. On May 2 Goya had asked for and on June 2 was granted a royal license to take the waters in the east of France at Plombières-les-Bains (Vosges); see Valentín de Sambricio, *Tapices de Goya* (Madrid, 1946), Docs. 251-256. There is no indication that he went anywhere near the place; see Núñez de Arenas, "La suerte de Goya en Francia," pp 234-245.

4. On Goya's stay in Paris, see ibid., pp. 234-245.

5. Three members of the family of Goya's daughter-in-law, Gumersinda – her father, Don Martín Miguel Goicoechea, her sister Doña Manuela, and her brother-in-law Don José Francisco Muguiro – had applied the previous day. On the Goicoecheas, see ibid., pp. 241-242.

6. Doña Leocadia appears to have been a step-sister of Don Martín Miquel Goicoechea's wife, see Miguel Lasso de la Vega, Marqués del Saltillo, *Miscelánea madrileña, histórica y artística*, primera serie, *Goya en Madrid: Su familia y allegados* (Madrid, 1952), pp. 39-40, 60, Doc. 17, and family tree, opposite p. 38.

7. This child, born October 2, 1814, is presumed to be Goya's daughter.

8. Letter from Goya to Joaquin Ferrer, Oct. 28, 1824, quoted in *Colección de cuatrocientas cuarenta y nueve reproducciones . . .* (Madrid: Saturnino Calleja, 1924), p. 54.

9. No survey of an aspect of Goya's work can properly be made until the artist's entire oeuvre has been carefully examined and false attributions that are commonly accepted have been discarded.

10. Possibly the birth of Mariquita in 1814 contributed to the persistence of this optimistic phase.

11. See Sambricio, *Tapices de Goya*, Docs. 230-148.

12. March 16, 1815, Archivo Histórico, Lego 4499, no. 3; G-W 743, 744.

13. Cathedral Sacristy, Seville, G-W 1569; Gud. 654.

14. San Antón Abad, Madrid; G-W 1638; Gud. 694.

USE OF THE CATALOGUE

Arrangement

So that Goya's works can be presented chronologically and the series of prints and drawings interspersed with paintings of the same period, the catalogue entries have been divided into three sections according to the following periods: 1761-1799, 1800-1814, 1814-1828. Paintings precede drawings and prints in each section. The first painting is a portrait of the enlightened monarch Carlos III, about 1761, by the court painter Anton Raphael Mengs. This work served as a model for other portraits of the king, including those by Goya.

Entry Headings

Titles: Whenever Goya gave a title to a work of art, that title has been put in italics in the entry heading, with a translation into English. Otherwise the title has been supplied by the author of the entry. (In the text and captions all titles are italicized.)

Dating: Most of the dates of the prints and drawings were assigned by Eleanor Sayre, whose introductions to Goya's print and drawing series give supporting evidence.

Medium and dimensions:
Paintings: Information on the medium and dimensions of paintings was supplied by the lenders to the exhibition or was derived from Pierre Gassier and Juliet Wilson, *The Life and Complete Work of Goya,* New York, 1971 (abbreviated as G-W). Dimensions of paintings are given in centimeters, height preceding width.

Drawings: With few exceptions, information on the medium and dimensions of drawings was taken from research notes based on direct observation by Eleanor Sayre. Drawing dimensions, in millimeters, are sheet measurements, height preceding width.

Prints: Print techniques were provided by Eleanor Sayre, and the dimensions are those given by Gassier and Wilson, based on measurements of the copper plates that have survived in the Calcographía Nacional, Madrid.

For techniques and terminology related to printmaking, please consult the Glossary.

Inscriptions: Inscriptions in Goya's hand or in the plate are transcribed as found on the works, reading from top to bottom and left to right. Numbers on prints and drawings that are not Goya's have not been indicated.

References: Full citations for short bibliographical references may be found in the list of Abbreviated References.

Place of exhibition: Unless otherwise indicated, paintings are exhibited in Madrid, Boston, and New York. Drawings and rare early impressions of prints are exhibited in either Spain or the United States, as specified. When it has been possible to borrow duplicate impressions of prints, a different impression has been selected for each side of the Atlantic.

Illustrations

Only one impression is illustrated, except in the case of cat. 141, where the two exhibited impressions were sufficiently different to warrant the illustration of both.

Entry Texts

In the texts, quotations are included in their original language, followed by the English translation, except in the entries on the *Disasters of War,* cat. 82-94. Most of the quotations in those entries are anonymous and were taken from official decrees, journals, and newspaper accounts. For the original Spanish of these, see the Spanish edition of the catalogue.

Author's initials are provided at the end of each entry.

I GOYA AND THE SPIRIT OF ENLIGHTENMENT
1761–1799

GOYA AND THE SPIRIT OF ENLIGHTENMENT
1761–1799

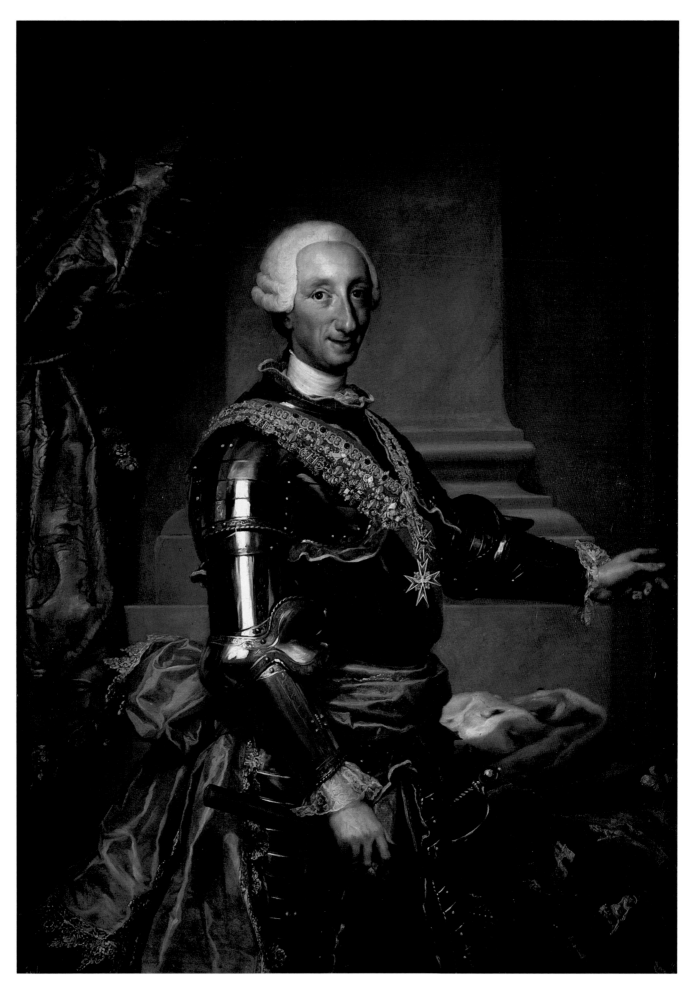

1
Anton Raphael Mengs
Carlos III
About 1761
Oil on canvas
154 x 110 cm.

Museo del Prado, Madrid, 2200

The portrait of Carlos III by Anton Raphael Mengs (1728-1779) is the most familiar image of the king who best embodied the Spanish Enlightenment. Painted by Mengs soon after his arrival in Spain, the portrait presents the king dressed in armor, as commander in chief, with the baton in his right hand, the Golden Fleece and the insignia of the French Order of the Holy Spirit and the Neapolitan Order of Saint Genaro on his chest.[1] The likeness soon became the official image of the king, often imitated and copied; Manuel Salvador Carmona made a print of it in 1783, which was widely disseminated.[2]

Carlos III, son of Felipe V and Isabel de Farnesio, was born in Madrid on January 20, 1716. While the sons of his father's first marriage – Luis (future Luis I) and Fernando (Fernando VI) – lived, it was difficult to imagine Carlos would be king, and his ambitious mother tried by every means to obtain an Italian crown for him. He was Duque de Parma between 1732 and 1734, when still practically a boy, and as Carlos VII was king of Naples and the Two Sicilies from 1738 until 1759. When the death without heirs of his brother Fernando brought him the Spanish throne, he entrusted the government of Naples to his third son, Fernando, an eight-year-old boy, under the tutelage of his trustworthy minister and friend, Tannuci, with whom he maintained a long, faithful correspondence that kept him well informed about the political and social life of Naples.[3]

Carlos III has always been considered the enlightened monarch par excellence. A polemical figure in many ways, inferior in intelligence to the other great enlightened monarchs of his age – Frederick II of Prussia and Joseph I of Austria – he had, however, the ability and prudence to elect extraordinarily capable ministers, who had a clear vision of Spain's needs

and a desire to undertake its economic and social transformation. The Italian ministers of the first years of his reign sometimes incited protests from his Spanish subjects, which culminated in the famous Esquilache uprising that obliged the king in March 1766 to dismiss this minister, sponsor of important hygienic measures in Madrid. Then followed a procession of illustrious Spaniards, including Aranda, Floridablanca (see cat. 4), Campomanes, Murquiz, and Roda, who were responsible for many measures that encouraged prosperity and the spread of the spirit of cultivation, as in enlightened and Encyclopedist France.

On the king's initiative the army was reorganized, for which he issued new ordinances; the navy was improved; and public finances were balanced, the debts of certain provinces being pardoned. In 1766 Carlos III initiated the important work of colonizing the Sierra Morena, building villages and hamlets that eased communications to Andalusia and provided new economic resources; he built various public ways, bridges, and inns, and reorganized the postal system. The Sociedades Económicas de Amigos del País (Economic Societies of Friends of the Nation) came into being to promote the widespread adoption of measures favoring the economy and fledgling industries, which were protected wherever they were established; hydrological needs were met with projects for dams and canals. He achieved, in sum, a score of projects and ideas for the transformation of all aspects of Spanish life.

In cultural matters, the publishing industry was stimulated; ample liberty of expression was allowed; and the power of the Inquisition was limited, although its suppression was not seriously considered because the presence and ancestral prestige of the institution were still strong. In religious matters, Carlos III adhered to a certain regalism, which provoked some confrontations with the Holy See, and he took a decided aversion to the Jesuits, who were expelled from Spain in 1767, while his ambassador, Floridablanca, managed to convince Pope Clement XIV to dissolve the order throughout Christendom in 1773.[4]

Carlos III was an extraordinarily healthy man, strong and vigorous, fond of hunting and of the open air, especially after the death of his wife, María Amalia. According to all the testimonies, he was altogether chaste, never known to indulge an erotic temptation, and implacable with those who did. Of a severe character, he nevertheless heard petitions that reached him, and he was extremely scrupulous in his personal conduct. With a "spirit given to maniacal routine,"[5] he maintained a life of absolute monotony and immutability and an obsessive faithfulness to his confessor's advice. However, he believed in the altogether divine nature of royal authority, which led him at times to take harsh stands that bordered on cruelty. Among the instructions sent to his son Fernando was the pronouncement: "El hombre que critica las operaciones del Gobierno, aunque no fuesen buenas, comete un delito" (The man who criticizes the Government's measures, even when they are not good, commits a crime).[6]

In the arts Carlos III did not seem to have very defined tastes, and some contemporary testimonies state emphatically that he had no liking for reading, music, or social life. He was educated in Italy, in an environment suffused with the spirit of the late baroque. Nevertheless, in architecture he preferred a certain sobriety of form that prefigured neoclassicism. He was Mengs's benefactor, and he sponsored the royal factories (Buen Retiro for porcelain and the Real Fábrica de Santa Bárbara for tapestries). The royal collections were considerably enriched under his reign, thanks to Mengs's initiatives, and he was wise enough to avoid the destruction of the nude paintings inherited from his forebears, which were condemned, by royal puritanism and at his confessor's instigation, to the fire.[7]

A.E.P.S.

1. Anton Raphael Mengs arrived in Spain on Sept. 7, 1761, disembarking in Alicante. The Bohemian artist came at the request of Carlos III, who had met him in Naples in 1759, when the new sovereign's move to Spain was being prepared. In Madrid Mengs was supported by the enlightened circle closest to the king, although there were difficulties with the Academia de San Fernando, whose noble counselors did not welcome the interference of artists in matters

of administration and whose artists were not inclined to accept Mengs's aesthetics. His role was fundamental to the evolution of Spanish artistic taste in the second half of the century. See catalogues for exhibitions on Mengs given at the Museo del Prado, Madrid, by F.J. Sánchez Cantón in 1929 and by Xavier de Salas and Mercedes Agueda in 1980; see also Mercedes Agueda, "Mengs y la Academia de San Fernando," in *II Simposio sobre el Padre Feijóo y su siglo* (Oviedo, 1983), pp. 445-476; Andrés Ubeda de los Cobos, "Proyectos de reforma y planes de estudio: La influencia de Mengs en la Real Academia de Bellas Artes de San Fernando," *Archivo español de arte,* no. 420 (1987), pp. 447-461.

2. See Elena Páez, *Iconografía Hispana: Catálogo de los retratos de personajes españoles de la Biblioteca Nacional* (Madrid, 1966), no. 1711-63.

3. For a biography of Carlos III, written with the most fervent devotion by a person who knew him, see Conde de Fernán Núñez, *Vida de Carlos III* (Madrid, 1898), which has been a basic source for all studies on the king. A somewhat idealized eulogy to the king is Gaspar Melchor de Jovellanos, "Elogio de Carlos III," in *Obras de Jovellanos,* Biblioteca de Autores Españoles, vol. 46 (Madrid, 1858).

4. Teófanes Egido, "Motines de España y proceso contra los Jesuitas: La 'Pesquisa Reservada' de 1766," *Estudios Agustinianos* 9 (1976), p. 246; P. Rodríguez de Campomanes, *Dictamen fiscal de expulsión de los jesuitas en España* (1766-1777), ed. J. Cejudo and T. Egido (Madrid, 1977); Teofanes Egido, "Oposición radical a Carlos III y expulsión de los jesuitas," *Boletín de la Real Academia de la Historia* 174 (1977), pp. 529-545.

5. Giacomo Casanova, *Memorias de España,* who alluded to Carlos's rigidity as if it were well known in the Madrid of his time. Biographers are unanimous about this aspect of the king's character.

6. Antonio Domínguez Ortiz, *La sociedad española en el siglo XVIII* (Madrid, 1956), p. 27.

7. P. Beroqui, *Tiziano en el Museo del Prado* (Madrid, 1946), pp. 152-153.

2

The Sacrifice to Priapus
1771
Oil on canvas
33 x 24 cm.
References: G-W 23; Gud. 15.

Private Collection, Barcelona

It has been said that the god to whom a libation is offered in *The Sacrifice to Priapus* is Pan;[1] however, Pan was traditionally represented as having the legs of a goat, arms to seize nymphs, and hands for making reed pipes. Since the body of the personage in the painting ends as a term rather than in legs, since he has neither arms nor hands, and, even more important, since his member is ithyphallic, he ought rather to be identified as the demigod Priapus.[2] This "hortorum decus et tutela" (glory and guard of gardens), this "quique ruber pavidas inguine terret aves" (Crimson One whose lewd image scares the timid birds), to use Ovid's words,[3] personified the fruitfulness of the earth, and it was customary to set a term with his image in a garden. It was logical that a phallus should be his symbol.

In *A Discourse on the Worship of Priapus,* published in 1786, the English patron of art and learning Richard Knight wrote: "Of all the profane rites which belonged to the ancient polytheism, none were more furiously inveighed against by the zealous propagators of the Christian faith, than the obscene ceremonies performed in the worship of Priapus. . . . Even the form itself, under which the god was represented, appeared to them a mockery of all piety and devotion, and more fit to be placed in a brothel than a temple. But the forms and ceremonials of a religion are not always to be understood in their direct and obvious sense; but are to be considered as symbolical representations of some hidden meaning, which may be extremely wise and just, though the symbols themselves, to those who know not their true signification, may appear in the highest degree absurd and extravagant."[4] Goya seems to have viewed the rite he is depicting with a similar objectivity, seeing in it a rightful affirmation of life. There can be no doubt that he would also have agreed

Fig. 1. *The Sacrifice to Vesta. 1771.*
Oil on canvas.
Whereabouts unknown

with Knight's view that "there is naturally no licentiousness in the moderate and regular gratification of any natural appetite; the turpitude consisting wholly in the excess or perversion."[5]

The Sacrifice to Priapus has a companion piece, *The Sacrifice to Vesta,* which is dated 1771 (fig. 1). In the latter, watched by three women, a man in classical garb stands holding a *patera* (dish) over a sacred fire in front of a small, steep pyramid, an allusion to the famous monument in Rome.[6] He can be identified as the Pontifex Maximus, or chief priest, an office created by the model king. Among his duties was teaching the correct manner of performing sacred rites and overseeing the Vestal virgins. It was to these last that the ruler had entrusted the care and worship of a perpetual fire either, as Plutarch put it, "because he thought the nature of fire pure and uncorrupted, and therefore entrusted it to chaste and undefiled persons, or because he thought of it as unfruitful and barren, and therefore associated it with virginity."[7]

Goya apparently did not invent this composition but based it on an unknown print used also by a French sculptor, Alexis Loir, whose attractive terracotta

relief of the subject is dated the following year.[8] Since Roman coins commonly show the sacrifice taking place in front of the small temple of Vesta, this representation is not traditional.[9] In Loir's relief, the role of the pyramid was that of picturesque detail, less important than the bushes and the large palm tree partially obscuring it. Goya, however, emphasized the pyramid as a monument to death by allowing its strong diagonals not only to dominate the composition but also to act as a barrier to almost all the leafy growth of nature. He made it clear that the leaves of the crowns worn by the two women next to the priest are from the laurel tree created by Apollo and thought for this reason to be flammable.[10] The bare-headed young woman stands apart from her companions; her robe is arranged to reveal the firm curve of her right breast, further emphasized with a delicate highlight; she holds her hands above her womb.

Already characteristic of Goya is his ability to give a psychological dimension to a scene. He achieved this not only through his ability to suggest the inner life of persons but also through the manipulation of color. The Pontifex Maximus, dressed in brown and intense earth-yellow, has the face of a man whose life has been fruitful; the two women next to him, wearing the colors of withering leaves, have a closed, virginal appearance; while the young initiate, dressed in dull white, stares toward the demanding fire and the traditional empty dish held above it in sad understanding that by vowing chastity for thirty years of her life she has dedicated a part of herself to death.[11]

While the general character of *The Sacrifice to Vesta,* where fertility is renounced, is somber, *The Sacrifice to Priapus* has a feeling of joyful solemnity, expressed by means of line, form, and color used expressionistically as well as naturalistically. Goya gave the foliage above the burning offering a summery green and represented the sky above it as limpid blue instead of clouded, as it is in the companion piece. A young matron, clothed in white, confidently offers a golden bowl to Priapus so that she will be made fruitful. Goya arbitrarily outlined

some of the folds on her dress with yellow brushstrokes and shaped the highlights on her face and arms so that they would direct our attention toward the demigod. Priapus is touched with golden light in such a manner that we are forced to notice his ruddy, earthy, smiling face, his well-developed body, and the position of his member. Other folds of white cloth, particularly those lying on the altar, lead down to a golden-haired girl in blue who kneels, bare-breasted, with one hand touching the demigod's term and the other holding a tilting pot. Goya took especial pains to ensure that we would notice both this pot and the crimson liquid escaping from it. Not only did he create what is almost a cascade of descending lines and gentle curves throughout the composition leading to the pot, but he also painted a wayward fold of the young woman's blue skirt so that it points like an arrow directly at the red. A pot spilling blood is the iconographical device Goya used to convey that a girl's maidenhead has been broken.[12]

It is possible that when art historians identify the engraving of *The Sacrifice of Vesta* used by Goya in 1771 for his painting, and by Loir the following year for his terracotta, they will discover that there is a companion print, a *Sacrifice to Priapus,* on which this painting will be seen to depend. A small riddle will have been solved, but we shall be left with the larger one of why an artist of such originality and inventive power should have relied on engravings. Possibly the two works were commissioned by a patron who, in addition to participating in an eighteenth-century vogue for paintings of satyrs, nymphs, gods, and goddesses, had strong feelings about just which designs he wanted as models.[13]

E.A.S.

1. See José Milicua, "Anotaciones al Goya joven," *Paragone* 5 (May 1954), pp. 19-20, figs. 4-5; see also G-W 23 and Gud. 15.

2. Goya used two light strokes to call attention to the erection. In an unconvincing replica of the painting, the attributes of the demigod have been intermingled with those of Pan; G-W 24; Gud. 16. Bronze and terracotta phalli in varying positions were to be seen in the royal collection in the Musaeum de Portici, Naples; see Richard, abbé Saint-Non, *Voyage pittoresque ou description des Royaumes de Naples et*

de Sicile (Paris, 1782), vol. 1, pt. 2, p. 52 and facing engraving by A.C. after N.V.

3. Ovid *Fasti* (trans. James George Frazer) 1.415, 400.

4. Richard Payne Knight, *An Account of the Remains of the Worship of Priapus, Lately Existing at Isernia, in the Kingdom of Naples . . . to which is added A Discourse on the Worship of Priapus,* (London, 1786; reprint, Secaucus, N.J., 1974), p. 14. The original edition was published for distribution by the Dilettanti Society, whose members included Sir Joseph Banks, Sir William Hamilton, and Horace Walpole. Because the book proved shocking to the sensibilities of English society and clergy, Knight recalled as many copies as he could; Preface, pp. i-ii.

5. Ibid., p. 17. It is the excesses and perversions of appetites that Goya attacks again and again in his satirical prints and drawings.

6. The famous Cestius pyramid in Rome, though steep, is considerably larger than the one in Goya's depiction; nor is it isolated. Piranesi etched two views of it in 1756, both of which are included in his "Views of Rome"; see Arthur M. Hind, *Giovanni Battista Piranesi: A Critical Study* (London, 1922), nos. 35, 36.

7. See Plutarch, *Lives* (trans. Bernadotte Perrin), *Numa,* 9. 4-5.

8. The terracotta, in a French private collection, was reproduced by José Lopez Rey, "Tradition, réalité et imagination chez Goya," *L'Oeil,* no. 292 (Nov. 1979), p. 24, fig. 2. Loir signed and dated it 1772 on the same part of the altar as Goya did. It is improbable that Loir, a student in Rome in 1735, copied the Goya.

9. For example, the obverse of a Severus ten denarius shows Domna and attendants sacrificing in front of her temple; see J. P. C. Kent, *Roman Coins* (London, 1978), pl. 111.

10. See *Alciato: Emblemas,* ed. Santiago Sebastián (Madrid, 1985), p. 251.

11. See Ovid *Fasti* 6.310.

12. Examples of the words *olla,* a round earthen pot, and *puchero,* a glazed earthen pot, used in this sense can be found in Alzieu, *Poesía erótica,* pp. 245-246, 277-282. *olla* could also suggest the girl; see the proverb cited by Terreros, *Diccionario,* 1786-1793, under *olla:* "Olla cave tizones, ha menester covertera, y la moza do hai garzones la madre sobre ella."

13. About one sixth of the paintings shown in the Paris Salon of 1769 consisted of such subjects; see Jules Marie Joseph Guiffrey, *Collection des livrets des anciennes expositions depuis 1673 jusqu'en 1800,* vol. 25: *Exposition de 1769* (Paris, 1870). The three Sobradiel paintings of 1770-1772 (G-W 10-12; Gud. 17-19) are after prints, a fact that suggests such a stipulation may have been made by the Conde.

Goya had copied prints as a student under Luzán in the Academia de Zaragoza, but when he left it, "empezó a pintar de su invención" (began to paint from his own invention); see Luis Eusebi, *Noticia de los Cuadros que se hallan colocados en la Galería del Museo del Rey* (Madrid, 1828), p. 67. The text on Goya appeared earlier in the 1819 edition; see José Camón Aznar, *Francisco de Goya* (Zaragoza, 1984), p. 30.

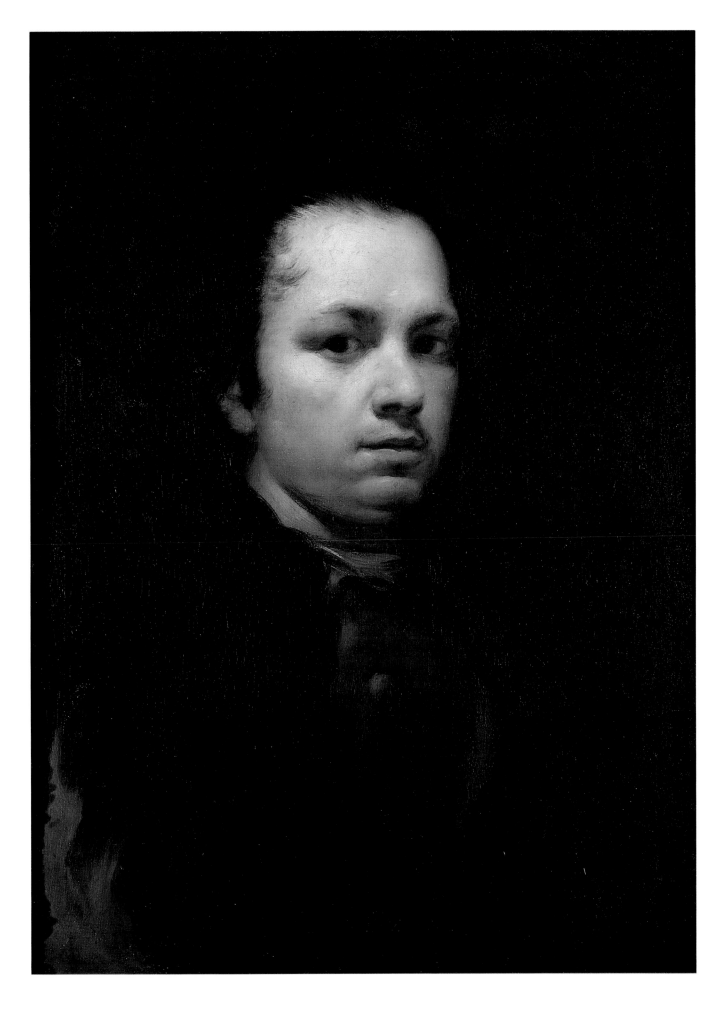

3

Self-Portrait
About 1773
Oil on canvas
58 x 44 cm.
References: G-W 26; Gud. 36.

Private Collection, Madrid

Probably Goya's first self-portrait or, at any rate, the earliest to be identified with precision, this work must correspond to the early, youthful years of his career, about 1771-1775, following his sojourn in Italy but before his definitive establishment in Madrid. The fact that the portrait remained in Zaragoza until the beginning of this century appears to lend weight to this hypothesis.[1] Gudiol believed that it was painted in 1773 on the occasion of Goya's marriage to Josefa Bayeu, although there is no evidence for this claim.[2]

The painting shows a marked attention to lighting, which brings out the face against a dark background that is only slightly relieved by the piece of lighter clothing (a shirt or tie) indicated under the chin. The broad style, with thick, sensuous brushstrokes on a reddish base, made Gudiol think of "a certain kinship with Murillo," judging by the pitch blacks of the hair, the ochers of the base, and the lively luminosity of the flesh tints.

Goya presented himself almost full face, gazing defiantly at the viewer, with his torso partly turned to the right. The face, round and fleshy, has a wide and high forehead, prominent nose, thick and sensual lips, with a shadow of a poorly shaved mustache and a rounded, pronounced chin, under which is implied a full-fledged beard and a powerful neck. The small, dark, and incisive eyes shine under the marked superciliary arches and short, thick brows. The long, preened hair reveals the artist's singular interest in its appearance, which is confirmed by later images.[3] The entire figure reflects an evident, rough obstinacy and an obvious sensuality.

This is the Goya who arrived in Madrid and began his career in the Real fábrica de tapices (Royal Tapestry Factory). In 1784, that is, probably ten years later, when he again showed us his face in

Predicación de San Bernardino de Siena (Sermon of Saint Bernardino of Siena) (San Francisco el Grande, Madrid; G-W 184), his expression had hardened and acquired a certain air of haughty detachment, a little aloof and disenchanted, although the commanding inquisitiveness of his expression, the sensuality of his mouth, now more tense, and the broad, penetrating, intelligent forehead are still recognizable. The self-portrait in the Musée du Agen (G-W 201) is analogous, the haughty imperiousness even more pronounced.

Without a doubt, Goya's self-confidence and his analytical capacities increased rapidly, but in this self-portrait those qualities have not yet obscured his probing and still essentially receptive sensibility.

A.E.P.S.

1. The portrait belonged to the Ena Collection in Zaragoza and later to the Marqués de Zurgena, passing into its present owners' hands in 1955.

2. Gud. 36, p. 28.

3. Julián Gállego, *Autorretratos de Goya* (Zaragoza, 1978), p. 22.

4

Conde de Floridablanca
1783
Oil on canvas
260 x 166 cm.
Signed: *Señor, Fran^{co} Goya*
References: G-W 203; Gud. 140.

Banco de España, Madrid

This painting is among the most important by Goya, for it is one of his first commissioned portraits, in which he invested many hopes. Given the prestige and influence of the subject, he trusted it would open doors and ease his introduction to and advancement in Madrid's official life. Goya alluded to these hopes in various letters to his friend Zapater in January, April, and July 1783.[1] He did not hesitate to insert himself into the portrait, though in a clearly servile pose, offering the minister a painting. (It has been suggested that this might represent one of the sketches for the altarpiece of San Bernardino of Siena for the Iglesia de San Francisco el Grande [see G-W 184-187], commissioned by Floridablanca at that time, but since the format is quite different, this would not appear to be the case.)

Don José Moñino y Redondo, Conde de Floridablanca, was a leading figure in Spanish political life under Carlos III and one of the outstanding representatives of the Enlightenment. Born in Murcia in 1728, he studied law in his hometown and in Orihuela and was later protégé of Esquilache, secretary of state for war and finances. Esquilache helped him to take his first steps in administrative life, entrusting him with certain tasks that he resolved with the political ability he later perfected. Judge of the Consejo de Castilla (Council of Castile) from 1756, he wrote several opinions and in 1766 was appointed attorney general of Castile; in 1773 he was ambassador to Rome. His title was conferred by Carlos III as a result of his important role in orchestrating the events preceding the expulsion of the Jesuits in 1767. Conde de Floridablanca was made Carlos III's prime minister in 1777, maintaining his influence in the final years of that monarch's reign. Under Carlos IV he was minister of state

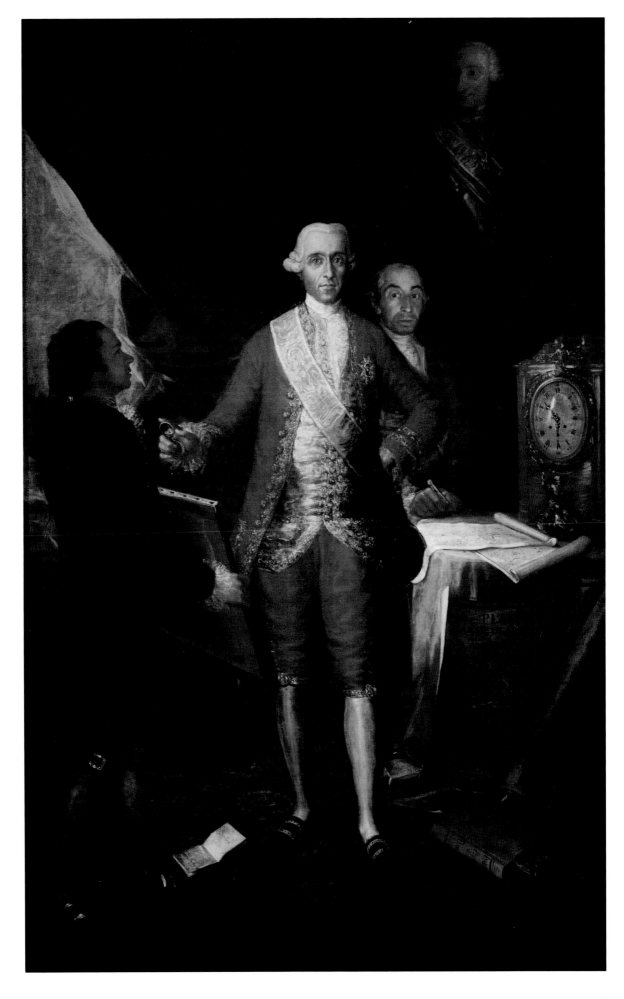

and prime minister between 1788 and 1792, having to face the difficult situation created by the French Revolution, to which he was altogether opposed. Manuel Godoy's and Queen María Luisa's open antagonism toward him brought about his fall from power in 1792 and his banishment to Pamplona. Brought before a court, he was acquitted but remained in retirement on his estate in Murcia. The French invasion of 1808 returned him to public life, when he was named chief of the Junta Central (Central Council) for defense against the invading power. He died later that year, however, on December 30.[2]

During the height of the Enlightenment in Spain, Floridablanca demonstrated a marked concern for the economic regeneration of the country, the development of industry and commerce, and the protection of the arts. He distinguished himself especially in attending to the problems of agriculture and irrigation and undertaking important hydraulic works, dams, and canals.[3]

Floridablanca's portrait may be regarded as an allegory of good government, within an iconographic tradition relatively common at the time. The presence of the royal portrait, which in fact presides over the composition, makes the monarch protagonist. The minister, surrounded by attributes that describe his function, assumes the significance of an intelligent instrument of royal policy.

The clock, so conspicuous in the overall composition, has an old, symbolic tradition, which gives it expressive weight. Symbol of moderation, it is also identifiable with the prince or king, whose conduct and will regulate the order of the republic. From Cesare Ripa, who saw in the clock an allegory of "prelacy," to Fray Antonio de Guevara, the sixteenth-century author of *Relox de Principes*, who stressed that clocks show "cómo ocupar cada hora y cómo dirigir y ordenar nuestra vida" (how to occupy each hour and how to direct and organize our lives), the clock often appeared in portraits of royalty and of the powerful, always underscoring majesty and government. Among the many texts that could be cited on this subject, perhaps the most appropriate and expressive is *Anneo Séneca ilustrado*

en Blasones políticos y morales (Madrid, 1670), by the sixteenth-century creator of emblems, Juan Baños de Velasco. He observed: "el Relox es Geroglyphyco de Príncipes y Ministros" (the clock is the hieroglyph of princes and ministers), for the minister is a cogwheel and the king a clock hand "que da honras y horas" (who gives honors and hours).[4] It is not easy to imagine that Goya was acquainted with Baños de Velasco's text, but it is logical to suppose that the iconography, already in public use, was known, for the clock appears in certain royal portraits by Velázquez that Goya admired, such as that of Doña Mariana de Austria.

Equally expressive in the portrait of Floridablanca are the maps on the table and the plan on the floor. The latter is inscribed: *Plano del Canal de Aragón / Al Excmo. Señor Floridablanca, año 1783* (Plan of the Aragón Canal / To His Excellency Mr. Floridablanca, 1783). At the time of the portrait, Floridablanca had assumed by royal decree, from the state secretariat, the crushing expenses carried by the Ministry of Finance, which "quería sacudir enteramente esta carga" (wanted to free itself entirely of this burden), as Floridablanca himself wrote in his report of 1792.[5] This was the most important undertaking sponsored by the ministry, and one of the works of which Floridablanca might have been proudest. There are many eighteenth-century testimonies of admiration for this enterprise; since it was so representative of the Conde's enlightened policy, it is not surprising it should occupy such an outstanding place in the painting.

The figure in the background has been identified with Francisco Sabatini[6] or Ventura Rodríguez, architects who maintained professional contacts with Floridablanca, as did Juan de Villanueva, who has sometimes also been suggested as a candidate.[7] However, the figure may well represent Julián Sánchez Bort, architectural engineer, nephew of the designer of Murcia Cathedral's facade, whom Ramón Pignatelli put in charge during that period of the building of the Aragon Canal, especially the reconstruction of the Canal de Touste, opened in 1781. Sánchez Bort died in 1785, two years after the portrait was painted, when he

was director of the Arsenal de la Carraca in Cádiz.

On the floor is a book whose spine can be read, though in a fragmentary way: *Palomino, Práctica de la Pintura* (Palomino, Painting Technique). It is the second volume of Palomino's famous book, universally considered the most important Spanish treatise on painting.[8] Its presence in the portrait must also be seen as an allusion to the support of the arts provided by the minister, under royal supervision.

Whether the portrait, painted at the time of Floridablanca's greatest political influence, worked to Goya's advantage is unknown. To judge by the artist's letters such as that of July 9, 1783, and especially that of January 7, 1784, which exude disillusionment, it did not: "nada ay de nuebo y aún ay más silencio en mis asuntos con el Señor Moñino, que antes de aberle hecho el retrato. . . . Lo más que me a dicho después de aberle gustado, Goya ya nos beremos más despacio, con que no te puedo decir más." (there is nothing new to report and even less about my business with Señor Moñino than before I painted his portrait. . . . The most he said to me after liking it, Goya we will see each other with more leisure, and otherwise I have nothing more to say.)[9]

There are, however, other versions of the portrait showing only the figure of the Conde. In one, probably painted in Goya's studio (now in the Museo del Prado),[10] the subject bears in his hand a "Memoria para la formación del Banco Nacional de San Carlos" (Report on the Establishment of the National Bank of San Carlos). The other (also in the Museo del Prado) is evidently a copy.[11]

Although the present painting seems to have been commissioned by Floridablanca, it is worth asking what occasioned it. It is feasible to imagine that the painting was intended for some destination in Aragón because Goya was from that region and because the allusions in the portrait are chiefly to an Aragonese enterprise.

A.E.P.S.

1. Goya to Zapater, Jan. 22, Apr. 26, and July 9, 1783, in *Cartas a Martín Zapater*, ed. Mercedes Agueda and Xavier de Salas (Madrid, 1982), pp. 95, 104-105.

2. On Floridablanca and his political role, see C. Alcázar, "Ideas políticas de Floridablanca: Del Despotismo Ilustrado a la Revolución Francesa y Napoleón (1766-1788)," *Revista de Estudios Políticos* 79 (1955), pp. 35-66; see also C. Alcázar, *Los hombres del Despotismo Ilustrado en España: el Conde de Floridablanca, su vida y su obra* (Murcia, 1934).

3. On his concern over these issues, his reports during his exile are very revealing, preoccupied as they are with the continuation of his projects; see A. Rumeu de Armas, *El testamento político del Conde de Floridablanca* (Madrid, 1962).

4. On the symbolism of the clock, see Julián Gállego, *Visión y símbolos en la pintura española del siglo de Oro* (Madrid, 1972).

5. Quoted in Rumeu de Armas, *Testamento*, p. 147.

6. Folke Nordström, "Goya's State Portrait of the Count of Floridablanca," Society of the History of Art, Stockholm, *Art Review* 31, nos. 3-4 (1962), pp. 83-93.

7. See Museo del Prado, Madrid, *Goya en las Colecciones Madrileñas* (1983), no. 3; José Camón Aznar, *Francisco de Goya*, vol. 1 (Zaragoza, 1980), p. 147.

8. It is no doubt the first edition of 1724. Around the time of the portrait a new edition of the book was being prepared by the printing house of Sancha, which did not appear until 1795 but which corroborates the interest in it. On the vicissitudes of this edition, which set the scholars Bosarte and Ceán Bermúdez against each other, see Isidoro Bosarte, *Viaje artístico a varios pueblos de España*, ed. A.E. Pérez Sanchez (Madrid, 1978), p. xli.

9. Goya to Zapater, in *Cartas*, p. 110.

10. Donated by its owner, the Marqués de Casa Torres. See Museo del Prado, *Catálogo* (1985), no. 3255. Xavier de Salas believes it was painted in 1788, when the portraits for the Banco de San Carlos were executed (see cat. 15).

11. Originally in the royal collection, deposited in the Dirección General de la Seguridad del Estado (Head Office of State Security). See *Boletín del Museo del Prado* 2, no. 6 (1981), p. 178, no. 6084.

5

The Family of the Infante Don Luis
1784

Oil on canvas
248 x 330 cm.
References: G-W 208; Gud. 152.

Fondazione Magnani Rocca, Corte de Mamiano, Parma

This important and unusual painting is the most direct testimonial of Goya's association with the Infante Don Luis de Borbón, Carlos III's youngest brother and a singular personality in late eighteenth-century Spanish society.

Destined by his mother for the Church, Don Luis was made archbishop of Toledo and cardinal in 1735, when he was six, and archbishop of Seville in 1739.[1] However, he never showed interest in or aptitude for a career in the Church, indulging in a life altogether inappropriate to his position. Fond of hunting and amatory diversions, he renounced the cardinal's hat and his post as administrator of the archdiocese in 1754 when he was twenty-six years old. From that moment onward, he lived as an Infante in the court of Fernando VI, serving as informer of events there to his mother, Isabel de Farnesio, who had been officially removed to the palace of La Granja de San Ildefonso, outside Madrid. Especially significant are his surprisingly cold and insensitive letters to Doña Bárbara de Braganza and Fernando VI during the former's illness and at her death.[2]

The Infante's amorous life, of a rather low tone, must have seemed highly scandalous to the puritanical Carlos III on his assumption of the throne. Some incidents, such as that which earned the painter Luis Paret banishment from the court for obscure procuring affairs, forced a matrimonial solution for the Infante. Among the matches considered was that with his niece María Josefa, youngest daughter of Carlos III, but it is possible – as has been noted – that this marriage would have been seen as complicating the succession to the throne by Carlos IV. Because Felipe V's Salic Law excluded from the succession princes not born and raised in Spain (Carlos IV was Neapolitan), children of the Infante and María Josefa would become heirs.[3]

The planned union was scuttled, and when the Infante proposed wedding a lady without royal blood but of the "clase de caballeros particulares, distinguidos y honrados" (class of distinguished and honored Lords), Carlos III authorized it, publishing the decree of March 23, 1776, which excluded the progeny of this and other "matrimonios desiguales" (unequal marriages) from the right to the title of Infante and the surname Borbón; the decree also established the wife's residence outside the court and royal sites, thus preventing the Infante from being accompanied by his family should he wish to visit the king.[4] Don Luis's chosen wife, Doña María Teresa de Vallabriga, was Aragonese, daughter of a Capitán de Caballería (Lord) and the Condesa de Torresecas. The couple lived apart from the court, first in Velada and later in Arenas de San Pedro. The king always maintained a cold detachment toward his brother's family, which bitterly humiliated Doña Teresa. Even family news, such as the birth of the children, Carlos III refused to hear personally; his prime minister, Floridablanca, unofficially kept the king abreast of the Infante's affairs.

This great painting of the family was executed in 1784 on Goya's second visit to Arenas de San Pedro, where he was invited to stay by the Infante during the summers of 1783 and 1784. A letter from Goya to Martín Zapater dated September 20, 1783, enthusiastically records his first visit there and the Infante's cordiality. Another letter, dated October 13, 1784, notes his second visit: "el Infante me dió treinta mil reales en gratificación de dos quadros que le he pintado" (the Infante paid me 30,000 reales for two works I painted for him).[5] One of the works Goya referred to is no doubt this one, and the other the portrait of Doña Teresa de Vallabriga, now lost and known only from the beautiful sketch in the Uffizi.

Recent study has shown that Goya's access to the small domestic court of the Infante was not Floridablanca's doing, as had been supposed. Rather, it depended on the fact that Don Luis's *secretario de cámara* (court secretary), Francisco del Campo, was the brother of Marcos del Campo, who, in March 1783, married a

sister of the Bayeus and thereby became an in-law of the artist, who was present at the wedding.[6] Thus, Marcos's friendship with Goya, which lasted many years, predated the wedding, as Goya himself affirmed in another letter to Zapater, in which he wrote, significantly, that the bride's brother-in-law "está con el Infante don Luis y es el amo" (is with the Infante Don Luis and is the master of the house).[7]

The great painting has always astonished viewers because of its complex composition and its tone of domestic intimacy. It was, without a doubt, the most ambitious composition Goya had attempted to date and, furthermore, was surprisingly innovative within the Spanish School. Its antecedents have to be traced outside of Spain, in Flemish works or works of Hogarth's England, probably known through prints. The studied artificial light also calls to mind works by the English painter Thomas Wright of Derby (1734-1797), but it is not easy to establish whether Goya could have known them.

In the painting Doña Teresa de Vallabriga occupies the center, seated almost in profile, facing a table upon which a simple, lighted candlestick rests, illuminating the center of the group. She is wearing a peignoir, and a smiling hairdresser busies himself with the sweep of her long hair. She is unquestionably the protagonist of the painting, a position that offers her, perhaps unconsciously, a certain compensation for her official banishment.[8] Beside her, seated in a housecoat, is Don Luis in profile, playing solitaire with very conspicuous cards. Behind him, with long hair and dressed in blue, is the eldest of the children, Don Luis María, future archbishop of Toledo, and the little María Teresa, future Condesa de Chinchón (see cat. 63), leaning with childish curiosity toward Goya, who portrayed himself seated at left on a low footstool, in the act of painting the scene as a direct homage to the memory of the Velázquez of *Las Meninas*. Behind the children, two ladies-in-waiting enter the scene, carrying trays of dressings for the lady's coiffure. They have been identified as Doña Antonia de Vanderbrocht and Doña Petronila Valdearenas.[9] The figures on the right have been identified

with people known to be in the Infante's household. The lady standing to Doña Teresa's left would be Doña Isidra Fuentes, holding in her arms the little María Josefa, born in 1783. The men could be Don Manuel Moreno, the stoutest fellow and official of the Infante's secretariat; Don Gregorio Ruiz de Arce, court assistant; Don Alejandro de la Cruz, court painter of His Highness; and the youngest and most cheerful, Francisco del Campo, court secretary.

The painting remained in the family, and, in 1904, when the Infante's last granddaughter married Prince Ruspoli, it was taken to Italy, after which Luigi Magnani purchased it for his foundation in 1974. It was not published by an art historian until 1967, having been judged previously through a copy still in the possession of the Duques de Sueca; thus, the painting has not, until very recently, had the renown it merits. The first great group portrait Goya attempted, preceding by seventeen years that of the family of Carlos IV, its only precedent was the portrait of Floridablanca (cat. 4) of the same year, which probably predates this work. The painter also put himself in that picture to share in the important subject's prestige, though in a discreet and servile way.

As Goya's correspondence of these years attests, he was interested in opening doors to a more distinguished intellectual and social milieu, and in the Infante's household he found, in a pleasing atmosphere, all that he desired. The Infante's "taste in art reflected his taste in life."[10] He was fond of musicians (he supported Luigi Boccherini) and painters, although – with the exception of Paret, linked with him in other circumstances, and Mengs, who portrayed him on some occasions and was hired to advise him on his collection – he did not have much luck with his protégés. Artistic disciples of the Genoese Sasso (died 1770), who may have passed on his love for genre scenes, neither Alejandro de la Cruz nor Gregorio Ferro had Goya's capacity or genius. Goya probably alluded to these artists in his letter to Zapater of September 23, 1783, when he wrote of "otros pintores" (other painters) who had tried to portray the family without "aber

acertado a esto" (having succeeded at it).[11] The artist must have been at ease, as is conveyed by the casual and familiar tone of the portrait, which surprised the first art historians to view it. The reactions it provoked among earlier critics seem to us today incomprehensible insofar as they are blind to what is most alive and modern in the painting, qualities the scholar Angulo knew so well how to appreciate.[12] Beruete was especially insensitive in describing the work as "an absolute failure" and in calling the standing figures "completely ridiculous servants," judging the painting to be "a crowded assembly of figures in bad taste that is affected and whose coloring is poor and opaque."[13] Sánchez Cantón did not seem to understand it either, for he called it "extravagant."[14] Goya's contemporaries did not see it that way, for, as Glendinning noted, the painting stands at the beginning of his increasingly successful career as the "fashionable" portrait painter of his day, even inducing others to want to imitate him. As Pedro González de Sepúlveda noted in his diary, January 17, 1792, "Fué Goya . . . con Peñafiel y otros señores a una cacería o montería con destino a pintar después las acciones más particulares y poner un cuadro de retratos, pintando a imitación de lo que hizo con el Infante Don Luis" (Goya went . . . with Peñafiel [the eldest Osuna's title] and other lords on a hunt, commissioned to later record the most exceptional events and to make a group portrait, painting in imitation of what he did for the Infante Don Luis).[15]

A.E.P.S.

1. On the Infante, see Ignacio Olavide, "Don Luis de Borbón y Farnesio y D. Luis de Borbón y Vallabriga," *Revista de Archivos, Bibliotecas y Museos* (June 1902), pp. 437-455.

2. Ibid., pp. 444-447.

3. Antonio Alvarez de Linera, "La extraña conducta de Carlos III con su hermano Don Luis," *Revista de la Biblioteca, Archivo y Museo Ayuntamiento de Madrid* (1948), pp. 33-71.

4. Olavide, "Don Luis."

5. Goya to Zapater, in *Cartas a Martín Zapater*, ed. Mercedes Agueda and Xavier de Salas (Madrid, 1982), pp. 107, 119. On Goya's relations with the Infante and his court, see José Manuel Arnáiz and Angel Montero, "Goya y el Infante don Luis," *Anticuaria* 27 (1986), pp. 44-55, which completes and enriches that of Pierre Gassier, "Les portraits peints

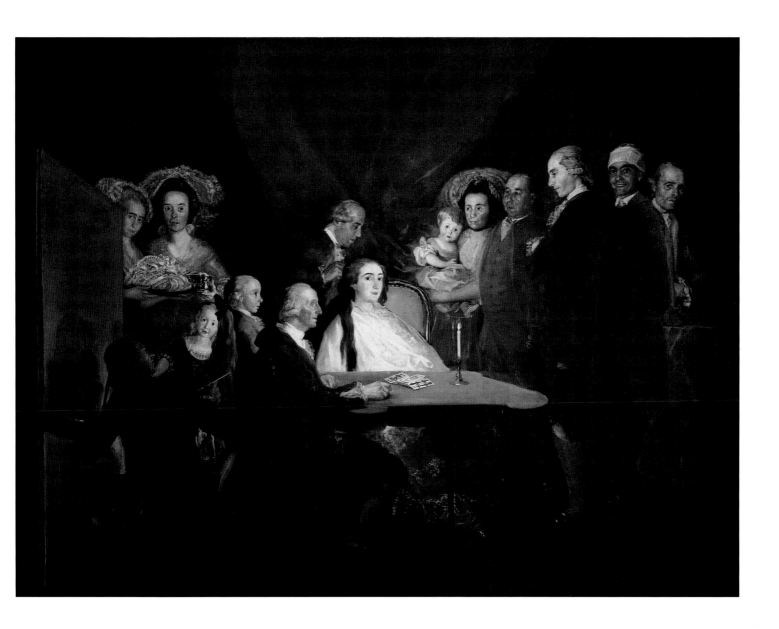

par Goya pour l'infant d[n] Luis de Borbón à Arenas de San Pedro," *Revue de l'Art* 43 (1979), pp. 10-22.

6. Arnáiz and Montero, "Goya y el Infante don Luis."

7. Goya to Zapater, undated letter, in *Cartas a Martín Zapater*, p. 99.

8. Diego Angulo Iñíguez, "La familia del Infante Don Luis pintado por Goya," *Archivo Español de Arte* 41 (1940).

9. These identifications were proposed by Arnáiz and Montero, "Goya y el Infante don Luis."

10. Nigel Glendinning, "Goya's Patrons," *Apollo* 114 (Oct. 1981), p. 238.

11. Goya to Zapater, in *Cartas*, p. 108. As Pierre Gassier noted for the first time in "Goya, pintor del Infante D. Luis de Borbón," in Museo del Prado,

Madrid, *Goya en las colecciones madrileñas* (Madrid, 1983), p. 18.

12. Angulo Iñíquez, "La familia."

13. Aureliano de Beruete, *Goya, pintor de retratos* (Madrid, 1916), p. 22.

14. F.J. Sánchez Cantón, *Vida y obras de Goya* (Madrid, 1951), p. 28.

15. Quoted in Nigel Glendinning, "La fortuna de Goya," in Museo del Prado, Madrid, *Goya en las colecciones madrileñas*, p. 27.

6

Condesa-duquesa de Benavente
1785
Oil on canvas
104 x 80 cm.
References: G-W 220; Gud. 165.

Fundación Bartolomé March Servera,
Mallorca

María Josefa Alonso Pimentel was a personality in her own right in the world of the Spanish Enlightenment. More than for her elegance and good taste she distinguished herself as a model of the enlightened woman, who used her position and wealth to support the work of scientists, artists, and writers. As one interested in culture and progress, immersed in a world she wished to improve, she epitomized the intellectual of her age.

Sole heir to the titles, estates, and properties of the Benavente family, María Josefa married the ninth Duque de Osuna in 1771, but owing to her strong personality and independence, she was known as the Condesa-duquesa de Benavente. The English traveler Lady Holland considered Benavente the most distinguished woman of Madrid by virtue of her talents, merit, and taste,[1] and thought she surpassed the Duque in importance. Their marriage must have been rather conventional and tolerant, since it was known that the Duquesa, like many noblewomen of the time, kept a *cortejo* (escort), Manuel de la Peña.[2]

María Josefa must have been very cultivated; in her extensive reading she was advised by the playwright Leandro Fernández Moratín and the French bookseller Pougens, who supplied her with French books almost until her death in 1834, at eighty-two years of age. She was one of the first two women admitted to the Sociedad Económica Madrileña (Madrid Economic Society) when it was established,[3] and later, when the Junta de Damas (Women's Council of the Society) was founded, she was named president for several years.[4] This group's work was very important: "For the first time in Spain, women, like men, participated in public life. An initial platoon of fourteen enlightened women headed by the Condesa de Benavente became the nucleus of the recently established Junta de Damas that began to provide significant services in education, industry, and charity after that first month of October, 1787."[5] During the meetings of the Junta de Damas, national problems such as the abuse of luxury, women's prisons, and the state of the orphanages were debated, and solutions were informed by enlightened ideology: social justice, improvements in hygiene, the importance of the nation's economic progress, education, and social reintegration were among the issues.

Another enlightened aspect of the Duquesa's life was patronage, which manifested itself in her commissions for works of art, such as those by Goya, and for plays, such as those by the social satirist Ramón de la Cruz. She helped the poet Meléndez Valdés financially and provided grants for the continuation of studies abroad, as in the case of the actor Isidoro Máiquez. She was concerned about the dissemination in Spain of all that related to material progress, such as understanding and using vaccines, as well as the promotion of art, for she was a member of an association supporting opera in Spain.

The rivalry between the Duquesa de Alba, another of Goya's patrons, and Benavente was noted by their contemporaries, especially the way their tastes represented opposite poles. Far more than fashions, or preferences for a particular bullfighter, they represented two different aristocratic attitudes toward the world. Since Benavente wished to transform and develop the country, she was interested in everything new and supported all initiatives tending toward that aim; as a result, she was the more prestigious in enlightened circles. The Duquesa de Alba, also endowed with obvious taste and grace, adopted some of the forms and pastimes of the common people but gave nothing lasting to the culture of her day. Jovellanos criticized this *majismo* or populism of the nobility, in which he saw nothing but the evasion of responsibilities to society and to the age.[6]

M.M.H.

1. Elizabeth Lady Holland, *The Spanish Journal of Elizabeth Lady Holland* (London, 1910), p. 195.

2. Ibid., p. 49.

3. See Paula de Demerson, *María Francisca de Sales Portocarrero, Condesa de Montijo: Una figura de la Ilustración* (Madrid, 1975), p. 132, referring to her admittance to the Society: "El 22 de julio de 1786, la Condesa de Benavente, esposa del director, conocida por su talento, su patriotismo y sus libertades, alcanzaba el mismo honor" (On July 22, 1786, the Condesa de Benavente, the director's wife, known for her talent, her patriotism, and her generosity, attained the same honor).

4. She was president during the Junta's first three years, 1787-1790, and again in 1801. Ibid., p. 141.

5. Paula de Demerson, *Catálogo de Socias de Honor y Mérito de la Junta de Damas Matritense, 1787-1811* (Madrid, 1971), p. 1.

6. The Duquesa de Alba never belonged to the Junta de Damas, despite what has been repeatedly published to this effect. Ibid., p. 1, n. 2.

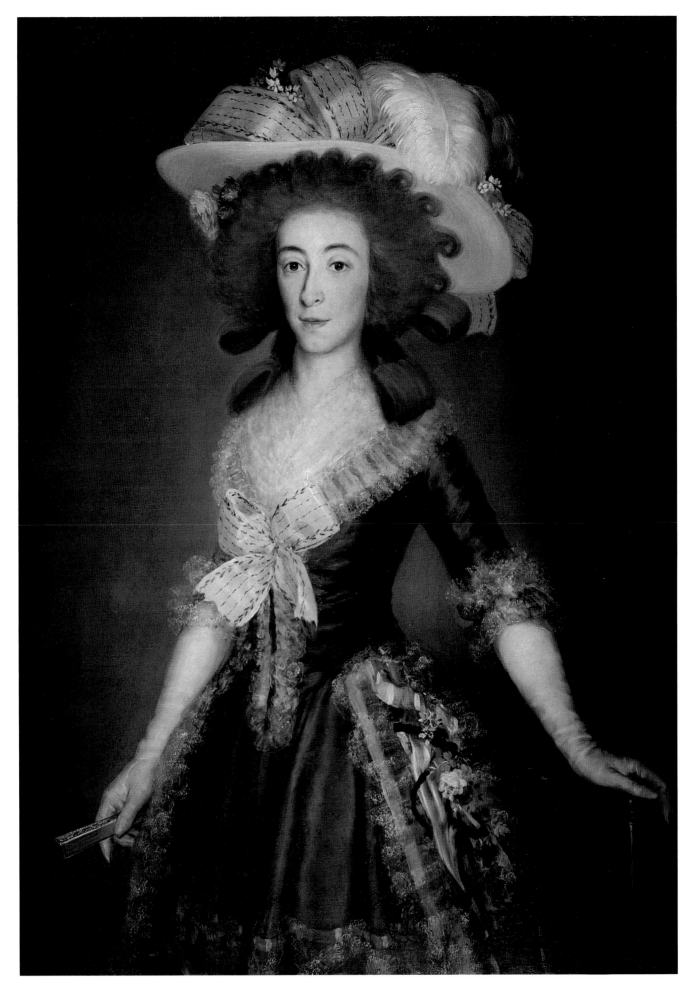

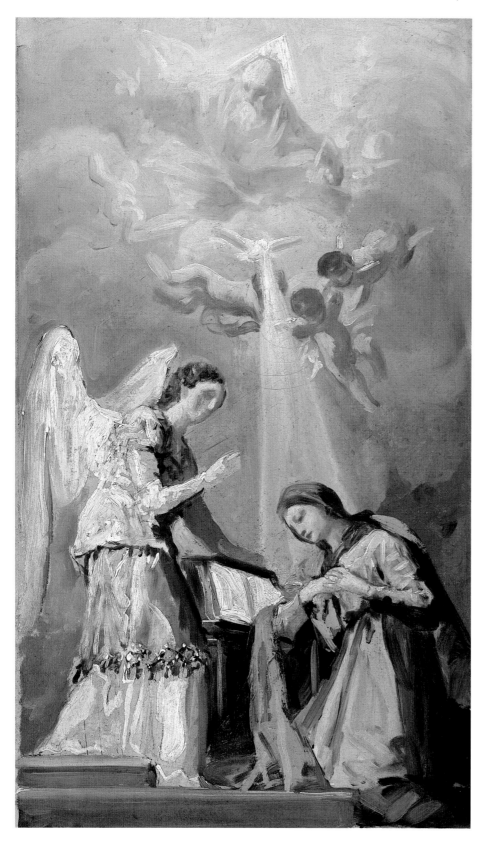

7
Sketch for The Annunciation
About 1785
Oil on canvas
42 x 26 cm.
References: G-W 235; Gud. 166.

Museum of Fine Arts, Boston, William
Francis Warden Fund, 1988.218

Of Goya's paintings with religious sub-
jects, the brilliant little sketch for the
Annunciation is one of the most exciting.
It was commissioned by the Duques de
Medinaceli for the consecration of the
chapel of the convent of San Antonio, in
Madrid, in 1785. The Medinacelis were
one of the richest families in the
country.[1]

In his sketches Goya, as Ceán
Bermúdez tells us, studied "formas, acti-
tudes, espresiones y efectos" (forms, atti-
tudes, expressions and effects)[2] in order
to be true to the idea he wanted to com-
municate. Here the subject was dictated
by the Medinacelis; nonetheless, it is
expressed with feeling. Goya chose the
representation of the Triune God for the
moment of the Annunciation. Although
this scheme was common in art,[3] Goya
added connotations from his own relig-
ious education. He had studied at the
school of the Escuelas Pías. Its founder,
San José de Calasanz, established the
cult of Mary as a second ideal, for which
"se recurriría, ante todo, al medio
potentísimo de la meditación y la ple-
garia" (one resorted, above all, to the
very potent means of meditation and
prayer).[4] Goya must have long meditated
on the subject before changing the com-
position so profoundly from the sketch to
the final painting.

Goya's small sketch shows the Holy
Spirit casting its light upon the Virgin; it
accords with the words in the Gospel of
Saint Luke, the only one to describe the
Annunciation to Mary: "The Holy Ghost
shall come upon thee, and the power of
the Highest shall overshadow thee: there-
fore also that holy thing which shall be
born of thee shall be called the Son of
God."[5] The colors employed illuminate
the differences between the angel and
Mary, as if Goya wanted to stress the
separation between the divine and the

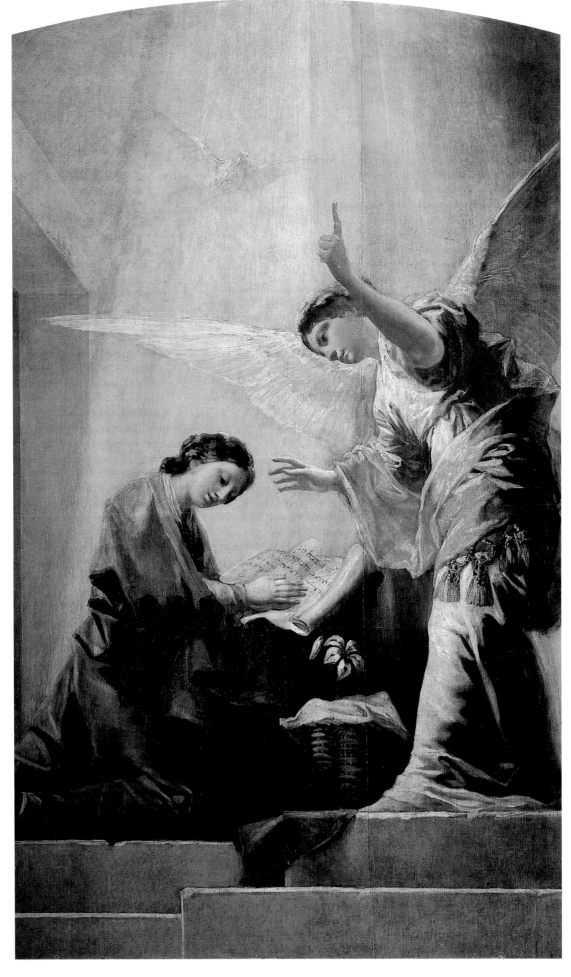

human: white, yellow, and green for the angel; pink and blue for the Virgin. Mary's mantle, which originally blended with the angel's tunic in the lower part, has been corrected to isolate each figure. The entire composition emphasizes Mary: the expression, the angel's hand, the Holy Spirit's light, God the Father's disposition. It thus points to Mary's having been chosen from among all women.

The idea of highlighting the figure of the Holy Trinity in the Virgin's election is related to Calasanz's educational program, which included "como mínimo indispensable en el campo de la santa fe . . . conocer los misterios de la Santísima Trinid, de la encarnación" (as a minimal requirement indispensable in the field of the Holy Faith . . . to know the mysteries of the Holy Trinity, of the Incarnation).[6] To promulgate these teachings among the students, Calasanz composed the prayer "Corona de las doce estrellas" (Crown of the Twelve Stars), which even today is used in the Escuelas Pías. Consisting of praise for the Holy Trinity and for Mary, it begins: "Alabemos y demos gracias a la Santísima Trinidad que nos manifestó a Maria" (Let us praise and give thanks to the Holy Trinity which was revealed to us by Mary). In this prayer the "misterios tan sublimes como el de la Encarnación, el de la Inmaculada Concepción y el de la maternidad divina son contemplados en unidad armoniosa" (such sublime mysteries as the Incarnation, the Immaculate Conception, and divine maternity are contemplated as a harmonious unity).[7] Underlying the composition of the sketch is the idea of the Holy Trinity choosing the Virgin, which coincides with the prayer "Alabemos y demos gracias a Dios Padre porque escogió a Mariá por hija suja . . . a Dios Hijo porque entre todas las mujeres escogió a Mariá por Madre . . . al Espírítu porque eligió a Mariá como esposa" (Let us praise and give thanks to the Holy Father for choosing Mary to be his only daughter . . . to the Son of God for choosing Mary from among all women to be his Mother . . . , and to the Holy Spirit for taking Mary as his bride).

M.M.H.

1. Lady Holland described them as "narrow-minded and illiterate . . . constantly surrounded by monks and priests"; the Duke as "a bigot; blind, and nearly imbecile"; and his wife as a "clumsy, vulgar woman"; *The Spanish Journal of Elisabeth Lady Holland* (London, 1910), pp. 196-197.

2. See Juan Augustín Ceán Bermúdez, *Analisis del cuadro que pintó D. Francisco de Goya para la catedral de Sevilla* (Madrid, 1817), p. ?.

3. The scheme in which God the Father appears in the upper zone of the painting, accompanied by seraphs and angels and the dove of the Holy Ghost, was usually followed by seventeenth-century Sevillian painters. See Jonathan Brown, *Imágenes e ideas en la pintura española del siglo XVII* (Madrid, 1980), p. 84. [*Images and Ideas in Seventeenth-Century Spanish Painting* (Princeton, 1978), p. 66.]

4. György Sántha, *San José de Calasanz* (Madrid, 1984), p. 481.

5. Luke 1:35.

6. Sántha, *Calasanz*, p. 439.

7. Ibid., p. 484.

8

The Annunciation
1785
Oil on canvas
280 x 177 cm.
References: G-W 234; Gud. 167.

Duquesa de Osuna, Seville

The final painting is very different from the sketch (cat. 7). Elements of traditional iconography were added, which must have pleased the Duque de Osuna: the flower, symbol of purity, and the basket. Important alterations in concept are notable. Goya embellished it with an erudite touch: the Virgin no longer kneels beside a book but bends over a scroll (*megil-lah*), which evokes the Old Testament. Arbitrarily repeating five letters of the quadric Hebrew alphabet, Goya simulated a Hebrew text; perhaps it alludes to the passage in Isaiah (7:14) describing the prophecy that augurs the birth of the Redeemer to the Virgin.

The second alteration is in the placement of the angel. A painting tends to be read from left to right. If the Virgin is located at the right, as in the sketch, the viewer lingers over her, and her role is thereby emphasized. But in the final painting Mary is placed at the beginning of the narration. The viewer first sees the Virgin's bowed head, follows the horizontal line of the angel's hand, which rises until reaching the index finger pointing toward heaven, whence comes the divine light. The composition, unlike that of the sketch, is open, dissolving in the upper reaches.

The angel was given an almost sculpturesque monumentality; its presence crowds the Virgin. Mary bows meekly beneath the angel's majestic wing – symbol of the divine plan – which simultaneously protects and subjugates her, overwhelming her with the power of God. The light, coming not from the Holy Spirit but from the Father, is a warm light that comforts the Virgin and illuminates the entire scene. These important changes – the significance of the light, the reference to the Old Testament passage prefiguring what would come to pass, and the monumental angel with its powerful wing – allude to three concepts: light, the Word, and the divine plan. In the face of the Almighty will, the Virgin accepts in such a humbled manner that it seems valid to ask whether she could have chosen to do otherwise.

M.M.H.

9

Mariana de Pontejos
Probably 1786
Oil on canvas
210 x 126.4 cm.
References: G-W 221; Gud. 266.

The National Gallery of Art, Washington,
Andrew W. Mellon Collection, 1937.1.85

This is one of a group of portraits with
landscape backgrounds that Goya
painted in the 1780s. The earliest were
those of María Teresa de Vallabriga (G-
W 207), wife of the Infante Don Luís
(brother of Carlos III), and her daughter,
María Teresa de Borbón (G-W 210), in
1783. Two conventions were common in
this type of work, particularly in France
and England: first, the depiction of the
country estates belonging to the persons
portrayed, to emphasize their status; sec-
ond, the creation of a nonrealistic, sym-
bolic setting for the sitters, reflecting
their role in life or personal qualities. In
this second tradition, women were often
placed in an idealized, natural environ-
ment, designed, as in the Pontejos por-
trait, to reflect or enhance their feminin-
ity or physical beauty. In Spain, Mengs's
portrait of María Luisa de Parma (1765)
provided one attractive model for such
work in Goya's time. The artist himself
presumably chose, or was requested by
his patrons, to follow this kind of
precedent.

Goya probably painted Mariana's por-
trait in 1786, the year in which she mar-
ried Francisco Antonio Moñino y
Redondo, Spanish ambassador to Portu-
gal at that juncture and brother of the
Conde de Floridablanca. Either the sit-
ter's parents or her future brother-in-law
could have selected Goya to make the
portrait. The Pontejos family was related
by marriage to the Marqueses de Santi-
ago, who were early patrons of the artist.
And Floridablanca himself sat to Goya in
1784 (see cat. 4) and gave him positive
encouragement in the early eighties.

Mariana was twenty-four when she
married, having been born on September
11, 1762.[1] She was the only child of
María Vicenta de Sandoval and Antonio
Bruno de Pontejos, who had been joined
in matrimony on April 5, 1760. On her

father's side of the family, her forebears
came from the Santander region and ulti-
mately from the town of Pontejos itself.
Most of the men had been army or naval
officers. One had been an admiral, and
several were knights of the orders of San-
tiago and Calatrava. The Pontejos family
did not belong to the old aristocracy but
came of *hidalgo* (petty noble) stock; their
title of Marqués was an eighteenth-cen-
tury creation. There was a title on Mari-
ana's mother's side too: that of Conde or
Condesa de la Ventosa, centered on
estates founded by the sixteenth-century
artist Berruguete. Mariana succeeded to
this countship after her mother's death in
1801, and she became Marquesa de
Pontejos when her father died in 1807.

The Pontejos family fortunes were
founded in the early years of the eight-
eenth century. Mariana's great-grandfa-
ther, Don Antonio de Pontejos (1676-
1735), moved to Madrid and became one
of Felipe V's *ayudas de cámara* (gentle-
men-in-waiting) and the first recipient of
the title of Marqués de Casa Pontejos. A
man of substance in his own right, he
added considerably to his wealth by mar-
rying first a niece and then the daughter
of the Marqués de Santiago. When he
died, his property was valued at
5,682,108 reales, and his second wife had
16,684,481 reales. An entailed estate
was established to go with the Casa
Pontejos title at that time. Part of the
Santiago picture collection came to the
family as well.

The title passed to Goya's sitter
through her grandfather, Antonio Juan
de Pontejos (1711-1773), and her father,
Antonio Bruno (1732-1807). Extensive
possessions went with it, including
houses in Santander and Cádiz, a country
residence at Torrejón de Ardoz, as well
as properties in Madrid. Since there was
no lack of money either, Mariana's wed-
ding was a lavish affair, celebrated by the
papal nuncio on December 23, 1786, in
Madrid, in the Pontejos palace on the
Carrera de San Jerónimo, with a group of
influential witnesses. According to the
marriage contract, the bride had a dowry
of half a million reales plus an annual
income of 132,000 reales and 22,000 re-
ales a year for food. Francisco Moñino,
for his part, brought another 132,000

reales per annum and the same 22,000
reales over and above that.[2] The main
attraction of Moñino for the Pontejos
family lay in the fact that his brother,
José Moñino, was Carlos III's chief minis-
ter and unmarried. Francisco was heir to
José's estates and titles; the latter had
been made Conde de Floridablanca and
Vizconde de Moñino in 1773.

Against this financial background,
Goya's full-length portrait of Mariana, at
ease in an idyllic setting, might seem to
epitomize a life of guaranteed comfort
and carefree leisure. But, in reality,
Mariana's path was far from being
smooth. She lost two children in child-
birth early in her marriage to Moñino,
and then Floridablanca's fall from power
in 1792 dragged his brother down too,
and there was a period of enforced exile
in Murcia. Later on, the Peninsular War,
followed by new personal misfortunes,
further upset the tenor of her existence.
Francisco Moñino died in December
1808, and although Mariana was soon
married again, her second husband, a
well-born Sevillian, Fernando de Silva y
Meneses, did not survive long either,
dying in January 1817. Furthermore, the
latter's estates were seized and sold dur-
ing José I's reign, and not inconsiderable
financial losses were sustained as a
result.

Mariana's spirit was not broken by
these adversities. In Cádiz, during the
Peninsular War, her residence was the
center of witty cultural gatherings, and
the poet Juan Nicasio Gallego improvised
a madrigal about Goya's portrait of her.[3]
Although she was delicate physically, she
was firm of purpose, still awash with
wealth, and entirely ready for an adven-
turous, perhaps willful, third marriage.
This was to Joaquín Vizcaíno, twenty-two
years her junior; he was the son of a law-
yer who was later to be famous as a
mayor and benefactor of Madrid. The
wedding took place a mere eight months
after the death of her previous husband.
Not long afterwards Vizcaíno joined the
National Militia in opposition to Fer-
nando VII in 1820. But, in November
1822, he was with his wife in Paris,
where many Spanish liberal exiles joined
them the following year. The French
police monitored Don Joaquín's political

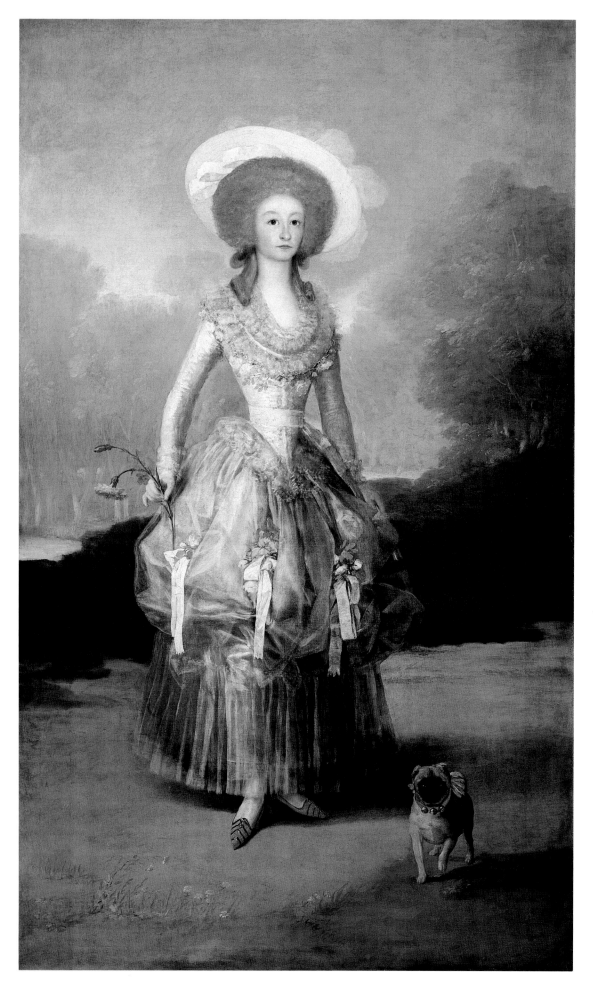

contacts and noted his more disreputable sexual exploits. They also observed Mariana's talent for intrigue, her extravagant lifestyle, and her outspoken criticism of the Spanish clergy.[4] She did not long survive her period in France, however, and died in Madrid on July 18, 1834. She was staying at the time with her eldest surviving daughter, Vicenta (born December 28, 1796). The latter (painted as a child by Agustín Esteve in 1800 or 1801) had inherited the Floridablanca title on the death of her uncle in 1809 and was now married to Don Manuel Pando, the future Marqués de Miraflores. Mariana was with her because the Pontejos palace in the Carrera de San Jerónimo (on the site of the present Teatro Reina Victoria and probably part of the adjacent Crédit Lyonnais as well) had fallen into disrepair by 1827. So Mariana died, and her portrait hung across the street in the Miraflores palace (Carrera de San Jerónimo, 19, originally designed by Pedro de Ribera in the 1730s), which still exists, though now much modified.

N.G.

1. Archivo parroquial de la Iglesia de San Sebastián, Madrid, Bautismos, Libro 39, fol. 384v.

2. José Valverde Madrid, "Un retrato de la Exposición de Arte Francés en España," *Adarve* (Córdoba), May 1, 1980, p. 9.

3. Ramón Solís, *El Cádiz de las Cortes* (Esplugas de Llobregat, 1978), p. 362.

4. Jacques Fauque and Ramón Villanueva Etcheverría, *Goya y Burdeos, 1824-1828* (Zaragoza, 1982), pp. 78-80.

10

Winter
1786-1787
Oil on canvas
275 x 293 cm.
References: G-W 265; Gud. 221.

Museo del Prado, Madrid, 798

A group of five men walk through a desolate, snowy landscape. Three of them, covered with blankets, go forward together, protecting each other from the cold. On one side a small dog pauses, on the other, a hooded man holds a rifle between crossed arms, and behind them a man wrapped in a cloak leads a donkey carrying a pig. There is a soft light, it is snowing, and the wind sharply bends the bare branches of the trees.

This work made up part of a group of cartoons for tapestries that would be used to decorate the dining room in the Pardo Palace, a room whose principal motif was the Four Seasons. The depiction of winter apparently was never executed as a tapestry.[1] Goya's interpretation of this subject is surprising. Although the theme is allegorical, he chose for the cartoon a realistic view instead of a more conventional representation that would be easily recognized as the image of winter.

Goya's view of winter takes into account the reality faced by countryfolk; it singles out the harsh manner in which the season treats society's less fortunate. The pig, split open and carried on the back of the donkey, possibly to be sold in the city, is used as a symbol. With the first cold weather of the year comes the slaughter, the most important event in peasant society. In traditional representations of the months, this activity served to identify December.

Nevertheless, the true protagonists are the laborers who appear to be from different social conditions. They travel by foot most likely because they could not afford the high cost of transportation. The painter reflected the rigorous climate in his depiction of these rustic men; since they lack adequate clothing, they have covered themselves with blankets, and one of them wears hemp sandals. The unsafe roads presented another difficulty: highwaymen often surprised travelers, making the transportation of goods dangerous. Perhaps that is one reason the hooded man feels obliged to carry a rifle despite the cold.[2]

In enlightened circles, an artificial vision of nature was giving way to a desire to understand the reality of the country. In poetry "the new valuation of natural reality encouraged a deeper meditation, heavy with problems of moral, economic and social and also political order."[3] Juan Antonio Meléndez Valdés, poet and magistrate (see cat. 24), a great friend of Goya, and also a protégé of the Duquesa de Osuna (see cat. 6 and 17), unveiled in his first poems about the seasons the origins of an authentic social poetry. Meléndez Valdés drew close to country life in order to praise it as a moral emblem. Goya approached the harsh reality of peasant life but did not make it exemplary as did his enlightened friend. The painter did not believe that virtue was exclusive to one particular group or place. Still, some men of the Enlightenment upheld country life as a moral example in contrast to the corruption at court and as a means to bring the aristocracy back to their estates and the cultivation of their lands.

In this painting Goya stressed the power of nature, which has caught the travelers unaware, and by subtly reducing the importance of the figures, he increased nature's role as protagonist. He employed a range of icy tones of grays and blues for the landscape, used ochers for the figures, and covered both with the heavy falling snow, painted with light, finishing brushstrokes. In the bending trees we see the force of the wind that slows the advance of the travelers.[4] The bitter cold is conveyed through their attitudes; expressed in the faces of the three wrapped in blankets is fatigue resulting from the difficulty of the journey. In this way, the snow, wind, and cold accentuate the sensuous nature of the composition. Goya contemplated the way in which man is at once drawn toward and made to suffer from nature's seductive power.

M.M.H.

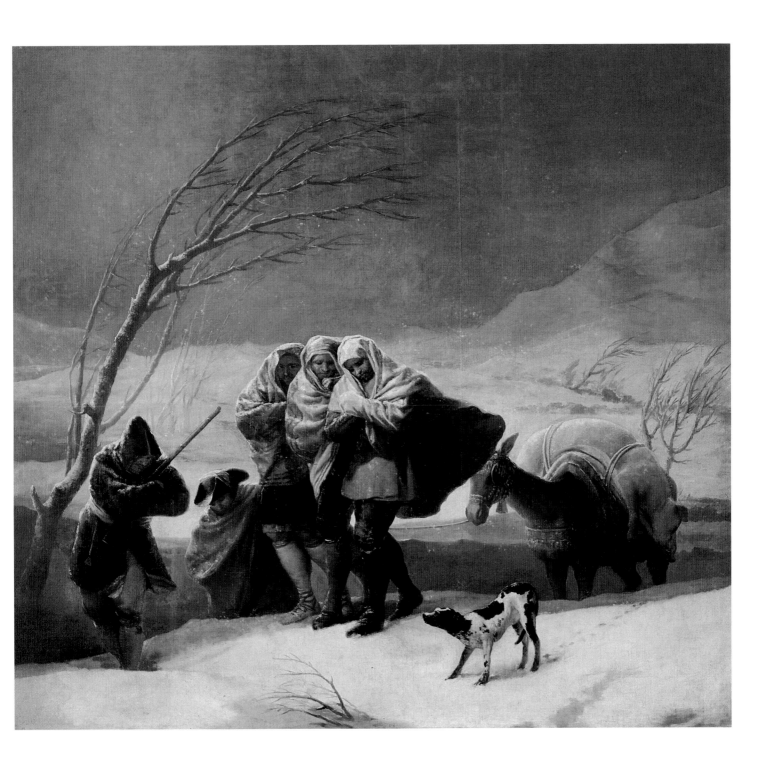

1. See Nordström, *Goya*, p. 58: "Was it too serious and depressing a scene for the gay happiness of the newly married Royal couple? At any rate the winter cartoon was never woven for El Escorial judging from the available inventories, and thus it was never hung with the other tapestries of four seasons."

2. The incorporation of the reality of the peasant's life into the allegory of winter was an important pictorial event. So claimed José Moreno Tejada, an artist and fellow student of Goya's at the Academia de San Fernando, in a poem published in 1804, *Excelencias del pincel y del buril* (Excellences of Brush and Burin). In the poem, Moreno Tejada applauded Goya's originality: "Pintó el invierno caprichosamente / Un celebre español bien conocido / Igualando el hermoso colorido / A la invención sublime de su mente" (He painted the winter whimsically / A celebrated well-known Spaniard / Matching the beautiful colors / To the sublime invention of his mind). Nigel Glendinning, in *Goya y sus criticos* (Madrid, 1982), p. 64, identified the poem with this painting.

3. Rinaldo Froldi, "El tema de la naturaleza," in *Historia crítica de la literatura española*, vol. 4: *Ilustración y Neoclasicismo*, ed. Francisco Rico (Barcelona, 1983), p. 456.

4. Valeriano Bozal, "El árbol Goyesco," in *Goya: nuevas visiones: homenaje a Lafuente Ferrari*, (Madrid, 1987), p. 123. He points out (p. 124) the role of the trees as symbolic icon. Goya gave it as much presence as the human figures; he was "concerned more with using elements as explanation of the subject matter than with using them to illustrate the landscape."

11

Highwaymen Attacking a Coach
1786-1787
Oil on canvas
169 x 127 cm.
References: G-W 251; Gud. 235.

Private Collection, Madrid

"Representa unos ladrones que han asaltado á un coche y despues de haberse apoderado y muerto á los claeseros, y a unoficial de guerra, que se hicieron fuertes, estan en ademan de atar á una muger y á un hombre" (Some thieves have attacked a carriage, and after having overpowered and killed the drivers and a war official who had stood up to them, they are in the act of tying up a woman and a man). Goya thus described the painting in a bill, of May 12, 1787,[1] sent to the Duquesa de Osuna (see cat. 6), who had commissioned him to do seven paintings of *asuntos de campo* (country scenes) for her summer house on the outskirts of Madrid.

This painting shows the influence of both its client and the place where it was to be exhibited. The Duquesa had an old house in the village of Alameda, acquired in 1783, which was converted into a palace named El Capricho.[2] Used for the enjoyment of *tertulias* (salons) with friends, the theater, and nature, it soon became famous for excursions and picnics in the country organized by its owner.[3] Perhaps these circumstances led Goya to view the subject of the painting in a theatrical rather than a realistic manner.[4] The use of such exuberant and lush landscape dilutes the story being told in such a way that it seems a mere anecdote: one blood-stained coachman lies dead on the ground; a bandit knifes the other one; a soldier, trying with his sword to stand up to them, dies in the attempt.

It has been said that in this composition "the picturesqueness of the natural atmosphere predominates over the fallen bodies and the violent outcome."[5] By "picturesque" is meant that which "refers to the original and pleasant curiosities of nature, those traits which allow for the enjoyment of the senses without agitation or terror, but with delicacy and

softness."[6] This description would have aptly suited the Duquesa's El Capricho.

Highwaymen Attacking a Coach is a commissioned work, which reflects the client's wishes or the painter's interpretation of them. The influence of Goya's enlightened client made itself felt years later. During his stay in Andalusia (1793-1794), Goya painted a picture of the same subject (cat. 20). At that time highway robbery was a major problem in Andalusia, the mountains of Toledo, and approaches to Madrid.[7] One of the objectives of Carlos III's program to repopulate the mountain regions was to reduce the incidence of highway robbery.[8] The bandit was a highwayman alternately involved in "other forms of delinquency – kidnapping, muggings, beatings."[9] Nevertheless, these criminals were elevated to the status of heroes by popular literature, which spread the myth of the honorable bandit who attacked the rich and respected the poor. Commenting on popular ballads, Juan Meléndez Valdés (see cat. 24) wrote: "Son sus temas comunes guapezas y vidas mal forjadas de foragidos y ladrones, con escandalosas resistencias á la justicia y sus ministros, violencias y raptos de doncellas, crueles asesinatos . . . creídas cual suelen serlo por el ignorante vulgo, encienden las imaginaciones débiles para quererlas imitar. . . . A estas clases estan reducidos cuantas jácaras y romances corren impresos, y se cantan y escuchan con indecible aplauso por el pueblo ignorante." (Their usual subjects are the bravado and the unsettled lives of wanderers and thieves, their scandalous resistance to justice and its ministers, violent acts and rape of young maidens, cruel murders . . . believed as they generally are by ignorant commoners, that stimulate susceptible imaginations to try and imitate them. . . . As many ribald songs and ballads as are published circulate among these classes, and they are heard and sung amidst thunderous applause by the ignorant populace.)[10]

In this painting Goya treated the subject of highway robbery more as a theatrical episode than a true incident. Yet he did not turn it into myth; in his depiction the first to die were the coachmen, who

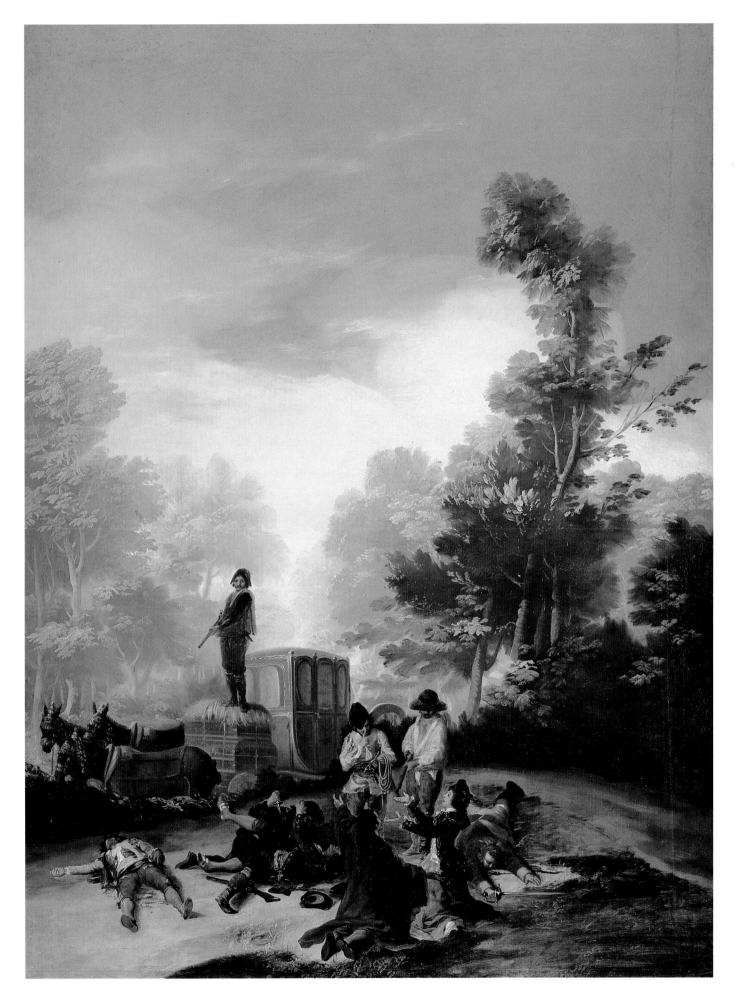

were just doing their job. The survivors
are dressed as *majos* (lower-class dan-
dies), that is, after the fashion of the
common people who glorified the high-
waymen, but these are not true *majos*. A
majo could not afford a coach drawn by
four mules.[11] They belong to the part of
the upper class that adopted the dress
and manners of the *majo*, "the aesthete
of impudence."[12] That section of the
upper class which, according to Jovella-
nos, should have been the model for
social reform imitated the common peo-
ple's coarsest customs; and that class
became a victim of the people because,
despite their *redecillas* (hairnets), there
was no mistaking their identity. The
leader of the bandits confirms this by his
expression. He does not believe a word
these *majos* try to say to him, and he will
get more from them than from the poor
coachmen.

 M.M.H.

1. See G-W, p. 383, Appendix V, under May 12,
1787, item 2.

2. Joaquín Ezquerra Bayo, *La duquesa de Alba y
Goya* (Madrid, 1928), p. 150.

3. Emilio Cotarelo y Mori, *Iriarte y su época*
(Madrid, 1897), p. 235.

4. See Charles Yriarte, *Goya: Sa biographie, les
fresques, les toiles, les tapisseries, les eaux-fortes et
le catalogue de l'oeuvre* (Paris, 1967), p. 86, who
observes that the scene seems more like theater than
realistic drama; p. 86.

5. Valeriano Bozal, "El árbol goyesco," in *Goya:
Nuevas visiones: Homenaje a Lafuente Ferrari*
(Madrid, 1987), p. 123.

6. Ibid., p. 121.

7. Julio Caro Baroja, *Literatura de cordel* (Madrid,
1969), p. 369.

8. Constancio Bernaldo del Quirós y Luis Ardila, *El
bandolerismo* (Madrid, 1934), p. 50.

9. Ibid., p. 61.

10. Juan Meléndez Valdés, *Discursos forenses*
(Madrid, 1821), pp. 170-171.

11. According to Juan Plaza Prieto, *Estructura
económica de España en el siglo XVIII* (Madrid,
1976), p. 401, "Journeys were very costly. . . . Travel-
ing by coach involved considerable expense."

12. Caro Baroja, *Literatura*, p. 216.

12
Village Procession
1786-1787
Oil on canvas
169 x 137 cm.
References: G-W 253; Gud. 239.

Private Collection, Madrid

"Representa una procesion de una aldea,
cuyas figuras principales ó de primer
termino, son el Cura, Alcaldes,
Regidores, Gaitero, etc. y demas acom-
pañamiento, con su pais corres-
pondiente" (It represents a village pro-
cession, whose main or foreground
figures are the Priest, the Mayors, the
Aldermen, the Bagpipe Player, etc., and
other company, shown according to their
corresponding region).[1] This is how Goya
described the scene in the bill he submit-
ted to the Duques de Osuna (see cat. 17).
The work belonged to a series of seven
paintings dedicated to rural subjects that
were to decorate El Capricho, the
Duques' house (see also cat. 11) in Ala-
meda, outside Madrid.

The religious procession was a subject
for debate in enlightened circles. Every-
thing alien to devotion was to be elimi-
nated in order to give religious ceremo-
nies greater authenticity. In this view
"there is the implied teaching . . . that
true religion does not lie in the exteriors
of religious practices, which many
observe without reflecting on or pene-
trating into their significance, nor in the
pomp or number of churches. . . . Christi-
anity, far from satisfying itself with
appearances, condemns them if they are
not accompanied by works that demon-
strate the professed faith."[2]

The procession makes its first appear-
ance in Goya's work in this painting and
was handled from a more critical point of
view in later works. Along with the
importance of the natural environment
and architecture, characteristic of the
entire series of the Osuna commission,
Goya emphasized two elements in the
composition: the people and the authori-
ties leading them, representatives of the
town hall and the parish priest, who are
segregated from the crowd.[3]

The protagonism of the civil authorities
was more obvious in so-called rogations,

or public prayer processions. José
Blanco White, the liberal clergyman,
explained that when an epidemic was
declared in Seville in 1800 "the civil
authorities wisely resolved to make an
application to the archbishop and chap-
ter for the solemn prayers called *Roga-
tivas*."[4] The twentieth-century scholar
and editor of Blanco White's *Letters*,
Antonio Garnica, observed: "The chroni-
clers agree in noting that many more
religious than sanitary measures were
undertaken. . . . More than sixty proces-
sions were held during the 100 days the
plague lasted."[5] In the *Libro de
Gobierno* (Government Manual) of the
Sala de Alcaldes (Mayors' Hall), the
twentieth-century historian Charles Kany
found that processions were called to
pray for rain in 1780: "Since the need
for water is becoming more urgent each
day, the council has resolved to continue
the public rogations."[6] The civil authori-
ties were among the first to divorce the
procession from its devotional character.

Regarding the religious authorities, the
historian Domínguez Ortiz commented:
"The rural parish priest was one of the
pillars of Spanish society, leader and
counselor of his flock, often the only
intellectual element in the village. There
is no reason to conceal his intellectual
and moral defects, recognized by unim-
peachable authorities."[7] As a result,
among the principal objectives of the
reformers and of the government itself
was the education of the clergy; an
improvement in the education of parish
priests would have an effect on the popu-
lace's knowledge of doctrine.

In the light of this situation it is under-
standable that the "figuras principales ó
de primer término son el Cura, Alcaldes,
Regidores" (the main or foreground
figures are the priest, mayors, and alder-
men), as Goya described them. They
attracted a mass of people "for whom
religion meant emotion and ceremony
and rested . . . on a mixture of faith and
folk belief."[8] The magistrate and poet
Meléndez Valdés (see cat. 24) was caus-
tic: "Porque ciertamente no se alcanza
ahora qué puedan significar en una reli-
ión, cuyo culto debe ser todo en espíritu y
verdad, esas galas y profusion de trages .
. . esas imágenes y pasos llevados por

ganapanes alquilados, esas hileras de hombres distraídos mirando á todas partes sin sombra de devoción . . . ese bullicio y pasear de la carrera, esa liviandad y desenvoltura de las mugeres, y ese todo, en fin, de cosas ó extravagancias que se ven en una procesión, si no son como el fiscal las juzga para sí, en vez de un acto religioso, un descarado insulto al Dios del cielo y á sus Santos" (Certainly in a religion where worship should be all spirit and truth one cannot explain those trappings and that profusion of finery, . . . those images and effigies carried by hired porters, those rows of men looking distractedly every which way, without a shadow of devotion, . . . that noise and bustle of the way, that bold and licentious manner the women have, and that everything, in sum, of extravagance that is to be seen in a procession, if not as this judge decided for himself as not a religious act, but a wayward insult to God in heaven and to his saints).[9] Goya did not go so far as his friend Meléndez; his opinion is discernible in the subtle mockery of the authorities' faces and in the attitudes of some of those present. The beauty and harmony of the colors take precedence over criticism in this composition: everything is in perfect balance to decorate the enlightened Duquesa's living room.

M.M.H.

1. G-W, p. 383, Appendix V, under May 12, 1787, item 4.

2. María Giovanna Tomsich, *El jansenismo en España* (Madrid, 1972), p. 124.

3. The religious procession in the modern era is always an expression of social order with a clearly marked hierarchy. "The *social body* will also be reflected in procession, distinguishing or exalting that part of it considered most important or significant"; Julio Caro Baroja, *El estío festivo* (Madrid, 1984), p. 53.

4. José Blanco White, *Cartas de España,* ed Antonio Garnica (Madrid, 1977), p. 161. (Blanco White, *Letters,* pp. 194-195.)

5. Blanco White, *Cartas,* p. 370, n. 2.

6. Kany, *Life and Manners,* p. 364.

7. Antonio Domínguez Ortiz, *La sociedad española en el siglo XVIII* (Madrid, 1956), p. 144.

8. Callahan, *Church,* p. 71.

9. Juan Meléndez Valdés, *Discursos forenses* (Madrid, 1821), pp. 193-194.

12A

The Greased Pole
1786-1787
Oil on canvas
169 x 88 cm.
References: G-W 248; Gud. 236.

Private Collection, Madrid

This painting belongs to the series of
works on country scenes commissioned
by the Duquesa de Osuna to decorate her
Alameda house (see cat. 11 and 12).
Goya's evocation of the world of popular
amusements is similar to that in a tapes-
try cartoon he painted for the Real
Fábrica de Tapices (Royal Tapestry Fac-
tory). His description of this painting
survives in his account of May 12, 1787,
to the Duquesa: "Otro cuadro que
representa un Mayo, como en la plaza de
un lugar con unos muchachos que van
subiendo por él, a ganar un premio de
pollos y roscas, que está pendiente en la
punta de él, y varias gentes que están
mirando" (Another painting that depicts
a Maypole, as in the main square of a
town with boys climbing it in order to
win the prize of chickens and cakes at
the top, and various spectators looking
on).[1] *Mayo* (maypole) and *cucaña*
(greased pole) are synonymous. Tall and
straight, the greased poles are hung with
a prize to be won by the first to reach it.
Goya succeeded in giving this children's
game observed by adults the feeling of a
merry event brimming with activity. The
subtlety of color and the adept handling
of the canvas's vertical format, in which
Goya played with the rich shades of over-
cast sky, make this painting, along with
the rest of the series, an early
masterpiece.

A.E.P.S.

1. G-W, p. 383, Appendix V, under May 12, 1787,
item 6.

13

The Wounded Mason
1786-1787
Oil on canvas
268 x 110 cm.
References: G-W 266; Gud. 225.

Museo del Prado, Madrid, 796

Two masons carry a fellow worker who
has probably fallen from the scaffold that
appears in the background. This painting
was part of a series of cartoons for tapes-
tries representing the seasons that were
to decorate the dining room of the Pardo
palace (see cat. 10). It has been
observed that in calendar illustrations,
the construction of buildings sometimes
symbolized the month of November or
the summer,[1] and Goya may have chosen
the subject for this painting in accor-
dance with that tradition. Goya painted
the Four Seasons for Carlos III with the
working world in mind. The ennoblement
and recognition of manual labor was one
of the great concerns of the government
and the Sociedades de amigos del Pais
(Societies of Friends of the Nation), who
considered the appreciation of such work
to be a first step toward economic pro-
gress. The general contempt of manual
labor had reached such an extreme that
it was thought to be almost more degrad-
ing and dishonorable to work than to beg.
 Pedro Rodriguez Campomanes, the
enlightened political economist, was one
of the first to try to change this situation,
affirming in 1774, "es también necesario
borrar de los oficios todo deshonor . . .
solo la holgazanería debe contraer
vileza" (it is necessary to erase dishonor
from all occupations . . . only loafing
should be infamous).[2] As the first solici-
tor general, he persuaded the king to
issue the royal decree of 1738, which
stated "que no sólo el Oficio de Curtidor,
sino tambien los demas Artes y Oficios
de . . . á este modo, son honestos y
honrados; y que el uso de ellos no
envilece a la familia, ni a la persona que
los exerce" (that not only the Occupation
of Tanner but also the other Arts and
Crafts . . . are honest and honorable; and
that their practice does not degrade the
family, or the person who practices
them). The law defines the objectives it

pursues, "para que con esta distincin se
ejerciten y sigan de padres a hijos" (so
that, thus clarified, they are practiced
and passed on from generation to
generation).[3]
 The interest in encouraging manual
labor was evidently on Goya's mind since
he included it in the iconography of the
Four Seasons. *The Wounded Mason* simi-
larly addresses these ideas. An edict
"published for the first time in 1778, and
reiterated several times thereafter was
commented on and praised by the press
. . . still in January 1784."[4] The decree
exacted losses and damages from the
master builder for the fall of a laborer; it
gave suggestions on standards for the
construction of scaffolds, which had to be
followed personally by the master
builder, whose negligence could result in
his being jailed and fined in case of an
accident; it also made provisions for the
injured and their families. The decree
went beyond the ennoblement of labor; it
also tried to protect it legally. The rela-
tion between the edict and this cartoon
was observed by Edith Helman, who
wrote: "when Goya thought of the theme
of the fallen mason – if it was he who
invented it – he was trying to obtain the
monarch's protection and that of his
powerful ministers of state. To do this, he
donned the trappings of an enlightened
courtier, accommodating himself to their
ways of thinking and feeling."[5] However,
in the same years, 1786-1787, he
repeated the theme for the Alameda pal-
ace of the Osuna family in *The Convey-
ance of a Stone* (Collection of the Conde
de Romanones, Madrid; G-W 252), in
which an injured mason is being carried
on an improvised stretcher; although in
the context of the latter painting, the
accident is not more than an anecdotal
detail. On the bill Goya presented to the
Duques de Osuna, he described the sub-
ject of the painting as "un pobre que se
ha desgraciado, que llevan en una
escalera, y tres carreteros que lo miran
lastimados" (a poor man who has had a
mishap being carried away on a ladder,
and three carters watching him with
pity).[6] We can deduce from those words
that Goya was not indifferent to the
endeavors of the enlightened to reform
society.

A sketch in the Museo del Prado[7] said to be for this work has the same composition as the painting, but there the masons who carry their fellow worker are laughing. In the inventory of the Osunas, who bought the sketch, the title is given as *El albañil borracho* (The Drunken Mason). In the tapestry cartoon, the mason is more dignified – his clothing is poor but mended; while in the sketch, the man appears not only as poor but also as negligent.[8]

The subject is wonderfully dealt with given the strict dimensions – extremely long and very narrow – required by the decorative scheme for the tapestries.[9] Goya carefully maintained the same scale for the figures as in the rest of the paintings in the series. Within the limits imposed by the frame, he managed to suggest amplitude by increasing depth. To do that from a very low viewpoint, he projected a succession of elements: stones, branches, masons, and sketchy scaffolds that dissolve in the blue-gray distance.

M.M.H.

1. Nordström, *Goya*, pp. 55-56.

2. Pedro Rodriguez Campomanes, *Discurso sobre la industria popular* (Madrid, 1774), quoted in "La polemica sobre los oficios viles en la España del siglo XVIII," ed. Antonio Elorza, *Revista del Trabajo* 22 (1968), p. 88.

3. Ibid.

4. Helman, *Trasmundo,* p. 36.

5. Ibid.

6. See G-W, p. 383, Appendix V, under May 12, 1787, item 7.

7. Prado, Madrid, 2782; G-W 260.

8. J. López Rey, *Francisco de Goya* (New York, 1951), p. 9, studied the differences between the sketch and the cartoon: "This variation corresponds to the differences between the subject that distinguishes one composition from the other; in *The Drunken Mason* there is social satire, and in *The Wounded Mason,* philanthropic sympathy. According to Lavater, both sentiments awaken the physiognomic observation in the human soul."

9. See Helman, *Trasmundo,* p. 36: "The subject in itself did not interest him; it was a pretext to solve new pictorial problems."

14

Sketch for The Death of Saint Joseph
About 1787
Oil on canvas
54.9 x 46.4 cm.
References: G-W 237; Gud. 245.

Courtesy of the Flint Institute of Arts,
Flint, Michigan, Gift of the Viola E. Bray
Charitable Trust, 1967.19

There are two known works by Goya on
the death of Saint Joseph. One is this
small sketch, and the other is the canvas
commissioned by Carlos III for the Santa
Ana convent in Valladolid (fig. 1).[1] We
cannot be certain the sketch is for the
Valladolid painting; although the differ-
ences are evident, Goya's sketches tend
to be substantially different from the fin-
ished works (see cat. 7 and 8). Goya
used preliminary oil sketches to solve
specific stylistic problems and to try out
an initial interpretation of the subject.

The splendid sketch contrasts with the
Valladolid painting in its freer pictorial
quality and greater perspectival depth.
The foreshortened lines of the bed lead
the viewer's gaze to Saint Joseph's coun-
tenance, toward which Christ, the Virgin,
and the two angels also look as witnesses
of the saint's agony. His legs convey the
agitation and his half-opened mouth the
anguish of his final moments. As he con-
fronts his death, the saint searches with
his eyes for confidence and security in
Christ. And this is where Goya shows us
the most moving aspect of the scene: the
enormous humanity with which Christ
consoles his earthly father; seated next to
the dying man's bed he bends over to be
closer to him. He raises his father's head
with an arm and takes Joseph's hand
with great tenderness.

Emile Mâle, the twentieth-century
medievalist who studied the iconography
of Saint Joseph, cited Isidorus Isolanus's
Summa de donis S. Joseph, which con-
tains a document of the Eastern Church
that claims to reproduce Joseph's last
moments according to Christ's own
words: "I sat at his head and my mother
at his feet. I held his hands in mine for a
long hour. The archangels Michael and
Gabriel drew near him, and he breathed
his last with contentment."[2] Mâle added

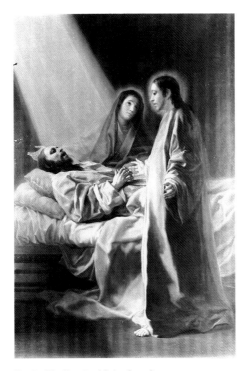

Fig. 1. *The Death of Saint Joseph*,
1787.
Oil on canvas.
Convent of Santa Ana, Valladolid

that this passage had great repercussions
in the history of art: "In Roman churches
Saint Joseph is often seen in bed, ready
to die a serene death, while Jesus and
the Virgin are at his side."[3] Saint Joseph
is the patron saint of the good death, for
he died between the Virgin and Christ,
but here Goya shows us that a good
death is not the absence of suffering or of
fear but the promise of the consolation
and support of the Son of God in the final
moments.

In the Valladolid painting, perhaps in
order to suggest Francisco Sabatini's
work, Goya emulated the style of Carlos
III's court architect, which he described
to his friend Zapater as that which "se
estila aora" (is now in fashion);[4] he was
referring to what we regard as neoclassi-
cism. The composition is shallower, the
horizontal and vertical lines are pro-
nounced, there is a marked tendency to
reduce and simplify, to clearly separate
light from shadow, to suggest the shape
of each fold, rendering each tone unam-
biguously. There is a more sculptural

effect; the scene has gained in monu-
mentality by "straightening the figure of
Christ and giving him a firm stance."[5]
Goya created an atmosphere of serenity
and balance to envelop the death of Saint
Joseph, who awaits it secure and trusting,
almost inert, before whom Christ
appears almost like a supernatural appa-
rition. With the new style the anguish
that convulsively moved Saint Joseph in
his dying moments is no longer present,
and the tenderness of the son consoling
his father is gone.

M.M.H.

1. In a letter dated June 6, 1787, Goya wrote to
Zapater: "Para el día de Santa Ana an de estar tres
quadros de las figuras del natural colocados en su
sitio, y de conposición, el uno de transito de San
Josef, otro de San Bernardo y otro de Santa Lud-
garda y aun no tengo empezado nada para tal obra y
se a de acer porque lo ha mandado el Rey, conque
mira si estare contento" (By the feast day of Santa
Ana three paintings must be ready whose figures are
to be done both from nature and imagination, one of
the death of Saint Joseph, another of Saint Bernard
[G-W 238], and another of Saint Ludgarda [G-W
239], and I still have not begun anything for such
work and it must be done because the king has com-
missioned them, so imagine how happy I must be).
The *Death of Saint Joseph* and the other two works
Goya mentioned in his letter were to decorate the
side altars in the Santa Ana convent, which was
designed by the architect Francisco Sabatini, whose
good offices procured Goya the king's commission.
See Francisco de Goya, *Cartas a Martín Zapater*, ed.
Mercedes Agueda and Xavier de Salas (Madrid,
1982), p. 173. See also F.J. Sánchez Cantón, "Goya
pintor religioso: precedentes italianos y franceses,"
Revista de ideas estéticas, nos. 15-16 (July-Dec.
1946), p. 292. Sánchez Cantón mentioned that
Emilio Orozco identified the painting that inspired
the composition for the Valladolid painting, a work
with the same name by Carlo Maratti. Emile Mâle
commented that this work was especially well known
in Rome; E. Mâle, *L'art religieux après le concile de
Trente: Etude sur l'iconographie de la fin du XVII
siècle* (Paris, 1932), p. 324, n. 3.

2. Mâle, *L'art religieux*, pp. 322-323.

3. Ibid., p. 323.

4. Goya to Zapater, June 6, 1787, in *Cartas*, p. 173.

5. Sánchez Cantón, "Goya pintor religioso," p. 292.

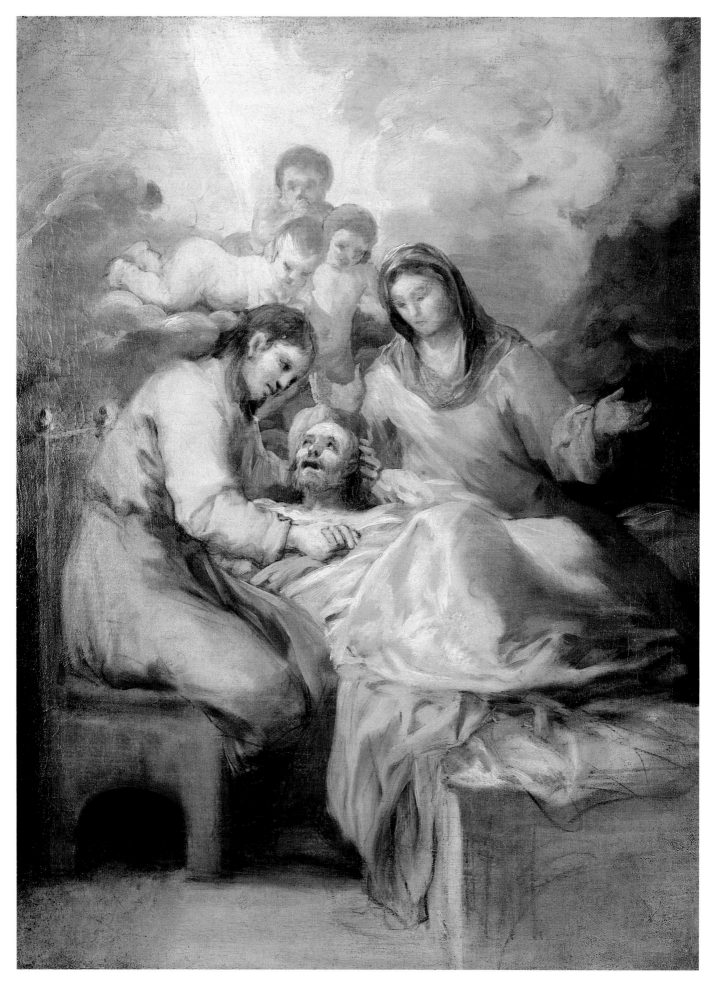

32

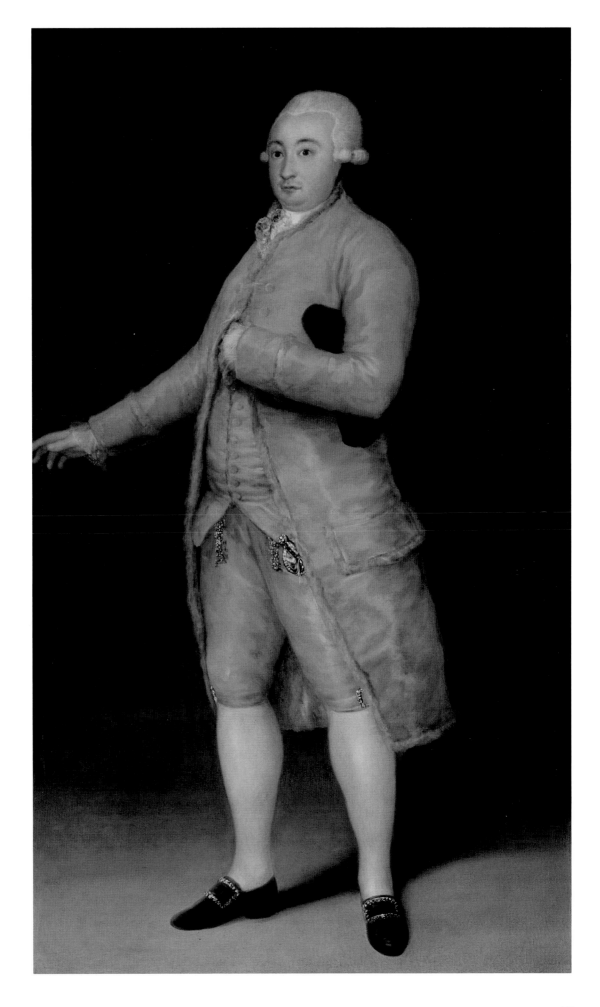

15

Francisco de Cabarrús
1788
Oil on canvas
210 x 127 cm.
References: G-W 228; Gud. 249.

Banco de España, Madrid

Francisco Cabarrús was one of the most attractive but also most polemical personalities of the enlightened society of Goya's time. A merchant born in Bayonne in 1752, he distinguished himself in Spain as an intelligent economist and financier, renowned for his role in the creation of the Banco de San Carlos, predecessor of the Banco de España.[1]

The establishment of the Banco de San Carlos was not an easy task. Cabarrús submitted the first proposal to Prime Minister Floridablanca (see cat. 4) in 1781, which he defended "with all the ardor, imagination, and eloquence of an authentic, born planner."[2] Although the prime minister favored it, the *ministro de hacienda* (minister of finance), Conde de Guasa, and the Cinco Gremios Mayores (Association of Five Major Guilds) opposed it. Cabarrús was obliged to write another long and detailed report in support of his idea. The royal decree establishing the bank was issued on June 2, 1782. Spain was then at war with England and as a result was not receiving American specie, but Cabarrús "turned [the loss] to account . . . [and] won official adoption of a project to issue interest bearing royal bonds, known as *vales reales*, which would circulate as legal tender. . . . After the signing of the peace, the pent-up treasure came in from America, and the bank began to retire the *vales*. These not only recovered their value but circulated at 1 to 2 per cent above par in the years 1786 to 1792. The credit of the king of Spain for once was as good as his Mexican silver and gold."[3] Abreast of these innovations, Goya participated in the new bank by purchasing fifteen shares, which he endorsed in 1788.[4]

Through the efforts of Goya's friend the art historian Ceán Bermúdez the bank commissioned a series of six official portraits. That of Cabarrús is not only the best of them but also the boldest and most modern. Perhaps it was the subject's personality that gave Goya sufficient confidence to dare so much. Cabarrús's character, as we know it from his letters to Jovellanos in 1792,[5] was altogether unconventional. He was a sensitive, fiery, and impassioned spirit who, concerned about the problems of his day, sought solutions that sometimes seemed scandalous to his contemporaries. He proposed that education be "común a todos los ciudadanos: grandes, pequeños, ricos y pobres deben recibirla igual y simultáneamente. ¿No van todos a la iglesia? ¿Por qué no irían a ese templo patriótico? Desde los seis años hasta los diez, críense juntos los hijos de una misma patria." (extended to all citizens: the great, the humble, the rich, and the poor ought to receive it equally and simultaneously. Do not all attend church? Why should they not also go to that patriotic temple? From the age of six to ten, let the sons of the same nation be raised together.) In primary education merriment should reign, wrote Cabarrús, for the art of pedagogy consists in "teaching by playing."[6] He opposed the indissolubility of marriage: "el divorcio nos asusta. Sin embargo pido a todo hombre sincero que me responda si está bastante seguro de sí para prometerse querer siempre a la misma mujer y no querer a otra." (divorce frightens us. On the other hand I ask any sincere man to tell me whether he is sufficiently sure of himself to commit himself to love one woman forever and to love no other.) Acknowledging the failure of the ban on prostitution to halt the spread of venereal diseases, he suggested reopening brothels as a form of control.[7] He questioned the system of hereditary nobility and of primogeniture and requested it be "suprimida para los que no la gozan, y reducida en sus individuos actuales á una mera denominacion" (suppressed for those who do not yet enjoy it, and limited in those individuals who do to a mere title).[8]

The audacity of Goya's style seems to correspond to the subject's courage. Cabarrús's attitude is the focus of attention, there being no other element in the picture to distract us, not even a table or chair. He has assumed the traditional stance representing oratory, an art at which he must have excelled, given "the active and capable businessman's talent for explanation and persuasion" Floridablanca ascribed to him.[9] The position of the feet on the verge of a step seems to suggest action. The composition recalls certain portraits by Velázquez, in particular that of Pablo de Valladolid.[10] To judge by the shadow he projects, Cabarrús is firmly planted in a monochrome, gray space that the light differentiates and in which even a horizon line is absent. The figure's profile is not outlined; in some areas a loose, wavy brushstroke describes it, a stroke that at times, in its transparency, allows the canvas to show through; or another stroke is juxtaposed that gives shape to the fur lining the coat. Goya's brush moved with absolute freedom, refusing to dwell on the anecdotal, on the detail; the buttons on the frock coat are merely indicated with light brushstrokes. The painting is a symphony of yellow and green, with black and white accents on a gray background. All of Cabarrús's character and intelligence is concentrated in his piercing eyes.[11]

M.M.H.

1. Luis García de Valdeavellano published the books of the Banco de San Carlos, recording the bill for the painting, which is dated April 21, 1788; Luis García Valdeavellanos, "Las relaciones de Goya con el Banco de San Carlos," *Boletín de la Sociedad Española de Excursiones*, no. 36 (1928), pp. 58-65.

2. Earl J. Hamilton, "El Banco Nacional de San Carlos (1782-1829)," *El Banco de España: Una historia económica* (Madrid, 1970), p. 201, cited in Juan Plaza Prieto, *Estructura económica de España en el siglo XVIII* (Madrid, 1976), p. 763.

3. Herr, *Revolution in Spain*, p. 146.

4. García de Valdeavellano, "Las relaciones de Goya," p. 61. Several letters to Zapater also refer to them. "En el banco nacional he puesto quinze acciones por consejo de algunos amigos que tengo aqui y es regular que ponga asta benticinco, sino se me ba todo el dinero come el humo pues esta tierra esto tiene de malo" (I have taken fifteen shares in the national bank on the advice of several friends I have here and I may take as many as twenty-five, because, if not, all my money goes up like smoke, one of this country's defects); Goya to Zapater, Nov. 3, 1784, in Francisco de Goya, *Cartas a Martín Zapater*, ed. Mercedes Agueda and Xavier de Salas (Madrid, 1982). p. 122. On May 23, 1789, he asked Zapater's advice: "Dime tu que tienes talento y tanto tino en las cosas, en donde estaran mejor cien mil reales, en el Banco o en bales reales o en los gremios y que me

traigan mas utilidad" (You who have talent and so great a knack for affairs, tell me where 100,000 reales would be put to the best advantage and would give me the best return, in the Bank or in royal promissory notes or in the guilds); ibid., p. 192.

5. Francisco Cabarrús, *Cartas sobre los obstáculos que la naturaleza, la opinión y las leyes oponen a la felicidad pública escritas por el conde de Cabarrús al señor don Gaspar de Jovellanos y precedidas de otra al Príncipe de la Paz* (Vitoria, 1808).

6. Quoted in Sarrailh, *L'Espagne éclairée*, p. 209.

7. Cabarrús, *Cartas*, p. 74.

8. Ibid., p. 56.

9. Plaza Prieto, *Estructura económica*, p. 764.

10. Museo del Prado, Madrid, 1198.

11. Another enterprise of Cabarrús's was the Compañía de Comercio de Filipinas (Philippines Merchant Company). Accused of fraud, he was jailed; once he proved his innocence, Carlos III made him a count. He also worked as a diplomat. He died as minister of finance under José I in 1810.

16

The Meadow of San Isidro
1788
Oil on canvas
44 x 94 cm.
References: G-W 272; Gud. 252.

Museo del Prado, Madrid, 750

On the gently sloping hillside that borders the Manzanares River, the citizens of Madrid, of every class and condition, celebrate the feast of their patron saint, San Isidro. On the opposite side of the river can be seen the profile of Madrid, prominent in which are the eighteenth-century church of San Francisco and the royal palace, enveloped in the light of a spring sunset.

This sketch for a tapestry cartoon was designed for the chambers of the king's daughters in the Pardo palace, near Madrid. The tapestry, however, was never executed, because upon Carlos III's death that same year, the new monarchs ceased to use the palace as a royal residence. The Duque de Osuna purchased it the following year to serve as his wife's apartments.

The subject was probably imposed by the Real Fábrica de Tapices de Santa Bárbara (Royal Tapestry Factory of Santa Barbara). The feast of San Isidro, which is celebrated on May 15, was one of the most important festivals in Madrid, beginning with a procession that set out from the church that was named for him. On this and the following days a *romería* (pilgrimage) was made to the saint's shrine. Afterwards, the pilgrims picnicked on the meadow.

According to a one-act farce written in 1766 by Ramón de la Cruz,[1] which bears the same title as Goya's sketch, gathered at the feast would be the gentleman in jacket and wig, the lady decked out in an overskirt and ruffled gown, the *petimetre* (dandy) with cape and sword, and the *majo* (lower-class dandy). Some of the pilgrims made a vow to the saint in exchange for some favor and heard a Mass; later, sitting on the grass, they ate and enjoyed the day. The children played noisily; the ladies were courted; a group of *majos* danced seguidillas; a row of carriages awaited the lords and ladies;

vendors of *tostones* (warm refreshments), bouquets, oranges, and water were there in swarms; and the gentleman would rub shoulders with his tailor and servant. It is probably the same ambiance that Goya depicted here as it existed two hundred years ago. Glendinning refers to this brief play by Ramón de la Cruz, in which the commotion of the day has been emphasized, as an example of the extraordinary visual qualities of the writer's work.[2]

Commotion is what Goya noticed of the celebration of San Isidro's feast in a letter to his friend Martín Zapater: "a mas de esto, ser los asumptos tan difíciles y de tanto que hacer, como la Pradera de San Ysidro, en el mismo día del Santo, con todo el bullicio que en esta Corte, acostumbra haver, te aseguro en fé de amigo, que no las tengo todas conmigo, pues ni duermo ni sosiego, hasta salir del asumpto" (Moreover affairs being so complicated, and there being so much to do, like the Meadow of San Isidro, on that saint's day, with all the tumult there is in the Court, I assure you as a friend that things are not well with me, because I can neither sleep nor rest until I am finished with the matter).[3] It may be gathered from the letter, once again, that Goya was not a spontaneous painter of the picturesque who went into the countryside, looked, and got it all down in his studio. What he searched for there was intangible; he wanted to capture on canvas the sensations of the day, the commotion, more than the exact description of a reality, and it is doubtless to this effort that the letter refers.

Goya executed the sketch with vigor. There is such confidence in his brushstrokes: soft here, sketchy there, thick in another place. With great economy and apparently with no earlier preparatory drawing, he modeled shapes with different shades of color from the pastel range – pinks, blues, and mother-of-pearl greens – without emphasizing contrast. The composition shows two different aspects of Madrid. In the foreground are the city's inhabitants on two slopes of the hill, which open into a fanlike vista; beyond the river is a panorama of the city's monuments. In the middle distance is a tiny multitude, in the softest colors.

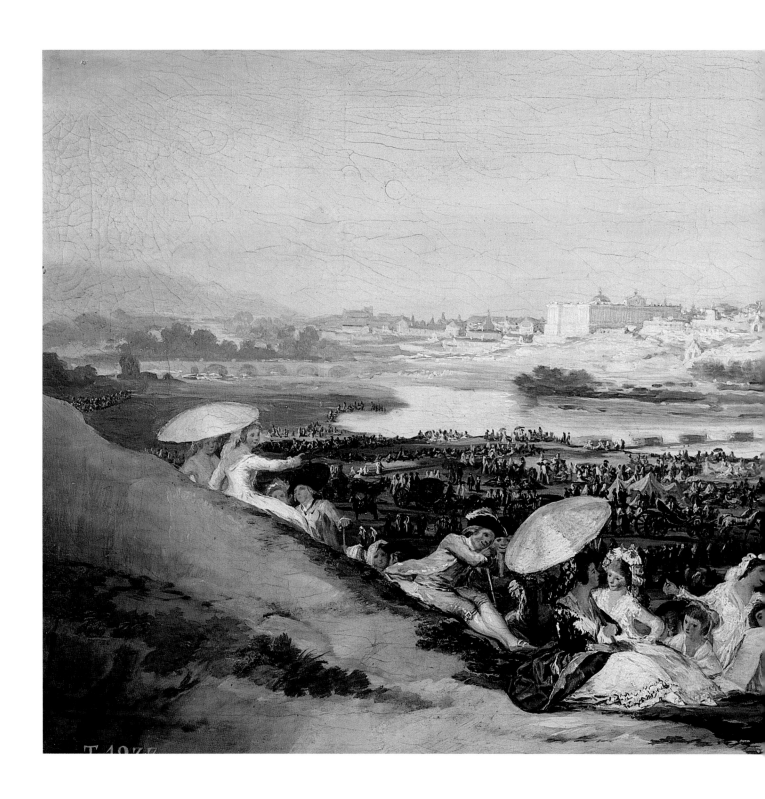

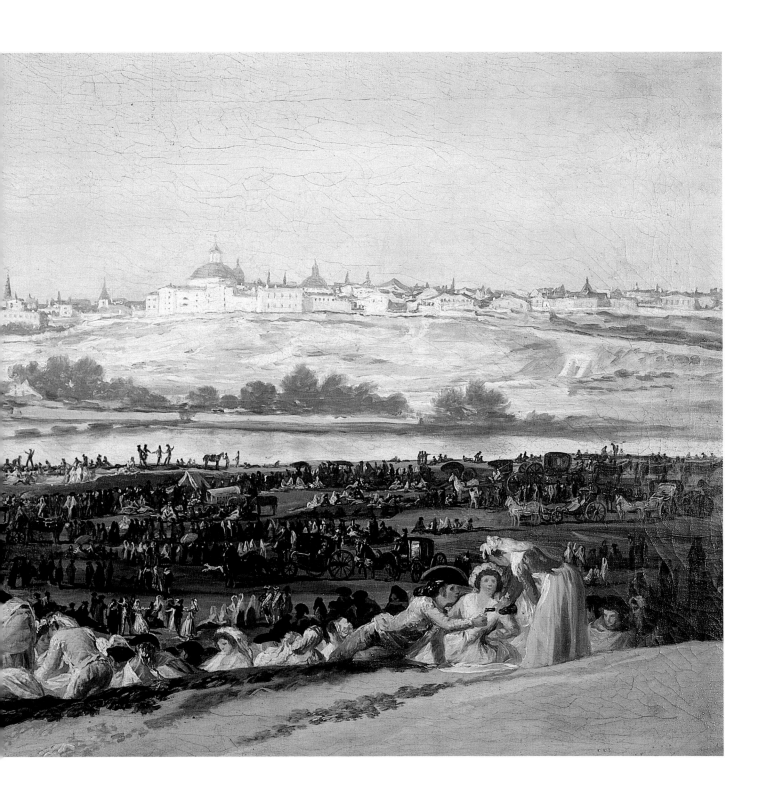

Here Goya demonstrated almost the skill of a miniaturist (an unusual quality in his art) to point out the various events of the day, the chatter, the diversity of amusements, and the people.

Goya represented the *romería* not as a religious act but as an amusement. Among the enlightened there were varying opinions about the *romerías*. According to Jovellanos they were a logical extension of the pilgrimage to the shrines. Commenting on their origin he wrote, "satisfechos los estímulos de la piedad, daban el resto del día al esparcimiento y el placer" (the needs of devotion being satisfied, they gave the rest of the day to amusement and pleasure);[4] he regarded them as public entertainment, highlighting their role in the promotion of folk dances. Referring to the *romerías* in Asturias, he wrote: "¿Y creerá usted que no faltan censores de tan amargo celo, que dictaminene contra estas inocentes diversiones? . . . Sé bien que á la sombra de estos regocijos suele andar alguna vez embozada la disolución, tendiendo sus lazos y acechando sus presas; pero ¿Están libres de este peligro las concurrencias más santas?" (And would you believe that there are so many embittered critics that they speak against these innocent diversions? . . . I know very well that in the shadow of these delights . . . dissolution is occasionally disguised, laying its traps and capturing its prey; but are the most saintly gatherings free from this danger?)[5]

Meléndez Valdés, also Goya's friend, attacked the *romerías,* especially that of San Isidro. He requested that the authorities be present to prevent disorders: "por el inmenso gentío que a ella concurre, y mayor rezelo que con él puede haber de alguna mas grave desazon" (because of the large crowd that it draws, and for fear that more serious disorder may be provoked). He added: "Para en adelante sería util á la religion misma y al Estado que la Sala meditase detenidamente sobre las profanaciones y escándalos de estas procesiones cual estan, distintas, por no decir opuestas, á los piadosos fines de su primitiva institución, y en discordancia manifesta con el espíritu humilde y com-

pungido, la sencillez, el retiro" (from now on it would be useful to religion itself and the State that this Court mediate carefully on the profanation and scandal of these processions, whose ends are different from, if not opposite to, their original pious intent, and in evident contradiction to the humble and contrite spirit, simplicity, calm). He emphasized "las irreverencias los desacatos, . . . gastos indebidos borracheras y desórdenes" (the irreverence, the blasphemies, . . . unnecessary spending, drunkenness, and disorders) brought about by the people's ignorance, and he requested that "suprimirlas del todo, ó reducirlas á los menos a lo que deben ser según el espíritu de nuestra santa religíon" (they be together suppressed, or at least reformed to correspond to what they should be, according to the spirit of our holy religion).[6]

It is clear that in this sketch Goya's view was closer to that of Jovellanos than of Meléndez; it could be not be otherwise if the work was designated for a palace. But when Goya painted the "Black Paintings" for his house many years later, he had come to share some of Meléndez's opinions: expressing the ignorance of the masses in the darkness of night.

<div align="right">M.M.H.</div>

1. Ramón de la Cruz, *Pradera de San Isidro* (Madrid, 1917).

2. Nigel Glendinning, *Historia de la literatura española* (Barcelona, 1983), p. 204.

3. Goya to Zapater, May 31, 1788, in Francisco de Goya, *Cartas a Martín Zapater*, ed. Mercedes Agueda and Xavier de Salas (Madrid, 1982), p. 182.

4. Melchor Gaspar de Jovellanos, *Memoria para del arreglo de la policía y los espectáculos y diversiones públicas, y su origen en España*, Biblioteca de Autores Españoles, vol. 46 (Madrid, 1963), p. 482.

5. Melchor Gaspar de Jovellanos, Carta octava, "Romerías de Asturias," in *Obras*, Biblioteca de Autores Españoles, vol. 50 (Madrid, 1952), p. 301.

6. Juan Meléndez Valdés, *Discursos forenses* (Madrid, 1821), pp. 192-193. Part of this quotation is included in Sarrailh, *L'Espagne éclairée*, pp. 656-657.

17

The Family of the Duques de Osuna
1788
Oil on canvas
225 x 174 cm.
References: G-W 278; Gud. 292.

Museo del Prado, Madrid, 739

The Osunas, the very model of the enlightened family, were among the best and most faithful of Goya's clients because of the number of their commissions and because of the high esteem in which they held his art.

Pedro de Alcántara married María Josefa Alonso Pimentel in 1771; he was the second son of the Osunas, who, owing to the death of the first-born, became the ninth Duque de Osuna shortly before his wedding. María Josefa was the sole heiress of the Condes de Benavente (see cat. 6). The Duque began his career as a military officer, in his youth served in the war with England, and in 1799 was destined for Vienna as ambassador, a post he never filled, since neither he nor his family was allowed to move to Austria. They lived that year in Paris, the same year of the Directorate and the rise of Napoleon. Pedro de Alcántara distinguished himself above all as a man with an interest in technical innovations, scientific progress, the arts, and literature; he personally patronized all these endeavors and supported them as president of the Sociedad Económica Madrileña (Madrid Economic Society) and as founder of the Sociedad Económica in Benavente, where he had properties. The Sociedades Económicas de Amigos del País (Economic Societies of Friends of the Nation), as they were known, "whose only end was national prosperity and whose programs tended invariably to practical, precise, and useful results,"[1] played a supremely important role, backed by the enlightened government, in the economic and cultural development of eighteenth-century Spanish society. In 1787 the Real Academia Española (Spanish Royal Academy) named the Duque de Osuna honorary member and in 1793 made him a regular member. The Duque understood that culture and knowledge must be dissemi-

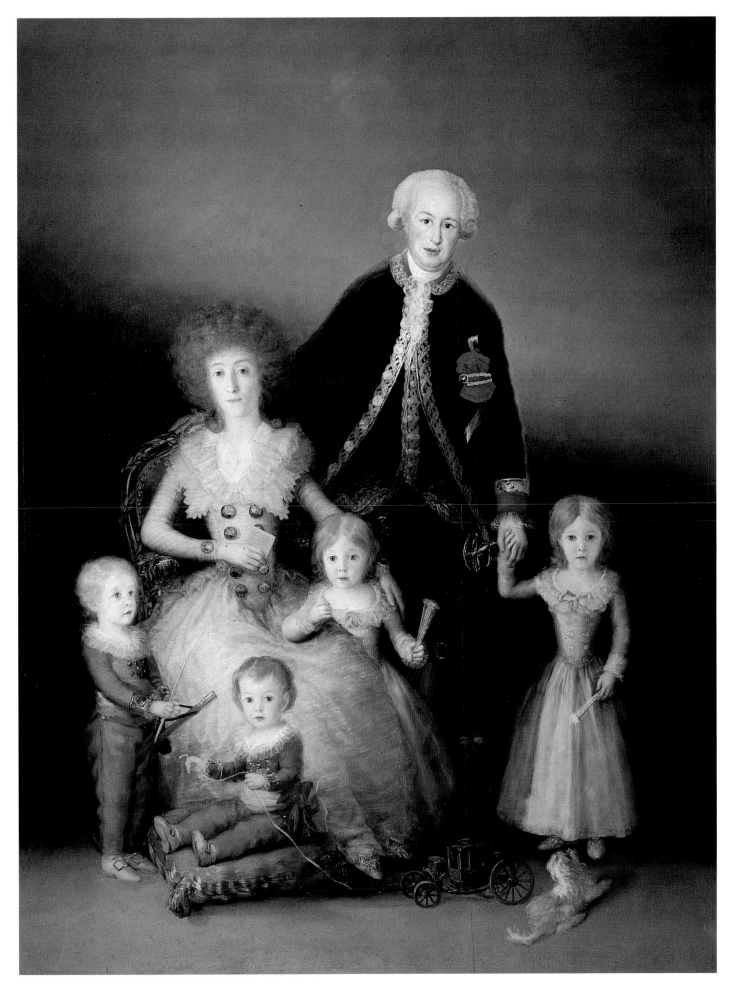

nated and therefore wished to give his splendid library – which included classical literature, history, travel, and science – a public character. The project was vetoed by the government because the library contained prohibited works. The Osuna children would make their father's desire a reality.[2] The Duquesa shared her husband's concerns but addressed them in her own independent manner (see cat. 6).

The Osuna palace was a meeting place for intellectuals and artists. The poet Tomás Iriarte, the playwright and poet Leandro Fernández Moratín, and the social satirist Ramón de la Cruz attended their *tertulias* (salons), and Goya also must have been present. Concerts were held there at the palace; Luigi Boccherini was hired to conduct its orchestra in 1786. The Duques were great aficionados of music, proof of which was their extensive collection of scores by composers such as Haydn, Boccherini, Rossini.[3] Plays were performed in their private theater; Ramón de la Cruz, Moratín, and the most celebrated actor of the day, Isidoro Máiquez, whom Goya also painted (G-W 858), were close to the family.

Goya's association with the Duques was fruitful and long-lived. The Osunas were admirers of innovation in artistic matters; the Duquesa had a taste for contemporary works and was very independent in her judgments.[4] Goya began his work as their portrait painter in 1785 and later received larger commissions, among them two series of cabinet paintings for the Duques' Alameda country retreat outside Madrid: seven depictions of rural life (see cat. 11) and six of witches (cat. 25-27). Although the style of these paintings recalls the tapestry cartoons and has not lost the decorative quality of the latter, the content, compatible with the ideologies of those who attended the Osunas' *tertulias*, is made apparent. The philosophical character of Goya's works was confirmed with the publication of the *Caprichos* in 1799, four copies of which the Duques purchased.

This portrait of the Osuna family is one of the most beautiful Goya painted. The protagonists are placed within a space that makes no reference to the luxurious interior of their residence, which – in

addition to the informal posing of the children with their toys – gives the portrait the intimate character of a domestic snapshot. In the attitudes of the Duques can be detected the affection they paid their children. Before the birth of María Josefa – the eldest who gives her hand to her father – four children had died in infancy. These tragic circumstances must have made the Osunas' dedication to their children all the more intense; the Duquesa raised them personally, accompanied them during long journeys, and devoted special attention to their education. This concern manifested itself in the great number of books on pedagogy housed in the library and in the care taken to choose a tutor. The chosen one, Diego Clemencín, a liberal man of letters, responded in the following way to the Duquesa's petition: "En conseqüencia desde esta misma hora me tengo por admitido en su casa . . . persuadido á que nunca me serian tan ventajosas, como servir a una S^ra de tanta ilustracion, y de tán bello modo de pensar en orden á la educación de sus hijos" (As a result, from this moment on I consider myself admitted into your household . . . convinced there could be nothing more advantageous to serving a Lady of such enlightenment, who has such a splendid way of thinking about the education of her children).[5]

The little girl in the Duquesa's arms was to become Marquesa de Santa Cruz, renowned for her beauty (see cat. 66). The Osuna heir, Don Francisco de Borja, to the right of the Duquesa, fought in the Peninsular War against the French and in Cádiz. On the occasion of the decree passed by the Cortes against the seigniories and jurisdictional rights of the grandees, he circulated a statement in which he hastened to declare: "Yo antes que Grande nací ciudadano, y soy el primero en sacrificar con gusto este vano oropel cuando la nación lo quito por convenir asi al bien general" (Before I am a grandee I am a citizen, and I will be the first to sacrifice this vain tinsel with pleasure when the nation decides it must be removed to suit the general good).[6] The Príncipe de Anglona, seated on the pillow, led an army in Andalusia during the Peninsular War and was loyal to the Con-

stitution of 1812, which earned him Fernando VII's enmity and the confiscation of his possessions on the king's return from exile. During the Liberal *trienio* (1820-1823) he was appointed coronel (colonel) of the Guardia Real de Infantería (Royal Infantry Guard), sat on the Consejo de Estado (State Council), and was also one of the first directors of the Museo del Prado. The parents and children in this portrait embody, in a sense, the transformation that took place at the turn of the century when enlightened Spain embraced Liberalism.

M.M.H.

1. Sarrailh, *L'Espagne éclairée*, p. 225.

2. Carmen Muñoz Roca Tallada, Condesa de Yebes, *La Condesa-duquesa de Benavente: una vida en unas cartas* (Madrid, 1955), p. 37.

3. Ibid., p. 88.

4. Nigel Glendinning, "Goya's Patrons," *Apollo* 114 (Oct. 1981), p. 239.

5. Jean Sarrailh, "Diego Clemencín," *Bulletin Hispanique* 2 (Apr.-June 1922), p. 129. Clemencín is known for his literary studies and translations; of a liberal cast of mind, he was a deputy at Cádiz, Ministro de Ultramar (Minister of Overseas Territories) and Ministro de Gobernación (Minister of the Interior), as well as one of the founders of the Museo Arquelógico (Archaelogical Museum).

6. Quoted in Condesa de Yebes, *Condesa-duquesa de Benavente*, p. 248.

18
Goya in His Studio
About 1790-1795
Oil on canvas
42 x 28 cm.
References: G-W 331; Gud. 96.

Real Academia de Bellas Artes de San
Fernando, Madrid, 1166

Goya in his Studio reveals the artist's
vocation.[1] In this small oil painting, Goya
demonstrated the main element in all his
paintings: light. Light plays a decisive role
in the creation of volume and atmos-
phere and of the illusion of reality.

Goya is painting while through the
great window behind him a powerful
stream of light bursts in, rendered in
dense, thick, white brushstrokes. Accord-
ing to his son, Javier, Goya never painted
in the evening but took advantage of the
morning's potent light; he added, how-
ever, that "los últimos toques para el
mejor efecto de un cuadro los daba de
noche con luz artificial" (for better effect
he gave the final touches to a painting at
night in artificial light).[2] According to
Pedro Beroqui, Goya used for this pur-
pose the hat shown in this portrait,
trimmed with the metallic pincers in
which he inserted candles.[3]

Goya carefully considered the light in
which the painting would be seen, adjust-
ing his technique to achieve the desired
effect. Many of the paintings he executed
for the nobility were to be seen at the
tertulias (salons), which were held in the
evening by candlelight. Eleanor Sayre
has noted that the low level of illumina-
tion allowed Goya to paint with brilliant
economy and to use various illusionistic
tricks that professional painters have
admired ever since. He knew that under
these lighting conditions his works would
appear wonderfully true to life.[4]

Light lends volume to things and
atmosphere to the painting. This self-por-
trait did not depend on a thorough pre-
paratory drawing; it came into being with
lights and shadows, in patches of color
that give the illusion of a third dimension.
The effects of light are handled with spe-
cial care and delicacy: in the light blue
touches at Goya's back and legs, in that
single and extremely subtle stroke at the

top of the painting, in the writing desk's
tiny reflection, in the gradation of the
wall under the window.

The brushstrokes are exact; width,
density, and length are perfectly mea-
sured with the speed and confidence that
characterize Goya's technique: delicate in
the fine blue lines of the vest, coarse in
the continuous strokes that divide the
windowpanes, detailed in the point of
light on the writing desk, secure in the
single stroke given a sheet of paper rest-
ing on the table. Not only did Goya use
various kinds of brushes (which we see
him holding), but he also applied paint
with his fingers or the point of a knife,
methods that Ceán Bermúdez, art critic
and friend, could not admire but whose
effects astonished him.[5]

The palette documents the colors he
used. He carefully placed the "ten col-
ors, . . . from the white through the light
ochres to the greens and blues, finishing
with the darker colors. Only one color –
vermilion – stands out from the others,
being the first color to the right of
white."[6] Also oval in shape, like the
palette, is the writing desk. It has an
important role to play, as indicated by
the lines that lead the eye to it, that is,
the lines establishing the depth of the
wall and the two that make up the win-
dow. The writing desk appears in Goya's
portraits as an attribute of writers (see
cat. 30). Perhaps he meant thereby to
affirm the intellectual and enlightened
character of his calling. If we examine
his eyes, we find they do not merely look
on but also penetrate the reality they
observe. Goya showed himself an abso-
lute master of the art of painting, framed
by light, symbol of the age and the very
essence of his work.

M.M.H.

1. Gassier and Wilson suggest that the painting's del-
icate execution and general atmosphere recall the
cabinet paintings of 1793-1794 as well as *La Duquesa
de Alba y su dueña* and *La dueña con dos niños*; G-
W, p. 63. Aureliano Beruete, *Goya, pintor de
retratos* (Madrid, 1916), p. 24, dates it 1784 or a little
later.
2. Pedro Beroqui published all the biographical
notes on Goya written by his son, Javier. They are
not signed but include an autographed note by
Valentín Carderera, the first great collector of Goya's
graphic work: "Nota que me pasó el hijo del pintor"
(Note given me by the painter's son). See Pedro

Beroqui, "Una biografía de Goya escrita por su hijo,"
Archivo español de arte 3 (1927), pp. 99-100.
3. Beroqui, "Una biografía de Goya."
4. Eleanor A. Sayre, "The Portrait of the Marquesa
de Santiago and Ceán's Criticism of Goya," in *J. Paul
Getty Museum Journal* 13 (1985), pp. 147-149.
5. Nigel Glendinning, "Goya's Patrons," *Apollo* 114
(Oct. 1981), p. 241. In the Academia's minutes of
1832, p. 92, one can also read: "Aunque siempre
merecieron su predileción los cuadros que tenia en
su casa, pues como pintados con libertad segun su
genio y para uso particular, los hizo con el cuchillo de
la paleta en lugar de pincel, logrando sin embargo
que causen un efecto admirable á proporcionada dis-
tancia" (Although he always favored the paintings he
kept at home, as they were painted freely and faith-
ful to his genius and for private use, he executed
them with the palette scraper instead of the brush,
nevertheless achieving an admirable result [when
viewed] at the appropriate distance).
6. Beruete, *Goya*, p. 25.

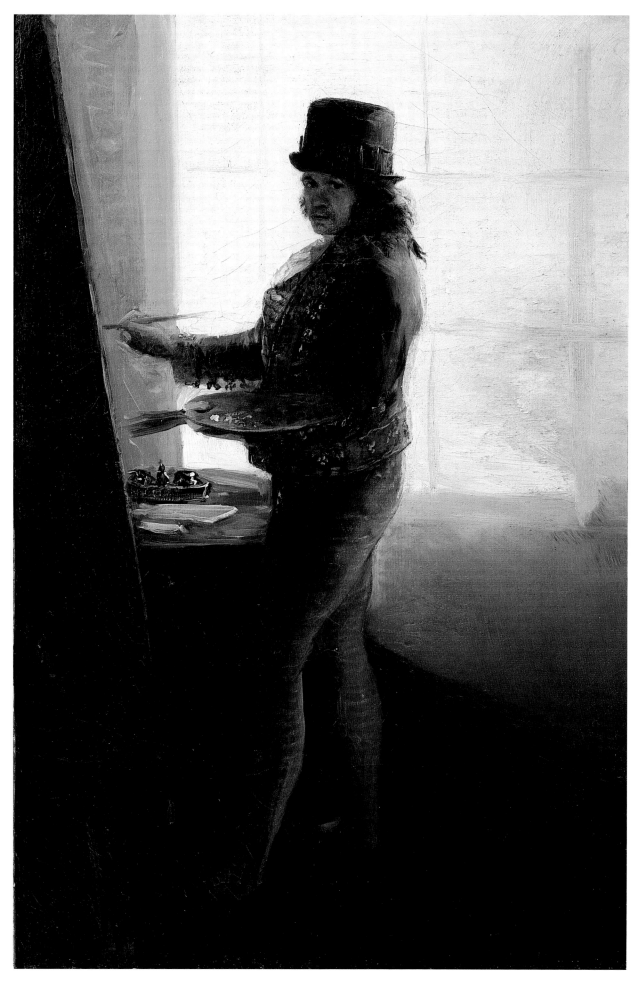

19

Sebastián Martínez
1792

Oil on canvas
92.9 x 67.6 cm.
Inscribed and signed: *D^n Sebastian /*
Martinez / Por su Amigo / Goya / 1792
References: G-W 333; Gud. 310.

The Metropolitan Museum of Art, New
York, Rogers Fund, 06.289

Sebastián Martínez, a wealthy business-
man and art collector, holds a sheet of
paper that presents him as a friend of
Goya. Those who knew the sitter would
have recognized the sheet as a print from
his important collection, evidence of his
taste for the fine arts.

Martínez was a self-made man. At
eleven he abandoned his native village in
the province of Soria, in north-central
Spain, and headed for the prosperous cit-
ies of the south, settling in Cádiz, where
he married. Until 1778 Cádiz enjoyed a
monopoly on trade with America and
until the end of the century was the
center of an important international dis-
tribution network linking cities in
Europe, Africa, and America. The foreign
community in Cádiz was therefore large
and cosmopolitan, with a predominance
of French and Italians, as well as English,
Germans, Flemish, Poles, and Swedes.

Although Cádiz had begun its definitive
decline in 1796, the English traveler Lady
Holland wrote in 1803: "The stir and
animation of Cádiz are very cheerful; it is
the best paved, lighted, built, and clean-
est town that can be seen."[1] In this set-
ting Sebastián Martínez nurtured his bus-
iness in wines, one of Spain's principal
exports.[2] About the time Goya painted
his portrait, Martínez became Tesorero
General del Consejo de Hacienda de
Cádiz (General Treasurer of the Cádiz
Financial Council). With his fortune he
acquired an impressive collection of art.
When the art historian Ponz visited him
in 1791, he commented: "Pero ahora
hemos de recorrer algunas casas de per-
sonas de buen gusto, vecinos de esta ciu-
dad, cuyas colecciones de pinturas y de
otras curiosidades son muy estimables y
dignas de que usted las sepa, como
también quiénes son sus poseedores. La

de mi buen amigo don Sebastián
Martínez debe llamar con particularidad
la atención de los inteligentes" (But now
we are to visit some houses of people
with good taste, inhabitants of this city,
whose collections of paintings and other
curiosities are very worthy of esteem and
of your acquaintance, as are their own-
ers. That of my good friend don Sebas-
tián Martínez should be particularly
called to the attention of the
intelligentsia).[3]

Martínez's painting collection was
diverse, containing, according to Ponz,
works by Titian, Leonardo da Vinci,
Velázquez, Murillo, Cano, Ribera, Guido
Reni, and Esteban Jordán. And to these
the present-day study of the inventory by
María Pemán adds others by Rubens,
Ostade, Batoni, Morales, Maella, Mengs,
Giulio Romano, and Goya, making a total
of 743 paintings.[4] His collection of prints
was also very important, numbering sev-
eral thousand, a part of which was dedi-
cated to reproducing foreign collections.
Furthermore, there were sculptures,
drawings, musical instruments, furniture,
silver plate, precision instruments, and a
splendid library, which represented
twenty-three percent of the value of his
estate in reales.[5] The library reflects the
interests of an enlightened man of the
period: in the arts, it included treatises,
histories, and biographies; in letters,
books of philosophy, classical and
humanistic literature, history, and travel;
in sciences, medicine, physics, chemistry,
mathematics; as well as works on eco-
nomics and finance.

Goya met Sebastián Martínez in
Madrid, perhaps by way of a mutual
friend, such as Ponz, Zapater, Pignatelli,
or Ceán Bermúdez. And in the winter of
1792-1793, he lived in Martínez's Cádiz
house, while recovering from an illness.
Needless to say (and it has been said
many times), Sebastián Martínez's collec-
tion must have been a revelation to Goya,
who must have extracted lessons from it
that would influence his later work.
Nigel Glendinning has suggested that the
high proportion of genre pictures in the
collection could have influenced Goya to
do the series of paintings he sent to the
Academia de Bellas Artes de San Fer-
nando (see cat. 21).[6] Martínez wrote to

the Academia about Goya's illness and
requested an extension of his leave
of absence, given the impossibility of his
return.[7] In 1796, Goya helped make
Sebastián Martínez a member of the
Academia de Bellas Artes.[8]

The composition emphasizes Sebastián
Martínez's humanity. The neutral back-
ground and the lines parallel to the frame
make the subject seem closer. The paint-
ing of the face is accomplished with virtu-
osity, with astonishing ease and economy,
so as to capture the sitter's vitality and
expression.[9] The refinement of
Martínez's clothing – whose brilliant col-
ors stand out against the uniform back-
ground – speaks of his elegance and his
status. For the doublet Goya used a
delightful technique: the blue patches
are loosely arranged across the reddish
ground of the canvas; superimposed, par-
allel lines laid down with a fine brush
cover the surface until the color dissi-
pates; the different densities of paint in
these lines create the effects of light. A
spatula was used for the shirt's lace, leav-
ing a square imprint. Goya achieved an
intimate portrait of his friend enjoying
one of his favorite pastimes: the exami-
nation of works of art.

M.M.H.

1. Lady Holland, *The Spanish Journal of Elizabeth
Lady Holland* (London, 1910), p. 51.

2. María Pemán, "La colección artística de don
Sebastián Martínez, el amigo de Goya, en Cádiz,"
Archivo español de arte, no. 201 (1978), pp. 53-62.
His business was called the "Compañía de vinos de
Jérez de Martínez y C. ^a." The author adds, how-
ever: "Ramón Solís noted he was in shipping. The
documents I have examined say nothing to this effect,
but the presence of various books in his library on
piloting, the art of navigation, ports, and ocean charts
may support this view, although ships do not figure in
the inventory"; ibid., p. 54, nn. 8 and 9.

3. Antonio Ponz, *Viaje de España*, ed. Casto María
del Rivero (Madrid, 1947), p. 1587.

4. According to Glendinning, the known commis-
sioned paintings from Goya in his collection, "apart
from his own extraordinarily elegant portrait and
that of his daughter Catalina Viola, mentioned in
nineteenth-century catalogues, consisted of three
overdoors. These are not traceable with complete
certainty, but way well have been the pair depicting
two women talking and a young woman sleeping, and
the larger painting of a woman sleeping now in the
National Gallery, Dublin. This trio with mysteriously
erotic overtones may indeed have been commis-
sioned by Martínez, who evidently had a taste for

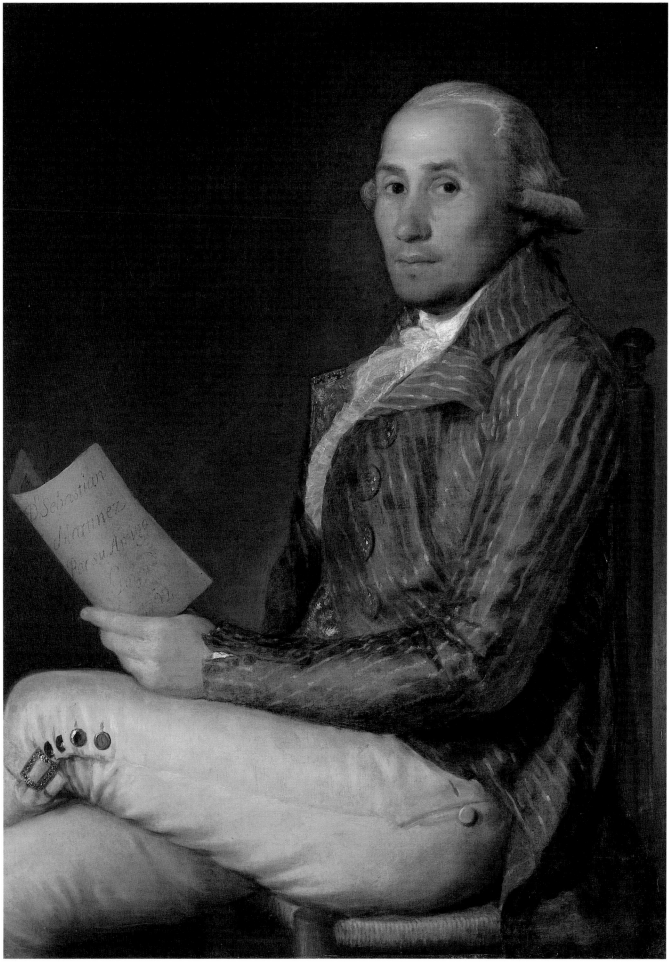

Sebastián Martínez

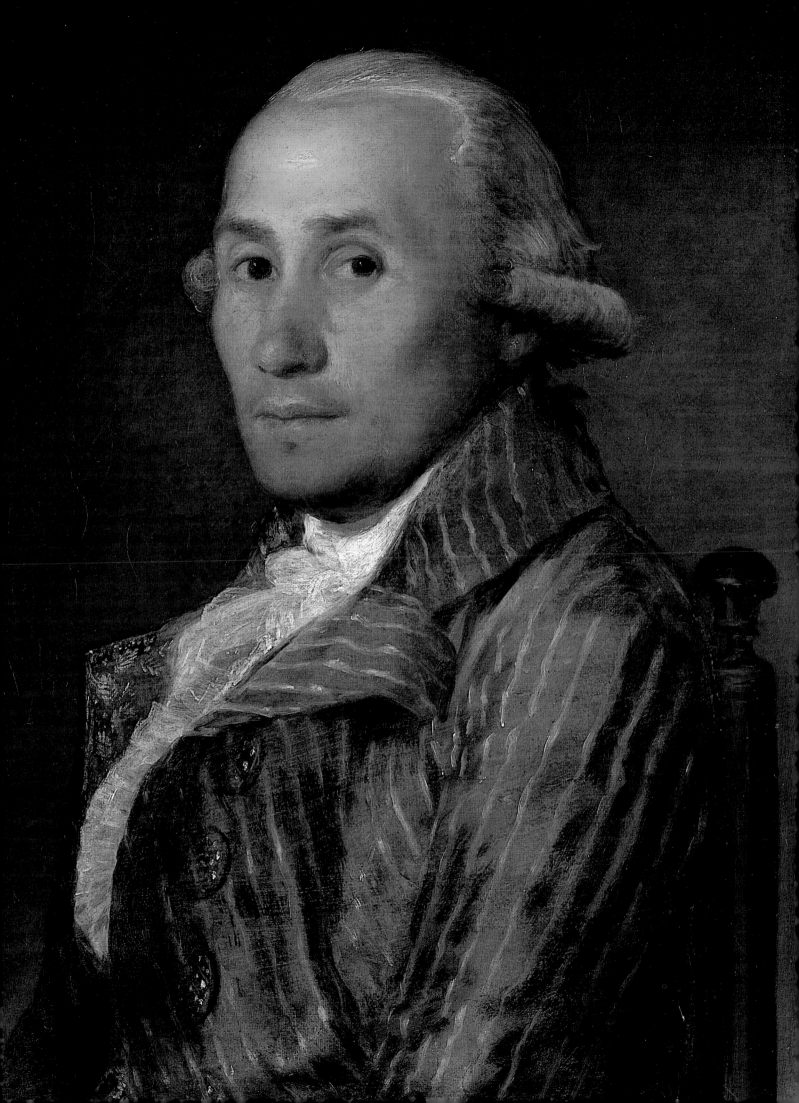

such subjects." Nigel Glendinning, "Goya's Patrons," *Apollo* 114 (Oct. 1981), p. 244.

5. According to the inventory of goods taken by his heirs at his death; see Pemán, "Colección de Martínez," p. 55.

6. G-W 317-330. See Glendinning, "Goya's Patrons," p. 244.

7. Angel Canellas López, *Francisco de Goya, Diplomatario* (Zaragoza, 1981), letter 68, p. 454.

8. "In 1796, don Sebastián was named honorary member of the Real Academia de Bellas Artes de San Fernando. One may suppose Goya's working, whether openly or not, in his friend's behalf, for although the latter was not only personally worthy as an important collector, and enjoyed status as a member and principal treasurer of the Real Consejo de Hacienda de Su Magestad [His Majesty's Royal Council on Finance], doubtless it was also necessary that the impulse arise from within the organization, and that impulse came from no other than Goya"; J. Guerrero Lovillo, "Goya en Andalucía," *Goya*, no. 100 (1971), p. 213.

9. Glendinning noted that the portraits of the time were expected to render likeness first and then the nature of the subject's life, adding that Goya "seems to have satisfied the artistic requirements of his time"; Nigel Glendinning, "El retrato en la obra de Goya: aristócratas y burgueses de signo variado," in *Goya: Nuevas Visiones: Homenaje a Enrique Lafuente Ferrari* (Madrid, 1987), p. 185.

20

Attack on a Coach
1793

Oil on tin plate
50 x 32 cm.
References: G-W 327; Gud. 235.

Private Collection, Madrid

Eleven small paintings on tin, to which Goya gave the general title *diversiones nacionales* (National Diversions), were the fruit of the artist's convalescence in Cádiz, which he spent in his friend Sebastián Martínez's house (see cat. 19). Eight are bullfighting scenes; rounding off the series are a scene of strolling players (G-W 325), a marionette vendor (G-W 326), and this work, depicting brigands attacking a coach. The subject of highwaymen had also appeared a few years earlier in Goya's *Highwaymen Attacking a Coach* (cat. 11), which he painted for the Duquesa de Osuna (see cat. 6). In both these works the incident and the figures are the same: a coach has been halted; a highwayman keeps guard on top of it, while another knifes one of the passengers, and others lie on the ground.

In Goya's letter to Bernardo de Iriarte, a friend and member of the Academia de San Fernando, he wrote about the eleven small paintings, which were to be exhibited in the Academia: "He logrado hacer observacio. a q. regularmente no dan lugar las obras encargadas, y en que el capricho y la invención no tienen ensanches" (I have managed to make observations that commissioned works do not ordinarily allow, and in which fancy and invention have no place).[1] The character of this painting of a highway robbery indeed differs from the one commissioned by the Osunas.

The style Goya used here was to lay down harmonious patches of color, then to add contours with a very fine brush, and give final touches, such as those on the boulders, that indicate falling twilight.

In *Attack on a Coach* Goya dispensed with the picturesqueness of the Osuna painting; he captured the kind of setting in Andalusia where banditry was so frequent, in a mountainous landscape with scant vegetation. Moreover, the painting has lost the theatrical and almost anecdotal character of *Highwaymen Attacking a Coach*. In the later painting the highwaymen's barbarity is truer to the social drama they represented for the Spain of the time. Goya characterized those heroes of popular ballads as criminals, instead of making them part of the myth that had been spun around them in verse. His interpretation is a faithful reflection of enlightened opinion. He emphasized the violence of the crime through the wounded man lying on the ground, his contracted hands bleeding; and the bestiality through the figure of the bandit wielding a knife, about to plunge it for the last time into the innocent traveler. We are made aware of the attackers' apparent indifference to brutality: the man standing guard and the other loading his gun are equally unruffled, but surpassing all is the robber aiming point blank at the passenger who is on his knees, perhaps commending himself to God, while looking away from his executioner. Nothing in the environment responds; the scene is made steelier by nature's repose and beauty, bathed in a languid sunset, while the stream in the foreground flows gently by.

<div style="text-align: right">M.M.H.</div>

1. Goya to Bernardo de Iriarte, Jan. 4, 1794, published in G-W, Appendix IV, p. 382.

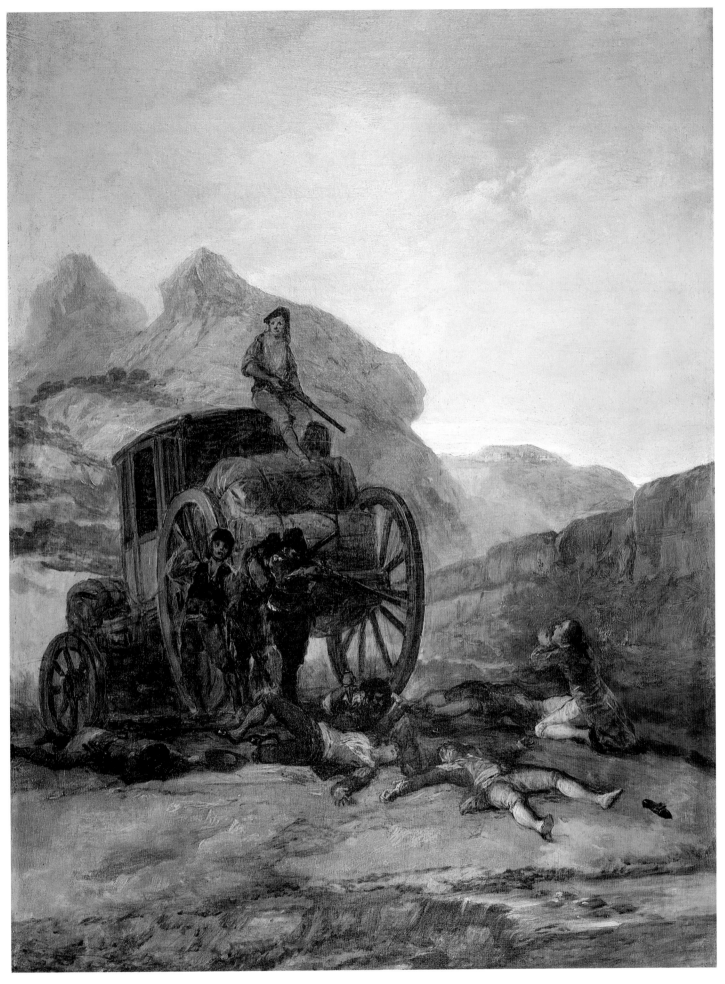

21

Courtyard with Lunatics
1793-1794
Oil on tin plate
43.6 x 32.4 cm.
References: G-W 330; Gud. 343.

Algur H. Meadows Collection, Meadows Museum, Southern Methodist University, Dallas, 67.01

In 1793 Goya, recovering from a serious illness that had left him deaf, began gradually to resume his artistic endeavors, which he had suspended for many months. In doing so he broke the fetters of the commissioned work he had considered, according to his own testimony, a true oppression.[1] In a letter of January 4, 1794, to Bernardo de Iriarte, writer and fabulist, his friend and protector at the Academia de San Fernando, Goya referred to a series of cabinet pictures that he wished to submit to the judgment of the academicians: "Para ocupar la imaginacin mortificada en la consideracin de mis males, y para resarcir en parte los grandes dispendios qe me an ocasionado, me dedique a pintar un juego de quadros de gabinete, en qe he logrado hacer observacios a qe regularmente no dan lugar las obras encargadas, y en que el capricho y la invención no tienen ensanches" (In order to distract my mind, mortified by reflection on my misfortunes, and in order to recoup some of the expenses they have occasioned, I executed a series of cabinet pictures, in which I have managed to make observations that commissioned works ordinarily do not allow, and in which fantasy and invention have no place).[2]

Although Goya did not mention the tin support in his letter of January 4 to Iriarte, a letter written three days later refers to his completing this series of cabinet pictures with "un corral de locos" (a yard with lunatics).[3] The series to which Goya referred has been identified with a group of fourteen small paintings of original subjects, executed on tin with great freedom (G-W 317-330).[4] The academic council of the Academia de San Fernando, at whose January 5 session several of these works were viewed, left equivocal evidence in its minutes: "El Sr.

Francisco de Goya remitió para que se viesen en la Academia once cuadros pintados por él mismo, de varios asuntos de diversiones nacionales y la Junta se agradó mucho de verlos, celebrando su mérito y el Sr. Francisco de Goya" (Sr. Francisco Goya sent for viewing in the Academia eleven paintings executed by himself, on various subjects related to national pastimes, and the Council was very pleased to see them, praising their quality and that of Sr. Francisco de Goya).[5] Either the council did not closely examine the works Goya sent or there was indeed another series, perhaps since lost.[6]

What seems certain is that this *Courtyard with Lunatics*, identified in 1967,[7] is the painting Goya described in his letter to Iriarte of January 7, 1794, in which he expressed his satisfaction with the high opinion held of his works by the academicians, no doubt conveyed by his friend Iriarte, confirming events in these words: "Tengo ygual satisfon de qe queden los quadros en casa de V.S.I. todo el tiempo qe guste, y en concluir el qe tengo empezado: qe represta un corral de locos, y dos qe estan luchando desnudos con el qe los cuida cascandoles, y otros con los sacos (es asunto qe he presenciado en Zaragoza) lo embiare a V.S.I. pa qe este completa la obra" (I am as satisfied about the paintings remaining in Your Illustrious Lordship's house as long as desired as I am to finish another I have begun: representing a courtyard with lunatics, in which two naked men fight with their warden, who pummels them, and others with sacks (a scene I have witnessed in Zaragoza), which I will send to Your Illustrious Lordship, so that it will round off the series).[8]

This "corral de locos" (courtyard with lunatics), as Goya termed it, is one of the most shocking of the artist's creations. He eventually dedicated another painting or two and a masterful series of drawings to the subject of insanity (see cat. 168-170). Just as in the later works the representation of madness and of the insane took on an almost symbolic character, in this early work the scene, Goya averred, was depicted as he witnessed it in Zaragoza. Although the work doubtless altered reality, as the astonishing har-

mony and careful organization of this irrational scene demonstrate, it is a living document of the asylums of the time, in which, according to all reports of the period, the insane, sometimes without the segregation of sexes, were crowded like animals in filthy places, abandoned by their families and cruelly treated by their guardians. An aristocratic diversion, according to numerous contemporary accounts, was a visit to the asylums. In the age of reason, those who lacked it served as entertainment, as if they were part of a stage play, for those who prided themselves on living in the enlightened century.[9]

Goya's work tells us very little of his own attitude toward madness or toward madness as entertainment. It does not indicate whether it is a denunciation of situations that degraded humanity. But the handling of the scene, the different poses, and the exasperated facial expressions of the insane are absolutely masterful. The patio shadows; the barred door in the background, behind which one senses the sunlight; and the upper area open to a dazzling sky, whose luminous power dissolves in the air the outlines of the high walls that contain the insane – all confer on the scene a dimension beyond reality, and thus the light and shadow acquire a symbolic value.

M.M.M.

1. In his correspondence with his friend Martin Zapater, Goya complained often of the unending series of tapestry cartoons he was obliged to execute for the Real Fábrica (Royal Tapestry Factory); *Cartas a Martín Zapater*, ed. Mercedes Agueda and Xavier de Salas (Madrid, 1982).

2. Goya to Iriarte, Jan. 4, 1794, published in G-W, Appendix IV, p. 382.

3. Goya to Iriarte, Jan. 7, 1794, published in G-W, Appendix IV, p. 382.

4. The series includes eight works on bullfighting and six others on diverse subjects, among which appeared the *Courtyard with Lunatics*. There has been some confusion between the paintings on tin and a series of five panels in which an insane asylum also appeared, now in the Academia de Bellas Artes de San Fernando, Madrid (G-W 966-970).

5. Gudiol, *Goya* (Barcelona,1970-1971), vol. 2, p. 98.

6. The success of these cabinet pictures may have persuaded Goya to create others of the same kind; those which are now dispersed in various collections would then be examples of different series.

7. See Xavière Desparmet Fitz-Gerald, "Una obra maestra desconocida de Goya," *Goya* 76 (1967), pp. 252-255.

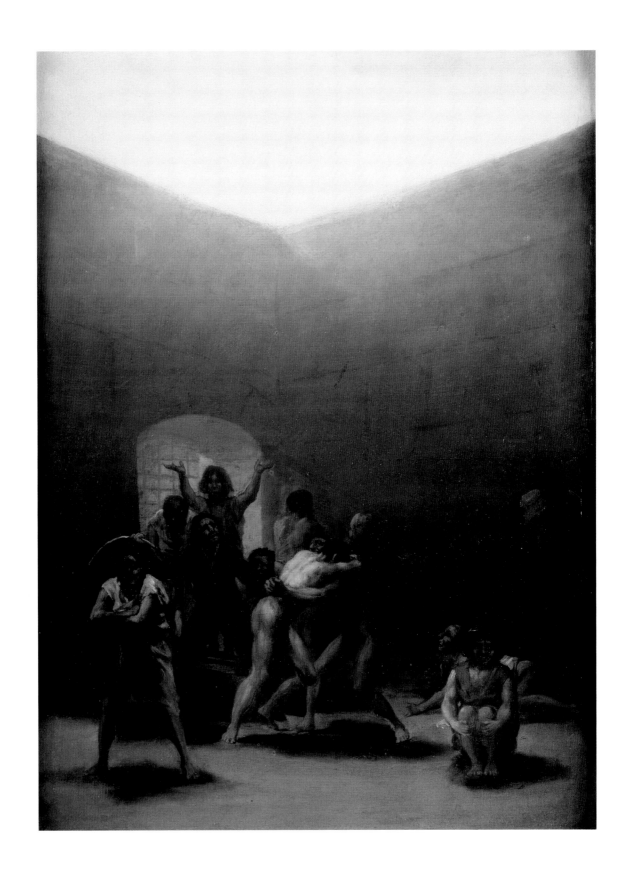

8. G-W, Appendix IV, p. 382. G-W also published the subsequent letter to Iriarte, dated January 9, in which Goya requested he send the cabinet paintings to the Marqués de Villaverde, whose daughter may have been interested in buying them.

9. A few years later, in 1819, this custom was still alive, according to Jean Etienne Georget, *Traité de la Folie* (Paris, 1819), who wrote on England.

22

Saint Ambrose
1796-1799
Oil on canvas
190 x 113 cm.
References: G-W 713; Gud. 179.

The Cleveland Museum of Art,
Leonard C. Hanna, Jr., Bequest, 69.23

23

Saint Gregory
1796-1799
Oil on canvas
190 x 115 cm.
References: G-W 715; Gud. 180.

Museo Romántico (Fundaciones Vega-Inclán-Madrid), Madrid, 21
Spain only

Goya's paintings of Saint Ambrose and Saint Gregory, together with those of Saint Augustine and Saint Jerome, are dedicated to the four Latin Fathers of the Church.[1] Study of the writings of the Church Fathers was one of the pillars on which enlightened religious reform was based, so that theology would affirm its scientific basis and thus recover its purity. Therefore, although the subject of the saints was a traditional iconographic theme, its representation had special relevance in the eighteenth century.

After the expulsion of the Jesuits from Spain in 1766, one of the principal tasks the government set itself was the reform of the schools and universities, which were dominated by scholastic Jesuit learning. With this purpose, Carlos III commissioned the scholar Gregorio Mayáns to prepare the *Informe sobre los estudios* (Report on Education). The author "había notado muchos años antes, la decadencia de los estudios bíblicos en España, lamentando amargamente la dejadez y el abandono intelectual" (had noticed, many years before, the decadence of biblical studies in Spain, lamenting the intellectual abandon).[2] In another work, *Orador Christiano* (Christian Orator), he commented: "el conocimiento de la Sagrada escritura va unido al estudio de los Santos Padres" (the knowledge of the Bible is connected to the study of the Church Fathers).[3] Pablo Olavide followed in Mayáns's steps with his *Plan de*

Estudios para la Universidad de Sevilla (Plan of Study for the University of Seville). He defined theology as the "ciencia de Dios, escrita en la Biblia e interpretada por la Iglesia y los Santos Padres" (science of God, written in the Bible and interpreted by the Church and the Church Fathers).[4] Olavide also attacked the scholastic theology "que por lo común se estudia en la nación. Fundada en los cimientos de la Filosofía aristótelica, casi nada tiene de la Revelación y Tradición . . . tratando por la mayor parte cuestiones inútiles y dudosas . . . hace ostentación de una sabiduría vana e hinchada, sin instruir a los fieles" (that was usually studied in the country [i.e., in Spain]. Built on the foundation of Aristotelian Philosophy, it took almost nothing from Revelation and Tradition . . . dealing mostly with doubtful and worthless matters . . . [and] boasts of a vain and inflated wisdom, without teaching the faithful).[5] Jovellanos also commented in the same vein when he proposed the *Plan de Estudios para el colegio imperial de Calatrava* (Plan of Study for the Imperial School of Calatrava), prohibiting "por ningun motivo permita leer en el refectorio aquellos legendarios que en otras partes se usan, y en los cuales, á vuelta de algunos casos y acciones verdaderamente maravillosas y bien averiguadas, ha introducido la superstición y la ignorancia muchedumbre de milagros apócrifos, de hechos inciertos y ridículos, y de relaciones vanas y supersticiosas, no solo poco conformes sino positivamente repugnantes á la santidad (under any circumstances the reading in the refectory of those legends which are studied in other parts and which, as a result of a few truly miraculous and well-documented cases, have introduced superstition and ignorance, apocryphal miracles, ridiculous and uncertain facts, vain superstitions and stories, not only unrelated, but positively not in accord with sanctity).[6] Jovellanos added: "el verdadero y sólido estudio (de la teología y del derecho canónico) se debe hacer en las fuentes" (the truly thorough study of theology and canon law must be done at its sources),[7] and among the sources he included the texts of the Church Fathers. He praised the "estilo,

erudición, crítica, profundidad y pureza de su doctrina" (style, erudition, critical sense, depth and purity in their doctrinal teachings) and continued: "Por esto se procurarán los regentes enseñar á sus discípulos la historia literatia de cada santo padre, pero mas particularmente en los puntos de dogmas, tradición, moral y disciplina" (For this reason professors would try to teach their disciples the literary history of each and every Church Father, but, even more carefully, the dogmas, tradition, morals and discipline).[8]

From these testimonies, one concludes that religious purity required distinguishing between the word of God and apocryphal legend; and theology had to have the intellectual character given by the Church Fathers. Strong interest in the study of the Church Fathers was a characteristic of the reformers; because of the polemic triggered by the publication of two pamphlets in the 1790s, Prime Minister Urquijo called them "unos sencillos expositores de las verdades del Evangelio y repetidores de lo mismo que han escrito los Santos Padres" (some simple expositions of the truth in the Gospel repeating what has already been written by the Church Fathers).[9]

Goya's paintings of the four Church Fathers thus participate in the spirit of the time; and for this reason it is not surprising that they should have been commissioned by a congregation favoring religious reform.

It has been pointed out that Goya's paintings show the influence of Murillo's *Saint Isidro* and *Saint Leandro* in the cathedral of Seville (figs. 1, 2).[10] Although Goya's visual interpretation of the subject is similar to that of the Sevillian painter, however, his conception is very different. Goya used such pictorial means as color, light, and composition to show the subject in the light of the new religious spirit of the time. Murillo, on the other hand, dwelt on the decorative and the anecdotal, achieving a work that is more rhetorical and less focused.

Saint Ambrose stands out for the brilliance of its brushstrokes as well as for the monumentality and simplicity of its composition, which give the subject a solemn and sober character. Absence of

Fig. 1. Bartolomé Estebán Murillo, *Saint Isidro.* 1655.
Oil on canvas.
Cathedral of Seville

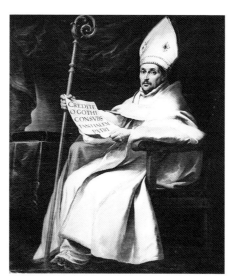

Fig. 2. Bartolomé Estebán Murillo, *Saint Leandro.* 1655.
Oil on canvas.
Cathedral of Seville

spatial depth makes the subject timeless and universal. Realistic details such as table and chairs are lacking. Moreover, some of the conventional attributes are omitted: the beehive, which refers to a legend in the life of Saint Ambrose,[11] and the crook, symbol of authority. These are not what Goya wanted to highlight. In the words of Ambrose himself, "San Mateo nos enseña que el Salvador encargó a sus apóstoles viajar sin báculo cuando fuesen a predicar el Evangelio. ¿Y qué se entiende por este instrumento sino el signo de la primera autoridad espiritual, y el instrumento del dolor destinado a castigar?" (Saint Matthew teaches us that the Savior instructed his apostles to travel without the crook when preaching the Gospel. And what do we understand by the crook but the sign of the first spiritual authority, and instrument of suffering designed to punish?).[12] Goya's painting suggests that Saint Ambrose's work is the result of his divine revelation of a dialogue with God. The saint, with eyes turned heavenward, seems to take divine dictation with his quill. In this manner, Goya's painting coincided with the philosophy of the supporters of religious reform in stressing revealed doctrine.

The painting of Gregory the Great is very similar in composition to that of Saint Ambrose, with its pyramidal scheme, absence of space outside the figure, and monumentality. But in the former the placement of lines and light tends to emphasize the book more than the figure. The vertical golden stripes of the cape converge at the head of the saint, who is bent in concentration over his writing. Thus, the pyramidal scheme that took us outside the canvas in *Saint Ambrose* is here enclosed within the painting. The horizontal lines of the arms and hands on the book again reinforce its importance. The light is placed with the same purpose: it comes in laterally from outside and below the canvas, illuminating like a pillar the base on which the manuscript rests. In the pages of the book, the shoulder, and the tiara, the light above fades away in height with gradually less intense strokes. Saint Gregory is known as the pope who left the most writings, a fact that did not

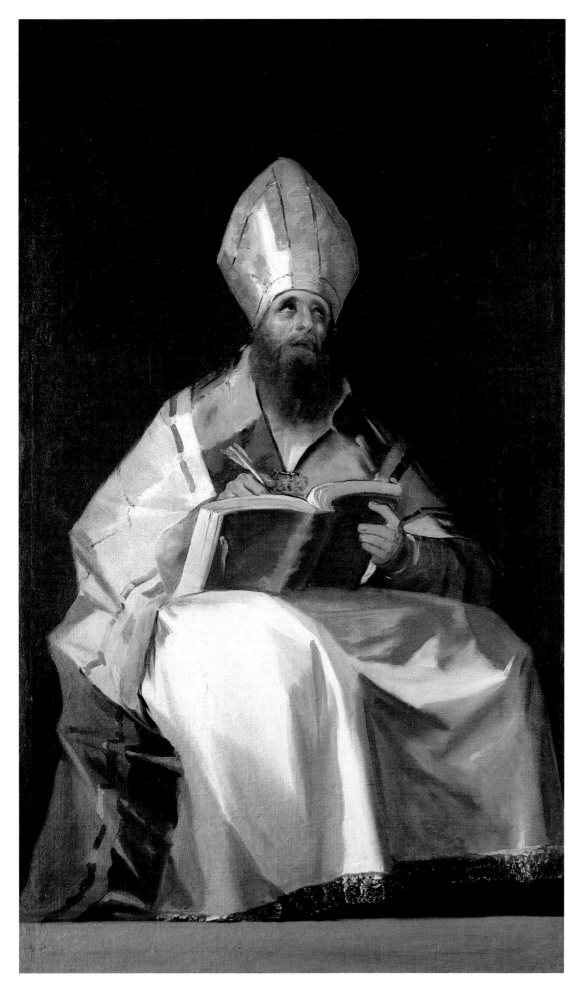

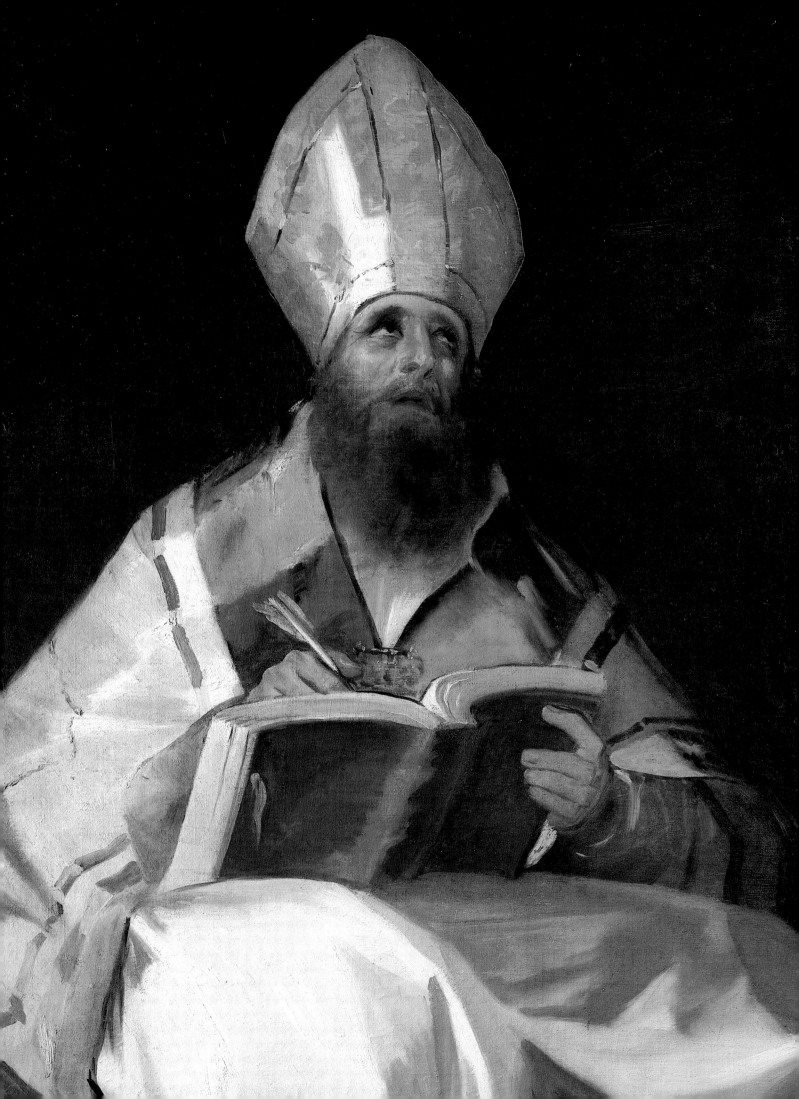

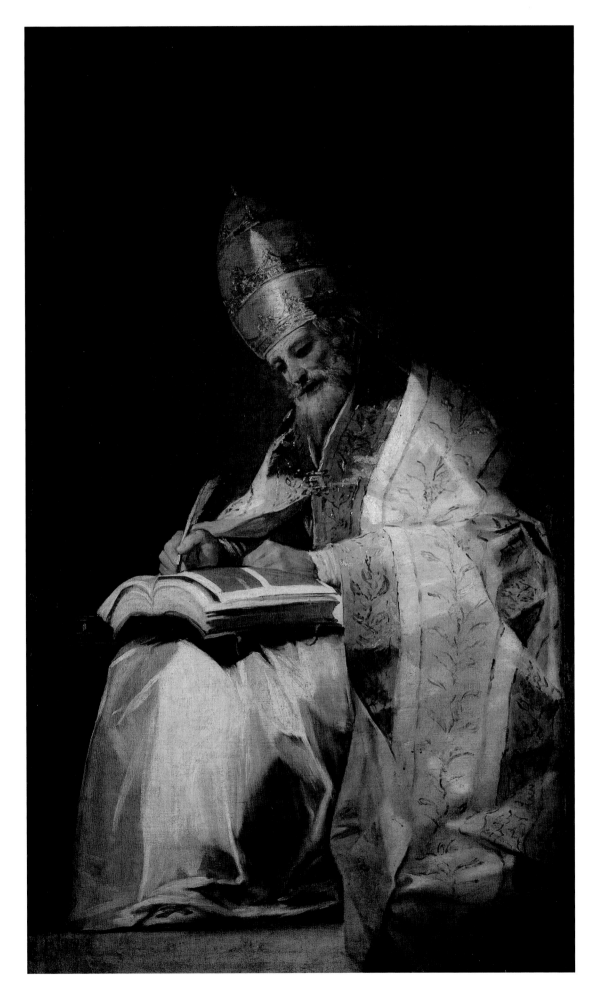

escape Goya when he included the ink-stand at the left as the only symbolic element. The brushstrokes seem to follow the same rules as those in a fresco; the pigment is thickly applied to the points of light, giving the impression of rapid execution. Shown from a very low viewpoint, the saint is leaning on a horizontal surface resembling a pedestal. Seen from a distance, the rough, almost crude sketch is transformed into a delicate, tranquil setting in which the saint devotes himself to his work – a work whose importance transcends that of the writer himself.

<div style="text-align:right">M.M.H.</div>

1. *Saint Augustine*, G-W 714, *Saint Jerome*, G-W 716. According to Gassier and Wilson, they were "probably painted . . . in 1796-97" and show the "clear influence of Murillo's *Saint Isidore* and *Saint Leander* in the Cathedral at Seville." Gudiol dates the paintings between 1781 and 1785.

2. Antonio Mestre, *Ilustración y reforma de la Iglesia: pensamiento político y religioso de Son Gregorio Mayáns y Siscar, 1699-1781* (Valencia, 1968), p. 326.

3. Ibid., p. 391.

4. Pablo de Olavide, *Plan de Estudios para la Universidad de Sevilla* (Barcelona, 1969), p. 151.

5. Ibid., p. 152.

6. Gaspar Melchor de Jovellanos, *Reglamento literario é institucional: Extendido para llevar efecto el plan de estudios del colegio de Calatrava, en la ciudad de Salamanca*, Biblioteca de Autores Españoles, vol. 56 (Madrid, 1858), p. 184.

7. Ibid., p. 201.

8. Ibid., pp. 203-204.

9. Richard Herr, *España y la Revolución del siglo XVIII* (Jerez de la Frontera, 1964), p. 353. The two pamphlets were a translation by Rocco Bónola against the Sínodo de Pistoia, *La liga de la teología moderna con la filosofía en daño de la Iglesia de Jesucristo*, and *El páxaro en la liga*, by the Augustine Fernandez de Rojas.

10. Sánchez Cantón, *Vida y obras de Goya* (Madrid, 1951), pp. 61-63, compares both these works with those of Murillo but gives preference to those of Goya because of their "visual strength and opulence of color."

11. See George Ferguson, *Signs and Symbols in Christian Art* (New York, 1966), p. 103.

12. Llorente, *Inquisición*, p. 172.

24

Juan Antonio Meléndez Valdés
1797

Oil on canvas
73.3 x 57.1 cm.
Inscribed: *A Meléndez Valdés su amigo Goya / 1797*
References: G-W 670; Gud. [372].

The Bowes Museum, Barnard Castle, Durham, England, 26

"Los principios de su filosofia eran la humanidad, la beneficencia, y la tolerancia; él pertenece á esa clase de hombres respetables que esperan del adelantamiento de la razon la mejora de la especie humana" (The tenets of his philosophy were humanity, generosity, and tolerance; he belongs to that category of respectable men who expect of reason's progress the improvement of the human race).[1] Such were the Liberal poet Manuel Quintana's words for his teacher Meléndez Valdés. Born in Ribera del Fresno, Badajoz, in 1754, Meléndez was a distinguished intellectual and member of the enlightened circle to which Goya belonged. Meléndez broached the problems of his time not only in his poetry – especially after the second edition of his works appeared in 1797, where the aesthetic is not separated from the ethical purpose – but also from his position as a judge.[2]

These two facets of his personality – the magistrate and the poet – were so integrated in his life that it has been said he practiced his career as a judge like a poet and that he wrote verses like a philosopher. The works of Meléndez are representative of enlightened poetry. Jovellanos encouraged him from the outset to cultivate the Anacreontic, which "belongs to the poetry of enlightened culture as much as a revolutionary poem does for its social ideals."[3]

In 1789, four years after publishing the first edition of his works, and nine years after receiving a prize from the Academia de Bellas Artes for his eclogue *Batilo*, Meléndez decided to become a judge. The *Discursos forenses* (Legal Discourses), a work published after his death in 1821, brings together some of his reflections as a judge. "In the prose

of those legal studies can be found Meléndez's opinions on the militia and the clergy, on work and mendicancy, on art and the sciences, on punishment and mercy, on equality and privilege; that is, on all that the law regulates."[4] Meléndez regarded laws with a certain flexibility in the sense that he expected them to take into account the character of each nation, which the judge was to interpret. The humanism that guided his judicial tasks may be summarized in the following text: "que siempre en nuestros pechos se ostente y resplandezca la indulgente equidad, que la conmiseración pese más que el rigor; que este no se despegue enteramente sino contra los crimenes reiterados y de deliberada reflexión; que aun a estos los mire el juez con respeto y humanidad; y que nunca, en fin, se encrudezca contra el delincuente, sino que se castigue llorando, y como apesar suyo cuando la misma clemencia no pueda perdonar" (may indulgent equity always prosper and shine in our hearts, and mercy weigh more than rigor; may rigor not be applied except against repeated, deliberate crimes; may even these be viewed by the judge with respect and humanity; and never, finally, should the offender be treated harshly, rather should the judge punish with tears in his eyes, and as if regretful that clemency itself cannot forgive).[5]

In Goya's portrait Meléndez is presented as a friend. Glendinning has noted that it is unlikely Meléndez greatly appreciated Goya's art, for he was more inclined to idealism than realism.[6] But ideologically there are obvious analogies; both were men who felt responsible for the world in which they lived, who reflected in their works the concerns and the philosophy of their time. Both were interested in the administration of justice; in Goya it manifested itself in his works on prisoners, jails, and executed criminals (see cat. 71, 95, and 96), which agree with Meléndez's statement: "Cualquiera castigo, Señor, superior á la ofensa recibida, al animo malefico y torcido del que la cometio, ó no necesaria al escarmiento público, es una tirania un atropellamiento, una inutil barbaridad, en vez de una justicia y saludable reparación" (Any punishment, Sir, greater than

the offense committed, the evil and perverse intent of the criminal, or its utility as a general warning is a tyranny, a violation, a useless barbarity, instead of a just and healthy indemnity).[7]

Begging was seen from a like point of view; Meléndez asserted that social justice and the organization of the state were more important than charity and alms, and he spoke unambiguously on the wiles of the beggar (see cat. 76). Meléndez shared with his enlightened contemporaries concern for the education of children, whom he called the "esperanza naciente del Estado" (the State's incipient hope), and for agriculture, in whose reform he believed lay Spain's progress. Several works by the two friends are critical of the vices of the age. In 1797 *La despedida del anciano* (The Old Man's Farewell) was published for a second time, a poem in which Meléndez denounced the vice-ridden court, the nobility, luxury, extravagance, and adultery.[8] "This is the first philosophical poem that Meléndez published, that is, a poetry that puts itself in the service of the ideals of the Enlightenment, or better yet, that attempts to have some impact on social problems; at last a poetry responsive to its time."[9] In the same year Goya was preparing the *Caprichos*. The advertisement for them appearing in the *Diario de Madrid* reads: "Persuadido el autor de que la censura de los errores y vicios humanos (aunque parece peculiar de la eloqüencia y la poesía) puede tambien ser objeto de la pintura" (The author is convinced that censuring human errors and vices – although it seems the preserve of oratory and poetry – may also be a worthy object of painting.)[10] That is, Goya made the same content traditional to poetry a worthy object of his art, giving his work in this way the same intellectual and philosophical status. Meléndez's poetry dwelt on the ideal of virtue in rural life and his subjects in general were limited to his time and environment, whereas Goya made them universal.[11]

In 1798 when Jovellanos was Ministro de Gracia y Justicia (Minister of Religion and Justice) Meléndez was appointed Fiscal de la Casa y Corte (Judge of the Royal House and the Court). He remained in this position for several months, for on Jovellanos's fall from grace at the end of the year he was banished to Medina del Campo, and thus began the most tragic years of his life. During the Peninsular War he served as Consejero de Estado (State Councillor) under José Bonaparte's government, not without first vacillating about which side to take, evidence of which was his having applied for a job in the Junta Patriótica Central (Central Patriotic Council), and his having written some patriotic verse calling citizens to arms. His decision earned him exile to Montpellier, in France, where he died in 1817.

Meléndez's twentieth-century biographer, Georges Demerson, saw the portrait of Meléndez as expressive of the unfortunate circumstances he was then facing. "The gods do not favor Batilo [Meléndez's pen name]: the slander, jealousy, calumny, all that intrigue that spells Godoy, and which Meléndez felt obscurely plotting around him in order to triumph. The judge feels hurt, disillusioned, by this hypocritical and malicious campaign; and this beautiful portrait painted in those circumstances may be read as a reflection of this concern. . . . If the knit brow, the earnest air, the absence of a smile express the disenchantment and bitterness, there is, however, an energy, a determination, and even a defiance in the look that speak of his will to fight, to carry on the battle."[12] Goya also gave us an idea of the personality of his friend, which he emphasized by using all of his artistic ability to that end. Quintana said of his teacher: "Fué Meléndez de estatura algo mas que mediana, blanco y rubio, menudo de facciones, recio de miembros, de complesion robusta y saludable. Su fisonomia era amable y dulce, sus modales apacibles y decorosos, su conversacion halagüeña; un poco tardo áveces en explicarse, como quien distraido busca la expresión propia, y no la halla á tiempo. Sus costumbres eran honestas y sencillas, su corazon recto, benéfico y humano; tierno y afectuoso con sus amigos, atento y cortés con todos. Tal vez faltaba á su caracter algo de aquella fuerza y entereza que sabe resolverse constantemente á un partido una vez elegido por la razón, y esto dependia de su excesiva docilidad y condescendencia con el dictámen ajeno." (Meléndez was of medium height, light-complexioned and fair, small-featured, strong-limbed, of a robust, healthy complexion. His expression was friendly and mild, his manners gentle and decorous, his conversation gratifying; a little slow sometimes in expressing himself, like a person anxiously seeking the exact word and not finding it in time. His habits were honest and simple, his heart upright, generous, and humane; tender and affectionate with his friends, civil and courteous with all. Perhaps his character lacked something of that force and integrity that knows how to remain faithful to one side once reason has elected it, and this was a result of his excessive flexibility and complaisance toward the opinions of others.)[13] There is also in this portrait a hint of his romantic spirit.[14]

M.M.H.

1. Manuel José Quintana, "Noticia histórica y literaria de Meléndez Valdés," in *Obras completas de Manuel José Quintana*, Biblioteca de Autores Españoles, vol. 19 (Madrid, 1946), p. 120. This "Noticia" prefaced the 1820 edition of Meléndez's collected poems.

2. Rinaldo Froldi, *Un poeta illuminista: Meléndez Valdés* (Milan, 1967), p. 123.

3. J. Miguel Caso González, *Ilustración y Neoclasicismo: Historia crítica de la literatura española*, ed. Francisco Rico (Barcelona, 1983), vol. 4, p. 422.

4. Francisco de Munsuri, *Un togado poeta* (Madrid, 1929), p. 62.

5. Juan Meléndez Valdés, *Discursos forenses* (Madrid, 1821), pp. 68-69.

6. Nigel Glendinning, "Goya's Patrons," *Apollo* 114 (Oct. 1981), p. 243. His sources for these remarks are poems Meléndez recited in the Academia de San Fernando in 1781 and 1787 and in the Academia de San Carlos in Valencia on the fine arts, in which his conception of naturalism has to do with the ideal of beauty and the classical form.

7. Meléndez Valdés, *Discursos*, p. 60.

8. Published in *El Censor*, no. 154 (1787); he later included it in the section called *Discursos* in 1797.

9. Caso González, *Ilustración*, p. 429.

10. *Diario de Madrid*, Feb. 6, 1799. Quoted in Edith Helman, *Trasmundo de Goya* (Madrid, 1983), p. 48.

11. "It is undeniable that the long-term value of the subjects Meléndez addressed has been, in general, limited, which is logical in this type of poetry; but this is not a strike against them. Poems that refer to very specific ideological, religious, social, or economic problems may end up having a merely historical value in terms of their subject. They do not aspire to

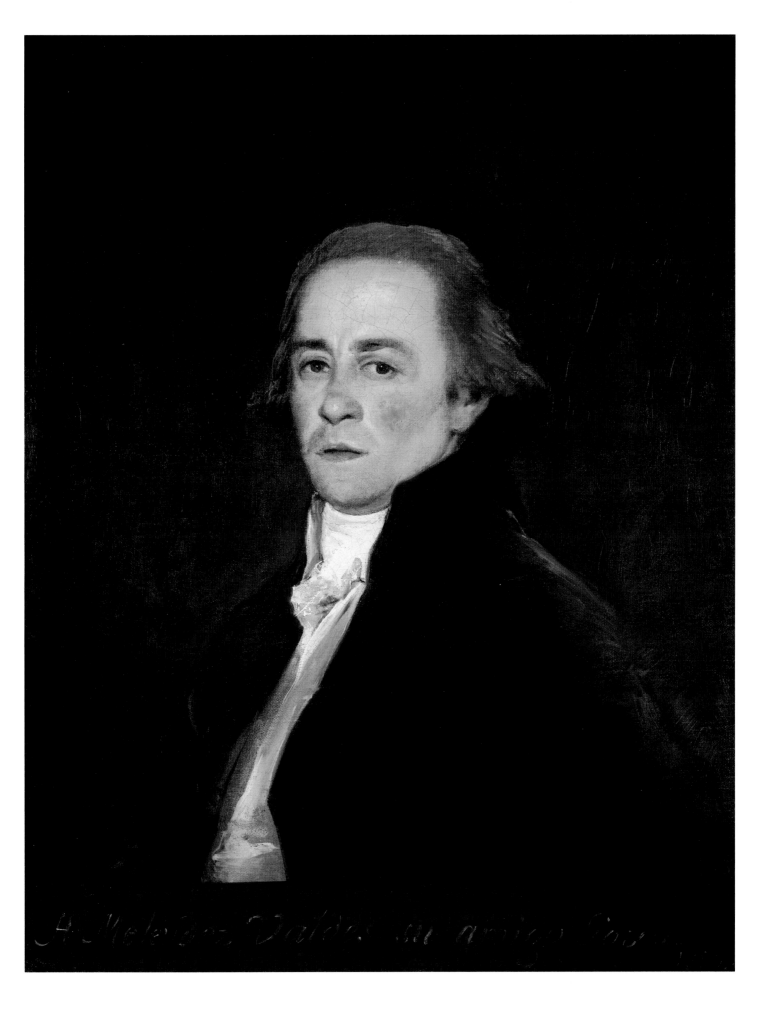

A Melendez Valdes su amigo Goya

anything else. . . . Meléndez renounced rational demonstration and based himself solely on feeling, but a feeling that attempts to become rational." Caso González, *Ilustración*, p. 430.

12. Georges Demerson, *Juan Meléndez Valdés y su tiempo: 1754-1817* (Madrid, 1971), vol. 1, p. 336.

13. Quintana, "Noticia," p. 120.

14. "Meléndez' romantic melancholy and its connection with Nature is present even in his early years, though it is not distributed uniformly throughout all his works. It reached the highest point both qualitatively and quantitatively in his last edition (1820)." William E. Colford, *Juan Meléndez Valdés: A Study in the Transition from Neo-classicism to Romanticism in Spanish Poetry* (New York, 1942), p. 221.

25

The Devil's Lamp
1797-1798[1]
Oil on canvas
42 x 30 cm.
Inscribed: *LAM / DESCO*
References: G-W 663; Gud. 359.

The Trustees of the National Gallery, London, 1472

26

The Witches' Sabbath
1797-1798
Oil on canvas
44 x 31 cm.
References: G-W 660; Gud. 356.

Museo Lázaro Galdiano, Madrid, M2004

27

Witches in the Air
1797-1798
Oil on canvas
43.5 x 30.5 cm.
References: G-W 659; Gud. 360.

Jaime Ortiz-Patiño

A bill signed by Goya records the fee – 6,000 reales – charged the Osuna family for "seis quadros de conposicion de asuntos de Brujas, que estan en Lameda" (six paintings on witches for the Alameda).[2] These paintings were to hang in the Duquesa's boudoir in her country house, El Capricho. She may herself have commissioned the series and proposed the subject; one wonders then what moved one of the women who best represented the Spanish Enlightenment to decorate her bedroom with such a motif.

Enlightened circles of the second half of the eighteenth century denied the existence of witchcraft. Belief in witchcraft was considered suitable only for common or old-fashioned people and was frequently derided. The Inquisition's position on this issue came in for criticism because its punishments, though rare and no longer severe, were believed to encourage popular superstition.[3] These ideas were not new in the eighteenth century. Julio Caro Baroja noted that it was "in the Baroque that the great crisis in witchcraft came to a head."[4] This cri-

sis appeared as such in works by Cervantes and Calderón and among some Inquisitors who considered the phenomenon a product of the imagination. The outstanding eighteenth-century precedent for this skeptical view was to be found in Padre Feijóo's writings, but the late seventeenth-century and early eighteenth-century satirical plays known as *teatro de figurón* also generally rejected this belief, and these literary sources weigh more in Goya's work than the intellectual debate on the subject.

In the series of paintings on witches for the Alameda, two at least allude to satirical (*figurón*) plays, *El convidado de piedra* (The Stone Guest) (G-W 664; whereabouts unknown) to the play with the same title and *La lámpara del diablo* (The Devil's Lamp) (cat. 25) to *El hechizado por fuerza* (Bewitched Against His Will), both written by the early eighteenth-century playwright Antonio Zamora. Given eighteenth-century society's enthusiasm for the theater, and especially the Duquesa's taste for it, these literary allusions come as no surprise. One scholar commented that her salon "was famous for the dramatic productions put on in her splendid personal theater. Leandro [Fernández de Moratín, the playwright] took the role of presiding authority in these gatherings."[5]

El hechizado por fuerza was one of the most successful eighteenth-century plays, first staged during Carlos II's reign as a satire on the *rey hechizado* (bewitched king) and his court and produced on numerous occasions well into the nineteenth century. The plot centers on an absurd character – a miserly, gluttonous, pious, and superstitious cleric – who is made to believe he is bewitched. The twentieth-century ethnographer and historian Julio Caro Baroja noted in his analysis of popular theater and magic: "From the *cultural* point of view the *comedia de figurón* is more important than from the psychological [point of view], for its characters appear ridiculous largely because of their ideas; and by ridiculing these characters the *comedia de figurón* hits its critical bull's eye, the target of its mockery, more or less universal ideas such as . . . those relating specifically to beliefs in spells, ghosts, or

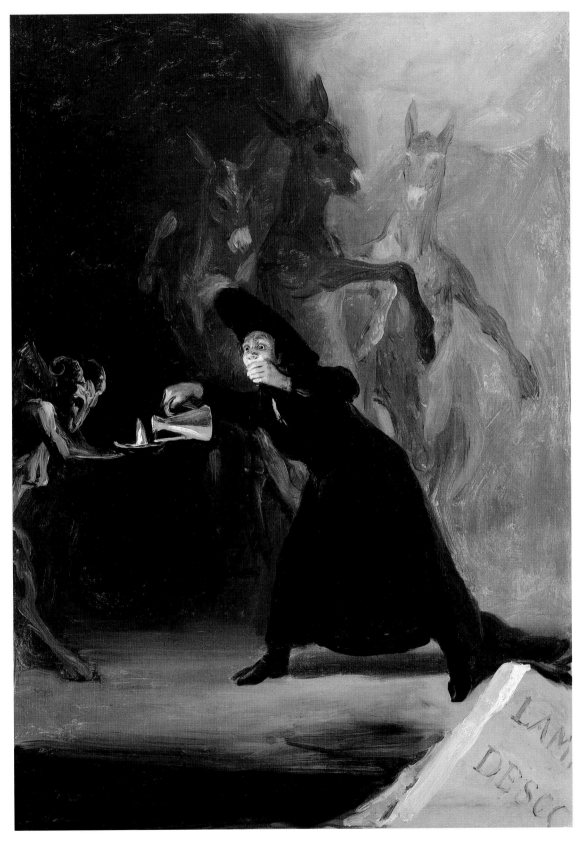

goblins.''[6] Caro Baroja included Zamora among those Spaniards who "began a gradual cultural reorientation toward Enlightenment" in the first half of the eighteenth century.

Goya's painting shows one of the most comical moments of *El hechizado*. The main character, Don Claudio, walks into the bedroom of a person supposed to be a witch, and, believing that his life will be snuffed out once the oil in the lamp is consumed, he attempts to refill it, carrying enough oil to "freírse un cochino" (roast himself a suckling pig).[7] Don Claudio covers his mouth, through which it was rumored the devil entered; in the foreground the partial words "LAM . . . DESCO . . ." can be made out, which refer to the most popular passage in the play: "Lámpara descomunal / Cuyo reflejo civil / Me va á moco de candil / Chupando el óleo vital: / En que he de vencer me fundo / Tu traidor influjo avieso, / Velis, nolis, pues para eso / Hay alcuzas en el mundo: / Otra panilla por mi arda, / Y aunque muy airada estás, / Si vivo ocho dias más, / ¡Ay Lucia!" (Monstrous lamp / Whose civil light / As if I were a wick / Sucks up my life's oil: / I hold my ground in the belief that I will conquer / Your perverse, treacherous influence / Willy nilly, since this is the purpose / of the oil cruets in this world: / Another small measure burns for me, / And, although you are quite vexed, / If I live another eight days, / Oh Lucia!)[8]

In the background of the painting asses appear seated on their haunches. In the play Don Claudio says as he walks into the room: "Una danza aquí se alcanza / A ver, aunque no muy bien, / De borricos; yo sé quien / Pudiera entrar en la danza" (A dance is taking place here / Let us see, although not too well, / [One can make out a dance] Of asses; I know those who / Could well take part in it).[9] He sees himself as a fool, for earlier he had expressly defined himself as one: "En este cuento hay dos cosas: / La una es que soy un asno" (In this story one should know two things: / The first is that I am an ass).[10] He also recognizes that his credulity is really just another form of ignorance.

Goya did not limit himself to Zamora's subject but emphasized the theatrical

backdrop in his composition. In this regard, the twentieth-century art historian Nordström has remarked: "To understand this picture correctly I think it is necessary to look at it as a representation of an acted play. In that way the composition is clearly built up: the jump from the large book with the words LAM . . . DESCO . . . at the place of a supposed prompter, the heavy shadow at the front edge of the floor, the narrow stage extending to the left, the great, credible but still somewhat theatrical gestures of Don Claudio. The lighting effects seem to be taken from the real theatre, too. There is, of course, the light of the lamp and its reflections on the wooden goat, on the hands and face of Don Claudio, but the darkness to the left and the light to the right are not because of *that* light. And the book in the foreground is without any shadow – it is within the picture but evidently outside the performed scene of the play, just as a commentary to the spectacle. And this is the explanation of the structural change or abrupt transition from the light, roughly sketched book in the foreground to the dark, suggestive scene of Act II of the play."[11]

The painting adheres to the play in both content and composition. Julio Caro Baroja's remark about the *figurón* plays could well be made about the painting: the humor does not arise from the characters but from their laughable beliefs.

The subject of *El Aquelarre* (The Witches' Sabbath) (cat. 26), the gathering of witches round the devil, is one of the most important ceremonies in witchcraft. Edith Helman related this painting to the account of the Auto de Fe of Logroño, published with humorous annotations by Leandro Fernández de Moratín in 1812, two centuries after the event and many years after the painting was executed.[12] "This scene," Helman wrote, "fully corresponds to an episode in the *Relación [del Auto de Fe]*, in which two young sisters confess to having poisoned their children in order to deliver them to the devil, who had scolded them for their lack of devotion; and they claim to have done it 'sólo por dar contento al demonio, que después se les mostró agradecido por-

que los mataron' (for no other reason than to please the devil, who later showed them his gratitude for killing their children)."[13]

Goya may have taken Moratín's "Auto de Fe" –which he could have seen in an early, unpublished form – as his point of departure; but in the painting for the Osunas he moved beyond it to express his own sarcastic view of the hackneyed attributes given to witches. It does not appear to be a mere illustration of a literary passage. One of the popular notions concerned the witches' appearance; save for the one offering the child, they are ugly and old. In relation to this is an ironic observation by the former secretary to the Inquisition Antonio Llorente, made also by Torres and Moratín: "entre las mugeres sólo ha recaído la calidad de brujas en las viejas, feas, pobres, y de clase ínfima como si no gustara el demonio de las jovenes hermosas, ricas y nobles ó de linage honrado" (female witches are only to be found among the old, ugly, poor, and lower classes as if the devil had no taste for beautiful, young, rich, and noble women).[14] Another commonplace was the blood-sucking witch. Julio Caro Baroja quoted the *Diccionario de Autoridades* on the original definition of *bruja* (witch), which was "ave nocturna semejante a la lechuza" (nocturnal bird resembling the owl), and the same dictionary explains that they were called witches by analogy to the night bird, which was also thought to suck blood. In *El Aquelarre* four children appear, one of them dead on the ground, another reaching out toward the devil, his emaciation an indication of illness or, perhaps, as it was rumored, his having blood sucked as a result of which "mueren los niños o se quedan enfermos por mucho tiempo" (children die or long remain ill).[15]

It was common in the eighteenth century to attribute afflictions to the doings of witches, among others, hail, livestock epidemics, and infant mortality. Moratín's sardonic gloss in the "Auto de Fe" reads: "Y los angelitos quedan tan flacuchos, tan descoloridos, tan débiles y tan tristes que sus pobres madres, tías y abuelas ni saben que hacer con ellos, ni adivinan cual sea su enfermedad. Regularmente suponen que sean lombrices . . .

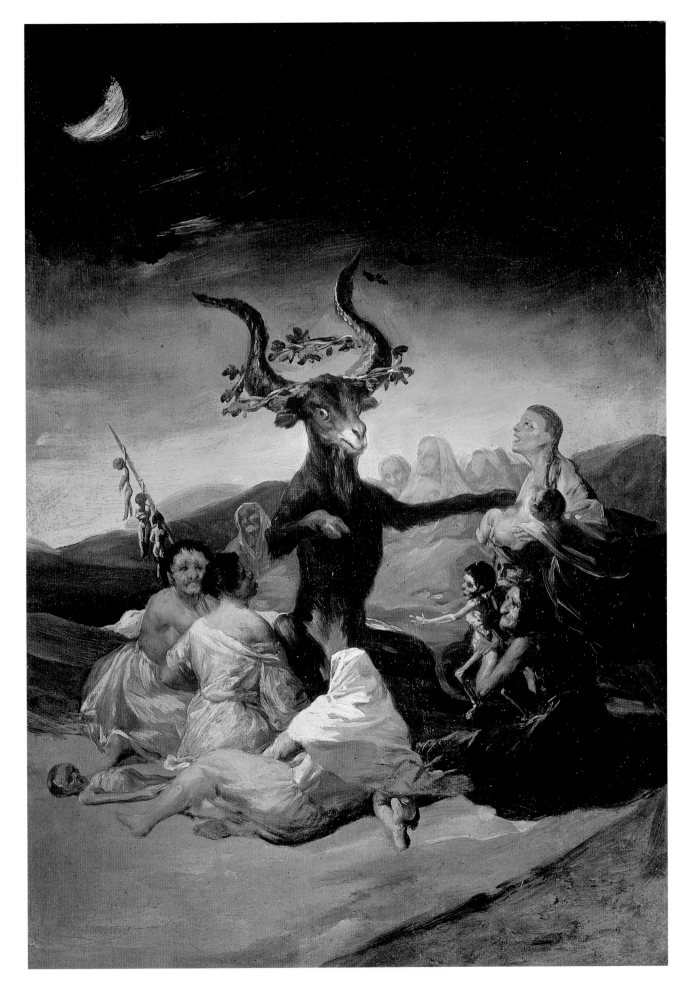

pero si la bribona de la bruja se los chupa de noche, ¿Quien hallara medicina tan eficaz que baste á curarlos? Yo lo dire lector amoroso. . . . Los padres de San Bernardo habían discurrido una oración ambidiestra, que tan buena era para el chupamiento de las brujas, como para las lombrices." (And the little angels are so emaciated, so pale, so weak, and so sad that their poor mothers, aunts, and grandmothers are at a loss about what to do with them, nor do they ever guess their illness. Ordinarily they imagine parasites are the cause . . . but if that rascally witch sucks them at night, who will have the medicine to cure them? I will tell you dear reader. . . . The Saint Bernard Fathers have devised an ambidextrous prayer, as good for sucking by witches as for parasites.)[16]

In *El Aquelarre* the devil is represented as a he-goat crowned with vine leaves, recalling the iconography of Bacchus. The incorporation of the he-goat into Christian culture has been studied by Isabel Mateo Gómez. "The he-goat is a lascivious animal, symbol of the devil and of impurity, and in Antiquity served as Aphrodite's and Dionysus's mount. . . . Satyrs were also represented with he-goat horns and legs to the extent that Christians envisioned the devil and the Anti-Christ in its image. In the moralistic bestiaries, it also appears as a personification of Lust."[17] With the crown of vine leaves Goya apparently wanted to emphasize this lustful vision of the devil, which becomes more obvious in his later representations of the he-goat.[18] Goya's mockery lies in his insinuation that these witches are more engaged in passions of the flesh than with magic. This point of view was not new. Pedro Valencia, a late sixteenth-century humanist and writer on many different subjects, "was convinced that confessions [of witches] were lies or dreams, [and] that the dishonest and horrible acts could be explained by "vía ordinaria humana" (ordinary human behavior) . . . and saw in the sexual orgies traces of the ancient Dionysian mysteries and nothing more."[19] Moratín, who knew Valencia's work, made a similar remark in the "Auto de Fe" when he wrote: "de día y de noche se les aparece el demonio en espantosa figura . . . y á las

mujeres . . . muy de ordinario se les va alas camas" (night and day the devil appears to them in frightful guise . . . and the women . . . quite often go to bed with him). Moratín also observed: "El cabrón ha sido un personaje muy respetable en la antigüedad, y muy estimado por las mujeres por sus bellas prendas" (The he-goat was a very respectable personality in Antiquity, and much esteemed by women for his handsome attire [or endowments]).[20]

Goya's mockery of the entire issue of witches in these paintings is quite different from his other uses of the witch theme, developed later in the *Caprichos* and the "Black Paintings," for here the tone is humorous while in the later works it is somber, even frightening. The witches in the "Black Paintings" inspire fear rather than laughter. According to the Stirling Maxwell manuscript commentary to the *Caprichos*: "Estas son las brujas de Goya, como dice el vulgo de los q^e las han visto; pero las verdaderas bruxerias q^e representan, son los vicios, que se disfrazan con capa de virtudes en la Sociedad. Deberan llamarse por lo tanto, *Las Satiras de Goya*, y es una de las obras filosoficas de este genero, que debemos por fortuna, original a un Pintor Espanol." (These are the witches of Goya, as is the common opinion of those who have seen them; but the true witchcraft they represent are the vices that, in Society, disguise themselves under the cloak of virtue. The work should therefore be called *The Satires of Goya;* and it is indeed one of the philosophical works of this genre, which we owe by good fortune to the invention of a Spanish painter.)

The painting *Brujos por el aire* ([Male] Witches in the Air) (cat. 27) is also known as *Vuelo de Brujas* (Flight of Witches), although the physical characteristics are more male than female in the proportions and powerful physiques. Their peculiar clothing recalls that of cowhide worn by flagellants. According to the twentieth-century historian of the Inquisition Henry Kamen, "a more common form of physical punishment was flogging. The use of the lash as chastisement was very old in Christian tradition, but under the Inquisition the punishment

became very much more than chastisement. The penitent was usually condemned to be 'whipped through the streets', in which case he had to appear stripped to the waist."[21] In the eighteenth century flogging was still a punishment for witches, necromancers, and sorcerers. Crowning the witches' heads are *corozas* (conical caps worn by Inquisitorial defendants), which the Holy Office required, among others, of sorcerers; at the same time they are cleaved *corozas* or *mitras*, that is, the miters worn by prelates. Goya played on the meanings of the two words (see cat. 59).

What have flagellants to do with witches? Valentín Foronda, a contemporary of Goya, included them in the same category as goblins: "De igual ralea son los fantasmas los expectros, los disciplinantes, los encadenados nocturnos (Ghosts, specters, flagellants, and chained nocturnal prowlers are of the same ilk).[22] The three flagellants raised above the ground seem to suck a man's blood; the man throws out his arms and screams. In Moratín's "Auto de Fe" is the following observation: "Los tales vampiros eran unos muertos que salian de los cementerios para venirse a chupar la sangre de los vivos, sacandosela o por el cuello o por el vientre; y concluida esta operación volvian a sus sepulturas. Los vivos chupados enflaquecian, se ponian cloroticos y contusos; y los muertos chupadores engordaban por instantes, adquirian muy buen color y reventaban de salud." (Vampires were corpses that emerged from cemeteries to suck the blood of the living, extracting it at the neck or the gut; once this operation was concluded they returned to their graves. Their living victims grew thin, becoming chlorotic and bruised; and the dead who fed on them grew fat by the moment, acquired a sanguine complexion, and burst with health.)[23] The image of the vampire originating in Hungary had become popular throughout Europe because of Father Augustine Calmet's book on the subject.[24] In the lower part of Goya's painting two figures try to protect themselves from what they imagine, because they neither hear nor see anything; one covers his head and steps lively, because he is persuaded his *higa*

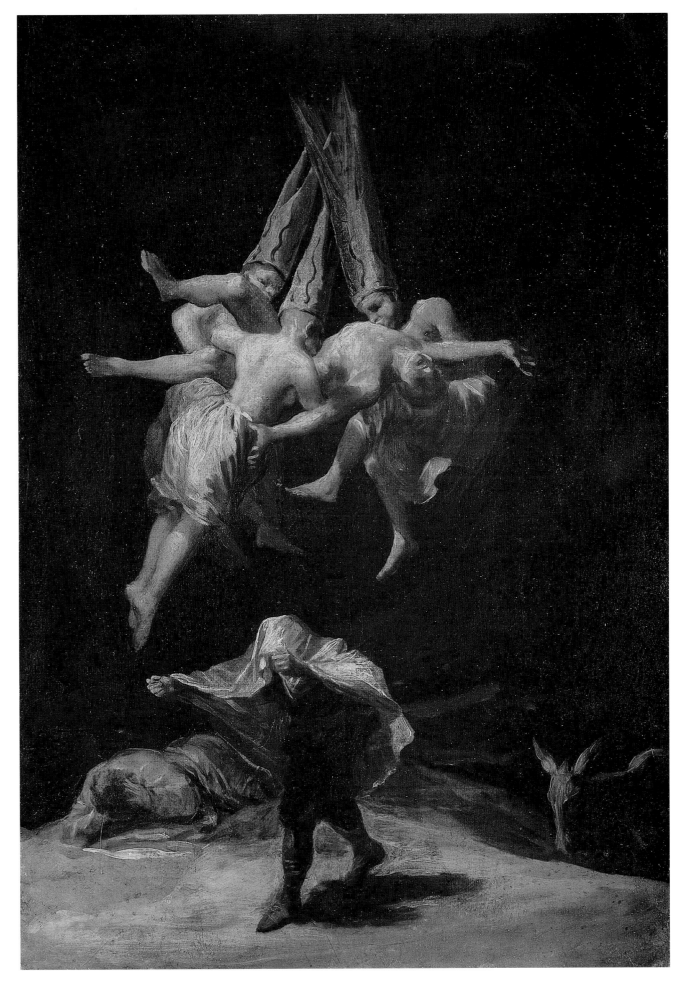

(fig) amulet will protect him. Already at the beginning of the eighteenth century, Father Jaime Barón Arin considered this practice ridiculous, and although he believed in the existence of witches, he attacked the use of *higas*. "Pero es bien que se dexen de hacer higas y otras vanas precauciones contra las brujas . . . y es cosa de risa, ver muchachos hombre y mugeres muy armados con la higa. . . . No se quien pudo inventar tal desatino." (It is high time *higas* and other vain precautions against witches stopped being used . . . and it is laughable to see children, men, and women heavily armed with the *higa*. . . . I do not know who could possibly have invented such an absurdity.)[25] The other figure lies on the ground, covering his ears and crossing his fingers in order to ward off evil spirits. Edith Helman may be right in her interpretation, but Goya's tone is mocking rather than neutrally descriptive; his intention probably remains to be discovered.[26]

M.M.H.

1. 1797-1798 is the date given by Gassier and Wilson (G-W 659-664). Gudiol dates the six paintings 1794-1795.

2. Miguel Herrero, "Un autógrafo de Goya," *Archivo Español de Arte*, no. 43 (1941), p. 176.

3. "In contrast to its advanced attitude in refusing to burn witches (in this measure Spain was ahead of the rest of Europe by 100 years), the Inquisition continued to hear cases related to witchcraft long after the rest of Europe had stopped doing so. . . . At the beginning of the nineteenth century vestiges of the intellectual basis of the belief in witchcraft were still in evidence." Gustav Henningsen, *El abogado de las brujas: Brujería vasca e Inquisición* (Madrid, 1983), pp. 342-343.

4. Julio Caro Baroja, *Las brujas y su mundo* (Madrid, 1973), p. 250.

5. Antonio Papell, *Moratín y su época* (Mallorca, 1958), p. 90.

6. Julio Caro Baroja, *Teatro popular y magia* (Madrid, 1974), p. 153.

7. Antonio Zamora, "El hechizado por fuerza," in *Dramáticos posteriorers a Lope de Vega*, Biblioteca de Autores Españoles, vol 2 (Madrid, 1859), p. 446.

8. Ibid., p. 447.

9. Ibid.

10. Ibid., p. 439.

11. Nordström, *Goya*, p. 158.

12. Leandro Fernández Moratín, "Auto de fe celebrado en la ciudad de Logroño en los días 6 y 7 de noviembre de 1610," in *Obras*, Biblioteca de Autores Españoles, vol. 2 (Madrid, 1859), pp. 617-631. See Helman, *Trasmundo*, pp. 186-199.

13. Helman, *Trasmundo*, p. 188.

14. Juan Antonio Llorente, *Historia crítica de la Inquisición en España* (Madrid, 1822), vol. 3, p. 260.

15. Moratín, "Auto de fe," p. 630.

16. Ibid., p. 629.

17. Mateo Gómez, *Sillerías de coro*, pp. 48-49.

18. As, for example, in *Capricho* 60, *Ensayo* (Rehearsal) (G-W 571), and in the *Aquelarre* (G-W 1623) in the "Black Paintings."

19. Helman, *Trasmundo*, p. 192.

20. Moratín, "Relación."

21. Kamen, *Inquisición*, p. 246. (Kamen, *Inquisition*, p. 187.)

22. Valentín Foronda, *Cartas sobre la policía* (Madrid, 1801), p. 125.

23. Moratín, "Auto de Fe," p. 628.

24. Ibid.

25. Caro Baroja, *Brujas*, pp. 125-126.

26. See Edith Helman, "Algunos Sueños y brujas de Goya," in *Goya: Nuevas Visiones: Homenaje a Enrique Lafuente Ferrari* (Madrid, 1987), pp. 196-205. Helman found affinities between this scene and the Uncle Mentirola anecdote Moratín recounted in the "Auto de Fe." Mentirola, having had his fill of food and drink, fell fast asleep in the fields. "A deshora de la noche le despertó un estruendo vespertino de voces y instrumentos músicos que sonaba en el aire. Estregóse los ojos se incorporó como pudo, y alzando la vista distinguió multitud de sombras, a manera de cuerpos humanos, que arracimados y en cuadrilla iban cruzando por la media región y oyó voces de hombres, y chillidos de mujer." (Suddenly one night he was awakened by a crepuscular clamor of voices and musical instruments resounding in the air. He rubbed his eyes, composed himself as well as he could, and looking up made out a throng of shadows, shaped like humans, making their way across the middle distance in clusters of groups, and he heard mens' voices, and women's shrieks.) Ibid., p. 203. But this story does not explain everything shown in the painting, and the Uncle Mentirola character of the story, which Helman identified with the person lying on the ground in the painting, is secondary in Goya's work. Nor does the anecdote explain what happens when witches fly.

28

Truth Rescued by Time, Witnessed by History
1797-1800
Oil on canvas
42 x 32.5 cm.
References: G-W 696; Gud. 482.

Museum of Fine Arts, Boston, Gift of Mrs. Horatio Greenough Curtis in honor of Horatio Greenough Curtis, 27.1330

At the left stands slender Truth, facing the viewer like a statue, waiting for Time with his hourglass to guide her.[1] A blinding light is deflected off Time's great wings and encroaches upon the darkness behind him, pushing owls and bats to frantic flight. In the foreground wingless History sits upon a broken fragment of cut stone. It seems Goya thought she should share Truth's unadorned nakedness. History looks back, as painters who represented her tended to depict her, and leaves her testimony in a great book.[2]

Martín Soria seems to have been the first scholar to notice that the subject of this painting was derived from Cesare Ripa's *Iconologia* (first published in 1593).[3] Soria remarked that Goya followed Ripa in showing History looking over her shoulder toward the past while simultaneously recording a testimony for the future.

Time is appropriately represented with an hourglass, since the hourglass was an emblem of the present taking flight.[4] The favored daughter of Time was Truth, which the world so often tried to deny, hide, and even kill. Time was usually shown confronting his daughter's enemies, whoever they might be – mean and poor or great and powerful; it was thought that in the end he would rescue Truth and reveal her to us.[5]

One of the predominant elements in Goya's composition is the light bursting in from the upper left. Time as savior turns his face in that direction, his great extended wings becoming barriers against the darkness in the background. Light has a symbolic meaning. In Goya's day it was often used to represent the Enlightenment – "las luces" (the lights, that is, the Enlightenment) – in a broad

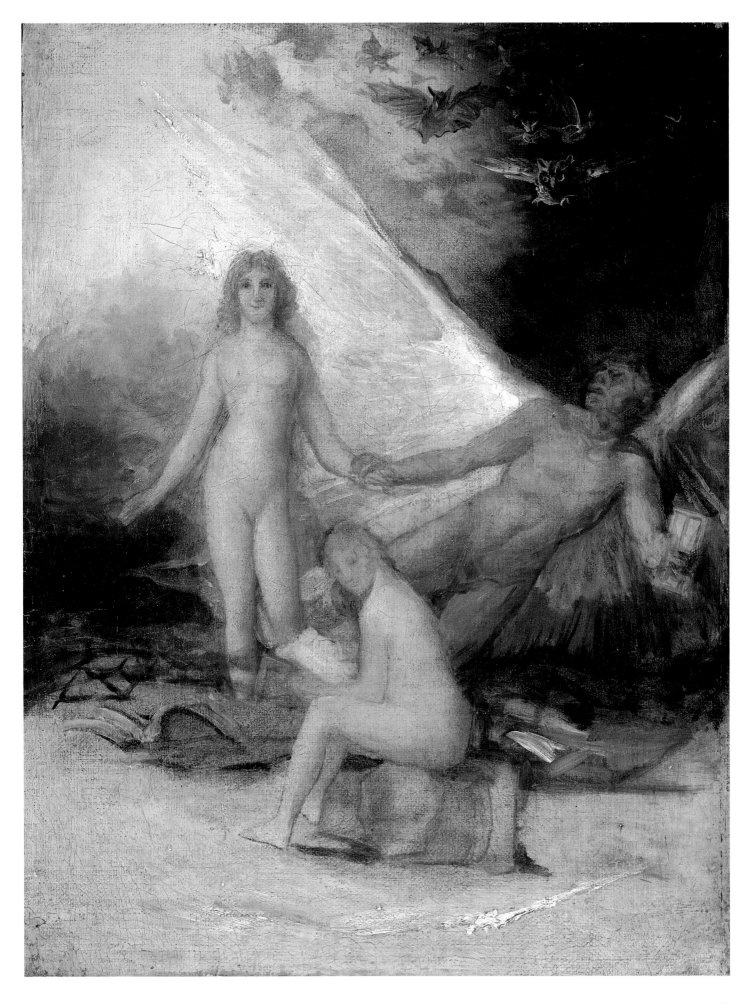

Fig. 1. *Time Flying with Truth*, 1797-1798.
Red chalk and wash.
Museo del Prado, Madrid, 423 (recto of 463)

Fig. 2. Figure of *Truth*.
Red wash.
Museo del Prado, Madrid, 463 (verso of 423)

sense, as Goya demonstrated with less subtlety on his original frontispiece to the *Caprichos* (cat. 52).

The style of the oil sketch can be dated to the 1790s. Goya's compositions then tended to complexity and an open angularity, and his human beings were characterized by the rococo lightness of their bodies, with shoulders that slope unrealistically.

The concept of Time the savior is to be found in two other drawings by Goya and in the *Allegory on the Adoption of the Constitution* (cat. 74). The first of these works to have been executed is a red chalk drawing (fig. 1). Stylistically, this drawing is very close to many studies by Goya for the *Caprichos* and was executed on the Netherlandish paper Goya then favored. We know the symbolism of the bats and the owls in Goya's work thanks to an inscription that appears in an ink drawing on the same kind of paper: "El Autor soñando. Su yntento solo es desterrar bulgaridades perjudiciales, y perpetuar con esta obra de caprichos, el testimonio solido de la verdad." (The author dreaming. His only purpose is to banish harmful ideas commonly believed, and to perpetuate with this work of *Caprichos* the solid testimony of truth.) (See cat. 51, 52.) Whatever Goya's intent may have been for this early version, Truth rescued by Time would have served as a perfect epigraph for the *Caprichos*. But he turned the drawing over and on the verso created an unfinished red chalk sketch of a naked, standing *Verdad* (Truth) (fig. 2). Her body is more erect there, and she no longer looks decidedly to the right, as she did in the drawing in which Time rescues her. This study is undoubtedly a preliminary drawing for *Truth Rescued by Time, Witnessed by History*.

M.M.H.

1. This entry is based partly on Eleanor A. Sayre, "Goya: A Moment in Time," Nationalmuseum, Stockholm, *Bulletin* 3, no. 1 (1979), pp. 28-49.

2. This small oil painting was etched in the series "El grabador al aguafuerte" (The Etcher), *Colección de obras originales y copias de las selectas de autores españoles* (Madrid, 1875), vol. 2, pl. 21. The series included prints of many works by famous Spanish painters. Because of this source we know the oil was "regalado por el autor a D. Juan Carñicero, Bibliote-cario que fue de Su Majestad" (presented as a gift by the painter to Juan Carñicero, who had been His Majesty's Librarian), and that it "pertenece hoy a Alejandro de Coupigny" (now belongs to Alejandro de Coupigny). In 1918 R.W. Curtis bought it in Spain for Horatio Greenough Curtis, whose wife donated it to the Museum of Fine Arts, Boston.

3. Martín S. Soria, "Goya's Allegories of Fact and Fiction," *Burlington Magazine* 90 (July 1948), pp. 196ff.

4. See Gravelot and Cochin, *Iconologie*.

5. For the authoritative study on Father Time, see Erwin Panofsky, *Studies in Iconology* (Oxford, 1939), chap. 3; on Truth as daughter of Time, in the sixteenth and seventeenth centuries, see Fritz Saxl, "Veritas filia temporis," in *Philosophy and History: Essays Presented to Ernst Cassirer* (Oxford, 1936), pp. 197-222.

29

Sketch for The Arrest of Christ
1798
Oil on canvas
40 x 23 cm.
References: G-W 737; Gud. 397.

Museo del Prado, Madrid, 3113

The Arrest of Christ was commissioned, according to Goya's friend Francisco Zapater, in 1788 by the archbishop of Toledo for the cathedral sacristy.[1] But Goya did not finish it until 1799, exhibiting it to great acclaim in the Academia de Bellas Artes.[2]

The sketch is an example of the deep religious feeling that underlies Goya's devotional works. This aspect of his art has never been sufficiently valued since the nineteenth-century historians saw him "como un escéptico que dudaba de dios y de sí mismo" (as a skeptic who doubted the existence of God and doubted himself), labeling him in accordance with their false, commonly held view of the eighteenth century as godless.[3] The twentieth-century historian Joël Saugnieux, who has studied the place of religious faith in the Enlightenment, observed: "The Enlightenment, far from being globally antireligious, appears rather, and in Spain more so than some other European countries, as the will to adapt faith to the new intellectual demands. . . . The Enlightenment was a century of spiritual and doctrinal renovation. . . . Religion became an inner force."[4]

One of the paths to pure religion was the reading of the Bible. Gregorio Mayans, from whom Carlos III in 1767 commissioned a report on the reform of theological study programs, noted: "que el único texto es la Sagrada Escritura y el principal fin de su estudio es conocer el sentido literal de la palabra revelada" (the only text is the Holy Bible and the principal purpose of its study is to understand the literal meaning of the revealed word).[5] Years later Jovellanos expressed the same opinion in his *Memoria sobre la educación pública* (Report on Public Education), recommending that young people study the Gospel not in "lecciones de coro, sino así estudiadas y entendidas, que pudiesen dar razón de su con-

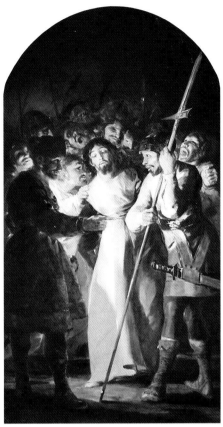

Fig. 1. *The Arrest of Christ*, 1798.
Oil on canvas.
Sacristy of the Cathedral of Toledo

tenidos" (lessons learned by heart, but studied and understood in such a way that students can explain their content). Furthermore he proposed studies be dedicated to the reading of the Bible in order to "facilitar la inteligencia é infundir amor y veneracion á este libro inspirado por el mismo Dios, que es el verdadero codigo cristiano. . . . Quisiéramos, en fin, que se les hiciese mirar como indigno de un cristiano darse con afán a otras lecturas y estudios, mirando con desden ó indiferencia el mas importante de todos, que es cima y complemento de la verdadera sabiduría." (familiarize people with and to instill love and veneration for this book inspired by God himself, which is the true Christian law. . . . In short, it would be desirable if they learned to regard as unworthy of a Christian to give himself with zeal to

other readings and studies, looking with contempt or indifference on the most important of all, which is the zenith and complement of all true wisdom.)[6]

The importance of the original sources in the new religious reform of the eighteenth century changed views of the way religion should be depicted. Antonio Ponz, one of the most important art critics of the age, commented: "Si al Santo Evangelio no se le puede contradecir con las palabras, ¿por qué se ha de hacer con las obras?" (If the Holy Gospel cannot be contradicted with words, how can it be with works [of art]?)[7] Goya shared in this spirit of renovation when he executed his religious paintings. According to Ceán Bermúdez, commenting on the painting of saints Justa and Rufina Goya created for the Cathedral of Seville in 1817 (G-W 1569), "antes de trazar Goya su obra, hizo lo que debe hacer todo Pintor, que desea instruirse para no caer en anacronismos ni en otros defectos históricos. Leyó con reflexión las actas del martirio de las dos hermanas. . . . Penetrado de la fe, fortaleza y amor á Dios, que las caracterizaron, puso todo su estudio en inventar las formas, actitudes, espresiones y efectos que mostrase estas mismas virtudes." (before composing his work, Goya did that which every painter should who wishes to avoid falling into anachronisms or other historical errors. He carefully read the accounts of the martyrdom of the two sisters. . . . Infused with the faith, strength, and love of God that characterized the two saints, he put all of his efforts into inventing the forms, attitudes, expressions, and effects that would convey these virtues.)[8] Ceán identified three elements that come together in Goya's working method: first, consultation of the sources of that which is to be represented; second, meditation on their meaning; and third, the pictorial interpretation of the sources. He shared, then, in the ideas advanced by Jovellanos: he sought to "explain their content."

To judge by the feeling that underlies this work it seems certain that Goya conceived of *The Arrest* in the same terms as the painting in the Cathedral of Seville, by consulting the main sources: the Gospels. In both style and conception

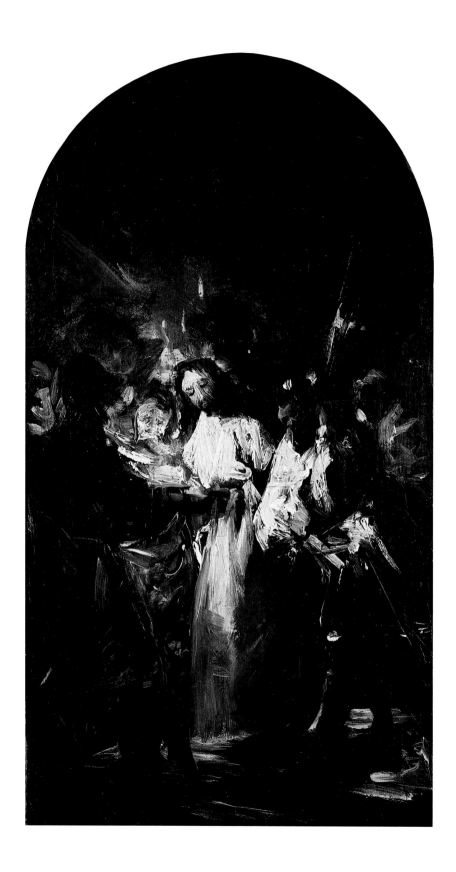

Sketch for The Arrest of Christ

this sketch approximates the Scriptures. The painting contains three main features related to passages from the Gospel: the vile treatment of the son of God, whose enemies attempt to subdue by force; Christ's sadness; and the contrast between light and darkness as a symbolic element. The first idea is to be seen in the detail of the spear and the sword hilt, alluding to the passage in Mark 14:48: "Are ye come out, as against a thief, with swords and with staves to take me?" Christ's facial expression is at the center of the composition, with head bent and eyes closed. Not long before, Christ had told his disciples (Mark 14:34): "My soul is exceeding sorrowful unto death." To God the Father he prayed (Mark 14:36) "take away this cup from me." Christ's countenance reflects his profound sadness and yet also his acceptance of the divine will (Mark 14:36): "nevertheless not what I will, but what thou wilt."

The dramatic contrast between light and shadow is used here with a symbolic charge.[9] The light emanates from Christ, who illuminates all that surrounds him; the rest is darkness. The dark vertical line takes up a third part of the sketch. In the moment of his arrest Christ says (Luke 22:53): "this is your hour, and the power of darkness." In his handling of light Goya showed the effect of his meditation on the holy texts. In the first chapter of his Gospel, Saint John calls Christ (1:9) "the true Light," saying: (1:5) "The light shineth in darkness; and the darkness comprehended it not"; (1:10) "the world knew him not"; and (1:11) "his own received him not." The never-ending battle waged by the enlightened so that the light of reason would dissipate the darkness of ignorance and superstition found its echo here. Christ illuminates the world with the force of truth, and darkness surrounds him with the weapons of ignorance in order to coerce him. In the final Toledo painting (fig. 1), the cosmic force of darkness takes the shape of a crowd attempting to intimidate the Redeemer with its cries.[10]

M.M.H.

1. Francisco Zapater y Gómez, *Colección de cuatrocientas cuarenta y nueve reproducciones de cuadros dibujos y aguafuertes de Don Francisco de Goya* (Madrid, 1860), p. 39. See Goya's letter to Martín Zapater, July 2, 1788: "pero lo mismo le ha sucedido al Arzobispo de Toledo, me tenia encargado un Quadro para su iglesia y ni aun el borron he podido hacer" (the same thing has happened to the archbishop of Toledo; he had commissioned a painting for his church and I have not even done the sketch). Francisco de Goya, *Cartas a Martín Zapater*, ed. Mercedes Agueda and Xavier de Salas (Madrid, 1982), p. 184.

2. F.J. Sánchez Cantón, *Goya en la Academia* (Madrid, 1928), p. 17. In the meeting of Jan. 6, 1799, it was said that the Junta (Council) of the Academia de San Fernando "celebró en él su buen partido, buen gusto de colorido, dibujo y maestría, que tan acreditados tiene el Sr. Goya" (celebrated the painting's excellent composition, good taste in coloring, drawing, and mastery, for which Mr. Goya is so renowned).

3. On how the historians of art presented Goya, see Zapater, *Colección*, p. 18.

4. Joël Saugnieux, "Ilustración y fe," paper delivered at the Conference on the Enlightenment (Oviedo, 1983).

5. Antonio Mestre, *Ilustración y reforma de la Iglesia: Pensamiento político religioso de Don Gregorio Mayáns y Siscar: 1699-1781* (Valencia, 1968), p. 327.

6. Gaspar Melchor de Jovellanos, "Memoria sobre la educación pública," in *Obras*, Biblioteca de Autores Españoles, vol. 46 (Madrid, 1858), p. 259.

7. Antonio Ponz, *Viage de España*, ed. Casto María del Rivero (Madrid, 1947), p. 407.

8. Ceán Bermúdez, *Analisis del cuadro que pintó D. Francisco de Goya para la catedral de Sevilla* (Madrid, 1817), p. 4.

9. On several occasions Goya's use of chiaroscuro has been compared to Rembrandt's, whom he considered one of his masters. However, Goya not only used it as a formal nod to a master but also gave it symbolic weight within the scene he represented.

10. On this painting see José López-Rey, "Goya's *The Taking of Christ:* Challenge and Achievement," *Apollo* 114 (Oct. 1981), pp. 252-254.

30

Gaspar Melchor de Jovellanos
1798

Oil on canvas
205 x 133 cm.
Inscribed: *Jovellanos / por / Goya*
References: G-W 675; Gud. 376.

Museo del Prado, Madrid, 3236

Gaspar Melchor de Jovellanos was without a doubt the greatest intellectual of the Spanish Enlightenment. Born in Gijón in 1744, to a noble but not wealthy family, he was destined for the priesthood; he first studied in Oviedo, later in the universities of Avila and in Alcalá as a scholarship student at San Ildefonso College. While in Madrid he abandoned service to the Church and became a judge. In 1767 he was appointed Alcalde de Crimen (criminal magistrate) and later Oidor (judge) in Seville, where he lived until 1778. There he put into practice the new interpretation of justice inspired by the Italian legal theorist Cesare Bonesana Beccaria; he also moved within Pablo Olavide's enlightened circle. In 1778 he went to Madrid to fill a post as Alcalde de la Casa y Corte (magistrate of the royal house and court) and thereafter became very active, accumulating memberships to the Sociedad Económica de Amigos del País (Economic Society of Friends of the Nation), and the Academias de Historia, de Bellas Artes de San Fernando, Española (language), and de Derecho (law). He submitted reports and papers to all these societies; his goal was always to bring about Spain's cultural renaissance. His intellectual life was centered on economic and political questions; he believed that the means by which transformation of the country could be achieved was educational reform, and to this purpose he dedicated a large part of his writings.

When Francisco de Cabarrús (see cat. 15) fell from power in 1788, Jovellanos was one of few friends to remain loyal, which earned him banishment to Gijón. But far from being discouraged, he enthusiastically put his ideas for reform into practice in his native land by founding the Instituto Asturiano. During these years he wrote one of his masterpieces, *El informe sobre la ley agraria* (Report on the Agrarian Law), finished his essay on public entertainment, began his *Diario*, and also pursued economic studies. The Instituto became a pedagogical model where scientific instruction predominated, along with some secondary fields. It was inaugurated in 1794; Jovellanos taught some classes there until all the teaching posts were filled. During his ministry under Carlos IV, Manuel de Godoy (see cat. 64), advised by Cabarrús, called Jovellanos to the court. In November 1798 Jovellanos was appointed Ministro de Gracia y Justicia (minister of religion and justice), a position he held for nine months.

It is not known with certainty whether the cause of Jovellanos's fall from power was the queen's intrigue or the proposal for reform of the Inquisition that Llorente had prepared (see cat. 73). It was the beginning of a series of banishments, each more distressing than the one before. He was exiled first to his native province then, in 1801, to Palma de Mallorca, at the Valldemosa Charterhouse; but, owing to the good treatment he received from and the respect he inspired in the friars there, Jovellanos was incarcerated in Bellver Castle, where he remained until the French invasion. In Mallorca he renewed his literary activity. During the Peninsular War he was provincial delegate to the Junta Central (Central Council), and in Madrid he attempted to reconcile the conservative faction of Spanish patriots, led by Floridablanca, with the revolutionary one. He died in 1811, fleeing from the French toward the bay of Cádiz.

Jovellanos's political, economic, and scientific life did not detract from his interest in the protection of the humanities, especially of literature, which he believed indispensable for the preparation of a scientist; hence, he always encouraged artists and writers.

Jovellanos was a man of great literary accomplishment, distinguished by the breadth and diversity of his work. His poetical work *Sátira a Arnesto* (Satire of Arnesto) was among the best of its genre in the eighteenth century; as a playwright, he introduced the bourgeois

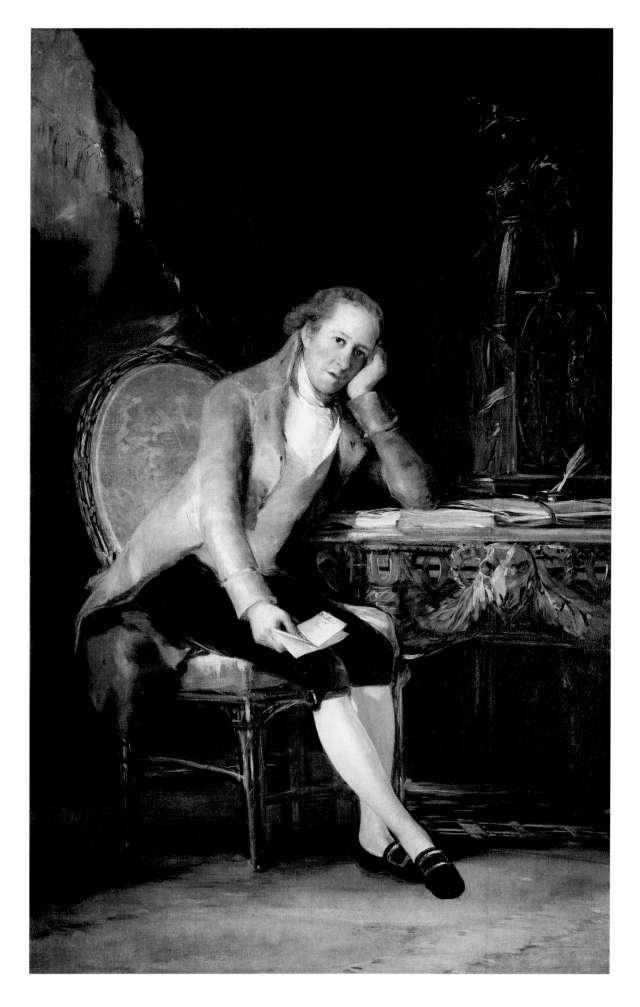

drama to Spain with *El delincuente honrado* (The Honorable Criminal), in which he addressed the theme of the nature of justice. His letters have been described as models of precise and exact use of language and of enlightened literature. His *Diario*, in which he revealed his searching, critical mind, is considered fundamental to an understanding of the Enlightenment.

Goya must have met Jovellanos when he arrived in Madrid in 1778.[1] Between these two figures – perhaps the most outstanding of their age – there was a certain ideological and aesthetic kinship. Jovellanos's aesthetic ideas are to be found in *El elogio a las bellas artes* (In Praise of the Fine Arts) of 1781, where he gave an account of the history of Spanish painting. His admiration for Velázquez is patent, and he "exhorts the young to follow the example of their illustrious countryman, especially in the study of nature."[2] Goya too in his report to the Academia de Bellas Artes of 1792 stressed the importance of nature studies in the training of a painter. Jovellanos was a great admirer of Goya's work, which he expressed several times in writing. Edith Helman has commented: "How much could Jovellanos have contributed to Goya's artistic development? This cannot, of course, be measured but it seems plausible that he would have guided him and advised him as he did all his friends: Ceán, Vargas Ponce, Meléndez and the rest of the Salamanca School of poets. He felt a calling to lead, to guide, to advise, and he practiced a kind of literary tutelage with his friends from Salamanca, sending them subjects for plays and counseling them on matters they should address in their poetry. . . . He could have suggested some social subjects for Goya's tapestry cartoons . . . and many years later some themes for his *Caprichos*. What is certain is that he always recommended Goya for individual or official commissions that came to his attention."[3] Helman thereafter affirmed that Goya owed Jovellanos his view of Spain: hence the indolent nobility, the sloth and uselessness of friars, the Inquisition, the farcical marriages, and the misunderstanding of true religious devotion addressed in Goya's works.

Jovellanos sat for Goya in the spring of 1798, the year he was appointed Ministro de Gracia y Justicia. This portrait lacks the intimacy that characterizes other portraits of Goya's friends, where the priority lay in the artist's search for the subject's character and likeness. It could be described as an emblematic portrait of the intellectual in power, for Goya reflects in it the hopes of the enlightened in a moment when their most prestigious figure stepped into office, along with the feelings of the man who took up the gauntlet.

Goya placed Jovellanos in a specific context, the official environment in which he was to be found: one of the palace annexes. This is clear from the richness of the furniture, the carpet, and the curtain. These elements are painted without detail, marvelously insinuated, as Goya was wont to do: for example, the patches of color on the floor suggest a sumptuous rug, but he has not even traced the pattern, and of the curtain we see only a fragment. On the table the work to be done piles up: there are a book, some papers, and pens; and a statue of Minerva, goddess of wisdom, the sciences, the arts, and industry, who seems to bless Jovellanos with her hand.[4] Light – symbol of Truth – enters from the opposite side. Nordström noticed the similarity between this composition and that of *Capricho* 43 (cat. 52), in which the positions of the subjects are identical.[5] Goya dealt in the same concepts of truth and wisdom that the enlightened used to praise Jovellanos. A poem by Meléndez Valdés reflects on Jovellanos's demeanor: "yo vi á Jovino / Triste, abatido, desolado, al mando / más lento que á Gijón le viera / Trocar un dia por la corte. Nunca / Más grande lo admiré; por sus mejillas / De la virtud las lágrimas corriendo" (I found Jovino [Jovellanos's pen name] / Sad, dejected, devastated, taking charge / More reluctantly than when he / Bartered Gijón for the court. Never / Was he greater in my eyes; down his cheeks / Coursed the tears of virtue).[6] Nordström studied Jovellanos's melancholy in iconographic and psychological terms; the melancholy strictly related to Minerva is the melancholy of geniuses.[7] Goya revealed a new

facet in the portrait of the statesman, who, at the moment of his greatest triumph, meditates sadly and humbly on the grave responsibilities of his position.[8]

M.M.H.

1. For thorough studies of Jovellanos's association with Goya, see Helman, *Trasmundo,* chap. 3; Edith Helman, *Jovellanos y Goya* (Madrid, 1970).

2. Helman, *Trasmundo,* p. 103.

3. Ibid., p. 104.

4. In Meléndez Valdés's and Quintana's eulogies to Jovellanos on his appointment mention is always made of Minerva. In Oviedo, in the series of festivals organized in homage to Jovellanos, *El premio de la sabiduría* (Wisdom's Reward) was staged. See Javier Varela, *Jovellanos* (Madrid, 1988), p. 142.

5. Nordström, *Goya,* p. 138.

6. Juan Meléndez Valdés, "Al Excelentisimo Señor Don Gaspar Melchor de Jovellanos, en su feliz elevación al ministerio Universal de Gracia y Justicia," Epistola 8, in *Obras,* Biblioteca de Autores Españoles, vol. 63 (Madrid, 1871), p. 208.

7. He also noted that Goya substituted the symbol of Minerva, the owl, with the goddess herself; Nordström, *Goya,* pp. 133-141. However, the owl in the *Capricho* is not a *lechuza* (barn owl) but a *buho* (horned owl) (see cat. 52).

8. Nordström, *Goya,* pp. 140-141.

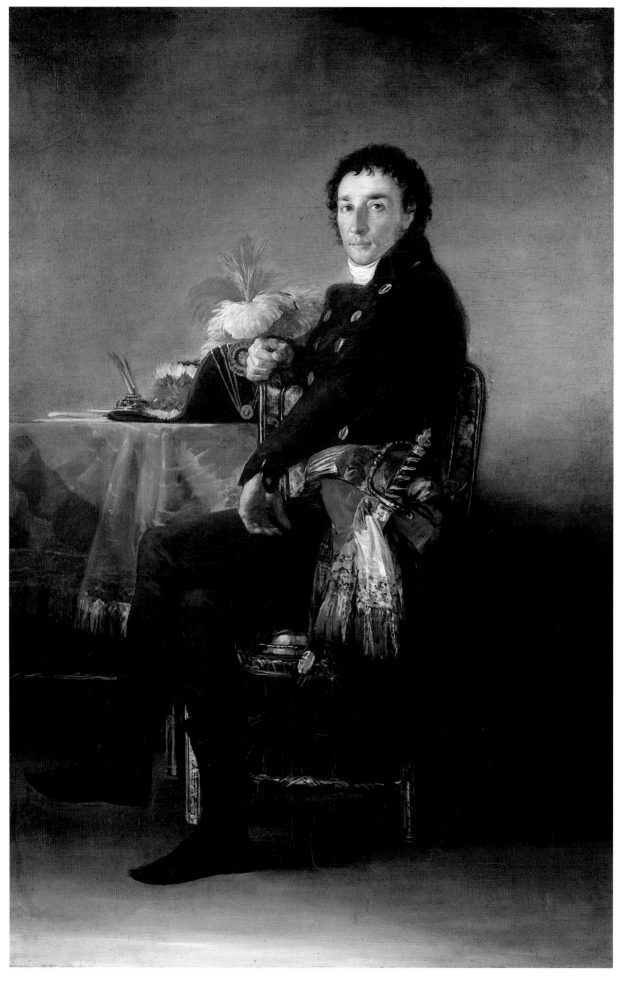

31

Ferdinand Guillemardet
1798
Oil on canvas
185 x 125 cm.
References: G-W 677; Gud. 375.

Musée du Louvre, Paris, M. I. 697

Guillemardet, a Burgundian doctor who
came to Spain in 1798 as French ambas-
sador, was the first known foreigner to
have been painted by Goya. He is best
remembered for his activities as a mem-
ber of the Convention and as a regicide.

Goya painted Guillemardet the year of
the latter's arrival in Spain. According to
one of Goya's earliest biographers, Lau-
rent Matheron (whose source was the
Brugada family, closely linked with the
artist), he is said to have declared "that
he had a marked liking for the portrait of
Guillemardet and that he had never done
anything better."[1] Executed in that same
year were the portraits of Jovellanos (cat.
30) and Francisco Saavedra (Courtauld
Institute, London; G-W 676), in which
the figures are also seated next to a
table. Among these portraits that of
Guillemardet stands out for the brilliance
of its colors and the subject's strained
posture.

Guillemardet's relevance in the history
of Goya's art was perhaps coincidental.
He took his portrait with him to France
on his return in 1800; his sons later gave
it to the Louvre, and until the end of the
nineteenth century it was the only paint-
ing by Goya that the museum owned.
Since Guillemardet was a close friend of
Eugène Delacroix's, it is likely that the
French artist discovered the *Caprichos*
through him. Michel Florisoone has
established that Delacroix knew, used,
and later may even have owned a copy of
the *Caprichos* that Guillemardet brought
with him from Spain.[2] The *Caprichos* had
been printed in the French embassy in
Madrid during his tenure there. Guil-
lemardet, then, was one of the first to
introduce Goya's work into France,
where it had such importance for the
romantic movement.

M.M.H.

1. Quoted by Jeannine Baticle, in Museo del Prado,
Madrid, *El arte europeo en la Corte de España
durante el siglo XVIII*, exhib. cat. (1980), p. 78.
2. Ilse Hemple Lipschutz, *Spanish Painting and the
French Romantics* (Cambridge, Mass., 1972), p. 10.
Delacroix also knew the two paintings by Goya the
Guillemardet family owned, this portrait and one
representing a woman.

32

King Carlos IV in Hunting Costume
1799
Oil on canvas
210 x 130 cm.
References: G-W 774; Gud. 418.

Patrimonio Nacional, Palacio Real,
Madrid
New York only

In the autumn of 1799 Goya traveled to
the royal palace at San Ildefonso, outside
Madrid, to execute the second official
portraits of Carlos IV and María Luisa de
Parma; he had painted the first pair of
portraits on the occasion of the corona-
tion in 1789. Goya had been named
court painter, and after completing the
second pair of portraits, which must have
pleased the monarchs because several
copies were made, he was named first
court painter.[1]

Carlos IV did not have sufficient char-
acter to choose the men who would lead
his government. His father bequeathed
him the Conde de Floridablanca (see cat.
4); his wife's whims and objects of
coquetry decided his selection of the
remainder. In general his ministers
favored progress, enlightenment, and the
arts, but the military and political bal-
ance of his reign was on the whole disas-
trous for the country. It is also true that
Carlos IV faced unusually severe tests,
such as the impact of the French Revolu-
tion and the catastrophic consequence –
the defeat at Trafalgar – of the wars with
France and Britain. The Aranjuez upris-
ing in 1808 forced Carlos IV to abdicate
in favor of his son Fernando, after which
he left for France and thereafter Rome,
where he died in 1819.

Carlos IV's indolence and his apathy
toward affairs of state enabled him to
dedicate himself fully to his favorite pas-
times, which included hunting. Hence
this portrait could not be more represen-
tative of what his *official* life was as titu-
lar head of the Spanish government. The
Liberal historian and aristocrat Conde de
Toreno, Carlos IV's contemporary, wrote
of him in his *Historia de la guerra de
España*: "Así terminó su reinado Carlos
IV, del que nadie mejor que él nos dará
una puntual y verdadera idea. Comía en

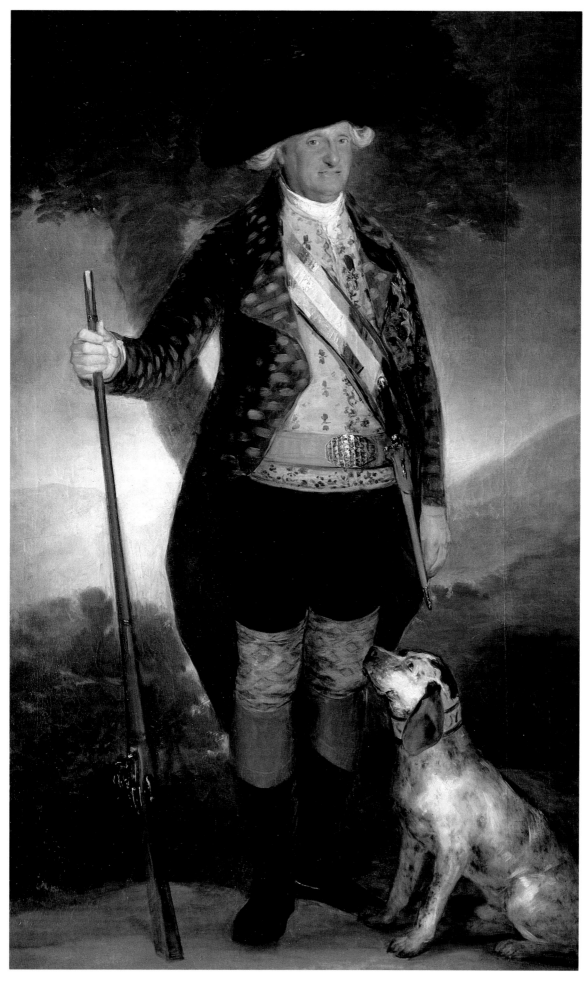

Bayona con Napoleón, cuando se expresó
en esto términos: 'Todos los días,
invierno y verano, iba de caza hasta las
doce, comía, y al instante volvía al
cazadero hasta la caída de la tarde.
Manuel me informabla cómo iban las
cosas, y me iba a acostar para comenzar
la misma vida al día siguiente, a menos
de impedírmelo alguna ceremonia
importante.'" (This is how Carlos IV's
reign came to a close, a precise and true
idea of which no one better than he can
give us. He was sharing a meal with
Napoleon in Bayonne when he expressed
himself in the following terms: "Every
day without fail, in winter and in sum-
mer, I went hunting until noon, I ate, and
immediately returned to the hunting
ground until evening. Manuel [Godoy,
the Prince of Peace] informed me about
affairs, and I went to bed only to begin
anew the same routine on the following
day, unless some important ceremony
disrupted it.")[2]

The portrait of the hunter king is com-
mon in Spanish painting. The most obvi-
ous precedent for this portrait is that by
Velázquez of the Infante don Fernando
hunting, which Goya drew and etched.[3]
Previously Goya had painted Carlos III
hunting, with evident allusions to Veláz-
quez.[4] However, the landscape does not
play the role it does in Velázquez's por-
traits, where the eye becomes distracted.
Goya took pains to render the king's
expression and even that of the dog.
There is a lingering over the decorative
details of the suit that is unusual for
Goya, along with a technical freedom he
did not dare or had been unable to mar-
shal before.

<div align="right">M.M.H.</div>

1. According to Sambricio, the monarchs' sincere
enthusiasm for these portraits (G-W 279-288) per-
suaded them to make Goya first court painter;
Valentín de Sambricio, "Los retratos de Carlos IV y
María Luisa, por Goya," *Archivo Español de Arte,* no.
30 (1957), p. 86.

2. José María Queipo Llano, *Historia de la guerra en
España* (Madrid, 1944), p. 117. The English traveler
Lady Holland recounted how his fondness for hunting
led him to forbid the burial of animal carcasses
because this facilitated crow hunting: "The air is in
some places infected with putrid matter; as it is not
allowed to bury any body or animal in the *sitio* [royal
site], therefore they are thrown on a heap and
allowed to rot. The King, besides, is not averse to
this custom, as the carcasses serve for food to crows,
&c., which is so much fish to his net, as he is indiffer-
ent about the quality of his *chasse* [hunting]." Eliza-
beth Lady Holland, *The Spanish Journal of Elizabeth
Lady Holland* (London, 1910), p. 76.

3. The drawing (G-W 98) is in the Hamburg Kunst-
halle (38538) and the print (G-W 97) in the Museo
del Prado, Madrid (1186), dated 1778-1779.

4. G-W 230, about 1786-1788, collection of the Con-
desa de Fernán Núñez, Madrid.

33

Queen María Luisa Wearing a Mantilla
1799
Oil on canvas
210 x 130 cm.
References: G-W 775; Gud. 419.

Patrimonio Nacional, Palacio Real,
Madrid
New York only

Goya's official portrait of María Luisa
wearing a mantilla flattered the queen's
coquetishness, while simultaneously
expressing one of her most criticized
weaknesses – her vanity – which report-
edly led her to displays of extravagant
luxury.

María Luisa in the gardens of the pal-
ace, possibly those of San Ildefonso,[1]
wears the dress then in fashion for the
promenade. Blanco White described it:
"The ladies' walking-dress is susceptible
of little variety. Nothing short of the
house being on fire would oblige a Span-
ish woman to step out of doors without a
black petticoat, called *Basquiña,* or *Saya,*
and a broad black veil, hanging from the
head over the shoulders, and crossed on
the breast like a shawl, which they call
mantilla. The *mantilla* is, generally, of
silk trimmed round with broad lace. In
summer-evenings some white *mantillas*
are seen; but no lady would wear them in
the morning, and much less venture into
a church in such a *profane* dress."[2]

The low point of view gives the queen's
figure a monumentality that is reinforced
by the impact of her presence. We know
from an account by the Duquesa de
Abrantes that María Luisa forbade the
use of gloves in the court in order to
show off her arms, of which she was very
proud.[3] Wearing a sleeveless bodice, she
lets her left arm fall against the black
background, which accentuates its shape
and pallor. Goya created the portrait
with the detail appropriate to a Mengs,
with a summary technique achieving
some flesh-colored tints that could be li-
kened to porcelain. The brushstrokes
become lighter gradually until they form
the airy passages of the landscape, where
the very diluted paint has almost the
transparency of watercolor. The mantilla
is rendered exquisitely, but with few and

very quick touches. The volumes of the skirt are conveyed with patches of brown, gray, and brilliant whites; the brushstrokes over them produce the lace. The colors blend harmoniously: bluish gray, rose-violet, black and gray-browns. The blurred radiance of the sky at sunset is echoed in the queen's bow.

The Danish ambassador to the Spanish court, Herman de Schubart, recounted that in the morning promenade in the palace garden the queen obliged the women to wear mantillas and top petticoats; and because of the high cost of the magnificent lace edging, many families were ruined.[4] Imports of this cloth were a serious problem for the national economy, which the queen, far from trying to minimize, encouraged. "The unbridled taste of Spanish women for crepe, lace, embroidery, and delicate stuffs made the country dependent on other nations more advanced in the manufacture of such articles. . . . Along with fabrics and cloths, Spain also consumed an enormous quantity of imported finished pieces (among which were the top petticoats). . . . All the clothing for both men and women came from abroad. Two powerful foreign companies . . . shared the monopoly of this trade. . . . Spain had even lost the advantage of assuring for itself the distribution of all those goods."[5] Although the government adopted vigorous measures, these could not limit, much less eliminate, the taste for luxury that was dragging the country into ruin.[6]

From the economic point of view, however, luxury could have advantages, so long as it favored national industry. The subject was also debated in moral terms; some condemned it because it was confined to a minority, while the majority were sunk in misery. Juan Antonio Meléndez Valdés (see cat. 24) criticized the use of the top petticoat and mantilla by all social classes indiscriminately. In a legal judgment of 1798 he wrote: "insulto que dia y noche está sufriendo el lujo escandaloso que va por todas partes, que provoca, digámoslo así, á la miseria pública, cuando mil infelices gimen consumidos del hambre y la desnudez. Los trages, singularmente los de calle, han llegado á un esceso que no podria

creerse: cuestan una basquiña y una mantilla millares de reales; y la prostitución y la más alta nobleza las usan á la par, confundiéndose en los aires y el vestido." ([it is] an insult that night and day scandalous luxury is seen everywhere and provokes, let us put it this way, public misery, while a thousand luckless people are in the throes of hunger and exposure. Fashion, especially street clothing, has reached an unbelievable extreme: a top petticoat and a mantilla cost thousands of reales; and both prostitutes and the highest nobility use them, and are indistinguishable in their airs and dress.)[7]

As a result, although the splendid portrait flattered the queen, it is also a revealing record of María Luisa's compulsive attachment to luxury. To an enlightened person, the official portrait of the queen wearing a mantilla, top petticoat, and silk and gold shoes could not but be further proof of the scandalous conditions into which the court had plunged.

M.M.H.

1. Goya had journeyed there in the fall of 1788 to paint portraits of the royal pair.

2. Blanco White, *Letters*, pp. 54-55.

3. Duquesa de Abrantes, *Souvenirs d'une Ambassade et d'un séjour en Espagne et Portugal de 1808 à 1811*, cited by Alfonso E. Pérez Sánchez in Brussels, 1985, no. 18, p. 203.

4. Herman de Schubart, "Lettres d'un diplomate danois en Espagne," *Revue Hispanique*, 1902, pp. 393-439. The letters were written between 1798 and 1800.

5. Paula de Demerson, *María Francisca de Sales Portocarrero: Condesa de Montijo: un figura de la Ilustración* (Madrid, 1975), pp. 152, 156.

6. During Floridablanca's ministry there was a proposal, addressed to him by a woman, to create a national costume in order to diminish the excessive luxury of women's dress. It was published as *Discurso sobre el luxô de las Señoras y proyecto de un trage Nacional* (Discourse on Women's Luxury and Project for a National Costume) (1788; facsimile ed., Madrid, 1985). Referring to luxury, it states: "Decir que es gravoso al Estado, es hablar con poca energia. La verday y la propiedad del lenguage piden que se le llame la corrupcion y la peste de España." (To say it is onerous to the state is to speak pusillanimously. Truth and propriety in language demand that it be called the corruption and plague of Spain.) Ibid., p. 27. The Junta de Damas (Women's Association [of the Madrid Economic Society]) agreed for its part not to use silk articles manufactured abroad. The decision was passed on to the queen "who skillfully responded that she too liked dressing with cloth made in this kingdom. But we have proof she

received whole chests of sumptuous dresses from France and that she never imposed the austerity measures decided by the Junta." Demerson, *María Francisca*, p. 155, n. 5.

7. Juan Meléndez Valdés, *Discursos forenses* (Madrid, 1821), p. 195. Quoted in part by Sarrailh, who wrote that Meléndez's petition to forbid this fashion was heard, because the following year the prohibition was decreed. See *Novísima recopilación* (Newest Compilation [of laws]), pp. vi, xiii, 18. Sarrailh, *L'Espagne éclairée*, pp. 95-96, n. 8.

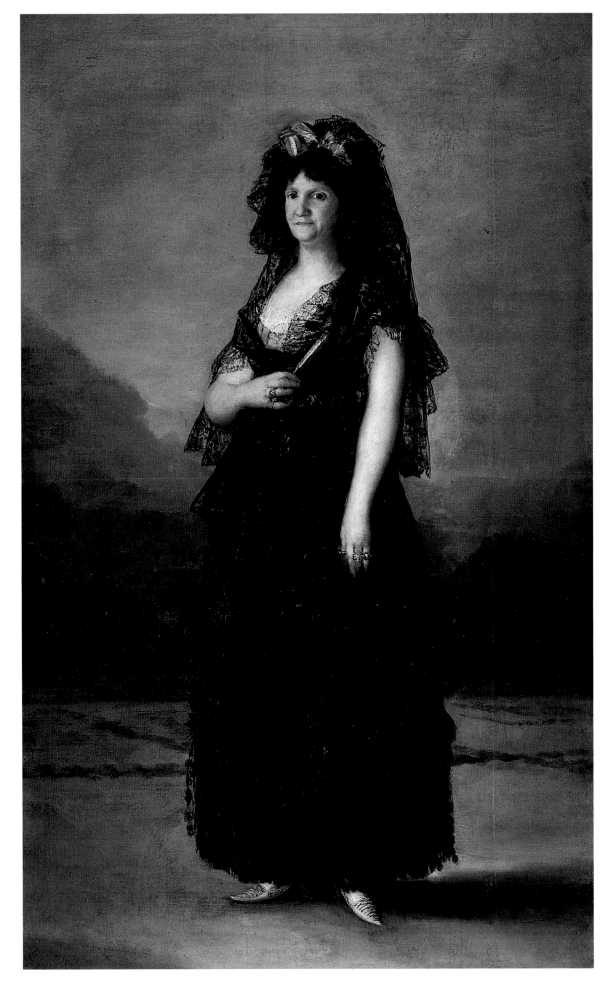

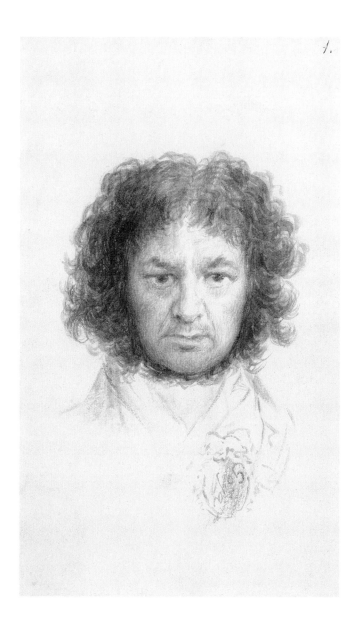

34

Self-Portrait
1795-1800
Indian ink wash
233 x 144 mm.
Inscribed upper right, in Indian ink
wash: *1*; signed on the lapel jewel: *Goya*
References: G-W 666; G., II, 331.

The Metropolitan Museum of Art, New
York, Harris Brisbane Dick Fund, 1935,
35.103.1
United States only

After Goya's death, his son, Javier, rear-
ranged the album drawings and gave
them a new order with a view to selling
them, grouping examples of great inter-
est for their beauty as well as their con-
tent. Of the albums Javier Goya made up
in this way, the one called the *Fortuny
Album* because it belonged to the Span-
ish artist Mariano José Fortuny, son of
the famous painter of the same name,
was perhaps the most interesting for the
quality of the drawings selected. Com-
prising fifty drawings taken from the
original albums now known as *B, D, E,*
and *F*, it was purchased in its entirety by
the Metropolitan Museum of Art in New
York in 1935.[1] Javier's selection of draw-
ings is distinguished not only by its qual-
ity but also by what seems to have been
his idea of grouping different aspects of
life and society just as Goya himself had
done in his albums and especially the
print series the *Caprichos*. Thus appear
majas and *majos* (young people of the
lower class known for their insolence and
wit), friars and monks, and constables, as
if Javier Goya had wished to make a
sequel to his father's etchings. Perhaps it
was this idea of paraphrasing, so to
speak, the work of his father that led him
to use as frontispiece for his album the
self-portrait of his father, much as the
Caprichos began with the famous self-
portrait in profile (cat. 38) "de gesto
satirico" (with a satirical expression).

Goya had nothing to do with the place-
ment of this self-portrait as frontispiece
to his son's album, but it is worth noting
that Javier Goya, like some of the artist's
contemporaries, must have conferred on
the earlier self-portrait the significance of

a witness, if not of a denouncer of ignorance, superstition, fanaticism, and corruption. Javier may well have used this self-portrait to begin his album with the same meaning, perhaps with the advice of the early nineteenth-century scholar Carderera.

We cannot know what Goya's original intention was for this self-portrait, since it does not seem to belong to any of his albums, or whether he created it with a view to making a print of it later, as in the case of the portraits of artists designed for Ceán Bermúdez's book.[2] But, certainly, among the many self-portraits of Goya that survive, whether drawings or paintings, this is one of the most beautiful, powerful, and dramatic, and it foreshadows the portraits of artists created during the full flowering of romanticism.[3]

Goya presented himself full-face, his hair forming a dishevelled circle round his countenance. The piercing inquisitiveness of his gaze is accentuated by the slight and subtle downward bend of his head, which stresses the depth of his eyes, themselves accented by the vigorous rendering of the brows.[4] The mouth is shaped into a hard sneer, a trace of the well-known expression of contempt that was increasingly and dramatically emphasized in the later self-portraits. Although we can judge by other, more realistic portraits of Goya that this one is based directly on reality and tries to faithfully reproduce Goya's features, there are small and subtle alterations of the physiognomy designed to give it a grandiose and sublime cast. He who presents himself in this way is not a calm, tranquil spectator but a person in turmoil induced by a vision of a changing world in crisis, of which he was an acute and sensitive witness, conscious victim, and implacable judge.

Dating this drawing is difficult, since its romantic character would suggest a date late in Goya's career, about 1820; but his apparent age here, fifty or fifty-five years old, has traditionally suggested a date of about 1795-1797. The short hair and long sideburns also agree with the fashion of the closing years of the century and recall the self-portrait that appears in the upper area of the preparatory

drawing for *El sueño de la razón produce monstruos* (The sleep of Reason produces monsters) (cat. 52), of the final years of the eighteenth century. On the other hand, the light strokes suggesting the bust do not enable us to specify the type of long coat and shirt Goya is wearing; this vagueness in the dress also makes precise dating difficult.[5]

M.M.M.

1. G., I, pp. 386-387. Gassier explained the drawings' dispersion, and it is possible to reconstruct the so-called *Fortuny Album* from the provenance of each drawing.

2. In 1800 don Juan Agustín Ceán Bermúdez published his *Diccionario Histórico de los más ilustres profesores de las Bellas Artes de España*, which was at first to be illustrated with etched portraits, some by his friend Goya, whom he visited in Andalusia in 1792-1793 and in 1796-1797. Goya used red chalk for all the preparatory drawings we know of. Xavier de Salas, "Portraits of Spanish Artists by Goya," *Burlington Magazine* 106 (1964), pp. 14-19.

3. There is a portrait of Goya (G-W 665), whose location is now unknown, that once belonged, it seems, to Tomás de Berganza, the Duquesa de Alba's steward. The artist represented himself there with the same disheveled hair and almost full face, although without the obvious romantic character of the drawing. Until the original can be studied, the attribution of this work to Goya cannot be accepted.

4. For comparison, see the self-portrait of the German romantic painter Ferdinand Wertmüller. See also Julián Gállego, *Los autorretratos de Goya* (Zaragoza, 1978).

5. Goya's portraits show him with this hairstyle in the first years of the 1790s, as do those of many of his contemporaries. The change in fashion in male hairstyles, which originated during the French Revolution, must have arrived very soon in Spain, but this type of short and somewhat unruly hair was more common and widespread after 1800. The extremely fine technique of brush and wash used by Goya here also corresponds to the most elaborate drawings traditionally ascribed to the first years of the nineteenth century.

35

Sⁿ Fernando ¡como hilan!
(San Fernando How They Spin!)
Album B, **page 84**
1796-1797
Brush and gray and black wash
236 x 147 mm.
Inscribed in brush and gray wash, lower margin: *Sⁿ Fernando,* in brown ink: *¡como hilan!,* in brush and gray, upper left: *84*
References: G-W 442; G., I, 87.

Private Collection, United States
Spain only

In an interior lit by large windows with gratings, three women seated on what are apparently stone benches seem to be spinning. Their heads appear to have been shaved recently and they wear identical clothing, probably a uniform, made of a dark-colored bodice and skirt and a white apron. The inscription *Sⁿ Fernando* indicates they are inmates of the hospice of the same name in Madrid.

The San Fernando hospice was inaugurated in 1766 mainly in order to house beggars, vagrants, and, in general, all those whose livelihoods were not derived from legitimate and honest jobs. The hospices were an eighteenth-century response to the extreme poverty of the lower classes. Although they were considered charitable foundations, in fact they had a marked penal character and confinement in them was obligatory. Theoretically, hospices were to educate inmates in order to ease their return to society. Enlightened opinion, on the other hand, was divided about the effectiveness of such measures.[1]

Among the female inmates of San Fernando, prostitutes must have constituted a very large proportion.[2] To judge by the particularly bold appearance of these women, it may be deduced that they are, indeed, three prostitutes. Goya stressed this by concentrating the most intense light on the white aprons, thereby leading the eye toward the lower part of the women's bodies and the viewer to the realization that all have more or less spread their legs, one of the most common iconographic symbols of lust since the late Middle Ages (see cat. 135).

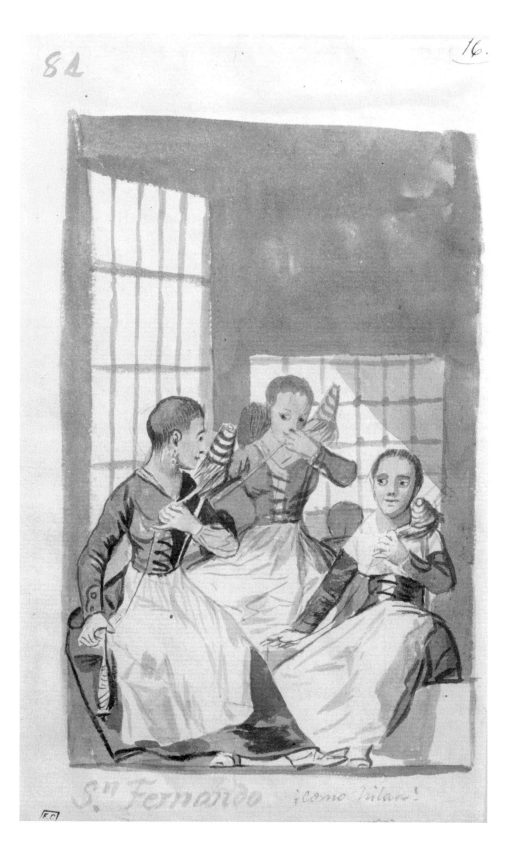

At first glance it might be supposed that Goya's intention in this drawing was to praise the enlightened measures of the time. These measures were designed to rehabilitate all idle persons by making them apprentices in a trade, as well as to improve the often inhuman conditions in prisons and hospices.[3] However, a careful analysis reveals Goya's purpose was very different.

The interior where the prostitutes are seen working is well lit, gay, almost aseptic, apparently reflecting the reforms achieved by the Junta de Damas de la Sociedad Matritense de Amigos del País (Women's Branch of the Madrid Society of Friends of the Nation).[4] In fact, the abundant light streaming through the windows shows the gratings; the uniform gray tone of the wall and ceiling contributes as well to the impression of confinement and segregation from the outside world.

Throughout the eighteenth century, economists and political figures (Bernardo Ward, Campomanes, and Antonio de la Cuadra) proposed that women learn spinning, a task considered appropriate to their gender, but insisted on instruction in the use of the spinning wheel.[5] The spinning wheel was logically favored over the distaff because, apart from being slower, the distaff method produced a thicker and more uneven thread, good only for certain domestic uses. By choosing to depict the most primitive method of spinning, Goya seems to suggest that the hospice cannot teach these women anything useful. The false appearances do not end there. The two women on the right look toward the woman in the left foreground, as if trying to follow the movements her hands make on the wool or flax as she spins it. A close look, however, reveals that no one is actually spinning.[6] In reality, the "teacher" shows the viewer her "yarn," and her smiling "disciples" direct their roguish looks toward it, trying to imitate her. This interpretation is confirmed by the convergence of lines (arms, thread, and part of the outline of the aprons) toward the spindle. Goya's aim becomes clear if we remember that in colloquial erotic language, *hilado* (yarn) is "el negocio de la prostituta" (the prostitute's

trade), just as *hilar* (to spin), *huso* (spindle), and *hilo* (thread) have corresponding meanings.[7] This symbolism, used as well in other works by Goya (see the essay by T. Lorenzo de Márquez in this catalogue, fig. 4), is very common in traditional erotic poetry and is not unknown in artistic representations of the late Middle Ages.[8] Using this sarcastic and burlesque twist, which must have made many of his contemporaries smile, Goya suggested that passing through the hospice would not free prostitutes from the ancient profession of "spinning."

Goya seems to have reflected in this drawing the opinion, shared by Jovellanos and other enlightened figures, that confinement in a hospice was an ineffective and uneconomical solution to lower-class poverty and involuntary unemployment in eighteenth-century Spain.[9]

T.L.M.

1. For a complete, well-documented study of the problem of the hospices, mainly those in Madrid, see Jacques Soubeyroux, "Pauperismo y relaciones sociales en el Madrid del siglo XVIII," *Estudios de historia social*, nos. 12-13 (1980), pp. 189-227.

2. *Alguaciles* (constables) taking prostitutes to San Fernando were a frequent subject in eighteenth-century *tonadillas* (ditties). See Nigel Glendinning, "Goya y las tonadillas de su época," *Segismundo* (Madrid), no. 2 (1966), p. 113.

3. See Paula de Demerson, *María Francisca de Sales Portocarrero, Condesa de Montijo, una figura de la Ilustración* (Madrid, 1975), pp. 183-213.

4. Ibid., p. 191.

5. The patriotic schools were among the centers created by the Sociedades de Amigos del País; mastery of the spinning wheel was the main skill imparted. See *Historia de España*, ed. José María Jover Zamora, vol. 31: *La época de la Ilustración*, vol. 1 (Madrid: Espasa-Calpe, 1987), pp. 41-42, 268.

6. In spinning, the left hand, which pulls the wool or flax from the bunch, and the right hand, which stretches and twists the thread at the same time that it makes the spindle rotate in order to wind what has already been spun, should be about 5 centimeters (2 inches) from each other. See *Enciclopedia universal ilustrada hispano-americana*, vol. 52 (Barcelona, 1926), under *rueca*.

7. On the double meaning of *hilado* and *hilar* as *futuere* (to copulate), see José Luis Alonso Hernández, *Léxico del marginalismo del Siglo de Oro* (Salamanca, 1977), under *hilado* and *hilar*. The symbolism of *hilo* as phallus is very common in traditional erotic poetry; *huso* can mean either sex according to usage in some erotic texts. See Alzieu, *Poesía erótica*, poem 45, p. 67; poem 76, p. 131; poem 77, p. 134.

8. The erotic meanings are derived from a universal myth in which the young woman spinning is identified with the highest and purest qualities of female sexuality. See Mircea Eliade, *Myths, Rites, Symbols* (New York, 1975), vol. 1, p. 415; Mateo Gómez, *Sillerías*, pp. 63-64.

9. The report Josef de Guevara Vasconcelos delivered in 1778 to the Sociedad Económica de Madrid remarked specifically that hospices "son inútiles para la educación, gravosos para el Estado, y nada oportunos para fábricas y manufacturas, y por consiguiente incapaces de destruir la pobreza" (are useless in education, a burden to the state, and not advantageous to factories and manufacturing, and therefore unable to eradicate poverty). In his *Informe sobre el libre ejercicio de las artes* (Report on the Free Practice of the Arts), Jovellanos too announced that all charitable institutions, particularly hospices, were more harmful than they were helpful. Soubeyroux, "Pauperismo," pp. 201-202.

36

Borricos de Mascaras / Estan muy contentos, de qe pr los bestidos, pasan por hombres / grandes (Masquerading asses. They are very pleased that, due to their clothing, they are taken for grandees.)
Album B, page 92
1796-1797
Brush and gray wash, heightened with black
236 x 147 mm.
Inscribed in brush and gray, above picture to left: *92*; in pen and brown ink, above and below picture: title
Recto: *fatal desgracia / toda la casa es un clamor, pr qe no à òbrado la Perrica / en todo el dia*
References: G., I, Album B, Lost drawings.

Private Collection, United States
United States only

Three asses look at one another, enormously pleased with their clothing, even though it cannot be said to fit them very well. Their sleeves, unlike those of the gentleman standing at the right, fail to reach their wrists, or rather their hocks. The collar of the ass sitting on the ground behind the gentleman does not rise halfway up his neckcloth as it should do; the coat of the ass in the foreground is too bulky, and his kneebands are too far down, circling what would be the calves of his legs; and the unfortunate ass at the left suffers from an unfashionable show of belly between his waistcoat and his breeches. That same seated ass has either forgotten to put on his breeches or has prepared himself for dalliance.

Goya indicated that the asses are to be seen as *hombres grandes* in the literal sense of the words: big men. In reality asses are small, but he depicted them as so large in scale that they tower over the courteous gentleman at the right. However, as Goya was aware, the ordinary meaning of *hombres grandes* was grandees. He added a psychological dimension to his visual punning on the word *grande* by having the gentleman make a sweeping bow to the asses because of their rank, and showing him looking up to them because he sees the nobility as larger than life.

E.A.S.

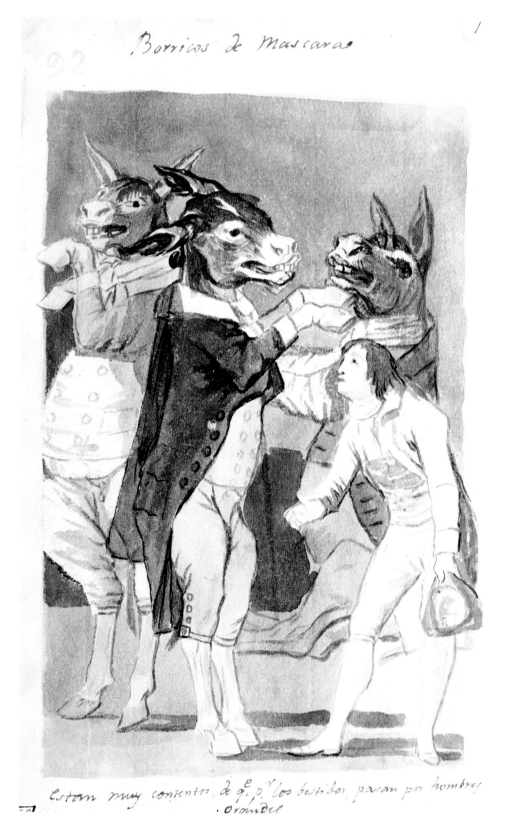

Borricos de Mascaras

Estan muy contentos, de q.^e p.^r los burridos pasan por hombres . Orondes

37

Conocēlos el aceitero y dice ¿ola? y empieza a palos con las mascaras / ellos huyendo, claman la injusticia del poco respeto a su representacion (The oil vendor knows what they are and says "Hey there?" and begins to cudgel the masqueraders. As they flee, they cry out against the injustice of the small respect given their appearance.)
Album B, page 93
1796-1797
Brush with gray and black wash, touched with pen and brown ink
236 x 146 mm.
Inscribed in brush and gray, above image to right: *93*; in pen and brown ink, above and below image: title
Verso: *Manda q^e quiten el coche, se despeina, y arranca el pelo y patēa . . .*
References: G-W 449; G., I, 94.

The Metropolitan Museum of Art, New York, Harris Brisbane Dick Fund, 1935, 35.103.17
United States only

The trio of asses encounters a common man in this drawing, which originally faced one where a gentleman was bowing to them (cat. 36). This vendor of oil is dressed in the jerkin, breeches with elaborate kneebands, gaiters, and curiously abstract hat that were characteristic of Andalusian peasants in the south of Spain. The first words of the title, *Conocē-los*, can mean both that he recognizes the masqueraders and that he knows all about donkeys. Well he might, for an oil vendor traveled about the country with a donkey of his own, which carried on its back his store of oil contained in a goat skin.[1] Because he has experience with donkeys, he perceives these *grandes* (nobles) not as bigger than himself (as did the gentleman in the previous drawing but, despite their fine clothing, as asses much like his daily companion, and he therefore cries, '¿Ola?' (Hey there?).

One ought not to address nobles in this fashion, for it is how one calls out to persons of a class inferior to one's own.[2] The vendor begins beating the asses with the very stick that he uses to drive his own donkey. They start to flee, and as they do so, *claman la injusticia del poco*

respeto a su representacion (they cry out against the unjust lack of respect accorded their *representacion*). This word signifies both the comedy they enact in their masquerade as *grandes* and the garb that made them swell with pride in the preceding drawing; it means not only the properties that will come to them through inheritance but also the dignity and authority of their noble persons.[3] Small wonder that they stare at the oil vendor, offended and incredulous.

Goya may have felt the wind of *egalité* blowing across the border from France; but the concept of the inherent equality of men had ancient roots in Spain. In the literature of the Golden Age it is not so uncommon that a man of lowly birth, appraising a noble with whom he has contact, should see himself in many respects the superior of the two. Then, too, as a boy Goya had studied with nobles eye-to-eye, as it were, at the remarkable school he attended in Zaragoza. The Escuelas Pías were a system of institutions started by San José de Calasanz in Rome in 1597, with the idea that education should be available and free to any boy who wished it.[4] Because the regulations of their founder had ensured the high academic standards of the schools,[5] they attracted members of the nobility as well. The Marqués de Lazán sent his sons, one of them José de Palafox (see cat. 75), to Goya's school in Zaragoza.[6] The Spanish crown prince, Fernando, was a student at another, and Joseph II, Emperor of Austria, had attended a third.[7]

E.A.S.

1. Tomás de Yriarte, *Coleccion de obras en verso y prosa* (Madrid, 1805), vol. 1: *Fábulas literarias*, no. 62, p. 98, *El burro del aceitero*. The first lines are: "En cierta ocasion un cuero / Lleno de aceite llevaba / Un Borrico, que ayudaba / En su oficio á un Aceitero. . . . The *Fábulas literarias* appeared first in 1782.

2. See Academia, *Diccionario*, 1791, under *hola*.

3. See Academia, *Diccionario*, 1791; Terreros, *Diccionario*, 1786-1793; Connelly, *Diccionario*, 1797-1798, all under *representacion*.

4. György Sántha, *San José de Calasanz*, rev. ed. (Madrid, 1984), pp. 60-66.

5. Ibid., pp. 75-235.

6. J. García Mercadal, *Palafox, duque de Zaragoza, 1775-1847* (Madrid, 1948), p. 13. They were there later than Goya.

7. S. Giner et al., *Escuelas Pías: Ser e historia* (Salamanca, 1978), p. 265.

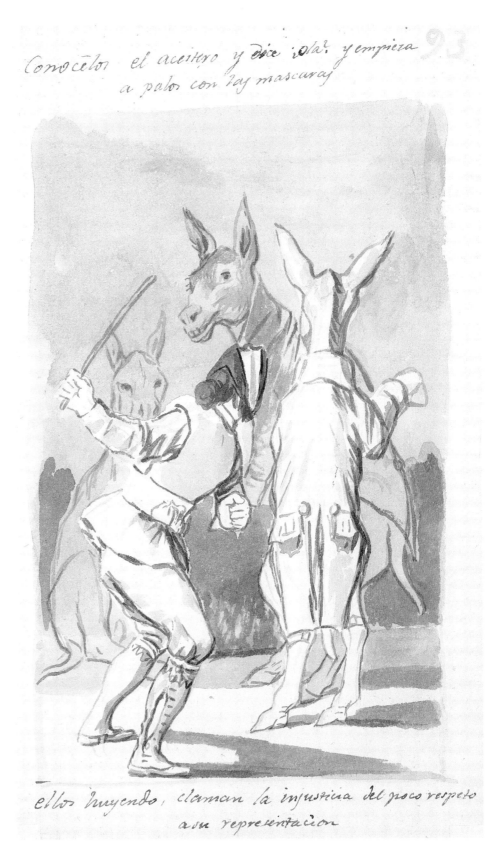

38

Fran^co Goya y Lucientes, Pintor.
(Francisco Goya y Lucientes, Painter.)
Caprichos, plate 1
First edition, 1799
Etching, aquatint, drypoint, and burin
215 x 150 mm.
Engraved, upper right margin: *P. 1*; lower
margin: title
References: G-W 451; H. 36, III, 1.

Spain: Biblioteca Nacional, Madrid,
45.666
United States: The Metropolitan Museum
of Art, New York, Gift of M. Knoedler,
18.64(1) [*illus.*]

Goya presented himself without vanity,
depicting uncompromisingly the linea-
ments of what he called his *romo* (snub
nose) and *ojos undidos* (deep-set eyes).[1]
Contemporaries, observing that he had
narrowed his eyes and thrust out his
lower lip, described his expression as
satírico (satiric) and *maligno* (malign)
and thought he was *de mal humor* (in a
bad humor). (See the commentaries
below.) From an art historian's point of
view, it has much in common with *mes-
pris* (contempt), as Le Brun illustrated it
in his enormously important canon of
facial expressions, first published in 1698
but as influential as ever in Goya's day
(fig. 1).[2] Contempt, when not modified by
another emotion, we learn, should be
expressed "par le sourcil froncé &
abaissé du côté du nez, & de l'autre côté
fort élevé, l'oeil fort ouvert, & la pru-
nelle au milieu, les narines retirées en
haut, la bouche fermée, & les coins un
peu abaissés, & la lévre de dessous exce-
dant celle de dessus" (by a cocked eye-
brow that is raised up on one side and
low alongside the nose, by wide-open
eyes with centered irises, by nostrils
drawn upwards, by a mouth that is closed
and slightly turned down, and by a lower
lip that juts out beyond the upper one).[3]
It is such an inhospitable – perhaps
unique – choice of expression for Goya to
have used on a plate serving to introduce
his *Caprichos* that we need to explore its
origin in his work and to ask what he
intended us to understand by it.

It was hardly Goya's normal aspect, for
none of Goya's earlier self-portraits show

Fig. 1. Bernard Picart, after Charles Le Brun, *Le Mespris.*
Engraving, in *Conference de Monsieur Le Brun . . .,*
Amsterdam, 1698.
Museum of Fine Arts, Boston, William A. Sargent
Fund

Fig. 2. Sketches for a Self-Portrait (verso of fig. 4).
(Detail of sheet)
Sanguine and black ink.
The Metropolitan Museum of Art, New York,
Bequest of Walter C. Baker, 1971

him with this censorious expression. To
find him in a comparable mood, we must
turn to an earlier drawing. Originally he
had intended to give this set of satirical
Caprichos the format of dreams. The pen
drawing for a frontispiece to a set of *Sue-
ños* (Dreams) (cat. 50) was designed
when he was thinking in those terms.
There Goya presented himself as the art-
ist who dreams. In rays of light issuing
from his head we see faces, among them
his own, reacting with varied emotions to
the content of dreams he intended to
depict. What the nature of these is to be is
is suggested symbolically by animals: an
ass, a dog, and surging bats. However, as
the work developed and a dream frame-
work seemed less vital, he decided to
replace this frontispiece with a more con-
ventional self-portrait.

One side of a double-sided sheet with
two preliminary drawings for this new
frontispiece indicates that he may have
considered showing himself nearly full-
face (fig. 2). Because of its placement on
the page, the upper sketch seems to be
the earlier one. It is interesting to see
these in conjunction with one of Goya's
faces in the frontispiece to the *Sueños*,
where his expression is both disdainful
and pained as he confronts what a dream
shows him (fig. 3). When we compare
that face with those in the pair of small
sketches, we realize that the latter are
not so much studies of Goya's physiog-
nomy as notes for what he thought would
be the most suitable expression for him
to assume in this etched plate. In the
upper sketch, his left eyebrow is cocked,
and the upper lip slightly lifted on the
same side. In the lower sketch, both eye-
brow and upper lip are lightly accented
with short, dark strokes, and two curved
lines are used to indicate the movement
of his nostrils. In the profile drawing on
the other side of the sheet, we again see
a lifted eyebrow, fully opened eye, and
reticulating nostril (fig. 4). More easily
observed now than it would have been in
a frontal portrait is Goya's mouth with its
corners turned down and lower lip
pushed forward.

In the print itself the lip, the most
striking element of Le Brun's description
of contempt, becomes even more promi-
nent. There is also a certain narrowing of

Fig. 3. Self-Portrait.
Detail of cat. 50

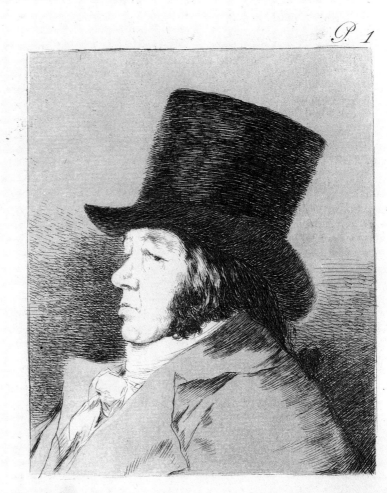

Fig. 4. Self-Portrait (recto of fig. 2).
Sanguine.
The Metropolitan Museum of Art, New York,
Bequest of Walter C. Baker, 1971

Goya's eyes, giving a psychological complexity to his expression that it did not have in the preliminary drawing. It is as though what will be depicted for our edification in the *Caprichos* not only fills Goya with contempt but also causes him pain. As we have seen, his expression in this aquatint was read as "malign," "satiric," and "in a bad humor." One contemporary, Gregorio González Azaola, described the contents of the set as "un libro instructivo de 80 poesías morales gravadas" (an instructive book of eighty printed moral poems).[4]

Contemporary Explanations:

Ayala: *Verdadero retrato suyo, de gesto satírico.* (A true portrait of him, with satirical expression.)

Stirling: *Verdadero retrato suio, de gesto maligno.* (A true portrait of him, with a malign expression.)

Biblioteca: *Verdadero retrato suyo, de mal humor, y gesto satírico.* (A true portrait of him, in a bad humor, and with a satirical expression.)

E.A.S.

1. Letter to Martín Zapater, Nov. 28, 1787, in Francisco de Goya, *Cartas a Martín Zapater,* ed. Mercedes Agueda and Xavier de Salas (Madrid, 1982), p. 178. Although part of the original letter has been lost, Goya's description of himself was preserved in Spanish by Francisco Zapater y Gómez, *Goya: Noticias bibliográficas* (Madrid, n.d.), p. 23. The remainder of the letter is known from a German translation.

2. *Conference de Monsieur Le Brun . . . Sur l'Expression generale & particuliere [Caracteres des passions]. Enrichie de Figures gravées par B. Picart* (Amsterdam, 1698), pl. 9. Museum of Fine Arts, Boston, 1981.140. Fermín Eduardo Zeglirscosac, *Ensayo sobre el origen y naturaleza de las pasiones, del gesto y de la acción teatral* (Madrid, 1800), p. 6, acknowledged that he based a good portion of his book on Le Brun.

3. Le Brun, *Conference,* p. 11.

4. Gregorio González Azaola, "Sátiras de Goya," in *Semanario Patriótico* (Cádiz), Mar. 27, 1811, p. 24. Enriqueta Harris, in "A Contemporary Review of Goya's 'Caprichos,'" *Burlington Magazine* 106 (Jan. 1964), p. 42, quotes the full text.

39

El si pronuncian y la mano alargan / Al primero que llega. (They say "yes" and give their hand to the first who comes.)
Caprichos, plate 2
First edition, 1799
Etching and burnished aquatint
215 x 150 mm.
Engraved, upper right margin: *P. 2*; lower margin: title
References: G-W 454; H. 37, III, 1.

Spain: Biblioteca Nacional, Madrid, 45.666
United States: The Metropolitan Museum of Art, New York, Gift of M. Knoedler, 18.64 (2) [*illus.*]

For the opening plate, Goya took his title from a poem by Jovellanos (see cat. 30), "A Arnesto" (To Arnesto), which was first published in 1786 in *El Censor* (The Censor).[1] Those who recognized the quotation were well aware that the piece was a stinging indictment of the lives of high-born ladies. "Yo persigo / en mi sátira al vicio, no al vicioso" (In my satire I pursue vice, not the sinner), Jovellanos wrote.[2] He then set out to embody all that he most scorned in women who belonged to the upper nobility in the imaginary person of one, Alcinda. Alcinda walks on the Prado in Madrid (as did also professional prostitutes), dressed provocatively to attract lovers. She is often away all night, leaving her cuckolded husband to snore happily in bed by himself. She contracts marriage for no other purpose than to be endowed with the right to behave as she pleases. Therefore, she will behave like other women of her class who, "sin que invoquen la razón, ni pese / su corazón los méritos del novio, / el sí pronuncian y la mano alargan / al primero que llega!" (without invoking reason, or weighing / in their heart the merits of the groom / they say "yes", and give their hand / to the first who comes)![3]

In the light of Jovellanos's satire, neither the spacious, if ambiguous, ecclesiastical setting Goya depicted for the nuptial event nor certain aspects of the high-born bride approaching the altar should surprise us. Through the use of light he made sure that we would observe her knowing smile, her prominent breasts, and the indelicate positioning of her feet and called attention to the fact that, while her father leads her by her left hand up the steps into the church, her right hand is hidden behind her, feeling (for all we know) the richly clad groom whose face is alight with lascivious anticipation as he accompanies her to the altar.[4] She looks at the world through one mask, itself an indication of her duplicity, while a second one is attached at the back of her head, implying another unattractive component of her nature. It has the unmistakable features of a monkey, which symbolized the bestial side of human nature, most particularly the deadly sin of lust.[5]

The explanations given the print by Goya's contemporaries indicate that they saw the social status of the personages in this *Capricho* as very high indeed. They are less explicit about the essential oddity of the wedding. Ill-dressed, ignorant, sullen-faced crowds are ordinarily excluded from such affairs. The bride, ignoring the last church step, chooses her own way as her father, at her left, looks at her solicitously. The groom, dressed in what suggests the ermine-trimmed ceremonial robe of a knightly order, is only slightly to her right and seems to have fallen behind. Bringing up the rear is a curiously garbed cleric who joins his hands in prayer. Standing above the procession, like the god to whom a sacrifice is rendered, is an unmistakably plebeian person, laughing at the spectacle before him.[6] It is the presence of this anomalous commentator that lends another dimension to the scene. It is almost as though Goya were depicting a mock wedding during Carnival. By making use of this visual allusion, Goya has suggested a common linguistic simile. One might say of this marriage ceremony, "es un carnaval" (it is a carnival), that is, it is as false and deceptive as as the bride herself.[7]

Contemporary Explanations:

Ayala: *Reprende los matrimonios á ciegas, como los de las princesas y camaristas.* (He censures marriages blindly made, like those of princesses and ladies in waiting.)

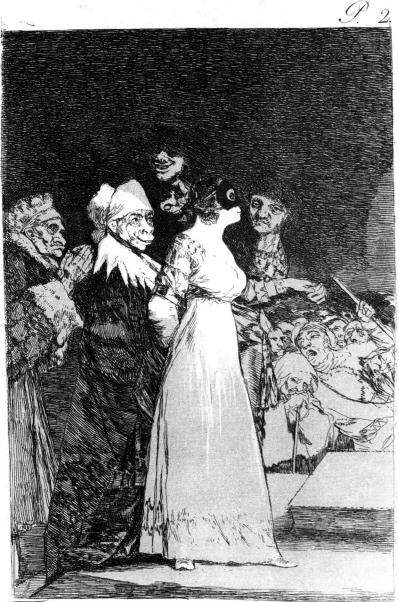

P. 2.

*El si pronuncian y la mano alargan
Al primero que llega.*

Prado: *Facilidad con qe muchas mugeres se prestan à celebrar matrimonio esperando vivir en el con mas libertad.* (The ease with which many women offer themselves up to marriage, hoping thereby to enjoy greater freedom.)

Stirling: *Reprende los matrimonios à ciegas de los Principes: una figura lleva manto real; la otra como una corona, y un inmenso pueblo necio aprueba y aplaude el enlaze. Hai que observar una especie de cara de mona que forma el colodrillo de la novia. Bodas de las Camaristas.* (He censures the marriages made blindly by princes: one figure wears a royal cloak; the other a sort of crown, and an immense crowd of ignorant people approve and acclaim the union. One should note a kind of monkey's face forming the back of the bride's head. Marriages of ladies in waiting.)

Simon: *Los matrimonios se hacen regularmente a ciegas: las novias, adiestradas por sus padres, se enmascaran, y atabian lindamente, para engañar al primero que llega: esta es una princesa con mascara, que luego ha de ser una fiera con sus vasallos; como lo indica el reverso de su cara, imitando un peinado: el pueblo necio aplaude estos enlazes: y detras viene orando un embustero en trage sacerdotal por la felicidad de la nacion.* (Marriages are very often blindly made: the affianced, instructed by their parents, don masks and dress prettily to gull the first man who comes. This is a masked princess, who later will behave like a beast to her subjects, as is indicated by the other side of her face, resembling a coiffure. The stupid populace acclaims these unions. And behind the bride comes a deceiver in priestly robes, praying for the felicity of the nation.)

E.A.S.

1. Gaspar Melchor de Jovellanos, *Poesías*, ed. José Caso González (Oviedo, 1961), pp. 235-240; it is discussed pp. 37-40. Enrique Díez Canedo is credited with having connected the poem with the print in Bibliothèque Nationale, Paris, *Goya: Exposition de l'oeuvre gravé de peintures, de tapisseri es et de cent dix dessins du Musée du Prado* (1935), no. 19.

2. Jovellanos, *Poesías*, p. 236.

3. Ibid., p. 237.

4. For reasons that have yet to come to light, the bride bears a striking resemblance to the unidenti-

fied lady in Goya's *Family of Carlos IV,* painted between 1800 and 1801 (Prado, Madrid, 726; G-W 783; Gud. 434). Fourth from the left in the family group, she stands beside the Príncipe de Asturias, Don Fernando, her face turned away from the viewer. She is generally presumed to have been under consideration as his fiancée. See for example, Gud. 434.

5. See Sillerías, Mateo Gómez, pp. 90-93. The attachment of the mask to her head is easier to see in the copper plate than in a fine impression.

6. Enrique Lafuente Ferrari, *Los Caprichos de Goya* (Barcelona, 1978), p. 36, commented on the *sonrisa burlona* of this personage.

7. See Alonso, *Enciclopedia*, under *carnaval*; he cites the use of this expression as early as the fifteenth century.

40

Que viene el Coco. **(The bogeyman is coming.)**
Caprichos, **plate 3**
First edition, 1799
Etching and burnished aquatint
215 x 150 mm.
Engraved, upper right margin: *P. 3*; lower margin: title
References: G-W 455; H. 38, III, 1.

Spain: Biblioteca Nacional, Madrid, 45.666
United States: The Metropolitan Museum of Art, New York, Gift of M. Knoedler, 18.64(3) [*illus.*]

In an indeterminate setting we see a mother with two frightened children by her side. Facing this group is the tall shrouded *coco* (bogeyman) of the title. One might assume that a specter has been summoned to scare credulous children into behaving as a mother believes that they should. "Duerma y sosiegue, / que a la fe que venga el coco / si no se duerme" (Sleep, and rest assured the bogeyman will come if you do not go to sleep), children were warned in a seventeenth-century cradle song.[1] Goya's contemporaries would probably have noticed that, whereas the frightened children take refuge with their mother lest they be carried off by the *coco*, she looks upward at the bogeyman with an expression of unreserved love, which accords precisely with its canon in a book for actors and artists published in 1800 in Madrid (fig. 1).[2] In a rich impression from the first edition of the *Caprichos*, such as this one, Goya's contemporaries would have needed sharp eyes to note a second, equally significant detail, one easily seen in the copper plate or in worn impressions printed from it later in the century. The bogeyman wears human shoes with pointed ends turning fashionably upwards.[3]

What Goya has depicted, then, is a mother receiving her lover, whose identity she conceals from her children by disguising him as a bogeyman. In the preliminary drawing Goya had been more explicit, setting the tryst in a bedroom beside a canopied bed.[4] A working proof of the print has survived on which

one of Goya's friends wrote a variant of the engraved title in pen, *Ay que biene el Coco* (Oh, the bogeyman is coming); to which a second friend added, *y era su padre* (and it was their father), therein making use of a phrase found in a traditional Castilian folk lullaby.[5]

This young wife was by no means the first one to disguise her lover as a supernatural being. We hear of others from the *Theatro crítico universal* (The Universal Critical Theater), that scourge of mindless orthodoxy and superstition written in the earlier part of the eighteenth century by the Benedictine Fray Benito Jerónimo Feijóo (1676-1764): "Pero los Duendes mentidos, que mas eficàz, y mas generalmente engañan, y passan por verdaderos, son los Duendes contrahechos, ò remedados por hombres, ò mugeres. . . . O quantos hurtos, quantos estrupos [*sic*], y adulterios se han cometido, cubriendose, ò los agressores, ò los medianeros con la capa de Duendes! Estas pesadas burlas se detuvieron, ò atajaron siempre que en la casa donde se

Fig. 1. Francisco de Paula Martí Mora, *Amor.* Engraving, in F.E. Zeglirscosac, *Ensayo sobre el origen y naturaleza de las pasiones . . .*, Madrid, 1800. Private Collection

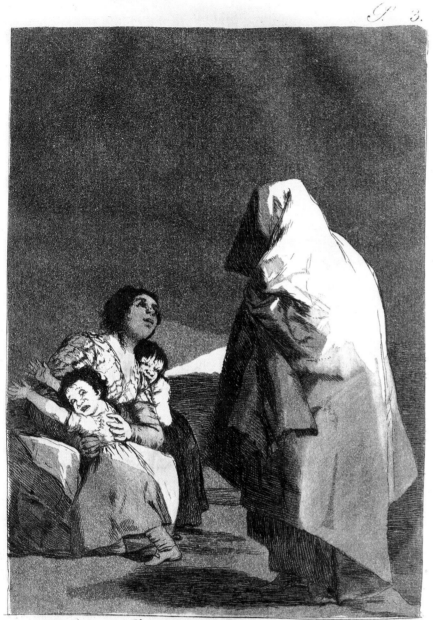

Que viene el Coco.

executaban, havia algun hombre de espiritu, que intrepidamente se empeñò en el examen de la verdad. Donde toda la familia se compone de gente facilmente credula, triunfa seguramente el embuste, salvo que algun accidente le manifieste." (But the false goblins who most effectively and most often deceive, and are regarded as real, are those goblins feigned, or imitated by men, or women. . . . Oh how many thefts, how many rapes and adulteries have been committed where the aggressors, or their intermediaries, have disguised themselves as goblins! These unbearable deceptions ceased, or were curtailed, whenever the house in which they took place held some spirited man who intrepidly set himself to investigating the truth of the matter. In instances where the family is constituted entirely of credulous persons, the deception will surely prevail, unless some accident exposes it to light.)[6]

Contemporary Explanations:

Prado: *Abuso funesto de la primera educacion. Hacer qe un niño tenga mas miedo al coco qe a su padre, y obligarle à temer lo qe no existe.* (Deplorable abuse of a child's early instruction. Making the child more afraid of the bogeyman than of his father, and forcing him to fear what does not exist.)

Stirling: *Un amante encubierto viene à ver à una Señora, qe para ahuientar los hijos, les mete miedo con el coco.* (A disguised lover comes to see a lady, who makes her children afraid of the bogeyman in order to be rid of them.)

Biblioteca: *Las Madres tontas hacen medrosas á los Niños figurando el Coco; y otras peores se valen de este artificio para estar con sus amantes á solas cuando no pueden apartar de sí á sus hijos.* (Stupid mothers make their children fearful by conjuring up the bogeyman; and worse mothers use this deception to be alone with their lovers when they cannot be rid of their children.)
E.A.S.

1. Eduardo [Martínez] Torner, *Lírica hispánica: Relaciones entre lo popular y lo culto* (Madrid, 1966), p. 154.

2. Fermín Eduardo Zeglirscosac, *Ensayo sobre el origen y naturaleza de las pasiones, del gesto y de la acción teatral* (Madrid, 1800), pl. III, 2. As the author acknowledges, p. 6, the facial expressions are derived from the *Conférence de Monsieur Le Brun* (Amsterdam, 1698); these remained as influential in Goya's day as they were when the book appeared.

3. See an elegant Parisian gentleman dressed for the street, *Journal des dames et des modes* (Paris, 1797), vol. 1, pl. 16; see also gentlemen in various plates of the *Caprichos*, e.g., 5, 6, 10, 14.

4. Sanguine, Prado, Madrid, 48; G-W 456; G., II, 68.

5. Working proof, Bibliothèque Nationale, Paris, 245. See [Martínez] Torner, *Lírica hispánica*, p. 155, "*Duerme el niño en la cuna / y dice su madre: / – Calla, que viene el coco. / Y era su padre.*" He cites a passage from the well-known picaresque novel *Lazarillo de Tormes*, where Lazarillo's half-negro step-brother mistakes the father for a *coco*. The source given for this version of the popular cradle song is Manuel García Matos, *Cancionero popular de la provincia de Madrid* (Barcelona, 1951), vol. 1, no. 109.

6. Fray Benito Jerónimo Feijóo y Montenegro, *Theatro crítico universal; ó discursos varios en todo genero de materias, para desengaño de errores comunes* (Madrid: Imprenta del Supremo Consejo de la Inquisicion, 1759), vol. 3, pp. 73-74, Discurso IV: *Duendes y Espiritus Familiares.*

41

El de la rollona. (The Childish Man.)
Caprichos, plate 4
First edition, 1799
Etching and burnished aquatint
207 x 151 mm.
Engraved upper right margin: *P. 4*, lower margin: title
References: G-W 457; H. 38, III, 1.

Spain: Biblioteca Nacional, Madrid, 45.666
United States: The Metropolitan Museum of Art, New York, Gift of M. Knoedler, 18.64(4) [*illus.*]

Goya depicted an unattractive, overgrown child with the body and the facial hair of an adult.[1] Man though he may be he still has trinkets tied to his waist, wears a dress and a toddler's padded cap to protect his head should he fall down and he puts one finger in his mouth like a booby. He is, as Roberto Alcalá Flecha has pointed out, a figure made familiar to the public by various theatrical pieces.[2]

These literary precedents shed light on Goya's title *El de la rollona* (The childish man), but it is impossible to comprehend it without taking cognizance of traditional Spanish proverbs that are implicit in it.

Erasmus had pointed out the ancient tradition and the inherent ethical value and beauty of proverbs in his introduction to the 1508 edition of his *Adagia* (Adages).[3] In Spain humanists were the first to follow his example and take a serious interest in their own extraordinary heritage of proverbs.[4] In 1605 Cervantes had Don Quixote remark, "Paréceme, Sancho, que no hay refrán que no sea verdadero, porque todos son sentencias sacadas de la misma experiencia, madre de las ciencias todas" (Sancho, I do not think that any proverb is untrue, since all are maxims drawn from experience itself, mother of all the sciences).[5] In 1611 the great lexicographer Covarrubias took pains to include a great number of folk sayings in his *Tesoro de la lengua castellana o española*. He cited the proverb "El niño de la rolloña, que tenía siete años y mamava" (The overgrown child who was seven and still suckled), adding the following gloss: "ay algunos muchachos tan regalones que con ser grandes no saben desasirse del regaço de sus madres; salen éstos grandes tontos o grandes vellacos viciosos" (there are some boys who are so spoiled that even when they are grown, they do not know how to climb out of their mothers' laps; these children become complete idiots, or great vice-ridden rogues).[6] Gonzalo Correas, a professor of Greek and Hebrew at the University of Salamanca, compiled 25,000 proverbs in a manuscript dated 1627. His work lay unpublished until the end of the eighteenth century, when the Real Academia Española had a great portion of it copied so that some of the folk wisdom it contained might enrich a new edition of their *Diccionario de la lengua castellana*.[7] According to Correas, who recorded a variant of the proverb given above, the phrase "el niño de la rollona" was commonly "apodo a un tocho o rronzero" (applied to a brutish or lazy person),[8] a meaning reflected in the variant title *Que bruto soy* (What a brute I am) written by an unknown contemporary of Goya on a trial proof of the print.[9]

Tied to the waist of this personage are four toys. Three of them are protective amulets: an elaborate fig-hand, a little book with pages from the Gospels (or perhaps the *Rule of San Benito*), a mole's paw; and the fourth is a little bell to help his lackey keep track of him.[10] One can find just such objects worn in exactly the same manner by noble children in seventeenth-century portraits. The best-known example is the *Infante Felipe Próspero in His Second Year* by Velázquez.[11] But since it had ceased half a century earlier to be fashionable for a well-born child to have such objects hanging from his waist, their presence in the *Capricho* suggests not only that this brutish person has failed to reach man's estate but that he is superstitious and anachronistic as well.

While a lackey tries to haul the child-man in one direction by his leading strings, his charge tilts obstinately in the other toward a great cauldron of food. At the far left there is a close stool for the child-man to use after eating grossly. In the eighteenth century there was a hierarchy of amenities for those wishing to defecate, most of which Goya

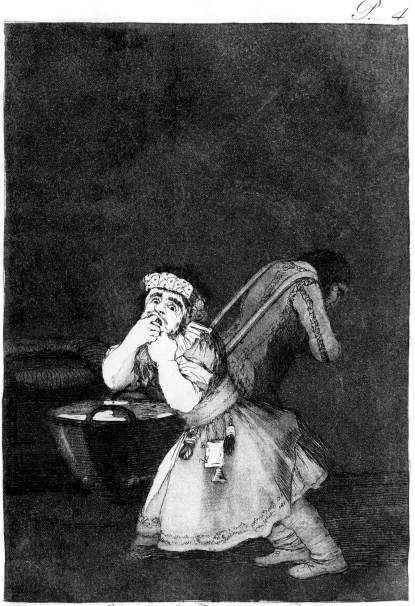

P. 4

El de la rollona)

depicted. Peasants used whatever stretch of earth was available; persons of modest pretensions owned chamber pots; and those with more money sat comfortably on close stools shaped like boxes or constructed like chairs, except for the appropriate opening.[12] Circle-shaped cushions, the ultimate in comfort, were reserved for the powerful, the rich, the noble. Precisely such a cushion lies on top of the close stool belonging to this brutish, high-born, antiquated child-man whose utterly useless life is spent in gorging himself and then producing only shit. It was a rare noble whose education fitted him for anything else.[13]

Contemporary Explanations:

Prado: *La negligencia, la tolerencia y el mimo hacen à los niños antojadizos obstinados soberbios golosos perezosos e insufribles. llegan à grandes y son niños todavia. Tal es el de la Rollona.* (Negligence, doting, and fondling make children capricious, obstinate, haughty, dainty-mouthed, lazy, and insufferable. They come of age [become grandees] and remain children. Such is this overgrown child.)

Biblioteca: *Los hijos de los Grandes se crian siempre niñotes, chupandose el dedo, atiborrandose de comida, arrastrados por los Lacayos, llenos de dixes supersticiosos, aun cuando ya son barbados* (The sons of grandees are always brought up as big babies, sucking their thumbs, stuffing themselves with food, dragged about by lackeys, laden with superstitious amulets, even after their beards are grown).

E.A.S.

1. See Academia, *Diccionario*, 1791, under *niño*: "Niño de la rollona, expr. bax. con que se nota al que siendo ya de edad, tiene propiedades y modales de niño. Puer de centum annorum"; and under *rollona*: "adj. fest. que se aplica á la muger rolliza y fuerte; y solo tiene uso diciendo el niño de la *rollona.*"

2. See Roberto Alcalá Flecha, "El tema del niño malcriado en el Capricho 4, El de la rollona, de Goya," *Goya*, no. 198 (1987), pp. 342 -343.

3. Desiderius Erasmus, *Adagia chillidiana* (Venice, 1508). The number of adages in this second edition was considerably larger than in the first, *Adagia collectianae* (1500).

4. Louis Combet, *Recherches sur le 'Refranero' Castillan*, Bibliothèque de la Faculté des Lettres de Lyon, fasc. 29 (Paris, 1971), pp. 11-12.

5. Miguel Cervantes, *Don Quixote*, bk. 1, chap. 21. The quotation was used by John Collins for the title page of *A Dictionary of Spanish Proverbs, compiled from the Best Authorities in the Spanish Language, Translated into English* (London [1823]).

6. Covarrubias, *Tesoro*, 1611, under *niño*.

7. Combet, *Recherches*, pp. 167-169. However, the *Autoridades*, 1726-1739, contained proverbs taken from Covarrubias, *Tesoro*, 1611.

8. "El hixo de la rollona ke tiene siete años i mama aún aora" and "El niño de la rrollona"; Gonzalo Correas, *Vokabulario de Refranes, y Frases Proverbiales i otras Formulas komunes de la lengua kastellana* (1627), ed. Louis Combet (Lyon, 1967), pp. 119, 615, respectively.

9. Working proof, Bibliothéque Nationale, Paris, 5249.

10. On fig-hands, see W.L. Hildburgh, "Images of the Human Hand as Amulets in Spain," *Journal of the Warburg and Courtauld Institutes* 18 (1955), pp. 67-80. On the Gospels and Rule of San Benito, see Terreros, *Diccionario*, 1786-1793, under *dijes*: "Lo que ponen comunmente por dijes á los Niños son campanilla, cascavalero, mano de tejón, coral, cuerno de ciervo, higa, chupadór, Evanjelio, bolsa de reliquias, Regla de San Benito, medallas, &." On the mole's paw, see Joseph Townsend, *A Journey through Spain in the Years 1786 and 1787* (London, 1791), p. 165.

11. *Infante Felipe Próspero*, Kunsthistorisches Museum, Vienna, L-R 129. See also *La Infanta Ana de Austria*, by Pantoja de la Cruz, Real Patronato de las Descalzas, and *El Infante Fernando de Austria*, attributed to Bartolomé González, coll. Marqués de Valverde de la Sierra, reprod. in Sociedad Española de Amigos del Arte, Madrid, *Exposición de retratos de niño en España* (1925), pls. I and V, respectively.

 In the seventeenth century, church figures of the child Jesus might wear a *ceñidor* (sash) from which hung such amulets made of precious materials; see Hospital de Tavera and Iglesia de San Pedro Mártir, Toledo, *El Toledo de El Greco* (1982), no. 228.

12. See, respectively: *Album F*, page 26, *Man Pulling up His Trousers*, Zuloaga coll., Zumaya, not known to G-W or G., reprod. in Enrique Lafuente Ferrari, "Un dibujo inédito de Goya de la serie sepia (cuaderno F)," *Goya*, nos. 148-150 (1979), p. 207; *Album C*, page 82, *Edad con desgracias*, Prado, Madrid, 292, G-W 1318, G., II, 227; *Album G*, page [b], *Comer mucho*, Prado, Madrid, 384, G-W 1759, G., II, 418.

13. For a summary of the deficiencies of this education, see Alcalá Flecha, "El tema del niño malcriado," pp. 340-345.

42

Ni asi la distingue. **(He cannot make her out even this way.)**
Caprichos, **plate 7**
First edition, 1799
Etching, aquatint, and drypoint
200 x 150 mm.
Signed lower left: *Goya*
Engraved, upper right margin: *7*; lower margin: title
References: G-W 463; H. 42, III, 1.

Spain: Biblioteca Nacional, Madrid, 45.639
United States: The Metropolitan Museum of Art, New York, Gift of M. Knoedler, 18.64(7) [*illus.*]

A fashionably dressed gentleman is seen holding his quizzing glass up to the smiling face of a young woman. During the Directoire (1795-1799), Parisian *incroyables*, or dandies, thought it the height of elegance to peer myopically at people through a lens whether or not there was anything wrong with their sight.[1] Carle Vernet caricatured one *incroyable* staring at another in an unusually popular print engraved for him by Louis Darcis between 1796 and 1797 (fig. 1).[2] On one level Goya, too, laughed at the idiocy of contemporary fashion.

However, he gave his *Capricho* a second, more significant level of meaning. Eighteenth-century men and women often stressed the difference between "to see" and "to perceive," as was done in a French print that must have seemed menacing to the Parisian upper class when it was published anonymously (fig. 2).[3] An *incroyable* finds himself transfixed between two critics. To the left a ragged urchin, holding a copy of Vernet's print, points to the living embodiment of what he has for sale, and says laughing, "*Ah! Quil est donc drole!*" (Oh! He is so funny!) To the right stands a *citoyen* with a heavy sword, cockaded hat, workman's vest, and sleeves rolled up. Looking through a lens, he perceives the inherent worthlessness lying behind the façade the *incroyable* presents to the world, lays a hand on the latter's arm, and cries: "*Hai! Dis donc ma lorgnette te fait peur?*" (Hey! Tell me then, does my glass frighten you?)

Fig. 1. Louis Darcis after Carle Vernet, *Les Incroyables*. Engraving, hand-colored. Bibliothèque Nationale, Paris

Fig. 2. Anonymous, *Ah! Quil est donc drole!* Stipple engraving. Bibliothèque Nationale, Paris

As Goya's title suggests, the fop in his *Capricho* is one who does not perceive. He sees the woman's smile but does not observe its character. Nor, judging from his expression, has he taken in the rest of her body and considered the implications of those swaying hips and absurdly turned-out toes. It is his misfortune that he has had no worldly preceptor such as the fictitious Perico, whom a subteniente (second lieutenant) of the Real Cuerpo de Ingenieros described in a manuscript of 1807 as explaining to a young man, Antonio, how one identifies prostitutes: they have "*las puntas de los pies hacia fuera, y el meneo que indica el modo de ganar la vida*" (their toes turned out, and a movement of the body that suggests the way they earn their livelihood).[4]

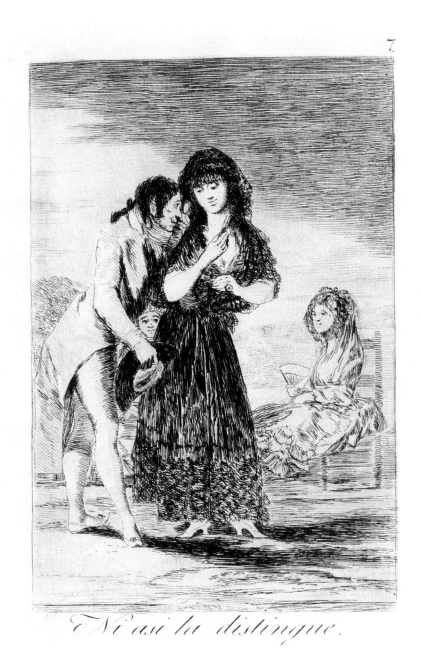

7.

Ni asi la distingue.

It is characteristic that in two drawings of very similar figures on which this *Capricho* depends, Goya should be concerned with variations of perception. The earlier of these, almost exactly contemporary with Vernet's print, is page 19 of *Album B, Fop staring with his quizzing glass at a woman in Spanish dress.*[5] Unlike the French print, it is not a caricature but a subtle drawing of an encounter between a man whose interest has been aroused and a woman whose morals he will determine. The second drawing, probably executed in 1797, is one of the *Sueños* (Dreams), which constituted the earlier form of the *Caprichos.*[6] A worldly fop has no need of his lens (which is barely indicated) to perceive what manner of *maja* stands before him on the *paseo* (promenade). Goya has called attention not only to the curving arc of her body, as sinuous as that of an amorous cat, and her knowing smile but also to the attentive stance of the gentleman who is remarking, "*por aberle yo dicho qe tenia buen mobimiento no puede ablar sin colear*" (because I told her that she moved gracefully, she cannot speak without swaying her hips). In the *Capricho*, a large quizzing glass is of no use to a smitten gentleman who sees only what he wishes to see. Blind to what Goya has depicted, he perceives neither the calculating smile of a prostitute nor the boldness with which she sways her hips.

Contemporary Explanations:

Prado: *Como ha de distinguirla? para conocer lo qe ella es no basta el anteojo se necesita juicio y practica de mundo y esto es precisamente lo qe le falta al pobre caballero.* (How is he to make her out? To know what she is a quizzing glass does not suffice; one needs judgment and worldly knowledge, and that is precisely what the poor gentleman lacks.)

Biblioteca: *Se ciegan tanto los hombres luxuriosos, que ni con lente distinguen que la Señora que obsequian, es una ramera.* (Lustful men blind themselves to such a degree that even with a glass they do not perceive that the lady to whom they pay court is a whore.)

E.A.S.

1. Jacques Ruppert, *Les arts décoratifs: Le costume, IV, Louis XVI - Directoire* (Paris, 1931), pp. 54-55.

2. See Armand Dayot, *Carle Vernet: Etude sur l'artiste, suivie d'un catalogue de l'oeuvre gravé et lithographié et du catalogue de l'exposition rétrospective de 1925* (Paris, 1925), no. 66 *b*; and Henri Béraldi, *Les graveurs du XIX^e siècle* (Paris, 1892), pl. XII, no. 1.

3. Anonymous stipple engraving, Bibliothèque Nationale, Paris.

4. "Los vicios de Madrid (1807)," ed. R. Foulché-Delbosc, *Revue Hispanique* 13 (1905), no. 43, p. 190. The manuscript is titled: *Los Vicios de Madrid. Dialogo entre Perico y Ant^o. Por el Subteniente del Real Cuerpo de Yngenieros. D^n J. M. S. Año de 1807.*

5. *Album B* 19, Prado, Madrid, 424; G-W 389; G., I, 34.

6. *Sueño* 21, Prado, Madrid, 29; G-W 464; G., II, 55.

43

Muchachos al avío. (Lads Making Ready.)
Caprichos, plate 11
First edition, 1799
Etching, burnished aquatint, and burin
215 x 150 mm.
Engraved, upper right margin: *11*; lower margin: title
References: G-W 472; H. 46, III, 1.

Spain: Biblioteca Nacional, Madrid, 45.658
United States: The Metropolitan Museum of Art, New York, Gift of M. Knoedler, 18.64(11) [*illus.*]

Four rough-looking men, cutting and smoking tobacco, are seated on boulders in a mountainous landscape. Goya's contemporaries would have known immediately not only where they came from but also how they gained their livelihood. Any group of men waiting with half-hidden guns in such terrain were akin to those described by the Englishman William Jacob, writing in 1810 from the Andalusian town of Ronda: "The mountains in this neighborhood are filled with bands of *contrabandistas*, who convey tobacco and other goods from Gibraltar to the interior of the country: They are an athletic race of men, with all the hardiness and spirit of enterprise which their dangerous occupation requires. They reside in the towns which are situated in the most mountainous parts of the country, and are well acquainted with all the passes and hiding places. They are excellent marksmen."[1]

It is instructive to compare Goya's etching with one designed by Antonio Rodríguez for his *Coleccion general de los trages que en la actualidad se usan en España* (Collection Showing the Dress Currently Worn in Spain), which began appearing in Madrid in 1801. Plate 98 depicts a person characteristic of Andalusia, the *contrabandista* (smuggler) (fig. 1).[2] He is dressed in the same fashion as the members of Goya's quartet: his hair is contained in a net at the back of his head; his cap, adorned with fringe, is angular, even cubist in shape; his breeches have elaborate knee bands and tassels, and his legs are protected by gaiters.[3] Since illicit traffic is the smuggler's

Fig. 1. Manuel Alegre after Antonio Rodríguez, *Contrabandista.*
Etching, hand-colored, in *Coleccion General de los Trages que en la actualidad se usan en España . . . ,* Madrid, 1801-

means of support, Rodríguez showed him with a blunderbus, a brace of pistols, and an ammunition belt around his waist. The fact that he is smoking suggests that the principal commodity he moves is tobacco. Below the picture is the wry comment *Cada uno á su negocio* (Each to His Own Business).

The intent of Rodríguez's *contrabandista* was no more than to represent a regional type in Andalusia; but in Goya's day this *Capricho* may not have been viewed as merely picturesque. Some of his contemporaries saw in it an implied criticism of specific government policies: the handling of *contrabandistas* and the stiffness of the royal excise taxes on tobacco, which served to encourage smuggling. Officially tobacco leaves were shipped from Havana to a well-laid-out factory in Seville, processed into snuff or *cigarros*, and from there distributed throughout Spain.[4] Since tobacco was a

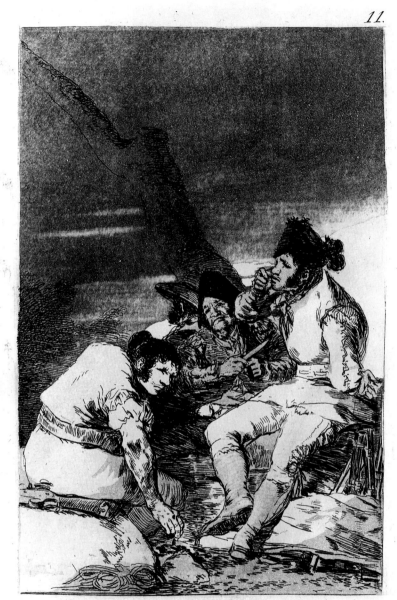

11.

Muchachos al avío.

royal monopoly, the excise taxes ought to have been highly profitable to the crown. In 1789, however, a Frenchman, de Marcillac, citing Jacques Necker, Louis XVI's finance minister, calculated that the Spanish government derived only about a sixth as much income from tobacco as did the French, even though the Spaniards consumed more. De Marcillac believed that the cause of this difference was that the Spanish crown set the price of tobacco far too high so that enormous quantities of tobacco were smuggled across the border from Portugal or through Gibraltar.[5] Another English visitor, Joseph Townsend, in Spain from 1786 to 1787, observed an increase in violence when the government raised "the price of tobacco from thirty to forty reals the pound, whilst the illicit trader purchased the same commodity in Portugal for eight."[6] "The penalty for smuggling," Townsend continued, "is commonly a confinement for seven or ten years to hard labour in the *presidios;* where, by communication with profligate and hardened villains, who are under similar correction, they are prepared for the perpetration of the most atrocious crimes; and, thus qualified, they are turned loose upon the public. Previous to this part of his education, the smuggler seldom robs on the highway, unless when he has been plundered, and is distressed for want of horses, of money, or of arms. In such circumstances he becomes outrageous, and frequently begins with murdering the traveller whom he means to rob."[7]

Two drawings were used for the print. In the earlier one, page 88 of *Album B,* Goya implied that the crime of smuggling might be less grave than many we commit, by giving it an ironic caption that comments on ourselves, *Buena Jente somos los Moralistas* (What fine people we moralists are).[8] In the *Sueño* (Dream) drawing Goya, anticipating Rodríguez, described smugglers as unsavory businessmen, *Los Mercaderes Silbestres* (The Outlaw Merchants).[9] The title of Goya's print, however, is distinctly ominous: *Muchachos al avío* (Lads Making Ready). The artist makes clear what they are prepared to do by adding a new detail on the ground by the rocks at the left: ropes for

the binding of victims. The quartet is now as ready to rob travelers as to smuggle tobacco.

Contemporary Explanations:

Ayala: *Los contrabandistas andaluces, cerca de un camino, pasan pronto á ser bandidos.* (Andalusian smugglers near a highroad soon become highway men.)

Prado: *Las caras y el trage estan diciendo lo qe ellos son.* (Their faces and clothing proclaim what they are.)

E.A.S.

1. William Jacob, *Travels in the South of Spain, in Letters Written A.D. 1809 and 1810* (London, 1811), p. 342. Writing from Ronda, Jan., 1810, during the Peninsular War, the author commented on the potential usefulness of smugglers as guerrillas.

2. Etching, hand-colored, by Manuel Alegre after Antonio Rodríguez, in *Coleccion general de los trages que en la actualidad se usan en España* . . . , pl. 98. The *Coleccion* may be consulted in the Biblioteca Nacional, Madrid, the Museo Municipal, Madrid, and the Boston Public Library.

3. For the jerkins worn by *contrabandistas*, see also the late eighteenth-century engraving by Marcos Téllez Villar, *Bestimenta que usan los Contrabandistas Españoles*; Páez, *Grabados españoles*, 2096, 2; reprod. in Joaquín M. de Navascués, "El folklore español," en *Folklore y costumbres de España* (Barcelona, 1934), vol. 1, p. 141. Jacob, writing again from Ronda, described the *montera* (cap), *Travels in the South of Spain*, p. 338.

4. See [M. de Marcillac] *Nouveau voyage en Espagne* (Paris, 1789), vol. 3, pp. 154-155; Joseph Townsend, *A Journey through Spain in the Years 1786 and 1787* (London, 1791), vol. 2, pp. 304-305.

5. De Marcillac, *Nouveau voyage*, vol. 2, pp. 11-14; Townsend, *Journey through Spain*, vol. 2, pp. 282-283.

In 1779 Andalusian revenue officers were the subject of one of Goya's tapestry cartoons, *El resguardo de tabacos*, for the antechamber of the Príncipes de las Asturias in the Pardo; Prado, Madrid, 788; G-W 136; Gud. 91.

6. Townsend, *Journey through Spain*, vol. 2, pp. 282-283.

7. Ibid., p. 283.

8. Hispanic Society, New York, A 3317; G-W 446; G., I, 91.

9. Prado, Madrid, 19; G-W 473; G., II, 59. On these two drawings, see also cat. 47, *Brujas disfrazadas en físicos comunes.*

44

Ya van desplumados. **(There they go plucked.)**
Caprichos, **plate 20**
First edition, 1799
Etching, burnished aquatint, and drypoint
215 x 150 mm.
Engraved, upper right margin: *20*, lower margin: title
References: G-W 491; H. 55, III, 1.

Spain: Biblioteca Nacional, Madrid, 45.666
United States: The Metropolitan Museum of Art, New York, Gift of M. Knoedler, 18.64(20) [*illus.*]

To understand this scene of prostitutes sweeping out customers, one must know something of the history of their profession in Spain. In 1623 Felipe IV, out of concern for religious principles and public health, ordered the closure of Spain's legal brothels, establishments that foreigners had found admirable, for they were clean, orderly, and exacting in respect to the young ladies, who were obliged to undergo medical examinations every eight days. The results of the king's policy were hardly what he had had in mind. Clandestine prostitution at once began to burgeon.[1]

The extent to which the situation changed is indicated in a passage from the *Arte de las putas* (Art of Whores), written in 1769 by Nicolás Fernández de Moratín, father of Goya's friend the playwright Leandro Fernández de Moratín: "pues en Madrid hay más de cien burdeles / por no haber uno solo permitido / como en otras ciudades, que no pierden / por eso; y tú, Madrid, nada perdieras, / antes menos escándalo así dieras." (In Madrid there are more than a hundred brothels / for lack of a single legal one as in other cities, which lose nothing / by it; and you, Madrid, would lose nothing, / rather would you give rise to less scandal.)[2] With some hyperbole, Moratín also asserted: "Más fácil fuera al estrellado globo / contarle los luceros, las arenas, / al mar que baña desde el Indo al Moro, / primero que yo cuente las muchachas / que hay en Madrid" (Sooner could I enumerate the spangled sphere's / stars, and the grains of sand / of the sea

CFECTOS DE LA SENSUALIDAD.

Fig. 1. Anonymous, *Efectos de la sensualidad.* Engraving and etching. Biblioteca Nacional, Madrid

that bathes both Indian and Moor, / than count the wenches / there are in Madrid).[3]

It is hardly surprising to learn that the proliferation of unregulated prostitution was accompanied by an increase in syphilis, to an extent that frightened Goya's contemporaries. Moratín gave very practical advice to those who chose to go whoring on how contagion might best be avoided, such as using condoms and where they could be found;[4] in 1793 the Conde de Cabarrús, economist and statesman (see cat. 15), writing to Jovellanos (see cat. 30) on public health, included among various proposals for curbing venereal disease the sensible, if daring, recommendation that legalized brothels be reinstated subject to strict controls, which he outlined.[5] Carlos IV did not adopt this measure.

Goya depicted here the interior of a brothel in which wretched males, debased, plucked naked, useless, are being driven out by scornful prostitutes. It has been pointed out that the title, *Ya van desplumados*, means that the men leave this place fleeced as well as plucked, the double meaning of Goya's

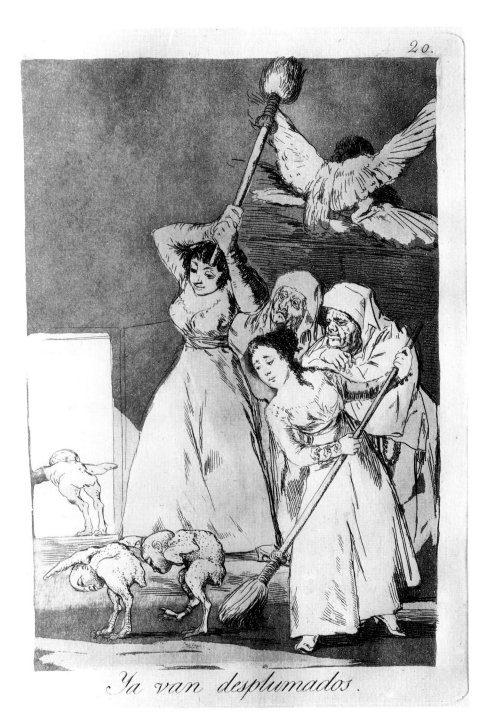

Ya van desplumados.

word, *desplumar*, reinforcing his visual pun. However, the word contains an additional implication. The verb *pelar* (to skin) was used interchangeably with *desplumar. Pelado* (past participle of *pelar*) was the common term for "bald"[6] Thus there is yet another pun in Goya's title, for it may also be translated: "There they go bald." Turning to the aquatint, we see that in fact little more than a last reluctant fringe of hair still clings to the pates of the three pathetic victims.[7] They have become bald because they have contracted syphilis.

Goya was not the first to employ this double pun. In the seventeenth century Quevedo made the same use of it, addressed to a courtesan: *"Que, por lo menos, no me has pelado, siendo lo mismo, cuando asi pasase, pegarme enfermedad que me pelase"* (At least you have not fleeced [skinned] me; yet it would come to the same, were it so, to give me a disease that would skin me [make me bald]).[8] In turn, Goya's etching on the spread of syphilis by prostitutes inspired an unknown Spanish print maker active during the first decade of the nineteenth century. Adapting motifs from the *Caprichos* and adding admonitory texts together with realistic figures of unhappy victims, he published a print called *Efectos de la sensualidad* (Results of Sensuality) (fig. 1).[9] The situation in Goya's *Capricho* is graver. Syphilis has had an additional deleterious effect on the bird-man at the rear of the procession, who is limping. His leg is bound; and this *ligadura* (ligature) conveyed information about the progress of his disease, for in both Spanish and English, ligature also meant a state of impotency, produced as though by an act of *maleficia*, or enchantment.[10]

Almost directly beneath the copulating birds stand two figures watching the scene with approval. One would assume them to be procuresses were it not that in Spain the universal symbol of the profession was an elderly hand prominently fingering a rosary.[11] Goya used this symbol to illuminate a number of prints and *Album* drawings and, indeed, a painting of a bawd and prostitute in the present exhibition (cat. 70). However, in this *Capricho*, the hand that should be hold-

ing the rosary is empty. Instead, a
double rosary, like that of a friar, hangs
from the belt of the figure to the far right,
whose face has a distinctly male cast. It
is impossible to be certain that Goya
intended him to be read as a friar,
although there were contemporaries who
saw both these figures as precisely that.
The poet Nicolás Fernández de Moratín,
whose *Arte de las putas* remained in
manuscript, suggested what Goya may
have seen as their role here: "A los
frailes también, si les pagares / en
tabaco, en pañuelos ó dinero, /
alcahuetes harás con advertencia / que
obligarán á dártelo en conciencia. /
Facilitan los pobres del Hospicio / los
virgos de las mozas de servicio / y las
horcajaduras de las amas" (Monks, too, if
you pay them / in tobacco, handkerchiefs
or money, / you will cleverly turn into
procurers, / who will see that it be given
you in good conscience. / They facilitate
poorhouse wretches, / maids' virginity /
and housekeepers' crotches).[12]

Monks may supply a moral warning
along with the young ladies, yet the ser-
mon does not alter the irony that instead
of concerning themselves with spiritual
well-being, they are employed in satisfy-
ing a physical lust, which, for some men,
will lead to sickness and death.

Contemporary Explanations:

Prado: *Si se desplumaron ya, vayan
fuera: q^e van à venir otros* (If they have
been fleeced [or plucked; or become
bald] put them out, for others are
coming).

Stirling: *Los avechuchos medio hombres
despues de desplumados por las mozas,
son arrojados à escobazos; uno ia va cojo
y ligada la pata: dos R.Rmos con rosario
à la cintura, y mui graves de aspecto
celebran la burla y guardan las espaldas
à las mozas.* (The ugly birds [paltry fel-
lows], who are half-men, are driven out
with brooms after being plucked [fleeced;
made bald] by the wenches; one already
limps with his leg bound [has become
impotent]. Two Very Reverend [Fathers]
with rosaries at their belts, and with very
solemn mien, celebrate the trick and form
the rear guard [protect the wenches].)

E.A.S.

1. See Roberto Alcalá Flecha, *Matrimonio y prostitu-
ción en el arte de Goya* (Cáceres, 1984), pp. 69-73.

2. Nicolás Fernández de Moratín, *Arte de las putas*
(Madrid, 1898), Canto II, p. 51. See also Alcalá
Flecha, *Matrimonio*, p. 73.

3. Moratín, *Arte de las putas*, Canto III, p. 61.

4. Ibid., see particularly Canto II, pp. 43-48.

5. Francisco de Cabarrús, *Cartas sobre los
obstaculos que la naturaleza, la opinion y las leyes
oponen a la felicidad publica* (Vitoria, 1808), Carta 5,
"Sobre la Sanidad pública," pp. 74-78; see also
Alcalá Flecha, *Matrimonio*, pp. 74-78.

6. The allusive richness of Goya's choice of word,
pelado, can be grasped in early dictionaries. See
Covarrubias, *Tesoro*, 1611, under *pelar*: "comerle a
uno su hazienda, como hazen las rameras que pelan a
los mancebos. Pelado, el que no tiene pelo"; Ter-
reros, *Diccionario*, 1786-1793, under *desplumado*:
"V. pelado"; *desplumar*: "quitar las plumas á una ave
. . . quitar á uno lo que tiene"; *pelado*: "el que no
tiene pelo . . . se dice tambien de un pájaro, ó ave á
quien se le ha quitado la pluma, habiéndose de decir
regularmente desplumado"; *pelar*: "quitar la pluma
desplumar . . . quitar el dinero, caudal, &c"; *pluma*:
"se toma jocosamente por dinero, caudal, mando,
gobierno, &c."

7. In two preliminary drawings (Prado, Madrid, 95
and 434), one can see that Goya experimented,
ascribing greater or lesser degrees of baldness to the
bird-men; G-W 493 and 492, G., II, 81 and 80,
respectively.

8. See Amédée Mas, *La caricature de la femme, du
marriage et de l'amour dans l'oeuvre de Quevedo*
(Paris, 1957), pp. 187-188, and n. 162.

9. Engraving and etching, 1800-1810. Biblioteca
Nacional, Madrid, 18138. The prostitute is derived
from *Capricho 72, No te escaparás*, the bird-man
from 19, *Todos Caerán*, the bat is reminiscent of one
in 45, *Mucho hay que chupar* and the principal admo-
nition is the same as the title of 23, *Aquellos polvos
[traen estos lodos]*. For a variant of the engraving
with additional text in the Correa collection, see
Salas del Palacio de Bibliotecas y Museos, Madrid,
Estampas: Cinco siglos de imagen impresa (1981),
no. 984.

10. See Rossell Hope Robbins, *The Encyclopedia of
Witchcraft and Demonology* (New York, 1959), under
ligature; see also Terreros, *Diccionario*, 1786-1793,
under *ligadura*.

11. Alcalá Flecha, *Matrimonio*, pp. 90-103.

12. Moratín, *Arte de la putas*, Canto III, p. 72.

45

¡Qual la descañonan! (Oh how they pluck
out her quills!)
Caprichos, plate 21
First edition, 1799
Etching and burnished aquatint
215 x 145 mm.
Engraved, upper right margin: *21*; lower
margin: title
References: G-W 494; H. 56, III, 1.

Spain: Biblioteca Nacional, Madrid,
45.666
United States: The Metropolitan Museum
of Art, New York, Gift of M. Knoedler,
18.64(21) [*illus.*]

A prostitute may find herself in difficul-
ties. Goya indicated their nature by
using visually two meanings of *desca-
ñonar*, a word not unlike *desplumar*,
which is used in the preceding *Capricho*
(cat. 44), but harsher. It implies that the
quill feathers are yanked from the bird's
wings and that she is left penniless. Hers
are not the stubby appendages of a hen,
useless for flying, which the well-known
Prado manuscript (see below) might lead
us to expect, but the long, strong wings of
a night-hunting bird. By means of these,
Goya suggested a second play on words,
since a traditional slang term for a street-
walker was *búho*, one of the principal
varieties of Spanish owl.[1]

The explanations given below make it
plain that Goya's contemporaries did not
have much difficulty in recognizing who is
despoiling the prostitute. To the right,
holding one wing, is an *alguacil* (a type of
constable) in his characteristic black
dress, with knee breeches, short cloak,
square white collar, wig, and sword. At
the left, gnawing on the other wing is a
notary. Behind this pair stands a magis-
trate who plainly countenances their
actions.

In this print (as in all the *Caprichos*)
Goya has drawn attention to certain parts
of the print through compositional
devices. His preliminary drawing, a night
piece, was illuminated primarily with the
logic of naturalism (fig. 1),[2] whereas,
here, light is used at will to focus our
attention on details that are of signifi-
cance. The most brilliant light is
reserved for the anguished face of the

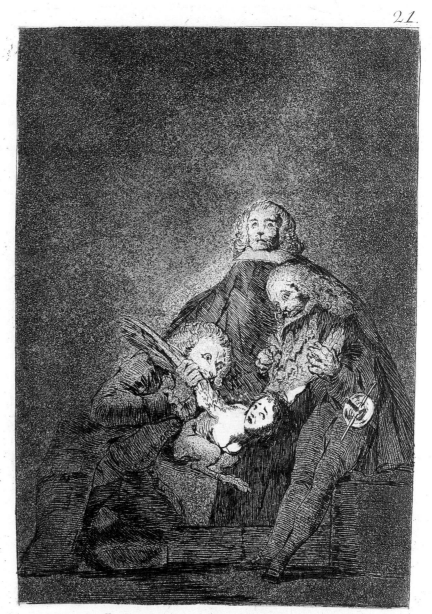

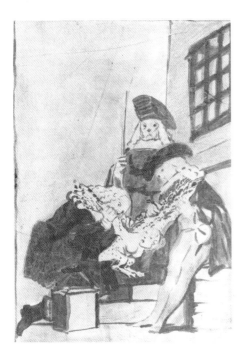

Fig. 1. Preliminary drawing for *Caprichos*, pl. 21.
Sanguine and sanguine wash.
Museo del Prado, Madrid

Fig. 2. Anonymous, *Virgen de Misericordia*.
Woodcut.
Imprenta Guasp, Mallorca.
(Manuel Trens, *María: Iconografía de la Virgen . . . ,*
Madrid, 1946.)

streetwalker, her splendid breasts, and the jointure of her wings. The hilt of the sword worn by the *alguacil* is almost equally bright lest we fail to be aware of his profession.

Highlighted more subtly are additional visual puns that give further information about the three predators. The faces of the magistrate and notary appear canine, indicating their insatiable desire to have what belongs to others.[3] The face of the *alguacil*, however, is unmistakably feline. One need look no further than an eighteenth-century Spanish dictionary to find the meaning of this imagery; a definition of *gato* (cat) is "El ladron ratero que hurta con astucia y engaño" (The petty thief who steals with cunning and deceit).[4] Goya also lightly emphasized the hand of the *alguacil* to make us aware that he has *garras* (claws) rather than fingers. Turning again to the dictionary, we learn that *gente de la garra* (people of the claw) are those who are habitual thieves and that, from the same root, an *agarrador* (one who grasps) was also a name for an *alguacil*.[5]

Satirical criticism of notaries and *alguaciles* had had a long, rich history in Spain. Both are to be found among the inhabitants of hell in the *Sueños*, written in the seventeenth century by Francisco de Quevedo Villegas;[6] and they were castigated in the following century by Nicolás Fernández de Moratín, playwright and poet and father of Goya's friend Leandro, in his *Arte de las putas* (The Art of Whores): "Ya sabe el mundo la perversa gente / que son los alguaciles y escribanos; / éstos persiguen a las pobres putas, / no con deseos de extinguir lo malo, / pues comen con delitos, y su vida / pende de hombres sin ley, facinerosos, / y la santa virtud es su homicida; / y aunque saben que no es el estafarlas / medio de corregirlas, pues quedando / pobres, prosiguen siempre puteando, / las roban con achaque de enmendarlas" (The world well knows what perverse people / *alguaciles* and notaries are; / they persecute the poor whores, / not because they wish to stamp out evil, / as they feed on crimes, and the prostitutes' lives / depend on lawless, iniquitous men, / and holy virtue is their victim; / and although they know that

defrauding them / is no way to reform them, for remaining / poor they ever persist in whoring, / nevertheless they rob them on the pretext of reforming them).[7]

In this *Capricho*, unlike the preliminary drawing, the magistrate seems to lift his arms so that his cape protects the notary and *alguacil*. As the *Diccionario* explains, "Ser capa de maldades, de ladrones, pícaros, &c." (To cloak iniquity, thieves, and rogues) means to cover up what they do or to protect them.[8] Goya called attention to this visual pun by adding burnishing above the left edge of the cape. He made this change after looking at a working proof of the print and before he had the edition printed.[9] Quevedo's criticisms of judges are even more devastating than those of the other two protagonists. In *El Alguacil Alguacilado*, a demon explains to Quevedo why judges are left on earth: "los Jueces son nuestros faisanes, nuestros platos regalados, y la simiente que mas provecho, y fruto nos dá á los diablos; porque de cada Juez que sembramos, cogemos seis Procuradores, dos Relatores, quatro Escribanos, cinco Letrados, y cinco mil Negociantes, y esto cada dia. De cada Escribano cogemos veinte Oficiales, de cada Oficial treinta Alguaciles, de cada Alguacil diez Corchetes" (The judges are our pheasants, our finest dishes, and the seed that gives us devils the most profit and fruit; for from every judge we sow, we reap six barristers, two court secretaries, four notaries, five lawyers, and five thousand merchants, and every day at that. From every notary we reap twenty officials, from each official thirty bailiffs, and from each bailiff ten sergeants.)[10]

Once we have noticed that spreading cape, we become aware that the entire composition of the *Capricho* constitutes a profoundly moral play on religious representations of the Virgen de Misericordia (Virgin of Mercy), specifically in her guise as Abrigo de Pecadores (Shelter of Sinners). In an anonymous eighteenth-century woodcut we see angels spreading out the Virgin's mantle to protect the sinners who cower below it from the just wrath of God the Father and his Son, seen standing in the clouds above, ready to hurl down their arrows (fig. 2).[11] In the

Capricho the venal magistrate neither executes justice nor tempers it with mercy. Instead he protects those who rob prostitutes.

Contemporary Explanations:

Ayala: *Los Jueces hacen capa á los Escribanos y alguaciles para que roben á las mujeres públicas impunemente* (Judges take notaries and constables under their cloaks so they can rob the women of the town with impunity).

Prado: *Tanbien las Pollas encuentran milanos qe las desplumen y aun por eso se dijo aquello de: Donde las dan las toman* (The hens [prostitutes] also encounter birds of prey to pluck [fleece] them; and for that reason they say: Claw me, claw thee).

Sánchez: *Ciertos Jueces hacen capa a los Escribanos y Alguaciles para arrancar hasta los cañones de los [sic] infelices qe caen en sus garras* (Certain judges take notaries and constables under their wings so they can pluck out even the quills [take all the money] of the luckless ones who fall to their claws).

E.A.S.

1. José Luis Alonso Hernández, *El lenguaje de los maleantes españoles de los siglos XVI y XVII: la germanía* (Salamanca, 1979), p. 41. See also Eleanor A. Sayre, "La visión del cazador de pájaros en el *Capricho* 19 de Goya: *Todos caerán*," in *Goya: Nuevas visiones: Homenaje a Enrique Lafuente Ferrari* (Madrid, 1987), pp. 368-373.

2. Sanguine and sanguine wash, 183 x 129 mm., Prado, Madrid, 104; G-W 495; G., II, 82.

3. This association can be traced back to Aesop's famous fable of a dog that saw its reflection in a stream while carrying a piece of meat in its mouth. Coveting the meat held by its image reflected in the water, it opened its mouth and thus lost what it had. Bosch shows two envious dogs with a pile of bones in a representation of Invidia and places a dog beside a rich miser in the depiction of Avaritia in his work *The Seven Deadly Sins and Four Last Things* (Prado, Madrid, 2822). Cesare Ripa, *Della piv che novissima iconologia* (Padua, 1630), p. 360, in the fourth description of Invidia gives her a black dog, "il quale come da molti effetti si vede è animale inuidiosissimo, e tutti li beni de gl'altri vorrebbe in fe solo, anzi racconta Plinio nel lib. 25. cap. 8." Composers of emblems continued this tradition, as, for example, Diego de Saavedra de Fájardo, in his *Idea de un príncipe político christiano representada en cien empresas* (Amsterdam, 1659); no. 9, on the harmful effects of envy, shows two dogs biting Hercules' spiky club.

4. Academia, *Diccionario*, 1791, under *gato*.

5. Ibid., under *garra* and *agarrador*, respectively. It is not the only instance where Goya pictured an *alguacil* as a cat. There are two drawings, close in time to *Capricho* 19; one is the *Alguacil Seeing Himself as an Aggressive Feline* (Prado, Madrid, 33; G-W 652; G., II, 324); and *Album B*, page 83, a scene of prostitutes afraid of an unseen *"Gato muy negro"* (very black cat) (private collection, United States; G-W 441; G., I, 86).

6. Francisco de Quevedo Villegas, *Obras escogidas*, 2nd ed. (Madrid, 1794), vol. 1; see pp. 134-138, *El Mundo por Dedentro*, for a description of how they batten on crime. Quevedo saw notaries rather than *alguaciles* as cats; see pp. 90-91, *Las Zahurdas de Pluton*.

7. Nicolás Fernández de Moratín, *Arte de las putas* (Madrid, 1898), p. 81. Edith Helman, "The Elder Moratín and Goya," *Hispanic Review* 23 (July 1955), p. 227, was the first to draw attention to this passage. For further discussion see also Helman, *Trasmundo de Goya* (Madrid, 1963), pp. 81-84; and Roberto Alcalá Flecha, *Matrimonio y prostitución en el arte de Goya* (Cáceres, 1984), pp. 121-124.

8. Academia, *Diccionario*, 1791, under *capa*.

9. The working proof (H. 56, I, 2) also lacks the light burnishing on the *garras* of the *alguacil*; reprod. in *Francisco de Goya: Los Caprichos: Twenty Working and Trial Proofs . . . and a New Census* (New York, 1987), no. 8.

10. Quevedo, *Obras escogidas*, vol. 1, p. 36, *El Alguacil Alguacilado*.

11. Manuel Trens, *María: Iconografía de la Virgen en el arte español* (Madrid, 1946), p. 280, fig. 173.

46

Asta su Abuelo. (Back to His Forebear.)
Caprichos, plate 39
First edition, 1799
Aquatint
215 x 150 mm.
Engraved, upper right margin: *P. 39*;
lower margin: title
References: G-W 526; H. 74, III, 1.

Spain: Biblioteca Nacional, Madrid, 46.655
United States: The Metropolitan Museum of Art, New York, Gift of M. Knoedler, 18.64(39) [*illus.*]

For this print Goya chose a curious technique: tones of aquatint, without any etched lines, to further define shading and contours. An ass sits in a seventeenth-century chair at a table emblazoned with his escutcheon – likewise an ass – and peruses a book on the subject matter that interests him more than any other, his own noble family tree. It makes no difference to him that, from beginning to end, it constitutes a long line of asses.

Goya was not alone in seeing a family relationship between nobles and asses, as can be seen, for example, in this etching issued on the eve of the French Revolution to illustrate Louis-Sébastien Mercier's witty *Tableau de Paris* (Portrait of Paris) (fig. 1), a work dealing with many of the same satirical themes as the *Caprichos*. The text given for this little print is:

> Anon.
>
> Il porte des paniers remplis de fleurs: il est conduit par une fraîche jardiniere: l'attirail forme un grouppe qui plaît à l'oeil, il réjouit la vue & l'odorat.
>
> Quel est cet ânon? Sa mere a nourri le marquis ***; c'est le frere de lait du marquis ***; on le voit, il a un air de famille.
>
> (Anon. [ass's colt]
>
> He carries paniers filled with flowers; he is led by a pretty gardener; his baggage forms a still life that is pleasing to look at, and gives great pleasure to one's senses of sight and smell.
>
> Who is this ass's colt [anonymous person]? His mother suckled the Marquis ____; he is the milk brother of the Marquis ____; one can see it, there is a family likeness).[1]

Fig. 1. Anonymous, *Anon.*
Etching in Louis-Sébastien Mercier, *Tableau de Paris*, Yverdon, 1787.
Museum of Fine Arts, Boston, William A. Sargent Collection

Goya's *Capricho* originated as a satirical drawing with a different target: gentlemen who have pretensions to literary talent, *Album B*, page 72, *Mascaras de B. Tambien ay mascaras de Borricos Literatos* (Masquerades of A[sses]. There are also asses masquerading as men of letters) (fig. 2).[2] There the ass, seated at a table with his book, is shown in his library. He turns his head toward us in that familiar attitude of false modesty (head bent, shoulders hunched) that authors assume when they are about to submit "a little trifle" they have produced. The theme of the asinine author is developed in *Sueño* (Dream) 26, *El Asno Literato* (The Literary Ass) (fig. 3).[3] The shelves of books are more impressive, and an elegantly dressed ass stares down his nose at us, confident that we have no choice but to admire him. If we are unable to praise him because he is a man of letters, we will doubtless feign that we

Fig. 2. *Mascaras de B. Tambien ay mascaras de Borricos Literatos, Album B,* p. 72.
Brush and gray wash, touched with pen and brown ink.
Private Collection, Switzerland

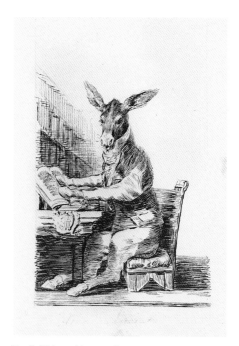

Fig. 3. *El Asno Literato, Sueño 26.*
Pen and brown ink over slight chalk sketch.
Prado, Madrid

are doing so because he is a nobleman; his coat of arms can be seen pretentiously carved on the end of the table.[4] This ass stands in need of the same moral lesson given the *Asinus Nobilis* (Noble Ass), portrayed in a woodcut in the *Memorias de la insigne Academia Asnal* (Annals of the Illustrious Academy of Asses), printed in France in 1792. Holding an architect's compass as well as a book, he is told: "Todo hombre es igual à otro hombre, / La virtud, y la razon / Hacen la real distincion, / . . . Y es una ilusion fatàl / Distinguir à un racional / De otro por el nacimiento. Dixi." (All men are equal; / True distinction is conferred / By virtue and by reason. / . . . And it is a fatal error / To distinguish one rational man / From another by his birth. I have spoken.)[5]

José Cadalso, enlightened essayist, poet, and playwright, and friend of the Duques de Osuna (see cat.17) and of Moratín, had commented earlier on *nacimiento* (lineage) in his *Cartas Marruecas* (Moroccan Letters), a work that he was unable to secure permission to publish but that appeared posthumously in 1789: "Nobleza hereditaria es la vanidad, que yo fundo en que ochocientos años ántes de mi nacimiento muriese uno, que se llamó como yo me llamo, y fué hombre de provecho, aunque yo sea inútil para todo" (Hereditary nobility is the vanity that I base on the fact that, eight hundred years before my birth, a man died who had the same name I have, and who was a worthy man, whereas I am of no use whatever).[6]

What Goya has to say in his *Capricho* is more slyly seditious. If it was not an *"hombre de provecho"* (worthy man) who founded this noble line, but an ass, what right has his asinine progeny to demand our praise and honor?

Contemporary Explanations:

Prado: *A este pobre animal le han vuelto loco los Genialogistas y reyes de Armas. No es el solo.* (This wretched animal has been driven mad by genealogists and Kings at Arms [i.e., heraldic officers]. He is not the only one.)

Stirling: *Los pollinos tienen mucho cuidado de sus geneologias, y escudos de armas, pero todos son asnos. Es de reparar qe el ultimo del arbol, rebuzna.* (Young asses worry a great deal about their genealogies and their escutcheons, but they are all asses. It is to be remarked that the final one on the tree is braying.)

Nelson: *Los Borricos preciados de nobles, son realmente borricos hasta el ultimo abuelo* (Asses that pride themselves on their noble lineage are in fact asses back to their most remote forebear).

E.A.S.

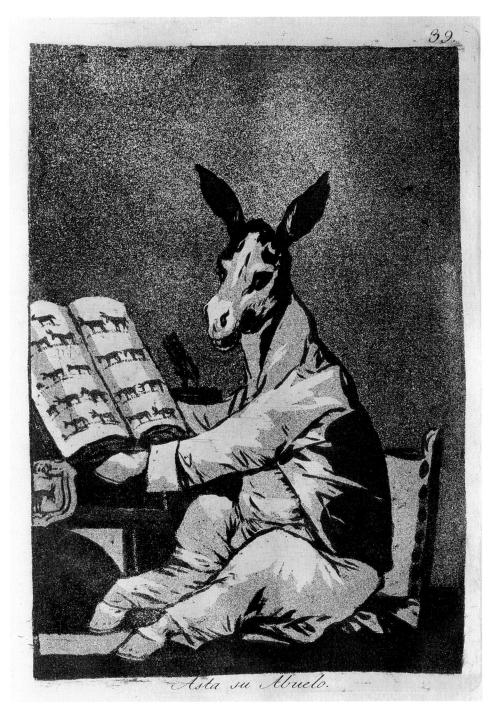

Asta su Abuelo.

1. Louis-Sébastien Mercier, *Tableau de Paris, ou explication de différentes figures, gravées a l'eau-forte, Pour servir aux différentes Editions du Tableau de Paris* (Yverdon, 1787), p. 39. Museum of Fine Arts, Boston, 37.1646. Balthasar Anton Dunker was responsible for some, and possibly all, of the etchings. This edition summarizes two chapters, 464, "Lait d'ânesse," and 465, "Anon," of the literary edition, Amsterdam, 1782-1783. In the former we read: "L'usage du lait d'ânesse est recommandé plus que jamais par tous les médecins. Il répare les tempéraments affoiblis par l'incontinence & la débauche."

2. Brush and gray wash, touched with pen and brown ink, 236 x 145 mm., private collection, Switzerland; G-W 432; G., I, 77.

3. Pen and brown ink over slight chalk sketch, 229 x 153 mm., Prado, Madrid, 25; G-W 528; G., II, 62. Goya's chalk number, slightly cut, is visible at the top of the sheet.

4. See Louis-Sébastien Mercier, *Songes et Visions Philosophiques* (Paris, 1790), pp. 171-172, *Songe* VIII, *Le Blason.* Mercier dreams that he is very rich and has bought a patent of nobility: "Aussitôt je fis peindre mes armoires sur les portes, les fenêtres, les cheminées de mon château; je les fis graver sur les chapeaux de mes domestiques, sur leurs bas, sur les fers de mes chevaux. . . . J'achetai tout exprès une bibliothèque, afin de faire mettre mes armes sur le dos de chaque volume; & je les prêtois à tout venant, me dispensant de les lire, vu mon opulence."

5. "Doctor de Ballesteros," *Memorias de la insigne Academia Asnal* (Bayonne, 1792); see Edith Helman, *Trasmundo de Goya* (Madrid, 1963), p. 65 and pl. II-19.

6. José Cadalso, *Cartas Marruecas* (Madrid, 1793), p. 51: Gazel to Ben-Beley, *Carta* XIII. The *Cartas,* completed by 1774, were published posthumously after Cadalso's death in 1782 in the *Correo de Madrid* during 1789 and then in book form, as above. See Nigel Glendinning, "New Light on the Circulation of Cadalso's *Cartas marruecas* before Its First Printing," *Hispanic Review* 28 (1960), pp. 136-149; Russell P. Sebold, *Colonel Don José Cadalso* (New York, 1971), Chronology. However, the *Cartas* were read in manuscript during Cadalso's lifetime.

In criticizing contemporary society, Cadalso used the popular device of letters purporting to have been written by men of another culture and religion, as had, for example, Montesquieu in his *Lettres persanes*, published anonymously in Amsterdam, 1721.

47

Brujas disfrazadas en físicos comunes
**(Witches Disguised as Ordinary
Physicians)**
Sueño 27 **(Dream 27)**
1797-1798
Pen and brown ink over a slight chalk
sketch
246 x 185 mm.
Inscribed in chalk, above image: *27*;
below image: title; not by Goya, in pencil,
bottom of sheet: *Casi inedita* (Almost
unpublished)
References: G-W 531; G., II, 58.
Museo del Prado, Madrid, 26

United States only

Two asinine doctors are treating a
patient. One, wearing an impressive
wig and the *quevedos*, or seventeenth-
century spectacles, used by Goya to
denote a wearer's antiquated views, sol-
emnly reads a text that we may assume
to be in Latin; the second, whom an anx-
ious wife seems to favor, gravely takes
the patient's pulse with his forehoof.

This drawing is from the *Sueños*
(Dreams), the earlier form in which the
Caprichos were cast. Goya had intended
to create an eighteenth-century, visual
refashioning of Quevedo's satiric *Sueños*
written between 1607 and 1635.[1] The
author described finding himself in Hell
and the conversations he had with its
inhabitants, native and otherwise. He
came to the conclusion that the most
striking difference between devils and
humans is that the former, who lack our
hypocrisy, readily acknowledge as sins
actions that those in the world so often
condone. In Goya's *Caprichos* the line
between humans and devils was equally
thin. However, he depicted depraved
men and women ripe for Hell, not as dev-
ils but rather as people who have aban-
doned their humanity to become animals,
monsters, goblins, witches, or warlocks.

Quevedo's notion of the interpenetra-
tion of the human and the diabolic is
unequivocally evident in Goya's *Sueños*.
In this dream an unfortunate patient
believes that two doctors have come to
relieve his suffering and consequently, as
is often the case, sees them as larger
than life. Unfortunately, they are in real-
ity warlocks who will do him grievous
bodily harm. To state what we see in uni-
versal terms: stupid physicians who
remain torpidly ignorant of important
medical discoveries violate us as do war-
locks. Goya tended to consider male and
female disciples of the devil as sexless,
rarely assigning them markedly male or
female physical characteristics. Although
there were words for warlock and witch,
brujo and *bruja*, in no case did he make
use of this linguistic distinction in his
titles, but he called all of them indiscrim-
inately *brujas*.

If one is to understand a print or draw-
ing by Goya, it is important to look at the
the context in which he placed it. Very
often it is related to what precedes and
follows it, the juxtapositions being
intended to contribute to the meaning. In
this instance, *Brujas disfrazadas en
físicos comunes* (Witches Disguised as
Ordinary Physicians) was followed by
Sueño 28, Mercaderes silbestres (Outlaw
Merchants), depicting four heavily armed
men prepared to combine banditry with
smuggling.[2] It is possible that Goya had in
mind a proverb such as one collected by
the industrious Correas in the seven-
teenth century, "Dios es el ke sana, i el
médiko lleva la plata" (The Lord cures,
and the doctor takes the money).[3] When
Goya placed a drawing of a doctor and
one of bandits together, he may have
seen the latter as having the moral
advantage. Some months earlier he had
drawn the same quartet of bandits on
page 88 of *Album B,* to which he gave
the title *Buena Jente somos los Moralis-
tas* (What fine people we moralists are),
commenting, ironically, not so much on
the bandits as on those who view them.[4]
On the following page, 89, he drew a
hardened bandit who stands facing us,
blunderbus cocked. Above this picture
Goya wrote, *el Abogado.* (The Lawyer.),
and below it, *Este a nadie perdona, pero
no es tan dañino como un Medico malo.*
(This one never lets anyone off, but he is
less noxious than a bad Doctor).[5] In this
world doctors and lawyers are respected
and bandits are not. In the next how will
each of them fare?

E.A.S.

1. Francisco de Quevedo Villegas, *Obras escogidas*
(Madrid, 1794), vol. 1, pp. 1-148, 374-454.

2. Prado, Madrid, 19; G-W 473; G., II, 59; see also
cat. A51.

3. Quoted by Louis Combet, *Recherches sur le
'Refranero' Castillan*, Bibliothèque de la Faculté des
Lettres de Lyon, fasc. 29 (Paris, 1971), p. 360.

4. Hispanic Society, New York, A 3317; G-W 446; G.,
I, 91.

5. Goya inadvertently wrote *como* twice. Private col-
lection, London; G-W 447; G., I, 92.

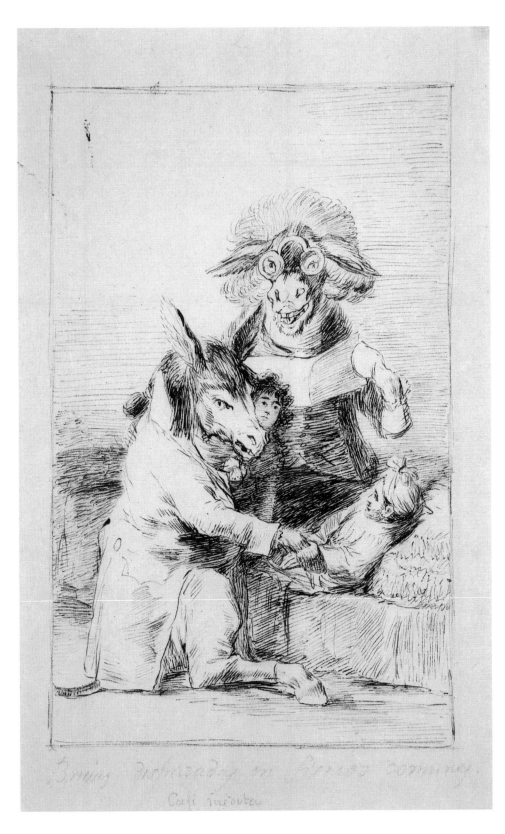

48

De que mal morira? (Of what illness will he die?)
Caprichos, plate 40
First edition, 1799
Etching and aquatint
215 x 150 mm.
Engraved upper right margin: *40*; lower margin: title
References: G-W 529; H. 75, III, 1.

Spain: Biblioteca Nacional, Madrid, 45.666
United States: The Metropolitan Museum of Art, New York, Gift of M. Knoedler, 18.64(20) [*illus.*]

An asinine physician, fashionably dressed, sits beside the bed of a patient and gravely takes his pulse. *"De que mal morira?"* (Of what illness will he die?), the title asks. The response that would have sprung most readily to mind was, "of the doctor," for a traditional Spanish name for a member of this profession was *matasanos* (killer of the well).[1] The Scottish philosopher David Hume had a similar mistrust of doctors for he warned a friend: "I entreat you, if you tender your own Health or give any Attention to the Entreaties of those that love you, to pay no regard to Physicians: That is a considerable part of your Distemper. . . . Your only Safety is in neglecting them altogether."[2]

In Quevedo's *Sueño* (Dream), *Visita de los Chistes* (Visit of the Jests), the first people he encountered were doctors astride mules, which, owing to their black trappings, resembled *tumbas con orejas* (tombs with ears). As Quevedo watched the medical students acting as lackeys to doctors, he remarked: "tratando mas con las mulas que con los Doctores se graduaron de Médicos" (having more communication with the mules than with the Doctors, they are graduated as Physicians); and he continued sourly: "Si de estos se hacen estos otros, no es mucho que estos otros nos deshagan á nosotros" (If out of these mules they make those others, it is not so strange that the others are our undoing). Every doctor wore a "sortijon en el pulgar, con piedra tan grande que quando toma el pulso pronostica al enfermo la

losa" (great ring on his thumb with a stone so large that when he takes a pulse the patient prognosticates the burial stone)[3]. The thumb was the customary place for a doctor to wear his ring. Goya showed one, with an enormous faceted stone, encircling the ass's hock.[4] In the late eighteenth century a fashionable doctor might "wear a ring with a diamond as large as an almond, and from his bearing and the profound respect shown him by all, might be taken for a field marshal or a lieutenant general."[5] Goya depicted his asinine doctor as larger than life.

By the end of the century there existed a wide variety of schools of medical practitioners. There were the *empiricos,* who believed in experimenting with medicines, some of them violent in their effects; *clinicos,* who stayed by bedsides, observing symptoms (unlike the *empiricos,* who went from town to town to try out their drugs); *astrolójicos,* who claimed to heal by means of their understanding of the planets; *botánicos,* who used simples from herbs and plants; *quirurjicos,* surgeons; *cosmetas,* or cosmeticians; *anatómicos,* who dissected bodies; *dogmáticos,* who relied on axioms from which they deduced and argued; *jatraliptos,* who relied on ointments; *májicos,* who preferred magic; *metódicos,* who had theoretical bases for what they did; *músicos,* who used music; *oculares,* oculists; *raciocinantes,* who searched for the single source of disease; *teóricos,* who tried to discover the hidden logic of human bodies; and *vulnerarios,* who treated wounds.[6]

Nevertheless the eighteenth century was a period of solid medical progress for a variety of reasons. There were great pioneers, such as the British surgeon and physiologist William Cullen and the Dutch philosopher-physician Hermann Boerhaave, who was outstanding as clinician, methodologist, chemist, and botanist; and there were individuals such as the Spanish physician and reformer Andrés Piquer y Arrufat at Valencia who had the intelligence and will to transmit what was new. The *philosophes* had an intense interest in scientific medical knowledge, and Diderot secured the collaboration of more than twenty physi-

cians for his great *Encyclopédie* (prohibited by the Inquisition); the writings of the *philosophes* did much to create a climate in which pluralistic empiricism was able to change the course of medical research during the latter part of the century; and, finally, enlightened rulers, believing that the health of their subjects was their responsibility, saw to the founding of medical schools and modern hospitals.[7]

In Spain under Carlos III (see cat. 1), the teaching of medicine in the University of Salamanca was revised (1771) so that Galen's second-century pathology might be replaced by Boerhaave's contemporary knowledge; a professorship of clinical medicine was discussed by the University of Granada in 1776. A decade later the University of Valencia, partly as a result of the intervention of Floridablanca (see cat. 4), was freed from the control of both the archbishop and the municipal board and was made autonomous. The medical curriculum was revised and given new scientific and philosophical breadth, Cullen and Boerhaave became predominant, and the first Spanish clinical professor taught medical students at the general hospital.[8]

The ass in Goya's print knows nothing of clinical medicine. He is feeling for the patient's pulse with his hoof but, because his eyes are firmly closed with the obstinacy of ignorance, he does not notice what Goya's subtle use of aquatint tonalities urges the viewer to observe. The man lies rigidly against his pillows, his mouth has fallen open, and the fingers of his hand have contracted. Dimly through the stuff of his bed-curtain, we see that a monk has drawn near and that the patient's weeping wife has turned her head away and covers her face with her hands.[9] The question posed by the title has already been answered.

Contemporary Explanations:

Prado: *El medico es excel^{te} meditabundo, reflexibo, pausado serio. Que mas hay q^e pedir?* (The doctor is excellent, pensive, thoughtful, deliberate, serious. What more could one ask?)

Stirling: *Que han de hacer sino matar enfermos los medicos barbaros e*

ignorantes! Sin embargo ellos afectan mucha seriedad y meditacion à la cabezera. (Whatever should they do, these barbaric and ignorant physicians, but kill the sick! Nevertheless they feign great solemnity and deep thought at the bedside.)

Douce: Ignorant physicians who feel the pulse of a dead man.

E.A.S.

1. Terreros, *Diccionario,* 1786-1793, defines *matasanos* as *curandero, empírico, mal Médico* (quack, experimenter, bad doctor).
 Eugène Piot, who knew people who had lived in Spain in Goya's day, noted in his "Catalogue raisonné de l'oeuvre gravé de Fran^{co} Goya y Lucientes" that to the question "De quel mal mourra-t-il?" it was customary to reply: "Il mourra du médecin." The catalogue raisonné accompanies a note by Théophile Gautier, "Fran^{co} Goya y Lucientes," in *Le Cabinet de l'amateur et de l'antiquaire* 1 (1842); see p. [3]51. Piot is identified in the index as the author of the catalogue.

2. Hume to John Crawford, July 20, 1767, in *New Letters,* p. 175; quoted by Peter Gay, *The Enlightenment: An Interpretation,* vol. 2: *The Science of Freedom* (New York, 1977), pp. 19-20.

3. Francisco de Quevedo Villegas, *Obras escogidas* (Madrid, 1794), vol. 1, pp. 378-379.

4. Wallace Woolsey, *Quevedo: Dreams* (New York, 1976), p. 127, illustrated this passage with *Capricho* 40.

5. From the anonymous *Madrid por adentro y el forastero instruido y desengañado* (Madrid, 1784), pp. 16-18; quoted by Charles E. Kany, *Life and Manners in Madrid, 1750-1800* (Berkeley, 1932), p. 240.
 Goya added the ring in a sanguine and wash drawing preparatory to the print, Prado, Madrid, 97; G-W 530; G., II, 98).

6. See Terreros, *Diccionario,* 1786-1793, under *medico.*

7. See Gay, *Enlightenment,* vol. 2, pp. 12-23; Herr, *Revolution in Spain,* pp. 41-46.

8. Jorge Navarro, "La transición de la medicina ilustrada a la romántica a través de la obra de Félix Miquel," in *La ilustración española,* Instituto Juan Gil-Albert, Diputación Provincial de Alicante, Actas del Coloquio Internacional celebrado en Alicante, Oct. 1-4, 1985 (1986), pp. 71-79; Diego Ferrer, *Historia del Real Colegio de Cirugía de la Armada de Cádiz* (Cádiz, 1983), pp. 109-163.

9. She can be seen more clearly in an impression printed from a clean-wiped, worn plate in a late edition such as the tenth (H. 75, III, 10) than in the present impression from the first edition of 1799.

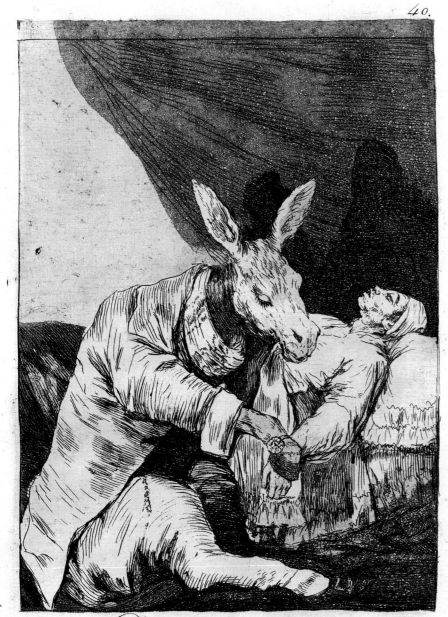

40.

De que mal morira?

49

***Tu que no puedes.* (You Who Cannot.)**
***Caprichos,* plate 42**
First edition, 1799
Etching and burnished aquatint
215 x 150 mm.
Engraved upper right margin: *42,* lower margin: title
References: G-W 534; H. 77, III, 1.

Spain: Biblioteca Nacional, Madrid, 45.666
United States: The Metropolitan Museum of Art, New York, Gift of M. Knoedler, 18.64 (42) [*illus.*]

Two men standing in a stretch of empty countryside hold a pair of donkeys on their backs. The inherent folly of the notion that a man should carry a beast of burden was pointed out by Aesop in his fable "The Miller, His Son, and Their Ass." The two set out for market, neither of them riding the ass so that it would arrive there fresh and fetch a high price. Responding to successive critics whom they met on the way, the boy mounted, the miller got up behind him, and, in the end, both dismounted, and the old man considered whether he ought perhaps to carry the ass himself.

A seventeenth-century version of this upside-down idiocy is found in the Italian proverb "Pazzo è colvi, che va à piedi per commodo del cavallo" (Crazy is the one who goes on foot for the convenience of the horse), which Giuseppe Maria Mitelli illustrated with an engraving of a gentleman trudging along the road leading his horse and carrying its saddle on his back.[1]

Goya's *Capricho,* however, is not as simple as either the fable or the proverb. The title, *Tu que no puedes* (You Who Cannot) was the beginning of a saying ending "llévame à cuestas" (carry me on your back), which meant, as a contemporary dictionary put it, "oppress the feeble who cannot resist."[2] It is plain that those from whom too much is demanded are poor, for the man at the left wears the primitive sandals and ill-fitting stockings of a peasant, while his companion is only slightly better shod. They strain to fulfill their task, and their eyes are closed with the blindness of ignorance. The two

asses, on the other hand, seem to be scratching one another leisurely where it does the most good. The one at the left wears a prominent, vicious-looking spur such as a noble might have, while its companion appears to be chewing.[3]

In the eighteenth century the plight of agricultural workers was of concern to a number of people throughout Europe. In 1776 the British economist Adam Smith pointed out that men working on the land were usually prohibited from joining together, whereas landowners were not so denied and thus ensured the promotion of their interests. "The landlord demands a share of almost all the produce which the labourer can either raise, or collect from it," he wrote. "His rent makes the first deduction from the produce of the labour which is employed on the land. It seldom happens that the person who tills the ground has the wherewithal to maintain himself until he reaps the harvest."[4]

In France, in 1789, a revolutionary counterpart of Goya's *Capricho* appeared with the title *A faut esperer q'eu se jeu la finira bentot* (Got to hope t'game ends soon) (fig. 1).[5] A white-gloved bishop and a duke, whose ruff and plumed hat are centuries out of date, are carried on the back of a farm laborer wearing ragged shirt and stockings. The pockets of those riding are stuffed with the titles and privileges that have been granted them, the peasant's with what his station in life requires from him: service in the militia, duty on salt and tobacco, the church tithe, tribute in the form of labor, and taxes on cultivation that peasants (unlike the nobility) were forced to pay. All but the tobacco tax can be found mentioned in lists of "grievances," "complaints," and "remonstrances" sent to the crown by four separate parishes that same year.[6] In a companion print, *J'savois ben qu' jaurions not tour* (I knew right we'd get our turn), a noble was shown carrying the peasant and the cleric bearing scales of justice, in whose pans rested papers inscribed: *Egalité et Liberté* (Equality and Liberty) and *Soulagement du Peuple* (Relief of Common People).[7]

In 1795 Gaspar Melchor Jovellanos (see cat. 30) published an admirable, detailed report on agriculture and on

A FAUT ESPERER Q'EU SE JEU LA FINIRA BENTOT

Fig. 1. André Basset,
A faut esperer q'eu se jeu la finira bentot.
Etching, hand-colored.
Private Collection

how Spanish law and policy affected it: "¿No ha bastado agravar su condicion, haciendo recaer sobre ella los pechos y servicios de que se dispensaba al clero, á la nobleza, y á otras clases menos respetables? . . . Las pensiones mas duras y costosas refluyen cada dia sobre el labrador por un efecto de las exenciones dispensadas á otras artes y ocupaciones. Las quintas, los bagages, los alojamientos, la recaudacion de bulas y papel sellado, y todas las cargas concejiles agovian al infeliz agricultor, mientras tanto que con mano generosa se exime de ellas á los individuos de otras clases y profesiones. La ganadería, la carretería, la cria de yeguas y potros las han obtenido, como si estas hijas ó criadas de la agricultura fuesen mas dignas de favor que su madre y señora. Los empleados de la real hacienda, los cabos de ronda, guardas, estanqueros de tabaco, de naipes y pólvora, los dependientes del ramo de la sal, y otros destinos increiblemente numerosos logran una exencion no concedida al labrador. ¿Pero qué mas? los ministros de la inquisicion, de la cruzada, de las hermandades, y hasta los sindicos de conventos mendicantes

han arrancado del gobierno estas injustas y vergonzosas exenciones, haciendo recaer su peso sobre la mas importante y preciosa clase del estado." (Was it not enough that their miserable condition should be made even worse by oppressing them [agricultural workers] with taxes on plebeians and obligatory service from which the clergy, the nobility, and now additional classes less worthy of respect are exempted? . . . As a result of exemptions granted to other crafts and occupations the harshest and heaviest annual charges come down each day upon men cultivating the soil. The conscription of soldiers and of beasts of burden, billeting, levies for bulls [indulgences], and for stamped paper, and all the municipal charges fall on the wretched husbandman, while with a generous hand members of other professions are exempted. Herders, cartwrights, and the breeders of mares and colts have obtained exemptions, as if those daughters, or servants, of agriculture were worthier of aid than the mother and mistress. Persons employed in the royal treasury, corporals on garrison patrol, guardians, retailers of government monopoly goods, tobacco, cards and gunpowder, persons involved in the collection of the salt duty, and an incredible number of other professions – all benefit from exemptions that are not granted cultivators. But what else? Officers of the Inquisition, of the crusade [indulgences], of the brotherhoods, and even syndics of mendicant orders have extorted from the government these unjust and shameful exemptions, so that the weight of their taxes falls upon the most important and valuable class of the state.)[8]

On one level the moral of Goya's print is that when men carry donkeys it is a state of things turned upside-down, as when a man tends the baby at home and his wife goes hunting. But there is a more profound moral: when productive men must spend their lives carrying on their back asses who eat, as they themselves cannot, and who spur them brutally, then society itself is upside down.[9] The theme of Aesop's fable had been put to similar use in expressing rebellion for centuries, especially in times of oppres-

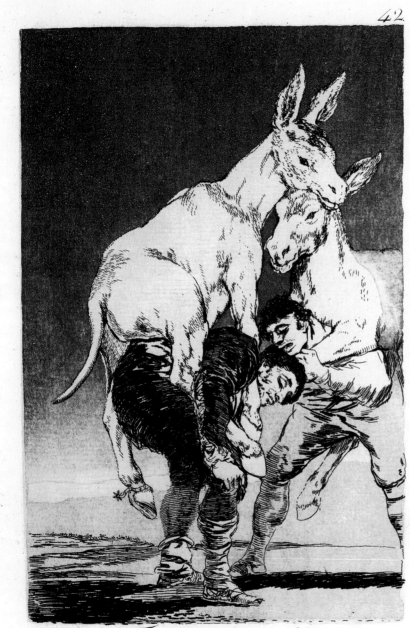

42.

Tu que no puedes.

sion and incipient class struggle.[10] These men with their eyes closed do not yet comprehend the injustice done them.

Contemporary Explanations:

Ayala: *Las clases útiles de la sociedad llevan todo el peso de ella, ó los verdaderos burros á cuestas.* (The useful classes of society bear all its weight, or the true asses on their backs.)

Prado: *Quien no dira que estos dos caballeros son caballerias?* (Who would not say that these two gentlemen were mounts [mules]?)

Biblioteca: *Los pobres y clases utiles de la Sociedad, son los que llevan acuestas à los burros, ó cargan con todo el peso de las contribusiones del estado.* (The poor and useful classes of society must carry the asses on their backs, or are burdened with the whole weight of the state's dues.)

Douce: The world upside down, or useful men the tools of rich asses.

<div align="right">E.A.S.</div>

1. Giuseppe Maria Mitelli, *Proverbj figvrati*, 1678, no. 25 of a group of engravings of proverbs dedicated to the Serenissimo Principe Francesco Maria di Toscana.

2. Connelly, *Diccionario*, 1797-1798; Academia, *Diccionario*, 1791, faults the person who makes the request: "explica la imprudencia y poca consideracion de algunos, que encargan, ó mandan executar lo que es imposible, ó no es capaz de hacerse"; both under *llevar*.

 F.J. Sánchez Cantón noted that the title was the first half of a saying, in *Los Caprichos de Goya y sus dibujos preparatorios* (Barcelona, 1949), p. 86.

3. Goya made the spur considerably more prominent in the print than in the preliminary sanguine chalk and wash drawing, Prado, Madrid, 98; G-W 535; G., II, 100.

4. Adam Smith, "Of the Wages of Labour," in *An Inquiry into the Nature and Causes of the Wealth of Nations*, reprinted in Peter Gay, ed., *The Enlightenment: A Comprehensive Anthology* (New York, 1973), p. 586. The translation into French of Smith's book by Boucher and Condorcet, *Recherches sur la Richesse des Nations*, is one of the books proposed for a French library in the Osuna manuscript "Projet de Bibliothéque dressé d'aprés les notes remises par S. E. Madame la Duchesse d'Ossuna [*sic*]," p. 14; Biblioteca Nacional, Madrid, MS. 11.140.

5. Three papers in the bishop's pocket are inscribed: *Eveque / Abbé de / Duc et pair / Comte D* (Bishop / Abbot of / Duke and peer / count of); *Pension* (Annuity) and *ostantation* (ostentation); while those in the

peasant's are labeled: *Sel et tabac / Tailles corveé* Salt and tobacco tax / (Taxes, tribute in the form of labor), *Dixmes / Millices* (Tithes / [service in the] Militia). The noble's sword is marked: *rouer de sang* (to thrash until blood is drawn), and the handle of the peasant's mattock: *moult de larmes* (much tears). The print seems to be a copy of that published by André Basset, 1798, reprod. in Peter Burke, *Popular Culture in Early Modern Europe* (New York, 1978), fig. 19.

6. See the lists from Saint-Jean-de-la-Ruelles, Lion-en-Sullias, Pithiviers-le-Vieil, and Erceville, in Philip Dawson, ed., *The French Revolution* (Englewood Cliffs, N. J., 1967), pp. 22-32.

7. Etching, hand-colored, signed: *AP* and dated *1789*, reprod. in Burke, *Popular Culture*, fig. 20.

8. Gaspar Melchor de Jovellanos, *Informe de la Sociedad Económica de Madrid al Real y Supremo Consejo de Castilla en el expediente de ley agraria (Madrid, 1820), pp. 172-173. (First published in 1795.)*

9. *See Sten Åke Nilsson, "The Ass Sequence in Los Caprichos," Konsthistorisk tidskrift 47, no. 1 (1978), pp. 33-36.*

10. Ibid.

50

Design for a frontispiece to a set of *Sueños* (Dreams), first version
1797

Pen and black and brown ink, over a slight chalk sketch
230 x 155 mm.
Verso: Drawing for *Caprichos*, plate 6 (G-W 462)
References: G-W 538; G., II, 101.
Museo del Prado, Madrid, 470

Spain only

The two designs by Goya for a frontispiece to a set of *Sueños* (Dreams) are of primary importance to our understanding of the *Caprichos*, for through their examination we apprehend the genesis of the set of prints.[1] In the earlier drawing, Goya sits in a painting chair with casters, his head resting on the box of painting materials set into its stand (fig. 1).[2] The lid is closed, for apparently Goya intends to address the world, not in his customary way with his brushes, but through a different medium, etching. Propped against the side of his chair and by a pile of books is the large copper plate for *Margarita de Austria, on horseback*, a set of prints after Velázquez he had etched almost twenty years earlier.[3] Since images in prints reverse those of their copper plates, the queen is seen riding toward the right, rather than the left. Although the sheet is badly stained from Goya's having run it through a press to transfer its image onto a copper plate, the head, chest, and forelegs of the horse, the long diagonal of the queen's skirt (foreshortened due to the angle of the plate), and the decorative plume atop her head are all clearly visible.[4]

In showing an earlier work at his feet, Goya was following a traditional practice as we see it, for example, in a 1793 frontispiece designed by Charles Monnet for volume 2 of Jean-Jacques Rousseau's *Philosophie* (fig. 2).[5] At the philosopher's feet lie various of his earlier works, most prominently the manuscript of the *Confessions*. Bathed by rays of light from the Triune God, he offers to an image of the Virgin and Child his new manuscript dedicated "a tout français aimants encore la justice et la verité" (to all Frenchmen

Fig. 1. Painting stand. Engraving in Denis Diderot, *Encyclopédie* (1771). Museum of Fine Arts, Boston

Fig. 2. Frontispiece. Etching and engraving in Jean-Jacques Rousseau, *Philosophie*, vol. 2 (1793). Museum of Fine Arts, Boston, Bequest of William A. Sargent

who still love justice and truth).

Goya's concept for his frontispiece differs from Rousseau's in several significant ways. Whereas the writer is active and frowns over his work, Goya seems to dream, or even sleep, for his eyes are closed. Furthermore the source of light in the drawing is not the Triune God, but the artist's own head, as indicated by the incisive, diagonal strokes depicting rays emanating from it. Caught in this stream of light are faces, among them that of Goya, looking amused, sad, or terrified by the content of the dreams that are to be depicted.

As an antecedent for the two designs for the frontispiece, as well as for *Capricho* 43, George Levitine reproduced an illustration used in 1699 in the collected works of the seventeenth-century poet and satirist Quevedo, where it served to mark the beginning of a piece called *La Fortuna con Seso y la Hora de Todos* (Fortune with Good Sense and the Last Judgment) (fig. 3).[6] With eyes closed as though dreaming, the poet sits somewhat stiffly at his work table, from which hangs a large paper bearing the titles of two well-known books: *LOS SUEÑOS DE DON FRANCISCO DE QUEVEDO* (The Dreams of Don Francisco de Quevedo) and *La Vida del gran TACAÑO* (The Life of the Great Cheat). Goya may, or may not, have used this illustration for his own composition. However, there can be no doubt that Goya had read the work featured on the scroll, *Los Sueños*, and that it played a significant role in the creation of the *Caprichos*. In a series of dreams Quevedo recounted that he visited the nether regions and there conversed with its inhabitants, both native and otherwise. He learned that the difference between demons and human beings is so slight that at times the two may be interchangeable. It was Goya's original intent to use the same device of dreams for his criticisms of the society in which he lived. For the first version of the *Caprichos* he made twenty-eight or more preparatory, satirical drawings for *Sueños* of human beings who all too often have transformed themselves not into demons, but into animals, monsters, or witches.[7]

From the prologue of one of Quevedo's

Fig. 3. *Quevedo Dreaming.* Engraving in Francisco de Quevedo y Villegas, *Obras,* vol. 1 (1699). Houghton Library, Harvard University

Sueños, La Visita de los Chistes (Visit of the Jests), Goya derived the curious visual device used in his frontispiece. There we read: "me quedé dormido: luego que desembarazada el alma se vió ociosa sin la tarea de los sentidos exteriores, me embistió de esta manera la comedia siguiente; y así la recitaron mis potencias á obscuras, siendo yo para mis fantasias auditorio y teatro." (I fell asleep; then when the soul found itself at leisure, free of the cares of the external senses, I was assaulted in this manner by the following comedy. Thus did my faculties present it in the dark, while I was both theater and audience for my fantasies.)[8] Huge creatures, watched by some of the faces at the left of the drawing, suggest what Goya may encounter in his own *Sueños*. At the top of the sheet is a donkey, well-known symbol of Ignorance, its jaws slightly open and hooves thrust toward us. To the right of them is the head of a dog with its tongue hanging out, symbolizing the insatiable desire for what others possess. Below this pair, bats wheel through darkness. Throughout the centuries various unfavorable symbolic meanings, such as Hypocrisy or Ignorance,

have been ascribed to these "hybrids," half-mammal and half-bird. In a sixteenth-century emblem by Alciatus, *Alivd de verpetilione,* bats are equated with persons of ill repute who take refuge in darkness because they fear justice.[9] We can recognize examples of all three vices in the pen drawings that were to follow. Covetousness is seen in *Sueño* 15, *Sacrificio del Ynteres* (Sacrifice to Interest), where a bargain is struck between parents who covet position and a deformed, elderly suitor who covets their daughter.[10] Among those who fear justice are the street walkers of *Sueño* 22, inscribed: *Asiento. Si ay culpa en la escena la tiene el trage* (Seat [buttocks]. If anything can be blamed in this scene, it is the dress).[11] *Sueño* 27 is an instance of unconscionable ignorance. Two doctors, depicted as the asses they are, tend a patient unlikely to survive their ministrations. *Brujas disfrazadas en fisicos comunes* (Witches Disguised as Ordinary Physicians) was Goya's title (see cat. 47).[12]

Poised alertly at Goya's feet is a lynx with pointed ears, an animal whose extraordinarily acute eyes enable it to pierce the darkness.[13] Because of this quality the Spanish eighteenth-century dictionary gives as its common metaphoric use: "el que tiene muy aguda la vista y gran perspicacia y sutileza para comprehender, ó averiguar las cosas dificultosas" (one who has very keen vision and great sagacity and subtlety in understanding or in inquiring into very difficult matters).[14] The lynx is to be Goya's guide and friend as he explores the dark realms of vice depicted in his *Sueños*.

E.A.S.

1. This drawing was not the earliest one for the title page since it was preceded by a very slight, hitherto undescribed sketch for the composition on the verso of another *Sueño, Se aberguenza de qe su Madre . . .* (Prado, Madrid, 28); G-W 484; G., II, 60.

2. See Denis Diderot, *Encyclopédie; ou dictionnaire raisonné des sciences, des arts et des métiers. Receuil de planches, sur les sciences, les arts libéraux, et les arts méchaniques,* vol. 7 (Paris, 1771), under *peinture,* pl. II, fig. 1. For the stand in use, see pl. I, fig. 1.

3. G-W 92; H. 6.

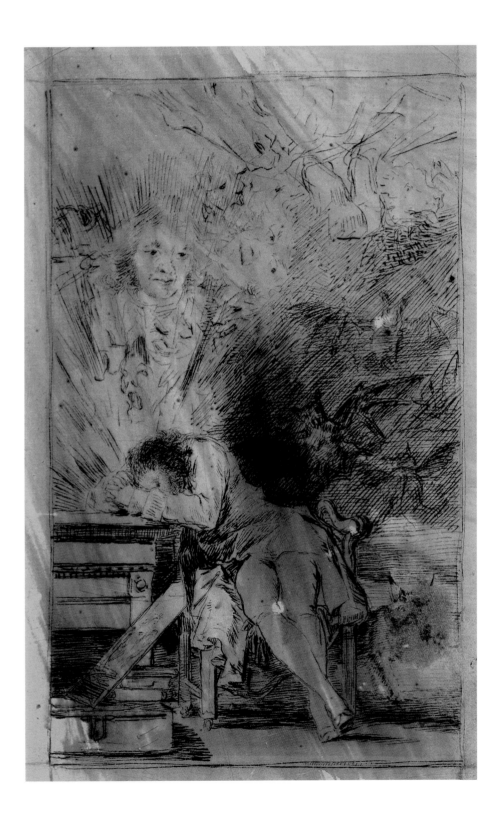

4. George Levitine, perhaps working from a reproduction rather than the original drawing, read this figure as "Minerva holding a shield and lance," although he admitted being unable to make an exact identification; see "Some Emblematic Sources of Goya," *Journal of the Warburg and Courtauld Institutes* 22 (1959), p. 121, n. 82.

5. Etching and engraving by J.B.M. Dupréel after Charles Monnet, in Jean-Jacques Rousseau, *Oeuvres completes*, vol. 30: *Philosophie*, vol. 2 (Paris, 1793), frontispiece; Museum of Fine Arts, Boston, Bequest of William A. Sargent, B Reg 2134 30/38.

6. Francisco de Quevedo y Villegas, *Obras. Nueva impresión corregida y ilustrada con muchas estampas muy donosas y apropriadas á la materia* (Antwerp, 1699), vol. 1, facing p. 229. The copper plate was reused in the same position in the 1726 edition cited by Levitine, "Some Emblematic Sources of Goya," p. 114 and pl. 16, fig. f.

7. The surviving drawings are owned by the Prado, Madrid; see G., II, 40-65; G-W 460, 464, 473, 477, 480, 484, 488, 505, 528, 531, 560, 572, 576, 578, 582, 584, 588, 590, 592, 593, 620, 622-625, 627.

8. Quevedo, *Obras escogidas de Don Francisco de Quevedo Villegas*, 2nd ed. (Madrid, 1794), vol. 1, p. 378.

9. *Alciato: Emblemas*, ed. Santiago Sebastián (Madrid, 1985), no. 70 (62), p. 98.

10. G-W 480; G., II, 51.

11. G-W 622; G., II, 56, reads this as *Ay viento* (It is windy). However, after a careful examination of the drawing, I agree with F.J. Sánchez Cantón's reading, *Asiento*, in *Museo del Prado: Los dibujos de Goya* (Madrid, 1954), vol. 1, no. 33.

12. G-W 531; G., II, 58.

13. Since its face is obscured by a particularly bad stain in the paper, it would be impossible to identify it as a lynx were it not that it reappears like a recumbent, wide-eyed, heraldic creature in the subsequent drawing for the title page (cat. A39), as well as in *Capricho* 43 (cat. A62), where Levitine was the first modern scholar to so identify it. Since Levitine derived his views on *Capricho* 43 and its drawings solely from the Prado manuscript (see cat. A62), he suggested that Goya's use of it was based in part on an emblem of *Fantaia* in *Iconologia del Cavaliere Cesare Ripa Perugino; Notabilmente accresciuta d'Imagini, di Annotazioni, e de Fatti dall' Abate Cesare Orlandi . . .* (Perugia, 1764), vol. 3, p. 12. Here, Fantasy, rejecting the chimeric monsters offered her, chooses Reason and turns her face toward a lynx and the symbols of Prudence; Levitine, "Emblematic Sources of Goya," pp. 119-121 and pl. 17, fig. f.

14. Academia, *Diccionario*, 1791, under *lince*.

51

**Frontispiece to a set of *Sueños*
(Dreams), second version**
1797
Pen and brown ink, over a slight chalk
sketch
248 x 172 mm.
Inscribed in chalk, upper margin: *Sueño
1⁰* (The First Dream); on pedestal: *Ydi-
oma univer/sal. Dibujado / y Grabado pʳ
/ Fᶜᵒ de Goya / año 1797* (Universal lan-
guage. Drawn and graved by Francisco de
Goya in the year 1797); lower margin: *El
Autor soñando. / Su yntento solo es
desterrar bulgaridades / perjudiciales, y
perpetuar con esta obra de / caprichos, el
testimonio solido de la verdad.* (The
author dreaming. His only purpose is to
banish harmful ideas commonly believed,
and to perpetuate with this work of
Caprichos the solid testimony of truth.)
References: G-W 537; G., II, 39.
Museo del Prado, Madrid, 34

Spain only

The composition of the first version of
Goya's frontispiece was as intricate as its
ideological content (cat. 50). Here both
the painting box and the prominent cop-
per plate representing his earlier set of
prints have been eliminated and replaced
by a square pedestal. Gone, too, is the
signal imagery of faces responding to the
dreams that will be unfolded, and in its
place is a great arc of light. The donkey
and the dog, which symbolized part of
the content of the satirical dreams, have
disappeared. From the original drawing
there remain only the sleeping artist, the
lynx, his keen-eyed mentor, and the
wheeling bats. One of these last has
grown immense, and owls have joined
the flight through their dark realm.

Continuing to use Quevedo's device of
dreams, or visions, Goya wrote *Sueño 1⁰*
(The First Dream) at the top of the sheet.
The pedestal on which the artist now
leans is inscribed *Ydioma universal* (Uni-
versal Language), the phrase having the
same connotations that his French con-
temporaries Gravelot and Cochin gave it
in the foreword to their *Iconologie par
figures* (Iconography in Figures) in the
latter part of the eighteenth century:

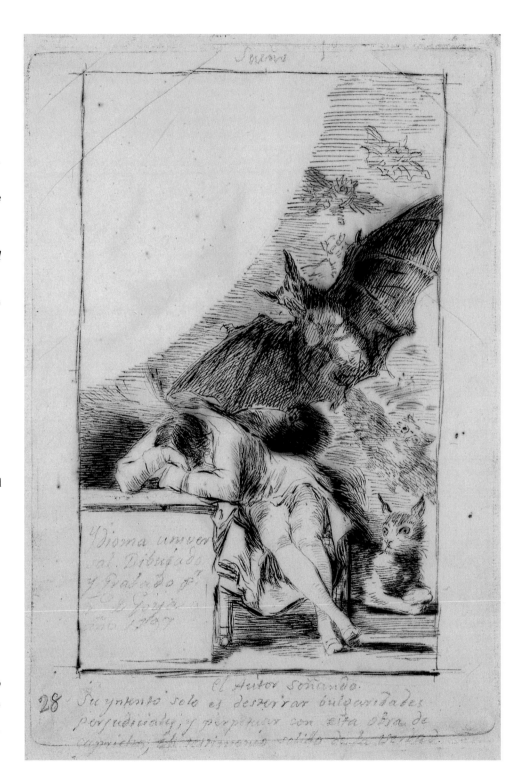

Fig. 1. Anonymous, *Excaecat Candor.* Engraving, in Diego Saavedra Fajardo, *Idea de vn principe politico christiano*, 1640.
Houghton Library, Harvard University

"l'allégorie, pour servir de langue universelle à toutes les nations, a besoin d'être claire, expressive, éloquente; privée de ces qualités indispensables, elle n'offre plus qu'une énigme obscure, déplacée, fatiguante, semblable à celles que les Egyptiens s'efforçoient de couvrir d'un voile impénétrable, pour en dérober la connoissance à ceux qui n'étoient point initiés à leurs mystères" (Allegory, if it is to serve as a universal language to all nations, must be clear, expressive, eloquent; when deprived of these indispensable qualities it offers no more than an obscure enigma, out of place, tiresome, like those the Egyptians were careful to hide under an impenetrable veil so that those not initiated into their mysteries should be deprived of understanding).[1] The first version of Goya's frontispiece was visually complex where the second is simpler, yet a more cogent reason for its revision may have been to alter the ideological content so that it would be universally understood.

In the earlier design (cat. 50), the ass, the dog, and the bats symbolized Ignorance, Greed, and Hypocrisy. However, bats and owls had also a role in Christian iconography. In the Middle Ages a bat was seen as an incarnate form of the devil, and the owl as a creature that preferred darkness since it did not tolerate the light of Truth. In this sense the owl was considered analogous to those who refused to acknowledge Christ.[2] In the eighteenth century a more specialized role was suggested for these creatures. Gravelot and Cochin tell us in their *Iconologie* that around Ignorance "volent des hiboux et autres oiseaux nocturnes" (fly owls and other night birds), adding that these symbols are "trop connus pour avoir besoin d'explications" (too well known to require explanation).[3]

Between the early Christian and the eighteenth-century view is a seventeenth-century emblem that forms a precedent for Goya's imagery; it is among those devised by the Counselor and Ambassador Diego Saavedra Fajardo, for the education of Christian princes (fig. 1).[4] On the right side, the sun sheds its light on the sphere of this world, while on the left, bats and owls take refuge from its rays. Saavedra summarized this emblem as *Delumbre con la Verdad la Mentira* (Overwhelm Falsehood with the Truth).[5] His explanation of the image reads in part: "porque ninguna cosa mas eficaz, que la verdad para deshazellos [engaños y artes], i para tener mas lejos la mentira, la qual no se atreve a mirar rostro a rostro a la verdad. A esto aludiò Pythagoras, quando enseñò, que no se hablase vueltas las espaldas al sol, queriendo significar, que ninguno devia mentir, porque el que miente, no puede resistir a los rayos de la verdad, significada por el sol, asi en ser vno, como en que deshaze las nieblas, i ahuyenta las sombras, dando a las cosas sus verdaderas luzes, i colores, como se representa en esta empresa, donde al paso, que se và descubriendo por los Orizontes el sol, se va retirando la noche, i se recòjen a lo obscuro de los troncos las aves nocturnas, que en su ausencia embozadas con las tinieblas hazian sus robos salteando engañosamente el sueño de las demas aves. Que confusa se halla vna Lechuza, quando por algun accidente se presenta delante del sol? En su misma Luz tropieza, i se embaraza: su resplandor la ciega, i deja invtiles sus artes." (for there is nothing more effective than Truth to undo them [i.e., deceptions and tricks], and to keep Falsehood at bay, which does not dare face Truth. Pythagoras alluded to this when he taught that one should not talk with one's back to the sun, by which he meant that no man should lie, for he who lies cannot withstand the bright rays of Truth. Truth is symbolized by the sun because it is one and also because it dissipates fog and drives away the shadows, giving things their true light and colors, as is represented in this emblem where, as the sun appears above the horizon, night begins to withdraw and nocturnal birds retire to the darkness of their tree trunks; in the absence of the sun, cloaked in darkness, they prey, slyly falling upon the other birds as they sleep. How disconcerted must an owl feel, when, by some chance, she comes upon the Sun. In that same Light, she stumbles and is confused; its brightness blinds her and renders her cunning useless.)[6]

Goya seems to have drawn on all three of these traditional iconographic uses of bats and owls in his emblem. But when we read his inscription in the lower margin, it becomes apparent that his principal aim, like Saavedra's, is to depict the age-old struggle between light and dark and that the purpose of his satirical dreams is a serious one: "El Autor soñando. Su yntento solo es desterrar bulgaridades perjudiciales, y perpetuar con esta obra de caprichos, el testimonio solido de la verdad." (The author dreaming. His only purpose is to banish harmful ideas commonly believed, and with this work of *Caprichos* to perpetuate the solid testimony of Truth). The light in Saavedra's emblem was the light of Truth. In the frontispiece to Rousseau's *Philosophie* (cat. 50, fig. 2), it was shed by the Triune God and fell on the philosopher as he worked. In this drawing the immediate source of light is human. Through the creative mind and intellect of an artist the darkness, with its symbolic bats and owls, is to be pushed back. He will shed light on "harmful ideas commonly believed" so that we may recognize them for what they are, reject them, and thus help "perpetuate the solid testimony of Truth."

E.A.S.

114

1. Gravelot and Cochin, *Iconologie*, vol. 1, pp. x-xi. The plates first appeared in 1765-1781 in the *Almanach iconologique*; see Vera Salomons, *Gravelot* (London, 1911), pp. 56-57.

2. On bats and owls see Mateo Gómez, *Sillerías*, pp. 93-94, 47-48, respectively.

3. Gravelot and Cochin, *Iconologie*, vol. 2, pp. 8-9.

4. Anonymous engraving, in Diego Saavedra Fajardo, *Idea de vn principe politico Christiano: Representada en cien Empresas* (Monaco, 1640), p. 74 [emblem XI; XII in later editions]. It was an enormously popular book. Mario Praz, *Studies in Seventeenth-Century Imagery*, 2nd ed. (Rome, 1964), p. 483, lists some twenty Spanish editions predating the year 1800, as well as later ones.

5. Saavedra, *Idea de vn principe politico Christiano*, index of emblems, no. XI.

6. Ibid., pp. 75-76.

52

El sueño de la razon produce monstruos. (The sleep of Reason produces monsters.).
Caprichos, plate 43
First edition, 1799
Etching and aquatint
215 x 150 mm.
Engraved upper right margin: *43*; on pedestal: title
References: G-W 536; H. 78, III, 1.

Spain: Biblioteca Nacional, Madrid, 45.667
United States: The Metropolitan Museum of Art, New York, Gift of M. Knoedler, 18.64(43) [*illus.*]

Goya finally abandoned the concept of *Sueños* (Dreams) for the title page to his *Caprichos* and substituted his own portrait (cat. 38). Yet he retained the general composition in this aquatint, which he placed in the middle of the series. Once again, we see the sleeping artist with the wide-eyed lynx at his side, and bats and owls continue their agitated flight. As always the visual changes made by Goya must be recognized as significant. Spread out on the pedestal are sheets of drawing paper and holders with chalks, one of which is proffered to the artist by an owl. A cat has joined those night-thriving creatures, and the great cleansing arc of light has vanished, leaving only darkness in its place.

In a scholarly analysis of the various components of this etched plate, George Levitine summarized its meaning as follows: "*Capricho* 43 is conceived not as a manifesto of a new dark art glorifying unfettered phantasy, but as a warning which shows what happens to an artist who lets himself be overcome by his own imagination."[1] This widely accepted interpretation is partly supported by Goya's etched title, which can be translated as "the sleep of Reason produces monsters," but even more so by the explanation given in the Prado manuscript (see below): "Imagination forsaken by Reason begets impossible monsters; united with her, she is the mother of the arts and the source of their wonders."[2]

Levitine's attractive interpretation contains, however, a major difficulty. One cannot rely on the Prado manuscript since its authorship is more credibly attributed to Goya's friend, the playwright and poet Moratín, than to the artist himself.[3] It has transformed Goya's straightforward title into the interesting statement on the importance of a disciplined imagination just quoted. But surely, if that is what Goya meant his aquatint to convey, it would have been logical to depict a dreaming artist surrounded by a wild phantasmagoria of bizarre, Bosch-like beings. However, that is not what Goya etched. We see only zoölogically recognizable birds and animals, which, with the exception of the cat, had been displayed earlier in an entirely rational context in his frontispiece drawings for the *Caprichos* (cat. 50, 51). There careening bats and owls symbolized the world's *bulgaridades perjuciales* (harmful ideas commonly believed) that Goya, borrowing the penetrating vision of a lynx, intended to expose to light by depicting them, so that we might recognize them, combat them, and thus perpetuate *el testimonio solido de la verdad* (the solid testimony of Truth).

The antithesis of the lynx, which turns its head toward Goya, is the crouching black cat. Traditionally allied through its color to the Prince of Darkness, it stares from the print with single-minded intensity of purpose.[4] To left and right of it are four owls, one alighting with an air of self-satisfaction on Goya's back. Three of these birds, like subjects in a portrait, concentrate their gaze on the viewer. The fourth, which has taken up Goya's chalk holder in its claw, looks toward the artist as if it were urging him to depict them in the flattering guise of wise owls. But Goya will not do it. His holder is as empty of chalk as are their pretensions to wisdom. These four owls, together with those wheeling behind them, belong not to any species sacred to Minerva (Goddess of Wisdom) but to the ill-augured *buho* (*bubo*, horned owl), recognizable by dark spots on their impressively large bodies, by the manner in which two tufts of feathers, resembling ears, rise from their heads, and by the characteristic shape of their curved beaks.[5] *Búhos* may pose in the light, as though they were

part of it, but their natural habitat remains its enemy, darkness.

Despite its position in the middle of the series, some of Goya's contemporaries continued to think of this plate as a title page (see below). Did they see it as marking the opening of a second and more disturbing part of the *Caprichos*, or did they still see it as summarizing the statements made throughout the series of etchings? There is a clear ideological sequence between the print and the two drawings that precede it. In the first drawing (cat. 50), Goya tells us that, aided by the recumbent lynx, he will portray the vices of society in a series of dreams, much as Quevedo did. In the second (cat. 51), where the lynx stands alertly, Goya says that his mind and his hand will be the instruments through which our vices are laid open to Light, so that another of its aspects, Truth, may be established in the world. In the print the lynx has a fresh look of alarm and warns us of the need for vigilance. When we sleep, we do not see, nor can we denounce, the monsters of ignorance and vice.

Contemporary Explanations:

Prado: *La fantasia abandonada de la razon produce monstruos inposibles: unida con ella, es madre de las artes y origen de sus marabillas* (Imagination forsaken by Reason begets impossible monsters: united with her, she is the mother of the arts and the source of their wonders).

Sánchez: *En durmiendose la razon, todo es fantasma y visiones monstruosas* (When Reason falls asleep, all is filled with phantoms and monstrous visions).

Stirling: *El sueño de la razon produce monstruos; y es preciso ser lince para descifrar su significacion* (The sleep of Reason begets monsters, and one must be a lynx [a person of great perspicacity] to decipher their meaning).

Simon: *Portada para esta obra. Cuando los hombres se hacen sordos al grito de la razon, todo se buelve visiones.* (Frontispiece for this work. When men deafen themselves to the cry of Reason, the world is filled with visions.)

E.A.S.

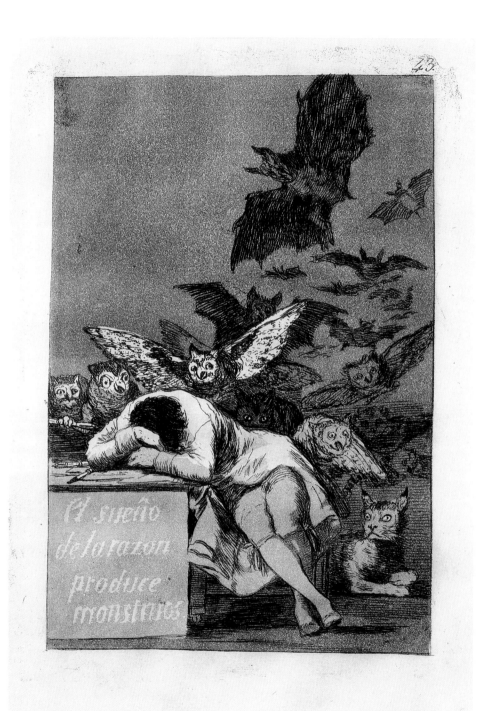

1. George Levitine, "Some Emblematic Sources of Goya," *Journal of the Warburg and Courtauld Institutes* 22, nos. 1-2 (1959), p. 130.

2. The Ayala version, on which the Prado MS. may have depended, reads: "La fantasía abandonada de la razón produce monstruos, y unida con ella es madre de las artes"; see C. Muñoz y Manzano, Conde de la Viñaza, *Goya: Su tiempo, su vida, sus obras* (Madrid, 1887), p. 344, where the MS. was published for the first time.

3. F.J. Sánchez Cantón, *Los Caprichos de Goya y sus dibujos preparatorios* (Barcelona, 1949), pp. 18-19, pointed out that the Prado MS. is stylistically unlike Goya's writing. René Andioc, "Al margen de los *Caprichos*: Las 'explicaciones' manuscritas," *Nueva revista de filología hispánica* 33, no. 1 (1984), pp. 257-283, suggested Moratín as its most likely author.

4. On the traditional iconography of the cat, see Mateo Gómez, *Sillerías*, p. 78; the cat was also associated with Sloth and Lust.

5. In the past, the definition of species of owls was less clear-cut than it is today; see Academia, *Diccionario*, 1791, and Terreros, *Diccionario*, 1786-1793. Covarrubias, *Tesoro*, 1611, described the *lechuza* (noctua) as the one dedicated to Minerva.

53

Duendecitos. (Little Hobgoblins.)
Caprichos, plate 49
First edition, 1799
Etching and burnished aquatint
215 x 150 mm.
Engraved upper right margin: *49*, lower margin: title
References: G-W 549; H. 84, III, 1.

Spain: Biblioteca Nacional, Madrid, 45.653
United States: The Metropolitan Museum of Art, New York, Gift of M. Knoedler, 18.64(49) [*illus.*]

Duendes (hobgoblins), the seventeenth-century lexicographer Covarrubias wrote, are commonly believed to be among the spirits that fell with Lucifer from heaven but, instead of going down to hell or living in the air, took refuge in the world. They frighten people, play tricks on them, and are given to hiding treasure in subterranean chambers.[1] In the earlier part of the following century, Padre Feijóo wrote with his customary good sense: "si se habla (como aqui hablamos) de aquellos demonios, à quienes con particularidad se dà el nombre de Duendes, esto es, demonios juguetones, chocarreros, que no hacen otra cosa, que andar moviendo trastos, tirando chinas, espantando la gente con terrores inutiles, ò divirtiendola con bufonadas indiferentes, digo que no los hay, ni los ha habido; porque Dios nunca permite al demonio estas apariciones, sino yà para el exercicio de los buenos, yà para enmienda, escarmiento, ò castigo de los malos. Pero de estos Duendes, que se dice andan habitualmente jugueteando en las casas, no vemos seguirse algunos de los expressados effectos." (Referring, as we do here, to those demons who are specifically called hobgoblins, that is, coarse, playful demons who do nothing but go about moving furnishings, throwing pebbles, frightening people with pointless fears, or amusing them with indifferent pranks, I say that they do not exist, nor have they ever done so; for the Lord never permits the devil such apparitions, unless it were to test good people, to reform, to make an example of, or to punish the wicked. But as for those hobgoblins who are said to go about habitually playing tricks in houses, we do not see them followed by a single one of these consequences).[2] By the end of the eighteenth century the term *duende* was often used to designate friars, perhaps in part owing to the editor of a widely read satirical review, *El duende de Madrid* (The Hobgoblin of Madrid), who included *Sueños* (Dreams) written by himself in which hobgoblins all too often wore the habits of friars.[3]

All these opinions on *duendes* are woven into Goya's *Capricho*. In the foreground he depicted two monastic *duendecitos* refreshing themselves in a vaulted chamber, lit by a barred window high in the wall. We recognize them as such even though Goya was careful to obscure certain details of their habits, such as making the cowl worn by the friar to the right unnaturally tall or leaving it uncertain whether the *duendecito* at the left is tonsured or simply bald. (In the preliminary drawing for the print, the tonsure is clearly depicted.)[4] In spite of similar obfuscations, the third hobgoblin is recognizable as a priest wearing his soutane.

Safe from the eyes of the laity, the *duendes* have poured themselves large glasses of wine. Through the subtle highlighting of their faces, Goya called attention to the way each of them drinks. As the manuscripts quoted below point out, the seated friar, whose shoes denote that he belongs to a calced (shod), or less rigorous order, takes a wholehearted enjoyment in his glass, adding to the pleasure by dipping a tidbit into it and sucking. The discalced (barefoot) friar, from a more rigorous order, half-hides his glass under his cloak with an expression of unconscionable hypocrisy. The eyes of the priest are wide with eager anticipation; his curiously pointed teeth constitute a visual pun on the Spanish saying "aguzar los dientes" (to sharpen one's teeth, i.e., to whet one's appetite). He clutches his glass in his left hand, and stretches his right, with its subtle highlights, upward toward the world on the other side of the barred window of his religious house, as though he sought even more. It is a monstrous hand. In the preliminary drawing, Goya originally

depicted it as more normal in size and then extended the fingers with such firmness that his chalk dug into the paper.

During the second half of the eighteenth century the Spanish Church was the wealthiest single institution in the nation. By 1759 it held about fifteen percent of the lands, for the most part those which were the richest and most arable, so that the Church's share of the agricultural wealth of Spain was slightly over twenty-four percent. In addition the Church received nearly one half of the income generated by the payment of tithes; it collected dues; was paid rents from its urban properties; and had a quasi monopoly over the *censo*, a kind of mortgage loan that was the single most important credit instrument for the upper classes. In that era the laity could see religious institutions spending huge sums on building, on decoration, and on what was known as "the splendour of the cult".[5]

Contemporary Explanations:

Prado: *Esta ya es otra gente. Alegres, Juguetones serviciaS; un poco golosos, amigos de pegar chascos; pero muy hombrecitos de bien.* (Now these are people of another sort. Merry, playful, accommodating, with a weakness for delicacies, fond of pranks – but quite honorable little men.)

Sánchez: *Los verdaderos duendes de este mundo son, ciertos espantajos de muchas especies, qe comen, beben, y se rien de los demas* (The true hobgoblins of this world are certain scarecrows of many sorts, who eat, drink, and laugh at others).

Stirling: *Pinta las escenas de unos duendes en un desvan: Uno de los verdaderos duendes es el Clero bien distinguido por el bonete, el zapato con evilla, la sotana, el diente agudo, ojo listo, y su mano pesada y larga. Otro es el clero regular representado pr un fraile descalzo, de aire brutal y gazmoño, que tapa las alforjas con el santo saial, y encubre el vaso de vino en la mano, y por otro fraile calcado, menos hipocrita que solo piensa en comer y beber francamente.* (This depicts a scene of hobgoblins in a garret; one of the true hobgob-

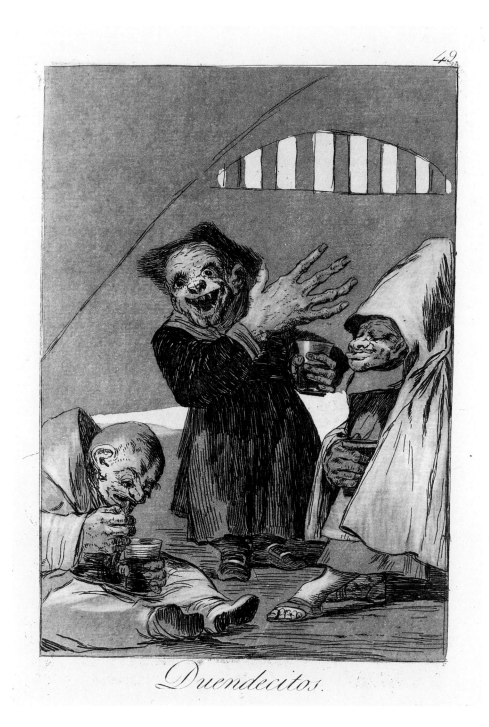

Duendecitos.

lins is the cleric, easily recognized by his square cap,[6] shoes with buckles, soutane, sharp teeth [whetted appetite], ready eye, and long and heavy hand. Another is the mendicant cleric represented by a barefooted friar [i.e., from a discalced, more rigorous order], coarse and affectedly devout in appearance, who covers his cache of booty with his holy sackcloth and hides the glass of wine in his hand; and by a shod friar [i.e., from a calced, or less rigorous order], who is less hypocritical and who openly thinks only of eating and drinking.)

Douce: Idle monks laughing at the folly of people giving them good cheer.

E.A.S.

1. Covarrubias, *Lengua*, 1611, under *duende*.

2. Fray Benito Jerónimo Feijóo y Montenegro, Discurso 4: "Duendes y espiritus familiares," in *Theatro critico universal; ó discursos varios en todo genero de materias, para desengaño de errores comunes* (Madrid: Imprenta del Supremo Consejo de la Inquisicion, 1759), vol. 3, pp. 76-77.

3. See Helman, *Trasmundo*, pp. 173, 179, who cited the review in connection with this print.

4. Sanguine, Prado, Madrid, 69; G-W 550; G., II, 107.

5. Callahan, *Church*, pp. 38-37.

6. Square caps were worn by priests who were not members of a monastic order.

54

La enfermedad de la razon (The Illness of Reason)
Sueños [number lost]
1797-1798
Pen and brown ink over a slight chalk sketch
236 x 161 mm.
Inscribed in pen and brown ink, lower margin: title, on top of an earlier inscription in chalk: *Pesadilla soñando q^e no me podia dispertar ni desen- / rredar de mi nobleza en dandoles [---]llas mons- / truos con la misma[?] [-]nt[---]a* (Nightmare, dreaming that I could neither wake up nor disentangle myself from my nobility when giving them monstrous [---]with the same[?] [---]
References: G-W 623; G., II, 65.

Museo del Prado, Madrid, 35
United States only

The *Sueño* (Dream), or in this case *Pesadilla* (Nightmare), takes place in a splendid residence, not an eighteenth-century building but one with high Gothic arches erected centuries earlier. A man in shirt sleeves and three wenches, two of them unmistakably whores, tend a pair of immobile nobles. What prevents them from moving are their impressive escutcheons or to use, as does the drawing, the pun on escutcheons, their *escudos de armas* (shields with arms). They seem to see nothing, and certainly they hear nothing for their ears are blocked by triple *escudos* (escutcheons), which in Spanish, as in English, is also the word for the metal plates with keyholes covering locks. Their helplessness is emphasized in that one noble is propped up by a cushion, and the other has to be held upright so that the pair may be fed with spoons. The only signs of activity on their part are the revealing bulges in their breeches brought about one may suppose by the young ladies.

In the eighteenth century the institution of the nobility was widely attacked. In an essay "Inutilidad del Rico ocioso" (The Uselessness of the Idle Rich), published in *El Censor* in 1781, we read: "El mas humilde artesano, el mas pobrecito oficial atareado al trabajo para servir à los demás, y no vivir à sus expensas, es para mi mas apreciable, y me parece mas digno de un verdadero honor que un Caballero el mas ilustre, el mas honrado, el mas rico; pero al mismo tiempo ocioso è inutil. Porque asi como las aguas mas puras y cristalinas se corrompen estando quietas, y esparcen la infeccion en sus rededores; asi la nobleza, aquella gran semilla de virtudes, y tan digna por otra parte de veneracion, con todas las demás bellas calidades que pueden adornar un sugeto, no pueden en la quietud del ocio, sin movimiento, sin uso, dexar de corromperse, y de inficionar la Sociedad." (The lowliest artisan, the poorest little workman given the task of serving others, and not living at their cost, is to me more valuable, more worthy of true honor than the most illustrious, the most highly revered, the richest gentleman, who at the same time is idle and useless. For even as the purest and most crystalline waters putrefy when they are still and spread infection to the surrounding area, the nobility – that great source of virtues, and otherwise so worthy of veneration, with all the other fine qualities that may adorn an individual – in the repose of idleness, without movement, without use, cannot but fail to decay and to infect society.)[1]

Jovellanos (see cat. 30) wrote a satiric poem, first published in *El Censor*, on the lamentable education of many members of the nobility.[2] He described the typical gilded noble ten generations removed from his forebear, King Chico.[3] He knows nothing of the history of Spain or of the geography of the world; indeed he has never mastered his ABCs, although he has an expert's knowledge of bullfighting.[4] Those who brought him up were "cocheros y lacayos, / dueñas, fregonas, truhanes y otros bichos" (coachmen and lackeys, / old maids, scullions, buffoons and other vermin).[5] On his life as an adult, Jovellanos commented: "¡Qué linda vida, / digna de un noble! ¿Quieres su compendio? / Puteó, jugó, perdió salud y bienes, / y sin tocar a los cuarenta abriles / la mano del placer le hundió en la huesa." (What a fine life, / worthy of a noble! Would you like a summary? / He whored, he gamed, he lost his health and worldy goods, / and before his fortieth spring / the hand of Pleasure plunged

him into his grave.)[6] Jovellanos asked:
"¿Y es éste un noble, Arnesto? ¿Aqui se
cifran / los timbres y blasones? ¿De qué
sirve / la clase ilustre, una alta
descendencia, / sin la virtud?" (And is
that a noble, Arnesto? Do crests and
coats of arms matter here? Of what use /
is an ancient lineage to the noble class /
without virtue?)[7]

*Pesadilla soñando q[e] no me podia
desenrredar de mi nobleza en dandoles
[---]llas monstruos con la misma[?]
[-]nt[---]a* (Nightmare, dreaming that I
could neither wake up nor disentangle
myself from my nobility when giving
them monstrous[---] with the same [?]
[---]): unfortunately, this earlier title by
Goya is no longer wholly legible and
lacks vital words so that we can only
speculate on aspects of this scene of
nobles and prostitutes. The nightmare
vision is Goya's, yet he does not seem to
be an actor in his dream since the male
figure in shirt-sleeves does not have the
artist's deep-set eyes and snub nose (see
cat. 38). He brandishes a great *cuchara*
(spoon), but the contents of his small
bowl are used to nourish one of the two
nobles. The other is fed from a large
bowl held by a prostitute.

How then should we interpret this
drawing? Goya seems to infer that it is
impossible to waken from a nightmare
state in which we are unable to free our-
selves from the nobility. We continue to
feed them, giving them something from
the great *cucharas* (spoons), which
appear, however, to be empty. Does
Goya mean us to see each of these uten-
sils as a *cuchar*, an antiquated form of
the word for spoon whose other meaning
was the duty on grain payable to the
crown?[8] If so, are we to ask ourselves
whether these high-born persons merit
the tribute that must be paid them? All
we know is that Goya changed the title
by writing over it in ink: *La enfermedad
de la razon* (The Illness of Reason).

<div align="right">E.A.S.</div>

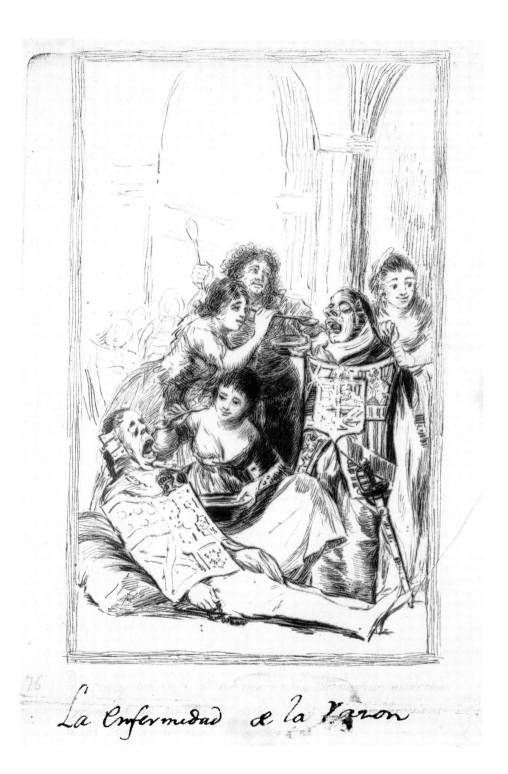

La Enfermedad de la razon

1. "Inutilidad del Rico ocioso," Discurso 9, *El Cen-
sor,* 1781, pp. 129-130; the author is not given. It is
headed by a quotation from Virgil's *Aeneid,* which is
then rephrased as a question: "¿Qué? ¿tanta confi-
anza os ha inspirado / Vuestro linage?" (What? Has
your lineage inspired so much confidence in us?)

2. Gaspar Melchor de Jovellanos, "Satira segunda. A Arnesto: Sobre la mala educacion de la nobleza," in *Poesías*, ed. José Caso González (Oviedo, 1961), pp. 242-253. The satire was published in *El Censor*, May 31, 1787, as Discurso 155; see Jovellanos, *Poesías*, p. 241.

3. Jovellanos, "Satira segunda," line 7, "un nono nieto del Rey Chico," i.e., Boabdil, the young fifteenth-century king who surrendered the kingdom of Granada.

4. Ibid., see lines 51-89.

5. Ibid., see lines 94-96.

6. Ibid., lines 222-226.

7. Ibid., lines 263-266.

8. See Academia, *Diccionario*, 1791; Connelly, *Diccionario*, 1797-1798; Terreros, *Diccionario*, 1786-1793, all under *cuchar*.

55

Los Chinchillas. (The Chinchillas.)
Caprichos, plate 50
First edition, 1799
Etching, burnished aquatint, and burin
205 x 150 mm.
Engraved upper right margin: *50*, lower margin: title
References: G-W 551; H. 85, III, 1.

Spain: Biblioteca Nacional, Madrid, 45.666
United States: The Metropolitan Museum of Art, New York, Gift of M. Knoedler, 18.64(50) [*illus.*]

It has been shown that the title of this print, *Los Chinchillas* (The Chinchillas), is derived from a popular comedy of manners by José de Cañizares, *El dómine Lucas* (Lucas, the Pedant).[1] Lucas de Chinchilla was a member of a family that became synonymous with nobles excessively devoted to their ancestors. We are told that Lucas is a student at the University of Salamanca; nevertheless he gives the following semiliterate account of his lineage: " . . . La ejecutoria / de los Chinchillas hidalgos / in saecula saeculorum, / quae tuarum, quae tuarum: / y esta, y el titulo antiguo, / que á un tal nuestro antepasado / Guitibamba de Chinchilla / dió Noé, estando embarcado / en la Arca, en que le hace / de la hermandad secretario, / familiar del Santo Oficio, / y Merino de Toranzos, / se las pusimos al duende." (. . . The pedigree / of the Chinchillas, nobles / for ages of ages, / quae tuarum, quae tuarum / and this one [pedigree], and the ancient title / that Noah gave to one of our ancestors, / some Guitibamba de Chinchilla, / when he was aboard the ark / where Noah made him / Brotherhood Secretary, / Servant of the Holy Office [Inquisition] / and District Judge of Toranzos, / and we held them [our pedigree and ancient title] up against the goblin.)[2]

Since the Chinchillas use their *escudos* (escutcheons) to protect themselves against a goblin and, in the literal sense of the word, as shields, when they fight a duel, it is fitting that Goya should show them wearing *cotas* (coats), which are in fact *cotas de armas* (coats of arms), the embroidered vestures worn by heralds

on which arms were displayed.[3] Nobles may trumpet their lineages; but their lineages may also render them inactive, for the one at the left is as constricted by his tabard as though he were still an infant in swaddling clothes. He compulsively tells his beads, while the other wears a ceremonial sword incapable of cutting.

These Chinchillas eat or, more accurately, are spoon-fed from an enormous cauldron by a thickset individual with donkey's ears and a blindfold. It is not surprising that Goya's contemporaries identified this person as Ignorance for the blindfold was considered a fitting way to suggest that an ignorant mind is one where light has yet to penetrate.[4] Those whom Ignorance feeds are as deplorable as the nobles in the drawing that preceded it, *La enfermedad de la razon* (The Illness of Reason) (cat. 54). Their eyes are so firmly closed that they can see nothing, let alone read a book. The locks on their ears are more massive than before, so that the size of the plates, or escutcheons (*escudos*), totally excludes another primary means of receiving knowledge. It is as though their *escudos*, in the sense of heraldic arms, have deafened them to knowledge. Nobles with such pedigrees have no use for it.

Capricho 43, *El sueño de la razon produce monstruos* (The sleep of Reason produces monsters) (cat. 52), marks the beginning of the second part of the *Caprichos*. In a number of instances a frailty depicted in the first half of the set reappears in the second, but in the latter the protagonists are seen to have strayed even further from the dictates of Reason. In *Capricho* 4, *El de la rollona* (The Childish Man) (cat. 41), a superstitious noble, straining toward a great pot of food, remains a child led about by a lackey. In *Capricho* 39, *Asta su Abuelo* (Back to His Forebear) (cat. 46), a vain noble displays his family tree, every member of which is an ass like himself. Here nobles, rosary in hand, passively accept what Ignorance feeds them. The needs of society cannot touch them for they are deaf and blind; and their overweening pride in their illustrious lineage has rendered them immobile.[5] However, there was one activity that was widely ascribed to nobles by their critics – sex-

ual. Goya emphasized this aspect of their lives by means of well-placed highlights.

Contemporary Explanations:

Ayala: *Los necios preciados de nobles se entregan á la haraganería y superstición, y cierran con candados su entendimiento, mientras los alimenta groseramente la ignorancia* (Fools that pride themselves on their nobility surrender to indolence and superstition, and they seal off their understanding with padlocks whilst they are grossly fed by Ignorance).

Prado: *El que no oye nada ni sabe nada, ni hace nada, pertenece a la numerosa familia de los Chinchillas qe nunca à servido de nada* (He who hears nothing, knows nothing, and does nothing belongs to the large family of the Chinchillas, which has never been good for anything).

Stirling: *Los necios preciados de nobles son satirizados por su desidia habitual y su supersticion. Recostados, floxamte, siempre con su espadin atravesado, su rosario en la mano, y su entendimiento cerrado à candado, son alimentados grosera y abundantte pr la ignorancia.* (Fools that pride themselves on their nobility are satirized for their customary indolence and their superstition. Reclining slothfully, with their ornamental swords always awry, holding rosaries, and with their understanding padlocked, they are grossly and abundantly fed by Ignorance.)

E.A.S.

1. Edith F. Helman, "Los 'Chinchillas' de Goya," *Goya* 9 (1955), pp. 162-167. In 1764 *El dómine Lucas* by José de Cañizares was selected to be performed at the wedding of the Infanta María Luisa to the Archiduque Pedro Leopoldo. Helman found that performances of the play were advertised frequently from 1784 to 1795.

2. José de Cañizares, *Comedias escogidas* (Madrid, 1829), vol. 1: *El dómine Lucas*, p. 56.

3. See Maurice Leloir, *Dictionnaire du costume et de ses accessoires des armes et des étoffes des origines à nos jours* (Paris, 1951), under *cotte*, and *dalmatique*; see also Academia, *Diccionario*, 1791, under *cota*.

4. Cesare Ripa Perugino, *Della piv che novissima Iconologia* (Padua, 1630), pt. 2, pp. 327-328. In the eighteenth century Ignorance was commonly personified as a thick, deformed female with bandaged eyes

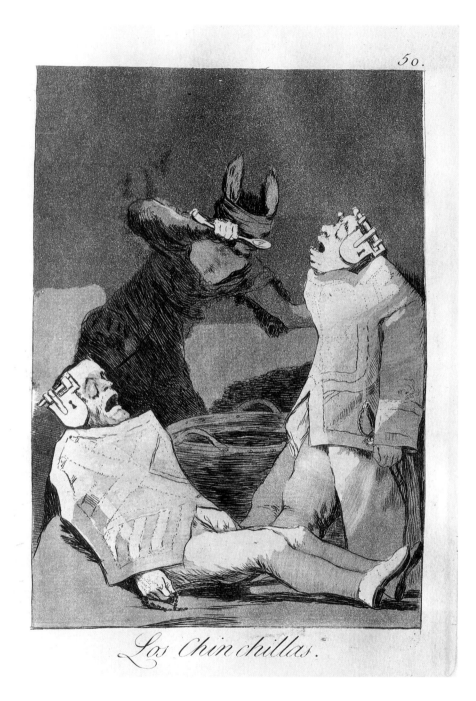

Los Chinchillas.

and donkey's ears; see Gravelot and Cochin, *Icono-logie*, vol. 2, pp. 7-8. The latter also preserve the tradition of a crown of poppies, with which Goya seems to have supplied a figure of Ignorance sitting among swine in *Album C*, p. 133, *todo lo desprecia*; G-W 1367; G., I, 276. For the swine see *Le petit trésor des artistes et des amateurs des arts* (Paris, VIII-IX [1799/1800-1800/01], vol. 3, p. 96, under *sottise*.

The etched figure in the *Capricho* was originally a male wearing a coat with pockets; Goya converted him into a thickset female with new work that thickens the waist and converts the trousers into a skirt.

5. Fourteen years after Goya's death, Eugène Piot (who had no knowledge of the Prado manuscript of explanations) observed in his "Catalogue raisonné de l'oeuvre gravé" of Goya, appended to a short biography by Théophile Gautier: "Goya avait l'habitude de dire: 'El que no oye nada, ni ve nada, ni hace nada, pertenece a la numerosa familia de los Chinchillas, que nunca han hecho nada'" (Goya liked to say: "He who hears nothing, sees nothing, does nothing, belongs to the numerous family of the Chinchillas, which have never done anything"); *Le Cabinet de l'amateur et de l'antiquaire: Revue* 1 (1842), p. [3]52.

56

Subir y bajar (To Rise and to Fall)
Caprichos, plate 56
First edition, 1799
Etching and burnished aquatint
215 x 150 mm.
Engraved, upper right margin: *56*, lower margin: title
References: G-W 563; H. 91, III, 1.

Spain: Biblioteca Nacional, Madrid, 45.666
United States: The Metropolitan Museum of Art, New York, Gift of M. Knoedler, 18.64(56) [*illus.*]

A satyr, seated on the rim of a great globe, raises one man into brilliant light as two others plunge downwards into obscurity. The primary meaning of this print, suggested by its title *Subir y bajar* (To Rise and to Fall), is that, although fortune may raise one man to high honor, the proud will be humbled for there is always a waiting hindleg.[1]

In the preliminary drawing for the print, it is plain that Goya originally conceived of the struggle as one for sexual supremacy (fig. 1).[2] The man at the left is completely naked and, if the victor wears anything at all, it is no more than something to cover his private parts. A satyr, the personification of Lust, perches on a great branch.[3]

In the *Capricho* all three men are clothed, and Goya changed the site of the competition from the leafless branch of a tree to the curving globe of the world. Nevertheless Lust still lifts the protagonist up above his fellows and by his mere presence suggests the secondary meanings of *subir y bajar:* to be made erect and then flaccid, or to penetrate and to withdraw.[4] Goya bathed the victor in intense light so that we would not fail to notice various details. Around his neck hangs an elaborate collar with its order. He wears an officer's jacket and sword but is naked from the waist down, with neither breeches nor hose covering his well-formed legs. The *espada* (sword) at his side constitutes a visual pun for the member by which he was enabled to rise,[5] and in each hand he holds a thunderbolt ready to hurl at his rivals. Finally, Goya commented on the character of this triumphant man: smoke comes billowing

Fig. 1. Preliminary drawing for *Subir y bajar.* Sanguine.
Museo del Prado, Madrid, 73

from his head as though it were fanned by wind, *humo* (smoke) constituting a visual pun for vanity and *viento* (wind) for arrogance.[6]

It is scarcely surprising that all these iconographical details should have led a number of Goya's contemporaries to identify the protagonist as Manuel Godoy (see cat. 64), the presumed father of the two youngest Infantes.[7] Entering the palace Guardias de Corps (royal bodyguard) in 1784 at seventeen, Godoy came to attract the attention of María Luisa and after the accession of Carlos IV (see cat. 33 and 32) rose meteorically. In 1792, shortly before his twenty-fifth birthday, he became teniente general (lieutenant general) of the army. That same year saw him created Duque de Alcudia and named to succeed Aranda as primer secretario de estado y del despacho universal (prime minister). Three years later he was given the title of Príncipe de la Paz (Prince of Peace). Among the decorations the sovereigns bestowed on him was the Order of the Golden Fleece. On March 28, 1798, he lost office because of a rift, it was thought, in his relationship with the queen and was replaced by

Francisco de Saavedra. The great states-
man Gaspar Melchor de Jovellanos
became Ministro de Gracia y Justicia (see
cat. 30). These two able men were dis-
missed in their turn the following August,
and Godoy's power again made itself felt.
It cannot but have been galling to believe
that the quality of the government of
Spain was dependent on what took place
in the queen's bed.

Contemporary Explanations:

Ayala: *Príncipe de la Paz. La lujuria le
eleva por los piés; se le llena la cabeza de
humo y viento, y despide rayos contra sus
émulos.* (The Prince of Peace. Lust raises
him by the feet; his head is filled with
smoke [vanity] and wind [arrogance],
and he discharges thunderbolts against
his rivals.)

Prado: *La fortuna trata muy mal à quien
la osequia. Paga con humo la fatiga de
subir y al qe ha subido le castiga con
precipitarle.* (Fortune is very unkind to
those who court her. Smoke [vanity] is
the reward she gives for the toil of the
climb and he who has risen she punishes
by casting him down.)

Sánchez: *La lujuria levanta à uno en
este mundo a la mayor fortuna, la cabeza
se le llena de humo y viento, despide
entonces rayos contra sus émulos; y al
cabo el tambien cae, y va rodando la bola*
(Lust raises a man to the highest fortune
in this world, his head is filled with
smoke [vanity] and wind [arrogance],
and then he dispatches thunderbolts
against his rivals; in the end he too falls,
and the world goes round).

<div align="right">E.A.S.</div>

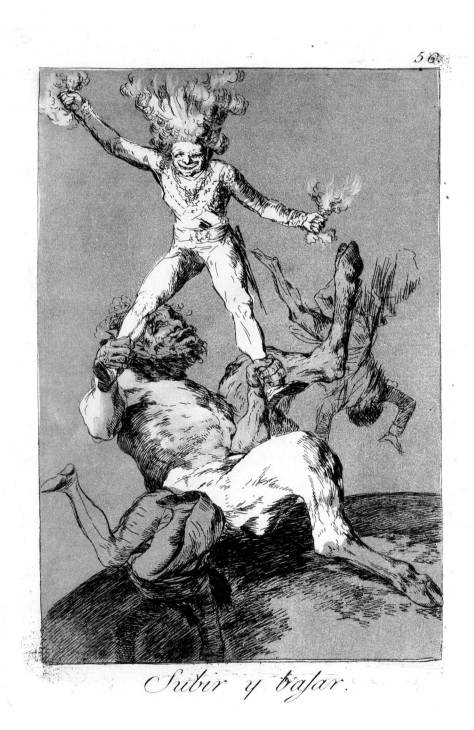

Subir y bajar.

1. In this sense it is related to an emblem by Covarrubias, *Emblemas, centuria* III, no. 55, *Vnos suben y otros baxan;* see also Henkel, *Emblemata*, p. 1429.

2. Sanguine drawing, Prado, Madrid, 73; G-W 564; G., II, 113.

3. Erwin Walter Palm, "Zu Goyas Capricho 56," *Aachener Kunstblätter* 41 (1971), pp. 20-27, insisted on the important role of Lust. A faun, a satyr, and Pan himself all traditionally personified Lust. See also *Alciato: Emblemas*, ed. Santiago Sebastián (Madrid, 1985), pp. 107-108. According to Covarrubias, *Tesoro*, under *sátiros*, their name was derived from a Greek term signifying their great lustfulness.

4. On *subir* as *salire* and *bajar* as *discedere*, Alzieu, *Poesía erótica*, cites no. 37, line 4; see also the Vocabulario under *alzar* and *alzarse*.

5. For *espada* as *penis*, see Alzieu, *Poesía erótica*, no. 97, note, verse line 223; no. 122, note, verse line 16.

6. Academia, *Diccionario*, under *humo* and *viento*.

7. On March 18, 1812, four days after the promulgation of the Constitution of Cádiz, the Cortes passed a decree excluding the Infantes María Isabel and Francisco de Paula from succession. See *Coleccion de los decretos y ordenes que han expedido las Cortes Generales y Extraordinarias*, vol. 2 (Cádiz, 1813), pp. 180-181.

Goya could not have given a recognizable portrait of Godoy in this particular etching. What resemblance exists is found in the well-set-up body; see Goya's 1801 portrait (cat. 64).

57

Linda maestra! (A Fine Teacher!)
Caprichos, plate 68
First edition, 1799
Etching, burnished aquatint, and drypoint
210 x 150 mm.
Signed lower left: *Goya*
Engraved, upper right margin: *68*, lower right margin: title
References: G-W 587; H. 103, III, 1.

Spain: Biblioteca Nacional, 45.654
United States: The Metropolitan Museum of Art, New York, Gift of M. Knoedler, 18.64(68) [*illus.*]

Observed by a solitary owl, two witches are carried on a broomstick high above the moonlit earth. Using spare means – a copper plate etched with lines, a little drypoint, and a single tone of aquatint, the plate then inked and printed in sober brown – Goya has suggested not only the play of light on naked bodies but also the subtle differences in color of the restless earth at night. Far below the viewer are trees with quivering leaves, tiny figures of people on foot, a laden donkey, and, in the distance, a small cluster of buildings.

At first glance this *Capricho* seems to represent no more than two witches using a broom to fly off to a Sabbat, or assembly. But when we look closely at that same light playing over the women, we see that the artist did not use it naturalistically but employed it to call attention to certain aspects of their bodies. It touches the withering thigh of the older woman and falls fully on her evil face and muscular shoulders and forearms. Light emphasizes the way the pupil has lifted her arms to cling to her mentor by the hair, and it reveals the firm roundness of young breast and thigh, of well-made leg, and of ample pelvis. Light gleams on the traditional broom that witches use to carry them through the air.[1] Finally, Goya called attention to the old woman's face, which supplied his contemporaries with a vital clue to the identities of mistress and pupil. The old woman's sly smile has all the cunning and resolute acquisitiveness of a *celestina* (procuress),[2] like the one Goya painted a decade later standing behind a prostitute on a balcony (cat. 70). Light was also used to subtly suggest

what she might be teaching her attractive pupil: it calls attention to the fact that the latter's legs are spread apart as she flies. A second meaning of *volar* (fly) is to have an orgasm, induced here, according to contemporary explanations (see below), with a broom handle used as a dildoe. Goya's title, "A fine teacher!," has a pungent irony.

Education, so beloved by the Enlightenment, can also have a dark side. One likes to think of it as being put to good ends, such as teaching little children to do what is ethical along with their ABCs, introducing an adolescent to a trade that would enrich the nation, or training someone in a profession; yet education can also corrupt, and seventeenth-century Spanish picaresque novels describe in detail how a boy is taught to be a knave, a rogue, or a criminal. In this *Capricho*, Goya has depicted a bawd who has begun the education of an inexperienced young woman. The presence of the *búho* a species of owl) flying in darkness at the upper right indicates that she is to be taught more than the art of enjoying her own sexuality; *búho* was a slang term for a streetwalker.[3]

Contemporary Explanations:

Prado: *La escoba es uno de los utensilios mas necesarios a las brujas porqe ademas de ser ellas grandes barrenderas (como consta pr las istorias tal bez conbierten la escoba en mula de pasa [sic] y van con ella qe el Diablo no las alcanzara* (The broom is one of the most necessary implements for witches, for they are not only great sweepers [thieves] (as old tales make plain), but at times they turn the broom into a saddle mule [i.e., a dildoe], on which they travel at such a pace that the Devil himself cannot overtake them).

Stirling: *Una vieja enseña à volar à una moza con un palo de escoba. Las criadas pierden las hijas de las casas; y las alcahuetas hacen volar à las muchachas ò tomar vuelo con qualquier cosa entre las piernas.* (An old woman teaches a maid to fly [have orgasms] with a broomstick. Women servants ruin the daughters of the house; and bawds make girls fly or take flight [have orgasms] with any object

whatsoever between their legs.)
Biblioteca: *Las Viejas quitan la escoba de las manos á las que tienen buenos vigotes; las dan lecciones de volar por el mundo; metiendolas por primera vez, aunque sea un palo de escoba entre las piernas* (Old women snatch the broom from the hands of those who have abundant pubic hair [literally, good mustaches]; they give them lessons on flying around [having orgasms]; penetrating them for the first time, even if it be a broomstick between the legs).

<div align="right">E.A.S.</div>

1. Julio Caro Baroja, *Las brujas y su mundo*, 4th ed. (Madrid, 1973), p. 122, points out that the Norman name for witches was *scobaces*, or *escobáceas*, akin to the Spanish word for broom, *escoba*.

2. This term is derived from the archetypal bawd la madre Celestina (Mother Celestina), Fernández de Rojas's creation in his *Tragicomedia de Calixto y Melibea* (1499), which has come to be known as *La Celestina*. See Goya's drawing of her, cat. 134.

3. José Luis Alonso Hernández, *El lenguaje de los maleantes españoles de los siglos XVI y XVII: la Germanía* (Salamanca, 1979), pp. 41-42.

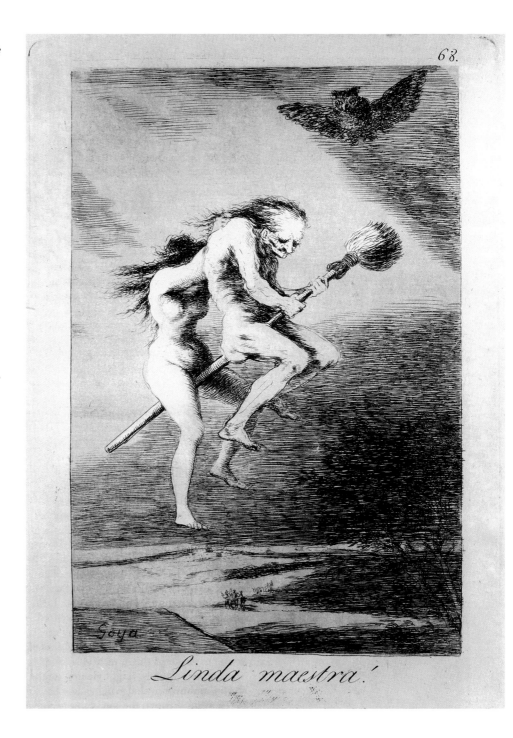

58

Sopla. (Blow)
Caprichos, plate 69
First edition, 1799
Etching, aquatint, drypoint, and burin
210 x 150 mm.
Signed lower left: *Goya*
Engraved, upper right margin: *69*, lower
margin: title
References: G-W 589; H. 104, III, 1.

Spain: Biblioteca Nacional, Madrid, 45.657
United States: The Metropolitan
Museum of Art, New York, Gift of
M. Knoedler, 18.64(69) [*illus.*]

The broad theme of education, touched
on in the preceding *Capricho, Linda
maestra!* (A Fine Teacher!) (cat. 57), is
continued in this scene of an assembly of
witches. One of them uses a small child
as a bellows to blow up a fire; two, sitting
at the left, look intently occupied while
their companions howl; a fourth is arriv-
ing with a fresh supply of children, and,
finally, a fifth witch is seen stretching his
wings protectively over the gathering as
he looks piously upwards.

The key to what is taking place lies in
that sudden, transitory flame at the left,
blown into being by the foul air emitted
from the child's bottom. The association
of fire with carnal love is traditional. For
example, a fifteenth-century Florentine
print, *The Triumph of Love from The Tri-
umphs of Petrarch*, depicted Love stand-
ing on a fiery pedestal.[1] In one of the
Emblemas morales (Moral Emblems)
published by Covarrubias in 1610, a gen-
tleman finding himself alone by the fire
with a *gentil dama* (high-born lady),
rather than a courtesan, couches what he
has in mind by using the simile of a fire
"que enfria de lexos, y de cerca quema"
(that chills from afar and burns up
close).[2] At almost the same time in Italy,
Bernardo Malpizzi designed a bawdy
woodcut of a bare-legged courtesan heat-
ing her private parts over a hearth fire.[3]

Blowing had also a traditional usage.
In a print engraved during the final years
of the fifteenth century, Dürer showed
the devil using a bellows to infiltrate a
slothful, academic doctor with vile ideas.[4]
Cupid was not above encouraging fires of
love by blowing on them; and it seemed

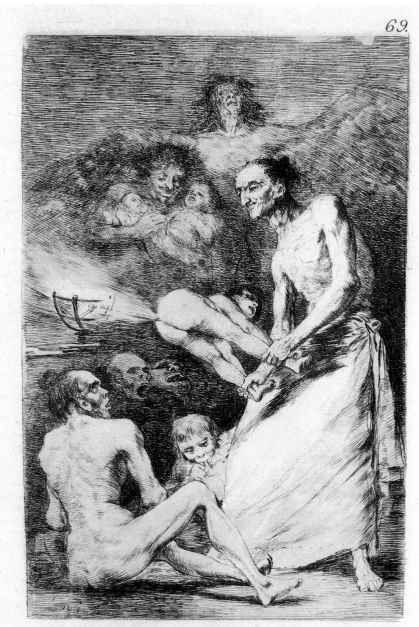

69.

Sopla.

127

appropriate to Parmigianino that Mars and Venus should make love in the presence of Vulcan working at a great forge with bellows.[5] There is also the Spanish proverb "El hombre es fuego, la muger estopa, venga el diablo y sopla" (Man is fire, woman is tow, along comes the devil and blows).[6]

Close examination of the print reveals the vileness of the passion these witches are arousing, for it is not the carnal desire of men and women for one another that is being kindled, but that of men for little boys. The boy made to serve as a bellows is an anthropomorphic emblem of what is to happen since Goya's title, *Sopla.*, has an additional slang meaning, "Fornicate."[7] In the foreground a seated pedophile sucks at the penis of one child, and it is horrifying to observe that even smaller ones, scarcely more than infants, are being brought to this unholy school. The young woman Goya depicted in *Linda maestra!* was being set on the road to prostitution. Here, an unnatural way of life is forced on children too young to understand what is being done to them. The title Goya gave to the drawing on which this print depends is *Sueño de Brujas / Consumadas* (Dream of Witches – Consummate [witches]),[8] for it is when men and women surrender themselves to evil that they turn themselves partly or wholly, as here, into witches.

Contemporary Explanations:

Ayala: *Los niños son objeto de mil obscenidades para los viejos y relajados* (Children are the target of a thousand obscenities on the part of old and licentious men).

Prado: *Gran pesca de chiquillos hubo sin duda la noche anterior el banquete qe se prepara sera suntuoso. Buen probecho.* (There must have been a fine catch of little children last night! The banquet being prepared will be splendid. Fall to.)

Stirling: *Las viejas se sirven de los niños pa muchas obscenidades. Una le chupa la cosilla; otra atiza la lumbre con otro haciendole servir de fuelle.* (Old women make use of children for many an obscenity. One sucks a child's small

thing [penis]; a second stirs up the fire [arouses passion] by making a child serve as bellows.)

Nelson: *Los hombres estragados hacen mil diabluras y obsenidades con los niños; les fornican unos con otros, les Chupan la minga, &a &a* (Depraved men commit a thousand deviltries and obscenities with little boys; they fornicate them with one another, they suck their member, etc., etc.).

E.A.S.

1. There is an impression in the Museum of Fine Arts, Boston; Arthur M. Hind, *Early Italian Engraving*, vol. 3 (London, 1938), pl. 191.

2. Covarrubias, *Emblemas*, 1610, centuria III, no. 29. It is included in Henkel, *Emblemata*, p. 134; see also pp. 135-136 for the French and Dutch emblems cited.

3. Chiaroscuro woodcut by Andrea Andreani after Bernardo Malpizzi, *Le feu au-dessous de la femme* (B. XII, 15), reprod. in *The Illustrated Bartsch*, gen. ed. Walter L. Strauss, vol. 48, ed. Caroline Karpinski (New York, 1983), p. 251. For a Spanish example of this motif on a misericordia, see Mateo Gómez, *Sillerías*, p. 370 and fig. 345.

4. Albrect Dürer, *Dream of the Doctor*, 1498-1499 (B. 76); see Erwin Panofsky, "Zwei Dürerprobleme," *Münchner Jahrbuch der bildenden Kunst*, n.s., 8 (1931), pp. 1-17; for two other examples by Dürer of the devil using bellows, see figs. 7, 8.

5. Engraving by Enea Vico after Parmigianino, B. 27, first state. The lovers were deleted in the second state. Both states reprod. in *The Illustrated Bartsch*, vol. 30, ed. John Spike (New York, 1985), pp. 38-39. For an English broadside dating from before 1700 that is related in imagery, see *A Lusty Young Smith*: "A lusty young Smith at his vice stood a-filing / Rub, rub, rub, rub, rub, rub in and out, in and out ho! / When to him a buxsome young Damsel came smiling, / And asked if to work at her Forge he would go; / . . . They stripped to go to it, 'twas hot Work and hot Weather, / She kindled a Fire and soon made him blow. / With a rub, rub, rub, rub, rub, rub in and out / In and out, ho!"; Ephraim John Burford, *Bawdy Verse* (Harmondsworth: Penguin Books, 1982).

6. John Collins, *A Dictionary of Spanish Proverbs, Compiled from the Best Authorities in the Spanish Language* (London, 1823), p. 126. Collins also quotes a Latin version: "Ignis vulcani est vir, stupaque femina sicca, / Ecce venit flatus congeminare satan."

7. See Cela, *Diccionario secreto*, particularly pt. 1, p. 198, and pt. 2, pp. 25-30.

8. *Sueño* 7; pen and brown ink; Prado, Madrid, 16; G-W 590; G., II, 46. Although Goya tended to depict witches as sexually ambiguous, the one at the far left is clearly male, being almost bald. In *Album B*, page 57, *La tia chorriones . . .*, the element of child abuse was not yet realized; G-W 417; G., I, 62.

59

Brujas à bolar (Witches About to Fly)
Album B, page 56
1796-1797
Brush and gray wash, heightened with black
237 x 150 mm.
Inscribed in brush and gray, upper left margin: *56*; lower margin: *Brujas;* in pen and brown ink: *à bolar*
Recto: *mascaras crueles*
References: G-W 416; G., I, 61.

Ian Woodner Family Collection, New York, WD-528
Spain only

The drawing is from a short sequence in *Album B*, which deals with various sexual themes.[1] Here, a satyr, with horns and cloven hooves, has lifted a naked woman with a face like a fox onto his shoulders. She raises her hands before a huge open volume held by two men in cone-shaped caps who perch on top of a great oblong stone.

Goya's title states that all four figures are *brujas* (witches). Throughout Europe both the Inquisition and the witch hunters aping them tended to think of witchcraft as an inversion of the Christian practice. Through the use of severe torture men and women were forced to confess to having caricatured the holiest services in the course of their perverted rites and Sabbats.[2] Stories of desecrations became standard fare, and in course of time one could read even of Christian monks celebrating masses on the bellies of naked girls.[3] In the light of such tales one ought not to be surprised that the witches in Goya's drawing seem to be vested as though for the celebration of mass or that the slab of stone on which they sit resembles an altar. This unsavory pair of clerics hold their book with pincers so that it does not touch them.

Goya used light to emphasize the satyr, the woman, the book, and the bleached and broken skull, symbol of *vanitas*, tumbled to the ground. Since, according to pagan and classical traditions, satyrs were associated with feasts of Bacchus and Priapus, they were presumed to attend Sabbats. However, Goya did not depict a traditional assembly of

witches, satyrs, and assorted monsters
come together to worship Satan in the
form of a goat.[4] A satyr, part goat, was
also identified with lewdness and became
a symbol of Lust.[5] It is this personifica-
tion of Lust who bears on his shoulders a
woman whose fox face betrays that she is
a *zorra* (vixen), a common name for pros-
titute.[6] Flames issue from the satyr's
hindquarters as though he were literally
burning with his own lust.[7] As he gazes
upwards at the clerics, the *zorra* lifts her
hands in the position of an officiant,
crooking her little finger gracefully as she
does so.

The two celebrants are as unsavory as
those who face them. Perched on an altar
whose face is decorated with heads of
gaping fauns, they half-cross their legs,
and one has pulled the skirt of his robe
above his knee. Their faces vacant, they
chant loudly, and they hold their book
with *tenazas* (pincers) used to tear pieces
of flesh from the condemned.[8] They are
recognizable as bishops because they
wear gloves, and this rank is confirmed
by a visual pun implicit in their headgear,
resembling the *coroza*, or penitential cap,
which had been worn in the past by fla-
gellants in the Holy Week processions.[9]
Coroza was also the name used for the
tall cap the Inquisition set on a prisoner
when he appeared in public. However,
an alternative name for this kind of
coroza was *mitra* (miter), or technically
mitra scelerata (infamous miter) to dif-
ferentiate it from the miters worn by
bishops and archbishops.[10] Quevedo
made use of this fusion of terms in one of
his *Sueños* (Visions): "Estaba Nepos,
Obispo, en quien fue coroza la mitra,
afirmando que los santos habian de
reynar con Christo en la tierra mil años
en lascivias y regalos" (There was Nepos,
the bishop, on whom the miter was a
coroza, stating that the saints would reign
with Christ on earth for one thousand
years, in lust and gluttony).[11] In short,
Goya could not have selected a more fit-
ting headgear for these obscene clerics.
Brujas à bolar (Witches about to fly [have
orgasms]) is the title he gave his drawing.
Inexorably, indulgence in sin has turned
two bishops into witches. The bleached
and broken skull in the foreground indi-

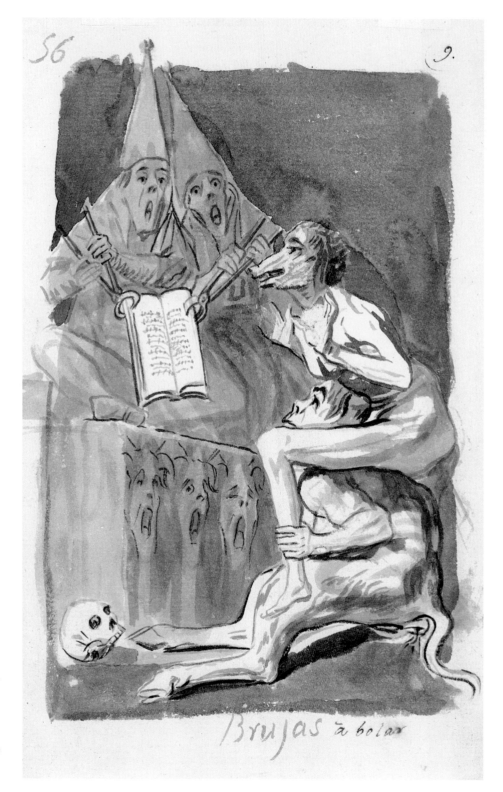

cates the direction toward which such pastors shepherd their flocks.

E.A.S.

1. Whereas this drawing was the source for *Capricho* 70 (cat. 61), the drawing that follows, *La tia chorriones enciende la Oguera. Brujas á recoger* (private collection, Paris; G-W 417; G., I, 62), was the source for *Capricho* 69 (see cat. 58).

2. The concept of the Black Mass became current only at the end of the nineteenth century; see Rossell Hope Robbins, *The Encyclopedia of Witchcraft and Demonology* (New York, 1959), under *Black Mass* and *confessions*.

3. Ibid., under *Black Mass* and *Sabbat*.

4. An engraving in Pierre de Lancre, *Tableau de l'inconstance des mauvais anges*, 2nd ed. (Paris, 1613), shows Satan, in the likeness of a goat, seated on a golden chair, preaching. One of his five horns is lighted to kindle the fires of the Sabbat. In front of him, a witch presents a child she has abducted. Women and satyrs engage in a salacious dance around a tree. Reproduced in Robbins, *Encyclopedia of Witchcraft*, p. 300.

5. See H. Lacombe de Prezel, *Dictionnaire iconologique, ou introduction a la connoissance des peintures, sculptures, medailles, estampes, &c.* (Paris, 1756), under *luxure* and *satyres*.

6. See Covarrubias, *Tesoro*, 1611, under *çurra*, "en cierto tiempo del verano se pela toda. . . . De donde nació llamar a la ruin muger zurrona, que vale tanto como la que pela, y se pela."

7. Possibly we are intended to see the satyr as literally heating up the *zorra*, to make a "caldo de zorra que está frio, y quema" (a fox broth that is cold yet burns), a saying used to describe a person who feigns affability in order to achieve their own hidden end; see Academia *Diccionario*, 1791, under *zorra*.

8. See Covarrubias, *Tesoro*, 1611; and Academia, *Diccionario*, 1791, under *atenazar* and *atenacear*, respectively.

9. Public flagellation was prohibited in 1777; see the Conde de la Viñaza, *Goya: Su tiempo, su vida, sus obras* (Madrid, 1887), p. 285.

10. Covarrubias, *Tesoro*, 1611, under *coroça*; see also Academia, *Diccionario*, 1791, under *mitra*, where its usage is characterized as "vulgar, impropia, é indignamente."

The *corozas* worn by prisoners of the Inquisition seem to have had various forms; see, for example, Francisco Rizzi de Guevara's large *Auto de Fe en la Plaza Mayor de Madrid* of 1683. In Goya's day the painting hung in the Retiro, Madrid; it is now in the Prado (1126). *Corozas*, which look very like *mitras*, can be seen, for example, in Philip van Limborch, *Historia Inquisitionis* (Amsterdam, 1692). These illustrations were copied by other writers; they are also reproduced in various books on the Inquisition: for example, Henningsen, *Witches' Advocate*, figs. 15a, b.

11. Francisco de Quevedo Villegas, "Las Zahurdas de Pluton," in *Obras*, vol. 1, p. 110.

60

Sueno. De Brujas (Dream. Concerning Witches)
**First drawing for *Sueños*, number 3
1797-1798**
Pen and brown ink over slight chalk sketch
238 x 180 mm.
Inscribed lower margin, in chalk: title
Verso: Definitive drawing for the same *Sueño*
References: G-W 593; G., II, 42.

Museo del Prado, Spain, 444
Spain only

Goya's Album drawings were private in the sense that they would be seen only by people he trusted. However, the *Sueño* (Dream) drawings were intended from their inception to be etched, printed, and sold publicly, and indeed the *Sueños* were transformed into the *Caprichos*. As in the preceding drawing (cat. 59), Goya depicted two persons holding a book with pincers and a naked figure seated on the shoulders of a satyr, but there are changes. The composition plays on religious representations of the Virgin, angels, or saints communicating with a human being worshiping or at prayer, as, for example, in Giovanni Domenico Tiepolo's etching *An Angel Holding the Eucharist for Saint Pascual Bailón to Adore* after the painting by his father for the Franciscan monastery at Aranjuez (fig. 1).[1] The resemblance is intentional, for by reminding us of such pictures, Goya forces us to ask what word these persons with their book will bestow on worshipers.

The sex of a Goya witch is often ill-defined (see cat. 58); nonetheless, it would seem that the figure sitting on the shoulders of the satyr is not a *zorra* (prostitute), as in the Album drawing, (cat. 59), but a young warlock looking toward the book with manifest eagerness. The extraordinary length of his ass's ears is a measure of the depth of an ignorance that causes him to be amazed and impressed by what he reads. In this respect he contrasts with the monkey to the right of the satyr, which stops up its nose and pulls at its lower eyelid to warn us, "Be alert!"[2]

Fig. 1. Giovanni Domenico Tiepolo after Giovanni Battista Tiepolo, *An Angel Holding the Eucharist for Saint Pascual Bailón to Adore.*
Etching

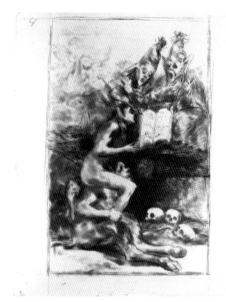

Fig. 2. *Sueño de Bruja principianta.*
Pen and brown ink.
Museo del Prado, Madrid

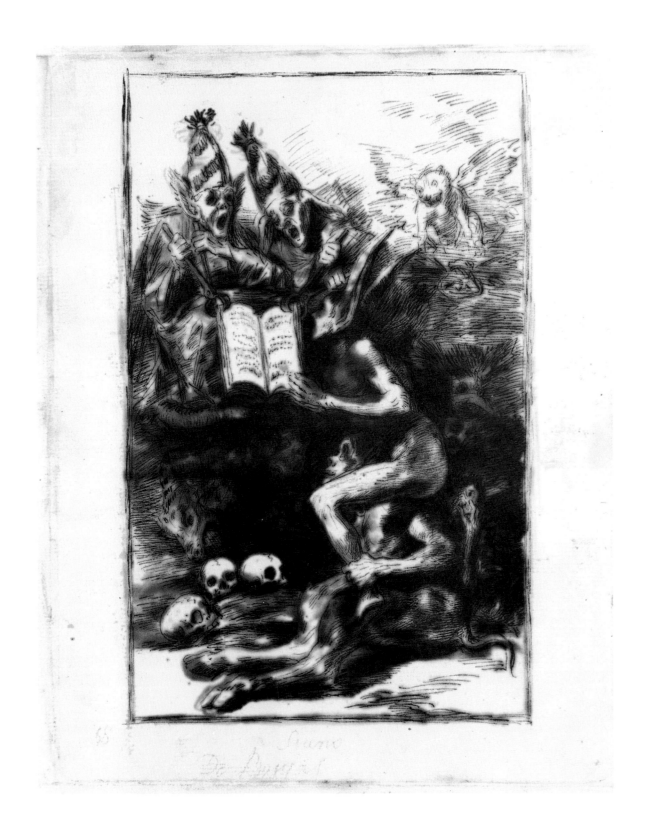

The clerics, wearing ambiguous robes and lacking the gloves that would have identified them as bishops, have also sprouted donkey's ears, but more modest ones. The darkness trailing in their wake is ominous, for it is infested by monstrous, threatening faces. These stupid men proclaim the contents of their volume loudly, but the pincers with which they hold it are *tenazas*, the instruments of torture used to tear pieces of flesh from condemned persons.[3] They are carried through the air on the back of a great serpent, which is vomiting death, symbolized by three skulls lying on the ground. Satan assumed the form of a serpent in order to bring about the expulsion of Adam and Eve from Paradise, and by logical extension this creature came to embody Heresy.[4] If the prelates have debased the holy texts with *tenazas*, and it no longer contains the meat that should be there, do they not, then, teach us lies?

Needless to say, it was impossible for Goya to publish such a brutally critical composition in late eighteenth-century Spain, where the Inquisition routinely seized any print considered potentially harmful. He therefore turned the sheet over and removed a little of the sting in a new version, inscribed *3⁰ / Sueño / de Bruja principianta* (Dream: of a Novice Witch; fig. 2).[5] Various iconographical changes have occurred. The prelates are no longer surrounded by a foul, unholy cloud of monsters, and they now ride on a huge bird rather than the ill-reputed serpent, Heresy. Although once more their robes suggest those of a priest celebrating Mass, their headgear resembles bonnets instead of *mitras* (or *corozas*).[6] There are also changes in the naked witch. Ears are smaller, hands have become feminine, indeed delicate, and thighs and buttocks are correspondingly rounded so that we are reminded of the *zorra* (prostitute) in the *Album B* drawing (cat. 59). The satyr, personifying Lust, has closed his eyes. In this version, the novice priest he bears seems to be aspiring to a share of power over what men shall believe and therefore prostitutes both mind and spirit by eagerly accepting what the prelates have transformed into empty phraseology.

E.A.S.

1. Etching, 505 x 290 mm., by Giovanni Domenico Tiepolo after the painting by Giovanni Battista Tiepolo, *San Pascual Bailón Adoring the Eucharist* for the high altar of the Franciscan monastery of Saint Pascual at Aranjuez; reprod. in Aldo Rizzi, *L'opera grafica dei Tiepolo: Le acqueforti* (Venice, 1971?), no. 149. Two fragments of the painting are preserved in the Prado, Madrid, 364, 364a; the preparatory oil sketch belonged to Count Seilern, F. J. Sánchez Cantón, *J. B. Tiépolo en España* (Madrid, 1953), pls. 18-20 and 17, respectively. On the saint, see Wifredo Rincón García and Alfredo Romero Santamaría, *Iconografía de los santos aragoneses*, vol. 2 (Zaragoza, 1982), pp. 63-66.

2. See "The Eyelid Pull," in Desmond Morris et al., *Gestures* (New York, 1979), pp. 69-78.

3. See Terreros, *Diccionario*, 1786-1793: "Atormentar á un delincuente con tenazas ardiendo"; and Academia, *Diccionario*, 1791: "Sacar pedazos de carne á una persona con tenazas"; both under *atenacear*.

4. Representations of the Virgin triumphing in the battle against Heresy, personified as a serpent, became popular during the Counter-Reformation; see Emile Mâle, *L'Art religieux après le Concile de Trente*, Paris, 1932, pp. 35-48. See also Cesare Ripa, *Della piv che novissima iconologia di Cesare Ripa Pervgino* (Padua, 1630), under *heresia*, pt. 2, p. 309.

5. Pen and brown ink, Prado, Madrid, 451; G-W 592; G., II, 41.

6. On *mitras* and *corozas*, see *Brujas à bolar* (cat. 59). In the earlier *Sueño, De Brujas*, Goya had drawn wide oblique stripes on the *mitras*, which suggest their double role as miters and sinners' caps. It might at first appear that he also included stripes in the second version (fig. 2). In fact he did not; stripes bled from the first to the definitive version when the paper was moistened for the transfer of the drawing to the copper plate.

61

Devota profesion (Devout Profession)
Caprichos, plate 70
First edition, 1799
Etching, aquatint, and drypoint
210 x 165 mm.
Signed lower left: *Goya*
Engraved upper right margin: *70,* lower margin: title
References: G-W 591; H. 105, III, 1.

Spain: Biblioteca Nacional, Madrid, 46.651
United States: The Metropolitan Museum of Art, New York, Gift of M. Knoedler, 18.64(70) [*illus.*]

The composition of the print is not the same as the drawings that preceded it (cat. 59 and 60). The monkey (in cat. 60) has vanished, and the skulls have been replaced by the heads of two men emerging from an expanse of water. The novice adoring the book has regained a masculine body and lost his donkey's ears. Once more bishops' bonnets suggest *mitras*, both in the sense of miters worn by bishops and caps set by the Inquisition on the heads of those it condemned. Now, however, the tuft at the top of the *mitra* worn by the bishop to the right has acquired the unmistakable shape of a winged bat, symbolizing by this means (rather than ass's ears) the ignorance of its wearer.[1] At first glance, we suppose that the bishops are sitting enthroned on a great vulture-like bird, as in the second version of the preceding *Sueño* (Dream) (cat. 60, fig. 2). It is only upon looking more closely that we see that Goya has joined to this bird the tail of the serpent Heresy, which had been vomiting death in the first version (cat. 60).

It is doubtful that Goya was attacking individual bishops in this print and more likely that he had Church policy in mind. In the early years of the sixteenth century, theologians had sought out Hebrew and Aramaic texts with which to compare the Latin Vulgate so that they might be able to recover the original wording and, as a consequence, the precise meaning of the Scriptures.[2] Spanish scholars stood in the forefront of the movement. The first polyglot Bible was composed, 1514-1517, at the Complutum, the trilingual University at Alcalá de Henares, and printed with texts in Latin, Greek,

Hebrew, and Chaldee at the expense of Cardinal Ximénez de Cisneros. The Pope authorized its publication in 1520.[3] That same year Martin Luther proclaimed that the Bible was man's ultimate recourse, declaring furthermore that neither the Pope nor the "unlearned lords at Rome" could be considered infallible as interpreters of the Scriptures.[4]

For Protestants it became vital to read the Bible for themselves, and consequently they took pains to ensure that the complete text became available in the vernacular. During the Counter-Reformation the Catholic Church adopted a different policy. Access to the Holy Scriptures was made difficult for the laity. In Spain prohibitions imposed by the Inquisition were even more drastic than those prescribed at the Council of Trent, 1545-1563.[5] As early as 1551 the first printed Index prohibited certain editions.[6] In 1559 the printing of Old and New Testaments in Spanish or in any other modern language was forbidden; vernacular versions available in Spain were illegally imported, given false imprints, or consisted of small portions of the Bible, such as the Psalms, usually paraphrased in verse.[7] By the seventeenth century, there were clerics whose mistrust of the reading of the Bible had become so profound that in the Zapata Index of 1632 the Bible was castigated as: "El más proporcionado instrumento, y más eficaz medio, que pudo inventar el padre de la mentira y engaño" (The perfect instrument and most efficient means that the father of lies and deceit could have invented).[8]

The inquisitorial ban on any vernacular prose translation of the Scriptures continued for over two hundred years. But in the eighteenth century the theological climate changed.[9] The complete Bible with the text in Spanish as well as Latin was published for the first time in Valencia, 1790-1793. The erudite man responsible for the translation was Padre Felipe Scio de San Miguel. He had been Provincial of the Escuelas Pías, where both the minds and souls of boys were considered important (Goya attended the school in Zaragoza), and was then Preceptor (tutor) to the Princípe de Asturías and

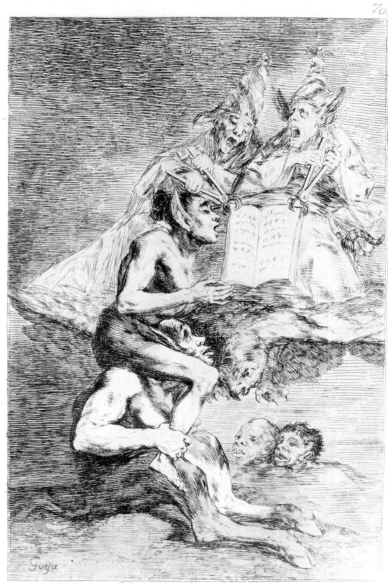

Devota profesion.

the Infantes, and confessor to the Princesa de Brasil, an Infanta.[10]

While the Spanish edition of the Bible was being printed, Joaquín Lorenzo Villanueva, officer of the Inquisition and doctoral chaplain to the king at the Real Capilla de la Encarnación, published in 1791, again in Valencia, a moving plea that the Bible be made widely available in the vernacular:

Con ella el justo crece en la virtud, el malo se refrena, el tímido cobra esfuerzo, el temerario se detiene, el ciego ve, y el sordo comienza á dar oídos a la verdad. . . . Este es como el mar océano de la divina sabiduria, en cuyo seno todas las verdades saludables que estan derramadas en los caños y rios de los Santos y demas Maestros de la Religion, se hallan juntas y amontonadas como en su propia fuente. . . . Las sagradas letras son un jardin amenísimo, hermosísimo, deleytosísimo, lleno de flores y frutos que enagenan el alma y le hacen perder todo aficion á lo que no es Christo ó no lleva á Christo. . . .

Allí se descubre nuestro rostro interior, si esta afeado, si flaco, si descarnado y ageno de todo lo que es virtud. . . .

Ha llegado el tiempo en que restituidas las cosas al primer estado, vuelve á darseos este pasto de las Escrituras. Abrese este tesoro con la franqueza que vuestros dias no vieron, y se pone de manifiesto, y de él se hace un convite general á todos para que cada uno de por sí llegue á tener de él lo que haya menester para las necesidades de su espíritu.

(With the help of the Bible the just man grows in virtue, the evil man is curbed, the timid man takes heart, the rash man pauses, and the deaf man begins to lend an ear to the truth. . . . It is the ocean of divine wisdom, in whose bosom all the salutary truths dispersed among the channels and rivers of Saints and other Masters of Religion come together and are pooled as if at their source. . . . The sacred texts are a most pleasant, beautiful, delicious garden, filled with flowers and fruits that transport the soul and make it lose its taste for anything that is not bound to Christ or leads to Christ. . . .

In it our inner face is revealed, whether it is grown ugly, weak, emaciated, and alien to everything that is virtuous. . . .

The time has come for matters to be restored to their original state and that once more you be served this scriptural repast.

Let this treasure be approached with an openness of heart that you have not known in your lifetime, let it be made generally known, and let an invitation be extended to all so that each person will take from it what he requires for his spiritual sustenance.)[11]

We have only to examine Goya's extraordinary paintings of subjects from the Gospels to become aware that he read what they had to say and, as Rembrandt had done, considered the implications (see cat. 7, 8, 14, 22, 23, 29, and 124). In this *Capricho*, in the persons of these bishops, he reminds us that it is impossible to teach truth by torturing the strong biblical words into twisted doctrines and petty precepts. The print is close in sentiment to the words of one of his contemporaries: "La sencillez de la palabra de Dios se ha oscurecido con los artificiosos comentarios de los hombres aquello que el Señor dijo para que todos lo entiendiesen se ha creído que apenas uno u otro doctor lo puede entender, y dando tormento a las expresiones más claras se las ha hecho servir hasta erigir sobre ellas el ídolo de la tiranía." (The simplicity of the word of God has been obscured by the artificial commentaries of men; that which the Lord spoke that all might understand has been deemed hardly intelligible save by one or another doctor, and by torturing the clearest expressions, they have made them serve even to raise upon them the idol of tyranny.)[12]

The monstrous bird-serpent on which the bishops sit as they mouth their nonsense is part bird of prey and part Heresy. It hovers over the heads of two men whom they have deprived of truth by giving them nothing but tortured scriptural excerpts. Using a visual pun on a traditional saying, Goya depicted the result: since the full means to salvation is denied them, "estan con el agua hasta la garganta" (they are in water up to the neck [in extreme danger]).[13]

Contemporary Explanations:

Ayala: *Eclesiásticos hay que, saliendo de la nada, subieron á las más altas dignidades atenaceando los libros santos* (There are clerics who, starting from nowhere, have climbed to the highest ecclesiastical benefices by torturing [tearing the flesh out of] the holy books with pincers).

Prado: *Juras obedecer y respetar a tus maestras y superiores? barrer desbanes, hilar estopa,[14] tocar sonajas – ahullar, chillar volar guisar, untar, chupar, cocer soplar, freir, cada y qdo se te manda? Juro. Pues hija ya eres Bruja. Sea en ora buena.* ("Do you swear to honor and obey your mistresses and superiors? To sweep garrets, spin tow [copulate with women], play tambourines [cunts], howl, screak, fly [have orgasms], garnish meat, anoint [bribe], suck [leech off others], heat up, blow [tattle], and fry [play slippery tricks], each and every time you are so ordered?" "I swear it." "Then, my dear [literally, my daughter], I hereby declare you a witch. Good luck to you.")

Stirling: *Dos vienen ahogandose, y se acogen á qualqr cosa; una especie de Satiro levanta á la ignorancia superstici-osa en hombros, y dos mitrados atenaze-ando un gran libro, se le presentan á leer, y adorar.* (Two men appear drowning [in trouble up to their necks], and will grab hold of anything. A kind of satyr raises superstitious Ignorance upon his shoulders, and two mitered ones [i.e., bishops] torturing [tearing the flesh out of] a great book, present it to [Ignorance] to read and to worship.)

E.A.S.

1. Gravelot and Cochin, *Iconologie*, vol. 2, pp. 8-9.

2. See Basil Hall, "Biblical Scholarship . . . ," in *The Cambridge History of the Bible*, vol. 3: *The West from the Reformation to the Present Day*, ed. S.L. Greenslade (1963; reprint, Cambridge, 1976), pp. 38-50.

3. *Biblia Sacra Polyglotta, complectentia Vetus Testamentum, Hebraico, Graeco, et Latino Idiomate; Novum Testamentum Graecum et Latinum; et Vocabularium Hebraicum et Chaldaicum Veteris Testamenti, cum Grammaticâ Hebraicâ, nec non Dictionario Graeco.* The Complutensian Polyglot, probably begun about 1502, was printed in Alcalá, 1514-1517, in folio size in an edition of 600. It does not seem to have been issued until about two years after its authorization; three of the seven editors were converted Jews; the scholar Elío Antonio Nebrija was accused by the Inquisition of tampering with the wording of the Vulgate when he corrected errors and was prohibited from continuing. A second edition was published in Antwerp, 1569-1572, at the expense

of Felipe II. See William Orme, *Bibliotheca Biblica* (Edinburgh, 1824), pp. 353-354; Thomas Hartwell Horne, *A Manual of Biblical Bibliography* (London, 1889), pp. 35-36; Henry Charles Lea, *Chapters from the Religious History of Spain Connected with the Inquisition* (1890; reprint, New York, 1967); Hall, "Biblical Scholarship," pp. 50-52.

4. Roland H. Bainton, "The Bible in the Reformation," in *Cambridge History of the Bible*, vol. 3, pp. 1-2.

5. Dirección General de Bellas Artes, Archivos y Bibliotecas, Madrid, *La Inquisición*, exhib. cat. (1982), p. 65.

6. The Index appeared in Toledo; E.M. Wilson, "Continental Versions to c. 1600: Spanish Versions," in *Cambridge History of the Bible*, vol. 3, p. 125.

7. Ibid., pp. 125-129.

8. Quoted in Palacio de Velázquez del Retiro, *La Inquisicion*, p. 64. Zapata, born in 1550, was highly regarded by Felipe II, and with reason; he died two years after the issue of the Index.

9. On these changes see *Historia de España*, ed. José María Jover Zamora, vol. 31: *La época de la ilustración*, vol. 1 (Madrid, 1987), pp. 395-435.

10. *La Biblia Vulgata Latina traducidá en Español* (Valencia, 1790-1793). The second edition appeared between 1794 and 1799, and there was an edition in Spanish only. In all, at least sixty-four editions were printed. See E.M. Wilson, "Continental Versions from c. 1600 to the Present Day: Spanish Versions," in *Cambridge History of the Bible*, vol. 3, p. 354; S. Giner et al., *Escuelas Pias: Ser e historia* (Salamanca, 1978), pp. 253-254.

11. Joaquin Lorenzo Villanueva, *De la leccion de la sagrada escritura en lenguas vulgares* (Valencia, 1791), pp. 244-247.

12. León de Arroyal, "Pan y toros," in *Pan y toros y otros papeles sediciosos de fines del siglo XVIII*, ed. Antonio Elorza (Madrid, 1971), p. 25. This work has been traditionally ascribed to Jovellanos. The English translation given here is from *Bread and Bulls, An Apologetical Oration on the Flourishing State of Spain in the Reign of King Charles IV. Delivered in the Plaza de Toros, Madrid, by Don Gaspar de Jovellanos . . .* (Mediterranean: printed on board HMS *Caledonia*, off Toulon, 1813), pp. 87-88.

13. See Covarrubias, *Tesoro*, 1611; and Academia, *Diccionario*, 1791, both under *Agua*.

14. On *hilar* as copulate, see Alzieu, *Poesía erótica*, no. 77. On *estopa* as a woman, see the proverb "El hombre es fuego, la muger estopa, venga el diablo y sopla," quoted, together with the Latin, "Ignis vulcani est vir, stupaque femina sicca, / Ecce venit flatus congeminare satan," in John Collins, *A Dictionary of Spanish Proverbs, Compiled from the Best Authorities in the Spanish Language, Translated into English* (London, 1823). Cossío called attention to the proverb when discussing El Greco's painting of two figures of men and a monkey; see Jonathan Brown et al., *El Greco of Toledo*, exhib. cat. (Toledo, 1982), p. 228.

62

Unos à otros. (Some to others.)
Caprichos, plate 77
First edition, 1799
Etching, burnished aquatint, drypoint, and burin
215 x 150 mm.
Engraved upper right margin: *77*, lower margin: title
References: G-W 607; H. 112, III, 1.

Spain: Biblioteca Nacional, Madrid, 45.666
United States: The Metropolitan Museum of Art, New York, Gift of M. Knoedler, 18.64 (77) [*illus.*]

Two men riding piggy-back on two other men take turns placing a *pica* (pic) in a basketry bull held by a fifth. The game of bullfighting in which they indulge is ordinarily played not by men but by little boys on village streets, as depicted in one of the royal tapestries designed by Goya's brother-in-law, Ramón Bayeu (fig. 1).[1] In Goya's print, a grown peasant wearing rawhide sandals plays the bull and crouches patiently in front of the fighters. Goya used light to call attention not only to the mock bull but also to the faces and clothing of the latter.

The rider at the left, waiting to make his thrust, wears the habit of a monk. His steed is an idiotic abbé who can be recognized by his buckled shoes, black clothing, and the characteristic, long, narrow tail of his coat visible between his thighs.[2] This pair might not be identified quite so categorically were it not that their professions are unambiguous in Goya's preliminary sanguine drawing, where he emphasized the monk's small black cap and the abbé's characteristic tail.[3] As for their opponents, the ostentatious frills over their wrists tell us that they are well-born, he who is the steed courteously helping the rider to retain his balance by giving him his left hand. The style of their shoes and the wide cuffs on their coats had ceased to be fashionable about the middle of the century, and their faces, particularly that of the one placing the *pica*, have a forbidding skeletal quality.

Both sartorially and physiognomically, these two figures seem to depend on *Sueño* (Dream) 16, one of the drawings

Fig. 1. Ramón Bayeu,
Boys Playing at Bullfighting.
Tapestry.
Patrimonio Nacional, Monasterio de San Lorenzo El Real de El Escorial, Madrid

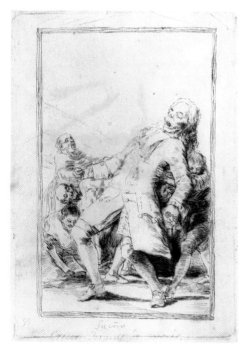

Fig. 2. *Sueño / Crecer despues de morir.*
Sueño 16.
Pen and brown ink over slight chalk sketch.
Museo del Prado, Madrid

that preceded the *Caprichos* (fig. 2).[4] Here a figure of a noble has grown to such monstrous proportions that it is no longer able to stand upright by itself but must be maintained by others who tug and push to keep it in position, among them a monk and an evil-looking old woman with a great book. Only the noble's enormous left hand seems to

have retained a modicum of life and
movement, but this is covered by a false
face wearing seventeenth-century
quevedos (spectacles) like those sold by
the devil in his spectacles shop, whose
principal function was not to reveal
truths but to cover them up.[5] The title of
the drawing, *Sueño / Crecer despues de
morir.* (Dream / To Grow after Dying.), is
apt since this richly dressed man has the
face of a corpse, and his clothing is even
further out of date than that of the two
gentlemen in the print. Just as the over-
grown child-man, *El de la rollona* (The
Childish Man), in *Capricho* 4 (cat. 41),
who wore amulets on his belt in seven-
teenth-century fashion, characterized an
out-of-date noble, so too this huge, mori-
bund figure may be seen as representa-
tive of a corpus of nobles that has lived
long past its usefulness and has grown
enormous.

One reason for the growth of this body
might be attributed to the government's
need for money. Exacted from grandees
and titular nobility on coming into their
estates or on succeeding to any office
were *Medias Anatas*, a one-time tax of a
half-year's revenue. The Marqués de
Esquilache, secretary of state for war and
finances until the uprising of 1766, "was
fond of this resource, and since his time,
near one thousand titles have been
given," reported the English observer
Joseph Townsend, in Spain twenty years
later.[6]

In the first decade of the nineteenth
century the *Diccionario de Hacienda* esti-
mated that 51.5 percent of the agricul-
tural land was owned by the nobility,
another 16.5 percent by the Church, and
the remainder by communes and the
peasantry.[7] Because of the great holdings
of the nobility and the Church, the num-
ber of farmers able to own what they
tilled was small. When a man rented
land, he might cultivate and sow an
assigned lot with a mattock he was
obliged to borrow, and then "después de
pagar el canon de su arriendo, después
de pagar el diezmo y la primicia, tiene
que pagar por fuerza el voto de Santiago.
¿Y qué le queda a esta infeliz después de
tanto afán, si no puede llevar a su casa ni
aun la simiente que arrojó a la tierra?"
(after paying the fee for his rent, after

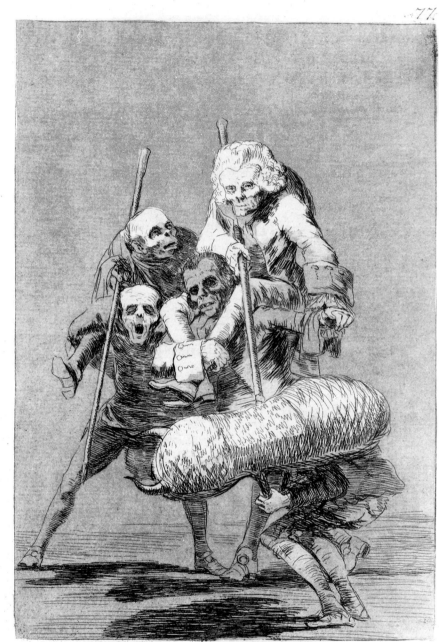

Unos à otros.

paying the [Church] tithe, and the first fruits, he is forced to make the Santiago offering [to the Church]. And what is left this unfortunate after such great toil if he cannot even take home the seed he sowed in the earth?)[8] The life of day laborers was no easier. Gaspar Melchor de Jovellanos left us glimpses of their plight in his diaries. On April 28, 1795, writing from Cabaña de Fuenmayor y Navarrete, after noting the richness of the land, he spoke of those who worked it: "Un pueblo de miserables jornaleros, que gastan cuanto trabajan y perecen en el descanso; que pendientes de pocos ricos propietarios, envidian su fortuna, y se irritan de compararla con su miseria. Estos jornaleros, son por lo común, para las labores menudas de las viñas; para las grandes, vienen aragoneses y campesinos; cuesta cada uno, en el día, doce y medio reales: los ocho de jornal, el resto de un cuartal de pan, dos comidas y alojamiento que se les da" (A village of miserable laborers, who spend what they earn and perish during their idleness; dependent on a few wealthy landowners, they envy their good fortune and are angered when they compare it to their indigence. These day laborers, for the most part, are used for the minor tasks of [cultivating the]vines; for the heavier tasks, Aragonese and peasants are brought in; each is paid twelve and a half reales a day: eight as a wage, the rest for a quarter of a loaf of bread, two meals, and the lodging given them).[9]

Enlightened men longed for a time when conditions for those working on the land might change. In 1786 Louis Sébastien Mercier added yet another section to his dream of an ideal world in the year 2440: "Tout ce qui concerne les travaux de la campagne & la réproduction des végétaux fut si bien protégé, honoré, encouragé, que le siecle s'appella le *siecle agriculteur*. . . . Le paysan, vu comme agriculteur, pasteur, pêcheur & chasseur, doit être considéré comme le véritable Atlas, portant le globe de la terre sur ses robustes épaules; car c'est par lui que le genre humain subsiste." (Everything to do with the work of the countryside and vegetable propagation was protected, honored, encouraged to such a degree that the century was called the *age of

agriculture*. . . . The peasant seen as cultivator, shepherd, fisherman, hunter, ought to be viewed as the true Atlas, carrying the globe of the world on his sturdy shoulders; for it is due to him that the human race endures.)[10]

Goya's *Capricho* sums up the hard and present reality to a degree that his cartoons for tapestries in the royal residence could not (compare cat. 10). The mounted monk and noble *torean* (fight a bull). But when, as here, it is a man, not a bull, that is being fought, the word means that the person is mocked, duped, kept waiting.[11] In Bayeu's tapestry (fig. 1) the village child who plays the bull stands up to his companions and gives as good as he gets; the peasant, however, must bend reverentially to his betters.[12] One urchin holds his basketry bull so that it both protects him and can be used offensively against his opponent playing the picador. The circumstances of the peasant's life are implicit in the manner in which he is being fought. Unlike a bull in the ring, he is forced to face two picadors, one clerical, the other noble, whose alternating attacks on him have worn down his resistance.[13] Worse, whereas a picador was allowed to thrust the *pica* only into the strong muscle at the base of a bull's neck, the noble has thrust his into the most vulnerable of parts: the belly. That same blow has knocked the basketry bull awry, leaving the peasant unprotected so that the *pica* may pierce his skull. Goya experimented with a different title in chalk in the lower margin of one trial proof: *Cosa rara, pero ay mas.* (Strange thing, but there are stranger.)[14] He then changed it to one that contains a haunting echo of Christ's precept: "Y así que, todo lo que queréis que los hombres hagan con vosotros, hacédlo tambien vosotros con ellos" (Therefore all things whatsoever ye would that men should do to you, do ye even so to them).[15]

Contemporary Explanations:

Ayala: *Aun siendo los hombres unos carcamales se torean los unos á los otros* (Even when men are withered old puts, they bullfight [dupe] each other).

Prado: *Asi va el mundo unos a otros se

burlan y se torean El q^e ayer hacia de toro hoy hace de caballero en plaza. La fortuna dirige la fiesta y distribuye los papeles segun la inconstancia de sus caprichos.* (That is the way of the world. People mock and bullfight [dupe] each other. He who yesterday played the part of the bull [was mocked] is today the mounted rider [or gentleman] in the ring. Fortune directs the fiesta and assigns roles according to the fickleness of her whims.)

Simon: *Todavia se torean y no se pueden ver los malos unos a otros, echandose en cara sus respectivos vicios* (Men still bullfight [dupe] one another and are unable to see the evil of their own deeds, throwing their own vices in each other's faces).

E.A.S.

1. Boys Playing at Bullfighting, tapestry woven from a design executed by Ramón Bayeu after the invention of Francisco Bayeu; Escorial, antedormitorio; see Jutta Held, *Die Genrebilder der Madrider Teppichmanufaktur und die Anfänge Goyas* (Berlin, 1971), p. 101 and no. 123. There is a small sketch of the design in the Prado, Madrid (2599). This subject is found in a group of paintings of children's games (extant in more than one version) that are often attributed to Goya; see G-W 159 and notes to 154-159; Gud. 207, 208.

2. For a rear view of an abbé's characteristic tails, see Abbé Pichurris in Goya's *Album B*, page 94; The Metropolitan Museum of Art, New York; G-W 450; G., I, 95.

3. Sanguine drawing; Prado, Madrid, 81; G-W 608; G., II, 127.

4. *Sueño* 16. Pen and brown ink over slight chalk sketch; Prado, Madrid, 18; G-W 627; G., II, 52.

5. See Andrés Davila y Heredia, *Tienda de antojos politicos* (Valencia 1673), p. 11.

6. Joseph Townsend, *A Journey through Spain in the Years 1786 and 1787* (London, 1791), vol. 2, pp. 168-169. The name of the marquis, an Italian, was more accurately Marchese de Squillace.

7. Quoted in F.D. Klingender, *Goya in the Democratic Tradition* (London, 1948), pp. 3-4. On agricultural life see also "La douloureuse existence de la masse rurale," in Sarrailh, *L'Espagne éclairée*, pp. 7-24.

8. Antonio José Ruiz de Padrón during the session of Oct. 12, 1812, on the Voto de Santiago, *Actas de las Cortes de Cádiz*, ed., Enrique Tierno Galván (Madrid, 1964), vol. 2, p. 914.

9. Gaspar Melchor de Jovellanos, *Diarios*, ed. Julio Somoza (Oviedo, 1954), vol. 2, pp. 46-47; Sarrailh, *L'Espagne éclairée*. p. 9, called attention to this text.

10. Louis Sébastien Mercier, *L'An deux mille quatre-cent-quarente: Rêve s'il en fût jamais; suivi de L'Homme de Fer, songe* (n.p., 1786), vol. 3, pp. 280-

281, from *L'Homme de Fer*. Mercier's *L'An deux mille quatre-cent-quarente* was also a desideratum for the French library proposed in "Projet de Bibliothéque dressé d'aprés les notes remises par S. E. Madame la Duchesse d'Ossuna [*sic*]," p. 4; Biblioteca Nacional, Madrid, MS. 11.140. (See also cat. 49, n. 4.) It is not known whether the Osuna list referred to this edition of Mercier's work, the first to contain *L'Homme de Fer*.

11. See Academia, *Diccionario*, 1791, under *torear*.

12. For various meanings of the word "bend" in this sense, see Academia, *Diccionario, 1791*, under *doblar*.

13. There is a saying used today, "A dos puyas no hay toro bravo" (After two goadings there is no brave bull), to express how difficult it is to resist repeated attacks; see José María Cossío, *Los toros*, 3rd ed. (Madrid, 1961), vol. 2, p. 241.

14. Rijksmuseum, Amsterdam, 1953:887.

15. Matthew 7:12. The Spanish text is from *La Biblia vulgata latina traducida en español, y anotada conforme al sentido de los santos padres y expositores católicos*, 3rd. ed., ed. Phelipe Scio de San Miguel (Madrid, 1807-1816). (First edition, 1790-1793.)

GOYA AND THE SPIRIT OF ENLIGHTENMENT
1800–1814

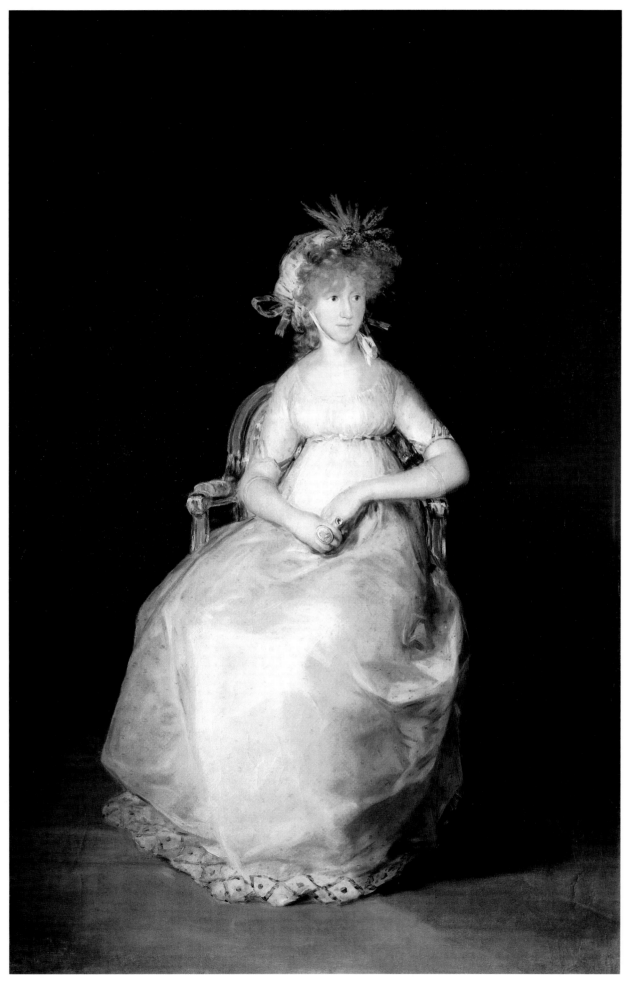

63

Condesa de Chinchón
1800
Oil on canvas
216 x 144 cm.
References: G-W 793; Gud. 425.

Private Collection, Madrid

The subject of this portrait is Doña María Teresa de Borbón y Vallábriga, fifteenth Condesa de Chinchón, Marquesa de Boadilla del Monte, and daughter of the Infante Don Luis Antonio de Borbón, Carlos III's brother. As a small child, she was represented behind her father and brother, peeping at the artist painting her family's portrait (cat. 5). She was married to Don Manuel Godoy, Príncipe de la Paz (Prince of Peace) (see cat. 64).

María Teresa was born on March 6, 1779, in Arenas de San Pedro, during her father's banishment from the court and royal sites, the result of his having married a lady beneath his station, Doña María Teresa de Vallábriga y Rozas, daughter of a capitán de caballería (cavalry officer) of the volunteers of Spain. Children of morganatic marriages could not succeed to their father's title, in this case, Infante of Spain.

When the Infante Don Luis died in 1785, his three young children were taken from their mother and sent by Carlos III to Toledo. The two sisters – María Teresa, the elder, and María Josefa, later Duquesa de San Fernando – were educated in the Real Convento de San Clemente (Royal Convent of Saint Clement), and the boy was tutored by the archbishop to take religious orders.

Carlos III granted the mother and the children each an annuity of 12,000 ducados, their share of Don Luis's will; later, in 1790, the new king Carlos IV raised the mother's annuity by another 12,000 ducados and allowed her freedom of residence, which had been denied her until then. In 1794 the son was granted the right to use the title of Conde de Chinchón, as his father had after his marriage, and, in 1797, the crown's concern for the Infante's family extended to the eldest child, María Teresa, when it was decided she would marry the most powerful man of the time in Spain, Manuel

Godoy.[1] Undoubtedly the match was Queen María Luisa's idea, as she schemed to separate the royal favorite from his new and dangerous lover Pepita Tudó, but the fact is that the marriage took place after María Teresa, then eighteen years old, had been consulted in Toledo.[2]

María Teresa's marriage to the Príncipe de la Paz enabled her to escape the convent and banishment and to acquire the rank she perhaps thought was owed her family. Her noble ancestry was thus recognized, and, as a result, her status at court was regarded as the highest after Queen María Luisa's.[3] Indeed, in 1799 she and her siblings were granted the right to use the surname and coat of arms of the Borbones. Having already received religious orders, her brother, Don Luis, was named archbishop-elect of Toledo in 1797; in 1800, by then archbishop of Toledo and Seville, he was made a cardinal. At Godoy's instigation the honors dispensed by Carlos IV and María Luisa were also posthumously bestowed on María Teresa's father, whose remains were transferred in 1800 to the pantheon of the Infantes in El Escorial.

The vision we have of the Condesa is, however, that of the austere and moralistic Jovellanos, Godoy's minister during the years of this marriage. In his correspondence Jovellanos told of being seated at Godoy's table as a dinner guest, with Godoy's wife on his right and on his left Godoy's lover Pepita Tudó: "este espectáculo me llenó de pesar; era más de lo que mi corazón podía soportar. No podía ni hablar ni comer, ni tener mi cabeza tranquila; salí huyendo" (this spectacle filled me with sadness; it was more than my heart could bear. I could neither speak nor eat nor think straight; I fled the scene).[4]

In the portrait Goya presented the young woman in April 1800, three years after her marriage to Godoy, when she was expecting her first child, the Infanta Carlota.[5] Queen María Luisa, who became Carlota's godmother and educator, felt maternal affection for her.[6] Perhaps the portrait was commissioned in view of the Condesa's approaching maternity (there are contemporary references to the commission in the queen's correspondence with Godoy),[7] and perhaps it was precisely the Condesa's special situation – expecting the first child of María Luisa's acknowledged favorite – that Goya succeeded in capturing with such admirable sharpness and sensitivity. This was the same Goya who had known the Infante Don Luis during his banishment in Arenas de San Pedro, exuding the contentment he had found in his marriage for love, for the sake of which he had renounced all his titles and honors.

The Condesa de Chinchón appears helpless and enchanting in her chaste white dress, her abundant, rich golden hair gathered in a coiffure shaped by wheat sprigs, symbol of fertility.[8] She has an air of timidity that is magnified by the emptiness of the sitting-room, which lies in shadow. Perhaps Goya wished to emphasize that such a tender and timid girl, raised in a convent from the age of five, could not possibly know how to oppose Queen María Luisa's blend of political and amorous interests.[9]

M.M.M.

1. There was a feeling among contemporaries who commented on these events that they were intended to favor Godoy as much as the family of the Infante Don Luis. See, for example, a letter of Blanco White: "Though not, hitherto, allowed to take their father's name, these children were considered legitimate; and it is probable that the King had been desirous of putting them in possession of the honours due to their birth, long before the Queen proposed the eldest of her nieces both as a reward for Godoy's services, and a means to prevent in future such sallies of youthful folly as divided his attention between pleasure and the service of the crown." Blanco White, *Letters*, p. 341.

2. Pepita Tudó was a young woman from Málaga with whom Godoy fell head over heels in love in 1796. The Aranjuez uprising of 1808 brought about Godoy's fall from power and flight from Spain, and hence his separation from the Condesa de Chinchón. When she decided to live in Toledo with her brother, Godoy sought to annul the marriage; he did not succeed in doing so, however, until his wife's death in 1828, upon which he married Pepita Tudó. Blanco White revealed the strength of Godoy's love of his mistress, which he described as "an attachment which bid fair to last for life." *Letters*, p. 339.

3. This kind of marriage, in which love played no role, was not uncommon at that time. Goya attacked it in many of his works, from the early *Wedding* of the tapestry cartoons (G-W 302) to the *Caprichos*, of 1799, where his criticism was sometimes fierce, as in *Capricho* 14, *Que sacrificio!* (What a Sacrifice) (G-W 679), or cat. 39. These two works analyze the social

predicament of the Spanish woman, turned into a victim but obliged as well to know how to make the best of the situations to which she was subjected.

4. Jovellanos, *Correspondencia*, quoted in José Gudiol, *Goya* (Barcelona, 1970-1971).

5. Goya had also painted María Teresa as a child, alone, standing before a landscape that serves as backdrop, in the enchanting portrait in the National Gallery in Washington (G-W 210). In a portrait attributed to Goya, dated 1797 (now in the Uffizi), the Condesa is standing, decorated with the Orden de la Reina María Luisa (Order of Queen María Luisa), at the time the most important decoration for women.

6. For the most complete information on the family of the Infante Don Luis, see Ignacio Olavide, "Don Luis de Borbón y Farnesio y Don Luis de Borbón y Vallabriga," *Revista de Archivos, Bibliotecas y Museos*, June 1902, pp. 453, 455. See also José Manuel Arnaiz y Angel Montero, "Goya y el Infante Don Luis," *Anticuario* 27 (March 1986); and Pierre Gassier's entry on the Condesa de Chinchón in Villa Favorita, Lugano, *Goya in spanischen Privat-Sammlungen*, exhib. cat. (1986), pp. 15, 55.

7. See María Luisa to Godoy, Apr. 22, 1800: "Amigo Manuel nos alegramos de que estes bueno, así como tu muger, esperando siga bien asta salir de todo, tambien nos alegramos se retrate, y si Goya puede acer ella la obra maestra, bien echa y parecida, mas vale alla la aga, pS de ese modo nos libramos de molestias, pS venga mas qe nos mortifiquemos . . ." (Dear Manuel we are pleased you are well, along with your wife, hoping she will remain well until everything is over, we are also pleased she will have her portrait done, and if Goya can make her a masterpiece, well done and a good likeness, it is as well that he do it there, for this way we will not be troubled, as we need no further vexation). And Apr. 24: "muy bien me parece lo qe le has dicho a Goya po dejale qe concluia bien el Retrato de tu muger" (I approve of what you told Goya but let him finish your wife's portrait well). Quoted in José Gudiol, *Goya* (Barcelona, 1970-1971).

8. On the description of the clothing and coiffure and the differences from French fashion, see María José Saez Piñuela (1971), pp. 234-235. Conde de Viñaza describes the ring bearing a likeness, doubtless that of Godoy, that the Condesa wears on her right hand. See Conde de Viñaza, *Goya: su tiempo, su vida, sus obras* (Madrid, 1887), item 42, p. 230.

9. Blanco White noted the Queen's viewpoint in commenting on the Condesa's marriage: "These or similar reasons (for history must content herself with conjecture, when the main springs of events lie not only behind the curtain of state, but those of a four-post bed) produced in the space of a few weeks, a public recognition of Don Luis's children, and the announcement of his eldest daughter's intended marriage with the Prince of the Peace." Blanco White, *Letters*, p. 341.

64

Don Manuel Godoy
1801
Oil on canvas
180 x 267 cm.
References: G-W 796; Gud. 435.

Real Academia de Bellas Artes de San Fernando, Madrid, 670

The Príncipe de la Paz (Prince of Peace) reclines in a field commander's chair on a battleground; in his right hand he holds a sheet of paper. At his left is his aide, who has been identified by some scholars as Conde de Zepa o de Marla, and in the background soldiers lead skittish horses. The scene suggests the calm following victory, as does Godoy's rather indolent pose.[1]

In this painting, as in other portraits, Goya showed his remarkable ability in rendering strength of character, which this powerful minister exudes despite the elegant abandon of his posture. The glitter of his uniform and decorations, the red silk flags, and the troops in the background do not obscure Goya's intention to focus on Godoy's personality in this portrait, especially the supreme self-confidence that precipitated his fall in 1808. However, it was owing to that confidence in himself and his own ideas that Godoy succeeded in establishing reforms and freedoms Spain needed during an extremely difficult, complicated period. He chose the most open and intelligent of the enlightened to run his government, and although he was not a man of great culture, he relied on the support of some of the most cultivated men of late eighteenth-century Spain.

At the turn of the century, Goya executed a series of important commissions for Manuel Godoy. Perhaps Meléndez Valdés (see cat. 24) secured Goya access to Carlos IV's all-powerful prime minister to paint a group of allegorical works for the palace on subjects of interest at the time: science, industry, commerce, and agriculture (all now in the Museo del Prado, Madrid; G-W 690-693). In 1797 and in 1800 Goya portrayed Godoy's wife, the Condesa de Chinchón (see cat. 63). The *majas* (G-W 743-744), too, were painted for the minister, since they

appear in his inventories. The naked *maja* was painted by 1800 because it was then seen in Godoy's palace by González de Sepúlveda. In a letter to his good friend from Zaragoza, Martín Zapater, Goya described how much he was valued: "El ministro se ha escedido en obsequiarme llevándome consigo a paseo en su coche aciendome las mayores expresiones de amistad qe se pueden acer, me consentia comer con capote pr qe acia mucho frio, aprendió a hablar por la mano, y dejaba de comer pr ablarme, quería que me estuviese asta la pascua y qe hiciese el retrato de Sabedra" (The minister has surpassed himself in his attentions, taking me with him in his coach for a stroll, regaling me with the greatest possible expressions of friendship, he allowed me to retain my cloak while we ate because it was very cold, learned to use sign language, and left off eating in order to speak to me, wanted me to remain until Easter, and to paint Saavedra's portrait).[2]

When Godoy sat for Goya in 1801, the minister was at the peak of his power. The occasion was probably a victory in the Portuguese campaign – known as the "War of the Oranges" – since the portrait includes two flags taken from the Portuguese army, delivered to Godoy on July 7, 1801, while he still lacks the insignia of *generalísimo* (commander in chief), a title that was bestowed on him on October 14.[3] It is in his role as army commander that Goya presented him, perhaps at Godoy's urging, in this magnificent portrait.

Manuel Godoy y Alvarez de Faria, a controversial figure, attacked by some, exalted by others, from his contemporaries to historians of today, was born on May 12, 1767, in Castuera (Badajoz, western Spain) of a noble but impoverished family. When he was a horse-guard in 1784, his slender and agreeable demeanor caught Queen María Luisa's eye. Ambitious and astute, Godoy turned María Luisa's favor to account, and thereafter the rise in his professional fortunes was meteoric. Between 1788, when Carlos III died, and 1792, when Godoy, at twenty-five, was named primer Secretario de Estado del Despacho universal (first secretary of state of the exec-

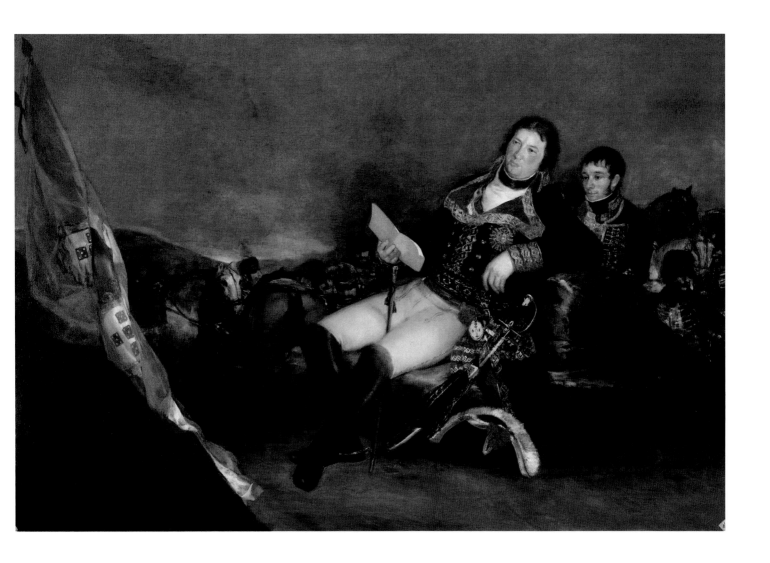

utive office), he held the following positions: cadet, general aide, brigadier, field marshal, sergeant major of the horse guards, gentleman-in-waiting, state councillor, superintendent of the post and roads, commander of the Order of Santiago, and Duque de la Alcudia with a Spanish grandeeship.[4] But Godoy's rise to power was not entirely due to the queen's weakness for him or to the affection and admiration of the new king, Carlos IV, who had not yet settled into power. Godoy himself affirmed, in answer to Conde de Aranda's attacks rebuking him for his youth: "Es cierto que tengo veintiseis años no más, pero trabajo catorce horas diarias, cosa que nadie ha hecho; duermo cuatro, y fuera de las horas de comer, no dejo de atender a cuanto ocurre" (It is true that I am only twenty-six years old, but I work fourteen hours daily, something nobody else has done; I sleep four, and apart from taking my meals, I never fail to look after everything that comes my way).[5]

This feature of Godoy's character, that of the indefatigable worker, was noted by contemporaries such as Blanco White: "an acute and perfectly disinterested observer, whose high rank gave him free access to the favourite during part of the period when with the title of Duke de la Alcúdia he was at the head of the Spanish ministry, [noted] that 'there was every reason to believe him active, intelligent, and attentive in the discharge of his duty; and that he was perfectly exempt from all those airs and affectation which men who rise by fortune more than merit are apt to be justly accused of.' "[6]

Upon signing the Peace of Basel in 1793, which brought to a close the first round of hostilities with the French revolutionary army, Godoy was named Príncipe de la Paz, and in 1801, at the end of the Portuguese campaign, Generalísimo del Ejército de Tierra y Mar (commander in chief of the army and navy). According to his enemies, his relationship with the army was superficial and motivated by personal interest: "Desde el tiempo de la escandalosa campaña de Portugal, mandó el ejército con el título de generalísimo, no teniendo a los ojos la ilustre profesión de las armas otro atractivo ni noble cebo que el de los

honores y sueldos; nunca se instruyó en los ejércitos militares; nunca dirigió al soldado ni se informó de sus necesidades o reclamaciones" (Since the time of the scandalous Portuguese campaign, [Godoy] led the army as commander in chief, the illustrious military profession having no appeal in his eyes or noble inducement other than that of honors and wages; never was he trained in the military; never did he direct himself to the soldier nor inform himself of his needs or complaints).[7] However, Godoy himself stated: "no me acomodo a vivir sin soldados, su vista me entretiene y nací para no separarme de ellos" (I cannot grow accustomed to living without soldiers, the sight of them amuses me and I was born not to live apart from them).[8] Doubtless to his discredit as a commander in chief was the ease of the battles in which he participated, some of them almost military parades, like that of Portugal, while in the war with England in 1805, the navy suffered tragic defeat at Trafalgar.

M.M.M.

1. José Camón Aznar, *Francisco de Goya* (Zaragoza, [1982?]), vol. 3, p. 135.

2. Goya to Zapater, Mar. 27, 1798, in Francisco de Goya, *Cartas a Martín Zapater*, ed. Mercedes Agueda and Xavier de Salas (Madrid, 1982), p. 231. It is uncertain whether the minister referred to here was Jovellanos or Godoy.

3. On a second portrait Goya executed on the occasion of the victory, perhaps an equestrian portrait, see A. Martínez Ripoll, "Un retrato alegórico de Godoy, por Goya," *Goya*, nos. 148-150 (1979), pp. 294-299.

4. On Godoy's personality, see Juan Plaza Prieto, *Estructura económica de España en el siglo XVIII* (Madrid, 1976), pp. 46-47; Antonio Domínguez Ortiz, *La sociedad española en el siglo XVIII* (Madrid, 1955), pp. 34-35; Conde de Toreno, *Historia del levantamiento, guerra y revolución de España*, Biblioteca de Autores Espanoles, vol. 64 (Madrid, 1953), pp. 64ff; and José Blanco White, *Cartas de España*, ed. Antonio Garnica (1986).

5. Domínguez Ortiz, *Sociedad*, p. 35.

6. Blanco White, *Letters*, p. 342.

7. Conde de Toreno, *Guerra*, p. 64.

8. Quoted in Camón Aznar, *Goya*, vol. 3, p. 135.

65

Bartolomé Sureda
About 1804-1806
Oil on canvas
119.7 x 79.4 cm.
References: G-W 813; Gud. 533.

National Gallery of Art, Washington, Gift of Mr. and Mrs. P.H.B. Frelinghuysen in memory of her father and mother, Mr. and Mrs. H.O. Havemeyer, 1941.10.1

Bartolomé Sureda was among those enlightened figures whose interest in science and love of the fine arts were joined in the quest for industrial applications. Among the enlightened there was a particular concern for the development of the so-called useful sciences – such as mathematics, modern languages, geography, and economics – because the regeneration and prosperity of the country depended on them. The search for knowledge was not usually understood to be the sole objective of research; rather, practical results were generally sought.

Sureda was born in Mallorca in 1769, to a family of probably limited means.[1] He studied drawing in the School of Fine Arts established by the Sociedad Económica (Economic Society) in his home town. At eighteen he moved to Madrid with Tomás Veri, owner of one of the best art collections on the island. In Madrid he became a disciple of Agustín de Bethancourt, the most distinguished engineer and inventor of enlightened Spain; he left for England with Bethancourt, where he spent three years. Bethancourt commented on Sureda's apprenticeship: "Habiendo conocido antes de mi ultima salida de España, el talento en el dibujo y la arquitectura, y el que tenía en muchas artes el referido Sureda, le propuse el que se fuese conmigo á Londres ofreciendome á costearle de mi sueldo todos sus gastos, pues sus padres y hermanos lejos de poder contribuirle con nada, dependian en cierto modo de él. llevado del deseo de aprender admitió la oferta, y en Londres fue tanta su aplicación que a pocas lecciones que tomó de un célebre dibuxante (las que la pagué yo á cien reales cada una) llegó casi a igualar a su Maestro. Despues aprendió a grabar con perfec-

cion, por método nuevo, y cuya muestra tube la honra de enviar a V.E. desde Londres. Luego conseguí introducirle en la manufactura de las principales de Inglaterra, donde se instruyó en la fundición y varias operaciones del hierro, y en la construccion de maquinas al mismo tiempo. Tuvo ocasion de instruirse en la fabricación de la loza Inglesa, y se aplico á ello hasta poseerlo perfectamente: recorrió conmigo la mayor parte de Inglaterra, y ha hecho casi todos los dibuxos y planos qe he tenido en mi viage, y ademas se halla instruido en el modo de levantar los mismos planos, hacer nivelaciones." (I proposed to Mr. Sureda he accompany me to London at my expense, his having cultivated his ability in drawing and architecture and in many arts before I undertook this journey abroad and his parents and siblings being far from a position to help him, rather to some extent depending on him. Persuaded by his desire to learn, he accepted the offer, and in London he was so diligent that within a few lessons received from a celebrated draftsman – which I underwrote at 100 reales each – he was nearly his teacher's equal. Then he learned to make prints to perfection by a new method, a sample of which I had the honor to send to Your Excellency from London. Later I managed to acquaint him with England's principal industries, at which point he studied metal casting and the various procedures for treating iron as well as building machines. He had occasion to learn about the manufacture of English ceramics, and applied himself to the task until achieving complete mastery: he joined me in traveling the better part of England, and he has made almost all the drawings and charts I have needed during my stay; moreover, he knows how to make surveys and to level.) Bethancourt added that in London and in Paris Sureda was made various offers, but that he preferred to return to Spain.[2]

Pedro González de Sepúlveda, a designer of coins, who must have been a friend of Sureda, explained the latter's method of softground etching, a process that imitates chalk drawing: "Sureda el mallorquín de Betancr coge y da a la chapa de barniz como para grabar, sienta

el dibujo como quien lo va a pasar, esto es, teniendo el perfil puesto en el papel, y luego lo dibuja y lo sombrea; y con aquel aprieto que hace con la punta del lápiz hiere el barniz de modo que cuando lo dibuja en el papel, esto es, sombrea aquel dibujo mirando el original, ya esta pasado a la lámina todos aquellos trazos del lápiz y levantando el papel se quita el barniz de aquellas partes, y queda dibujado exactamente en el revés pegándose al papel el negro del humo que se le dio al barniz: pero creo dá algún barniz al papel para que agarre y recoja el negro y aún arranque aquellas lapizadas el barniz, y se pueda grabar con exactitud el dibujo" (Betancor's Sureda from Mallorca takes the plate and gives it a coat of varnish as though it were to be etched, places the drawing on the plate as though it were to be put through the press, that is, with the varnished side against the paper and then he draws and shades; and through the pressure of the point of the pencil the varnish is penetrated in a manner similar to the drawing on the paper, that is, the print is shaded like the original drawing, all the pencil marks having been transferred to the plate, and when the paper is removed it takes the varnish with it in those places, so that clinging to the verso of the paper is an exact drawing in reverse of the black with which the varnish was smoked; but I believe he applies some varnish to the paper so that it will seize and pick up the black; and the varnish even picks up touches with pencil, so that the drawing is etched with exactitude).[3]

On April 2 Bethancourt exhibited in the Academia de San Fernando various prints created by Sureda imitating India ink, chalk, and etching. Soon thereafter, in 1800, Sureda obtained a fellowship to continue his studies in Paris. The purpose of the sojourn was to examine cotton, porcelain, and ceramic factories. On his return in 1803, he began working for the Real Fábrica de Porcelana de Buen Retiro (Buen Retiro Royal Factory of Porcelain), and in the following year the king named him general director of the institution with a salary of 40,000 reales, then a considerable amount. He was responsible for important technical improvements and reorganized the factory so as to turn

the enterprise into a true industry, since the royal factories supplemented industrial development in the absence of adequate private enterprise. In this moment of professional success and prosperity, Sureda and his wife sat for Goya.[4] According to the testimony of Sureda's son, Goya painted the portraits in gratitude for being taught a new print technique.[5]

The composition of Sureda's portrait is similar to that in the paintings of the Marqués de San Adrián (G-W 818) and Evaristo Pérez de Castro (G-W 815), of the same period. The model leans forward, supports himself on one arm, and rests his other hand on his hip. Of the three portraits, this one, which lacks any indication of Sureda's profession or interests, gives the most attention to the sitter's facial expression and personality. Sureda seems to be lost in his own thoughts.

On the arrival of the usurper king, José Bonaparte, Sureda left his job in the Real Fábrica. During the first brief period of French withdrawal from Madrid, he again took charge of the factory so that it could be used to make artillery casings. He also requested "he be allowed to join the group commissioned by the junta central [the Spanish opposition's central government] to prepare the topographical map of Spain's borders."[6] When Napoleon's troops reentered Madrid, Sureda "desperate about having no fixed position or income, sought José Bonaparte's protection, submitting a long report in which he offered his services to the royal factories."[7] His petition was ignored, and the French army partially destroyed the factory by setting it on fire. Sureda chose voluntary exile in Paris; he thought of continuing on to Russia, but Napoleon denied him permission.[8] In France he learned a new lithographic technique.[9]

When the war was over, Sureda returned to Spain and began to work in the Real Fábrica de Paños de Guadalajara (Royal Textile Factory of Guadalajara), where "he introduced newly invented wool carding machines and perfected every aspect of the factory, giving it a new character."[10] After 1821 he was director of several royal and scientific

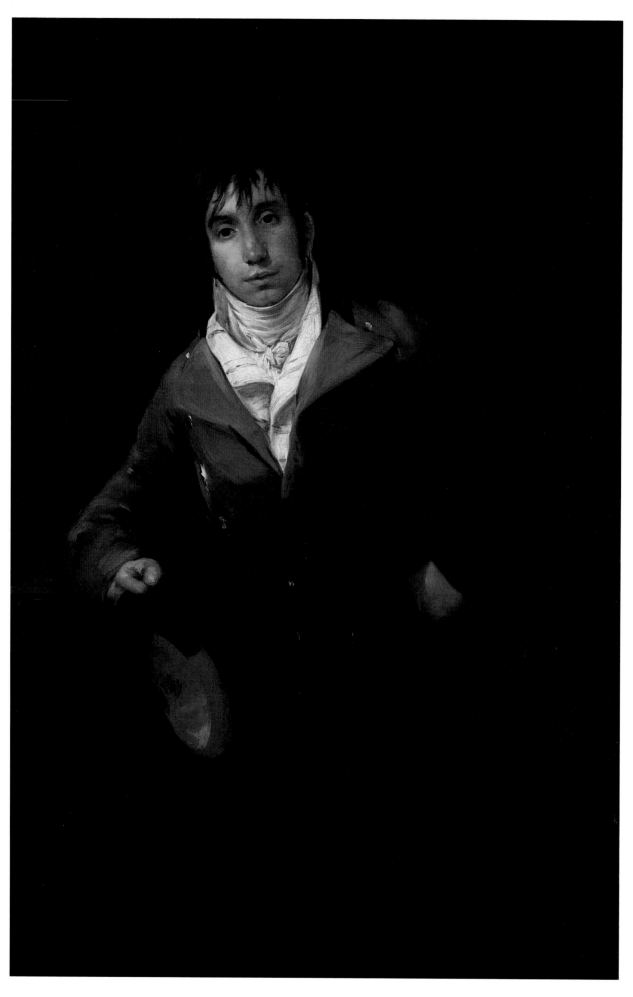

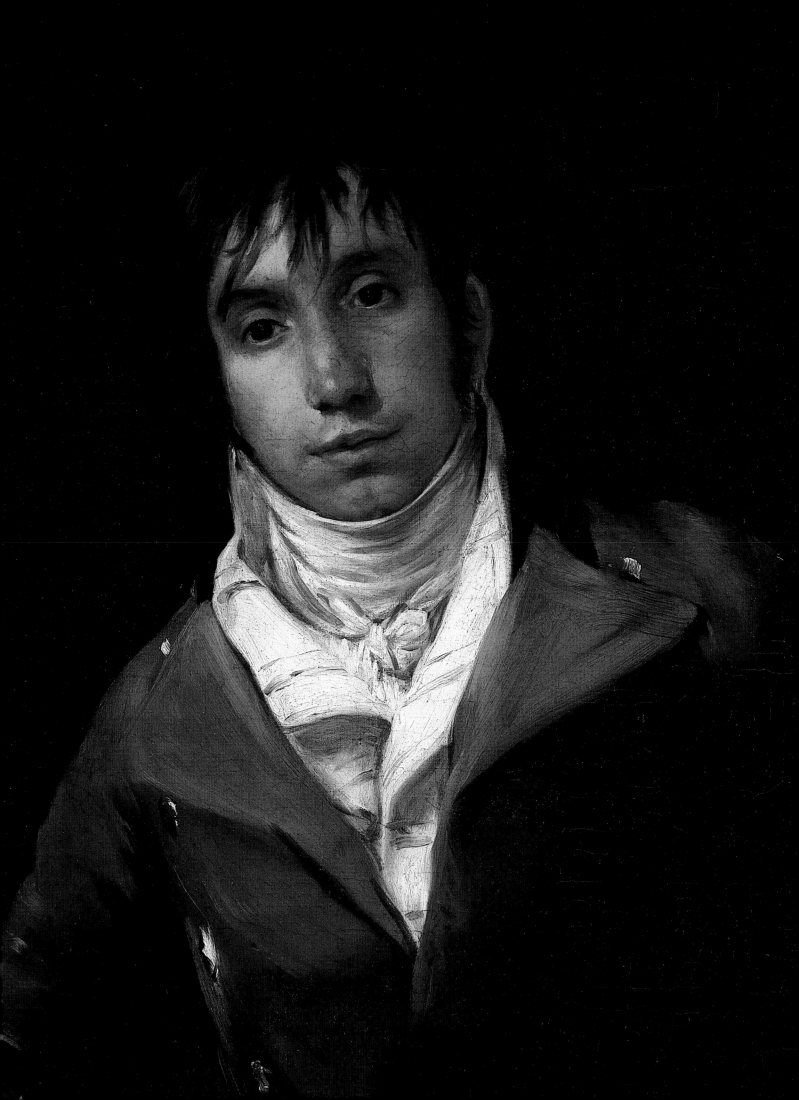

institutions, being named acting director of the Real Fábrica de Loza de la Moncloa (Royal Ceramic Factory of Moncloa) and later chief director; two years later he obtained the directorship of the Real Fábrica de Cristales (The Royal Glass Factory) and was also a full professor at the Real Conservatorio (Royal Conservatory), the only scientific and technical center of the time. Sureda retired in 1829 to his hometown, Palma de Mallorca, but continued to be active. Antonio Furió, who wrote a biographical note on Sureda in 1839, when he was still alive, commented that he was then in charge of "directing road works, the drawing school, and other useful enterprises."[11] Furió also referred to Sureda's paintings, mostly landscapes, along with some religious works executed for the island's churches.

M.M.H.

1. In 1797 Sureda requested that part of what the state owed him should be sent to his father. Agustín de Bethancourt also wrote that Sureda maintained his family. Conde de Mopox Expedition in the Museo Naval, Madrid, MS 2243, vol. 4, document 49, fol. 47. This manuscript is cited by Antonio Romeu de Armas, *Ciencia y tecnología en la España ilustrada: La escuela de caminos y canales* (Madrid, 1980).

2. Conde de Mopox Expedition, pp. 48-50.

3. "Diarios de Pedro Gonzalez de Sepúlveda," Fábrica Nacional de Moneda y Timbre, 1797-1802, bk. 9, fol. 33. I am grateful to Professor Nigel Glendinning for supplying me with this quotation and for bibliography on Sureda.

Sureda must already have been known as an expert printmaker, though not as a master of the latest techniques, for Sepúlveda sent his son to Paris to study them. In September 1797 he included a note on instructions he gave his son in Paris.

4. The portrait of his wife, Teresa Sureda (G-W 814), is also in the National Gallery, Washington.

5. On Sureda's friendship with Goya, see Manuel Pérez-Villamil, *Artes e industrias del Buen Retiro: La fábrica de china* (Madrid, 1904), p. 48.

6. Romeu de Armas, *Ciencia*, p. 350.

7. Ibid., p. 352. The source is a report sent to José I by Sureda. Archivo Histórico Nacional, Hacienda, Registro de reales órdenes, bk. 10, fol. 857.

8. Antonio Furió, *Diccionario histórico de los ilustres profesores de las Bellas Artes en Mallorca* (Palma, 1839), p. 174.

9. Felix Boix, "La litografía y sus orígenes en España," *Arte español* 7 (1925), pp. 279-302. In 1811 Sureda signed four small ink lithographs; he was in Paris that year and must have been in contact with Baron Vivant-Denon, who engaged in this "amusing novelty." Ibid., pp. 280-281. Walter Cook, "Spanish Paintings in the National Gallery of Art, pt. II: Portraits by Goya," *Gazette des Beaux-Arts* 28 (1945), p. 160, also referred to these works: "Four lithographs of women in French costume, done and signed by Sureda between 1808 and 1811, when in Paris, are among the earliest lithographs by a Spanish artist."

10. Furió, *Diccionario*, p. 175.

11. Ibid., p. 176.

66

Marquesa de Santa Cruz
1805

Oil on canvas
130 x 210 cm.
Inscribed: *Dª Joaquina Giron, Marquesa de Santa Cruz / Por Goya 1805*
References: G-W 828; Gud. 496.

Museo del Prado, Madrid, 7070

The *Marquesa de Santa Cruz* is important not only because of its extraordinary visual qualities but also because it is the most significant example of synthesis by a great Spanish artist of the advanced artistic language of the late eighteenth century and the spirit of classicism fostered by the Napoleonic empire.[1]

Goya had previously placed his most ambitious works – especially court portraits – within the tradition of Velázquez, even adhering literally to the style of the great baroque painter in the equestrian portraits, in the portraits in hunting dress, and in those of Carlos IV's family. Perhaps through his sojourns in Cádiz or in Seville in 1792 and 1796 he had occasion to study and to be inspired by contemporary English baroque painting, which may have influenced some of his remarkably distinguished portraits of the aristocracy, such as those of General Ricardos (G-W 337-338), the Duque de Alba (G-W 349-350), Jovellanos (cat. 30), the Marqués de San Adrián (G-W 818), and the Condesa de Chinchón (cat. 63).

In the portrait of the Marquesa de Santa Cruz, Goya was perhaps influenced by the increasing collaboration between Spain and Napoleonic France, which must have produced a growing traffic in books, prints, and fashion. The composition shows severity of form in the architectural arrangement of parallel planes; these create rather than diminish a spatial depth, which Goya's magic brush has filled with mystery. Goya's son, Javier, especially praised this portrait in his biography of his father.[2]

The figure lies on pillows, not diagonally as in the *Majas* (G-W 743-744) – paintings that are still indebted to the baroque in structure – but rigorously parallel to the canvas's plane. She appears almost as if in low relief, which is empha-

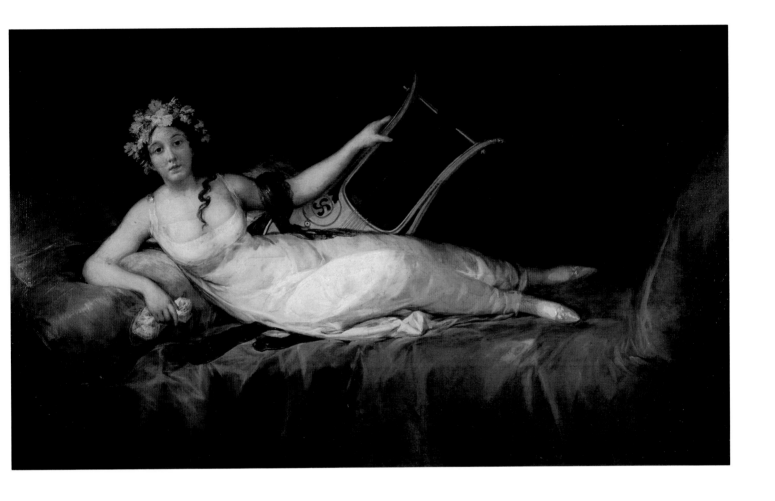

sized by the powerful light. The Marquesa's costume, with the low neckline that leaves the breast almost uncovered, reflects Empire fashion with a faithfulness to be found only in a few Spanish portraits of the time. Her head is crowned with a wreath that appears to be composed not of vine leaves, as Gudiol suggested, but of oak leaves, symbolizing virtue, constancy, and long life. Even the classical Spanish guitar has been replaced by a classical lyre. Despite this external apparatus of attributes, which suggest a historicized portrait, there is more to the painting than can be explained by the bare circumstances of a commission. There is in it a tremor of lyricism that banishes all detachment.

Joaquina Tellez de Girón, the young Marquesa de Santa Cruz, was the daughter of Condesa de Benavente and Duque de Osuna (see cat. 6). Goya had known her since she was a child and was close to her (see cat. 17). This association is apparent in the painting. There is, of course, no fierceness here, no flashy elegance or bravura. There could be none, given the social status of the woman and the attitude of serene intimacy Goya sought in the subject, who seems to receive us with an expression of abstracted welcome. In this portrait, executed scarcely five years after David's celebrated portrait of the reclining Madame Recamier (1800) and at the same time as Canova's sculpture of the reclining Paulina Borghese (1804-1808), we are aware of Goya's personal perception beneath the veneer of international neoclassicism.[3]

M.M.H.

1. Napoleon was crowned the year before, in 1804.

2. See Angel Canellas López, *Francisco de Goya, Diplomatario* (Zaragoza, 1981), p. 518.

3. This entry is partly derived from material published in *Boletín del Museo del Prado* 7, no. 19 (Jan.-Apr. 1986), p. 62.

67

Water Carrier
1808-1812
Oil on canvas
68 x 52 cm.
References: G-W 963; Gud. 579.

Szépművészeti Műzeum (Museum of Fine Arts), Budapest, 760

68

Knife Grinder
1808-1812
Oil on canvas
68 x 50.5 cm.
References: G-W 964; Gud. 580.

Szépművészeti Műzeum (Museum of Fine Arts), Budapest, 763

These paintings have traditionally been viewed in two ways. Some scholars have considered them folkloric works illustrating trades, others as paintings signifying a step toward nineteenth-century realism.

If they were folkloric, one would expect them to conform to the peculiarities of prints on trades.[1] But in these paintings the anecdotal and descriptive elements have been reduced to the most significant: the pitcher and glasses, the grinding stone and knife, discharging "the anecdotal, architectural elements that serve as theatrical backdrop, such that the figures can move freely within the space . . . in order to lend a greater sense of reality and vigor to the scene."[2] The light and shadow and no other indication of place produce the uniform background of the *Knife Grinder*. The *Water Carrier* places its subject in an unusual setting for the representation of this trade: in the countryside at twilight, the sky suffused with a beautiful grayish color, the trees in shadow, with no one about to buy her water.

These paintings, along with *The Forge* (cat. 150, fig. 1), have also been regarded as precursors of realism.[3] But, although they may share some formal and thematic aspects with realistic works, the symbolic and ideological content responds to quite a different context and intention.

Both works were probably executed before 1812. In an 1812 inventory appear "la aguadora y su compañero"

(the water seller and her companion [piece]), which may refer to these works.[4] For stylistic reasons – the thickset, strong, and not particularly lithe human types, far from those in the *Caprichos* but close to that of the *Allegory of the City of Madrid* (G-W 874) – one may suppose they were not done before 1808. They would thus have been executed during the Peninsular War, between 1808 and 1812.[5]

It is worth analyzing the historical context in which Goya lived during those years. There is evidence he traveled to Zaragoza in 1808, two months after the siege, summoned by Palafox (see cat. 75) when events were still fresh.[6] Goya may well have been moved by the spirit of the city, regarded elsewhere in Spain as the bulwark of Spanish resistance to the French.[7]

First-hand chronicles of the first siege of Zaragoza recount that the women's main task in the war was to carry water, wine, or brandy to the soldiers at the front, up to the lines of fire in the countryside as well as in the city.[8] The commentators noted the bravery with which the women cheered the men, encouraging them to sustain the fight, never hesitating to take up arms when the situation became critical. According to the eyewitness Casamayor, "la accion de las mujeres en mucha parte afianzó la victoria, logrando reanimar a nuestros vencedores" (the women's role in great measure ensured victory, for they succeeded in inspiring our victors [to rejoin the fight]).[9] Grandmaison, on the French side, noted: "no había cobardes allí donde las mujeres compartían el riesgo" (there were no cowards where women shared in the dangers).[10] The English traveler Charles Vaughan observed: "but in this act of humanity none were more conspicuous than women, who persisted in their humane exertions, equally undaunted by the shot, and shells of enemy, and the flames of the building before them."[11] Palafox himself, in the proclamation of June 16, 1808, two days after the attack, wrote: "Ved la heróica conducta de las zaragozanas que inflamadas todas del amor a su patria y á su rey y á su religión corren presurosas a prestaros todo tipo de auxilios" (Behold

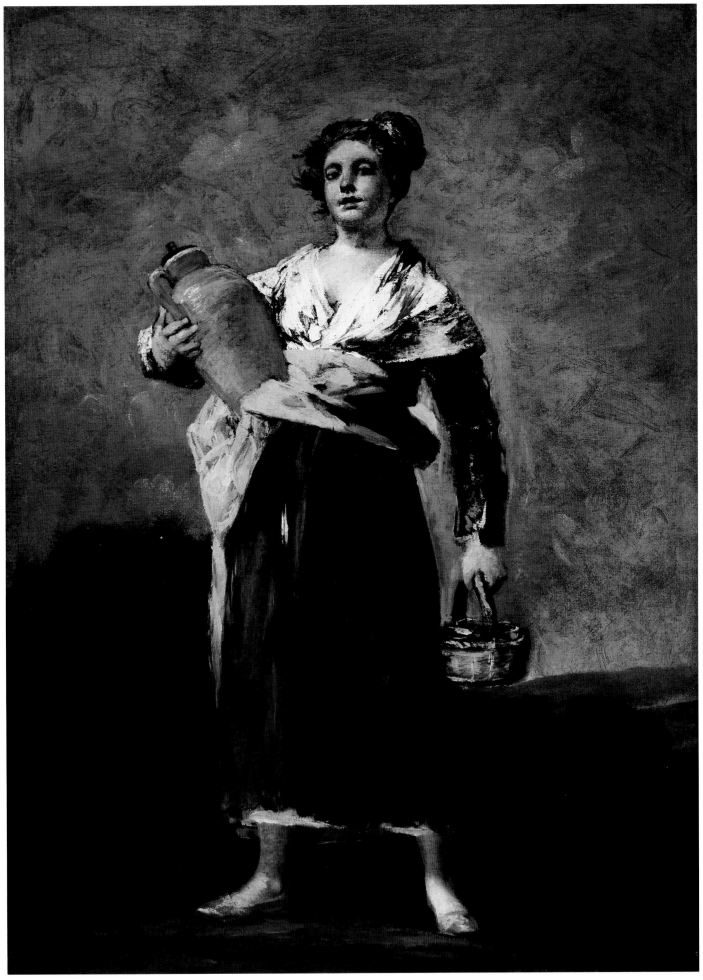

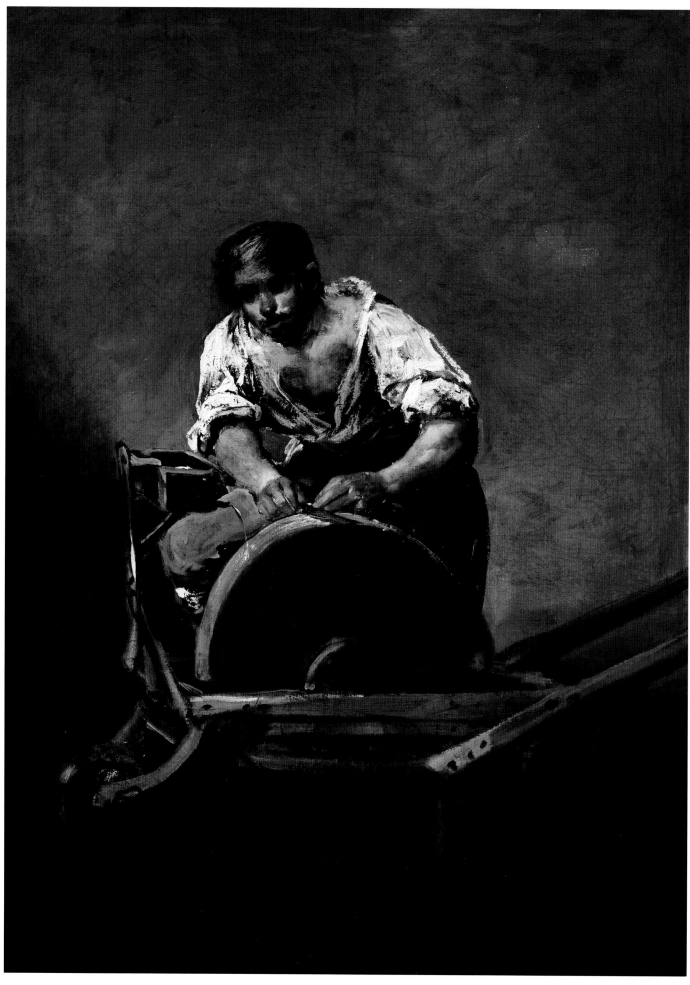

the heroic acts of the women of Zaragoza who, stirred up by their love of country and king and religion, hurry to lend you every kind of assistance).[12] The most renowned heroines were María Agustín, who supplied the soldiers with cartridges and brandy;[13] and Agustina de Aragón who, on a trip to the front with refreshments, came upon a defenseless area and did not flinch from manning the artillery.[14] According to the chronicles of the siege, the French preferred fighting by night because "el mejor momento para los ataques era siempre de noche, a favor de las tinieblas y la oscuridad" (the best time to attack was always at night, owing to the darkness and the gloom).[15]

In the *Water Carrier* Goya's composition forces the viewer to look up to the figure. Such a low point of view is not frequent in Goya's work, and it is generally designed to exalt the subject. Fred Licht observed the compositional similarity between this work and *Santa Justa y Rufina*, executed in 1817 for the sacristy of the cathedral of Seville (G-W 1567): "The deliberately low point of view that Goya has chosen for his saintly sisters is fairly traditional when dealing with saints or with exalted personages because it automatically imposes an attitude of reverence on the spectator."[16]

Two interpretations of this work come into play. The first centers on the historic moment in which the work was painted and from which can be derived the meaning of the allusion to a water seller. The other view places less emphasis on the painting as historical documentation since it does not specify an action or particular person. Because of the low point of view of the composition and the symbolism of the pitcher and the glasses, the painting can be said to convey a universal admiration for the kind of female vitality that inspires action.[17]

The stylistic characteristics of the *Knife Grinder* are similar to those of the *Water Carrier*, but the heroic exaltation of the companion is absent. The knife grinder bows next to his grinding stone and gazes at us. Unlike the water carrier, he is neither beautiful nor monumental; he does not have her aplomb or power. Although his expression is not intelligent,

he seems capable of heroic enterprises. He wields a knife, which had a special meaning and mission during the war. The knife passed from being a common work tool to a defensive weapon. During the two sieges of Zaragoza, the Aragonese distinguished themselves in hand-to-hand fighting with the knife.[18] It was a symbol of the people's resistance. During the first siege, "la respuesta inmediata del general Palafox fue la siguiente: Quartel general de Zaragoza, *guerra y cuchillo*" (General Palafox's immediate answer was the following: General Headquarters of Zaragoza, [give them] *war and knife*). According to the same source, civilians were prepared to fight with the knife alone: "la voz general resonó en los oidos del bizarro Palafox, quando pasaba a caballo a través del pueblo, fue, que si las municiones faltaban, estaban prontos a atacar al enemigo con daga y cuchillo" (the consensus resonated in valiant Palafox's ears whenever he passed through a village on horseback; if the ammunition supplies failed, they were prepared to fall upon the enemy with dagger and knife).[19] The French used this fact as a pretext to massacre villagers (see cat. 87). Blanco White recounts that, following the events of May 2, Murat wished to make "an example" of "a certain number of the lower classes of citizens. As the amnesty excluded any that should be found bearing arms, the French patrols of cavalry, which were scouring the streets, searched every man they met, and making the clasp knives which our artisans and labourers are accustomed to carry in their pockets, a pretext for their cruel and wicked purpose, they led about one hundred men to be tried by a Court Martial; in other words to be butchered in cold blood . . . having ascertained that no person of note was among the destined victims."[20]

Goya glorified the anonymous popular heroes, both men and women. Their efforts helped the army against the invader. Neither fanaticism nor insanity (see cat. 82) nor desperation (see cat. 83) led them to defend their country. It was civic virtue in its eighteenth-century sense – the virtue of the people – that accomplished victory during the first

siege of Zaragoza. An anonymous report declared: "No perdiendo de vista, que los que han consequido estos triunfos han sido la mayor parte unos sencillos labradores, que en su vida habían oido, la caxa ni el estrepito de las armas, sino sus podaderas y dallas para recoger los frutos, se conocerá que no el aparato de los exercitos, sino las virtudes sociales son las que inspiran el verdadero valor" (If we do not lose sight of the fact that those who are responsible for these victories were for the most part simple laborers, who had never in their lives heard the hunt nor the din of guns, rather their pruning hooks and scythes to gather the fruit, we will see that not the apparatus of the army, but the social virtues inspire true bravery).[21]

M.M.H.

1. Valeriano Bozal defined the characteristics of these prints as follows: "the event is the center of attention, its details, its most notable or illustrative facets; description is its keynote." Valeriano Bozal, *Imagen de Goya* (Barcelona, 1983), p. 32.

2. Ibid., p. 33.

3. Commenting on *The Forge*, Fred Licht has written: "We cannot tell just where Goya expected this painting to be displayed but we may be sure that he intended it to fulfill the kind of purpose that Courbet later was to envision for these pictures; an eloquent testimonial to the modern human condition addressed not to the collector but to the artist's contemporaries in general"; *Goya: The Origins of the Modern Temper in Art* (New York, 1983), p. 266.

F.D. Klingender observed: "There exists a group of three closely related paintings which, with Daumier's paintings and groups of working people, Courbet's *Roadmaker*, a few of the more objective Millets, and some early drawings by Van Gogh, belong to the most important pictures of manual workers produced during the nineteenth century. One shows a *Forge* with three men at work at an anvil (Frick Collection, New York) [cat. 150, fig. 1], the other two a *Knife Grinder* and *Girl Carrying Water* (Museum, Budapest). They are wholly documentary paintings of workers at their tasks"; *Goya in the Democratic Tradition* (London, 1948), p. 209.

4. F.J. Sánchez Cantón, "Como vivía Goya," *Archivo español de arte* 19 (1947), pp. 73-109. Sánchez Cantón first published the document, which gives as belonging to Francisco Xavier Goya, "una aguadora y su compañero con el número trece" (a water carrier and companion with the number 13). Ibid., p. 106.

5. Gassier and Wilson date these paintings to these years.

6. "Efectivamente, apenas se levantó el primer sitio, el general Palafox llamó al célebre aragonés Don Francisco de Goya, pintor de cámara de S. M. que llegó á Zaragoza á últimos de octubre de 1808 . . . y como a últimos de noviembre se aproximaron de nuevo las tropas de Napoleón . . . partió al lugar de

Fuen de Todos" (Indeed, the first siege had hardly been lifted when General Palafox summoned the celebrated Aragonese Don Francisco de Goya, court painter to His Majesty, who arrived in Zaragoza at the end of October 1808 . . . and as the Napoleonic troops drew near the city again at the end of November . . . he headed for the village of Fuen de Todos). Agustín Acaide Ibieca, *Historia de los sitios que pusieron á Zaragoza* (Madrid, 1830-1831), vol. 3, p. 51. See also notes 2 and 3 in the Introduction to the *Disasters of War.*

7. "[Zaragoza] had acquired the esteem of all Spain, and even of all Europe"; Pedro María Ric, *An Exposition of the Most Interesting Circumstances Attending the Second Siege and Capitulation of Zaragoza* (London, 1809), p. 10. Translated from *Semanario patriótico* (Seville).

8. Casamayor, who lived in Zaragoza during the first siege, observed: "la confusión de las gentes no influyó en lo más mínimo en aquel singular heroismo . . . especialmente en las mujeres que desde que dió el principio del ataque, fueron a darles agua, vino y aguardiente introduciéndolo hasta las mismas filas" (the confusion of people did not in the least affect that singular heroism . . . especially in the women, who from the beginning of the attack, went to supply them with water, wine, and brandy, penetrating to do so as far as the front line). Faustino Casamayor y Ceballos, *Los sitios de Zaragoza: Diario de Casamayor* (Zaragoza, 1908), p. 40.

9. Ibid., p. 40.

10. Quoted in Casamayor, *Sitios de Zaragoza*, p. 77.

11. Vaughan was with Palafox for several weeks during the siege. Charles Richard Vaughan, *Narrative of the Siege of Zaragoza* (London, 1809), p. 21.

12. Quoted in Casamayor, *Sitios de Zaragoza*, p. 23.

13. María Agustín, in spite of a gunshot wound, "lejos de intimidarse, se hizo curar provisionalmente, y cargada con otra provisión igual de cartuchos y un cántaro de aguardiente salió otra vez a socorrer y alentar a los compatriotas que hicieron por fin huir al enemigo" (far from being intimidated, had herself healed provisionally, and loaded with another equal supply of cartridges and a pitcher of brandy she sallied forth once again to help and encourage her compatriots, who finally put the enemy to flight). Joaquín Ezquerra del Bayo, *Guerra de la Independencia: Retratos* (1935). A print by Juan Galvez y Fernando Brambila (who visited Zaragoza after the first siege), *Bateria del Portillo,* from the series *Ruinas de Zaragoza,* illustrates a specific event, in contrast to Goya's depiction, which is more generalized. For a reproduction of *Bateria del Portillo,* see Sayre, *Changing Image,* p. 134.

14. "The French fire had absolutely destroyed every person that was stationed [there]. The citizens, and the soldier, for a moment hesitated to re-man the guns; Agustina rushed forward over the wounded, and slain, snatched a match from the hand of a dead artilleryman, and fired off a 26-pounder, jumping upon the gun, made a solemn vow never to quit it alive during the siege, and having stimulated her fellow-citizens by this daring intrepidity to fresh exertions, they instantly rushed into the battery, and again opened a tremendous fire upon the enemy." Vaughan, *Narrative,* pp. 15-16.

15. *Resúmen histórico del primer sitio de la ilustre ciudad de Zaragoza por los franceses* (Valencia, 1809), p. 21.

16. Licht, *Goya,* p. 272.

17. The pitcher and the glasses are symbols of femininity.

18. "The knife is a very formidable weapon in the hands of Aragonese in close combat." Vaughan, *Narrative,* p. 23, note.

19. *Resúmen histórico,* pp. 21-22.

20. Blanco White, *Letters,* pp. 414-415. Goya addressed the same subject in *Disaster* 34, *Por una navaja* (For Carrying a Knife) (cat. 87, fig. 1).

21. *Memoria de lo mas interesante que ha ocurrido en la ciudad de Zaragoza con motivo de haberle atacado el Exército Francés* (Madrid, 1808), p. 82.

69

The Colossus
1808-1812
Oil on canvas
116 x 105 cm.
References: G-W 946; Gud. 610.

Museo del Prado, Madrid, 2785

Of all the works of Goya's maturity, *The Colossus* is one of the most dramatic, poetic, and enigmatic. Its visual beauty, mysterious power, and the multiplicity of interpretations to which its deliberate ambiguity lends itself make it extraordinarily appealing. Even its dating is conjectural. In October 1812, it was listed simply as "Un gigante" (A Giant) in an inventory of paintings Goya, after the death of his wife, Josefa Bayeu, bequeathed to his son. This enables us to establish at least the date by which this work must have been executed.[1]

The Colossus has always provoked astonishment and surprise because of its strange blend of the ordinary and the fantastic. The imposing giant, with his back to us, the lower part of his body lost in fog, the left hand clenched in a fist in a seemingly threatening posture, and eyes closed, is like a blind force that does not perceive the fear of a multitude that is fleeing through the valley. The ambiguity of the image does not allow us to determine whether the giant is walking or whether, buried to the knees, like the two men in the later *Fight with Cudgels* (cat. 152, fig. 2), he raises his arms in a gesture of impotence. The painting seems to depict something like the birth or awakening of a powerful and irrepressible force emerging from the bowels of the earth rather than the frightening approach of a giant.

This giant has been interpreted in many different ways. War and Napoleon, "coloso de Europa" (Colossus of Europe), have been among the chief political interpretations.[2] A tempest has been another, insofar as it is an unbridled force of nature, frightening and unforeseeable, which would give the painting a more cosmic and romantic view of human beings in the face of indomitable nature. Nigel Glendinning's explanation,[3] accepted today by many

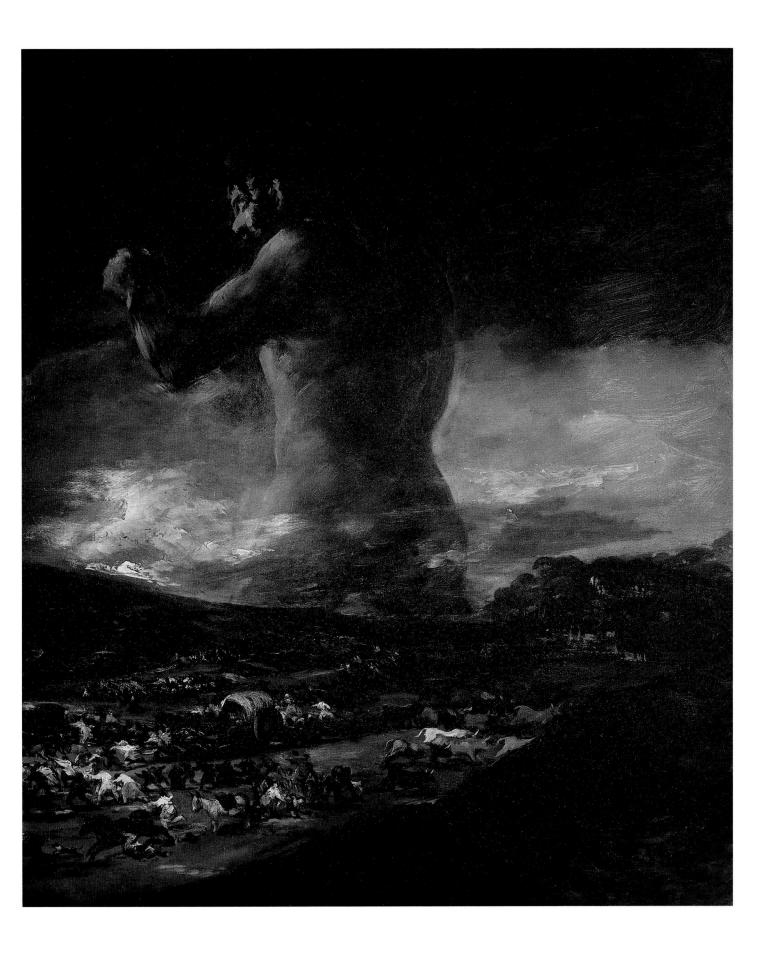

155

Fig. 1.
X-ray photograph of *The Colossus*

historians, conjectures that Goya had read Juan Bautista Arriaza's patriotic poem *La profecía de los Pirineos* (The Prophecy of the Pyrenees), published in 1808, which describes how a giant would rise out of the Pyrenees, a guardian spirit over historic Spain, that would oppose and defeat Napoleon's troops.[4] The dramatic figure would therefore embody the protective and vengeful spirit of the Spanish people under threat of invasion. The supposition that the giant does not pursue the throngs but rather turns his back on them, threatening some invisible enemy, would be in accord with this interpretation. Some of the verses of Bautista Arriaza's poem bear a resemblance to Goya's painting: "Ved que sobre una cumbre / De aquel anfiteatro cavernoso, / Del sol de ocaso a la encendida lumbre, / Descubre alzado un pálido coloso, / Que eran los Pirineos, / Basa humilde a los miembros giganteos. / Cercaban su cintura / Celajes de occidente enrojecidos, / Dando expresión terrible a su figura. / Con triste luz sus ojos encendidos; / Y al par del mayor monte, / Enlutando su sombra el horizonte." / (Behold upon a peak / Of that cavernous amphitheater, / From the twilight sun to the flaming light, / Appears a pale, erect colossus, / For which the Pyrenees were / Humble foundation for gigantic limbs. / Gathered round his waist were / Streaks of clouds reddened by the western sun / Endowing his face with a terrifying expression. / His eyes were inflamed with a sad light; / On an equal footing with the highest mountain, / The horizon veiling his shadow.)

The idea of the giant, spirit of the Spanish people, that halts Napoleon's advance seems to be reflected as well in a short pamphlet of 1808, entitled *Las dos tiranías* (The Two Tyrannies), which made a violent attack on the French emperor. Written in French by a certain Pelter, it was translated into Spanish by a priest from Cádiz: "Ved por otra parte a este hombre cuyo nombre llenaba la tierra despojado ya de los prestigios de la gloria y de la fortuna y poseído del terror y el asombro ante el Coloso que se levanta contra él" (Behold this man whose name resounded everywhere stripped of the prestige of glory and good

fortune and seized with terror and astonishment in the face of the colossus that rises against him).[5]

A more certain date for Goya's painting would make his intention easier to understand. If *The Colossus* were painted in 1808, at the beginning of the Peninsular War at the height of patriotic reaction, it would not symbolize the same thing as if it were executed in 1812, in the closing years of the war, as Napoleon's army began to withdraw. One must bear in mind that the term *coloso* (colossus) or *gigante* (giant) was given various meanings in Spain and could refer not only to Napoleon, or to Godoy (see cat. 64.),[6] or to the Spanish people up in arms, but also to an unflattering comment on the Inquisition: "este Coloso que ha sido siempre el genio tutelar de toda clase de ignorancia y vicio" (this Colossus which has ever been the tutelar genius of all kinds of ignorance and vice).[7] That Goya executed the painting for himself, in the manner of his most intimate drawings, seems to be confirmed by the fact he kept it in his house. Thus, interpretation of the *The Colossus*, as well as of the aquatint on a similar subject (cat. 117), is even more difficult; there are no explanations by the artist's contemporaries for these works (such as exist for the *Caprichos*); nor did Goya give them inscriptions (as he did for many of his drawings and prints) that would offer clues to their meaning, however ambiguous.

Analysis of a composition often helps to clarify the meaning of a work, but in this case it gives rise to controversy. Where some view the giant as a threatening figure, others consider him a protective one; to some he walks, while to others he rises from the earth. And scholars differ in their perception of the degree of fear shown by the multitude in the foreground – a people in flight with caravans, household goods, and animals; there are those who see simple alarm and those who see unbridled panic. The ass standing still in the middle has been interpreted, by analogy with other works by Goya, as a symbol of ignorance and stupidity, since it does not run with the others. Yet it seems to be one of several animals belonging to a group of people

Fig. 2. Hendrik Goltzius, *The Farnese Hercules*, about 1592-1593. Engraving. Museum of Fine Arts, Boston, Harvey D. Parker Collection

behind it who have not yet taken flight; moreover, equally motionless are several bulls on the right near the caravan.

A recent X-ray photograph of the painting (fig. 1) permits examination of the changes in the composition, most of which concern the figure of the Colossus.[8] The photograph reveals that, despite impressions to the contrary, Goya initially placed the giant facing the viewer, with left hand on hip, in a classical attitude that might recall that of the *Farnese Hercules*, which became known throughout Europe thanks to the engraving by the Netherlandish printmaker Hendrik Goltzius (fig. 2); the giant's original static pose was therefore less impressive and enigmatic than the one in the final version. In the lower right, the hill that seems to be covered by a copse originally appeared bare and snow-covered, perhaps closer to the idea of a colossus rising from the snow-covered Pyrenees. In spite of the X-ray analysis, which brings to light Goya's compositional alterations, the ultimate and definitive explanation of this masterpiece remains elusive, and the interpretations that have

been offered to date can only be considered more or less logical hypotheses.

Goya's opinions on war, the Inquisition, violence, oppression, and the absolute power of princes are sufficiently known, but the creative and suggestive force of his imagination must have been qualified by his own doubts, given the variety of events and situations of those difficult war years.[9]

In any case, the painting is admirable because of the extraordinary confidence of its strokes, laid down with a scraper or brush, which are quick, agitated, singularly precise, and vigorous. The range of colors, apparently reduced in its overall effect to a ubiquitous gloom, takes on an extreme richness and variety in the crowd – where reds, yellows, greens, blues, and golds vibrate and scintillate amid the blacks – and in the reflections of the sun in the mist, rendered in blue and gray brushstrokes.

M.M.M.

1. F.J. Sánchez Cantón, "Como vivía Goya," in *Archivo español de arte* 19 (1946), pp. 79-109; Xavier de Salas, "Sur les tableaux de Goya qui appartinrent à son fils," *Gazette des Beaux-Arts* 63 (1964), pp. 99-110. *The Colossus* was donated to the Prado in 1930 as part of the Don Pedro Fernández Durán Bequest.

2. Valeriano Bozal, "El 'Coloso' de Goya," in *Goya* no. 184 (1985), pp. 239-244.

3. Nigel Glendinning, "Goya and Arriaza's *Profecía del Pirineo*," *Journal of the Warburg and Courtauld Institutes* 26 (1963), pp. 363-366.

4. Juan Bautista Arriaza y Superviela, "Profecia del Pirineo," dated July 1808, was published in *Poetas líricos del siglo XVIII*, Biblioteca de Autores Españoles, vol. 67 (Madrid, 1953), p. 69.

5. *Las dos tiranías* (Cádiz, 1808).

6. The use of the term *coloso* to refer to Napoleon is studied by Valeriano Bozal, in "'Coloso' de Goya"; its use to refer to Godoy can be seen in pamphlets and texts of the time, as in *Gaceta de Madrid*, Mar. 21, 1814, which appeared toward the end of the Peninsular War and in which Godoy's prewar situation was described as follows: "contra las maquinaciones de este gran coloso, que desapareciendo como el humo, sufre, cuando menos lo esperaba, el golpe que terminó la carrera de su elevación" (against the machinations of this great colossus, who vanished like smoke, for when he least expected it, he received the blow extinguishing his meteoric career). Already before 1808, when Godoy fell, he was spoken of in this way: "ve obligado a mandar sus tropas a España y venir en persona y derribar este Coloso, aparentando otros designios para que no se fugase" ([Napoleon] feels obliged to send his troops to Spain, lead them in person, and overthrow this colossus, feigning other purposes so [Godoy] will not flee); A.

Rodríguez Moniño, *Relato de la caída de Godoy por un testigo presencial* (Badajoz, 1958).

7. Puigblanch, *Inquisition*, prologue, p. lxxxiii. Antonio José Ruiz de Padrón, in his speech to the Cortes, Jan. 18, 1813, also alluded to the Inquisition as a colossus: "Señor, este Coloso se asemeja a la estatua de Nabucodonosor" (Sir, this Colossus resembles the statue of Nebuchadnezzar).

8. The X-ray photograph was taken by Carmen Garrido in the Department of Technical Documentation, Museo del Prado.

9. The respect many enlightened Spaniards felt for French revolutionary ideas was jarred no doubt by the behavior of Napoleon's troops in Spain. This situation of conflict between political ideas and patriotic sentiment was described by other enlightened intellectuals of the time. For example, José Blanco White gave heart-rending expression to the struggle between feelings and ideas: "But I cannot endure that blind, headlong, unhesitating patriotism which I find uniformly displayed in this town and province – a loud popular cry which every individual is afraid not to swell with his whole might. . . . I am, indeed, as willing as any man to give my feeble aid to the Spanish cause against France; but I feel indignant at the compulsion which deprives my views of all individuality"; Blanco White, *Letters*, pp. 423-424. He commented further: "Some wild visions of freedom from his religious fetters had been playing across his troubled mind, while the French approached Madrid; and though he now looked on their conduct with the most decided abhorrence, still he could hardly persuade himself to escape from the French bayonets, which he seemed to dread less than Spanish bigotry"; ibid., pp. 419-420.

70

Maja and Celestina on a Balcony
1808-1812
Oil on canvas
166 x 108 cm.
References: G-W 958; Gud. 574.

D. Bartolomé March Servera

A beautiful young woman leans on a balcony railing; we cannot be sure whether she is gazing at us or deep in her own thoughts.[1] Behind her, in shadow, an old woman smiles, bearing a rosary in one hand and pointing at the girl with the other. Although the weather must not be particularly fine, for the old woman wraps her hands in her cloak, the girl's generous cleavage, which is emphasized by the strong swathe of light, is exposed to view. This, along with the inclination of her body, echoed by the curve in the curtain, makes clear her profession.

Goya addressed prostitution almost exhaustively in his work. In the *Caprichos* and a number of drawings he analyzed its many aspects, such as the man as victim (cat. 44), the prostitute as victim of the authorities (cat. 45), and the procuress (cat. 134). The precedent for the treatment of this subject in the Spanish School, as Diego Angulo indicated, was Murillo's painting *Mujeres en la ventana* (Women at the Window),[2] although Goya's work shows a clear "literary background lacking in Murillo."[3] The scholar Alcalá Flecha saw in the bawd Celestina's piety, symbolized by her rosary,[4] an unambiguous literary characteristic of works by the archpriest de Hita, Rojas, Torres Villarroel, and Nicolás Moratín.[5] Goya must have known Fernando de Rojas's *La Celestina*, which was much esteemed by his literary contemporaries and especially by his friend Moratín (see cat. 134). Alcalá Flecha noted in addition that not only is it a theme taken from literature but it also "acquires in the eighteenth century the character of an authentic social problem, an appropriate solution to which could not ignore public order and public health."[6] Prohibited by Felipe IV, prostitution had grown considerably in the eighteenth century, along with an alarming proliferation of venereal diseases.

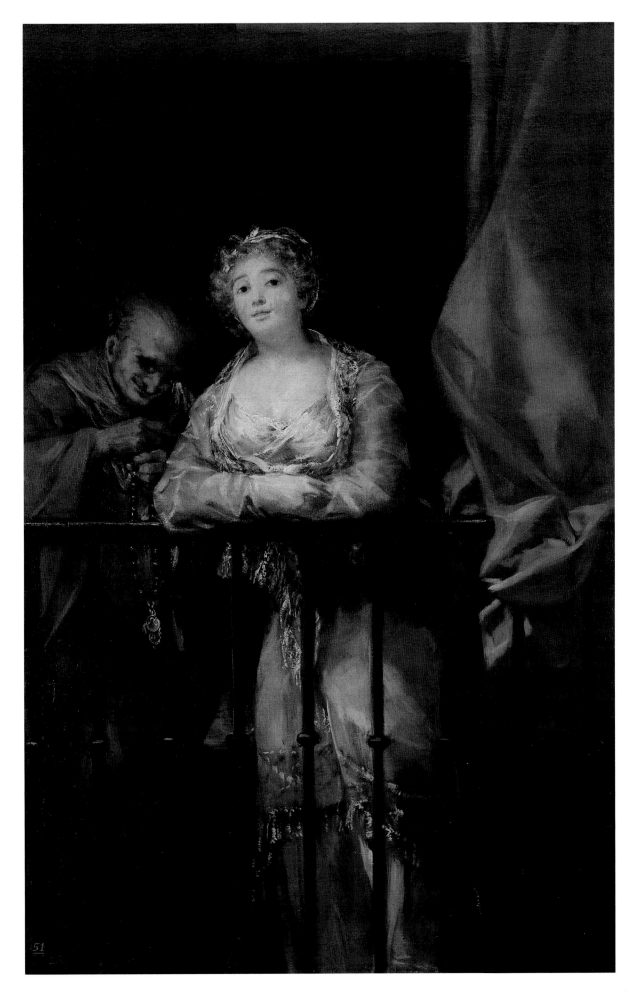

51

Cabarrús (see cat. 15) advanced the most daring solution in his time, proposing to legalize and regulate prostitution with sanitary controls, while he also saw the prostitute as a victim of an unjust society.[7]

The *maja* seems to be a decoy that the cunning Celestina manipulates from the shadows, awaiting clients. This theme appears in *Capricho* 19, *Todos caerán* (All will fall) (G-W 489), in which the prostitute, a bird with prominent breasts and a beautiful face, acts as a decoy for Celestina, who works her strings from below.[8] According to the manuscript commentary on this *Capricho* in the Biblioteca Nacional, "Una puta se pone de señuelo en la ventana" (A whore acts as a decoy in the window).[9] But in this painting, although the meretrix adopts the posture of her profession, she has a certain air of melancholy, of reverie. Perhaps she is only deceiving us, but she evokes, behind those thick bars, a bird caged by her destiny.

M.M.H.

1. In the 1812 inventory, which lists the paintings in Goya's house in the Calle de Valverde that were later given to his son, Javier (or Xavier), there is a record of "Dos quadros de unas jovenes a un balcón" (Two paintings with young women on a balcony) (G-W 958 and 959). Both were given the mark "X 24" (X indicating Xavier). The mark formerly on the *Maja and Celestina* is visible in a Moreno Archives photograph. See G-W, p. 256 and p. 381, Appendix I, no. 24.

2. Diego Angulo considered it likely that Goya knew Murillo's painting, since "until it was sold in 1823, it belonged to the Duque de Almodovar in Madrid (d. 1794), adviser to the Academia de San Fernando"; or he could have known it through the print by J. Balles- ter (d. 1803), who worked in the National Print Shop. "The 1814 inventory of the Royal Palace in Madrid records a copy smaller than the original of Murillo's painting"; Diego Angulo Iñiguez, "Murillo y Goya," *Goya*, nos. 148-150 (1979), p. 212.

3. Ibid.

4. Roberto Alcalá Flecha, *Matrimonio y prostitución en el arte de Goya* (Cáceres, 1984), p. 90.

5. Nicolas Moratín wrote *Arte de las putas* (Art of Whores) in 1769; claiming it to be a manual on prostitution, he mocked the didactic treatises of the time. The work is rooted in the previous literature on the subject, but it is also realistic in its abundant documentation of prostitution in Madrid in that period. On the relationship between this poem and Goya's work, see "Don Nicolás Fernández Moratín y Goya sobre *Ars Amatoria*," in Edith Helman, *Jovellanos y Goya* (Madrid, 1970), pp. 219-235.

6. Alcalá Flecha, *Matrimonio*, p. 78.

7. Francisco de Cabarrús, *Cartas sobre los obstáculos que la naturaleza, la opinión y las leyes oponen a la felicidad pública escritas por el Conde de Cabarrús al señor don Gaspar de Jovellanos y precedidas de otra al Príncipe de la Paz* (Vitoria, 1808), letter 2.

8. Eleanor A. Sayre, "La visión del cazador de pájaros en el *Capricho* 19 de Goya *Todos Caerán*," in *Goya: Nuevas Visiones: Homenaje a Enrique Lafuente Ferrari* (Madrid, 1987), pp. 368-373.

9. Biblioteca Nacional, Madrid, MS. 20258.

71

Prison Interior
About 1808-1814
Oil on tin
42.9 x 31.7 cm.
References: G-W 929; Gud. 470.

The Bowes Museum, Barnard Castle, Durham, England, 29

Boston only

The interior of a prison depicted here is a dim room where prisoners bound with manacles and leg irons serve their terms or perhaps merely await sentencing. Although there is no certain date for this work, because of its relationship to the three etchings of prisoners (G-W 986, 988, 990; see discussion cat. 95-96), it is generally placed during the war years, 1808-1814.[1]

Penal matters, especially prison conditions and sentences, were much debated in the second half of the eighteenth century almost everywhere in Europe. The treatise *Degli delitti e delle pene* (1764) by the Italian philosopher and criminologist Cesare Beccaria established the standards for reform: "All the nations awakened. All the judicial systems were moved."[2] The Enlightenment set out to humanize penal law. "Enlightened magistrates, steadily growing in number, desired a revision in criminal laws, judging them too severe and often disproportionate to the crimes."[3] An important step at Carlos III's court was taken by the minister Manuel Roda, who persuaded the king to commission a study of the situation. The monarch requested that his Consejo (Council) examine penal laws, with the purpose of making punishment a means of serving society as well as a corrective, and reflect on the use of torture, which forced innocent prisoners to declare themselves guilty.[4]

Ideas on penal reform were debated not only by legislators. In the Real Academia de Bellas Artes de San Fernando, the new ideas led to the redesign of jails.[5] The prisoner's rehabilitation – not his torture – had to be guaranteed; in some cases the architect eliminated basements in order to prevent abuses.

Both means – architecture and laws – by which the new reforms were imple-

mented were familiar to Goya. His magistrate friends, Jovellanos (see cat. 30) and Meléndez Valdés (see cat. 24), knew of and supported the reforms. Goya, who was a member of the Academia, maintained close ties with several architects there, among them his friend Tiburcio Pérez Cuervo (see cat. 122) of the so-called "generación de la revolución" (generation of the Revolution).

Goya's painting of a prison interior was executed in a special context: the coming into being of some of these legal reforms. In 1811 a measure suppressing judicial torture appeared before the Cádiz Cortes (parliament). Although torture at this time was legal and regulated, it was not popular practice, and no judge who applied it escaped being called bloodthirsty.[6] There was no debate about this measure. "Tratar de discutir este asunto es degradar el entendimiento humano" (To try to discuss this matter is to degrade human understanding), asserted one of the deputies.[7] The most interesting twist was the attempt to broaden the meaning of torture to include "los apremios, medio no menos infame que el tormento, y en el cual se ha subrogado por el despotismo de los últimos reinados" (judicial orders [to compel compliance], no less infamous than torture, for which they were substituted by the despotism of recent reigns).[8] After all, leg irons, manacles, and chains were also forms of torture under which some prisoners died, as were gloomy, cramped, and fetid prisons where the accused were thrown without their crimes being distinguished, without judicial control, without knowing when their cases would be heard.

Prison Interior banishes any doubt that a prisoner's "security" involved torture (see cat. 95). It is not likely that Goya saw these scenes; perhaps he learned of them from a description by a jailed friend, or perhaps he used a model. In any case, Goya's painting is not a factual representation of events that occurred during the war; the work has the same characteristics as the manifestos, allegations, and denunciations against all forms of torture. He used a style with strong contrasts. The monumentality of the space reduces its inhabitants to a negligi-

ble scale, emphasizing their defenselessness; plunged into darkness, the prisoners are robbed of the splendor of the light shining outside, and, chained to a passive resignation, they already look inert.

M.M.H.

1. G-W, p. 254. Gassier and Wilson also note the analogy to some prints in the *Disasters of War* (1011), drawings (1428), and prison etchings (986, 988, 990). Jeannine Baticle included the painting in the series of 1793-1794 because it is executed on the same foundation and has similar dimensions, although it is vertical in format. She adds that the scene Goya paints is in keeping with other subjects he addressed; Museo del Prado, Madrid, *Arte Europeo en la Corte de España durante el siglo XVIII*, exhib. cat. (1980), p. 73.

2. Philarète Chasles, *Voyages d'un critique à travers la vie et les livres* (Paris, 1869), p. 115, quoted in Sarrailh, *L'Espagne éclairée*, p. 538.

3. Sarrailh, *L'Espagne éclairée*, p. 536.

4. Ibid., p. 537. As a result of this royal petition Manuel Larizábal published *Discurso sobre las penas* (Discourse on Punishments) in 1782; ibid.

5. Carlos Sambricio, *La arquitectura española de la Ilustración* (Madrid, 1986), p. 135.

6. Agustín de Argüelles claimed as much in the parliamentary session in Cádiz of April 2, 1811. "Es verdad que la tortura está, por decirlo así, fuera de uso en España; mas esto sólo es debido al espíritu público de la nación, pues no habría consentido a un juez recurrir a este horroroso medio sin condenarle al odio y execración general" (It is true that torture is, so to speak, obsolete in Spain; but this is only owing to the civic spirit of the nation, for it would not have allowed a judge to make use of such a horrible means without condemning him to general hate and execration). See *Actas de las Cortes de Cádiz: Antología*, ed. Enrique Tierno Galván (Madrid, 1964), p. 56.

7. *Actas de las Cortes de Cádiz*, p. 53.

8. Ibid., p. 56.

72
Manuel Silvela
About 1809-1812
Oil on canvas
95 x 68 cm.
References: G-W 891; Gud. 567.

Museo del Prado, Madrid, 2450

Goya's friendship with Manuel Silvela began during the Peninsular War and continued during the exile they shared with the playwright Leandro Fernández de Moratín, in the progressive Spanish circle in Bordeaux. Silvela was born in Valladolid in 1781. After finishing his studies in philosophy, graduating in arts, and taking a law degree in Avila and Valladolid, he arrived in Madrid during the French occupation and was appointed Alcalde de la Casa y Corte (Judge of the Royal Family and Court). In these years he formed a great friendship with Moratín, whose biography he later wrote. Silvela emigrated to France in 1813 as José Bonaparte's army withdrew. In France his life changed course, and he dedicated himself to teaching and to literature. He founded a school in Bordeaux in 1820 and wrote *Biblioteca selecta de literatura española* (A Select Library of Spanish Literature) and *Compendio de Historia Antigua hasta los tiempos de Augusto* (Compendium of Classical History up to the Augustan Age), along with other works in prose and poetry.

Silvela sat for Goya during the Peninsular War, at a time when he was enjoying a good position owing to his role in the French administration. He appears as an elegant, fashionably dressed man. As was his custom, Goya emphasized the subject's character and facial expression, which in this instance is conveyed through the composition and somewhat anodyne colors. It is the compositional simplicity in Goya's portraits – which he generally reduced to a simple geometric form – that brings out the character; but here Silvela's posture, with arms akimbo and body neither frontal nor in profile, gives rise to some confusion. It seems Goya wished to diminish this effect with light, which demonstrates what is essential about the subject, while concealing in

shadow one of the arms. In this portrait Goya put his genius in the vigor and sparkle of the facial expression, brought out by the light, the marvelously rendered kerchief tied round the neck, and the extraordinary shine in the vest.

M.M.H.

73

Juan Antonio Llorente
About 1810-1812
Oil on canvas
189.2 x 114.3 cm.
References: G-W 881; Gud. 570.

Museo de Arte, São Paulo, 176

Juan Antonio Llorente was a key intellectual in the enlightened movement's attempts to reform or suppress the Inquisition. From within the Holy Office, of which he was named commissary in Logroño in 1782, he first planned its reform and later contributed to its liquidation under José I.

In 1793 the inquisitor general commissioned Llorente to write a report on the reform of trial procedures; his work was interrupted when the inquisitor general was dismissed. During his ministry, Jovellanos intended to use the projected reform to introduce changes into the Holy Office.[1] This plan was not carried out, however, and according to Llorente, its discovery contributed to Jovellanos's and his own fall. In this unpublished report, "Discursos sobre el orden de procesar en los tribunales de la Inquisición" (Discourses on Trial Procedure in Inquisition Tribunals), Llorente opposed the secret trials conducted by the Holy Office: "Añadí que todo se remediaría si se adoptase la publicidad de los juicios, como en los tribunales eclesiásticos de la España. En un discurso preliminar hice ver la enorme diferencia de circunstancias que había entre los últimos años del siglo XV en que se estableció el tribunal contra los cristianos nuevos judaizantes, y los fines del siglo XVII, en que las controversias debían ser con filósofos, sabios y llenos de crítica la más acentrada: de lo que se infería yo que no podía el tribunal conservar ahora la nota de justo por los medios que tres siglos." (I added that all would be solved by adopting public trials, as in the ecclesiastical tribunals in Spain. In a preliminary discourse I made known the enormous difference in circumstances between the fifteenth century, in which the tribunal was established against new Christian Judaizers, and the end of the seventeenth century, in which the controversies were

to arise with philosophers and scientists, and in which the most judicious case would rouse much criticism: from which I inferred that the tribunal could not preserve its claim to being just if it continued to use the methods of three centuries past.)[2]

Once the Inquisition was abolished, José I made Llorente state councilor and commissioned him to organize the existing documents in order to "escribir la historia de la Inquisición de España, conforme a lo que resultase originalmente de los documentos conservados. Yo acopié infinitos materiales a costa de fatigas y de dinero, pues ocupé muchas personas por espacio de dos años en copiar, extractar y anotar lo que les designaba. Con estos preparativos y los excelentes manuscritos de mi colección comenzada en 1789, y continuada sin intermisión en los años siguientes, me habilité bien para escribir las obras de que daré noticia en sus respectivas épocas, sobre asuntos del Santo Oficio" (write the history of the Inquisition in Spain, according to the original documents that have come down to us. I copied a prodigious amount of material at the cost of fatigue and money, for I hired many people over a two-year period to copy, extract, and annotate what I assigned them. With this groundwork and the excellent manuscripts of my collection, begun in 1789, and continued without interruption during the following years, I prepared myself well to write the works that I will bring to light in their time, on the proceedings of the Holy Office).[3] Among them is his most important work, the *Historia crítica de la Inquisición en España* (Critical History of the Inquisition in Spain). It was at the moment of its publication, during the French occupation, that Goya executed this official portrait, whose subject wears the decoration bestowed by the French king, the Orden Real de España (Royal Order of Spain).

The *Historia crítica de la Inquisición en España* was published in 1818. Llorente proved himself a rigorous historian, rejecting tales and legends with which history was still often written, using primary sources, and doing archival research. Llorente specified what, if any,

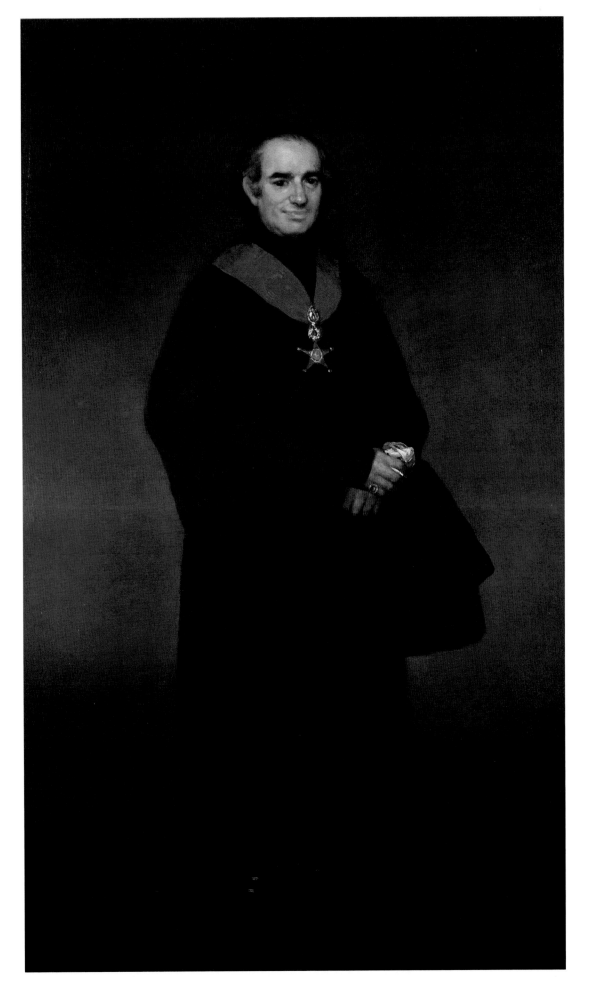

function the tribunals should have: "Confieso que si yo aprobase la existencia del tribunal de la Inquisición, sería contra los reos de esta especie, y otros falsos devotos hipócritas, que hacen más daño a la religión católica que los herejes ocultos y no dogmatizantes" (I confess that if I were to approve the existence of the tribunal of the Inquisition, it would be against offenders of that kind, and other falsely devout hypocrites, more harmful to the Catholic religion than hidden heretics who do not proselytize).[4] He distinguished between the character of the eighteenth-century Inquisition and that of earlier centuries, rejecting the exaggerated commentaries of foreign literature of the time, which ascribed to the Spanish Inquisition acts buried in the remote past. "Yo no he visto ni leído haberse dado tormento a ningún confesor en la Corte, ni creo que haya sucedido fuera de ella en la segunda mitad del siglo XVIII; porque, a pesar del sistema inquisitorial, es innegable que las luces del tiempo han penetrado hasta lo más interior del Santo Oficio" (I have neither seen nor read of any confessor's being tortured in the court [Madrid], nor do I believe that it happened elsewhere in the second half of the eighteenth century; because in spite of the inquisitorial system, there is no denying the lights of the age have penetrated into the deepest recesses of the Holy Office).[5] "En el último tercio del siglo XVIII ninguno era puesto en cárceles secretas sólo por tener o leer libros prohibidos si no concurría el crimen de haber pronunciado o escrito proposiciones heréticas o contrarias al sistema del Santo Oficio; el castigo solía ser una multa pecuniaria y la declaración de ser sospechosos *de levi* de herejía, y aun esta calificación se omitía si se observaban motivos de creer que sólo se había pecado por curiosidad de saber y no por adhesión a la mala doctrina" (In the last third of the eighteenth century, nobody was thrown into secret prisons merely for owning or reading prohibited books if that person did not also speak or write heretical propositions or those contrary to the Holy Office's strictures; the punishment tended to be a fine and the charge of being suspect of heresy *de levi*, and even this accusation

was omitted if there appeared to be reason to believe the sin was committed only out of curiosity and not because of adherence to incorrect doctrine).[6] On the other hand Llorente was implacable in his criticisms of the Inquisition of the time, especially with regard to trial procedure, as mentioned; and also for obstructing the advance of the sciences: "Uno de los males que produce la Inquisición en España es impedir el progreso de las ciencias, de la literatura y de las artes" (One of the evils the Inquisition in Spain gives rise to is the hindrance of scientific, literary, and artistic progress).[7]

The ideology conveyed in this history of the Inquisition was also expressed in some of Goya's works on the same subject, and it was shared by enlightened Spaniards. Llorente's and Goya's notions coincided in mainly three ways. Both denounced the inquisitorial methods of the eighteenth century as an inhumane trial system based on the abuse of power and the humiliation of the defendant (see the essay "*Album C:* Inquisition Drawings," fig. 1). Both also made an effort to reveal the horrors of the past: Llorente published the documented Inquisition cases taken from its entire history, much as Goya in *Album C* (see cat. 98-106) included drawings representing past victims of the Holy Office, not limiting himself to its contemporary reality. When Fernando VII's regime once again legalized the Inquisition, these works expressed the widespread rejection of the Inquisition and the desire to abolish it. Finally, Llorente's denial of witchcraft, and his interpretation of it as a product of the imagination sometimes related to prostitution, also made itself felt in Goya's works (see cat. 25-27).

Llorente went into exile in France as the French army withdrew. He was accused of betraying his country when in fact his patriotism was unimpeachable. If he agreed to collaborate with the French, it was because he believed resistance was futile: "Acepté creyendo contribuir algo al bien de mi pátria, y no dudando sobre la permanencia de la nueva dinastia, . . . la batalla de Baylen . . . causa de que se dividiera la España sobre si era posible ó no librar el territorio español de la

dominacion francesa. Yo tuve la desgracia de creer por cierto el extremo negativo, porque no había fuerzas en España para resistir á las de Francia. En consecuencia forme el concepto, de que si la Nacion tomaba parte activa, sería para ver destruidos sus pueblos, saqueadas las casas. . . . Pensé que la pátria seria feliz haciendo de la necesidad virtud, como el mismo Fernando hacia, y mandaba que hiciésemos." (I relented in the belief that I could do some good for my country, never doubting the new dynasty would remain. . . . [After] the battle of Bailén . . . which divided Spain as to whether Spanish territory could be freed of French domination . . . I had the misfortune to believe it impossible, because there were no forces in Spain to resist the French. As a result I came to the conclusion that if the Nation actively resisted it would be to watch its towns razed, its houses looted. . . . I thought the country would be content making a virtue of necessity, much as Fernando himself did and enjoined us to do.)[8] There were no great ideological differences between Llorente and those Spanish Liberals who abolished the Inquisition in Cádiz; the most talented people were either in Cádiz or working for José I.

The portrait, very sober in composition and color, underscores the subject's strength of character; from his facial expression we sense the brilliant intellectual that he was. Goya was Llorente's friend, and each knew the other's work; Llorente even wrote commentaries on the *Caprichos*.[9] If Goya's work is a reflection of the ideas of his time, some of those ideas certainly originated with Llorente.

M.M.H.

1. "En 1798 pensó hacer uso de su situación para reformar el modo de proceder en el tribunal de la Inquisición, haciendo uso de la obra que yo había escrito, año de 1793, sobre el propio asunto, por orden del inquisidor general"; Jovellanos, quoted in Llorente, *Inquisición*, vol. 2, p. 382.

2. Llorente, *Noticia biográfica*, ed. Antonio Márquez (Madrid, 1982), p. 95, note.

3. Llorente, *Noticia*, p. 114.

4. Llorente, *Inquisición*, vol. 4, pp. 8-9.

5. Ibid., vol. 3, p. 31.

6. Ibid., vol. 2, p. 29.

7. Ibid., p. 307.

8. Juan Antonio Llorente, *Defensa canónica y política* (Paris, 1816), pp. 10-11.

9. Llorente's manuscript containing his commentaries, written in French, is in the Museum of Fine Arts, Boston, 1973.730.

74

Allegory on the Adoption of the Constitution of 1812
1812-1814
Oil on canvas
294 x 244 cm.
References: G-W 695; Gud. 483.

Nationalmuseum, Stockholm, 5593
United States only

Goya revised the composition of an oil sketch executed between 1797 and 1798, *Truth Rescued by Time* (cat. 28).[1] In this painting the figure of Truth has been replaced by a young woman dressed in white who holds a scepter and a book. The threatening bats and owls have entirely disappeared from the scene, and beyond the great spread of Time's wings are a barren tree and darkness. First published in 1867 by Charles Yriarte as *Spain Writing Her History*, the painting was then owned by the Austrian consul at Cádiz, who had in addition another large allegorical painting by Goya, *The Apotheosis of Music*.[2] Both works were described as heavily restored.[3]

For something like a century, the old, unsympathetic restoration obscured the character of this painting, and critics found it dull. But today it has an air of triumphant joyousness utterly unexpected in an intellectual allegory. The painting may also have been misunderstood through our tendency to assume that a sketch must be painted in immediate preparation for a large canvas and to forget that some artists, including Goya, occasionally put an earlier work to a new use. Goya's style, in particular, developed not progressively but, rather, dialectically; he scattered his explorations across a broad front, striding along here, incorporating earlier satisfying concepts there, or sometimes turning unashamedly backwards. The *Caprichos*, etched within the narrow space of time of 1797 to 1798, are a striking example of Goya's ability to work happily in a variety of styles almost simultaneously. Therefore, an art historian who seeks to date a single work by Goya solely on the basis of style treads an exceptionally precarious ground. Nevertheless, if one surveys his paintings and graphic work decade by decade, there is a visible sweep of observable change.

At the end of the 1790s Goya's figure compositions tended toward complexity and open angularity, while his human beings could be characterized by their rococo slightness of body and tendency toward improbably sloping shoulders (see cat. 25-29, 35-62). Some ten years later the sharp corners were usually tempered with small curves, and the angularity became submerged into a classical feeling for unity. By the beginning of the Peninsular War in 1808, Goya's human protagonists had given way to the hardier, more plebeian race with sturdy limbs and rounder flesh, presented to us in convincing solidity of volume (see cat. 67-71, 76-96, 98-115). Had the Boston sketch not survived, I think that art historians looking at the Stockholm painting as a single work (that is, without a thematic relationship to an earlier painting) would have dated it around 1810. Stylistically it is close to *The Allegory of the City of Madrid*, a large canvas on which Goya was working during the final days of February 1810.[4]

A dominating element in the Stockholm painting is the light streaming in from the upper left. Time, the rescuer, turns his face in its direction, and his great lifted wings form a barrier against the darkness behind him. A young woman welcomes the light with her outstretched arm. The light has an iconographical meaning. In Goya's day it was often used to represent enlightenment in a broad sense (as Goya shows it, though handled less subtly in his 1797 title page) (see cat. 50-52). Here, the vibrant light entering the left side of the canvas is inevitably put to various painterly uses as well. One function is the formation of such a strong highlight on Time's left wrist that our attention is forced on the dark structure of the hourglass in his hand. The hourglass is startling. Time has just turned it so that all the sand lies in the upper chamber. Through this device Goya made it known that his painting celebrates the dawn of a new era.

We may assume that Yriarte identified the principal figure as Spain because of her scepter; and for over a century,

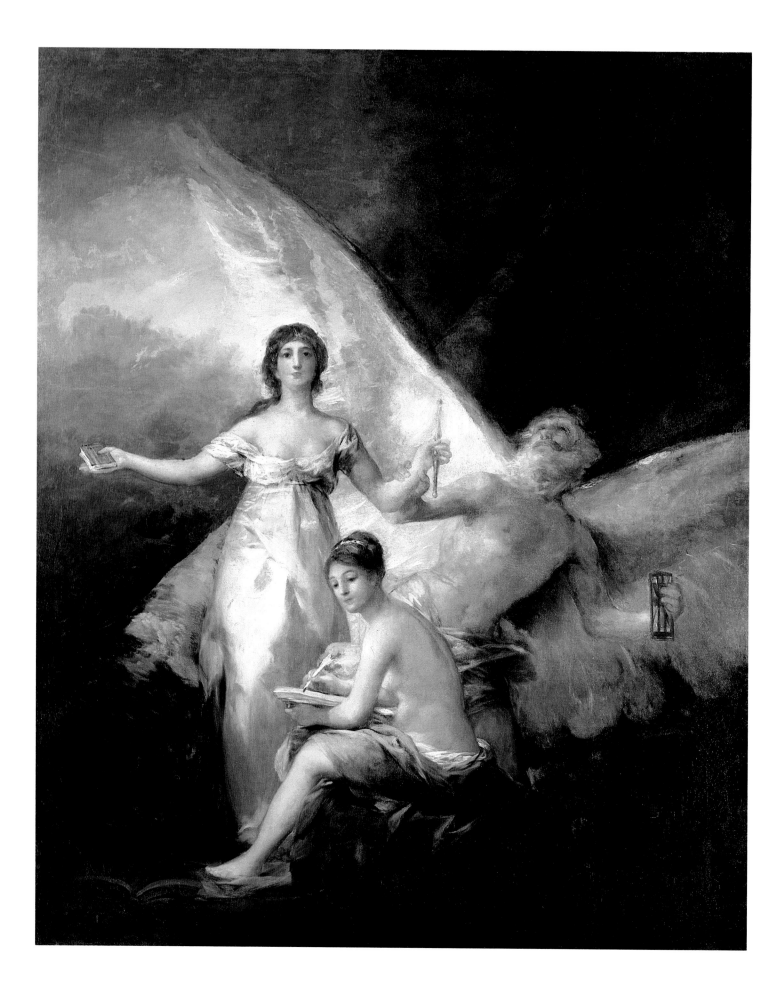

scholars, with the notable exception of Folke Nordström,[5] have echoed him. Yet it must be admitted that if this figure is the embodiment of Spain, Nation, Empire, or Monarchy, Goya's portrayal is somewhat surprising. The Royal Palace at Madrid is well supplied with eighteenth- and early nineteenth-century paintings of these concepts. These ceiling decorations teach us to expect matronly women having not only the attributes of power – crown, scepter, mantle, rich dress, and throne (often raised to the clouds) – but also visible signs that allow for no doubt that Spain is represented – lions, castles, and the pillars of Hercules.[6]

But Goya omitted all of it. He painted instead a young woman, holding a book and a scepter, and wearing a simple white frock that leaves her right nipple exposed and almost uncovers the left. Allow what one will for the exigencies of decorating a palace for royalty, Goya's portrayal is so far removed from the others that he can scarcely have expected his allegorical figure to be understood in precisely the same sense.

Goya has shown History recording an era that is just beginning, when a young, unpretentious, allegorical figure stretches a book toward Light and is brought by Time away from Darkness. The most plausible candidates for this role are the three scholarly fields – Metaphysics, Rhetoric, and Philosophy – together with Liberty.

In Goya's day, Time was often portrayed bringing to light areas of learning, with History a frequent witness to the happy event. Goya would probably not have undertaken such a theme on his own initiative, although he might have done so on commission from a patron. But if that were the case, the patron would surely have insisted that his friends be able to recognize with ease, through the use of standard attributes, which of these intellectual pursuits was the one he fancied. Liberty seems a more plausible candidate. Like Goya, Cesare Ripa dressed her simply in white but placed in her hand the cap given by Romans to slaves when they were freed. Her scepter represents the dominion she maintains through her absolute independence of spirit, soul, and body. A cat, the

enemy of confinement, stands by her side.[7] In the eighteenth century Gravelot and Cochin elaborated the image with a flight of birds and added to her attributes the role of true mother of the liberal arts.[8] It is tempting to see Goya's white-clad woman as this attractive personification, for in his lifetime Liberty, like Truth, needed succor. If this were true, Goya would be painting a new era of freedom, its beginning or simply the dream thereof. The new era is brought to pass by means of the book that replaces the Phrygian liberty bonnet as a symbol of freedom. I suspect, however, that Goya's iconography is more complex and that for the key to it we must look further.

The book merits our close attention since Goya gave it great emphasis. He placed the scepter in the young woman's less important left hand, put the volume in her right, and showed her holding it toward the source of beneficent Light that streams into the painting. In his choice of hands, consciously or not, Goya was using an iconographical device that can be traced back to Ripa, who occasionally stipulated that a personification hold the scepter in her left hand, leaving the right free for a more significant attribute. Ripa's woodcut of Philosophy balancing a pile of three thick books in her right hand is an example.[9] But what is perhaps without precedent, allegorically at least, is the size of Goya's book. It is so unsuitably small that it is easily contained in the palm of the woman's hand. History's bound chronicle in the foreground is far more impressive.

There is a second instance in Goya's work of an allegorical figure holding a little book. She is to be seen in a wash drawing in the Prado (cat. 109). Hovering in the air, she turns her head toward the book lying open in her hands, with an expression of loving reverence. Head and book are bathed in a circle of light that glows brilliantly in the darkness and casts faint reflections on the upturned faces of a multitude of people standing on the ground below her. Goya did not add the title in his customary energetic script but lettered it in Latin with unusual care and in capitals, LUX EX TENEBRIS (Light from Darkness).

No one has ever doubted F.J. Sánchez Cantón's proposal that this allegory concerns the promulgation of a constitution in Spain.[10] But as Sánchez Cantón noted, there was not just one occasion in Goya's lifetime when a Spanish constitution was adopted; there were three occasions: 1808, 1812, and 1820. The physical clue, the appearance of the book in the drawing and the painting, cannot help us to pinpoint the date of execution of these pictures, for each of the three constitutions was printed more than once, each can be found in a small format, and in each case the buyer was expected to be responsible for the binding.[11] Then, too, we must keep in mind that Goya never dated the pages of his journal-albums and that he was recording his thoughts about issues rather than the physical aspects of events he had observed. What we need to do is to investigate the circumstances surrounding the promulgation of each constitution and attempt to sense the atmosphere and the events that would not only have called forth the intense, confident series of drawings in *Album C* on the freedom of the press (cat. 107), the coming of the Constitution and, with it, justice (cat. 109, 110), and the curtailment of monastic orders (cat. 111-115) but would, in addition, account for the joyousness of the painting.

If we accept as subject of the Stockholm painting the adoption of the Constitution of 1812 by Spain, then what we see becomes understandable: Time's turning of his hourglass to mark the new era; the smallness of that all-important book, which seems to draw light into the painting; even the simple white dress. For during the first years of constitutional government in the United States, artists groping for a cogent personification of their new nation consciously rejected the rich trappings of the traditional representations and invented a new image formed in part from the personification of Liberty.[12] Goya may have followed where they led but transforming, as he so often did, the commonplace into the extraordinary.

E.A.S.

1. This entry is an abridged version of my article "Goya: A Moment in Time," published in *Nationalmuseum Bulletin* (Stockholm) 3, no. 1 (1979), pp. 28-40, and reprinted in Spanish, in Madrid, 1982, pp. 53-69. The reasons this painting cannot be considered a companion piece to the *Apotheosis of Poetry* (G-W 694; Gud. 484) and must be considered later than the Boston sketch are there discussed. Inherent iconographical problems are also explored.

2. Nationalmuseum, Stockholm, 5592; oil on canvas, 298 x 326 cm.

3. Charles Yriarte, *Goya* (Paris 1867), p. 148.

4. Ayuntamiento, Madrid, no. 1048, 260 x 195 cm.; G-W 874; Gud. 555. See also Felipe Pérez y González, *Un cuadro . . . de historia, Obras completas* (Madrid, 1910), p. 52.

5. For Nordström's view, see "Six Allegories on Human Activities," in Nordström, *Goya*, pp. 105-115.

6. For a contemporary identification of the figures, see Francisco José Fabre, *Descripcion de las alegorías pintadas en las bóvedas del real palacio de Madrid* (Madrid, 1829): España, pp. 4, 81; Magestad de España, pp. 163, 232; Monarquía Española, pp. 60, 95, 99, 106, 225, 233, 267.

7. Cesare Ripa, *Iconologia* (Padua, 1630), vol. 2, pp. 444-445; see also *Le petit trésor des artistes et des amateurs des Arts* (Paris, year VIII of the Republic), vol. 2, p. 79.

8. Gravelot and Cochin, *Iconologie*, vol. 3, p. 31, and the illustration.

9. Ripa, *Iconologia*, vol. 1, pp. 250-261.

10. Felix Boix and F.J. Sánchez Cantón, *Museo del Prado: Goya. Cien dibujos inéditos* (Madrid, 1928), nos. 81, 82.

11. For various editions of the Constitution, see Sayre, "Goya's 'Spanien, Tiden och Historien,' " nos. 25-27, 41-42; and Madrid, 1982, pp. 19-27, and nos. 127-131.

12. See E. McClung Fleming, "From Indian Princess to Greek Goddess: The American Image, 1783-1835," *Winterthur Portfolio* 3 (1967) pp. 37-66. French revolutionary symbolism was even more strongly influenced by Liberty.

75

General José de Palafox
1814
Oil on canvas
248 x 224 cm.
Inscribed: *El Excm. Sñr. Don José Palafox y Melci. Por Goya año de 1814*
References: G-W 901; Gud. 620.

Museo del Prado, Madrid, 725

José de Palafox (1780-1847) was one of the most prominent and polemical figures of the Peninsular War. When Goya painted his portrait, he was enormously popular in Spain and throughout Europe for his role in the defense of Zaragoza during the siege.

Palafox's rapid rise in Spanish political circles was seen by some as opportunistic and by others as proof of patriotism. The youngest son of an Aragonese family of ancient lineage, he entered the guards at an early age; altogether lacking in active military experience, he was a brigadier at the beginning of the French invasion in 1808. In May of the same year he was named commander in chief and president of the council of Aragón by the Aragonese Cortes (parliament).

At the outset Palafox was an ardent partisan of Fernando VII. Investing his trust in him, the king requested that Palafox join him in exile in Bayonne. Palafox returned to Spain with the intention of turning Zaragoza into the center of resistance to the Napoleonic invasion. Combining political and diplomatic ability with a capacity to win over the masses, he took power peacefully and legally. On May 26, armed civilians acclaimed Palafox in the streets, led by ringleaders who had been in touch with him. At the same time, Mori, who had taken Guillelmi's place as governor the day before, resigned. The Real Acuerdo (Royal Resolution) named Palafox commander in chief, and the Cortes ratified the appointment, turning themselves into an advisory council.

Palafox immediately and very efficiently set about organizing the army and the administration. In the course of two weeks, he raised the contingent of men from 1,500 to 7,500.[1] The French attacked Zaragoza on June 15, 1808, and

Fig. 1. *El Exmo. Sr Dn José Revolledo de Palafox y Melci, Capitan General del Exerto. y Reyno de Aragon.*
Engraving, in *Resúmen Histórico del Primer Sitio de lá ilustre ciudad de Zaragoza por los franceses*, Valencia, 1809.
Private Collection

withdrew after placing the city under siege for more than a month. In this event lies Palafox's greatest – though not unclouded – glory. During the struggle, when events seemed to augur an imminent French victory, Palafox abandoned the city without informing anybody of his decision. After the French army was repulsed, he returned, insisting he had left in search of reinforcements. According to Alcaide Ibieca, who lived through the siege, the defense of Zaragoza "no sólo impuso á los franceses, sino que asombró a todas las naciones extranjeras. En Londres, Petersburgo, Berlin, Varsovia y Viena se hablaba con entusiasmo de los sucesos que la fama iba divulgando." (not only impressed the French, but astonished all foreign nations. In London, Petersburg, Berlin, Warsaw, and Vienna, the events fame was making known were spoken of enthusiastically.)[2] On December 20 Zaragoza was again put under siege.

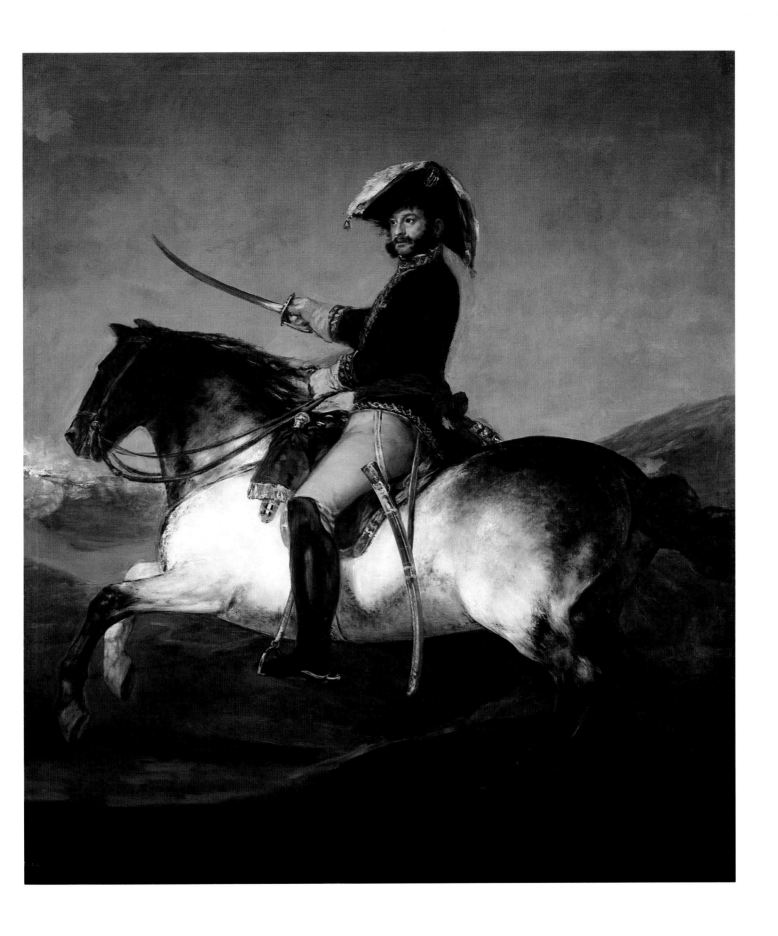

After two months of resistance, the situation was critical: the city, ringed by continuous French fire, was destroyed, the population starved, and an epidemic was declared; ammunition was scarce. The French demanded unconditional surrender and let it be known that Madrid had capitulated. Palafox's answer was emphatic: "no se capitular; no se rendirme; después de muerto hablaremos de eso" (I do not know how to capitulate; I do not know how to surrender; after I am dead we will speak of that). He added: "Si Madrid capituló . . . Madrid no es más que un pueblo y no hay razón para que éste ceda" (If Madrid surrenders . . . Madrid is no more than a village and there is no reason for this [city] to yield).[3] The Junta (Council) signed the surrender when power was reinvested in it. Palafox was taken prisoner to Valençay, where he remained until 1813.

Palafox's energy and drive seem to be the protagonists of this painting. Unlike other equestrian portraits of Palafox (fig. 1), Goya's painting eliminated allusions to the battle, such as medals and other descriptive elements, that would help us to identify Zaragoza; there is only the red cockade on the hat, which recalls the battle insignia adopted by the people of Zaragoza, and the baton of authority signifying his military rank.[4] Although the horse has been paused and posed, it appears to be heading toward the background, where a patch of color suggests fire. Echoing this sense of movement is the combative flourish of the drawn sword. By emphasizing action, Goya underscored Palafox's energetic character.

Palafox requested that Goya come to Zaragoza after the first siege "con el fin de pintar las glorias de aquellos naturales" (in order to portray the glories of its citizens).[5] But this portrait was executed when Palafox was in Madrid, after the war. In that year he suffered the "desengaño de Valencia" (Valencia deception), in allusion to the city where Fernando VII first publically declared himself in favor of absolutism. Palafox's political ideas were not among the most progressive represented in the Junta Central (Central Council), but he was decidedly in favor of the Constitution of 1812. Before the king's arrival in Madrid, in Daroca's and Segorbe's political meetings Palafox alone supported the February 2 decree by which the Cortes established that the royal authority would be recognized only on condition that the king swear allegiance to the Constitution. It may be supposed that as a result of this, his was an awkward presence in the absolutist court and yet an untouchable one because of his popularity. He was, in consequence, banished to the margins of official life. He never received a special reward, although a decree of 1809 had stipulated one on his release from prison, and he received only a third of his salary as commander in chief (although his fellow officers were paid in full) until 1826, when, after twenty applications, it was granted him in full. Looking back, we may say that Palafox was rewarded with this splendid portrait by Goya.

M.M.H.

1. *Historia de España*, ed. Ramón Menéndez Pidal, vol. 26: *La España de Fernando VII* (Madrid: Espasa-Calpe, 1968), p. 105.

2. Agustín Alcaide Ibieca, *Historia de los dos Sitios que pusieron á Zaragoza* (Madrid, 1830-1831), vol. 1, p. 266.

3. *Suplemento de la Gazeta del Gobierno*, Feb. 3, 1809, pp. 97, 99.

4. "El distintivo que tomaron los labradores fue una escarapela encarnada, pero luego la llevaron todos, para lo que bastaron las primeras insinuaciones" (As a mark of distinction the laborers adopted the red cockade, but everybody came to wear it, after only the merest intimation); Alcaide Ibieca, *Historia*, vol. 1, p. 10. An English army regulation of Oct. 15, 1808, stated: "Upon entering Spain, in compliment to the Spanish nation, the Army will wear the Red Cockade in addition to their own"; James Moore, *A Narrative of the Campaign of the British Army in Spain* (London, 1809), p. 10.

5. Letter from Goya to Don Josef Munarriz, Oct. 2, 1808; Real Academia de San Fernando archives; quoted in Sayre, *Changing Image*, p. 126. Lady Holland noted there were several drawings by "the celebrated Goya" in Palafox's room when he was captured; *The Spanish Journal of Elizabeth Lady Holland* (London, 1910), p. 324.

76

P^r no trabajar (For Not Working)
Album C, page 1
About 1808-1814
Brush with gray and black wash
206 x 145 mm.
Inscribed in brush and gray, upper right: *1*; in pen and brown ink, below image: title
References: G-W 1244; G., I, 151.

Museo del Prado, Madrid, 86
Spain only

This drawing is one of Goya's most expressive works on mendicancy. The middle-aged man with curly, disheveled hair wears picturesque rags, masterfully rendered by Goya's brushstrokes in more or less dark touches that allow the white of the paper to show, achieving thereby a more effective modeling of the figure. Shod with broken sandals that expose his toes, the man bears a curious resemblance to a beggar described by Torres Villarroel: "Pisaba con dos vainas de cuchillo de monte en vez de zapatos, con sus roturas y enrejados, como que traía los pies en jaulas" (He wore two hunting knife sheaths for shoes, crisscrossed with rents and lattices as if he had caged his feet).[1] In his right hand he holds a hat for alms, but he also reaches out with his left in order to make his plea sadder and more effective. His belongings – one might well imagine all his worldly goods – are strapped to his back. The facial expression – with its wide-open, almost bulging eyes, and open mouth – and the rank, matted hair make of this beggar a paradigm of absolute indigence, a living incarnation of hunger and extreme degradation.

Goya, however, does not appear to have felt compassion for this creature. His inscription is emphatic: the man has fallen to this state "por no trabajar" (for not working), a severe judgment against the idleness in which many in Spain lived, ruining themselves and therefore the country.[2] A universal theme among Goya's enlightened contemporaries was this repudiation of idleness and a similar denunciation of shameless begging. Thus, Campomanes, the eighteenth-century advocate of economic and educa-

tional reform, estimated that there were 140,000 beggars in Spain. He backed economic reforms that would rescue many poor people from misery, although he also blamed the existence of numerous beggars on what he regarded as an innate Spanish disposition to idleness.[3] Antonio Ponz, Pedro Antonio Sánchez, Olavide, and Cavanilles were among those who described movingly "la pobreza de algunas zonas rurales españolas" (the poverty of some Spanish rural areas); in 1750 Bernardo Ward in his *Obra Pia* (Pious Work) proposed the establishment of hospices to take in the poor.

Floridablanca (see cat. 4) and Jovellanos (see cat. 30) tried to put an end to mendicancy and Meléndez Valdés (see cat. 24) and Cabarrús (see cat. 15) likewise denounced the tragic existence of such a large number of people affected by the most extreme poverty, although they also discussed professional beggars, which they estimated at one in five: true idlers who fled work. Meléndez Valdés, in the *Discursos forenses* (Legal Essays), published in Zamora in 1821, which includes fragments of an 1802 essay on mendicancy, referred to "la corrupción moral y embrutecimiento de los mendigos . . . sin patria, sin residencia fija, sin consideración ni miramiento alguno . . . dados al vino y a un asqueroso desaseo" (the moral decadence and brutalization of beggars . . . without a country, without a fixed home, without the least obligation or care . . . prone to drink and a filthy slovenliness). For Meléndez Valdés, like his enlightened contemporaries, among them Goya, poverty that led to begging, lying, crime, and punishment brought about "el envilecimiento y deshonor de la nación" (the debasement and dishonor of the nation). He described Spain as two peoples: the "ciudadanos" (citizens) and the "degradados" (degraded); since "la mendiguez es ociosa, disipada, inmoral y opuesta por lo mismo a las santas máximas del Cristianismo, . . . es una plaga de la sociedad que la degrada y la destruye, y que el que la autoriza con sus limosnas indiscretas es un mal ciudadano, que trabaja sin saberlo en la corrupción

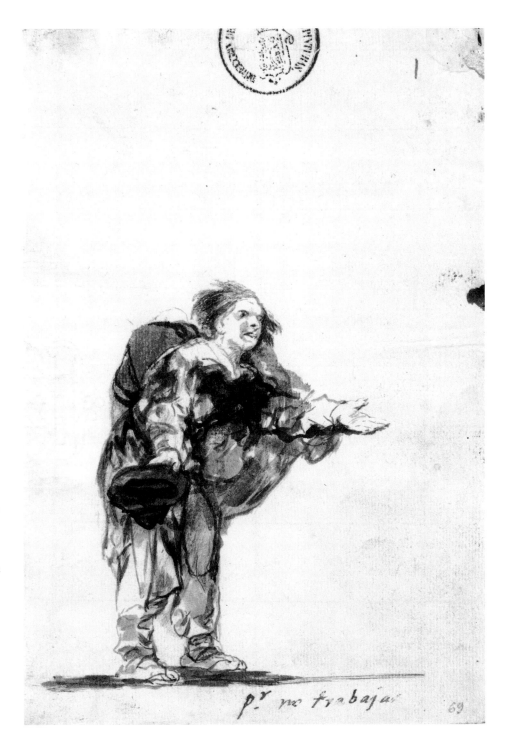

física y moral de sus semejantes" (mendicancy is idle, dissipated, immoral, and therefore contrary to the sacred strictures of Christianity, . . . it is a plague that degrades and destroys society, and he who sanctions it with his injudicious alms has failed in his civic duty, unwittingly fostering the physical and moral perversion of his fellow citizens). Goya's image and inscription, therefore, shared the critical attitude toward mendicancy of other enlightened Spaniards. That poverty and especially mendicancy were more notorious in Spain than in certain other parts of Europe would seem to be substantiated by their being described as typical of the country in accounts written by foreign travelers.[4]

In addition to attacking mendicancy, contemporary observers commented on the various characteristics of beggars, such as their arrogance in begging or their underhandedness, feigning diseases or using gestures and expressions that moved others to compassion. Torres Villarroel described with his satirical pen duplicitous beggars in the interior of the Madrid Hospice: "Pobre hubo, señor don Francisco, que descalabraba con alaridos las orejas, aullando entre rabia y lacería el ¿No hay para este pobre, imagen de Cristo, algún socorro? Y cuando llegó el lance de recogerlo, le encontraron acolchonado el capote de pesos mejicanos." (There was a poor man, Mr. Francisco, who assaulted ears with his howls, wailing in a cross between anger and suffering, 'Is there no help for this poor man, the very image of Christ?' And when the time came to cart him away, he was found wearing a cloak padded with Mexican pesos.)[5]

In this drawing Goya seems to have denounced the beggar's absolute indifference and moral and physical debasement rather than his falseness. The traces of biting caricature (see cat. 78) or the allusions to deceptions beggars sometimes used (see cat. 81 and 82) are absent. In sum, he censured here a kind of life that violated all the dictates of reason. In some drawings Goya praised work, sometimes openly, as in that of the young woman sewing, in *Album E* (G-W 1417), which he underscored by inscribing *El trabajo siempre premia* (Work is always

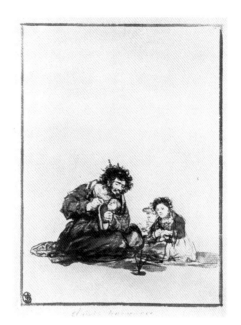

Fig. 1. *El ciego trabajador* (The Blind Laborer), 1814-1817,
Album E, page [D].
Black and gray wash.
Graphische Sammlung, Albertina, Vienna

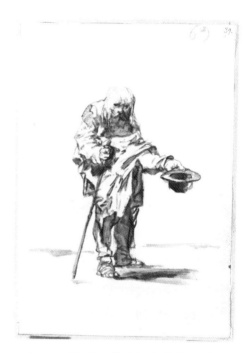

Fig. 2. *Beggar Holding a Stick in His Right Hand*, 1817-1820,
Album F, page 69.
Brown wash.
The Metropolitan Museum of Art, New York, Harris Brisbane Dick Fund

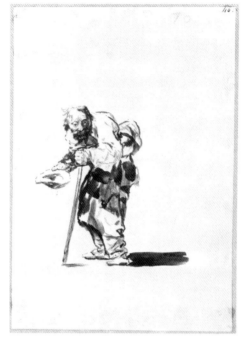

Fig. 3. *Beggar Holding a Stick in His Left Hand*, 1817-1820,
Album F, page 70.
Brown wash.
The Metropolitan Museum of Art, New York, Harris Brisbane Dick Fund

rewarding), or in *El ciego trabajador* (The Blind Laborer) (fig. 1), in which the blind man, despite his disability, which would otherwise have reduced him to indigence and begging, joins his family in his labors as a cobbler. Elsewhere Goya's interpretation of beggars is quite different; he took more interest in the peculiarities of a specific person than in the general subject of mendicancy, as, for example, in drawings in *Album F* (figs. 2 and 3) and those executed later in Bordeaux, in *Album G* (cat. 167 and cat. 167, fig. 1).

M.M.M.

1. Diego de Torres Villarroel, *Visiones y visitas de Torres con D. Francisco de Quevedo por la Corte,* ed. Russell P. Sebold (Madrid, 1966), p. 29.

2. For monographic studies on poverty in eighteenth-century Spain, see R.M. Pérez Estevez, *El problema de los vagos en la España del siglo XVIII* (Madrid, 1974); Jacques Soubeyroux, "Pauperismo y relaciones sociales en el Madrid del siglo XVIII," *Estudios de historia social,* nos. 12-13 (1980).

3. Pedro Rodríguez de Campomanes, *Apéndice a la educación popular* (Madrid, 1775-1777), vol. 2, p. 126.

4. Some travel accounts by foreigners who visited Spain mention the wealth of the few in contrast to the poverty of the many; see *Historia de España,* ed. José María Jover Zamora, vol. 31: *La época de la Ilustración,* vol. 1 (Madrid: Espasa-Calpe, 1987), pp. xi-xxv.

5. Torres Villarroel, *Visiones,* p. 68.

77

Salvage menos qe otros (Less Savage than
Others)
Album C, page 2
About 1808-1814
Brush and gray and black wash
206 x 144 mm.
Inscribed in brush and gray: *2*; in pen
and brown ink, below image: title
References: G-W 1245; G., I, 152.

Museo del Prado, Madrid, 87
United States only

Goya represented a savage standing and
facing the viewer before a broad, empty
landscape. The man wears strange cloth-
ing: a dark skirt, of a material that is not
clearly defined but whose texture sug-
gests animal hide or feathers; a kind of
light bodice, which leaves the chest
uncovered and ends in wide sleeves
made of the same material as the skirt;
and a small hat, resembling a turban and
trimmed with feathers. The exotic figure
is armed with a yataghan (wide, short
sword) and a kris (long, curved dagger),
and in his left hand he carries a bow,
whose arrows are bound to his waist.

The man has a rather dusky complex-
ion, which Goya underscored with a uni-
form dark tone, but he is not black. The
beard around his lips and the small
goatee under his lower lip are as worn by
Pacific Ocean natives; the kris is a char-
acteristic weapon of the Malaysian or
Indonesian peoples. The precision with
which Goya represented the dress and
the weapons does not appear to arise
purely from his fertile fantasy but seems,
rather, to have been based on a specific
model. At the end of the eighteenth cen-
tury and the beginning of the nineteenth,
travel accounts and prints of an ethnolog-
ical nature were fairly common, and
through them distant and exotic cultures
came to be known. Thus it is possible
that Goya was inspired by a work of this
kind.[1] The depiction of the savage indi-
cates the extraordinary variety of Goya's
interests and also his acquaintance with
the most advanced ideas of his time, for
we can find here an echo of Rousseau's
concept of the "noble savage."[2]

The mordant phrase Goya added
below the image represents once again a

judgment of his contemporaries. Goya
acknowledged the man's savage state but
concluded that in his natural state and in
his undoubted backwardness he was
comparatively less savage than many so-
called civilized men. The inscription
does not allow us to specify who those
otros (others) might be to whom Goya
referred with such harshness as savages.
In reviewing the ideas he expressed in
the drawings and etchings, however, we
find that Goya regarded as irrational

those who did harm to others, along with those ruled by superstition and fanaticism, those who attacked and perverted children, those who oppressed the weak in the name of religion or politics, and those soldiers carried away by the blind fury of war. Perhaps all these deviations together moved Goya to write that phrase, which is so charged with pessimism. The savagery Goya assumed in the drawing's subject seems justified only if we consider that, in comparison with his European contemporaries, the man probably lived in a condition of ignorance, without intellectual and philosophical traditions.

Goya's savage faces the viewer, head raised as if examining the sky, with a deeply attentive look and places his right hand in the pouch or game bag hanging from his waist. There is in his posture a certain resemblance to the figures of hunters in some of the *Album F* drawings (see G-W 1514), and perhaps Goya meant to suggest that this man is hunting. (This is no more than a hypothesis, which demonstrates the difficulties that confront us in analyzing this work.) The weapons serve the savage not to murder other humans but to hunt; this is the man's main activity, which nourishes him, and, finally, the kind of work that gives him dignity as a complete human being, deserving of Goya's deepest respect.

On other occasions Goya did not quite so respectfully handle figures whose appearance suggests they are savages; see, for example, the expressive drawing of a half-naked man, dressed in skins, who clubs another lying on the ground (cat. 151), which some scholars have regarded as a fight between two savages.

M.M.M.

1. It has not been possible to locate prints of this period in which types resembling Goya's savage are represented, and the documentary material to which I have had access is sparse.

2. This idea of Rousseau's spread throughout Europe after the publication of *Emile* in 1759-1760. The publication of Daniel Defoe's *Robinson Crusoe* in 1719 had also furthered eighteenth-century interest in the savage.

78

Este fue un cojo q^e tenia señoria (**This man was a cripple who possessed a seigniory**)
Album C, page 5
About 1808-1814
Brush and gray and black wash
205 x 142 mm.
Inscribed in brush and gray, upper right: 5; below image in pen and brown ink: title
References: G-W 1248; G., I, 155.

Museo del Prado, Madrid, 90
Spain only

This drawing is unusual among those by Goya on poverty and mendicancy, since the figure appears dressed in late sixteenth- or early seventeenth-century style, not in that of the first decades of the nineteenth, when Goya created it. Goya sometimes outfitted his subjects in the Spanish fashion of the sixteenth or seventeenth centuries to allude to that historical period, as in the *Tauromaquia* (1815-1816) or in the short drawing series on dueling (see cat. 144 and 145), in which the figures intentionally recall a bygone time.[1] Goya, therefore, clearly meant this anachronistic attire to tell us something. The figure, showing his right profile, leans on a cane with his right hand and extends his hat with his left. The composition is very similar to that of another, perhaps contemporary, drawing, *Trabajos de la guerra* (Hardships of War) (fig. 1), in which a cripple who similarly leans on a crutch holds out his hat for alms. However, in the latter Goya presented a soldier (identifiable by his jacket), perhaps a patriot of the Peninsular War, emaciated and disabled, whose war wounds have destroyed his life and reduced him to begging as his only *trabajo* (work). It is an image of solemn dignity, handled with all the respect toward suffering humanity Goya was capable of mustering.

This is not the case in this drawing of the cripple, with its obvious elements of caricature. By the eighteenth century, late sixteenth- and early seventeenth-century dress was altogether out of fashion, and the satirist Torres Villarroel, commenting on his visits to the Spanish

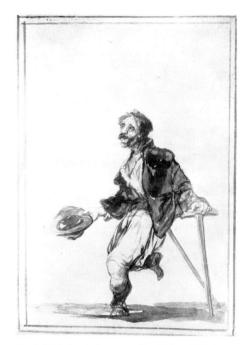

Fig. 1. *Trabajos de la guerra* (Hardships of War), 1814-1817, *Album E*, p. [C].
Black and gray wash.
Baron de Gunzberg, Paris

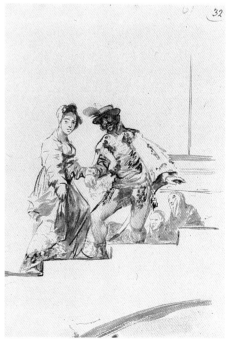

Fig. 2. *Gentleman Helping a Woman to Climb Steps*, 1817-1820, *Album F*, p. 61.
Brown wash.
Private Collection, Paris

court with Quevedo, made it clear that nobody wore this type of clothing: "Yo no quisiera salir por la Corte contingo en ese traje, porque nos esperan los chiflidos y la grita de los que nos vean, porque ya sólo en los entremeses se ven las golillas" (I don't want to stroll about the court with you dressed in that garb because we will only invite the whistles and catcalls of those who see us, for ruffs are only found nowadays in *entremeses* [one-act farces presented between acts of a play]).[2] Goya therefore knowingly used the anachronistic dress and undoubtedly with a specific purpose.

In the eighteenth and early nineteenth centuries, the idea of poor *hidalgos* (minor nobles) without a job or income, who survived by openly begging, was widespread. Blanco White alluded to their poverty, especially that of the Asturian *hidalgos*: "As the *Hidalguia* branches out through every male whose father enjoys that privilege, Spain is overrun with *gentry*, who earn their living in the meanest employments."[3] In this drawing Goya may have been caricaturing the many people who prided themselves on their *hidalguía* but were compelled to beg. But perhaps Goya sought to strike more deeply against the society of his time, censuring the traditional pride of a class on the verge of disappearance, which preferred to make a living by begging rather than by manual labor. Perhaps the use of an outmoded costume was another element of Goya's mockery of a social class, wed to its ancient privileges, which he therefore presented wearing the attire of a bygone age they regarded as glorious.

In the early *Album C* drawings Goya addressed the themes of poverty (see cat. 76 and 79) and extreme physical disability, like crippling, in which he summarized and symbolized the moral defects of an entire class, along with the contrasting theme of figures who fill their leisure hours with work, such as the friar weaving baskets, in *Album C*, page 8, *A lo menos hace algo* (At least he does something) (G-W 1250), or the shepherdess spinning while guarding the flock, *Album C*, page 11, *Esta pobre aprobecha el tiempo* (This poor woman makes good use of her time) (G-W 1388).[4] For this

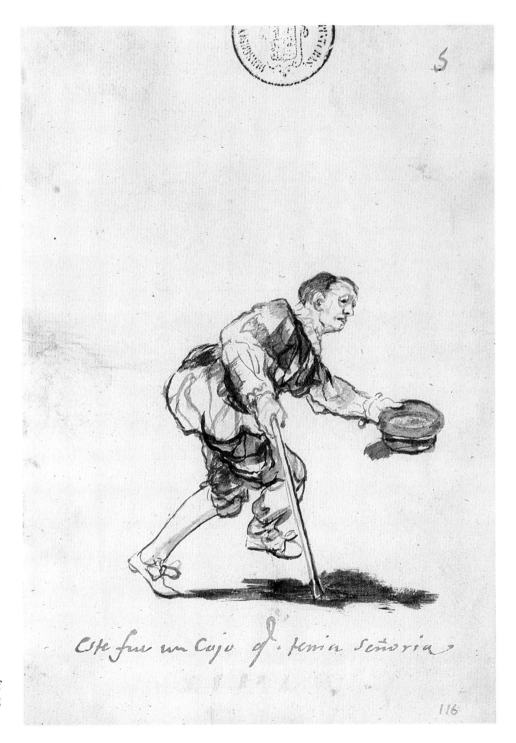

Este fue un Cojo q. tenia señoria

reason the drawing of the cripple should be understood as representing a *hidalgo* who disdains work. The friar works, the shepherdess works, but the proud nobleman, wrapped in obsolete clothing, begs for alms.

On the other hand, there is no reason to believe that seventeenth-century Spanish literature did not have some influence as a source for this powerfully expressive image. Quevedo was a poet, novelist, and essayist who influenced Goya particularly as he began working on the *Caprichos*. This drawing could well serve as an illustration to some passages in Quevedo's novel *Historia de la vida del buscón llamado Don Pablos* (The Life of the Cheat Don Pablos) in which the writer depicted the picaresque underworld of the seventeenth-century Spanish court, especially the scenes of begging *hidalgos*. But certain other novels of the Spanish Golden Age could have served Goya as well, for example, the anonymous *La vida y hechos de Estebanillo González* (The Life of Estebanillo Gonza-lez): "Tenía una desdicha, que nos alcanzó a todos sus hijos, como herencia del pecado original, que fue ser hijodalgo, que es lo mismo que ser poeta; pues son pocos los que escapan de una pobreza eterna o de una hambre perdurable" (His misfortune, which he passed on to all of us, his children, as if a legacy of original sin, was to be gentry [literally, son of something], which comes to the same as being a poet; for only a few of them escape eternal poverty or everlasting hunger).[5]

M.M.M.

1. Goya presented gentlemen dressed in sixteenth-century attire in one of his paintings, *The Life of San Franciso de Borja* in the cathedral of Valencia, and also in a drawing (fig. 2) in which a gentleman dressed in sixteenth-century fashion helps a lady climb some steps. This drawing, without an inscription, has not been satisfactorily explained; it could be a scene from a play or an illustration of ancient courtly customs, which Goya perhaps thought had been abandoned by his own time.

2. Diego de Torres Villarroel, *Visiones y visitas de Torres con D. Francisco de Quevedo por la Corte*, ed. Russell P. Sebold (Madrid, 1966), p. 23. In the eighteenth century, this work was published in 1727-1728, 1743, 1752, and 1791. In the ninth vision, Torres again spoke of the Spanish ruff: "Aquí acudió Quevedo y me dijo: ¿Es posible que se acabó aquel traje tan propio de la gravedad española? Si le respond[í?]ió, y de tal manera, que para representar a Judas muy ridículo el Jueves Santo le cuelgan en algunas partes vestido de golilla." (Here Quevedo responded by saying: Is it possible that a costume so suited to Spanish solemnity should have gone out of fashion? Yes, I answered, and to such an extent, that on Holy Thursday in some areas Judas is given a ruff so as to make him look ridiculous.) Ibid., p. 66.

3. Blanco White, *Letters*, p. 38.

4. The term *cojear* (to limp or hobble) can also mean to suffer from some vice or defect: "saber de qué pie cojea alguien" (literally, to know which is his lame foot) is to know someone's vices or weaknesses.

5. [Attributed to Luis Vélez de Guevara,] *La vida y hechos de Estebanillo González: Hombre de buen humor, compuesta por el mismo*, ed. Juan Millé Giménez (Madrid, 1956), vol. 1, p. 61.

79

¡Q^e Necedad! dar los destinos en la niñez (What Foolishness to Decide Children's Destinies)
Album C, page 13
About 1808-1814
Brush and gray-brown and black wash
206 x 143 mm.
Inscribed in brush and gray, upper right: *12* altered to *13*; in pen and brown ink, below image: title
References: G-W 1254; G., I, 163.

Museo del Prado, Madrid, 15
Spain only

At the center of a balanced, harmonious, triangular composition, a woman wearing coarse clothing of the lower classes – a skirt and petticoat, and a shawl that covers her head and casts her face in shadow – walks, taking two children by the hand. The landscape is empty, desolate, with a mountain silhouette in the background toward which one of the children points. The children do not seem to be following cheerfully, and this together with the woman's somber aspect and Goya's harsh inscription oblige us to conclude that the children are being led against their will.

In this drawing, as in many other works, Goya depicted the scene with deliberate ambiguity, and it is impossible to establish what the woman represents to the children, whether, mother, grandmother, servant, or governess. Furthermore, it is difficult to judge whether the children are a girl and a boy or two girls. The child on the left, wearing a skirt and a cloak, seems to be a girl, and the one on the right, with pants and a short cape, a boy. The woman resembles the old witchlike bawds that appear in other drawings by Goya. In any case, the key to this drawing may lie not in the figures but in the inscription. Was Goya lamenting, in general, society's loss of useful citizens as a result of a poor education in childhood?

Perhaps the clothing of these figures was sufficiently recognizable to the viewers of Goya's day so that they could interpret the scene without need for further explanation; but today, because of the vagueness of the image, the drawing

comes across as a general denunciation.
The children do not appear to be noble,
although they are well dressed. We need
only compare them with children of the
nobility depicted in Goya's other works
(see cat. 41) to realize that the artist did
not intend here to censure the ignorance
of some members of the upper classes in
eighteenth-century Spain but, rather,
seems to have had the lower classes in
mind.[1] Perhaps they represent the off-
spring of well-off farmers, manual labor-
ers, or artisans, since they are dressed
with a certain care, unlike the children
wrapped in rags in Goya's depictions of
the poor.

Goya seems to have wished to expose
the obstinacy of certain social classes,
which could have emerged from misery
and ignorance and revolutionized the
traditional social hierarchy of Spain
under the Old Regime through education
and which, on the contrary, stubbornly
insisted on separating their children from
the true wealth that education would
have brought them, in order to prepare
them, while they were still children, for a
future. It must be borne in mind that
throughout the eighteenth century and
especially in the second half, education
was increasingly accessible to the lower
classes and that great strides were being
made in this direction, sometimes under
the influence of Rousseau's ideas,
imported from France, and sometimes
under that of other educational systems,
such as the Escuelas Pías, schools estab-
lished in Spain by the seventeenth-cen-
tury reform-minded pedagogue San José
de Calasanz, which were open to the low-
est social echelons.

Upon close inspection the drawing is
seen to give shape to this idea. It is an
interesting example of Goya's sensitive
handling of emotions and behavior,
which is manifested in all his works. The
girl has planted her little feet on the
ground and points toward the back-
ground, pulling on the woman's hand, as
if she has decided not to take another
step forward and to return to her point of
departure; the other child, who looks
serious and bows his (or her) head,
seems resigned to continuing the journey.
But it is perhaps in the rough-looking
woman leading the children that Goya

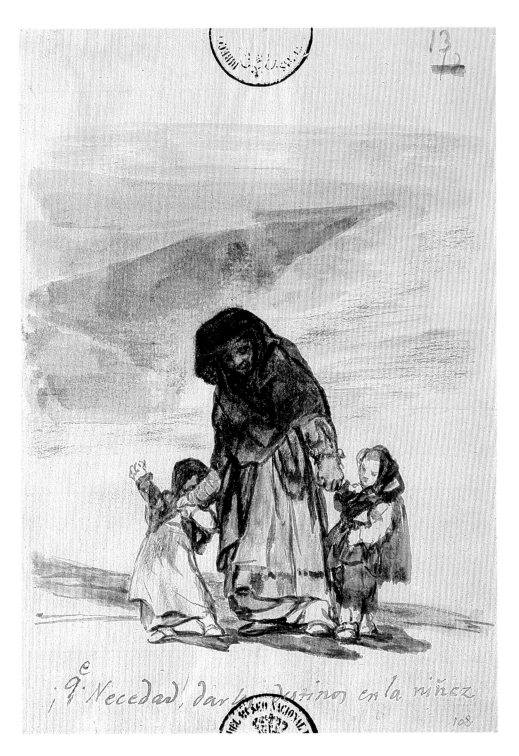

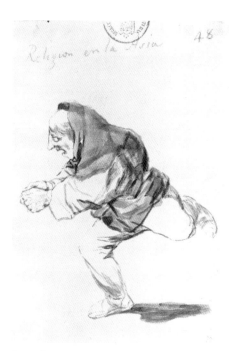

Fig. 1. *Religion en la Asia* (Religion in Asia),
Album C, p. 48.
Black and gray wash.
Museo del Prado, Madrid

most successfully conveyed the sense of fateful inevitability. Firmly gripping the children's hands, she seems determined not to let them go but to keep to her objective; with head bent in a gesture of obstinacy, she reveals her acceptance for them of a tragic destiny.

The woman's attitude is one that Goya regarded as foolish. For what could fate have in store for these children? For them there was service in a nobleman's palace, or with a farmer, or a city dweller; in the case of boys, even at an early age, there might be apprenticeships in an artisan's shop or religious service, first in a monastery or convent and later within one of the many religious orders, which filled their ranks with village youth lacking adequate education or wealth to take another path.[2] Goya seemed to foresee that through ignorance and lack of education, these children would be unable to improve themselves and their country.

<div align="right">M.M.M.</div>

1. To judge from Goya's works, as well as contemporary literary sources, some Spanish nobles were completely ignorant. Diego de Torres Villarroel, in the tenth Visit in the satire *Visiones y visitas de Torres con D. Francisco de Quevedo por la Corte* (first published in 1728 and again in 1743, 1752, and 1791), had already lamented: "Los nobles cortesanos criaban a sus hijos delicados, ignorantes y libres. . . . A empujones les enseñaban el alfabeto castellano, y el más instruido a los veinte años burrajeaba la gramática latina." (Court nobles raised their children to be finicky, ignorant, and unruly. . . . They reluctantly learned the Castillian alphabet, and the most educated of them at twenty scrambled Latin grammar.) José Blanco White described the Spanish aristocracy in similar terms: "Surrounded by their own dependents, and avoided by the gentry, who are seldom disposed for an intercourse in which a sense of inferiority prevails, few of the grandees are exempt from the natural consequences of such a life – gross ignorance, intolerable conceit, and sometimes, though seldom, a strong dose of vulgarity." Blanco White, *Letters,* p. 33.

2. Goya's views on this aspect of the Church in Spain are well known from the many works in which he depicted the corruption of friars and nuns and their lack of vocation (see cat. 111 and 115). In these works Goya merely expressed the ideas of other enlightened intellectuals.

80

La misma (Likewise)
Album C, page 49
About 1808-1814
Brush and gray and black wash
207 x 142 mm.
Inscribed in brush and gray, upper right: *46* altered to *49;* in black chalk, upper left: title
References: G-W 1287; G., I, 196.

Museo del Prado, Madrid, 45
United States only

Goya devoted some of his *Album C* drawings to oriental figures as a means to upbraid and criticize the vices and shortcomings of contemporary Western society, especially Spanish society. Among them are three drawings on Asian religion (fig. 1, the present drawing, and cat. 81), interpreted according to the ideas of the time, which occasionally revealed Western prejudices. Some European observers seemed shocked by certain aspects of Eastern religion, and some writers recounted events they had never witnessed themselves but had simply lifted from accounts by other travelers.

Goya's drawing *Religión en la Asia* (Religion in Asia) (fig. 1) presents the figure as a caricature of a man who, with hands clasped as if in prayer, stands on one foot, while he raises his other leg and perhaps turns in a circle.[1] The mouth open, perhaps in chant or because of the strain of his pose, and the eyes fixed straight ahead suggest both the harshness of the penance and the obsessive fanaticism that leads him to perform the religious dance. According to Lafuente Ferrari, Goya was perhaps alluding to the *mawlawiyah* (whirling dervishes) who prayed and testified to their beliefs in this manner.[2] *Religión en la Asia* is also undoubtedly related to the immediately preceding *Album C* drawing (fig. 2), the last of the series known as dreams or visions.[3] In this series Goya presented various figures whose attire certainly marks them as monks or friars; they appear to intone processional hymns, and in them Goya found the same fanaticism he illustrated in their Asian counterparts.

At the end of the eighteenth century, through the reports of travelers and

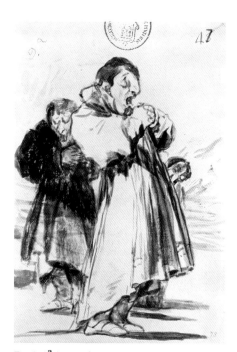

Fig. 2. *9^a* (Ninth) [Night or Vision]
Album C, p. 47.
Black and gray wash.
Museo del Prado, Madrid

merchants on the one hand and missionaries on the other, aspects of oriental culture became known in Europe, although certainly in a superficial way, and Goya must have based his drawings on these accounts.[4] Although it is difficult to ascertain the precise source of inspiration for this drawing, a work entitled *Cérémonies et coutumes religieuses de tous les peuples du monde* (Religious

GUEUX *devot qui se heurte de la tête sur une*
pierre pour recevoir la CHARITÉ.

Fig. 3. Bernard Picart,
Gueux devot qui se heurte de la tête sur une pierre
pour recevoir la Charité (Religious Beggar Who
Strikes His Head against a Rock so as to Receive
Alms).
Etching and engraving, in *Cérémonies et coutumes*
religieuses de tous les peuples du monde, vol. 7,
Paris, 1808, plate 10.
Widener Library, Harvard University

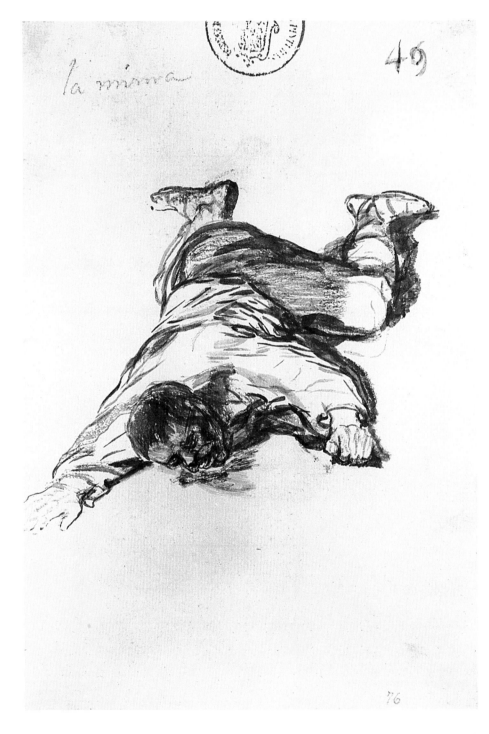

Rites and Customs of all the Peoples of
the World), with illustrations by Bernard
Picart, may have provided Goya with
ideas.[5] The text, which discusses religion
in China, refers to itinerant priests,
under the generic term of Bonzes, and
their forms of penance, which were
designed to obtain alms from the faithful.
The author describes a custom of some
monks that seems strange to him: "Une
autre manière de payer des contributions
aux moines Chinois est de se faire écrire
dans une espèce d'*album* qu'un d'eux
présente aux passans. Nous pourrions
encore placer ici cet ordre de coureurs
qui amusent le public par leurs tours"
(Another way of making contributions to
the Chinese monks is to record one's
name in a kind of album that one of them
offers to passersby. We could also

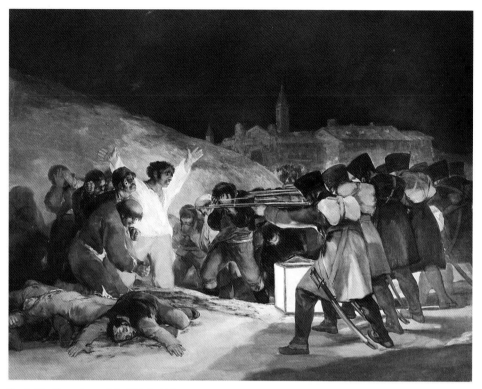

Fig. 4. *The Executions of the Third of May,* 1808.
Oil on canvas.
Museo del Prado, Madrid

include with them that order of runners who amuse the public by rotating).[6]

La misma, which follows *Religion en la Asia* in *Album C,* must be studied in conjunction with the latter, since Goya's inscription, *La misma* (Likewise), refers to "the same" religion in Asia. Here Goya presented a man stretched out on the ground, face down, with his legs spread and bent at the knee, and his arms extended forward. His slightly raised head appears to be streaming blood, and a dark stain on the ground seems to be the result of injuries received to the face. It is difficult to interpret this drawing. According to Gassier, the drawing has been incorrectly understood, for its original position in *Album C* would have been page 46, that is, following *Ninth Night,* originally p. 45 (fig. 2), and within the series of dreams and visions in this album; the inscription should therefore be read as *La misma [noche]* (The Same [Night]).[7]

In the opinion of Lafuente Ferrari, *La misma* follows *Religión en Asia* and could

represent an unusual form of penance practiced by Chinese monks.[8] The French publication *Cérémonies* described another manner in which Chinese monks obtained alms from passersby: "Les Bonzes, au rapport du P. le Comte, ne sont qu'un amas de malhonnêtes gens et des fourbes, que l'oisivité, la mollesse, la nécessité assemblent pour vivre des aumônes publiques; tout leur bout est d'engager les peuples à leur en faire. . . . Tels sont ceux . . . qui se tiennent dans les places et dans les grands chemins pour s'attirer la charité des passans en frappant de leur tête contre un gros caillou, jusqu'à ce qu'ils obtiennent l'aumône" (The Bonzes, according to Father le Comte, are nothing more than a band of dishonest and swindling men, in whom idleness, sloth, and need have joined hands in order to live off public charity; their only aim is to get people to give. . . . Such are those . . . who install themselves in squares and on highways to attract the charity of passersby by striking their heads against a large stone

until they obtain alms).[9] An illustration in the book by Picart (fig. 3) shows an oriental monk face down on the ground and indeed striking his head against a rock.[10] Perhaps *La misma* is Goya's interpretation of a curious form of penance or, according to some skeptics of the time, of an effective way of soliciting alms.

Whatever its subject may be, *La misma* is drawn with surprising freedom and has a remarkably expressive power. The conspicuous foreshortening of the figure and the total absence of a realistic setting make the drawing comparable to those of nightmarish visions which precede it in *Album C* and confer on it a quality of timelessness that Goya often achieved in his works. The similarity of this fallen figure to that in the foreground of *The Executions of the Third of May* (fig. 4) is striking. Although it is unlikely that Goya used the drawing as a preparatory sketch for the painting, it is possible that he made use of the idea. If so, this drawing could be dated about the time of the painting, that is, about 1814, and would provide a clue to the dating of *Album C,* which has hitherto been dated anytime between 1802 and 1824.[11]

M.M.M.

1. G-W 1286; G., I, 195.

2. Enrique Lafuente Ferrari, *El mundo de Goya en sus dibujos* (Madrid, 1979), pp. 248-249.

3. G-W 1285; G., I, 194.

4. Pierre Gassier suggested commentaries or narrations by Spanish missions abroad. G., I, 197.

5. *Cérémonies et coutumes religieuses de tous les peuples du monde. Représentées par des figures dessinées de la main de Bernard Picart, avec des explications historiques et des dissertations curieuses,* 12 vols. (Paris, 1807-1810). (An earlier edition was published in 1723-1727.) The customs of Asia are dealt with in volume 7 (1808), where the commentary on China was based in part on that by the Jesuit Louis Pamel le Conte, in *Mémoirs de la Chine* (1697). Plate 10 in *Cérémonies,* volume 7, was suggested by Eleanor A. Sayre as a source for this drawing and for cat. 81.

6. *Cérémonies,* vol. 7, p. 40.

7. G., I, 196.

8. Lafuente Ferrari, *Mundo de Goya,* pp. 248-249.

9. *Cérémonies,* vol. 7, p. 39.

10. Ibid., vol. 7, fig. 10.

11. See Eleanor A. Sayre's introduction to the *Album C* drawings in this catalogue.

81

Pobre en Asia qe se enciende la cabeza hasta qe le dan algo (A Poor Man in Asia Who Sets His Head on Fire until He Is Given Something)
Album C, page 50
About 1808-1814
Brush and gray and black wash
204 x 142 mm.
Inscribed in brush and gray, upper right: *50;* in chalk, above image: title
References: G-W 1288; G., I,197.

Museo del Prado, Madrid, 273
United States only

Among the three drawings on Asia (see cat. 80, fig. 1, and cat. 80), this one most clearly indicates Goya's use of oriental themes to establish analogies with mendicancy in Spain. He presented the figure standing, feet together and arms extended, dressed in strange clothing – wide pants, and an ample, floating tunic. Although Goya lavished unusual care on the clothes, he did not create a faithful reproduction of a Chinese monastic habit. The facial features do indeed appear oriental, and a few adept dabs of the brush convey flames round the man's head. A small dish is placed at his feet to receive alms from passersby.

Goya's inscription on the drawing suggests that he read accounts of curious methods of begging for alms, including perhaps the description in *Cérémonies et coutumes religieuses de tous le peuples du monde* (Religious Rituals and Customs of all the Peoples of the World), illustrated by Bernard Picart. In the text as in Goya's drawing, this odd manner of soliciting charity is regarded as a deception practiced by Chinese beggars, or monks, to provoke pity more effectively. In additon to the monks who strike their heads with stones, there are those who "se font bruler quelques drogues sur la tête pour exciter la compassion des gens: peut-être la peine est moins rude qu'elle ne paraît d'abord; il y a des secrets pour se garantir du feu" (burn certain drugs on their heads in order to move people to pity: perhaps the pain is less severe than it might seem at first sight; there are secret ways to protect oneself from the fire).[1] Picart's illustration of this scene is

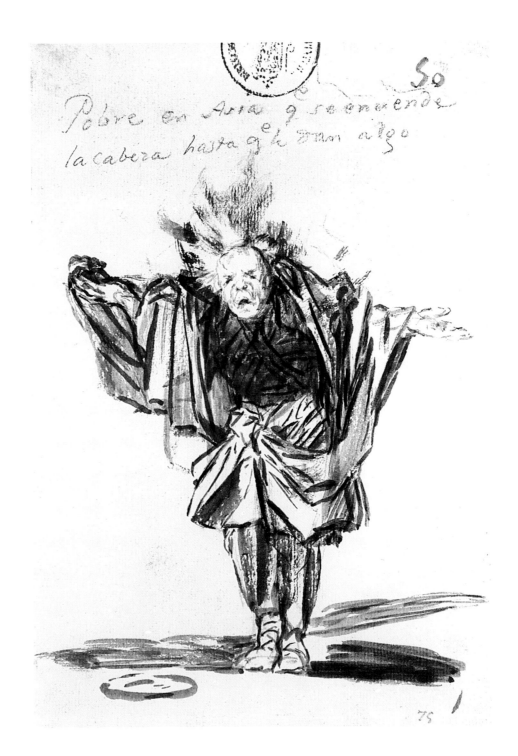

GUEUX devot qui se fait bruler des drogues sur la tête jusqu'à ce qu'on lui donne la CHARITÉ.

Fig. 1. Bernard Picart,
Gueux devot qui se fait bruler des drogues sur la tête jusqu'à ce qu'on lui donne la Charité (Religious Beggar Who Burns Drugs on His Head until He Is Given Alms).
Etching and engraving, in *Cérémonies et coutumes religieuses de tous les peuples du monde,* vol. 7 (Paris, 1808), plate 10.
Widener Library, Harvard University

accompanied by an inscription that is very similar to the one used by Goya: "Gueux devot qui se fait bruler des drogues sur la tête jusqu'à ce qu'on lui donne la Charité" (Religious Beggar Who Burns Drugs on His Head until He Is Given Alms) (fig. 1). Although Picart's figure is very different from Goya's, it could well have served as inspiration for this drawing, which is entirely Goya's in its conception of an old monk or beggar. Picart appears to have based his print on an illustration appearing in a book by the Dutch writer Jean Niewhoff, *Description générale de l'Empire de la Chine* (1665); this work refers critically to the practices of oriental beggars and monks, among which were setting their heads on fire and burning a limb to the bone.[2]

By referring in these drawings to the Asian faithful, or monks who practiced this kind of sometimes fraudulent penance in order to induce more copious alms, Goya was probably relating customs abroad to Spanish problems. At first the viewer may be inclined to see the drawing as a documentation of reality, an interpretation that the inscription encourages; but, taken with Goya's grotesque drawings on this subject and those of an anticlerical nature, it appears as an expression of profound irony. The shameless begging of these people, with their nagging insistence on obtaining alms, paralleled certain aspects of the situation in Spain (see cat. 76), which prompted Meléndez Valdés to exclaim: "Cuadrillas de vagos andrajosos que con sus alaridos, su palidez, sus importunidades nos persiguen sin cesar, golpean continuamente nuestros cerrojos y en ninguna parte nos dejan respirar" (Gangs of ragged vagrants knock at our doors continually and nowhere give us respite, relentlessly pursuing us with their howls, their pallor, their importuning).[3]

Goya's technique in these three drawings on Asia is very free. Curiously, the brush moves with the same assurance and with identical tonal shades as are visible in Chinese and Japanese drawings, which the artist probably could not have seen in Spain.

M.M.M.

1. *Cérémonies et coutumes religieuses de tous les peuples du monde,* vol. 7, (Paris, 1808), p. 39. See cat. 80, n. 6 and fig. 3.

2. See also Louis Pamel le Conte, *Mémoirs de la Chine* (1697).

3. Juan Meléndez Valdés, "Fragmentos de un discurso sobre la mendiguez," in *Discursos forenses* (Madrid, 1821).

Goya's View of the Fatal Consequences of the War

In 1808 the sixty-year-old Goya was a victim and a witness of one of the most significant military debacles in Spanish history: the Peninsular War (1808-1814). In general terms the war was a result of Napoleon's policy of expansionism and continental isolation of England, which led him to invade Portugal, thereby pitting the Spanish people against his troops. Napoleon took advantage of the weakness and progressive deterioration of the regime of Carlos IV and his favorite, Manuel Godoy, to introduce a large contingent of troops into the Peninsula, which enabled him to supplant the Bourbon dynasty reigning in Spain with the upstart Bonaparte dynasty.

The war against the "gobierno intruso" (intruder government) of José Napoleón I was initiated on the one hand by that part of the army that remained loyal to the dethroned Fernando VII, Carlos IV's son, and on the other by the populace, which had rapidly organized itself into guerrilla groups. As a result, the Peninsular War engulfed the entire kingdom and touched all social classes. Along with the war, which divided Spaniards – some having decided to collaborate with the new dynasty in hopes of introducing profound reforms into Spanish society – the Liberal revolution broke out, aiming to put an end to the absolutist monarchy in favor of national sovereignty.

Goya and his work must be understood in the context of this conflict. The artist lived in Madrid when the well-known popular uprising took place on May 2, 1808, an event that can be considered the beginning of the Spanish resistance and, as such, the war.[1] A few months later, in the first week of October 1808, the artist went to Zaragoza, which had endured a long and destructive siege by French forces; he was summoned there by General Palafox (see cat. 75) to "examinar las ruinas de aquella ciudad con el fin de pintar las glorias de aquellos naturales" (examine the ruins of that city in order to illustrate the glories of its citizens) and felt it was a commission he could not refuse given his concern for the glory of his country.[2]

It seems likely that the so-called *Disasters of War* owe their origin to the events of Zaragoza. In Zaragoza Goya learned about the war by inspecting its consequences and listening to accounts of it. Along with some oil sketches, he is known to have made various drawings.[3] The chronicles of the first siege of Zaragoza may have inspired almost twenty prints in the series, but the rapid sequence of events, Goya's journey through lands afflicted with the sufferings of war, the extension to the whole kingdom of the bloody struggle involving both soldiers and civilians – a conflict that spread insecurity and hunger – were sufficiently powerful circumstances to substantially transform his initial conception.

Through the *Disasters of War,* Goya showed himself to be a citizen in the thick of a deep crisis, brought about by the great contradiction that many who were later systematically persecuted as Liberals had to resolve when they discovered "the empire of liberty, equality, and fraternity that France offered the world had been turned into the fraternity of the gallows, the liberty of death, and the equality of the grave, and neither philanthropy nor peace, but tyranny and force dominated within and without France."[4]

It is true that Goya, who, like the Liberal poet Manuel José Quintana, was associated with the Junta Central Suprema (Supreme Central Council), conveyed profound bitterness in his illustrations of the horrors and atrocities of war, but something sets the artist apart from the writer. In his works Goya always appealed to reason; he intended not merely to stir up passions but also to invite reflection.[5] As has often been said, the *Disasters* are not a manifesto. The introduction to the anonymous *Elogio de los buenos españoles . . .* (In Praise of Good Spaniards . . .) could well serve as a preamble to this series: "The spectacle of war makes humanity tremble and moan. It seems impossible that man, who is by nature social and compassionate, could have degraded himself to such an extent that the laws of human behavior should allow those atrocious depredations, those horrible cruelties that take place after battles and turn the land into a chaos of crimes and calamities. What a

barbaric sight! Thousands of men born to love and help one another burn with the desire to destroy and await a signal to attack and quarter each other."[6] But in these prints, Goya reflected on a specific war: that carried on by Spaniards against Napoleon's army, which not only failed to honor the "derecho de gentes" (the rights of nations) but also systematically violated the codes of behavior that governed war.[7]

The *Disasters* are an indictment of despicable and ignoble warfare. However, Goya never blamed the people; for him there was only one culprit: tyranny. In the words of Quintana, "puesto que es absolutamente necesario un sacrificio de sangre, mejor es ofrecerla en holocausto a la Patria que a la ambición de un tirano" (given that it is absolutely necessary to shed blood, better to offer it in a holocaust to the fatherland than to a tyrant's ambition).[8] Goya excoriated homicidal war but believed it was reason, making use of force, that safeguarded liberty. In the prints in this exhibition, reason and courage are exalted; fanaticism, cruelty, and injustice, which give rise to terror, hunger, and death, are reviled. Facing an unjust and barbaric situation, reason is besieged by doubt: whether to choose the fight for independence or the peace of surrender. In the *Disasters* Goya showed himself defending the necessary fight for independence, using his art to identify the heroes and victims, the culprits and traitors.

J.V.

1. In 1814 Goya painted the famous works *The Second of May of 1808 in Madrid: the Battle against the Mamelukes* (Prado, Madrid, 748; G-W 892) and *The Third of May of 1808 in Madrid: The Executions on the Príncipe Pío Mountain* (cat. 80, fig. 4). On these paintings and their relation to the *Disasters of War,* see E. Lafuente Ferrari, *Goya: El Dos de Mayo y los fusilamientos* (Barcelona, 1946).

2. Letter from Goya to Don Josef Munarriz, Real Academia de San Fernando, Oct. 2, 1808, quoted in Sayre, *Changing Image*, p. 126, n. 9.

3. The English traveler Lady Holland commented in her diary that after the second siege, when Zaragoza surrendered, several drawings by Goya were found in General Palafox's room, among them a famous one of Agustina de Aragón; *The Spanish Journal of Elizabeth Lady Holland* (London, 1910), p. 324.

4. F. Blanco García, *La literatura en el siglo XIX* (Madrid, 1891), quoted in Albert Dérozier, *Manuel José Quintana y el nacimiento del liberalismo español* (Madrid, 1978), p. 365.

5. See Valeriano Bozal, "La obra grabada de Francisco de Goya," *Summa Artis*, vol. 31 (Madrid, 1987), p. 728. Manuel José Quintana appealed equally to the heart and to the head in his manifestos and proclamations; see A. Dérozier, *Quintana*, p. 395.

6. *Elogio de los buenos españoles que han muerto en esta guerra* (Murcia, 1809); the work was written in commemoration of the Spanish victory at Bailén.

7. In addition to the works cited above on the *Disasters of War*, see Lafuente Ferrari, *Desastres*; C. Dérozier, "La Guerre d'Indépendance espagnole à travers l'estampe (1808-1814)," PH.D. diss., L'Université de Toulouse-le-Mirail, 1974; Valeriano Bozal, *Imagen de Goya* (Barcelona, 1983). For the entries on the *Disasters of War*, primary sources were consulted at the following collections in Madrid: Colección del Fraile (Archivo Histórico Militar) and Colección Gómez Imaz (Biblioteca Nacional). Also examined were periodicals of the time, particularly the *Gaceta de Madrid*, since this was the official daily newspaper in which the government's decrees were published, as well as many anonymous pamphlets on war conditions. Quotations from anonymous works are given here in English translation only. For the quotations in the original Spanish, see the Spanish edition of this catalogue: Museo del Prado, Madrid, *Goya y el espíritu de la Ilustración* (1988).

8. *Manifiesto de la Nación Española a la Europa* [Seville, 1809]. The *Manifiesto* was published anonymously. On the work and its author, Manuel José Quintana, see A. Dérozier, *Quintana*, pp. 390ff.

82

Lo mismo (Likewise)
Fatales consequencias de la sangrienta guerra en España con Buonaparte. Y otros caprichos enfaticos [Disasters of War], plate 3
Working proof
1810-1814
Etching, lavis, drypoint, burin, and burnishing
160 x 221 mm.
Inscribed in plate, upper left: *3;* lower left: *48*, scored through with burin
References: G-W 996; H. 123, I, 3.

Museum of Fine Arts, Boston, Gift of Russell B. Stearns, 1973.720
United States only

Spanish civilians confront French soldiers. The inscription, *Lo mismo* (Likewise), refers to the immediately preceding print in the *Disasters of War, Con razon ó sin ella* (Whether Right or Wrong) (fig. 1),[1] and in both works Goya placed the popular rising against the French in the foreground. The French had availed themselves of friendly relations so as to station troops strategically in Madrid as well as in the kingdom's remaining important cities. Even though neither of these prints was executed when Goya began working on the *Disasters*, there is no doubt that when he decided on the order of the series,[2] these images were meant to follow the dramatic frontispiece with its laconic and agonized commentary: *Tristes presentimientos de lo que ha de acontecer* (Sad Forebodings of What Will Happen).[3]

It stands to reason that violent scenes comparable to those Goya etched took place in all those cities where the inhabitants resisted French domination. Nevertheless, Goya could have witnessed them on May 2, 1808 in Madrid. In this city such was "the fury of the people, and such the insolence of the guests, transformed into masters," that once the confrontations began, it was clear that the war was to be a "cruda guerra" (harsh war) fought by a people that showed themselves to be "not only disposed to sacrifice, but also anxious to do so. . . . The upper classes stood on their balconies in districts where shots were not

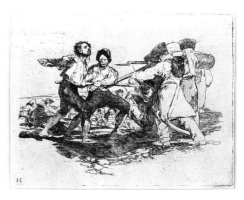

Fig. 1. *Con razon ó sin ella* (Whether Right or Wrong),
Disasters of War, plate 2.
Working Proof. Etching, lavis, and drypoint.
Museum of Fine Arts, Boston, 1951 Purchase Fund

being fired, and, watching and listening, tried to understand what was happening, [while] only enraged civilians could be seen in the street – almost all of them belonging to the lower classes – provoking, and some soldier or another restraining them. Of the first kind there were those who demonstrated blind courage, hurling themselves at the French – who were armed and in groups – looking for certain defeat and death. . . . Gangs began forming so ridiculously armed that it was foolish to believe they could take on French soldiers".[4] In the words of a French soldier, a protagonist of those events, "the streets were seething with obstinate people armed with guns, pistols, swords, pikes, axes, sticks; nothing but cries of death and revenge rent the air."[5]

The behavior of Madrid's inhabitants became the model and example to follow.[6] According to a newspaper commentary, "the war waged by the Spanish is a national war in which all take up arms; and they take them up not in order to protect the whims of a despot, but in order to defend everything they hold most sacred and precious."[7]

In this print Goya showed one of those confrontations in which the Spanish "sustained the fight with tenacity, in many areas with advantage."[8] The focus is on the imposing figure, with disproportionately large eyes, about to deliver a fatal blow with the ax to the French soldier, who, still gripping his sword, tries to foil

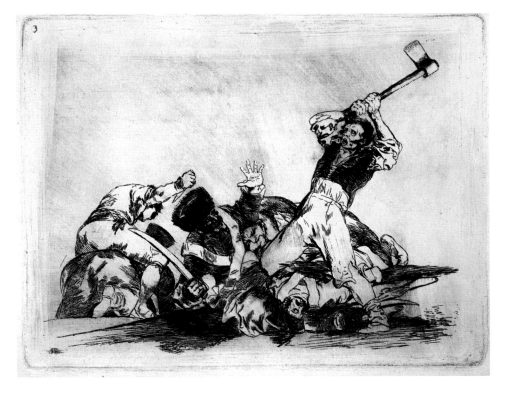

8. [Quintana], *Manifiesto de la Nación Española*, p. 1.

9. C. Dérozier has noted the manner in which Goya dehumanized the physiognomy of the Spaniard's face to reflect the figure's unreason, reason being understood to moderate the passions, a faculty without which humans become beasts. C. Dérozier, "La Guerre d'Indépendance espagnole à travers l'estampe 1808-1814," Ph. D. diss., L'Université de Toulouse-le-Mirail, vol. 2, p. 841.

10. M. Freyre, *Remedio y preservativo contra el mal frances de que adolece parte de la Nacion Española* (Valencia, 1809), p. 16.

11. *La Junta Suprema del Reyno á la Nacion Española* [Seville, 1809], p. 5.

12. On the pathetic as a modern aesthetic category and its presence in Goya's war scenes, see Valeriano Bozal, "Categorías estéticas de la modernidad: sublime y patético," *La balsa de la Medusa*, no. 3 (1987), pp. 67-86.

him with his raised hand and anguished look.[9] This moment of atrocious violence is a visual expression of the slogan: "Amemos pues ciegamente á nuestra patria hasta la locura" (Let us blindly love our country even to madness).[10] Unreason overcomes and moves these men; in order to express folly, therefore, Goya recalled expressions and gestures that he himself had created in the painting *Patio de una casa de locos* (Courtyard of a Madhouse) (cat. 21). Behind the two monumental figures in the foreground one civilian is using his teeth to attack, and at the left another is mounted on his victim's back at the moment of plunging his knife into him.

This is how the war began, with a struggle, "to sum up, of ferocity and barbarism on one side, of resistance and indomitable constancy on the other; all of it presents a whole as terrible as it is magnificent."[11] It is true that Goya did not in any way condemn the resistance, but his work is not only terrifying, it also conveys pathos; there is nothing magnificent in the behavior he showed.[12]

J.V.

1. G-W 995; H. 122, I, 2.

2. See Sayre, *Changing Image*, p. 131.

3. See Lafuente Ferrari, *Desastres*, pp. 134-135. On the other hand, those *tristes presentimientos* were shared by a part of the population put off by the unhappy regime of Carlos IV and his favorite, Manuel Godoy: "What a sad sight Spain was in the years 1806 and 1807! With what black tones, with what lugubrious images would Tacitus have rendered the sad state of our agonizing monarchy had he written the history of its disasters! . . . Spain was in this situation . . . when we felt the first symptoms of the unfortunate illness menacing the nation, which for twenty years had resisted all kinds of adversity, all the moral sickness that stealthily undermined and weakened her, until the fatal moment of the explosion arrived. Great and recurring events augured an imminent political crisis, which did not take long to break." *Colección de documentos interesantes, que pueden servir de apunte para la historia de la revolución de España por un amante de las Glorias Nacionales* (Valencia, 1809), prologue.

4. A. Alcalá Galiano, "Memorias," in *Obras*, Biblioteca de Autores Españoles, vol. 83 (Madrid, 1955), pp. 335-337.

5. M. Núñez de Arenas, "Páginas de la Historia: La jornada del Dos de Mayo contada por un francés," in *L'Espagne des Lumières au Romantisme* (Paris, 1963), p. 164.

6. See [Manuel José Quintana], *Manifiesto de la Nación Española a la Europa* [Seville, 1809], p. 1.

7. *Observador*, July 27, 1810, p. 63.

83

Y son fieras (And they are wild beasts)
Fatales consequencias de la sangrienta guerra en España con Buonaparte. Y otros caprichos enfaticos [Disasters of War], plate 5
Working proof
1810-1814
Etching, burnished aquatint, and drypoint
156 x 208 mm.
Inscribed in plate, lower left: *28*
References: G-W 998; H. 125, I, 2.

Spain: Cabinet des Estampes, Bibliothèque Nationale, Paris
United States: Museum of Fine Arts, Boston, 1951 Purchase Fund, 51.1625
[*illus.*]

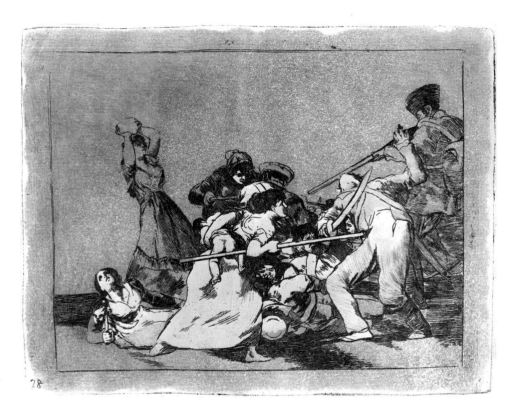

French troops confront a group of Spanish women. The inscription *Y son fieras* (And they are wild beasts) refers, no doubt, to the women, as does the immediately preceding *Disaster* 4, *Las mugeres dan valor* (Women give courage).

Chronicles of the first siege of Zaragoza mention the part played by women during the struggle: "devout women, trusting in the Virgin Mary, agitated in the streets and on balconies, armed with lime, stones, and weapons to prepare the most vigorous defense."[1] Armed in the same way as the remaining civilians, women made their way toward the battle along with "children and old people, clerics and friars; hundreds armed with pikes, poles, knives or daggers, strapped to one side, with rapiers, foils, with rifle or shotgun."[2] Some women ran with their children on their backs to assist those who were fighting.[3] In many houses, women "stockpiled bricks and stones in case they should have to hole up, defend themselves, and die killing, making every house an unassailable fort."[4] In fact, this type of confrontation took place during the first siege of Zaragoza; the accounts have it that every person fighting "was like a fierce lion when it sees the hunter wants to rob its cubs."[5]

It is very likely that Goya heard such descriptions during his sojourn of October 1808 in Zaragoza; soon thereafter these stories no longer bore an exclusive relation to the city, since it was hoped this zeal would take hold throughout the kingdom.[6] Thus a royal decree of February 12, 1809, exhorted "all important towns to resist the enemy if by misfortune he should reach those areas, gathering together all the inhabitants and adopting for the purpose all means of defense afforded by that part of the country, even making use of stones, sticks, etc. in the absence of other weapons, for everything can be used to cripple the enemy's advance and thus will we give them a good idea of what patriotism can do when it decides to win or die."[7] The ninth item of this decree ordered that for "those lacking firearms and cutting weapons, including knives and daggers, the Justices [would] arrange to have pickaxes, pikes, and other weapons of this kind made and ready." A royal decree of November 28, 1809, continued in the same vein: "For the same purpose stones, bricks, and even boiling water, . . . and other appropriate materials will be stored up in apartments to hinder the enemy and cause casualties by being hurled through the windows or from the rooftops."[8]

Using this reality as his point of departure, Goya showed a pathetic, unreal, but plausible image, especially in his use of female instead of male figures, to address an aspect so characteristic of the Peninsular War – popular resistance to foreign domination – which helped to soil the reputation of Napoleon's generals as experts in strategy. On the behavior of women in the war, even the *Gaceta de Madrid* during Napoleon's reign commented on the response of this sector of the population: "in revolutions, in those terrible crises of political bodies, is when the fair sex experiences 'pasiones fuertes' (strong emotions) in grand fashion, and transmits them to us."[9] It is worth dwelling on the "pasiones fuertes," because Goya conceived of this print in virtue of this idea; in these fighting women and in the concise inscription *Y son fieras*, Goya created a metaphor for desperation. According to the classical iconography of desperation, all parts of the body appear at their most disorderly and violent, "in such a state of upheaval the soul is dominated by the pain or desire of revenge and thinks on nothing else but violence and destruction:

188

if the object of our affliction appears before us, then in a rapid and unpremeditated movement we hurl ourselves at it, lacerate it, injure it with our own hands, or with the dagger or sword we grip, delivering blows of fury and rage as if we were thirsty for blood."[10]

The distribution of light calls attention to the central group, where a woman, defending her child, attacks a Frenchman with a pike. Behind her other fallen women cry out desperately, while the woman in the background defends herself with a sword. But on the left, Goya completed the picture with a Spanish woman who, in some aspects recalling Lucrecia, looks up while she fiercely grips a knife with her right hand.[11] As a commentator on the passions explains, "if the desire for revenge cannot find its object, whether because it is elsewhere or because of some bonds or chains that impede it, in either case when anger is heightened to an extreme and cannot build up further, then we turn the desire for revenge against ourselves, . . . and if by a sudden and unforeseen accident [we find] a mortal weapon is at hand . . . supposing it is a dagger, we pierce and destroy our breast."[12] But this figure, toward which Goya drew our attention, is important because those who stirred up women, treating them as if they were modern heroines of Sagunto or Numancia (Spanish cities whose inhabitants fiercely resisted the Romans in 133 B.C. and killed themselves rather than be conquered), did not in fact want to encourage this type of death. The women were encouraged to resist the French but with restraint. The difficulty lay in teaching them to act with prudence and with an awareness of the danger war entailed.[13] It was requested that before the arrival or imminent victory of the French, the women should flee, after having destroyed everything that could be useful to the invaders, even including houses; but never were they incited to self-immolation.[14] Nevertheless, some women in their desperation chose to kill themselves and their children.[15]

In this print Goya demonstrated the danger and absurdity of provoking women and of fanning fury and vengeance among the ignorant. On the left

and right, in shadow, we find the artist's critical commentary: the French gun is matched against the Spanish woman's rock, a perfectly fitted-out army against the women's determination. Reason does not sanction facing up to the soldiers. In this desperate man-to-woman fight, the women may well kill, as we see in the central group where the figure of a French soldier about to fall is highlighted, as is the woman attacking him. But inevitably the women will also die.

J.V.

1. *Memoria de lo mas interesante que ha ocurrido en la ciudad de Zaragoza con motivo de haberle atacado el Exército Francés* (Madrid, 1808), p. 40.

2. "Breve relación del 1er sitio de Zaragoza en 1808," a report by the engineer De Gregorio, commissioned by his corp. Biblioteca Nacional, Madrid, MS. R-60070^{10}, fol. 2v. This account was the Conde de Toreno's source for the event in his *Historia del levantamiento, guerra y revolución de España*, 5 vols. (Madrid, 1835-1837).

3. See *Relación exacta de lo ocurrido en la Ciudad de Zaragoza, y de la derrota que en ella han padecido los Franceses* (Zaragoza, 1808).

4. A. Alcaide Ibieca, *Historia de los dos sitios que pusieron a Zaragoza en los años de 1808 y 1809, las tropas de Napoleón* (Madrid, 1830), p. 76.

5. *Memoria de lo mas interesante*, p. 41.

6. When the French entered the city of Talavera on July 1809, an anonymous proclamation was issued on the city's sacking, which was felt to be unjustified because its citizens did not resist; in that proclamation the figure of the bird was substituted for that of the lion: "The most timid and peaceful birds, attacked in their nests, become birds of prey who want to devour their chicks, and perhaps die with their instinctive courage roused and defending themselves." *A los españoles* (Seville, 1809).

7. This decision provoked ironic criticism from the French authorities. The *Gaceta de Madrid*, Mar. 8, 1809, published the following response: "Orders dated February 14 and sent from General Cuesta to different towns in order to incite them to rebel have been intercepted. He admits the impossibility of sending any troops; and, having no guns to distribute, tells them to arm themselves with pickaxes, sticks, and stones."

8. This decree (like that of Feb. 12, 1809) was issued by the regency in the name of Fernando VII to all Juntas Superiores Provinciales (Higher Provincial Councils) to ensure that "the most vigorous and prompt measures are taken so that the capital and towns of every province resist the enemy, observing the fundamental rules and maxims governing the defense of towns and great cities in the present war."

9. *Gaceta de Madrid*, Feb. 21, 1810, pp. 212-213. The commentator tried to demonstrate how reason is more vulnerable in women, who let themselves be seduced by love as mistresses, mothers, and wives,

and by piety and religious devotion, which he believed to be the explanation for their susceptibility to fanaticism.

10. Fermín Eduardo Zeglirscosac, *Ensayo sobre el origen y naturaleza de las pasiones, del gesto y de la acción teatral* (Madrid, 1800), p. 109.

11. Nicolás Fernández de Moratín's play *Lucrecia* deals with the defense of liberty against despotic power. Goya's figure may be compared with representations of Lucrecia, or even of Cleopatra, painted by artists of the Italian School. A painting of Lucrecia attributed to Guido Reni, formerly in the Palacio de San Ildefonso, Segovia, is now in the Museo del Prado, Madrid (208). Goya's composition may also be compared with that of the *Massacre of the Innocents*, a subject that in some Italian painters such as Guido Reni and Massimo Stanzione is treated with theatricality.

12. Zeglirscosac, *Ensayo*, pp. 109-110.

13. See Robert Southey, *History of the Peninsular War* (London, 1832), vol. 1, p. 411, quoted by Sayre, *Changing Image*, p. 131, no. 97.

14. "Numancia and Sagunto, giving in to desperation in the face of a superior enemy, stained the courage that ought honorably to overcome all adversity in fortune; but Zaragoza, endowed with nobler sentiments, has shown for the first time to the whole world the singular and appealing spectacle of a people that in cold blood answers the final efforts of misfortune with the last recourse of courage and ingenuity." *Resumen historico del primer sitio de la ilustre ciudad de Zaragoza por los franceses, desde el 14 de Junio al 15 de Agosto de 1808* (Valencia, 1809), p. 24.

15. There was such a case in Zaragoza, Aug. 4, 1808; as the French arrived, a woman threw herself with a baby at her breast into a water well. Ramón Cadena [?], "Guerra de Independencia: Episodios de Zaragoza en 1808 y 1809," Biblioteca Nacional, Madrid, MS. R-63151, fol. 14r.

84

Que valor! (What Courage!)
Fatales consecuencias de la sangrienta
guerra en España con Buonaparte. Y
otros caprichos enfaticos [Disasters of
War], plate 7
Working proof
1810-1814
Etching, drypoint, and burnishing
155 x 208 mm.
Inscribed in plate, upper right: *7;* lower
left: *41*
References: G-W 1000; H. 127, I, 2.

Spain: Cabinet des Estampes, Bib-
liothèque Nationale, Paris
United States: Museum of Fine Arts,
Boston, 1951 Purchase Fund, 51.1627
[*illus.*]

A woman prepares to fire a cannon
against the enemy. Once again this act
must be placed within the context of the
first siege of Zaragoza, in which women
distinguished themselves for their deci-
siveness in the face of unforeseen events.
An anonymous eyewitness reported: "As
supplies were very limited, the defend-
ers' ammunition was soon exhausted;
and since there was no one to give
orders, the problem was hardly antici-
pated, when women and youngsters
mobilized, fanning out across the city,
some going to the storehouses for gun-
powder and cartridges. . . . The women
themselves appeared alongside the can-
non they loaded, ceaselessly giving the
exhausted artillerymen water and wine,
encouraging them with the most tender
expressions. . . . The serenity with which
such heroines appeared amidst the cross-
fire, some of them taking up the match or
in its absence a firebrand, alternating
with the artillerymen, was a goad aggra-
vating already sore spirits."[1]

The defense of the gates of Zaragoza
was left in great measure to the artillery,
but the first rows of artillerymen fell
"like spikes by the strokes of a sickle,
their places soon taken by others. The
intrepid [jumped] over corpses, and
[flung] themselves forward up to the
mouth of the cannon."[2] In the attacks of
July 2 and 15 some cannon were loaded
and fired by women after all the artillery-
men had died.[3] These acts, recognized by

Fig. 1. Preparatory drawing for *Que valor!* (What
Courage!)
Red chalk.
Museo del Prado, Madrid

the chroniclers of the first siege of Zara-
goza, must have been recounted to Goya,
who had visited the war-torn city in
order to inform himself.

On the other hand, the resistance of
the city to the French was followed
by a ground swell of genuine enthusiasm
throughout the kingdom,[4] and thereafter
different soldiers were rapidly held up as
heroes whose behavior was to be emu-
lated. Preeminent among them was Gen-
eral José de Palafox (cat. 75), but it
became necessary as well to consecrate
popular heroes with whom the other part
of the fighting population – the civilians –
could identify.[5] There was, as a result, a
clear process of identification of popular
heroes, although some writers were evi-
dently reluctant to individualize.[6] The
popular heroine par excellence was
Agustina de Aragón. According to the
reports, she was probably "the wife of an
artilleryman," "a robust girl from San
Pablo parish," who, soon after the events
and already famous, was "decorated with
the epaulets and wages" of artillerymen.
In some references she became a "tall
and lovely young woman," with "a beau-
tiful figure and good looks" and "dark
hair gathered in a jumble."[7] In one
highly romanticized account of Agustina's
exploit she is presented as the "goddess
of war": "There was a moment in which
the Spanish artillery pieces fell silent; all
those who had manned them had suc-
cumbed. There was in this breach of Por-
tillo a solemn moment of silence; the
resistance seemed to be exhausted. Sud-

denly . . . a beautiful girl . . . engaged to
an injured artilleryman whom she fol-
lowed to the front, received her lover's
dying breath; . . . Agustina felt that her
heart burned with the desire for revenge.
She seizes the smoking match from her
lover's hand . . . and rushes to the near-
est cannon to light it. The volley is fired,
its detonation stops the instinctive retreat
of the peasantry; that woman gave them
an example; they return, throw them-
selves [into battle], and on seeing the
enemy retreat, Agustina drowns her
tears in a savage cry of triumph."[8]

Although the identification of the figure
Goya shows us is seemingly straightfor-
ward, the fact is that the print does not
show us Agustina de Aragón. If it did, its
significance would be limited, and its
value would be merely as an accurate
historical document. Moreover, it would
be the only print in the series to have this
characteristic.[9] To confirm that the fig-
ure portrayed is not Agustina de Aragón,
it is necessary to compare the print with
the preparatory drawing.

Two drawings of this subject are on the
recto and verso of the same sheet. A
light sketch is followed by a red chalk
drawing (fig. 1) that corresponds in most
respects to the print, although there are
notable differences.[10] The female figure,
at the center of both compositions,
stands on unnaturally stretched-out bod-
ies; some raised legs indicate the violence
of the situation. Goya placed the woman
with her back toward us and abandoned
any attempt at a portrait; furthermore,
he reduced to a minimum the formal ele-
ments customarily used to convey the
sensation of violence: for example, facial
expression, which can contribute
powerfully to the understanding of a situ-
ation. From the outset Goya dispensed
with gestural rhetoric. The print is even
more removed than the drawing from the
event that probably served as point of
departure for the composition. There are
three states of the print, in which can be
followed the successive changes Goya
introduced into the female figure –
changes that were intended to obtain
correct proportion and balance.[11]

This composition was conceived in a
classical manner as a triangle whose
apex is the woman's head; the imbalance

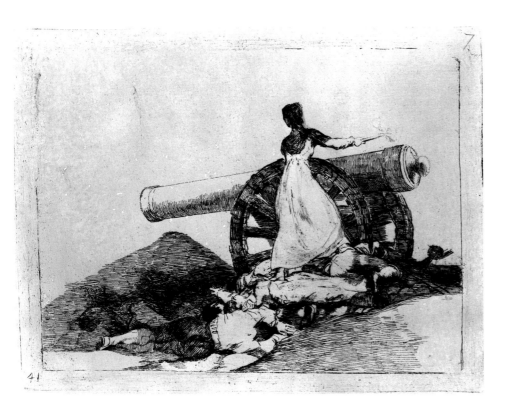

times observe them.[15] The courage of those who follow is sustained by the dead, whose dignity too must be assured. Goya here demonstrated his profound respect for the dead.

J.V.

1. *Memoria de lo mas interesante que ha ocurrido en la ciudad de Zaragoza con motivo de haberle atacado el Exército Francés* (Madrid, 1808), p. 37.

2. Ibid., p. 34.

3. On the part played by women during the attack of July 2, see F. Casamayor y Ceballos, *Los sitios de Zaragoza* (Zaragoza, 1908), pp. 71-72. On the assistance given by women on July 15, see *Memoria de lo mas interesante,* appendix, p. 15.

4. On the pluck of the Madrilenians while these events took place – a spirit Goya must have shared, since he was so concerned with his country's glory – see A. Alcalá Galiano, "Recuerdos de un anciano," in *Obras,* Biblioteca de Autores Españoles, vol. 83 (Madrid, 1955), p. 37. Zaragoza's resistance was proposed as a model, and many claimed that although a town had been surrendered, "the promise of not being unworthy of Zaragoza" had been kept. A. Pérez Herrasti, *Relación histórica y circunstanciada de los sucesos del sitio de la plaza de Ciudad Rodrigo en el año de 1810, hasta su rendición al exército Frances* (Madrid, 1814), p. 87.

5. "Palafox came to be regarded as a demigod; and those who knew him in his youth were astonished that, soon after reaching maturity, he should have become such an illustrious general." Alcalá Galiano, "Recuerdos," p. 37. On the controversy over Palafox, see Ramón Cadena [?], "Guerra de Independencia: Espisodios de Zaragoza en 1808 y 1809," Biblioteca Nacional, Madrid, MS. R-63151, fols. 28v., 29r.

6. For two clear examples of this attitude, see the engineer de Gregorio, in "Breve relación del 1er sitio de Zaragoza en 1808," Biblioteca Nacional, Madrid, MS. R-60070[10]; and *Memoria de los mas interesantes,* p. 121.

7. For these allusions to Agustina, see Casamayor y Ceballos, *Los sitios de Zaragoza,* pp. 70, 75; *Relación de lo occurrido en la Ciudad de Zaragoza y de la derrota que en ella han padecido los Franceses* [Zaragoza, 1808]; *Combate del día quatro de julio en las calles de Zaragoza* (Valencia, 1808), p. 7; *Resumen histórico del primer sitio de la ilustre ciudad de Zaragoza por los franceses, desde 14 de junio al 15 de agosto de 1808* (Valencia, 1809), p. 16. For a full account of Agustina's heroic deed, see *Resumen histórico,* p. 17. This pamphlet was translated almost in its entirety in R. Vaughan, *Narrative of the Siege of Zaragoza* (London, 1809).

8. Geoffroy de Grandmaison, quoted in Casamayor y Ceballos, *Los sitios de Zaragoza,* pp. 76-77.

9. See C. Dérozier, "La guerre d'Indépendance espagnole à travers l'estampe (1808-1814), Ph.D. diss., L'Université de Toulouse-Le-Mirail, 1974, vol. 2, p. 850, in whose opinion the print does not depict Agustina.

10. Sketch: Prado, Madrid, 455; G-W 1002; G., II, 168; fig. 1: Prado, Madrid, 430; G-W 1001; G., II, 169.

caused by the cannon is compensated for by the triangular, tent-shaped heap in the background. The mood is tranquil, without the least evidence of the violence that would have been inherent if Goya had set out to represent Agustina de Aragón's heroic feat at El Portillo. The heap of victims is highlighted, as are the woman's dress and hand, and the cannon's mouth. The dead do not lose their dignity by serving as support for the woman, whose feet, small and delicate, are firmly planted, adapting perfectly to the shape of the bodies. Courage sinks its roots into and raises itself upon the land and the men who resisted domination. There is not the least indication that Goya criticized this attitude. The defensive war is accepted and assumed, for the Spanish war was a just war; however, war that becomes desperate cannot be just.[12] The only living hand will launch death through the mouth of the cannon; Goya captured the moment between the decision to act and its consequence: death. The stillness reaffirms that moment,

which even the sparks from the fuse are not allowed to disturb.

It is important to try to clarify who is that woman who has been transformed into a symbolic figure.[13] Light focuses attention on her elegant figure, and above all on the dress, whose luminosity is broken only by lightly etched lines that are, in any case, necessary to adjust the dress to the position of the legs. The contrast between the dress and the mouth of the cannon, which are given equal importance in the print, appears to represent not only women's courage but also heroic Spain insofar as the Spanish people were right in making war. In this moment of calm, Reason lights the cannon's fuse, knowing she will send forth death.[14] Although courage is needed to take that step, it must stem not from desperation and revenge but from Reason. The war's justness has been demonstrated according to standing military codes, and since the only honorable means of making war is by those codes, the participants in the struggle must at all

Goya's first preparatory drawing is quite close to the drawing and print Juan Galves and Fernando Brambilla dedicated to this event, *Bateria del Portillo*, in their series *Ruinas de Zaragoza* (Cádiz, 1814). One edition of this work is in the Biblioteca Nacional, Madrid. On the possibility the three artists met at the site where the events took place, see Sayre, *Changing Image*, p. 98.

11. Two of these states are reproduced in Sayre, *Changing Image*, pp. 135-136.

12. A war could only be justified when it could be considered "precise, just, and useful." The Peninsular War in Spain was necessary because the invasion of national territory was an attack on sovereignty and a violation of the rights of nations. See P. Bolaños y Noboa, *Acusación o exposición de los preceptos del derecho de gentes violados por el gobierno francés* (Madrid, 1808). Moreover, according to the military theorist A. Navia Ossorio, "the war is just if its aim is to recover the country's prince, whom another has usurped" and "to punish the very model of tyranny [Napoleon]"; see A. Navia Ossorio, Marqués de Santa Cruz de Marcenado, *Compendio de los veinte libros de Reflexiones Militares que en diez tomos en quarto escribió . . ., por Don Juan Senen de Contreras, Teniente del Regimiento Provincial de Alcázar de San Juan* (Madrid, 1787), vol. 1, pp. 48-50.

13. Dérozier, "Guerre d'Indépendance espagnole," vol. 2, p. 850.

14. The gesture of decision that follows reflection appears to represent the mental process some Spaniards had to work through before "the kingdom of liberty" the French hoped to implant had become hateful. I refer to the Spanish dilemmas of which A. Dérozier wrote in his *Manuel José Quintana y el nacimiento del liberalismo en España* (Madrid, 1978), pp. 363ff.: "Quintana, without hesitation or remorse, without guilt, without the least nostalgia, would defend his native land against the invader whether he brought good laws or not." Ibid., p. 255.

15. Through the *Gaceta de Madrid*, the intruder government, relying on Navia Ossorio's *Compendio de Reflexiones*, tried to explain why the system of guerrillas and popular resistance was not authorized by the laws of war and announced that the final result would be a war of extermination. *Gaceta de Madrid*, July 16, 1809, p. 893.

85

No quieren (They do not want to)
Fatales consequencias de la sangrienta guerra en España con Buonaparte. Y otros caprichos enfaticos [Disasters of War], plate 9
Working proof
1810-1814
Etching, aquatint, burin, and burnishing
155 x 209 mm.
Inscribed in plate, lower left: 29
References: G-W 1005; H. 129, I, 3.

Museum of Fine Arts, Boston, 1951
Purchase Fund, 51.1629
Spain only

A French soldier tries to abduct an adolescent girl. Women, mainly the young, were victims on repeated occasions of atrocities committed by the French army. Detailed descriptions of this type of behavior, which occurred when cities and towns were sacked, are infrequent. One of the most renowned cases reported followed the sacking of the town of Uclés on January 13, 1809. The soldiers "chose the most desirable [women] the village had and took them to the fields to renew the same scandalous tragedy with a better disposition and calm. Miserable luck that reserved the greatest misfortune for those whom nature endowed with the most graces."[1]

Few are the Spanish prints illustrating the horrors committed by French troops against the inhabitants of towns they devastated. For example, after the resistance of Tarragona, the soldiers vented their anger not on the garrison but "on the disarmed inhabitants, who would never have expected such infamy and cowardice from a nation on whose lips honor, humanity, philanthropy, benevolence, civilization, etc. were always to be heard."[2] Curiously, these events gave rise to a collection of prints, *Los horrores de Tarragona*, the first of which showed the "rapto de una doncella a vista de sus Padres" (abduction of a girl in the presence of her parents) (fig. 1). Although there are differences in composition and technique between that print and *No quieren*, it may be affirmed that Goya chose the same subject.

These abductions thus took place in different cities and towns and resulted from the insubordination rampant in some divisions of Napoleon's army,[3] in which Lord Blayney, an English prisoner of war who crossed the peninsula toward the end of 1810, continually "saw degenerate Spaniards, Frenchmen, Poles, and Germans who formed the contingent of the Rhine Confederation."[4] According to a French soldier, Limouzin, the Spaniards' hatred of the Polish soldiers was even greater than that of the French: "it is true they committed the most repugnant excesses in the peninsula. Their discipline was so lax in this respect that the commanders appeared not to concern themselves with it. On the other hand, our generals feared taking severe measures, so that they were a kind of free corps permitted everything. . . . The name *Pole* spread terror and fright everywhere."[5]

Goya chose for this scene a prototype of a French soldier without clearly identifying the regiment or corps to which he belonged (the distinguishing hat that would have made it possible to specify this was eliminated in the end) or the rural surroundings (represented by the water wheel in the background) where the soldier had no reason, in principle, to attack. Even when the villages or peasantry did not resist the French, this did not mean they were not harmed. For example, at the entrance to Talavera, no one could feel safe from the brutality of the bandits: "there is no refuge they do not overrun, nor human bond they do not break: they are a throng of tigers who do not distinguish between those who attack them and those who have no weapons with which to hurt them; women, children, the old, what does it matter?"[6]

In the face of this violation of rights, sometimes women "putting up no resistance, [were] docile victims of their ineffable anger";[7] others placed themselves "under the protection of the general aiming to escape the brutalities of the soldiers";[8] and still others, as in the case illustrated in Goya's print, fought back. The viewer's attention is focused on the adolescent whose beauty lies in her full figure and her ingenuousness. She does not know how to defend herself; she sinks her nails into the face of the man

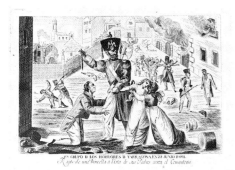

Fig. 1. Anonymous,
Rapto de una doncella en el saqueo de Tarragona el 28 de junio de 1811 (Abduction of a Maiden in the Sacking of Tarragona, June 28, 1811), about 1811.
Etching and burin.
A. Correa Collection, Madrid

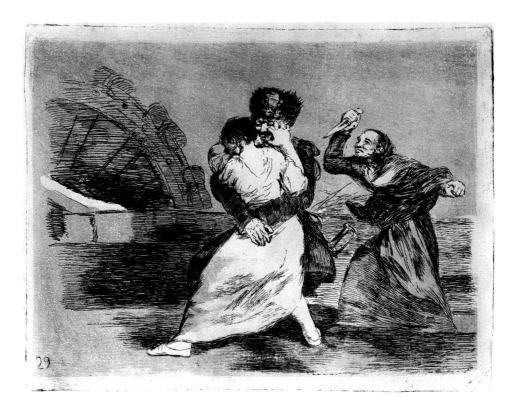

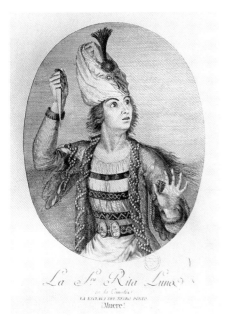

Fig. 2. Anonymous,
La Sra Rita Luna ([The Actress] Rita Luna), late 18th or early 19th century.
Etching and burin.
Biblioteca Nacional, Madrid

who attacks her, and at the same time turns away. There is a real contrast between the child-woman and the old woman who is about to attack the soldier. The young woman does not want to fight but defends herself naively; the old woman knows perfectly well the nature of the Frenchman's assault, and in her face is an expression of revenge.

The background suggests that this scene does not take place as an aftermath of battle; the young woman is not war booty. The situation is the result of a lascivious soldier's coming upon an isolated house; he intends to obtain his prey by sheer force. The soldier is aware of his strength; he knows he runs no risk in committing this irrational act so removed from the virtues that befit a soldier. Before an old woman and a girl there is nothing to fear; he has therefore dropped his guard and has allowed himself to be overcome by desire. But Goya shows us what reward this behavior merits; the old woman, who seems to emerge from the earth, sallies forth in defense of the innocent. The agitation of her body contrasts

with the firmness of her hand and the coldness of her face. Once again Goya used theatrical means to represent a figure in which one of the great dramas of the war is summed up. The attitude of the woman is similar to that of the patriot in the foreground of *Disaster* 2, *Con razon o sin ella* (Whether Right or Wrong) (cat. *82*, fig. 1), and identical to that assumed by the actress Rita Luna as she shouted "¡Muere!" (Die!) in *La esclava del negro Ponto* (Black Ponto's Slave) (fig. 2).

J.V.

1. "España. Entrada bárbara, sangrienta y abominable de las tropas francesas en Uclés después del ataque que dieron a unas tropas el 13 de enero último en las cercanías de aquella villa," Biblioteca Nacional, Madrid, MS. R-62665[1]. An account of the events was also given by R. Southey, *History of the Peninsular War* (London, 1832), vol. 2, pp. 66f., quoted in Sayre, *Changing Image*, p. 139. The magistrate of Rioseco, in a letter to the *Gaceta de Madrid*, reported that on the arrival of the French in that city on August 14, 1808 "they took many single women to the fields . . . abusing them until they left, from which handling some died." *Diario de Madrid*, Sept. 8, 1808, pp. 173-174.

2. Juan Senén de Contreras, *Sitio de Tarragona, lo que pasó entre los franceses, el general Contreras que la defendió, sus observaciones sobre la Francia y noticia del nuevo modo de defender las plazas* (Madrid, 1813), p. 52.

3. See letter from General Moncei, Duque del Imperio, to the Capitán General, July 4, 1808: "Among all the precautions I take to avoid and contain excesses, which I am the first to lament, I cannot conceal, nor refrain from telling you . . . that they are always committed, or at least directed by men foreign, it is true, to the Spanish nation; but who [are] in [the French] service and appear to have passed into our ranks in order to bring the spirit of disorder and insubordination." *Cartas del Mariscal del Imperio Moncey dirigidas a esta Suprema Junta de Gobierno y contestación de esta al General* ([Madrid], 1808), p. 16.

4. Quoted in A. Savine, *España en 1810. Memorias de un prisionero de guerra inglés* (Paris, about 1910), p. 179.

5. Quoted in Savine, *España en 1810*, p. 69, n. 1.

6. *A los españoles* (Seville, [1809]) [a proclamation occasioned by the arrival of the French in Talavera]. Many villages suffered the excesses committed by the French army, but the French were not the sole perpetrators. On passing through Consuegra, one of the principal towns of La Mancha, Blayney commented: "It had suffered much from the war, especially at the hands of German troops, who were much more cruel than the French." Quoted in Savine, *España*, p. 106.

7. *Carta sobre las maldades cometidas por los Franceses en Cuenca* (Valencia, [1808]), p. 3.

8. Savine, *España en 1810*, p. 83.

86

Y no hai remedio (And there is nothing to be done)
Fatales consequencias de la sangrienta guerra en España con Buonaparte. Y otros caprichos enfaticos [Disasters of War], plate 15
Working proof
1810-1814
Etching, drypoint, burin, and lavis
141 x 168 mm.
References: G-W 1015; H. 135, I, 1.

Spain: Museum of Fine Arts, Boston, 1951 Purchase Fund, 51.1637 [*illus.*]
United States: The Metropolitan Museum of Art, New York, Harris Brisbane Dick Fund, 32.62.17

Spanish patriots are being shot. The print is closely related compositionally to the famous painting *Executions of May 3* (cat. 80, fig. 4) in Madrid,[1] but there is a considerable difference. In the painting the victims are the people of Madrid; in the print the victims are determined patriots fighting in the war against Napoleon's army.

According to the intruder government's decree of October 19, 1809, capital punishment by firing squad was replaced by the garrote. Prior to the decree, persons of rank (ecclesiastical, military, or civilian) had been killed by firing squad, a method considered less degrading than the garrote. Following the decree, the mere pronouncement of the death sentence stripped all persons of their rank, and the garrote was used for all capital punishments without differentiation.

Use of the firing squad became limited to situations in which executions had to be immediate, and these generally arose in chain gangs and in the aftermath of battles. On May 9, 1810, the Maréchal Duque de Dalmacia's regulations were published, stipulating in item nine: "There is no Spanish army but that of His Majesty King José Napoleón; therefore, all contingents in the provinces, however numerous, and whoever their commander is, will be treated like bandits whose only aim is to rob and murder. All individuals belonging to these companies caught with arms in their hands will be tried on the spot by the provost and shot:

their corpses will remain exposed on the public highways." Spanish prisoners were often shot, since French commanders of a convoy of prisoners were ordered "to shoot not only those who fall ten paces behind the column but also those who falter from exhaustion or illness." These orders were to be enforced "more or less strictly according to the humanity or cruelty of the officer and even of the soldiers of the guard";[2] thus, once prisoners fell behind or gave indications of flight, they were "immediately shot."[3]

Prisoners' lives also depended on other unforeseen events, such as whether the convoy was attacked; thus Lord Blayney, an English prisoner of war, explained how "in a council of war, composed mainly of officers of the guard, it was decided that all Spanish prisoners would be shot at the moment of an attack, as a result of which the prisoners were bound in pairs in anticipation of events."[4] Ordinarily, prisoners were eventually transferred to France, but they arrived in considerably reduced numbers. This was partly because of the harsh circumstances of the journey and partly because the French authorities, hoping that the prisoners would desert the Spanish army and pledge allegiance to José I, took pains to delay sending them to France.[5] It was therefore important for the Spanish partisans to stimulate the prisoners' courage so that they would maintain their "firm and unwavering resolution . . . to die for the Principe y la Nación (the Prince and the Nation)", and they were exhorted with such expressions as "do not let yourselves be intimidated, do not be cowardly hypocrites."[6]

Goya thus represented those Spaniards who, in spite of "hunger, thirst, exposure," and misfortune did not hesitate "for an instant in their generous and loyal resolutions," accepting with dignity and resignation and to the end the consequences of their convictions. In the composition the monumental figure with blindfolded eyes, resigned to death, draws the viewer's attention. His tattered clothing does not diminish his dignity, and the serenity manifested by his figure turns him into one of those who "died without witnesses of his courage

other than his own conscience."[7] Goya also highlighted the bodies of those who had already been executed at the feet of the man about to be shot, and above him another in the middle ground who, having been shot, leans forward and begins to fall. In this manner Goya played with simultaneous action: he will die, he is dying, he is dead. Moreover, the dramatic content is emphasized by the disposition of the gun barrels at the right, which have not yet been fired, and the squad in the middle ground that has already fired, giving the viewer to understand that an unlimited succession of these events will follow one another in time and space. The worst of it all is that this is war and there is nothing to be done about it; the sequence cannot be altered. Nevertheless, the contrast of light and darkness at the left could be a sign of hope; Goya does not appear to have agreed with the official French opinion, which assumed "only blindness and unreason could conceive the hope of coming out well in a war" that the French themselves considered unjust on their part, but absurd on the Spanish part.[8]

<div align="right">J.V.</div>

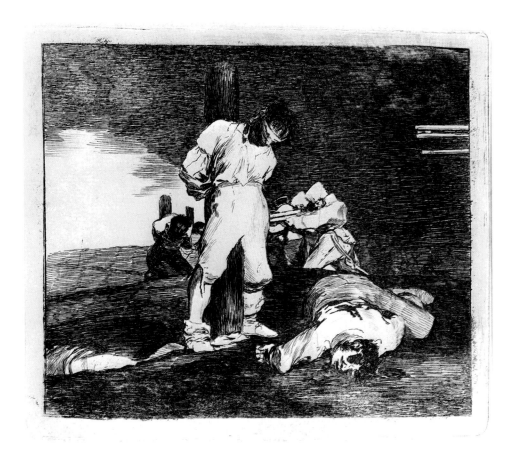

1. Prado, Madrid, 749; G-W 984.

2. Juan Senén de Contreras, *Sitio de Tarragona, lo que pasó entre los franceses, el general Contreras que la defendió, sus observaciones sobre la Francia y noticia del nuevo modo de defender las plazas* (Madrid, 1813), p. 40.

3. A. Pérez Herrasti, *Relación histórica y circunstanciada de los sucesos del sitio de la plaza de Ciudad Rodrigo en el año de 1810, hasta su rendición al exército Francés* (Madrid, 1814), p. 37. In his *L'Espagne cinquante ans d'intervalle: 1809-1859*, Fee gave the following description: "We found several columns of Spanish prisoners taken in the battle of Ocaña. . . . They were harshly driven and many of them, young and weak, succumbed to fatigue. Those who could not walk were shot." Quoted by A. Savine, *España en 1810: Memorias de un prisionero de guerra inglés* (Paris, about 1910), p. 69, n. 1. In the convoy in which Lord Blayney, an English prisoner, traveled, the Spanish prisoners had similar luck: "A third of the soldiers were half-naked children dying of hunger, another third old men who could hardly walk. Those who had not been able to keep up with the soldiers were charitably shot by the guard in the middle of the way."

4. Quoted in Savine, *España en 1810*, p. 89. For an account of Spanish maneuvers that were intended to liberate prisoners, see Luis de Bassecourt, *Manifiesto de la liberación de los militares de la División de Cuenca* (Cuenca, 1811), p. 3. On May 25, 1811, during a battle to free a large convoy of prisoners, "the vile Spaniard D.N. Balbuena Edecán – sworn supporter of the intruder king, who barbarically ordered twenty-three unhappy men among these same prisoners shot on the Guadarrama climb, because they could not continue marching for lack of nourishment – was killed."

5. According to Blayney, his convoy "was made up of various caravans and more than 2600 persons, including Spanish prisoners they had used in public works in Madrid, intending to compel them to enter into the service of King José." Quoted by Savine, *España en 1810*, p. 153.

6. *Proclama al exército Español con motivo de la entrada de los prisioneros de Uclés en Madrid* (1809).

7. Ibid.

8. Senén de Contreras, *Sitio de Tarragona*, p. 36. One of the characteristics of the Peninsular War was the continuous publication of pamphlets, manifestos, and proclamations encouraging the population to resist the French. Many Spaniards committed themselves in total ignorance of the risks involved in war, led in some cases by friars and clerics, and moved by their hatred of the French, a hatred that was stoked by the political and military leadership directing the movements of the Spanish army, making it easier for the people to understand the otherwise unnatural alliance with the English. The following text by General Contreras summarizes this situation: "Spanish hatred for the French had reached its limits because of the injustice of their aggression and the atrociousness of their behavior in the villages and toward prisoners. . . . It was a gross mistake, a contemptible lie, and shameful ignorance (on the part of the French) of the Spanish character to try to persuade the world that this courageous nation had risen and taken up arms instigated by the friars, clerics, and the English: Spain rose up spontaneously to avenge the wrongs committed against the people and the royal family, to ward off the offense of receiving another king who is not the one we prefer, the legitimate king, and finally in order not to suffer the yoke, which is hateful to us: these ideas are inherent to the heart of every Spaniard and more ancient than ecclesiastical institutions or our friendship with the English." Ibid., pp. 37-38.

87

No se puede saber por qué (There is no way of knowing why)
Fatales consequencias de la sangrienta guerra en España con Buonaparte. Y otros caprichos enfaticos [Disasters of War], plate 35
Working proof
1810-1814
Etching, burnished lavis, and drypoint
155 x 208 mm.
References: G-W 1050; H. 155, I, 2.

Spain: Kupferstichkabinett, Staatliche Museen Preussischer Kulturbesitz, Berlin, 767-1906
United States: Museum of Fine Arts, Boston, 1951 Purchase Fund, 51.1658
[*illus.*]

Eight Spaniards have been garroted. The garrote, "an old Spanish punishment [that] seems to be one of the easiest kinds of death," in the words of the English prisoner of war Lord Blayney,[1] was adopted by José I on October 19, 1809, as the only suitable method of execution "for every prisoner sentenced to death without exception."[2] The scene Goya presented here was therefore fairly common throughout Spain, and such executions were conceived "as a general example and to thus obtain the respect of all and domestic security."[3] Blayney explained that a day did not pass "in which the French did not arrange to dispatch various unfortunate Spaniards whom they attempt to pass off as rebels and bandits,"[4] and the causes for which they were sentenced were detailed in gazettes and daily newspapers with only one purpose: "that the good rest assured of the protection of the law, the bad fear punishment, and to serve as an example to all."[5]

The ceremony accompanying these events was minutely described by Fee, a French military observer: "I was strolling sadly with no fixed purpose when I saw in an inconspicuous square a great throng of spectators whose number swelled with each passing moment. Executions were confirmed here and four criminals were already being led to their deaths. The executioner's device consisted in a very low platform, where there were four

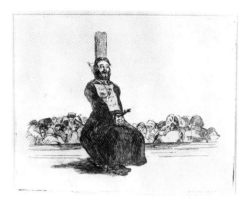

Fig. 1. *Por una navaja* (For Carrying a Knife), *Disasters of War*, plate 34.
Working proof.
Etching and drypoint.
Museum of Fine Arts, Boston, 1951 Purchase Fund

benches attached to four garrotes intended for the poor devils. . . . The sentenced were strangled to death with an iron collar that was tightened by a screw placed in the rear of the pillar. After the execution the victim's face, which at first is hidden by a cloth placed by the executioner, is uncovered that it may be viewed by the spectators."[6] (See fig. 1.)[7]

More than forty executions were reported in the *Diario de Madrid* between 1810 and 1812. On December 29, 1808, the governor of Madrid issued a decree in French and Spanish. In Article I it was declared: "Every inhabitant of Madrid who has not surrendered his weapons must deliver them within twenty four hours to the district mayor's house. At the end of this period, which will end on *the twenty-ninth at 6 in the evening*, every citizen in whose house daggers, sabers, swords, or firearms are found will be arrested, handed over to a military commission, and sentenced to death." In Article II it was stated: "Every citizen of Madrid or Spaniard found in the streets with a dagger or any other weapon and any inhabitant attacking a member of the French or allied army, or a Spaniard, will be arrested, handed over to a military commission, and sentenced to death."[8] These measures, designed at first for Madrid,[9] were extended to the entire kingdom; on April 19, 1810, a decree was issued establishing criminal

tribunals in all the provincial capitals as a judicial measure against the collaboration between the people and the guerrilla groups fighting the French army.[10]

Articles III and IV of the decree of December 1808 were pivotal in that they set forth the crimes for which the garrote was prescribed. Article III announced: "Once these councils have been formed, the following crimes will be established: (1) Spying or correspondence in favor of the insurgents, recruitment, sedition, rebellion and disobedience and whatever other subversive act against our government, even if the intention was not realized, and the hindrance or dissuasion of the Municipalities in their just defense against the so-called guerrillas or gangs of bandits; (2) murder, highway robbery, or assault with a weapon; (3) use of a dagger or poignard and of firearms without permission from the corresponding authority." Article IV was more specific: "Prisoners of whatever class or condition, accused of the aforesaid crimes, will be judged by the councils within twenty four hours, once the written proceedings are completed; and if there is sufficient evidence of their having committed the crime they will be sentenced to death, which will be carried out without right to appeal."[11]

All those sentenced to death were required to wear around their necks the weapon they had been found carrying and a placard explaining precisely the reason for the sentence, such as "for highway robbery in a gang, with firearms."[12] Soon after the execution all the crimes committed by the executed were detailed in the daily newspapers and gazettes.

This situation is reflected in the crudest fashion in Goya's print. The subject had been handled previously in *El agarrotado* (The Garrotted Man) of 1778-1780 (G-W 122), but neither *Por una navaja* (For Carrying a Knife) (fig. 1) nor *No se puede saber por qué* shows any relationship to the earlier work other than in the common subject. In this print the distribution of light calls attention to certain points: to the tied feet, which cause a greater distortion of the lifeless bodies, whose strange and varied disposi-

tions lend a rigid movement to the scene; to the hands gripping crucifixes (a detail shown also in *El agarrotado*), as if to make plain that these condemned were given spiritual assistance, as was traditionally done in Spain; to the weapons and the placards that describe the crimes and try to justify the punishment, although there is no doubt that such objects worn round the neck make the figures more ignominious. The stiff faces of the executed men – the final highlighted detail – far from suggesting their condition as a "gang of murderers" seem rather to emphasize their condition as "desgraciados" (unfortunate individuals) or "pobres diablos" (poor devils).

In this fashion Goya cast doubt on what passed for justice under the French; all efforts to convince citizens of the correctness of their acts – hence so many published explanations and the great size of the placards – are diluted in the light of these images. But, as if these tragic images were not enough, Goya added the comment *No se puede saber por qué*. In this connection, the commentary that appeared in the *Gaceta de Madrid* on August 25, 1812, immediately after José I had abandoned Madrid, is interesting: "In the Court [the French] established their tyrannical police system, created commissaries, named agents, and unleashed in the general population thousands of vile men who secretly observed citizens, jailing them for no other reason than whim or any accusation whatsoever. They were never known to pronounce anyone innocent; they never called the commissaries' or agents' procedures unjust; on the contrary, they warned and watched even those against whom they could prove nothing: such was their arrogance, such their injustice, such the contradictions of what they published in their gazettes. Their inquisitorial system in the initiation and execution of trials was diametrically opposed to the principles of a liberal constitution. The weight they gave to an anonymous witness, or the simple tale of a base informer, opened the doors of revenge, and induced a general unease and distrust in the population."[13] The newspaper commentary concludes: "Along with the police a bloody tribunal

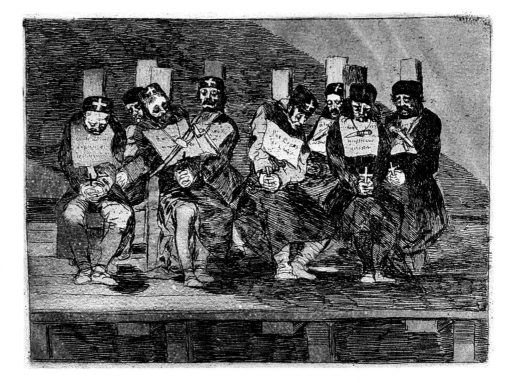

was erected and called the criminal council. Inept and cruel judges, directed by an infamous decree written in human blood, offered a picture of favoritism and bribes. This council sentenced to death both the man who read the same papers that the French abstracted in their gazettes and the rebel taken prisoner in battle, calling the former a spy and the latter a murderer or horse thief."[14]

Finally, a word should be said about an important difference between *Por una navaja* (fig. 1)and *No se puede saber por qué*. In the former, people can be seen behind the gallows, whereas in this print there is a different viewpoint, the figures appearing closer but also above the viewer. Here the platform's beams are visible so that the condemned seem more remote from the viewer. Behind them there is only a black shadow merging with the gallows at the right. The audience that customarily took part as spectators has disappeared, transformed into shadows.

J.V.

1. Major-General Lord Andrew Thomas Blayney, *Narrative of a Forced Journey through Spain and France as a Prisoner of War in the Years 1810 to 1814* (London, 1814), vol. 1, p. 73, quoted in Sayre, *Changing Image*, p. 175.

2. In spite of the publication of this decree, hanging still took place in different parts of Spain. See *Gaceta de Madrid*, Dec. 20, 1811, p. 1443.

3. *Diario de Madrid*, Dec. 6, 1811, p. 642.

4. Quoted in A. Savine, *España en 1810: Memorias de un prisionero de guerra inglés* (Paris, about 1910), p. 44.

5. *Gaceta de Madrid*, Feb. 8, 1810, p. 160.

6. *L'Espagne: Cinquante Ans d'Intervalle: 1809-1859*, quoted in Savine, *España en 1810*, p. 44, n. 1. Fee's account, though not referring specifically to Madrid, applied to cities throughout Spain. In Madrid executions always took place on the plaza de la Cebada, which was described in the nineteenth century by the scholar and chronicler Ramón de Mesonero Romanos as a square "surrounded by private houses of little note" and "famous because death sentences" were carried out there; *Manual de Madrid: Descripción de la Villa y Corte* (Madrid, 1931), p. 288.

7. In *Por una navaja* (G-W 1049), Goya's composition includes a large audience witnessing the execution. On this hair-raising spectacle, Fee observed: "I did not need to remain till the end to flee horrified, but I had to walk for a long while before I could shake it off. Every which way Brothers of Misericord carrying lighted lamps cried out in mournful voices: 'Brothers give alms for the souls of the unfortunate convicts.' "

Quoted in A. Savine, *España en 1810*, p. 44, n. 1.

8. *Diario de Madrid*, Dec. 29, 1808, p. 711. The well-known decree by the French general Murat, issued after the events of May 2, 1808, was phrased in similar terms, bringing about the execution by firing squad of many Madrid citizens on May 3. *Por una navaja* (fig. 1) corresponds to the enforcement of this new regulation issued by the governor of Madrid. Through the inscription Goya showed his complete disagreement with the French authorities' way of proceeding; for the French the knife was a dagger. But Alcalá Galiano's commentary on this subject is rather eloquent: "as few lower-class Spaniards lack knives, if for no other reason than to cut tobacco, those who were caught and examined in the street (on the occasion of the May 2 uprising) were convicted of carrying concealed weapons and treated like delinquents." A. Alcalá Galiano, "Memorias," in *Obras*, Biblioteca de Autores Españoles, vol. 83 (Madrid, 1955), p. 339.

9. On August 22, 1809, the people of Madrid were warned that subjects found to possess any kind of weapon or ammunition after a period of three days would be "under pain of being handed over to a military commission." *Diario de Madrid*, Aug. 23, 1809, p. 215.

10. Among the Spanish authorities who tried to organize the uprising and resistance at an early stage, there was this kind of appeal to citizens to collaborate in such a fight: "A war of guerrilla groups, of obstructions, of exhausting the enemy troops for lack of food, of cutting bridges. . . . Spain's terrain invites this strategy, the many mountains and narrow passes offered by its rivers and streams, the very arrangement of the provinces ensure such a war can be carried off happily." See *Prevenciones que convendrá se tengan presentes en las varias Provincias de España en la necesidad en que han puesto a esta los Franceses de oponerse a la posesión injusta y violenta que pretenden tomar del Reyno los Exercitos de aquellos . . . por disposición de la Suprema Junta* (Valencia, 1808), p. 2. Later, on Jan. 29, 1809, the *Instrucciones sobre las facultades de los señores comisarios de la Junta Suprema gubernativa del Reyno* were issued by royal decree; item 10 urged the formation of "independent guerrilla groups of sufficient strength to cover the areas closest to the enemy . . . and to provide our armies, courts, and towns with all appropriate news."

11. *Diario de Madrid*, Dec. 29, 1808, p. 711.

12. Ibid., July 10, 1812, p. 38.

13. The *Gaceta* dwelt on the climate of distrust: "The father distrusted his son, the brother his sister, and the friend his friend, and there was good reason, for there were fathers, siblings, and friends who broke the most sacred social bonds. . . . In a word, the establishment of the police . . . banished security and calm from our midst, and only the wise Constitution that now governs us was capable of restoring it." *Gaceta de Madrid*, Aug. 25, 1812, pp. 46-47.

14. Ibid.

88

Tampoco (Nor This)
Fatales consequencias de la sangrienta guerra en España con Buonaparte. Y otros caprichos enfaticos [Disasters of War], plate 36
1810-1814
Etching, aquatint, burnishing, drypoint, and burin
158 x 208 mm.
Inscribed in plate, upper left: *36*; lower left: *39*
References: G-W 1051; H. 156, I, 2-3.

Spain: Cabinet des Estampes, Bibliothèque Nationale, Paris
United States: Museum of Fine Arts, Boston, 1951 Purchase Fund, 51.1659
[*illus.*]

The print illustrates a fairly common situation in various parts of the kingdom: Spanish patriots have been hanged. The participation of civilians in the war gave rise to a scenario in which they were treated with the same rigor as the soldiers in the regular army fighting Napoleon's troops.[1] The death scenes Goya bequeathed to us in the *Disasters of War* customarily have as protagonists common people who suffered both the brutality of soldiers out of control, as in *Disasters* 32 and 33: *Por qué?* (Why?) and *Que hai que hacer mas?* (What more can be done?), and the cruelty of indiscriminate French judicial sentences (see cat. 87). The title *Tampoco* (Nor This) refers to the previous print, *No se puede saber por qué* (There is no way of knowing why) (cat. 87), which also expresses Goya's inability to comprehend this type of behavior, altogether alien to strict military discipline or the reasonable application of a just punishment.

Hanging was a dishonorable punishment, and although it was replaced by the garrote in provincial capitals following the decree of October 19, 1809, (see cat. 86), it was apparently used systematically by the French to execute many of the citizens who belonged to guerrilla groups and who had been taken prisoner.[2] Guerrillas "caught carrying arms were immediately hanged on trees by the roadside."[3] The bodies of the executed remained exposed on highways to intimidate travelers, for, in the end, they served as a warning; in this manner, the trees assumed the same function as the gallows in the cities.[4]

The scene depicted here would therefore not have been unfamiliar during the Peninsular War; nevertheless, it is difficult to interpret this print.[5] Goya used an exaggerated perspective to suggest that the row of hanging men stretches into infinity, a procession of death, of total immobility. He captured the absolute calm that follows moments of great agitation. Several men have been hanged from the trees; in the absence of a rope, the sash that held up one victim's trousers has been used. The leafy branches, lying broken on the ground, echo the fractured life that hangs from the trunk.

The only violence in the scene does not arise from death, or the hanged man's face, or the abuse of nature but lies in that figure who so complacently leans back in order to take in the reality before his eyes.[6] The posture of the Polish soldier – reputed to be the horror of the Napoleonic army for his cruelty and bloodthirsty spirit (see cat. 85) – is somewhere between that of reflection, melancholy, and seduction; the face, lacking a definite expression, conveys satisfaction, if possible all the more disturbing to the viewer.[7] This soldier's situation can be related to scenes of martyrdoms, in which there is always a place for witnesses of another's suffering, who watch without participating in the execution itself. But in Goya's print everything is deliberate. The classical pyramidal composition helps to rationalize this kind of death and introduces a heightened sense of tragedy.[8]

In this manner a world is revealed in which human reason does not obtain, a world of terror that generates victims – neither martyrs nor heroes – and in which horror no longer needs darkness or the traditional elements of torture. The only living element here is a human being, and only human beings are capable of creating that world and sitting down to rest and to contemplate it as if they were images of God. Nevertheless, Goya put this man who believes himself God – drunk with power, lord of life and death – on the ground and extremely

near us in order to heighten our revulsion. This soldier's power extends only into the world of the unfortunate who fall into his hands, some supposedly terrible guerrillas who in reality were often no more than isolated peasants.[9] In this case the figure of the Polish soldier could be Goya's representation of the *miles gloriosus* juxtaposed with the object over which he gloats.

<div style="text-align:center">J.V.</div>

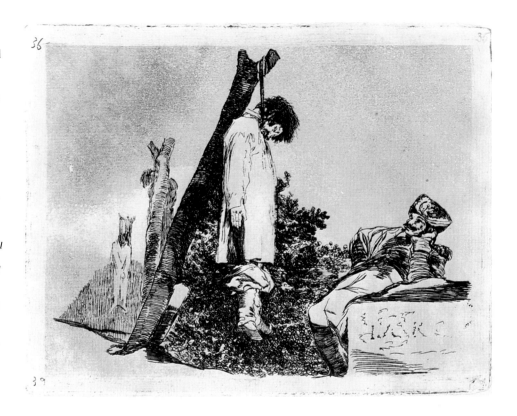

1. There was a change of attitude by the French government toward the treatment of civilians. At first, as a demonstration of goodwill and as a means of dissuading citizens from taking up arms, the French sent civilians home disarmed. On this, see *Cartas del Mariscal del Imperio Moncey dirigidas a esta Suprema Junta de Gobierno y contestación de esta al General* (1808), pp. 5, 9. As the war ground on and hostilities sharpened, the treatment of civilians became progressively more violent to the extent that some French officers boasted of having "distinguished their worthy soldiers for not forgiving any citizen caught carrying arms." *Semanario Patriótico*, May 25, 1809, p. 56.

2. On February 3, 1809, General Carrié informed Marshal Bessières that he had given orders to hang at Carrión half the Spanish prisoners taken in the north. See G.H. Lovett, *Napoleon and the Birth of Modern Spain* (New York, 1965), vol. 2, pp. 725-726, quoted in Sayre, *Changing Image*, p. 176.

3. General Lejeune, quoted by Lafuente Ferrari, *Desastres* p. 160.

4. Valeriano Bozal noted the transformation of the tree in Goya's work and the function of this old element of pleasure as a new means of torture during the war; "El arbol goyesco," in *Goya: Nuevas Visiones* (Madrid, 1987), pp. 129ff.

5. The absence of a preparatory drawing makes it impossible to know what changes Goya made between his original idea and the print. Study of these changes often helps us to understand the print, for it is in the steps from drawing to print that the most profound changes in meaning occur and the event is distilled.

6. Goya made use of a stone slab for his arrangement of the soldier, a device he had used earlier in the *Caprichos* (see cat. 52). See Valeriano Bozal, *Imagen de Goya* (Barcelona, 1983), p. 208.

7. Lucas Dubreton described the Polish soldier in this way, in *Napoleon devant l'Espagne: Ce qu'a vu Goya*, quoted in Lafuente Ferrari, *Desastres*, p. 160.

8. "Goya has handled the subject as if it were a strictly classical motif, yet, nevertheless, with an extraordinary dramatic and expressive power, establishing a sharp contrast between the two figures through all the compositional elements at hand, emphasizing an extraordinary serenity, appropriate to a retrospective view of the tragedy. The clear, almost exemplary pyramidal composition frames the scene within a geometric and balanced space. It is the contrast between the balance and the calm of the presentation and the horror of the narrative subject

that gives rise, putting all rhetoric aside, to the tragic feeling." Bozal, *Imagen de Goya*, p. 209.

9. The English prisoner of war Lord Blayney recounted the following incident in his diary: "Some horsemen having been spotted at the top of a hill, a detachment of Polish lancers was sent to reconnoiter. . . . The Poles hurled themselves toward the mountain with great speed and returned soon thereafter with five horses they asserted they had taken from bandits. . . . These horses were in deplorable condition. Instead of a riding saddle, they had been fitted with a kind of packsaddle that peasants used to convey produce to market. This circumstance, along with several others, made me suppose not without reason that the so-called bandits were simply a few peasants, whose horses the Poles had robbed to serve as evidence of their prowess." Quoted in A. Savine, *España en 1810: Memorias de un prisionero de guerra inglés* (Paris, about 1910), p. 38.

89

Grande hazaña! Con muertos! (Heroic feat! Against the dead!)
Fatales consequencias de la sangrienta guerra en España con Buonaparte. Y otros caprichos enfaticos [Disasters of War], plate 39
Working proof
1810-1814
Etching and lavis
157 x 208 mm.
Signed in plate, lower left: *Goya*
References: G-W 1055; H. 159, I, 2.

Spain: Kupferstichkabinett, Staatliche Museen Preussischer Kulturbesitz, Berlin, 770-1906
United States: Museum of Fine Arts, Boston, 1951 Purchase Fund, 51.1663 [*illus.*]

Three men are tied to a tree, killed and mutilated probably because they were taken for traitors. In war high treason is the most serious crime and in all times has been the most severely punished. In the Peninsular War many were accused of high treason, sometimes for having sworn "fidelidad al rey intruso" (loyalty to the intruder king), but it was difficult to get the supposed traitors tried with justice and equity before the sentence was carried out. The historical record shows that there were many victims who died because they were suspected of treason. It was "a terrible suspicion in those circumstances," observed Alcalá Galiano, "followed usually by the most barbaric treatment. Many humble people and others who were famous fell in that period before the blind fury of the people in the smaller towns."[1]

Nobody could feel free from this suspicion, not even the generals of the Spanish army. The Spanish patriot General Castaños reported: "The towns respect neither the courts nor the government, and scandalously carry out whatever excesses and insults are provoked by some perverse rabble-rousers, who are full of the execrable rumors spread by the prodigious number of army deserters and stragglers, saying that all the generals are traitors, that the soldiers were sold for so much, that they were taken to the slaughterhouse, etc., etc., basing these proposi-

tions on the most detestable and ridiculous ideas that go with the foolishness and fear their crimes instill in them in order to avoid being arrested and treated like delinquents, which unfortunately the indiscriminate and unreflective mob has heeded and believed."[2]

The alarming extent of this problem made it necessary for the Spanish authorities to decree on February 3, 1809, the *Penas sobre bullicios y conmociones populares* (Sentences for Popular Disturbances and Commotions) in order to limit these excesses: "He who calls another traitor in public or spreads rumors to that effect will be arrested and compelled to justify it, and if he fails will be punished according to the laws governing false slanderers," a punishment that could even be death.[3] Moreover, there was an attempt to educate the people and to instill moderation: "Know once and for all that the impunity and tolerance of crimes and mutinies of armed men, entirely dissolving the ties that bind the soldier with his chief, eventually result in excess and license. . . . It is not for you to judge whether a general is a *traitor* or not, whether he has done his duty well or ill. The true traitor is the soldier who abandons his flag, who turns the people against his officers, who spreads terror in the provinces, who uses weapons to loot and kill, and who thus opens the door to the conquests of his enemies."[4] Generals, mayors, police, and magistrates were among those who were victims of the people for opposing or not encouraging "the whim of anybody who out of malice, enmity, or revenge" accused another of being a traitor.[5]

Among the deaths that caused the most horror – perhaps because it was one of the first – was that of General Benito San Juan. In Guadarrama the general had had to retreat to Talavera to regroup and there was murdered, on December 7, 1808, by several dispersed soldiers of his, who accused him of being a traitor.[6] The murderers were not "satisfied with his death, but set about amplifying the horror of the spectacle: they stripped the corpse, leaving it naked, and dragged, mutilated, and hung it on a public promenade."[7]

Knowing the circumstances of this

murder, the viewer finds it easier to identify those who accomplished such a *grande hazaña* (heroic feat) and those who were the *muertos* (dead). Once again, Goya unsparingly expressed what can be expected from an ignorant people, but on this occasion he avoided making the image of the people explicit.[8] There is no action; in fact the print is "a monument to barbarity and atrocity" in which the nobility and dignity of those mutilated bodies are exalted, highlighted in such a way that the unjust torture to which they were subjected is thrown into relief. To convey the extent of the sufferings endured by these victims, Goya chose a composition in which postures and forms could be identified with torture: the old man bound by the feet can be interpreted as Tityus or Marsyas; the middle figure is similar to that in the etching *La seguridad de un reo no exige tormento* (The custody of a criminal does not call for torture) (see cat. 95 and 96, fig. 2); the torso appears to correspond to those classical sculptures mutilated by the passage of time and by ignorance. The beauty of the body is accompanied by that of nature, for Goya did not show a sterile and ravaged countryside; on the contrary, leafy trees appear in the background, a branch of which is in the foreground. "Unhappy Spaniards! Their good faith, their zeal, and unreflective patriotism make them rush headlong, without realizing that the true traitors are those who incite popular disturbances, so that there are mutinies in the army and no general can be found who is willing to take command, and so that anarchy and disorder reign without an authority's or government's control."[9]

Goya's purpose in presenting this spectacle is not to horrify.[10] The victims' faces even show calm,[11] and the beautiful proportions of the bodies invite viewing. Rather, Goya set out to incite reflection before these images, for heroic feats can never be the fruit of excesses of "sanguinaria crueldad" (bloody cruelty), "heroismo" (heroism), or "amor patrio" (love of country).[12]

Goya could have avoided creating this print, but his attitude toward the "barbaric murder" of General San Juan coincided with that of contemporary writers:

"The pen and national honor resist recounting it, but the sincerity that guides us in this account does not allow silencing it."[13] This print culminates the series on unjust and violent deaths that began with *Disaster* 31; the first and last reflect the actions of those supposed "Spanish patriots." Although Goya decided against showing their faces – to be fair, not all Spanish people were such "monsters," in Alcalá Galiano's words – the print captures enough key information for the viewer to understand that among loyal patriots an enemy was hiding as fierce as the one they were trying to expel; it was an enemy allied to ignorance and thus deserved to be treated with the same frank sincerity that characterizes all of Goya's work.[14]

<div style="text-align:right">J.V.</div>

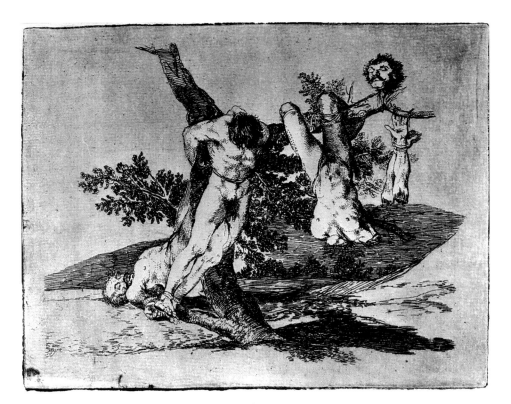

1. A. Alcalá Galiano, "Memorias," in *Obras*, Biblioteca de Autores Españoles, vol. 83 (Madrid, 1955), p. 360.

2. Report by General Castaños, Dec. 21, 1808, in *Reales Ordenes de la Junta Central Suprema del Gobierno del Reino, y su separación del mando del exército de operaciones del Centro* (1809).

3. Quoted by Albert Dérozier, *Manuel José Quintana y el nacimiento del liberalismo en España* (Madrid, 1978), p. 415.

4. *Semanario Patriótico*, July 20, 1809, p. 185.

5. Junta Central's answer, Jan. 6, 1809, in *Reales Ordenes*. In the decree on the *Penas sobre bullicios y conmociones populares* it was written: "All those raising seditious voices against the established courts or authorities will be immediately arrested and tried." Quoted by Dérozier, *Quintana*, p. 415.

6. "The word *treason* no longer means what we have understood it to mean till now," wrote General Castaños. "A traitor is a general who does not attack when a soldier or anybody who is two hundred leagues from the enemy wants him to; a traitor if he has the army beat a retreat instead of being surrounded and sacrificed without benefit or use to the nation. . . . and traitors are all the officers if by misfortune a battle is lost." *Reales Ordenes*, Junta Central's answer, Jan. 6, 1809.

7. The drawn and quartered body was on view for four days, and there "the French found it as they advanced from Madrid, giving them more than enough reason for bitter rebukes." *Semanario Patriótico*, May 18, 1809, pp. 34-35. Such rebukes were published in the *Gaceta de Madrid*, Dec. 14, 1808, p. 1592.

8. This is one substantial difference between *Grande hazaña!* and *Disaster* 28, *Populacho* (Mob), although both demonstrate acts in which barbarity is confused with "justicia popular" (popular justice).

9. *Reales ordenes*, Junta Central's answer, Jan. 6, 1809.

10. The destroyed body, which now repels us, must be placed in its historical context because sentences carried out against traitors were rather similar to those Goya illustrates. Thus Antonio Sánchez and Antonio Asnar, jailed for high treason, were sentenced as follows: "Let them be sentenced to ordinary hanging and their corpses beheaded and their right hands cut, with the understanding that they should be dragged and their heads and hands be placed in the gates of this city, to be openly viewed, so that they might serve as an example to other Spanish scoundrels." *Castigo de dos españoles indignos absolutamente de tal nombre executado en la ciudad de Tarragona, acompañado con el dictamen del fiscal* (Tarragona, July 9, 1809).

11. Compare with *Disaster 37, Esto es peor* (This is worse) (G-W 1052).

12. Alcalá Galiano, "Memorias,' p. 360, gave a perfect portrayal of the kind of individuals who were responsible for such acts, especially of their boastfulness.

13. *Semanario patriótico*, May 18, 1809, p. 34.

14. The sequence is hair-raising: *Fuerte cosa es* (This is too much), *Por qué?* (Why?), *Que hai que hacer mas?* (What more can be done?), *Por una navaja* (For Having a Knife), *No se puede saber por qué* (There is no way of knowing why) (cat. 87), *Tampoco* (Nor This), *Esto es peor* (This is worse), and *Bárbaros* (Barbarians) (H. 151-H. 158).

90

Asi sucedio (This is how it happened)
Fatales consequencias de la sangrienta guerra en España con Buonaparte. Y otros caprichos enfaticos [Disasters of War], plate 47
Working proof
1810-1814
Etching, burnished lavis, drypoint, and burin
155 x 205 mm.
Inscribed in plate, lower left: *33*
References: G-W 1069; H.167, I, 3.

Spain: Cabinet des Estampes, Bibliothèque Nationale, Paris United States: Museum of Fine Arts, Boston, 1951 Purchase Fund, 51.1671 [*illus.*]

After injuring a friar, soldiers rob the jewels, silver, and ornaments in a church. In many Spanish cities and towns sacking was the consequence of the arrival of French troops, and on some occasions, sacking was a punishment meted out to the population for having resisted.[1] Although the military treatises of the period recognized that sacking was a way of compensating troops, reasons were given to avoid it. The general ought to "honor the constancy of the defeated." There appeared to be no "more harmful abuse in war than looting" because "before the sacking when the general has not had time to examine each person, and to safeguard the churches, and the houses that did not deserve punishment, and [to form] patrols who could prevent disorders, the follower as well as the enemy . . . suffer[ed], the innocent along with the criminal, and the sacred places as well as the profane."[2]

Churches, convents, and houses were systematically sacked from the outset of the war.[3] Manifestos and proclamations described these events, following set formulas to refer to "French savagery" with phrases such as "religion profaned, the treasures of the church robbed" and "the sanctuary of churches sacrilegiously stripped and splattered with the blood of the defenseless priests."[4] This situation raised the hopes of those who sought to turn the Peninsular War into a holy – and therefore always just – war and into a crusade. But the Junta Central

restrained these impulses, confronting the clergy every time it expressed "too noisily its desire to monopolize the 'crusade' and to wage a mystical and bloody war like all religious wars"; both "prudent and understanding," the Junta maintained the clergy within "reasonable limits of its functions, preferring it grip the aspergillum to the gun, and be ensconced within churches rather than inciting noisy public demonstrations," mainly processions.[5]

Nevertheless, as the Junta Central knew, it was necessary to publish descriptions of French pillaging in order to prove their savagery. On many occasions it was the parish priests who sent or arranged to print the narrations of the sackings, as a result of which profanations of churches figured prominently. "Where [the French] unleashed all their fury was in the church, profaning the sacrament, ripping out the tabernacle, and trampling the images of Christ, of the Holy Virgin, and other saints, demolishing the altars, robbing all those treasures the church contained, and turning all the vestments and ornaments on their heads."[6] The French sacking of Cuenca on June 17, 1808, was counted among the most terrifying of that time: "The darkness made the din and forcing of doors, destruction of houses, monasteries, pious houses, and churches more frightening: they robbed all the treasures, monstrances, including the magnificent one in the cathedral: they carried off the sacred vessels, scattering the consecrated hosts on the floor, destroying the ornaments and images: they killed several persons, among them an old and venerable prebendary."[7] Another victim of this sacking was "the Father confessor of the nuns of Conception [convent]. . . . After having wounded him, . . . they applied, so that he would admit where the money was stored, a new kind of torture no less painful to modesty than to nature, in those parts that both [modesty and nature] take equal trouble to conceal because they are shameful and delicate."[8]

It is almost impossible to relate Goya's print to a particular example of French plundering, but the texts quoted here allow us a fuller understanding of what

appears to be represented in it. The light draws attention to the friar – a Franciscan perhaps – who has been wounded in the chancel possibly because he did not take flight and attempted to oppose the robbery of the images and ornaments that were being hurriedly spirited away by the soldiers. The other highlight falls on this treasure: a processional cross, a chalice, four candle holders, and an image of the Virgin are easily made out. The soldier, bent under the weight, begins to lose his grip on the bundle, and through an opening another ornament becomes visible. In this print Goya thus illustrated a robbery with all the violence it entails and even the friar's nobility in trying to stop it. The setting – the interior of a church – can suffer no greater desecration; the thieves have focused all their attention on the loot they later sell "at low prices in streets and squares".[9] It probably happened just as the artist presented it; his attitude coincided with that of the Junta Central in omitting any element that would induce a viewer to think of a "crusade" against the Antichrist, that is, Bonaparte.[10]

To create the atmosphere of semidarkness and silence that pervades empty churches, Goya used a technique that distinguishes this print. Covering the plate with a very fine layer of aquatint, he used the burnisher to lighten some areas, producing a soft and velvety atmosphere, as in the "Black Paintings." As a result, the lines made with the burin seem more violent, reinforcing the sense of action in the figures; at the same time they clearly delimit the areas of light – the friar and the stolen treasure –giving greater dramatic power to the scene because both are victims of those faceless thieves.

J.V.

1. The French General Caulincourt wrote from Cuenca: "Two hours of looting and sacking [of this town] should warn other towns. . . . If my orders had not kept me, I should have erased Moya from the map of Spain; but if this people does not immediately shape up it will have to suffer a terrible punishment." Letter of July 9, 1808, quoted in *Cartas de varios generales franceses sorprendidas a dos espias* (1808), p. 23.

2. A. Navia Ossorio, Marqués de Santa Cruz de Marcenado, *Compendio de los veinte libros de Reflexiones Militares que en diez tomos en quarto escribió . . ., por Don Juan Senén de Contreras, Teniente del*

Regimiento Provincial de Alcázar de San Juan (Madrid, 1787), vol. 1, pp. 152, 383. In the capitulation of Tarragona the French general Suchet remonstrated with General Juan Senén de Contreras, saying "he [Senén] was the cause of the horrors his troops had committed in Tarragona because he defended it more than the laws of war call for . . . and [the French] had the right to carry off everything by fire and sword." Senén rebutted this supposed right, citing the French military theorist Carnot: "If by chance a city were taken by force, after a vigorous well-executed resistance, the culprit will not be the side sustaining the fight to the death, but the side abusing its victory. The former heroically did its duty, the latter dishonors its achievement. And they should not try to tell us looting is a right of war: this right never existed except among the barbarians"; and General Senén added, "in effect, in war there is no such right to sack and kill, except those opponents caught armed, for if they fling them down and surrender after having stopped fighting and make themselves harmless, they obtain the right to expect humanity from the enemy, who should spare their lives." Juan Senén de Contreras, *Sitio de Tarragona, lo que pasó entre los franceses, el general Contreras que la defendió, sus observaciones sobre la Francia y noticia del nuevo modo de defender las plazas* (Madrid, 1813), pp. 27ff.

3. Some of these actions were carried out, as mentioned in the case of Cuenca (see note 1, above), with the full indulgence of the French generals. The French government must have felt compelled to admit this reality in order to publish its authorization to the Minister of Ecclesiastical Affairs to supply from suppressed monasteries and convents what was needed in the way of "holy vessels, ornaments and other necessary implements," since it desired that "the divine cult not be interrupted . . . in the parishes that [had] suffered the inevitable damage troops tend to commit when they enter obstinate towns." *Gaceta de Madrid,* May 7, 1809. The division chief of the Ministry of Ecclesiastical Affairs was Juan Agustín Ceán Bermúdez.

4. See A. Dérozier, *Manuel José Quintana y el nacimiento del liberalismo en España* (Madrid, 1978), p. 375, and pp. 390ff., referring to [Manuel José Quintana], *Manifiesto de la Nación Española a la Europa* [Seville, 1809], pp. 19-20.

5. Ibid., pp. 372, 413. As the author rightly pointed out, p. 472, "in the upper echelons the word 'crusade' was heard reluctantly."

6. The French arrival in the town of Venturada. *Diario de Madrid,* Aug. 9, 1808, pp. 5-6. For accounts of the sackings by the French of Torquemada, Aug. 17, 1808; Rioseco, Aug. 10, 1808; Segovia; and Uclés, Jan. 13, 1809, see, respectively, *Diario de Madrid,* Sept. 5, 1808, p. 158; ibid. Sept. 8, 1808, p. 173; *Noticia de Segovia,* Biblioteca Nacional, Madrid, R-60034; "España: Entrada bárbara, sangrienta y abominable de las tropas francesas en Uclés después del ataque que dieron a unas tropas el 13 de enero último [1809] en las cercanías de aquella villa," Biblioteca Nacional, Madrid, MS. R-62665.

7. *Gaceta de Madrid,* Sept. 5, 1808, p. 158. The sacking of Cuenca was indeed terrible, but one example of the ecclesiastical authorities' interest in spreading the notion of French antireligiousness in

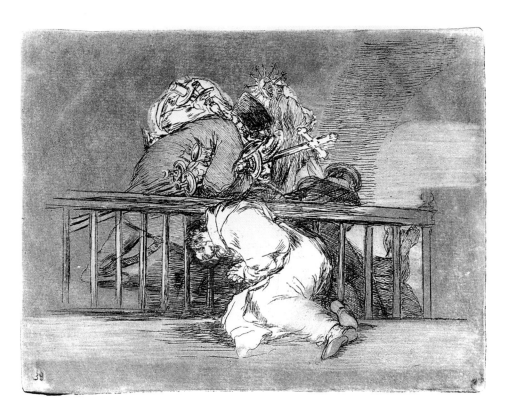

the hope of turning the war into a crusade appears in the *Carta sobre las maldades cometidas por los Franceses en Cuenca* (Valencia, [1808]), written by a "wise cathedral prebendary": "I will pass over the looting and destruction of houses, the emigration, famine, the bitterness, the tortures, and helplessness of the citizens of this town. . . . I will report on that which most cuts us to the quick, which is the profanation of churches and insults to the priesthood and the cult."

8. *Carta sobre las maldades,* p. 4.

9. Ibid., p. 5. The French were also observed selling the loot – fruit of the sackings of the kingdoms of Navarra and Aragón – in Pamplona. See Robert Southey, *History of the Peninsular War* (London, 1832), vol. 1, p. 422, quoted by Sayre in *Changing Image,* p. 152.

10. *Carta sobre las maldades,* p. 8.

91

Lo peor es pedir (The worst is to beg)
Fatales consequencias de la sangrienta
guerra en España con Buonaparte. Y
otros caprichos enfaticos [Disasters of
War], plate 55
Working proof
1810-1814
Etching and lavis
155 x 205 mm.
Signed in plate, lower left: *Goya*;
inscribed, lower left: *37*
References: G-W 1084, H. 175, I, 2.

Spain: Cabinet des Estampes, Bibliothèque Nationale, Paris
United States: Museum of Fine Arts, Boston, 1951 Purchase Fund, 51.1676
[*illus.*]

A young woman walks past a group of starving people in the presence of a soldier in Napoleon's army. Among the many effects of the war throughout the kingdom was the abandonment of much agricultural land, which inevitably reduced the civilian food supply. There was also the need to feed the large French army and the allied army of Spaniards, Englishmen, and Portuguese. In entire districts all traces of cultivation disappeared, either because they were the scene of continuous clashes or because the local population abandoned their agricultural tasks to participate in the war on one or the other side. To this was added the insecurity of the roads and difficulty of transporting goods.

One of the centers that most suffered from the scarcity of food was Madrid. Its situation was aggravated because it served as a magnet for the population: "A consequence of the isolation of each province has been that of each town, and a consequence of the isolation of each town that of each individual: thus, this capital, residence of the Spanish monarchs, which owed all of its splendor to the affluence of the powerful in the court and to the treasures the towns gave as tribute to the sovereign, no longer receives any visitors but the unfortunate who come in search either of the bread they cannot obtain in the provinces or the justice and the protection they expect only from their monarch."[1]

The decline in agricultural production led to a continual rise in the price of legumes and bread; at the same time, meat became extremely scarce so that "basic nourishment became increasingly inaccessible not only to the common people, but also the most well-to-do persons and families."[2] "As the greater part of the employees of the legitimate government had been dismissed from their jobs, many distinguished people were reduced to begging."[3] According to one account of the time, the city looked devastated: "One cannot go for a stroll without the most hardened heart softening at the sounds and sight of some who complain of not having breakfasted although it is six in the evening, of others who have death marked on their faces, of still others who faint from hunger, and yet others who have just died of hunger; there a group or row of children abandoned by their parents, crying for bread; here a livid, disfigured widow; and farther off a maiden, assuring one she is begging in order not to prostitute her honesty."[4]

Goya's preparatory drawing for *Lo peor es pedir* (fig. 1)[5] depicts a scene that could often be observed in the streets of Madrid: starving beggars. But next to the beggars he incorporated a young prostitute. The artist presented her according to the canons for describing a woman of her profession – in her attitude and the disposition of her feet she resembles the prostitutes shown in the *Caprichos* – and included the figure of a bawd. The young woman's client is undoubtedly the best possible one at the time: a soldier in Napoleon's army who leads her away. As the French enthusiasm for the women of Madrid was well known, these soldiers were easy prey. "The women of Madrid," wrote Limouzin, "are prettier than they are beautiful. Their faces more piquant than regular. Though customarily small, their form is pliant, elegant, and voluptuous. They possess the most beautiful eyes, and their look is expressive and gentle. Nothing can be compared with the delicacy of their feet. Thus, they give the greatest care to their shoes. Their dresses are on the short side . . . and

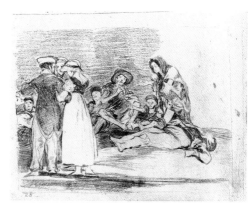

Fig. 1. Preparatory drawing for *Lo peor es pedir*. Red chalk and pencil. Museo del Prado, Madrid

these dresses admirably outline their beautiful figures and allow an irresistible leg to show. Their clothing is simple but seductive. . . . Naturally inclined to affection in virtue of their ardent constitutions and the influence of climate, they know the power of love from a very tender age."[6]

Goya introduced important changes in the print. No one in the group of starving people raises a hand to beg; they consist of three famished and unkempt adults and a child of horrible aspect. Hiding behind the boy, who shows his emaciated legs and serves as a lure, is an old man. Although none of them begs, each one in his poverty seeks "sorrowful positions and tones capable of inducing charity."[7]

There are differences also between the prostitute in the drawing and the young woman who walks past the hungry people in the print. Just as the starving show their emaciated bodies to rouse compassion, the young woman – who now wears a longer dress and appears without her bawd – parades her beauty with grace, hoping to attract such clients as the French soldier, who fixes his gaze on her. She has chosen that path as a way to avoid begging. Goya does not criticize her choice; on the contrary, he convinces us of her shame and ingenuousness. But, if her weakness is understandable in those circumstances, what is unacceptable is the indifference with which she walks past the starving people. As a result, a dramatic face in the background silently

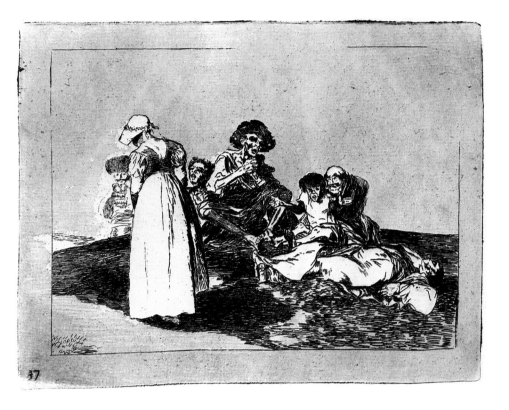

reproaches her and challenges her to look squarely at the reality she seeks to evade.

<div align="center">J.V.</div>

1. *Gaceta de Madrid,* May 8, 1812, p. 523.

2. Ramón Mesonero Romanos, *Memorias de un sesentón* (Madrid, 1975), p. 84.

3. Basilio Sebastián Castellanos, *Retrato actual y antiguo de la muy H. N. L. y C. Villa y Corte de Madrid* (Madrid, 1831), p. 161. The author added: "Everywhere the rich trappings of houses were sold at negligible prices, and it can be assured that if the Madrilenes' luck was not worse it was because of the many jewels and the money in their possession."

4. *Diario de Madrid,* Aug. 27, 1812, p. 229.

5. Prado, Madrid, 147; G-W 1085; G., II, 204.

6. Quoted in A. Savine, *España en 1810: Memorias de un prisionero de guerra inglés* (Paris, about 1910), p. 83, n. 1.

7. *Gaceta de Madrid,* Aug. 25, 1812, p. 47.

92
Sanos y enfermos (The Healthy and the Ill)
Fatales consequencias de la sangrienta guerra en España con Buonaparte. Y otros caprichos enfaticos [Disasters of War], plate 57
Working proof
1810-1814
Etching and burnished aquatint
155 x 205 mm.
References: G-W 1088; H. 177, I, 2.

Spain: Kupferstichkabinett, Staatliche Museen Preussischer Kulturbesitz, Berlin, 773-1906
United States: Museum of Fine Arts, Boston, 1951 Purchase Fund, 51.1678 [*illus.*]

In this print Goya presented another scene that could have taken place in Madrid during the years of famine. The shortage of wheat and its high price led to the use of flour derived from other grains, even legumes, to make bread.[1] Although some of these innovations in the making of bread, considered a staple, may not have been unhealthy,[2] flour blends were beginning to be used almost universally, and the municipal authorities felt compelled to prohibit them.[3] On July 1, 1812, manufacturers were informed that if they were found to be making bread that contained a "blend of seeds or other extraneous ingredients, positively harmful to the public health," they would be subjected to "all the rigor of the laws" for making an attempt on the life and safety of their fellow citizens.[4]

Nevertheless, because of the famine in Madrid, the use of adulterated flour could not be avoided. The effects of consuming it were quite visible. According to a ditty published in 1812, "Sin que se detengan / En si es comestible / Sano o digestible / Su fin es tragar. / Por esto se hinchaban / E iban de manera / Que al alma mas fiera / La hacian llorar." (Whatever is not stopped / Is eatable / Healthy or digestible / Its purpose is to be swallowed. / This is why they grew bloated / And had such an appearance / That the fiercest heart / Was brought to tears by the sight.)[5]

The starving people that Goya depicted

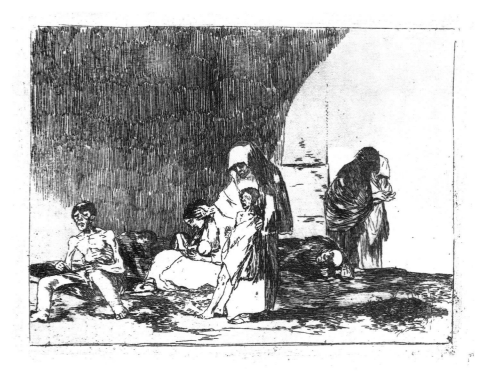

silhouettes and attitudes of the two women at the right. Moreover, in the print there is a strong juxtaposition of light and darkness, a duality that heightens the dramatic power of the scene. That duality could be interpreted as the opposition of two distinct conditions, which would explain Goya's title: *Sanos y enfermos* (The Healthy and the Ill). But another interpretation is possible. The population of Madrid at that time was subjected on the one hand to famine caused by the scarcity of grain and on the other to the constant demand by José I's government for money to subsidize the high cost of maintaining his army and his staff.[10] This situation led to the indigence of "la parte sana de la Nación" (the healthy part of the Nation) as well as the unhealthy.[11] On the other hand, hunger and poverty touched the majority of the population and ruined even those who collaborated in the consolidation of the foreign government. They "did not begin to feel this iron rod until payment of salaries was suspended and needs were multiplied by the extraordinary shortage of goods, [and they] found themselves joining the insurgents in poverty, only dejected all the more by the weight of their crime, which did not afflict the latter. Thus began the first revenge of this generous people, which for more than four years had suffered insults and the most unbearable yoke, seeing those who had cleared the way for beggary begging themselves."[12]

This is the reality that Goya depicted, but in it there is not the least hint of revenge. He merely conveyed with frankness one of the consequences of that unfortunate war.

J.V.

both in the preparatory drawing for *Sanos y enfermos* (fig. 1)[6] and in the print exhibit in their bodies the extreme consequences of eating this adulterated bread. Their paralyzed legs probably indicate that they suffered from lathyrism, that is, poisoning caused by the ingestion of purple vetch flour.[7]

In the preparatory drawing the urban landscape that surrounds these debilitated people begging for alms could be any of the city's arcades in which the "poor citizens found shelter during the great and terrible illnesses that struck down entire families of so many honorable Spaniards." Lacking medical assistance and nourishment because of the shortage of bread, they had "no other bed in which to die but the streets and arcades."[8] Goya introduced notable differences when he transferred the subject to the copper plate;[9] he changed the architectural setting, incorporated new human figures, and redefined the

Fig. 1. Preparatory drawing for *Sanos y enfermos* (The Healthy and the Ill).
Red chalk.
Museo del Prado, Madrid

1. "The *fanega* (1.6 bushels) of wheat costs as much as 500 reales, as a result of which each two-pound loaf of bread, usually short of the full weight and with some admixture, was sold at 14 reales, a price that only a few of the . . . well-to-do could afford." Basilio Sebastián Castellanos, *Retrato actual y antiguo de la muy H.N.L. y C. Villa y Corte de Madrid* (Madrid, 1831), p. 161.

2. One citizen sent a letter to the newspaper "On the advantages of making bread with ordinary potato paste during the current wheat shortage." *Diario de Madrid*, Jan. 16, 1812, p. 62.

3. On April 17, 1812, a decree was issued: "The councilmen of the reweighing office will take the most rigorous precautions so that the bread made and sold be of salubrious quality . . . and that its weight be ascertained with the greatest precision." *Diario de Madrid*, Apr. 18, 1812, p. 440.

4. *Diario de Madrid*, July 2, 1812, p. 5. Further attempts were made to control the quality and weight of bread. On September 15, 1812, the mayor of Madrid issued a stern warning: "The baker who blends foreign substances with wheat flour in his bread will lose his entire stock, which will be burned publicly while his name is announced, and will be immediately sent to prison." *Diario de Madrid*, Sept. 16, 1812, pp. 313-314.

5. *El hambre en Madrid Padecida en el ultimo año de la dominacion de Bonaparte, por los habitantes de este heroyco pueblo P.D.M.L.M.P. quien la dedica a los distinguidos cuerpos de Empecinados de España* (Madrid, 1812). In 1814 the song, printed on four pages, was sold at 4 reales, according to an advertisement in the *Diario de Madrid*, Oct. 19, 1814, p. 435. A print depicting the famine in Madrid illustrated the first page of the song; reprod. in J. Carrete, E. de Diego, and J. Vega, *Catálogo del Gabinete de Estampas del Museo Municipal de Madrid* (Madrid, 1985), vol. 1, pt. 2, no. 173-89.

6. Prado, Madrid, 149; G-W 1089; G., II, 206.

7. Purple vetch is a legume native to Spain. Its use during the Peninsular War as food for the starving population of Madrid is well documented; Goya also referred to it in *Disaster* 51, *Gracias a la almorta* (Thanks to Purple Vetch Flour) (G-W 1076). Lathyrism is a disease caused by the consumption of large quantities of certain species of legumes or their seeds during a more or less prolonged period. The disease is characterized by spastic paraplegia. In the preparatory drawing the man seated at the left points to one of his deformed legs; the child shown in both the drawing and the print has extremely rigid legs and cannot stand.

8. *Diario de Madrid*, Nov. 3, 1814, p. 493.

9. A precise description of the changes and innovations introduced by Goya and their consequences for interpretation of the print can be found in Valeriano Bozal, *Imagen de Goya* (Barcelona, 1983), pp. 212-214.

10. Robert Southey described the hardships inflicted on the citizens of Madrid: "Being the seat of the Intrusive Government, more of those traitors were collected there who had made the miseries of their country a means for their own advancement. . . . The duties payable upon the entrance and the exit of wheat, rice, and pulse of everykind were repealed by a decree, but continued to be exacted as before, and at the same time, new duties were imposed upon wine, oil, meat and vegetables. . . . Having collected a great quantity of grain, the Government sold it at a price more suited to its own wants than to the condition of the people"; *History of the Peninsular War* (London, 1832), pp. 514-515.

11. The expression "la parte sana de la Nación" was used by José I's followers as well as by the protagonists of the resistance. For an example of its use by a member of the resistance, see M. Núñez de Arenas,

"Héroe o Traidor, según conviene a S. M.," in *L'Espagne des Lumières au Romantisme* (Paris, 1963), p. 184. For an example of the French government's use of the expression, see an article listing the "virtues" of the new regime that José I wanted to establish, published in *Gaceta de Madrid*, June 16, 1812, p. 680.

12. *Diario de Madrid*, Sept. 23, 1812, p. 314.

93

No hay quien los socorra (There is no one to save them)
Fatales consequencias de la sangrienta guerra en España con Buonaparte. Y otros caprichos enfaticos [Disasters of War], plate 60
Working proof
1810-1814
Etching and burnished aquatint
150 x 205 mm.
Inscribed in plate, lower left: *31*
References: G-W 1094; H.180, I, 2.

Spain: Cabinet des Estampes, Bibliothèque Nationale, Paris
United States: Museum of Fine Arts, Boston, 1951 Purchase Fund, 51.1681 [*illus.*]

A group of children and adults lying on the ground horrifies a starving man who manages to stand. Because of the famine suffered by the citizens of Madrid, José I issued a decree, on November 19, 1811, organizing the Establecimiento de Beneficencia (Charity Establishment) to "provide the inhabitants of Madrid with abundant, healthy nourishment at a reasonable price" and authorizing the Minister of the Interior to "set aside in the budget of his ministry the monthly sum of 50,000 reales to cover the expenses of this establishment."[1] However, some months later the municipal authorities in Madrid submitted the following report to the king: "The ills afflicting this town are so great that their needs cannot be met either by His Majesty's generosity or by the means administered by the municipality. . . . The hospitals, hospices, reformatories, and other shelters for incapacitated citizens contain more than 8,000 people, who daily receive nourishment from the town, sustained by the funds His Majesty's generous heart has provided. This exorbitant number of unfortunate people is a tiny fraction of those who clamor for the same help: houses, streets, churches, all resound with the outcries of the suffering and needy; all of them deserve a consolation we cannot give them. . . . The picture of public misery, which so afflicts His Majesty's devout heart in the capital is even more horrible in those places where acts of humanity cannot penetrate."[2]

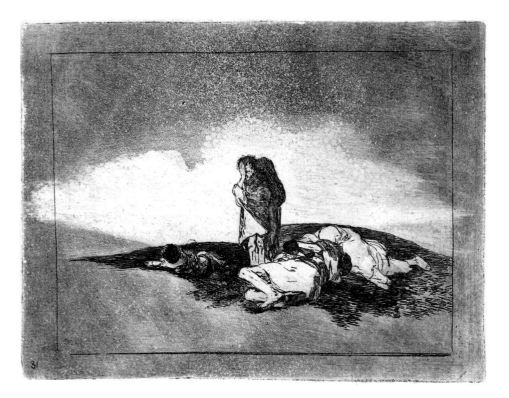

In the preparatory drawing for *No hay quien los socorra* (There is no one to save them) (fig. 2), a man looks at the figures of a child and a woman lying on the ground, and in the background there seems to be a gathering of people.[3] In the print the background was suppressed so that the scene takes place in a setting where "acts of humanity" never arrived.[4] The composition especially recalls that of *Disaster* 18, *Enterrar y callar* (Bury and hush) (fig. 2),[5] conveying the same feeling of impotence and desolation. On the other hand, in the print the number of prostrate figures was increased: there are two adults already dead and two children with some signs of life. The central figure, standing on emaciated legs (in the drawing they were fairly well concealed by clothing), hides his sorrowful expression by covering his face with his hand, for neither he nor anyone can do a thing to help the afflicted. Goya exaggerated the squalid deformity of this man, who corresponds to the stereotype of the poor man (see cat. 76); his clothing is arranged in such a way that he is made into a humpback rather than a man doubled over under the weight of a burden. In the background a highlight that appears to encroach upon the darkness of night suggests early dawn. In this manner the feeling of desperation is sharpened, since the bodies indicate they did not survive the night – they will not waken – and the children will go the same way, without hope of being rescued.

Once again, the combination of etching and aquatint with burnishing is effective, guiding the viewer to points of interest and softening the scene. In spite of the desolation and abandonment, the handling of the ground and the horizon, far from suggesting a hostile environment, makes these unfortunate, starving people appear serene.

J.V.

1. In the first week of the Establecimiento's operation "11,631 persons, as well as 403 servants and dependents of the Commission" were given "12,244 rations." *Gaceta de Madrid*, Jan. 21, 1812, p. 84.

2. *Gaceta de Madrid*, May 8, 1812, p. 523. The withdrawal of French troops from the capital in the middle of 1812 did not in the least change the situation, although the Establecimiento de Beneficencia was substituted by the Junta de Caridad (Charity Council) on September 7, 1812.

3. Prado, Madrid, 152; G-W 1095; G., II, 209.

4. These acts of humanity are represented in *Disasters* 49, *Caridad de una muger* (A Woman's Charity); 51, *Gracias a la almorta* (Thanks to Purple Vetch Flour); and 59, *De que sirve una taza* (What is the use of cup) (H. 169-171); all are in urban settings.

5. G-W 1020; H. 138, I, 3.

94

Si son de otro linage (But they are of another breed) *Fatales consequencias de la sangrienta guerra en España con Buonaparte. Y otros caprichos enfaticos* [Disasters of War], plate 61
Working proof
1810-1814
Etching, lavis, drypoint, and burin
155 x 205 mm.
Inscribed in plate, lower left: *35*
References: G-W 1096; H. 181, I, 3.

Museum of Fine Arts, Boston, 1951
Purchase Fund, 51.1682
United States only

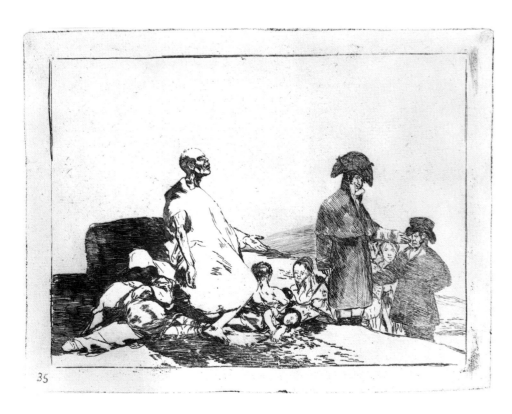

The food shortage brought speculation in its wake, and nobody could prevent "the bakers from lining their pockets at the expense of public health."[1] It is easy to believe in the truth of the comment, "With the war the traders fleece us incredibly."[2] The new rich flaunted their wealth in their manner of dressing; evidently they followed the latest fashion, which always imitated designs coming from France: "Can we call ourselves independent –reflected the 'Español rancio' [traditional Spaniard, a journalist's epithet] – if we wear their livery, and if in order to make a dress or baste a hat or beautify ourselves, we wait for some damned frog to give us permission, as a servant awaits that of his master?"[3]

The new rich and the starving could be found in the same places: "The houses and streets of Carretas, Puerta del Sol, Montera, Mayor, and other important ones were a long *morgue* where corpses could be found every day";[4] at the same time, the Puerta del Sol was "the meeting place for merchants."[5]

In the preparatory drawing for *Si son de otro linage* (But they are of another breed) (fig. 1),[6] the urban environment is clearly discernible. The starving are grouped around the ashlar wall, while the rich stand and converse at different levels as if they were on different steps of a grand staircase. Once again Goya introduced important changes in the print. The number of impoverished people has increased. The man at the center of this group is intensely highlighted so that his misery appears resplendent; his head – apex of the pyramid composed of these

Fig. 1. Preparatory drawing for *Si son de otro linage* (But they are of another breed).
Red chalk.
Museo del Prado, Madrid

unfortunate people – is noble and dignified; his facial expression summarizes all suffering. At his feet are children and a woman, but none expresses the ugliness of misery emphasized in *Disaster 55*, *Lo peor es pedir* (The worst is to beg) (cat. 91). The distressing situation does not mar the figures' dignity or serenity; a profound resignation characterizes this group of unhappy citizens.[7]

In the print Goya replaced the block of stone in the center with a figure whose back is to the viewer and who holds a child in his arms. This figure links two very different worlds that are not as remote from each other as we might think. The two gentlemen at the right draw attention to that other world; Goya exaggerated the differences between them in height, dress, and gesture. Conspicuous sideburns framing an aquiline nose, a malicious smile reinforced by the shape of the large two-cornered hat, a *carrick* (cape), and a small cane[8] distinguish this person; his relentless economic and social climb has distanced him from the inferred speaker, so that his left hand (which rested on the speaker's shoulder

in the drawing) is suspended in empty space. His companion, whose face is withered, shows a lightly indicated grin; his eyes are fixed not on the gentleman before him but on the poor, hungry man who is situated at the same height as the rich one. His clothes, though of quality, are less elegant, suggesting a difference between the two gentlemen in buying power.[9] The confidence and hauteur of the former contrasts with the wry grin and dejection of the latter.

Near the center of the print a woman, neat but modest, looks at the poor; she could belong to a social class in decline because of the war that faces the hungry squarely, since it finds itself almost at the same level. In the background at the right, a pretty young woman strolls, somewhat removed from her surroundings. In the print Goya captured reality in all its harshness, for his images seem faithful interpretations of an observation by a contemporary witness: "Vimos levantarse de la nada colosos de poder y riqueza; vimos cubrirse con el andrajoso manto de la indigencia a otros que en algún tiempo habían nadado en la opulencia" (We saw colossi of power and wealth rise from nothing; we saw others who had once swum in opulence cover themselves with the tattered cloak of indigence).[10] In this print a *coloso* (colossus) turns his back on the starving; he can extract nothing more from them and thus turns his attention to those who still have something to give up.

No printmaker or painter of the time was able to represent human behavior during the famine years with the unflinching frankness that Goya used in the *Disasters*. But in this print, with its inscription *Si son de otro linage*, he showed more clearly than in any other those people who profited from the war: those who, turning their backs on misery, lived in opulence and enriched themselves at the expense of the health and the needs of their fellow citizens.

J.V.

1. As evidence of this flourishing business, see an advertisement by a newly established baker who instituted a "subscription service for those who desire to reserve bread for a time that suits them"; *Diario de Madrid*, Feb. 15, 1812, pp. 181-182.

2. Ibid., May 25, 1812, p. 586.

3. *Delicias de Bonaparte*, p. 8. According to this text, men's fashion at that time was characterized by large sideburns, little vests, the short double cape, colossal hats, and enormous tippets.

4. Basilio Sebastián Castellanos, *Retrato actual y antiguo de la muy H.N.L. y C. Villa y Corte de Madrid* (Madrid, 1831), p. 162.

5. A. Savine, *España en 1810: Memorias de un prisionero de guerra inglés* (Paris, about 1910), p. 123.

6. Prado, Madrid, 153; G-W 1097; G., II, 210.

7. "In spite of such suffering, the Madrilenes showed unsurpassed stoicism, for they died in view of bread without daring to break the laws or disturb the peace." Castellanos, *Retrato actual*, p. 157.

8. Lafuente Ferrari, *Desastres*, p. 177.

9. Hats of various kinds were worn in those years, and because they were an important accessory, some houses advertised the remaking of high-crowned hats "according to the current fashion"; those who opted for this solution were probably going through a precarious period in their finances but wished to avoid looking foolish in public, especially on the Paseo del Prado, where, according to Lord Blayney, the English prisoner of war, people mocked each other "for their outfits without realizing they too cut a ridiculous figure." Quoted in Savine, *España en 1810*, p. 129. An edict published by the municipal authorities on April 19, 1809, was designed to control disturbances occasioned by this problem, and these measures were reiterated during the constitutional period by the edict of May 31, 1813.

10. *Gaceta de Madrid*, Aug. 25, 1812, p. 46.

95

Preparatory drawing for the etching *La seguridad de un reo no exige tormento* (The custody of a prisoner does not require torture)
About 1810-1814
Pen, brush and brown ink over slight graphite sketch; sanguine border; the outlines of the image incised for transfer and the verso of the sheet rubbed with red chalk
106 x 71 mm.
References: G-W 989; G., II, 164.

Museum of Fine Arts, Boston, Bequest of W. G. Russell Allen, 1974.223

96

Preparatory drawing for the etching *Si es delinquente qe muera presto* (If he is guilty, let him die quickly)
About 1810-1814
Brush and brown wash over slight sanguine sketch; the outlines of the image incised for transfer and the *verso* of the sheet rubbed with red chalk
155 x 121 mm.
References: G-W 991; G., II, 165.

Museo del Prado, Madrid, 389

These two drawings are preparatory studies for the last two in a group of three etchings on the subject of the torture of prisoners: *Tan barbara la seguridad como el delito* (The custody is as barbarous as the crime) (fig. 1; G-W 986), *La seguridad de un reo no exige tormento* (The custody of a criminal does not call for torture) (fig. 2; G-W 988), and *Si es delinquente qe muera presto* (If he is guilty, let him die quickly) (fig. 3; G-W 990). Two additional drawings exist, both related to *Tan barbara la seguridad como el delito*. One of these (fig. 4)[1] may be a first idea for the etching, while the other, closer to the print, has been doubted as being the work of Goya because of a certain harshness in the contrasts of light and shadow and a weakness in the brushstrokes and pen lines that indicate form.[2] The method Goya used to transfer the designs of the two drawings in the exhibition to his copper plates reversed the direction of the compositions. Working proofs of these three prison etchings

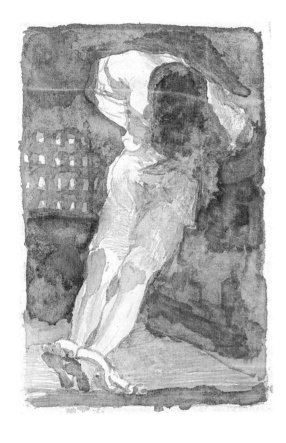

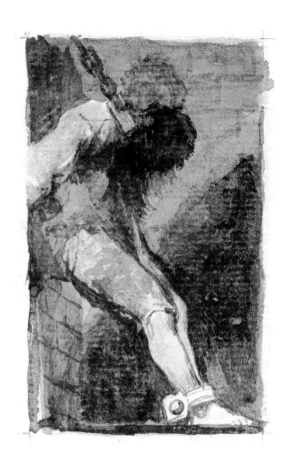

were included by Goya at the end of the mock-up set of the *Disasters of War,* whose titles, written by Goya, were to have been corrected by his friend the art historian Juan Agustín Ceán Bermúdez.[3]

Although some scholars have dated these drawings of prisoners between 1810 and 1820, they are closely related in style to a small number of preparatory drawings in wash for plates of the *Disasters of War* that appear to have been executed about 1811, such as those for plate 15, *Y no hai remedio* (And there's nothing to be done)[4] (see cat. 86) and for plate 30, *Estragos de la guerra* (Ravages of War) (fig. 5)[5], which enables us to suggest a date close to these drawings. In *Estragos de la guerra,* there is the same use of spots of ink and of very free blotting. The artist obtained the basic chiaroscuro through brush alone and in additon, thanks to his complete mastery, the definitions of forms and of movement; furthermore, he achieved in these drawings an astonishing suggestion of

horror and cruelty through his dramatic use of ambient light and shadow.

That the etchings made from these drawings were included by Goya as an appendix to his volume of proofs of the *Disasters of War* suggests that these works, and their inscriptions in the artist's hand, refer to the numerous Spanish prisoners taken during the Peninsular War and to the cruelty that the French invading army showed toward its opponents – subjects depicted by Goya in scenes of executions and massacres in the *Disasters.* However, in this case, the subject matter seems to differ somewhat from the more concrete and realistic scenes of the war etchings, taking the form (to judge by the tone of Goya's inscriptions) of a conceptual denunciation not merely of war – with all its horrors, including executions that took place almost without reason – but also of the treatment given ordinary prisoners and offenders, in the delaying of trials, in the use of torture to obtain confessions, and

even in pretrial punishment for putative crimes. Thus, *Tan barbara la seguridad como el delito, La seguridad de un reo no exige tormento,* and *Si es delinquente qe muera presto* seem to refer to what were current Spanish judicial practices predating the Peninsular War.

The use of shackles and chains in prisons was general, and there is substantial literary evidence of it spanning the eighteenth century. Meléndez Valdés, commenting on an earlier trial in one of his legal essays, described the detention and custody of a woman who killed her husband: "Pero se dice que la Doña María Vicente debió ser tratada, como hijodalgo que es, muy de otro modo, y no aherrojada con los grillos; y aun aherrojada que era de obligacióm del juez examinar antes su estado y calidad para mandárselos poner según derecho" (But it is said that Doña María Vicenta should have been treated like the noblewoman she is, that is in a very different manner, and not fettered with leg-irons; and it is even

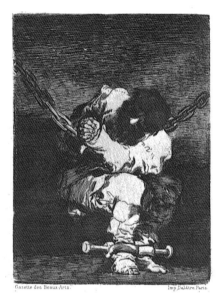

Fig. 1. *Tan barbara la seguridad como el delito* (The custody is as barbarous as the crime), about 1810-1814.
Etching and burin, posthumous impression.
Museum of Fine Arts, Boston, Bequest of W.G. Russell Allen

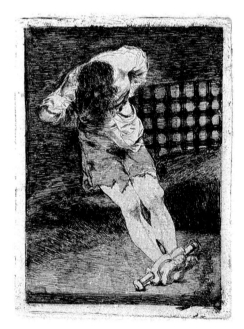

Fig. 2. *La seguridad de un reo no exige tormento* (The custody of a criminal does not call for torture), about 1810-1814.
Etching and burin, posthumous impression.
Museum of Fine Arts, Boston, Bequest of W.G. Russell Allen

said that, according to the law, it was the judge's obligation to first examine her rank and her condition before ordering that fetters be applied).[6] The notorious case of this woman, executed on April 23, 1798, must certainly have impressed Goya. Many contemporaries believed her to be the subject of *Capricho* 32, *Por que fue sensible* (Because she was susceptible).[7] Goya may also have depicted her in a dungeon wearing leg-irons and chained to a wall in a rejected plate for the *Caprichos* as well as in its preliminary drawing.[8] In this last there is a stronger sense of realism than there is in these later drawings of prisoners, making it a paradigm of the classic view of a dungeon and prisoner.

In the impressive image of pain and lack of liberty that Goya presented in the drawing *Si es delinquente qe muera presto* (cat. 96), the intense light illuminates specifically the fetters – whose size is disproportionately large in relation to the prisoner – as well as the chains that hold him upright against the wall. Goya markedly altered the position of the prisoner's head; the original position, still visible, made the figure appear more erect. It is precisely the collapse of the body that now heightens the cruelty of the chains. In the other drawing, *La seguridad de un reo no exige tormento* (cat. 95), the disposition of the figure with his feet in the foreground again draws attention to the imposition of leg-irons. Chains and leg-irons are also the prominent elements in the three etchings and in the third wash drawing. Goya seems to have wanted to indicate his true purpose in these works: his criticism of torture and cruelties inflicted on prisoners; and his belief that if the crime was great, the measures taken by the authorities were no less criminal.

The revealing character of these works justifies the supposition that the prison etchings were Goya's contribution to the debate on the abolition of torture in the Constitutional *Cortes* (parliament) in Cádiz, which must have deeply moved his sense of justice.[9] What appears in these drawings is not the denunciation of a concrete, individualized situation but a manifesto of profound visual beauty in

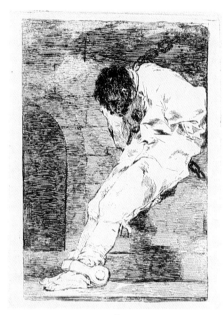

Fig. 3. *Si es delinquente qe muera presto* (If he is guilty, let him die quickly), about 1810-1814.
Etching and burin, working proof, first state.
Museum of Fine Arts, Boston, Lee M. Friedman Fund

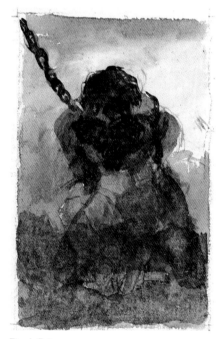

Fig. 4. *Prisoner*.
Drawing for a proposed etching.
Brush and brown wash over slight pencil sketch, sanguine border.
Museo del Prado, Madrid

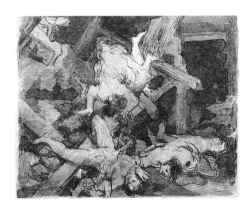

Fig. 5. Drawing for *Estragos de la guerra* (Ravages of War), *Disasters of War*, plate 30.
Pen, brush and brown wash, touched with graphite.
Prado, Madrid

Fig. 6. Anonymous, after Giulio Romano.
Prison Interior, 16th century.
Engraving.
Museum of Fine Arts, Boston, 1894 Purchase Fund

which faceless prisoners are exalted and dignified by the artist's brush.

Goya probably used his direct knowledge of Madrid's prisons for these drawings,[10] but the stony interiors rendered here are reminiscent of prisons created by earlier artists, such as in Piranesi's *Carceri* (Prisons) and in an anonymous print after a work by Giulio Romano (fig. 6).[11] The postures and the classical monumentality of some of the prisoners in the Renaissance print seem to have been echoed in Goya's drawings.

As far as the dating of this series of prints and drawings is concerned, if their relationship to the abolition of torture by the Cortes of Cádiz is accepted as valid, they would have been done sometime in the spring of 1811. The sessions on this issue led by Agustín Argüelles opened on April 2, 1811, with these words addressed to the king in absentia: "No pudiendo subsistir en vigor en el Código criminal de España ninguna ley que repugne a los sentimientos de la humanidad y dulzura que son tan propios de una nación grande y generosa . . . pido que declaren las Cortes abolida la tortura y que todas las leyes que hablan de esta manera de prueba tan bárbara y cruel como falible y contraria al objeto de su promulgación, queden derogadas por el decreto que al efecto expida Vuestra Majestad" (Because a law that contradicts feelings of humanity and clemency that are inherent to a great and generous nation cannot remain in Spain's body of law . . . I move that the Cortes abolish torture, an unreliable and self-defeating test, and that all laws authorizing such a barbaric and cruel procedure be repealed by the decree His Majesty issues to this effect).[12]

The debate was long, and certain unofficial practices were brought to light, such as the use of torture to force prisoners to confess, which persisted although it had been prohibited under Carlos III, and the use, though forbidden, of *perrillos* (manacles), known as "apremios ilegales" (illegal constraints). One of the senators proposed that the use of leg-irons and cells be continued "por ser necesarios a la seguridad de los presos" (because they are needed for the custody of prisoners).[13] The similarity of Goya's titles to those phrases is perhaps not surprising since transcripts of the debates were published.[14]

In the minutes of the April 19 session there is a paragraph in the opinion handed down by the Judicial Commission that also finds an echo in Goya's inscriptions: "Las proposiciones hechas por el señor don Agustín Argüelles sobre creación de una Junta que revea las causas criminales para que no se dilaten . . . [y la de Don Manuel de Llano] para establecer la ley de *Habeas corpus* y varios incidentes suscitados en cuanto a la seguridad personal de los presos y quejas de otros, que pasan de veinte, sobre que se les prolonga su padecer y se tienen sus causas sin curso . . ." (Don Agustín Argüelles's proposals on the establishment of a council that would review criminal cases so that they do not suffer delays . . . [and that of Don Manuel Llano] to establish the law of *habeas corpus*, and several incidents pertaining to the personal security of the prisoners and complaints by others, over twenty, on the prolongation of their suffering and that there are cases not brought to trial).[15]

M.M.M.

1. Prado, Madrid, 388; G-W 992; G., II, 163.
2. Prado, Madrid, 387; G-W 987; G., II, 163.
3. Ceán Bermúdez Album, British Museum, London; see Juliet Wilson Bareau, *Goya's Prints: The Tomás Harris Collection in the British Museum* (London, 1981), pp. 46-60 and figs. 43-45.
4. Prado, Madrid, 189; G-W 1016; G., II, 175.
5. Prado, Madrid, 436; G-W 1045; G., II, 189.
6. Juan Meléndez Valdés, *Discursos forenses* (Madrid, 1821), p. 23.
7. The Ayala and Biblioteca Nacional manuscripts are among those which so identify the woman.
8. On the trial of María Vicenta Mendicta, see Nigel Glendinning, "Goya on Women in the *Caprichos*: The Case of Castillo's Wife,"*Apollo* 107 (Feb. 1978), pp. 131-134. The rejected plate is G-W 616; H. 117; and its preliminary drawing G-W 617; G., II, 130.
9. *Actas de las Cortes de Cádiz: Antología*, ed. Enrique Tierno Galván (Madrid, 1964), pp. 51-92.
10. John Howard, *The State of the Prisons in England and Wales with Preliminary Observations and an Account of Some Foreign Prisons and Hospitals* (London, 1792), described some Spanish prisons, including those in Madrid, in all of which (though in some more than in others) there were dungeons and chains. Howard, an English philanthropist who advocated improvement in prison conditions in the late eighteenth century, wrote of the Cárcel de Corte (Court Prison): "There were various rooms in the upper floor, some with stone slabs fitted with rings that served to chain prisoners. Among these there were those with chains on both legs lying on planks in dungeons." In the Cárcel de la Villa (Town Prison) the situation was even worse: "the walls of one of [the dungeons], which was used for the odious procedure of torture, were stained with blood." Quoted by Eugenio Cuello Colón, "Lo que Howard vió en España: Las cárceles y prisiones de España a fines del siglo XVIII," *Revista de estudios penitenciarios* 1 (Apr. 1945), p. 14.
11. The engraving *Prison Interior* after a work by Giulio Romano is attributed to Giorgio Ghisi by Bartsch (15, 412, 66); see *The Illustrated Bartsch*, vol. 31 (New York, 1986).
12. *Actas de la Cortes*, p. 52.
13. Ibid., p. 54.
14. *Diario de las discusiones y actas de las Cortes*, 23 vols. (Cádiz, 1811-1813).
15. *Actas de las Cortes*, p. 66.

97

Portrait of General the Marquis of Wellington, later first Duke of Wellington
1812
Pencil and sanguine
234 x 177 mm.
Inscribed in pencil, lower margin, not by
Goya: *Lord Welingn estudio pa el retrato
/ equestre qe pintó Goya* (Lord Welling-
ton, study for the equestrian portrait
painted by Goya)
Verso: *Al espirar Fray Juan Fernandez
Augustino*[1]
References: G-W 898; G., II, 19.

Trustees of the British Museum, London,
1862.7.12.185
Spain only

The drawing is such a haunting portrait
of a hard-pressed, exhausted man that
one is compelled to examine the circum-
stances of its execution. It was acquired
by the British Museum in 1862, together
with a document by the artist's grandson,
Mariano Goya, who wrote that a small
group of prints and papers important to
Goya had been hidden away "todo el año
1818 . . . sin saberse con qe objeto" (the
whole of 1818 . . . and it is not known just
why).[2] The present work was described
as "Un dibujo hecho en Alba de Tormes
despues de la batalla de Arapiles del
Duque de Weelington [*sic*] por el qe se
hizo el retrato" (A drawing of the Duke
of Wellington for whom the portrait was
made, done in Alba de Tormes after the
battle of Arapiles).

The battle of Arapiles took place on
July 22 near the city of Salamanca, begin-
ning in midafternoon and continuing until
it was too dark to see.[3] That night Wel-
lington stayed in Alba de Tormes, a small
town lying about eight miles to the south-
east of Arapiles. He can have been there
only a few hours, for he reported in a
dispatch that the pursuit of the French
was resumed "at break of day in the
morning with the same troops."[4] It is
hard to imagine Wellington sitting for his
portrait under these conditions, and it is
likely that Goya's grandson was mistaken
and that the drawing was made in
Madrid, probably between August 12 and
September 1.[5]

Wellington reached the capital on

Fig. 1. *Order of the Bath.*
Sanguine.
Verso of *Las resultas* (cat. 158).
Museum of Fine Arts, Boston, 1951 Purchase Fund

August 12, 1812, as the French, who had
occupied the city from 1808 began their
evacuation. An early Spanish historian
with access both to living witnesses and
to state papers, Muñoz Maldonado,
reported: "Los habitantes de Madrid
enmedio de la languidez é indigencia que
los afligia, volaron al encuentro de las
tropas aliadas, disputándose el obse-
quiarlas, y poniendo á su disposicion sus
casas y cuanto poseian. La entrada de
Lord Wellington el 12 por la tarde en la
capital fue un verdadero triunfo." (The
citizens of Madrid, afflicted by exhaus-
tion and penury, rushed to meet the
allied troops, vying with one another to
give them gifts, and placing their houses
and all their possessions at their disposal.
The entry of Wellington into the capital
on the afternoon of the twelfth was a ver-
itable triumph.)[6] On August 14, the
French, still holding the Retiro on the
eastern side of the city, capitulated,[7] and
the following day parish churches were
opened so that Masses might be held, the
Constitution read and sworn to, and a *Te
Deum* sung.[8]

In addition to the devastated condition
of Madrid, Wellington had other serious
concerns. His dispatches, written during
his brief stay, indicate the enormous
complexity of planning the war on a day-
to-day basis when his forces stretched
across the whole peninsula; they also
reveal his bitter frustration at the diffi-
culty in extracting money from England
to pay troops or to care for his fever-
stricken and wounded.[9] Nevertheless he
took time to sit for Goya for a painting of
himself on horseback.[10] Surprisingly he
appears there dressed as a gentleman,
rather than as a victorious, decorated
general, although the original intention
may have been to portray him in uni-
form. Goya made a sketch of the Order
of the Bath, noting that the circle should
be crimson (fig. 1).[11]

Nigel Glendinning has shown the unre-
liability of posthumous accounts that
Wellington complained about the portrait
to Goya and that violence between two
angry men was only barely averted.[12] A
different, more credible explanation of
Wellington's show of temper was given
by the general's able chief of medical
staff, Sir James McGrigor. While Wel-
lington was sitting for his portrait,
McGrigor came to make his report on the
wounded British soldiers at Salamanca.
When he informed Wellington that to
relieve the suffering of the seriously ill he
had "ordered up purveying and commis-
sariat officers," the general angrily
accused him of acting without orders.
"His lordship was in a passion, and the
Spanish artist, ignorant of the English
language, looked aghast, and at a loss to
know what I had done to enrage his lord-
ship so much."[13] On August 26 Goya
wrote that Wellington had come to see
him the preceding day to discuss a plan
to exhibit the painting in the Real
Academia de San Fernando,"qe mani-
festo mucho gusto" (which pleased him
very much).[14] The portrait was hung in
the Academia on September 2, the day
after Wellington left Madrid.

For several reasons it appears unlikely
that the present drawing was a study for
the equestrian portrait. Surviving evi-
dence shows that it was Goya's custom to
conceive of a painting from the very
beginning in terms of paint on canvas

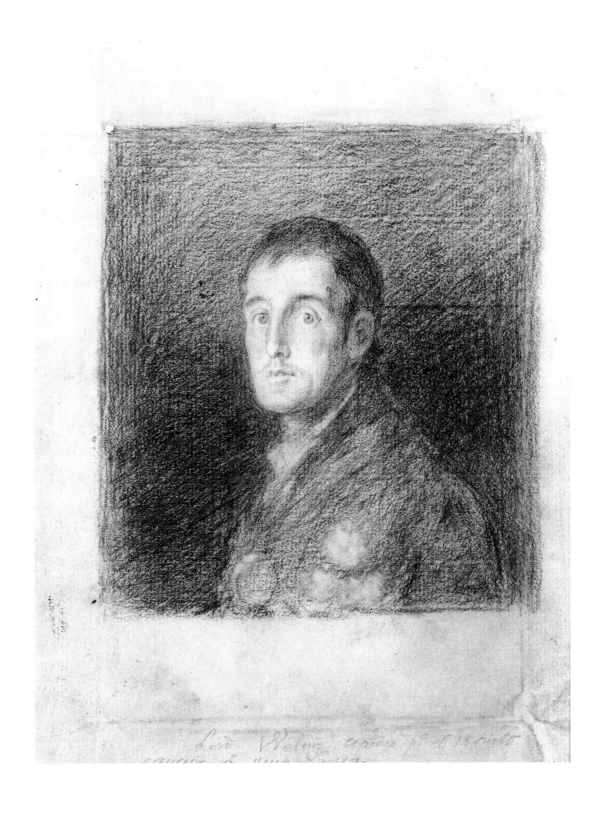

rather than in a graphic medium. Then, too, the rather finished character of the portrait, its neat rectangular background, and the empty space below suitable for an inscription all suggest that the drawing was intended to be engraved, probably by a professional printmaker. As Gassier and Wilson noted, the sheet of paper was at one time wrapped around a copper plate to transfer the drawing, although no impression from the finished plate is known.[15] The publication of a print of Wellington was only intermittently practicable. On November 2 the French reoccupied Madrid, were driven out four days later, and took it again on December 2. The following year, on March 17, they began an evacuation, although they did not leave the city permanently until May 27. A print of Wellington might have been as difficult to publish as the so-called *Disasters of War* when Fernando VII returned to Spain. On May 4, 1814, before the monarch entered Madrid, he abrogated the Constitution, nullified all laws made in his absence, and declared it was to be "como si no hubiese pasado jamás tales actos" (as though such events had never taken place).[16]

Goya left the specifics of the orders worn by Wellington to whoever might execute the print and, in the same sum-

mary fashion used in the portrait studies for *The Family of Carlos IV*, indicated by means of light and a line or two merely their size and location.[17] Showing the decorations may have been a later idea, for they seem to have been created by rubbing out and drawing over shading that was already there. Of the three badges on Wellington's breast, the uppermost is undoubtedly the Star of Bath (fig. 1). Hanging about his neck a fourth decoration is suggested, the collar and badge of the Order of the Golden Fleece. On August 30 Wellington wrote twice to his brother, Sir Henry Wellesley, Ambassador to Spain. One dispatch notes that the collar had been delivered to him by the *ministro de gracia y justicia* (minister of religion and justice). The other reassured Wellesley that he would not wear this high order proper to the Spanish royal family until he had been invested by "some Sovereign."[18] Later Wellington did not prove to be a supporter of constitutional government.

What makes Goya's portraits memorable is his ability to convey the individual spirit and intelligence of each of his subjects. Here, the artist has perceived that it is not the glory of a victory just won that preoccupies a great general but the terrible gravity of his day-to-day problems.

E.A.S.

1. G-W 1562; G., II, 375. The identification of the monk as Fray Juan Fernández de Rojas, who died between 1817 and 1819, is not in Goya's hand. The attribution of the drawing to Goya is open to question since it is drawn in an unfocused manner and lacks the strong sense of underlying bone structure visible in the *Portrait of Wellington*, recto, or in the *Head of a Dying Man* drawn in 1818 (Prado, 490), reprod. in Manuela Mena, "Un nuevo dibujo de Goya en el Museo del Prado", *Boletín del Museo del Prado* 5, no. 13 (1984), p. 50. The possibility that the drawing of the monk is a copy of the Prado drawing should be considered.

2. Note from Mariano Goya, preserved with the drawing in the British Museum.

3. See Wellington to Earl Bathurst: "There was no mistake; everything went on as it ought; and there never was an army so beaten in so short a time. If we had had another hour or two of daylight, not a man would have passed the Tormes"; *The Dispatches of Field Marshal The Duke of Wellington, during his various campaigns in India, Denmark, Portugal, Spain, The Low Countries, and France, from 1799 to 1818*, comp. John Gurwood, 2nd ed. (London, 1838), vol. 9, p. 308.

4. Wellington to Earl Bathurst, *Dispatches*, vol. 9, p. 304.

5. F.J. Sánchez Cantón, *Vida y obras de Goya* (Madrid, 1951), p. 95, dismissed Mariano Goya's statement.

6. D. José Muñoz Maldonado, Conde de Fabraquer, *Historia política y militar de la Guerra de la Independencia de España contra Napoleon Bonaparte desde 1808 á 1814, escrita sobre los documentos auténticos de lo gobierno* (Madrid, 1833), vol. 3, p. 263.

7. Wellington to Major General H. Clinton, *Dispatches*, vol. 9, p. 358.

8. The Masses are described in the *Diario de Madrid*, Aug. 15, 1812, pp. 181ff.

9. See Wellington, *Dispatches*, vol. 9, pp. 350-392.

10. Wellington Museum, London, WM1566.1948 (G-W 896; Gud. 557).

11. Sanguine, drawing, and inscription, 107 x 96 mm.; inscribed, in sanguine, in the circle surrounding the three crowns: *encarnado* (red); above the drawing, the Latin motto to be used: *[j]unta [sic] in uno tria*. Having copied the words from the circular frame on Wellington's decoration, Goya was mistaken about their correct sequence: *Tria juncta in uno*. Part of the sheet on which the order was drawn was later used for a working proof of a *Capricho enfático, Las resultas* (cat. 158); H. 192, I, 1; Museum of Fine Arts, Boston, 51.1690. This drawing has been hitherto unpublished. Wellington was required to hand back this insignia when he was given the Order of the Garter in 1813; see Brig. Sir Ivan de la Bere, *The Queen's Orders of Chivalry*, London, 1861, pp. 104, 108-110.

A technical examination of the equestrian portrait of Wellington has revealed the presence of an earlier portrait underneath, thought to be that of Joseph Bonaparte in uniform; see Allan Braham, "Goya's Equestrian Portrait of the Duke of Wellington," *Burlington Magazine* 108 (Dec. 1966), pp. 618-621.

12. The story seems to have first been recorded in an article by José Somoza, "El pintor Goya y Lord Wellington," in *Semanario pintoresco español*, 1838; see Nigel Glendinning, "Goya and England in the Nineteenth Century," *Burlington Magazine* 106 (Jan. 1964), p. 5.

13. Sir James M[c]Grigor, *The Autobiography and Services of Sir James M[c]Grigor, Bart, Late Director-General of the Army Medical Department* (London, 1861), pp. 301-302. Muriel Wellesley called attention to this account in *The Man Wellington, through the Eyes of Those Who Knew Him* (London, 1937), pp. 243-244.

14. "Ayer à estado el Exmo Sor Willington [sic] duque de Ciudad Rodrigo. Se trato de poner su Retrato al publico en esa R[l] Academia de lo q[e] manifesto mucho gusto; selo participo à V[m] para q[e] lo comunique al S[r] D[n] Pedro Franco y se pueda determinar en la sala q[e] se juzgue con mas decoro: Es un obsequio à S.E. al publico. No tengo tiempo p[a] nada disimue V. a su af[mo]. Fr[co] de Goya." Reprod. in William Ruck et al., *La coleccion Lázaro de Madrid* (1926), p. 1, p. 219. The date is given by Lord Gerald Wellesley and John Steegmann, *The Iconog-raphy of the First Duke of Wellington* (London, 1935), p. 14.

15. G-W, p. 253, note to 898. The rectangular background is so even that it may have been reworked by a different hand, possibly by the person who was to engrave it. A comparable example of a reworked background can be seen in Goya's small self-portrait of about 1783, Museum of Fine Arts, Boston; G-W 202; G., II, 316.

16. Decreto de Valencia; see Fernando Diaz-Plaja, *El siglo XIX*, La Historia de España en sus documentos (Madrid, 1954), p. 135.

17. See the five studies in the Prado, Madrid, 729-733; G-W 784-788; Gud. 428-432.

18. Wellington to the Right Hon. Sir Henry Wellesley, K.B., *Dispatches*, vol. 9, p. 388. The Golden Fleece is normally shown hanging from a jeweled pendant featuring a burst of flames, as seen, for example, in the *Equestrian Portrait of Carlos IV* of 1799 or the great *Family of Carlos IV* of 1800-01, where Fernando, Príncipe de Asturias, the king, and Luis de Borbón, Príncipe de Parma, all wear it; Prado, Madrid, 719 and 726, respectively; G-W 776; Gud. 422 and G-W 783; Gud. 434.

The Fleece is not fixed to a round platter like a lamb, as depicted in a copy of Goya's drawing in the Kunsthalle, Hamburg (38547; G-W 899; G. II, 20). There are additional reasons to doubt the genuineness of this piece. Where the individual lines in the British Museum drawing show energy and purpose, those in the Hamburg version appear weak and often tentative; Goya's forms, which are conceived in terms of light and shadow, have a robust sense of volume in striking contrast to the general cardboard flatness of those in the copy.

Album C: Inquisition Drawings

On the eighty-fifth sheet of *Album C*, Goya began a series of thirty drawings (of which twenty-nine are known to us) dealing with the physical, mental, and spiritual punishment and degradation inflicted on individuals by those in society who abuse the powers entrusted to them. At least fifteen clearly represent or implicate the Santo Oficio de la Inquisición (Holy Office of the Inquisition), the ecclesiastical tribunal established in the Middle Ages dedicated to the purification of the Roman Catholic faith through the elimination of heresy.[1] Others refer in a more general way to various aspects of pain and persecution, demonstrating how the human spirit and dignity are maintained or lost in the face of them. In these, the Inquisition's role is only inferred by the context. Throughout the sequence Goya's focus is on the victim rather than the prosecutor, but his concern is not with the innocence or guilt of the individual but with the effects on the individual of a system that was both outmoded and unjust.

At approximately the same time that he worked on this album, Goya painted five works on panel addressing a related theme: the various ways in which humans can be diminished, degraded, or simply diverted by society's institutions and customs. One of the subjects is an Inquisition scene (fig. 1). The other subjects depicted are a procession of flagellants (cat. 172, fig. 2), a madhouse, a bullfight in a village, and the carnivalesque rite of the Burial of the Sardine (cat. 136, fig. 1).[2] In the painting of the Inquisition, Goya represented the ceremonial reading out of charges and declaration of penitence against those found to be guilty. By the eighteenth century, this procedure, called an *autillo*, usually took place within a church or other public place, rather than as part of an immense, spectacular ceremony conducted in a city square, as had been the case in earlier days when it was called an *auto de fe* (literally, act of faith). (See cat. 98 on the *auto de fe*.) Judging by the costume of the notary or secretary who is recording the case, the scene seems to be set at a time earlier than that of the painting's execution. The other paintings in the

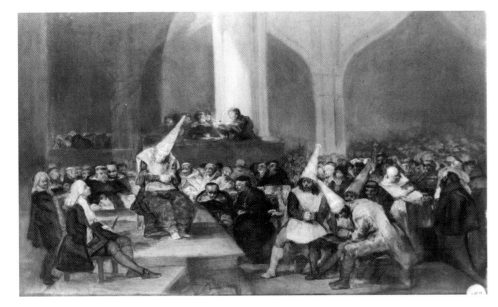

Fig. 1. Inquisition Scene, 1812-1814.
Oil on panel.
Real Academia de Bellas Artes de San Fernando, Madrid

group also deal with conditions of an earlier period, rather than the events of 1812-1814. Nevertheless, the sense of observed space, the attention to the details of judicial procedure, and the variety of clerical demeanor and costume give the Inquisition scene an air of documentary reality. Goya's figures in the *Album C* drawings, in the modeling of form and their proportions and gestures, appear to have been taken directly from this painting.

How can we view Goya's drawings of the Inquisition in this album? The Inquisition's influence was considerably diminished after the mid-eighteenth century, and it confined its jurisdiction primarily to cases of superstition and "proposition" (verbal offenses indicating wrong belief, such as blasphemy) and, in the 1790s at royal behest, to censorship of revolutionary materials from France.[3] Although many enlightened and liberal writers and governmental ministers were denounced to the Holy Office for "philosophism" or "Jansenism," almost all were never tried or their cases were unproved because of insufficient evidence.[4] Inquiries in these cases were usually handled in private, and when penalties were imposed, they usually involved spiritual penance.[5] In

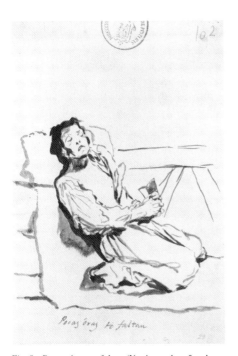

Fig. 2. *Pocas óras te falten* (You've only a few hours left), *Album C*, p. 102.
About 1810-1814.
Brown and gray wash.
Museo del Prado, Madrid

fact, by the end of the century, the Inquisition in Spain rarely proceeded against individuals denounced for heresy, with the notable exception of the case of the reformer Pablo Olavide, from Peru, in 1776-1778.[6] Thus, while it is clear that the Inquisition had little bite, it was perceived by many as an instrument that could be utilized for the harassment and persecution of those whose ideas seemed to threaten its existence, the monarchy, or traditional order.

Throughout the tribunal's history, many Spaniards, cognizant of its propensity for abuse, had debated the value of the Holy Office as an effective and just protector of the Catholic faith.[7] In the 1790s, in an atmosphere of dissent generated by royal and ecclesiastical power struggles, the reform-minded and enlightened Inquisitor General Manuel Abad y Sierra had commissioned a history of the institution.[8] During the Constitutional debates of 1810-1812, Spaniards were again engaged in heated discussion about whether the Holy Office should be revived after its abolition by the usurper José Napoleon in 1808. After the enactment of the Constitution in March 1812, which did not outlaw the Inquisition, the debates continued. From the Inquisition's inception in Spain in the late fifteenth century, heterodoxy had been viewed with varying degrees of zeal as a threat to the stability of the nation.[9] Roman Catholicism as the state religion had never been called into question by Napoleon's Bayonne Constitution of 1808 or that enacted by the Cortes (parliament) at Cádiz in 1812. Liberal thinkers, however, called for the abolition of the Inquisition as no longer necessary for the preservation of the nation's political or spiritual well-being and several of them voiced their opinions with eloquence. One of these was Juan Antonio Llorente, the former secretary to the Inquisition, who had been asked in 1793 by Abad y Sierra to write a discourse on the procedures of the Holy Office, and whom Goya painted in 1810 (see cat. 73). Under José Napoleon, Llorente's earlier effort (which had been set aside because of political expedience) was revived for the Real Academia de la Historia, to which he delivered an address on the subject in

1810. This was published in 1812 as *Memoria histórica sobre qual ha sido la opinión nacional de España acerca del tribunal de la Inquisición* (A Memorial, in which the Opinion of the Spaniards Concerning the Inquisition Is Examined).[10] One of his primary arguments was that since the tribunal conducted its proceedings in secrecy, it was beyond scrutiny and therefore prone to abuse its powers.[11] Another urgent and eloquent argument against the Inquisition came from Antonio Puigblanch, whose influential *L'Inquisición sin Máscara* (The Inquisition Unmasked), written originally as a series of pamphlets under the pseudonym Natanael Jomtob, was published in Cádiz in 1811. One of Puigblanch's main contentions was that the Holy Office was not worthy of the task of serving as the state's guardian of religion and that its powers should be transferred back to the bishops from whom they were taken in the Middle Ages.[12]

One of the foremost contributions to the constitutional debates within the Cortes was made by Antonio José Ruiz de Padrón, a parish priest and deputy to the Cortes of Cádiz from the Canary Islands. Ruiz de Padrón's address to the Cortes was published in Cádiz in 1813 as *Dictamen del Dr. Antonio José Ruiz de Padrón sobre el Tribunal de la Inquisición* and in English as *The Speech . . . of January 18, 1813, Relative to the Inquisition* (Mediterranean, 1813). Ruiz de Padrón centered his arguments on three main points: he declared that the Inquisition was ineffective as a deterrant to heresy, used illegal methods according to the Constitution, and was against God's laws since it had not been ordained in the Scripture.[13]

Goya's drawings from *Album C*, in which the Inquisition figures in the persecution of individuals, can be viewed as part of the polemical struggle to abolish this institution. He may have begun them as early as 1810, the year in which Llorente addressed the Real Academia de Historia. His primary concerns appear to be twofold: the toll or effect of persecution on the individual human being and the broader idea of specific freedoms curtailed. Like the authors Puigblanch and Ruiz de Padrón, Goya

made use of a number of literary and rhetorical conventions of the time: repetitive language patterns, insinuation, ambiguity, ridicule, irony, and hyperbole.[14] Unlike the historian Llorente, he did not illustrate details of specific cases with factual accuracy. But in his own way, he was equally persuasive in his use of history to serve truth by calling forth as examples of injustice past cases of the persecution of celebrated historical figures.[15] Demonstrating the effect of spiritual and physical pain on the human spirit, these particular cases – Galileo (cat. 102), the physician Zapata (cat. 106) and the Italian sculptor Torrigiano[16] – vivify and punctuate his pictorial essay, as well as give it an air of credence.

The drawings within this sequence have both a visual and literary cohesiveness. For example, Goya's captions unify several of the drawings that deal directly with the Inquisition's methods of inquiry. When we examine the group that employs as its captions the judicial declaration of charges, as in *P^r haber nacido en otra parte* (cat. 98), in *P^r linage de Ebreos* (For Being of Jewish Ancestry (cat. 99), or in *P^r Liberal?* (For Being a Liberal?) (cat. 104), it is apparent that Goya, using mocking ridicule as only one of his weapons, is attacking the judicial system of the Holy Office and exposing the inherent injustice of combining in one body the function of both judge and jury. Viewing the images together with these captions, we are immediately aware of the enormous disparity between the relatively minor offense and exceedingly harsh penalty.[17] A recurrent theme is the unjust and unreasonable abridgement of human liberties. These freedoms, not taken for granted anywhere in Europe at the time, were a central issue in the constitutional debates in Spain.

The drawings of victims of injustice perpetrated by the Inquisition are arranged within the album with a sense of dramatic structure and progression. They can be divided loosely into three groups. The first, represented here by cat. 98-101, deals with trial and punishment. The second, of which cat. 104-106 are examples, depicts forms of enslavement. The final group anticipates release, either through death, as in *Pocas*

óras te faltan (You've only a few hours left) (fig. 2), *Mejor es morir* (It's better to die),[18] and *Muchas viudas an llorado como tu* (Many widows have wept like you),[19] or through freedom (cat. 105). There is an ebb and flow in this last group until it moves from *Pronto seras libre* (Soon you will be free)[20] to a culmination in the first sheet of the constitutional series, *Divina Libertad* (cat. 107). Only through the guarantees of freedom of the press and constitutional law are human freedom and true justice achieved.

Goya's drawings in this sequence, like many of his other works, can be elucidated in relation to the philosophical ideas and reform movements of his day. But if they are perceived fully as artistic entities, they cannot be explained entirely as illustrations of history, journalistic depictions of current events, or expositions of contemporary ideas held by others. The Inquisition drawings are relatively straightforward in their language and imagery compared with some of Goya's more complex and ambiguous compositions such as the *Disparates* (cat. 137-143) and the *caprichos enfáticos* of the *Disasters of War* (cat. 154-163). But even these drawings still seem to defy precise analysis and cannot be identified exactly with a particular historical phase of the Inquisition. The content and ideas expressed in the drawings are not wholly dependent on those of his contemporaries, such as the documented history of Llorente or the persuasive, polemical arguments of Puigblanch and Ruiz de Padrón. Study of them in relation to historical evidence about the Inquisition reveals that they do not accurately represent either past or contemporary practices of the Inquisition. Goya's ideas about and images of the Inquisition are original in conception as well as execution. He created a unique visual essay, with a historical perspective, on an institution he viewed as inherently cruel and unjust. That Goya's drawings are also enduring and masterful artistic creations with universal themes that go beyond their subject matter marks his true genius.

S.L.S.

1. The Inquisition was not formally introduced into Spain until 1480, by Fernando and Isabella. On the origin of the Inquisition in Spain, see Kamen, *Inquisition*, pp. 6-43.

2. These five panels are in the Real Academia de Bellas Artes de San Fernando, Madrid (G-W 966-970).

3. Llorente, *Inquisition*, pp. 546-548; Lea, *Inquisition*, vol. 3, pp. 540-545, vol. 4, pp. 390-391; Herr, *Revolution in Spain*, pp. 239-267; and Callahan, *Church*, pp. 32-36.

4. Among those who were denounced, but whose cases were unproved, were Feijóo (heresies and iconoclasm); T. Iriarte (anti-Christian philosophy), Meléndez Valdés (reading prohibited philosophical works); the Condesa de Montijo (Jansenism), Conde de Aranda (philosophism); José Nicholas de Azara (philsophism); Campomanes (anti-Catholic philosophism); Jovellanos (Jansenism and being an enemy of the Inquisition); because of court intrigue Jovellanos was banished by Carlos IV); Floridablanca (for being an enemy of the Inquisition). In many of these cases, the individuals were under royal protection, and the Inquisition did not dare press too far; Llorente, *Inquisition*, pp. 277-371.

5. Severe penalties for philosophism were confiscation and banishment. Llorente (*Inquisition*, pp. 548-549) mentions only one individual during this period who received such treatment from the Inquisition. This was Don Bernardo-María de Calzada, who translated French books and wrote in a satirical vein; he suffered confiscation of property, banishment from Madrid, and loss of social position.

6. Olavide's philosophism seems to have been elevated to heresy for political reasons; on the important implications of his case for writers of the period, see Llorente, *Inquisition*, pp. 342-343; Lea, *Inquisition*, vol. 4, pp. 308-311; Herr, *Revolution in Spain*, pp. 209-210; Cecil Roth, *The Spanish Inquisition* (New York, 1964), pp. 254-256; Callahan, *Church*, pp. 34-35; and Kamen, *Inquisición*, pp. 337-340.

7. Kamen, *Inquisition*, pp. 44-61, 257.

8. Llorente, *Inquisition*, pp. 369, 546-565; Lea, *Inquisition*, vol. 4, pp. 386-395.

9. Callahan, *Church*, p. 82; Kamen, *Inquisition*, pp. 74-75.

10. Also published in 1812-1813 were the two volumes of Llorente's *Anales de la Inquisición* (Annals of the Inquisition), which covered the years 1477-1530. His *Histoire critique de l'Inquisition d'Espagne* was first published in 4 volumes in Paris, 1817-1818; in Madrid, in 1822, it was published in 10 volumes as *Historía crítica de la Inquisición de España*; in London, in 1826, an abridged version was issued in 1 volume as *The History of the Inquisition of Spain*.

Since Llorente had access to Inquisition archives, his accounts, for the most part, are considered reliable. However, his statistics relating to numbers of victims are very much exaggerated according to the calculations of the most reliable modern writers; Lea, *Inquisition*, vol. 4, pp. 517-518, 524; Glendinning, *Eighteenth Century*, p. 5; and Kamen, *Inquisition*, p. 369.

11. Llorente, *Inquisition*, p. 357.

12. Puigblanch, *Inquisition*, p. 9. Puigblanch's book was published in 2 volumes in 1816-1817 in London, under his own name, with the title *The Inquisition Unmasked, Being an Historical and Philosophical Account of That Tremendous Tribunal, Founded on Authentic Documents and Exhibiting the Necessity of Its Suppression as a Means of Reform and Regeneration*.

13. A similar plea came from the liberal deputy Manuel García Herreros, "Discurso sobre la abolición de la Inquisición, 9 de enero de 1813," in *Escritores Políticos Españoles 1780-1854* (Madrid, 1975).

14. On Spanish literary styles of the eighteenth century, see Glendinning, *Eighteenth Century*. On Goya's relationship to some of these styles, see Nigel Glendinning, "A Solution to the Enigma of Goya's 'Emphatic Caprices,'" *Apollo* 107 (Mar. 1978), pp. 186-191; idem, "Changing Patterns of Taste in Goya's Time," in Collection Thyssen Bornemisza, Lugano, *Goya in spanischen Privatsammlungen* (exhib. cat.) (1986), pp. 46-65.

15. It was characteristic of the polemic of some these writers to speak of past abuses as if they were still a current problem. See Lea, *Inquisition*, vol. 4, p. 405, on Puigblanch; see also cat. B37 on Ruiz de Padrón.

16. *"No comas celebre Torregiano,"Album C,* page 100, Prado, Madrid, 339 (G-W 1336).

17. The same phrasing and connotation are found in one of the etchings in the *Disasters of War*, pl. 34, *Por una navaja* (For Carrying a Knife) (cat. 87, fig. 1), which also depicts the overzealous punishment of an individual.

18. *Album C*, p. 103, wash, Prado, Madrid, 341 (G-W 1339).

19. *Album C*, p. 104, brown and gray wash, Prado, Madrid, 354 (G-W 1340).

20. *Album C*, p. 114, brown and gray wash, Prado, Madrid, 355 (G-W 1349).

98
***Pr haber nacido en otra parte* (For Having Been Born Elsewhere)**
Album C, page 85
About 1810-1814
Brush and brown wash heightened with pen and brown ink
206 x 145 mm.
Inscribed in brush and brown, upper right: *85*; in pen and brown ink at bottom of drawing: title
References: G-W 1321; G., I, 230.

Museo del Prado, Madrid, 309
United States only

Goya introduced his sequence on judicial abuse in *Album C* with a drawing of a woman in a posture of anguished shame, wearing the Inquisition's garments intended to purify and bring about penitence: the *sanbenito* (scapular) and *coroza*, a tall conical cap. In all probability Goya intended her as the condemned at an *auto de fe* (act of faith), the ceremony, usually public, at which charges were read out and punishments declared. The flames depicted on her *sanbenito* and the fire leaping up and beginning to burn the platform at her feet convey that the penalty for her offense was death by fire, the form of capital punishment reserved for impenitent or relapsed heretics.

Goya's caption declares that the woman is being persecuted for being of foreign birth. But since being a foreigner was obviously not a crime in Spain, the viewer becomes immediately aware of an enigmatic tension between the words and image. Neither fully explains the other, nor can either be taken literally. In addition to ambiguity, irony is expressed because the words borrow the very language of that which Goya is criticizing. The succinct phrase *Pr haber nacido en otra parte* is characteristic in syntax and style of many titles throughout the series; it takes on the accusatory tone of the inquisitors themselves. On Page 89 of the album, *Pr mober la lengua de otro modo* (For Wagging His Tongue in a Different Way) Goya showed an *auto de fe* at which a *fiscal* (prosecutor) is reading out the charges against someone whose "wrong" beliefs had been signaled by

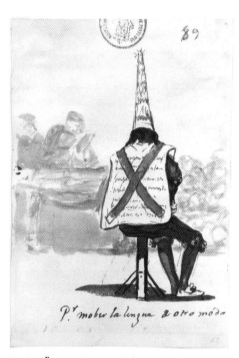

Fig. 1. *Pr mober la lengua de otro modo* (For Wagging His Tongue in a Different Way), *Album C*, p. 89. Brush and brown wash.
Museo del Prado, Madrid

verbal utterances (fig. 1). This phrasing of the captions, beginning with *Pr* (contraction for *Por*; Because or For) is echoed eleven times throughout this sequence of drawings, unifying the images and creating a dramatic, resonant impact that reverberates with a solemn and chilling effect.[1]

The drawing *Pr haber nacido en otra parte*, as is true of other works in this group, does not represent with strict accuracy the practices of the Holy Office, either in the past or in Goya's own day.[2] Because the tribunal's proceedings were to a great extent conducted in secrecy, Goya would not have had extensive first-hand knowledge of how cases were handled. He would therefore have relied on written accounts, more or less accurate, and perhaps conversations with the former secretary of the Inquisition, Juan Antonio Llorente, whom he painted in 1810 (cat. 73). By the mid-eighteenth century, the *autillo*, the act of faith conducted privately, had replaced the more spectacular public ceremony of the *auto de fe*.[3] In the past, burnings, which were

conducted under secular authority, took place at locations quite separate from the *auto de fe*, outside the city walls.[4] Those condemned to death were tied to a stake. In most cases, because they repented at the last minute, they were not burned alive but garroted first. In other instances, because the victim had escaped or died, effigies or bones were cast onto the flames. The *sanbenito* and *coroza* were removed prior to execution, and the former was placed in the accused's parish church as a reminder of the infamy and shame to be borne by the family and community for generations.[5] During the reign of Carlos III (1759-1788) there were only four burnings and after that, none.[6] The last, for the heresy of following the ideas of the mystic Miguel de Molinos took place in Seville in 1781.[7]

Goya's drawing is thus not a factually accurate creation but an artistic evocation of a past situation. It was executed in the same polemical spirit as some of the written arguments against the Inquisition during the debates prior to and after the enactment of the Constitution of 1812. For example, the deputy to the Cortes, A.J. Ruiz de Padrón, asserted that the Holy Office, arrogant and unmerciful, was an unworthy guardian of the nation's religious security and spiritual health; in particular, its brutal treatment of heretics was incompatible with the teachings and virtue of Jesus Christ.[8]

Goya's tone of bitter irony in declaring the crime to be foreign birth and his frightening depiction of impending immolation make the viewer acutely aware of how excessive he considered the death penalty to have been for the heresy of Protestantism. Undeniably, in the sixteenth and seventeenth centuries, thousands of Spaniards had been sentenced to death at the stake for refusing to abjure beliefs (in this case, Protestant) considered to be heretical. There were enough instances of the denunciation of foreign sailors and traders to the Inquisition for heresy (some were imprisoned and tortured, a few even received death sentences) to give Spain the reputation of being unsafe for avowed non-Catholics to travel or to settle in.[9] Goya's caption is especially insightful in that when taken at face value it exposes a historical truth:

that much of the Inquisition's persecution of foreigners can be attributed to the political strife that existed between England and Spain at the time of the Counter Reformation in the mid-sixteenth century.[10]

Goya incorporated many rich ideas about justice and humanity into this simple composition. The female figure is a shining beacon of light against the dark, smoky shadows that literally and figuratively oppress her.[11] Her stance communicates a sense of deeply personal shame. It is not clear whether this woman has abjured at the last moment and whether this is the source of her humiliation. Nevertheless she is unfettered; she is neither given over to terror nor cowering in fear and thus retains a measure of dignity. In his title, as well as in his depiction of the figure, Goya expressed the utter futility of persecuting an individual for something beyond her control. His drawing can be seen as an indictment of a total system of justice that tries to hold people accountable for what they cannot decide. For Goya, the Inquisition's ability to instill fear through its secret proceedings and the threat of torture and death was intolerable. He used its language, props, and accoutrements as verbal and visual metaphors and symbols of power gone awry.

<div align="right">S.L.S.</div>

1. This judicial syntax, which communicates both the crime and the alleged reason for the accused's predicament or circumstances, is used by Goya on pages 85-90, 92-94, 96, and 98 of *Album C* (G-W 1321-1326, 1328-1330, 1332, 1334). Goya had used it previously to indicate punishment meted out or misfortune as a consequence of certain actions in *Caprichos* plate 32, *Por que fue sensible* (Because She Was Susceptible) and on the first page in this album, *P.r no trabajar* (For Not Working) (cat. 76). It also occurs in the title of plate 34 of the *Disasters of War*, *Por una navaja* (For Having a Knife) (see cat. 87, fig. 1). This construction is employed for the enumeration of charges found throughout Inquisition documents (see, for example, the records pertaining to various *autos de fe* in Lea, *Inquisition*, vol. 1, appendix XII, pp. 592-611).

2. By contrast, in the *Caprichos*, plate 23, *Aquellos polbos* (Specks of Dust) (G-W 498), and plate 24, *Nohubo remedio* (Nothing could be done about it)

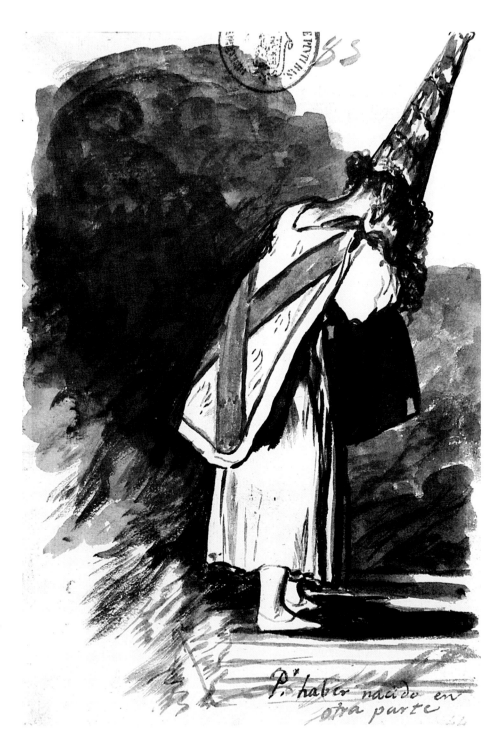

(G-W 499), Goya had presented the practices of the Inquisition with greater attention to realistic detail.

3. Llorente, *Inquisition*, p. 545; Lea, Inquisition, vol. 3, p. 220.

4. Lea, *Inquisition*, vol. 3, p. 220; Kany, *Life and Manners*, p. 110; Kamen, *Inquisition*, p. 194.

5. Until the late eighteenth century, when the practice was discontinued, *sanbenitos* were replaced when they deteriorated with age; Kamen, *Inquisition*, p. 123. A frequent penance imposed by the Holy Office on the guilty was the wearing of the *sanbenito* in public for a designated period of time; Lea, *Inquisition*, vol. 3, pp. 162-172.

6. Kamen, *Inquisition*, p. 189, whose source is Jean Antoine Llorente, *Histoire critique de l'inquisition d'Espagne* (Paris, 1817-1818), vol. 4, p. 92.

7. Callahan, *Church*, p. 33; see also Lea, *Inquisition*, vol. 4, pp. 89-90, 241, n. 5.

8. This idea is contained in Ruiz de Padrón's third proposition, that "the tribunal of the Inquisition, is not only prejudicial to the State, but also contrary to the evangelical spirit it was intended to defend"; see *Inquisition*, p. 2, and for the elaboration of this point, pp. 20-35.

9. Lea, *Inquisition*, vol. 3, pp. 457-479; Kamen, *Inquisition*, pp. 77, 215-218.

According to Llorente, the mid-sixteenth century "trial of Juan Gil, Bishop of Tortosa, so much alarmed many Lutherans that they quitted the kingdom"; *Inquisition*, p. 196, also pp. 165-169, on the trial. See also Llorente, *Inquisition*, pp. 223-225, on cases of wealthy foreign travelers in Spain bothered by the Inquisition. By his accounts, three traders refused to abjure their Protestant beliefs and were burned alive.

10. See Kamen, *Inquisition*, pp. 65-77, 217. Lea's chapter on Protestantism, *Inquisition*, vol. 3, pp. 411-479, indicates how much the attitude of the Holy Office toward foreigners was tied to historical events. Cecil Roth, *The Spanish Inquisition* (New York, 1964), in his chapter "The Protestant Martyrs," pp. 163-183, also touched on the political reasons for the persecution of Protestants in Spain as well as on inflated accounts by Northern Europeans of the extent to which this happened.

11. See M. Mena, in Brussels, 1985, no. 17, on Goya's use of the female subject as a tribute to the heroines of the Peninsular War.

99

P^r linage de ebreos (For Having Jewish Ancestry)
Album C, page 88
About 1810-1814

Brush, brown and gray wash, touched with very dark black-brown wash
204 x 142 mm.
Inscribed in brush and gray brown, upper right: *78* altered to *88*; in pen and brown ink, below image: title
References: G-W 1324; G., I, 233.

British Museum, London, 1862.7.12.187
Spain only

On the two album pages immediately preceding this, Goya represented individuals as the subjects of Inquisitorial proceedings. Solitary figures at an *auto de fe*, one humbled, the other still defiant, they are the objects of intense and glaring scrutiny, accentuated by an isolating bright light (see cat. 100, figs. 1 and 2). The victims of Inquisitorial persecution Goya drew on this sheet, *P^r linage de ebreos,* are *conversos*, converts to Christianity or their descendants, whose Jewish heritage made them suspect of "following the laws of Moses" or Judaizing, engaging in practices or rituals considered to be Jewish.[1] A long procession of figures in penitential garments of *sanbenito* (scapular, from *saco bendito* [sacred sac]) and *coroza* (conical cap) is depicted filing out from what we can assume is a prison. They walk in deep shadows between what appears to be an *alguacil* (a rather high executive officer of the Inquisition with the powers of constable or bailiff), with his wand of office, and a *fraile* (friar), who would be attempting to extract a final conversion or repentance.[2] The drawing of condemned in parade has an implicit dimension in time, as well as space. For the mark of the infamy of having Jewish ancestry was passed on for generations.

As in the previous sheets, there is a tension between the irony of the words and the straightforward poignancy of the image. Goya's words are a mocking distillation of the charge and serve to emphasize the insignificance of the offense: a mere matter of ancestry. To many Spaniards at that time, the word *linage* would have suggested the idea of *limpieza de sangre* (purity of blood), which at certain times the Spanish Inquisition concerned itself with preserving. The idea that a person's worth, even honor, derived from "untainted blood" (belonging to a family that could prove no intermarriage with Jews or Moors) provoked controversy throughout Spanish history. Inquisitors and Church theologians vehemently argued both for and against its value for Spanish society.[3] One of the central challenges of Spanish Enlightenment was to redefine the meaning of honor by examining what contributed to a person's worth (see cat. 138, 140, 144, 145).

By the end of the eighteenth century, there were virtually no Jews in Spain, and Judaizing was merely a curiosity.[4] However, some offices and privileges were still barred to known *conversos*. Carlos III's prime minister, Count Floridablanca (see cat. 4) denounced as unjust the practice of discriminating against those known to have Jewish ancestors: "They [penalties for impurity] punish a man's sacred action, that is, his conversion to our holy faith, with the same penalty as his greatest crime, that is, apostasy from it."[5] Similar words were written in 1798 by Carlos IV's secretary of religion and justice, Gaspar Melchor Jovellanos (cat. 30), who castigated the Inquisition for its treatment of *conversos*: "From this arose the infamy that covered the descendants of these conversos, who were reputed infamous by public opinion. The laws upheld this and approved the statutes of *limpieza de sangre*, which kept out so many innocent people not only from posts of honour and trust but also from entering churches, colleges, convents and even unions and trade guilds. From this came the perpetuation of hatred not only against the Inquisition but against religion itself."[6]

There is a compositional similarity between Goya's drawing and traditional representations of the *Ecce Homo*, Christ depicted in the garments of his humiliation, purple robe and crown of thorns, at the moment when he is presented by Pilate to the people for judgment (John 19:5) (fig. 1).[7] Goya thereby drew an analogy between Christ's public humilia-

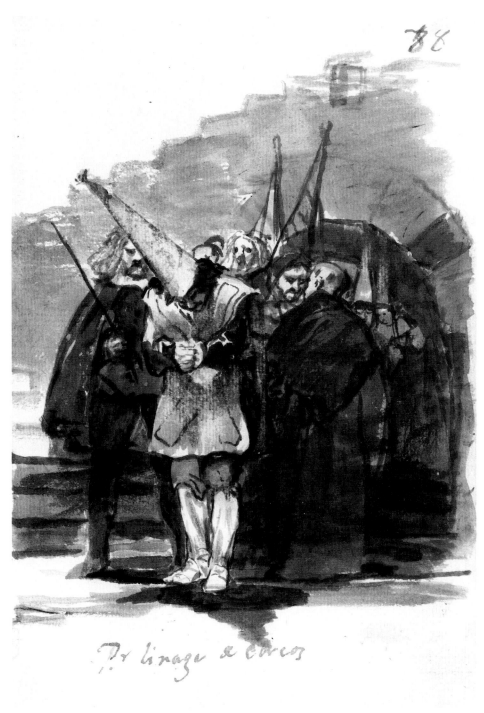

Fig. 1. Lucas van Leyden,
Christ Presented to the People, 1509.
Engraving.
Museum of Fine Arts, Boston, Gift of George Peabody
Gardner

tion and that of the *conversos* at the hands of the Inquisition. *Pr linage de ebreos* also recalls in a general way Goya's earlier treatment of *El prendimiento de Cristo* (The Taking of Christ) (cat. 29). A.J. Ruiz de Padrón, a deputy to the Cortes, in his ardent speech of 1813 directed at the suppression of the Inquisition, expressed a similar idea when he contended that Jews, like Jesus, are descendants of Abraham and are "an authentic and eternal testimony of the truth of the sacred Scriptures."[8] Ruiz de Padrón continued: "And who has given the inquisitors the power to destroy, with fire and sword, this dispersed people, whom God will assuredly preserve until the consummation of time? If any Jew is discovered among us, and he commits a crime, let him be punished by the laws of the State, but not hung by a pulley, nor tortured on the rack, neither let him be cast into the flames merely because he is a Jew."[9]

S.L.S.

1. After the first half of the eighteenth century, the number of cases of Judaizing handled by the Inquisition was extremely small (there were sixteen during the years 1780-1820); see Lea, *Inquisition*, vol. 3, pp. 308-311.

2. For two eighteenth-century accounts of such processions connected with an *auto de fe*, as well as further information on the procedures associated with Inquisitorial trial and punishment, consult Kamen, *Inquisition,* pp. 178-197. These practices are treated in greater detail in Lea, *Inquisition,* vol. 3, pp. 209-229. According to most accounts, the *familiar,* not the *alguacil,* was present for these processions from prison to the *auto de fe.* The latter executive officer of the Inquisition was present when the penitents were conducted back to the prisons. This discrepancy between Goya's depiction and what is considered to be accurate information taken from archival documents and eyewitness accounts is only one of many pieces of evidence that Goya's drawings are artistic creations, not to be taken as historical documents of Inquisitional practices.

3. See Kamen, *Inquisition,* pp. 124-133, 257-258.

4. Ibid., p. 132.

5. Ibid., for which the source is Antonio Domínguez Ortiz, *Los conversos de origen judío después de la expulsión* (Madrid, 1957) p. 129, n. 14.

6. G.M. de Jovellanos, "Representación a Carlos IV sobre lo que era el Tribunal de la Inquisición," in *Obras* (Madrid, 1956), vol. 5, pp. 333-334, quoted from Kamen, *Inquisition,* p. 258.

7. This observation was made in Hamburg, 1980, p. 185.

8. Ruiz de Padrón, *Inquisition,* p. 47.

9. Ibid., p. 48.

100

***Por no tener piernas* (Because He Had No Legs)**
Album C, page 90
About 1810-1814
Brush with dark brown and gray wash
205 x 144 mm.
Inscribed in brush and brown, upper right: *80,* crossed out; in brush and gray brown, slightly higher to the right: *90;* in pen and brown ink, bottom of image: title, written over: *yo lo conoci á este baldado q.^e no tenia pies, / y dicen q.^e le pedia limosna al cura,* then indicated as an insertion: *cuando salia de Zaragoza,* and continuing: *y en la calle de Alcala cuando entraba lo encontraba pidiendole*
References: G-W 1326; G., I, 235.

Museo del Prado, Madrid, 314
United States only

Goya depicted a crippled man perched on a pedestal as the accused at an *auto de fe* of the Spanish Inquisition. The terse comment as caption, *Por no tener piernas* (Because He Had No Legs), which can be interpreted as both a charge brought by the Holy Office and the reason for his humiliation, was written over a longer legend: "I knew this cripple who had no feet, and they say that he was asking alms of the priest when he was leaving Zaragoza and when he arrived on the calle de Alcala [in Madrid] he found him begging." Goya gave this event an air of credibility with the assertion that this man was known to him. But then doubt is immediately cast by the use of the rhetorical device "they say" (*y dicen*) to suggest the extent to which rumor and credulity played a part in the evidence brought before an Inquisitorial inquiry. A previous sheet, page 87, *P^r q^e sabia hacer / Ratones* (Because She Knew How To Make Mice) (fig. 1) indicates similar so-called evidence by a witness. It is incorporated within the image, in the form of the charges the Inquisition inscribed on the accused's *sanbenito: Le pusie / ron mor / daza p^r / q^e habla / ba / y le di / eron palos / en la / cara // Yo la bi / en Zaragoza á Orosia Moreno* (They put a gag on her because she talked, And hit her about the head. I saw her in Zaragoza, Orosia Moreno). Given the

Fig. 1. *P^r q^e sabia hacer Ratones* (Because She Knew How To Make Mice), *Album C,* page 87. Brown wash. Museo del Prado, Madrid

Fig. 2. *Por traer cañutos de Diablos de Bayona* (For Carrying Diabolical Tales from Bayonne), *Album C,* page 86. Brown wash. Museo del Prado, Madrid

historical evidence, it does not seem likely that Goya could have encountered the crippled man or Orosia Moreno under the precise circumstances conveyed in the drawings.[1] It thus seems reasonable to suppose that Goya was employing the first-person singular in his captions as a literary device.

The shamming, fraudulent behavior often associated with begging at that time was not a concern of the Inquisition (see cat. 76). In *Por no tener piernas* it is likely that Goya had intended the accused beggar as someone denounced on trumped-up charges of sorcery or witchcraft (transporting himself from Zaragoza to Madrid).[2] The priest (to whom Goya alluded), seeing beggars with no feet in both cities, supposes that it is a single person who has traveled with supernatural powers. But the circumstances revealed and implied here and in *Pr qe sabia hacer Ratones* are not compatible with the available evidence about Inquisitorial procedures relating to witchcraft and sorcery during Goya's lifetime. There were only four witchcraft trials in Spain from 1780 to 1820, and while sorcery cases abounded (469 during the same time period), the accused were almost always imposters who made impossible claims of supernatural feats or duped the gullible with cures and love potions. Public *autos de fe* such as Goya drew belonged to the past. The Holy Office as well as enlightened liberals desired to root out the credulity and superstition that was a particular problem among clergy and laity in poor rural areas. Where the two sides differed was in the methods.[3] Supporters of the Inquisition such as the vocal Fray Francisco Alvarado maintained in its defense that the Holy Office aimed to root out superstitious beliefs and the practice of witchcraft.[4] On the other side of the issue, liberals, who wanted the Inquisition's reform or complete suppression, stated that its very handling of sorcery cases provided a forum that encouraged delusion and claims to the practice of magic and that its secret methods encouraged false testimony.[5] A.J. Ruiz de Padrón, in his speech related to the Constitutional debates on the Inquisition declared: "it has been guilty of the greatest absurdi-

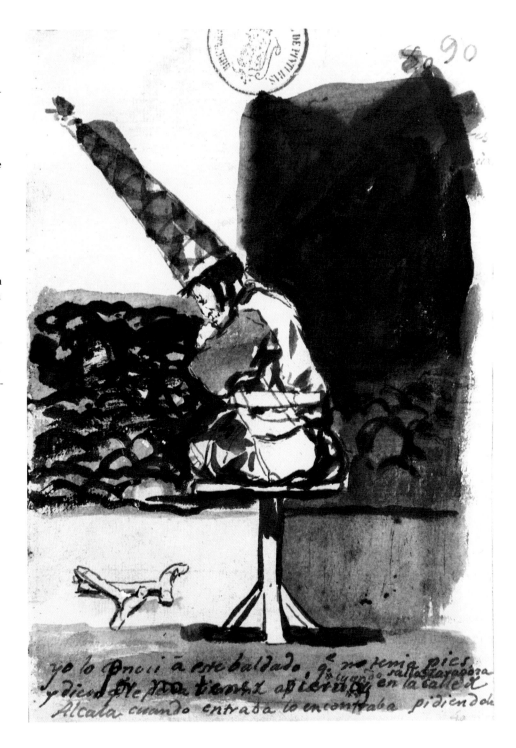

ties, and punished crimes which it is not possible to commit. Who can believe in such legends of spirits and fairies,– of imps and demons changed into toads and vipers and dragons, – in witches and wizards flying through the air, . . .? Thanks to this enlightened age, all these visions have now disappeared, and the Inquisition has ceased to persecute them."[6]

Goya's first inscription on this drawing told of a man without feet; in the second, shorter form, the disability changes to the lack of legs. The revised version may have called forth in the mind of Goya's audience two well-known contemporary cases brought before the Inquisition. In the 1790s an illiterate traveler between France and Spain named "Piernas" was denounced and tried by the Zaragoza Inquisition for dispersing seditious pamphlets acquired from Bayonne, France.[7] It may or may not be a coincidence that Goya's drawing falls so closely after page 86 in *Album C*, captioned *Por traer cañutos de Diablos de Bayona* (For Carrying Diabolical Tales from Bayonne) (fig. 2); the latter drawing similarly conflates sorcery and sedition and suggests how the charge of sorcery might have been brought to condemn someone for political reasons. Another celebrated case, which involved suffering endured by a lame person at the hands of the Holy Office, was that of Don Miguel Solano, one of the last to die in the Inquisition's prisons – in Zaragoza, 1805. Solano, a priest from Aragon, made lame by illness, was examined and found guilty of believing heretical propositions, although he was never a participant in an *auto de fe*.[8]

The primary idea expressed in Goya's drawing is not the precise nature of the offense, nor is it the cripple's guilt or innocence. Goya's final caption alleges that this man has been condemned as an indirect consequence of his infirmity. His infirmity, of course, would not have been the literal charge brought by the Holy Office but might have been included in the evidence. The drawing indicts by holding to ridicule a judicial system whose aim was not to do justice but to find incriminating evidence, whatever that might entail – a system that would concern itself with picayune matters and

use evidence as slight as a man's disability to convict him. To its detractors the Holy Office had become an institution that measured its success by the extraction of a confession, not by establishing the truth. Elements of Goya's drawing itself – the weight of the *coroza*, which might topple the figure, and the crushing shadows around him – reveal the cruelty of methods that could subject a human being to this humiliating scrutiny. The striking, carefully arranged and balanced composition of opposing lights and shadows brings the figure into intense focus so that his innate dignity and exposed vulnerability are equally expressed.

S.L.S.

1. Sayre, "Goyas 'Spanien, Tiden och Historien'", no. 11, n. 20, could find no evidence that Goya saw this woman in Zaragoza in 1808. At that time the Inquisition had been suppressed by José Napoleon.

2. On the problem of beggars, see Kany, *Life and Manners*, pp. 20-24, 60; Herr, *Revolution in Spain*, pp. 32-34; and Jacques Soubeyroux, "Pauperismo y relaciones sociales en el Madrid del siglo XVIII," *Estudios de Historia Social*, nos. 12-13 (1980).

3. The above discussion was based on information contained in Lea, *Inquisition*, vol. 4, pp. 179-247; and Kamen, *Inquisition*, pp. 198-218.

4. Fray Francisco Alvarado was one of the staunchest defenders of the Inquisition in the Cortes debates of 1810-1813. His ideas were published as collected letters in *El Filósofo Rancio* (The Antiquated Philosopher). See Lea, *Inquisition*, vol. 4, pp. 242, 405; and Henningsen, *Witches' Advocate*, p. 389.

5. On the Inquisition's attitude toward sorcery and witchcraft, see Lea, *Inquisition*, vol. 4, pp. 194-247; Henningsen, *Witches' Advocate*; and Kamen, *Inquisition*, pp. 208-214.

6. Ruiz de Padrón, *Inquisition*, p. 8.

7. On this case see Herr, *Revolution in Spain*, p. 277. The Inquisition was charged by Carlos IV's minister of state, the Conde de Floridablanca, with stopping propaganda related to the ideas of liberty associated with the French Revolution; Llorente, *Inquisition*, p. 547.

8. Solano was condemned to death, but the Supreme Council of the Inquisition, not wanting him or the country to be subjected to an *auto de fe* made extraordinary efforts to allow him to recant his beliefs. He died in prison. This tragic case was told by Llorente, *Inquisition*, pp. 560-563.

101

Por casarse con quien quiso (For Marrying As She Wished)
Album C, page 93
About 1810-1814
Brush with gray and brown wash, heightened with pen and brown ink
205 x 144 mm.
Inscribed in brush and gray brown, top right: *93*, altered from brush and gray: *83*; in pen and brown ink, below image: title
References: G-W 1329; G., I, 238.

Museo del Prado, Madrid, 342
United States only

A woman is shown bound to a rack so that her head is lower than the rest of her body.[1] Clustered around her legs in deep shadows are five cloaked figures, which appear to be clerical. All that is clearly visible is her anguished face, highlighted. Goya's inscription *Por casarse con quien quiso* (For Marrying As She Wished) implies that the woman is being persecuted because she exercised her free will and followed her heart. However, taken with the content of the drawing, ambiguities become apparent. There are discrepancies between what is said and what is depicted; as usual, they cannot be interpreted in a straightforward manner.

The device to which the woman is bound is probably a *potro* or *escalera*, the rack or trestle on which a prisoner was stretched when torture was employed to procure a confession.[2] Torture, which was used customarily to elicit an admission of guilt by both secular and ecclesiastical authorities in most European countries, diminished in the eighteenth century. There is evidence that the Spanish Inquisition was generally more judicious and humane in the application of torture than other tribunals, both in Spain and in other countries that employed torture.[3] Although Goya's use of clerical figures indicates that he was referring to the Inquisition, he draws our attention not to the prosecuting institution but to the almost complete degradation of the victim.

The free choice of a spouse would never have been a punishable offense,

nor does there seem to be any evidence that the Holy Office, intrusive as it could be, concerned itself with this. Possibly the woman's plight is an indirect consequence of her marriage; she is either presumed guilty by association or is being forced to testify against the heresy of her husband. As a confession was not considered complete until accomplices were named, torture was allowed to extract this information. Torture of witnesses who were not also accused was not permitted unless they wavered or recanted.[4] Antonio Puigblanch, in *The Inquisition Unmasked*, first published in 1811, referred to these ideas when discussing about the victimization of women: "If in a general sense, harshness towards prisoners is blameable in a tribunal, it is rendered absolutely unpardonable when it extends to persons of the female sex. Astonishment is excited at the multitude of victims of this class which the proceedings of the Inquisition present, immolated, not so much on account of their opinions, for rather than being their own they were those of their fathers, husbands, or perhaps of some deluding or seductive director, as owing to the whim and cruelty of the inquisitors."[5]

Another possible interpretation of Goya's drawing might be that the woman is being subjected to torture as part of an inquiry into the nature of a bigamous marriage. The title can be read "For marrying [whomever] she wished." In a time and country in which marriage was a sacrament and divorce was not permitted, bigamy was not uncommon. Historically, the offense was the subject of jurisdictional conflict between civil, Church, and Inquisitorial authorities.[6] Statistics on the Inquisition reveal that throughout its history approximately five percent of cases involved bigamy.[7] Since multiple marriage or a relaxed attitude toward marriage was considered a characteristic of one who was not Christian, the Holy Office was known to go to great lengths to determine whether the accused held heretical beliefs. In 1796 the Inquisition prohibited the importation from France of two prints depicting the legalization of divorce.[8] Expounding against the Inquisition's involvement in laws regarding marriage, Puigblanch wrote: "the Inquisition

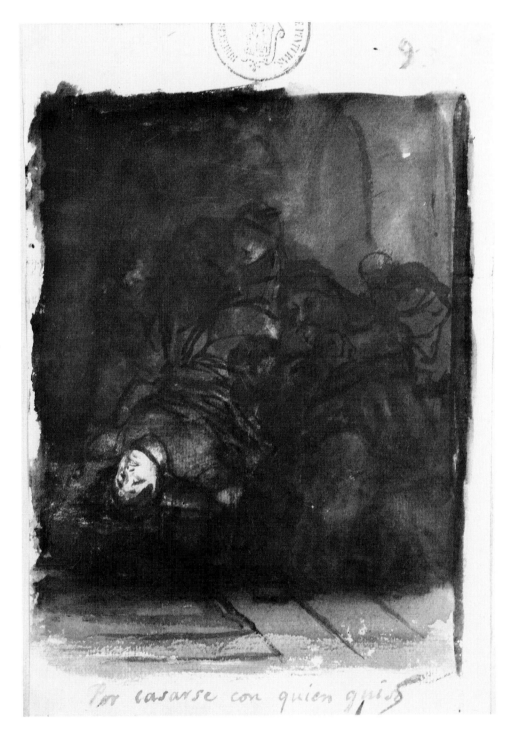

has arrogated to itself the cognizance of the other crimes from principles of self-accord; or from that propensity generally found in all privileged courts, particularly in the ecclesiastical ones, to draw into their own hands as many matters as they possibly can. Certainly the suspicion of heresy attributed by the Inquisition to a person married more than once is devoid of all foundation, when he might have been led into this crime by a thousand impelling causes, without trespassing against the faith."[9]

Goya's drawing vividly captures the Inquisition's ability to intrude into all aspects of life, even the most intimate. It also discloses the use of cruelty by over-zealous Inquisitors protected by secrecy laws. Goya's composition, of a single female with hooded friars engulfing her lower body, reveals how a woman's being has been invaded figuratively.[10] He used light and dark as a metaphor for the opposition of truth and honesty against the furtive, sadistic doings of the Inquisitors. The woman's face, bathed in light, so vital even in its pain, tells us that her spirit has not been destroyed.

S.L.S.

1. According to the numbering at upper right, this drawing may have been intended as *83,* immediately preceding the drawing entitled *Nada nos ynporta* (Nothing matters to us) (Prado, Madrid, 249, G-W 1320), which deals with a related subject, a couple who put their love above all else. See López Rey, *Goya's Drawings,* p. 105.

2. It appears that the woman in the drawing is about to be given the water torture; see Lea, *Inquisition,* vol. 3, p. 19.

3. Lea, *Inquisition,* vol. 3, pp. 1-18; Henningsen, *Witches' Advocate,* p. 44; Kamen, *Inquisition,* p. 174.

4. Lea, *Inquisition,* vol. 3, pp. 11-12. See Ordinance 45 in the "Ordinances of 1561" given in Llorente, *Inquisition,* p. 241.

5. Puigblanch, *Inquisition,* vol. 2, p. 185.

6. On the Inquisition in relation to bigamy, see Lea, *Inquisition,* vol. 4, pp. 316-327; and Cecil Roth, *The Spanish Inquisition* (New York, 1964), pp. 203-204. In the sixteenth century a strong campaign was mounted against the Inquisition's meddling in private and secular matters; see Kamen, *Inquisition,* pp. 58, 206. Ordinance 65 of "The Ordinances of 1561," which established rules to be followed by the Holy Office, stipulated that Inquisitors should ascertain if bigamous behavior truly involved heretical beliefs; Llorente, *Inquisition,* p. 247. In the eighteenth century the ministers of Carlos III and Carlos IV attempted to take powers of granting matrimonial dispensation away from Rome and give it to the bish-

ops. On this see Puigblanch, *Inquisition,* pp. 148-149; Llorente, *Inquisition* pp. 545, 551-552; Lea, *Inquisition,* vol. 4, p. 389; Herr, *Revolution in Spain,* pp. 425-430; and Callahan, *Church,* p. 76.

7. Kamen, *Inquisition,* pp. 183-184.

8. Juan Carrette Parrondo, "Les Estampes Hétérodoxes en Espagne au XVIIIe et au début du XIXe siècle," *Gazette des Beaux-Arts* 96 (Nov. 1980), pp. 177-178.

9. Puigblanch, *Inquisition,* vol. 1, p. 148.

10. The idea of figurative rape in this drawing is expressed in Hamburg, 1980, no. 138.

102

Por descubrir el mobimiento de la tierra (For Discovering the Movement of the Earth)
Album C, page 94
About 1810-1814
Brush with gray and brown-black wash
206 x 144 mm.
Inscribed in brush and gray brown, upper right: *85* altered to *94;* in pen and brown ink, below image: title
References: G-W 1330; G., I, 239.

Museo del Prado, Madrid, 333
United States only

On the preceding sheet, *Por casarse con quiso* (For marrying as she wished) (cat. 101), Goya moved away from depicting the superficial paraphernalia of the Inquisition, the *sanbenito* and *coroza,* toward focusing more intently on the effect of its methods on the individual. Here, the punitive tribunal language employed for the caption – *Por descubrir el mobimiento de la tierra* (For Discovering the Movement of the Earth) – is retained but Goya had no need to say more to communicate the identity of the prisoner. The figure would surely have been identified as the Italian mathematician, astronomer, and physicist Galileo Galilei (1564-1642), who was denounced in 1633 to the Roman Inquisition for upholding the Copernican theory of the revolution of the earth around the sun.

The charge against Galileo was suspicion of heresy for expounding beliefs contrary to the Scriptures. In his celebrated *Dialogo dei due massimi sistemi del mundo (Dialogue on the Two Principal World Systems)* of 1632 he had not, it was deemed, sufficiently stressed that Copernicism was merely a theory. This was taken by some as a defiance of Church authority. He was found guilty of having taught Copernican doctrine and was forced to recant. He spent the remainder of his life under house arrest on his estate near Florence, where he continued working. The details of this case were probably not available to Goya; they are debated even today.[1] The drawing must be viewed in the context of what was known or believed about it in Goya's lifetime.[2]

In the 1770s Galileo's theories, along

with those of other modern astronomers, were discussed and debated in Spanish universities. [3] He was the subject of one of the biographical portraits of scientists and philosophers based on Alexandre Savérien's *Histoire des philosophes modernes* that appeared in 1789-1790 as a series in the *Correo de Madrid*, a periodical that occasionally published "advanced" or controversial ideas. [4] Enlightened and liberal writers of the late eighteenth and early nineteenth centuries cited Galileo as a symbol of the man of modern science martyred by the forces of darkness that would obstruct the truth. [5] Bartolomé José Gallardo's *Diccionario crítico-burlesco*, first published in 1812, dealt with enlightened and liberal ideas in a satirical and critical style (see also cat. 113). [6] In the entry on geology, Gallardo used Galileo as an example of one of the Inquisition's victims. [7] In his acerbic language, full of allusion and double meanings, Gallardo suggested that Church theologians and the Inquisition felt threatened by the notion that the earth's movements would not fall under their control. He wrote "Lo que dice la historia es que el año de 33 se volvió a empeñar Galileo en que el sol se había de estar quedo, y la tierra había de andar; y el Santo-Tribunal se empeñó en que él no había de andar suelto." (History tells us that in 1633 Galileo once again insisted that the sun stayed put, and that earth had to move; and the Holy Tribunal insisted he [Galileo and the sun] should not be let loose). [8] Goya's caption, like Gallardo's entry on geology, plays with the words "mobimiento de la tierra" (movement of the earth), suggesting the idea that Galileo had given rise to an earthquake. In his passionate diatribe of 1813 calling for the abolition of the Spanish Inquisition, A.J. Ruiz de Padrón, often given to hyperbole, spoke of Galileo as being immediately cast into the dungeons of the Inquisition when he alluded to erudite persons in and out of Spain who were persecuted by theologians jealous of their knowledge. [9]

Goya's drawing was executed in a similar ardently polemical vein. Not strictly an illustration of historical fact, it is a work of the imagination that reveals with intense power a more universal truth, the

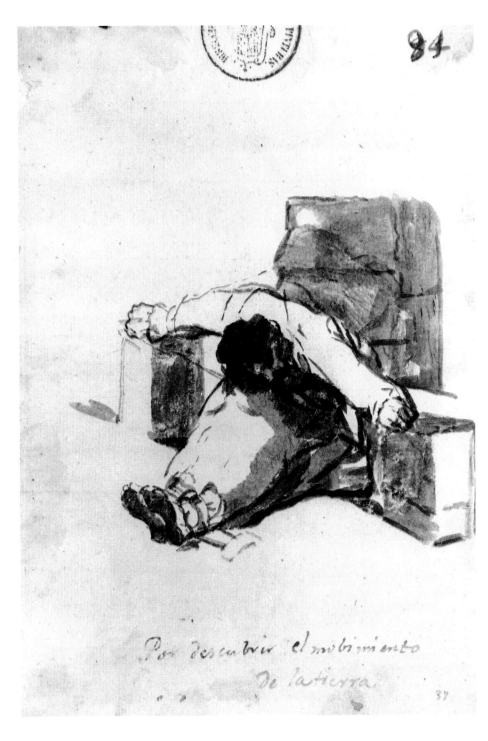

effect of the loss of intellectual freedom on the human spirit. The image, taken by itself without the caption, does not focus on specific characteristics of the individual. The inscription is the only clue to Galileo's identity. Nor is the physical anguish of punishment revealed through facial expression, as in the previous drawing (cat. 101). Here the humiliation of the individual forced to deny his own convictions is expressed by the debasement of the human figure, literally bowed. Goya's imagery, like the caption, may have been inspired by Gallardo's description, cited above, of the Church's need to restrain Galileo, just as it desired to brake the earth's motion. The figure is presented bound and shackled in a position that suggests both the configuration and pent-up energy of a crossbow. Even in such submission the figure conveys vigor. The crosslike arrangement of the body integrated with the stonework calls to mind a Crucifixion and altar. Using an image conveying both sacrifice and redemption, Goya deified the man of truth. The Church, even though restraining Galileo, did not succeed in disarming him but instead gave him the power of a martyr.

S.L.S.

1. See Pietro Corsi, review of Pietro Redondi, *Galileo Heretic* (Princeton, 1987), *New York Times Book Review*, Nov. 15, 1987, pp. 13-14. On Galileo's case see Stillman Drake, *Galileo at Work* (Chicago and London, 1978).

2. See López Rey, *Goya's Drawings*, pp. 115-118; and Sayre, "Goyas 'Spanien, Tiden och Historien,'" no. 14 (reprinted in Madrid, 1982, no. 39), on Galileo and this drawing in relation to some of the ideas of the time.

3. Sarrailh, *L'Espagne éclairée*, pp. 493-495.

4. Herr, *Revolution in Spain*, pp. 189-190.

5. See, for example, the ironic tone used by the Conde de Peñaflorida, in the letter contrasting ancient and modern philosophers and scientists "Les Campagnards critiques," in the *Aldeanos críticos*, quoted in Sarrailh, *L'Espagne éclairée*, pp. 436-440. See also the ode by Manuel José Quintana, "A la invención de la imprenta" (Ode to the Printing Press) (1800), quoted in Sarrailh, *L'Espagne éclairée*, pp. 465-466. Joseph Blanco White in *Letters* (1822), p. 109, spoke of Galileo as having been bound and gagged.

6. López Rey, *Goya's Drawings*, pp. 32, 36, n. 2, noted the structural and ideological similarities between Goya's *Album C* drawings and Gallardo's *Diccionario crítico-burlesco*.

7. López Rey, *Goya's Drawings*, pp. 116-117.

8. Gallardo, *Diccionario*, p. 48.

9. Ruiz de Padrón, *Inquisition*, p. 23.

103

Te comforma? [sic] (Do you confirm it?)
***Album C*, page 97**
About 1810-1814
Brush with gray and brown washes
204 x 135 mm.
Inscribed in brush and brown, upper right: *97*; in pen and brown ink, below image: title
References: G-W 1333; G., I, 242.

Museo del Prado, Madrid, 344
United States only

This drawing, following two scenes of prisoners in solitary confinement, depicts a bound and fettered prisoner who is being asked by her examiners, "Te conforma?" (Do you confirm it?). It is clear from the fiendish faces and threatening postures of her persecutors and the *garrucha* (pulley), the instrument of torture behind her, that she is being coerced to make a statement. But it is not clear whether Goya is dealing with the procurement of a confession from a prisoner or its confirmation. In the former case, it was desired that a prisoner agree with charges made by witnesses who had brought forth a denunciation. The latter judicial procedure, called ratification, was used in both civil and Inquisitorial tribunals to ensure that confessions made by prisoners or testimony given by witnesses had been freely given.[1] Until the mid-eighteenth century, torture (the judicial use of specific procedures to inflict various degrees of pain) had been routinely used by many European court systems to obtain confessions in support of other evidence. Since heresy, the Inquisition's chief concern, was difficult to prove by witnesses, torture was employed or threatened in many of these cases to procure a confession from the accused who would not admit to the charges. Inquisitors saw themselves as just that, gatherers of information and evidence, not as judges or jury. Confession was therefore crucial to this process, since it was considered proof of guilt. Of equal importance, confession was perceived as necessary for the soul's repentance or salvation.[2] The Inquisition, which employed torture no more freely than the civil courts, was especially sensi-

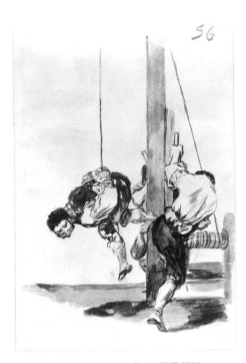

Fig. 1. Use of a *garrucha* (pulley), 1817-1820, *Album F*, p. 56.
Brush and brown wash.
The Hispanic Society of America, New York

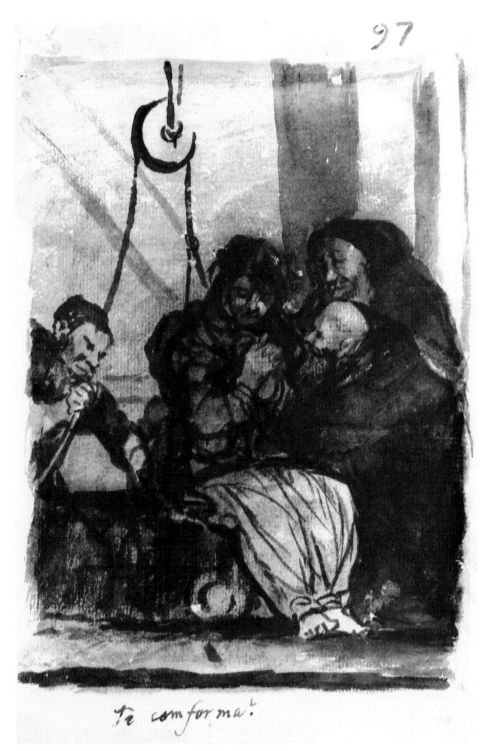

tive to the fact that confessions obtained by its means were often untrue and thus was scrupulous in its demand for ratification.[3] Since the two interrogators appear to be friars, it is plain that they are Inquisitors.[4] Again Goya's caption takes on the voice of the prosecution and, by so doing, mocks it. The short interrogatory remark emulating the voice of the *fiscal* (prosecutor) leveling charges is typical of the kind of harsh, coercive, yet dispassionate questioning used by Inquisitors during a procedure that was often just a routine formality and, because of the presumption of guilt, of questionable value in obtaining the truth.[5]

Eighteenth-century writers and thinkers such as Valentín de Foronda, Manuel de Lardizábal, J.M. Acevedo y Pola, Meléndez Valdés (see cat. 24), Jovellanos (see cat. 30), and Cadalso wrote against the use of torture to procure confessions and advocated legislation to bring about penal reform.[6] Carlos III's ministers acted in favor of their recommendations.[7] At the same time the use of torture

231

diminished greatly in Inquisitorial tribunals. In a passage on the use of torture, Llorente wrote in *The History of the Inquisition of Spain,* which was based on his investigations in the 1790s and about 1808-1812, "It is true, that it is so long since torture has been inflicted by the inquisitors, that the custom may be looked upon as abolished, and the fiscal only makes the demand in conformity to the example of his predecessors, yet it is equally cruel to make the prisoners fear it."[8] Nevertheless torture was still permitted by ordinance until the Inquisition's suppression in 1813, and there seems to have been a perception (it is difficult to determine whether false or true) that torture was still employed at least as a threat. This procedure involved placing the prisoner *in conspectu tormentum* (in view of torture).[9] No doubt a factor contributing to this impression was the discovery in 1798 that thumbscrews were still used illegally in some civil courts.[10]

The excessive use of torture and torment as violating the rights of the citizen was one of the charges leveled at the Inquisition by those who wanted its abolition. With only a passing reference to the fact that this was not a current practice, A.J. Ruiz de Padrón, in his 1813 *Speech . . . Relative to the Inquisition,* wrote, "In the first case, sentence is passed after a thousand mysterious questions; but in the second, besides the confinement in dark dungeons, destitute of all human consolation, they employ dreadful torments to extort confession. A pulley, suspended to the ceiling, through which is passed a thick rope, is the first spectacle which meets the eye of the unhappy victim. The attendants load him with fetters, and tie a hundred pounds of iron to his ancles [*sic*]; then they turn up his arms to his shoulders, and fastens [*sic*] them with a cord; they fasten the rope round his wrists, and having raised him from the ground, they let him fall suddenly, repeating this twelve times, with a force so great, that it disjoints the most robust body."[11]

Like the words of the Ruiz de Padrón passage, Goya's drawing vividly describes the use of tactics of terror and intimidation. Although the hand on the rope

seems ready to begin the torture if the evidence or confession is not confirmed, Goya's drawing does not dwell on realistic detail. For example, the pulley is not nearly high enough to accommodate the height of the intended victim. By contrast, several years later in *Album F,* Goya depicted another *garrucha* employed to inflict physical torment in circumstances quite unrelated to the Inquisition (fig. 1). There, in an explicit scene of outright, brutal violence, Goya revealed again how unspeakable acts can result from differences in belief (see also cat. 151). In *Te co[n]forma?,* by incorporating in one frame the instrument of torture and the eliciting or confirmation of testimony by the victim's tormentors, the artist, with supreme clarity, exposed the procedure as both cruel and senseless. Since the confession or ratification process is discredited when torture is threatened, Goya demonstrated how meaningless was the question "Te conforma?" (Do you confirm it?).

S.L.S.

1. On the practice of ratification see Lea, *Inquisition,* vol. 2, pp. 544-548, and vol. 3, p. 27. On the Inquisitorial rule governing ratification, see "Ordinances of 1561, no. 53," in Llorente, *Inquisition,* p. 244.

2. Lea, *Inquisition,* vol. 3, p. 1; Kamen, *Inquisition,* p. 178.

3. Llorente, "Ordinances of 1561, no. 49," *Inquisition,* p. 243.

4. According to Ordinance 30 of the "Ordinances of 1561," given by Llorente, *Inquisition,* p. 235, two upstanding Christians, preferably clerics, were required to be present as witnesses at a ratification.

5. Lea, *Inquisition,* vol. 2, p. 546, vol. 3, p. 18. During ratification, at which the *fiscal* was not allowed, the accused was asked to repeat his or her crimes; if these were not recalled, the specific charges to be ratified were presented (Henningsen, *Witches' Advocate,* p. 43). The accused was not ever permitted to know the source of the charges. This stipulation was designed to protect witnesses, but it was a source of great abuse.

6. Some of the ideas of these authors and their works on the subject of the judicial reform are discussed in Sarrailh, *L'Espagne éclairée,* pp. 535-541; and Herr, *Revolution in Spain,* pp. 61-62.

7. The canon of Seville, Pedro de Castro, defended the use of torture in judicial practice. He was not able to procure a license to publish his views from the Consejo de Castilla, which held administrative powers under royal authority. However, he did publish clandestinely; Herr, *Revolution in Spain,* pp. 12 and 62.

8. Llorente, *Inquisition,* p. 64.

9. See Lea, *Inquisition,* vol. 3, pp. 6, 13; and Kamen, *Inquisition,* p. 174.

10. Lea, *Inquisition,* vol. 3, p. 34. In 1814 Fernando VII ordered that no undue force be allowed against the accused or witnesses in the gathering of testimony.

11. Ruiz de Padrón, *Inquisition,* pp. 44-45.

104

P^r Liberal? (For Being a Liberal?)
Album C, page 98
About 1810-1814
Brush with gray and brown wash
205 x 143 mm.
Inscribed in brush and brown, upper
right: *98*; in pen and brown ink, at lower
left of image: title
G-W 1334; G., I, 243.

Museo del Prado, Madrid, 335
Spain only

Goya confronts us with an image of a
woman in captivity: bound, chained, and
fettered, subjected to the treatment given
a caged wild animal. Her torn clothing,
dishevelled appearance, stunned facial
expression, and utterly drained,
exhausted stance tell us that she has
endured and barely survived an ordeal.
She does not appear in any condition to
understand the charges brought against
her. This drawing may may well rep-
resent the consequence of the kind of
harsh and relentless interrogation shown
in the preceding drawing *Te co[n]forma?*
(Do you confirm it?) (cat. 103). Because
Goya's caption here, *P^r Liberal?* (For
Being a Liberal?), is also framed as a
question, the idea expressed by *Te con-
forma?*, that information procured by the
threat of torture is of questionable valid-
ity, is reiterated and reinforced. In this
drawing, in which Goya makes the
inquiry, we comprehend no more clearly
than the dazed woman can the nature of
her guilt.

The term *liberal* was first applied in a
political sense in late 1810 by the press
to members of the Cortes (parliamentary
assembly) at Cádiz, who upheld freedom
of the press, except in religious dogma,
and the idea that sovereignty should rest
with the people, not the crown.[1] The
term *servile* was applied to the conserva-
tive clergy and both moderate and reac-
tionary Spaniards who opposed these
measures desiring, among other things,
the retention of censorship powers by the
Inquisition and the maintenance of sover-
eignty by the monarch. The Cortes
assembled at Cádiz consisted chiefly of
substitute deputies since the city was
under bombardment and most of the rest

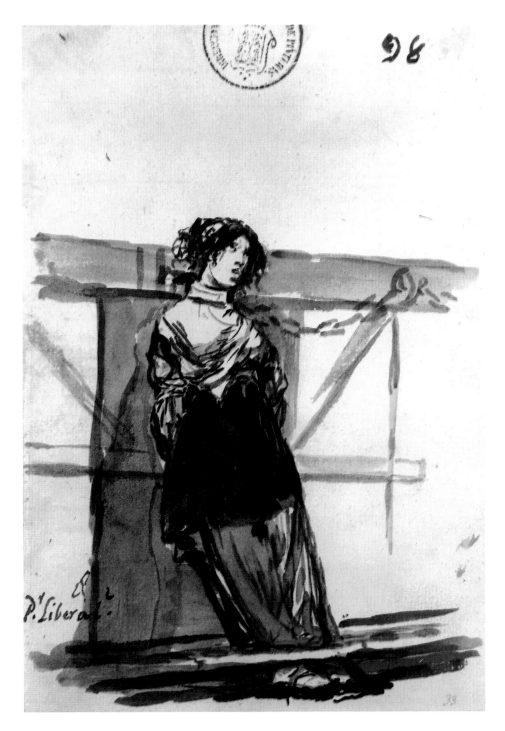

of Spain was occupied by French troops. This Cortes, dominated by younger liberals, many of whom were members of the secular clergy, wrote the Constitution that was promulgated on March 19, 1812. A heated debate ensued raising the question of whether the Inquisition should remain suppressed, as it had been by Napoleon in 1808, or be revived. On February 22, 1813, it was declared unconstitutional, and many of its powers were transferred to civil or episcopal authority.[2] But the Constitution was short-lived. In May 1814, some five months after Fernando VII was returned to power and welcomed with joy by most of Spain's citizens, he declared the Cortes at Cádiz illegal and nullified their acts. Almost all of the most vociferous liberal ministers and deputies, 52 out of a total of 308 deputies, were arrested in the night of May 10.[3] In July of that year, in an attempt to restore Spain to its prior state (before its fall under the so-called evil influence of foreign invaders) and with the promise to reform the institution, Fernando reinstated the Inquisition.[4]

To the conservative opposition, liberalism carried connotations of its source, *liberale*, which was associated with generosity to the point of profligacy and thus libertinism. Furthermore, they blamed Spain's problems on the free-thinking, revolutionary ideas allegedly held by the French invaders and those who supported them, called *afrancesados*.[5] Beginning in 1815, under the guise of proceedings investigating the loyalty of citizens during the Peninsular War, those who had publicly declared liberal ideas were investigated as traitors.[6] Goya was among them and was vindicated. The Inquisition, though weak and impoverished, was enlisted in this effort.[7]

Goya's drawing of a woman enchained does not reflect the nature of these proceedings, which were primarily bureaucratic. Although intimidation was surely a factor, there were no reports of the threat or use of physical abuse or torture. Although a few liberals were imprisoned, most of the better-known *afrancesados* had already fled the country with Napoleon and his troops.[8] In arguments against the Inquisition, it was characteristic of the rhetoric of writers such as

Antonio Puigblanch and Ruiz de Padrón, and even to some extent Llorente, to speak of past injustices as if they were still occurring and to cite them as a reason to abolish the institution.[9] As we have seen, Goya too was neither slavish to historical detail nor strictly realistic in his treatment of the Inquisition. Instead he used its language and trappings figuratively to emphasize broader ideas such as the curtailment of liberty (cat. 106), the enslavement of the human spirit (cat. 102), or the terrible effect of cruelty and injustice on the individual (cat. 101). Goya's drawing here reflects the strident, intensely antagonistic spirit of the conflict between liberals and absolutist, anticonstitutional *serviles*.

In other drawings in this group within *Album C* as well, Goya explored a range of ways in which humans can be physically restrained, even rendered immobile. We are shown a catalogue of methods, building impact through repetition. The effect of viewing a panoply of devices for restraint and punishment in drawing after drawing is not the morbid fascination that might be experienced in a chamber of horrors; Goya's concern is less with the instruments themselves or the abusiveness of the Inquisitors than with various ways humans can feel and withstand both mental and physical pain.

P^r Liberal?, having enslavement as one of its motifs, falls in the series of drawings between those dealing with trial and punishment (cat. 98-101) and those about freedom and release (107). According to Goya, liberty would be achieved through an unrestrained press and law assured by a constitution. Advocates of the suppression of the Inquisition stressed that constitutional law guaranteed that a prisoner should be made aware of charges being brought and that torment should not be used.[10] Goya's rendering of the drained victim in *P^r Liberal?* makes it clear that she has been treated without regard to these rights. In addition, her heavenward gaze and the crosslike configuration of the scaffolding to which she is pinioned suggest a crucifixion; Goya depicted another martyr in the struggle for liberty and sanctified this quest by giving his composition religious overtones.

S.L.S

1. *Liberal* is derived from *libre* (free) which was used in 1808 by Quintana, who stated that people must be free in order to form a Constitution; José Alvarez Lopera, "De Goya, La Constitución y La Prensa Liberal," in Madrid, 1982, p. 31. See Herr, *Modern Spain*, p. 73; and Sayre, "Goyas 'Spanien, Tiden och Historian,'" no. 17 (reprinted in Madrid, 1982, no. 52), citing Toreno, deputy from Asturias, on the origination of the political term "liberal."

2. See Ruiz de Padrón, *Inquisition*, pp. 15-16, on practices of the Inquisition that were considered to violate the new Constitution. For example, prisoners should be informed of the charges being brought and witnesses making allegations should be identified, torment and confiscation should no longer be permitted, and punishment should not pass to the family. The Inquisition's censorship functions, as well as its control over heresy, were transferred to the bishops.

3. Attempts during the next one and a half years to prove the guilt of these 52 by gathering witnesses' testimony were unsuccessful, since all who voted along the same lines would also have been implicated. To demonstrate his absolute power Fernando VII ordered them from prison into exile, the clergy into convents; Lea, *Inquisition*, vol. 4, p. 423.

4. Llorente, *Inquisition*, pp. 568-569; Lea, *Inquisition*, vol. 2, p. 463.

5. Callahan, *Church*, p. 113.

6. Llorente, *Inquisition*, pp. 569-570; Herr, *Modern Spain*, pp. 74, 78; Callahan, *Church*, p. 107; In 1817, 400 publications issued during the war and Constitutional years were prohibited. Many of these are listed in the Introduction to the 1816-1817 English edition of Puigblanch, *The Inquisition Unmasked*.

7. The preceding discussion was based on information provided in Lea, *Inquisition*, vol. 2, p. 463, vol. 4, pp. 399-433; Herr, *Modern Spain*, pp. 65-76, 78; and Callahan, *Church*, pp. 73-117; Llorente, *Inquisition*, pp. 565-574. According to Lea, *Inquisition*, vol. 2, p. 463, the Inquisition was too busy repairing its fortunes to spend time in the accumulation of information on heretics. Callahan, *Church*, p. 107, reports that in 1815, the Inquisition handled a small number of cases of liberal sympathizers.

 A.J. Ruiz de Padrón, who spoke and wrote so eloquently against the Inquisition in 1813, was not on the list of those to be investigated but was relegated to a convent and suffered severe reprimands from his bishop, whose powers, ironically, he had worked so hard to restore. His published *Speech . . . Relative to the Inquisition* was the object of a prosecution in Madrid and Valladolid; Lea, *Inquisition*, vol. 4, pp. 423-424.

8. Among these were friends and acquaintances of Goya: Moratín (see essay by N. Glendinning, fig. 4), Silvela (cat. 72), and Llorente (cat. 73).

9. Lea, *Inquisition*, vol. 4, p. 405. See also cat. 103. The 1776 case of Pablo Olavide (see cat. 98 and n. 9) was used as an example of excessive Inquisitorial power in the Cortes debates at Cádiz; Lea, *Inquisition*, vol. 4, p. 311, note.

10. Ruiz de Padrón, *Inquisition*, pp. 15-16.

105

El tiempo hablará (Time will tell)
Album C, page 107
About 1810-1814
Brush with gray and brown wash
205 x 143 mm.
Inscribed in brush and brown, upper
right: *107;* in pen and brown ink,
below image: title
References: G-W 1343; G., I, 252.

Museo del Prado, Madrid, 340
Spain only

There is a statuesque calm in the render-
ing of this imprisoned woman. Although
her wrists are bound, she attempts no
struggle, and her form is characterized by
an attitude of quiet but pensive repose.
As is true of several other drawings in
this sequence (for example, cat. 98 and
103) about the miscarriage of justice, the
figure is not represented in scale in rela-
tion to her surroundings. She looms
monumentally, dominating the picture
space, her human stature emphasized.
Light enters her cell, but that which
boldly illuminates her body is not from
without but from an inner light, presuma-
bly symbolic of truth.[1] Goya's comment
El tiempo hablará (Time will tell) implies
that the truth of the woman's situation
will be known with the passage of time.

Goya's treatment of isolated, impris-
oned figures such as this suggests that he
intended them to be seen in the so-called
cárceles secretas (secret prisons) of the
Inquisition, where those accused of the
most severe crimes were confined while
evidence was gathered, often during
extremely lengthy trials. These prisons
inspired immense fear in the general
population, not because of excessively
poor conditions or treatment but because
the inmates were virtually cut off from
the outside world and were sworn to
secrecy about Inquisitorial procedures.
Although officers of the Inquisition fre-
quently strove to keep prisoners isolated
so as to prevent communication, because
of limited space, prisoners were not rou-
tinely kept in solitary confinement.[2]

The drawing's placement within this
series and the forlorn demeanor of the
prisoner leave little doubt that Goya had
the Inquisition in mind as jailer. But the

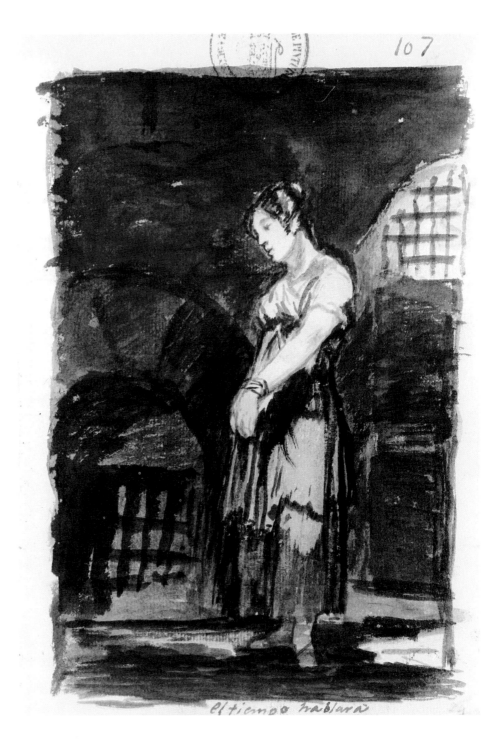

rigors withstood in the secret prisons were not the artist's primary focus here. On an earlier page of this series, *Pocas óras te faltan* (You've only a few hours left),[3] Goya's comments began to anticipate the future, either the immediate, through imminent death, or remote, through immortality (cat. 106). In *El tiempo hablará*, this heroic woman stands contemplative and self-possessed, with the knowledge and assurance of eventual release and redemption, because the truth will be made evident. Goya imbues her with the certainty that the Inquisition will not escape history's judgment.

S.L.S.

1. This observation was made by P. Gassier, see G., I, 252.

2. On the prisons of the Inquisition, see Lea, *Inquisition*, vol. 2, pp. 507-534; and Kamen, *Inquisition*, pp. 171-173. There is ample evidence that the prisons of the Inquisition had the reputation of being, and were in fact, more comfortable and humane than those in civil or episcopal tribunals.

3. *Album C*, p. 102, Prado, Madrid, 352; G-W 1338; G., I, 247.

106

Zapata tu gloria será eterna (Zapata your glory will be eternal)
Album C, page 109
About 1810-1814
Brush with gray and brown wash
205 x 144 mm.
Inscribed in brush and gray brown, upper right: *109*; in pen and brown ink, to left, below image: title
References: G-W 1345; G., I, 254.

Museo del Prado, Madrid, 351
Spain only

By examining an individual page of *Album C* in the context of those surrounding it and observing the rhythm and momentum of the group as a whole, we arrive at a fuller and more lucid interpretation of the particular drawing. The previously discussed sheet, *El tiempo hablará* (Time will tell) (cat. 105) and this drawing, both representations of calm dignity, are interrupted by an image of extraordinarily brutal pain suffered by a man undergoing torture (fig. 1). His anguish is underscored with Goya's comment *Que crueldad* (What cruelty). The cross, identifying the Inquisition rather than the civil system as the authority, is evocative of the pain endured by Christ during the Passion. The victim is thus elevated to a kind of martyrdom. Furthermore, we are shown a picture of what is truly blasphemous: the link between the religious institution and the perpetration of such abuse.[1]

On this page, in striking contrast, we see an aged man, wrapped in a dark cloak and skull cap; he is immobile, crouched and chained, a study of despair and surrender. Compared with the tension and physical distress shown in the previous drawing, the pain revealed in this subject and composition is quiet and spiritual, yet no less potent. The inscription suggests immortality, just as the implied martyrdom had on the previous sheet. The words *tu gloria será eterna* (your glory will be eternal) were probably first put down by Goya; the name *Zapata*, in a less assured hand, appears to have been written later.

Scholars have proposed several candidates for the Zapata Goya had in mind.[2]

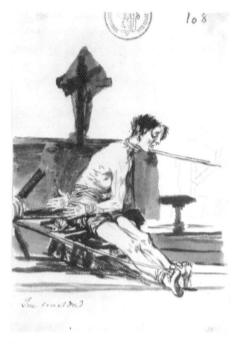

Fig. 1. *Que Crueldad* (What Cruelty),
Album C, page 108.
Brush and brown wash.
Museo del Prado, Madrid

The most likely is Diego Mateo Zapata, an influential medical doctor from Murcia, who in the late seventeenth and early eighteenth centuries followed the theories of Galen and advocated an experimental approach to medical studies.[3] With Juan Muñoz y Peralta he founded what has been termed the first modern academic center in Spain, the Regia Sociedad Médico-Quimica de Sevilla (Royal Medical Chemical Society of Seville), and after 1702 served as its president. He owned a large philosophical library, served as physician to nobility, high clergy, and at the courts of Carlos II and Felipe V, and enjoyed a reputation as one of the most brilliant men of science of the day. In 1721 professional rivals, jealous of his influence at court and opposed to his ideas, denounced him to the Inquisition.[4]

The discovery in Madrid in 1714 of a clandestine Jewish congregation, small but well organized, rekindled feelings of anti-Semitism and gave rise to zealous persecution of *conversos* (descendants of converts to Christianity from Judaism),

who were suspected of being insincere converts.[5] Zapata's ancestors had converted from Judaism, and his mother had been tried by the Inquisition. In a campaign to discredit him, he was accused of being a Judaizer, one who engaged in rituals and practices associated with crypto-Judaism.[6] Historical evidence has demonstrated that Zapata was a Judaizer.[7] After arrest and threat of torture, the physician confessed to the charges but refused to ratify his confession as required on the following day (see cat. 103). Since it was against regulations to apply torture more than twice, the proceedings against Zapata were discontinued. On January 14, 1725, he appeared penitent at an *auto de fe* in Cuenca, where he was charged with being vehemently suspect of errors; he received a reprimand, warning, and precautionary absolution. As punishment, he was sentenced to a year in prison, half of his property was confiscated, and he was ordered banished for ten years from Madrid, Murcia, Cuenca, and all royal sites.[8] To the dismay of his enemies (who thought he was safely out of the way for an extended period), with the help of protectors such as the dukes of Medinaceli and Felipe V himself, within a year of his sentence he returned to favor in Madrid and continued to practice medicine, write, and participate in the founding of Madrid's Royal Academy of Medicine in 1734. His book *Ocaso de las formas aristotélicas* (Twilight of the Aristotelian Forms), published posthumously in the year of his death in 1745, played a significant part in the challenge to Aristotle's authority by such early Enlightenment thinkers in Spain as Feijóo and Andrés Piquer.[9] Zapata and his ideas are considered to be at the very core of the movement of experimental modern science and philosophy in Spain during the first third of the eighteenth century.[10]

It can be debated whether Zapata was the scapegoat of warring political factions or a true martyr persecuted for his beliefs. Goya's drawing portrays the doctor in a way that suggests an Old Testament sage or scholar, who retains his dignity and wisdom even in submission to enslavement. Goya has presented yet another dimension of human suffering

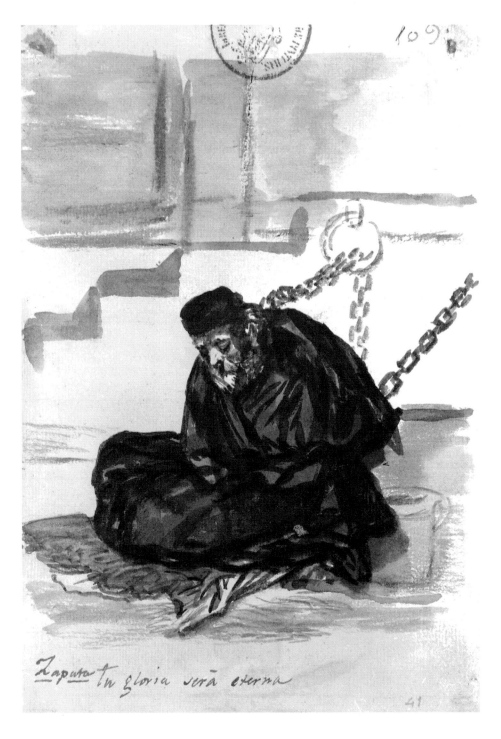

Zapata tu gloria será eterna

and how it can be endured. The mass of the figure is like a rock and therefore conveys immutable truth. The almost abstract configuration of brushstrokes that delineate the background reinforces the architectonic quality of the lines of his crouched position, giving added permanence, strength, and power to this picture of one of the most celebrated men to suffer at the hands of the Inquisition.

S.L.S.

1. One of the primary charges leveled by those who advocated the suppression of the Inquisition was that it was unmerciful. The first chapter heading in Puigblanch, *Inquisition*, p. 19, is "The Inquisition being an ecclesiastical Tribunal, its Rigor is incompatible with the Spirit of Meekness which ought to distinguish the Ministers of the Gospel."

2. These possibilities are summarized by López Rey, *Goya's Drawings*, pp. 127-129. Not included in López Rey's discussion is a poet named Louis Zapata, mentioned by Llorente, *Inquisition*, p. 133. L. Zapata wrote in 1566 a poem entitled *Carlos Famoso*, which included a character, Eugenio Torralba, a Cuenca physician, prosecuted for sorcery by the Inquisition. The name Zapata had rich associations for the nineteenth-century Spaniard.

3. On the life, ideas, and influence of Diego Mateo Zapata, see the following: Sarrailh, *L'Espagne éclairée*, p. 430; Julio Caro Baroja, *Los Judíos en la España Moderna y Contemporánea* (Madrid, 1961), vol. 3, pp. 68-79, 387-391; Juan Bta. Vilar Ramírez, *El Dr. Diego Mateo Zapata (1664-1745)* (Murcia, 1970); Antonio Domínguez Ortiz, *Hechos y Figuras del Siglo XVIII Español* (Madrid, 1980) pp. 234-241; H. Kamen, *La Inquisición Española* (Barcelona, 1985, 1st ed. 1967), pp. 303-304, 328; and Kamen, *Inquisition*, pp. 233-234.

4. In 1692 Zapata had also been been arrested and charged as a Judaizer by the Inquisition. Although he spent a year in prison in Cuenca, he was eventually released, the charges unproven; Vilar Ramírez, *Zapata*, p. 21. The charges are given in Caro Baroja, *Los Judíos*, vol. 3, p. 387.

5. On the survival of Judaism in Spain, as well as the practice of traditional rituals associated with Judaism by otherwise faithful converted Christians, see Lea, *Inquisition*, vol. 3, pp. 231-236, Cecil Roth, *A History of the Marranos* (Philadelphia, 1932), pp. 168-194, 352-357; Mair José Benardete, *Hispanismo de los Sefardíes Levantinos* (Madrid, 1963); Baruch Braunstein, *The Chuetas of Majorca* (1936; reprint, New York, 1972), pp. 96-121; Joachim Prinz, *The Secret Jews* (New York, 1973).

6. The charges and proceedings against Zapata (Biblioteca Nacional, MS. 10938) can be read in two recent publications (Caro Baroja, *Los Judíos*, pp. 387-391; Domínguez Ortiz, *Hechos*, pp. 241-247) and were known to others who discussed the Zapata case in relation to the Inquisition (Lea, *Inquisition*, vol. 3, pp. 29-30, 33; and Vilar Ramírez, *Zapata*).

7. Vilar Ramírez, *Zapata*, pp. 22-27. Secret but observant Jews, as well as sincere converts to Christianity who retained certain domestic practices over the generations, when examined by officials of the Inquisition routinely declared themselves innocent of heresy. There was no alternative. It was the only way to escape death. A person who wanted to practice Judaism openly was beyond the jurisdiction of the Holy Office but had to leave Spain.

8. Lea, *Inquisition*, vol. 3, pp. 29-30, 33. While in prison Zapata was treated with the dignity accorded someone of his position in society. From his protectors he received tobacco, firewood, furniture, and warm clothing; Vilar Ramírez, *Zapata*, pp. 33-36.

9. Sarrailh, *L'Espagne éclairée*, p. 430; and Marcelino Menéndez Pelayo, *Historia de los Heterodoxos Españoles*, vol. [3], Colección "Sepan Cuantos . . .," no. 389 (Mexico, 1983), pp. 48-49 (first published in Madrid, 1882). The first edition of Zapata's book had been suppressed by the Inquisition; Vilar Ramírez, *Zapata*, p. 40.

10. Domínguez Ortiz, *Hechos*, p. 238.

107

Divina Libertad (Divine Liberty)
Album C, page 115
About 1812-1814
Brush with gray and gray-brown wash
205 x 143 mm.
Inscribed in brush and gray-brown ink, upper right: *115*; in pen and brown ink, below image: title
References: G-W 1350; G., I, 259.

Museo del Prado, Madrid, 346
United States only

A man kneels and raises his arms in gratitude for those vigorous shafts of light; here as elsewhere (cat. 52 and 109), the light embodies the Enlightenment pushing back the darkness. Goya's highlights make us notice the man's face, his hands, and his pose. The moment has been long awaited, and its coming elates him. Attributes of a writer – an inkstand, quill pens, and a half-filled sheet of paper – lie next to him. The overcoat with cape and the low-crowned hat he wears were favored by fashionable men during the Peninsular War (1808-1814).[1]

Freedom of the press was among the first issues broached by the Cortes (parliament) assembled in Cádiz in 1810 (see cat. 109).[2] As in most parts of Europe, in Spain law and custom had imposed ecclesiastical censorship on all forms of writing. Many eighteenth-century thinkers believed the censorship customary under absolutist monarchies was a deadening influence on thought and was responsible for the decay of letters. Numerous writers wrote works that never saw the light of day.[3] Liberals defended freedom of the press as an inherent natural right serving the highest interests of the country, among them the eradication of corruption; it was believed to give rise to peace and harmony, just as its absence would lead public opinion to express itself through violence.[4] Most of the outstanding ecclesiastical deputies backed freedom of the press, providing it applied solely to nonreligious matters. Those who opposed it feared for religion, obedience of the laws, and family unity.[5]

Freedom of the press was decreed on November 10, 1810.[6] The Cortes deferred to their large clerical representation and

restricted the airing of controversial
religious issues, instituting censorship
boards to monitor the press; political
issues could be discussed freely. In prac-
tice, freedom of the press obtained in all
but matters relating to the war with the
French.[7] Both pro- and antigovernment
journalism flourished; in fact, its very
success may have planted the seeds of its
destruction. The Duke of Wellington was
not alone in characterizing it as libelous,
and the near-libertine atmosphere of
wartime Cádiz may have done more than
any legal measure passed by the Cortes
to create a solid anticonstitutional front
within the Church, where factionalism
and confusion had reigned.[8]

Chief among the anticlerical writers
during the Peninsular War was the Lib-
eral José Gallardo Blanco, Goya's friend,
whose notorious *Diccionario*, first pub-
lished in 1812, matches many of Goya's
Album C drawings in imagery and tone.[9]
For Gallardo liberty was an "aura
benigna" (benign aura). Fond of rhetori-
cal questions, he asked: "Al pronunciar
esta voz, que humano pecho no se siente
animado de un espiritu casi celestial"
(What human bosom does not feel
moved by an almost celestial spirit on
speaking this word)?[10] Gallardo called
freedom of the press "un derecho impre-
scriptible" (an inviolable right) and
added: "Así como á cualquier ciudadano
le está concedido el uso de la palabra,
debe estarle igualmente el uso de la
imprenta; para que todos contribuyan á
la pública ilustracion y urbano pasa-
tiempo, ya sembrando verdades, ya estir-
pando errores, celebrando virtudes, y
vituperando vicios" (Just as any citizen
has the right to speak as he thinks, he
should have an equal right to publish so
that all might contribute to public
enlightenment and civilized entertain-
ment, sowing truths, uprooting errors,
celebrating virtues, or censuring vices).[11]
Gallardo's aim echoed what Goya had
written fifteen years earlier on the title
page (cat. 51) to his *Sueños* (Dreams).

Goya's *Divina Libertad* is not allegori-
cal, unlike the personifications of Consti-
tution (cat. 109) and Justice (cat. 110) in
this series. He chose to represent free-
dom of the press by depicting its psycho-
logical effect on the kind of person it

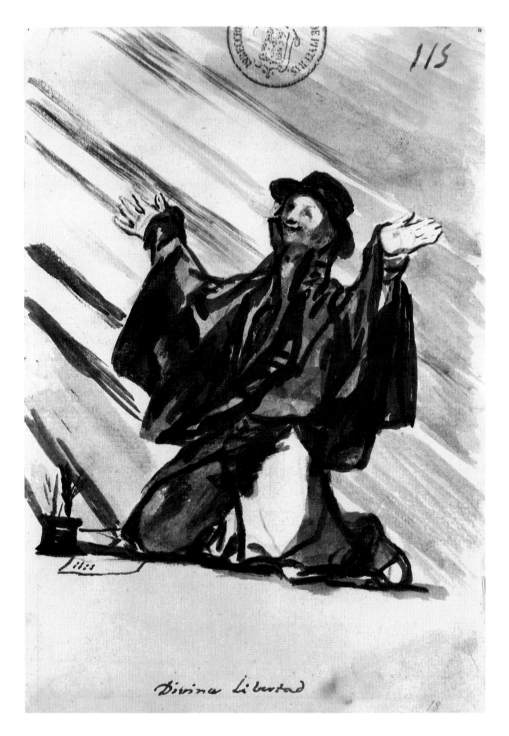

most directly touched. Goya made the light rays visible as a pictorial metaphor for the divine and natural basis of freedom of thought as conceived by his Liberal contemporaries: "La libertad natural y divina que yo tengo de opinar y de publicar francamente mis opiniones cuando no se oponen á la ley de Dios ni á las leyes de la sociedad en que vivo, no está sujeta á ninguna autoridad humana: si me excedo en mis opiniones merezco el correspondiente castigo: si mis opiniones no alteran el órden público, tienen por lo menos derecho á ser toleradas." (The natural and divine right I have to think and publish my opinions openly when they do not conflict with God's law or the laws of the society in which I live is not subject to any human authority. If my opinions go too far, then I deserve the corresponding punishment; if my opinions do not alter public order, at the very least they have the right to be tolerated.)[12]

<div align="right">M.A.R.</div>

1. Eleanor Sayre suggests a date nearer 1812 than 1820 because the low-crowned hat and overcoat with long cape are what fashionable gentlemen wore in the great famine scenes of 1811 to 1812 of the *Disasters of War* 48, 50, 54, 58, 61 (G-W 1070, 1074, 1082, 1090, 1096), unlike what they wore in the second constitutional period of 1820 to 1823. See Madrid, 1982, p. 124. See also *Journal des dames et des modes: Costume Parisien* (Paris, 1812), pls. 1908, 1921.

2. Goya was not alone in spontaneously associating freedom of the press with Enlightenment and its propagation. In 1800 Manuel José Quintana did so in *Oda a la imprenta* (Ode to the Press). Manuel José Quintana, *Poesías completas*, ed. Albert Dérozier (Madrid, 1969), pp. 254-255, lines 33-39; p. 255, lines 61-63; p. 256, lines 75-79; p. 257, line 124; p. 265, lines 154-158. On the use of the term "freedom of thought" in seventeenth- and eighteenth-century Spain, see José A. Maravall, "Notas sobre la libertad de pensamiento en España durante el Siglo de la Ilustración," *Nueva revista de filología hispánica* 33, no. 1 (1984), pp. 34-58. Gallardo also symbolized truth as "la benéfica luz del sol" (the beneficent light of the sun); like some of his contemporaries, he equated freedom of the press with knowledge and power. Gallardo, *Diccionario*, p. 12. José Cadalso observed that the European penchant for self-congratulatory talk of liberty masked widespread self-censorship. Cadalso, *Cartas*, pp. 79-80. At least one writer believed a constitution responding to the needs of the country could not be produced in the absence of liberty. The pioneering newspaper *Semanario patriótico* published this statement, which may have been written by its founder, the Liberal poet Manuel José Quintana: "Haya en España un cuerpo nacional, haya cortes que merezcan legítimamente aquel nombre y ellas irán formando la Constitución que necesitamos, mejor que si Locke mismo resucitara para formarla: no es menester ser sabio para cuidar de los intereses propios: la condición que se requiere es ser *libre*." (Let there be in Spain a national body, let there be a parliament truly worthy of that name and it will begin drafting a Constitution that we need, better even than if Locke were resurrected to draft it. It is not necessary to be wise to guard one's own interests; the necessary condition is to be *free*.) See Madrid, 1982, p. 31.

3. See Blanco White, *Letters*, p. 386.

4. See Nigel Glendinning, "Cambios en el concepto de la opinión pública," *Nueva revista de filología hispánica* 33, no. 1 (1984), pp. 163-164.

5. See Miguel Angel González Muñoz, *Constituciones, Cortes, y elecciones españolas: Historia y anécdota, 1810-1936* (Madrid, 1978), p. 18; Callahan, *Church*, p. 103.

6. Article 131, section 24, of the Constitution of 1812. See Madrid, 1982, p. 124. See also Alcalá Galiano, *Recuerdos*, p. 97.

7. See Alcalá Galiano, *Recuerdos*, p. 97; Madrid, 1982, p. 32.

8. In 1813 an unsympathetic Wellington complained: "In truth there is no authority in the state, excepting the libellous newspapers; and they certainly ride over both Cortes and Regency without mercy." *The Dispatches of Field Marshal the Duke of Wellington*, ed. Lieutenant Colonel Gurwood, vol. 10 (London, 1838), p. 54.

9. Gallardo was the Cortes' librarian. On Gallardo and Goya's rapport, see Antonio Rodríguez-Moñino, "Goya y Gallardo: Noticias sobre su amistad," *Relieves de erudición (del Amadís a Goya): Estudios literarios y bibliográficos* (Madrid, 1959), pp. 327-340. On the reception accorded Gallardo's *Diccionario*, see Alcalá Galiano, *Recuerdos*, pp. 187-189; C. Torra, "Bartolomé José Gallardo y el Diccionario crítico-burlesco," *Estudios sobre Cortes de Cádiz* (Pamplona, 1967), pp. 209-272; Ramón Solís, *El Cádiz de las Cortes: La vida en la ciudad en los años 1810 a 1813* (Madrid, 1969), pp. 308ff; Callahan, *Church*, p. 97.

10. Gallardo, *Diccionario*, p. 76.

11. Ibid., p. 80.

12. Antonio Bernabeu, *España venturosa por la vida de la Constitución y la muerte de la Inquisición . . .* (Madrid, 1820), p. 15. Biblioteca Nacional, Madrid, R 60.122.

108

Dure la alegria (May the Joy Last)
Album C, page 116
About 1812-1814
Brush with gray-brown and dark-brown wash
204 x 145 mm.
Inscribed in brush and brown ink, above image: *116*; in pen and brown ink, below image: title
References: G-W 1351; G., I, 260.

Museo del Prado, Madrid, 356
Spain only

Wrapped in a shawl, a young woman in white and a man slumped in a chair sit at angles to a table crowded with glasses. The man seems to have drunk himself into a stupor. Distorted people mock the couple and urge them on. In the wings several figures bide their time.

The man hunched in the chair may well be Napoleon's brother, José I, puppet king of Spain.[1] He was widely believed to have been a tippler, for which he accumulated unflattering sobriquets – such as *Pepe Botellas* (Pepe Bottles) and *El rey de copas* (King of Goblets), in a pun on a Spanish card suit – as weil as caricatures (see fig. 1).[2] José I had a reputation for keeping mistresses while in Spain, which explains the presence of the young woman. His wife, Julie, never joined him there.[3] Along with the preceding drawing on freedom of the press (cat. 107) and the following allegory of the coming of the Constitution (cat. 109), this drawing belongs to a sequence depicting landmark events in the final years of the war, when José I was on the verge of losing his throne. His letters to Napoleon reveal he was a vacillating, ineffectual, dependent man, given to fantasy, but there is some evidence he took his responsibilities seriously.[4] His inclination to drink may well have been fabricated by his refractory subjects in order to discredit him. Even so, José I as a drunkard is an apt symbol of his imperfect control over the country.

José I never had the upper hand in Spain. The war destroyed any hope of establishing a constitution supported by all but the small minority of Spaniards who were *afrancesados* (French col-

Fig. 1. Anonymous,
*Cada qual tiene su suerte, la tuya es de borracho
hasta la muerte* (Everyone has his destiny; yours is to
be a drunk to the death), 1814
Engraving, hand-colored.
Museo Municipal, Madrid

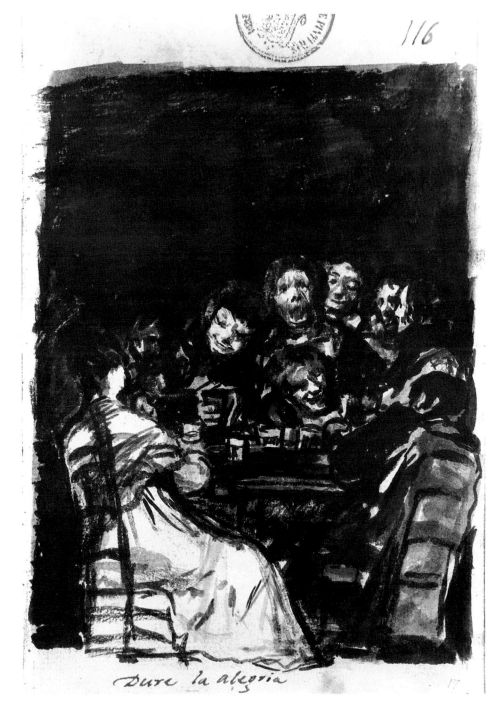

laborationists). The French arrived with
a more high-minded purpose than mere
occupation; there were promises of
reform, even if their only function was to
co-opt the population into tolerating the
annexation. The result, however, was
war, sieges, slaughter, and famine.

Goya drew an allegory of the precari-
ousness of José I's position in Spain: a
king with no real power, supported by an
army mired in a protracted guerrilla war.
The two figures marking time, one on the
right and the other on the left, may rep-
resent more serious opponents – perhaps
the Liberals who had formed an alterna-
tive government to the French at Cádiz –
than the boon companions egging the
couple on. José I is already too far gone
to imbibe any more. He has had his final
drink. The false cheer of this drawing,
marred as it is by vice, makes a strong
contrast to the genuine happiness, bor-
dering on rapture, of the following two
drawings on the coming of the Constitu-
tion (cat. 109 and 110), and is a poignant
metaphor for the drawn-out agony of
José I's last months in Spain.

M.A.R.

1. See Sayre, "Goyas 'Spanien, Tiden och His-
torien,' " pp. 29-30.

2. He was also called *tuerto* (bent or one-eyed)
although he was neither. On José I's reception in
Madrid, see Alcalá Galiano, *Recuerdos*, pp. 90ff.
José I reentered Madrid for the last time on Nov. 2,

1812; he was definitively expelled on Mar. 17, 1813. See Manuel Morán Orti, *Poder y gobierno en las Cortes de Cádiz (1810-1813)* (Pamplona, 1986), p. 338. The young woman wearing the wide, long shawl is dressed according to the fashion of 1812; her dress is not trimmed with ruffles or quilting nor is she wearing one of the large hats fashionable about 1820. See *Journal des dames et des modes: Costume Parisien* (Paris, 1812), pls. 1223, 1257; Max von Boehn, *La moda: Historia del traje en Europa: Desde los orígenes del Cristianismo hasta nuestros días*, vol. 5 (Barcelona, 1951), p. 162.

3. See Gabriel H. Lovett, *Napoleon and the Birth of Modern Spain*, vol. 2 (New York, 1965), pp. 493-494.

4. See Miguel Artola Gallego, *Los afrancesados* (Madrid, 1953), pp. 159, 191. See also Lovett, *Napoleon*, pp. 497-506.

109

LUX EX TENEBRIS (Light from Darkness)
Album C, page 117
About 1812-1814
Brush with gray and black wash touched with brown, paper scraped to indicate a few highlights
205 x 143 mm.
Inscribed in brush and brown wash, center right: *117*; in chalk, lower left: title
References: G-W 1352; G., I, 261.

Museo del Prado, Madrid, 347
Spain only

An idealized young woman hovers, reverently bearing a book. Irradiating from her head and the tiny book, an intense nimbus of light penetrates the darkness. With some difficulty the light filters down to reveal a monk facing us, other ecclesiastics with their backs to us, and in the lower part of the drawing, what may be a man wearing a cocked hat favored by fashionable gentlemen in this period.[1]

This image and that of Justice (cat. 110) in the following drawing may have been derived from a roundel on the title page of many copies of the Constitution (fig. 1).[2] The flame issuing from the head of the personification of Constitution has expanded to become the halo in this drawing.[3] The young woman – with her simple white gown and her radiance – is an embodiment of constitutional Spain, whose iconography is based in part on Liberty.[4] The book she holds is a copy of the Constitution of 1812. The drawing is also related to Goya's painting the *Allegory on the Adoption of the Constitution of 1812* (cat. 74).[5]

On September 24, 1810, the Cortes (parliament) were officially inaugurated by a civic procession and mass on the island of León in Cádiz.[6] Their work was completed on January 23, 1812. Among other principles established was the equality of all Spaniards throughout the empire (August 18, 1811), enacted through the suppression of proof of nobility for admission to military schools and the abolition of all seignorial rights and, therefore, of vassalage. The commission charged with drafting the Constitution

Fig. 1. P. Gassó after F. Pilar, Etching on title page of the Constitution of 1812 (detail).
Private Collection, United States

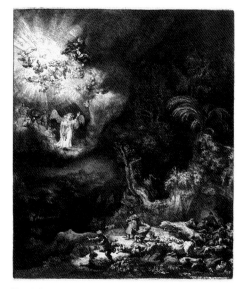

Fig. 2. Rembrandt van Rijn, *Angel Appearing to the Shepherds*, 1634. Etching, engraving, and drypoint.
Museum of Fine Arts, Boston, Anonymous Gift

was made up of fourteen delegates, five of them clerics, including its president, the Liberal priest Diego Muñoz Torrero; two of the other clerics (Espiga and Oliveros) were also distinguished Liberals. Otherwise, the balance between Serviles and Liberals was even.[7]

One of the peculiarities of this Constitution is that it contains no Bill of Rights; the protection of civil liberties, property, and so on is established in diverse articles. The delegates believed a formal declaration of rights to be French in

character, and they wished to avoid any association with the invaders. Most of Spain was still occupied by French troops, and war-induced starvation and devastation were ruining the country. Another peculiarity is that the Constitution's preface denies all originality and describes the text as a recovery of ancient Spanish liberal and representative traditions, embodied in the *fueros* (laws), which were said to have been subverted by Carlos I (Carlos V of the Holy Roman Empire) and his "funesta política del absolutismo" (unfortunate absolutist policy).[8] The stress on restoring ancient traditions and values betrays the Constitution's enlightened roots. Enlightened Spaniards studied the country's past achievements in every field in order to preserve what was worth preserving and to build upon it; Jovellanos did this for the laws of the country, just as Moratín did for the theater. In spite of the Constitution's traditional sources, the deputies borrowed some of their terms from the English Constitution, others from the French Constitution of 1791; and still others were expressions of the mentality of the enlightened Spaniards gathered in the Cortes, especially their belief in the capacity of laws to change society (see cat. 163).[9]

The Constitution is dated March 18, was sworn and promulgated on March 19, and was published with the signatures of 194 delegates, among them those of the most powerful ecclesiastics.[10] The first edition of the Constitution was to be published in three formats: a deluxe edition in folio for sale; another in quarto for the congressional deputies, the Regency, ambassadors, and other dignitaries; and the third in duodecimo for the public at large in order that, in the words of Garoz y Peñalver, the deputy to the Cortes from La Mancha, "no carezca el pobre que la compre . . . y se proporcione la economía y el frecuente uso de ella a toda clase de personas, pudiendo llevarla en la faltriquera á todas partes" (the poor be able to purchase it . . . and to enable all classes of people to enjoy economies and frequent use of it, as they will then be able to carry it in a purse wherever they go).[11] In fact, two editions were published: one in folio on vellum,

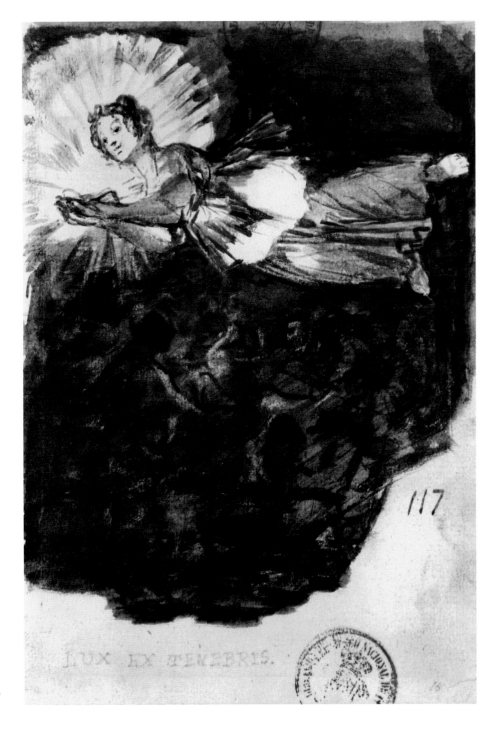

the other in octavo on common paper. It did not escape Goya that this interest in widely distributing the text of the Constitution was informed by the same democratic spirit in which it was conceived. He showed Liberty delivering the most modest of the two versions of the first edition to the multitude for which it was intended. His republican inclinations are evident because he represented the advent of the Constitution without ceremonial rhetoric and without the presence of a monarch.[12]

The inscription is unusual for Goya: It is in Latin and is the only one he carefully lettered in capitals with serifs. The title may be derived from Genesis 1:4: "God divided the light from the darkness." The analogy is not surprising; Goya saw the Constitution of 1812 as marking the beginning of a new era for Spain. The tragedies endured by Spain seemed to be nearing an end; the close of hostilities with Napoleon's troops would bring longed-for peace (see cat. 163) and the promulgation of the Constitution throughout Spain.

Goya made use of traditional religious iconography. Not only the young woman in white, but the suggestion of tidings of great joy recall the angel's appearance to the shepherds, as in an etching by Rembrandt (fig. 2), which has the same feeling of darkness pierced by light. This infusion of new political meanings into traditional religious imagery was echoed in 1820 at the beginning of the second constitutional period, in a publication that because it, too, carries a strong emotional charge, helps us to understand the enthusiasm with which Liberals received the Constitution: "Ensalzada sea pues la divina Providencia que por medio de la Sabia Constitución de la Monarquía Española ha convertido nuestros sollozos en regocijo, y ha vestido de gala á las almas sensibles, que desoladas y cuasi exánimes de dolor, vivian enlutadas al ver que hubiera ciudadanos que se creyesen honrados en ser alguaciles . . . de la inquisición" (Praised be Divine Providence, which, through the wise Constitution of the Spanish monarchy, has turned our lamentations into rejoicing and has given full dress to those sensitive souls plunged into mourning because

there were citizens who believed themselves honored to be constables . . . of the Inquisition).[13]

<div align="right">M.A.R.</div>

1. The seated friar wears the self-satisfied expression of his brother in cat. 112; his smugness is related to the false importance another cleric gives himself in *Album C*, p. 123 (G-W 1358), as implied by the Spanish word for ghost in Goya's title. The suggestion of the fashionable gentleman, along with the friar – both in the shadow of the Constitution – may indicate Goya had in mind the suppression of noble and ecclesiastic seignorial rights as decreed by the Cortes (see cat. 112).

2. See Eleanor A. Sayre, "A Moment in Time," *Stockholm Nationalmuseum Bulletin* 3, no. 1 (1979), pp. 40-44; Madrid, 1982, p. 126.

3. See Sayre, "A Moment in Time," p. 33.

4. Ibid., p. 47.

5. Ibid., p. 33.

6. The delegates numbered about 300, of which approximately 90 were clerics (including 3 inquisitors), 60 jurists, 50 civil servants, 40 military, 14 professors, 14 nobles, and smaller numbers of merchants, landowners, writers, and doctors. The estimates vary. See Miguel Angel González Muñoz, *Constituciones, Cortes, y elecciones españolas: Historia y anécdota, 1810-1936* (Madrid, 1978), p. 17; Pedro Farias García, *Breve historia constitucional de España: 1808-1978* (Madrid, 1981), p. 30.

7. See Farias García, *Breve historia*, p. 31.

8. González Muñoz, *Constituciones*, p. 19.

9. Ibid., p. 20.

10. Ibid.

11. See Madrid, 1982, p. 24.

12. González Muñoz, *Constituciones*, pp. 32-33.

13. Antonio Bernabeu, *España venturosa por la vida de la Constitución y la muerte de la Inquisición . . .* (Madrid, 1820), p. 17. Biblioteca Nacional, Madrid, R 60.122.

110
The Coming of Justice
Album C, page 118
About 1812-1814
Brush with gray, black, and brown wash
205 x 144 mm.
Inscribed in brush and brown wash, upper right: *118*
References: G-W 1353; G., I, 262.

Museo del Prado, Madrid, 345
United States only

The dark sky is permeated by a luminous haze, and the scales of Justice appear in a glory of light.[1] Common people throng below, dance, or stare in awe. The drawing is suffused with the optimism of the moment when the Constitution of 1812 was first established.

This is an allegory of the reception of Justice, intimately associated in its iconograpy with the preceding drawing of the coming of the Constitution (cat. 109).[2] On the title page of many copies of the Constitution, the scales of Justice lie beside the personification of constitutional Spain (see cat. 109, fig. 1). The motto above her – *sic erat in fatis* (so it was decreed by fate) – corresponds to the Judgment tone of the drawing.

On the left Goya illuminated the blessed, those awaiting Justice with eagerness: a woman clasping her hands with rapture and another, younger, woman dancing joyfully. On the right he cast light on the damned, those who believed they had the most to lose in the new constitutional order: a friar or monk, a nun, and a priest, who turns round and flings himself into the darkness. Their reactions to personal misfortune range from suspicion and disgust to fear. The fasces in the roundel (cat. 109, fig. 1) symbolized the belief in the Constitution's power to bring people together; Goya's drawing shows that in reality the Constitution divided Spain.[3]

Goya's Liberal friend the writer José Gallardo Blanco wrote of the gathering storm generated by the collision between Liberals, who favored the Constitution, and their opponents, the Serviles. Gallardo used the same imagery of light and darkness to represent an ideological clash: "La lucha de la luz y las tinieblas

habia de renacer: lucha terrible y porfiada que apénas deja tal cual respiro á las naciones, y que empezó con el mundo y con él acabará" (The struggle between light and darkness had to resume: a terrible, persistent fight that allows no nation a moment's respite, a fight that began with the world and so will it end).[4] He went on to observe that among ecclesiastics resisting the imposition of the Constitution, the war with the French had become secondary to a holy war against "infieles y hereges" (infidels and heretics), by which Liberals were meant. Philosophers were the most ardent supporters of the Constitution because "á nadie gustan mas las cosas en razon, que á los hombres de razon" (nobody likes things in their place more than men of reason).[5] The reactionaries among the ecclesiastics had lost everything in the war but their ambition to own and control without limits.[6]

Many clergy mobilized against the constitutional Cortes (parliament). They feared the Cortes' first timid steps toward reducing the burden on laborers of supplementary dues to the tithe, as well as toward limiting and regulating the Church's functions and finances, would be followed by an all-out assault (see cat. 112, 114, and 115).

<div align="center">M.A.R.</div>

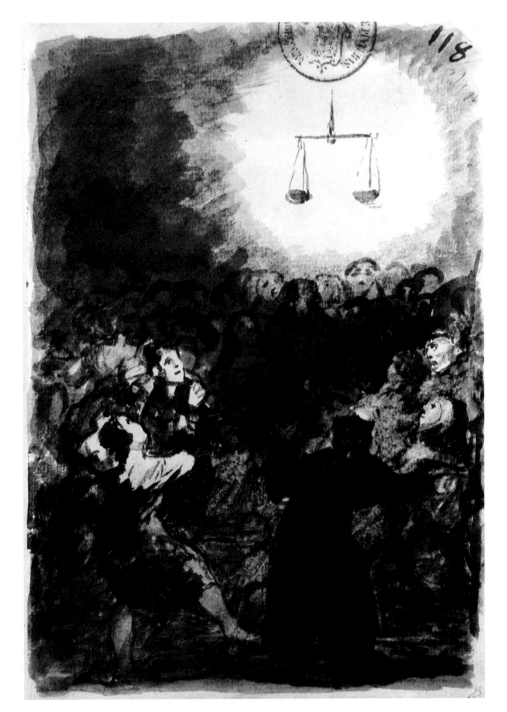

1. The customary title of this drawing, *Sol de Justicia* (Sun of Justice), was given by F. J. Sánchez Cantón from the sunlike burst of light where Goya placed the scales of Justice. See G., I, 380. This title refers to a religious iconographic tradition in which Christ was described by the same expression. The coming of Christ portended the expiation of sins and the realization of the kingdom of God, in which justice would reign. This expression is found in such Christmas carols as: "En un humilde portal / que anublo estaba arruinado / nació aquel sol de justicia, / de frío todo temblando" (In a humble portico / ruined with blight / was born that sun of justice, / trembling with cold). Marius Schneider and José Romeu Figueras, eds., *Cancionero popular de la provincia de Madrid*, vol. 1 (Barcelona and Madrid, 1951), p. 30, song 55.

2. A similar sequence in which Justice and Constitution are associated appears again in the *Disasters of War* (cat. 161, 162). Goya evidently did not believe that truth or justice could exist in the absence of a constitution.

3. See López Rey, *Goya's Drawings*, p. 132. For a more detailed discussion of iconography related to that here, see cat. 156.

4. See Gallardo, *Diccionario*, p. 117.

5. Ibid., p. 23.

6. Ibid., p. 118.

111

*Ya hace mucho tiempo, q^e som^s
Conoc^{dos}* (They've known about us
for a long time)
Album C, page 119
About 1812-1814
Brush with gray and brown
wash touched with black
205 x 143 mm.
Inscribed in brush and gray
wash, upper right: *119*, above image, in
brush and gray wash: title
References: G-W 1354; G., I, 263.

Museo del Prado, Madrid, 358
United States only

Standing in the foreground are a friar in
a black habit and another in black and
white, who bow their heads feigning
humility; at the far left a second brother
in black and white stares impassively.
The remaining two are in gray habits.
The friar with a pointed hood is prepar-
ing to squat down, much as the other has
already done. The brothers' hands are
hidden in ample sleeves. These listless
friars belong to different orders, but
Goya grouped them together under the
same damning title.[1]

This is the first of twelve drawings on
the religious orders, which follow those
on the coming of the Constitution of 1812
and Justice. Reform of the Church and
disentailment of ecclesiastical property
were broached as separate issues in the
eighteenth century. In the course of the
war they were confused, the constitu-
tional Cortes (parliament) using reform
as a pretext for disentailment.[2] The fun-
damental weakness of the eighteenth-
century Church was its poor distribution
of clergy and wealth.[3] Because friars
were concentrated in the cities, where
they were least needed, a situation in
which boredom, routine, and a decline of
religious discipline prevailed even as
outside the cities, parishes begged for
pastors.[4] Nepotism, simony, and other
forms of corruption were inevitable con-
sequences of a system in which the men-
dicant and monastic foundations received
a share of the tithe out of all proportion
to their services, particularly at the
expense of the parish priest.[5] The vow of
poverty was sometimes neutralized by

specious arguments, such as pretending
that wealth brought to the community
and enjoyed by the individual in fact
belonged to the house. The vow of chas-
tity may not have been any more faith-
fully observed.[6]

The Church's tax exemption gave it an
advantage when it came time to acquire
the choicest properties.[7] Already under
Carlos III, royal ministers had resisted
the advancing tide of entailment it made
possible. The secretary general of the
Inquisition, Juan Antonio Llorente, ana-
lyzed the problem with an unabashedly
Liberal outlook: Institutions should come
or go depending on their demonstrated
utility to society. "Todos los institutos
dirigidos á la contemplacion y cántico de
las alabanzas divinas, pueden llamarse
inútiles civilmente, y en su consecuencia
perjudiciales, porque poseen estancados
muchos bienes raices, que puestos en cir-
culacion enriquecerian al estado y á
crecido número de sus familias. La
poblacion creceria mucho, la agricultura
se mejoraria, el comercio hallaria mas
recursos, las fábricas tendrian mas
manos activas, y todo el cúmulo general
de habitantes participaria de estas
ventajas." (All institutions dedicated to
contemplation and singing of divine
praise may be called useless to society
and harmful in their consequences
because they possess great landholdings
that would enrich the state and a large
number of families if they were put into
circulation. The population would grow,
agriculture would improve, commerce
would be supplied with fresh resources,
industry would have more available
labor, and the population as a whole
would benefit from these advantages.)[8]

The idle hands and large sleeves bring
to mind several expressions.[9] *Manga
ancha* (wide sleeve) was applied to the
confessor who absolved too readily.[10]
Contrasting clerical reformers – called
Jansenists by their enemies – with their
opponents, Gallardo wrote: "Los apo-
dantes son gente de manga ancha y cor-
don flojo, y los apodados los quieren
meter en cintura: á aquellos les gusta
vivir de cucaña, y estos quieren reducir-
los al pan cotidiano." (The name-callers
are people of wide sleeves and loose gir-
dles, and the name-called want to make

them tighten their belts; the former like
to live at the expense of others, and the
latter want to limit them to their daily
bread.)[11]

M.A.R.

1. Among Liberals, the friars' reputation for hypoc-
risy was an article of faith. José Gallardo Blanco
accused them of cowardice toward the French. "Y
ahora que estais en seguro ¿venis blasonando de
zeladores de la religion y la patria? ¡Hipócritas! se
os conoce: vuestra religion es vuestro vientre, y vues-
tra patria todo pais de cucaña." (And now that you
are safe, you pretend to be protectors of religion and
country? Hypocrites! We know what you are: your
religion is your belly, and your country is every ref-
uge of the cuckoo [literally, greased pole (see cat.
12A), which refers to acquiring without effort and at
the expense of another].) See Gallardo, *Diccionario*,
pp. vii, 20. The monastic (monk's) life was known for
its wealth, ease, and indulgence; the mendicant
(friar's) for its vulgarity, filth, and vice. On the repu-
tations of the various orders, see Blanco White, *Let-
ters*, Letter 7.

2. On Nov. 30, 1810, the distinguished Liberal
Agustín Argüelles proposed that some kinds of eccle-
siastical income be applied to the war cause, the first
step toward disentailment. On this measure, subse-
quent proposals, and ensuing debates, see Martínez
Albiach, *Religiosidad*, pp. 297ff.

3. The number of clerics was not itself a problem;
the clergy made up about 1.5 percent of Spain's pop-
ulation, a lower proportion than in some other Cath-
olic countries. See Artola, *Orígenes*, pp. 34-38;
Revuelta González, *Política*, pp. 39-40; Callahan,
Church, pp. 8, 20-21.

4. Because the priests, cathedral canons, and friars
preferred the cities, many villages paid tithes and
went without spiritual services while the cathedrals
engaged some ministers merely to sing. See Revuelta
González, *Política*, p. 38; Callahan, *Church*, pp. 14-15,
20-21, 24-25. On the relationship between the
orders' feudal rights and their relaxation of religious
discipline, see Martínez Albiach, *Religiosidad*, pp.
304-305.

5. See Revuelta González, *Política*, pp. 45-47, 58ff.;
Callahan, *Church*, pp. 25-27. For cases of relaxation
of discipline, see Fontana Lázaro, *Quiebra*, p. 187.

6. See Juan Antonio Llorente, *Defensa de la obra
intitulada Projet d'une Constitution Religieuse* . . .
(Barcelona, 1821), pp. 192, 198. According to
Llorente, the vow of chastity was observed only by
the weak and sickly, and concubinage and onanism
were not uncommon. See also Glendinning, *Siglo
XVIII*, p. 118.

7. In his *Tratado de la regalía de amortización* (Trea-
tise on the Privilege of Entailment), Carlos III's minis-
ter the Conde de Campomanes ascribed mendicancy
among peasants and the depopulation of the country-
side to the Church's growing absorption of lands.
See Fontana Lázaro, *Quiebra*, p. 185. Where the
Church possessed seignorial rights, it could decide
when local producers sold their grain, sometimes
creating apparent scarcity and thereby driving up
prices for its own grain and the value of the tithes
exacted. Ibid., p. 186.

8. Llorente, *Defensa*, pp. 218-219. See also Gallardo, *Diccionario*, p. 30.

9. The hidden hands suggest the Church's right to hold lands in perpetuity, called *manos muertas* (mortmain; literally, dead hands), a form of ownership that discouraged enterprise because the lands were not directly cultivated by the owners but by tenant farmers whose contracts were uncertain and who were heavily taxed by owners. See López Rey, *Goya's Drawings*, p. 133. The Spanish expression of hands resting on each other, *mano sobre mano*, means idleness when used with the verb "to be" and hypocrisy when used with other verbs such as "to come." See Cesar Oudin, *Tesoro de las dos lenguas Española y Francesa* (Paris, 1968), under *mano sobre mano, estar*; José Luis Alonso Hernández, *Léxico del marginalismo del Siglo de Oro* (Salamanca, 1977), under *mano sobre mano, venir*. Martínez Albiach, *Religiosidad*, p. 599, quotes a Servile text of the time using *mano oculta* (hidden hand) to mean the fifth column (i.e., the enemy that undermines secretly from within). Could Goya in this way have illustrated what some regarded as conservative clerical duplicity toward the French and the Cortes, mouthing support for the latter while undermining it at every step (see cat. 161)? See Madrid, 1982, p. 51.

10. Terreros, *Diccionario*, under *manga*. This laxity was attributed to the Jesuit doctrine of *molinismo*. The Jesuits' reputation for excusing everything and thus corrupting morality earned them expulsion from Spain in 1767, and they were not readmitted until 1815, following Fernando VII's accession. Their easy way with penance did not suit the reforming spirit of the Jansenists within the Church, Carlos III, or his ministers. See Gallardo, *Diccionario*, pp. 62, 86; Callahan, *Church*, pp. 30-31.

11. See Gallardo, *Diccionario*, p. 54; see also p. 22.

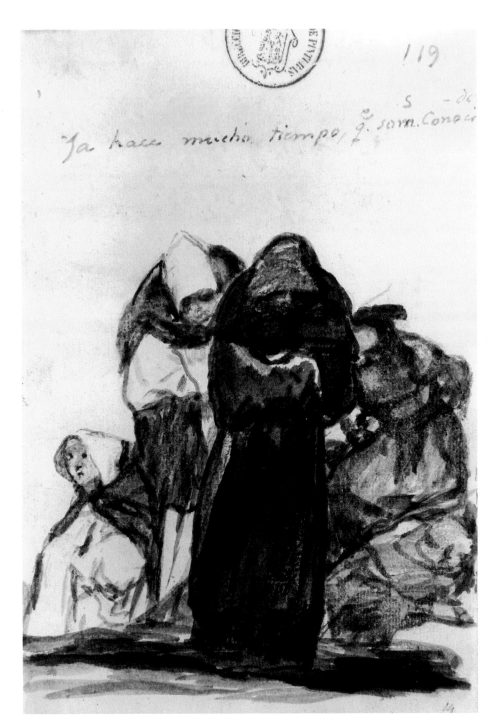

112

No sabias lo q^e llevabas aquestas (You didn't know what you were bearing)
Album C, page 120
About 1812-1814
Brush with gray, black, and brown wash
200 x 142 mm.
Inscribed in brush and gray wash, upper right: *120,* lower left, in brush and gray wash: title; verso, brush and gray wash: *la ora de las lombrices* (The Hour of the Worms)
References: G-W 1355; G., I, 264.

Museo del Prado, Madrid, 361
Spain only

A peasant digs into the earth with his hoe. Complacently mounted on his back, a cosseted friar feeds himself daintily.[1] Goya emphasized the full, puckered lips and oversize hands that mark a glutton. The peasant's right foot is mired in a hole partly of his own making, and his eyes are shut, like those of the two men in *Capricho* 42 (cat. 49) bearing donkeys on their backs. The title of that print, *Tu que no puedes* (You who cannot), is the beginning of a Spanish saying that ends *llévame a cuestas* (carry me on your back).[2] Like the *Capricho,* this drawing resembles a French print in which allegorical figures of the Church and the aristocracy ride on a peasant's back (cat. 49, fig. 1).

The Church possessed between one-fifth and one-sixth of the nation's wealth.[3] The tithe, intended for the priest and the cult, was largely appropriated by the mendicant and monastic orders and the episcopal Curia.[4] After paying their tithes, villagers found themselves making fresh outlays in alms and odious surplice dues so that their parish churches might be maintained with some decency and the priest not have to beg for his sustenance. The *estola, pan de froses,* and *luctuosa* dues were paid for such sacramental services as baptisms, marriages, and burials. Many villages had no priest at all.

The contrast between the opulence of some monasteries and the miserable situation of parish priests impressed reformers. Just before the Constitution went into effect in 1812, the Asturian lawyer

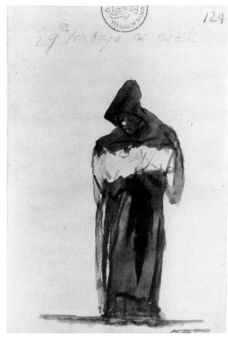

Fig. 1. *¿q^e trabajo es ese?* (What kind of work is that?),
Album C, page 124.
Black and brown wash.
Museo del Prado, Madrid

Calella called for a reform of the Church, centered on the parishes, a program inspired in the best enlightened tradition. "La misma necesidad les hace envolverse en negociaciones profanas, indecentes a la pureza de su estado, indecorosas a la religión y perjudiciales a la nación" (Necessity itself makes priests engage in profane affairs, indecent to the purity of their state, indecorous to religion, and harmful to the nation).[5] The *luctuosa* was especially noxious, discouraging a livestock industry, for on the head of the household's death, the noble or clerical lord had a right to the best animal, even if there were no other.[6] Calella proposed to abolish surplice dues and reorganize parishes so that one priest served one church and the distance between the faithful and their priest was minimal. The priest would receive a fixed income in order to avert the proliferation of surplice dues that were such a burden on the rural population. How great the burden was is suggested in a report read to

the full Cortes (parliament) on September 3, 1813, from one hundred Galician laborers who "suplicaban que dotándose suficientemente a los curas se les redimiese de tan pesada contribución" (beseeched [the Cortes] that priests be paid well enough so they [the peasants] would be liberated from such an onerous due).[7]

The peasant's blindness is an attribute of ignorance (see cat. 55 and 157). Some writers critical of the clergy accused them of propagating ignorance and superstition among the common people in order to live at their expense (see cat. 155 and 158).[8] Goya held the peasant partly responsible for his oppressed state, for the peasant's ignorance allowed the friar to take advantage of him before the Cortes brought injustices – symbolized here by the friar causing the peasant to sink into a hole under the weight of dues – to light. The friar seems equally ignorant of the extent to which his life would be changed by the Cortes' reforms of the clergy and entailment (see cat. 114).[9] On the verso Goya inscribed *la ora de las lombrices* (The Hour of the Worms), an expression recalling both death and parasites, which Goya repeatedly associated with friars, as in *Album H,* page 4 (cat. 173) and *Album C,* page 124 *¿q^e trabajo es ese?* (What kind of work is that?) (fig. 1), whose title, addressed to a cleric, would as well have suited this drawing. To many minds the Old Regime practice common throughout Europe of exempting the nobility and clergy from taxation was indeed a form of parasitism.[10]

M.A.R.

1. Goya may owe this detail to the expression *traga tajadas* or *tragatajadas* (literally, swallow-slice), meaning the rogue who lives and eats at the expense of another. See José Luis Alonso Hernández, *Léxico del marginalismo del Siglo de Oro* (Salamanca, 1977), under *traga tajadas.* Blanco White observed that friars were inclined to "shameless begging" and thought nothing of sharing a meal with laborers, although they "extorted" through the tithe. Blanco White, *Letters,* p. 219.

2. Some of Goya's contemporaries believed these donkeys symbolized the clergy and the nobility carried by laborers. See Madrid, 1982, p. 194.

3. See Fontana Lázaro, *Quiebra,* p. 190.

4. See Martínez Albiach, *Religiosidad,* pp. 305-307.

For example, in the archdiocese of Tarragona, 52 percent of tithes went to the archbishop and cathedral chapter in Tarragona, 25 percent to laypeople, and 12 percent to monasteries. Little more than 10 percent was divided among the bishop of Vic, the cathedral chapter at Ibiza – which had nothing to do with the diocese of Tarragona – and, finally, the parish priests of Tarragona. See Fontana Lázaro, *Quiebra*, pp. 188-189.

5. Quoted in Artola, *Orígenes*, p. 507.

6. See Valentín de Foronda's comment of 1812 on the *luctuosa*, quoted in M. Benavides and C. Rollán, eds., *Los sueños de la razón* (Madrid, 1984), p. 195.

7. Artola, *Orígenes*, p. 508; Martínez Albiach, *Religiosidad*, p. 305.

8. In 1811 Manuel José Quintana had already predicted ignorance would be an obstacle to reform. "El interés, la ignorancia y el artificio sostienen entre nosotros los abusos civiles o eclesiásticos. . . . Es una locura tratar de convencer a los interesados en los abusos; más directo es el medio de instruir a los que hablan por ignorancia, y a los ignorantes que los escuchan. En un pueblo poco instruido abundan los bribones en razón del alimento que proporcionan. Váyase disminuyendo poco a poco la cosecha de abusos y se irán en proporción disminuyendo los que viven de ellos. Bien lo conocen, y por eso claman, no solo contra las reformas, sino contra la ilustración que las trae consigo. No hay, pues, que esperar ni que empeñarse en destruir todas las preocupaciones a un tiempo; es obra de muchos días, y debe seguir la misma marcha que la ilustración, a fin de que no perdiendo el pueblo de vista el objeto de las reformas, y conviniéndose de las ventajas que le resultan de ellas, no puedan extraviarlo los artificiosos interesados en el sistema anterior." (Interest, ignorance, and deceit maintain civil and ecclesiastical abuses among us. . . . It is folly to try to win over those with a stake in abuses; it is more effective to teach those who talk out of ignorance, and the ignorant who pay attention to them. Among poorly educated people, idlers abound in virtue of the nourishment they give. As the harvest of abuses shrinks, those who live off them will too. They know it well, and so they clamor, not only against reforms but against the Enlightenment that brings them. One must not expect or even try to destroy all of these interests at one time; it is a task for many days and should follow the same progress as Enlightenment, in order that the people will not lose sight of the aim of the reforms and will learn the advantages that result from them, such that they will not be misled by those deceitful, entrenched interests of the old order.) Quoted in Madrid, 1982, p. 34, n. 12.

9. Such was the change in mentality wrought by the Cortes that the restoration of feudal privileges in 1814 mobilized the peasantry against their former noble and ecclesiastical lords; their resistance to paying tithes also caused the Church's income to drop by half between the 1790s and 1820. See Fontana Lázaro, *Quiebra*, pp. 262-274. A political fable warned Liberals in 1813 against complacency in the power struggle with monarchist Serviles in these terms: "Donde se encuentren á miles / hombres, como el mochuelo, que serviles / huyan de la ilustracion, / muy bien pueden los Topos liberales / dexar de ser tan Topos animales, / à dexarse poner el

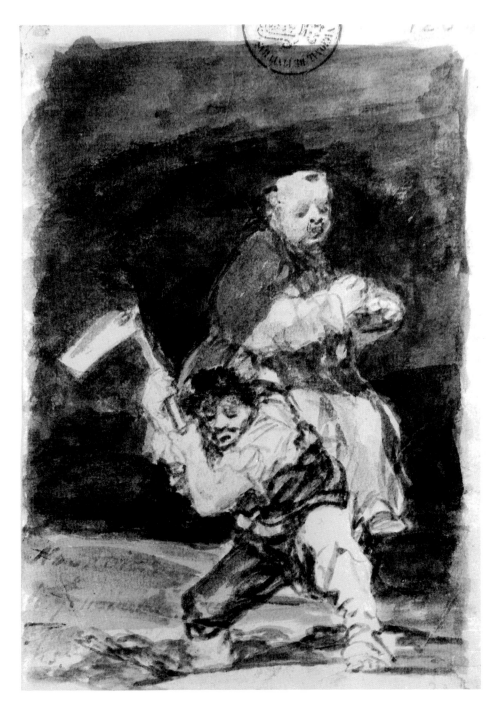

albardon" (Where there are thousands / of men, who, like the owl, being Serviles / flee from Enlightenment, / Liberal moles would do well / to stop being such stupid animals / that they allow themselves to be saddled.) The closing image of surrender – being saddled for riding – resembles Goya's. See D.C. de B***, *Fabulas politicas* (London, 1813), fable 4. Biblioteca Nacional, Madrid, R62076.

10. *Ora de lombrices* may be derived from proverbs that depended for their effect on the way worms emerge in great numbers at indicated times, as before a rain. For example, *lombrices a flor de tierra, lluvia venidera* (when worms are abundant, rain is on its way). See Luis Martínez Kleiser, *Refranero general ideológico español* (Madrid, 1953), nos. 37.622-37.624. Perhaps the meeting of the constitutional Cortes represented such a signal moment when many clerical "worms" would be flushed out all at once.

113

Divina Razon: No deges ninguno (Divine Reason: Don't spare a single one)
Album C, page 122
About 1812-1814
Brush and silver-gray wash, touched with brown in pen and brush
206 x 145 mm.
Inscribed in brush and brown ink, upper right: *122*; below image, in brush and gray wash: *Divina Razon*, below this, in pen and brown ink: *No deges ninguno*
References: G-W 1357; G., I, 266.

Museo del Prado, Madrid, 409
Spain only

Reason strides aggressively across the sheet, gripping the scales of Justice in her left hand.[1] With a scourge in her right, she scatters a flock of ravens. Goya recast the episode of Christ driving the money-changers from the temple in a composition similar to that of Rembrandt's etching of the subject (fig. 1).[2]

"And [Jesus] found in the temple those that sold oxen and sheep and doves, and the changers of money sitting: And when he had made a scourge of small cords, he drove them all out of the temple, and the sheep, and the oxen; and poured out the changers' money, and overthrew the tables; And said unto them that sold doves, Take these things hence; make not my Father's house an house of merchandise."[3] Goya's victorious Reason – crowned with laurel – purges the Church of its unholy elements.[4] Her dress resembles that of Reason in a French Revolutionary print (fig. 2).[5]

Noah released a raven from the ark so that it would find land; long awaited, it never returned. As a result of this derivation, in seventeenth-century literature the raven was a symbol of a promise never fulfilled or something forever lost.[6] The use of ravens to represent ecclesiastics who strayed has a long tradition. In the Renaissance the raven was identified with the devil.[7] In Cervantes's time it was sometimes regarded as a symbol of rapacity, sometimes as a bad omen.[8] Goya may have alluded to the expression *echacuervos* (literally, raven purger), known as early as the sixteenth century and meaning peddler of papal bulls, so

Fig. 1. Rembrandt van Rijn,
Christ Driving the Money-Changers from the Temple, 1635.
Etching.
Museum of Fine Arts, Boston, Gift of the Estate of Lee M. Friedman

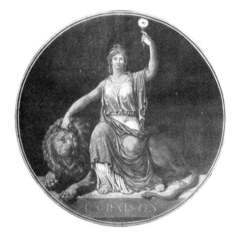

Fig. 2. Anonymous,
La Raison (Reason), 18th century

called because the bull was thought to flush out evil spirits from the body.[9] In the sixteenth century the *echacuervos* was the exorcist who expelled ravens from another's soul, ravens being understood as devils or the damned.[10] Goya's contemporary and friend José Gallardo Blanco called ravens, along with *proyectistas* (political visionaries) and vultures, a sure sign of dead meat – "y donde ellos abundan, se nota que no sobra mas que la miseria" (and where they abound nothing proliferates more than misery)[11] – and ecclesiastical opponents of the Lib-

eral cause "la negra banda de los cuervos" (the black band of ravens).[12] Another Liberal observed in 1820 that "muy puestos en razon estarían los esmeros de las autoridades para purgar el santuario de las sordideces que la deshonran y reducir en lo posible a sus ministros á las peculiares funciones de su sagrado carácter" (any efforts made by the authorities to purge the sanctuary of the sordid business that besmirches it and to confine its ministers wherever possible to the peculiar functions of its sacred character would be very appropriate indeed).[13] The metaphor of the defiled sanctuary is close to that of Goya's drawing.

On December 1, 1810, various prebends and other forms of ecclesiastical income were suppressed. On September 18, 1812, some properties of certain convents passed into state hands. The *voto de Santiago*, a tax on bread and grain that peasants paid to the Catedral de Santiago, was abolished on October 14, 1812. On February 22, 1813, the Cortes (parliament) abolished the Inquisition and declared its goods property of the nation. On March 22, the Inquisition's ancient rights over customs were abrogated. Finally, in July 1813, the papal nuncio was expelled after attempting to impose the Pope's authority in Spain.[14]

The fierce tone of this drawing and its allegorical rather than descriptive character make it seem more a reflection of the debates that took place from 1810 to 1814 over how far the reform of the Church should go than a depiction of the systematic secularization of the monastic orders carried out in 1820. In this drawing Goya sided with the most extreme reformist party within the Cortes. He stood with the Liberal aristocrat and historian Conde de Toreno, whose doctrine of the disentailment of Church properties and ecclesiastical reform can be summarized in two statements no less radical than this drawing. First, religious bodies could be reformed or extinguished from the moment they were no longer useful to society. Second, mortgaging the regular clergy's properties would not suffice to honor the nation's debt obligations; these properties would have to pass entirely into state hands.[15] This program

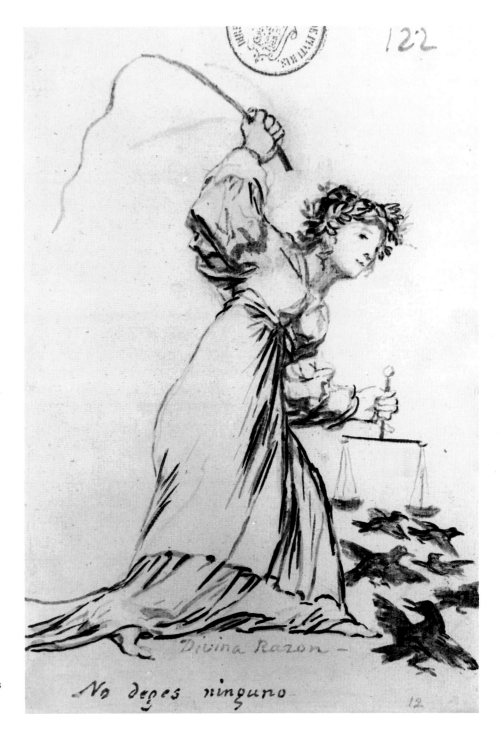

began to be realized from 1820 to 1823 but was not fully enacted until after Fernando VII's death in 1833.

The political differences between Serviles and Liberals increasingly took on the tinctures of a holy war (see cat. 147), at least from the anticonstitutional side. Goya undermined the Serviles' claim to divine protection by using their characteristic discourse – the language of divine wrath – to denounce what he saw as a contradiction between the clergy's desire to maintain its privileges and its rhetoric. Associating Reason with Christ, Goya expressed the belief characteristic of his generation's reformers that no fundamental incompatibility between Reason and Faith need exist, only that between Reason or Justice and those ecclesiastics who paid more attention to preserving Church privileges than to their evangelical mission. He used the iconography of Christ (see cat. 109 and 110), here driving out the money-changers, to personify Reason purging the evils within the Church. Christ had overturned the scales, but Goya placed them in Reason's hand to suggest she is guided by a sense of Justice. The Church, healer of souls, was itself in need of a cure.

M.A.R.

1. The scales of Justice are an attribute common to Goya's Constitution and Reason, visually establishing the link between them in the artist's mind. See cat. 110, 161.

2. See López Rey, *Goya's Drawings*, p. 134; Madrid, 1982, p. 202.

3. John 2:14-16. See also Matthew 21:12-13, Mark 11:15-17, Luke 19:45-46. Scio's illustrated Bible (3rd ed., Madrid, 1807-1816) includes an illustration of Mark 2:15-17 in which Christ's dress and powerful forward stride resemble Reason's in Goya's drawing. See Don Phelipe Scio San Miguel, *La Biblia Vulgata Latina Traducida en Español* . . . vol. 12 (Madrid, 1815), pl. 73, facing p. 267.

4. Gravelot and Cochin, *Iconologie*, vol. 4, p. 49.

5. Reason's simple dress is an attribute as well of J. M. Moreau-le-Jeune's version of her of about 1774. See the frontispiece for J.-J. Rousseau, *Collection Complette des Oeuvres*, vol. 1: *Julie ou la Nouvelle Héloïse* (London [Brussels], 1774). (Print reproduced from Ernest F. Henderson, *Symbol and Satire in the French Revolution* [New York, 1912], pl. 165.)

6. On the biblical derivation of *echacuervos*, see Joan Corominas and José A. Pascual, *Diccionario crítico-etimológico castellano e hispánico* (Madrid, 1980), under *echacuervos*.

7. On the medieval and Renaissance iconography of the raven, see Mateo Gómez, *Sillerías*, pp. 68-69.

8. Miguel de Cervantes, *Don Quijote*, ed. Diego Clemencín (Madrid, 1966), pt. 2, chap. 2, pp. 242, 248.

9. One kind of bull, the Bill of Crusade, was still an important source of revenue in Carlos III's time. See Joseph Townsend, *A Journey through Spain in the Years 1786 and 1787*, vol. 2 (London, 1791), pp. 170-173, 184.

10. *Echacuervos* at first referred to the fraudulent exorcist. Later, it came to mean all quacks and mountebanks. See Covarrubias, *Tesoro*, under *cuervo*; *Lazarillo de Tormes*, ed. Francisco Rico (Barcelona, 1967), p. 69, n. 10.

11. Gallardo, *Diccionario*, p. 100.

12. Ibid., p. 1. In an anonymous French revolutionary print *La Chasse des Corbeaux* (Raven Hunt), a French patriot fires at monks transformed into ravens perched in a tree. See Paul Prouté, Paris, *Catalogue 90* (spring 1988), *Unité, Indivisibilité de la République: Liberté, Egalité, Fraternité*, pl. 180.

13. He was referring specifically to the Inquisition. Antonio Bernabeu, *España venturosa por la vida de la Constitución y la muerte de la Inquisición* (Madrid, 1820), p. 49. Biblioteca Nacional, Madrid, R 60.122.

14. See Albert Dérozier, *Manuel Josef Quintana et la naissance du libéralisme en Espagne* (Paris, 1968), pp. 584-585.

15. See Artola, *Orígenes*, p. 529. See also cat. 111, 112, 114, 115.

114

Se desnuda p^a siempre (He undresses for good)
Album C, page 127
About 1812-1814
Brush with gray, gray-brown, and brown wash
206 x 144 mm.
Inscribed in brush and gray, upper right: *127*, above image, in chalk: title
References: G-W 1362; G., I, 271.

Museo del Prado, Madrid, 371
Spain only

A young, tonsured friar turns partially away as he removes his habit. His head is in deep shadow and his posture and expression suggest vague apprehension.

After the dispersion occasioned by Bonaparte's secularization of the male orders and the chaos and destruction of war, in 1812 the Cortes (parliament) discussed the conditions under which the orders would be reestablished. There were reports of clerics roaming the countryside in search of shelter, and the Cortes took responsibility for their welfare and rehabilitation.[1] A special commission on the reform of the regular clergy reported on the matter; its conclusions were typically enlightened reflections on what the Church's role should be. The orders' usefulness to society was requisite; for this reason, the secular clergy – the priests and bishops, who were thought useful because they provided pastoral services – would not be reformed. The regulars – that is, the monastic and mendicant orders – would be allowed if they ministered to the faithful, taught, or cared for invalids, all functions of undoubted social utility. The contemplative orders would be dissolved, since they did not meet this requirement, and their members transferred to orders in the first category.[2] Regulars would not be allowed back until they had proved their loyalty to the Cortes during the war. Pensions would be given the secularized; no monastery would contain fewer than twelve members or reopen without means to feed its community; those not meeting these requirements would be closed. No town, however populous, would support more than one monastery

Fig. 1. Anonymous,
Jadis je fut un bon gros Moine . . .
Etching, hand-colored

or convent of the same order, and the number reopened would correspond to the population and the spiritual needs of each province. All teaching and hospital orders would be reestablished, and members of closed orders would be received into them. Novices would not be admitted during the war. All income from monasteries and convents not strictly necessary for subsistence and the needs of the cult would be applied to the war cause.

In 1813 the commission issued a second report drastically limiting the number of monasteries in the peninsula and again called for a utilitarian adjustment of the nonmonastic population – the mendicant orders and the secular clergy – to the size and needs of the general population. Surplus income would go to the state, the communities would not be allowed to acquire property, and the vows of poverty and communal ownership of goods would be strictly enforced. In the second report, then, disentailment and state control of Church finances were already being considered together with the reform of clerical behavior. The Cortes never settled the question definitively but in 1813 made provisional rules

and resolved concrete cases. In the spirit of the reports cited above, the Cortes decreed on February 18, 1813, that those monasteries not destroyed in the war could be reestablished so long as there were at least twelve clerics and no two houses of the same order coincided in a town.[3]

In France clerical caricatures inspired by the confiscation of Church lands in 1789 were unsparing (see fig. 1).[4] Vindictive feelings could run as high in Spain. Predicting the disappearance of the orders, José Gallardo Blanco wrote in 1812: "Les van quitando las guaridas; de suerte que se van quedando como gazapos en soto quemado. ¡Animalitos de Dios! es cosa de quebrar corazones el verlos andar arrastrando, soltando la camisa como la culebra, atortolados y sin saber donde abrigarse. ¡*Oh tempora!*" (They're taking away their dens, such that they look like baby rabbits in a burnt grove. Little creatures of God! It is enough to break one's heart to see them dragging about, letting go of their shirts, stupefied and not knowing where to turn for shelter. *Oh, Ember Days!*)[5]

Goya understood that reform could revitalize society but never forgot it could also be debilitating for individuals caught up in processes they did not understand or were not prepared for. He evidently felt sympathy for those who had known nothing but the cloister, with no qualifications for life outside of it. Monks and friars were recruited mainly from the lower classes – the upper classes tended to join the secular clergy – and many of them had never learned to support themselves. In effect, poverty and not the religious vocation persuaded many to don habits of one order or another.[6]

Goya showed the moment when that measure of recognition and security the habit represented must be cast away. The dressing down is different in spirit from Goya's strictly anticlerical works, which tend to unmask hypocrisy concealed by the sanctity of clerical vestments (see cat. 111, 112, and 155); what the ritual undressing reveals here is the young man's vulnerability as he faces exposure to an unfamiliar world in which he must be accountable for himself. This friar is young, slight, and even shows a

touching modesty as he turns away, unlike the stereotype of the old, well-fed, self-satisfied friar (see cat. 112); he is, above all, fearful for his future.

M.A.R.

1. See Manuel Morán Orti, *Poder y gobierno en las Cortes de Cádiz (1810-13)* (Pamplona, 1986), pp. 257-260.

2. See Artola, *Orígenes*, p. 532.

3. Ibid., pp. 532-535; Martínez Albiach, *Religiosidad*, p. 317.

4. *Jadis je fut un bon gros Moine / Plein d'alimens jusques au Cou / Comme le Porc de St. Antoine / Mais je suis aujourdhui maigre come un Coucou* (Once I was a good fat Monk / Stuffed with food to the Gills / Like Saint Anthony's Hog / But now I am as scrawny as a Cuckoo). (Etching reproduced from Ernest F. Henderson, *Symbol and Satire in the French Revolution* [New York, 1912], pl. 54.) See Madrid, 1982, p. 202.

5. Gallardo, *Diccionario*, p. 44.

6. See Blanco White, *Letters*, p. 88.

115

esta lo deja pensativa (She gives this up thoughtfully)
Album C, page 131
About 1812-1814
Brush and gray wash, heightened with brown and black and touched with chalk
206 x 147 mm.
Inscribed in brush and gray wash, upper right: *131*, above image, in black chalk: title
References: G-W 1366; G., I, 275.

Museo del Prado, Madrid, 373
United States only

A young, attractive nun removes her black habit and lets it fall, revealing a white shift. Forming a backdrop to her sadness and foreboding are the simple furnishings – two tables, the leftmost one decorated with a holy image – of a convent cell.

A certain number of convents were closed during the constitutional period (see cat. 114). Nuns numbered less than half their male counterparts, and their reputation was higher.[1] Most lived in contemplative communities. Some communities were refuges for genteel women who could not find husbands.[2] Most of the convents were poor, and the absence of adequate income sometimes meant novices had to bring a "dowry" with them. The monasteries, on the other hand, took in anyone who applied. The convents had already undergone reform in the seventeenth century; in the eighteenth century visitors were reduced to a minimum, and the cloistered life became more rigorous than ever. As a result, the secularization measures applied to the convents in the nineteenth century were relatively mild and there was a more sympathetic tone in the anticlerical literature dealing with them.[3] Ordinarily, nuns were more often pitied than ridiculed, although satirical-burlesque or critical literature generally showed an inability to comprehend that true vocations could exist among young women.[4]

Goya's contemporary José Blanco White trained for the clergy himself, although he never took orders.[5] In his nuanced account of life in Spain at the end of the eighteenth century, Blanco

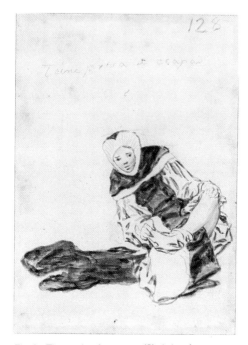

Fig. 1. *Tiene prisa de escapar* (She's in a hurry to escape),
Album C, page 128. Black wash.
Hispanic Society of America, New York

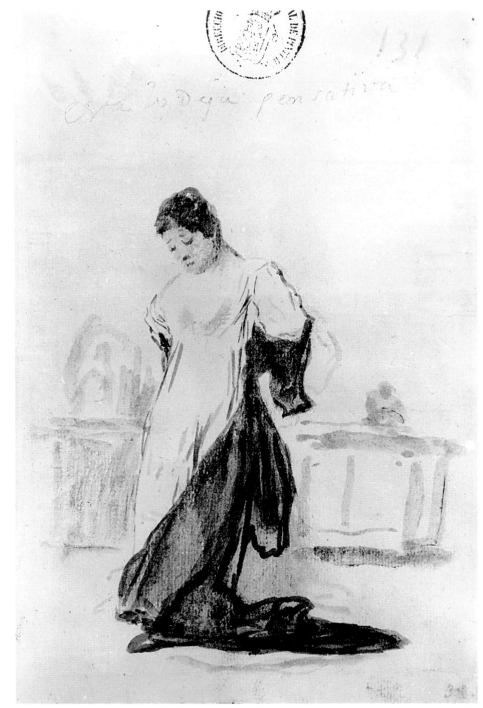

White described the ritual of the taking of the clerical veil as a marriage ceremony and the convent – because of the severity of the perpetual vow – a prison. Because the vows were perpetual, Blanco White was against them for the young, as they were nearly impossible to renege. Even those who discovered their unsuitability for the religious life during the year-long probationary period were sometimes reproached for "fickleness and relaxed devotion."[6]

A recurrent theme in the Liberal press was the nun who wished to abandon her convent yet faced an array of obstacles, "infelices religiosas víctimas de la arbitariedad de sus padres y del fanatismo y preocupacion de sus superiores" (unhappy religious victims of their parents' arbitrariness and their superiors' fanaticism and self-interest).[7] The Cortes (parliament) disposed in 1813 that regulars – monks, friars, nuns – wanting to leave the cloister should be allowed to break their vows. Even though some suffered "exquisite misery," many were

quite happy and reconciled to the hard-ships of confinement and solitude.[8] This nun – in contrast to her sister (fig. 1) – seems to have been one of them. The drawing is especially poignant because Goya rendered the moment when a young nun takes off her habit and with it her confinement. She is revealed in her shift, still innocently unaware of her sensuality.[9]

M.A.R.

1. See Martínez Albiach, *Religiosidad*, p. 406.

2. See Blanco White, *Letters*, pp. 241-252; Callahan, *Church*, p. 27.

3. See Martínez Albiach, *Religiosidad*, pp. 406-407.

4. See Revuelta González, S. J., *Política*, pp. 68-69.

5. See especially Blanco White, *Letters*, pp. 238-258.

6. Ibid., p. 246.

7. Madrid, 1982, p. 51.

8. Blanco White, *Letters*, pp. 246-247.

9. For a similar association of the clergy, morality, and dress, see Gallardo, *Diccionario*, p. 118.

116
Great Pyramid
About 1814
Black chalk
291 x 414 mm.
References: G-W 754; G., II, 334.

Heirs of the Marqués Casa Torres
Spain only

The unusual presence of architecture in Goya's work gives a special significance to his drawings in which this form of art is made protagonist.[1] Among these scarce examples are the so-called *Great Pyramid* and *Proposal for a Monument* (fig. 1).[2] Both have been regarded, since José Moreno Villa suggested the idea, as proposals for monuments to the victims of the May 2, 1808, uprising in Madrid against the French.[3]

Two aspects of the *Great Pyramid* support Moreno Villa's hypothesis: first, the style and technique Goya used in the drawing, which can be tentatively dated about 1814; second, his sense of the patriotic fervor that gripped Madrid upon the withdrawal of José I and the Napoleonic troops from the city in 1813.

It is known that the proposal to dedicate a monument to the heroes of May 2, 1808, emerged scarcely five months after the historic event and that there was a dispute between the two citizens who each claimed to have been the originator of the idea – a dispute that serves to demonstrate the sensititve feelings that prevailed at that time.[4] On April 26, 1812, the Cortes (parliament) agreed to perpetuate the memory of the victims of May 2 with a monument, and this decision was ratified on March 24, 1814, in these terms: "El terreno donde actualmente yacen las víctimas del *Dos de Mayo* contiguo al Salón del Prado, se cerrará con verjas y árboles, y en su centro se levantará una sencilla pirámide que trasmita a la posteridad la memoria de los leales, y tomará el nombre de *Campo de la Lealtad*" (The grounds in which the victims of the *Second of May* lie buried next to the Salón del Prado will be enclosed with gates and trees, and in its center a simple pyramid will be raised transmitting to posterity the memory of these patriots, and it will be called *Loy-*

alty Field).[5] Angel Monasterio's idea was evidently accepted by the deputies to the Cortes, both in the type of monument – "a simple pyramid" – and in its placement: "located thus where the tragedy took place and alongside a public promenade, it will embellish the latter, while eternally recording, for passersby, the courage of Madrid's sons."[6] The effect of such a construction near the Salón del Prado could be gauged in advance, given that, on the occasion of the entry of Spain's regent into Madrid in 1814, a pyramid was raised in memory of the victims.[7]

Therefore, the possibility that the *Great Pyramid* was a sketch for an unrealized proposal for a monument dedicated to those who fell on the day the Peninsular War began is quite plausible. The originality of Goya's drawing then lies neither in the idea nor in his choice of a pyramid but in the design of the monument. In fact, we find ourselves before one of those rare Spanish examples of the "architecture of Reason,"[8] or, better yet, of the "architecture of the sublime," as manifested in many funerary projects in the last decades of the eighteenth and the first decades of the nineteenth centuries in France.[9] As in Etienne-Louis Boullée's projects, the architecture Goya conceived is not made to the measure of human experience but is inspired by the grandiose scale of nature.

On the other hand, Goya placed his pyramid in an urban environment; far from imagining such a monument in an isolated and enclosed space, he emphasized its context within a city.[10] Therefore, instead of designing a closed building with porticoes opening onto a funerary church or chapel – an arrangement that would have given the structure a religious dimension – he pierced the pyramid with a great arch. This arch allows people to move through it in such a way that the dynamic of the public promenade, where citizens rest, stroll, or amuse themselves, is not disrupted. The function of the pyramid as a gate and the dimensions of its inner space evoke a triumphal arch.[11] In this manner, the commemorative character of the monument is reinforced, while the pyramid serves as

Fig. 1. Proposal for a Monument, about 1820.
Graphite, gray and black wash.
Museo del Prado, Madrid

a funerary vessel housing the victims buried there.

Goya's pyramid is extraordinarily well suited to the spirit that moved the Cortes to erect a monument to the heroes of May 2, 1808. There are substantial differences between the *Great Pyramid* and the *Proposal for a Monument* (fig. 1). In the latter the structure is more intricate, and the urban context has disappeared, along with any reference to victory. Nevertheless, with the advent of the Trienio Liberal (three-year period of Liberal government, 1820-1823), the idea of raising a monument to the victims of May 2 resurfaced, an idea that had been banished during the first six years of absolutist rule under Fernando VII (1814-1820). This second proposal, which can be

257

dated about 1820, could have been the fruit of the new patriotic spirit that animated the brief constitutional period, although this stepped pyramid is closer to the idea of a pantheon or mausoleum than to a monument dedicated to such a resonant victory and its victims.

<div align="right">J.V.</div>

1. See Fernando Chueca Goitia, "Goya y la Arquitectura," *Revista de Ideas Estéticas*, nos. 15-16 (1946), pp. 431-448.

2. Prado, Madrid, 407; G-W 758; G., II, 338.

3. José Moreno Villa, "Proyecto arquitectónico de Goya ¿Para las víctimas del Dos de Mayo?" *Arquitectura* 110 (1928), pp. 199-201.

4. On the disagreement between Wenceslao de Argumosa and Angel Monasterio, see *Diario de Madrid*, Oct. 17, 21, Nov. 17, 27, 1808. In the *Diario de Madrid*, Aug. 13, 1814, Argumosa again insisted that he had originated the idea, and he reiterated his claim in *Los cinco días célebres de Madrid, dedicados a la nación y a sus heróicos defensores* (Madrid, 1820). On this subject, see also Felipe Pérez y González, *Un cuadro . . . de historia: Alegoría de la Villa de Madrid, por Goya ¿Goya fue afrancesado?* (Madrid, 1910), pp. 169-191.

5. Quoted by J. Pérez de Guzmán y Gallo, *El Dos de Mayo de 1808* (Madrid, 1908), p. 790. According to the author, the advertisement inviting artists to present their projects appeared in the *Gaceta de Madrid*, May 28, 1814.

6. Quoted by Pérez y González, *Cuadro*, p. 174.

7. The description of the monument is in the *Relación de los objetos que presenta la M.N.H.L.I. y Coronada Villa de Madrid en su recibimiento a la Regencia del Reyno por la Carrera que debe transitar desde el puente de Toledo hasta el Real Palacio Nuevo* (Madrid, 1814). One part of the pyramid served as background for the portrait of Fernando VII engraved by Blas Ametller, from a drawing by José Ribelles that illustrated the *Descripción de las Honras, Gracias y Mercedes que S.M. ha dispensado á los Parientes de las ilustres Víctimas del 2 de mayo de 1808: Dedicada a su Augusta Persona por el Exmo. Ayuntamiento de la Heróica Villa de Madrid* (Madrid, 1817). For the 1821 memorial ceremony for the victims of May 2 a pyramid was raised. A print of the latter is in the Museo Municipal, Madrid. Both works are reproduced in J. Carrete, E. de Diego, and J. Vega, *Catálogo del Gabinete de Estampas del Museo Municipal de Madrid* (Madrid, 1985), vol. 1, no. 7-8 and no. 173-41, respectively.

8. On this subject, see Carlos Sambricio, "Dos dibujos de arquitectura de Francisco de Goya, pintor," in *Madrid no construido: Imágenes arquitectónicas de la ciudad prometida* (Madrid, 1986), pp. 76-80. On the possible relation of the third generation of enlightened Spanish architects to the French architects of the Revolution, see Carlos Sambricio, *La arquitectura española de la Ilustración* (Madrid, 1986), pp. 261-290.

9. On the recovery of the pyramid as a funerary and commemorative element in eighteenth-century France, see R.A. Etlin, *The Architecture of Death: The Transformation of the Cemetery in Eighteenth-Century Paris* (Cambridge, Mass., 1987), pp. 101-159.

10. Sambricio, "Dos dibujos," p. 78.

11. Moreno Villa, "Proyecto arquitectónico," p. 201.

117
Giant
By 1818
Aquatint
285 x 210 mm.
References: G-W 985; H. 29.

Spain: second state, Biblioteca Nacional, Madrid
Boston: first state, Museum of Fine Arts, Boston, Katherine Eliot Bullard Fund, 65.1296 [*illus.*]
New York: first state, The Metropolitan Museum of Art, New York, Harris Brisbane Dick Fund, 1935, 35.42.

In the print known as the *Giant*, Goya used no etched lines, but only tones of aquatint, so that the pictorial image, conceived solely in terms of tonal relationships, is a work in which painterly values reign supreme.[1] Goya probably dusted the copper plate with the resinous mixture used for aquatint and then let it be bitten by acid. If printed at that stage, the plate would produce a uniform, velvety black tone. Goya then worked with the scraper and burnisher on the prepared copper plate to create the extraordinary richness of shadings in the lights and halftones and thereby give the figure its powerfully modeled sense of volume.[2]

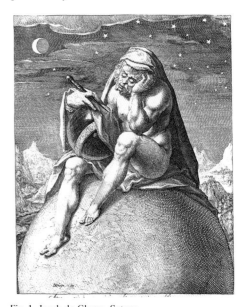

Fig. 1. Jacob de Gheyn, *Saturn.*
Engraving.
The Metropolitan Museum of Art, New York, The Elisha Whittelsey Collection, The Elisha Whittelsey Fund, 1949

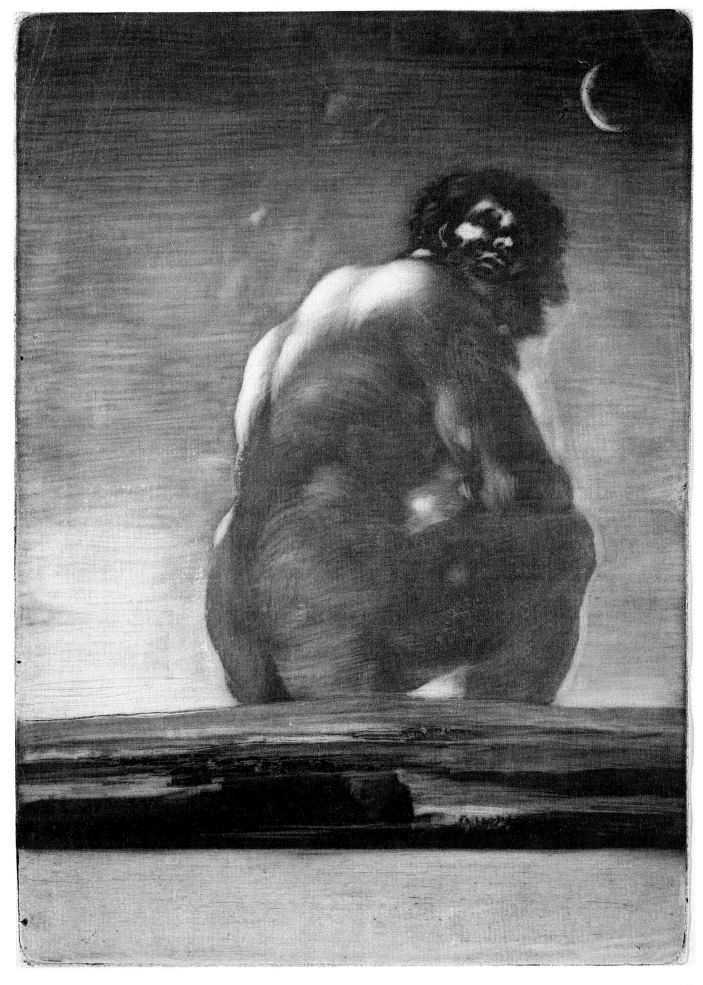

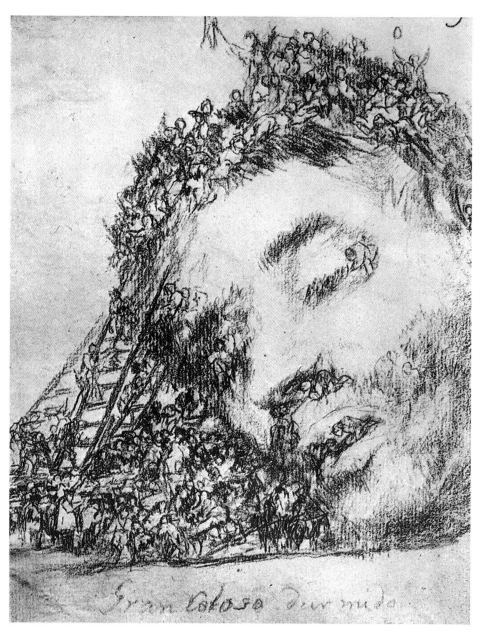

Fig. 2. *Gran coloso dormido* (Great Sleeping
Colossus), 1824-1828, *Album G*, p. 3.
Black chalk.
Formerly Gerstenberg Collection, Berlin

Only six impressions of this work are
known; all are working proofs taken
before the reported cracking of the plate
occurred. Three are shown in this exhi-
bition. The two United States impres-
sions are of the first state, printed before
Goya did additional burnishing.

This figure is seen at once to be a giant,
not only because of the contrast between
his size and that of the hamlets scattered
here and there in the shadow of the plain
in the foreground, but also because of the
sense of power conveyed by his muscula-
ture and huge limbs. The rapid and
dynamic modeling strokes, which master-
fully suggest the giant's muscles and
bones, also undoubtedly contribute to
this sense of power. The meaning of the
image, one of the most enigmatic and dis-
turbing in all of Goya's work, has not
been entirely revealed. The giant, seated
on a plain with his back to the viewer,
bent slightly forward with his elbows
resting on his knees, raises his head and
gazes at something that seems to attract
his attention. This pose allows us to see
his bearded face with its serious expres-
sion, tinged with a certain melancholy.
In the darkness of the night sky, pierced
by an undefinable light of sunset or dawn
that illuminates the giant's back and face,
a quarter moon appears.

This image has been related to the *The
Colossus* (cat. 69) because of its obvious
formal similarities, but there are no hints
here of the terror or threat (though
ambiguous) that surrounds the gigantic
figure in the painting. Like the figure in
The Colossus, the one in the print has
been interpreted in various ways, associ-
ated inevitably with Napoleon and also
linked with Prometheus or Humanity,
which "espera el amanecer de un nuevo
día" (awaits the dawning of a new day).[3]
However, none of these hypotheses
seems to fully explain the *Giant,* nor do
the purely formal interpretations that
have related it to two prints by Pieter
Brueghel or to *Saturn* by Jacob de Gheyn
II (1565-1629) (fig. 1).[4] Nevertheless, the
Giant shows sufficient analogies to de
Gheyn's engraving to justify the supposi-
tion that Goya knew the Flemish master's
work firsthand and perhaps drew his
inspiration from it. In any case, Goya's
giant does not appear to have the same

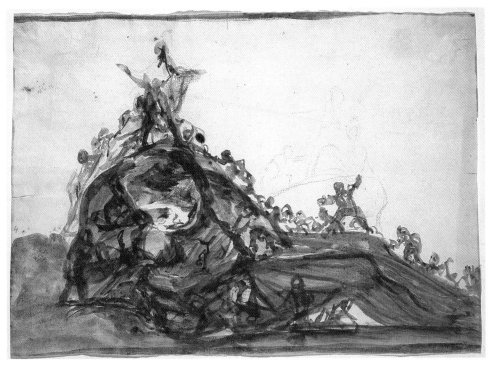

Fig. 3. *Figures Climbing over a Reclining Giant*,
1816-1817.
Drawing for a proposed *Disparate*.
Red chalk and sanguine wash.
Museo del Prado, Madrid

meaning as de Gheyn's, which is related to Saturn and therefore to melancholy.[5]

It is clear that the interpretation of this work demands taking into account the historic, social, and political events of the beginning of the nineteenth century in Spain. The print must be dated before 1818, since Goya's grandson Mariano referred to it in a letter to Valentín Carderera as "un gigante cuya plancha se rompió" (a giant whose [copper] plate was broken), and it appeared that year among other works and papers by Goya in a closet where he apparently had hidden it. No doubt it must be understood in the context of the ideas provoked in the artist by the war and the following years of repression under Fernando VII.[6] The dynamic stance of the giant in the painting has been compared with the pose of the figure in this aquatint, which is meditative and still, imbued with an obvious passivity; and here, in contrast to the painting, the giant is seated in a desolate and empty landscape in which any reference to human activity has vanished, perhaps as a result of the war.[7]

If it is possible to establish a relation between the two representations of the giant and Spain, perhaps a third work in which Goya again addressed the theme of the giant could be regarded as the last link in this sad chain of reflections on Spain's destiny. Thought to have been destroyed in 1945, a drawing in the Bordeaux series Goya entitled *Gran coloso dormido* (Great Sleeping Colossus) (fig. 2) shows the enormous head of a giant, surrounded by a multitude of tiny people, some of whom, having scaled the head, run up a flag as a sign of victory.[8] The calm, majestic features of the face, along with the beard, are similar to those of the two earlier giants of the painting and the aquatint. Goya, at peace during his years of self-imposed exile in France, seems to reflect on the sadness of Spain's destiny, to which those resigned words *gran coloso dormido* perhaps refer.

M.M.M.

1. Goya had experimented in the *Caprichos* with using only aquatint: in plates 32 (G-W 515) and 39 (cat. 46) and the rejected proof, *Woman in Prison* (G-W 616). Only in the last is the aquatint burnished.

2. This print is often described as a mezzotint produced by roughening the surface of a copper plate with a tool called a rocker. However, examination of the print under magnification shows that the tone has been bitten in an aquatint process. There are no rocker marks.

3. For the bibliography on these interpretations, see Frank Heckes, "Supernatural Themes in the Art of Goya," Ph.D. diss., University of Michigan, 1985, p. 278, n. 356.

4. C. Newmann, "Drei merkwürdige Künstlerische Anregungen bei Runge, Manet, Goya," *Sitzungsberichte der Heidelberger Akademie der Wissenschaften* 7 (June 1916), pp. 14-20. Quoted in Jan Bialostocki, *Estilo e iconografía: Contribución a una ciencia de las artes* (Barcelona, 1973), p. 160.

5. See Bialostocki, *Estilo*, p. 160. On melancholy, see R. and M. Wittkower, *Born under Saturn*, Norton Library (New York, 1969), which examines the relationship between genius, artists, and melancholy.

6. Edith Helman, "Fray Juan Fernández de Roxas y Goya," *Homenaje a Rodríguez Moñino* (Madrid, 1966), vol. 1, p. 242.

7. Heckes, "Supernatural Themes," pp. 204-205.

8. G-W 1713. From a formal point of view, the drawing is similar to another of Goya's related to the *Disparates* (G-W 1611) (fig. 3), which may illustrate *Gulliver's Travels* (1726). Swift's work, extremely popular in the eighteenth century, was available in Spanish translation. However, the *Album G* drawing does not appear to be merely an illustration of *Gulliver's Travels*.

GOYA AND THE SPIRIT OF ENLIGHTENMENT
1814–1828

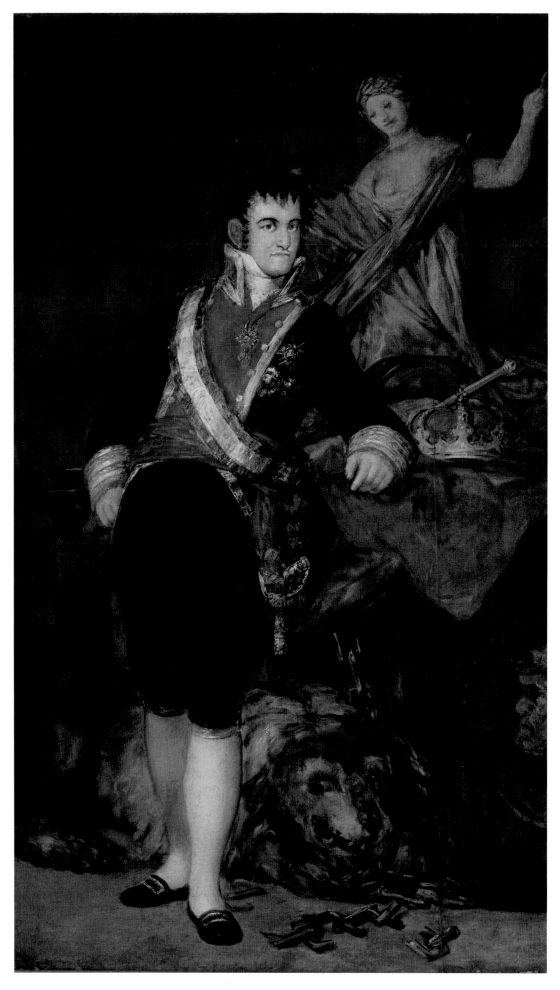

118
Fernando VII
October-December 1814
Oil on canvas
225.5 x 124.5 cm.
References: G-W 1538; Gud. 630.

Museo Municipal de Santander

119
Fernando VII in an Encampment
About 1814
Oil on canvas
207 x 140 cm.
Signed, lower left: *Goya*
References: G-W 1539; Gud. 631.

Museo del Prado, Madrid, 724

Goya's position as painter to the king, as well as his financial circumstances, obliged him to paint Fernando VII's portrait on several occasions, although he must not have felt much sympathy for the monarch.

Fernando, Carlos IV's eldest child, was born in 1784. Because of his dislike for Manuel Godoy (see cat. 62), he became the leader of a group that favored the removal of his mother's favorite from power. When the plot to overthrow Godoy was discovered, Fernando was put on trial at El Escorial in 1808. However, in March of that year the Aranjuez uprising compelled Carlos IV to abdicate in favor of his heir. These events almost coincided with the French invasion, and the new king left for France. There he renounced the throne in favor of José I and did not return from exile until March 1814.

During the war years (1808-1814), the Spanish people fabricated an image of the exiled king quite removed from the one he presented on his return. Known as the *deseado* (desired one), Fernando VII disappointed those who had fought for independence and for a Spain different from that of the Old Regime, which was spent and corrupt. He prolonged the climate of terror and bloodshed that prevailed during the war. His return to Spain amounted to a new declaration of war when he both refused to recognize the Constitution of 1812 and persecuted and jailed many of its makers and supporters. The same fate awaited those

who had collaborated with the French government. Political persecution and measures such as the reestablishment of the Inquisition and the closing of the universities could not but shock progressive Spaniards, of whom Goya was one.

The first and apparently the only time Fernando as monarch sat for Goya was immediately after his accession in 1808 (just before Napoleon's invasion).[1] On that occasion the king posed twice. The portraits of Fernando that Goya painted on his return in 1814 followed the pre-war models.[2]

This portrait was commissioned for the Santander town hall by the city council, which specified the characteristics and iconography of the work. "El retrato debera ser de frente y de cuerpo entero, vestido de coronel de Guardias con las iniciales reales. Debera tener la mano apoyada sobre un pedestal de una estatua de España coronada en laurel y estaran en este pedestal el cetro la corona y el manto; al pie un leon con cadenas rotas entre sus garras." (The portrait should be full face and full length, with the king dressed as colonel of the guards, wearing the royal initials. His hand should be resting on a statue of Spain crowned with laurel and on this pedestal will be the scepter, the crown, and the mantle; at his feet will lie a lion with broken chains between his paws.) The council noted that the work of the head should be polished and that the likeness should be close. It also requested that the painting be done as soon as possible. Goya agreed to execute it in fifteen days for 8,000 reales.[3]

To the iconography imposed by the council Goya added nuances that reveal his hostility to the king. There is a distinct difference in style between the figure of Fernando VII and the background. The image of the king is painted over a very finished drawing, with small, quick brushstrokes that outline the profile. In contrast to the clearly defined figure is the airy background of vaguely defined objects modeled by broad brushstrokes. The abrupt interruption of the brushstrokes of the background at the outlines of the king's figure indicates that the portrait of the monarch was superimposed on an initial sketch. In this case Goya

was so true to the letter of the contract that, by using such a polished style, foreign to him, he created what seems like a workshop painting, as if he had not wanted to paint any part of the king.

The background fits the specified iconography. The personification of Spain, which the council insisted should be a statue, is so lifelike that we find a paradox: the king appears more statuelike than the personified Spain, whose gesture he seems to ignore. Blanco White suggested that this rendering had a basis in reality. Of the events following the Aranjuez uprising and Fernando VII's arrival in Madrid he wrote: "Never did monarch meet with a more loyal and affectionate welcome from his subjects; yet, never did subjects behold a more vacant and unmeaning countenance even among the long faces of the Spanish Bourbons. On top of his unprepossessing features, either shyness or awkwardness contributed a stiffness, which, but for the motion of the body, might lead us to suspect we were wasting our greetings on a wax effigy."[4] Spain lets her right hand rest on the king's head and with her left seems to indicate something to him, perhaps the path to follow. Her downcast expression and the shape of her mouth suggest a certain regret rather than triumph or pleasure.

The portrait of Fernando VII in an encampment, of about the same time, is not a little paradoxical. In the foreground the king appears in full military dress, and in the background there is military action. Nothing could be further from the truth about the monarch's participation in the war, for he took no part in fighting, or if he was involved, he merely followed French orders. The composition recalls other military portraits, like that of Godoy, where action is shown at a low horizon line. If the style of the king's dress is compared with that of the Santander painting, the differences are obvious. Here Goya did not copy decorative details; he suggested them. He did not even pay attention to consistency: gilt decoration is rendered on only one of the boots. An overall effect is what he sought, and the result is more brilliant than in the Santander painting.

After the death of 250,000 Spaniards in

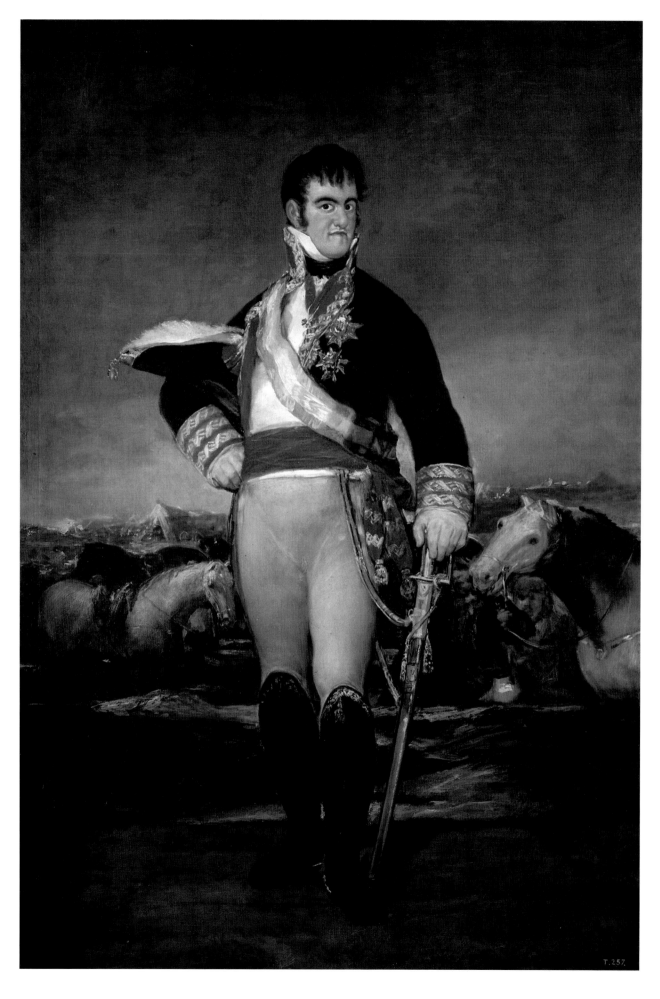

the Peninsular War and in civilian and political struggles, the people yearned for the return of Fernando VII, although his abdication to Napoleon in 1808 may have been partly to blame for the subsequent bloodshed. But most of Fernando's policies were disastrous for the country and resulted in the ruin of a budget of 500 million reales.

M.M.H.

1. The equestrian portrait is in the Real Academia de Bellas Artes de San Fernando, Madrid (679); G-W 875.

2. Gassier and Wilson attributed six 1814 portraits of Fernando VII to Goya (G-W 1536-1541).

3. The document detailing the council's instructions is in the Museo Municipal de Santander. See Valentín de Sambricio, in *Francisco de Goya*, exhib. cat. (Madrid, 1961), p. 27.

4. Blanco White, *Letters*, p. 406.

120
Fray Juan Fernández de Rojas
About 1800[1]
Oil on canvas
75 x 54 cm.
References: G-W 1555; Gud. 640.

Real Academia de la Historia, Madrid
Spain only

Fray Juan Fernández de Rojas (1752-1819) was one of the most interesting intellectuals of Goya's age. A versatile man, dedicated to theology and philosophy, a literary critic and poet, he voiced the profound critical spirit of the age with humor and subtle irony.

Fray Juan took orders from the Augustinians of San Felipe el Real in Madrid in 1768. At that time the Augustinian order was promoting a cultural renaissance, supporting studies of poetry, theology, and philosophy, along with those of mathematics and physics. Rojas was educated by his teacher and friend Fray Diego González in the so-called Salamanca School of poetry, to which Meléndez Valdés also belonged (see cat. 24). His poetry, at first lyrical in a light vein, developed philosophical and moral concerns after Jovellanos's tutelage at the Salamanca School.

Rojas was a professor of theology and philosophy in Toledo. He wrote the additions to the *Año Cristiano* (Christian Year), by P. Croiset, and the first five volumes of the *Año Cristiano, o exercicios devotos para todos los Domingos, dias de Quaresma y fiestas movibles* (Christian Year, or Devotional Exercises for Sundays, Lent, and Movable Feasts).[2] To the enlightened, his activity as Christian orator was essential for the reform of religious customs and habits. But Rojas owed his fame more to two satirical works than to scholarly or devotional ones: *Crotalogía* (1792) and *Libro de moda en la feria* (1795). Both criticize the Encyclopedists' sometimes shallow pretensions. He described *Crotalogía* as a work about the science of playing castanets and the *Libro de moda en la feria* as a manual on the "science of dandyism": "la que enseña á vestir, andar, baylar, cantar, hablar, pensar y hacer al uso del dia, ó lo que es lo mismo á la moda" (that

which teaches one how to dress, stroll, dance, sing, speak, think, and do according to the uses of the day, or, what comes to the same, according to fashion).[3] *Crotalogía* is an attack on the norm, on neoclassical rules; *Libro de moda en la feria* demonstrates the absurdity of taking fashion to extremes. In these years Rojas was prolific, and from 1794 until 1799 he also served under various pseudonyms as literary critic for the newspaper *Diario de Madrid*.

Rojas's most polemical publication was a defense of modern theology, which his opponents called Jansenism. This work advocated a return to the sources of religion and, attacking the vices that had seeped into the Church, set out to recover its original purity. The conflict arose when the Ultramontane faction, the most conservative sector of the Church, sponsored the publication in Castilian of Rocco Bonola's *La liga de la teología moderna con la filosofía en daño de la Iglesia de Jesucristo* (The Alliance of Modern Theology with Philosophy at the Expense of the Church of Jesus Christ) (1798), which attacked the Jansenists. Rojas returned the fire in the same year with *El páxaro en la liga* (The Bird in the Birdlime [with a play on alliance]), published under the pseudonym of Cornelio Suárez de Molina. One historian noted that "the two rival pamphlets became the talk of informed circles. One witness, who probably exaggerates, says that three thousand copies of *El páxaro en la liga* were sold in one day." The same author added that the dispute reached such a pitch that "Urquijo was forced to issue a royal order in January 1799 to collect all copies of both works," but in an explanation accompanying the decree he let it be understood he sided with Rojas.[4]

Goya must have been on close terms with Rojas, according to the latter's niece Carmen Arteaga Fernández de Revoto: "El imortal Goya, conociendo sus grandes conocimientos no hacía pintura, ni ejecutaba ninguna obra sin consultarle el dibujo, el colorido y demás proporciones de tan noble arte, habiendo sucedido no pocas veces borrar todo un cuadro, o la mayor parte de sus formas para adoptar las que le había propuesto, permane-

ciendo antes, como aturdido y confuso, al considerar tan justas observaciones, llegando a tanto su amistad y consideraciones que le tenía, que a pesar de haber hecho mi tio los más vivos esfuerzos para evitar que le hiciese su retrato, nada bastó, ni fue suficiente a impedirlo; pues Goya, logró al fin retratarle, pero echando, como suele decirse el resto de sus artísticos conocimientos particularmente en el parecido y en el colorido, el cual también conservo en mi poder con la mayor satisfacción" (The immortal Goya, knowing his [Rojas's] erudition, did not paint, or execute a single work without discussing the drawing, the color and other aspects of so noble an art, and not infrequently he erased an entire painting, or the greater part of its forms to adopt those [Rojas] had proposed, at first looking as if dazed and confused on considering such apt observations, their friendship and mutual consideration being such that in spite of my uncle's making the most strenuous efforts to avoid being portrayed, nothing sufficed, and he could not prevent it; for Goya managed at last to portray him, but surpassing, as it were, his other artistic accomplishments, particularly in the likeness and coloring; [it is a portrait] that I also maintain in my possession with the utmost satisfaction).[5] Thus is revealed Rojas the art critic, although it is doubtful that Goya's art was limited by the Augustinian friar's opinions. In the works of these two men there is an evident ideological parallel for both criticized the vices and defects of their time. Criticism of fashion taken to ridiculous lengths, as in Rojas's *Libro de moda en la feria*, is to be found, for example, in *La moda al revés* (Upside-Down Fashion), a preparatory drawing for the *Caprichos*, on which Goya worked not long after the book's publication.[6] Both writer and artist insisted on freedom as a necessary condition for the development of artistic creation. Rojas mocked the imposition of norms in his *Crotalogía* (recall the limitations on the theater with its rule of the three unities). Goya also expressed himself in the same vein in his *Memoria sobre el Estudio de las Artes para la Academia* (Report on the Study of the Arts for the Academy) (1792), in which he wrote: "Daré una

prueba para demostrar con hechos, que no hay reglas en la Pintura, y que la opresión, ú obligación servil de hacer estudiar ó seguir a todos por un mismo camino, es un grande impedimento á los Jóvenes que profesan este arte" (I will give an example to demonstrate with deeds that there are no rules in painting, and that the oppression or servile obligation of making others study by following the same path is a great impediment to the young who profess this art).[7] The analogies between Goya and Rojas appear as well in the form of critical expression through irony and satire; Goya's style in the *Caprichos* is satirical, as the last Stirling Maxwell manuscript commentary on the *Caprichos* has it: "Deberan llamarse por lo tanto, *Las Satiras de Goya*" (They should therefore be called, *Goya's Satires*).

There is no certain date for this portrait, although 1800 seems the most likely.[8] In that year Rojas was chosen to continue *La España Sagrada* (Sacred Spain), a landmark in eighteenth-century historical criticism, and perhaps Goya took advantage of this occasion to portray him.[9] The composition seems to fall between that which he used for the series *Retratos de los Españoles ilustres* (Portraits of Illustrious Spaniards)[10] and the preparatory drawings for artists' busts in 1798 and 1799 that were to illustrate the *Diccionario de los más ilustres profesores de Bellas Artes* (Dictionary of the Most Illustrious Professors of Fine Arts), by the art historian and Goya's friend J.A. Ceán Bermúdez.[11] Goya's portrait of Meléndez Valdés (cat. 24) follows this latter compositional scheme. In contrast to those portraits, this work gives no information about the sitter's professional life, providing no attributes of the writer or historian. It seems to emphasize the Augustinian's facial expression and even his character, and for this purpose the artist elongated the bust to heighten the triangular composition; the resulting lines converge on the face. Goya also used a simple, harmonious blend of colors, and the contrasts between the light in the facial expression and the darkness of the habit once again underscore the friar's face. The work was donated by the family to the Real Academia de la Historia in 1857.[12]

M.M.H.

1. The date 1815 has traditionally been given to this painting (G-W 1555; Gud. 640) and has been considered in the arrangement of this catalogue. For further discussion of the dating see note 8.

2. See Edith Helman, *Jovellanos y Goya* (Madrid, 1970), p. 277.

3. *Libro de moda en la feria, que contiene un ensayo de la historia de los Currutacos, Pirracas, y Madamitas del nuevo cuño, y los Elementos, o primera[s] nociones de la Ciencia Currutaca* (Madrid, 1795), p. 55. Rojas did not give his name as author and claimed that the work was written by a *currutaco* philosopher and published and annotated by a *pirracas* gentleman.

4. Herr, *Revolution in Spain* (Princeton, 1958), p. 423.

5. Quoted in María Rosario Barabino Maciá, *Fray Juan Fernández de Rojas: Su obra y su significación en el siglo XVIII* (Madrid, 1981), p. 93.

6. Museo del Prado, Madrid, 84; G-W 629; reprod. in Barabino Maciá, *Rojas*.

7. Quoted in Angel Canellas López, *Francisco de Goya: Diplomatario* (Zaragoza, 1981), p. 311.

8. "[Rojas] sat for Goya at the turn of the century, probably when he was commissioned to continue *La España Sagrada*" on May 24, 1800. Helman, *Jovellanos*, p. 277. F.J. Sánchez Cantón observed that Rojas does not appear to be over fifty years old (he was born in the middle of the eighteenth century) and therefore did not date the portrait after 1800; *Los cuadros de Goya en la Real Academia de la Historia* (Madrid, 1946), p. 18. This is not in accord with the date assigned by Gassier and Wilson (see note 1 above).

9. Rojas never published any of this work, which it seems he did not complete because of "la poca salud . . . y su preferente atención a otras tareas literarias y estudios distintos a los de la *España Sagrada*" (poor health . . . and his pursuit of literary tasks and studies other than *España Sagrada*), according to a note to the secretary of the Real Academia de la Historia dated 1856; see Sánchez Cantón, *Los cuadros*, p. 20.

10. The series consisted of a collection of prints published periodically, 1791-1814, with a prologue and accompanied by a brief biography of each subject. Juan Carrete Parrondo, *Memoria histórica del siglo de las luces* (Madrid, 1988), includes a selection of the portraits.

11. See G-W 697-707.

12. Sánchez Cantón, *Los cuadros*, p. 21. There has been some speculation about the possibility that Goya drew Rojas's death mask (*Cabeza de agonizante*, Museo del Prado, 490). Manuela Mena indicated in her study of the drawing that the similarities are not very obvious. Another drawing entitled *Al expirar Fray Juan Fernández Agustino* (British Museum, London, 1862.7.12.185 verso) differs in technique from the Prado drawing as well as the drawing of the moribund man. See Manuela Mena Marqués, "Un nuevo dibujo de Goya en el Museo del Prado," *Boletín del Museo del Prado*, Jan.-April, 1984, pp. 47-56.

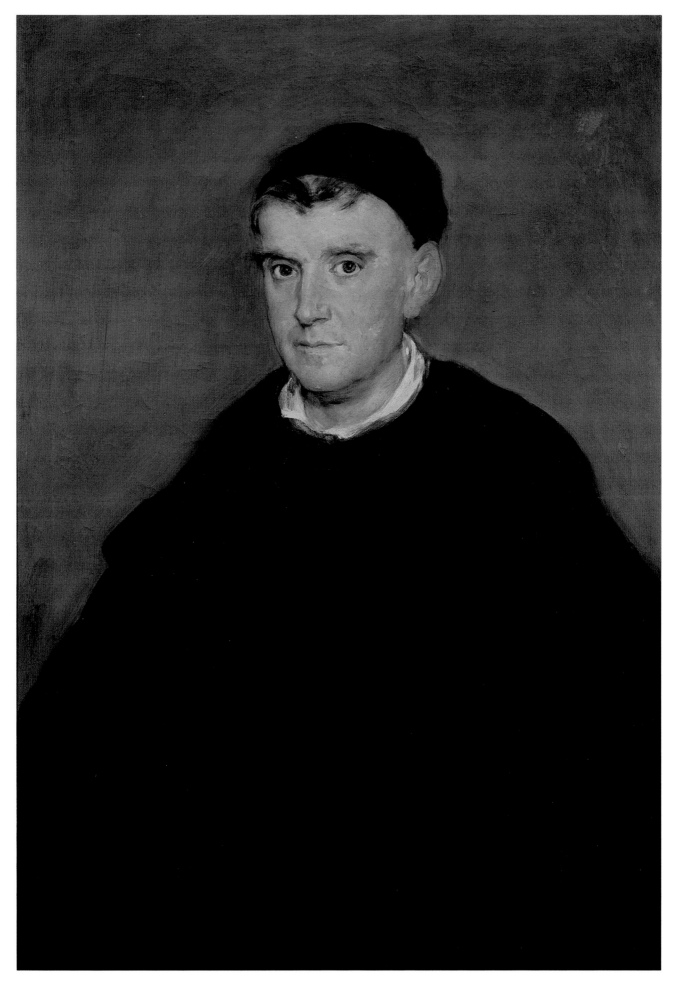

269

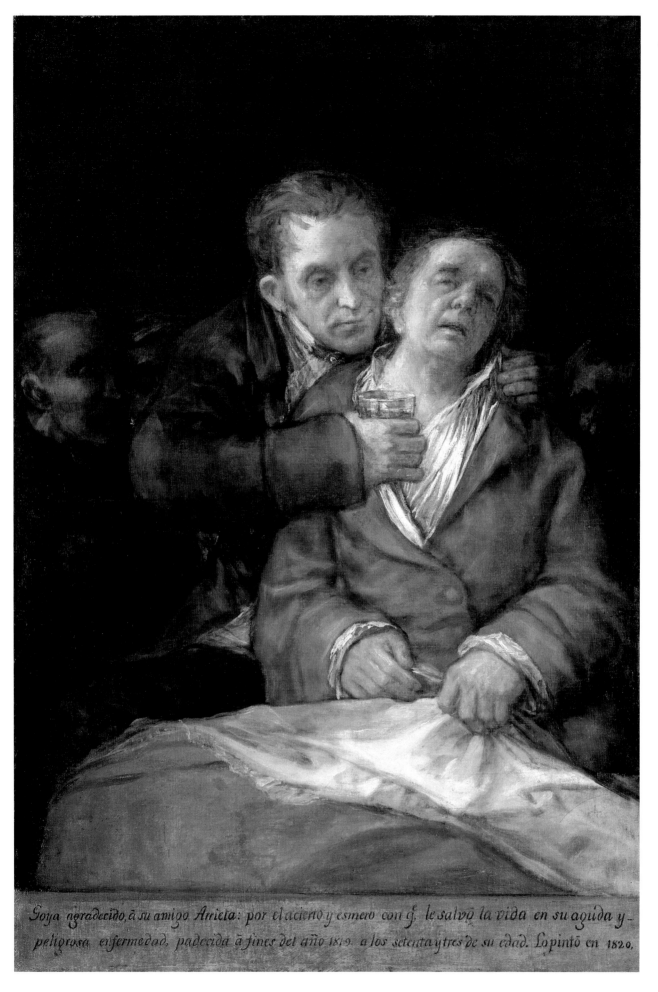

*Goya agradecido, á su amigo Arrieta: por el acierto y esmero con q. le salvó la vida en su aguda y_
peligrosa enfermedad, padecida á fines del año 1819. a los setenta y tres de su edad. Lo pintó en 1820.*

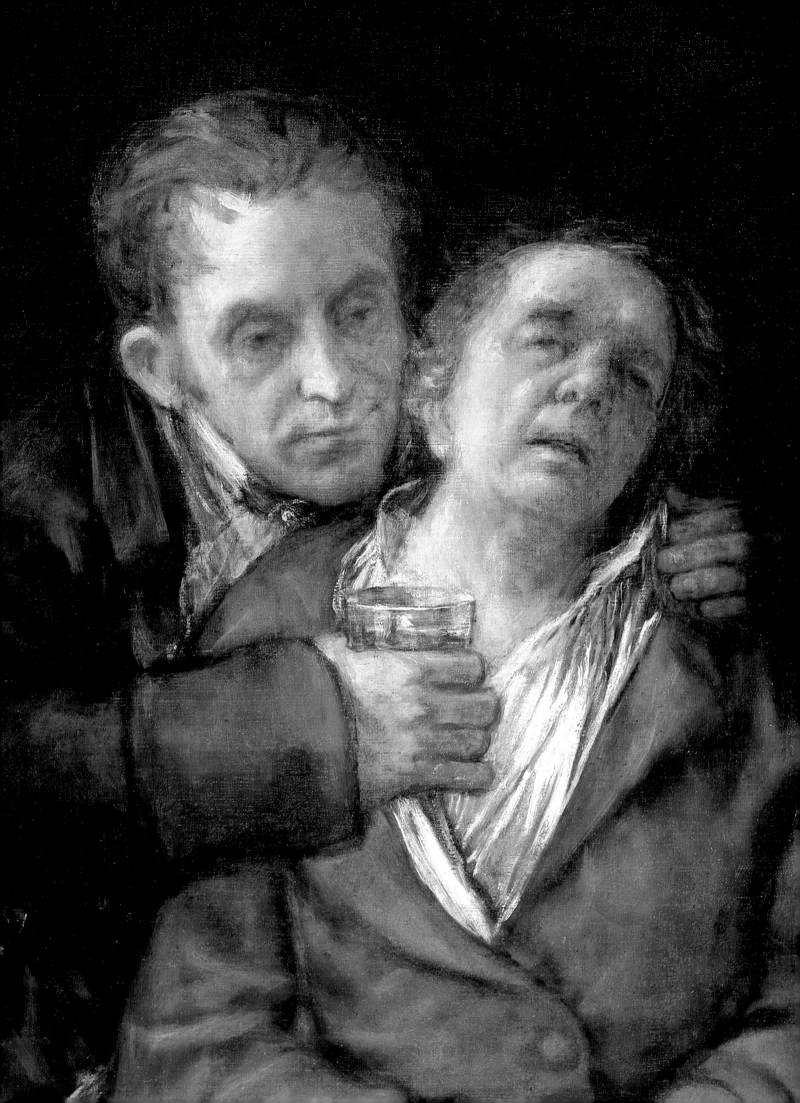

121

Goya Attended by Doctor Arrieta
1820
Oil on canvas
117 x 79 cm.
Inscription: *Goya agradecido, á su amigo Arrieta: por el acierto y esmero con q^e le salvo la vida en su aguda y / peligrosa enfermedad, padecida á fines del año 1819, a los setenta y tres años de su edad. Lo pinto en 1820.* (Goya thankful, to his friend Arrieta: for the skill and care with which he saved his life during his short and dangerous illness, endured at the end of 1819, at seventy-three years of age. He painted it in 1820.)
References: G-W 1629; Gud. 697.

The Minneapolis Institute of Arts, The Ethel Morrison Van Derlip Fund, 52.14

The inscription reveals the subject of this original, extraordinary work by Goya. The painting was executed in 1820, that is, during the years the artist spent unofficially removed from the court, almost a refugee living on the outskirts of Madrid in the Quinta del Sordo (The Deaf Man's Country House), within the walls that already were, or would be soon thereafter, covered with the fabulous late creations now known as the "Black Paintings" (see cat. 152, fig. 2, and cat. 158, fig. 1). In spite of the optimistic and hopeful character of its subject, this painting shares in those nightmare visions that are the essence of the "Black Paintings."

Not everything about the work is obvious. First, the modernity of the scene – the self-portrait of the moribund artist supported by his doctor – is derived, as in so many other works by Goya, as much from the most directly observed reality as from the symbolism that transcends it. The vaguely defined figures in the background have been seen as friends as well as servants (even as his mistress, Leocadia), as demons awaiting his death, or – in an allusion to the classics – as the Fates about to snip the artist's thread of life.[1]

The painting seems to contain features that are characteristic of a religious work, evidently to transcend them to become the votive offering to, and even

exaltation of, science that would mark the final years of the nineteenth century.[2] Goya here seems to have abandoned the biting satire characteristic of the eighteenth century that was rooted in a much older tradition. The coarse, sometimes vulgar, criticism of the doctor as *matasanos* (quack, literally slayer of the healthy) or as "aliado de las Parcas" (ally of the Fates) appeared in Spanish literature from the Middle Ages and achieved its greatest expression in seventeenth-century works such as those by Quevedo.[3] Goya's interpretation is quite removed from some of his earlier interpretations, such as *Capricho* 40, *De que mal morira?* (Of what illness will he die?) (cat. 48), which is a fierce condemnation of the ignorant doctor who assumes the form of an ass.

Goya presented the doctor as a friend and as a kind of redeemer who wrests him from the teeth of death not so much with the medicine he administers but with his arm and his profound humanity. This was Goya's second serious illness. Although his first illness of 1792 left him deaf, there is no evidence that he believed he was as close to death as at this time, when he was seventy-three years old.[4] This self-portrait is one of the most awe-inspiring of the many documents the artist left of himself. The pallor of the face and the open mouth emphasize his shortness of breath, and the grip of his hands on the folds of the sheets and the lost gaze are characteristic of the absence of full consciousness and of the final agony. Goya's image is therefore not of his real agony but of his imagined one. He used features resembling those with which he presented himself in the slightly earlier self-portraits of about 1815 in the Prado (G-W 1552) and in the Academia de San Fernando (G-W 1551). Perhaps he recalled others' final moments; there is a similarity in expression to that of the saint in *The Last Communion of San José de Calasanz* (G-W 1638) of 1819, painted a year before this portrait.

Scholars have noted the compositional allusion to the theme of piety, in which the dead Christ appears sustained by an angel or by holy women; Goya used such figures in other works, not only in those of a religious character but also, for

example, in *The Wounded Mason* (cat. 13) or the *Disasters of War*, plate 20, *Curarlos y á otras* (Curing Them and Others) (G-W 1024).[5] There is no record of contemporary reaction to this painting. According to vague references by the art collector Valentín Carderera,[6] this may have been the painting exhibited in the Academia de San Fernando. The only certainty is that Asensio Juliá, a minor disciple of Goya's, copied it in works preserved to this day, which would appear to indicate that this work – which Goya presented as a gift to his doctor, Eugenio García Arrieta – had some resonance.[7]

M.M.M.

1. Many scholars have discussed this work. The most novel hypotheses have been advanced by John Moffitt, "Goya y los demonios: El Autorretrato con el doctor Arrieta y la tradición del 'Ars Moriendi,'" *Goya*, no. 163 (1981), pp. 13-23; and Robert W. Baldwin, "Healing and Hope in Goya's Self-portrait with Dr. Arrieta," *Source* 4, no. 4 (1985), pp. 31-36.

2. This painting by Goya could be a precursor of such works as Picasso's *Ciencia y Caridad* (Science and Charity).

3. Antonio Domínguez Ortiz, *La sociedad española en el siglo XVIII* (Madrid, 1955), p. 59.

4. On Goya's illnesses, on which there is an extensive bibliography, see José Gudiol, *Goya* (Barcelona, 1985), vol. 2, p. 198.

5. See Baldwin, "Healing," p. 32.

6. See Conde de la Viñaza, *Goya: Su tiempo, su vida, sus obras* (Madrid, 1887), p. 253.

7. F. Boix, "Asensio Juliá (El Pescadoret)," *Arte español* 10 (1931), p. 140.

122

Tiburcio Pérez Cuervo
1820

Oil on canvas
102.1 x 81.3 cm.
Inscribed: *A Tiburcio Pérez Goya 1820*
References: G-W 1630; Gud. 698.

The Metropolitan Museum of Art, New
York, Bequest of Theodore M. Davis,
1915, Theodore M. Davis Collection,
30.95.242

The architect Tiburcio Pérez Cuervo
must have been a good friend of Goya's,
for Goya entrusted him with the care of
his presumed daughter, Rosario, when
the artist went to Bordeaux in 1824. The
portrait corroborates this relationship.

Tiburcio Pérez Cuervo was born in Ovi-
edo in 1785 or 1786.[1] He began his stud-
ies in architecture in the Academia de
Bellas Artes de San Fernando when he
was sixteen; six years later he received a
first prize for "el monumento que se ha
de eregir en el Campo de Bailen en
honor a los españoles y su heróica victo-
ria" (the monument to be raised on
Bailén Field in honor of the Spanish and
their heroic victory). His uncle Juan
Antonio Cuervo, among the most influen-
tial architects of the final years of the
century, with whom he probably lived
when he began his studies, was director
of the Academia.[2] In 1818, two years
before sitting for Goya, he was named
Académico de Mérito (member of the
Academy by merit). With Isidoro Gonzá-
lez and Javier de Miriategui he was put in
charge of the medical school project in
Madrid; we also know of a design of his
for a gymnasium on the Paseo del Prado.[3]

The portrait of Tiburcio Pérez belongs
to Goya's last period. By comparison with
the portrait of his uncle Juan Antonio
Cuervo (fig. 1), in which the subject's offi-
cial capacity is made evident – the rich
chair, the elegant dress, the compass,
and the map are all professional attri-
butes – that of Tiburcio Pérez is seen to
have an intimate character, like that of
Sebastián Martínez (cat. 19) painted
many years earlier. In his attempt to
simplify and concentrate on the subject's
expression, Goya created a rudimentary

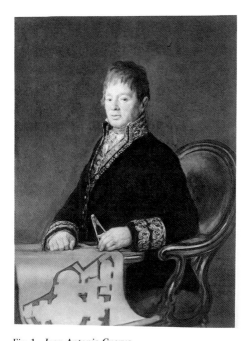

Fig. 1. *Juan Antonio Cuervo.*
1819.
Oil on canvas.
Cleveland Museum of Art, Mr. and Mrs. William H.
Marlatt Fund, 43.90

composition, as in the portrait of Sebas-
tián Martínez. But here, the distillation
has also affected the range of hues, in
that there is an almost complete absence
of color. Goya emphasized the volumes
and the density of the brushstrokes. It is
worth recalling that preceding this por-
trait was the series of "Black Paintings,"
whose style evidently left its mark here.

M.M.H.

1. I am grateful to Nigel Glendinning for providing
me with biographical information on Tiburcio Pérez
Cuervo.

2. See Carlos Sambricio, *La arquitectura española de
la Ilustración* (Madrid, 1986), p. 322.

3. Carlos Sambricio places Tiburcio Pérez with the
third generation of enlightened architects, which he
calls the generation of the Revolution. Ibid., pp. 261-
290.

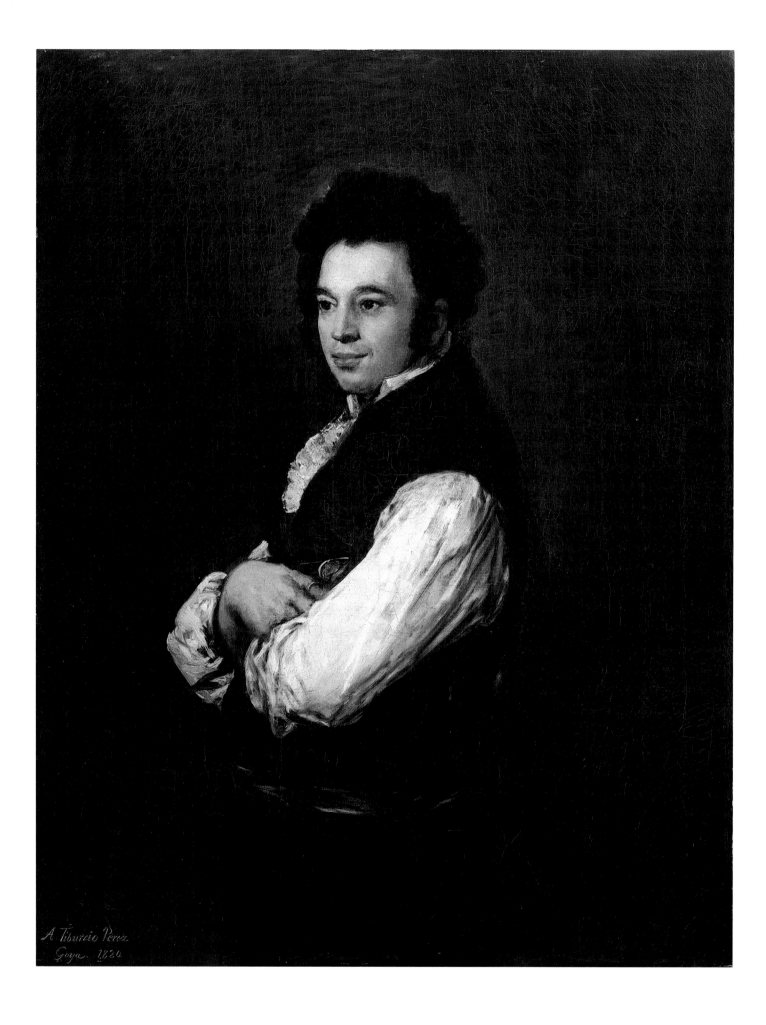

274

123

The Repentant Saint Peter
About 1820-1824
Oil on canvas
744 x 642 cm.
Inscribed at bottom: *Goya*
References: G-W 1641; Gud. 725.

The Phillips Collection, Washington, D. C.

"And Peter remembered the word of Jesus, which said unto him, Before the cock crow, thou shalt deny me thrice. And he went out, and wept bitterly" (Matthew 26:75). This is the moment Goya presented us on this canvas, which was perhaps one of his last religious works before his departure for Bordeaux.[1] To the conventional, apocryphal iconography of a bald and bearded Saint Peter bearing keys Goya added the feeling of bitterness that overwhelms the apostle for his betrayal of Christ, which is the reason for his repentance.

The new eighteenth-century spirit of religious reform attacked apocryphal legends and those who used them, among whom were artists more attentive to describing the details of this literature than the essence of the Gospel. In *Pan y toros* (Bread and Bulls) – "the clandestine pamphlet with the widest circulation in late eighteenth-century Spain"[2] – León de Arroyal commented: "Los pintores imbuidos de estas especiotas han representado en sus tablas a estos títeres espirituales, y el pueblo idólatra les ha tributado una supersticiosa adoración" (Painters suffused with these hoaxes have depicted these spiritual puppets on their canvases, and the idolatrous public has rendered them superstitious adoration).[3] Reformers viewed religious art as a means of reinforcing devotion, not of stimulating "idolatry." In this vein, breaking with conventions that conformed only to the descriptive details that helped to identify Saint Peter, Goya set out to capture the sentiment, to extract and emphasize that which was authentic in the saint's life. A print by Ribera on the same subject (fig. 1), which was known in the eighteenth century, bears certain similarities to this painting; but comparison of the two works reveals how Goya managed to give expressive

Fig. 1. José de Ribera,
Repentant Saint Peter, 1621.
Etching.
Teresa Fernández de Bobadilla, Madrid

power to the image, whereas Ribera did not.

Goya here dispensed with the anecdotal and synthesized pictorial elements to concentrate on the facial expression of Saint Peter, in a rendering that demonstrates the artist's style in all its fullness. We are brought close to the saint, framed in half-figure; in contrast to Ribera's print, where our gaze takes in the landscape, there is no space outside Saint Peter's rotund mass, which is molded to a geometric shape – a triangle – suggested by the composition of the cloak. In free, confident brushstrokes the color is reduced to a harmonious blend of blues. The light singles out the face and the apostle's coarse hands vigorously clasped together in an attitude of deeply felt prayer. His sad expression suggests heartfelt repentance and profound sorrow for having denied Christ, rather than a plea for forgiveness.

Goya's use of Saint Peter's countenance to convey sincere regret reflects the meaning of repentance as viewed in the context of the new reforming currents of the eighteenth century. Repentance, it was thought, should be born of

sincere love of God, not fear. In this sense, José Yeregui, who wrote a catechism in 1770, declared: "establezco . . . la necesidad del amor de Dios . . . para justificarse el pecador en el Sacramento de la Penitencia" (I establish . . . the need for love of God . . . if the sinner is to justify himself in the Sacrament of Penance)[4] against those who defended "atrición formidolorosa" (frightening attrition) or repentance motivated by fear of punishment. "[Yeregui] explains why he has introduced 'el amor a Dios' (love of God) in his definition of attrition (repentance); in order to light that divine virtue which is the essence, the character, and the synopsis of the Catholic Faith, in those unhappy times 'en que se ve el horrible abuso, y la ninguna disposición con que ya se acercan muchísimos al Sacramento' (in which can be seen the horrible abuse, and the absolute disinclination with which many already approach the Sacrament)."[5]

In presenting a human Saint Peter, moved to repentance by his love of God, Goya, like the reformers of his time, celebrated the spirit they believed to be Christian.

M.M.H.

1. This work is paired with a painting of Saint Paul (G-W 1642), private collection, United States.

2. León de Arroyal, "Pan y toros," *Pan y toros y otros papeles sediciosos de fines del siglo XVIII,* ed. Antonio Elorza (Madrid, 1971), p. 7.

3. Ibid., p. 26.

4. Letter from José Yeregui to Don Francisco de Mena, Archivo Histórico Nacional, Secretario de Estado, leg. 2872. Quoted by María Giovanna Tomsich, *El jansenismo en España* (Madrid, 1972), p. 63. Yeregui's catechism was published in France in 1803.

5. Tomsich, *El jansenismo,* p. 63.

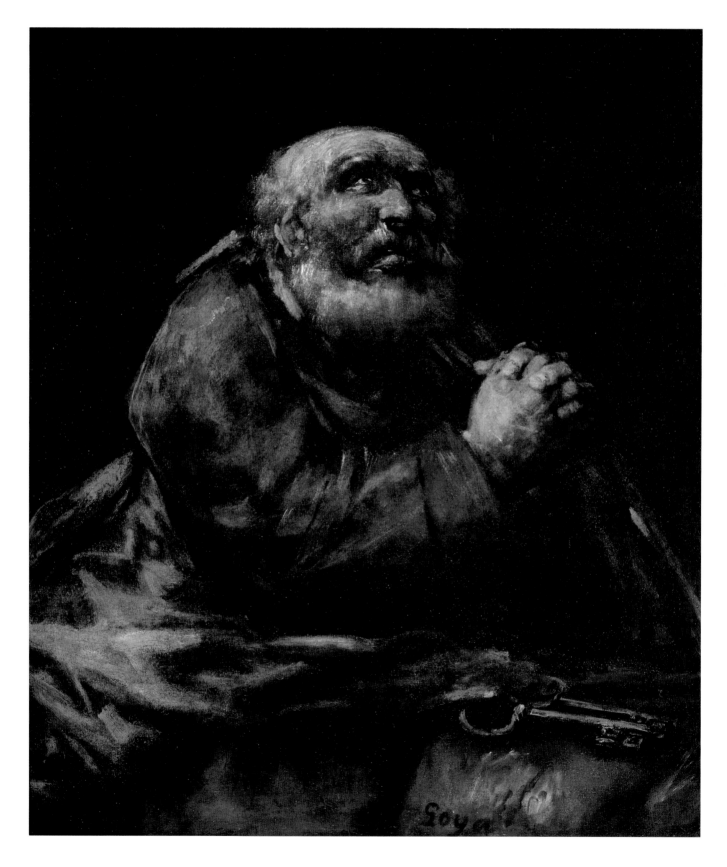

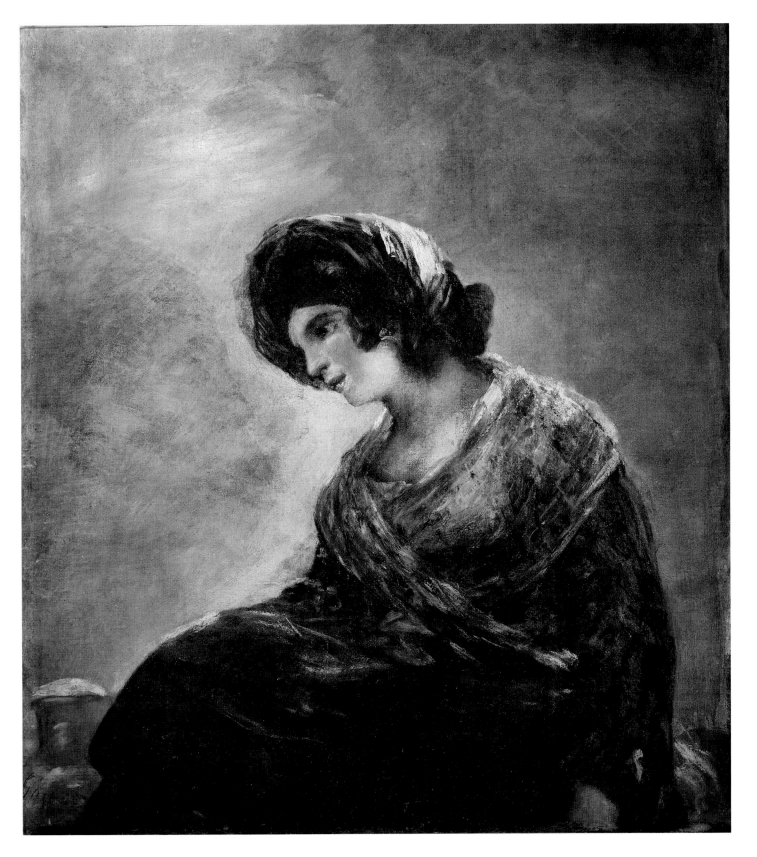

124

The Bordeaux Milkmaid
1825-1827
Oil on canvas
74 x 68 cm.
Signed, lower left: *Goya*
References: G-W 1667; Gud. 767.

Museo del Prado, Madrid, 2899

Goya was about eighty years old and in exile in France when he painted *The Bordeaux Milkmaid*, his last great work. Not long before he had escaped "por esta vez del Aqueronte avaro" (this time from the avid Acheron, that is, from death), as Moratín (with whom the artist shared his Bordeaux exile) put it in a letter.[1]

Goya's pictorial freedom reached its zenith in this work, which does not seem to have come about by commission, or even by an enlightened ideological intention. The painting is rather a product of the life Goya led in Bordeaux. As Moratín wrote, "Le gusta la ciudad, el campo el clima, los comestibles, la independencia, la tranquilidad que disfruta" (He likes the city, the countryside, the climate, the cuisine, the independence, the calm).[2] Goya had also gained confidence and facility in his art. Moratín wrote further of Goya: "Esta muy arrogantillo y pinta que se las pela, sin querer corregir jamás nada de lo que pinta" (He is very cocksure these days and paints furiously, never wanting to correct anything he paints).[3] That is, his style was absolutely free, he no longer needed to worry about "haber pasado de moda" (being out of fashion), the fashion of the moment being developed in the court of Madrid by Vicente López with his goldsmith's technique. Goya's palette once again incorporated a gamut of colors, and it seems as if he was entirely preoccupied with capturing beauty.

This painting was bequeathed to Leocadia Zorrilla, Goya's last companion, who sold it to Juan Muguiro. According to the letter Zorrilla wrote Muguiro, Goya much prized it: "El difunto me decía que no la tenía que dar por menos que una onza" (The deceased would tell me that I should not have to sell it for less than a doubloon).[4]

M.M.H.

1. Leandro Fernández de Moratín to Juan Antonio Melón, June 28, 1825. Published in Angel Canellas López, *Francisco de Goya: Diplomatario* (Zaragoza, 1981), letter 164, p. 503.

2. Moratín to Melón, Apr. 14, 1825. Ibid., letter 160, p. 501.

3. Moratín to Melón, June 28, 1825. Ibid., letter 164, p. 503.

4. Leocadia Zorrilla to Juan de Muguiro Iribarren, Dec. 9, 1829. Ibid., letter 184.

125

No sabe lo q^e hace **(He doesn't know what he's doing)**
Album E, page 19
About 1814-1817
Brush and gray and black wash
269 x 179 mm.
Inscribed in graphite, lower margin: title; in brown ink, upper margin: *19*
References: G-W 1392; G., I, 120.

Staatliche Museen Preussischer Kulturbesitz, Kupferstichkabinett, Berlin, 4391
United States only

This robust laborer, perched on a ladder, is engaged in the deplorable task of destroying a sculpture. In his right hand he raises a pickax, while with his left he points to the place where the work once stood. Among the pieces scattered on the ground appears a sketchily indicated neoclassical female bust. Goya did not take pains to specify where the vandalism is taking place. A slight indication of the floor of the interior and part of the base of the sculpture are the only clues he gave to the location.

The powerful figure of the man is at the center of the composition and focuses the viewer's gaze. His closed eyes result in a blank expression, almost that of an automaton, corresponding perfectly to the title of the drawing, *No sabe lo q^e hace* (He doesn't know what he's doing). His posture contributes to this impression. He is trying to keep his balance by inserting his knee between the rungs of the ladder, without realizing that the force he needs to deliver his destructive blows could make him fall. Because in Goya's iconographic language, closed – sometimes blindfolded – eyes symbolized ignorance, this drawing's target begins to come into view.[1] An ignorant common man, blindly and without an obvious reason, knocks down what may have been a beautiful female sculpture; meanwhile, he may well fall down with a resounding thud.

But there is more to this work. Similar scenes took place in Madrid in 1814 on Fernando VII's return from France, when he and his followers abrogated the Constitution and reinstated absolutist

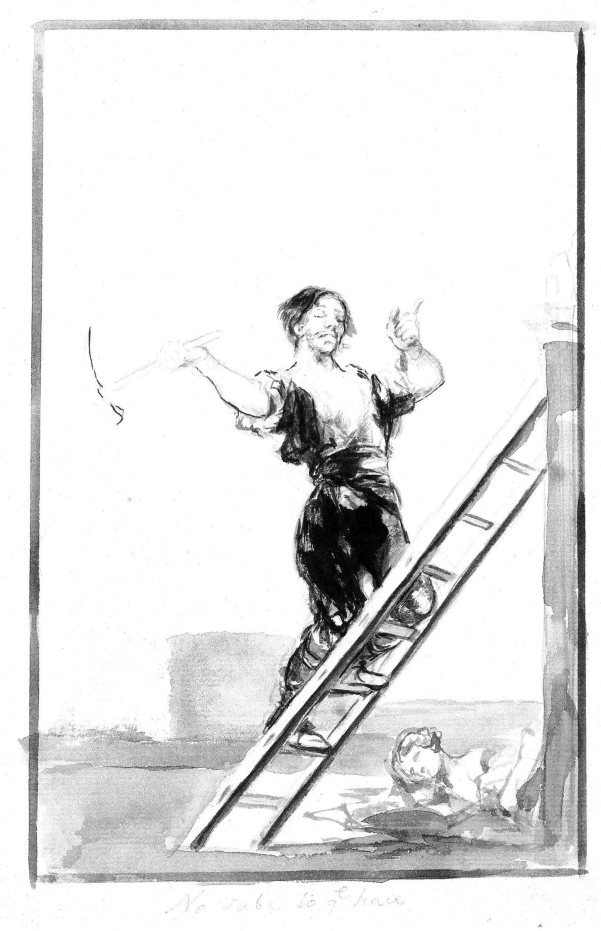

No sabe lo q.e hace

monarchy. During the preceding disturbances, a Madrid mob assaulted the Palacio de las Cortes (parliament building) and almost entirely destroyed its Hall of Sessions. The nineteenth-century writer Ramón de Mesonero Romanos, a witness, vividly described the people's despicable behavior as he remembered the "grosero, repugnante y antipático" (vulgar, repugnant, and disagreeable) spectacle years later: "La segunda parte del *programa* elaborado . . . por los pérfidos consejeros de Fernando . . . era el movimiento y manifestación *popular* preparada con dos o tres centenares de personas, de la ínfima plebe, reclutadas al efecto en tabernas y mataderos, para salir por las calles ultrajando todos los objetos relacionados con el Gobierno constitucional. . . . La turba hostil y desenfrenada corrió a la Plaza Mayor, invadió la casa Panadería y arrancando la lápida de la Constitución (que se les señaló como símbolo) la hicieron mil pedazos. . . . Transladáronse luego al palacio de las Cortes . . ., apedrearon y mutilaron las estatuas y letreros como si estuvieran – que si lo estarían – *embriagados* de furor." (The second part of the *program* drawn up . . . by Fernando's treacherous advisers . . . was the *popular* demonstration and agitation incited by two or three hundred people of the dregs recruited to this end in taverns and slaughterhouses, to spill out into the streets vandalizing all objects associated with constitutional government. . . . The hostile and wanton mob made for the main square, broke into the bakery house, and, seizing the plaque of the Constitution (to which they were prompted by its symbolic charge), tore it into a thousand pieces. . . . They later headed for the Palacio de las Cortes . . . , stoned and defaced the statues and signs as if they were – and they probably were – *drunk* with fury.)[2]

The nineteenth-century historian Francisco Pi y Margall wrote that the Madrid mob, paid and overseen by the Conde de Montijo, dragged the plaque of the Constitution and the statue of Liberty (probably the one represented by Goya in this drawing) through the streets, along with other symbolic figures that decorated the Hall of Sessions.[3] In other towns the com-

memorative plaques of the Constitution were also removed and destroyed amidst great popular commotion.[4] These plaques had been installed in town halls and main squares by parliamentary decree, which the Conde de Toreno reports "sirvió de pretexto a parcialidades extremas para rebullir y amotinarse enrededor de aquella señal" (served as pretext for partisans of extreme views to stir and incite around that symbol).[5] All these events in which the physical destruction of symbols was so marked (in effect turned into a countersymbol) shed light on the meaning of the toppled sculpture: the perfidious abandonment, on Fernando VII's part, of the Constitution of Cádiz of 1812 by the May 4, 1814, royal decree. And the common man, blind instrument of the king's followers, also helped to destroy a form of government that held out the only hope in his wretched life. The drawing conveys this irony in the suggestion of the man's potential fall from the ladder. It is easy to imagine the emotional impact the sight of such barbaric acts must have had on Goya, given the special affection with which he infused the allegorical figure of the liberal Constitution, demonstrated by the drawing *LUX EX TENEBRIS* (cat. 109) and the painting *Allegory of the Constitution of 1812* (cat. 74).[6]

In this drawing Goya achieved a complete mastery of the technique of layering different tonalities of wash. A very light one is used as the base for the whole of the composition, followed by another, much more intense, almost black one, which allowed him to stress the contrast of light and shadow with great subtlety. His aim was to focus the viewer's attention on certain key details. The intense patches on the open shirt and breeches give a more effective impression than pronounced musculature would of the strength this man emanates.

On the other hand, Goya understood and forgave this poor and ignorant representative of the long-suffering Spanish people and, recalling the gospel, entitled his drawing *No sabe lo q^e hace* (He doesn't know what he's doing).

T.L.M.

1. Gravelot and Cochin represent the personification of Ignorance with blindfolded eyes and ass's ears. Gravelot and Cochin, *Iconologie*, p. 7. The same idea appears in greater detail in Cesare Ripa, *Iconologia* (Perugia, 1765), vol. 3, p. 247. In *Capricho* 50, *Los Chinchillas* (cat. 55), Ignorance, who feeds an impassive and indolent nobility, wears a symbolic blindfold on his forehead, and his face appears to lack eyes.

2. Ramón de Mesonero Romanos, *Memorias de un setentón* (Madrid, 1961), vol. 1, pp. 210-211.

3. Francisco Pi y Margall and Francisco Pi y Azuaga, *Historia de España en el siglo XIX* (Barcelona, 1903), vol. 2, p. 162.

4. Toward the end of April 1814, a mob in Valencia destroyed the plaque inscribed *Plaza de la Constitución* (Constitution Square), putting in its place another inscription in wood bearing the name *Real plaza de Fernando VII* (Royal Square of Fernando VII). See Antonio Ballesteros y Beretta, *Historia de España y su influencia en la Historia Universal* (Barcelona, 1956), vol. 10, p. 151.

5. Conde de Toreno, *Historia del levantamiento, guerra y revolución de España* (Madrid, 1835-1837), vol. 5, p. 545.

6. See Eleanor A. Sayre, "Goya: A Moment in Time," Nationalmuseum, Stockholm, *Bulletin* 3, no. 1 (1979), pp. 28-49.

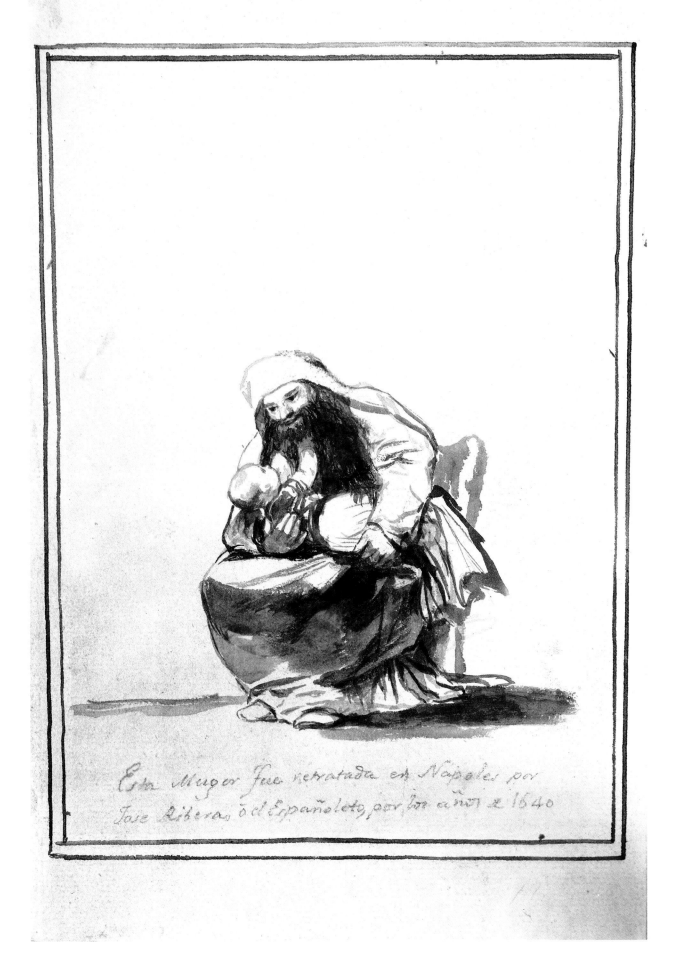

Esta Muger fue retratada en Napoles por
Jose Ribera ó el Españoleto, por los años e 1640

126

Esta Muger Fue retratada en Napoles por José Ribera o el Españoleto, por los años de 1640 (This woman was painted in Naples by Jose Ribera or lo Spagnoletto, about 1640)
Album E, page 22
About 1814-1817
Brush and gray and black wash
259 x 178 mm.
Inscribed in graphite, below image: title; upper margin: traces of *22*
References: G-W 1395; G., I, 123.

Museum of Fine Arts, Boston, Gift of Frances and Philip Hofer in honor of Eleanor A. Sayre, 1973.504
Spain only

Fig. 1. José de Ribera,
Magdalena Ventura with Her Husband and Son, 1631.
Oil on canvas.
Museo Fundación Duque de Lerma, Hospital Tavera, Toledo

Fig. 2. Bartolomé Esteban Murillo,
San Félix de Cantalicio, about 1668-1676.
Oil on canvas.
Museo de Bellas Artes, Seville

Goya's inscription at the bottom of the drawing identifies the inspiration for this surprising depiction of maternity: the well-known portrait of Magdalena Ventura with her husband and son, painted by José Ribera in 1631 as a commission from the viceroy of Naples (fig. 1).[1] When Goya drew this work, the painting was easily accessible in Madrid; it hung in the Real Academia de San Fernando, where it remained from 1815 until 1828.[2] But the similarities between the two works are scant; both artists could not have handled the subject in a more distinct spirit. Goya's inscription seems to invite comparison of the two points of view, directing our attention to the different meanings of each work.

The physical anomaly of a bearded woman roused the curiosity of all social classes, much as the dwarf, the fool, and the idiot had throughout the seventeenth century. The art of that period reflected this interest, as can be seen in Ribera's portrait of Magdalena Ventura and in another painted almost half a century earlier by Sánchez Cotán.[3] The "magnum naturae miraculum" – that is how Ribera described her in the Latin inscription that tells the story – is fifty-two years old, appearing as if she were on a stage, object of the avid curiosity of all those who look at her.[4] The fact that she is about to nurse her child serves no other purpose but that of emphasizing her hybrid character: she has the head of a man and the body of a woman. The sub-

ect of maternity recedes, leaving only that of the monster – the wonder – exposed before our gaze with all its raw realism. Ribera let some of the human tragedy show in the expressions of the couple; Magdalena's grim and melancholic, her husband's sad and perplexed.

In contrast Goya showed a seated woman with her son lovingly cradled in her lap. They exchange looks and smile in a mute dialogue, altogether oblivious to all that lies beyond them. The mother's face glows with maternal love, and her abundant beard becomes incidental, a plaything for the child.

The universal subject of Mary in loving play with the Child appears in the Christian art of all periods. During the Renaissance and the Baroque it was a favored theme. An interesting variation on the subject is that of a male saint and the Child reaching out with his hands toward the beard or face in a playful gesture. In the Spanish school, Bartolomé Esteban Murillo, painter par excellence

of religious subjects, most successfully captured the Virgin's maternal tenderness and delicate spontaneity of the Christ child in numerous versions infused with deep human sentiment. And Murillo also managed to render so touching a subject as a saint in intimate communion with the divine child. Several paintings depict this moment,[5] but the most interesting example is *San Félix de Cantalicio,* where Jesus extends his arms and entangles his fingers in the now gray beard of the old saint (fig. 2).[6] Goya's drawing is much closer iconographically to Murillo's work than to Ribera's.

The artistic treatment parallels the psychological one. The drawing reads like a sculpture, as firm and solid as the relationship between mother and child. The abundance of rounded forms and the contrast between luminous white tones and gray tones, touched with velvety black, contribute to this impression of tenderness and stability.

Goya was inclined to represent a whole

gallery of monstrous – deformed, ignoble, mean-spirited – beings as true portraits not of the physical likenesses but of the souls of his subjects. In contrast, this poor woman, whom many considered a monster or freak of nature, is much more human and noble in sentiment than other individuals who lack a physical defect and yet figure in the world of Goya's art. Against the interest in the monstrous that characterized one aspect of the baroque aesthetic, Goya carried on the tradition initiated by Velázquez of embodying in his dwarfs, idiots, and fools the human dignity that not all the painters of the seventeenth century could or would see in those unfortunate, grotesque beings.

T.L.M.

1. The painting was taken to Spain by the viceroy, Duque de Alcalá, in 1631. Later it belonged to the Medinaceli family and finally the Duques de Lerma. It is now exhibited in the Museo Fundación Duque de Lerma, Hospital Tavera, Toledo. See Kimbell Art Museum, Fort Worth, *Jusepe de Ribera lo Spagnoletto, 1591-1652*, ed. Craig Felton and William B. Jordan (1982), no. 11, p. 131.

2. There are references to two copies of Ribera's painting, one in the Palacio de la Granja, outside Madrid, and the other in the Madrid collection of Ruiz de Alda. Museo del Prado, Madrid, *Monstruos, enanos y bufones en la corte de los Austrias* (1986), no. 20, p. 80.

3. Juan Sánchez Cotán, *La muger barbuda de Peñaranda*, about 1590. Ibid., no. 17, p. 69.

4. The Latin inscription reads: *EN MAGNU[M] NATURAE MIRACULVM MAGDALENA VENTURA EX OPPIDO ACVMULI APVD SAMNITES VVLGO EL A BRVZZO REGNI NEAPOLI TANI ANNORVM 52 ET QVOD INSOLENS EST CV[M] ANNVM 37 AGERET COE PIT PVBESCERE, EOQVE BARBA DEMISSA AC PROLIXA EXT VT POTIVS ALICVIVS MAGISTRI BARBATI ESSE VIDEATUR QVAM MV LIERIS QUAE TRES FILIOS ANTE AMISERIT QVOS EX VIRO SUO FELICI DE AMICI QVEM ADESSE VIDES HA BVERAT. IOSEPHVS DE RIBERA HIS PANVS CHRISTI CRVCE INSIGNITVS SVI TEMPORIS ALTER APELLES IVSSV FERDINANDI II DVCIS III DE ALCALA NEAPOLI PROREGIS AD VIVVM MIRE DEPINXIT XIIIJ KALEND. MART. ANNO MDCXXXI.* Kimbell Art Museum, *Jusepe de Ribera*, no. 11, p. 129.

5. Diego Angulo Iñíguez, *Murillo* (Madrid, 1981), vol. 3, pl. 357. Another painting of the same subject is now hung in the main sacristy of the cathedral of Seville.

6. Having been painted for the Capuchin convent, *San Félix* remained in Seville except for a brief period from 1810 to 1813, when it was removed to Cádiz for safekeeping during the war. The painting was exhibited in the church, forming part of a mag-

nificent retable of Murillo's works. Angulo, *Murillo*, vol. 2, no. 61, p. 61. It is very likely Goya knew the work Murillo left in his native city, since Ceán Bermúdez reported that during Goya's second journey to Andalusia, he visited Seville on three occasions and that he had "visto y examinado con detención todas las obras, que los más famosos profesores andaluces de los siglos XVI y XVII habían pintado para su catedral" (seen and examined in detail all the works that the most renowned Andalusian masters of the sixteenth and seventeenth centuries painted for the cathedral). J.A. Ceán Bermúdez, *Análisis de un cuadro que pintó don Francisco Goya para la catedral de Sevilla* (Seville, 1817), p. 1. It does not seem far-fetched to suppose Goya visited other Sevillian churches with paintings by the same artists.

127
Mother with Deformed Child
Album E, page 23
About 1814-1817
Brush and gray and black wash
266 x 185 mm.
Inscribed, below image: traces of title, in brown ink, upper margin: *23*
References: G-W 1396; G., I, 124.

Musée du Louvre, Département des arts graphiques, Paris, RF6911
Spain only

Although it is not known whether this drawing and the previous one in the catalogue (cat. 126) were sequential in Goya's original album, the affinity between them is evident. Both are about physical monstrosity: on the one hand the bearded woman, on the other the deformed child. Knowledgeable about the aesthetic of the monstrous – as the etchings of dwarfs, buffoons, and other physically defective beings after Velázquez attest – Goya broached the subject directly in these two drawings to give form to his point of view.

A young mother shows her deformed child to a pair of common women. It is probably not an isolated incident; the baby is naked and rests on a piece of cloth or a blanket that enables it to be exhibited – the drawing captures this moment – and covered with ease. The scene seems to take place outdoors.

Always careful about giving important clues, Goya laid the light on the body of the child and on the shawl covering one of the women, thereby emphasizing the infant's nakedness at a time of year when the cold is perhaps making itself felt. Following these juxtapositions, the outline of the concave cloth revealing the baby echoes the outline of the convex wrap covering the principal spectator, who is avidly bent toward the child. All the details clearly identify the nature of the subject: the exhibition of unfortunate, deformed beings, who were regarded, according to the norms of the time, as monstrous, and whose display at fairs and markets was a business.[1]

The undeniable center of the composition and by all indications the protagonist of the drawing is the child, portrayed by Goya with great compassion. The draw-

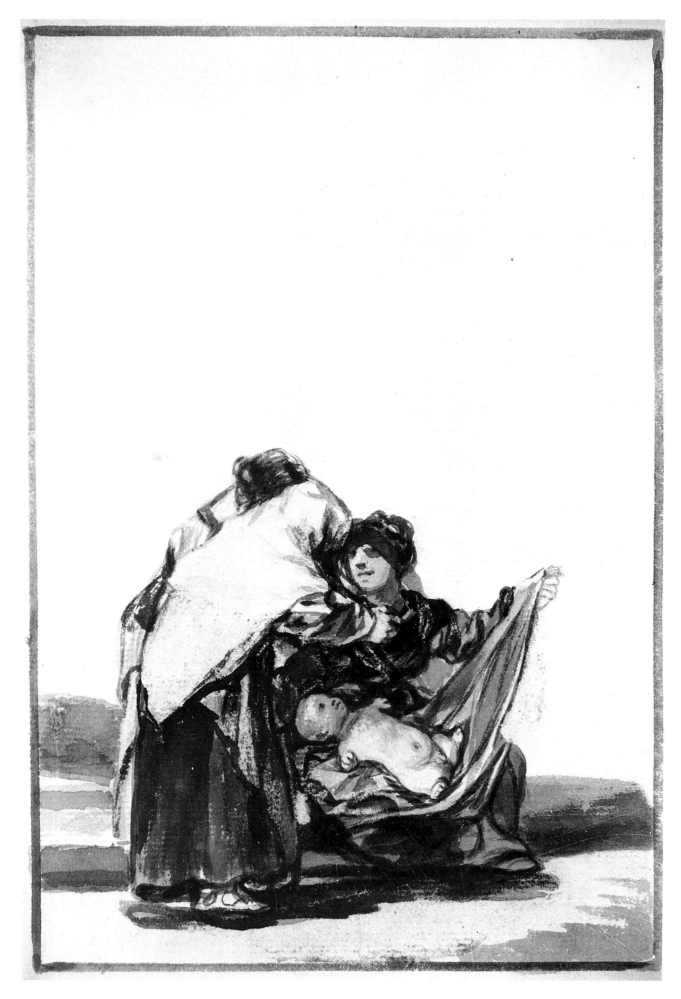

284

ing reveals a manifest knowledge of the specific anatomical deformity *phocomelia* (congenital atrophy of the extremities),[2] which suggests it is based on a case known to Goya.[3] And yet he is interested in stressing not the physical monstrosity but that which is beautiful and dignified in this tiny child. We notice the lovely head and tranquil, contented appearance before we do the atrophied limbs.

The group formed by the mother, the child, and the spectators recalls the Renaissance compositional scheme characteristic of the Adoration of the Shepherds, so often treated by the painters of northern Italy, especially the Venetians, in which the Virgin presents the baby Jesus to humble peasants by lifting the cloth in which the child is swaddled. In Spain the painters of the seventeenth century used this iconography for the same subject; among them, Bartolomé Esteban Murillo incorporated it most often (see fig. 1).[4] Goya recalled the same scheme in this drawing: the light and the compositional lines concentrate on the child, and the mother shows the baby by using one hand to raise a corner of the cloth. Goya also used well-known religious iconography to bring home an important point in other works (see, for example, cat. 61, 126, and 176).

The parallel between the drawing of the bearded woman (cat. 126) and this one of the deformed child is extended by the same use of religious iconography found in Murillo. In the former, the mother delights in the contemplation of her baby as Mary does with Jesus; in the latter, another woman exhibits her child, unfortunately deformed, not for the adoration and love of the shepherds – once again there is a cruel paradox – but for the meddlesome curiosity of two women. The similarities apply also to interpretations of these works. The physical monstrosity of the bearded mother vanishes before the beauty of her affection in the same way that the severe physical defects of the child are secondary to its tender innocence. Implicitly, the drawing denounces the moral insensitivity of those apparently normal beings who gather round the baby and, in a wider sense, of a society that encourages such exploitation. At the same time the mater-

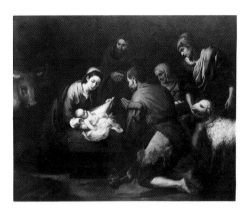

Fig. 1. Bartolomé Esteban Murillo,
Adoration of the Shepherds, about 1655-1660.
Oil on canvas.
Museo del Prado, Madrid

nal care that the physical well-being of the child reflects is notable. Goya does not appear to entirely condemn the mother, almost certainly herself a victim of the poverty so often associated with the lower classes in the eighteenth century.

The drawing's inscription was erased, and only traces of some strokes remain; their meaning has not yet been discovered. It is thought the title may have been *Cosa rara* (Strange Thing), which would be logical given the characteristic style of Goya's other inscriptions.[5]

T.L.M.

1. Goya was markedly interested in the life and public exhibition of beggars and rogues (see *Album G*), social victims of poverty and ignorance, and in the displays of monstrous beings as attractions at fairs (see cat. 178).

2. Samuel X. Radbill, M.D., "A *phocomelus* of the Eighteenth Century as Seen by Francisco Goya," *Clinical Pediatrics* 2 (June 1972), pp. 367-368.

3. In *Diario de Madrid*, July 4, 1791, appeared the following description of a print representing a creature similar to that in this drawing: "Retrato de un Monstruo de naturaleza, sin manos ni pies, y del principio del muslo le sale un dedo con el que toca el tambor, y escrive, y con la boca enebra una aguja, y hace otras varias habilidades" (Portrait of a freak of nature, without hands or feet, at the top of whose thigh there is a finger with which it plays the tambourine and writes, and threads a needle with its mouth and does various other things). Evidently the advertisement responded to a strange taste of the public of the time for everything connected with abnormal beings. Cited in Edith Helman, "Cadalso y Goya: sobre Caprichos y monstruos," in *Jovellanos y Goya* (Madrid, 1970), p. 131.

4. In addition to the Prado's painting illustrated here, depictions of the Adoration of the Shepherds by Murillo that are close to Goya's drawing include, for example, one (about 1660) formerly in the Kaiser Friedrich Museum, Berlin (destroyed in 1945), reprod. in Diego Angulo Iñíguez, *Murillo* (Madrid, 1981), vol. 3, pls. 188, 189; and one (about 1668-1670) now in the Museo de Bellas Artes, Seville, ibid., pls. 248, 249. Goya could have seen the last mentioned in the church of the Capuchins in Seville, where he may also have seen *San Félix de Cantalicio* (see cat. 126, fig. 2, and n. 6). There is no doubt he knew the work now in the Prado because it appears in two inventories of the royal collections for the years 1772 and 1794; ibid., vol. 2, no. 222.

Murillo was well known in the eighteenth century and the first half of the nineteenth, in Spain and abroad. Already in 1729, Isabel de Farnesio had acquired an important collection of his works for the royal palace in Madrid; ibid., vol. 1, p. 215. Thus, not only was Goya surrounded by Murillo's works but he also must have been aware of the great prestige the Sevillian painter had enjoyed in the courts of Carlos IV and Fernando VII.

5. See G., I, 214.

128

¡Si yerras los tiros! (If You Miss the Mark!)
Album E, page 27
About 1814-1817
Brush and gray and black wash
261 x 187 mm.
Inscribed in graphite, lower margin: title;
in brown ink, upper margin: *27*
References: G., I, E.27.

Private Collection, United States
United States only

A man stands tense and erect in high grass that has been trampled. With an alert face he looks about him ready to fire the gun in his hands. Bound to his waist is a hunting knife. His social status cannot be specified, but his good country clothing suggests he belongs to the upper class. To the right a shorthaired, spotted dog, perhaps a pointer, stretches its neck toward the man and lowers its muzzle toward his feet as if it were smelling out a recently discovered quarry.

Although it is uncertain whether the figure is a hunter – he does not carry cartridges or a game bag – this is the image he projects with his gun and knife and the presence of the dog at his feet. At first glance the drawing might be interpreted as a satire on inept hunters, since one could suppose the dog was indicating prey the hunter has missed.[1] But the viewer cannot see the prey either, since Goya did not take pains to show it or to suggest that something lay hidden in the tall grass. On the contrary, the animal's posture clearly indicates that the man alone is the prey to be retrieved. And its disposition also intimates the presence of one or more adversaries – to whom the dog must belong – lying in ambush, hidden to the hunter as well as to the viewer. In this way Goya directs our attention to the main figure. The hunter's body is extremely tense, like that of a person sensing imminent danger, and his facial expression seems alert, almost as if he were cornered. Furthermore, the man's feet appear entangled in the tall grass – where he may have been hiding – as if he were "cogido en su propia trampa" (caught in his own trap) or "prendido en

Fig. 1. Georg Pencz, *Hunters Hunted by Hares* (detail), 1534-1535.
Woodcut, hand-colored.
Museum of Fine Arts, Boston, Horatio Greenough Curtis Fund

sus propias redes" (entangled in his own net). The drawing thus could be an interpretation of the proverb "a las veces do cazar pensamos, cazados quedamos" (sometimes when we set out to hunt, we end up hunted), which the *Diccionario de autoridades* (1726-1739) defined as "refrán que reprehende y advierte los engaños con que se emprenden algunas cosas: pues sin mirar el fin, solemos quedar enredados de los medios" (a saying that reprimands and warns against the deception with which some matters are undertaken; without looking to the end, we are sometimes mired in the means).[2] By choosing this popular image, Goya appears to cast a shadow on this man's character.

Since the Middle Ages, in popular tradition, including the *Romancero* (collection of romances and ballads) itself, the hunt had negative connotations. Hunters abound in ballads, but only rarely do they succeed in retrieving game. The hunt is presented as a backdrop to tragic or sinister scenes that often prefigure misfortune, if not the well-deserved death of the protagonist.[3] The association of the hunt and death characteristic of the Spanish *Romancero* was well-known to common people. The premonition of the suspect hunter's death in this drawing, or at the least its possibility, was a clear message to Goya's contemporaries.

The title, *¡Si yerras los tiros!* (If You Miss the Mark!), was as deliberately chosen as the drawing's symbolism. Apart from its literal meaning, the expression plays on a second one, which Gonzalo Correas had already noted in the seventeenth century: "Errar el tiro, 'Kedar burlado'" (to miss the mark, to be deceived or cheated).[4] The idea conveyed in the drawing (the hunted hunter) is restated by the title (the cheater cheated), which deliberately includes the verb *errar* (to fail, to err).[5]

In fact, the concept of the hunted hunter is an inversion of the natural order of things known in art, literature, and colloquial language since the late Middle Ages as images of the world turned upside down, used in Western Europe in a satirical sense, often criticizing the social and religious order. A sixteenth-century woodcut (fig. 1) by the German artist Georg Pencz represents a strange scene of a group of hares engaged in the act of slaughtering and cooking two hunters and their dogs, after having tried them. In the commentary added to the print by Hans Sachs in 1550, titled *Ein yeder trag sein joch diese zeit und uberwinde sein ubel mit gedult* (In these times may everyone bear his yoke and overcome his troubles with patience), a comparison is made between the scene in the print and the fate that awaits tyrants, not altogether unlike the thought Goya expressed in this drawing: "War ist es wie Seneca spricht / Welcher Man treibt gross Tiranney / Macht vil ausffsetz und schinderey / Maint zu drucken sein underthann / Auff das sie foerchten sein person / Der selb muos ir auch foerchten vil / Und Wenn ers gar ubermachen wil / Wirts etwan mit ungstuem gerochen / Und hart gespannter bogen brochen. / Wie Kueng Rehabeam geschach / Auch andren mehr vor und hernach. / Wer aber saenfftmuetig Regiert / Von den seinen geliebet wirt / Thund im freywilig alles gut / Und setzen zu im guot und bluot / Der underthann gehorsam hend / Befestigen sein Regiment." (It is true what Seneca says: / A ruler who tyrannizes his people / Causes much oppression and suffering, / And means to crush his subjects / So that they may fear his person. / This same ruler

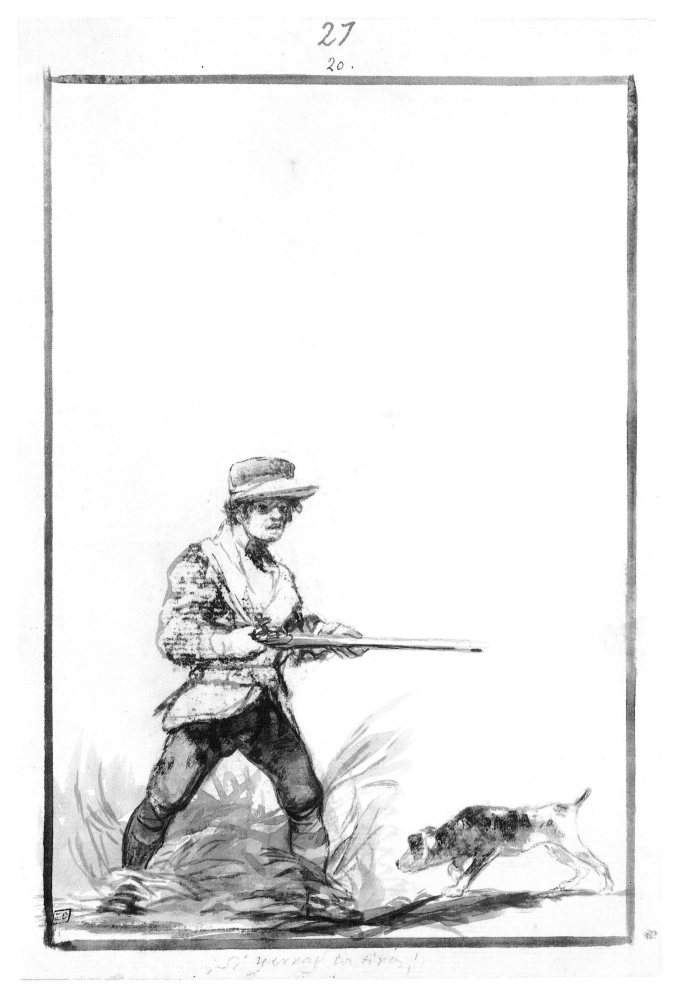

¿Sí yerras el tiro?

must also fear many of them, / And if he goes too far, / It will sometimes be avenged with violence, / For a bow that is overstretched will break. / As it happened with King Rehabeam / And many others before and after him. / But whoever rules kindly / Will be loved by his people. / They will freely do for him all that is good / And trust him with their possessions and life. / Whoever has his subjects' obedience / Will strengthen his rule).

In the light of popular imagery – transmitted in literary texts and artistic works, Carnival language, and sayings – and also in that of Goya's inscription, the false hunter is defined as a man caught in his own snares, whose death is possibly foreseen. But Goya goes further. The following drawing in *Album E* shows an allegorical figure of Philosophy in the guise of a poorly dressed young woman; its title is a verse from Petrarch: *Pobre e gnuda bai filosofia* (Poor and naked goes Philosophy) (G-W 1398).[6] As Philosophy, Constitution, Liberty, and Reason were related and complementary ideas in the eighteenth century, there is reason to believe both drawings may constitute a commentary on the tyranny Spain suffered after Fernando VII's restoration of absolutism as a form of government.[7]

<div align="right">T.L.M.</div>

1. There are many sayings with an unfavorable view of the hunter. See Luis Martínez Kleiser, *Refranero general ideológico español* (Madrid, 1953), pp. 113-116, under *caza*. They could all be summarized by the following proverb (no. 10213), brimming with Andalusian wit: *¿Qué es cacería? Una poca e gente perdía* (What is hunting? Nothing more than wayward people)

2. See *Autoridades*, 1726-1739, under *cazar*.

3. For an overview of the theme of the hunting ballad, see Edith Randam Rogers, *The Perilous Hunt: Symbols in Hispanic and European Balladry* (Kentucky, 1980), pp. 1-40. See also Daniel Devoto, "El mal cazador," in *Studia Philologica: Homenaje ofrecido a Dámaso Alonso* (Madrid, 1960), vol. 1, pp. 481-491.

4. Gonzalo Correas, *Refranes*, p. 634.

5. "*Errar.* Del verbo latino *erro, as,* pecar, no acertar. . . . Errado, el descaminado, el pecador; y assí dice la confessión en romance: 'Yo pecador mucho errado' " (To falter. From the Latin verb *erro, as,* to sin, to fail. . . . The fallen, the wayward, the sinner; and so goes confession in Spanish: "I, a sinner, who have erred"); Covarrubias, *Tesoro,* 1611. See Corominas, *Diccionario etimológico,* under *errar.* See also Alonso, *Enciclopedia,* under *errar,*

where this usage is found between the fifteenth and the eighteenth centuries. Its use in this way can still be documented in 1812. In the sessions of the Cortes of Cádiz concerning the problem of seignories, the laws protecting them were described as "prácticas erradas" (unjust practices). See *Actas de las Cortes de Cádiz: Antología,* ed. Enrique Tierno Galván (Madrid, 1964), vol. 2, p. 869.

6. The same verse is quoted in Cesare Ripa's commentary on the allegorical representation of Philosophy in his *Iconologia,* where Goya probably found the verse. See G., I, p. 215.

7. Several times throughout *Album E* (see cat. 125, 130, 131), Goya showed his concern over the spectacle of a society in which crimes and assaults abounded in spite of brutal repression and in which the peasant and laboring classes became steadily more impoverished.

129
La resignacion (Resignation)
Album E, page 33
About 1814-1817
Brush and gray and black wash
269 x 190 mm.
Inscribed in graphite, lower margin: title
References: G-W 1402; G., I, 129.

Museum of Fine Arts, Boston, Centennial Gift of Landon T. Clay, 69.68
Spain only

The figure of this woman partly stretched out and resting against a dead or hewn tree is delicate and attractive. She wears a vaguely defined religious habit consisting of a tunic, a characteristic coif or headdress, and a shawl covering her head and wrapped about her body. The image of the nun and withered trunk form a compact and isolated whole. This impression is reinforced by the placement of the shawl at the base of the tree and by the absolute absence of any other detail of landscape.

For centuries women, even though lacking a religious vocation, were obligated to enter convents for family reasons, sometimes as girls, in general because they did not have the means for the indispensable dowry of every "good" marriage. It is known how Santa Teresa de Jesús did not want any women in her convents who came only "por remediarse" (to help themselves). Denunciations of these abuses were frequent from the sixteenth century.[1] The problem soon required legislation, and in the seventeenth century the amount of marriage dowries was limited by law.[2] Enlightened writers in fact attempted to abolish them once and for all, with the aim of encouraging legal unions and in this way stimulating an increase in population. One of the advantages cited was that "no entrarían tantas mujeres sin vocación en los conventos por no tener dote" (so many women without vocations would not enter the convents because they lacked a dowry), according to one commentary in a political text of 1777.[3] Nearer the time of Goya's drawing, José Blanco White analyzed the pathetic situation of these women in Seville toward the end of the eighteenth century and early

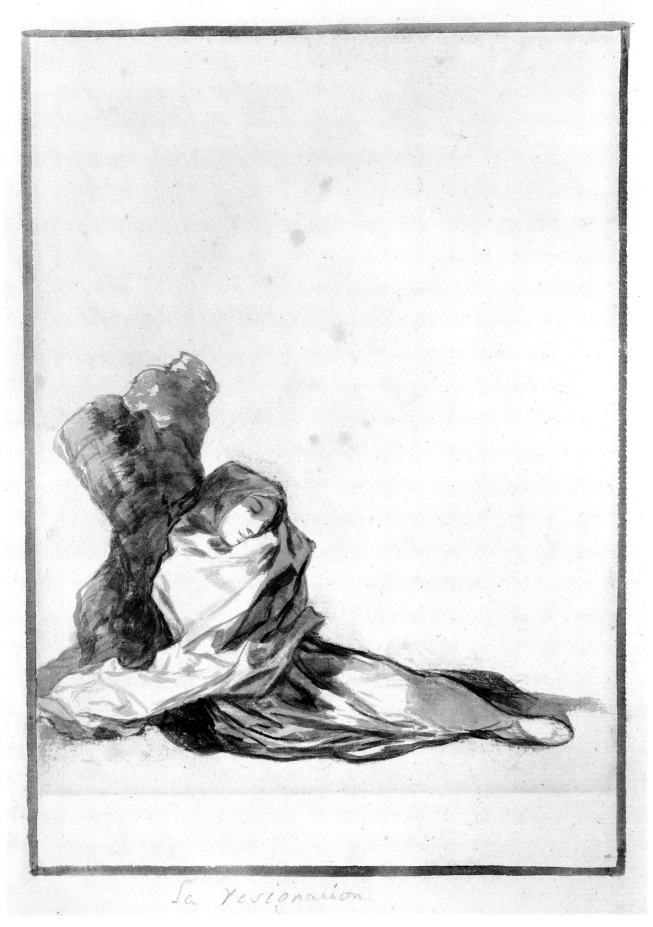

La resignacione

nineteenth century in his *Letters from Spain.* He dedicated many pages to this problem, which he described as a "process which condemns a female 'to wither on the virgin thorn,' and 'live a barren sister all her life.' "[4] Even though he recognized the dilemma of these women displaced by society and the need to seek "a dignified asylum" for them, he criticized "the . . . church law, which . . . binds the nuns with perpetual vows, makes the convent for females the *Bastilles* of superstition, where many a victim lingers through a long life of despair or insanity."[5]

Goya showed this nun, with her head bent in a characteristic humble gesture, languorously resigned to her destiny, although a closer analysis reveals the woman's tragedy and Goya's harsh criticism of it. The drawing emphasizes sculptural values in the careful lines of the clothing, where the different tones of the wash masterfully stress volume. Contributing to this impression is the way the figure leans against the tree, hewn or dead in its prime. The resemblance of the trunk to a human torso clearly suggests the idea of a sterile and truncated life. The complete absence of action supports this interpretation; not even the nun's eyes are open, and although her arms and hands are hidden under the coif – where light falls so that we do not overlook this detail – they appear to be bound by the religious habit. A similar association – virginity, sterility, death – is established in the painting *Sacrifice to Vesta* (cat. 2, fig. 1), in contrast to the image of fertility and life suggested by the leafy tree in *Sacrifice to Priapus* (cat. 2). Yet Goya left no doubt that the subject of this drawing is a young woman, replete with life and beauty. Her lovely face, which somewhat recalls the Mater Dolorosa (Mother of Sorrows at Calvary), is sunk in reverie, and the viewer can sense, in spite of the habit, that her body is beautiful and lithe. The delicate handling of the skirt intimates the presence of the young woman's leg with a subtle sensuality that, far from scandalizing, provokes the viewer's sympathy regarding the problem of the woman cloistered perhaps against her will.

The sober title, *La resignacion* (Resignation), seems to hint at the idea of a nun who is not merely passive but aware of her powerlessness to redirect her life along different lines.

T.L.M.

1. Characteristic are the words of Alfonso de Valdés in a description of the damned soul of a nun lamenting the way she was committed against her will: "y despúes de entrada nunca tuve un día bueno" (and once inside I never had a single good day); *Diálogo de Mercurio y Caron,* ed. José F. Montesinos (Madrid, 1965), pp. 82-83.

2. Especially the decree of 1623, reiterated in 1723, and still in effect when the *Novísima recopilación de las leyes* (Newest Compilation of laws) was published in 1805. See Antonio Domínguez Ortiz, *Hechos y figuras del siglo XVIII español* (Madrid, 1980), p. 302, n. 25. At the end of the eighteenth century, married people in Madrid made up less than 38 percent of the population. It is well known that in eighteenth-century upper-class marriages interests still played a fundamental role. Less often commented upon is the fact that dowries were exacted even for marriages among the poor. When the poor were accused of cohabiting, they often justified themselves by pointing out their insufficient means to marry. See Jacques Soubeyroux, "Pauperismo y relaciones sociales en el Madrid del siglo XVIII," *Estudios de historia social,* nos. 12-13 (1980), pp. 110-111.

3. Text by Felipe Argenti Leys quoted in Domínguez Ortiz, *Hechos y figuras,* pp. 302-303, n. 26.

4. Blanco White, *Letters,* p. 244.

5. Ibid., p. 238.

130

***No haras nada con clamar* (Crying out will get you nowhere)**
Album E, page 39
About 1814-1817
Brush and gray and black wash
265 x 181 mm.
Inscribed in graphite, lower margin: title, in brown ink, upper margin: *39*
References: G-W 1408; G., I, 134.

Private Collection, United States
Spain only

This drawing speaks volumes about the desperate situation and wretchedness of the Spanish farm laborer of the time. Unshod, his hoe lying on the bare ground where not a blade of grass grows, the peasant cries out to heaven with his arms raised and his hands clenched. His disheveled hair, mournful eyes, and expression convulsed by the violence of his exclamation seem to convey the bitter disillusionment and frustration brought about by the conditions in which he lives.

This is not the only occasion in which Goya's brush portrayed the hard life of the peasant. *Capricho* 42, *Tu que no puedes* (You Who Cannot) (cat. 49), in which peasants bear the overwhelming burden of a useless society, is concerned with their plight. Everything is endured in the *Capricho* with closed eyes as well, but without the least murmur of complaint. Goya thus indicated in the print the passive attitude of the masses, unable to organize a revolt or advance a program of social reforms.[1] The title of this drawing, *No haras nada con clamar* (Crying out will get you nowhere), suggests a very different idea: Goya's disillusionment over a pressing national problem.

Although eighteenth-century Spain's population and economy were 80 percent rural, the much-needed agrarian revolution had not taken place. The peasants' living conditions were hard; they dwelled in shacks, were poorly dressed and shod, and sometimes lacked basic nourishment. In Andalusia and other regions they had to turn to gleanings or even thievery of fruit. The situation was similar in all Spanish regions with the exception of Navarra and especially Cataluña, where an agrarian middle class was

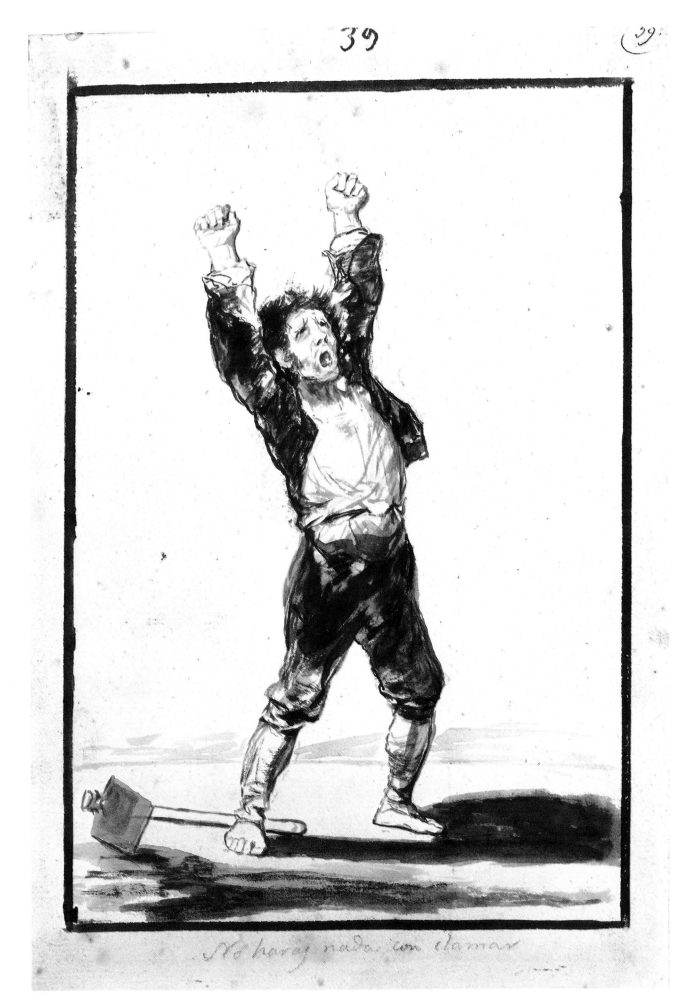

No harás nada con clamar

established.[2] In Jovellanos's *Diarios* (Diaries) there is ample evidence of the desolate vision the Spanish countryside offered. The contrast between so much fertile land and so many miserable laborers made him exclaim: "¿Cómo, pues, tanta pobreza? Porque hay baldíos, porque las tierras están abiertas, porque el lugar es de señorío del duque de Alba, porque hay mayorazgos, vínculos y capellanías. ¡Oh suspirada Ley Agraria!" (How then so much poverty? Because there are unworked lands, because the lands are not enclosed, because the village [Mancilla de las Mulas, in the province of León] is under the jurisdiction of the Duque de Alba, because primogeniture, entail, and ecclesiastical foundations exist. Oh longed-for Agrarian Law!)[3] Toward the end of 1795, the *Informe de la Sociedad Económica de Madrid, al Real y Supremo Consejo de Castilla, en el expediente de ley agraria* (Report of the Madrid Economic Society to the Royal and Supreme Council of Castile on the Agrarian Law) was printed in the fifth volume of the *Memorias de la Real Sociedad Matritense* (Papers of the Madrid Royal Society), in which Jovellanos analyzed the profound legislative measures required for agricultural progress: abolition of dues and all forms of obstacles to the free circulation of goods and sale of lands.[4]

During Carlos III's reign, enlightened economists and theorists attempted the long-desired reform with only mixed results, in spite of the encouragement Campomanes gave the Sociedades Económicas de Amigos del País (Economic Societies of Friends of the Nation).[5] Pablo de Olavide drafted a sensible agricultural plan based on the division of property into small parcels, improved farming tools, artificial meadows, and limited organized movement of livestock in search of green pastures, ideas he had put into practice in the Sierra Morena colonies.[6] But the theory was never applied in the general and systematic manner Spain needed, and at the beginning of the nineteenth century, many of the institutions of the old order remained. After the Peninsular War the situation only worsened. Between 1811 and 1812 the Cortes of Cádiz began to

test the waters for an agrarian reform and in different sessions proposed possible solutions to the problems of unworked and common lands, seignorial jurisdiction, primogeniture, and the *voto de Santiago* (feudal due for the Cathedral of Santiago de Compostela).[7] The return of Fernando VII and the restoration of absolutist monarchy nipped these projects in the bud. Goya must then have persuaded himself that only an active role by the peasantry could change such a social and political situation. From such a state of mind the idea for this drawing may have emerged.

On level ground whose flatness is stressed by the hoe, the image is conceived, from an artistic point of view, as a rising line pointing toward the man's haunting expression, framed by his raised arms. The compositional line begins in his strong, strained legs and continues in the deep black patches of his breeches and short jacket, as if accompanying the clamor that rises out of the depths of his being. In contrast the man's chest is partly bared and highlighted as a reminder of his vulnerability and helplessness.

T.L.M.

1. See Antonio Domínguez Ortiz, *Hechos y figuras del siglo XVIII español* (Madrid, 1980), pp. 270-271.

2. For a general overview of the situation of the Spanish peasant of the time, see Antonio Domínguez Ortiz, *Sociedad y estado en el siglo XVIII español* (Madrid, 1976); Sarrailh, *Espagne éclairée*, passim. See also Jacques Soubeyroux, "Pauperismo y relaciones sociales en el Madrid del siglo XVIII," *Estudios de historia social*, nos. 12-13 (1980), pp. 116, 140-145.

3. Gaspar Melchor de Jovellanos, *Diarios (Memorias íntimas): 1790-1801* (Madrid, 1915), p. 209b.

4. The Madrid Inquisition began proceedings against Jovellanos as a result of ideas contained in a series of paragraphs on the abandonment of the countryside and its poor cultivation. However, the case was suspended. See Edith Helman, "Algunos antecedentes de la persecución de Jovellanos," in *Jovellanos y Goya* (Madrid, 1970), pp. 33-69. See Gaspar Melchor de Jovellanos, *Informe de la Sociedad Económica de Madrid al Real y Supremo Consejo de Castilla en el Expediente de Ley Agraria* (Madrid, 1820).

5. The privileged classes did not cooperate. When Pablo de Olavide was Intendant of Seville, he tried to distribute common lands among the laborers, but town hall and the great landowners who leased the lands blocked the attempt. See Domínguez Ortiz, *Sociedad y estado*, p. 428.

6. These ideas about agriculture were explained in Olavide's book, which was published anonymously, *El Evangelio en triunfo, o historia de un filósofo desengañado* (The Gospel Triumphs, or the History of a Reformed Philosopher), 4 vols. (Valencia, 1797-1798). Olavide was tried and jailed by the Inquisition in 1778. In 1780 he managed to escape to France, where he was received with open arms by the encyclopedists and where he remained until 1798.

7. *Actas de las Cortes de Cádiz: Antología*, ed. Enrique Tierno Galván (Madrid, 1964), vol. 1, pp. 441-459; vol. 2, pp. 757-879, 881-887, 899-1025.

131

Dios nos libre de tan amargo lance (God save us from such a bitter fate)
Album E, page 41
About 1814-1817
Brush and gray and black wash
268 x 188 mm.
Inscribed in graphite, lower margin:
title, in brown ink, upper margin: *41*
References: G-W 1410; G., I, 136.

The Metropolitan Museum of Art,
New York, Harris Brisbane Dick Fund,
1935.103.50
United States only

The subject of this beautiful drawing was an enormous social problem in Goya's day, when assaults and kidnappings were frequent. A bandit, dagger in hand, takes a young woman by the head. She is accompanied by a child who clings to her in fear. They are probably walking toward the hideout of the criminal, passing by a thick grove. Above the figures hangs, as if a sinister curtain, an intense dark gray area (menacing cloud? shadow of an escarpment?) cutting diagonally across the luminous background as if to merge with the landscape.

While Goya's memory of his sojourn in Andalusia was still fresh, he used the images of the smuggler and the highwayman, though in a different context from this drawing, in *Album B,* page 88, *Buena Jente somos los Moralistas* (What fine people we moralists are) (G-W 446), later to be transformed into *Capricho* 11, *Muchachos al avío* (Lads Making Ready) (cat. 43), and *Album B,* page 89, *El abogado* (The lawyer) (G-W 447). It is worth drawing attention to the background of trees that appears in both these works, as well as in this drawing, a similarity that is not mere coincidence.

With its mountainous and sparsely populated terrain, Spain had always seen banditry. Beginning in the eighteenth century the bandits' range was almost entirely limited to the southern meseta (plateau) on the road from Madrid to Seville, especially in Andalusia.[1] About the precautions to take against an unhappy encounter, José Blanco White commented that "robbers seldom attack people on horseback, provided they take

care, as we did, never to pass any wooded ground without separating to the distance of a musket-shot from each other."[2] In the flatlands of the Guadalquivir Valley, bandits hid among the trees; in the mountainous areas they hid in thickets (which are abundant in the area of Despeñaperros) and caves near the trails, from which they could ambush victims. The background of trees in the drawing can therefore be explained as an appropriate setting for the subject of banditry.

It is revealing to study the sequence of drawings made up of this work and two preceding ones in *Album E: No haras nada con clamar* (Crying out will get you nowhere) (cat. 130) and *Dejalo todo a la probidencia* (Leave it all to providence) (G-W 1409), both with peasant themes. In the former, the man cries out to heaven against his unjust fate; in the latter, the woman sadly resigns herself to hers and trusts in divine power. On the following page, quite intentionally, there is this abduction scene. Another contrast is the difference in the dress of the two women; humble and austere is the peasant woman's attire, rich and elegant that of this lady. The coexistence of a large agrarian proletariat, on the fringe of misery, and a limited landowning aristocracy often led to assaults (see cat. 11 and 20), kidnappings, and other crimes, a fact recognized even in Goya's time, especially by the enlightened. Campomanes observed in his *Alegaciones fiscales* (Fiscal Allegations) that the peasant who had lost his lands had nothing to defend, nothing to lose, nor any reason to uphold the law.[3] On a trip to La Rioja, Jovellanos lamented the sad condition of the laborers of Fuenmayor, a region of luxuriant orchards. In the long periods without work, these laborers "perecen en el descanso; que pendientes de pocos ricos propietarios, envidian su fortuna y se irritan de compararla con su miseria" (perish in idleness, and, dependent on a few wealthy landowners, envy their fortunes and are angered by the contrast with their poverty), and who, driven by hunger, even turn to thievery in order to survive.[4] One of the reasons for the establishment of the *Nuevas Poblaciones* (New Settlements) on the road to Anda-

lusia (the Sierra Morena crossing and the stretch from Ecija to Córdoba) during Carlos III's reign was precisely to do away with extensive unpopulated areas, which were so inviting to highwaymen. Pablo de Olavide, director of the project, understood the need to carry out agrarian reform and to establish an ideal society without differences of class, mortmain, privileges, seignorial rights, and so on.[5] But these reforms, which the ruling classes only allowed on a small scale, were not sufficient, and after the Peninsular War the problem grew worse, persisting throughout the nineteenth century.

The different gray shades, the blacks, and the white of the paper are used with symbolic overtones. The leaden color overhead resembles that of the grove. Clear white and gray tones are given the victims, whereas the somber tones and the black patches appear in the bandit's outfit. The woman's fright, reflected in the pallor of her face, contrasts with the confused passions that play across the man's agitated countenance. Often Goya gave the merest suggestion of a background in his drawings or gave no background at all. However, he took special pains with this one because the trees, light, and darkness of the sky are essential to its meaning. The figures are outlined by light, which gives way to the shadow, an allusion to the lady's lost liberty. But there may be a second symbolic meaning. The contrast between light and darkness, so often used metaphorically in Goya's work (see cat. 52, 109, and 110), and the classical marble-like appearance and profile of the woman, as if she were a statue, perhaps alludes to that other lost lady in Fernando VII's Spain: Liberty.

T.L.M.

1. See Constancio Bernaldo de Quirós y Luis Ardila, *El bandolerismo andaluz* (Madrid, 1978).
2. Blanco White, *Letters,* p. 162; see also p. 182. References to robbery and assaults abound in the literature of the time. See, for example, Gaspar Melchor de Jovellanos, *Diarios (Memorias íntimas): 1790-1801* (Madrid, 1915), p. 210b; J. Cavanilles, *Observaciones sobre la historia natural, geografía, agricultura, población y frutos del reino de Valencia* (Madrid, 1895-1897), vol. 2, pp. 36, 40, 48, 82; Juan Meléndez Valdés, *Discursos forenses* (Madrid, 1821), p. 149.

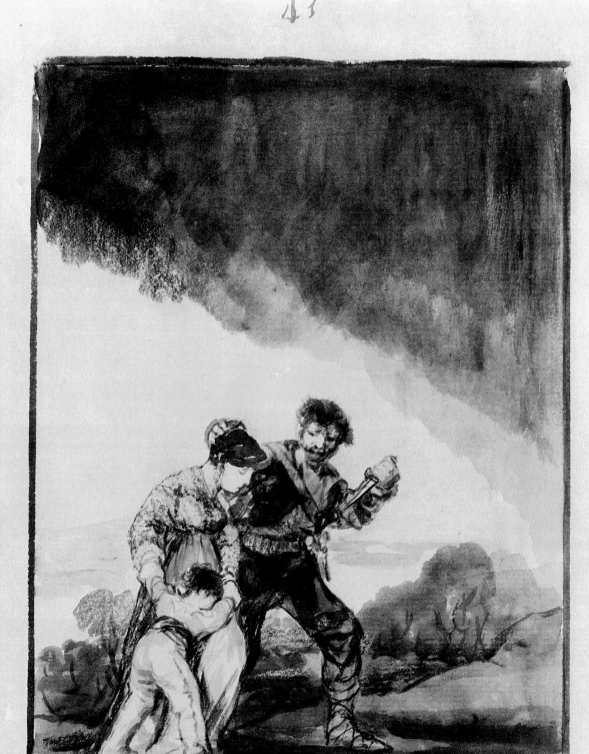

Dios no libre Etan amargo lance

3. Jacques Soubeyroux, "Pauperismo y relaciones sociales en el Madrid del siglo XVIII," *Estudios de historia social,* nos. 12-13 (1980), pp. 169-170. See also Bernaldo de Quirós, *Bandolerismo andaluz,* pp. 76-88, 257-262, on the Andalusian social problem that gave rise to banditry. Bernaldo de Quirós affirms that "in Diego Corrientes's day, at the end of the eighteenth century, there was no protest in Andalusia but that of the bandit." Ibid., p. 247. Diego Corrientes, an agrarian laborer executed in 1781, fit the mold of the generous thief who said "that he only took from the rich in order to give to the poor," a phrase that inspired the popular Andalusian ballad "Aquél que en Andalucía por los caminos andaba, er que a los ricos robaba y a los probes socorría" (He who traveled the Andalusian roads, he who robbed the rich and gave to the poor). Ibid., p. 258. For another work on the same subject drawing similar conclusions, see D. Pastor Petit, *El bandolerismo en España* (Barcelona, 1979).

4. Jovellanos, *Diarios,* p. 217a.

5. See Antonio Domínguez Ortiz, *Sociedad y estado en el siglo XVIII español* (Madrid, 1976), p. 428.

132

Lo mismo (Likewise)
Album E, page 47
About 1814-1817
Brush and gray and black wash
261 x 187 mm.
Inscribed in graphite, lower margin: title, in brown ink, upper margin: *47*
References: G-W 1429; G., I, E.k.

Musée du Louvre, Département des arts graphiques, Paris, RF 31.854
Spain only

A laborer seen from behind guides a plow pulled by a team of oxen. His right hand grips the plowhandle while his left holds the plowstaff. His body is bent by the effort of cutting through the rocky earth. His head, scarcely visible since it is inclined toward his chest, appears to be covered, perhaps by a *montera* (cloth cap). He wears sandals.

This work was offered for sale in 1877 in Paris, with other Goya drawings of an anonymous collector, bearing the auction catalogue number 100 and the title *Le Laboureur* (The Laborer), since the autograph inscription *Lo mismo* (Likewise) did not mean anything outside its context in Goya's original album. It is now believed that drawing number 99 in the same sale, *Travail pénible mais necessaire* (Hard but Necessary Work), also preceded *Lo mismo* in *Album E.*[1] Although the subject represented has not been established because the present whereabouts of *Travail pénible* is not known and no reproductions exist, its title helps us understand the inscription of *Lo mismo.* Both drawings may reflect the great concern of the enlightened to revalue and ennoble agriculture and, in general, all the manual and mechanical arts, regarded as essential for the economic revival of the country and the improvement in lower-class living conditions.[2]

On the other hand, Goya's brush did little to contribute to a poetic vision of peasant life, although the theme of the idealized countryside was in favor in this period, influenced as it was by Rousseau. On the contrary, Goya's critical mind took pains to reveal in these albums the unfortunate situation of Spanish agriculture and farmers, nowhere more pathetically expressed than in the *Album E* drawing *No haras nada con clamar* (Crying out will get you nowhere) (cat. 130). It would not, therefore, be farfetched to believe that the "hard but necessary work" to which the title *Lo mismo* (Likewise) may refer is also a commentary on the difficult life of the small-scale owner or laborer of the time, who in spite of his arduous work scarcely managed the merest subsistence.

The intense contrast between the light and dark areas helps to throw the laborer's enormous effort into relief. The lines indicating strain begin in the legs, with the knees bent, continue in the velvety black patches of the breeches and in the broad and bent back, and end in the powerful arm guiding the plow. The hand that grasps and bears down on the plowhandle suggests the hard jaw of a vise. With this image Goya masterfully conveyed the idea that one must have an "iron fist" in order to cut through such rocky terrain. The poor laborer seems to "break his back" doing this hard work.

The bent posture of the laborer not only expresses the intensity and difficulty of his task, but also his discouragement at the injustice condemning him to a miserable life. The agricultural policy of Carlos III's economists favored the poorest peasants by distributing common lands. As this redistribution of lands was carried out by the local authorities in a climate of hatefulness and dishonesty, the unfortunate laborers were given only the most marginal lands. In 1762 the *Memorial de agravios de los pegujaleros de Osuna* (Report on the Grievances of the Small Farmers of Osuna) noted that the powerful did not allow the poor "más tierras que sembrar que las montuosas, distantes y estériles" (any lands to sow but the hilly, remote, and barren).[3] The situation had not changed by the beginning of the nineteenth century. The fact that this peasant has a plow pulled by a team of oxen does not necessarily indicate prosperity, even if the team belongs to him. In fact, many small farmers lived on credit drawn on the next harvest, ever on the verge of losing their miserable parcels and descending to the category of laborer. In order to survive they often alternated the cultivation of their parcel

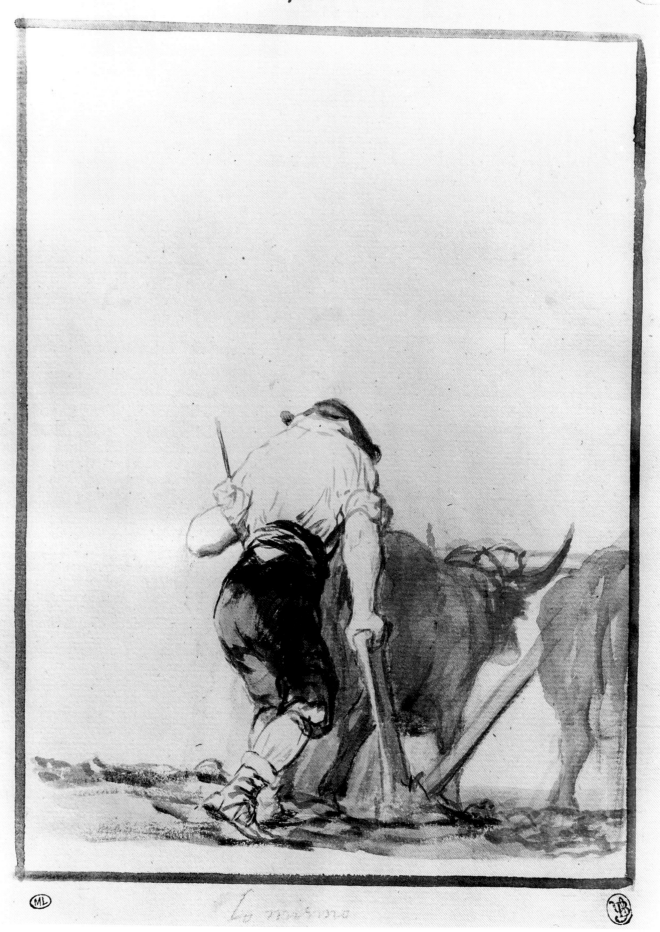

Lo mismo

with work on a wealthier owner's lands. The boundaries between the small farmers and laborers were fluid and changing.[4] In a text of one of the parliamentary sessions of the Cortes of Cádiz in 1812 – in which the abolition of the ecclesiastical duty known as the *voto de Santiago* was being discussed – we see how the use of a team of oxen did not necessarily imply ownership, because the team was often shared by several peasants who thereby helped each other, and was sometimes also rented. "En muchas partes paga el labrador una medida de grano por una sola yunta; la misma medida, aunque esta yunta se componga de dos vacas que uncen dos vecinos para ayudarse recíprocamente, por no tener otro recurso. En otras partes paga dos medidas el que labra con dos yuntas, ya sean propias, ya prestadas a jornal o tornayuntas." (In many areas the laborer pays a measure of grain for a single team; the same measure is paid even if the team is made up of a pair of oxen that two neighbors yoke up in collaboration because they have no choice. In other areas he who plows with two teams, whether his or rented or borrowed by rotation, pays two measures).[5] The situation of Spanish agriculture was even more unjust and wretched at the time Goya created this drawing.

T.L.M.

1. Both Pierre Gassier (G., I) and Eleanor A. Sayre, in unpublished research, have filled in some of the gaps in Goya's albums by using posthumous series of numbers. Javier Goya took his father's albums apart and pasted them on pink paper books, often in sequential groups. His numeration may therefore reflect Goya's order. In the Hôtel Drouot sale, 1877, the auction house broke up two of Javier's albums and likewise offered them in groups. Since their numbers tended to preserve the order Goya's son gave, they sometimes provide clues to Goya's order. The sale ended with a large group of *Album E* drawings. Number 99, *Travail pénible mais nécessaire*, no longer known, was followed by one described as *Le Laboureur*. The latter may be identical with *Lo mismo* (Likewise).

2. See Jacques Soubeyroux, "Pauperismo y relaciones sociales en el Madrid del siglo XVIII," *Estudios de historia social*, nos. 12-13 (1980), pp. 161, 186-192.

3. Quoted in Antonio Domínguez Ortiz, *Sociedad y estado en el siglo XVIII español* (Madrid, 1976), pp. 424-427.

4. Ibid., p. 413; Soubeyroux, "Pauperismo," p. 169.

5. See *Actas de las Cortes de Cádiz: Antología*, ed. Enrique Tierno Galván (Madrid, 1964), vol. 2, p. 914.

133
Suben alegres (They rise merrily)
Album D, page 2
About 1816-1818
Brush and gray and black wash
233 x 141 mm.
Inscribed in black chalk, below image: title; in brown ink, above image: *2*
References: G-W 1368; G., I, 96.

Musée du Louvre, Département des arts graphiques, Paris, RF 29772
Spain only

This drawing is a typical example of a series Goya dedicated to the subject of old people and some of their *non sanctae* (unholy) occupations. A woman holding castanets in her right hand and a punctured tambourine in her left flies through the air, accompanied by an old man, probably a friar, as the sketch of a cowl in the collar of the habit suggests. While he rises, he grips a tambourine with both hands, but in contrast to the woman's instrument, this one appears to be intact.

Apart from *Suben alegres*, three other drawings belonging to the same album represent figures flying or floating in an open space: *Cantar y bailar* (To Sing and to Dance), *Regozijo* (Rejoicing) (G-W 1369, 1370), and *Sueño de azotes* (Dream of Floggings) (cat. 135). Rising through the air and floating are symbols of sexual pleasure that appear in literature of all ages.[1] Goya used this image with the same meaning in several works, as in *Capricho* 68, *Linda maestra!* (A Fine Teacher!) (cat. 57), where two naked witches fly on a broomstick. It is worth noting that in this group from *Album D*, the sense of flight is especially emphasized by the motility of the clothing. In *Suben alegres* the bodies appear to be weightless, and the impulse that carries them aloft is masterfully suggested by the air-filled skirts. Intense patches of black and gray tones along with the overlaid quick, free strokes also help to suggest a movement resembling levitation.

Since the Middle Ages, musical instruments have been used to symbolize vanity and immorality.[2] The choir stalls of the fifteenth and sixteenth centuries abound in profane scenes of musicians that have a sexual dimension, particularly those of male and female minstrels who sing and dance to the accompaniment of tambourines.[3] The association of these with the *pudendum muliebris* (female sex) was well known and used quite often in literature[4] and in medieval carnival language.[5] Thus, the expressions *tañer* (to play) or *repicar el pandero* (to strike the tambourine) offer a manifest and well-defined sexual meaning.[6] The significance of the punctured membrane could not have been more obvious to Goya's contemporaries.

Although both figures are shown in flight and with their respective tambourines, their gestures and facial expressions are very different. The man grasps his tambourine avidly, with a satisfied and triumphant expression, while the woman holds hers up, her face marked by a malicious smile and an ironic look. The broken musical instrument is also a symbol of the bawd, who was sometimes called "maestra de pintar panderos" (versed in the painting [mending] of tambourines),[7] an obvious reference to her wicked talents in the matter of *restitutio virginitatis* (restoration of virginity).[8] And of course the bawd is, above all, a helpful intermediary in *desarreglarlos* (breaking them). This may well be the key to the evident relationship between what may be a bawd and the fornicating man in the drawing.

And yet Goya's intentions were, as always, critical and moralistic. The sad spectacle of amoral humanity, even in old age, becomes in *Album D* a vision of repugnant bawds and friars showing their physical and moral decay. In this drawing Goya added the detail of the bad friar who makes use of the vile services of the procuress.[9]

T.L.M.

1. See Donald McGrady, "Notas para el enigma erótico, con especial referencia a los 'Cuarenta enigmas en lengua española,'" *Criticón* 27 (1984), pp. 83-84.

2. For a thorough overview of the iconography of the subject of musicians, their instruments, and the activities related to them, see Mateo Gómez, *Sillerías*, pp. 332-337. The panel of Hell, in *The Earthly Paradise* by Hieronymus Bosch (Madrid, Museo del Prado) shows a group of people going mad around enormous musical instruments, which have been interpreted as the sins committed to their music. See Isabel Mateo Gómez, *El Bosco en España* (Madrid, 1965), p. 21.

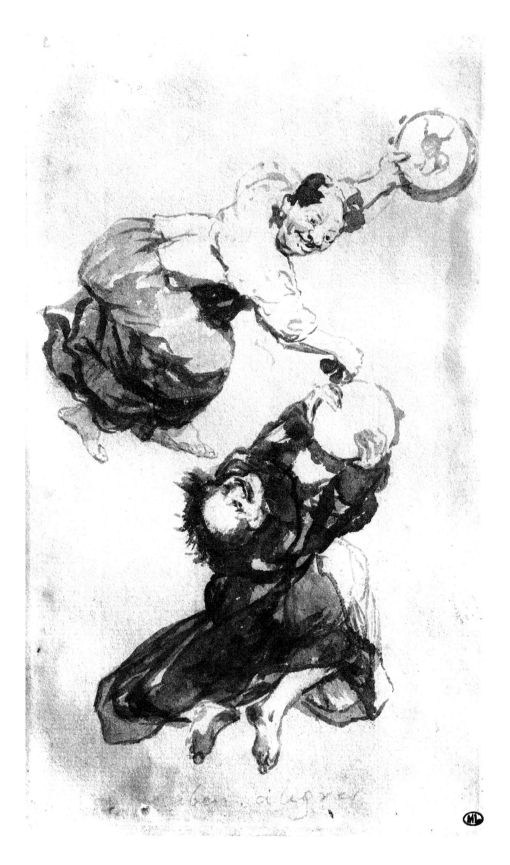

3. One minstrel, playing a tambourine, can be seen in a misericord in the Cathedral of Seville, as well as in a *brazal* (arm rest) in the Cathedral of Barcelona. See Mateo Gómez, *Sillerías*, pp. 334-335, fig. 311. The female minstrel was a wandering woman who made a living from the contributions she received for her performances. Female *soldaderas* (prostitutes following the troops) and minstrels were similar inasmuch as both sold not only their songs but also their bodies to the audience. Ibid.

4. "Casó de un Arzobispo el despensero, / y, la noche que el novio se acicala, / para hacer de la novia cata y cala / y *repicar el virginal pandero*" (The Archbishop's steward was just married, / and, in the night the groom primped himself / in order to sample and penetrate the bride, / and *play the virginal tambourine*). See Alzieu, *Poesía erótica*, poem 101, p. 211; see also poem 135, verse 8, p. 270. See Camilo José Cela, *Diccionario del Erotismo* (Barcelona, 1988), under *pandero*.

5. The drum with a punctured membrane had the same sexual meaning; therefore, playing this or any other percussive instrument symbolized the sexual act. See Mikhail Bakhtin, *Rabelais and His World* (Cambridge, Mass. and London, 1968), pp. 204-205.

6. All percussion instruments have been given erotic connotations since the Middle Ages. See Jean Gagné, "L'érotisme en la musique médiévale," in *L'érotisme au Moyen Age*, ed. Bruno Roy (Montreal, 1977), pp. 92-94.

7. George A. Shipley, "A Case of Functional Obscurity: The Master Tambourine-Painter of *Lazarillo*, Tratado VI," in *MLN* 97 (1982), pp. 237-240.

8. This is another of Celestina's great talents (see cat. 134). See also Fernando de Rojas, *La Celestina*, ed. Dorothy Severin (Madrid, 1986), pp. 56, 60, 62, 132.

9. See *Capricho* 21, *Ya van desplumados* (There they go plucked) (cat. 44).

134

La madre Celestina (Mother Celestina)
Album D, page 22
About 1816-1818
Brush and gray and black wash
233 x 145 mm.
Inscribed in black chalk, below image:
title, in brown ink, above image: *22*
References: G-W 1377; G., I, 106.

Museum of Fine Arts, Boston, William
Francis Warden Fund, 59.200
Spain only

Creator of many satires about prostitu-
tion and bawds, Goya could not have
avoided portraying the *summum* and
quintessence of procuring, the peerless
Mother Celestina. She is the main char-
acter of *Tragicomedia de Calixto y
Melibea* (Tragicomedy of Calixto and
Melibea), written in 1499 by the *bachiller*
(student) Fernando de Rojas, a work that
soon came to be known simply as *La
Celestina*. The enlightened in the eight-
eenth century read and favored this
work, which, in a sense, fit so well into
what is now called the dark side of the
Enlightenment: the interest in the erotic
and the pornographic. It is worth recal-
ling that in 1624 Caspar Barthius trans-
lated *La Celestina* into Latin, giving as its
title *Pornoboscodidascalus,* literally man-
ual of prostitution. The work was first
expurgated in 1632 and expressly prohib-
ited by edict in February 1793, a prohibi-
tion reiterated in the Supplement to the
Index in 1805.[1]

 The drawing depicts an old woman
comfortably seated next to a table on
which rest glass containers of various
sizes. Her face is shown in three-quarter
profile. A rosary hangs from her right
hand, and in her left she grasps a nearly
full bottle. She wears a skirt, and a
shawl covers her head. Goya's title, *La
madre Celestina* (Mother Celestina),
leaves no doubt that this drawing is about
the original Celestina and not just any
procuress.[2]

 The mother is more or less seventy
years old – "seis docenas de años" (six
dozen years), according to one of
Calixto's servants[3] – and her clothing is
modest: a well-worn shawl and a skirt
made of coarse fabric, a little threadbare

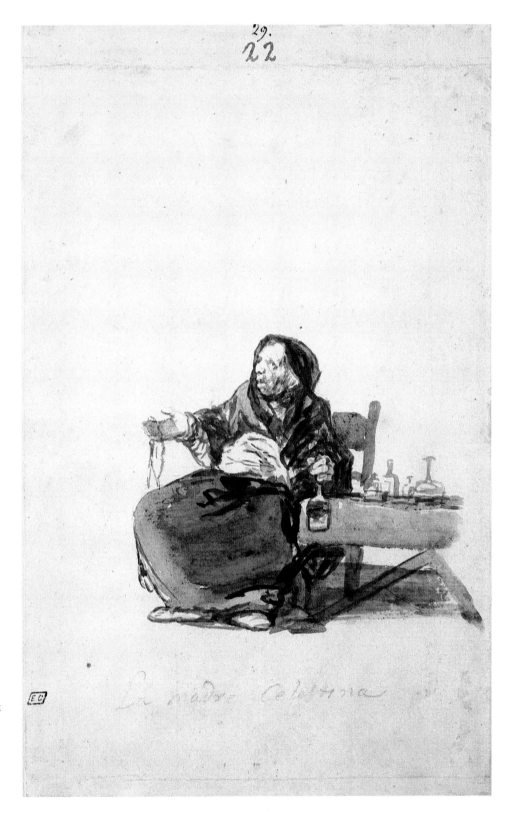

at the hem. Note how those tiny black dots in the wash masterfully give the impression of old wool whose hair is fuzzed. With these details Goya expressed the bawd's penury at the opening of the *Tragicomedia,* down to the detail of the torn skirt: "antes me recibirá a mí con esta saya rota, que a otra con seda y brocade" (she [Melibea] will sooner receive me in this torn gown than others in their silks and cloths of gold), Celestina assures Calixto.[4] Her head is turned to her right; evidently Goya wished to show an almost animal profile and an astute gaze and also draw our eyes to Celestina's cheek. Here, a conspicuous black line may be read as a scar, since it does not follow the natural contour of the cheekbone, carefully drawn by Goya, nor does it contribute to the modeling of the face. The *madre Celestina* of the literary work has a scar "que traviesa la media cara" (that crosses half her face), which brands her in the same way the black feature in the drawing marks half the old woman's face.[5]

The table with a variety of glass containers is a clear allusion to that "cámara de alambiques, de redomillas, de barrilejos de barro, de vidrio" (room full of alembics, little vials, pots, some of earth, some of glass),[6] which her vocations as "perfumera, maestra de hacer afeites y de hacer virgos, alcahueta y un poquito hechicera" (perfumeress, maker of cosmetics, mender of cracked maidenheads, bawd, and something of a witch)[7] make indispensable. Her elbow rests on the table as a symbol of the union of the woman with her base profession. Both arms open toward the viewer and the right hand grips a rosary, sketched with light strokes of the brush in order, perhaps, to suggest the hypocritical nature of her devotion to the "cuentas" (rosary beads), which she carried on her rounds of churches and monasteries in search of clients.[8] In contrast the bottle of wine, which she grasps with her left hand, is well defined; those overlaid black touches attract our attention to it, their vigorous and nervous character expressing the intensity of Celestina's passion for wine: "De esto aforro todos mis vestidos, cuando viene la navidad; esto me

calienta la sangre; esto me sostiene continuo en un ser; esto me hace andar siempre alegre; esto me para fresca; de esto vea yo sobrado en casa, que nunca temeré el mal año. Que un cortezón de pan ratonado me basta para tres dias." (I fur all my clothes with this at Christmas; it warms my blood; it keeps me still in one estate; it makes me always merry; it makes me look fresh; so long as I am well stocked with this at home, I need never fear a lean year. A mouse-eaten crust of bread will serve me for three days.)[9]

In this psychological study Goya could not overlook the bawd's first job. That posture, with legs widely separated and knees as far from each other as possible, announces her earlier condition as a prostitute, following the medieval iconographic tradition of Lust, which Goya used also in the *Caprichos Bien tirada esta* (She is quite cheap) (G-W 485) and *Ruega por ella* (Pray for her) (see the essay by T.L. Márquez, fig. 2), with exactly the same meaning.[10] Like a finishing stroke of this moral portrait, Goya focused the most intense light on a sash covering Celestina's belly, to indicate that her humanity is dominated by low passions. He also laid light on her face, with its ignoble features: the eyes – wolf or fox eyes, another symbol of the trade – appear to be on the lookout for a suitable victim.

We cannot aver that Goya read *La Celestina,* but we can say that he knew all the distinguishing marks of the literary character. The human passions observed in the *Tragicomedia* would have been enormously appealing to Goya, and it is not difficult to imagine him fascinated by it. The drawing of *La madre Celestina,* which would be a perfect frontispiece illustration for Rojas's work, suggests as much.

T.L.M.

1. See Antonio Márquez, *Literatura e Inquisición en España (1478-1834)* (Madrid, 1980), p. 179.

2. Old village women were frequently addressed as mother in that time, as is Celestina by all of Rojas's characters. Roberto Alcalá Flecha, *Matrimonio y prostitución en el arte de Goya* (Cáceres, 1984), p. 79, notes that so important a literary creation as Rojas's character was absent from Spanish art until Goya.

3. Fernando de Rojas, *La Celestina: Tragicomedia de Calixto y Melibea,* ed. Dorothy S. Severin (Madrid, 1986), p. 78. For the translations of texts quoted from *La Celestina,* James Mabbe's version (1631), ed. Dorothy S. Severin (Warminster, 1987) was consulted.

4. Rojas, *La Celestina,* p. 107. Calixto promises her a new skirt and shawl as rewards for her good offices. Ibid., p. 113.

5. Ibid., p. 92. Celestina is described in the text several times as the old woman with the knife scar. Ibid., pp. 88, 187.

6. Ibid., p. 61.

7. Ibid., p. 60.

8. Ibid., pp. 90, 142. The image of the procuress with her rosary has a long and well-established literary pedigree. The Arcipreste de Hita, Rojas, Torres Villarroel, and Nicolás Fernández de Moratín put the beads in their old women's hands as an emblem of their services. See Alcalá Flecha, *Matrimonio y prostitución,* pp. 90-93.

9. Rojas, *La Celestina,* pp. 82, 93, 144.

10. Mateo Gómez, *Sillerías,* pp. 364-365, 370. The symbolism of the posture, sometimes accompanied by an obscene gesture, is common knowledge today.

135

Sueño de azotes (Dream of Floggings)
Album D, page [A]
About 1816-1818
Brush and gray and black wash
233 x 143 mm.
Inscribed below image, in black chalk:
title; above image: traces of a number
References: G-W 1378; G., I, 107.

The Art Institute of Chicago, The Clarence Buckingham Collection, 1961.785
United States only

In this strange scene three old women – the figure at the top may be a monk – of ignoble appearance surround a half-naked man, whom one of them is about to thrash with a cowhide *penca* (whip shaped like a leaf), while her companions hold him aloft.[1] The group appears to float in space.

The women in flight wrap around the pale, highlighted body in a spiral movement. It is unclear whether this man is asleep or dead. Although he wears something similar to a nightcap, the loose clothing covering his shoulders and chest suggest a shroud. Furthermore, his expression seems to be more that of a dead person than a sleeping one. The light also falls on the ample skirt of the woman in the foreground, emphasizing the two main characters in this drama of floggings. A magic rite with a long tradition in Spanish literature is that of flogging a corpse in order to revive it momentarily by demonic possession, and in the course of this rite dark prophecies of an historical or political character are told. Juan de Mena writes of this necromantic ritual in *El laberinto de fortuna* or *Las trescientas*,[2] as does Cervantes in *La Numancia*: "Y aunque esta carne fuera polvos hecha, / siendo con este azote castigada, / cobrará nueva, aunque ligera vida, / del áspero rigor suyo oprimida" (And though this flesh were dust, / Thrashed with this whip, / It will breathe new, although fleeting, life, / From the flail's harsh rigor).[3]

However, *azotar* (to whip) and *golpear* (to bang) also have clear and well-defined sexual meanings. Classical literary texts and artistic representations of the Augustan Age show that young

women were beaten during fertility rites and mystical weddings.[4] Spanish Carnival celebrations echoed these pagan rites. Many involved men in costume or masked men hitting whoever crossed their paths, preferably young women, with whom special liberties were taken. These Carnival traditions must have been familiar to Goya, for the custom of costumed, whipping figures was widespread in Aragón and Cataluña.[5]

Over the years these customs made their way into popular speech. In slang *golpe* meant the brothel door and even the brothel itself. This use of the word was thought to be derived from *cerradura de golpe* (spring lock), but it seems more likely that the meaning of *golpear* as *futuere* (to copulate) was used here, bearing in mind that in argot *golpear* meant "insistir o realizar varias veces la misma cosa" (to persist or carry out one thing several times).[6]

Females also enjoyed the privilege of *azotar* or *golpear* during the celebration of certain feast days for women (with special reference to married women), like those of Santa Agueda, patron of nursing mothers, celebrated frequently in Aragón and Cataluña. During these celebrations, women assumed the tasks normally reserved for men and even ran the village. In some areas they were especially daring and the custom included striking men and making them do domestic chores. Wherever these holidays were observed, they were linked with rites of fertility.[7]

Rising through the air was a well-known symbol of the sexual act and repeatedly appeared with this meaning in Spanish literature.[8] Thus Goya heightened the eroticism of this drawing by showing the group floating in space and giving the composition an undulating movement resembling a serpentine curve, which emphasizes the feeling of flight.

This scene also suggests the possibility of reviving a sexually dead man by awakening his senses. In fact, this language was often used in traditional poems.[9] There is no doubt it was known in Goya's time, and even today it is preserved in everyday language. In the Ayala and Prado manuscript explanations of

Capricho 9, *Tántalo* (Tantalus) (G-W 467), the verb *revivir* (to revive) is used with this meaning.[10]

The literary image of witchcraft and the carnavalesque symbols served Goya in this *Sueño* (Dream) as a criticism of Lust, a subject that recurs throughout his work, especially in *Album D*. This drawing is related to the original form of the *Caprichos* – the *Sueños* – and with the *Caprichos* themselves, not only by the shared title but by the theme of real or literary witchcraft used to denounce a corrupt society. The present *Sueño de azotes* thus becomes a *pesadilla de lujuria* (nightmare of lust).

T.L.M.

1. The woman appears to hold in her hand something shaped like a leaf of the *penca* variety. Academia, *Diccionario* [1984], under *penca*. In the seventeenth century Covarrubias noted that this word was known: as a leaf, "particularmente llamamos pencas las hojas y cimas de los cardos; y porque éstas tienen muchas espinas se dixeron assí, *quasi* punços, *a pugendo* (we refer especially to thistle leaves and stalks as *pencas*; and because the latter have many thorns they were thus called, *quasi* awls, *a pugendo*); and as a special whip, "se llama el açote del verdugo, *a forma*, por ser ancha, como la penca del cardo" (it is called the executioner's scourge, *a forma*, because it is wide, like the thistle leaf). Covarrubias, *Tesoro*, 1611, under *penca*. José Luis Alonso Hernández, in *Léxico del marginalismo del Siglo de Oro* (Salamanca, 1977), cites texts in which *penca* is used as *azote* and variations on the word.

2. In the "Séptima orden de Saturno," part of the poem *El laberinto de fortuna* or *Las trescientas*, don Alvaro de Luna's fall into disgrace is foretold by a corpse, revived by the incantations and ritual floggings of a sorceress. See Juan de Mena, *El laberinto de fortuna* or *Las trescientas*, ed. José Manuel Blecua (Madrid, 1943), lines 243-257, pp. 126-132.

3. Miguel de Cervantes, *El cerco de Numancia*, ed. Rober Marrast (Salamanca, 1965), p. 66.

4. Plutarch, *Rómulo, XXI*. See Caro Baroja, *Carnaval*, pp. 341-342. For a study of the frescoes of Dionysian rites found in Pompeii, see Alan M. G. Little, *A Roman Bridal Drama at the Villa of the Mysteries* (Wheaton, MD, 1972).

5. Caro Baroja, *Carnaval*, pp. 355-365.

6. Covarrubias, *Tesoro*, 1611, under *golpe*; Alonso Hernández, *Léxico*, under *golpe* and *golpear*. The latter has corroborated this double meaning of *golpear* in conversations with the author.

7. Caro Baroja, *Carnaval*, pp. 371-381.

8. Donald McGrady, "Notas para el enigma erótico, con especial referencia a los 'Cuarenta Enigmas en lengua española,'" *Criticón* 27 (1984), pp. 83-84.

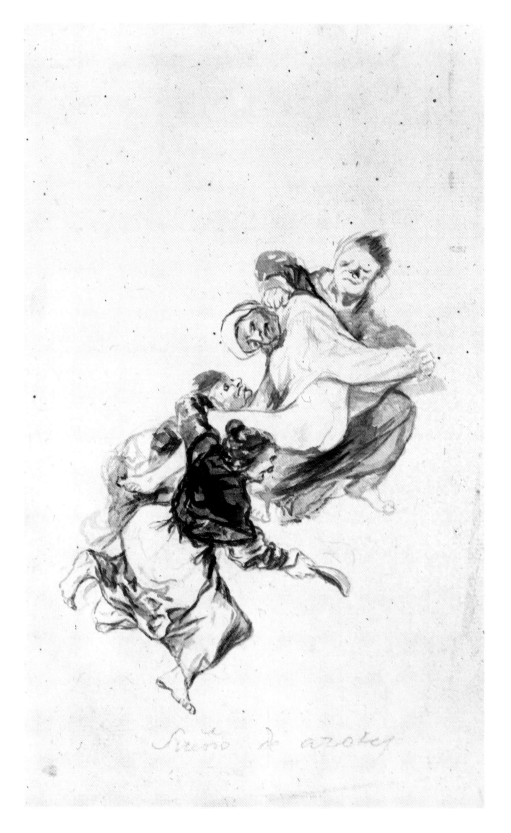

Sueño de azotes

9. To die and to be revived have an obvious sexual meaning in erotic poetry, as can be seen in amorous jousts such as in Alzieu, *Poesía erótica*, poem 3, p. 8.

10. Ayala: "Si él fuese más galán ella reviviría. Esto sucede a los viejos que se casan con las mozas" (If he were more gallant [a better lover], she would revive. This happens when old men marry young women). Prado: "Si él fuese más galán y menos fastidioso ella reviviría" (If he were more gallant [a better lover] and less fastidious, she would revive).

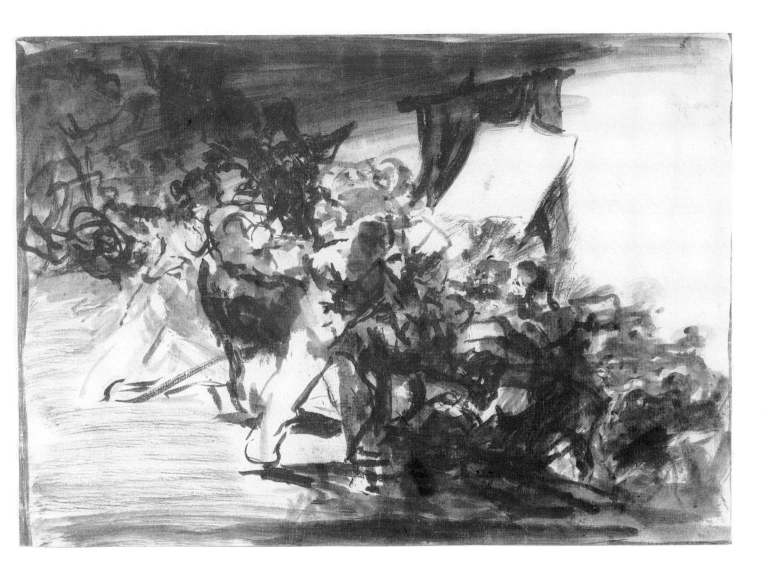

136

Procession
Preparatory drawing for a *Disparate*
About 1816
Sanguine chalk and wash
230 x 330 mm.
References: G-W 1612; G., II, 310.

Harvard University Art Museums (Fogg
Art Museum), Bequest of Frances L.
Hofer, 1979.55
Spain only

Were it not for the banners, it would be
impossible to tell whether this was a pro-
fane or sacred procession. It has a feel-
ing of movement and abandon resem-
bling that in Goya's *Burial of the Sardine*
of the same period (fig. 1).[1] Goya
achieved this hallucinatory effect by indi-
cating only the broader volumes and
larger areas of light and darkness.

Processions were not held in high
repute by enlightened thinkers. They
were thought to be too expensive and too
often marred by drunkenness and disor-
der (see cat. 16).[2] Comments such as the
following were characteristic: "Salen en
publico las procesiones sacramentales de
las parroquias con la mayor solemnidad y
pompa y aparato, concurriendo á ellas un
gentio inmenso y de todas las clases, esci-
tando mas que de devocion de la curio-
sidad, la vanidad, el ocio, y esta impa-
ciencia activa y bulliciosa que arrastra al
hombre en todas partes a la agitacion y al
movimiento" (The sacramental parish
processions appear in public with the
greatest solemnity and pomp and circum-
stance, attended by an immense sea of
people of all classes, producing not so
much devotion as curiosity, vanity, and
idleness, and that nervous and bustling
impatience that drags men everywhere to
agitation and movement).[3] "No se da
paso que no se encuentre una cofradía,
una procesión o un rosario cantado, por
todas partes resuenan los chillidos de los

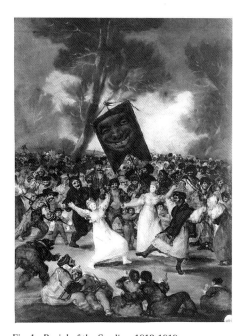

Fig. 1. *Burial of the Sardine*, 1812-1819.
Oil on canvas.
Academia de Bellas Artes de San Fernando, Madrid

capones, los rebuznos de los sochantres y la algarabía sagrada de los músicos, entreteniendo las almas devotas con villancicos, gozos y arrietas de una composición tan seria y unos conceptos tan elevados, que sin entenderlos nadie hacen reír a todos" (Take a step and you cannot fail to come across a devotional brotherhood, procession, or sung rosary, the eunuchs' shrieks, the subcantors' braying, and the sacred din of the musicians resonate everywhere, entertaining pious souls with cantatas and poems in praise of the Virgin and the saints so earnestly composed and of such elevated thought that nobody understands them but everybody laughs).[4] "Somos cristianos en el nombre y peores que gentiles en nuestras costumbres" (We are Christians in name and worse than pagans in our customs).[5] Observing a clerical procession, another commentator could not tell whether it was an "ejército, mogiganga ó procesion de disciplinantes" (army, masquerade, or procession of flagellants).[6]

If Goya had removed all the redeeming features of a religious procession and left only an enlightened critic's image of a

procession, this drawing would be it.[7] It captures the perceptions of the writers cited above. The abstract essence of dissolution, Goya's procession is pointless, with neither a clear beginning nor end, all motion, lacking in solemnity or reflection. Identities are lost in a triumph of disorder. A procession could be a solemn ritual or a joyful celebration. What Goya has represented in this design for a *Disparate* never made into a print is the procession as an unsettling, vaguely threatening expression of collective madness.[8]

M.A.R.

1. This Carnival ritual was peculiar to Madrid, where Goya lived most of his adult life. See Caro Baroja, *Carnaval*, pp. 110-112.

2. Under Carlos III there was, in fact, a fear that popular evangelical missions, which sometimes held processions, would get out of hand and be used to rouse the populace against the government. See Callahan, *Church*, p. 60.

3. Juan Meléndez Valdés, *Discursos forenses* (Madrid, 1821), p. 190.

4. León de Arroyal, "Pan y toros," in *Pan y toros y otros papeles sediciosos de fines del siglo XVIII*, ed. Antonio Elorza (Madrid, 1971), p. 19.

5. Ibid., pp. 26-27.

6. Gallardo, *Diccionario*, p. 6.

7. In contrast *Album G*, p. 57 (see cat. 172), comments on the social and cultural reality of the procession and enlightened scorn of its liberties and license.

8. This work is believed to be a preparatory drawing for a *Disparate* because, like the other preparatory drawings for the series, it was done on MANUEL SERRA paper and in sanguine wash. Stylistically, Goya's interest in masses of light and darkness also relates it to this series.

137

Frontispiece for *Disparates*
***Disparates*, working proof [plate 18]**
About 1816-1817
Etching, burnished aquatint, and burin
245 x 350 mm.
References: G-W 1600; H. 265, I, 2.

Private Collection, Germany
United States only

In this working proof from the *Disparates* (Follies) an elderly man, trailing some sort of covering behind him, leaves his body to move toward a world of malevolent, phantasmagorical creatures. When one compares the recumbent figure with the corpses in the so-called *Disasters of War* (cat. 82-94), one sees that it is not dead, but slumbering, and that the being of the sleeper is rising from his body. It is a curious concept, the only visual precedent that comes to mind being William Blake's border decoration for a passage in the 1797 edition of Edward Young's *Night Thoughts* (fig. 1).[1] Although Young was admired in Spain, it is unlikely that Goya saw Blake's illustration since, because of the lack of subscribers, the undertaking was abandoned when it was only partly printed.[2] Nor does what Goya depicted suggest Young's text.[3]

The probable source for Goya's *Disparate* is a work by Diego Torres Villarroel, a professor of mathematics at Salamanca who was known both for his almanacs and satirical literature. In 1728 he followed Quevedo's seventeenth-century

Fig. 1. William Blake,
Border decoration.
Engraving, hand-colored, in Edward Young, *The Complaint . . . or Night Thoughts*, London, 1797.
Museum of Fine Arts, Boston, William A. Sargent Collection

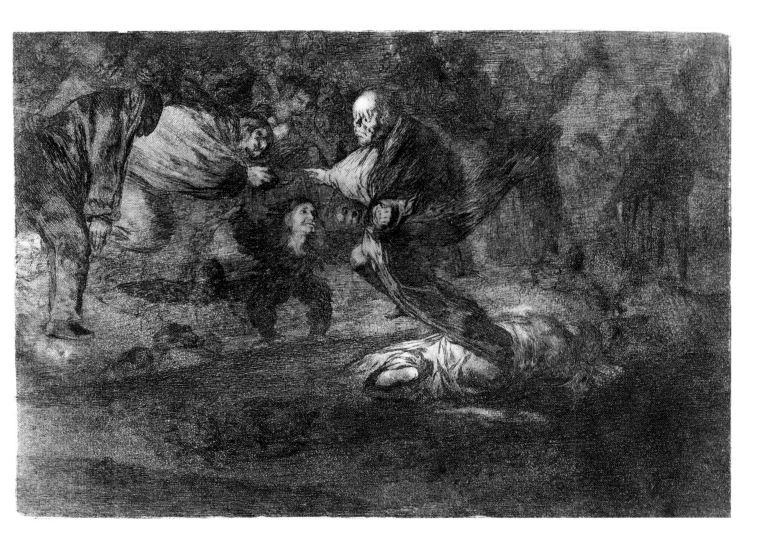

Sueños with other visions of his own: *Visiones y visitas, de Torres con don Francisco de Quevedo por la Corte* (Visions and Visits by Torres, with Don Francisco de Quevedo in the Capital). Torres avers that he fell deeply asleep on his camp bed, and a million goblins appeared, but what then followed "fue mas visto, que soñado" (was more real than imaginary).[4] Quevedo came to visit him and the two men set out on the first of a series of journeys through Madrid to ascertain whether things might have changed for the better since Quevedo's day. Torres is pessimistic and says to Quevedo, "En tu tiempo havia un hombre soberbio, otro luxurioso, otro ladron y otro mohatrero, y ahora en cada uno vive de assiento la luxuria, la soberbia y la avaricia, y cada viviente es una galera de maldades" (In your day one man was proud, another was lustful, another was a thief, and another was a swindler; and now permanently installed in each person are Lust, Pride and Avarice, and every living person is a hospital ward of iniquities).[5]

In this *Disparate* the balding dreamer with deep-set eyes and snub nose, pointing at disquieting creatures, looks very much like Goya himself in his self-portrait with Doctor Arrieta of 1820 (cat. 121).[6] It is interesting that the expression of the dreamer is one of contempt: the mouth closed and turned slightly down, the lower lip thrust out, nostrils drawn upwards, eyes wide open, and an eyebrow cocked. It was in this manner that the artist had portrayed himself in the opening plate of the *Caprichos* of 1799 (see cat. 38). There, as we saw, the expression had been derived from the earliest design for the frontispiece, drawn when he was making use of Quevedo's imagery in the introduction to one of the author's *Sueños* (Dreams), where he describes himself as being simultaneously actor and audience while he slept (see cat. 50). Goya also depicted himself asleep with, rising from his head, faces expressing varying reactions to the contents of the *Sueños* he intended to depict.

Some twenty years later Goya made

use of Torres's dream imagery in this print, which was almost certainly intended to introduce his new series on the follies of his contemporaries. The artist rises from his sleeping body to point contemptuously at what he will depict: the mocking, menacing embodiments of evil and unreason that inhabit the shadowy world of the dark side of his nation. As in the final design for the frontispiece to his *Sueños* (see cat. 51), the bat (seen below Goya's outstretched arm) and the owls (lower left side of the print), with their preference for darkness, still symbolize "bulgaridades perjudiciales" (harmful common beliefs). In that earlier drawing, Goya's creative mind and intellect were seen shedding light on such ideas so that we might recognize and reject them. Here the unseen light of Truth comes from the left side of the print and is reflected by Goya on details of the scene to illuminate what he points out to us. It touches the bat's face, falls fitfully on a figure whose dog-face betrays an envious, avaricious nature (as it did in the earlier drawing for the *Sueños* frontispiece), and throws the face of a harpy into relief. Sebastián de Covarrubias Orozco's lexicon of 1611 defined harpies as "aves monstruosas, con el rostro de donzellas y lo demás de aves de rapiña, crueles, suzias y asquerosas" (monstrous birds, with the faces of maidens and otherwise birds of prey, cruel, filthy and loathsome). Goya supplied his harpy with an outstretched right hand, perhaps because Covarrubias also wrote that they were symbols of "los usurpadores de haziendas agenas, de los que las arruinan y maltratan, de las rameras que despedaçan un hombre, glotoneándole su hazienda y robándosela" (those who usurped the worldly goods of others, of those who ruined and abused others, of prostitutes who tear a man to pieces, devouring his worldly goods and stealing them).[7]

Almost hidden by darkness, because Goya has yet to point to them, is a group of three great tortoises on the ground a little below the feet of the harpy. They are possible to see in this trial proof, though all but invisible in most impressions from the published editions. These creatures may well have had a connota-

tion for Goya similar to that published a year earlier by Covarrubias in an emblem on Freedom, *Sera respexit inertem* (The bar of the door stares back at the sluggard): ". . . el que està pasmado, y como muerto / Que ni el pie mueue, ni las alas bate, / Es como la tortuga, torpe y tarda, / Que para dar vn passo, vn año tarda" (. . . he who is stunned, and as though dead, / Who neither moves his foot, nor beats his wings / Is like the tortoise, dull and slow, / Who takes a year to make one step).[8]

Goya's *Disparate* seems to echo Feijóo's heartfelt cry of nearly a century earlier in one of his discourses on *errores comunes* (common errors): "La mayor parte de mi vida he estado lidiando con estas sombras, porque muy temprano empecè à conocer que lo eran" (The better part of my life I have been jousting with these shades, for early in life I recognized them for what they were).[9] Goya saw the common errors against which he had battled for years spreading like a miasma during Fernando VII's despicable reign after 1814.

E.A.S.

1. Engraving, hand-colored, by William Blake in Edward Young, *The Complaint and the Consolation; or Night Thoughts* (London, 1797), p. 4, Museum of Fine Arts, Boston, William A. Sargent Collection, 37.249.

On the hand-coloring, see Martin Butlin, *The Paintings and Drawings of William Blake* (New Haven, 1981), pp. 178-180.

2. E. Allison Peers, "The Influence of Young and Gray in Spain," *Modern Language Review* 21 (Oct. 1926), pp. 404-415. On the Blake edition of Young's poem, see David Bindman, *The Complete Graphic Works of William Blake* (New York, 1978), pp. 477-478.

3. The relevant text from *Night the First* reads: "While oe'r my limbs sleep's soft dominion spread: / What, though my soul fantastick measures trod / O'er fairy fields; or mourn'd along the gloom / Of pathless woods; or down the craggy steep / Hurl'd headlong, swam with pain the mantled pool; / Or scaled the cliff; or danced on hollow winds, / With antick shapes wild natives of the brain?"

4. Diego de Torres y Villarroel, *Visiones, y visitas de Torres con D. Francisco de Quevedo por la Corte* (Seville, after 1759), p. 3, introduction to *Vision, y visita primera*.

5. Torres, *Visiones*, p. 5.

6. The resemblance was noted by Selma Holo, *Goya: Los disparates* (Pullman: Washington State University Press, 1976), p. 47.

7. Covarrubias, *Tesoro* (1611), under *harpías*. By the eighteenth century a harpy was, in addition, thieves' cant for a *corchete* (penal guard), see Academia, *Diccionario* (1791), under *arpia*.

Harpies are supplied with hands to rob a miser of his gold in an edition of Octavio van Veen, *Theatro moral de la vida humana, en cien emblemas; con el Enchiridion de Epicteto, y la Tabla de Cebes, philosofo platonico* (Antwerp, 1733), *Emblema* 53, p. 107. Nigel Glendinning, "Goya and Van Veen: An Emblematic Source for Some of Goya's Late Drawings," *Burlington Magazine* 119 (Aug. 1977), pp. 568-570, showed that Goya quoted from *Emblema* 61 in *Album G*, p. 60.

8. Sebastián de Covarrubias Orozco, *Emblemas Morales . . .* (Madrid, 1610), *centuria* II, *Emblema* 43. On the symbolism of tortoises, see also his *Tesoro* (1611): "Del galápago ay algunos geroglyficos: sinifica al tardo, al pereçoso, por el espacio con que se mueve"; as well as Terreros, *Diccionario* (1786-1793): "llaman asimismo al hombre que tiene mucha picaresca, y conchas, V. Picaro, astuto, bellaco: y de aqui dicen de personas semejantes, que tienen mas conchas que un galápago"; both under *galapago*.

9. Fray Benito Jerónimo Feijóo y Montenegro, *Theatro critico universal; ò discursos varios en todo genero de materias, para desengaño de errores comunes* (Madrid, 1760), vol. 5, p. 105. The discourse is titled "Observaciones comunes." The eight volumes of the *Theatro critico* first appeared during the years 1726-1740.

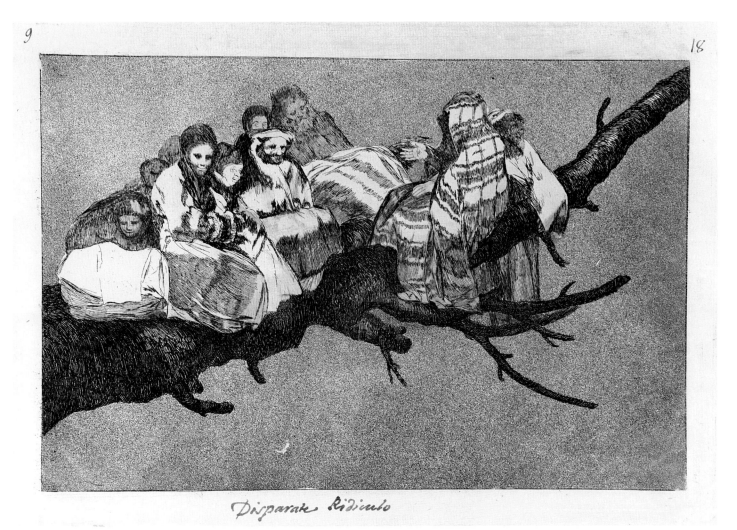

9

18

Disparate Ridiculo

138

Disparate Ridiculo (Ridiculous Folly)
Disparates, plate [3]
Working proof
About 1816-1817
Etching, aquatint, and drypoint
245 x 350 mm.
Inscribed in pen and brown ink, lower
margin: title
References: G-W 1575; H. 250, I, 2.

Museo Lázaro Galdiano, Madrid
Spain only

A mysterious figure cloaked in a striped
garment, perhaps a Persian (see cat.
139), addresses an assembly of people.
Next to him, on a lower branch, a person
whose face is partially obscured by what
may be a veil looks away from the others.
Only three people seem attentive to the
speaker, among them, in the center, a
character in vaguely ecclesiastical garb.
The bearded patriarch is dozing off; two
others, wrapped in their own thoughts,
have let their gazes drift; and an aristo-
cratic woman warms her hands in a fur
muff and smiles sweetly to herself. She
resembles the witch with a muff in *The
Great He-Goat* (fig. 1), one of the "Black
Paintings" Goya executed a few years
later on the walls of his Madrid villa.
One simian creature – with the flat face,
small eyes, ears placed on the lower side
of the head, and sloping shoulders of

another of Goya's humanized monkeys
(see the essay by T.L. Márquez, fig. 16) –
peers over her right shoulder. Everyone
takes pains to conceal his or her hands,
but for the gesturing character on the
right. All are perched complacently on
the great dead branch of a tree (see cat.
56) suspended in space without any visi-
ble connection to the ground. For all we
know, the only force keeping that leafless
bough aloft is the sovereign conviction of
the people on it. Huddled though they
are, they seem to lead altogether sepa-
rate lives, as if they were mad.

In the preparatory drawing for this
print, Goya conceived of a tree trunk
bent over by the sheer weight of a flock

307

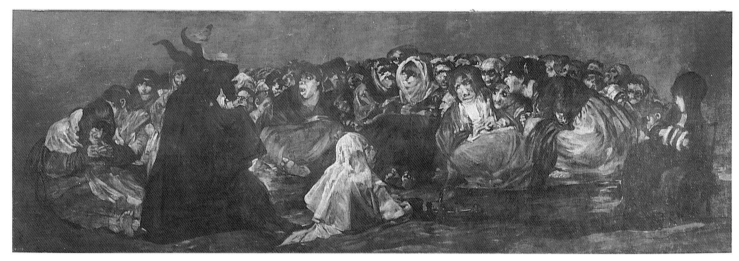

Fig. 1. *The Great He-Goat*, 1820-1823,
Oil.
Museo del Prado, Madrid

of sinister humans resembling birds: they fly, jostle, and stand as if perched.[1] The trunk was transformed into a single dead branch, the flock became well-defined humans, and the ripple of activity that brought the earlier branch alive dissipated; the effect now is settled and sedate. Goya created a graphic representation of the Spanish expression *andarse por las ramas* (to walk along the branches). The expression, still current today, was defined as "[d]etenerse en lo ménos substancial de algun asunto, dexando lo mas importante" (to dwell on the least important aspect of something, overlooking the most important).[2] *Rama* (branch) also meant, as it does in English, a division of a family tracing its ancestry to a common origin. Goya established the motif of the family tree in the image and in one stroke, not least through his title, mocked it. What we see is one dead branch of a titled family.

Witches and monsters in Goya's world are not fantastic creatures but humans who have been changed into them by indulging in sloth, avarice, or animal desires (see the *Caprichos*); traditional bogey monsters – witches, goblins, half-human chimera – he often used to embody those people who were parasitic,unjust, or immoral. Monkeys were

associated with both witchcraft and lust.[3] With a simian creature against her, the young woman is linked with lust or vice in general; this may explain why she smiles so blissfully. Just as some of Goya's contemporaries said the true goblins of this world were clerics who took orders so as to avoid working for a living, Goya implied, in the unearthly way this branch stays up, that the privileges and pretensions of the nobility were sometimes disconnected from any quality, such as virtue, that would justify them (see cat. 163). This, so to speak, is their witchcraft. The Persian, a reactionary, may be a false prophet – given his indefinitely oriental garb – and hypocritical because his face alone is hidden; he works the flatterer's magic, making unctuous but sustaining speeches to a willing and self-satisfied audience. The idle and exploitative among the nobility and clergy were often targets of satirical or burlesque criticism, for it was in the eighteenth century that, throughout Europe, the feeling grew that many members of these classes were no longer of the same service to society as when privileges were first granted them; but the nobility, like the clergy, were also often victims of the requirement to maintain reputation. The concealed hands refer to such expressions as *tener las manos*

atadas (to have one's hands tied), *manos muertas* (mortmain, literally dead hands in Spanish), and *mano sobre mano* (hand over hand, i.e., to be idle).[4] There was also a long ideological tradition associating idleness (in particular, the idleness of the nobility and the clergy) with sexual license.[5]

The patrician's sleep is perhaps that of indolence, and the dead tree the vestige of a buried past. The old regime of agrarian exploitation was characterized by a concentration of lands in few hands through entail and a social life governed by the consumption rather than production of goods, as a result of which those with money could not invest in lands and those with lands could not sell them and did not have much of an incentive to improve them. The basis of wealth was not trade but the tributary capacity of vassals. Heavy dues reduced the buying power of peasants, retarding the formation of a capitalist economy based on production for the masses; purchasing power was limited to the lords (whether nobility or the Church), which stimulated not an industrial market but a market for luxury goods.[6] The nobility was itself subdivided into a titled minority numbering 1,323 in 1797 and 402,059 gentry. While the former remained stable, rich, influential, with the leisure and culture to

patronize science, art, and industry, the latter declined by half in the course of the eighteenth century as a result of stricter guidelines for the establishment of *hidalguía* (nobility). The gentry's means were sometimes insufficient; they were criticized by enlightened reformers for allowing their noble status to stand in the way of engaging in profitable activities.[7]

The medieval notion of nobility as a reward for military service or counsel to the king had been transformed into a purely honorary distinction, although the Bourbons succeeded in restoring the original meaning of nobility at least with respect to the titles they bestowed. There was an increasing insistence on merit or service to society as a prerequisite for nobility.[8] A new role was sought by some nobles who became leaders of the reform movement under the absolutist monarchs and the early years of constitutional Liberalism. Because of this spirit of renovation in some sectors of the nobility, the distinction retained its prestige.[9] Before the university reforms of 1770, proof of nobility was still required to obtain admission into the *colegios mayores* (residences) of the universities. Suppressed under constitutional government, proof of nobility was again obligatory under Fernando VII for those aspiring to military careers as officers.[10] Family connections and so-called purity of blood determined the degree of nobility (see cat. 55).[11]

José Blanco White described the pedigrees of the grandees and the nobility as so many "cankered branches," since many were in fact descended from *conversos* (converts). Following a letter on the nobility, Cadalso referred to needed reforms in Spain using imagery similar to Goya's: "Bien sé que para igualar nuestra patria con otras naciones, es preciso cortar muchos ramos podridos de este venerable tronco, ingerir otros nuevos y darle un fomento continuo; pero no por eso le hemos de aserrar por medio, ni cortarle las raíces, ni menos me harás creer que para darle su antiguo vigor, es suficiente ponerle hojas postizas y frutos artificiales" (I am well aware that if our nation is to recover its leading position, many rotten branches must be cut from

this venerable tree, new ones grafted, and continuous care given; but this does not mean it should be hewn, or uprooted, nor will I be convinced that in order to restore its ancient vigor we need only dress it with fake leaves and artificial fruits).[12] The liberal newspaper *El Conservador*, which appeared after the restoration of the Constitution in 1820, described the hereditary nobility as "una clase ridícula pero gravosa de privilegios" (a ridiculous class, but laden with privileges). The writer coincided with Goya even in his choice of adjectives.[13] The seventeenth-century poet and essayist Francisco de Quevedo had anticipated Goya in this as in other ways. In a passage contrasting proper virtue and virtue – therefore, privilege – acquired by blood relation, Quevedo had a devil remark: "Tres cosas son las que hacen ridículos a los hombres: la primera, la nobleza; la segunda, la honra; y la tercera, la valentía" (Three things make humans ridiculous: the first, nobility; the second, honor; the third, bravery).[14]

The figures of this print are marked out as nobility because they are elevated, seated idly (resembling their clerical counterparts living on the backs of the common people in cat. 112), rest on their ancestral laurels (in this case, their genealogical tree), and are prey to immoderate desires. There is no foundation for their privileges; the hot air of vanity and the dead weight of custom maintain them where they are. Yet Goya rarely indicted representative types. He made them individuals differentiated by age, beauty, and character, endowing each with a consciousness, moral responsibility, and destiny. Beneath the appearance of the rejection of a class through satire, there is empathy, since Goya understood what gave rise to abuses. Absolute power and privilege take their toll: idly marking time makes life narrow and dull (see cat. 55), and a lack of accountability can distort character and give rise to swollen pride, indolence, wastrel ways, even cruelty.[15] Along with his contemporaries José Cadalso and Jovellanos (cat. 30), Goya understood that the tragedy of an idle class is each individual's as well as the nation's; unrealized lives are like dead branches.[16]

M.A.R.

1. Concealing the hands also makes the figures look more like birds.

2. Academia, *Diccionario*, 1791, under *rama*.

3. See Horst W. Janson, *Apes and Ape Lore in the Middle Ages and the Renaissance* (London, 1952); Mateo Gómez, *Sillerías*, pp. 88-93.

4. For a discussion of the Spanish expressions cited in the text, with sources, see cat. 111, n. 9. Indeed, aristocrats were sometimes restricted in their choice of livelihood and in their freedom of behavior because of antiquated notions about the nobility of industrial or commercial activities, and lands were often tied up in unproductive and untaxed uses as a privilege (mortmain); moreover, nobles were sometimes believed to be lacking in patriotic feeling and therefore to be potential turncoats; some bitterly resisted taxation, and others were accused of spending their leisure time in frivolous pursuits. See Cadalso, *Cartas*, pp. 17-18, on the relationship of luxury, infidelity, and the lack of patriotism of the European nobility, who were said to be disconnected from their native lands, forming a new nation of their own. Cadalso complained the Spanish nobility had all the vices common to the European nobility but had lost its characteristic virtues. The problem of the compatibility of nobility with productive activity had been recast already in the seventeenth century under the ministry of the Conde-Duque de Olivares. The eighteenth century ushered in a flurry of manufacturing enterprises sponsored by the nobility, among them the Conde de Aranda's ceramic factories (see cat. 65), the Duque de Béjar's textile production, and the Conde de Fernán Nuñez's assorted industrial activities. See Antonio Domínguez Ortiz, "Política nobiliaria en la Ilustración," Paper delivered at the Conference on the Enlightenment (Oviedo, 1983), pp. 4, 15.

5. See Cadalso, *Cartas*, pp. 17-18. Twice Leandro Fernández Moratín chided friends who had neglected to answer his letters by ascribing their laziness to large testicles, which symbolized hypersexuality. René Andioc discusses this and contemporary texts on the vanity, uselessness, and ignorance of some nobles in connection with *Capricho* 50 (cat. 55) in "Al margen de los *Caprichos*," *Nueva revista de filología hispánica* 33, no. 1 (1984), pp. 274-275, n. 34. In the late eighteenth century, upper-class Spaniards sometimes married because it enabled them to take lovers. See Carmen Martín Gaite, *Usos amorosos del dieciocho en España* (Madrid, 1972), pp. 25-65, 113-136. See also John Sekora, *Luxury: The Concept in Western Thought, Eden to Smollett* (Baltimore, 1977), pp. 23, 63ff.

6. See Artola, *Orígenes*, pp. 60-61.

7. See Domínguez Ortiz, "Política nobiliaria," pp. 8-9.

8. See Artola, *Orígenes*, pp. 44-46.

9. See Domínguez Ortiz, "Política nobiliaria," pp. 6, 9, 11, 15-16.

10. Antonio Domínguez, *Hechos y figuras del siglo XVIII español* (Madrid, 1980), p. 283.

11. See Blanco White, *Letters*, p. 161. There is a *tonadilla* (ditty) by Esteve that satirized nobles presuming to possess pure blood: "Dice un noble que su sangre / es de limpieza dechado, / y un cirujano, con hierbas / se la está purificando" (A

nobleman says his blood / is a model of cleanliness, / and a surgeon with herbs / is purifying it). See José Subirá, *Tonadillas satíricas y picarescas* (Madrid, 1927), pp. 25-26. In spite of the nobleman's claims, his blood is in fact tainted by a *converso* (converted) forebear; hence, the treatment. Some nobles commissioned false genealogies in order to establish a purely Old Christian lineage. See also cat. 55.

12. See Cadalso, *Cartas*, p. 84. On the nobility, see also pp. 17-18, 28-30, 49-50, 65-66, 70, 82, 92, 115, 181. Goya may have been lampooning the solemn respect accorded by some to family trees and the belief in purity of blood in yet another way. All of the characters are thickly wrapped and two are covered; as Blanco White explains, it was an exclusive privilege of only the most exalted grandees to appear before the king with their heads covered (*tapados*). This usually meant the nobleman was allowed to wear a hat in the presence of the king. But could it be that Goya caricatured what is purely a ritual symbol of both noble privilege and subservience to custom and king by swamping his characters in folds of clothing? See Blanco White, *Letters*, p. 32. See also Giacomo Casanova, *Memorias de España*, ed. and trans. Angel Crespo (Barcelona, 1986), p. 36.

13. *El Conservador*, June 26, 1820. See José Alvarez Lopera, "De Goya, la Constitución y la prensa liberal," in Madrid, 1982, p. 49.

14. Quevedo, *Sueños*, pp. 123-124. See also León de Arroyal's lament of 1793 about some gentry who held "a decayed legal patent of nobility" in higher esteem than "merit and virtue"; León de Arroyal, "Pan y toros," *Pan y toros y otros papeles sediciosos de fines del siglo XVIII*, ed. Antonio Elorza (Madrid, 1971), p. 31.

15. On the consuming vanity of some nobles, see Cadalso, *Cartas*, pp. 82, 115.

16. On the need to train the nobility for leadership of society, see Cadalso, *Cartas*, p. 30; Sarrailh, *L'Espagne éclairée*, pp. 78-79, 185-221.

139
Giant
Disparates, plate [4]
Working proof
About 1816-1817
Etching
245 x 350 mm.
References: G-W 1576; H. 251, I, 1.

Spain: Kunsthalle Bremen, Kupferstichkabinett, 09/104
United States: S.P. Avery Collection, Miriam and Ira D. Wallach Division of Art, Prints and Photographs, The New York Public Library, Astor, Lenox, and Tilden Foundations

A giant moves to the rhythm of his castanets.[1] Facing him, a man shrinks behind a holy image, concerned perhaps that he not be unmasked and shown for what he is (see cat. 37, 111, and 155); another stands behind him. The man holding the prop concentrates on the giant; he appears to be in control, but there is wariness in his expression. Behind the giant are two phantasmagoric figures, one of them winged.

In the preparatory drawing for this print (fig. 1), there is only one man, a friar, kneeling with his head buried in the back of a dummy. In this working proof, Goya changed the friar's habit so that it would not be obviously clerical. He is now ambiguous, perhaps a layman, save for the cape of a cowl and traces of a habit. In the print Goya added a second figure and gave the female effigy a delicate foot.[2]

The traditional title of this *Disparate* – Bobalicón – is not Goya's but a posthumous inscription written on an impression printed in the middle of the nineteenth century.[3] Nevertheless, it contains a valuable insight. The *bobón* is the Carnival fool; when a *bobón* is a moron of gigantic proportions, he is a *bobalicón*.[4] Castanets were used to accompany any one of four related dances: the seguidilla, the bolero (which was derived from the seguidilla), the capriole, or the fandango, all of them potentially erotic.[5] The dancing giant in *Disparate* 4 personifies folly worshiping a holy image.

Many enlightened reformers believed it dangerous for the Church to indulge peo-

Fig. 1. Preparatory drawing for *Giant, Disparates*, plate [4].
Red chalk.
Museo del Prado, Madrid

ple's worst instincts, because doing so discredited true religion and in the long term loosened the clergy's hold over the flock. This may explain the tense posture and wary expression of the cleric or lay person wielding his dummy. The giant may, after all, get out of hand and turn on him. Fulminating against the abuse of religious idols (see cat. 155), León de Arroyal charged: "Los pintores . . . han representado en sus tablas estos títeres espirituales, y el pueblo idólatra les ha tributado una supersticiosa adoración. La Iglesia ha trabajado de continuo en desterrar de los fieles la preocupación de virtud particular de las imágenes y los eclesiásticos no han cesado de establecerlas." (Painters . . . have represented these spiritual puppets on their canvases, and the idolatrous public has rendered them a superstitious adoration. The Church has worked unceasingly to banish from believers' minds the notion of particular virtues associated with images, and ecclesiastics have not ceased to ingrain it.)[6] Note the distinction between the Church and ecclesiastics.[7] Both print and spurious title bring to mind the sixteenth-century Dutch humanist Erasmus's account of the follies that sometimes accompany the veneration of images, especially the illusion that people can pay off the moral morass they have made of their lives in order to prepare themselves for a new round of sin.[8] "Confesamos todos los meses y permanecemos en los vicios toda nuestra vida" (We confess every month and go on sinning all of our lives).[9] The tradi-

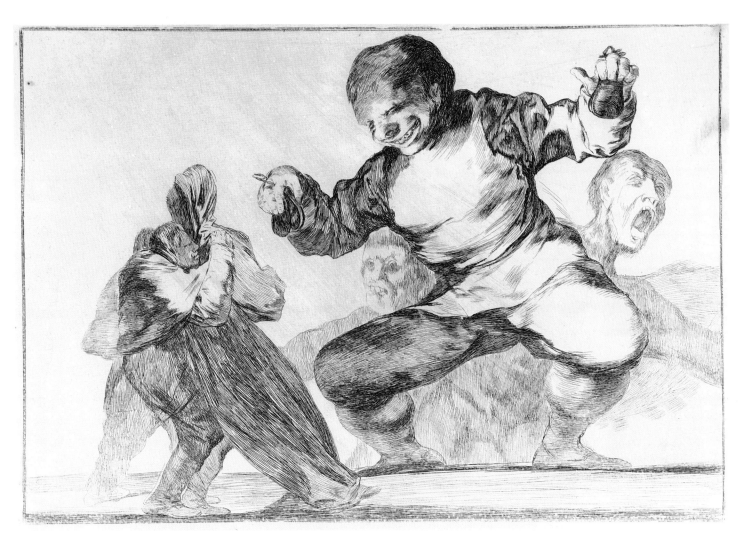

tional balance between Carnival (indulgence) and Lent (abstinence) was upset when too much attention was paid the details of the ritual – the sounds, the sights, the words – and too little to its spiritual significance.[10]

The ritual of parading, judging, and burning joyful, dancing, papier-mâché processional giants on Corpus Christi day was banned in Goya's lifetime because it was deemed an unseemly mix of profanity, superstition, and irreverence, unsuitable as a show of devotion and often leading to unruly behavior.[11] Its festive character was thought to degenerate into frivolity. In 1768 the bishop of Ciudad Rodrigo demanded that the government examine pious associations, so offended

was the prelate at the money spent by a local *cofradía* (brotherhood) on plays, meals, and refreshments for Corpus Christi.[12] On the fringes of official Church life was a world of hermits and *santeros* (peddlers of religious objects), who often, especially in the latter case, lived roguish lives. *Santeros* were repeatedly (1747, 1750, 1762, 1764, 1783, and 1784) forbidden their lucrative profession of exhibiting holy images in villages and towns.[13] Despite official disapproval by Church and state of these mixtures of popular piety and indecorous fun, some thinkers believed certain spectacles on given dates – controlled disorder – were officially tolerated because such toleration served the interests of the authorities. "¿Quién

podrá dudar de la sabiduría del gobierno, que para apagar en la plebe todo espíritu de sedición la reúne en el lugar más apto para todo desorden? . . . Gobierno ilustrado, pan y toros pide el pueblo. Pan y toros es la comidilla de España. Pan y toros debes proporcionarla para hacer en lo demás cuanto se te antoje *in secula seculorum. Amen.*" (Who will doubt the wisdom of a government that, in order to extinguish all seditious thoughts in the people, gathers them together in the place most apt for disorder? . . . Enlightened government, the people clamor for bread and bulls. Bread and bulls are the favorite pastimes of Spain. Bread and bulls you must provide so that in everything else you may do what you wish *in*

Fig. 2. Bernard Picart after Le Brun,
Etonnement (Astonishment).
Engraving in *Conference de Monsieur Le Brun*
(Amsterdam, 1698), fig. 25.
Museum of Fine Arts, Boston, William A. Sargent
Fund

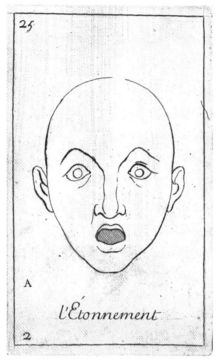

Fig. 3. Bernard Picart after Le Brun
Frayeur (Fright).
Engraving in *Conference de Monsieur Le Brun*
(Amsterdam, 1698), fig. 14.
Museum of Fine Arts, Boston, William A. Sargent
Fund

secula seculorum. *Amen.*)[14] The two
diaphanous creatures behind the giant
have understood this; they do not dance,
but one looks in astonishment (see fig. 2)
toward the fake cowering behind his
dummy, while the other screams in fright
(see fig. 3). They have the same horrify-
ing expressions as some of the humans
and demons Goya showed witnessing a
man being dragged into hell in his draw-
ing *Inferno* (cat. 141, fig. 1).

<div align="right">M.A.R.</div>

1. The giant's grin is not unlike that Goya put on the banner in his roughly contemporary painting of the Carnival ritual called the Burial of the Sardine, in the Real Academia de San Fernando, Madrid. The giant was a leading figure in celebrations of Carnival. Pro-cessional giants, *gigantones*, were also commonplace in Corpus Christi processions. See Terreros, *Dic-cionario*, under *gigante*. The Corpus Christi proces-sional giant was said to embody the sins over which Christ triumphs and was also seen as a symbol of God's omnipotence, followed by the strongest men of the community as a ritual act of submission. See J. Amades, *Gegants, Nans i Altres Entremesos* (Barce-lona, 1934), p. 47. See also note 11 below.

2. When Goya added aquatint to the later state, he eliminated the second man; he also increased the size of the foot and gave it an elegant shoe. Reform-ers of devotional rites often lamented the custom of dressing up holy images, not only for its poor taste but also for drawing attention away from the relig-ious mystery the rites expressed. See Sarrailh, *Espagne éclairée*, pp. 652ff.

3. H. 251, n. 1.

4. See Caro Baroja, *Carnaval*, p. 41.

5. See Blanco White, *Letters*, pp. 186, 306; Kany, *Life and Manners*, p. 280. In his memoirs Casanova described the fandango in ecstatic terms; apparently it very clearly suggested the sexual act. The year he was in Madrid – 1768 – special permission had to be given to dance it by the king's chief minister, the Conde de Aranda, who sponsored the masquerade balls at the Teatro del Príncipe; when it did not meet with ecclesiastical objections, the dance would invari-ably begin at midnight. Giacomo Casanova, *Memorias de España*, ed. and trans. Angel Crespo (Barcelona, 1986), p. 30.

6. León de Arroyal, "Pan y toros," in *Pan y toros y otros papeles sediciosos de fines del siglo XVIII*, ed. Antonio Elorza (Madrid, 1971), p. 26.

7. Even the virulently anticlerical Gallardo was care-ful to make this distinction: "La religion no son errores, las prácticas absurdas, ni los bárbaros y atroces establecimientos que se la han allegado: cuando todo esto se censura, la religion queda intacta, por mas acre que sea la censura. Al oro con liga se le aplica el agua fuerte: la liga se deshace, y el oro queda siempre puro é intacto." (Religion is not the errors, the absurd practices, nor the barbaric and horrible establishments that have accrued to it: when all of this is censured, religion remains intact, how-ever bitter the censure. Acid is applied to alloyed gold: the alloy dissolves, and the gold always remains pure and intact.) Gallardo defended a free press on the grounds that abuses ascribed to the Church should be ferreted out with at least as much vigor as abuses by others, in view of the Church's transcendent claims for itself as spiritual and moral arbiter of the community. Gallardo, *Diccionario*, pp. 81-82. The spirit of Goya's anticlericalism is similar. See cat. 155.

8. See Erasmus of Rotterdam, *Praise of Folly*, trans. Betty Radice (1971; reprint, Harmondsworth, 1976), pp. 125-140. Blanco White believed this kind of wor-ship of holy images encouraged vice. Blanco White, *Letters*, pp. 470-471.

9. Arroyal, "Pan y toros," p. 26.

10. Erasmus noted that a ritual such as fasting should be accompanied by less pride or anger and the Eucharist by a like mastery over passions associ-ated with the body in order better to commemorate the death of Christ. Erasmus, *Praise*, pp. 205-206.

11. See Blanco White, *Letters*, p. 303. On giants and processions, see Sarrailh, *L'Espagne éclairée*, p. 656; on Padre Isla's mockery of holy images, see p. 652; see also p. 688 for a discussion of Juan Meléndez Valdés's views on true religion and the cult of appearances, the letter and the spirit of dogma, and processions. It may be significant that the giant was sometimes a symbol of such calamities as war, plague, and famine, which were exorcised by being borne in procession, judged, and burned. See Caro Baroja, *Carnaval*, p. 199. In his use of the giant, Goya may well have set out to embody a novel calam-ity – vice in the guise of folly – whose destructive power the artist insisted again and again throughout his work could be equal to the traditional calamities. If this interpretation were correct, this print could be said to record Goya's indignation at the ritual use of holy images to cultivate vice rather than remove it. Ibid., pp. 90-92, 144-149.

12. See Callahan, *Church*, pp. 57, 67.

13. Artola, *Orígenes*, p. 44.

14. Arroyal, "Pan y toros," pp. 28, 31.

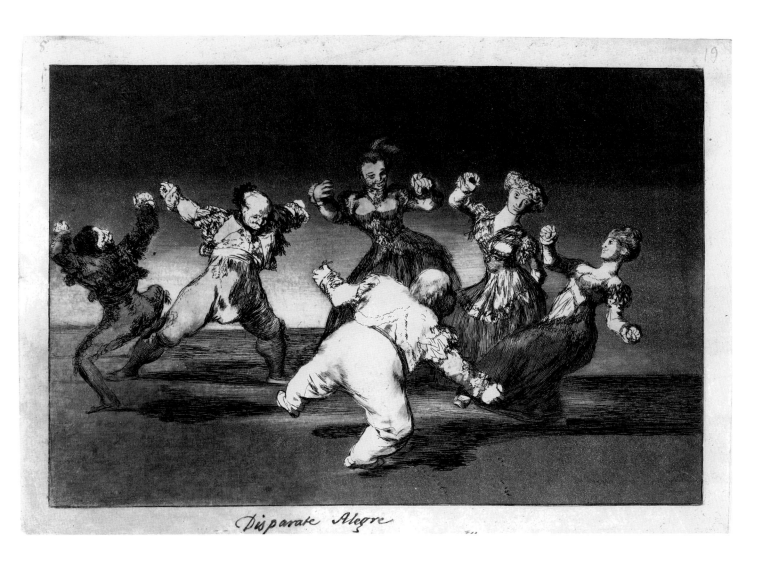

140

Disparate Alegre (Merry Folly)
Disparates, plate [12]
Working proof
About 1816-1817
Etching, burnished aquatint, and drypoint
245 x 350 mm.
Inscribed in pen and brown ink, in lower
margin: title
References: G-W 1589; H. 259, I, 2.

Museum of Fine Arts, Boston, Gift of Mr.
and Mrs. Arthur E. Vershbow, Dorothy
and Samuel Glaser, Mr. and Mrs. Joseph
Edinburg, and the M. and M. Karolik
Fund, 1973.702
Spain only

Six people with castanets dance in a cir-
cle (see cat. 139). They move with the
stiff formality of aristocrats and are
dressed in their own luxurious versions
of Spanish native dress, a fashion favored
by Queen María Luisa (see cat. 33).[1] The
two men on the left wear the tight
breeches, stockings, short jackets, and
sashes of the lower-class *majo* (dandy).[2]
They not only belong to another class,
but they are also too old to be true *majos*
and have none of the grace of movement
and youthful gaiety of the *majos* and
majas dancing seguidillas on the banks of
the Manzanares in Goya's tapestry car-
toon of 1777 (fig. 1).

Public entertainment did not escape
the enlightened reformers' attention.[3]

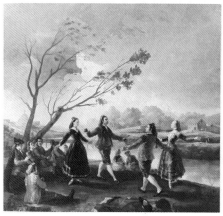

Fig. 1. Dance on the Banks of the Manzanares, 1777.
Oil on canvas.
Museo del Prado, Madrid

"La influencia de la riqueza, del lujo, del ejemplo y de la costumbre en las ideas de las personas de esta clase, la fuerza, por decirlo así, a una diferente distribución de su tiempo, y las arrastra a un género de vida blanda y regalada, cuyo principal objeto es pasar alegremente una buena parte del día. . . . Es verdad que una buena educación sería capaz de sugerir muchos medios de emplear útil y agradablemente el tiempo sin necesidad de espectáculos. Pero suponiendo que ni todos recibirán esta educación, ni aprovechará a todos los que la reciben, ni cuando aproveche será un preservativo suficiente para aquellos en quienes el ejemplo y la corrupción destruyan lo que la enseñanza hubiere adelantado, ello es que siempre quedará un gran número de personas para las cuales las diversiones sean absolutamente necesarias. Conviene, pues, que el gobierno se las proporcione inocentes y públicas, para separarlas de los placeres oscuros y perniciosos." (The influence of wealth, of luxury, of example, and of custom on the ideas of people of this class [the nobility], obliges them, as it were, to a different use of their time, and mires them in a kind of soft and indulgent life, whose principal aim is to pass the time of day pleasantly. . . . It is true that a good education would by itself suggest many ways of passing the time usefully and agreeably without the need of spectacles. But supposing that not all receive this education, or that it not serve all who receive it, or when it does have effect that it is not sufficient protection for those in whom example and corruption destroy what education has accomplished, there will always be a large number of people for whom diversions will be absolutely essential. The government should therefore provide such people with innocent, public pastimes in order to protect them from the dangerous, pernicious kinds.)[4]

Gaspar Melchor de Jovellanos viewed entertainment as an expression of an underlying economic reality; modifying the character of entertainment was not only a moral act, but a measure that would help transform the economy, "pues ciertamente los que se hallaban en la corte sin destino no vinieron en busca de otra cosa que de la libertad y la diversión, que no hay en sus domicilios. La tristeza que reina en la mayor parte de las ciudades echa de sí a todos aquellos vecinos que, poseyendo bastante fortuna para vivir en otras más populosas y alegres, se trasladan a ellas usando de su natural libertad, la cual, lejos de circunscribir, debe ampliar y proteger toda buena legislación. Tras ellos van sus familias y su riqueza, causando, entre otros muchos, dos males igualmente funestos: el de despoblar y empobrecer las provincias, y el de acumular y sepultar en pocos puntos la población y la opulencia del Estado, con ruina de su agricultura, industria, tráfico interior y aun de sus costumbres." (because to be sure those who are at court without business there did not come but in search of liberty and diversion, which they cannot find in their habitations. The sadness that reigns in the better part of the cities expels all those who, possessing sufficient fortune to live in other, more populous, and entertaining cities, use their natural liberty to move, which, far from circumscribing, all good legislation should augment and protect. Their families and wealth follow them, causing two equally unfortunate ills, among others: the depopulation and impoverishment of the provinces, and the accumulation and burial in a few centers of the population and wealth of the nation, with the consequent ruin of its agriculture, industry, interior commerce, and even its customs.)[5] Jovellanos recommended recovering the ancient Spanish riding tradition, establishing dramatic academies, and promoting balls, masquerades, cafés for public conversation, sports, and the theater.[6]

The scene in this print is obviously not an innocent pastime, as Jovellanos envisioned it, according to the texts quoted above. Many Spanish dances popular in the eighteenth century, particularly the fandango, were extremely erotic. The man to the far left resembles a monkey, and the older man's lewd smile complements the bulge in his groin, which had long been considered a sign of sexual excess.[7] The balding man in the center suffers from a form of dwarfism that suggests a man transformed by lust into a cretin, a condition that makes his legs appear as if he were about to mount a horse (or *cabalgar*, that is, to copulate.)[8] The two younger women on the right resemble dolls, with their blank stares and mechanical movements. This falsely gay dance is certainly not an expression of that "love of life" Jovellanos considered necessary to "actividad y amor al honesto trabajo, la frugalidad y parsimonia, la moderacion y templanza en el placer, la constancia en el estudio y observacion, y esta venturosa curiosidad, que nos lleva constantemente hacia la verdad, y haciéndonos buscar con insaciable afan cuanto es sublime, bello y gracioso en el órden físico, y cuanto es honesto, provechoso y deleitable en el órden moral" (activity and love of honest labor, frugality and parsimony, moderation and restraint in pleasure, constancy in study and observation, and that venturesome curiosity that carries us inexorably toward truth, making us search with insatiable striving all that which is sublime, beautiful, and gracious in the physical realm, and that which is honest, advantageous, and pleasant in the moral realm); it is rather closer to "el desordenado amor á la vida" (the immoderate love of life) that results in "la pereza, la ociosidad, la indolencia, la acedia, la molicie, la afeminacion, la cobardia, la indiferencia en los males ajenos, el abandono de los deberes propios, y en una palabra, aquel desenfreno de nuestros deseos que enflaqueciendo nuestras fuerzas físicas, entorpeciendo nuestra razon y corrompiendo nuestra voluntad, nos sepulta en perpétua torpeza é ignorancia, y nos expone á los errores y excesos que mas degradan la dignidad de nuestro ser" (sloth, laziness, indolence, melancholy, softness, effeminacy, cowardice, indifference to the misfortunes of others, abandonment of one's responsibilities, and in a word, that wantonness of desire that – weakening our bodies, retarding our minds, and corrupting our wills – buries us in a perpetual torpor and ignorance, exposing us to the errors and excesses that most degrade the dignity of our being).[9]

Jovellanos defended the aristocratic ideal of *otium cum dignitate* (leisure with dignity) against an indolence that wasted minds and squandered the country's

resources in pointless luxuries and entertainment. Medieval nobles earned their privileges in virtue of their services as soldiers and counselors to the king. By the early eighteenth century, legal developments had turned this reward for service into a merely honorific and hereditary title, as a result of which the enlightened monarchs amended the rules of ennoblement to ensure titles corresponded to merit (see cat. 138, n. 4).[10] Jovellanos hoped to breathe new life into the nobility by restoring the relationship between privileges and service to king and society. Goya showed what became of nobles when they failed to rise to the new challenge.[11]

M.A.R.

1. Goya's contemporary Anton Raphael Mengs painted the Duquesa de Llano in *maja* costume, castanets in one hand (a mask in the other to indicate it is Carnival), wearing the characteristic tilted cloth cap in a portrait in the Academia de Bellas Artes de San Fernando in Madrid.

2. See Kany, *Life and Manners*, p. 222.

3. On diversions for the laboring classes, see Gaspar Melchor de Jovellanos, *Espectáculos y diversiones públicas en España* (1790), ed. Camilo G. Suárez-Llanos (Salamanca, 1967), pp. 95-102.

4. Ibid., p. 103.

5. Ibid., p. 104.

6. Ibid., pp. 105-112.

7. See Joan Corominas and José A. Pascual, *Diccionario crítico-etimológico castellano e hispánico* (Madrid, 1980), under *potra*.

8. The slang meaning of *bailar* (to dance) is to rob, *alegría* (merriness), drunkenness, and *cabalgar* (to ride), to copulate. See José Luis Alonso Hernández, *Léxico del marginalismo del Siglo de Oro* (Salamanca, 1977). On this print, see also Sayre, *Changing Image*, p. 267.

9. Gaspar Melchor de Jovellanos, "Memoria sobre educacion publica," in *Biblioteca de Autores Españoles*, vol. 46 (Madrid, 1858), p. 264. On the sterile idleness of the nobility and the importance of their education, see Cadalso, *Cartas*, pp. 28-30.

10. See Artola, *Orígenes*, p. 45.

11. See also Cadalso, *Cartas*, pp. 28-30.

141

Disparate claro (Evident Folly)
Disparates, plate [15]

a
Working proof
About 1816-1817
Etching, touched with chalk
245 x 350 mm.
References: G-W 1594; H. 262, I, 1.

Graphische Sammlung Albertina, Vienna
1924/648
Spain only

b
Working proof
About 1816-1817
Etching, burnished aquatint, and lavis
Inscribed in pen and brown ink, in lower margin: title
245 x 350 mm.
References: G-W 1594; H. 262, I, 2.

Museum of Fine Arts, Boston, Gift of Mr. and Mrs. G. Peabody Gardner and Museum Purchase Funds, 1973.703
United States only

Men clamber on each other's shoulders to raise a dark canopy and let in the light. Owing to this light, the viewer is able to see a cleric on a platform, transformed into a monster by his fanaticism, and in the earlier state of the print (cat. 141a), a single aristocrat – who wears outmoded clothing (see also cat. 41 and 154) – kneeling before him. The light singles out the cleric's hands, one of which points toward the opening in the canopy, the other to the hellish abyss next to a barred window at the far left; it also reveals a cluster of clerics and laymen next to him. In the later state (cat. 141b), the flames and barred window are replaced by an officer plunging headlong into a pit. On the left, pointing toward the officer is a man wearing *quevedos* (spectacles); his mouth is frozen open. The cleric in front of him points as well. In the second state, the person standing between the frenzied cleric and the bespectacled man is clearly a woman; Goya changed the figure behind the aristocrat so that he too would be perceived as noble and blind.

The Church and the aristocracy were natural allies of Fernando VII because he restored the seignorial system, including its feudal dues and political privileges (see cat. 154). That the Church and the aristocracy had joined the crown in restoring the abuses of arbitrary government was widely recognized by such writers as Blanco White in his *Letters from Spain* of 1822.[1] Already in 1812 the Cortes' (parliament's) librarian, José Gallardo, had commented on ecclesiastical opposition to constitutional measures, summing up in terms resembling Goya's in this print. "El manto de la noche acaba de envolvernos en medrosas sombras: los luminares del orbe parece que han estinguido todos su vivífica lumbre" (The cover of night has just wrapped us in frightening shadows: the luminaries in the sky seem to have extinguished all their living light).[2]

During the Peninsular War, the Cortes' reforms made the military a bastion of the Liberal cause in Spain. Proof of nobility as a prerequisite for promotion to the rank of officer had been suppressed by the Cortes, and many soldiers had advanced rapidly during the war. Fernando VII's restoration of this requirement was one of the causes of disaffection in the officer corps.[3] One military *pronunciamiento* (insurrection) in favor of constitutional rule followed another: Mina's in 1814; Porlier's in 1815; the Triangle conspiracy in 1816; the rebellion in Cataluña, as well as the great Masonic conspiracy in 1817; the attempts to restore Carlos IV and the conspiracy of Valencia in 1818; and, finally, General Riego's successful rising in 1820.

In the Prado's preliminary drawing (G-W 1595) the viewer is aware only of the figures standing on one another to lift the heavy canopy that keeps out the light. In the first state of the print (cat. 141a) an apocalyptic fire is revealed, and in the second state (cat. 141b) the cleric condemns the military officer to an open pit, perhaps for partially letting in the light, toward which the cleric points with an accusing finger.[4] That partial illumination allowed by the raising of the canopy may represent the effect of the military risings in favor of constitutional rule.[5] The darkness of that canopy is perhaps a reference to Fernando VII's reign, noted for

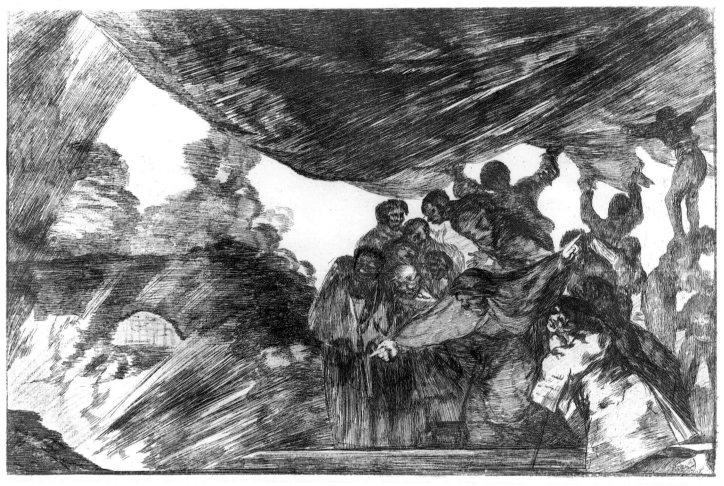

141a

its obscurantism and repression. The poet and Liberal journalist Manuel José Quintana, jailed for constitutional sympathies, wrote around 1815: "Nuestra persecución y nuestra ruina son ya en España un estado natural, que ni en pro ni en contra se extraña ni se admira; las prevenciones cunden y se arraigan, y el que nos acusa menos, ése nos tacha de imprudentes que merecen su suerte por su temeridad y su ilusión" (Our persecution and our ruin are now a natural state in Spain, which is no wonder or surprise to anybody with us or against us; trials multiply and spread, and he who least accuses us calls us imprudent and deserving of our fate for our temerity and our hope).[6] The cleric may well represent

one of Fernando VII's orators or apologists, for example, Blas de Ostolaza or Padre Vélez.[7] The figure wearing the *quevedos* appears in other prints and drawings of this period dealing with constitutional themes (see cat. 148 and 161). Such *quevedos* allude to opportunists who saw matters as it suited them. The man's mouth is frozen open with fear and astonishment at the grotesque sight; he cannot speak, but with his pointing gesture helps direct the viewer to what Goya thought important in the scene. Liberal officers and their followers partially lifted the veil over a country brought to its knees by fanatical clerics supporting Fernando VII, allowing some rays of hope to fall on other Liberals

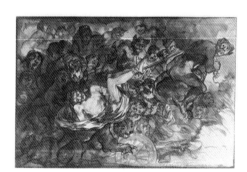

Fig. 1. *Inferno*, about 1819.
Preparatory drawing for a lithograph ink wash transfer. British Museum, London.

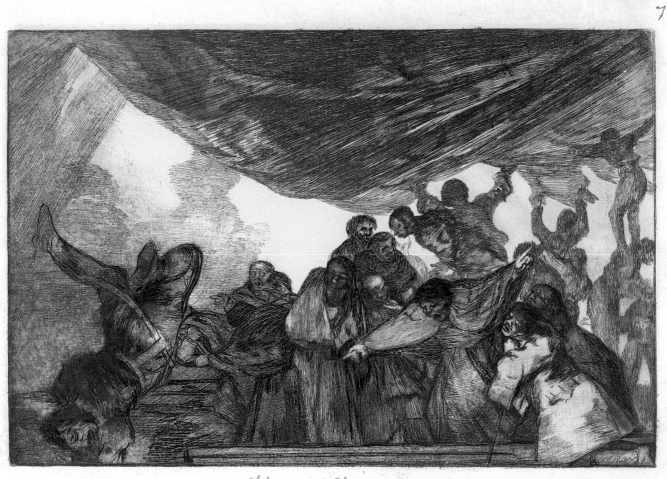

141b

marking time.

Whoever the culprits may be, what is clear is that fanaticism can overcome and kill a person's humanity. The apocalyptic feeling of this print resembles that of a slightly later drawing called *Inferno* (fig. 1), in which a demon drags a man into hell.

<div align="center">M.A.R.</div>

1. See, for example, Blanco White, *Letters*, p. 34.

2. Gallardo, *Diccionario*, p. v.

3. On the *pronunciamentos* (insurrections) in Fernando VII's reign, see José Luis Comellas, *Los primeros pronunciamientos en España: 1814-1820* (Madrid, 1958), pp. 31ff.

4. The pit belching smoke is perhaps intended to recall the biblical pit in the Book of Revelation 9:2.

5. On the suppression of the revolts, see Ferrán Soldevila, *Historia de España*, ed. J. Sales (Barcelona, 1973), vol. 6, pp. 373-374.

6. Manuel Josef Quintana, "Memoria," in *Quintana revolucionario*, ed. M. E. Martínez Quinteiro (Madrid, 1972), p. 43.

7. See Albert Dérozier, *Manuel Josef Quintana et la naissance du libéralisme en Espagne* (Paris, 1968), pp. 583-584, 588-589, 647-648, 664; Revuelta González, *Política*, pp. 4, 19, 42-43, 47, 201.

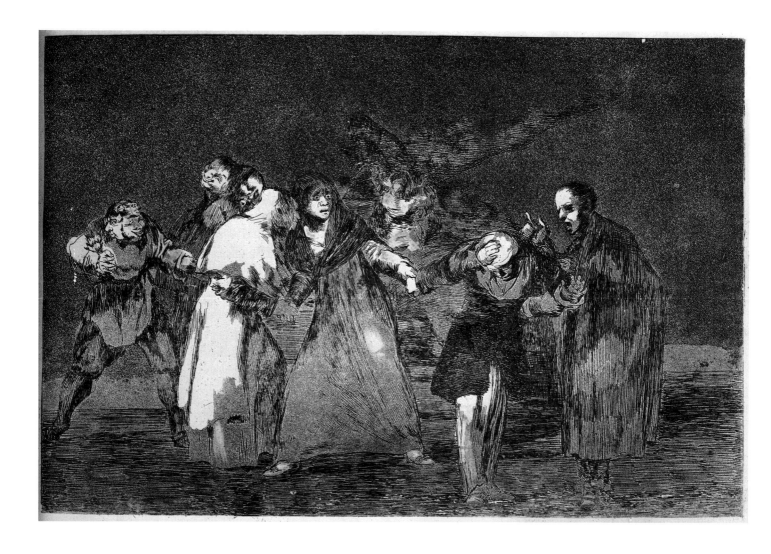

142

Indecision
Disparates, plate [16]
About 1816-1817
Rare posthumous edition, about 1848[1]
Etching and burnished aquatint
245 x 350 mm.
References: G-W 1596; H. 263, II.

Museum of Fine Arts, Boston, Bequest of
Horatio G. Curtis, by exchange, and the
Harvey D. Parker Collection, by
exchange, 1973.701

United States only

Men and women form a human chain
facing in different directions. In the
background the line seems to lead to a
dead tree; in the foreground a man in a
white cap bows his head as he is scolded
by another wearing a cape.

The three figures at the left have
sprouted double, even triple faces, signi-
fying their duplicity (see cat. 39), showing
a happy or sad one as the need arises.
The man being lectured does not have
two faces, but he does have two right
arms, one of which he uses to cover his
head and the other to hold the hand of
the woman who looks toward him in ter-
ror, as if she were afraid of the lecturer's
influence on his listener. There is a mask
on the elbow of the man whose hand she,
in turn, has taken hold of, indicating that
his words and deeds are equally false. In
the preparatory drawing (fig. 1), the man
at the far left is tonsured, the woman
looks more determined than fearful, and
the man in the foreground, wearing a
fashionable low-crowned hat instead of a
cap, is not exhorted so much as advised,
perhaps so that he might open his eyes to
what is happening. The masks – symbols
of guile – have yet to be added. In the
drawing it is even more obvious than in
the print that the woman and the man in
the cape each wishes to convince the
man between them which way he should
go, that is, to open his eyes, which are in
shadow. He shows his uncertainty by
pointing in opposite directions, wavering
between opposing forces, of two minds.
In the print the man in the cape has
become more vehement and appears to
be having some effect since the woman is
now frightened, perhaps because she will
not be able to pull the man with the

318

Fig. 1. Preparatory drawing for *Indecision*, *Disparates*, plate [16]. Sanguine and wash. Museo del Prado, Madrid

bowed head toward her treacherous clerical companion.

The human chain, the wandering character of the path taken, and the blindness of one of the figures foreshadow *Disaster 70, No saben el camino* (They don't know the way) (cat. 157), where clerical and lay people wander blindly toward a pit. It is possible that Goya placed Fernando VII in the center of this struggle between the counseling man at the right and the unsavory alliance of a mistress – her splayed legs tell us what she is – and hypocritical clerics. Fernando VII was known for the capricious, perverse pleasure he took in betraying his ministers, dismissing them on the smallest pretext, making decisions contrary to the information provided by them, and often allowing himself to be swayed by a kitchen cabinet called the *camarilla*, made up of a motley assortment of lowlifes and conniving clerics.[2] In the background a figure in white, tied to the trunk of a dead tree – perhaps a cleric who can be read as facing toward or away from the viewer – may symbolize the weight of the past on the present, represented by Old Regime privileges enforced once again on Fernando VII's restoration, much as the dead tree does in *Disparate Ridiculo* (cat. 138).

The people forming the chain do not come full circle nor do they face in the same direction, signs of their deceitfulness. They have no common goal except, perhaps, self-interest. They push and pull and get nowhere, working against each other. Elsewhere, Goya singled out the

clergy for supporting Fernando VII's unjust regime (see cat. 112 and 160). Their duplicity brought them physical and spiritual enslavement. And Goya saw that Spain would have to choose between liberalism and absolutism, the latter the path of blindness, enslavement, and damnation.

M.A.R.

1. The print is a copy in a contemporary paper binding of the *Disparates*, whose cover is inscribed in pen: *GOYA / LOS PROVERBIOS / Madrid hacia 1848.*

2. See Ferrán Soldevila, *Historia de España*, ed. J. Sales (Barcelona, 1973), vol. 6, pp. 363-364.

143

Disparate de Bestia (Animal Folly)
Disparates, plate [C]
Working proof
About 1816-1817
Etching, burnished aquatint, and drypoint
245 x 350 mm.
Inscribed in pen and brown ink, lower margin: title
References: G-W 1603; H. 268, I, 2.

Museo Lázaro Galdiano, Madrid

An Indian elephant is being lured out of the ring of light – a partly enclosed arena – by four Near Eastern men. The folds at the edge of its mouth give the impression it has had its tusks removed. One of the men carries a harness with bells in his left hand and holds up a large book for the elephant to see. They will bell it as the cat is belled in the fable.

There was an elephant in Aranjuez, near Madrid, until December 1777, when it died. Until then it seems to have enjoyed quite a notoriety, making its way into fables by Félix Samaniego and Tomás Iriarte. Iriarte wrote a sonnet offering to renounce all glory in arms and letters if the court at Madrid would only speak of him half as much as of the elephant.[1] Even after the elephant's death, its likeness (fig. 1) was preserved in Juan Bautista Bru de Ramón's illustrations of the animals constituting the royal natural history collection. Bautista Bru de Ramón's elephant may have been Goya's source, as it seems from Bru de Ramón's account of it to have been the only live one in Spain before it died. In the etching the elephant's thick mouth, flat head, and swollen upper trunk also make it doubtful that Goya rendered a live elephant rather than freely adapting an illustration.[2]

Strength, intelligence, piety, and meekness are traditional attributes of the elephant.[3] This elephant, however, does not seem to realize its own power. Having lost its tusks, it would appear to be defenseless other than for its great bulk. It is being lured out of the light, so often associated by Goya with the Enlightenment (see cat. 52). Despite its proverbial intelligence, the elephant is being seduced by four men whose beards and clothes resemble those Goya gave the

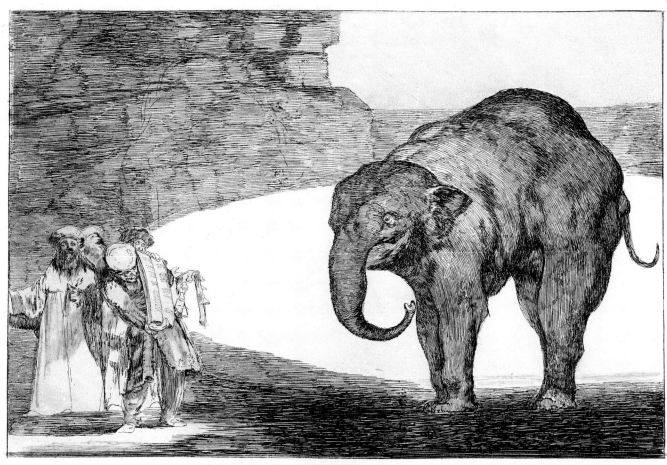

Disparate de Bestia

Moors in the *Tauromaquia*, the series of etchings published in 1816 on the history of the bullfight (especially G-W 1153-1163 and G-W 1184) (see fig. 2).[4] They use the decoy and the coaxing gesture much as a bullfighter lures a bull.[5]

The men could well be Persians, the name by which supporters of Fernando VII's absolutist reign were known after the publication of the so-called Persian Manifesto, drafted by sixty-nine anticonstitutional deputies to the Cortes, inviting Fernando VII to abolish the Cortes and rule by fiat on his return to Spain in the spring of 1814. The manifesto is widely credited with persuading Fernando VII to issue his infamous May 4, 1814 decree

annulling all constitutional laws enacted in his absence. The first article of this manifesto, which is awash in fantastic claims against the Liberals and is in many ways a mirror image of the Constitution of 1812, accounts for this bizarre connection with Persia: "Era costumbre en los antiguos persas pasar cinco días en anarquía después del fallecimiento de su rey, a fin de que la experiencia de los asesinatos, robos y otras desgracias les obligase a ser más fieles a su sucesor. Para serlo España a V.M. no necesitaba igual ensayo en los seis años de su cautividad" (It was the custom among the ancient Persians to spend five days in anarchy after the death of their king in

order that the experience of murder, robbery, and other misfortunes would compel them to remain that much more loyal to his successor. In order to be loyal to Your Majesty, Spain did not require a similar experience during the six years of your captivity).[6] The exact nature of Fernando VII's duplicity in 1808 – his abdication to Napoleon – was not at first known; he was welcomed by the people as *El Deseado* (The Desired One), hopefully anticipated as the captive king who was freed to reclaim his throne in a country that had endured its own trials in captivity.[7] Goya may have seen the elephant as a symbol of the Spanish people duped by the tintinnabulation of the false claims

Fig. 1. Juan Bautista Bru de Ramón, *Elephant*, 1784. Etching, in *Coleccion de Laminas que representan los Animales y Monstruos del Real Gabinete de Historia Natural de Madrid*, vol. 2 (Madrid, 1784), plate 54. Private Collection, United States

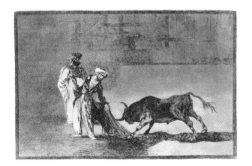

Fig. 2. *Los moros hacen otro capeo en plaza con su albornoz* (In the ring the Moors do another set of passes with their burnooses), 1816, *Tauromaquia*, plate 6.
Etching and aquatint.
Bequest of W.G. Russell Allen

and promises of the Persian reactionaries of 1814 and disarmed by an ingenuous vision of their king.

In European literature of the time, there was a tendency to associate oriental, in this case specifically Muslim, character and forms of government with cruelty and despotism. In 1820, Antonio Bernabeu wrote that to be denied the right to think and publish his ideas without censorship, so long as he respected public order, was "tirania . . . crueldad, y . . . en fin proceder segun la legislacion del alcorán" (tyranny . . . cruelty, and . . . in sum to proceed according to the laws of the Koran).[8] "Koranic" appears to have been a shocking insult to a Liberal. In 1814, when Fernando VII had returned to power and abolished the Constitution (including freedom of the press), at least one Liberal newspaper, *La Abeja*, gracefully exited the public stage, alluding to "los vientos que llegan de Levante" (the winds that blow from the East).[9] Could this defenseless elephant be the people, the book the Persian Manifesto posing as the Koran, and the darkness the reign of Fernando VII as Liberals regarded it?

M.A.R.

1. Tomás de Yriarte, *Obras completas en verso y prosa* (Madrid, 1805), vol. 2, sonnet 14. The first edition was published in 1782. For other satirical verses on the life and death of the celebrated pachyderm, see Emilio Cotarelo y Mori, *Iriarte y su época* (Madrid, 1897), pp. 133-135.

2. A pen drawing (Prado, Madrid, 420; G-W 1603; G., II, 303) of a man in uniform – a handler – with two elephants has been considered a preliminary drawing for this *Disparate*. Gassier believes it was traced onto the copper plate. But the dimensions of the single elephant etched by Goya are larger than those of the elephant in the drawing. Besides, the second elephant, traces of which may be visible in the rock wall on the left, is too far from the first to correspond to the drawing and is facing in the wrong direction. The medium Goya customarily used for preliminary drawings for the *Disparates* was sanguine wash. It may be that the drawing was based on the print. Sánchez Cantón suggests that the drawing was executed in Bordeaux after 1823. See F. J. Sánchez Cantón, *Los dibujos de Goya* (Madrid, 1954), vol. 2, no. 453 of index. Goya may also have seen Pietro Testa's etching of 1630 showing an elephant and a man in oriental dress.

3. Mateo Gómez, *Sillerías*, pp. 76-77; Cesare Ripa Pervgino, *Iconologia* (Padua, 1630), pp. 11, 89, 119, 273, 457, 572; Lacombe de Prezel, *Dictionnaire Iconologique* (1779; reprint, Geneva, 1972), vol. 1, pp.

202-203; *Le Petit Trésor des Artistes et des Amateurs des Arts* (Paris, Year VIII of the Republic), pp. 92, 107.

4. The costumes are anachronistic; they are based on the dress of the Mamelukes of Napoleon's imperial guard, which appear in Goya's painting commemorating the Madrid uprising against the French on May 2, 1808 (G-W 982).

5. In the 1790s, long before the French invasion in 1808, the term *mamelucos* was reserved for Spanish Republicans who opposed Napoleon's imperial pretensions. Most Spaniards then were sympathetic to Napoleon, viewing him as a conqueror, legislator, and protector of Spain, in virtue of the dynastic alliance that bound Spain and France. See Alcalá Galiano, *Recuerdos*, p. 55. In Spain Moor and Mameluke were general terms of opprobrium that could be applied to variable targets. Goya obviously meant us to sympathize with the elephant and to disapprove of the Moors. Alcalá Galiano also gave an account of the impression made by the Napoleonic Mamelukes in Madrid; ibid., pp. 111-112.

6. "Manifiesto de los 'Persas'" (April 12, 1814), excerpted in Albert Dérozier, *Escritores políticos españoles (1780-1854)* (Madrid, 1975), p. 202.

7. On Fernando VII's schemings in 1807 and 1808 against his parents and his mother's lover Godoy, see Honorato Castro Bonel, "Manejos de Fernando VII contra sus padres y contra Godoy," *Boletín de la Universidad de Madrid* 2 (1930), pp. 307-408. On Fernando VII as *El Deseado*, see Richard Herr, "Spain's Rising Against Napoleon," in *Ideas in History* (Durham, 1965), pp. 165-181. On Fernando VII's generally distrustful, unscrupulous, conniving, and vindictive nature, see Ferrán Soldevila, *Historia de España*, ed. J. Sales (Barcelona, 1973), vol. 6, pp. 359-367.

8. Antonio Bernabeu, *España venturosa por la vida de la Constitución y la muerte de la Inquisición . . .* (Madrid, 1820). Biblioteca Nacional, Madrid, R 60.122, p. 15. See also Gallardo, *Diccionario*, p. 61.

9. José Alvarez Lopera, "De Goya, la Constitución, y la prensa liberal," in Madrid, 1982, p. 43. The same author cites José Gallardo Blanco's satirical *Noticias* (News) on political luminaries of the day, published in 1813, which described deputies of the Cortes in the service of "His Despotic Highness" [Fernando VII] as "Mamelucos Barbatrompa" (Beardtrunk Mamelukes); ibid., p. 36.

144

Duel to the Death
Album F, page 10
About 1817-1820
Brush and brown wash
207 x 150 mm.
Inscribed in pen and brown ink, upper
right: *10*
References: G-W 1438; G., I, 284.

Museo del Prado, Madrid, 284
United States only

Two men are engaged in a duel, the traditional way nobles settled disputes (compare cat. 152). A jagged line of shadow separates them. The creeping shadows and the wan light playing against the trees, which form a backdrop on hilly terrain, suggest the sun is rising. Goya arranged lines and light to ensure we always return to the faces. The crowns of the trees generate a descending line from the left and to the right so that the right fighter's head is partially outlined; the lines of his legs send our gaze up his torso. His opponent's face is brought into focus by the patch of light on his temple, cheek, and nose, the subtle highlight on his legs, and the strong white of his shirt sleeve, and also by the way the eye follows his rapier to the shield, the shine on which sends the eye back to the face. The drawing is unusual for Goya in that it is the only representation of dueling in which the differences between the fighters in age and temperament are important.

What do these faces tell us? The pallor and sparse, precisely gathered hair of the figure on the right identify him as an older, more calculating man. Even in profile, the younger man has a rounder face, a fuller, disheveled head of hair, and softer features. The impression of a contest between hard-bitten experience and reckless youth is strengthened by the narrow, almost beady eyes; sharp nose; drawn expression; and firm stance of the older man, who even stands taller than the younger. The young man is tense and insecure; his eyes and mouth betray despair, anticipation of pain, and fear. The older man's eyes are nearly closed, and the face is hard; there is a determined and ruthless air about him. On

the ground lies a hat, another sign that an affair of honor is in progress.[1] It appears that whoever is right or wrong the youth will die, because the older man has one foot firmly planted in the light, while the youth is nearly swallowed in shadow.

This is the first of six drawings Goya dedicated to the subject of dueling. Goya was not interested in depicting clothing with historical accuracy. What the duelers wear merely suggests the sixteenth century; their round shields, or bucklers, were the accoutrements of a Carlos V, not of a nineteenth-century gentleman. Goya meant us to understand this duel as something belonging to the past. In fact, the code of honor from which dueling sprang had been under attack in Spain since the mid-sixteenth century.[2] In the eighteenth century, dueling became increasingly confined to the military, especially after Fernando VI published the royal decree of 1757, making duelers subject to the death penalty and the confiscation of all their goods.[3] It was not characteristic of Goya to look condescendingly on the past so that we cannot say he merely intended to illustrate a barbarous custom that had survived a harsh and remote past. Archaic customs represented in his work are often symbols of reprehensible laws or behavior that persist in spite of apparent progress. His contemporaries, among them the philosopher and poet Gaspar Melchor Jovellanos (see cat. 30), often proceeded in the same way.

In 1773, Jovellanos wrote *El delincuente honrado*, a play defending duelers who fell afoul of the law.[4] In this play Jovellanos set out to examine a law that condemned the provoker of the duel and the provoked equally. The two principal characters of the play represent the clash of the old and the new ideas of justice. Don Simón, a rigid formalist, applies existing laws without questioning their ethical basis, whereas Don Justo judges both the law and the individual illegally engaged in dueling. A man challenged to a duel must refuse it, according to the law, but if he upholds the law, he will be branded a coward. Jovellanos opposed the law of 1757 because he believed that so long as the preoccupa-

tion with honor remained alive in society its failure to distinguish between the criminal (understood as he who challenges another to a duel) and the victim would force the victim to choose between breaking the law and flouting public opinion.[5] Laws, Jovellanos reasoned, must be made to the measure of society as it is and must be based on a study of its customs, even though many are merely prejudices.[6]

Neither Jovellanos nor Goya made an issue of dueling itself. Jovellanos used dueling to dramatize the problem of the nature of laws and justice in an imperfect society. In Jovellanos's play as in Goya's drawing, the question is whether people routinely apply appropriate or even rational solutions to their problems. The play takes it for granted that dueling is criminal, but finds its antidote – a cruel law that is unjust, to boot – worse. The pretext of the duel in the drawing is probably some real or imagined slight, while its resolution – symbolized by the duel – obtains nothing, because it neither gives back honor nor decides who was right. By the eighteenth century being quick to draw one's sword was sometimes an epithet for nobles who were touchy about their reputation.[7] Goya may have drawn on this expression to comment on the danger of private justice in a society concerned about establishing the rule of law; it may have had special resonance in view of the revenge killings and persecution that took place during and after the war (see cat. 152).[8] The duel symbolized just this kind of primitive justice. The contrasts in age and temperament suggest that maturity is no particular guarantee of wisdom or prudence or mercy, that ruthlessness or experience rather than justice often decide the outcomes of such mindless contests of will, and that youth may well repeat the mistakes of elders, not always prevailing or even surviving to learn from its errors.

M.A.R.

1. Hats are involved in many of Goya's dueling scenes. In eighteenth-century amorous paintings and prints, as in Fragonard's *The Swing* and *The Wardrobe*, the hat is a symbol of male potency. See Donald Posner, "The Swinging Women of Watteau and Fragonard," *Art Bulletin* 64 (Mar. 1982), p. 85. In a dueling scene, it may thus indicate the fighters' mas-

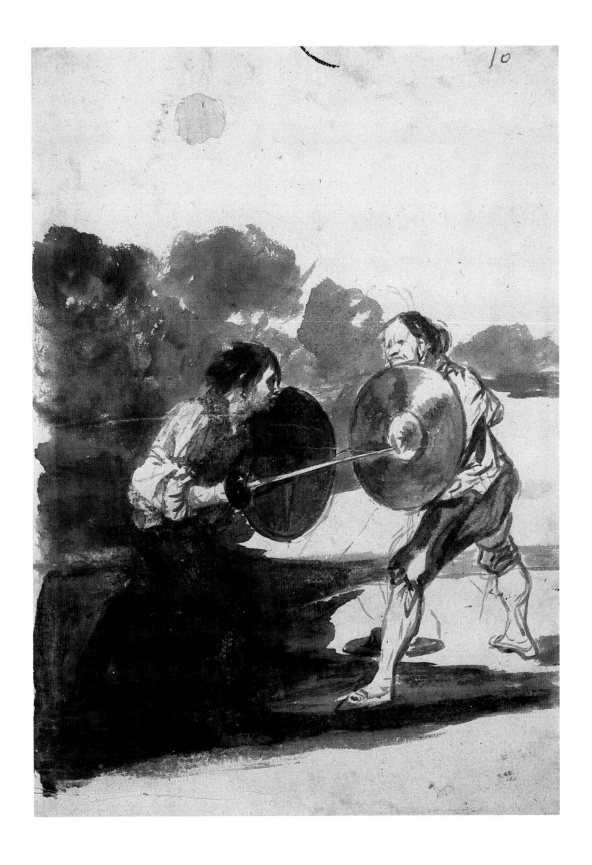

culinity is being put to the test; it may also suggest that a woman's affections are at stake. The duel could have been sparked by the rivalry between the younger man and the older for the affections of the older man's young wife, the theme of numerous classical and eighteenth-century plays; see cat. 145. On the privilege of standing in the king's presence without removing the hat, see also cat. 138, n. 10.

2. In the anonymous picaresque classic *Lazarillo de Tormes* (1554), Lazarillo both admires and pities his *hidalgo* (gentleman) master's *presunción* (presumption), which induces him to starve happily if it enables him to avoid menial labor and thereby preserve his gentlemanly rank. Lazarillo comments: "this illness [honor] alone will kill them [the *hidalgos*]." Francisco Rico ed., *Lazarillo de Tormes* (Barcelona, 1967), p. 54. There are many instances in which Goya's contemporaries referred to the preoccupation with honor, and duels especially, as a residue of the "siglos caballerescos" (the age of chivalry). See, for example, Gallardo, *Diccionario*, p. 51; Llorente, *Inquisición*, vol. 4, p. 124. See also cat. 138.

3. This decree confirmed another published in 1716. See Antonio Domínguez Ortiz, *La sociedad española en el siglo XVIII* (Madrid, 1955), p. 50.

4. Jovellanos wrote the play on the occasion of a discussion in Pablo Olavide's literary *tertulia* (salon) in Seville. It was widely represented. See Elena Catena, *Teatro español del siglo XVIII* (Madrid, 1969), p. 12. For other commentary on the play, see Glendinning, *Siglo XVIII*, pp. 159-163. See also José Miguel Caso González, *Ilustración y neoclasicismo* (Barcelona, 1983), p. 409. A new edition of the play appeared in Madrid in 1814. See John Dowling, "La sincronía de *El delincuente honrado* de Jovellanos y las *Noches lúgubres* de Cadalso," *Nueva revista de filología hispánica* 33, no. 1 (1984), p. 220.

5. According to the political notions of that time, honor was to be valued because it was considered the basis of government by monarchy, just as virtue was the basis of a republic, and fear of tyranny. On Montesquieu's *The Spirit of Laws*, see Raymond Aron, *Main Currents in Sociological Thought*, trans. Richard Howard and Helen Weaver (New York, 1968), vol. 1, pp. 23-24.

6. It had also become the accepted view among the enlightened that unjust laws, especially those in which the punishment was exceptionally severe in proportion to the crime, were unenforceable, because people would be too appalled by them to report the crime. On the eighteenth-century polemic about the law, punishment, and public opinion, see Sarrailh, *Espagne éclairée*, pp. 535-541.

7. Ibid., pp. 518-526.

8. See also León de Arroyal, "Pan y toros," *Pan y toros y otros papeles sediciosos de fines del siglo XVIII*, ed. Antonio Elorza (Madrid, 1971), p. 22. For a possible political interpretation of this drawing, see cat 145, n. 9.

145
Consequences of a Duel
Album F, page 13
About 1817-1820
Brush and brown wash over chalk sketch
207 x 148 mm.
Inscribed in pen and brown ink, upper right: *13*
References: G-W 1441; G., I, 287.

Museo del Prado, Madrid, 295
Spain only

In ruff and plumed hat, the victor stands tall. He swaggers as he gazes into the distance, resting his left hand on his hip and pointing with his rapier at his dead opponent's neck. In the foreground the trunk of a tree cuts diagonally across the scene. This drawing is fourth in a series of six drawings on duels (see cat. 144).

Many of Goya's contemporaries denied that jealousy, quickness of temper on points of honor, and readiness to fight were peculiarly Spanish traits. José Blanco White observed: "You have in England strange notions of Spanish jealousy. I can, however, assure you, that if Spanish husbands were, at any time, what novels and old plays represent them, no race in Europe has undergone a more thorough change."[1] Dueling had been outlawed in Spain in 1757 (see cat. 144). What then moved Goya to address it? Through the use of costume, Goya took pains to emphasize its outdated nature; the plumed hat and ruff are characteristic of the dress worn by sixteenth-century courtiers. In some of Goya's dueling scenes, there is even an echo of the seventeenth-century *capa y espada* (cloak-and-dagger) play. *Album B* 77 (fig. 1) is an example of the duels for love that motivated many traditional plays of honor and intrigue; its scenario – her brothers kill her lover, and she then does away with herself – could have been lifted from such a source.[4] It was not uncommon for these plays to be revived or for playwrights of Goya's day to recast the plots and themes of the so-called honor plays so as to respect the classical rules governing the unity of time, place, and action then in fashion among the cultivated, or to address moral issues in a more modern language for their audi-

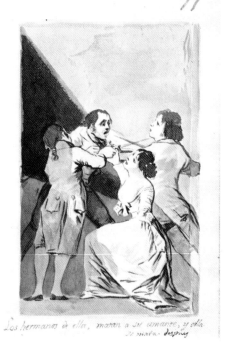

Fig. 1. *Los hermanos de ella, matan a su amante, y ella se mata despues* (Her brothers kill her lover, and she then does away with herself), 1796-1797, *Album B*, page 77.
Gray and black wash.
The Metropolitan Museum of Art, New York, Harris Brisbane Dick Fund

ences.[3] In Gaspar Melchor Jovellanos's *Pelayo*, based on a medieval Spanish legend that a number of dramatists were still adapting, honor – that is, social standing or reputation, as well as a clean conscience – is preserved by cleaving to a moral code that all reasonable people can agree to, instead of an abstract code of behavior imposed either by a religious authority or by public opinion.[4]

In a society increasingly preoccupied with imposing the rule of law, even such a once-heroic value as the sense of honor not only had no place, but appeared grotesque, even perverse.[5] Goya illustrated this transformation by making the authority of death so strong here it overshadows the victor's self-satisfaction. There is no light in the victor's eyes; they are cold and impassive. He shows no remorse. A play of contrasts sustains the drama. The victor's hat rests squarely on his head, the dead man's lies on the

ground; the highlight on the victor's left trouser and the subtle modeling the light lends to the left side of his face give him volume and contrast with the unearthly pallor of his victim; his features are razor-sharp, even aquiline, the dead man's sagging. Where the victor is framed in light, the dead man is engulfed in shadow. The only signs of life are the leafy branches at the base of the tree.

The motif of the dead tree trunk can be traced back to the fallen tree in the Book of Daniel (4:8-28); in Goya's day it found an exponent in Juan Meléndez Valdés, particularly in his *romance* (ballad) *el arbol caído* (the fallen tree).[6] Meléndez Valdés used the image to express the passing nature of worldly things and the inevitability of death, describing it as "hollado, horroroso, yerto" (trampled, horrifying, stiff). His choice of adjectives indicates that when he looked at his fallen tree, he was really seeing a corpse. In this poem the very symbol of life is made into the image of absolute death.[7] The real protagonist of Goya's drawing is death triumphant, which is given emphasis by the slanting tree trunk slashing across the scene and virtually upstaging the victor of the duel. In one of Goya's last treatments of dueling – *Album G 58*, titled *Quien vencera* (Who Will Win?) (G-W 1762) – two men fire point blank at one another; death alone will win.

The classical theater generally ended in some form of redemption, usually religious. Goya's drawing does not. Amidst the desolation, the solitary theatricality of the victor rings hollow; it shows that in order to save his reputation, a part of him – his humanity – has died too. Goya brought home the finality of death and the ugliness of violence and thereby achieved something characteristic of the eighteenth century: the separation of honor from virtue. He showed how a primitive sense of honor in a society valuing justice could lead to unspeakable acts; in effect, he made this victor of a duel, who might once have been hailed as a hero, look little better than a murderer.[8]

M.A.R.

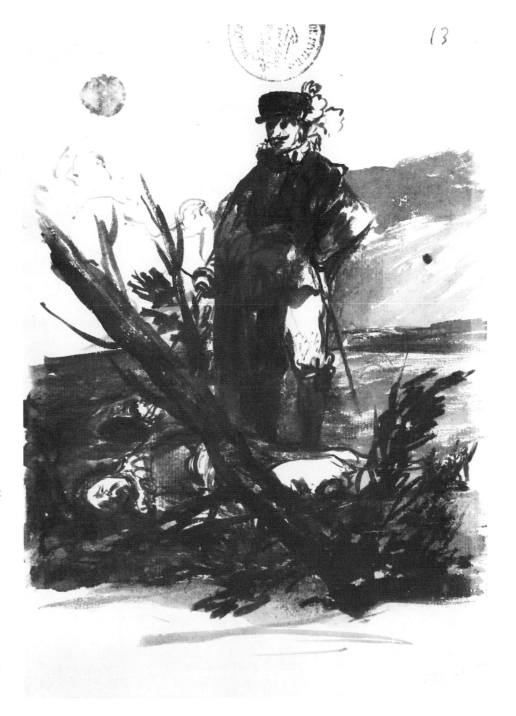

1. Blanco White, *Letters*, p. 49. On the other hand, the knife sometimes did still decide the claims of "humble lovers"; Blanco White ascribed this to the "constitutional irritability" of the "lower classes"; ibid., p. 268. See also the entry for *honra* in Gallardo, *Diccionario*, p. 51. The French traveler Bourgoing observed that Spain possessed the fewest jealous husbands in Europe; it was even considered eccentric to take an unfaithful wife to court. Kany, *Life and Manners*, pp. 212, 214. In his defense of Spain against unjust criticisms by the French philosopher Montesquieu, Cadalso insisted that duels and death in the name of love belonged to the past. José Cadalso, *Defensa de la nación Española contra la Carta Persiana LXXVIII de Montesquieu*, ed. Guy Mercadier (Toulouse, 1970), pp. 22-23. On the eighteenth-century modification of the sense of honor in love and marriage, see Carmen Martín Gaite, *Usos amorosos del dieciocho en España* (Madrid, 1972), pp. 158ff. In Moratín's play *El viejo y la niña* (The Old Man and the Maid), the old man treats a situation of marital fidelity as a question of morality instead of honor. Glendinning, *Siglo XVIII*, p. 175.

2. See also *Capricho* 10, *El amor y la muerte* (Love and Death). The Prado manuscript commentary on this *Capricho* acknowledges one of the masters of the seventeenth-century cloak-and-dagger play and quibbles on the meaning of sword to suggest how love can lead to foolhardy, even fatal, acts: "See here one of Calderón's lovers who, unable to laugh at his rival, dies in the arms of his lover and loses her for his temerity. It is not wise to draw the sword very often."

3. Glendinning, *Eighteenth Century*, pp. 140ff. On the theater of the Golden Age in the eighteenth century, see René Andioc, *Teatro y sociedad en el Madrid del siglo XVIII* (Valencia, 1976), pp. 123ff.

4. See José Miguel Caso González, *Ilustración y neoclasicismo* (Barcelona, 1983), p. 371.

5. In fact, in the eighteenth century the choice between dishonor and death was often less dramatic, but no less compelling than in Goya's representation of it. Before Carlos III's successful attempt to ennoble industrial and commercial activities, some members of the lower gentry found themselves forced to elect between their reputation and solvency. On the question of honor and honorable trades in eighteenth-century Spain, see William J. Callahan, *Honor, Commerce, and Industry in Eighteenth-Century Spain* (Boston, 1972); Javier Guillamón Alvarez, *Honor y honra en la España del siglo XVIII* (Madrid, 1981).

6. See Gregorio Salvador, *El tema del arbol caído en Meléndez Valdés* (Oviedo, 1966).

7. See also Goya's drawing *Album H 36* (G-W 1798), which shows a tree trunk resembling the one in this drawing and a wounded, possibly dead, figure against it. For another discussion of the tree motif in Goya's work, see Valeriano Bozal, "El arbol goyesco," in *Goya: Nuevas Visiones: Homenaje a Enrique Lafuente Ferrari* (Madrid, 1987), pp. 119-133.

8. Quevedo too observed that honor is sometimes merely a pretext for crime. See Quevedo, *Sueños*, p. 209. The great Liberal poet and journalist Manuel José Quintana described his own and fellow Liberals' imprisonment in the same terms as this drawing: "El vencido cae, y el vencedor resuelve; y según su furor, sus recelos, su compasión o su desprecio, así absuelve, así olvida, o inexorablemente condena" (The vanquished falls, the victor decides; and according to his anger, his suspicions, his compassion, or his contempt, so he absolves, so he forgets, or inexorably damns). Manuel José Quintana, "Memoria," *Quintana revolucionario*, ed. M.E. Martínez Quinteiro (Madrid, 1972), p. 42. We need only remember the treacherous circumstances of Fernando VII's return to power in 1814, his advocacy of all that was deemed archaic and obscurantist, and his persecution of Liberals to imagine this drawing's power of suggestion for Goya's contemporaries. On May 30, 1814, Fernando VII decreed that all *afrancesados* (collaborators with the French regime) would be banished, although in negotiations with the Cortes he had promised a general amnesty on his restoration (see cat. 156); Lafuente, *Historia*, p. 172. Artola blames the internecine wars of this period on Fernando VII's lack of political talent, his incapacity to understand the real problems of the country, and his absolute lack of concern for finding a solution. See Artola, *Orígenes*, p. 632. When Fernando VII was restored he and his followers had no desire for reconciliation with Liberals, only to defeat, humiliate, and exterminate them. See Ferrán Soldevila, *Historia de España*, ed. J. Sales (Barcelona, 1973), vol. 6, p. 361. On the first period of Fernando VII's reign, see Fontana Lázaro, *Quiebra*.

146
Seeking a Cure
Album F, page 27
About 1817-1820
Brush and gray and brown wash, touched with pen and brown ink
206 x 147 mm.
Inscribed in pen and brown ink, not by Goya, upper right: *27*[1]
References: G-W 1453; G., I, 299.

Museo del Prado, Madrid, 316
United States only

An old woman and a tonsured friar hold up a girl who is either dead or catatonic. A cowled cleric raises his arms and rolls his eyes toward heaven. To the right there is an architectural structure suggesting a column or perhaps an altar.

The subject of healers working at the margins of the established medical profession is an old one. In the anonymous sixteenth-century classic novel *Lazarillo de Tormes*, the boy's first master, a blind man, had perfected techniques giving him a lucrative practice that depended largely on the credulity of poor women. "Ciento y tantas oraciones sabía de coro. Un tono bajo, reposado y muy sonable, que hacía resonar la iglesia donde rezaba; un rostro humilde y devoto, que con muy bien continente ponía cuando rezaba, sin hacer gestos ni visajes con boca ni ojos, como otros suelen hacer. Allende desto, tenía otras mil formas y maneras para sacar el dinero. Decía saber oraciones para muchos y diversos efectos: para mujeres que no parían; para las que estaban de parto; para las que eran malcasadas, que sus maridos las quisiesen bien. Echaba pronósticos a las preñadas: si traía hijo o hija. Pues en caso de medicina decía que Galeno no supo la mitad que él para muela, desmayos, males de madre. Finalmente, nadie le decía padecer alguna pasión que luego no le decía: 'Haced esto, haréis estotro, cosed tal hierba, tomad tal raíz.' Con esto andábase todo el mundo tras él, especialmente mujeres, que cuanto les decía creían. Déstas sacaba él grandes provechos con las artes que digo, y ganaba más en un mes que cien ciegos en un año." (He knew a hundred odd

prayers by heart. A low tone, reposed and sonorous, made the church resonate where he prayed; he wore a humble and pious countenance when he prayed, without gesturing or mugging with his mouth or eyes, as others tend to do. Beyond this, he had a thousand ways and means of making money. He said he knew prayers for many and diverse effects: for women who did not give birth, for those who did, for the mismated so that their husbands would love them. He made forecasts for the pregnant: whether it would be a boy or a girl. In medicine he said Galen did not know half what he did for toothache, fainting, uterine pains. Finally, nobody confessed to a passion to which he did not say: "Do this, do the other, take this herb, take that root." As a result, the whole world followed him, especially women, who believed whatever he told them. He took great advantage of them by the methods I have described, and he earned more in one month than a hundred blind men in a year.)[2]

Some orders of friars were compelled by their poverty to support themselves providing services of one kind or another. As the result of abuses by a minority, the orders acquired a reputation for an unscrupulousness that was felt by enlightened reformers to smear religion. "El delicadísimo ministerio de la predicación, que por particular privilegio se permitió a un Pantero, a un Clemente Alejandrino, a un Orígenes, hoy es permitido . . . a cualquiera frailezuelo que lo toma por oficio mercenario" (The very subtle vocation of preaching, which as a special privilege was allowed a Pantaenus, a Clement of Alexandria, an Origen, today is allowed . . . any little friar who takes it up as a money-making profession).[3] Although the Church officially frowned on what were regarded as superstitious practices, these wayward friars alarmed enlightened critics by encouraging them: "El influjo frailesco ha hecho pasar por verdades reveladas, los sueños y delirios de algunas simples mujeres y hombres mentecatos" (The friars' influence has made the dreams and deliriums of a few simple women and foolish men pass as revealed truths).[4]

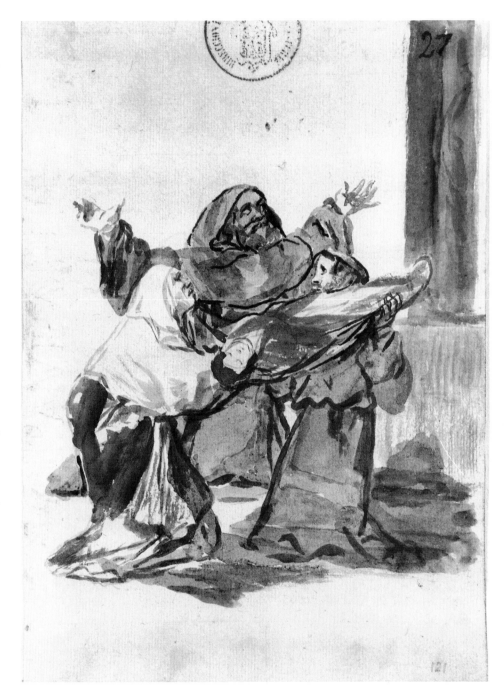

The friars in Goya's drawing are indeed lending themselves to the old woman's illusory hopes; the younger cleric even appears to believe the charade. Like some of their brothers, they have perhaps confused the healing of souls with the healing of bodies. Their histrionics inspire no more trust than did the cleric in the earlier drawing, *Album C*, page 121, *Busca un medico* (Look for a doctor) (G-W 1356), where Goya's title indicates his lack of faith in the clergyman's capacity to cure physical illness. By striking a theatrical pose and rolling his eyes falsely, the cowled friar seems more interested in impressing the desperate old woman and perhaps taking her money than in getting to the bottom of the girl's problem. In fact, so involved is he in his act, he may not realize it is already too late (see cat. 48).

M.A.R.

1. Though not in Goya's hand, the number may be a copy of the artist's number, which was lost when the drawing was cut.

2. *Lazarillo de Tormes*, ed. Francisco Rico (Barcelona, 1967), p. 15.

3. León de Arroyal, "Pan y toros," in *Pan y toros y otros papeles sediciosos de fines del siglo XVIII*, ed. Antonio Elorza (Madrid, 1971), p. 19.

4. Ibid., p. 25.

147
Funeral Procession for Constitutional Spain
Album F, page 44
About 1817-1820
Brush and brown and gray-brown wash
206 x 139 mm.
Inscribed in brush and brown ink, upper right: *44*
References: G-W 1469; G., I, 314.

Staatliche Museen Preussischer Kulturbesitz, Kupferstichkabinett, Berlin, 4292
Spain only

A procession of clerics, most of them friars or monks, winds its way up a hill toward a classical building with a tympanum. Some carry funeral banners, others pour out song in a full-throated show of triumph and self-sufficiency. Those clerics bearing the body, whose head emits rays of light, are about to enter the portal.

Owing to the powerful rays of light the corpse irradiates, the supine figure recalls Goya's personification of the Constitution of 1812 (cat. 109). This and the following drawing (cat. 148) are thematic precursors of the two *Disasters of War* on the Constitution (cat. 160 and 161).[1] The classical structure may be a church or even a mausoleum; it may also be a government building symbolizing political administration.

The Cortes' (parliament's) reforms – revolutionary in some minds – involved the abolition of both ecclesiastical and noble seignories, the abrogation of supplementary dues to the tithe, the reorganization of the Church so its wealth would be more evenly distributed among its dioceses, the administration by the state of the properties of the religious communities closed by the *afrancesado* (French collaborationist) regime, and the suppression of the Inquisition.[2] Although the Cortes were composed more of clergy than of any other estate, and the Constitution enshrined Catholicism as the state religion, the perception spread that the Cortes were fundamentally anticlerical. Because of this perception, based largely on misinformation, a campaign against the Constitution, launched in the early months of 1814, played into Fernando

VII's hands. The collapse of the first constitutional experience in Spain was in no small measure the work of the reactionary sectors of the Church, which welcomed Fernando VII's restoration on May 4, 1814, with unconcealed jubilation. All over the country, innumerable Te Deums, rogations, novenas, and processions marked the solemn occasion.[3] The alliance of Throne and Altar that made Fernando VII's regime possible was born; this drawing gives visual expression to it.[4] Goya emphasized the anonymity of the clerical throng by turning most faces away from the viewer and muting the outlines of the bodies so they almost blend together (an effect even more marked in *Album H*, page 13; G-W 1776).

During the war with the French, Liberals were astonished to find that some clergy were as keen on fighting them as the invader and had turned their ideological battle into a holy war against the constitutional cause. "¿No les ois entonar el fatal exurge? ¿No sentis el clamor rabioso de herejia, herejia! que casi sufoca el grito de salvacion de VIVA LA LIBERTAD, Y MUERAN LOS TIRANOS, ¿No los veis caminar impávidos . . . con un libro negro por escudo en el siniestro brazo, y en el derecho un tizon encendido que giran y revuelven haciendo estrambóticas culebrinas, las cuales quieren figurarnos que son fuego del cielo? . . . Contra los patriotas tiran: su empeño es destruirlos, destruir sus obras, derribar el baluarte de nuestra independencia." (Do you not hear them intoning the fatal chant? Do you not hear the rabid clamor of heresy, heresy! that almost drowns out the cry of salvation LONG LIVE LIBERTY, AND DEATH TO THE TYRANTS? Do you not see them walking fearlessly . . . with a black book for a shield in the left arm, and in their right a firebrand, which they turn and roll to make bizarre, luminous patterns they want to make us believe are fire from heaven? . . . They take aim against the patriots; their purpose is to destroy them, to destroy their work, to demolish the bulwark of our independence.)[5] Liberals may indeed have been obsessed with neutralizing the clergy and not sufficiently concerned about explaining the work they had done in Cádiz and there-

fore building up popular support for the Constitution.[6] The Duke of Wellington, one of the Cortes' harshest critics, complained: "The people of the country, at least those 20 miles from Cadiz, never think of what passes there; nor is there sufficient communication between Cadiz and the country for them even to know of your [his brother, the ambassador's] absence. The people think of nothing but getting rid of the French, and avoiding to contribute any thing towards the support of any army. And if they can accomplish these objects, they do not care much about others. . . . All [the Cortes] appear to care about, is the war against the clergy; and it appears as if the measures for carrying on the war against the enemy were incompatible with those for the prosecution of the more favorite hostilities against the priests."[7]

Under Fernando VII's reign the choicest prebends and miters were not bestowed on those who stood out for their Christian virtue, their apostolic zeal, their wisdom or learning, but on those who openly and continually sang the king's praises, demonstrated the most intolerant and exaggerated support for the monarchy, were loudest in advocating the reestablishment of the Inquisition, and most heated in recommending the jail cell for those alleged impious innovators who were responsible – according to the absolutist *Persian Manifesto* (see cat. 143) – for fomenting revolution in Spain during the king's absence.[8] Goya and Gallardo each imbued the funeral procession and chanting monks with political significance, thereby expressing the threat of anti-Liberal forces. As it happened, their worst fears were realized.

M.A.R.

1. See Sayre, *Changing Image*, p. 291.

2. See José Manuel Cuenca, *Estudios sobre la Iglesia española del XIX* (Madrid, 1973), pp. 43-44.

3. Ibid., p. 47. The bishop of Santiago was responsible for an especially sinister procession when he returned to his diocese in 1814 after having been exiled by the Cortes; he led two chained groups wearing placards reading "Impiety and Heresy" and "Iniquity and Persecution." See Callahan, *Church*, p. 112.

4. See Gallardo, *Diccionario*, p. 47.

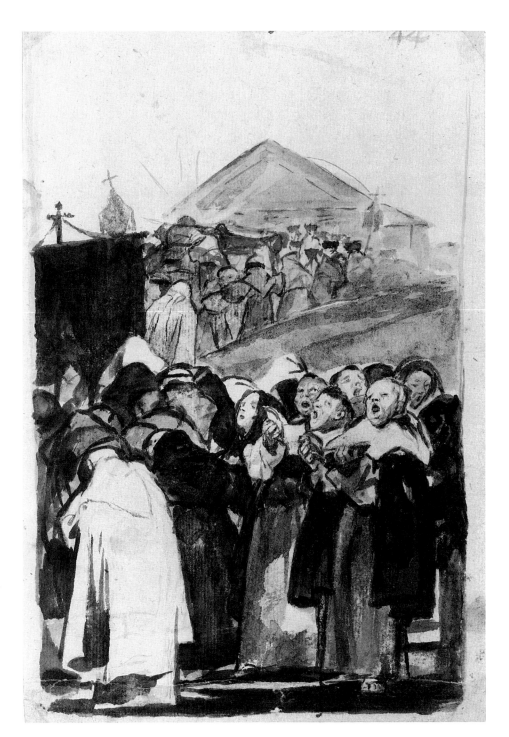

5. Ibid., pp. 6-7, 117-118.

6. The Duke of Wellington, who was not predisposed to republican principles, said of the deputies gathered at Cádiz: "We and the powers of Europe are interested in the success of the war in the Peninsula; but the creatures who govern at Cadiz appear to feel no such interest. All that they care about really is to hear the praise of their foolish Constitution. There is not one of them who does not feel that it cannot be put in practice; but their vanity is interested to force it down people's throats." *The Dispatches of Field Marshal the Duke of Wellington, During His Various Campaigns . . . , from 1799 to 1818,* comp. John Gurwood, 2nd ed. (London, 1838), vol. 11, p. 474. There is evidence that the Constitution was not much understood outside of Cádiz. Wellington commented: "The Cortes have formed a constitution very much on the principle that a painter paints a picture, viz., to be looked at; and I have not met one of the members, or any person of any description, either at Cadiz or elsewhere, who considers the constitution as the embodying of a system according to which Spain is, or can be, governed." Ibid., vol. 10, pp. 54-55. In fact, resistance to the Constitution was roused not only among the clergy; in the Basque country it was rejected because the Basques felt it breached their traditional privileges.

7. Ibid., vol. 11, p. 472. Wellington believed that if the Cortes acted too swiftly and violently against the clergy, many clerics would jump camp and support the French. Ibid., p. 474. This seems highly unlikely given the severity of the *afrancesado* government's secularization measures in comparison with those of the Cortes.

8. See Lafuente, *Historia,* p. 179. See also Martínez Albiach, *Religiosidad,* p. 465; Callahan, *Church,* p. 113. On Goya's view of the Church's role in subverting the Constitution, see cat. 161.

148

Constitutional Spain Beset by Dark Spirits
Album F, page 45
About 1817-1820
Brush and brown wash
205 x 142 mm.
Inscribed in brush and brown ink, upper right: *45*
References: G-W 1470; G., I, 315.

The Metropolitan Museum of Art, New York, Harris Brisbane Dick Fund, 35.103.30
United States only

A swath of light behind a thoughtful young woman in a simple white dress separates her from a threatening friar or monk on the left and a priest on the right. The priest wears the characteristic cassock and *sombrero de teja* (soft, wide-brimmed hat). The light the woman emits from her head penetrates the space around her and throws her enemies' grotesque faces into relief. Standing above it all is an owlish man peering through *quevedos* (spectacles) (see cat. 42 and 47). Below him a grotesque with a stupid grin looks at the young woman, while, on the left, as if in disapproval, a giant turns away from the others.

In the preceding drawing (cat. 147), the Constitution of 1812 is personified as a figure that, although dead, irradiates light. In *Album F,* page 45, a young woman incarnates the Constitution, but in her apotheosis; she will not allow herself to be buried.[1] Along with the preceding drawing and the related *Disasters of War* (cat. 161 - 163), this drawing belongs to Goya's narrative of the Calvary, burial, and rebirth of truth as manifested in the Constitution of 1812.

Although there were many exceptional Liberals in its ranks, the Church threw its institutional weight behind the restoration of Fernando VII and the Old Regime (see cat. 147). Goya's ecclesiastics undoubtedly belonged to this party. One points his finger to heaven as if to suggest they act in the name of God. But their lewd expressions and obscene positions belie the purity of their motives for attacking the Constitution.[2]

Numerous sixteenth- and seventeenth-century emblems testify to the power of those *quevedos* to transform "lo negro por blanco, lo claro por escuro, y lo falso por verdadero" (black into white, light into dark, falsehood into truth).[3] According to one commentator, whatever the person looking through the spectacles sees "conforme al a passion que la señorea, poniendose delante de los ojos de la razon, y perturbandola de manera, que si es con [aborreçimiento que se mira] aquello mismo pareçe luego malo, feo, aspero, y dificultoso" (agrees with the passion that overcomes him, which blinds the eyes of reason and perverts them in such a fashion that if [something is gazed on with . . . hate] that which is seen will therefore appear bad, ugly, sour, and problematic."[4] Goya knew opportunists were as conspicuous in crises as those who acted with integrity. Spontaneous declarations of support for Fernando VII in the form of paeans in the press, letters of congratulations, solemn processions (as in the preceding drawing), rogations, the restitution of names to the royal sites, and the imprisonment of Liberals are not evidence that the balance of popular approval favored Fernando VII because the same effusions greeted the promulgation of the Constitution by the Cortes (parliament) in 1812 and that again by General Riego in 1820.[5] In prison memoirs written after the restoration, the Liberal poet and journalist Manuel José Quintana wrote this about Spaniards' choices when the French invaded and Fernando VII abdicated in 1808: "La opinión necesariamente se debía dividir en tres partidos: uno el de ceder a la agresión francesa y sufrir la coyunda del tirano; otro el de resistirla con todos los medios y con todos los sacrificios; otro, en fin, de mantenerse a la mira, no hacer nada exclusivamente por una ni por otra causa, y estar a viva quien vence" (General opinion had to divide itself three ways: first, to acquiesce in French aggression and bear the tyrant's yoke; second, to resist the invasion using all means and making every sacrifice; third and last, to be on the lookout, to do nothing favoring one side or the other exclusively, and to be ready to cheer the winner).[6]

Goya's image of the Constitution is

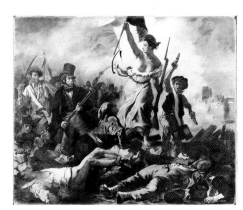

Fig. 1. Eugène Delacroix,
Le 28 Juillet: La Liberté Guidant le Peuple (July 28:
Liberty Leading the People), 1830.
Oil on canvas.
Musée du Louvre, Paris

quite different from such militant French
images as Delacroix's Liberty (fig. 1),
who is depicted as a heroic leader of the
barricades during the revolution of 1830.
Yet Goya's Constitution is no less power-
ful; her strength lies in the justice she
assures (see cat. 110 and 161). Such is
her capacity to remain alive in the minds
of many that although her enemies may
try to bury her, she rises stronger than
before. They cannot kill the memory of
her, which stands inviolate and unassaila-
ble. Though suppressed in 1814, the
Constitution was not forgotten. Virtually
every year of Fernando VII's reign was
marked by an armed uprising or plot in
favor of constitutional rule.[7]

M.A.R.

1. In the curve of her body, in the tilt of the head, in
the radiant light, and, above all, in the expression of
serene acceptance, Goya's Constitution may evoke
Claudio Coello's *Immaculate Conception* (San Jeró-
nimo, Madrid). The virginal association emphasizes
the purity of spirit, innate freedom from sin, and
unassailable integrity of the Constitution and its mak-
ers, as well as its immortality, that is, its worthiness
as an object of veneration. See also Städtische
Galerie im Städelschen Kunstinstitut, Frankfurt am
Main, *Goya: Zeichnungen und Druckgraphik*, exhib.
cat. (1981), p. 212. Her hands come together in the
traditional gesture of melancholy. For an illustration
of melancholy, see Johann Jacob Engel, *Idées sur le
geste*, vol. 1 (1795; reprint, Geneva, 1979), pl. 20, fig.
2.

2. The clerics closing ranks against the Constitution
may resemble the Black Sabbath priests described in
such seventeenth-century confessions as those of
Logroño's auto da fe of 1610, on which both Leandro
Fernández de Moratín (see N. Glendinning's essay,

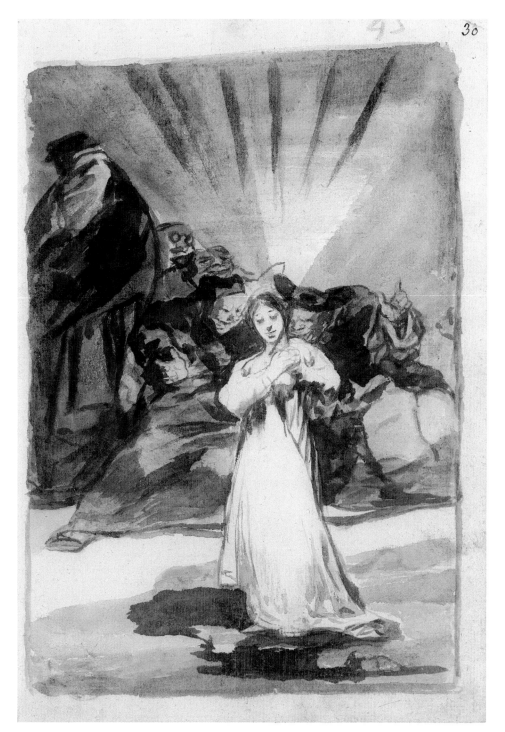

fig. 4) and Antonio Llorente (see cat. 73) commented in print. The Liberal secretary general of the Inquisition Antonio Llorente summarized the testimonies in this way: the officiating devil was said to take the shape of a man "triste, iracundo, negro y feo...los dedos todos iguales, con uñas largas, enfiladas hacia lo alto en punta; la parte superior de las manos corva como de ave de rapiña y la de los piés como de ganso...su semblante melancólico y enojado" (sad, irate, dark, and ugly, . . . the fingers are all alike, with long nails sharpened upward to a point; the upper part of the hands curves like the talons of birds of prey and the feet like those of a gander, . . . his countenance melancholic and angry). The Black Mass was a "diabolical pastiche" of the Christian ceremony, and the priest wore a black cassock and alb, received reverences from his followers on his left side, and blessed with his left hand. Llorente, *Inquisición,* vol. 3, pp. 286-303.

3. Henkel, *Emblemata,* pp. 1424-1425, under *brille.* By the eighteenth century spectacles and beards were such commonplace emblems of gravity and wisdom they had become debased by association with impostors; it was sometimes enough to say somebody wore them in order to be understood as having called that person a fake or even a hypocrite. See José de Cadalso, *Defensa de la nación española contra la Carta persiana LXXVIII de Montesquieu,* ed. Guy Mercadier (Toulouse, 1970), p. 16. See also Quevedo, *Sueños,* p. 205; Julio Caro Baroja, *El teatro popular y la magia* (Madrid, 1974), p. 16.

4. Henkel, *Emblemata,* pp. 1424-1425, under *brille.*

5. Artola, *Orígenes,* p. 626.

6. Manuel José Quintana, "Memoria," in *Quintana revolucionario,* ed. M. E. Martínez Quintero (Madrid, 1972), p. 50.

7. Espoz y Mina in 1814; Porlier in 1815; the Triangle Conspiracy in 1816; Lacy and Milans del Bosch in 1817; Vidal in 1819; and, finally, Riego, who succeeded, in 1820. See Artola, *Orígenes,* p. 631; Ferrán Soldevila, *Historia de España,* ed. J. Sales, vol. 6 (Barcelona, 1973), p. 374.

149

Construction in Progress
Album F, page 46
About 1817-1820
Brush and brown and gray-brown wash
205 x 143 mm.
Inscribed upper right in brush and
brown: *46*
References: G-W 1471; G., I, 316.

The Metropolitan Museum of Art, New York, Harris Brisbane Dick Fund, 35.103.31
Spain only

We see under construction a building whose grandiose dimensions are accentuated by the small size of the men who, in considerable numbers, are engaged in moving or placing the large blocks of stone. With a few light brushstrokes Goya suggested the wooden scaffolding, which reveals the structure of the building and the blocks and pulleys that help to raise the materials. In the foreground a group of workmen are bent under the strain of pulling ropes; behind them, highlighted, stands the man who seems to be their foreman; and on the left a man wearing a cape and top hat, who is observing the work, raises his right hand in a gesture that suggests he is in charge.

Large groups of figures do not appear in many of Goya's drawings, and, apart from the *Tauromaquia* (G-W 1149-1243), almost all are in *Album F.*[1] Goya dedicated most of his drawings to exploring the behavior and psychology of one character or the relations between two, three, or more figures. The absence of inscriptions by Goya in the *Album F* drawings makes interpretation of these even more difficult than others. In some cases, the images are sufficiently revealing, while in others, scholars' efforts have managed to establish the relations between contemporary events and the works or Goya's sources of inspiration (see cat. 144-148, 150-153).

In contrast to other *Album F* drawings with numerous figures, such as *Ice Skaters* (G-W 1456) or *Crowd in a Park* (G-W 1457), in which the main theme seems to be relaxation and leisure, in *Construction in Progress* the central theme is an example of common endeavor.[2] Goya's inten-

tion, however, remains unclear. Gassier suggested, as a hypothesis, that Goya was inspired by a real event, recording work on the Madrid Opera House, begun in 1819; since it was the largest building then under construction in the city, it must have required a great number of laborers.

The project seems to have a positive character. The tiny figures are pooling their resources to achieve a monumental structure. However, some elements of the work induce a slight unease. The elegant gentleman at the left, who seems to want to preside over the masses below, and the foreman who seems to compel rather than encourage the workers in their efforts, give rise to doubts about the optimistic nature of the scene. The immense proportions of the building recall, if only slightly, the well-known depictions of prison interiors by Piranesi, with which Goya must have been familiar. Moreover, we must bear in mind that the official constructions of the time were built by convicts and that the workers Goya would have seen at such projects were undoubtedly forced.[3] The similarity in the laborers' dress in the drawing is curious (the shirt, dark breeches, and cap recall the regulation uniform of convicts of that period),[4] as is their disposition in pairs.[5]

However, it seems unlikely that Goya would oppose forced labor for convicts, since even at the beginning of the nineteenth century this corresponded to an enlightened idea: the rehabilitation of criminals through social work.[6] This powerful image, which may be dated about 1819, could instead suggest the social structure under Fernando VII's absolutism and the return of authoritarian and enslaving forms of absolute power (see cat. 149).

M.M.M.

1. See, for example, *Ice Skaters* (G-W 1456; G., I, 301), *Crowd in a Park* (G-W 1457; G., I, 302), *Multitude Forming a Circle* (G-W 1467; G., I, 312), and *Funeral Procession for Constitutional Spain* (cat. 147).

2. G.,I, 316; see also Manuela Mena Marqués, "Un nuevo dibujo de Goya en el Museo del Prado," *Boletín del Museo del Prado* 5, no. 13 (1984), pp. 54-55 and fig. 8.

3. On the regulation of convicts and of forced laborers on public works at the end of the eighteenth century and in the nineteenth century, see Fernando Cadalso, *Instituciones penitenciarias y similares en España* (Madrid, 1922).

4. Goya represented masons in a tapestry cartoon (cat. 13) and in a cabinet painting, *The Drunken Mason*, for the Duquesa de Osuna, both in the Museo del Prado. In those works the character of the workers, who wear a variety of clothes, differs greatly from that of this *Album F* drawing.

5. Cadalso summarized the Prison Regulations for Cádiz in 1802; *Instituciones*, pp. 333-334. On the Prado Prison in Madrid, see regulations for 1805 and 1807, in which the prisoners' clothing is described as made up of a jacket, trousers, and hat; ibid., p. 234.

6. On the establishment of the Cádiz prison in 1802, it was written that "los delincuentes se corregirían por la falta de libertad, trabajo y sonrojo de estar en prisión a la vista del público" (the convicts will be reformed as a result of their lack of freedom, work, and embarrassment at being in prison in view of the public); ibid., pp. 332-333.

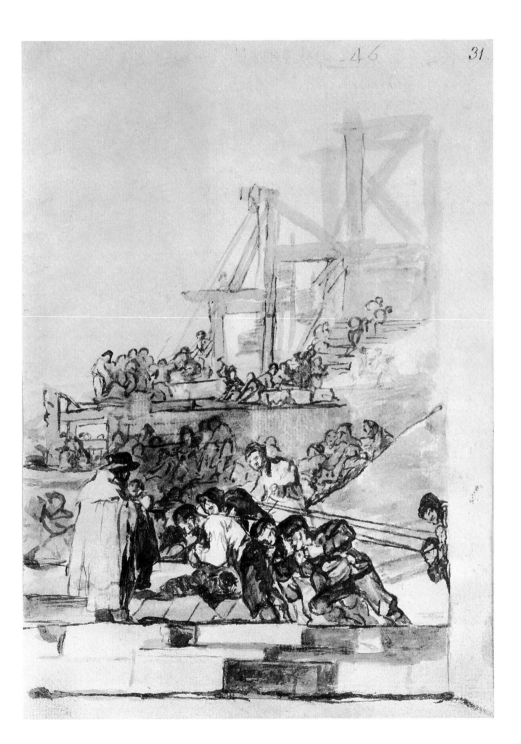

150

Gravediggers
Album F, page 51
About 1817-1820
Brush and brown and gray-brown wash
206 x 142 mm.
Inscribed in brush and gray-brown wash,
upper center: *51*
References: G-W 1472; G., I, 317.

The Metropolitan Museum of Art, New
York, Harris Brisbane Dick Fund,
35.103.32
United States only

Three powerful men strike the earth with
heavy implements (perhaps hoes). It is
plain they have been at it for awhile, hav-
ing fallen into an alternating rhythm.
Goya took pains to conceal their faces
and stress the tension in their muscles.

This work is considered a preparatory
drawing for *The Forge* (fig. 1), since the
attitudes of the three men are similar.
However, the viewpoint is much lower in
the painting; the viewer must look up at
them, so that the figures seem larger
than life. Moreover, two faces are visible
in the painting, unlike the drawing. In
the painting the men hammer at an anvil;
in the drawing they use farm tools to dig
a hole. Earlier, Goya had in fact drawn a
peasant using a hoe to break the earth
(see cat. 112). But the activities in both
the drawing and the painting seem
abstracted from reality; neither is a con-
vincing portrayal of men working in a
forge or on a farm, partly because both
are lacking in anecdotal context, but
more importantly because three men
working so closely would get in each
other's way.

In a French revolutionary print (fig. 2),[1]
the three estates – nobility, clergy, and
commoners – hammer away at the
French Constitution of 1791. Goya may
have designed his painting along the
same ideological lines but in commemo-
ration of the drafting of the Spanish Con-
stitution of 1812. The smiths' faces
resemble that of the *The Knife Grinder*
(cat. 68), which shares with *The Forge* an
absence of context. And just as the *The
Knife Grinder* refers to the role of the
common people and, in particular, the
symbolic significance of the knife as an

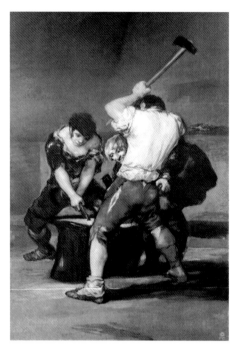

Fig. 1. *The Forge*, 1812-1819.
Oil on canvas.
Copyright The Frick Collection, New York

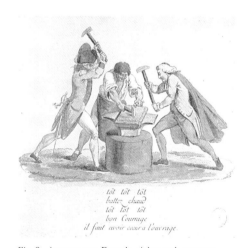

Fig. 2. Anonymous, French, eighteenth century.
. . . *il faut avoir coeur a l'ouvrage* (one must put one's
heart into the work).
Etching, hand-colored.

instrument of resistance to the French,
The Forge perhaps refers to their partici-
pation in the making of the Constitution.
Although they cannot be dated with pre-
cision, both the drawing and painting
were probably done several years after
the return of Fernando VII in 1814
because stylistically they are closer to the
"Black Paintings" than to the wartime
work of around 1812.

Supposing the French print of smiths
working at a forge as a metaphor for the
making of a Constitution or another
based on the same theme were a prece-
dent for this drawing, Goya would logi-
cally have made the proper changes to
reflect the fate of the Constitution of
1812, showing the spadework for its bur-
ial. It should come as no surprise then
that in a few drawings before this one in
Album F, Goya rather more explicitly
drew allegories of the burial and apothe-
osis of the Constitution (see cat. 147 and
148). Whether he intended all the inter-
mediate drawings as commentaries on
the vicissitudes of constitutional govern-
ment cannot be determined because sev-
eral are missing, but, in *Album F* 46 (cat.
149), a caped figure in the low-crowned
hat of the kind fashionable men wore
toward 1820 presides over a vast army of
laborers on a construction site, a work
that may represent either the restoration
of the old feudal order or, in a more sin-
ister turn, the gallows. The two drawings
that follow page 51 in *Album F* may well
support this interpretation because in 52
there is a wounded soldier and in 53 a
stabbing, in keeping with the strife and
lawlessness following Fernando VII's
restoration.

The marked anonymity of the gravedig-
gers in comparison with the smiths may
now be understandable. As Fernando
VII made his way from Valencia to
Madrid, sounding out his support among
the military and the people,
promonarchist mobs, sometimes aided by
troops, were said to stone the plaques
reading *Plaza de la Constitución* (Consti-
tution Plaza) the Cortes had decreed be
placed in the principal square and town
hall of every city.[2] Perhaps Goya chose
to portray such mobs as faceless com-
moners turned into gravediggers, a varia-

tion on a theme that appears in a slightly earlier *Album E* drawing (cat. 125).

<div align="right">M.A.R.</div>

1. Reproduced in Ernest F. Henderson, *Symbol and Satire in the French Revolution* (New York, 1912), plate 33.

2. Lafuente, *Historia*, pp. 17, 20.

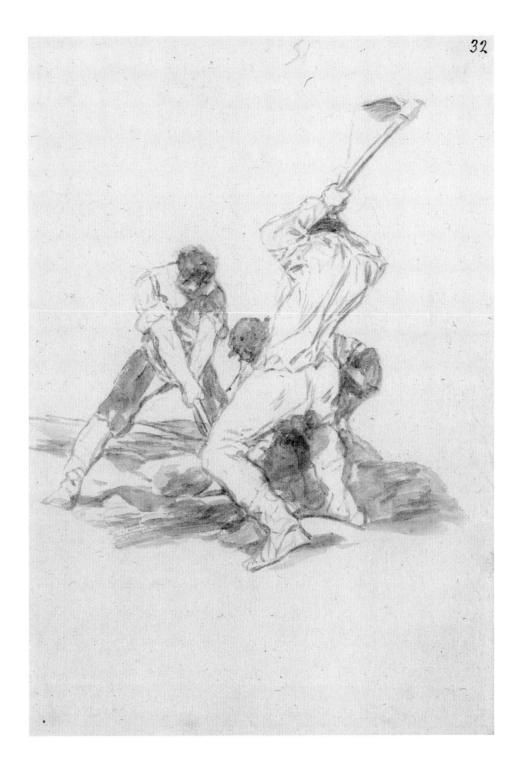

151

Cain and Abel
Album F, page 57
About 1817-1820
Brush and brown and gray wash
207 x 142 mm.
Inscribed in brush and brown wash,
upper right: *57*
References: G-W 1478; G., I, 323.

Visitors of the Ashmolean Museum,
Oxford

One powerful man clothed in skins and
brandishing a jawbone towers over a
slighter one whose head has fallen
against what is perhaps a stone altar.[1]
The frailer man is trying to fend off the
blow. The victim's limbs flow into the
assailant's; the two figures are so closely
bound that it seems removing one would
upset the other's balance. The angle of
the elbows, the expression in the eyes,
and the tilt of the head and body indicate
that the attacker, at the critical moment
when he is about to club the victim to
death, is putting all of his weight into that
blow.

The drawing is a remarkable pictorial
synthesis of the story of Cain and Abel.[2]
Cain is traditionally represented killing
Abel with a club or with an ass's jaw-
bone, most frequently the latter. Like
the Dutch sixteenth-century printmaker
Lucas van Leyden (fig. 1), Goya chose to
arm Cain with the jawbone. There is no
mention of the jawbone in Scripture; art-
ists adopted it by analogy to Samson's
use of one when he avenged the death of
his wife.[3] Cain was the elder brother and
Goya dramatized this point by emphasiz-
ing the age difference. Cain has a fuller
face, sharper features, a more mature
frame and weathered look, larger eyes,
even traces of wrinkles. Abel has more
abundant hair, softer features, and a
slighter, more youthful frame. Abel is
not only youth, but youthful innocence.
His offering of the firstlings of his flock of
sheep was accepted; Cain's of the fruit of
the ground was not. Scripture indicates
Cain erred in the form of his offering.
Suggesting an altar, as does this illustra-
tion in the eighteenth-century Scio Bible
(fig. 2),[4] Goya made Abel the sacrificial
lamb.

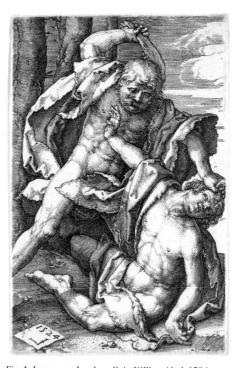

Fig. 1. Lucas van Leyden, *Cain Killing Abel*, 1524.
Engraving.
Museum of Fine Arts, Boston, Harriet Otis Cruft
Fund

Fig. 2. Mariano Brandi, *Cain mata por envidia á su
hermano Abél* (Cain Kills His Brother Abel out of
Envy), 1807-1816.

Goya probably did not intend to illus-
trate the story of Cain and Abel. Rather,
it served him as a metaphor for brutality
against innocence in the context of differ-
ences in forms of worship. Cain appears
blinded by his hate and single-minded
concentration on the clubbing. Goya
often worked a theme through variations
in his album drawings. But he did not
dwell further on the biblical attributes of
the two brothers, and the other drawings
of this series of *Album F* are modulations
on the theme of man's violence to man.
Album F, page 56, immediately preceding
this drawing, is related to Cain and Abel
in showing a man torturing another with
the *garrucha* (pulley) (see cat. 103). It
too is a bald statement of violence of the
peculiar kind that humans inflict when
others disagree with their beliefs.[5] Both
drawings seem to question the legitimacy
of creeds and institutions that, in the
quest for truth, give rise to violence,
especially when love of God is said to
move them and when they are capable of
turning brother against brother.

Fernando VII's reign was known for its
repression, treachery, vindictiveness,
uprisings, and near civil war between
Liberals and anti-constitutional Serviles,
which might account for the fratricidal
theme of Cain killing Abel. Like most
political disputes, this one was very like a
difference in religion; the language used
and the form the struggle between them
took had strong religious overtones (see
cat. 147).[6] But Goya did not set the vio-
lence in his own time nor give the fight-
ers contemporary costume. He repre-
sented the slaying in such a way that
although we might sympathize with Cain
we must ask ourselves whether there are
any circumstances that could justify such
behavior.

M.A.R.

1. This scene has been regarded as a struggle
between savages. See G., I, p. 487. But Goya's true
savages are as different from the "noble savage" as
they are from the figures in this drawing. The Prado
owns two oil paintings, *La hoguera* (The Furnace) (G-
W 927) and *La degollación* (The Beheading) (G-W
926), dating from the war period in which Goya rep-
resented savages. The faces of the savages are brut-

ish, the figures are nearly naked, and the whole impression is of a prehistoric race. In the drawing *Salvage menos q.e otros* ([He is] Less Savage than Others) (cat. B28), Goya deliberately undercut the official condescension of Enlightenment thinkers toward natives – again, the noble savage – by representing one fully clothed in skins and headdress, armed with a curved sword, and clutching a bow, all of which are sure signs of a degree of civilization. Goya's inscription could not be more ironic. Goya neither vilified the brute nor idealized the noble savage, both of which were tendencies of eighteenth-century thought. Instead, he warned us against associating moral superiority with civilized appearance. Goya showed these two figures with cut stone, out of place in a scene of neolithic savagery. Most telling, there is none of the egalitarianism, exaltation of nature, moral purity, and belief in reason as a sure guide to knowledge of good and evil that were bound up with the eighteenth-century vision of the savage. For further information on savages and the Enlightenment, see Blanco White, *Letters*, p. 466; Gallardo, *Diccionario*, p. 73; Glendinning, *Eighteenth Century*, p. 119. In Goya's time, a play called *La muerte de Abel* (The Death of Abel) by S. Gessner was staged in Madrid. See Glendinning, *Siglo XVIII*, p. 38. On ritual dressing in skins and ritual fights related to Carnival celebrations, see Caro Baroja, *Carnaval*, pp. 207-208, 225-228, respectively. And on the late medieval iconography of the savage and bibliography, see Mateo Gómez, *Sillerías*, pp. 213-221.

2. See G., I, p. 487.

3. See James Hall, *Dictionary of Subjects and Symbols in Art* (New York, 1979), p. 56.

4. Don Phelipe Scio de San Miguel, *La Biblia Vulgata Latina Traducida en Español . . .* , 3rd ed. (Madrid, 1807-1816), vol. 1, plate facing p. 29.

5. *Album F*, p. 53 (G-W 1474), illustrates a murder. Just as *Album F*, p. 57, shows the consequences of an excess of passion, the following, *Album F*, p. 58 (G-W 1479), gives its antidote, symbolized by a man restraining a bolting horse.

6. See Frederick B. Artz, *Reaction and Revolution: 1814-1832* (New York, 1934), pp. 134-136; José Luis Comellas García-Llera, *El Trienio constitucional* (Madrid, 1963), pp. 26ff; Ferrán Soldevila, *Historia de España*, ed. J. Sales (Barcelona, 1973), vol. 6, pp. 393-435.

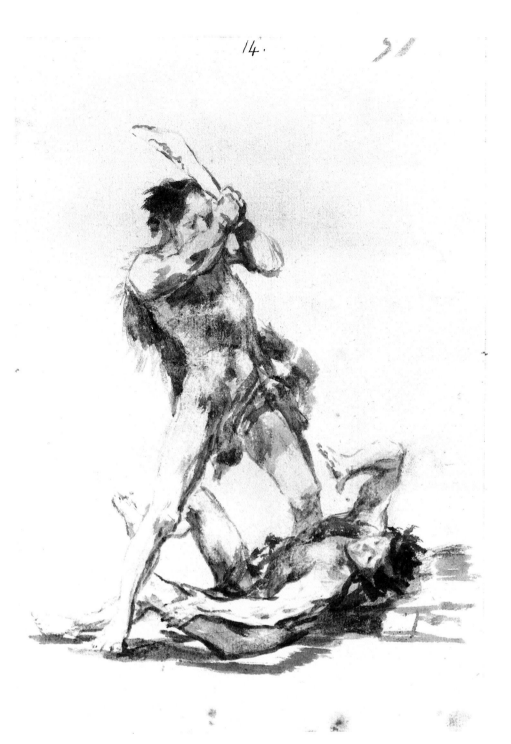

152

Death Struggle
Album F, page 73
About 1817-1820
Brush and brown wash
206 x 145 mm.
Inscribed in chalk, upper right: *73*
References: G-W 1492; G., I, 337.

Private Collection, United States
United States only

Two men, probably peasants, are locked in combat. We do not know the cause, but whatever it is, the fight appears to be to the death.

Goya could not have seen such a fight. First, it is too abstract to be realistic; there is no landscape, and the light is unearthly. Second, the anatomy is deliberately distorted. As a result, the struggle assumes a symbolic dimension.[1] The dramatic tension is intensified by the sensation of white-hot sunlight infusing the scene and bleaching the features and clothing against the dark breeches and shadows; those shadows are unnaturally deep and have a life of their own; they resemble puddles more than shadows and they are not the shadows the characters would cast in natural light. The whiteness and grip of the hands belonging to the fighter facing us, which appear to dig into the other's back as if poised to rip him apart; his unnaturally long arms wrapped round his opponent's back; the strain in the muscles of his face and legs; the tightness of his hold; and the distortion of his right leg, which is too long, too arced, and has too much torque, depersonalize these figures until they become the very embodiment of obstinacy and hate. Along with the pronounced lines of the eyes, nose, brows, and hair of the man facing us, the dissociation and exaggeration of members give the impression that this man was born to do nothing if not to drive the other into the ground, jackhammer-fashion. The disintegration of anatomy corresponds to the destructiveness of obstinacy and hate; the deadlock to futility. The difference between this and Romeyn de Hooghe's more realistic representation of how to break a hold when wrestling (fig. 1) could not be greater. In wrestling, the struggle for

domination is regulated by an overarching principle of fairness, and the fight is itself codified by rules. In Goya's drawing, ritual domination is not sufficient; only death will do.

The *Fight with Cudgels* (fig. 2), one of the "Black Paintings" Goya painted on the walls of his Madrid villa at roughly

Fig. 1. Romeyn de Hooghe, *Two Men Wrestling*, 1712, *L'Académie de l'Admirable Art de la Lutte* (The Academy of the Admirable Art of Wrestling), plate 69.
Etching.
Museum of Fine Arts, Boston, William A. Sargent Fund

Fig. 2. Duel with Cudgels, 1820-1823, "Black Paintings."
Oil.
Museo del Prado, Madrid

the same time as this drawing, and *Album G*, page 47, *Sucesos Campestres* (Things That Happen in the Countryside) (G-W 1752), bear a close thematic relation to this drawing.[2] All three are about violence committed by peasants. *Album G*, page 47, dates from after 1823 when Goya was in Bordeaux so that it seems likely it records his memory of some incident he witnessed or was told about. In the countryside it was probably not uncommon for peasants to take justice into their own hands and to settle accounts through violence. If these works were intended to convey this, they would stand in stark contrast, perhaps serve as a corrective, to the glorification of the rural life that is one of the hallmarks of Goya's generation of enlightened writers (see cat. 163).

By 1819 chaos had such a grip on the country that "in every town and village families, coteries, and individuals fought bitter feuds by intrigue and murder unhampered."[3] *Sucesos Campestres* is the best evidence we have by Goya's hand of vigilante justice filling a power vacuum left by Fernando VII's rule, which had the effect of polarizing Spaniards into two irreconcilable camps.[4] Unlike *Sucesos Campestres* this drawing comes to no resolution. Its tragedy lies in the disfiguring of humanity by passions that have found no more rational or orderly release. For a drawing about a fight, there is very little sense of movement; Goya represented the men in a

deadlock. Mutual hatred is sterile and can only bring them to a standstill.[5]

M.A.R.

1. On the agony or dispute between light and darkness as it appears in Carnival celebrations and in classical Greek tragedy, see Caro Baroja, *Carnaval*, p. 266. Representations of fighting men in Spain are found as early as the Middle Ages. Medieval legal, moral, and literary texts suggest these images embody irascibility, vengeance, and the inclination to provoke or resolve disputes by fighting: in a word, the spirit of Anger or Wrath. Like Goya's drawing, this tradition is not realistic, but conceptual; the fight is an expression of an idea. Unlike Goya's, traditional images of fights are religious allegories; see Mateo Gómez, *Sillerías*, pp. 184-186, 319-323, 395-397. In giving one of his fighters dark pants and the other white, Goya may have enriched this traditional picture of Wrath by recalling the struggle between the Liberals – the blacks – and the Serviles – the whites – that made of Fernando VII's reign a tissue of uprisings and lawlessness; see Ferrán Soldevila, *Historia de España*, ed. J. Sales (Barcelona, 1973), vol. 6, p. 362. See also cat. 151, n. 5, for other sources on this period.

2. See F.J. Sánchez Cantón, *Goya*, trans. Henry Mins (New York, 1964), pls. 33-35. On cudgeling and laws prohibiting it in Goya's time, see Kany, *Life and Manners*, p. 282. In some villages of Salamanca, ritual fights between young men of neighboring villages armed with *podones* (mattocks) did not end till someone died; see Caro Baroja, *Carnaval*, p. 228.

3. Hermann Baumgarten, *Geschichte Spaniens . . .* (Leipzig, 1865-1872), quoted by F.D. Klingender, *Goya in the Democratic Tradition* (New York, 1968), p. 159. On revenge killings in the name of patriotism during the war with the French, see Blanco White, *Letters*, p. 439. Liberal and Servile secret societies flourished in Fernando VII's reign. The country was plagued in the latter years of his reign with roving bands of thieves and bandits, which mocked official justice and made every citizen responsible for his own welfare, particularly in the more remote areas of the countryside; see Lafuente, *Historia*, pp. 255, 258.

4. In a contemporary fable about two wolves, the commentary says: "¿Como obedecer la ley / el pueblo rudo podrá / quando no la obedece quien la dá" (How can the simple people / obey the law / when he who gives it doesn't)? D.C. de B***, *Fabulas politicas* (London, 1813), fable 17. Biblioteca Nacional, Madrid, R62076.

5. In another contemporary fable on a war between animals for the ownership of certain lands, the commentary says: "¡Quantas veces los hombres neciamente / suelen unos à otros destrozarse, / y el imbecil, lo mismo que el valiente / sin lo que causa su rencor quedarse" (How often have men foolishly / sought to destroy each other, / the idiot as often as the worthy / for a prize that nobody won)! D.C. de B***, *Fabulas politicas*(London, 1813), fable 25. Biblioteca Nacional, Madrid, R62076.

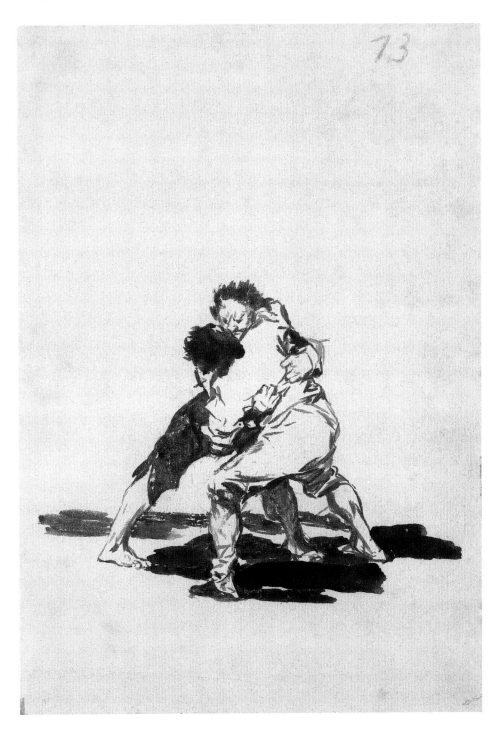

153

Pygmalion and Galatea
Album F, **page 90**
About 1817-1820
Brush and brown wash
Inscribed, in brush and brown, upper right: *90*
205 x 150 mm.
Reference: G., II, Album F, Lost drawings [i]

The J. Paul Getty Museum, Malibu, California, 85.GA.217
United States only

In a drawing first published in 1877 as *Un Sculpteur* (A Sculptor),[1] an artist is seen adding the final touch to a statue. At first sight this title seems more legitimate than the one given above, since the legend of Pygmalion and Galatea was related by Ovid in the *Metamorphoses,* whereas the sculptor shown here does not wear classical dress. According to Ovid, Pygmalion, an extraordinarily gifted sculptor, had carved a female figure out of ivory that he admired, loved, adorned with jewels, dressed and treated as though she were real. He prayed to Venus that he might have such a wife. Venus granted his wish and, at the instant that he kissed the statue on its lips, it came to life as Galatea, who blushed, and in due time bore him a daughter.[2]

The legend was illustrated a number of times in Goya's day, owing in part to the taste for classical themes and in part to the enormous popularity of an innovative brief drama by Jean-Jacques Rousseau (first performed in 1770), *Pygmalion; scène lyrique,* interspersed with music describing the feelings of the two protagonists.[3] Most of the play consists of a long soliloquy by Pygmalion. He is in his studio with blocks of marble and works he cannot finish. He longs to work but fears that, though still young, his creative genius is extinct and, for this reason, he has concealed his masterpiece behind a veil lest the sight of this monument to the glory of his hands make it impossible for him to carve anything more; he asks himself whether what he feels is admiration for the statue or pride that he created it. Trembling, he draws aside the veil to

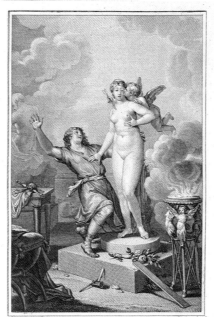

Fig. 1. Louis François Mariage after Jean-Michel Moreau le jeune,
Ce n'est plus une illusion. . . .
Engraving, in *Les Métamorphoses d'Ovide . . .,* Paris, 1806.

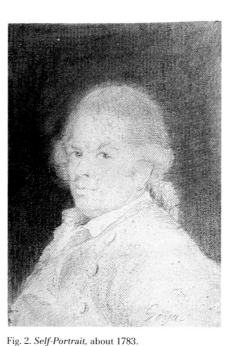

Fig. 2. *Self-Portrait,* about 1783.
Graphite.
Museum of Fine Arts, Boston, Gift of the Frederick J. Kennedy Memorial Foundation

examine the statue for any imperfection. Pygmalion then says: "Je vois un défaut; ce vêtement couvre trop le nud; il faut l'échancrer davantage: les charmes qu'il recèle doivent être mieux annoncés." (I perceive a defect; this dress is too concealing; it must be cut lower: the charms it suggests must be more clearly stated.)[4] With difficulty he summons the courage to rectify the bodice, and it is when he touches it with his chisel that Galatea comes to life. Although all Rousseau's works were prohibited in Spain, an exception was made of *Pygmalion.* It was performed publicly in Spanish as early as 1788; and with the omission of Rousseau's name, various translations, some free, amplified, or both, appeared in print.[5]

Eighteenth-century illustrators seem to have been universally correct in trying to depict the Pygmalion and Galatea of both Ovid and Rousseau in classical dress, such as, for example, Jean-Michel Moreau le jeune in designing a plate for the *Metamorphoses* (fig. 1).[6] Moreau chose the moment when the sculptor discovered to his amazement that the ivory statue had become a human being and felt the living flesh. As Cupid whispered in her ear and pierced her with an arrow, she became aware of her sexuality and, with an expression of astonishment, touched her breast, meanwhile keeping Pygmalion at a distance.

In Goya's drawing it is plain that the statue is in the process of undergoing change. The arm and lower part of the body still have the rigid stillness of a carved image, but the head and even the breast seem alive. The work does not seem to be made of ivory, as in Ovid's original, but has the monumentality of Rousseau's marble; and indeed the tools Pygmalion is using are suited to stone. The cloth slanting across the foreground also suggests that Rousseau's play was Goya's immediate source since the motif of concealing the statue behind a veil was the Frenchman's invention. Psychologically Goya's depiction of Galatea's reaction is more sensitive and complex than that of either author, for her eyes are wide, and she looks puzzled and slightly apprehensive at what is happening to her. On the other hand Goya's manner of

suggesting the cause of Galatea's trans-
formation is more basic: it was neither
Ovid's kiss on the lips nor Rousseau's
touching of a breast, but a forthright
blow given by Pygmalion with mallet and
chisel on another part of the body. Since
the compositional organization calls
attention to these tools, one may suppose
that Goya was referring to the fact that
escoplo (chisel) and *mazo* (mallet) could
signify the male organ.[7] The unwork-
manlike stance of the sculptor is empha-
sized by a dark outline. It, too, consti-
tutes a visual pun, on the word *cabalgar*
(to ride), which signified to copulate.

To an art historian, Pygmalion's cos-
tume appears to be of the seventeenth
century and Galatea's of the fourteenth.
For Goya, observant about contemporary
clothing but notoriously inexact about
that of the past,[8] their dress was
intended, like the carved piece of furni-
ture, merely to indicate a bygone Spanish
age. His choice of such dress suggests
that he interwove a second meaning into
the legend. Pygmalion has been recast as
a sculptor whose work Goya himself
admired. Despite the anachronistic date
of the clothes, a likely candidate is the
Florentine Pietro Torrigiano (1472-1528),
who died in Seville. In the eighteenth
century his work was compared with that
of Michelangelo.[9] Vasari wrote that Tor-
rigiano was accused of heresy by the
Duque de Arcos for having attacked a
statue of the Virgin and Child he had
carved for the noble. The artist was
angry that he had been paid an insult-
ingly small recompense for what he knew
to be a masterpiece, and he broke it in
pieces. Torrigiano died in the Inquisition
prison by starving himself,[10] an event
Goya had depicted in *Album C, No comas
celebre Torregiano* (Don't eat, renowned
Torrigiano).[11] His best-known sculpture
in Spain was a life-sized terracotta, *Saint
Jerome*, at the monastery of San Jeró-
nimo in Seville.[12] In describing this
sculpture in his dictionary of Spanish art-
ists, Juan Augustín Ceán Bermudez
repeated what Goya had said to him:
"Todo quanto se ve en esta estatua es
grande y admirable: todo está executado
con acierto despues de una profunda
meditacion: todo significa mucho, y nada
hay en ella que no corresponda al todo.

Por tanto, no solamente es la mejor pieza de escultura moderna que hay en España, sino que se duda la haya mejor que ella en Italia despues de sus conquistas." (Everything about this statue is great and admirable: everything is well carried out after a profound meditation: everything is full of meaning, and there is nothing in it which does not correspond to the whole. As a result, not only is it the best example of modern sculpture in Spain, but it is doubtful that anything surpasses it in Italy after the conquests.) Céan added that Goya "á nuestra presencia la exâminó, subiendo á la gruta en que está colocada, en dos distintas ocasiones, deteniéndose en cada una mas de cinco quartos de hora" (examined it in our presence, climbing into the grotto in which it stands, on two separate occasions, remaining each time more than an hour and a quarter).[13]

In Goya's drawing, the face of the sculptor, with its deep-set eyes and snub nose, is reminiscent of his own, not as he looked at the time but some thirty years earlier (fig. 2).[14] Pygmalion's statue of Galatea, a marvelous work of art, had been granted life and bore the sculptor a daughter.[15] The legend has survived but none of Pygmalion's statues. Yet surely he would have belonged to that small number of artists of whom one might say that their creations have a life apart from the maker for they endure on their own through succeeding centuries, the power of their presence undiminished. If Goya showed himself here as sculptor, doubtless it was because he understood his own genius and knew that he, like Pygmalion and Torregiano, was capable of creating works of art that had an abundant measure of the essence of life.

For years the drawing was in a Paris collection. It is possible that Picasso saw it, for the prints he etched between 1933 and 1934 enlarge on Goya's theme and show a preoccupation with the independence of works of art.[16] A sculpture may have more presence than the model who posed for it, or even than the man who created it;[17] a sculpted head is capable of mute but cogent comment on models or on the attraction between artist and model.[18] Painter and painting may become inextricably intertwined, so that

Fig. 3. Pablo Picasso,
Standing Nude and Portrait of Rembrandt with Palette.
Etching.
Museum of Fine Arts, Boston, Lee M. Friedman Fund and Gift of William A. Coolidge

Rembrandt, or possibly Picasso in the guise of Rembrandt, is seen simultaneously as himself and as his painted portrait, stretching out his hand from the canvas to take that of a model (fig. 3).[19]

E.A.S.

1. Hôtel Drouot, Paris, sale, *Catalogue de 105 dessins par Goya*, April 3, 1877, no. 54.

2. Ovid *Metamorhoses* 10. 239-297 (Loeb Classical Library).

3. Jean-Jacques Rousseau, *Collection complette des oeuvres*, vol. 7 (London [Brussels], 1776), pp. 45-52. Written in 1762, the play swept Europe. The author's concept that declamation, recitative, gesture, and music should all function equally was imitated; see Jefferson Rea Spell, *Rousseau in the Spanish World before 1833* (Austin, 1938), pp. 117-127.

4. Rousseau, *Collection complette*, vol. 7, p. 47.

5. In Cádiz; see Spell, *Rousseau*, p. 121; on the various early Spanish editions, see pp. 119-124; 292-293. On the statement by a member of the French legation that the Inquisition found no less than sixteen heretical assertions in the piece, see pp. 119-120, and n. 12.

6. *Ce n'est plus une illusion: c'est un corps qui respire, et dont les veines s'enflent mollement sous les doigts.* Engraving by Louis François Mariage after Jean-Michel Moreau le jeune (1741-1814), in *Les Métamorphoses d'Ovide, traduction nouvelle avec le texte latin, suivie d'une analyse de l'explication des*

fables, trans. M.G.T. Villenave (Paris, 1806), vol. 3, facing p. 320; Emmanuel Bocher, *Jean-Michel Moreau le jeune* (Paris, 1882), no. 1273, fourth state.

Moreau had illustrated the legend before: a series of vignettes for Arnaud Berquin's versification, *Pygmalion, Scène Lyrique de Mr J.J. Rousseau* (Paris, 1775) (Bocher nos. 300-305); and the following year in Rousseau, *Collection complette*, vol. 7, facing p. 45 (Bocher no. 1484).

7. See Cela, *Diccionario secreto*, vol 2, pt. 2, p. 352, under *mazo*; vol 1, pt. 2, pp. 284-285, under *escolpo*.

8. In the *Tauromaquia*, of 1816, the dress of Carlos V (died 1558), seen in plate 10, and of Rodríguez Díaz de Bivar, "El Cid" (died 1099), plate 11, are quite similar; G-W 1167, 1171; H. 213, 214. However, when Ceán Bermúdez had recommended Goya in 1817 to the Chapter of the cathedral at Seville to paint the saints Justa and Rufina, he was afterwards able to report that, before beginning, the artist "hizo lo que debe hacer todo Pintor, que desea instruirse para no caer en anacronismos ni en otros defectos históricos (collected the information that every painter needs if he wants to avoid anachronisms and other errors of fact). See Nigel Glendinning, *Goya and His Critics* (New Haven, 1977), pp. 56, 288; and Juan Agustín Ceán Bermúdez, *Análisis de un cuadro que pintó D. Francisco Goya para la catedral de Sevilla* (Madrid, 1817), p. 4.

9. See Antonio Ponz, *Viaje de España; seguido de los dos tomos del viaje fuera de España*, ed. Casto María del Rivero (Madrid, 1947), vol. 9, letter 5, para. 17, p. 801.

10. Giorgio Vasari, *Lives of the Most Eminent Painters, Sculptors and Architects, Translated from the Italian*, ed. Mrs. Jonathan Foster (London, 1890-1892), vol. 2, pp. 487-488.

11. *Album C*, page 100, about 1810-1814; Prado, Madrid, 339; G-W 1336; G., I, 245.

12. The terracotta is now in the Museo Provincial de Bellas Artes, Seville.

13. Juan Agustín Ceán Bermúdez, *Diccionario histórico de los mas ilustres profesores de las bellas artes en España* (Madrid, 1800), vol. 5, pp. 68-69. Neither the lion nor the pedestal was believed to be by Torrigiano. Although Ceán based his account of Torrigiano on that in Vasari's *Lives*, he was skeptical of various aspects of it. He thought it more likely that the sculptor was denounced to the Inquisition for his rudeness to the Duque de Arcos than for breaking the statue of the Virgin; ibid., pp. 66-67.

14. Self-Portrait, about 1783, graphite; the signature and probably the dark background are posthumous. Museum of Fine Arts, Boston, Gift of the Frederick J. Kennedy Memorial Foundation, 1973.699; G-W 202; G., II, 316

15. Ovid *Metamorphoses* 10. 296-297.

16. See Bernard Geiser, *Picasso, Peintre-Graveur*, vol. 2: *Catalogue raisonné de l'oeuvre gravé et des monotypes, 1932-1934* (Berne, 1968). The preoccupation is notable between March 15, 1933, and March 10, 1934; see nos. 197-424.

17. See, for example, Picasso's etching of Mar. 21, 1933; ibid., no. 304.

18. See, for example, Picasso's etchings of Apr. 1, Apr. 3, May 5, 1933, and Mar. 10, 1934; ibid., nos. 323, 325, 347, and 424.

19. Standing Nude and Portrait of Rembrandt with Palette, etching, Jan. 31, 1934, Museum of Fine Arts, Boston, Lee M. Friedman Fund and Gift of William A. Coolidge, 1974.399; ibid., no. 413.

154

Extraña devocion! (Strange Devotion!)
Fatales consequencias de la sangrienta guerra en España con Buonaparte. Y otros caprichos enfaticos [Disasters of War], plate 66
Working proof
About 1820-1823
Etching, touched with graphite
175 x 220 mm.
References: G-W 1106; H. 186, I, 2.

Museum of Fine Arts, Boston, 1951
Purchase Fund, 51.1686
United States only

Lay people kneel before a glass coffin borne by a donkey; the bells announce its coming. Inside is an intact corpse. In the background to the left are two other figures, one perhaps in an ecclesiastical habit, watching the crowd's response.

The donkey bearing something precious was a common theme in fables. This print has been interpreted as a moral satire on vanity, based on versions of the fable by Goya's contemporaries Félix María Samaniego and Ibáñez de la Rentería.[1] Although these sources may have suggested the idea of a donkey with relics to Goya, it seems a broader explanation is needed to account for the print's place within the *Disasters of War* and, in particular, its connection with *Esta no lo es menos* (This is no less so) (fig. 1), to which it is linked by the title.

Scholars have also interpreted both prints as enlightened criticism of the cult of processions and relics.[2] The English traveler Joseph Townsend described a typical Holy Week procession in Barcelona around 1787: "One hundred and four score penitents engaged my attention. . . . These were followed by twenty others, who walked in the procession bare-footed, dragging heavy chains, and bearing large crosses on their shoulders. . . . Immediately after them followed the sacred corpse, placed in a glass coffin, and attended by twenty-five priests."[3] In Goya's print the body may be that of the discalced Mercedarian nun Mariana de Jesús, beatified by Pius VI in 1783 and the object of popular devotion. Her body was kept in the Mercedarian convent in Madrid and was moved in

Fig. 1. *Esta no lo es menos* (This is no less so), *Disasters of War*, plate 67.
Working proof.
Etching.
Norton Simon Museum of Art, Pasadena

1809.[4] In *Esta no lo es menos* Goya depicted effigies of Nuestra Señora de la Soledad in the foreground and, in the background, the Virgen de Atocha, a black virgin much revered by both the people and Fernando VII. Both are being carried into a church.[5]

But neither print is a realistic rendering of a religious event. In *Extraña devocion!* there is no sign of banners, penitents, or other characteristics of a procession normally accompanying a relic. The donkey, a few laypeople, and those observers at the left are abstracted from such a possible context. In *Esta no lo es menos*, two bowed, decrepit aristocrats in oversize and outdated clothing bear the image indecorously tipped on its side, revealing the casters and wooden frame on which its trappings are draped.[6] Members of artisan guilds and *cofradías* (brotherhoods), not nobles, would ordinarily have carried processional images.[7] The aged figures and the old-fashioned dress correspond to a backwardness in mentality.[8] Goya had developed this idea explicitly in *Sueño 16, Crecer despues de morir* (To Grow after Dying) (cat. 62, fig. 2), in which a blind (ignorant), gargantuan, tottering aristocrat in oldfashioned clothing (see cat. 157) is held up by his lackeys. Goya meant, perhaps, to comment on the persistence of noble privileges regarded as honorific and hereditary rather than as rewards for service to society or for merit and the nobility's fail-

ure to adapt to a changing society.

Disasters 66 and 67 belong to that part of the series that Goya thought of as *caprichos enfaticos*, that is, as works of the imagination containing veiled meanings.[9] The aged and bowed men bearing the devotional images may well represent the Servile supporters of absolutist monarchy. According to Goya's inscription to the series, the second part of the *Disasters* records the consequences of the war with Napoleon (see cat. 156-163). It is reasonable then to assume these prints correspond to events leading up to and following Fernando VII's restoration, whereupon the seignorial system, along with the special legal and economic status it conferred on the Church and the aristocracy, was restored, as were guild regulations and the monasteries; proof of nobility was also again required of military officers. A similar reaction took place throughout Europe after Napoleon's defeat.[10] On May 4, 1814, Fernando VII issued his infamous decree abolishing the Constitution: "Mi real ánimo es . . . declarar aquella Constitución y aquellos decretos nulos y de ningún valor ni efecto, ahora ni en tiempo alguno, como si no hubiesen pasado jamás tales actos y se quitasen de en medio del tiempo" (My royal will is . . . to declare that Constitution and those decrees null and void, now and forever, as if such acts had never taken place, and they were removed from time).[11] He intended to uproot the constitutional system and Liberal commentators understood this: "Quien vió el Madrid y la España de 1815, con sus pretensiones á ser fiel renovacion de lo antiguo, se forma de lo pasado una idea, cuando no mucho, bastante equivocada. Los que aspiran á resucitar muertos no estando dotado por Dios del dón de hacer milagros . . . equivocan un cadáver galvanizado con un cuerpo venido á vida nueva. Fué muy duro el golpe, llegó á penetrar muy en lo hondo el movimiento que recibieron nuestra monarquía y nuestra sociedad en 1808, y desde entónces hasta 1814, para que pudiesen tener efecto cumplido los deseos y conatos de quienes querian pasar por encima de seis años, y no años ordinarios, como si tal hueco no hubiese existido." (Whoever knew the Madrid and Spain of 1815, with their pretensions of being faithful restorations of the old, will form an idea of the past that is rather mistaken, though not excessively. Those who aspire to revive the dead, not being endowed by God with the ability to do miracles, . . . mistake a galvanized body for one resurrected to new life. The blow was sharp, the repercussions affecting our monarchy and our society in 1808, and thereafter until 1814, penetrated too deeply for the desires and endeavors of those who wished to overlook six years, which were not ordinary years, to be realized as if such a period had never existed.)[12]

A distinctive aspect of *Extraña devocion!* is the reluctant submission of the people. Utter abjection does not seem the appropriate response to a relic, however venerated. The man in the foreground at the left clenches his right fist as if in impotent anger, and the muscles of his back, which is highlighted in this working proof, are tense, too. The Liberal commentator quoted above suggested a return to the old economic, political, and psychological norms was impossible, equivalent to breathing life into a corpse.[13] In this context the print takes on a new significance. Processions such as this one had long been deemed an unseemly expression of devotion by such enlightened clerics as the Benedictine Padre Feijóo and the Jesuit Padre Isla and had been condemned by both the enlightened monarchy and the Inquisition. The archaic religious practice was scorned by Goya as well, but for him it also symbolized Fernando VII's absurd attempt to turn back the clock. Old Regime institutions were artificially preserved, largely by the collaboration of a repressive military and the Church (see cat. 160). The people were compelled to submit to a ritual and hierarchy that had lost its meaning. It is not by chance that a donkey, symbol of ignorance, bears the corpse; the regime's survival was based upon the veneration of ignorance through the kind of hollow ritual depicted in this print and in *Disaster* 67 (see also cat. 155). That strange devotion to which Goya's title refers is to a bankrupt past.

M.A.R.

1. According to this interpretation, the donkey believes the crowd is worshiping it instead of the sacred object on its back. See Nigel Glendinning, "El asno cargado de reliquias en los *Desastres de la Guerra*, de Goya," *Archivo Español de Arte* 35, no. 139 (1962), pp. 224ff, who quotes Samaniego's and Ibáñez de la Rentería's fables in full. The donkey traditionally represented stupidity, ignorance, and obstinacy. See Mateo Gómez, *Sillerías*, p. 44. On possible emblematic sources for this print, see Roberto Alcalá Flecha, "Fuentes emblemáticas del asno cargado de reliquias," *Goya*, nos. 167-168 (1982), pp. 274-278.

2. See Glendinning, "El asno cargado de reliquias," p. 223.

3. Quoted in Callahan, *Church*, p. 56.

4. See Ramón Mesonero Romanos, *Manual de Madrid: Descripción de la Villa y de la Corte* (Madrid, 1831), p. 155. There are numerous prints of her image in the Museo Municipal in Madrid, testifying to her popularity. On her transfer, see *Gaceta de Madrid*, June 2, 1809, p. 718.

5. On the Virgen de Atocha, see Mesonero Romanos, *Manual de Madrid*, p. 148. See Ministerio de Cultura, Madrid, *Estampas: Cinco siglos de imagen impresa*, exhib. cat. (1981), for an image of Fernando VII praying before the Virgen de Atocha. For a print of Nuestra Señora de la Soledad, see A. Bonet Correa, *Vida y obra de Fray Matías de Irala: Grabador y tratadista español del siglo XVIII* (Madrid, 1980).

6. Plate 67 recalls *Capricho* 52, *Lo que puede un sastre* (What a Tailor Can Do) (G-W 555) in its suggestion of the power of appearance – or disguise – to inspire faith in the credulous. See cat. 172 for an account of Holy Week processional figures in Seville.

7. See Blanco White, *Letters*, p. 30.

8. Some aristocrats who figured as leaders of the anticonstitutional cause, such as the Marqués de Villafranés, dressed in the traditional style. See Glendinning, "El asno cargado de reliquias," p. 227, n. 12. Don Francisco Eguía, Fernando VII's Capitán General of New Castile, who represented all that was reactionary both in ideas and manners, was called *Coletilla* (Pigtail), since he wore his hair gathered and tied in the back as in Carlos III's time. See Lafuente, *Historia*, p. 18.

9. See Nigel Glendinning, "A Solution to the Enigma of Goya's 'Emphatic Caprices,'" *Apollo* 107 (Mar. 1978), p. 186.

10. On the Holy Alliance of reactionary powers, see Frederick B. Artz, *Reaction and Revolution* (New York, 1934), pp. 117-118.

11. Quoted in Lafuente, *Historia*, p. 417.

12. Alcalá Galiano, *Recuerdos*, pp. 80-81, 258.

13. Ibid., pp. 80-81.

155

Que locura! (What Folly!)
Fatales consequencias de la sangrienta guerra en España con Buonaparte. Y otros caprichos enfaticos [Disasters of War], plate 68
Working proof
About 1820-1823
Etching
160 x 220 mm.
References: G-W 1110; H. 188, I, 1.

Museum of Fine Arts, Boston, 1951
Purchase Fund, 51.1687
United States only

A monk crouches to relieve himself. He has been eating, for there is a spoon in his hand. At his side is a chamber pot. An incongruous heap of religious artifacts – including a dummy in female dress, holy images, devotional offerings such as crutches, effigies of limbs, and trousers – is stacked at the right; the cleric turns his head toward the pile of masks on the floor. A procession of brothers files toward the left in the darkness behind him; in the right background, a swollen-faced old woman with a shawl draped over her head clasps her hands to her breast as a man next to her raises his hands with fingers interlocked in the traditional gesture of exclamation.[1]

The monk's spoon evokes the expression *comer la sopa boba* (to eat the daily portion of soup for the poor), that is, to live at the expense of another, a staple insult of the anticlerical literature of Goya's time.[2] A few years later, in the *Album G* drawing (see page 00, fig. 6), *Comer mucho* (To Eat a Lot), a monk defecates; the title is the beginning of an expression that ends *cagar mejor* (and shit better).[3] The only signs of piety in *Que locura!* are the ghostly procession and the devotional offerings. But processions were often said to dissolve into irreverence and drunkenness (see cat. 173), and the paintings and dummy – which lacks a head so that its falsity stands out all the more (see cat. 154) – were sometimes regarded as hoaxes intended to amuse common people or enslave their minds with superstitious beliefs (see cat. 139). The crutches were given as devotional offerings following

Fig. 1. *O S^te brague* (O Holy Breeches),
Album C, page 81.
About 1808-1814.
Black and gray wash.
Museo del Prado, Madrid

miraculous cures; one of them rises out of a pair of trousers standing in a position that recalls the expression *cabalgar* (to ride a horse), that is, to engage in intercourse, which indicates a person cured of syphilis has given thanks.

In a later drawing, *Album C* 81, *O S^te brague* (O Holy Breeches) (fig. 1), breeches are raised by a cleric as if they were a holy processional banner. The moral reputation of the lower clergy, particularly the friars, was not generally high (see cat. 53 and 111, n. 5).[4] Goya's cleric turns his head toward an abundance of masks, perhaps an echo of Quevedo's punning remark about hypocrites who counted "las caras que tenían, y espantábanse que les sobrasen tantas habiendo vivido descaradamente" (the faces they had and were astonished at the surfeit having lived so shamelessly [literally, without face]).[5] The monk's disrespect for the religious artifacts is evident, since they are not being displayed carefully but gather dust in the lowest of places.[6] "Una imagen de Cristo

o de la Virgen se ven en un rincón descuidada, sucia y sin culto, al paso que otras se ostentan en costosos retablos y no se muestran sino con muchas ceremonias y gran suntuosidad" (An image of Christ or of the Virgin lies neglected in a corner, dirty and lacking worshipers, while others are displayed ostentatiously on costly retables and are not shown but with great ceremony and much sumptuousness).[7] The monk seems to view the devotional paraphernalia simply as the tools of his trade, which allow him to live well fooling people who do not know better. "La luz no ofende á la verdad; pero ofende á los que viven de errores populares" (Light cannot offend truth, but it offends those who live off popular errors).[8]

Among the proliferating rites Liberals criticized because they took advantage of the credulous were false miracles and the propagation of apocryphal legends, "ya para atraer las ofrendas con la opinion de curaciones milagrosas, ya para conservar los bienes adquiridos" (whether to attract offerings in exchange for the hope of miraculous cures or to protect goods already amassed).[9] Lower-class men did often join the orders so as to escape a life of menial labor; this gave rise to a reputation for – if not a reality of – grossness, vice, and hypocrisy, symbolized perhaps by the masks in this print (see also cat. 39 and 41).[10]

During the Enlightenment the Church – particularly such orders as the Dominican, linked to the Inquisition – was held responsible for cooperating with despotic governments in order to maintain people in ignorance, submissive to both Church and state. Above all, monks and friars were considered useless, parasitic, and an impediment to national prosperity (see cat. 163).[11] "De 24 millones de habitantes que cuenta el imperio español, los que producen no son tantos como los que consumen: mas claro, todos comen, pero ¿quien trabaja" (Of 24 million inhabitants in the Spanish empire, those who produce are not as numerous as those who consume: to put it more clearly, everybody eats, but who works)? The culprits were often thought to be "monasterios, cabildos y otros establecimientos" (monasteries, cathedral

chapters, and other foundations).[12] Gross misconduct was, in fact, rare, but in an increasingly Liberal and utilitarian society, monks and friars could no longer count on the habit to shield them from searching questions about their private morality and public utility.[13]

Fray Luis de Granada, the Golden Age author of the classic *Guía de pecadores* (Guide for Sinners), had distinguished between spiritual and carnal men in this way: "'En esto se diferencian los hombres *carnales* de los *espirituales*: que los unos, a manera de bestias brutas, se mueven por estos afectos (*los de carne y sangre*), y los otros, por el *espíritu* de Dios y *por razón*'" (This is the difference between *carnal* and *spiritual* men: the former are moved by the passions [*those of flesh and blood*], after the fashion of brutish beasts, the latter by the *spirit* of God and *by reason*).[14] Thus, carnality included not only acting in a manner opposed to the Christian spirit, but also committing irrational, even mad, acts.[15] Residues of man's irrationality – poor education, false devotion, superstitious beliefs – abound in this print. Goya's title suggests this monk is indeed acting irrationally as well as subverting the Christian principles of moderation and the contemplative life. Typical of the Enlightenment was the belief that error arose from ignorance (see cat. 157). The power of hypocrisy unchecked by reason (or justice) to endow vice with the appearance of virtue is perhaps one form of the folly to which Goya's title refers. This monk's religion is dictated by his appetite; his sacred vows cannot save him because his religion amounts to no more than a superstition he uses to deceive others. The sanctity of the holy images and devotional offerings should serve as antidote to what the chamber

pot and masks symbolize, but for this monk they are expressions of the same. The natural priorities of the spiritual and physical world expected in a minister of God are inverted. This inversion, along with the masks, is perhaps meant to recall Carnival's subversion of the established order. But Carnival was transient; the folly here is not. As in Carnival parodies of Church dignitaries, Goya's monk has become an obscene parody of what a true cleric should be.[16]

The anticlerical literature of 1820 to 1823 set out to demythologize the tithe, Church properties, and, above all, the clergyman himself; by making it understood that clerics had weaknesses like those of other humans if not sometimes worse, this literature became an ideological support for the economic and institutional reforms of clerical life that the second constitutional Cortes carried out in those years.[17] In mocking the clergy's claim to sanctity, Goya questioned the arbitrary power of the Church. Goya's monk is discredited as a spiritual intermediary between God and the faithful, since he disregards the one and manipulates the other. Goya was seemingly offended by the aesthetic, moral, intellectual, and economic incoherence of orders that had failed to adapt to the demands of an increasingly Liberal, capitalist society. This monk gives nothing back for his entitlements except what Goya has him doing here (see also cat. 111-115 and 163).

This print is the third of three (see cat. 153 and 154) on sham, antiquated religious practices veiling attacks on the retrograde character of Fernando VII's regime, which was responsible for the restoration of the orders' seignorial privileges and properties in 1814 (see cat. 158 and 160).[18] In *El Conservador*, a Liberal newspaper that appeared in 1820 about the time of this print, Fernando VII's six-year reign was reviled as an "albergue indecoroso de la ignorancia, el fanatismo y la tiranía" (indecorous refuge for ignorance, fanaticism, and tyranny), words that could just as well describe this monk's habitation.[19]

M.A.R.

1. See D. Fermin Eduardo Zeglirscosac, *Ensayo sobre el origen y naturaleza de las pasiones* (Madrid, 1800), pl. xvii, fig. 4, text on pp. 110-111.

2. See Revuelta González, *Política*, p. 67.

3. A longer inscription was erased. The rest of the saying is given in G-W 1759.

4. Blanco White saw Capuchins playing guitars and singing boleros "in mixed company," cited cases in which friars took "gross liberties" with women of the lower classes, and, in general, observed that for grossness and vice they set a bad example for the poor. Blanco White, *Letters*, pp. 88, 475. On the other hand, Cadalso believed it a misconception that friars socialized outside their monasteries. José de Cadalso, *Defensa de la nación española contra la Carta persiana LXXVIII de Montesquieu*, ed. Guy Mercadier (Toulouse, 1970), p. 38.

5. Quevedo, *Sueños*, p. 76.

6. See Lafuente Ferrari, *Desastres*, p. 181.

7. León de Arroyal, "Pan y toros," in *Pan y toros y otros papeles sediciosos de fines del siglo XVIII*, ed. Antonio Elorza (Madrid, 1971), p. 26.

8. Gallardo, *Diccionario*, p. 13.

9. Antonio Bernabeu, *España venturosa por la vida de la Constitución y la muerte de la Inquisición* (Madrid, 1820), p. 21. Biblioteca Nacional, Madrid, R 60.122.

10. Ibid., p. 88. Since the Middle Ages friars had been mocked or criticized for drunkenness and licentiousness or any vice that transformed the cleric into an animal symbolizing that vice. See Mateo Gómez, *Sillerías*, pp. 251ff and figs. 238-260, 336, 340, 348. Under the impact of the sixteenth-century Dutch humanist Erasmus, friars were held responsible for the spread of superstition. On the eighteenth century, see Sarrailh, *Espagne éclairée*, pp. 653-661. See also Llorente, *Inquisición*, vol. 2, pp. 370, 384; Kany, *Life and Manners*, pp. 390-396; *Lazarillo de Tormes*, ed. Francisco Rico (Barcelona, 1967), pp. lxiii, 12, 66, n. 1; Claudette Dérozier, "La Guerre d'Independance Espagnole à Travers l'Estampe (1808-1814)," Ph.D. diss., L'Université de Toulouse-Le-Mirail, 1974, pp. 936, 940.

11. See Blanco White, *Letters*, pp. 470-471; Arroyal, "Pan y toros," pp. 25-26; Manuel Josef Quintana, *Quintana revolucionario*, ed. M. E. Martínez Quinteiro (Madrid, 1972), p. 148.

12. Gallardo, *Diccionario*, p. 12. See also Revuelta González, *Política*, p. 68.

13. See Blanco White, *Letters*, p. 255. See also Gallardo, *Diccionario*, p. 81.

14. Quoted in Caro Baroja, *Carnaval*, p. 48.

15. For a seventeenth-century emblem by Covarrubias on the relationship between folly and vice, see Henkel, *Emblemata*, p. 1129.

16. It is worth noting that the leading satirists of clerical life were themselves clergymen, such as the Jesuit Padre Isla, the Augustine Fray Fernández de Rojas, and the priest Salvador Miñano Bedoya. As with Goya, their principal targets were the monastic and mendicant orders. See Revuelta González, S. J., *Política*, pp. 60ff. There is evidence that priests tended to side with enlightened and later Liberal reformers against the mendicant and monastic orders. See, for example, Giacomo Casanova,

Memorias de España, ed. and trans., Angel Crespo (Barcelona, 1986), p. 67. On Carnival parodies of Church officials, see Caro Baroja, *Carnaval*, pp. 297ff.

17. See Revuelta González, S. J., *Política*, pp. 92-97.

18. See Martínez Albiach, *Religiosidad*, pp. 609-612. Fernando VII was himself regarded as a bigot who paid homage to the Virgen de Atocha while indulging in low-life escapades in the seedier districts of Madrid; his personality perhaps set the tone of his reign. See Ferrán Soldevila, *Historia de España*, ed. J. Sales (Barcelona, 1973), vol. 6, p. 366.

19. See José Alvarez Lopera, "De Goya, la Constitución, y la prensa liberal," in Madrid, 1982, p. 49.

156

Nada. Ello lo dice (Nothing. It says as much)
Fatales consequencias de la sangrienta guerra en España con Buonaparte. Y otros caprichos enfaticos [Disasters of War], plate 69
Working proof, bound in volume
About 1820-1823
Etching, burin, and plate tone
155 x 200 mm.
References: G-W 1112; H. 189, I, 1.

Biblioteca Nacional, Madrid, 45.685
Spain only

A corpse inscribes *Nada* (Nothing) on a sheet of paper. On the right side of the print, a maelstrom of shapes scarcely resolves itself into a cleric with the highlighted head of a dog, traditional symbol of avarice (see cat. 45, n. 3), pointing in the darkness. Justice sits behind a raised surface resembling a lectern, irradiating light as she reads with absorption. Her scales are tilted and the light she emits grows wan.

The title is what Goya wrote in the set of working proofs he gave his friend Ceán Bermúdez so that he would correct the titles; it was changed to *Nada. Ello dirá* (Nothing. [It] will tell) when the set was first published by the printing shop of Madrid's Academia de San Fernando in 1863.[1] Additional work and the dark, grainy aquatint in the trial proof changed its character (fig. 1). This unique working proof with plate tone shows Goya's intent more clearly.

After long years of effort, affliction, and loss of life during the war (see cat. 82-94), disillusioned Liberals realized the return of their king had brought them worse than nothing. Fernando VII could hardly have been more ungrateful. While his subjects fought in his name, he lowered himself to congratulating Napoleon on his victories in Spain; and when he crossed the border to reclaim his throne, his only desire was to undo the work of the constitutional Cortes, reestablish the old order, and punish those who had encroached upon royal prerogatives and traditional institutions, in spite of the fact the Liberals never stopped recognizing him as king.[2]

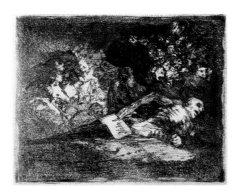

Fig. 1. *Nada. Ello lo dice, Disasters of War*, plate 69.
Working proof.
Etching, burin, and plate tone.
Norton Simon Museum of Art, Pasadena

The three preceding *Disasters of War* are satires on the practices of reactionary clergy or those nobles favoring the king. The cleric in *Disaster* 69 has been transformed by his avarice into a dog, a metaphor that may allude to the obstinate selfishness with which the privileged of the old order reclaimed their rights and properties on the king's restoration (see cat. 158).[3] During the war the Cortes' librarian José Gallardo, in a prophetic vein, wrote that if the Liberals succeeded in neutralizing the Church, "quedáranse a la luna de Valencia tanto mochuelo, tanto vampiro, cáravo y lechuso" (so many little owls, vampires, beetles, and screech owls would be exposed to the clear light of day), but, if not, "toda la sangre española derramada desde el cruento DOS DE MAYO lejos de servir para nuestra redencion, no servirá mas que para nuestra condenacion eterna" (all the Spanish blood spilled on the cruel SECOND OF MAY [when the war with Napoleon began], far from being our redemption, will have served nothing but our eternal damnation).[4] This note was sounded many times, as in the April 6, 1814, issue of the newspaper *El Duende de los Cafés*: "We Spaniards have spilled blood for seven years to recover our independence and our king in order that he return to command us at his pleasure, dispose of our lives, of our goods, of our liberty, of our thoughts and our words, to impose arbitrary taxes, and plunge us into a civil war? . . . He wants to rob us of our rights? . . . He intends to

rip the sacred leaves of our Constitution with his despotic sword? . . . Never! He who thinks this is badly deceiving himself. And if it is the king who thinks it . . . the king himself is deceived!"[5] The Liberals had naively trusted in Fernando VII, and his prestige enabled him to carry the day on his return in 1814.[6]

The scales of Justice were thereafter tilted by arbitrariness and caprice (see cat. 160 and 161).[7] Goya left surface tone on the plate, selectively wiping clean the area to the left of Justice, perhaps to suggest her waning light, which diminishes with each succeeding state (see cat. 52). An underlying message in this latter part of the *Disasters* is made most explicit in this print: The horrors of the war and the accomplishments of the constitutional Cortes had only served to provoke the forces of absolutism and obscurantism in Spain to deny everything for which most Spaniards had fought. This print is perhaps Goya's form of mourning for the ideals betrayed by Fernando VII and his supporters and the artist's dismay at the renewal of fanaticism and injustice, which were, to judge by the second part of the *Disasters*, as horrifying to him as the atrocities of war. The nihilism in this print does not appear to be a final statement because the triumph of truth is once again reaffirmed in the latter part of the series (see cat. 161 and 163).

Fig. 2. Juan de Valdés Leal, *Finis Gloriae Mundi*, 1672.
Oil on canvas.
Hospital de la Santa Caridad, Seville

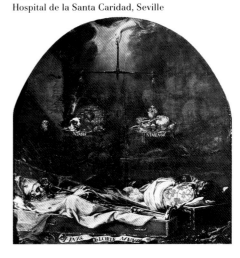

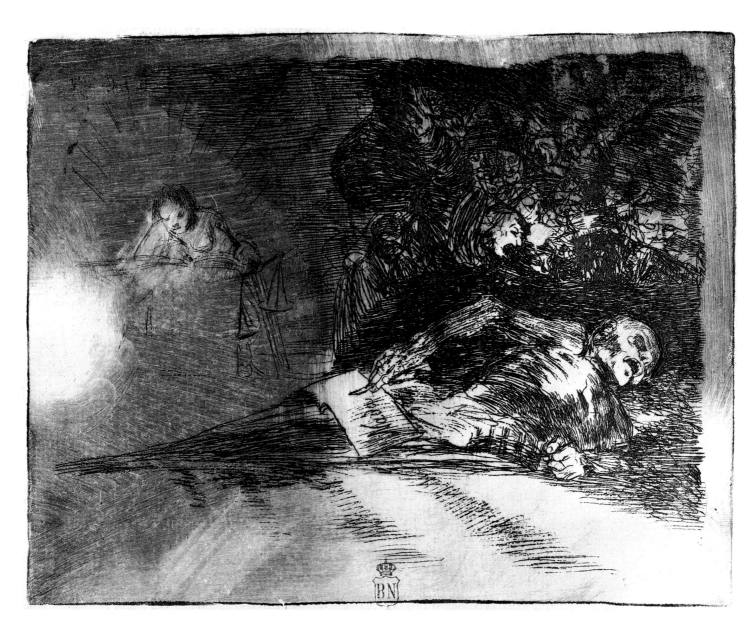

The corpse clutches a straw crown in both the proof and the published print. The print is related iconographically to baroque images of the transience of worldly things, especially the hieroglyphs of death by the seventeenth-century Sevillian painter Valdés Leal.[8] His canvas on the *vanitas* motif *Finis Gloriae Mundi* (fig. 2) includes many of the same elements as Goya's print: the crown of straw (symbol of the transience of worldly power and glory); the scales, which represent Justice in Goya's print, whereas in Valdés Leal's painting they

balance symbols of the seven deadly sins – including a dog for Avarice – with attributes of penance and mortification (such as the rosary, scourges, and the Psalms of David); and death, incarnated in Valdés Leal's painting by three figures in various stages of decomposition. Valdés Leal's inscription is in the same spirit as Goya's, reading *nimas nimenos* (No More and No Less). It hung with a companion piece in the Hospital de la Santa Caridad in Seville, a city where Goya had spent time in the 1790s.[8] Conspicuously absent in Goya's print are the

attributes of penance and mortification. The baroque *vanitas* motif was intended to inspire guilt and remorse in preparation for the afterlife; Goya invoked the imagery of death in a lament over opportunities for change won in the war and lost in its aftermath. For Valdés Leal the scales illustrated the baroque conception of the balance between sin and penance; Goya's scales symbolized the ideal of Justice in the name of which Liberals set out to transform society. If redemption is to be found anywhere in this image, it is not in the afterlife but in the triumph of Jus-

tice on earth. It seems for Goya Justice alone is lasting; all else passes (see cat. 110 and 161).

<div style="text-align: right">M.A.R.</div>

1. The mock-up set is in the British Museum; see Sayre, *Changing Image*, pp. 129-130.

2. See Ferrán Soldevila, *Historia de España*, ed. J. Sales (Barcelona, 1973), vol. 6, p. 361.

3. See Fontana Lázaro, *Quiebra*, pp. 269-270.

4. Gallardo, *Diccionario*, p. 101.

5. Translated from the French, quoted in Albert Dérozier, *Manuel Josef Quintana et la naissance du libéralisme en Espagne* (Paris, 1968), p. 587, n. 277.

6. See Lafuente Ferrari, *Desastres*, p. 185; Claudette Dérozier, "La Guerre d'Independance Espagnole à Travers l'Estampe (1808-1814)," Ph.D. diss., L'Université de Toulouse-Le-Mirail, 1974, p. 947.

7. See Lafuente Ferrari, *Desastres*, p. 182; C. Dérozier, "Guerre," pp. 941-942.

8. I owe this observation to María Brey, widow of Rodríguez Moñino.

9. Elizabeth du Gué Trapier, *Valdés Leal: Spanish Baroque Painter* (New York, 1960), p. 57.

157

No saben el camino (They do not know the way)
Fatales consequencias de la sangrienta guerra en España con Buonaparte. Y otros caprichos enfaticos [Disasters of War], plate 70
Working proof
About 1820-1823
Etching and drypoint, touched with graphite
175 x 220 mm.
References: G-W 1114; H. 190, I, 1.

Museum of Fine Arts, Boston, 1951
Purchase Fund, 51.1689
Spain only

A grim procession – two friars, one tonsured, the other cowled, both glowing in their white habits; three nobles, one wearing a tied wig and long waistcoat, all three wearing outdated breeches and hats; two priests in cassocks and *sombreros de teja* (wide, soft-brimmed hats); and other lay people, all with their eyes closed – staggers through uneven, barren terrain.[1] Rocky outcroppings make it impossible for the members of the procession to keep to a straight path. Roped together like a string of mules, in single file, some with heads bowed, they seem unaware of each other and of the person leading them into a gorge.[2] He has raised his hand in supplication or perhaps bewilderment. Light from the right side of the print penetrates the darkness, forming an abstract pattern, and plays off the polished surfaces of the rocks lining the abyss, and off the leader.

Goya's etching brings to mind the biblical passage of the blind leading the blind and falling into a ditch (Matthew 15:14 and Luke 6:39) and the proverb of the blind leading the blind, then current in Spanish as it now is in English.[3] But Goya's image is different from traditional renderings in important ways. He multiplied the number of the blind compared to Hieronymus Bosch's two, Massys's four (fig. 1), and Pieter Brueghel's six. Goya's blind men are proportionally smaller and are dwarfed by the imposing landscape; the diminishment is both moral and physical. His other innovation was to rope them together as if to suggest they

Fig. 1. Cornelis Massys, *The Blind Leading the Blind*, about 1540.
Etching.
Rijksmuseum, Amsterdam

are slaves of their inner blindness. Those who do not see truth must lose their way and fall into the abyss. One article of the enlightened creed was the notion that moral, as well as intellectual, error was the fruit of ignorance (see cat. 155).

Goya's truth is moral and political rather than religious in nature: the rule of just laws as embodied in the Constitution, founded on personal responsibility and bringing peace (see cat. 161, 162, and 163). *Album C*, page 117 (cat. 109), proclaims this truth and invites all to rejoice in the freedom of press (cat. 107) and justice (cat. 110) it guarantees. The reward Goya held out for cleaving to the straight path was not salvation in the next world or the Stoic pleasure in virtue, but freedom of expression, reduced corruption, and prosperity (see cat. 107). Compare the barrenness in this landscape to the fertility of that in *Esto es lo verdadero* (cat. 163). Even when the Constitution of 1812 is dead and buried, her rays of light endure. In *No saben el camino* Goya showed the fate awaiting those who did not perceive this simple truth.[4]

The theme of the blind leading the blind abounds in Spanish literature.[5] The medieval poet Gómez de Manrique reflected on the court of his day in this way: "Los cuerdos fuyr devrían / de do locos mandan más, / que quando los çiegos guían / !quay de los que van detrás" (The sane should flee / from where fools rule / because when the blind lead / woe to those who bring up the rear)![6] In 1812 Goya's friend the Liberal satirist José Gallardo Blanco referred to anticonstitutional ecclesiastics

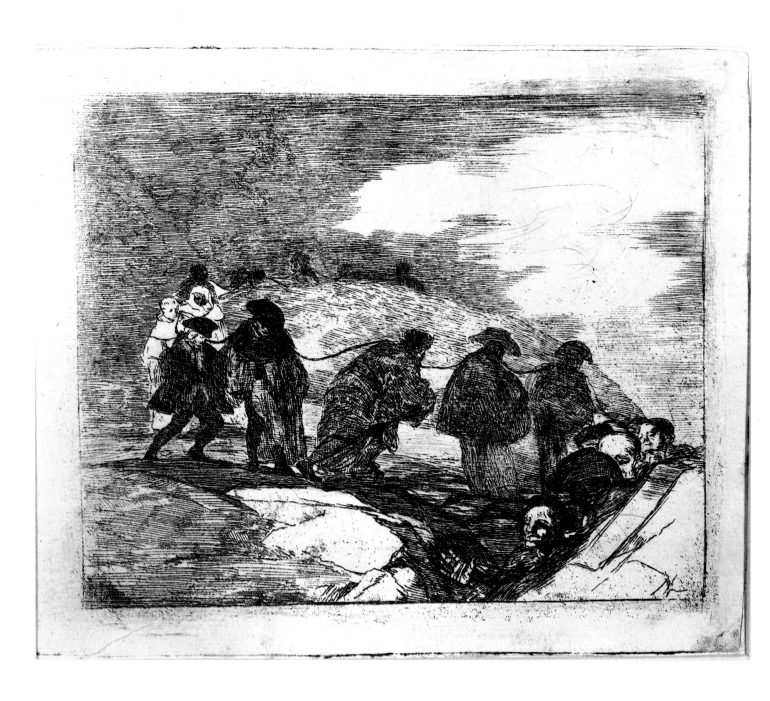

as those who "see without opening their eyes," for they lack civic spirit and put their interests before those of the country; Liberal ideas, he said, removed "las trabas que les impiden el caminar libremente por la senda de la virtud á la felicidad" (obstacles that keep [people] from walking in freedom along the path of virtue to happiness).[7] Elsewhere, he employed the same figure of blindness to establish the affinity of virtue to knowl-

edge: "Las sendas de la virtud, para que podamos bien seguirlas, han de estar alumbradas por la luz de la sabiduría: el entendimiento guia á la voluntad: con los ojos vedados y la cadena al pie no se puede hacer gran jornada en el camino de la perfeccion" (The ways of virtue, if we are to follow them with a sure step, must be illumined by the light of wisdom. Understanding guides the will; with blindfolded eyes and a chained foot one

cannot get very far along the path of perfection).[8] Speaking for the Liberal cause, Gallardo wrote: "Si podemos ir por sendas de flores, no caminemos por entre espinas y abrojos" (If we may go along flower-bordered paths, let us not walk through thorns and thistles).[9] When the Liberal poet and journalist Manuel José Quintana wrote his post-war prison memoirs, he insisted his model was not the French Revolution and that

he never aimed to raze the monarchy; instead, he supported Liberalism because he did not want the country to go on being a victim "de una arbitrariedad ciega que por más de tres siglos la estaba consumiendo" (of a blind arbitrariness that had been consuming it for three centuries).[10]

Goya prepared these prints for publication during the second constitutional period when he could look back on the six years of Fernando VII's reign and judge it with sovereign distance, so that amidst the desolation he recorded signs prefiguring the restoration of constitutional rule in 1820 (especially in cat. 159-163). In this print the blindness of Fernando VII's supporters damns them; political and religious repression enslaves them physically and spiritually.[11] On March 9, 1820, Fernando VII was compelled by the Liberal General Riego, backed by a popular uprising, to accept constitutional rule; on March 10 the famous *Manifiesto del rey á la nación espanola* (The King's Manifesto to the Spanish Nation) appeared, containing these sadly celebrated words, betrayed three years later: "Marchemos francamente, y yo el primero, por la senda constitucional" (Let us frankly march, and I first of all, along the constitutional path).[12] Could the way in Goya's print have been the constitutional path that Fernando VII and his followers failed to walk in the previous six years?

M.A.R.

1. The top hat was fashionable by 1820. For gentlemen's fashion of 1820 to 1823, see *Journal des Dames: Costume Parisien* (Paris, 1820-1823).

2. Claudette Dérozier, "La Guerre d'Independance Espagnole à Travers l'Estampe (1808-1814)," Ph.D. diss., L'Université de Toulouse-Le-Mirail, 1974, p. 944. A related image was used in the 1790s to symbolize despotic government: "Al gran Felipe debe nuestra legislación . . . el que los diversos ramos del gobierno y la justicia se dirijan por una sola mano como las mulas del coche" (Our legislation owes it to the great Phillip [II] . . . that the various branches of government and justice are controlled by one hand like the mules of a coach). See León de Arroyal, "Pan y toros," in *Pan y toros y otros papeles sediciosos de fines del siglo XVIII*, ed. Antonio Elorza (Madrid, 1971), p. 22.

3. See Sayre, *Changing Image*, p. 284; Priscilla E. Muller, *Goya's 'Black' Paintings: Truth and Reason in Light and Liberty* (New York, 1984), p. 190. Muller finds the title alludes to another biblical passage (Job 12:24-25), which may shed light on Fernando VII's role in this print as discussed: "[God] taketh away the heart of the chief of the people of the earth, and causeth them to wander in a wilderness where there is no way. They grope in the dark without light, and he maketh them to stagger like a drunken man."

4. In 1787 the poet and Liberal journalist Manuel José Quintana used the figure of blindness to suggest a state of vice: "ciego / en torpe vicio yace" (blindly wallows / in perverse vice). Manuel José Quintana, *Poesías completas*, ed. Albert Dérozier (Madrid, 1969), pp. 70-71, lines 46-47. In effect, the disastrous economic situation in post-war Spain and Fernando VII's inept handling of it – because of, among other reasons, an appalling corruption – was as responsible for his downfall as the unpopularity of his regime's repressive apparatus. See Ferrán Soldevila, *Historia de España*, ed. J. Sales, vol. 6 (Barcelona, 1973), pp. 359-360, 363-364, 366-367; Fontana Lázaro, *Quiebra*, pp. 322-343.

5. Among the classic texts are the Arcipreste de Hita's *El libro de Buen Amor*, Don Juan Manuel's *El Conde Lucanor, o Libro de Patronio*, and Juan de Mena's *Sobre la justiçia e los pleytos, e de la grant vanidad deste mundo*. See Mateo Gómez, *Sillerías*, pp. 167-168.

6. Mateo Gómez, *Sillerías*, pp. 167-168.

7. Gallardo, *Diccionario*, pp. 19, 75.

8. Ibid., p. 10.

9. Ibid., p. 13.

10. Manuel José Quintana, "Memoria," in *Quintana revolucionario*, ed. M. E. Martínez Quinteiro (Madrid, 1972), p. 45.

11. They are not high-ranking, but middle-class agents of reaction, duped by their own ignorance and working against themselves, a theme that appears elsewhere in Goya's work of the post-war period (see cats. 112, 125). The ditch of the biblical parable was sometimes glossed as *engaño* (deception) in ideological disputes of Goya's time. See "Respuesta Verdadera y Solida Que dan los que tienen vista á dos Cartas que Conduxo el Correo de los Ciegos de Madrid . . . ," in Juan Cosme de Nergan, *Los Frayles Vindicados por Volter* (Madrid, 1813), p. 2. Biblioteca Nacional, Madrid, R60419.

12. Lafuente, *Historia*, pp. 23, 235-236.

158

Las resultas (The Consequences)
Fatales consequencias de la sangrienta guerra en España con Buonaparte. Y otros caprichos enfaticos [Disasters of War], plate 72
Working proof
About 1820-1823
Etching
175 x 220 mm.
Inscribed upper right margin: *72*, in sanguine, verso: part of a sketch for the Order of the Bath[1]
References: G-W 1118; H. 192, I, 1.

Museum of Fine Arts, Boston, 1951
Purchase Fund, 51.1690
United States only

Vampire bats converge on a shrouded man; one sucks at his breast, another pulls at his shoulder, feeding on what little blood there is.[2] The light singles out the bat's remarkably human face, its prey's face, and the shroud. The composition's rigid geometry, the interconnectedness of figures, and the repetition of flying shapes reinforce the impression of inevitability. The bat's suctionlike gesture resembles Rubens's Saturn as he devours the flesh of his newborn son (fig. 1), in a painting that Goya may have seen in the royal palace in Madrid.[3]

The title relates the print to the one preceding it, *Contra el bien general* (Against the Common Good) (fig. 2). A clerical scribe with bat wings for ears and long-nailed hands and feet – which give away his avaricious nature – sits writing. We may conclude this cleric is at home in the world, for his feet rest on a globe. The seventeenth-century chair is suitable to a person fixated on the past. With his left hand the cleric writes something *contra el bien general*, while with his right he points up, signifying he acts in the name of God (see cat. 161). "Common good" is an expression rooted in the Liberal political tradition; the cleric may therefore be drafting laws restoring Old Regime privileges on Fernando VII's return to power in 1814. The print following *Las resultas*, *Gatesca pantomima* (Feline Pantomime) (fig. 3), could refer to the same events; a friar kneels obsequiously before a cat – another way of say-

Fig. 1. Peter Paul Rubens
Saturn, 1686
Oil on canvas
Museo del Prado, Madrid, 1678

ing thief in Spanish – that has been raised on an altar. The cat may well stand for Fernando VII, who takes counsel from an owl, symbolizing ignorance and vice dressed up as wisdom (see cat. 52), a suitable metaphor for Fernando VII's *camarilla* (kitchen cabinet) of shady advisers.[4] The noun bat and its companion verb *chupar* (to suck) were colloquial expressions for corruption;[5] "suck" was slang for "rob," and by the middle of the eighteenth century Diego Torres Villarröel had used vampires and sucking as metaphors for secular vice: "Que los jueces y hechiceros, / Todos chupamos / Unos niños y otros cuartos" (We judges

and sorcerers / All of us suck / Some children and others money).[6]

On Fernando VII's return to power, the clergy's influence over the state was even greater than before the French invasion of 1808. The Jesuits, expelled in 1767 by Fernando VII's grandfather, Carlos III, were recalled to control all branches of education. Monasteries and convents converted into agricultural, technical, or general schools were reestablished; their occupants' properties and privileges, confiscated and abolished by the Cortes (parliament), were restored. Monasteries and convents destroyed in the war were rebuilt, an effort the war-ravaged country could ill afford and the increased tithe collection for which only stoked laborers' hostility toward the Church, manifesting itself in anticlerical violence from 1820 to 1823.[7] Most vexing of all, the full panoply of tithes and supplementary dues (see cat. 112) was again exacted, meeting, however, with stiff popular resistance.[8] At the beginning of the second constitutional period, these dues (see cat. 155) provoked the following tirade from a Liberal when the Constitution was restored in 1820: "La infamia y la vejez, el crimen y la virtud, la vida y la muerte; todo, todo estaba sujeto a contribucion por un sinnúmero de sagrados vampiros; no habia objeto religioso cuyos respetos no fuesen atropellados por la insaciabilidad del oro. El purgatorio, las indulgencias, las revelaciones, apariciones, y prodigios de todas especies, seducian á la credulidad de los pueblos para chuparles el quilo." (Infamy and old age, crime and virtue, life and death; everything, everything was subject to tribute by an infinite number of sacred vampires; there was no religious object whose dignity was not trampled by the insatiability of gold. Purgatory, indulgences, revelations, apparitions, and prodigies of all kinds seduced the people to credulity in order to suck their substance.)[9] The imagery calls to mind the Reformation metaphor of the Pope feasting on corpses. Gallardo's *Diccionario*, first published in Cádiz in 1812, rounded out this catalogue of Church enterprise by ridiculing the trade in habits for use by the ill or as burial shrouds.[10] The dead man in the print is wearing a

Fig. 2. *Contra el bien general* (Against the Common Good) *Disasters of War*, plate 71
Working proof
Etching and burnishing
Norton Simon Museum of Art, Pasadena

Fig. 3. *Gatesca pantomima* (Feline Pantomime) *Disasters of War*, plate 73
Working proof
Etching, burin, and burnishing
Norton Simon Museum of Art, Pasadena

shroud, and those bats are carrying out the ultimate dispossession: that of life. Perhaps for Goya the true vampires of this world were clerics who fed on the dead through their burial and related surplice dues (see cat. 53, "Contemporary Explanations").

Rubens's *Saturn* is perhaps unique in its sucking imagery. Saturn devoured his child because it was prophesied his son would depose him. The expression His Majesty was appropriated by Liberals to refer to both the Cortes and the nation in their addresses during the constitutional proceedings in Cádiz before 1812.[11] The Constitution declared sovereignty rested

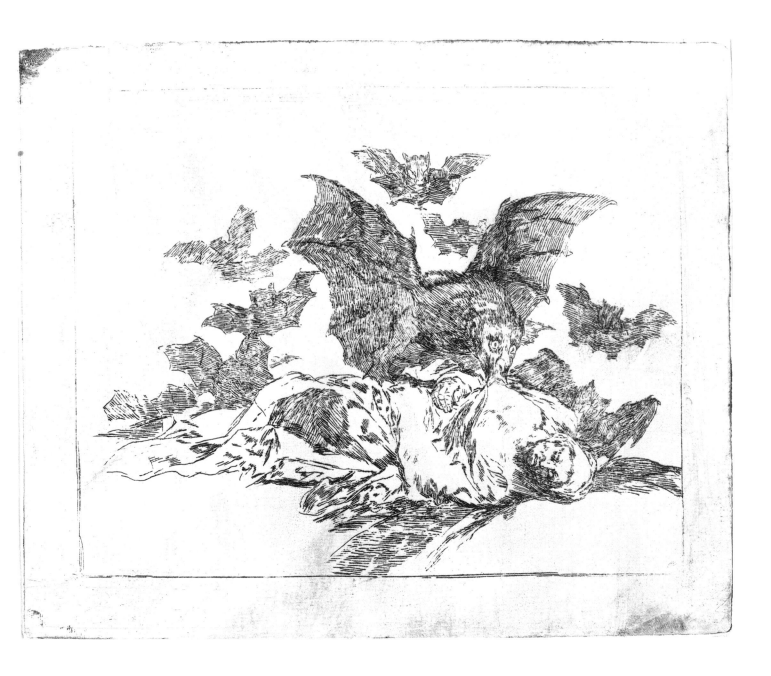

in the nation and not the king. Like Saturn's progeny, the Spanish people were perceived by the Liberal Cortes as the rightful wartime heirs to Fernando VII, who had abdicated to Napoleon in 1808. In a sense like Saturn, Fernando VII and his ecclesiastical agents devoured the country lest they be deposed by constitutional forces – as they would be in 1820 – through repression, corruption, overtaxation, and inept policies, which tended to

impoverish an already war-ravaged economy and to undermine resistance (see cat. 157, n. 4).

M.A.R.

1. On this sketch, see cat. 97. The drawing was cut when the sheet was divided. The paper used for this working proof is unique in the *Disasters of War*. In general these 1820 to 1823 working proofs are on SERRA paper.

2. Lafuente Ferrari saw the body as Spain bled white by six years of war against Napoleon's armies and

ravaged by the fortune hunters who followed Fernando VII into power in 1814. Lafuente Ferrari, *Desastres*, p. 185. Glendinning suggests the bats may be derived from Giam Batista Casti's Canto 24 of *Gli animali parlanti* (The Talking Animals), in which a vampire plays the role of a legal adviser and capo of a gang of greedy sowers of discord, among them notaries, criminals, and economists. Nigel Glendinning, "A Solution to the Enigma of Goya's Emphatic Caprices," *Apollo* 107 (Mar. 1978), p. 188.

3. We know from an inventory of 1776 that this painting hung in the antechamber of the quarters of the crown prince and princess in the royal palace in

Madrid. See Antonio Ponz, *Viaje de España*, ed. Casto María del Rivero (Madrid, 1947), vol. 6, p. 528, item 48.

4. See Felix Samaniego, *Fábulas en verso castellano* (Madrid, 1803), vol. 2, bk. 2, fable 4. See also Lafuente Ferrari, *Desastres*, p. 185; Quevedo, *Sueños*, p. 208.

5. The bat was represented in medieval relief sculpture as an incarnation of the devil, following a biblical tradition. In Aesop's fables, its supposed hybrid nature – a cross between a mouse and a bird – caused it to be regarded as an emblem of hypocrisy. See Mateo Gómez, *Sillerías*, p. 93. See also Samaniego, *Fábulas*, bk. 3, fable 6; Cadalso, *Cartas*, p. 185. Both Cadalso and Moratín mocked the belief in vampires. See Cadalso, *Cartas*, p. 147; Leandro Fernández de Moratín, "Auto de fe celebrado en la ciudad de Logroño, en los dias 6 y 7 de noviembre de 1610," in *Biblioteca de Autores Españoles: Dramáticos posteriores a Lope de Vega* (Madrid, 1859), vol. 2, p. 628, n. 53.

6. See Edith Helman, *Jovellanos y Goya* (Madrid, 1970), pp. 175, 180. Torres used *chupar* to indicate what legal agents do with laborers' money for their suits and claims. See Guy Mercadier, "Literatura popular e ilustración: *El Piscator Económico* de Bartolomé Ulloa (1765)," *Nueva revista de filología hispánica* 33, no. 1 (1984), p. 191.

7. See Albert Dérozier, *Manuel Josef Quintana et la naissance du libéralisme en Espagne* (Paris, 1968), p. 588. See also Callahan, *Church*, p. 116.

8. See Fontana Lázaro, *Quiebra*, pp. 264-274.

9. Antonio Bernabeu, *España venturosa por la vida de la Constitución y la muerte de la Inquisición* (Madrid, 1820), p. 21. Biblioteca Nacional, Madrid, R 60.122.

10. Gallardo, *Diccionario*, pp. 89, 101. See also Moratín, *Auto de fe*, p. 630 n. 57. On the sale of discarded cowls and the burial of the dead in the garb of religious orders, see Kany, *Life and Manners*, p. 391.

11. See the salutation, for example, in Ruiz de Padrón, *Inquisition*, p. A. Wellington seconds this fact, albeit with scorn: "I wish that some of our reformers would go to Cadiz to see the benefit of a sovereign popular assembly, calling itself 'Majesty'; and of a written constitution; and of an executive Government called 'Highness' acting under the control of 'His Majesty' the assembly!" *The Dispatches of Field Marshal the Duke of Wellington, During His Various Campaigns . . . from 1799 to 1818*, comp. John Gurwood (London, 1838), vol. 10, p. 54.

159

Que se rompe la cuerda (The rope is fraying) *Fatales consequencias de la sangrienta guerra en España con Buonaparte. Y otros caprichos enfaticos* [Disasters of War], plate 77
Working proof
About 1820-1823
Etching, burnished aquatint or lavis
175 x 220 mm.
Engraved upper left margin: *77;* lower center margin: title
References: G-W 1128; H. 197, I, 3.

Museum of Fine Arts, Boston, 1951
Purchase Fund, 51.1692
Spain only

A high ecclesiastical dignitary balances on a tightrope about to give way. The crowd below watches expectantly: some skeptically, some apprehensively, others frightened by what is about to happen. One of the spectators points at the frayed place where the rope will break.

In an earlier print called *Disparate puntual* (Punctual Folly) (fig. 1), a horse stands on a tightrope with a woman posed on its back. But the feat is illusory, for the horse is really resting on the ground. And yet the crowd is taken in. In Goya's preparatory drawing for this *Disaster of War,* the official on the tightrope is clearly Pope Pius VII. He wears the papal tiara and gloves, and he resembles the pope as we know him from portraits of the time.[1] In both the drawing and the print, he gazes serenely ahead, unaware the spectacle is almost over. The proverbial expression – *bailar* or *andar en la cuerda floja* (to dance or walk on the slack rope) – means to be in a delicate situation, that is, to skate on thin ice.[2] Another related expression current then as now is *andar en la maroma* (to walk on the tightrope), referring to a person with a stake in some difficult or dangerous business.[3]

The enlightened secretary of the Inquisition in the 1790s, Juan Antonio Llorente (cat. 73), was the second constitutional government's ambassador to the Vatican from 1820 to 1823. After his mission there ended, he wrote a history of the papacy, devoting the concluding chapter to the reigning pope, Pius VII. A

Fig. 1. *Disparate puntual* (Punctual Folly), *Disparates*, plate 12.
Etching and aquatint.
Museo Lázaro Galdiano, Madrid

recurrent motif in this account is the pope's opportunistic character. "Pio VII será ingrato si negare que debe á Napoleon Bonaparte la libertad y facultad de sus electores y la pacifica posesion de su silla en Roma" (Pius VII would be ungrateful if he denied owing to Napoleon Bonaparte the liberty and power of his electors and the peaceful possession of his chair in Rome).[4] Further on, Llorente stated: "Los franceses quisieron elevar su primer consul á la dignidad de emperador y Pio VII fue de Roma á Paris muy contento para coronarle, como lo hizo en gran céremonia con solemnidad incomparable. Posteriormente los negocios politicos tomaron otro aspecto, y el emperador despojó a Pio VII de la soberanía temporal de los estates romanos." (The French wished to elevate their first consul to the dignity of emperor, and Pius VII very happily went from Rome to Paris to crown him, which he did with great ceremony and incomparable solemnity. Afterward, political affairs took another turn, and the emperor robbed Pius VII of his temporal power over the papal states.)[5]

After Napoleon's defeat Pius VII tasted revenge; he removed all the bishops Napoleon had appointed under the terms of the concordat the pope and emperor had negotiated; at Fernando VII's request the pope issued a bull absolving all monks and friars who had headed guerrilla groups and who were responsible for robbing and killing French and Spaniards alike.[6] In his own territories the pope was less compassionate toward

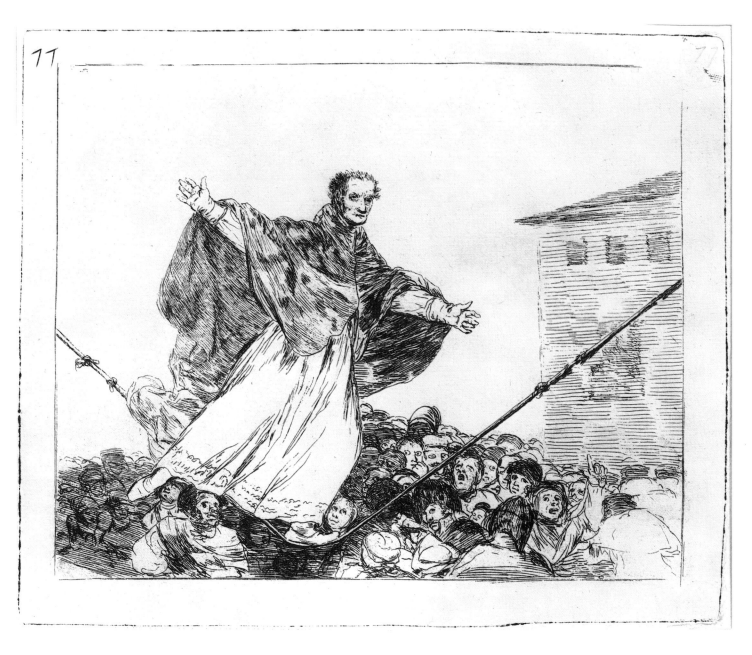

Liberals than the absolutist kings who formed the reactionary Holy Alliance, despite the clause in the peace treaty ending the war with Napoleon that stipulated that no persecution would take place on political grounds. "Pio VII, como vicario del Dios de paz, de misericordia y de bondad, estaba obligado á cumplir este articulo con mas exactitud que los otros soberanos; y por desgracia sucedió lo contrario" (Pius VII, as vicar of the God of peace, compassion, and goodness, was obliged to carry out this clause with more exactitude than the other sovereigns; unfortunately, the contrary happened).[7]

Fernando VII and Pius VII both returned to power at the same time. Decrees against Liberals and favoring the Church followed the restoration of the king in close order; as a result, Liberals could not have helped linking their persecution with the Church's ascendancy.[8] Nevertheless, the Church was repeatedly called on by Fernando VII to contribute portions of its income to keep the state from going bankrupt and to give ideological support from pulpits, in censorship boards, and through the political tribunals (see cat. 160).[9] Not only did Fernando VII fail to create the theocratic state some conservative prelates desired, he also kept the traditional royal control over episcopal appointments and revenues and used these liberally – invariably with the pope's approval – to fill the

Church with cronies favorable to his regime and to palliate the national debt.[10] The result was a persistent decline in the Church's wealth, already depleted by the war with the French and the fiscal levies imposed by the first constitutional Cortes.

What was to have even more disastrous consequences for the Spanish Church was that its fortunes became tied to those of Fernando VII's absolutist regime. When constitutional government was restored in 1820, the Church suffered an even greater blow to its patrimony through widespread disentailment than it had in the first constitutional period of 1812 to 1814.[11] Goya's metaphor of a high cleric walking a frayed tightrope is a fitting one of the Church's precarious position and loss of credibility on the eve of the Constitution's restoration (see also cat. 161-163).[12]

M.A.R.

1. See, for example, Jacques Louis David's *Distribution of the Eagles,* which shows the pope about twenty years earlier during the coronation of Napoleon, reproduced in Richard Cantinelli, *Jacques-Louis David: 1748-1825* (Paris and Brussells, 1930), pl. 70, no. 122. The composition may also be influenced by Covarrubias's seventeenth-century print with an elephant balancing on a rope in Rome; its inscription contrasts the elephant's apparent clumsiness with its real ingenuity as a high-wire artist. See Henkel, *Emblemata,* p. 418.

2. See H. 267, II.

3. Academia, *Diccionario,* under *maroma;* Martín Alonso, *Enciclopedia del idioma* (Madrid, 1982), under *maroma.* See also Nigel Glendinning, "A Solution to the Enigma of Goya's 'Emphatic Caprices,' " *Apollo* 107 (Mar. 1978), p. 190.

4. Juan Antonio Llorente, *Retrato politico de los papas* (Madrid, 1825), p. 281.

5. Ibid., p. 282.

6. See Callahan, *Church,* p. 105.

7. Llorente, *Retrato,* pp. 284-286.

8. See Martínez Albiach, *Religiosidad,* p. 576.

9. On Fernando VII's appropriation of ecclesiastical benefices and the crisis of monastic revenues, see Callahan, *Church,* p. 115.

10. See Martínez Albiach, *Religiosidad,* pp. 443, 465-468; José Manuel Cuenca, "Iglesia y Estado en la España contemporánea (1789-1914)," in *Estudios sobre la Iglesia española del XIX* (Madrid, 1973), pp. 48-53. On relations between the papacy and the second constitutional government, see Manuel Cuenca, "Iglesia y Estado," pp. 57, 61-63; Callahan, *Church,* pp. 113-116.

11. See Callahan, *Church,* p. 117.

12. On relations between the papacy, the Church, and the second constitutional government, see Revuelta González, *Política,* pp. 20-21.

160

Se defiende bien (It defends itself well)
Fatales consequencias de la sangrienta guerra en España con Buonaparte. Y otros caprichos enfaticos [Disasters of War], plate 78
Working proof
About 1820-1823
Etching, drypoint, burin, and burnishing
175 x 220 mm.
Inscribed upper left margin: *78*
References: G-W 1130; H. 198, I, 2.

Museum of Fine Arts, Boston, 1951 Purchase Fund, 51.1693
Spain only

A white horse desperately kicks as a pack of gray wolves closes in. Facing the wolves, four watchdogs wearing protective collars do nothing to protect it.

Goya may have adapted the biblical story of the unfaithful shepherd; whereas Christ the Good Shepherd lays down his life for his flock, the hireling shepherd flees from the wolf, which then catches and scatters the sheep (John 10:12). Just as *Disaster* 70 (cat. 157) alludes to the proverb of the blind leading the blind and the pitfalls of ignorance and lack of proper guidance, this print illustrates what may come of neglecting the duties of religious leadership.

If Goya did draw on the Bible, it was not merely to illustrate; he synthesized several sources. The dogs are *mastines* (mastiffs) – identified by the collars studded with iron nails to protect them from wolves – a breed featured often in eighteenth-century fables about wolves, livestock, pastors, and watchdogs.[1] In the eighteenth century the *mastín* was defined as "una especie de perro grande, quales son aquellos que guardan las casas y ganados. . . . Mastines, analógicamente, se toma por los Eclesiásticos, y Predicadores que guardan el rebaño de Christo." (a kind of large dog, like those which guard houses and livestock. . . . By analogy, mastiffs are taken to mean clerics and preachers who watch over Christ's flock.)[2] The source Terreros's eighteenth-century dictionary gives for this figurative meaning is the anonymous fifteenth-century poem *Las coplas de Mingo Revulgo,* an elaborate political and

moral allegory on the sufferings of the Castilian people under the reign of Enrique IV, a reign notorious for the corruption of its court.[3] The people are the livestock, the absence of religious and secular leadership a pastor abandoning them to indulge his own pleasures, and the evil that afflicts them the wolf. "Oja, oja los ganados / y a la burra con los perros / quales andan por los cerros / perdidos, descarriados" (Look, look at the herds / and the donkey with the dogs / which are wandering off / lost, astray).[4] Justice, Fortitude, Prudence, and Temperance – the four cardinal virtues symbolized by four dogs watching over the flock, the same number as in Goya's print – keep the wolves from penetrating and destroying it. The people deserved their pastor, according to the medieval poem, because they lacked Faith, Charity, and Hope, as a result of which war, famine, and plague were visited upon them. The wolves then are predatory vices and the dogs lost virtues.[5]

Numerous texts of Goya's time compared the Inquisition to a pack of wolves. Ruiz Padrón imagined inquisitorial agents as wolves of so little respect for communities they carried off both sheep and shepherds.[6] On July 21, 1814, the Council of the Inquisition and all of its other tribunals had been reestablished by Fernando VII.[7] Ecclesiastical collaboration was the price the Church paid for the restoration of its rights and properties. The Church was asked to fight the relaxed discipline occasioned by the disorders of the war and to help eliminate political enemies; sometimes the bishops outdid the regime in anti-Liberal zeal, opposing, for instance, a general amnesty.[8] The Inquisition's jurisdiction was extended to political matters, and the confusion of religious with political dissent meant that a person foolish enough, paraphrasing Antonio Llorente, to express in public a reasonable wish for a constitutional order in which rights were defined and in which justice and, therefore, public order prevailed could be punished by the Holy Office as a heretic.[9] The Inquisitor General, D. Francisco Javier de Mier y Campillo, called those errors ' "las doctrinas nuevas y peligrosas que han infestado España' " (the new and

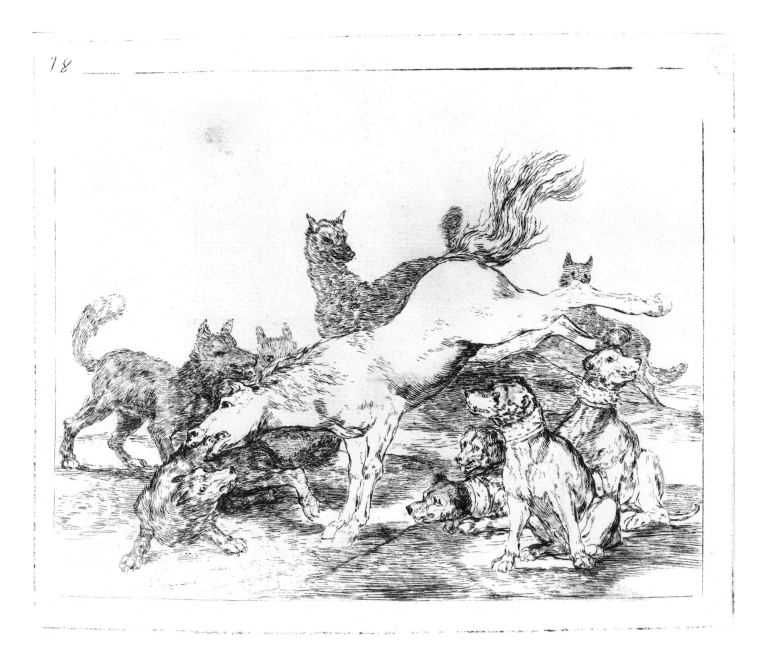

18

dangerous doctrines that have infested Spain).[10] The Inquisition's vigilance was trained less on masons and heretics, as in the past, than on proponents of Liberal ideas contrary to absolute monarchy.[11] The Church's collaboration was sometimes material; the cathedral chapter of Santiago donated 50,000 reales to the governor to put down Porlier's uprising in 1815, and Barcelona's bishop Pablo de Sicar bought the captain general's unpaid

troops when they were about to desert to General Lacy's cause in 1817.[12] Liberals, defeated and reviled, were watched and harassed by a Ministry of Police created especially for them and the *afrancesados* (French collaborationists), with whom they were then and have been since often confused.[13] When Fernando VII wrote to his royal commissaries, he requested they never report to him unless to give an account of Liberals they had dispatched;

Negrete, in Cádiz, was so severe Fernando VII himself advised he let up.[14]

The horse may well be Liberal Spain persecuted by the myrmidons of Absolutism (see cat. 148, n. 7), since the following two prints of this series (cat. 161 and 162) are about the Constitution's burial and resurrection.[15] The horse's kicks are aimed at the dogs; slashing diagonally across the composition, the horse divides its true enemies from its treacherous

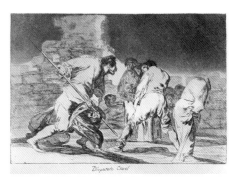

Fig. 1. *Disparate cruel* (Cruel Folly),
Disparates, plate 6.
Working proof, 1816-1817.
Etching and aquatint.
Museum of Fine Arts, Boston, Bequest of W.G. Russell Allen

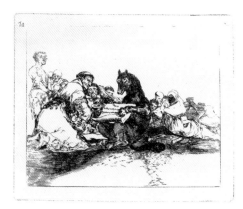

Fig. 2. *Esto es lo peor* (This is the worst),
Disasters of War, plate 74.
Working proof.
Etching and burnishing.
Norton Simon Museum of Art, Pasadena

keepers, as evil as the ravagers because they not only fail in their duty but look away like the witnesses of a crime in *Disparate cruel* (fig. 1).[16] The two wolves in the background (center and right) and the dog farthest to the right are attentive to something beyond the frame of the drawing, yet one more bond between the dogs and the wolves.[17]

M.A.R.

1. See, for example, Felix María Samaniego, *Fábulas en verso castellano,* vol. 2 (Madrid, 1803), bk. 4, fable 5.

2. Terreros, *Diccionario,* under *mastín.*

3. Such was the corruption, many comparable satires appeared, among them *Coplas hechas al rey don Henrique reprehendiéndole sus vicios y el mal gobierno de esto reynos de Castilla* (Verses to don Henrique chastising his vices and his bad government of the kingdom of Castile). In 1812 José Gallardo Blanco wrote an anticlerical pastiche of this poem. Gallardo, *Diccionario,* pp. 20-23. On account of Gallardo's text and Terreros's dictionary reference (see n. 2), we may suppose these anonymous poems were well known in the eighteenth century.

4. See Eduardo Rincón, ed., *Coplas satíricas y dramáticas de la Edad Media* (Madrid, 1968), p. 36, strophe 4.

5. Ibid., pp. 35-47. In the Bible, in classical and modern fables, and in proverbial expressions, the wolf's reputation for cunning is legendary. See Mateo Gómez, *Sillerías,* p. 145. Wolves were also reviled for their supposed fierceness and greed and, specifically, for heresy. See James Hall, *Dictionary of Subjects and Symbols in Art* (New York, 1979), p. 343. On the iconographic tradition of the dog, see Mateo Gómez, *Sillerías,* pp. 102-107.

6. Ruiz de Padrón, *Inquisition,* pp. 39-40. See also Kamen, *Inquisition,* pp. 109, 282, n. 6, 283, n. 20.

7. Even the Liberal Alcalá Galiano recognized that Fernando VII's Inquisition was a very different institution from the Hapsburg one. An antimonarchist conspirator, Van-Halen, was thrown into an inquisitorial jail; but not only was he not mistreated, he also escaped without difficulty in 1817. Alcalá Galiano, *Recuerdos,* p. 216. Furthermore, Fernando VII confirmed the Cortes' abolition of torture on July 25, 1814. See also Artola, *Orígenes,* p. 631.

8. See Revuelta González, *Política,* p. 20.

9. Llorente, *Inquisición,* vol. 4, pp. 126-128.

10. Quoted in Llorente, *Inquisición,* vol. 4, pp. 126-128. Llorente defended the role of the bishop as guardian of the faith, a role he believed had been usurped by the Inquisition.

11. This was confirmed by an edict appearing July 22, 1815, prohibiting a series of works contrary to religion and state, published in the preceding years, many of which were exclusively political. See Revuelta González, *Política,* pp. 5-10. Only religious sermons or elegies exalting the new regime were permitted. The theater was subject to a censorship worse than that of Carlos III and Carlos IV. See Albert Dérozier, *Manuel Josef Quintana et la naissance du libéralisme en Espagne* (Paris, 1968), pp. 588-589. Cathedral chapters were purged of Liberal canons; benefices were open only to those clerics free of "erroneous" opinions. See Callahan, *Church,* p. 113. The Inquisition was merely the most extreme manifestation of this confusion between the temporal and the spiritual in the Church of Fernando VII's reign; because the Inquisition dedicated itself to squelching antimonarchist dissent, its abolition on March 9, 1820, was one of the first acts of the reestablished Liberal government. See José Manuel Cuenca, "Iglesia y Estado en la España contemporánea (1789-1914)," in *Estudios sobre la Iglesia española del XIX* (Madrid, 1973), pp. 52-53.

12. See Callahan, *Church,* p. 113.

13. See Dérozier, *Quintana,* pp. 588-589.

14. See Ferrán Soldevila, *Historia de España,* ed. J. Sales, vol. 6 (Barcelona, 1973), p. 375.

15. See Dérozier, *Quintana,* p. 589. In Canto 25 of Giam Batista Casti's *Gli animali parlanti* (The Talking Animals), the horse, long deemed a noble and rational creature, stands for constitutional monarchy. See Nigel Glendinning, "A Solution to the Enigma of Goya's Emphatic Caprices," *Apollo* 107 (March 1978), p. 188. There is an anonymous fable of 1813 that identifies the people with a *potro* (colt). The concluding strophe says: "Sufre callando el pueblo con teson / de un gobierno la bàrbara impiedad / hasta que estimulàndole un baldon / pònese como el potro en libertad, / y venga con la fuerza su razon" (The people quietly and patiently suffer / the barbarous impiety of a government / until an offense provokes it / whereupon it frees itself like a colt / and forcefully avenges its sense of righteousness). D. C. de B***, *Fabulas politicas* (London, 1813), fable 19. Biblioteca Nacional, Madrid, R62076.

16. See Sayre, *Changing Image,* p. 290.

17. See Claudette Dérozier, "La Guerre d'Independance Espagnole à Travers l'Estampe (1808-1814)," Ph.D. diss., L'Université de Toulouse-Le-Mirail, 1974, p. 961. The wolves here may be kin to the wolf in *Disaster* 74 (fig. 2) of the same series, who dictates sentences to a long line of supplicants, aided and abetted by a friar holding the inkwell for him, symbolic perhaps of those sentences Fernando VII personally meted out to Liberals in 1815. See Lafuente, *Historia,* p. 181.

161

Murió la verdad (Truth died)
Fatales consequencias de la sangrienta
guerra en España con Buonaparte. Y
otros caprichos enfaticos [Disasters of
War], plate 79
Working proof
About 1820-1823
Etching and burnishing
175 x 220 mm.
References: G-W 1132; H. 199, I, 1.

Museum of Fine Arts, Boston, 1951
Purchase Fund, 51.1593
United States only

Constitution is being buried, but the light
she emits refuses to die out. A bishop
looms over her, obscene pleasure in his
expression; he gives what ought to be but
is not the funeral benediction. Two
monks wield shovels with an unseemly
eagerness to get on with the task. Seated
at the right, Justice, clothed like Constitu-
tion, forlornly clutches her tilted, entan-
gled scales, weeping disconsolately.
Another woman behind Justice buries
her face in her hands in a gesture of
profound despair.[1] At the far left a bald
man whose eyes are hidden behind anti-
quated spectacles called *quevedos* (see
cat. 47, 141, and 148) stands beside a
priest who has turned his back to the
burial. Another looks past the bishop's
right shoulder with astonishment. Strong
diagonals draw attention to the young
woman, and the light that emanates from
her body selectively illuminates the cler-
ics, the bishop's inappropriate gesture,
and grieving Justice.

Goya's title is unambiguous: Truth
must die with Constitution. Stretched
out on the ground and threatened by her
enemies, Constitution wears a laurel
wreath to mark her inevitable victory.
Goya's title implies that he thought of the
Constitution as a manifestation of Truth,
who is naked traditionally as well as in
Goya's conventional allegorical depic-
tions of her, such as the oil sketch *Truth,*
Rescued by Time, Witnessed by History
(cat. 28). Here Constitution is dressed in
a simple white gown cut low so as to
reveal her breasts, not unlike the way
she is envisioned in the *Allegory on the*
Adoption of the Constitution of 1812

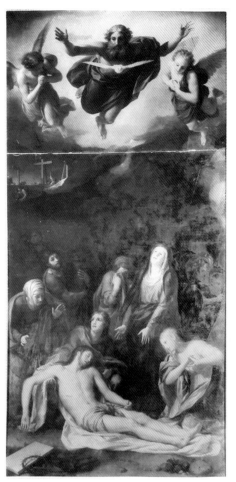

Fig. 1. Anton Raphael Mengs,
Descent from the Cross, about 1761-1769.
Oil on canvas.
Real Casa, Patrimonio Nacional, Palacio de
Pedralbes, Barcelona

(cat. 74). The triangular composition is
characteristic of religious paintings, espe-
cially those of Christ descended from the
Cross, as in an example by Mengs, Carlos
III's court painter (fig. 1). In Goya's print
Constitution replaces Christ as the lan-
guishing central figure and Justice, Mary
Magdalen, gesturing like Melancholy.

In spite of the absolutists' attempts to
bury Goya's Constitution, she continues
to give off light, much as she does in
Album C 117 (cat. 109), where light
forms an aureole around her body and
penetrates the darkness, auguring her
resurrection. As in *Constitutional Spain*
Beset by Dark Spirits (cat. 148), the light
she radiates keeps her enemies at a

respectful distance. The Constitution is a
source of Enlightenment and therefore of
Truth. As in the following drawing in
Album C, page 118 (cat. 110), both the
Constitution and Justice are embodiments
of one Truth, Justice being a consequence
of the Constitution. In *Murió la verdad*
her scales are tilted and she mourns,
whereas in plate 80 (cat. 162), Justice dis-
appears altogether, displaced by two
monks hostile to the Constitution.

The bishop is not blessing the death of
Truth, for this would be heresy. The cus-
tomary benediction is right-handed and
three-fingered; his is a two-fingered ges-
ture.[2] Instead of blessing, he points
toward heaven and in the name of God
oversees the burial of Constitution. In
1833, a Liberal examining the failures of
the first two constitutional regimes in
1814 and 1823 observed that most of the
bishops and cathedral chapters backed
Fernando VII because they feared
reforms favoring the poorer parish
priests – who were overwhelmingly Lib-
eral,[3] a fact that is perhaps suggested on
the left by the priest turning away from
the proceedings – and because they
found freedom of the press offensive.[4]
Those *quevedos* worn by the bald man on
the left are the telltale sign both of the
opportunist (see cat. 148) and the person
with backward notions (see cat. 47). But
in connection with the malevolent
bishop, they may also have served Goya
as a sly reference to the infamous bishop
of Orense, Pedro Quevedo y Quintano,
president of the Regency during the
Peninsular War when the Cortes (parlia-
ment) were drafting the Constitution of
1812. The bishop was a dyed-in-the-wool
defender of the Old Regime Church and
monarchy; his resignation over the Cor-
tes' declaration that sovereignty resided
in the nation and not the monarchy gave
rise to the schism between royalists and
Liberals that eventually brought the Con-
stitution down.[5] The only bishop to
openly disavow the Constitution by refus-
ing to take the oath to uphold it, he
embodied the most aggressive and
intransigent forces of reaction, refused to
come to terms with his opponents, and
exploited every tactical error committed
by his enemies.[6] On July 19, 1812, four
months after the promulgation of the

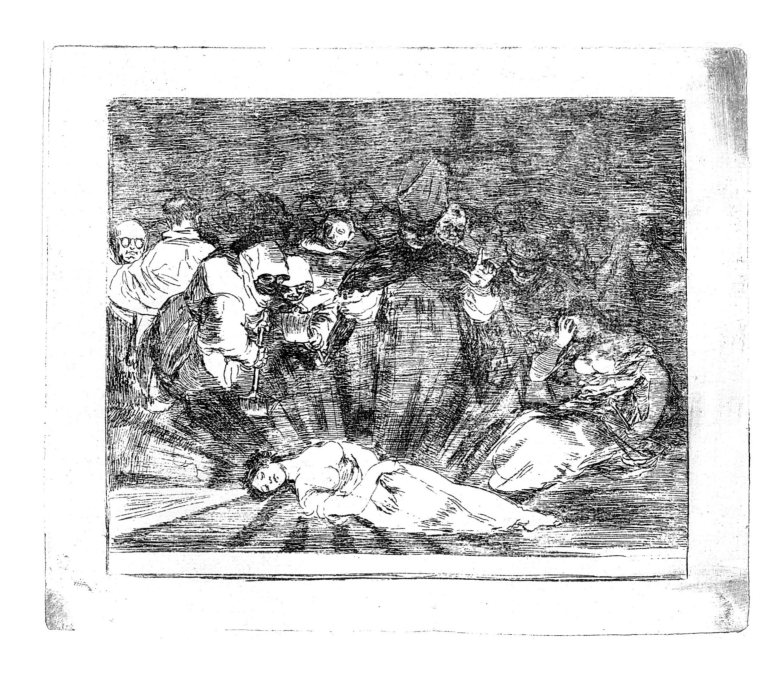

Constitution, the bishop declared that swearing to uphold it was not equivalent to swearing to its truth or the legitimacy of the principles that informed it or indeed of any of its articles. His hostility to the Constitution earned him banishment on August 17, 1812; this punishment transformed him into a martyr around whom the partisans of "traditional" Spain rallied.[7] He was a model candidate for the bishop in Goya's print.[8]

M.A.R.

1. See Claudette Dérozier, "La Guerre d'Independance Espagnole à Travers l'Estampe (1808-1814)," Ph.D. diss., L'Université de Toulouse-Le-Mirail, 1974, pp. 964-965.

2. This gesture recurs in *Disaster* 77 (cat. 159) and *Disaster* 82 (cat. 163).

3. See Dérozier, "La Guerre," pp. 964-965. A list of 355 *exaltados* (exalted, the most radical Liberal faction) and, therefore, suspect clerics in cathedral chapters and parish churches was drawn up in 1823 when the Liberal government fell. See Callahan, *Church*, p. 290, n. 35.

4. See Artola, *Orígenes*, p. 627; Callahan, *Church*, pp. 88-89, 95-96, 100-101, 112-113.

5. See José Manuel Cuenca, "Iglesia y Estado en la España contemporánea (1789-1914)," in *Estudios sobre la Iglesia española del XIX* (Madrid, 1973), pp. 43-44.

6. See Callahan, *Church*, pp. 96-97.

7. See Albert Dérozier, *Manuel Josef Quintana et la naissance du libéralisme en Espagne* (Paris, 1968), pp. 519-524.

8. Contrast the enlightened ideal of the bishop as preacher of the gospel, leading men along the path of peace rather than of disputes. See León de Arroyal, "Pan y toros," in *Pan y toros y otros papeles sediciosos de fines del siglo XVIII*, ed. Antonio Elorza (Madrid, 1971), p. 25.

162

Si resucitará? (She will rise again?)
Fatales consequencias de la sangrienta guerra en España con Buonaparte. Y otros caprichos enfaticos [Disasters of War], plate 80
Working proof
About 1820-1823
Etching and drypoint, touched with graphite
175 x 220 mm.
References: G-W 1134; H. 200, I, 1.

Museum of Fine Arts, Boston, 1951 Purchase Fund, 51.1695
United States only

Darkness has made inroads since the previous print, in which Constitution died (cat. 161). But she is rising from her grave. Her radiance is more circumscribed yet more intense than when she expired. The tombstone at the right only partly covers her, for no grave will hold her. Her head, framed in a mandorla, is turned, but she has yet to open her eyes and see the circle of creatures who threaten her with clubs and books. On the right, where grieving Justice once sat, a monk in a white habit lifts a club in his right hand and grasps a rock in his left; another with a beastly face holds a scroll. A third person, probably another cleric – with a dog's head to represent Avarice (see cat. 45, n. 3) – is about to use a book to bludgeon Constitution.[1] On the far left there is a priest wearing a characteristic *sombrero de teja* (wide-brimmed hat).[2] Constitution's only partisan, who is gagged, is seated next to her, shares her light, and hopefully awaits her recovery, perhaps so that he might then be free to speak.[3] Bats hover in the upper right.

Because it was the second constitutional period and Goya knew the Constitution would be reinstated, the artist stressed the last syllable in the second word of the title; hence the accent in the handwritten title of the set Goya gave to Ceán Bermúdez. As it is written, the title is a baid statement of fact – she *will* rise – qualified only by the question mark, which may have been put there to express the mood of hopeful anticipation before Constitution's resurrection, since "what would happen if she should rise?"

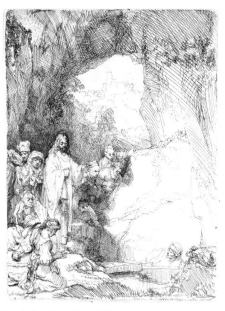

Fig. 1. Rembrandt van Rijn,
The Raising of Lazarus, 1642.
Etching.
Museum of Fine Arts, Boston, Katherine Eliot Bullard Fund

is another possible reading. Both the title and the theme of the corpse rising belong to Christian tradition. The wording of the title may be derived from Psalm 85, verse 11: "Truth shall spring out of the earth; and righteousness shall look down from heaven."[4] The composition recalls Rembrandt's etching (fig. 1) of the dead Lazarus being raised from his grave (John 11:1-44), especially its gathering round the grave and its mood of expectation.[5]

The imagery and hopeful spirit of reform were shared by fellow Liberals. One of them wrote referring to the Church: "Despertó por fin, la razon adormecida, abriósele el paso al imperio de las luces; pero i plugiera á Dios que las naciones todas, participando con abundancia de su saludable influencia, hubieran acabado de sacudir el odioso yugo que les impuso la tenebrosa e implacable tiranía de la supersticion" (Slumbering Reason awoke at last, opening the way to the empire of lights; if only all nations had abandoned themselves to its salutary influence, they would have finished shaking off the hateful yoke that the dark and implacable tyranny of superstition imposed on them)![6]

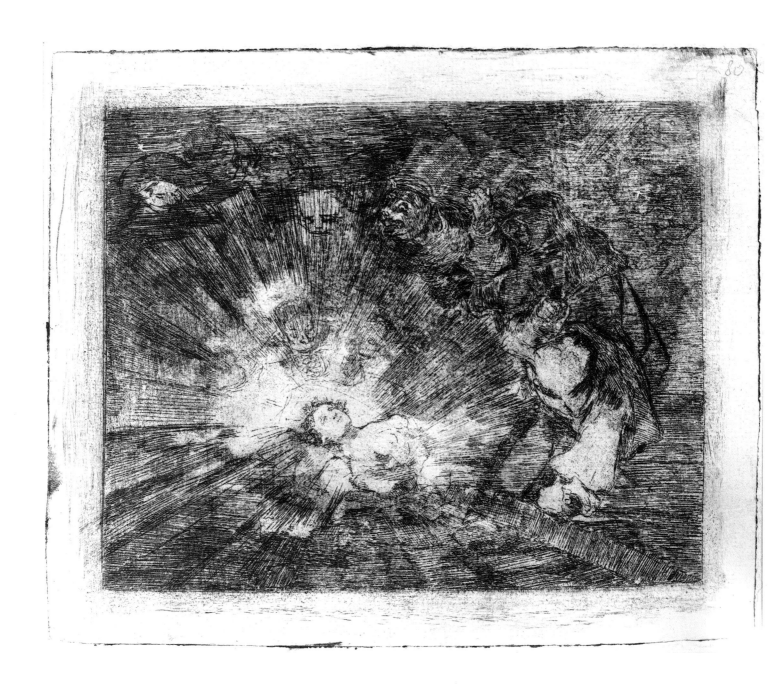

Twenty years had passed between the *Caprichos* and *Disasters of War*, but the circumstances, though changed, presented the same fundamental problem of the tension between reason and unreason (see cat. 155, 161) that Goya had depicted in *Capricho* 43 (cat. 52).[7] Both prints are peopled with the beings let loose when Reason is off its guard, whether asleep or dead, and in both the real subject is the palpable antagonism of light and darkness. In the preparatory drawing for *Si resucitarà?* bats, a toad, and an owl encircle the light, ready to creep back if it should fail. In this later print Goya weighed his hopes and fears and plumped confidently for the triumph of Truth as a result of the Constitution's reestablishment, a belief reflecting Liberalism's second coming from 1820 to 1823.

M.A.R.

1. This book may be related to the tome in which the thieving ecclesiastic of *Disaster* 71 (cat. 158, fig. 1) inscribes laws *contra el bien general* (against the common good).

2. Only priests still wore *sombreros de teja* and heellength capes in 1820. See B. Escandell Bonet, "La Inquisición española en Indias y las condiciones americanas de su funcionamiento," *La Inquisición Española* (Madrid, 1982), p. 86, fig.

3. This image appears in the title of a publication of 1820 celebrating the restoration of freedom of the press. See Revuelta González, *Política*, p. 54, n. 3.

4. See Hamburg, 1980, p. 155.

5. Goya's wording matches Quevedo's in *El sueño del Juicio Final* (The Dream of the Last Judgment) and perhaps was meant to bring the Judgment to mind. The narrator overhears one sinner committed to hell for avarice ask another "si habían de resucitar aquel día todos los enterrados, si resucitarían unos bolsones suyos" (if all the buried were to rise on that day, would some of his [the greedy man's] large purses [of money] rise too). Quevedo, *Sueños*, p. 73.

6. Antonio Bernabeu, *España venturosa por la vida de la Constitución y la muerte de la Inquisición* (Madrid, 1820), p. 22. Biblioteca Nacional, Madrid, R60.122.

7. See Sayre, *Changing Image*, p. 293.

163

Esto es lo verdadero
(This is the true [way])
Fatales consequencias de la sangrienta guerra en España con Buonaparte. Y otros caprichos enfaticos [Disasters of War], plate 82
Working proof
About 1820-1823
Etching and drypoint, touched with graphite
175 x 220 mm.
References: G-W 1138; H. 202, I, 1.

Museum of Fine Arts, Boston, 1951 Purchase Fund, 51.1696
Spain only

A stocky, hirsute, roughly dressed laborer and a radiant young woman wearing an embroidered dress each place a hand on the other's shoulder.[1] He contributes his strength and his hoe, she a sure sense of the road to follow. Surrounding her are a full basket of produce, a sheep ready for shearing, and sheaves of wheat. Framing the right side of the print is a tree laden with fruit. Goya, as always, laid his light where he most wanted our eyes to go, letting it play across the laborer's coat and *alpargatas* (hemp sandals), the young woman's ample, bared breasts, her serene expression and pointing hand, and on the wheat and ripened fruit. The strong diagonal of the composition draws attention to the hoe. Emanating from the pair is the familiar light of Reason. This print is a vision of what would pass under constitutional rule.[2]

The young woman is linked with grain and other fruits as is the traditional allegorical figure of Agriculture and, like Agriculture, is joined by a laborer and bares her breasts (see fig. 1).[3] She emits that characteristic nimbus of light we have come to associate in Goya's work with the Constitution of 1812 (see cat. 161 and 162), the light of Truth that both Agriculture and Constitution share, a bond Goya emphasized in the titles to this print and *Disaster* 79 (cat. 161).

Why does an almost providential force infuse Goya's interpretation of both the rule of constitutional law and labor? Liberalism held labor as the sole source of

Fig. 1. Anonymous,
Agriculture.
Etching, in *Le Petit Trésor des Artistes et des Amateurs des Arts*, Paris, year VIII in the Republican calendar (1799-1800).
Private Collection

wealth and enlightened self-interest labor's stimulus. Wealth, according to this utilitarian philosophy, was synonymous with well-being, if not happiness. This formulation had profound consequences.[4] An official revaluation of manual labor took place, induced in part by acute economic and fiscal crises, the results of population growth on the one hand and costly wars on the other.[5] Utility became the measure of legitimacy. In the first constitutional period from 1810 to 1814, such restrictions on labor as guild regulations and the various forms of collective ownership held in perpetuity (for example, entailment, mortmain, and commons) were ended; proliferating tithes and feudal and surplice dues were lifted; and state and chartered monopolies were dismantled in favor of liberty of commerce and manufacture.[6] The sale of ecclesiastical lands, it was believed, would erase the national debt and increase prosperity by putting lands into private hands. Many writers, particularly dramatists, collaborated with the government in the revaluation of manual labor, producing a large and varied literature in which the theme of *menosprecio de corte* (disdain for the court) often went hand in hand with praise of rural life. Much of the Anacreontic vein of late eighteenth-century poetry answered the aim of painting life in the country in seductive

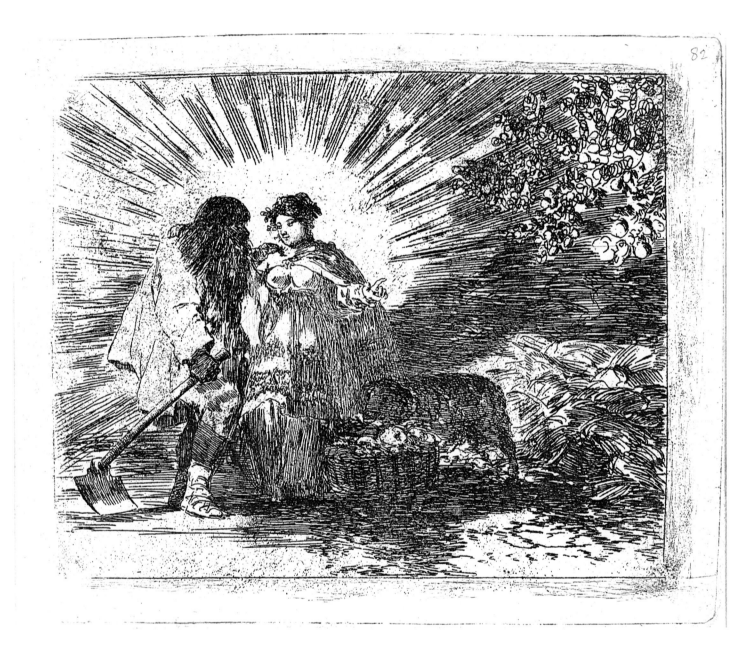

tones so as to encourage landowners to live there and improve productivity and conditions for their laborers.[7]

On April 26, 1794, Gaspar Melchor Jovellanos submitted his *Informe* (Report) on the causes and remedies of the decline of Spanish agriculture, a magisterial analysis of the physical, legal, and moral impediments to prosperity.[8] Typical of the Enlightenment, Jovellanos believed in the redemptive power of laws. He held that apart from natural

factors "aquellos estorbos tenian en él [cultivo] mas principal é inmediata influencia, que se derivaban de las leyes relativas á su gobierno; y que la suerte del cultivo fué siempre mas ó menos próspera, segun que las leyes agrarias animaban ó desalentaban el interes de sus agentes" (the principal, most immediate impediments [to agriculture] have been the laws governing it; the fate of agriculture has always been more or less fortunate according to whether the laws

rewarded or discouraged the owner's initiative).[9] Liberty, prosperity, and contentment depended on each other. "Un pueblo libre y alegre será precisamente activo y laborioso, y siéndolo, será bien morigerado y obediente a la justicia. . . . Este pueblo tendrá más ansia de enriquecerse, porque sabrá que aumentará su placer al paso que su fortuna." (A free and happy people are active and hardworking and thus temperate and obedient to the laws. . . . Such a people

have a greater desire to enrich them-
selves knowing their pleasure will keep
pace with their wealth.)[10]

In *Esto es lo verdadero* Goya recreated
the state of nature without idealizing the
laborer. Divinity has no place here. The
sense of partnership between labor and
wise laws that permit the laborer to reap
the fruits of his work is even more evi-
dent in the preparatory drawing (fig. 2),
in which the halo of light is generated by
both figures.[11] Goya's unsentimental
handling of the subject helped him avoid
the naive, Arcadian tendency of eight-
eenth-century pastoral literature. He
was not prepared to sanitize reality in
order to persuade under false pretenses.

Between Constitution's death and res-
urrection in this series there is an etching
of a beast, *Fiero monstruo* (Fierce Mon-
ster) (fig. 3), resembling a tapir on its
side, disgorging human corpses. *Fiero*
and *monstruo* were labels applied to tyr-
anny or despotism as often by critics of
Fernando VII's reign as by those of Bona-
parte's.[12] Given Fernando VII's role in
subverting the Constitution and the ensu-
ing persecution of its supporters (see cat.
160), in this final summing up of the
series, the monster may well stand for
Fernando VII's regime brought down in
1820 by its own excesses, followed chron-
ologically and in Goya's sequence by the
redeeming virtues of constitutional rule.

M.A.R.

Fig. 2. *Preparatory drawing for Esto es lo verdadero.*
Red chalk.
Museo del Prado, Madrid

Fig. 3. *Fiero monstruo* (Fierce Monster),
Disasters of War, plate 81.
Working proof.
Etching, drypoint, and burin.
Norton Simon Museum of Art, Pasadena

1. In the eighteenth century beards were said to pro-
mote health and propriety. See Kany, *Life and Man-
ners*, p. 179. This usage may be derived from Eras-
mus's *Folly*, which comments on Stoics growing
beards as marks of wisdom. Erasmus of Rotterdam,
Praise of Folly, trans. Betty Radice (Harmondsworth,
1976), pp. 75, 89.

2. For a related sequence on the Constitution, see
cat. 107-110.

3. See *Le Petit Trésor des Artistes et des Amateurs
des Arts*, vol. 1 (Paris, year VIII in the Republican
calendar [1799-1800]), under *Agriculture*, p. 75;
Lacombe de Prezel, *Dictionnaire Iconologique*, vol. 1
(Paris, 1779), under *Agriculture*, pp. 21-22; Gravelot
and Cochin, *Iconologie*, vol. 1, under *Agriculture*, p.
13. In Goya's painting *Alegoría de la Agricultura*
(Allegory on Agriculture), completed about 1800,
Agriculture is seen with a laborer bearing a basket of
flowers. See José Gudiol, *Goya: 1746-1828* (New
York, 1971), vol. 3, fig. 765, p. 629 for text.

4. See Artola, *Orígenes*, p. 588. On the relationship
of poverty to idleness as viewed in the eighteenth
century, see Jacques Soubeyroux, "El discurso de la
Ilustración sobre la pobreza," *Nueva revista de

filología hispánica* 33, no. 1 (1984), pp. 116-121.

5. In the first half of the eighteenth century, Padre
Feijóo defended the inherent nobility of agricultural
(as well as other manual) labor and linked nobility to
merit and to service to the country. Padre Feijóo,
"Honra y provecho de la agricultura," *Teatro Crítico
Universal*, ed. Agustín Millares Carlo (Madrid, 1925),
vol. 3, pp. 277ff. See also Conde Francisco de Cabar-
rús, *Cartas sobre los obstaculos que la naturaleza, la
opinion y las leyes oponen a la felicidad publica*
(Vitoria, 1808), especially letter 4, written in 1792 to
Jovellanos. See also cat. 138, n. 6.

6. See Artola, *Orígenes*, pp. 588-591. On overtaxa-
tion and the state's monopoly of enterprise, see León
de Arroyal, "Pan y toros," in *Pan y toros y otros
papeles sedicios de fines del siglo XVIII*, ed. Antonio
Elorza (Madrid, 1971), p. 23. See also Fontana
Lázaro, *Quiebra*, pp. 259, 261.

7. Paeans to the simple, virtuous, useful life of the
agricultural laborer flourished, particularly when this
life was contrasted with the avarice, grasping ambi-
tion, pride, and pointless luxuries of the court, espe-
cially of the aristocratic absentee landlord (see cat.
138). This subject can be traced back to Horace,
whose work was influential in eighteenth-century

Spain. See Glendinning, *Siglo XVIII*, pp. 17-19, 88,
97, 115-116, 120, 125-128, 131-134, 146-147, 173,
184-186. See also Felix María Samaniego, *Fábulas en
verso castellano* (Madrid, 1803), vol. 2, bk. 1, fables
1, 5; bk. 4, fable 16, which subvert the propagandistic
image and allow the harsh reality of rural life to
show; D.C. de B***, *Fabulas politicas* (Londres,
1813), fables 4, 5. Biblioteca Nacional, Madrid, R
62076. For Spanish medieval sources and images,
see Mateo Gómez, *Sillerías*, pp. 242-243, fig. 230.
For seventeenth-century emblematic references, see
Saavedra Fajardo, *Theatro Moral de la Vida Humana
y Philosophia de los Antiguos y Modernos en cien
emblemas* (Amberes, 1701), pp. 62-69. On the prob-
lem of the absentee landowner, see Sarrailh,
Espagne éclairée, p. 78. The peasants' manner was
often represented as crude, but virtuous; the city
dwellers' civilized, but degenerate. See José Esco-
bar, "Más sobre los orígenes de civilizar y civilización
en la España del siglo XVIII," *Nueva revista de filo-
logía hispánica* 33, no. 1 (1984), pp. 97-98, 208.

8. Jovellanos, *Informe de la Sociedad Económica de
Madrid al Real y Supremo Consejo de Castilla en el
Expediente de Ley Agraria* (Madrid, 1820). The first
edition appeared in 1794. On the genesis and recep-
tion of the *Informe*, see Gonzalo Anes, *Economía e
'Ilustración' en la España del siglo XVIII* (Barcelona,
1969), pp. 97-138. On the importance of public opin-
ion for economic reform in the work of Cabarrús,
Arroyal, and Jovellanos, see Nigel Glendinning,
"Cambios en el concepto de la opinión pública a fines
del siglo XVIII," *Nueva revista de filología hispánica*
33, no. 1 (1984), p. 161. On the advantages of owner-
ship as opposed to tenancy, the problems of both
overconcentration of lands on the one hand and infi-
nite subdivision on the other, and mortmain and
entailment as perceived by Jovellanos, see José
Miguel Caso González, "La emigración asturiana en
el pensamiento de Jovellanos," *Nueva revista de filo-
logía hispánica* 33, no. 1 (1984), pp. 250-253.

9. Jovellanos, *Informe*, section 16, p. 9.

10. Gaspar Melchor de Jovellanos, *Espectáculos y
diversiones públicas en España*, ed. Camilo G.
Suárez-Llanos (Salamanca, 1967), pp. 98-99. The
first edition was published in 1790.

11. For a related image, see Jean-Michel Moreau-le-
Jeune's frontispiece – showing Labor, the genius of
Liberty, and Agriculture – to the *Almanach His-
torique de la Révolution Françoise* (Paris, 1791).
Emmanuel Bocher, *Catalogue Raisonné* (Paris, 1882),
item 1295, p. 467.

12. See Gallardo, *Diccionario*, pp. 14, 76-77;
Martínez Albiach, *Religiosidad*, p. 611, n. 157; and *El
Universal*, Mar. 23, 1814, quoted in José Alvarez
Lopera, "De Goya, la Constitución, y la prensa libe-
ral," in Madrid, 1982, pp. 42.

164
Animal de letras (Learned Animal)
Album G, page 4
1824-1828
Black chalk
191 x 151 mm.
Inscribed in chalk, above image: *4*; below image: title
References: G-W 1714; G., I, 368.

Museo del Prado, Madrid, 398
United States only

A man, transformed into an animal, holds an open book. He has the short, pointed ears, flat face, rounded, gathered shoulders, and claws of a cat, but the thoughtful eyes, upright position, and dexterous hands of a human. His eyes look to the left as though he were about to exchange glances with the man behind him, who holds a broom, or perhaps a knife, and laughs.

Animal de letras is probably a pun on *letrados* (men of letters, that is, learned men). Although *letrados* might have been genuinely learned, they were generally thought pedants, and the word usually specifically meant lawyers.[1] As lawyers, they had terrible reputations. Already in the sixteenth century, the poet Quevedo had a demon in hell say of *letrados*, notaries, and scribes: "Y el no haber escribanos por el camino de la perdición no es porque infinitísimos que son malos no vienen acá por él, sino porque es tanta la prisa con que vienen, que volar y llegar y entrar es todo uno, tales plumas se tienen ellos . . . que acá por gatos los conocemos" (Just because there are no scribes on the road to perdition does not mean there are not countless evil ones who travel it, but as they come in such a hurry, flying [that is, robbing] and arriving and entering are all one, such quills have they . . . that we know them as cats [that is, thieves] here).[2]

In the early eighteenth century, Diego Torres Villarroel deplored *letrados* for destroying property, honor, and lives with their lies, and exploiting the credulity of the people, whom he believed deserved greater respect.[3] In the late eighteenth-century, the satirist León de Arroyal wrote: "Nuestros predicadores y nuestros abogados han descubierto el

inestimable tesoro de ser letrados, sin cultivar las letras y vender caras las más insulsas arengas y pajosos informes" (Our ministers and our lawyers have discovered the priceless treasure of being *letrados*, without cultivating letters and selling dear the most insipid harangues and stuffed reports).[4] *Letrados* charged too much for their pointless services; worse, they made themselves an instrument as well as a millstone of despotic government because "la fortísima falange de letrados . . . armados de sus plumas y cubiertos de sus eternos pelucones, todo lo vencen y todo lo atropellan" (the powerful phalanx of *letrados*, . . . armed with their quills and covered in their eternal wigs, defeat everything and trample it

underfoot).[5] About the same time the enlightened political economist Conde de Cabarrús dismissed the following vocations as largely useless: "las vocaciones al sacerdocio, al estado religioso, a la milicia, a la jurisprudencia y a todas las clases parásitas de procuradores y agentes, de oficinistas y de criados" (vocations for the priesthood, cloister, military, jurisprudence, and all the parasitic classes of procurers [lawyers] and agents, clerks, and servants).[6]

The *letrado*'s long *garras* (claws) draw attention to his thieving, grasping ways, which have changed him into an *animal de letras*.[7] He puts on the airs of an erudite man and uses his knowledge in order to live at the expense of those who do not know better. But the man wielding his broom or knife laughs mockingly because he sees this *letrado* – evidently uneasy – for what he is (see cat. 37): a *gato* (cat), that is, a thief.[8]

M.A.R.

1. *Letra* also referred to the beggars' cant. See José Luis Alonso Hernández, *Léxico del marginalismo del Siglo de Oro* (Salamanca, 1977), under *letra*.

2. Quevedo, *Sueños*, pp. 138, 208.

3. See Iris M. Zavala, "Utopía y astrología en la literatura popular del setecientos: los almanaques de Torres Villarroel," *Nueva revista de filología hispánica* 33, no. 1 (1984), p. 208.

4. León de Arroyal, "Pan y toros," in *Pan y toros y otros papeles sediciosos de fines del siglo XVIII*, ed. Antonio Elorza (Madrid, 1971), p. 22.

5. Ibid.

6. Instead, he praised — again in the same utilitarian vein — farmers, artisans, industrial workers, and merchants. Conde Francisco de Cabarrús, *Cartas sobre los obstaculos que la naturaleza, la opinion y las leyes oponen a la felicidad publica* (Victoria, 1808), p. 82. Quoted in Sarrailh, *Espagne éclairée*, p. 209. These letters were written to Jovellanos in 1792.

7. *Gente de la garra* (people of the claw) were habitual thieves. Academia, *Diccionario*, 1791, under *garra*. See cat. 45.

8. See Hernández, *Léxico*, under *gato*.

165

El perro volante (The Flying Dog)
Album G, page 5
1824-1828
Black chalk
192 x 150 mm.
Inscribed in chalk, upper right: 5; below image: title
References: G-W 1715; G., I, 369.

Museo del Prado, Madrid, 394
Spain only

A *mastín* (mastiff), bred to guard livestock, bares its teeth fiercely as it swoops down upon the people below. It wears the characteristic nail-studded collar to protect itself against wolves (see cat. 160) and has sprouted wings and grown webbed hind feet. A book is harnessed to its back.

The *mastín* was a symbol of the cleric, for just as the mastiff guarded sheep, a priest was considered the spiritual

369

watchdog of Christ's flock (see cat. 160). This dog, however, is not a pure *mastín*. Its wings, webbed feet, and doglike body make it a hybrid of creatures of the air, sea, and land. This hybrid ecclesiastic is neither fish, flesh, nor fowl, or as in the Spanish expression, *ni carne ni pescado* (neither flesh nor fish).[1] Rather than guard his flock, he is like a bird of prey that swoops down to ravage it. The dog sometimes symbolized greed (see cat. 45), and already in the sixteenth century, *volar* (to fly) was slang for "to rob" (see cat. 158).[2]

Mercenary clerics were certainly not unheard of. Friars sometimes even sold their discarded habits as shrouds. In 1812 the Liberal José Gallardo put the following speech into such an avid friar's mouth: "¿Qué es vender? Acá no vendemos nada; pero á nadie se le cortan los vuelos." (What is selling? Here we sell nothing; but no one's wings are clipped.)[3] Clerics were supposed to train their eyes on the spiritual and look with benevolence on the faithful; this one, instead, is so attached to the worldly life that he plunges toward the earth and preys on his flock.[4] The open book on his back indicates he does his thieving in the name of God (see cat. 147 and 161).

M.A.R.

1. Similarly, because the bat was presumed to be a cross between a mouse and a bird, it came to symbolize hypocrisy (see cat. 50, 51, 158).

2. See José Luis Alonso Hernández, *Léxico del marginalismo del Siglo de Oro* (Salamanca, 1977), under *volar*; see also Quevedo, *Sueños*, p. 220.

3. Gallardo, *Diccionario*, p. 102.

4. Goya suggested in *Disaster* 72 (cat. 158) that the absolutist regime established by Fernando VII after the war was as predatory as that of the French army. Fernando VII was restored once again to full absolutist power in 1823 because of the intervention of French troops acting against the second constitutional government in the name of the Holy Alliance of conservative powers. The viciousness of the reaction against the Liberals, as a result of which Goya went into voluntary exile in 1824, may have reminded the artist of Fernando's first restoration in 1814.

166

Ni por esas (Not Even with Those)
Album G, page 8
About 1823-1828
Black chalk
192 X 152 mm.
Inscribed in chalk, upper right: *8*, below image: title, above which is the earlier, half-erased title: *qué tirania* (What Tyranny)
References: G-W 1717; G., I, 371.

Museo del Prado, Madrid, 405
United States only

A young woman in white, resembling traditional representations of Melancholy, is mewed up in a garment fitted with locks and a padlock.[1] Even her fingers are pinioned, and her head is bent in an expression of wistful sadness. The *alguacil* (constable) – in his characteristic short cape, black suit, and hat – is vainly trying various keys to the padlock.

The young woman resembles the allegory of the Constitution in *Album F*, page 45 (cat. 148), and the allegorical figure bearing the Constitution in *LUX EX TENEBRIS* (cat. 109). Crowning her head is perhaps the laurel wreath of victory. Her hair is piled high and she is bathed in light, while he stands slightly behind her, almost in her shadow. Despite his keys, the *alguacil* will fail to work the lock and thereby overcome her. Her sadness and the eloquence of her gesture (see cat. 161) tell us she longs to be freed, only this pretender will not redeem her. Partly erased is Goya's earlier inscription: *qué tirania* (What Tyranny).

The *alguacil* represents established authority. He was responsible for keeping the peace and for minor judicial duties. Long regarded in Spain as the very distillation of dishonesty, he was particularly noted for consummate thievery. Describing the various kinds of thieves he found in hell, Quevedo gave the *alguacil* the highest honors, observing: "Sólo el alguacil hurta con todo el cuerpo, pues acecha con los ojos, sigue con los pies, ase con las manos y atestigua con la boca; y, al fin, son tales los alguaciles, que de ellos y de nosotros defiende a los hombres la santa Iglesia romana" (Only the constable robs with

his whole being, for he stalks with his eyes, pursues with his feet, seizes with his hands, and testifies with his mouth; and, in the end, the constables are such, that the Holy Roman Church protects men from them and from us [devils]).[2] In another passage commenting on the venality of judges, Quevedo used the archetypal image of the thief with a counterfeit key, the emblem of thievery if there is one.[3] Such was the *alguacil's* reputation that to this day in Spanish he has given his name to the skeleton key. The *alguacil* in Goya's drawing uses his counterfeit keys to something not rightfully his. Fernando VII pretended to rule under constitutional law after being compelled to do so by General Riego, who successfully led the Liberal uprising of 1820. Goya may well have implied that Fernando VII's attempt to discredit the Constitution and persecute its supporters was bound to fail.

The woman stands in front of a curtained niche. Along with the erotic theme of the lock and key, this setting might lead us to believe the drawing is based on the Pygmalion and Galatea legend Goya illustrated in an earlier drawing (cat. 153). Goya's Pygmalion wields a sculptor's chisel, bringing his work of art to life by a sublimation of erotic energy. In eighteenth-century slang the key stood for the penis and the lock for the cunnus.[4] In *Ni por esas* sexual awakening is thwarted; instead of a chisel the *alguacil* holds keys that will not fit. He is evidently trying to rob the young woman of her virginity. But not only is he shorter, he also appears to be on the lower side of a slightly tilted platform; she is thereby made to dwarf him all the more. He must look up to her; he will fail because he is not up to her. Either her hair or a hat vaguely suggests a Phrygian cap, symbol of Liberty. Goya's Constitution could not be brought to life under false pretenses, to legitimize Fernando VII's rule by those whose real intent was to rape her; nor could the Constitution be discredited by those who favored absolutist rule.[5] The Constitution's moral ruin was impossible, her chastity – transformed into an abstract principle now of Truth, now of Justice (as in the *Disasters of War*), around which her Liberal sup-

porters rallied – was unassailable.
Through her virtue (and in the fullness of
time, as in cat. 28), she would triumph
over her pursuers.

<div align="right">M.A.R.</div>

1. For an illustration of Melancholy, see Johann
Jacob Engel, *Idées sur le geste* (1795; reprint,
Geneva, 1979), pl. 20, fig. 2.

2. Quevedo, *Sueños*, p. 100. See also cat. 45.

3. Ibid.

4. For an emblem on Venus, chastity, and the key,
see Henkel, *Emblemata*, p. 1749. In Spanish litera-
ture there are countless examples of this metaphor.
In Cervantes's "El celoso extremeño," the story of an
adultery revolves on a master key that opens all locks
in the house, behind which the old husband has shut
away his young wife. The moral of this literature is:
Wherever there is a lock, there will be a key to work
it. See Miguel Cervantes, *Novelas ejemplares*, ed.
Antonio Roldán (Madrid, 1969), p. 166, for the refer-
ence to *llave maestra* (master key), and p. 189, where
Cervantes calls the story an "ejemplo y espejo de lo
poco que hay que fiar de llaves, tornos y paredes
cuando queda la voluntad libre" (example and reflec-
tion of how little we should trust keys, nunnery win-
dows, and walls when free will remains). See Alzieu,
Poesía erótica, no. 81, p. 145; no. 82, p. 150. See also
popular songs, in Marius Schneider and José Romeu
Figueras, eds., *Cancionero popular de la provincia de
Madrid* (Barcelona and Madrid, 1951), vol. 1, no. 76;
vol. 2, nos. 228, 242, 408.

5. This is particularly relevant to the events of 1820,
when Fernando VII was forced to swear allegiance to
the Constitution and did everything in his power for
three years to sabotage it, until he finally succeeded.
For sources on this period, see cat. 151, n. 5.

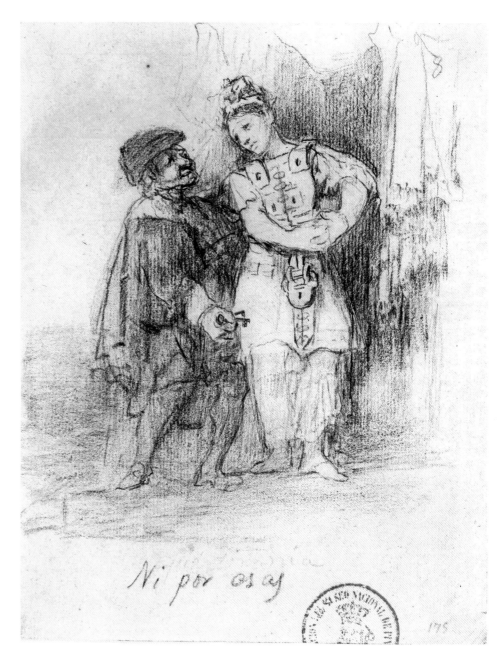

167

Mendigos q^e se lleban solos en Bordeaux
(Beggars Who Get about on Their Own
in Bordeaux)
Album G, page 29
1824-1828
Black chalk
184 x 142 mm.
Inscribed in black chalk, below image:
title
References: G-W 1734; G., II, 387.

Ian Woodner Family Collection, New
York, WD-815

United States only

The inscription places this drawing
among those of Goya's on the subjects of
poverty and mendicancy, subjects he
often returned to throughout his life.
However, on this occasion Goya was
apparently more interested in the precise
rendering of the vehicle transporting the
beggar than in analyzing mendicancy.

In the two Bordeaux albums, *G* and *H*,
beggars appear only twice: in this draw-
ing and in one of an old woman in a cart
pulled by a dog, *Yo lo he visto en París* (I
saw it in Paris) (fig. 1). Goya's inscription
on the latter also reflects his interest in
the unusual system of transportation
rather than in the woman's poverty.[1] In
both drawings, motives other than
exploring the subject of mendicancy
moved Goya to gloss reality. It is as if
with his departure from Spain Goya dis-
sipated a concern that while he lived in
his own country had become almost an
obsession. Mendicancy had also been a
fundamental concern of the entire group
of enlightened writers and politicians
(see cat. 76, 78, 81). The moral degrada-
tion wrought by extreme poverty as well
as willful idleness, which sometimes
resulted in fraudulent mendicancy, were
censured in enlightened circles. Valentín
Foronda, for example, remarked in his
Cartas sobre la policía (Letters on Public
Order): "Los holgazanes, los que no
tienen oficio ni beneficio, los que mendi-
gan solo por huir del trabajo, son una
materia dispuesta para ser ladrones,
incendiarios, asesinos, sediciosos; en una
palabra, para emprender todos los
crímenes; así es preciso perseguirlos
hasta que sean laboriosos, y coman con el

Fig. 1. *Yo lo he visto en Paris*, 1824-1828,
Album G, p. 31.
Black chalk.
Private Collection, Paris

Fig. 2. *En el talego de carne lleba su patrimonio*,
1808-1814,
Album C, p. 35.
Black and gray wash.
Museo del Prado, Madrid

sudor de su rostro, según el precepto que
impuso Dios al hombre" (Idlers, those
who have neither job nor income, those
who beg in order to escape work, are
predisposed to being thieves, arsonists,
murderers, rabble-rousers, in a word, to
committing all kinds of crimes; thus it is
essential to hound them until they take
work and eat from the sweat of their
brow, according to the injunction God
handed down to man).[2]

The Bordeaux albums, especially
Album G, continue to reveal Goya as an
artist deeply concerned about his world.
Perhaps in France the problems of pov-
erty and mendicancy were less evident or
in fact less severe than in Spain and for
this reason were not among the most
important subjects of the works Goya
created in the final years of his life.

In this drawing Goya presented the
beggar seated on a wagon, his hands
working handles that doubtless helped to
propel the conveyance. It could be called
a tricycle, with two large front wheels
and a small back wheel for steering. The
man, who seems to be short, is perhaps
without legs. At the rear of the vehicle is
a bag in which the beggar probably
stashes his belongings. The hat casts a
shadow on the upper part of the man's
face, leaving the nose and cheekbones
strongly highlighted. The cheeks, mouth,
and chin remain in shadow. The curious,
bearded character seems to be smoking a
cigarette butt. Goya was a master of
characterization and in this case gave the
beggar a decided air of independence.
This is not a picture of a wretch plunged
in dire poverty or of a shameless beggar
who tries by wiles to obtain alms from
passersby. Although this man depends
on charity, forced perhaps by his disabil-
ity, he is depicted by Goya as a dignified
person. Perhaps the inscription could
have the double meaning Goya gave
others; the beggar "se lleba solo" (gets
about on his own) thanks to his convey-
ance, as Goya comments, but this also
allows him to "llevarse solo" (fend for
himself) without needing to depend on
the help of others. The scene no doubt
records something Goya saw in the
streets of Bordeaux – a mode of trans-
portation for certain beggars – but with
his impressive power to capture the

deepest, most individual essence of each person, he created a splendid image of the human capacity to overcome adversity.

It is instructive to compare this drawing with another, very similar one created in Spain, a fierce mockery of mendicancy and of the exploitation of physical incapacity: *En el talego de carne lleba su patrimonio* (That bag of flesh is his entire patrimony) (fig. 2).[3] In this drawing Goya presented a beggar seated on a cart, perhaps pulled by a companion; it seems that, unlike the man in the later Bordeaux drawing, he could not "llevarse solo" (fend for himself). The monstrous deformity of the beggar's leg is made conspicuous because he supports the leg with his left hand. With his right hand he holds out a hat for money. Just as monstrous as the man's leg is the smile at the corners of his mouth and the look – somewhere between humble, trusting, and self-satisfied – with which he gazes up at the invisible passersby. This and the caricaturelike deformation of the profile summarize the man's total degradation; he is content with a deformed leg, which no doubt makes it possible for him to make a living without working. Goya played here perhaps with the dual meaning of the word *talego*, which means bag as well as money; thus the leg is a bottomless money bag from which the beggar liberally draws his sustenance.

M.M.M.

1. G., I, 389.

2. Valentín Foronda, *Cartas sobre la policía* (Madrid, 1801), p. 111.

3. Gassier discussed both these drawings in terms of the beggars' form of locomotion; G., I, 182, p. 362.

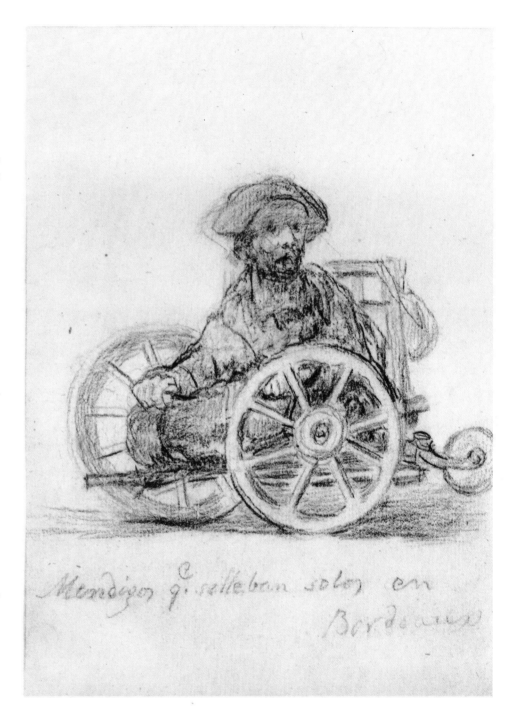

168

Album G: Loco furioso (Raging Lunatic)
Album G, page 33
1824-1828
Black chalk
193 x 145 mm.
Inscribed in black chalk, above image:
Loco furioso 3
References: G-W 1738; G., I, 391.

Ian Woodner Family Collection, New York, WCII-116

United States only

Throughout his career Goya executed various works on the subject of insanity or folly (see cat. 21, 169, 170), although in the last period of his life, when he lived in Bordeaux, this theme appeared most frequently and in the most diverse guises. In the small paintings in the Meadows Museum, Dallas (cat. 21), and the Academia de San Fernando, Madrid (G-W 968), Goya represented the interior of a madhouse: the bare and somber architecture and the figures of lunatics engaged in strange and ambiguous activities arising from their illnesses. It is precisely this descriptive character of an odd reality that interested him at that point rather than the analysis of madness and its effects on humans.

However, Goya later took advantage of the freedom that drawing afforded him to give shape to some of the most expressive and dramatic, not to mention singular, lunatics to be found in art. Goya undoubtedly shared with his enlightened friends philanthropic opinions on insanity and the treatment the insane deserved, and in his works he seems to have intuitively presaged the discoveries of modern psychology by denouncing traditional, commonly held ideas on mental illness.

Goya also used the facial expressions of lunatics to more forcefully punctuate works not strictly on madness. A world whose reality was distorted, a world bordering on madness is to be found in the *Disparates* and in the "Black Paintings" so that for a while Goya scholars were led to believe that the artist must have been mad or at least unbalanced.

Goya's drawing in *Album D*, page 11, *Locura* (Madness) (fig. 1) presents a

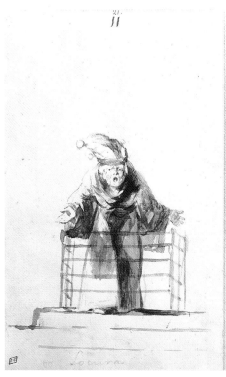

Fig. 1. *Locura* (Madness), 1816-1818, *Album D*, page 11.
Black and gray wash.
Mr. and Mrs. E. V. Thaw, New York

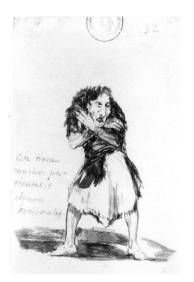

Fig. 2. *Este tiene muchos parientes y algunos racionales* (This one has many relatives, some of them sane), 1808-1814,
Album C, page 52.
Black and gray wash.
Museo del Prado, Madrid

somewhat ambiguous figure of an old man or woman, wearing a long habit and a pointed hat trimmed with bells. The shape of the mouth and the gesture of the open arms suggest he or she is speaking. The elevated position of the figure, on a kind of balcony, immediately brings a pulpit to mind, perhaps recalling the preachers, religious or otherwise, that Goya often made the target of his scorn. Goya's interest in representing the lunatic also appears in *Album C*, page 52 (fig. 2). The inscription leaves no room for doubt about the subject, nor does the sad figure – half human, half animal – whose features have been altered by madness.

In this drawing, *Loco furioso*, we see an old man shut behind a barred window; he puts his head and one of his arms between the bars. The man's expression is attentive, and his gaze lucid, showing no signs of the madness indicated by the inscription. Perhaps Goya wished to denounce the way this unfortunate man was being treated, that is, as if he were a savage animal, for he is naked, his hair grows rankly, and it almost seems that there has been a delib-

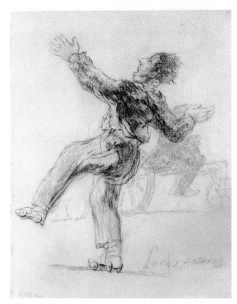

Fig. 3. *Locos patines* (Mad Skates), 1824-1828, *Album G*, p. 32.
Black chalk.
Museum of Fine Arts, Boston, Arthur Tracy Cabot Fund

erate attempt to erase any sign of humanity. Goya used the same title for *Album G*, page 40 (G-W 1740), in which the figure is seen within his cell, a barred window in the background. The hands tied behind the back, the seminudity, and the violent expression of insane rage on the face speak eloquently of the deplorable condition in which this person exists. This drawing has been related to a print entitled *Damned Soul* in J.B. Boudard's *Iconologie*, dated 1766.[1] There is a certain similarity between these works that could explain the intention behind Goya's drawing, thus establishing a connection between the lunatic and the psychological suffering of the damned soul.

Although it is difficult to know what the colloquial terms referring to insanity were in Goya's day, we do know that *loco furioso* is still used to refer to the most extreme manifestations of schizophrenia. And as a vestige of the way the insane were treated in the not too distant past, we hear in colloquial usage the expression "loco de atar" (mad enough to be tied up).[2] Goya used the word equivocally, as it can be used in modern Spanish, for the term "locura" (insanity or folly) or "loco" (lunatic or fool) can refer not only to mental illness but also to extravagant or unusual behavior. Goya used it in the latter sense, but with a humorous twist, in *Locos patines* (Mad Skates) (fig. 3), the drawing preceding *Loco furioso*, in which a skater is about to fall and a cyclist recedes in the background — the skates and the bicycle probably being examples of "crazy novelties" to the old artist.

It is also difficult to explain Goya's late-blooming interest in madness, which led him to create a procession of masterpieces in his twilight years. Taken together, these works are not merely a meditation on the eighteenth-century concept of Reason as opposed to chaos or the irrational, but rather the fruit of his alert curiosity about human behavior and motives. In Bordeaux Goya continued to associate with his old circle of enlightened friends, for whom the subject of madness had been so important. However, we must also remember that in the artist's final years, his frequent illnesses

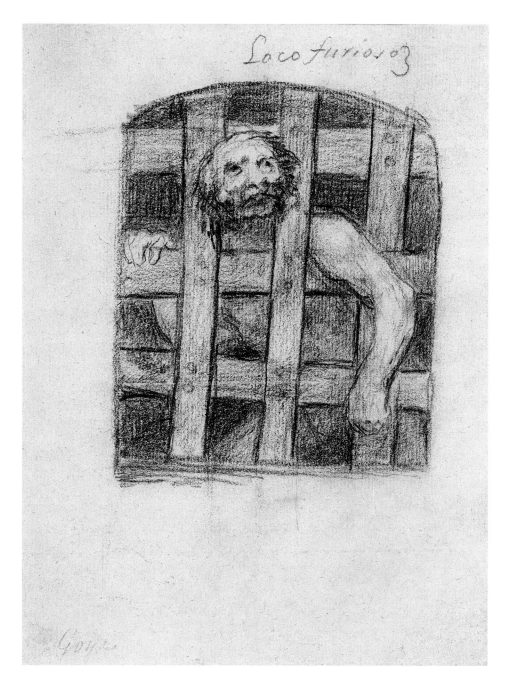

put him in contact with doctors, perhaps French, and that not long before his arrival in France there appeared an especially important work on insanity, *Traité de la folie* (Treatise on Madness), by Etienne Jean Georget, chief doctor of the Salpetrière Hospital in Paris.[3] This treatise for the first time discussed the insane not as beings possessed by the devil but as ill people, whose diseases could be cured by science. Around 1819 ten portraits of lunatics were executed by the French painter Géricault, Georget's friend, perhaps for scientific purposes.[4] Although they express a different vision of madness from Goya's, both artists shared an interest in the subject.

M.M.M.

1. See Städtische Galerie, Städelschen Kunstinstitut, Frankfurt am Main, *Goya: Zeichnungen und Druckgraphik*, exhib. cat. by Margret Stuffmann (1981), p. 219.

2. In early nineteenth-century treatises on madness, such as that cited by E. J. Georget, *loco furioso* was applied to extreme cases of insanity and the description corresponds well to some of Goya's works on the subject: "La fureur est une exaltation des forces nerveuses et musculaires. . . . Le furieux, les yeux étincelants, la figure animée, vocifère, injurie, menace, et se porte souvent à des voies de fait, casse et brise tout. Les forces musculaires des aliénés sont alors augmentés à un point extreme." (Rage is an excitement of nervous and muscular energy. . . . The insane person, his eyes flashing, face animated, shouts, insults, threatens, and often commits assault and battery, breaking and wrecking everything. The muscular strength of the lunatic is then magnified to an extreme.) E. J. Georget, *Traité de la folie* (Paris, 1819), pp. 106-107.

3. Georget summarized the history of insanity and recorded the opinions of his most immediate predecessors, Charcot and M. Pinel, his teacher. See note 2.

4. Five of the ten he executed have been identified and belong to various collections. Very realistically done, these portraits, it seems, were used by Georget in his classes on madness.

169

Locos (Lunatics)
Album G, page 35
1824-1828
Black chalk
184 x 145 mm.
Inscribed in black chalk, above image: title; upper right: *35*
References: G-W 1740; G., I, 393.

Museum of Fine Arts, Boston, William E. Nickerson Fund, No. 2, 55.662

Spain only

Among the thirteen drawings on lunatics in the Bordeaux albums, this one and page 37 (fig. 1), with the same title, present various gatherings: here a group and in figure 1 two people.

In the exhibited drawing the group seems to be carrying out some joint action; all the people facing the viewer appear to surround a person with his back to us, his head bowed, and his right arm bent; directly beyond his arm, there is what appears to be a violin bow held diagonally. Thus this person could be playing the violin while the others listen; and perhaps some, whose mouths are open, are singing.

The strange expressions distorting the faces make Goya's inscription – which indicates we are witnessing lunatics – superfluous. But at this point we are stopped short, for it is difficult to further analyze the meaning of this work. Is a group of lunatics in an asylum trying unsuccessfully to perform a melody in tune without succeeding? Or is this an illustration of the attempt to cure mental illness with music?

M.M.M.

Fig. 1. *Locos* (Lunatics),
Album G, page 37.
Black chalk.
Formerly Gerstenberg Collection, Berlin

170

Loco pr errar **(Lunatic Because He Erred;
or Lunatic to Be Fitted with Leg Irons)**
Album G, **page 44**
1824-1828
Black chalk
191 x 146 mm.
Inscribed: in black chalk, above image,
effaced: title; upper right: 44; at lower
right: *. . nto*
References: G-W 1749; G., I, 402.

Museum of Fine Arts, Boston, Arthur
Tracy Cabot Fund, 53.2378

Spain only

This drawing is one of the most enigmatic
of the series on madness or folly. The
upper part of the inscription, which is
hard to make out, has been given the
interpretation "a man who has gone mad
because he is convinced of his errors" or,
given Goya's poor spelling, in the sense
of *loco por herrar*, "a lunatic who is to be
fitted with shackles or fetters."[1] The let-
ters of the lower part of the inscription,
of which only the last – *nto* – can be
read, have been interpreted as *santo*
(saint), although there is too little evi-
dence to support this hypothesis; given
the image, the letters could be part of
convento (convent).[2]

Before a dark background that could
be either a nighttime exterior or a som-
ber room in shadow, a male figure is
presented dressed in clothing with ample
folds suggesting a monastic habit. His
head is bowed, and his eyes are closed as
if in meditation or prayer. In his hands
he bears what appears to be a book or an
image. The drawing is difficult to inter-
pret; it may express Goya's opposition to
the religious orders, whose members he
considered ignorant and fanatical (see
cat. 111-115).

M.M.M.

1. José López Rey, "Goya at the London Royal Acad-
emy," *Gazette des Beaux-Arts* 63 (May-June 1964), p.
366.
2. Ibid.

171

Enrredos de sus vidas (Entanglements of
Their Lives)
Album G, page 46
1824-1828
Black chalk
191 x 155 mm.
Inscribed in chalk, below image: title;
upper right: *46*
References: G-W 1751; G., I, 404.

National Gallery of Canada, Ottawa /
Musée des Beaux-Arts du Canada,
Ottawa, 2997
Spain only

Two young women wearing white dresses
float in space, surrounded by a shadowy
confusion of bat and butterfly wings,
monstrous and mocking faces, and heads
with animal features. The woman with
her back to the viewer reaches out to the
other – who seemingly emerges from and
blends in with the demons surrounding
the pair – as if to draw her close.

In the background of the painting – and
even more in the oil sketch (G-W 243) –
*San Francisco de Borja at the Deathbed
of an Impenitent* (Chronology, fig. 2) – in
the Cathedral of Valencia, monstrous
beings appear for the first time in Goya's
work as symbols of human vices and sins.
The same iconographic motif of floating
monsters resurfaces years later in the
Bordeaux albums (1824-1828), specifi-
cally in this drawing and *Fiesta en el
ayre. Buelan buelan* (Celebration in the
air. They fly, they fly), *Album G*, page 53
(G-W 1757).

Among the hordes in *Enrredos de sus
vidas*, there are faces with somewhat
simian features, and between the two
women can be seen something that
recalls a pig's head, especially its snout.
Both monkey and pig are traditional alle-
gorical figures of Lust.[1] Another of the
nonhuman heads, perhaps the most rec-
ognizable, is that of the dog on the upper
left, near the edge of the circle. The dog
was regarded in medieval iconography as
an impure animal, symbol of vice and
sin.[2] Although butterfly wings are a uni-
versal symbol of female frivolity and
inconstancy, the noun *mariposa* (butter-
fly) is also used to refer to prostitutes and
even has a long tradition in Spain and

some Spanish American countries as a synonym for homosexual.[3] The word *enrredos*, used by Goya in the inscription, reinforces the sexual imagery contained in the drawing. *Enredo* and *enredar* were used repeatedly in erotic poetry and colloquial language to indicate illicit sexual relations.[4]

The drawing could be interpreted as an attack on female frivolity. The diabolical circle would allude to the women's amorous *enrredos* or involvements, and the contrast between the white, graceful figures and the cluster of monstrous heads surrounding them also calls hypocrisy to mind. However, there may be another meaning. The fact that one of the young women initiates an embrace, as if she wished to draw the other close to her, the insistent symbols of lust, and, above all, Goya's ambiguous inscription perhaps suggest a homosexual relationship. This drawing would not be the only one in which Goya addressed lesbianism. The *Album E* drawing *Two Women Embracing* (G-W 1426) clearly refers to the same subject. But in *Enrredos*, Goya shows greater sensitivity in his handling of it, although at the same time he appears to criticize sexual excesses.

T.L.M.

1. Although the monkey was identified in the Middle Ages with the devil and the seven deadly sins, usually it represented Lust, as it so often did in Gothic choir stalls. See Mateo Gómez, *Sillerías*, pp. 88-93. Since biblical times, the pig – symbolizing Gluttony as well as Lust, and as such a frequent subject in Gothic choir stalls – has been among the least esteemed of animals. See Mateo Gómez, *Sillerías*, pp. 61-66. In Latin, *porcus* can mean female sexual organs. See J. N. Adams, *The Latin Sexual Vocabulary* (Baltimore, 1982), p. 82.

2. See Mateo Gómez, *Sillerías*, pp. 102-103. A frequently used expression in popular speech is *estar como una perra salida* (to be like a dog in heat), applied "a la mujer que por sus palabras o acciones da a entender que abriga apetitos lujuriosos" (to the woman whose words or behavior make it understood she harbors lustful desires). See *Enciclopedia universal ilustrada europeo americana*, vol. 43 (Barcelona, 1921), under *perra*. Strangely, one of the two women appears to float *salida* (out or away) from the diabolical situation; thus Goya may have intended to compare the *mujer salida* with the *perra salida* of the colloquial expression. See also Camilo José Cela, *Diccionario del Erotismo* (Barcelona, 1988), vol. II, under *salido*.

3. See Manuel Criado del Val, *Diccionario español equívoco* (Madrid, 1981), under *mariposa*. By the

fifteenth century *mariposa* was used to refer to hermaphrodites. See Isabel Mateo Gómez, *El Bosco en España* (Madrid, 1965), p. 16.

4. This meaning was already acknowledged in the *Diccionario de Autoridades*, 1726-1739, under *enredar*: "Por analogía vale enlazar, trabar y mezclar a uno, haciéndole entrar en un empeño y ocasión, de la qual difícilmente se pueda desembarazar: como suele suceder a los que viven amancebados" (By analogy it means to link, to bind, and to involve someone, making him incur an obligation and participate in an endeavor from which he can only free

himself with difficulty: as tends to happen to those cohabiting illicitly). In Navarra, which neighbors Goya's native Aragón, it also meant "toquitear, sobar" (to handle, to pet) and in colloquial language was equivalent to "amancebarse" (to cohabit illicitly). See Alonso, *Enciclopedia*, under *enredar*.

172

Semana S^{ta} en tiempo pasado en España
(Holy Week in the Past in Spain)
Album G, page 57
1824-1828
Black chalk
192 x 147 mm.
Inscribed in chalk, upper right: *57*; lower
left: title
References: G-W 1761; G., I, 413.

National Gallery of Canada, Ottawa /
Musée des Beaux-Arts du Canada,
Ottawa, 2999

Spain only

A Holy Week procession is under way.[1]
We see the great standards, a trumpet,
and masked flagellants in conical hats,
who strike their own backs with
scourges.[2] In *Album B*, page 80, *Mas-
caras de semana santa del año de 17..*
(Holy Week Masks [Masquerades] in
17..) (fig. 1), of 1796 or 1797, Goya dealt
with the same subject, as he did in the
Academia de San Fernando painting *Pro-
cession of Flagellants*, of 1812-1814 (fig.
2). In all three works the light and com-
positional lines lead to the bared and
wounded backs mortified in deference to
a god conceived as a vindictive rather
than a forgiving spirit. The title of the
Album B drawing gives Goya's opinion of
these putative displays of devotion; he
called them *máscaras* (masquerades).[3]

Processions held during Holy Week
and other sacred occasions were criti-
cized by reformers for glorifying rituals of
penance over inner faith and contempla-
tion; for some these rituals wrongly
embodied fear of punishment more than
love of God. In the 1790s, for example,
León de Arroyal described devotion to
processional images as a form of idolatry:
"La religión la vemos reducida a meras
exterioridades y, muy pagados de nues-
tras cofradías, apenas tenemos idea de la
caridad fraterna" (Religion is reduced to
mere externals, and taking pride in our
brotherhoods [associations that partici-
pated in holy processions], we scarcely
have an idea of fraternal charity).[4]
"None are admitted to this religious act
[the Thursday midnight procession of
Holy Week] but the members of that *fra-
ternity*; generally young men of fashion,"

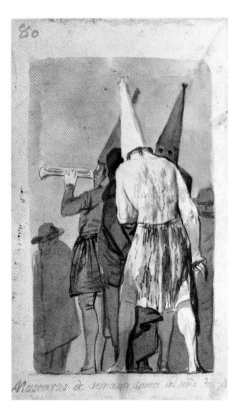

Fig. 1. *Mascaras de semana santa del año de 17..*
(Holy Week Masks in 17..), 1796-1797,
Album B, page 80.
Brush and gray wash.
Norton Simon Museum of Art, Pasadena

Fig. 2. Procession of Flagellants, 1812-1814.
Oil on panel.
Real Academia de Bellas Artes de San Fernando,
Madrid

wrote José Blanco White in 1822. "The
pleasure of appearing in a disguise, in a
country where masquerades are not tol-
erated by the Government, is a great
inducement to our young men for sub-
scribing to this religious association. The
disguise, it is true, does not in the least
relax the rules of strict decorum which
the ceremony requires; yet the mock
penitents think themselves repaid for the
fatigue and trouble of the night by the
fresh impression which they expect to
make on the already won hearts of their
mistresses, who, by preconcerted signals,
are enabled to distinguish their lovers, in
spite of the veils and the uniformity of
the dresses."[5] The magistrate and poet
Juan Meléndez Valdés was harsher.
"Porque ciertamente no se alcanza ahora
qué puedan significar en una religion,
cuyo culto debe ser todo en espiritu y
verdad, esas galas y profusion de trages,
esas hachas y blandones sin número . . .
esas imágenes y pasos llevados por
ganapanes alguilados, esas hileras de
hombres distraidos mirando á todas
partes y sin sombra de devocion . . . ese
bullicio y pasear de la carrera, esa li-
viandad y desenvoltura de las mugeres, y
ese todo, en fin, de cosas o extrava-
gancias que se ven en una procesion, si
no como el fiscal las juzga para si, en vez
de un acto religioso, un descarriado
insulto al Dios del cielo y a sus Santos"
(Certainly in a religion where worship
should be all spirit and truth one cannot
explain those trappings and that profu-
sion of finery, those innumerable candles
and torches, . . . those images and effigies
[representing stages of the Passion] car-
ried by hired porters, those rows of men
looking distractedly every which way,
without a shadow of devotion, . . . that
noise and bustle of the way, that bold
and licentious manner the women have,
and that everything, in sum, of extrava-
gance that is to be seen in a procession, if
not as this judge decided for himself:
instead of a religious act, as a wayward
insult to God in heaven and to his
saints).[6]

Although the Church frowned on the
excesses of such displays, they arose
from the same belief that produced its
historical "splendor of the cult"[7] – the
ceremonial pomp of processions and ser-

vices, magnificent vestments, great candles, censers, bejewelled statues, and sumptuous retables – the belief that religion entered through the senses.[8] As a result of the authorities' hostility and the guilds' deteriorating economic position, the *cofradías* (brotherhoods) – serving charitable, mutual benefit or merely devotional purposes – declined after the middle of the eighteenth century.[9] President of the Consejo de Castilla (Council of Castile) from 1766 until 1773, Conde de Aranda had the *cofradías* investigated because both civil and religious authorities believed they were spending lavish sums on processional paraphernalia and related refreshments and amusements, straying from their simple devotional purpose.[10] Carlos III and his ministers were zealous in their reform of public spectacles, and it is revealing of the enlightened view of religious rituals that they were sometimes examined together with the theater and masquerades.[11] In 1772 it was decreed that various painted and festooned cardboard allegorical figures should be purged from the Corpus Christi procession because they tended to inspire indecency and disorder and distracted from devotion to God. In 1777 public flagellation was prohibited. Blanco White wrote later about this decree: "It is scarcely forty years since the disgusting exhibition of people streaming in their own blood, was discontinued by an order of the Government. These *penitents* were generally from among the most debauched and abandoned of the lower classes. . . . Having, previously to their joining the procession, been scarified on the back, they beat themselves with a cat-o'-nine-tails, making the blood run down the skirts of their garment. It may be easily conceived that religion had no share in these voluntary inflictions. There was a notion afloat that this act of penance had an excellent effect on the constitution; and while vanity was concerned in the applause which the most bloody flagellation obtained from the vulgar, a still stronger passion looked forward to the irresistible impression it produced on the strapping belles of the lower ranks."[12]

On February 20, 1777, penitents were forbidden to practice flagellation during

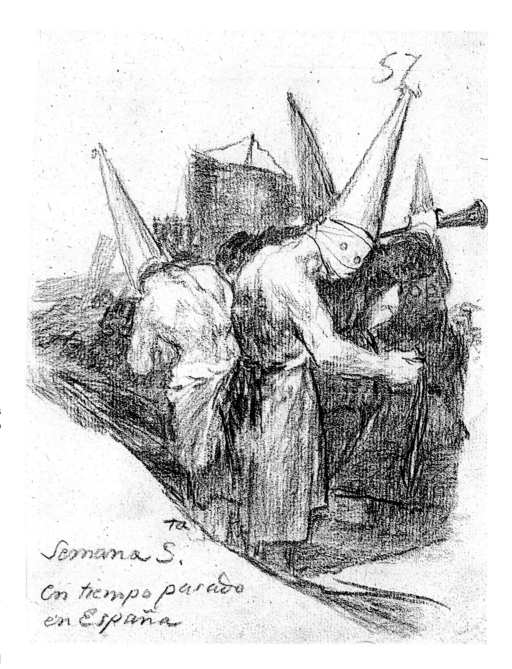

Semana S.
En tiempo pasado
en España

the Holy Week procession, but the decree had to be issued twice thereafter, the last in 1802.[13] The practice, in fact, was never entirely eradicated, and so the drawing with its inscription may well express the tension between an official culture that had forbidden public flagellation fifty years earlier and a popular culture in which collective and outward displays of piety persisted.[14]

M.A.R.

1. For a description of religious processions in the late eighteenth century, see Kany, *Life and Manners*, pp. 358-383

2. For an eighteenth-century illustration of the masked trumpeter in a Holy Week procession, see Manuel de la Cruz's design in Juan Cruz Cano y Olmedilla, *Colección de Trajes de España . . .* (Madrid, 1777), vol. 1. See also Elena Páez Ríos, *Repertorio de grabados españoles* (Madrid, 1981), no. 17.

3. As elsewhere (see cat. 139, 154-163), Goya's ironic use of Carnival attributes suggests that the excesses

of Carnival were not necessarily less Christian than those of the political or religious authorities when they imposed their notions of order and acceptable behavior on others.

4. León de Arroyal, "Pan y toros," in *Pan y toros y otros papeles sediciosos de fines del siglo XVIII*, ed. Antonio Elorza (Madrid, 1969), p. 26.

5. Blanco White, *Letters*, p. 289; see also pp. 288, 290.

6. Juan Meléndez Valdés, *Discursos forenses* (Madrid, 1821), p. 194. Cited in Sarrailh, *Espagne éclairée*, p. 688.

7. See Callahan, *Church*, p. 55.

8. See Martínez Albiach, *Religiosidad*, p. 303.

9. See Callahan, *Church*, pp. 54, 57.

10. Ibid., pp. 58-59.

11. See, for example, Gaspar Melchor de Jovellanos on *romerías* (pilgrimages) in *Espectáculos y diversiones públicas en España*, ed. Camilo G. Suárez-Llanos (Salamanca, 1967), pp. 54ff.

12. Blanco White, *Letters*, p. 291. See also Kany, *Life and Manners*, pp. 369-370.

13. See Conde de Viñaza, *Goya: Su tiempo, su vida, la sus obras* (Madrid, 1887), p. 285. See also Callahan, *Church*, p. 57.

14. Of the "ominous decade," the second period of Fernando VII's absolutist reign beginning in 1823, Ramón de Mesonero Romanos wrote in 1880: "La decantada religiosidad de aquellos tiempos no sólo se manifestaba en rosarios, procesiones y solemnidades; pero precisamente en ellos era también mayor el escándalo que la ignorancia de los predicadores producía en el templo del Señor, con manifestaciones de las que hoy no se puede formar idea. La indiscreta juventud, que hacía alarde, no del escepticismo moderno, más aparente que real, sino de la más cínica impiedad, seguía ese instinto fatal, no contenida, antes sobreexcitada, por las persecuciones y anatemas." (The exaggerated religious sentiment of those times expressed itself not only in rosaries, processions, and solemnities; but in that time greatest scandal was provoked by the ignorance of ministers preaching in the Lord's temple, taking forms scarcely imaginable today. Indiscreet youths, boasting not of modern scepticism, which is more apparent than real, but of the most cynical impiety, followed its fatal instinct, all the more stimulated rather than restrained by persecutions and anathemas.) Quoted in Ferrán Soldevila, *Historia de España*, ed J. Sales (Barcelona, 1973), vol. 6, pp. 409-410. See cat. 155.

173
A Friar and a Boy
Album H, page 4
1824-1828
Black chalk
192 x 154 mm.
Inscribed in chalk, upper right, enforced by another hand: *4*
Signed in chalk, lower right: *Goya*
References: G-W 1767; G., I, 421.

Museo del Prado, Madrid, 402
United States only

A seated friar looms menacingly; a severe and commanding presence, he glares past the boy, plunging his right index finger into the mouth of a skull and raising a crucifix in his left hand. The boy, dressed and shod in middle-class attire, lifts a hoe in answer.

The cowled cleric and skull recall traditional portrayals of friars meditating on death, symbolized by a skull, such as Francisco de Zurbarán's *Saint Francis* (fig. 1). Although the seventeenth-century painting celebrated the triumph of eternal life over death – of the spiritual over the worldly – Goya's friar sits rather than kneels, places the skull on the ground, and, rather than gaze heavenward, lets his finger indicate where his faith lies.[1] The theme of this drawing recurs in Goya's work. Because the friar is seated, and his finger points into the mouth of the skull, the hand and skull may be a visual transcription of the legal term mortmain (*manos muertas*, literally, dead hands), that is, property held by an ecclesiastical corporation in perpetuity (see cat. 111 and 112). The boy wielding his hoe is perhaps the alternative, the life of labor and productivity (see cat. 163), specifically that made possible by disentailment of the great landholdings of the Church. His choice of vocation was not only a personal one; collectively Spaniards made similar choices during the constitutional Cortes (parliament) of 1810 to 1814 and again when the Constitution was restored in 1820. The boy's hoe overshadows the friar and appears to ward off the hostile friar's crucifix; in this struggle between two opposing world views, the laborer with his hoe seems to embody the spirit of the teachings of

Fig. 1. Francisco de Zurbarán, *Saint Francis in Meditation*, 1635-1640.
Oil on canvas.
The Trustees of the National Gallery, London

Christ more than the sedentary friar. Goya cast the problem of ecclesiastical disentailment in terms of an opposition between the sterile monastic life and the productive life of the laborer.[2]

The disentailment of Church properties had been a way to discharge a pressing wartime debt; more importantly, it was hoped turning lands over to private hands would increase prosperity. The Liberal deputy García Herreros put the general view succinctly: "La propiedad muy repartida es la que fomenta y aumenta la población; la acumulada en pocas manos es perjudicial y muy contraria a un buen sistema de agricultura" (Property divided among many owners is the kind that encourages and increases population; that accumulated in few hands is harmful and counterproductive to a good system of agriculture).[3] One-fifth to one-sixth of the nation's wealth was owned by the Church, and mortmain made it impossible for a private, capitalist agriculture to emerge in some parts of

the country (see cat. 111 and 112). Population was the classic eighteenth-century measure of prosperity; but reproduction and productivity were linked in other ways. Summarizing his report on the value of entailed goods in Spain, the Liberal deputy Alvarez Guerra used the same "language" as Goya to distinguish the laboring from the idle classes: "Mi objeto ha sido demostrar que si la nación no paga cuanto debe, si no tiene dinero para continuar la guerra y sostener el Estado . . . es porque los intereses de las clases esteriles que son las que mandan, están en oposición con los de las clases productivas, que son las que obedecen" (I set out to demonstrate that if the nation does not pay what it owes, if it does not have the funds to pursue the war and sustain the government, . . . it is because the interests of the sterile classes, who rule, are in opposition to those of the productive classes, who obey).[4]

Using the language of sterility and productivity, Goya showed how personal and national destinies crossed. He made the boy especially small to lend symbolic power to the hoe he wields and young to punctuate the peculiar tragedy of taking perpetual vows in youth (see cat. 115). Just as insufficiently exploited lands in Church hands were linked with less productivity and, therefore, less population growth, when the young man took the vow of chastity he also chose reproductive death.[5] Liberalism affirmed life, material prosperity, and individualism, including private property, and viewed the Church as fostering economic stagnation, common ownership, and subservience to the past. Liberals rejected mortmain because it enabled the will of the founder of an estate to condition that of its owner, who, unlike a true proprietor, could not therefore dispose of it freely. As Liberalism made headway, the contemplative life could not but seem a perversity, "haciendo profesion de no tener mas bienes propios que los agenos" (professing to reject all personal possessions but those of others), and would always seem so as long as it depended on the industry of others.[6]

M.A.R.

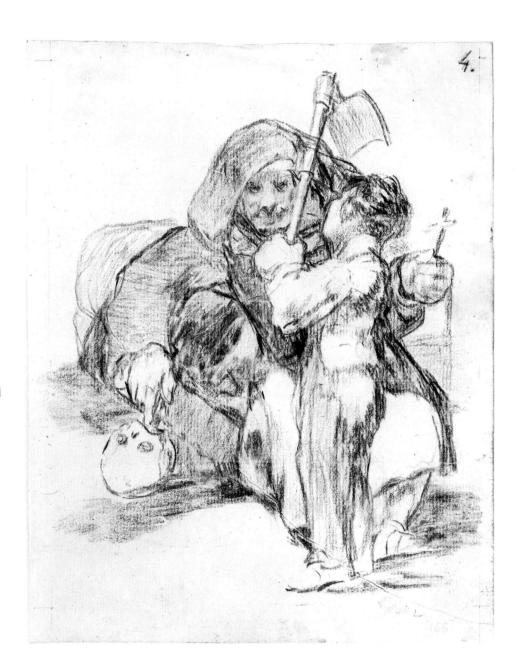

1. Another *Saint Francis* by Zurbarán shows a signaling gesture. The Metropolitan Museum of Art, New York, *Zurbarán*, exhib. cat. (1987), no. 67.

2. The exaltation of labor so characteristic of the late nineteenth century was largely aimed at encouraging the landed nobility and bourgeoisie to live year-round on their estates rather than in their urban palaces and to make improvements in farming methods and their workers' lives. On the relationship between idleness and poverty as viewed by Campomanes and Cabarrús, see Jacques Soubeyroux, "El discurso de la Ilustración sobre la pobreza," pp. 119ff; on Forner's and Campomanes's encouragement of industry by modifying the general contempt for the manual arts, the merchant, the artisan, and the laborer, see Nigel Glendinning, "Cambios en el concepto de la opinión pública a fines del siglo XVIII," p. 162; on measures taken against vagrancy, see "Literatura popular e Ilustración: El *Piscator Económico* de Bartolomé Ulloa (1765)," p. 189. All of the above appear in *Nueva Revista de filología hispánica* 33, no. 1 (1984). See also Cadalso, *Cartas*, pp. 65-70. Among those professions Cabarrús identified as "mostly useless" were "las vocaciones al sacerdocio, al estado religioso, a la milicia, a la jurisprudencia y a todas las clases parásitas de procuradores y agentes, de oficinistas y de criados" (vocations for the priesthood, cloister, military,

courts, and all the parasitic classes of lawyers and agents, clerks, and servants). He praised – in the same utilitarian vein – farmers, artisans, industrial workers, and merchants. Letter from Francisco de Cabarrús to Gaspar Melchor de Jovellanos, quoted in Sarrailh, *L'Espagne éclairée*, p. 209. These letters – *Cartas sobre los obstaculos que la naturaleza, la opinion y las leyes oponen a la felicidad publica* – were first published in 1792.

3. Quoted in Artola, *Orígenes*, p. 525.

4. Ibid., p. 601.

5. The number of individuals allowed to enter the regular orders and the conditions of their admission were also vital concerns. In 1809 the bishop of Cuenca requested that only as many mendicants be allowed to take vows as there was income to maintain them because itinerant clergymen who wandered from village to village begging were discrediting the orders among the general population as a result of their "relaxed discipline." The bishop also proposed the regular clergy be brought under the control of the episcopacy and exemptions from the rules of the orders not be permitted. Manuel Fernández Manrique, a chaplain from Cuenca, recommended the number of monasteries in the peninsula be reduced in proportion to the needs of the population and no new regulars be admitted for eight years. Because adolescents who knew little of life took orders at ages violating canon law as established in the Council of Trent, vocations were not always the fruit of experience, reflection, and a considered dedication to religious life. Fernández Manrique proposed that among reforms of external discipline, monasteries not admit men till they were twenty-four and not accept professions of faith and taking of vows till the candidates were twenty-five "pues así parece conviene en las actuales circunstancias y lo exije la ley suprema del bien de la nación" (as this seems appropriate given the present situation, and the supreme law of the nation's good requires it). On the above, see Artola, *Orígenes*, p. 43. On corresponding measures adopted in 1820, see José Manuel Cuenca, "Iglesia y Estado en la España contemporánea (1789-1914)," in *Estudios sobre la Iglesia española del XIX* (Madrid, 1973), p. 56.

6. See Gallardo, *Diccionario*, p. 91; Artola, *Orígenes*, p. 486.

174
The pen is mightier than the sword
Album H, page 7
1824-1828
Black chalk
192 x 157 mm.
Inscribed in chalk, upper right: *7*, altered from *6*
References: G-W 1770; G., I, 424.

Syndics of the Fitzwilliam Museum, Cambridge, England, 2068
Spain only

An old, balding man resembling an apostle kneels, his steady, benevolent gaze fixed on the viewer.[1] He wears a habit, and his head is framed in a halo of short shafts of light. In his left hand he holds scales whose pans are tilted: a quill pen outweighs a sword, perhaps alluding to the expression *la espada, vence; la pluma, convence* (the sword conquers; the pen persuades).[2] In his right hand there is something resembling an amulet or a key.

In spite of the years and the contretemps, Goya could still muster a moving tribute to the power of constitutional law as symbolized by the pen. There is a print entitled *El Persa aterrado delante de la Constitución* (The Persian [that is, the absolutist] Frightened by the Constitution) (Madrid, Museo Municipal) in which a Persian (see cat. 143) backs away from an allegorical figure of the Constitution of 1812, who says: "La verdad me ilumina y la Justicia me guia" (Truth enlightens me and Justice guides me). Constitution bears a shield on her left arm and holds the scales of Justice in her right hand; the manacles of absolutist monarchy in one pan are outweighed by the just laws the Constitution conveys in the other.[3]

A few years earlier the Liberal poet Manuel José Quintana had made the image of the pen mightier than the sword into a metaphor for freedom of the press, associating it with Freedom in general, Enlightenment, and Justice. In the final strophe of Quintana's *Oda a la invención de la imprenta* (Ode to the Invention of Printing), published in 1800, Quintana intoned, apostrophizing Gutenberg: "¿Pues qué honor, qué loores / bastar

podrán al inventor divino / del arte celestial, que ante los hombres / a la áurea perfección abrió el camino? / !Gloria a aquel que la estúpida violencia / de la fuerza aterró, sobre ella alzando / a la alma inteligencia! / !Gloria al que en triunfo la verdad llevando, / su influjo eternizó libre y fecundo! / !Himnos sin fin al bienhechor del mundo!'' (What honor, what praises / suffice for the divine inventor / of the celestial art, who before men / opened the golden way to perfection? / Glory to him whom the stupid violence / of force frightened, raising over it / the soul of intelligence! / Glory to him who carried truth in triumph, / immortalizing her free and fertile influence! / Hymns without end to this benefactor of the world!)[4] And in another poem Quintana wrote: "¡O, Imprenta, Imprenta! ¿Son éstos los grandes bienes que has traido a los míseros mortales? ¡Ah! La guerra que nos haces con las letras nos da heridas más profundas e incurables que las de las armas." (O, printing, printing! Are these the great blessings you have brought us miserable mortals? Ah! The war you declare on us with words wounds us more deeply and incurably than that of the sword.)[5]

Goya's drawing is an expression of his belief in the apostolic force of Enlightenment and freedom of the press (see cat. 107). Just means in the service of just ends – ideals defended by constitutional law – prove more lasting than force, and in the fullness of time, Justice, served more effectively by a redeeming freedom of the press than a leveling sword, will triumph so that differences may be settled by peaceful discourse.

M.A.R.

1. In early documents and images Paul was represented as old and bald and, like all the apostles, with his head framed in a nimbus. See James Hall, *Dictionary of Subjects and Symbols in Art* (New York, 1979), p. 235.

2. Among Paul's attributes were the pen (for his letters) and the sword (for his martyrdom). Ibid., p. 235. For the proverb, see Luis Martínez Kleiser, *Refranero general ideológico español* (Madrid, 1953), no. 22.670. In letter XXVIII in *Cartas marruecas* (Moroccan Letters), Cadalso's fictional correspondent Ben-Beley reflects on posthumous fame and what moves people to desire it: True wisdom does not lie in seeking military glory or recognition

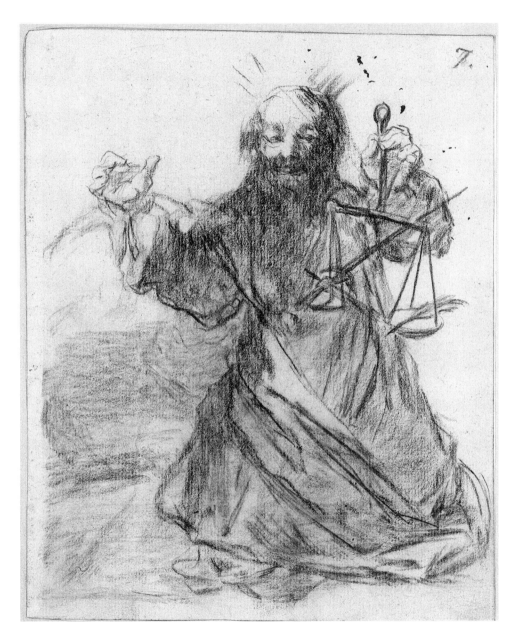

knowledge, but in cultivating virtue, understood as
goodness to others. Cadalso, *Cartas,* pp. 73-75.

3. For a reproduction, see Museo Municipal, Madrid,
La Inquisición, exhib. cat. (1982), p. 83. The print is
also reproduced in Jesusa Vega, "Estampas del
Trienio Liberal," in *Villa de Madrid* 25 (Apr. 1987),
pp. 28-52, fig. p. 45, which gives an exhaustive
account of prints for sale in Madrid during the sec-
ond constitutional period.

4. See Manuel José Quintana, *Poesías completas,* ed.
Albert Dérozier (Madrid, 1969), p. 259.

5. Ibid., p. 267 n. 214.

175

Apocalyptic Wrath
Album H, page 15
1824-1828
Black chalk
191 x 154 mm.
Inscribed in black chalk, upper right: *15*
Signed in black chalk, lower right: *Goya*
References: G-W 1778; G., I, 432.

Museo del Prado, Madrid, 391
United States only

An ambiguously female figure, whose
eyes are blackened and who covers her
head with a shawl, rides a bird of prey.
Her feet in stirrups, she brandishes a
sword in her right hand and wields a
buckler (see cat. 144) in her left.

The principal attributes of this drawing
– the sword and the shield – are tradi-
tional symbols of sometimes incompati-
ble ideas. The sword identifies the
Christian martyr as well as the apostle
Paul; in allegory it is associated with Jus-
tice, Constancy, and Rhetoric. A female
warrior with a sword can be either Forti-
tude or Wrath; Goya's sinister figure
bears affinity with the two biblical horse-
men who wield swords: War and Death
(Revelation 6:4,8). He emphasized the
bird's kinship with the forces of darkness
by giving it the body of an owl and the
membranous wings of a bat, along with
claws, which he associated with preda-
tory forces of the night, among which he
included Ignorance (see cat. 52 and 158).
The female warrior riding a hybrid mon-
ster is more likely the embodiment of
Wrath than Fortitude. A shield deco-
rated with images signified either
Minerva or Fortitude; an undecorated
shield was the attribute of the virgin god-
dess Diana, of the allegorical figure of
Rhetoric, and of a warrior, including Bel-
lona, sister of Mars. The hybrid bird of
prey, the sword, and the undecorated
shield argue most of all for apocalyptic
Wrath, who is indeed a female warrior
responsible for War and Death.[1]

Goya created this work in the period
following Fernando VII's restoration in
1823, during his self-imposed exile in
Bordeaux. The atmosphere of vindictive-
ness; the civil, military, and ecclesiastical
purges of people suspected of Liberal

sympathies; imprisonment; exile; and executions had persuaded the artist to abandon Fernando VII's Spain. Particularly worth noting is the reactionary secret society called *El Angel Exterminador* (The Exterminating Angel), founded by the bishop of Osma, with agents throughout Spain serving as instruments of the absolutist reaction against Liberals, the beginning of a ten-year period known as the *ominosa década* (ominous decade), lasting until Fernando VII's death in 1833.[2] It is perhaps the fierce and violent climate of restored absolutism to which Goya gave form in this drawing.

<div align="right">M.A.R.</div>

1. On the iconography discussed above, see James Hall, *Dictionary of Subjects and Symbols in Art* (New York, 1979), under *apocalypse, eagle, shield, sword,* and *warrior.*

2. See Ferrán Soldevila, *Historia de España*, ed. J. Sales (Barcelona, 1973), vol. 6, p. 406.

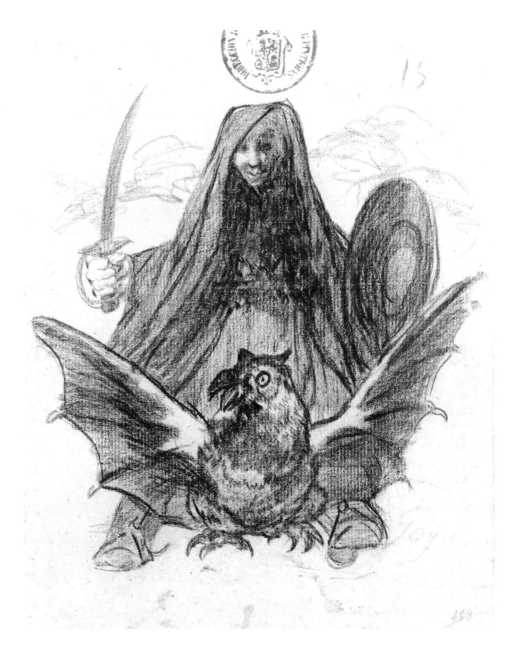

176

Malefic Prophet
Album H, page 26
1824-1828
Black chalk
191 x 154 mm.
Inscribed in chalk, upper right: *26*
References: Not in G-W; G., I, under 443.

Private Collection, United States
Spain only

A thoughtful figure, seated on what appears to be a rock, is posed as if he were writing in a book or on a tablet.[1] His clothing vaguely suggests a religious habit for men. Behind the image there is a strange and angular background outlined in gray tones. To the left of the scribe and next to the boulder rests an object whose ambiguity makes its identification difficult.

Highlighted and singled out of the dark mass of clothing are the face of the writer and his hands and the book, along with the mysterious object lying on the ground. The most carefully defined feature of the face is the nose. Its anomalous curvature, sharpness, and point, emphasized by lines in wet chalk, suggest an eagle's beak. In *Capricho* 63, *Miren que grabes!* (Behold how grave!) (see the essay by T.L. Márquez, fig. 7) and in *Disaster* 75, *Farándula de charlatanes* (Quacks' Patter), together with its preliminary drawing (G-W 1125), Goya also used the features of the bird of prey in order to give a psychological portrait of the ecclesiastical hierarchy, thus perpetuating the tradition begun in medieval Christian art.[2] The thoughtful intensity reflected in the face and the highlighted hands in the Bordeaux album drawing attract the viewer's attention immediately. The hand holding the book or tablet has thick fingers. In contrast, the line defining the edges of the right hand, the shading of part of the hand, and the line down the middle do not suggest human fingers but a hoof, possibly that of a he-goat, symbol of the devil according to popular tradition. Thus it could be said that the figure writes and is guided by the hand of the devil, or as in the colloquial expression "dejado de la mano de Dios" (abandoned by the hand of God, that

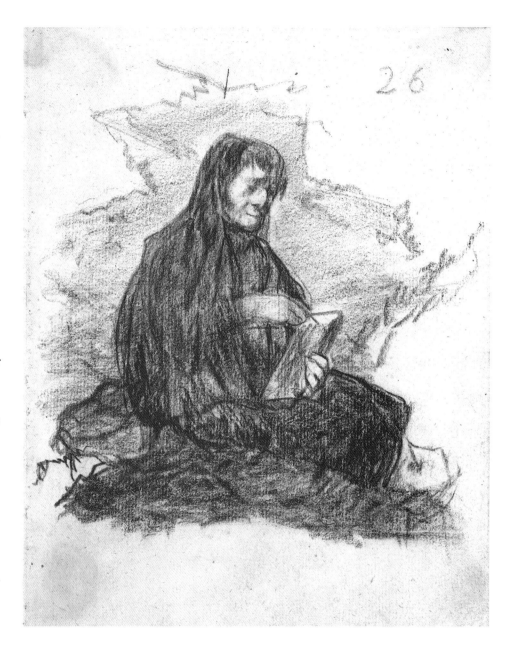

is, to behave in a way he should not).[3] This image suggests a diabolical inspiration, an idea reinforced by the dark background, which frames the figure in a shadowy halo.

In this drawing Goya seems to harshly criticize the clergy, in accord with liberal opinion of the time. It is possible, however, to be even more precise. Tablets, parchments, and books are well-defined, recurrent symbols in Christian art that often refer to the transmission of holy knowledge.[4] The idea expressed in the drawing is similar although *al revés* (reversed): the transmission of diabolical knowledge. Goya seems to have followed the medieval Christian tradition of parody, in which the comparison with divine subjects makes the sinful condition of humans stand out all the more.[5]

As is typical elsewhere (cat. 128, 131), Goya completed the idea begun here in the following drawing in the same album, where two winged demons with gro-

tesque faces bear through the air an aged man, who is seated on a piece of cloth (fig. 1). His ample cloak or cape and his skullcap suggest a religious habit. The traveler's expression – somewhere between terror and madness – and the fact that his garment immobilizes him as though it were a straightjacket, imply that his journey will be frightful. The drawing is a visual translation of the expression *llevóselo el diablo* (he was carried off by the devil), defined in the eighteenth century as "expressión con que se da a entender que alguna cosa sucedió mal, o salió al contrario de cómo se esperaba" (a saying used to indicate that something went wrong or turned out exactly contrary to what was expected).[6] Goya's scribe thus appears to announce not good news but a malefic prophecy. Since both drawings show their protagonists in vaguely clerical garb, Goya perhaps meant to suggest that the clergy itself inexorably works its own destruction.

Underlying this drawing there may well be a specific reference to the iconography of Saint John the Evangelist on the Isle of Patmos, which was popular in Spain from the sixteenth century.[7] Often shown seated on stony ground, the apostle writes Revelation in a book, on parchment, or on sheets of paper (fig. 2).[8] The analogy runs deeper, however, than a simple similarity in appearance. Whereas the saintly evangelist, inspired by God, ends his work announcing the Second Coming and the Last Judgment, Goya's malefic scribe seems to augur a different omen: damnation for the ecclesiastical hierarchy. Drawn in the years following the Liberal *trienio* (1820-1823), this work may also represent a commentary on the higher clergy's responsibility for the resurrection of absolutism.[9]

T.L.M.

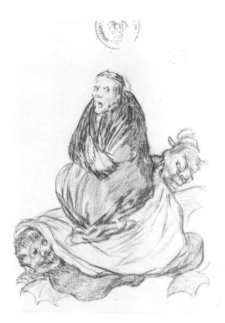

Fig. 1. Figure Carried by Demons, 1824-1828,
Album H, page 27.
Chalk.
Museo del Prado, Madrid

Fig. 2. Nicholas Poussin,
Landscape of Saint John on the Isle of Patmos
(detail), 1640.
Oil.
The Art Institute of Chicago, Chicago, A.A. Munger
Collection

1. Although it might be thought Goya's figure holds a compass and not a quill, a laboratory examination with a microscope indicates that the apparent second arm follows the vertical line of the paper and does not appear to have been intentional. In two preparatory drawings for *Caprichos* (G-W 630, 631) and in *Album H,* page 37 (G-W 1799), Goya put clearly defined compasses in his figures' hands.

2. On the symbolism of certain animals depicted by Goya, see the essay, in this catalogue, by T.L. Márquez, "Carnival Traditions in Goya's Iconic Language."

3. *Dejar Dios de su mano a uno* is defined as "proceder uno tan desarregladamente que parezca que Dios le ha abandonado" (to act in such a disorderly way that it appears God has abandoned one). In contrast, *tener Dios a uno de su mano* (to be in God's hands) is "ampararle, asistirle, detenerle cuando va a precipitarse en un vicio o exceso" (to shelter, help, restrain when one is about to commit some vice or excess). See Alonso, *Enciclopedia,* under *Dios.*

4. The evangelists, however, are most often represented in the act of writing. In Byzantine miniatures, Saint John gazes up at God's hand, whose rays of light stream toward him. In the triptych of Saint John painted by Hans Burgkmair in 1518 (Munich Pinakoteke), the rays of light emanate from the virgin's hands toward the evangelist. Louis Réau, Iconographie de l'Art Chrétien (Paris, 1958), vol. 3, pt. 2, p. 716, plate 44. In one of Dürer's illustrations for the woodcut series on the Apocalypse (1498), inspiration derives from the rays of divine intelligence and from God's hand, which sustains the book. Saint Luke wrote his Gospel under the virgin's inspiration and in the painting by Caravaggio for the Church of Saint Louis, king of France, in Rome, an angel guides Saint Matthew's hand. Ibid. vol. 3, pt. 2, pp. 830, 929.

5. On this use of religious iconography *al revés* (reversed), employed on diverse occasions throughout Goya's work (cat. 60, 45, 127), see T.L. Márquez, "Carnival Traditions," n. 37.

6. Academia, *Autoridades,* 1726-1739, under *Dios.*

7. Sculptures representing Saint John the Evangelist were well known. In almost all convents there were (and still can be seen all over Spain) altars dedicated to the two Johns, the Baptist and the Evangelist, which reflected the devotions of nuns partial to one or the other saint. From the sixteenth century these partisanships found their way into literature. See Sebastián de Horozco, *El cancionero,* ed. Jack Weiner (Bern and Frankfurt, 1975), p. 63.

8. The strange object laid out next to the boulder at the scribe's feet could be interpreted as an echo of the book or the sheets of paper that, on occasion, appear at the feet of the apostle, as in the painting on the same subject by Nicholas Poussin (fig. 2). At the same time it also suggests an inkwell, a common symbol in depictions of Saint John the Evangelist. The aquiline nose in profile could well indicate the eagle symbolic of Saint John in the Tetramorph. See Louis Réau, *Iconographie de l'Art Chrétien* (Paris, 1958), vol. 3, pt. 2, p. 716.

9. The preceding catalogue entry, *Apocalyptic Wrath* (cat. 175), is closely related to *Malefic Prophet,* not only in the garment of the ambiguous female figure, but also in Goya's apocalyptic vision.

177
False Victory
Album H, page 38
1824-1828
Black chalk
191 x 154 mm.
Inscribed in chalk, upper left corner: *38*
Signed: in chalk, lower left corner: *Goya*
References: G-W 1800; G., I, 454.

Museo del Prado, Madrid, 399
United States only

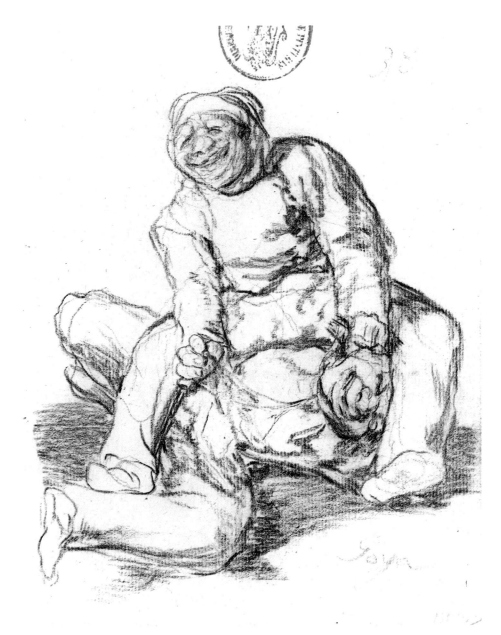

This strange drawing seems to represent a fight between two men. The victor immobilizes the defeated by sitting on him. With his left hand he grips the fallen man's head, while in the right he clutches what appears to be a knife. Save for the different expressions – frank laughter on the one and a grimace on the other – both fighters are identical, as if they were twin brothers.

Although it cannot be doubted that Goya depicted a fight, the lack of strain in the bodies of the protagonists is odd. The man on the floor does not attempt to defend himself, and his opponent does not appear to have made any effort to floor him. The legs of the man on top, which should be pressing down firmly on the fallen one are, on the contrary, arched like those of a person mounted on horseback. This is most likely the intention behind the intricate and strange position. The laughing man has assumed the attitude of *cabalgar* (to ride) and therefore his *lucha* (fight) seems to be purely symbolic.

Since the Middle Ages the verb *cabalgar* has been synonymous with fornicate and regarded in colloquial language and in erotic literature as a commonplace euphemism.[1] Its visual representation abounds as well in Gothic choir stalls, on which the vice of Lust was personified by the figure of a woman mounted on a man's back. Also common in misericords of choir stalls are the men or friars who ride each other, with an obvious homosexual connotation.[2] In the eighteenth century the obscene meaning of *cabalgar* was so common that the *Diccionario de Autoridades*, 1726-1739, defines it in the following terms: "Este verbo, por haverle corrompido el vulgo, y dádole un signifi-

cado indecente, ya no se usa en este sentido en lenguaje cortesano, y sólo ha quedado en la facultad y arte de la Artillería'' (Because this word has been corrupted by the people and given an indecent meaning, it is no longer used in polite discourse, and has remained only in the field and art of artillery). Forms of the word fight (*luchar, lucha,* and *pelea*) were also common euphemistic and poetic expressions of Lust and were used

repeatedly in literature and colloquial language.[3]

This masculine posture of arched legs appears several times in Goya's work, as in an *Album F* drawing (cat. 153) and in another, in *Album G*, entitled *Locos* (Fools) (fig. 1). In the latter the appearance of half-animal and human figures on all fours between the arched legs of the man standing implies the homosexuality of these characters in the same fashion

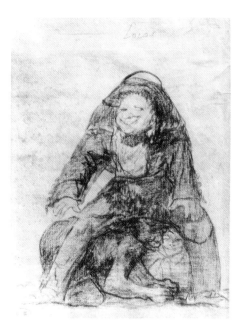

Fig. 1. *Locos* (Fools), 1824-1828,
Album G, page 39.
Black chalk.
Private Collection, Spain

as homosexuality is implied on the misericords of the Gothic choir stalls.[4]

The idea, of oriental and biblical origin, that all sexual excess is harmful to health was common in medical literature from the Middle Ages on, and was well known by the people.[5] The death of don Juan, Ferdinand and Isabella's only son, was attributed to the conjugal excesses of a young, recently married couple, and the prince has passed into history with the epithet "el príncipe que murió de amor" (the prince who died of love). In Goya's day his friend Jovellanos, commenting in his journal on the death of the minister Lerena, noted the rumor that many ascribed it to "excesivo uso de su nueva mujer" (excessive use of his new wife).[6]

It is not difficult to understand now why, in this drawing, the apparent victor overcomes his image and likeness only with the effort necessary to *cabalgar* (ride), while he laughs with pleasure. The expression "amigo de Venus, enemigo de sí mesmo" (friend of Venus, enemy of himself), among many others, could serve as an inscription to this drawing.[7] Goya appears to echo the med-

ical theory that the abuse of sexual pleasure can bring about physical degeneration, impotence, and even death.

T.L.M.

1. See Alzieu, *Poesía erótica*, poems 99, 103, 108, pp. 203, 213, 220.
2. See Mateo Gómez, *Sillerías*, figs. 212, 243, 342, 348, pp. 368-369, 375.
3. Alzieu, *Poesía erótica*, poems 5, 28, 97, pp. 11, 44, 191.
4. Goya reinforced the same idea by placing the breeches over the head and torso of the main figure. On the use of this image *al revés* (reversed), see the essay, in this catalogue, by T.L. Márquez, "Carnival Traditions in Goya's Iconic Language."
5. See Fred Rosner, *Sex Ethics in the Writings of Moses Maimonides* (New York, 1974), pp. 48, 54, 55.
6. Gaspar Melchor de Jovellanos, *Diarios (Memorias íntimas): 1790-1801* (Madrid, 1915), p. 61a.
7. Luis Martínez Kleiser, *Refranero general ideológico español* (Madrid, 1953), nos. 37247-37260.

178
Feria en Bordeaux (Fair in Bordeaux)
Album H, page 39
1824-1828
Black chalk
193 x 150 mm.
Inscribed in black chalk, upper left: title; in upper right: *39*
Signed in chalk, lower left: *Goya*
References: G., I, see under 455.

Private Collection, United States
United States only

Goya's inscription *Feria en Bordeaux* (Fair in Bordeaux) identifies the setting of this drawing. An unusually tall woman – endowed with a substantial bust, wearing good city clothes and a ribboned hat – is exhibited as a fair attraction before a group of men.

Apart from this drawing, there are three others of attractions seen at the same fair in Bordeaux in 1826 belonging to *Album H*: two with exotic animals, *Serpiente de 4 bar[a]ˢ en Bordeaux* (Snake 4 *Varas* [a measure just short of a meter] Long in Bordeaux) (G-W 1801) and *Cocrodilo en Bordeaux* (Crocodile in Bordeaux) (G-W 1802), and another showing an extremely thin man, entitled *Claudio Ambrosio Surat Llamado el Esqueleto vibiente en Bordeux año 1826* (Claudio Ambrosio Surat Called the Living Skeleton in Bordeaux in 1826) (G-W 1806).

In addition to *Claudio Ambrosio Surat* there are two *Album E* drawings (cat. 126 and 127) closely related to the subject of *Feria en Bordeaux*. In all four, the main figure is a being regarded, according to the notions of the time, as monstrous because of its unusual physical characteristics, which make it a target of the unhealthy or meddlesome curiosity of others. In his diary Jovellanos noted in considerable detail the sensation caused by a pair of dwarfs: "Todo el mundo va a ver a dos enanos que llegaron anteayer, y se presentan a las seis al público en el Ayuntamiento viejo, a real la entrada. Son lapones, y dicen ser marido y mujer, él de veinticinco años y ella de veinticho. Dice estar embarazada y habérsele muerto ya tres hijos: su altura treinta y ocho pulgadas." (Everybody is going to

see two dwarfs who arrived yesterday, and they will appear in public at six in the old town hall; admission is one *real*. They are Lapps and claim to be married; he twenty-five years old, she twenty-eight. She says she is with child and that three of her children died; she is thirty-eight inches tall.)[1]

In *Feria en Bordeaux* Goya's modeling of forms in terms of light and dark tones is exceptional. At the same time light and shadow are distributed in the drawing with a symbolic charge. As a result, the first thing a viewer notices is the contrast between the tall, highlighted female figure and the clustered group of males almost sunk in a darkness that diminishes them even more. The woman seems to ignore them and turns her head to the left with an expression between weariness and irritation. The tallest men reach only up to her bust, toward which several of them direct their eyes; others are bent and gaze at certain parts of her body as if amazed and enormously pleased at the conceivable proportions. As is well known, Goya was unusually adept at giving visual form to popular expressions, sayings, and turns of phrase that best enabled a viewer to understand the meaning of his works. We can say that the heroine of this drawing is *muy por encima* (head and shoulders above) her questionable admirers, not only because of her height but also because of the dignity that Goya conferred on her; she alone is highlighted and fully realized as an individual. Otherwise, only two faces are shown with any degree of clarity. One of them, looking like a simpleton, is *embobado* (stupefied) by what he imagines, and the other, with catlike features, has the eyes of an *encandilado* (dazzled) cat before succulent prey. The others, whose faces and bodies are in the penumbra, are no more than mere *figurones* (pretentious nobodies) or *fantasmas* (ghosts, another word for *figurones*). Goya thereby robbed them of human intelligence, features, or well-defined physical shape and relegated them to a symbolic world of shadow, so often used with a similar meaning in his work. Once again Goya expressed the idea, already shown in the two *Album E* drawings (cat. 126 and 127), of the mon-

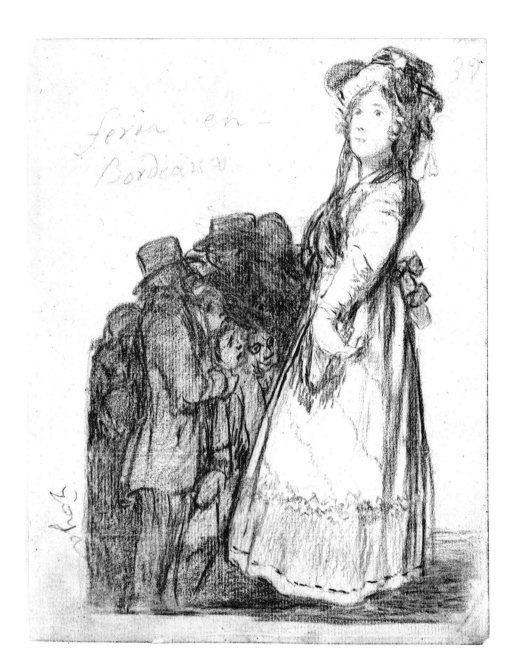

ster as a noble and beautiful creature, standing in stark contrast to the moral monstrosity of apparently normal humans.

T.L.M.

1. Gaspar Melchor de Jovellanos, *Diarios (Memorias íntimas): 1790-1801* (Madrid, 1915), entry for Feb. 12, 1794, p. 127.

179

Old Man on a Swing, among Demons
Working proof
About 1824-1828
Etching and burnished aquatint
185 x 120 mm.
References: G-W 1825; H., 32, I, 2.

Staatliche Museen Preussischer Kul-
turbesitz, Kupferstichkabinett, Berlin,
793.1906
Spain only

A smiling old man swings with pleasure
over a dark chasm. The background of
the print is phantasmagorical. Two
demonic creatures watch over the man,
and a huge hand, lightly sketched,
reaches toward him, perhaps to drag him
into the abyss whence it came.

The print is part of a series of
Caprichos Goya began in Bordeaux when
he was almost eighty years old. From
this late work four copper plates have
survived. One of them, etched on the
front and back, is that of this cheerful old
man and his companion on the verso, a
woman gaily attempting to rise through
the air, overseen by a cat crouched on a
dried-out branch, lying in wait. The
remaining three show a *maja* (a lower-
class, sporty, foxy young woman) sur-
rounded by demons, a smuggler, and a
blind guitarist, respectively.[1] The second
maja and the false bullfighter, etched on
the versos of two plates, are not by Goya;
they were engraved after his death.[2]

The subject is not without precedent in
Goya's work. In *Album H* the same sub-
ject – an old man swinging happily – is
treated, although the drawing (G-W
1816) lacks the phantasmagorical back-
ground of the etching. Iconographically
the etching is also very close to the
Capricho 62, *Quién lo creyera!* (Who
would believe it!) (fig. 1), where two
figures are shown fighting, surrounded by
and suspended in the dark, while from
below a hairy, catlike monster pulls at
them with one of its paws and from
behind another watches menacingly.

For centuries in almost every region of
Spain, the custom of swinging was linked
with Carnival and Carnival celebrations.[3]
Traditionally, however, the swings were
taken down by Ash Wednesday and were

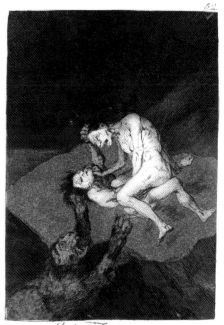

Fig. 1. *Quien lo creyera!* (Who would believe it!),
1797-1798,
Caprichos, plate 62.
Etching, burnished aquatint, and burin.
Museum of Fine Arts, Boston, Gift of Lydia Evans
Tunnard in honor of Henry P. Rossiter

never used during Lent. Swinging was
prohibited much as sexual relations were
during the period of penance. If to this
one adds that the rhythmic movement of
subir y bajar (to rise and to fall) also has
an erotic meaning, the action of
columpiarse (to swing oneself), apart
from its obvious sense as an amusement,
clearly suggests a symbolic *futuere* (to
copulate).[4] The gallant scenes of young
people swinging, common in eighteenth-
century French art, are at times artistic
interpretations of these popular erotic
images.[5] Furthermore, in the Bordeaux
etchings the swings appear to hang by
themselves. Although in *Old Man on a
Swing, among Demons* both ropes extend
to the margins, the ropes are blurred by
a very dense application of aquatint to
give the impression of the swinger's float-
ing in space. This sexual metaphor is
used in other drawings and prints (see
cat. 133 and 135) with the same
connotation.

The motion of the swing can also be
regarded as a *subir y bajar* (to rise and to

fall) in space, a movement that is some-
times accompanied by falling, as the ety-
mology of the word *columpio* indicates.
The simile is identical to that of tradi-
tional allegorical falls, which had been so
important since the Middle Ages. The
same idea is reflected in the popular
expression *mientras más alto subas, de
más alto caerás* (the higher the climb, the
greater the fall). Furthermore, *columpio*
and *columpiarse* have pejorative mean-
ings – to make a mistake, to look foolish
– not always associated with the amorous
metaphor, judging by the evidence of col-
loquial language to this day.[6]

The print exhibited is a working proof
and lacks added work visible in the first
edition, printed in 1859 by the English
diplomat John Saville Lumley, or in later
impressions. The movement and vitality
Goya gave his male figure are stressed by
the clothes, which seem to flutter loosely
and freely with the swinging motion.
This quivering sense of clothing made to
tremble by the movement of the swing is
altogether lost in late impressions (fig. 2).
The misguided idea of covering the arms
and the attempt to define the outlines
precisely, adding new folds and not very
subtle shadows to the jacket and
breeches, only diminish the beauty of the
etching and have nothing in common
with Goya's intelligent corrections in
other prints. He would generally correct
the drawing of principal figures, develop
their form, and give them greater
cogency. He also tended to balance his
composition by adding shadows or very
subtly readjusting a complex relationship
of light and dark areas with burnishing or
delicate tones of aquatint.[7]

The half-veiled backdrop of demons
that seem to emerge from the abyss and
the fact that the swing is at the lowest
point of its arc, so near the menacing
chasm, suggest that the old man's reck-
oning hour is nigh, although he continues
to enjoy himself. There is no doubt that
this image of the swinger, whose sinful
character is implied, corresponds visually
to the expression *estar al borde del
abismo* (to be on the verge of the pit),
perhaps the infernal abyss described in
Revelation 9:2 in almost the same terms:
"And he opened the bottomless pit; and
there arose a smoke out of the pit, as the

Fig. 2. *Warlock on a Swing, among Demons,*
Late *Caprichos,* 1824-1828.
Etching and burnished aquatint, posthumous modern
impression, 1954.
Museum of Fine Arts, Boston, Gift of Philip Hofer

smoke of a great furnace; and the sun
and the air were darkened by reason of
the smoke of the pit.''

<div align="right">T.L.M.</div>

1. Three double-sided copper plates now belong to
the Museum of Fine Arts, Boston: *Old Man on a
Swing, among Demons* (G-W 1825, H.32) and *Witch
on a Swing* (G-W 1826, H.33); *Maja Surrounded by
Demons* (G-W 1823, H.30) and the false *Maja* (H.31);
Smuggler, unknown to G-W and H., and the false *Old
Bullfighter* (G-W 1828, H.34). The fourth plate is
that of the *Blind Guitarist* (G-W 1829, H.35). See
Eleanor A. Sayre, *Late Caprichos of Goya: Fragment
from a Series* (New York, 1971), pp. 9-11.

2. Sayre, *Late Caprichos,* pp. 20-24, 35-42.

3. Studied by Caro Baroja, this custom in fact carries
the magical-religious symbolism of the swing in
antiquity, which had clear erotic associations, since
its motion was thought to help fertilize the earth.
Caro Baroja, *Carnaval,* pp. 51-53, 64.

4. On the obscene meaning of *subir y bajar,* see Don-
ald McGrady, "Notas sobre el enigma erótico, con
especial referencia a los 'Cuarenta enigmas en lengua
española,' " *Criticón* 27 (1984), p. 86; Alzieu, *Poesía
erótica,* poem 88, p. 162 and verse 25 note, p. 163.
Since the Middle Ages rhythmic movement has been
a metaphor, in literature as well as in popular

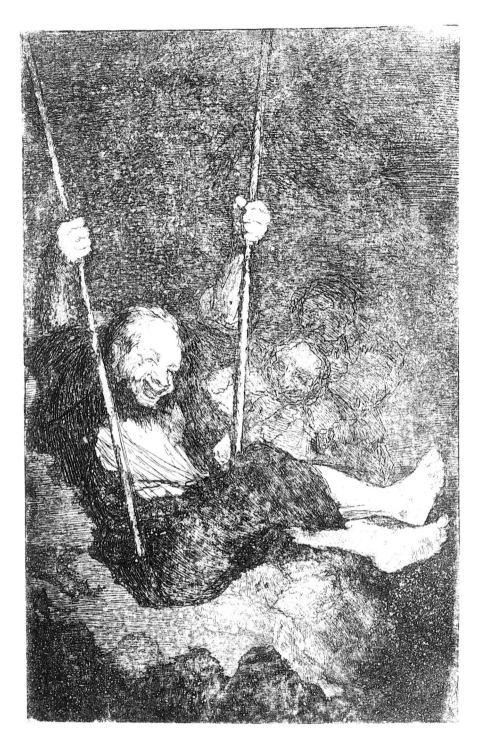

speech, of the sexual act, much as the *arriba y abajo*
(rise and fall) of the swing. See Alzieu, *Poesía erót-
ica,* poem 37, p. 55, poem 135, verse 20, p. 270.

5. See Donald Posner, "The Swinging Women of
Watteau and Fragonard," *Art Bulletin,* vol. 64, no. 1
(1982), pp. 75-88.

6. See the etymology of *columpio,* in Corominas, *Dic-
cionario etimológico.* The expression *andar a lo
columpio* is defined as "moverse balanceándose de
una parte a otra al andar; andar de manera
presumida, propia de rufianes y valientes" (to sway
when walking; to walk with an affected manner,
characteristic of scoundrels and braggarts). See José
Luis Alonso Hernández, *Léxico del marginalismo del
Siglo de Oro* (Salamanca, 1977), under *columpio.* See
also the figurative meaning of the verb *columpiarse*

preserved to this day, in Alonso, *Enciclopedia,* and
the Real Academia Española's *Diccionario de la
lengua española* (1984).

7. Sayre, *Late Caprichos,* p. 36.

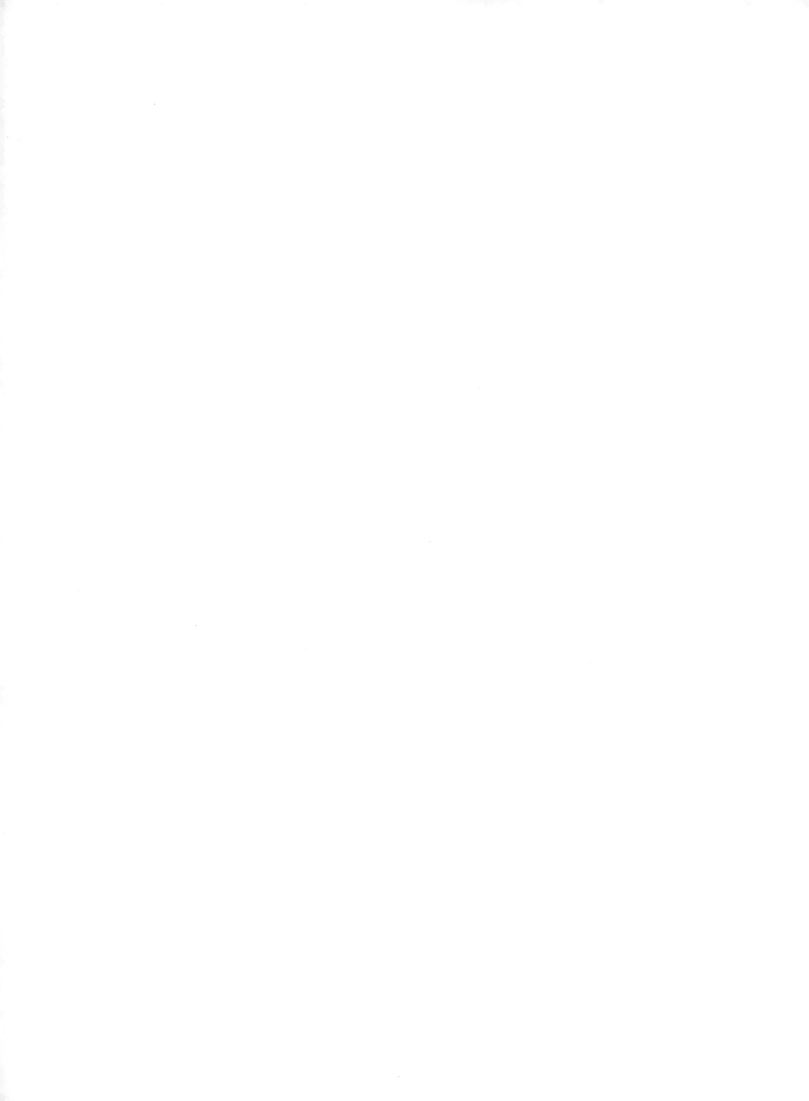

CHRONOLOGY

by Gary Tinterow

Author's note:
The information in this chronology was gathered by Anne M. P. Norton, with the assistance of Susan Alyson Stein.

March 30, 1746

Goya is born at Fuendetodos, 40 kilometers southwest of Zaragoza, one of six known children of Gracia (Lucientes), the daughter of minor Aragonese aristocrats, and José Goya, a master gilder.

1750s

Attends the Escuelas Pías de San Anton in Zaragoza, where he befriends Martín Zapater (Glendinning essay, fig. 3). Later, he will paint two of his greatest works for the fathers of the Escuelas Pías de San Antonin of Madrid: *Last Communion of San José de Calasanz* (G-W 1638) (fig. 7) and *Christ on the Mount of Olives* (G-W 1640).

1759

Fernando VI of Spain dies. His half-brother Carlos, who as a Bourbon reigned for 24 years over the Kingdom of the Two Sicilies, leaves Naples to assume the Spanish throne as Carlos III.

1760

At 14 enters studio of José Luzán, a minor painter with whom Goya apprentices for 4 years. Goya states in the 1828 Prado catalogue that Luzán taught him to draw by copying "the best prints he possessed."[1]

1761

El Pensador, a journal of enlightened essays, first appears, ceasing publication in 1767.

October 7: Anton Raphael Mengs arrives in Madrid as court painter, to be followed in 1762 by Giovanni Battista Tiepolo and his two sons.

1763

Goya's first visit to Madrid, where he unsuccessfully enters a drawing competition for a grant given by the Real Academia de Bellas Artes de San Fernando. The painter Francisco Bayeu sets up shop in Madrid with his brother Ramón, and Goya works in their studio.

1766

Goya again competes without success at the Academia de San Fernando.

March 23: Esquilache uprising: demonstrations in Madrid against price of food and new regulations of dress and conduct.

1769

Nicolás Fernández de Moratín's "Arte de las putas" is written, and the manuscript is circulated.

1770

Goya travels in Italy. Exact itinerary not known, but it is assumed that he visited Naples in addition to Rome and Lombardy.

1771

April: Still in Italy, Goya enters competition at the Royal Academy of Fine Arts, Parma. Described by the jury as a "Roman" and by himself as a student of Francisco Bayeu, he receives special mention and praise. Paintings executed in Italy are classical in subject and neoclassical in style (see cat. 2).

End of June: Goya returns to Zaragoza.

October 21: Secures first important commission, a ceiling decoration, *The Adoration of the Name of God*, in the small choir at the basilica of Santa María del Pilar in Zaragoza (G-W 30).

1773

July 25: Goya marries Josefa Bayeu, sister of his colleagues Francisco and Ramón

1774

Pedro Rodriguez Campomanes's *Discursos sobre el fomento de la industria popular* is published.

Goya executes wall decorations for the Carthusian monastery of Aula Dei near Zaragoza (G-W 42-48).

Winter 1774: Summoned to Madrid by Mengs to furnish cartoons for the Royal Tapestry Factory at Santa Bárbara, Goya executes designs for nine hunting scenes destined for the personal dining room at El Escorial of the heir to the throne, the Prince of Asturias. Five delivered May 24, 1775, four on October 30 of the same year (G-W 57-61, 63, 66, 68, 69).

1775-1777

The publication of P. Rodriguez Campomanes's *Discurso sobre la educacion popular de los artesanos y su fomento.*

1775

December 15: Birth of Goya's first child, Eusebio Ramón. According to birth certificate, the family lived in the Bayeu household at Calle Reloj 7 y 9.

1776

July 13: Mengs requests a salary of 8,000 reales a year for Goya.

October 30: Goya is assigned second series of cartoons for ten tapestries to decorate the Prince of Asturias's dining room in the Pardo Palace (G-W 70, 74, 76, 78-84).

1777

January 22: Birth of Goya's son Vicente Anastasio, at his house at Calle del Espejo 1.[2]

April 16: Goya suffers serious illness; writes to Zapater that he has "only just escaped alive."[3] ("Pues Amigo ya estoy bueno gracias a Dios.")

1778

January 25: Goya delivers last cartoons for the dining room at the Pardo. The King's household administration orders another design for the antechamber, which Goya delivers in April. In October this design, *El ciego de la guitearra* (The Blind Guitarist) is returned to Goya for correction (G-W 85).

July 28: Advertisement in the *Gaceta de Madrid* announces publication of nine prints, drawn and etched by Goya, after paintings by Velázquez (G-W 90, 92-94, 96, 101, 103-105). Two more prints announced on December 22 (G-W 88, 90) (fig. 1).

October 7: Resides at Carrera de San Gerónimo 66.[4]

October 13: Pablo de Olavide, advocator of land reform, is brought in front of Inquisition and sentenced a "formal heretic." Charges filed against him are many, but above all his correspondence with Voltaire and Rousseau was cited. Olavide condemned to lose his property, banished for life from Madrid, Seville, the Sierra Morena colonies, and Lima, and confined to a monastery for 8 years. One of the most sensational trials of the century, it causes a stir among literary circles of Spain.

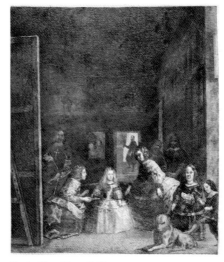

Fig. 1. After Diego Velázquez,
Las Meninas (The Ladies-in-Waiting), about 1778.
Working proof.
Etching, drypoint, roulette, and aquatint.
Museum of Fine Arts, Boston, 1951 Purchase Fund

1779

January 9: Goya personally presents to the King and to the Prince and Princess of Asturias his sketches for tapestries for their antechamber and bed chamber at the Pardo and receives a favorable response. First cartoons for the antechamber delivered July 20 and the last on January 24, 1780 (G-W 124-130).[5]

June 29: Mengs dies in Rome.

July 24: Goya petitions the King for position of Pintor de Cámara, but Mariano Salvador Maella, ten years older than Goya, is appointed instead.

October 9: Birth of a daughter.

1780

The great Campomanes edition of Benito Gerónimo Feijóo y Montenegro's *Teatro critico* (1st. ed. 1726) and *Cortas eruditas* (1st. ed. 1740) is published in 33 vols.

March 15: In an effort to economize, all tapestry production is suspended by royal decree; rescinded in 1783.

May 23: With Francisco and Ramón Bayeu, Goya secures commission for mural decorations of Santa María del Pilar in Zaragoza. Sketches received by building committee "with great attention and pleasure" on October 5.

July 5: Goya unanimously elected to the Real Academia de Bellas Artes de San Fernando; *Christ on the Cross* (G-W 176) accepted as presentation piece. Probably meets Jovellanos (cat. 30) who remains his friend for life.

August 20: Birth of Goya's son Francisco de Paula, Antonio Benito. Goya resides at Calle del Desengaño 1.[6]

1781

El Censor, a journal of enlightened essays reminiscent of *El Pensador,* first appears, lasting until 1787.

February 11: After disagreeing with his brothers-in-law on matters of style, Goya completes *Queen of Martyrs* (G-W 177) for the cupola of Santa María del Pilar.

March 10: Goya's sketches for pendentives of Santa María del Pilar are rejected.

July 20: By order of Carlos III, Goya receives commission to paint an altarpiece for the Church of San Francisco el Grande in Madrid; over summer develops sketches for *Sermon of Saint Bernardino of Siena* (G-W 184).

December 17: Death of Goya's father.

1782

Manuel Lardizábal y Uribe, a criminologist, publishes *Discurso sobre la penas.*

The Conde de Floridablanca founds Banco de San Carlos in Madrid; employs Jovellanos and Ceán Bermúdez. Goya, an early stockholder, is commissioned to paint a portrait of Floridablanca (cat. 4). He writes to Zapater, "I would like you alone to know that I have to paint his portrait. This could mean a great deal to me; I owe a lot to this gentleman. I was with his lordship this afternoon two hours after he had eaten. He came to have lunch in Madrid." Between 1785-1788 Goya painted six portraits for the Banco de San Carlos (see cat. 15 and G-W 223-228).[7]

1783

September 20: Goya returns to Madrid from a long stay at Arenas de San Pedro with the Infante Don Luis, who commissions a portrait of himself with his family (cat. 5).

1784

The first complete edition of José Francisco de Isla's novel *Fray Gerundio de Campazas* appears (1st ed. 1758).

October 11: Goya completes four large paintings (G-W 188-191), whose commission is secured with the help of Jovellanos, for the College of Calatrava in Salamanca. (They are destroyed during the French invasion of 1808-1812.)

November: Completes altarpiece for Church of San Francisco el Grande, Madrid.

December 2: Birth of Franciso Javier, Goya's sole offspring to survive childhood.

1785

Infante Don Luis dies.

March 18: Goya is named assistant director of painting at the Academia de San Fernando.

1786-1787

Pedro Montengón's *Eusebio* is published.

June 25: Goya and Ramón Bayeu named painters to the king at a salary of 15,000 reales a year, following death of Cornelio Vandergoten, former director of the Royal Tapestry Factory. On July 7, 1786, the artist announced to Zapater: "Yo soy Pintor del Rey con quince mil reales."[8]

Autumn: At El Escorial, Goya presents to Carlos III sketches for tapestries for the dining room of the Pardo Palace, depicting the Four Seasons and scenes of everyday life (G-W 256-261).

1786

Gaspar Melchor de Jovellanos's satirical poem "Satira segunda. A Arnesto: sobre la mala educacion de la nobleza," is written (published in *El Censor,* May 31, 1787).

1787

April 12: Carlos III commissions three altarpieces for church of the Santa Ana convent in Valladolid; paintings consecrated on October 1 (G-W 236, 238, 239). See also cat. 14.

April 30: Goya completes cartoons for the Pardo Palace (cat. 10 and 13).

May 12: In addition to the bill for his services, Goya sends descriptions of the seven "country pictures" (cat. 11, 12, 12A) (G-W 248-254) he executed to dec-

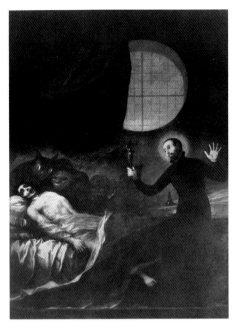

Fig. 2. San Francisco de Borja at the Deathbed of an Impenitent, 1788.
Oil on canvas.
Cathedral, Valencia

orate a room in the Osunas' country house, El Capricho, outside of Madrid. The paintings had been delivered by April 22.

1788

The publication of Manuel José Quintana's *Poesías.*

May 31: Goya describes to Zapater the presentation of sketches for tapestries for a bed chamber (of the Infantas) at the Pardo Palace (cat. 16). The King, Carlos IV, will order a new series of cartoons on February 11, 1789.[9]

October 16: Requests payment for two paintings commissioned by the Duque de Osuna for a chapel in the cathedral in Valencia, dedicated to an Osuna ancestor San Francisco de Borja (fig. 2 and G-W 240).

December 14: Death of Carlos III. The 40-year-old Prince of Asturias accedes to the Spanish throne as Carlos IV; his wife, María Luisa de Parma, is queen.

1789

April 25: Goya promoted from court painter to Pintor de Cámara to Carlos IV. First of a series of royal portraits com-

missioned for the coronation (G-W 279, 280).

February 11: Carlos IV orders new series of cartoons for bed chamber at the Pardo Palace.

1790

April 20: Carlos IV commissions tapestries for the royal secretariat at El Escorial, deciding on "rural and humorous" themes. Work is delayed until May 1791 and still incomplete on June 30, 1792 (G-W 300-306).

July: Goya obtains permission to accompany his ailing wife, Josefa, to Valencia for saltwater baths. There, he is elected to the Real Academia de Bellas Artes de San Carlos.

Autumn: In Zaragoza for the feast of the Virgin, Goya is made Socío de Meríto (honorary member) of the Socieded Aragonesa.

Oldest son, Eusebio Ramón, dies of smallpox, and Goya falls ill.

1792

February: Carlos IV dismisses his Prime Minister, the Conde de Floridablanca, in a disagreement over policy toward France. Friendly relations between the two nations, united in their opposition to England, had been strained by the events of the French Revolution and the ensuing changes in government. Floridablanca, a progressive monarchist and foe of the revolution, attempted to suppress news from across the Pyrenees. He enlisted the Inquisition to support this censorship and a number of publications were suspended, as were the activities of the Amigos del Pais, a progressive and enlightened organization dedicated to economic and cultural reform. The King appoints a new Prime Minister, the Conde de Aranda, who was sympathetic to the Revolution; he is succeeded by Emmanuel Godoy, a twenty-five year old guardsman – the favorite of the king and the lover of the queen – recently named duque de Alcudia. Godoy is instructed to resume relations with France.

September 2: Goya attends a session of the Academia de San Fernando in Madrid.

October 14: Sends a letter to the Academia on the instruction of painting.

Winter: Goya becomes gravely ill in Seville. Arrives in Cádiz at the house of Sebastián Martínez "in a very bad state"; the infection will leave him deaf. Goya's portrait of his friend Martínez dated 1792 (cat. 19).

1793

First authorized edition of Jose Cadalso's *Cartas Marruecas.*

January 21: Louis XVI, Bourbon cousin of the King of Spain, executed in France.

March: France declares war on Spain and takes several fortresses in the Pyrenees.

March 29: Martínez writes to Zapater that the "noises in (Goya's) head and the deafness have not improved, but his vision is much better and he is no longer suffering from the disorders that made him lose his balance." Goya is still in Cádiz.[10]

Summer: Goya returns to Madrid and resumes work.

1794

Publication of second edition of Diego de Torres Villaroel's *Obras* (1794-1798), *Visiones y visitas* (1st ed. 1727).

January 4: Goya sends to Bernardo de Iriarte, vice-protector at the Academia de San Fernando, a set of eleven cabinet pictures (see cat. 20-21) "in which I (Goya) have managed to make observations for which there is normally no opportunity in commissioned works which give no scope for fantasy and invention."[11]

August 2: Goya's friendship with the Duquesa de Alba presumably dates to this time, as does an equestrian portrait of Godoy, which the artist never completed (G-W 344).[12]

1795

Goya dates his portrait of the Duquesa de Alba (G-W 351).

Publication of Gaspar Melchor de Jovellanos's *Informe de la Sociedad Economica de Madrid al...Consejo de Castilla en el expediente de ley agraria.*

July 23: Godoy is forced to sign a humiliating agreement with France, the Peace of Basel. Carlos IV names Godoy "Principe de la Paz" (Prince of Peace).

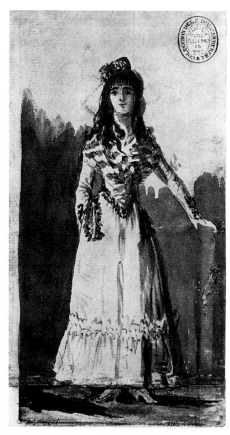

Fig. 3. The Duchess of Alba, 1796-1797, *Album A*, p. [a]. Black and gray wash. Biblioteca Nacional, Madrid

August 4: Death of Francisco Bayeu. Goya's unfinished portrait of Bayeu (G-W 345) exhibited at the Academia.

September: Goya obtains the position of director of painting of the Academia.

1796

May: Goya stays with Ceán Bermúdez in Seville.

June 9: Duque de Alba dies.

Spring or summer: Goya goes to Andalusia for eleven months. Stays in Sanlúcar with the recently widowed duquesa between May and July; returns to Sanlúcar in early February 1797. While in Sanlúcar, Goya makes an album of drawings of women (now known as *Album A*); several are reminiscent of the Duquesa de Alba (fig. 3 and G-W 356-376).

August 18: France and Spain in alliance sign Treaty of San Ildefonso, a defensive and offensive pact against Great Britain.

October 7: Spain declares war on Great Britain, in protest, among other reasons, of British seizure of Spanish ships laden with goods from the Americas.

1796-1797

Goya executes *Album B* drawings (cat. 35-37, 59) and (G-W 377-450).

1797

Goya dates his second portrait of the Duquesa de Alba (G-W 355) and portrait of Juan Meléndez Valdés (cat. 24).

February 16: Duquesa de Alba signs a will leaving to Goya's son Javier a sum of 10 reales a day, for life.

April: Goya leaves Andalusia and returns to Madrid.

April 1: Due to ill health, Goya resigns his directorship of the painting classes at the Academia de San Fernando.

November: Godoy appeases reformists by forming a new government; Jovellanos, Francisco de Saavedra, Bernardo de Iriarté, and Meléndez Valdés appointed.

November 1: Goya's portrait of Iriarte (Baticle essay, fig. 11) exhibited at the Academia.

1797-1798

Goya executes *Sueños* drawings; works on *Caprichos* (cat. 38-62 and G-W 451-647) which were published in 1799.

1798

Goya completes portraits of Jovellanos (cat. 30), Saavedra (Glendinning essay, fig. 5), General Urrutia (G-W 679), and the French ambassador to Madrid, Ferdinand Guillemardet (cat. 31).

March: Goya delivers memorandum to the King in which he states that "for six years I have been completely bereft of good health and in particular of my hearing, and I am so deaf that without using sign language I cannot understand anything, for which reason I have not been able to attend to the business of my profession."[13]

March 28: Sensing the failure of Godoy's rapprochement to France, Carlos IV replaces him with Jovellanos and Saavedra at the head of the government, who

are replaced again by Godoy the next year.

August: Goya is commissioned to decorate with frescoes the small church of San Antonio de la Florida in Madrid; work is completed within the year (G-W 717-735).

1799

January 6: *The Taking of Christ* (cat. 29, fig. 1) is shown to great praise in the Academia de San Fernando and two days later is delivered to the cathedral sacristy at Toledo. For the sketch, see cat. 29.

February 6: The *Diario de Madrid* carries a long front-page announcement of Goya's suite of eighty etchings — *Caprichos* — which he had drawn over the previous two years (see cat. 38-62). The Duquesa de Osuna had acquired four sets on January 19.

February 19: *Gaceta de Madrid* carries similar announcement. The prints are available at Calle del Desengaño 1, in a perfume shop in the same building as Goya's apartment. In a letter to Soler, Goya explains that after twenty-seven sets were sold in two days, the prints were removed from sale.

July: Goya's portrait of Guillemardet (cat. 31) and the six witchcraft scenes painted for the Osunas (cat. 25-27 and G-W 661, 662, 664) are exhibited at the Academia.

July 11: Consecration of San Antonio de la Florida.

September 24: María Luisa writes Godoy from the summer palace, Palacio de la Granja, that "Goya is painting my portrait in full-length with a mantilla; they tell me it is coming out well" (cat. 33).[14] Goya paints *King Carlos IV in Hunting Costume* (cat. 32).

October 3: Goya brags to Zapater: "The king and queen are crazy about yours truly."[15]

October 9: María Luisa, at El Escorial, writes to Godoy of her sittings for Goya's equestrian portrait: "The portrait on horseback has been completed in three sittings, and they tell me it is even more like me than the one with the mantilla" (G-W 777).[16]

October 31: Prime minister Mariano Luís de Urquijo (Baticle essay, fig. 15) appoints Goya Primer Pintor de Cámara

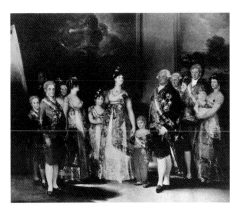

Fig. 4. The Family of Carlos IV, 1800-1801.
Oil on canvas.
Museo del Prado, Madrid

with an annual salary of 50,000 reales, plus 500 ducats for carriage maintenance.

1800

Goya, through the intermediary of the general treasurer Antonio Noriega, sells his quarters in the Calle del Desengaño to Godoy, and buys a house at Calle de Valverde, 15. Godoy gives the Calle del Desengaño apartment to his mistress, Pepita Tudó. Godoy commissions portrait of his wife, Condesa de Chinchón (cat. 63).

May-June: At Aranjuez, Goya paints studies from life (G-W 784-788) for the group portrait *Family of Carlos IV* (fig. 4), commissioned by the king and completed in June 1801.

Summer: Carlos IV poses for his equestrian portrait (G-W 776).

October 1: Secret treaty of alliance between France and Spain signed at San Ildefonso. Spain agrees to aid France in all its wars.

1801

Goya paints portrait of Noriega (G-W 801).

March 27: Spain, cooperating with France, declares war on Portugal. Godoy personally declares peace on June 6, but Napoleon compels Carlos IV to refuse to ratify the peace treaty. To celebrate the peace, Goya is commissioned to paint a portrait of Godoy (cat. 64).

1802

March 27: In pursuing peace with Great Britain, Napoleon cedes the Spanish colony of Trinidad to the British without consulting Spain and, in violation of the Treaty of San Ildefonso, agrees to sell Louisiana to the United States of America.

July 23: Sudden death of the Duquesa de Alba.

1803

Goya acquires a house at the Calle de los Reyes, 7. He attempts to exchange the original copper plates of the *Caprichos* and 240 unsold sets for a lifetime annuity for his son from the crown.

Martín Zapater dies.
Napoleon involves Spain in war with England.

1804

May 18: Napoleon declares himself Emperor of France.

December 2: Napoleon's coronation in Paris.

1805

Goya's portraits of Isabel Lobo de Porcel (G-W 817) and the Marquesa de Villafranca (G-W 810) are exhibited at the Academia.

July 8: Goya's son Javier marries Gumersinda Goicoechea, daughter of a wealthy merchant family. At the wedding Goya probably meets Leocadia Zorilla de Weiss, a member of the Goicoechea family, who becomes his favorite. Goya gives his house at Calle de los Reyes to the newlyweds in 1806.

October 21: French and Spanish fleets defeated at Trafalgar.

1806

Goya's portraits of Antonio Porcel (G-W 855) and Don Manuel Sixto Espinosa (now lost) are exhibited at the Academia.

June 10: Friar Pedro de Zaldivia captures the bandit El Maragato in Extremadura. Goya will paint six panels on the popular subject (G-W 864-871).

July 11: Goya's grandson Mariano baptized in the church of San Martín in Madrid.

1807

October 17: French troops under Junot pass through Spain to attack Portugal, only to find that the Portuguese monarchs have fled to Brazil. Junot's French forces remain in Spain.

October 27: Godoy discovers that Fernando, Prince of Asturias, has entered into secret talks with Napoleon's brother-in-law, Eugène Beauharnais. Fernando had wished to undermine Godoy, but Godoy denounced the prince's actions as a plot against Carlos IV. Fernando is arrested, but later pardoned.

1808-1814

The drawings in *Album C* are executed (cat. 76-81, 98-106) (G-W 1244-1367).

1808

Four works by Goya are exhibited at the Academia.

Early: Led by Murat, more French troops pour into Spain, and it becomes evident that the capture of Spain rather than Portugal is their aim.

March 18: Sensing capitulation to France, high-placed individuals instigate a demonstration against the court, now in Aranjuez, demanding the removal of Godoy. In order to save Godoy's life, Carlos IV abdicates in favor of his son; Fernando VII declared king of Spain.

March 23: Murat, dissatisfied with Carlos IV's resignation, insists that the former king sign a statement that his abdication had been forced upon him.

March 24: Fernando VII stages triumphal entry into Madrid.

March 29: Real Academia de Bellas Artes de San Fernando commissions Goya to paint equestrian portrait of Fernando VII (G-W 875).

April 10: Fernando VII leaves Madrid for Bayonne, where the French are holding Carlos IV, María Luisa, and Godoy. Fernando is forced to return the crown to Carlos, who abdicates to Napoleon.

May 2: Beginning of War of Independence (Peninsular War); citizens of Spain are in massive revolt against Napoleon's invasion.

May 3: French troops stage large-scale executions beside the hill of Príncipe Pío.

France's enormous military machine easily takes Madrid, but local resistance drives French troops from Valencia. Spanish conduct guerilla warfare for the next four years in support of the regular army.

June 12-August 14: First seige of Zaragoza. The city of Zaragoza is under siege by French troops. The troops leave in August and return in December.

June 6: Napoleon puts his brother, José Bonaparte, on the Spanish throne and retires Carlos and María Luisa to Rome. A delegation of church leaders, government officers, and grandees is convened in Bayonne to ratify José as king and to adopt a constitution prepared under Napoleon's direction. Fernando is kept under French arrest in Valençay.

July 11: French army routed at Bailén. Spanish troops retake Madrid.

Summer: Provincial juntas, established by local gentry, proclaim Fernando VII legitimate king.

September 25: At Aranjuez the opposition government – the Supreme Central Junta – proclaims Floridablanca their president.

October 2: Goya delivers equestrian portrait of Fernando VII (still under French arrest) to the Academia. In a letter to José Muñarriz the artist recounts that General Palafox had invited him to examine the ruins of Zaragoza in order to paint the glory of the local citizenry better.

December: Napoleon enters Spain personally, to restore José Bonaparte to the throne; Junta flees to Seville; Floridablanca dies en route. When Seville is taken by France, the patriots regroup in Cádiz, which becomes the capital of the Liberal opposition to the French.

1809

February 21: Fall of Zaragoza.

1810-1814

Goya executes etchings for the *Disasters of War* pls. 2-64 (cat. 82-94 and G-W 995-1103)

1810

Goya paints the parents of his son's wife: Martín Miguel and Juana Galarza de

Goicoechea (Baticle essay fig. 3, G-W 886, 887). Also portrays General Nicholas Guye (G-W 883).

February 27: Goya delivers to the city council of Madrid a large painting they have commissioned, depicting an allegorical figure representing the city of Madrid, gesturing toward a portrait of José I as king of Spain (G-W 874).

December: The Cortes reconvene in order to draft a constitution. Over the next years a number of Liberal reforms are passed. The Inquisition is suppressed as are many powers of the Church and local grandees.

1811

The publication of Antonio Puigblanch's *La Inquisition sin mascara*.

March 11: Orden Real de España is conferred by José Bonaparte upon Goya. However, on November 14, 1814, he will claim never to have worn it.

1812

Léandro Fernández de Moratín's *Auto de fe celebrado en la ciudad de Logroño en los 6 y 7 noviembre de 60* is published.

Publication of the satirical dictionary of José Gallardo Blanco, *Diccionario critico-burlesco...*

Publication of Juan Antonio Llorente's *Memoria histórica sobre qual ha sido la opinión nacional de España acerca del tribunal de la Inquisición*.

March 19: The Constitution of Cádiz is adopted, creating a unicameral legislature, the Cortes, chosen by universal male suffrage. Power of kings is limited; the feudal *señoríos* abolished; freely elected city councils established; Roman Catholicism is declared the sole religion.

June 12: Death of Goya's wife, Josefa. Inventory made of artist's studio when Josefa's estate settled.

August 12: Arthur Wellesley, Marquess of Wellington, enters Madrid after successfully defeating French forces. José I retreats to Valencia. Goya draws Wellesley's portrait (cat. 97).

September 1: Wellington departs from Madrid. A notice in the *Diario de Madrid* announces that Goya's equestrian portrait of Wellington (G-W 896) can be

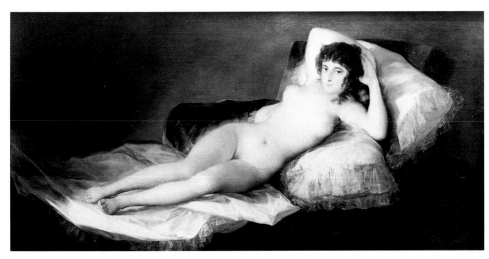

Fig. 5. The Nude Maja.
Oil on canvas.
Museo del Prado, Madrid

November 2: French forces occupy Madrid but are driven out four days later.

December 2: Again, French troops occupy Madrid.

1813

Publication of León de Arroyal's "Pan y toros," in *Pan y toros y otros papeles sediciosos de fines del siglo XVIII*, traditionally ascribed to Jovellanos. (It was circulated clandestinely in the 1790s under the title "Oracion apologetica").

February: The Cortes abolish the Office of the Inquisition.

March 17: José I again evacuates Madrid, followed by French troops.

June 21: Wellington, at Victoria, soundly routs French forces and begins march on France. José I flees.

December: Fernando VII, released by Napoleon, signs a treaty of alliance with France against Great Britain.

1814-1817

Album E drawings are executed (cat. 125-132) (G-W 1385-1430).

1814

Goya paints *Allegory on the Adoption of the Constitution* (cat. 74).

January 6: A council of regency established in Madrid, led by Don Luís María de Borbón, son of the Infante Don Luís.

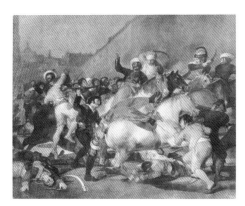

Fig. 6. The Second of May, 1814.
Oil on canvas.
Museo del Prado, Madrid

February 24: Goya informs the regency of his "burning desire to perpetuate by means of the brush the most notable and heroic actions and scenes of our glorious insurrection against the tyrant of Europe."[17]

March 9: Goya granted an allowance while he paints *The Second of May* (fig. 6), *The Third of May* (G-W 984), *Making Gunpowder in the Sierra* (G-W 980), and *Making Shot in the Sierra* (G-W 981). Also paints at this time a portrait of Palafox on horseback (cat. 75).

March 22: Fernando VII met at Figueras by a delegation from the Cortes asking him to swear to uphold the Constitution of 1812.

April 6: Napoleon abdicates.

May 4: Fernando VII revokes Constitution of 1812 and reinstates Inquisition. He establishes himself as an absolute ruler by divine right.

May 7: Fernando VII reenters Madrid.

May 21: Goya and his son survive initial palace purge. After a lengthy process that lasts until April 14, 1815, their salaries, pensions, and civil rights are confirmed.

October: Leocadia Zorilla de Weiss gives birth to a daughter, Rosario; Goya may be the father.

1815

Completes a number of portraits of noblemen and noblewomen, in addition to colleagues such as the painter Rafael Esteve (G-W 1550).

March 16: Goya is summoned before the Inquisition to answer obscenity charges on the *Nude Maja* (fig. 5; G-W 743) and the *Clothed Maja* (G-W 744).

1816-1817

Disparates are etched (cat. 136-143) (G-W 1571-1613).

1816-1818

Album D drawings are executed (cat. 133-135) (G-W 1368-1384).

1816

October 28: Publication of the thirty-three etchings of the *Tauromaquia* begun in 1815 (G-W 1149-1243).

1817-1820

Album F drawings are executed (cat. 144-153; G-W 1431-1518).

1817

September: Through Ceán Bermúdez, Goya receives commission to paint *Saints Justa and Rufina* for Seville cathedral (G-W 1569).

1819

February: Establishment of a lithographic press in Madrid prompts Goya to try the new technique.

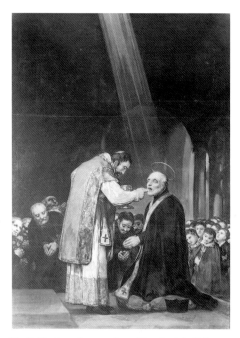

Fig. 7. The Last Communion of San José de Calasanz, 1819.
Oil on canvas.
Real Colegio de las Escuelas Pías de San Antonio Abad, Madrid

February 27: For 60,000 reales, acquires a country house, Quinto del Sordo, and 25 acres along the Manzanares River.

May: The fathers of the Escuelas Pías in Madrid commission altarpiece for their chapel: *Last Communion of San José de Calasanz* (fig. 7); It is unveiled August 27.

November 19: Public opening of the Museo del Prado; two paintings by Goya on display: *Carlos IV on Horseback* (G-W 776) and *Queen María Luisa on Horseback* (G-W 777).

Winter: Gravely ill, Goya is treated by his friend Doctor Arrieta (see cat. 121).

1820-1823

Disasters of War, pls. 65-82, known as *caprichos enfáticos*, are etched (cat. 154-163; G-W 1104-1139).

1820

Goya begins to paint fresco decorations for the Quinto del Sordo, which he later repaints with the compositions known as the "Black Paintings" (see cat. 138, fig. 1, and cat. 152, fig. 2; G-W 1615-1627a); he

will work on these until before he leaves for Bordeaux in 1824.

January 1: Revolution of 1820; mutiny at Cádiz led by General Riego leads to overthrow of government of Fernando VII.

March 9: Fernando VII is forced to swear allegiance to the restored Constitution of 1812, thereby establishing himself as a constitutional rather than an absolute monarch. Liberal sections of the army and population dominate king until 1823.

April 4: For the last time Goya attends a meeting at the Real Academia de San Fernando. He swears allegiance to the Constitution and monarch.

1821

Juan Meléndez Valdés' *Discursos forenses* are published.

1822

Publication of *Letters from Spain* by José Blanco White (Leocadio Doblado, pseud.).

1823

April: With the sanction of the Holy Alliance of reactionary powers, Louis XVIII of France sends troops, led by the duc d'Angoulême, to Spain under the pretext of suppressing the Liberal government and restoring Fernando VII to absolute power. (Czar Alexander I of Russia had offered assistance as early as 1820, but Metternich refused to allow Russian troops to cross Germany.)

August 30: French capture fort at Trocadero.

September 17: Goya assigns Quinta del Sordo to his grandson Mariano.

September 30: Surrender of Spanish Cortes to the duc d'Angoulême at Cádiz. Fernando VII released; swears to an amnesty for the Liberals but immediately resumes unbridled power and encourages punitive action. Initiating a reign of terror, Fernando VII has many Liberal officers imprisoned, while others are shot outright.

November 7: Execution of General Riego.

November 13: Fernando VII makes triumphal reentry into Madrid in a chariot drawn by twenty-four young men.

Fig. 8. Young Woman, Half-Nude, Reclining Against Rocks, 1824-1825.
Miniature on ivory.
Museum of Fine Arts, Boston, Ernest Wadsworth Longfellow Fund

1824-1828

Album G and *Album H*, drawings executed in Bordeaux.

1824

Late January to mid-April: Hides at house of his friend, the Jesuit priest José Duaso y Latre; Goya paints his portrait in gratitude (G-W 1633).

May 1: General amnesty declared. Goya immediately petitions for six months' leave, on the pretext of taking a cure in France at Plombières but with the intention of expatriating.

May 30: Fernando VII personally grants Goya's leave.

June 24: On his way to Paris, Goya arrives at the house of his friend Moratín, already in exile in Bordeaux.

June 27: Moratín recounts in a letter that "Goya has indeed arrived, deaf, old, clumsy, and weak, without a word of French, and without a valet (which no one needs more than he), and so happy and so anxious to try everything. He stayed here three days, on two of which he ate with us just as if he were a student. I have encouraged him to come back and see us in September and not to get stuck in Paris, lest the winter, which would be the death of him, take him by surprise."[18]

June 30: Armed with a letter of introduction from Moratín, Goya arrives at the home of Vicente Gonzáles Arnao in Paris. Arnao arranges for him to stay at Hotel Favart, 5 rue Marivaux. While there, Goya sees many of his former patrons now exiled. Joaquín María de Ferrer commissions portraits of himself (Glendinning essay fig. 7) and his wife (G-W 1660), and a bullfight scene (G-W 1672). Goya probably visits the Salon, where works by Ingres, Delacroix, and Constable are exhibited.[19]

September 1: Goya quits Paris for Bordeaux. Stays at a hotel in the rue Esprit des Lois.

September 16: Goya moves to a house at 24 Cours de Tourny; Leocadia Zorilla de Weiss and her two children, Guillermo and Rosario, arrive from Spain.

1825

January 13: Fernando VII consents to another six months' leave for Goya.

Spring: Goya is extremely ill; doctors diagnose paralysis of the bladder, and a large bone tumor is found on one of his legs.

June 30: Martín Miguel de Goicoechea, Javier Goya's father-in-law, dies in Bordeaux.

July 4: Having been led to believe Goya's condition is terminal, Fernando VII grants him a year's leave.

October 13: Goya settles in a house at 10, chemin de la Croix-Blanche.

November 17-December 23: The printer Gaulon, in Bordeaux, registers the edition of one hundred sets of Goya's four lithographs *Bulls of Bordeaux* (G-W 1642-1675).

December 20: In a letter to Ferrer, Goya mentions that, over the previous winter, he had painted some forty miniatures on ivory (fig. 8 and G-W 1676-1697).[19]

1826

May 30: Goya appears in Madrid to personally present his petition for retirement.

June 17: King grants Goya annual pension of 50,000 reales; Goya returns to Bordeaux.

1827

Summer: Goya visits Madrid again; probably then paints the portrait of his grandson Mariano at age 19 (G-W 1664).

September 27: Goya receives his passport and leaves Madrid.

1828

March 28: Javier Goya's wife and son Mariano arrive in Bordeaux to find Goya near death.

April 16, 1828

Goya dies at 2:00 A.M. in Bordeaux. The young artist Brugada and his friend José Pío de Molina are at his bedside. He is buried in Bordeaux beside Martín Miguel de Goicoechea. In 1901, his remains were exhumed and transferred to Madrid. In 1929 his remains were again transferred, this time to the hermitage of San Antonio de la Florida.

1. G-W, p. 48.
2. Francisco de Goya, *Cartas a Martín Zapater*, ed. Mercedes Agueda and Xavier de Salas, Madrid 1982, letter 2, p. 38.
3. Ibid., letter 3, p. 41.
4. Ibid., letter 6, p. 46.
5. Ibid., letter 8, p. 49.
6. Ibid., letter 16, note 3.
7. Ibid., letter 39, pp. 94-95.
8. Ibid., letter 79, p. 148.
9. Ibid., letter 104, pp. 182-183.
10. G-W, pp. 105-106.
11. G-W, p. 108.
12. Goya, *Cartas,* letter 135, pp. 225-226.
13. G-W, p. 139.
14. Elizabeth du Gué Trapier, *Goya and His Sitters: A Study of His style as a Portraitist* (New York, 1964), p. 19.
15. Goya, *Cartas,* letter 138, p. 233.
16. Trapier, *Goya and His Sitters,* p. 19.
17. G-W, p. 223.
18. Jacques Fauqué and Ramón Villanueva Echevarría, *Goya y Burdeos* (Zaragoza, 1982), pp. 548-549, (trans. M.A.R.); p. 71 in Spanish.
19. Ibid., p. 550; p. 72 in Spanish.
20. Ibid., 636; p. 72 in Spanish.

GLOSSARY of Printmaking Terminology Used in the Catalogue

In the *etching* process the copper plate is covered with a waxy ground that is impervious to acid. With an etching needle the artist lightly scratches away the ground to delineate the image. The uncovered copper is then exposed to acid, and it is this biting or etching by acid that produces the grooves that will hold the printer's ink. The size of the line is determined by the breadth of the needle and the duration of biting time. The corrosive action of the acid may be controlled by stopping out or masking areas of the plate with a varnish or waxy substance.

Drypoint lines are incised into the plate with a sharp needle. Held at the proper angle, the point displaces a fine shaving of metal which forms a ridge or burr on either side of the line. Goya also used the drypoint needle to scratch lines without raising a burr. Unlike engraved lines, these strokes tend to be very fine. Drypoint was often used in combination with etching to elaborate etched passages or to make small additions and corrections without regrounding and rebiting the plate.

Engraved lines are achieved by gouging out the line with a burin (a lozenge-shaped steel bar, cut on the bias at the point, and set in a wooden handle). The thin ribbon of displaced metal is scraped away to maintain the clarity of the line. Goya used the burin to supplement his etched lines or to shade and model forms further.

The *aquatint* method is a means of etching a continuous tone. A porous ground of powdered resin is dusted onto the copper plate and fused to it by heat. The metal that remains exposed around these droplets of acid-resistant resin is bitten, creating a reticulated pattern of crevices. These crevices hold the ink and print as a tone.

Lavis (French for "wash") simulates the effect of an ink wash on paper and is another means of achieving continuous tone. This tone is produced by the direct application of acid to an unprotected area of the copper plate; the finely pitted surface holds ink and prints as a pale gray tone. Passages may be stopped out and the plate briefly exposed to acid, or the acid may be brushed onto the plate.

Changes on the plate can be made by scraping the copper to remove the unwanted work. A sharp blade or scraper removes the copper from the surface of the plate, thereby reducing the depth of the lines. This roughened area is then smoothed and polished with a rounded finger-like steel tool or *burnisher*. Goya used scraping and burnishing to correct passages, to produce half-tones, and to extract highlights from a dark bitten tone, such as aquatint.

When a plate is inked for printing, the excess ink is removed and the plate cleanly wiped. During the printing process, the ink that is held in the incised grooves is forced out onto the paper as the plate passes through the press. Sometimes a film of ink may intentionally be left on the surface of the plate and will print as tone. When the inked plate is run through the press with a sheet of paper, the copper plate embosses the paper, leaving a *platemark*.

In this catalogue, the term *working proof* is used to designate an impression taken for or by Goya in the course of executing a plate. A *trial proof* is one that is taken from the completed plate before the printing of an edition; in this catalogue it indicates one taken after the artist's death in preparation for a posthumous edition.

This Glossary has been derived from the one by Barbara S. Shapiro that appeared in Eleanor A. Sayre and the Department of Prints and Drawings, *The Changing Image: Prints by Francisco Goya*, Boston, 1974.

ABBREVIATED REFERENCES
Used in the Catalogue

Academia, *Diccionario*, 1791
Real Academia Española, *Diccionario de la lengua castellana compuesto por la Real Academia Española*. 3rd ed. Madrid, 1791.

Alcalá Galiano, *Recuerdos*
Alcalá Galiano, Antonio. *Recuerdos de un anciano*. Madrid, 1890.

Alonso, *Enciclopedia*
Alonso, Martín. *Enciclopedia del idioma*. 3 vols. 1958. Reprint. Madrid, 1982.

Alzieu, *Poesía erótica*
Alzieu, Pierre; Jammes, Robert; and Lissorgues, Yvan. *Poesía erótica del siglo de oro*. 1975. Reprint. Barcelona, 1984.

Artola, *Orígenes*
Artola, Miguel. *Los orígenes de la España contemporánea*. Madrid, 1959.

Autoridades, 1726-1739
Real Academia Española, *Diccionario de Autoridades*. 6 vols. in 3. 1726-1739. Reprint. Madrid, 1963.

Ayala
Manuscript explanations to the *Caprichos* that belonged to Adelardo López de Ayala. Published by the Conde de la Viñaza, *Goya: Su tiempo, su vida, sus obras*. Madrid, 1887.

Biblioteca
Manuscript explanations to the *Caprichos*. Biblioteca Nacional, Madrid, MS. 20258, no. 23.

Blanco White, *Letters*
Blanco White [Leocadio Doblado], José. *Letters from Spain*. London, 1822.

Brussels, 1985
Musées Royaux des Beaux-Arts de Belgique, Brussels. *Goya*. Exhibition catalogue. 1985.

Cadalso, *Cartas*
Cadalso, José de. *Cartas marruecas*. Edited by Lucien Dupuis and Nigel Glendinning. London, 1966.

Callahan, *Church*
Callahan, William J. *Church, Politics, and Society, in Spain, 1750-1874*. Cambridge, Mass., and London, 1984.

Caro Baroja, *Carnaval*
Caro Baroja, Julio. *El Carnaval: Análisis histórico-cultural*. Madrid, 1965.

Cela, *Diccionario secreto*
Cela, Camilo José. *Diccionario secreto*. Madrid, 1968. Reprint. Madrid, 1974.

Connelly, *Diccionario*, 1797-1798
Diccionario nuevo de las lenguas española é inglesa . . . compuesto por Thomas Connelly y Thomas Higgins. 2 vols. in 4. Madrid, 1797-1798.

Corominas, *Diccionario etimológico*
Corominas, J., and Pasqual, J.A. *Diccionario crítico etimológico castellano e hispánico*. 5 vols. Madrid, 1980.

Correas, *Refranes*
Correas, Gonzalo. *Vocabulario de refranes y frases proverbiales [ca. 1623]*. Edited by Louis Combet. Bordeaux, 1967.

Covarrubias, *Emblemas*, 1610
Covarrubias Orozco, Sebastían de. *Emblemas morales de don Sebastían Covarrubias Orozco*. Madrid, 1610.

Covarrubias, *Tesoro*, 1611
Covarrubias Orozco, Sebastián de. *Tesoro de la Lengua Castellana o Española*. 1611. Reprint. Madrid, 1984.

Fontana Lázaro, *Quiebra*
Fontana Lázaro, Josep. *La quiebra de la monarquia absoluta: 1814-1820*. Barcelona, 1978.

G., I
Gassier, Pierre. *Francisco Goya: Drawings: The Complete Albums*. New York, 1973.

G., II
The Drawings of Goya: The Sketches, Studies and Individual Drawings. London, 1975.

G-W
Gassier, Pierre, and Wilson, Juliet. *The Life and Complete Work of Francisco Goya, with a Catalogue Raisonné of the Paintings, Drawings and Engravings*. New York, 1971.

Gallardo, *Diccionnario*
Gallardo Blanco, José. *Diccionario crítico-burlesco del que se titula Diccionario Razonado Manual para intelligencia de ciertos escritores que por equivocacion han nacido en España*. Marseilles, 1823. (First edition, Cádiz, 1812.)

Glendinning, *Eighteenth Century*
Glendinning, Nigel. *The Eighteenth Century*. A Literary History of Spain, vol. 4. London, 1972. (For Spanish edition, see Glendinning, *Siglo XVIII*.)

Glendinning, *Siglo XVIII*
Glendinning, Nigel. *El siglo XVIII*. Trans-

lated by Luis Alonso López. Historia de la literatura española, vol. 4. Barcelona, 1977. (For English edition, see Glendinning, *Eighteenth Century*.)

Gravelot and Cochin, *Iconologie*
Bourguignon, Hubert-François []known as Gravelot], and Cochin, Charles-Nicolas. *Iconologie par figures ou traité complet des allégories, emblêmes &c. Ouvrage utile aux artistes, aux amateurs, et peuvent servir á l'éducation des jeunes personnes.* 4 vols. Paris, n. d. (The 204 plates, with 350 allegorical figures, appeared earlier in the *Almanach iconologique, ou des arts, 1765-1781.*)

Gud.
Gudiol, José. *Goya, 1746-1828: Biography, Analytical Study, and Catalogue of His Paintings.* Translated from Spanish by Kenneth Lyons. 4 vols. New York, 1971.

H.
Harris, Tomás. *Goya: Engravings and Lithographs.* Oxford, 1964. Vol. 2: *Catalogue raisonné.*

Hamburg, 1980
Kunsthalle, Hamburg, *Goya: Das Zeitalter der Revolutionen, 1789-1830.* Exhibition catalogue. 1980.

Helman, *Trasmundo*
Helman, Edith. *Trasmundo de Goya.* Madrid, 1963.

Henkel, *Emblemata*
Henkel, Arthur, and Schöne, Albrecht. *Emblemata: Handbuch zur Sinnbildkunst des XVI und XVII. Jahrhunderts.* Stuttgart, 1967.

Henningsen, *Witches' Advocate*
Henningsen, Gustav. *The Witches' Advocate.* Reno, 1980.

Herr, *Revolution in Spain*
Herr, Richard. *The Eighteenth-Century Revolution in Spain.* Princeton, 1958.

Herr, *Modern Spain*
Herr, Richard. *An Historical Essay on Modern Spain.* Berkeley, Los Angeles, and London, 1974.

Kamen, *Inquisición*
Kamen, Henry. *La Inquisición Española.* Barcelona, 1985. (First edition, 1967.)

Kamen, *Inquisition*
Kamen, Henry. *Inquisition and Society in Spain.* Bloomington, 1985.

Kany, *Life and Manners*
Kany, Charles E. *Life and Manners in Madrid, 1750-1800.* Berkeley, 1932.

Lafuente, *Historia*
Lafuente y Zamalloa, Modesto. *Historia general de España.* Vol. 18. Barcelona, 1889.

Lafuente Ferrari, *Desastres*
Lafuente Ferrari, Enrique. *Los desastres de la guerra de Goya y sus dibujos preparatorios.* Barcelona, 1952.

Lea, *Inquisition*
Lea, Henry Charles. *A History of the Inquisition of Spain.* 4 vols. New York, 1906-1907.

Llorente
Manuscript explanations to the *Caprichos*, written in French by Juan Antonio Llorente. Museum of Fine Arts, Boston, 1973.730.

Llorente, *Inquisición*
Llorente, Juan Antonio. *Historia Crítica de la Inquisición en España.* 4 vols. 1822. Reprint. Madrid, 1980.

Llorente, *Inquisition*
Llorente, Juan Antonio. *The History of the Inquisition of Spain.* London, 1826.

López Rey, *Goya's Drawings*
López Rey, José. *A Cycle of Goya's Drawings.* London, 1956.

Madrid, 1982
Museo Municipal, Madrid. *Goya y la Constitución de 1812.* Exhibition catalogue. 1982.

Martínez Albiach, *Religiosidad*
Martínez Albiach, Alfredo. *Religiosidad hispana y sociedad borbónica.* Burgos, 1969.

Mateo Gómez, *Sillerías*
Mateo Gómez, Isabel. *Temas profanos en la escultura gótica española: Las sillerías de coro.* Madrid, 1979.

Nelson
Manuscript explanations to the *Caprichos.* William Rockhill Nelson Gallery of Art and Mary Atkins Museum of Fine Arts, Kansas City.

Nordström, *Goya*
Nordström, Folke. *Goya, Saturn and Melancholy.* Acta Universitatis Upsaliensis. *Figura*, n.s. 3. Stockholm, 1962.

Páez, *Grabados españoles*
Páez Rios, Elena. *Repertorio de grabados españoles en la Biblioteca Nacional.* 4 vols. Madrid, 1981-1985.

Prado
Manuscript explanations to the *Caprichos.* Museo del Prado, Madrid. First published in full by the Conde de la Viñaza.

Puigblanch, *Inquisition*
Puigblanch, Antonio. *The Inquisition Unmasked.* 2 vols. London, 1816-1817. (First Spanish edition, Cádiz, 1811.)

Quevedo, *Obras*
Quevedo y Villegas, Francisco de. *Obras escogidas.* 2nd. ed. 2 vols. Madrid, 1794.

Quevedo, *Sueños*
Quevedo y Villegas, Francisco de. *Sueños y discursos.* Edited by Felipe C.R. Maldonado. Madrid, 1973.

Revuelta González, *Política*
Revuelta González, Manuel, S. J. *Política religiosa de los liberales en el siglo XIX.* Madrid, 1973.

Ruiz de Padrón, *Inquisition*
Ruiz de Padrón, Antonio Joseph. *The Speech . . . of January 18, 1813, Relative to the Inquisition.* Mediterranean: Printed on board His Majesty's ship Caledonia, off Toulon, 1813.

Sánchez
Manuscript explanations to the *Caprichos* that belonged to Sánchez Gerona. Private collection, United States.

Sarrailh, *L'Espagne éclairée*
Sarrailh, Jean. *L'Espagne éclairée de la seconde moitié du XVIIIe siècle.* Paris, 1954.

Sayre, *Changing Image*
Sayre, Eleanor A., and the Department of Prints and Drawings, *The Changing Image: Prints by Francisco Goya.* Boston, 1974.

Sayre, "Goyas 'Spanien, Tiden och Historien' "
Sayre, Eleanor A., "Goyas 'Spanien, Tiden och Historien.' " In Nationalmuseum, Stockholm, *Konstverk i blickpunkten* 1 (1980).

Simon
Manuscript explanations to the *Caprichos.* Norton Simon, Pasadena.

Stirling
Manuscript explanations to the *Caprichos* that belonged to Sir William Stirling Maxwell. Private collection, Canada.

Terreros, *Diccionario,* **1786-1793**
Terreros y Pando, P. Esteban de. *Diccionario castellano con las voces de ciencias y artes y sus correspondientes en las tres lenguas francesa, latina é italiana.* 4 vols. Madrid, 1786-1793.